Praise for Mary Gabriel's
NINTH STREET WOMEN

A *New York Times* Critics' Top Book of the Year • A *New York Times* Best Art Book of the Year • A *Boston Globe* Best Book of the Year • A *Time* Magazine Best Book of Year • A WBUR (NPR) Best Book of the Year

"Generous and lush but also tough and precise... There's so much material roiling in *Ninth Street Women,* from exalted art criticism to the seamiest, most delicious gossip, that it's hard to convey even a sliver of its surprises."
—Jennifer Szalai, *New York Times*

"Gripping and enthralling. Mary Gabriel made me share every turbulent moment of these remarkable women's lives... The most devastatingly accurate portrayal of five women who had the temerity to call themselves artists in the male-dominated twentieth century."
—Deirdre Bair, author of *Al Capone: His Life, Legacy, and Legend*

"The author weaves a vivid tapestry of bohemian life in New York as that city was supplanting Paris as the capital of the art world... *Ninth Street Women* is like a great, sprawling Russian novel, filled with memorable characters and sharply etched scenes." —Ann Landi, *Wall Street Journal*

"A marvelously enjoyable book... Written in a fluid, conversational manner, readers will find it difficult to put down despite its considerable length." —Terry Hartle, *Christian Science Monitor*

"Abstract Expressionism is considered the first major American art movement, but, as Gabriel shows, it was also a movement that could only have happened in America... Gabriel has achieved a comprehensive, landmark study of what it was like, in the time of the Abstract Expressionist movement, to be a woman and an artist in a man's world."
—Leann Davis Alspaugh, *The New Criterion*

"A must-read... Gabriel seamlessly weaves the intimate and the public, the lives and the art, making us feel we were there... It is a story that is a part of the American story, told here in vivid, meaningful detail, an absolutely pivotal text." —Margaret Randall, *Women's Review of Books*

"Sheer delight. With palpable empathy for the flawed brilliance of her five stars, their jealous foes, and their long-suffering enablers, Gabriel conjures the high-risk paths they chose, what making great art cost their lives, and what they lost and won in the end."
—Michael Findlay, director of Acquavella Galleries and author of *Seeing Slowly: Looking at Modern Art*

"An avidly researched, deeply analyzed, gorgeously written, and endlessly involving five-track mix of biography and history... Gabriel has created an incandescent, engrossing, and paradigm-altering art epic."
—*Booklist* (starred review)

"A compulsively readable book... The detailed, sensitive portrait is one not just of these five women but of the complicated era that birthed them. *Ninth Street Women* reads like a novel."
—Jan Weismiller, Iowa Public Radio

"I loved every page of this necessary book."
—Brad Gooch, author of *Rumi's Secret: The Life of the Sufi Poet of Love*

"The stories of these women remind us of the duty of the artist in the face of crisis. At a time when hatred and bigotry ran rampant, women committing themselves to their art was itself an act of defiance. As Gabriel says, 'These women would still be radical today.'"
—Jessica Jacolbe, *Vice/Garage*

"Fascinating. Gabriel is deft at teasing out the behind-the-scenes drama in these women's lives and careers. Essential reading for any student of the period, and of the New York School generally."
—David Salle, author of *How to See: Looking, Talking, and Thinking about Art*

"Richly atmospheric, *Ninth Street Women* vividly chronicles its subjects' overlapping life stories and path-breaking careers against a backdrop of dramatic cultural and social change." —Edward M. Gómez, *Hyperallergic*

"Masterful. Mixing critical insight with juicy storytelling, Gabriel brings five brilliant female painters to the fore of the art revolution that cut a wide swath in postwar America."
—Patricia Albers, author of *Joan Mitchell: Lady Painter*

NINTH STREET WOMEN

Also by Mary Gabriel

Notorious Victoria: The Life of Victoria Woodhull, Uncensored
The Art of Acquiring: A Portrait of Etta and Claribel Cone
Love and Capital: Karl and Jenny Marx and the Birth of a Revolution

NINTH STREET WOMEN

Lee Krasner, Elaine de Kooning, Grace Hartigan,
Joan Mitchell, and Helen Frankenthaler:
Five Painters and the Movement That
Changed Modern Art

MARY GABRIEL

Back Bay Books
LITTLE, BROWN AND COMPANY
New York Boston London

For my mother

Copyright © 2018 by Mary Gabriel

Hachette Book Group supports the right to free expression and the value of copyright. The purpose of copyright is to encourage writers and artists to produce the creative works that enrich our culture.

The scanning, uploading, and distribution of this book without written permission is a theft of the author's intellectual property. If you would like permission to use material from the book (other than review purposes), please contact permissions@hbgusa.com. Thank you for your support of the author's rights.

Back Bay Books / Little, Brown and Company
Hachette Book Group
1290 Avenue of the Americas, New York, NY 10104
littlebrown.com

Originally published in hardcover by Little, Brown and Company, September 2018
First Back Bay paperback edition, September 2019

Back Bay Books is an imprint of Little, Brown and Company, a division of Hachette Book Group, Inc. The Back Bay Books name and logo are trademarks of Hachette Book Group, Inc.

The publisher is not responsible for websites (or their content) that are not owned by the publisher.

Copyright and permissions acknowledgments appear on pages 723–26.

The Hachette Speakers Bureau provides a wide range of authors for speaking events. To find out more, go to www.hachettespeakersbureau.com or call (866) 376-6591.

ISBN 978-0-316-22618-9 (hardcover) / 978-0-316-22617-2 (paperback)
LCCN 2017962712

Printing 11, 2024
LSC-C

Printed in the United States of America

Contents

Introduction — xi

Prologue: The Ninth Street Show, New York, May 1951 — 5

PART ONE, 1928–1948

Lee

1. Lena, Lenore, Lee — 21
2. The Gathering Storm — 35
3. The End of the Beginning — 44

Elaine

4. Marie Catherine Mary Ellen O'Brien Fried's Daughter — 55
5. The Master and Elaine — 66

Art in War

6. The Flight of the Artists — 77
7. It Is War, Everywhere, Always — 90
8. Chelsea — 100
9. Intellectual Occupation — 110
10. The High Beam — 122
11. A Light That Blinds, I — 136
12. A Light That Blinds, II — 148

The Turning Point

13. It's 1919 Over Again! — 165
14. Awakenings — 173
15. Separate Together — 182
16. Peintres Maudits — 195
17. Lyrical Desperation — 203

18. Death Visits the Kingdom of the Saints	217
19. The New Arcadia	226

PART TWO, 1948–1951

Grace

20. The Call of the Wild	241
21. The Acts of the Apostles, I	255
22. The Acts of the Apostles, II	262
23. Fame	271
24. The Flowering	284
25. Riot and Risk	296

Helen

26. The Deep End of Wonder	311
27. The Thrill of It	326
28. The Puppet Master	340

Joan

29. Painted Poems	357
30. Mexico to Manhattan via Paris and Prague	371
31. Waifs and Minstrels	387

PART THREE, 1951–1955

Oh, to Leave a Trace

32. Coming Out	405
33. The Perils of Discovery	414
34. Said the Poet to the Painter	422
35. Neither by Design nor Definition	439

Discoveries of Heart and Hand

36. Swimming against a Riptide	457
37. At the Threshold	468
38. Figures and Speech	480
39. Refuge	493

40. A Change of Art	505
41. Life or Art	518
42. The Red House	530

Five Women

43. The Grand Girls, I	547
44. The Grand Girls, II	560
45. The Grand Girls, III	576

PART FOUR, 1956–1959

The Rise and the Unraveling

46. Embarkation Point	593
47. Without Him	608
48. The Gold Rush	620
49. A Woman's Decision	635
50. Sputnik, Beatnik, and Pop	650
51. Bridal Lace and Widow's Weeds	661
52. Five Paths…	676
53. …Forward	687
Epilogue	701
Acknowledgments	717
Copyright and Permissions Acknowledgments	723
Notes	727
Bibliography	866
Index	892

Introduction

THE IDEA FOR this book arose out of a conversation I had with painter Grace Hartigan in the fall of 1990. At sixty-eight, she was in the midst of her biggest year in decades, with multiple exhibitions scheduled and a monograph of her work newly released. The publisher of the art magazine where I worked decided that all this activity warranted a feature, which she asked me to write. It was an assignment I approached with trepidation. I had known of Grace for years; she was the head of the graduate painting program at the Maryland Institute College of Art while I was an undergraduate. From a safe distance, I had watched terrified as she walked, blond and imperious, ahead of a gaggle of eager students, held forth loudly amid rapt listeners at the Mount Royal Tavern next door, and delivered withering critiques as she toured classrooms and studios. From my student perspective, she was a tough old bird who I imagined had had to fight throughout her career against art world prejudices that viewed a woman's art as "women's work" (inherently lesser) and that, having endured such systematic debasement, she was not inclined toward magnanimity. I therefore rang the bell at her Baltimore loft braced for an hour with an impatient, dismissive diva. Of greatest interest to me as I waited on the street below was how many minutes would pass until I could return there.

And then Grace opened the door.

The woman who greeted me warmly and generously was utterly disarming. She bore no resemblance to the person I had grown to fear. Confused and smitten, I followed her up the many flights to her studio, where we sat as our one-hour interview stretched into four, as the light through her massive windows faded from gold to gray, as the story she told stirred my imagination and changed my life. I was in the presence of a woman who had sacrificed everything, including her only child, to be what she was: an artist. The rewards had been few, beyond a life well lived (not materially, but spiritually) and the recognition in her waning years that she had been honest about who she was and what she needed. A rare accomplishment for a woman of any generation, it was particularly so of hers, when servitude to family was the only goal toward which a "healthy" woman was to aspire. Grace was living proof that, on the contrary, a life

dreamed could be a life lived. All it took was courage, commitment, and humor. I remember both of us laughing a lot that afternoon. Though the subject was serious, the stories Grace told were fantastic and the woman who recounted them was as wild as the twenty-six-year-old who had abandoned everything in 1948 to paint, though she wasn't even sure how.

Grace was part of the art movement born in New York in the 1930s that shifted the capital of Western culture from Paris to New York, and changed the very history of art. It was nothing short of a revolution and, like every revolutionary endeavor, it was peopled with an assortment of talented, brilliant, and mad visionaries who existed, initially, so far outside society that they were invisible to everyone but each other. She described the people she counted as friends—men and women, straight and gay, writers and painters and composers—who survived and thrived during the most turbulent two decades of modern U.S. history and amid a society so timidly conservative that its greatest ambition was conformity. Grace and her friends were outlaws in that world, joyfully upending every tradition that presented itself—artistic and social—and in the process creating a new way of painting, sculpting, writing, and composing that shaped the standards by which we still make and appreciate art today. But Grace's stories went beyond the sweeping importance of the movement. She described the intimate struggles endured and victories achieved by people who became legend and, almost more interestingly and significantly, people long forgotten who were nonetheless vitally important to their peers. In each of those stories, because Grace spoke of friends, the trials and triumphs felt immediate. Art wasn't removed from life, it was life.

I had never encountered art history as stirring. Paintings I had only half understood now came alive because I felt I had met, if only figuratively, the artists who made them. I began to understand the cross-pollination between painting and music, or painting and poetry, through Grace's myriad tales of the writers and composers she knew and loved. And I recognized the necessity of understanding the times in which Grace and her fellow artists lived. They did not create in a vacuum, as those who rely on theory to explain art often imply. They had not expunged all recognizable imagery from their work on an aesthetic whim or to coldly advance the progression of modern art begun in the previous century. They stripped their work of all life except their own internal meanderings because they existed in a world destroyed by war, dehumanized by the death camps, and denied a future by the atomic bomb. Under those circumstances, what else could they paint with any degree of honesty?

As Grace spoke, she didn't dwell on the fact that she was a woman artist or that other women formed an important part of the Abstract Expressionist group. But each time she mentioned a woman painter or sculptor, I

found myself wondering why, in the official history, those names so rarely surfaced. Their contributions were significant. In fact, in the cases of Lee Krasner and Elaine de Kooning, the movement would not have existed or unfolded as it did without them. And yet, the story of that movement has been taught and accepted as the tale of a few heroic men.

There are many reasons for that interpretation, some endemic to the history of art, in which man is traditionally the creator and woman the muse, and some specific to America at mid-century. Prior to the Abstract Expressionists, Americans generally mistrusted male artists (female artists weren't even worth discussing) and labeled them as effete or elitist. The New York crowd, beginning in the 1930s, was the first generation to make painting and sculpture an American "manly" occupation. The movement's macho character was, therefore, part and parcel of the transformation it initiated. But another important reason the Abstract Expressionist story has belonged to men involves something much more insidious: the market. When art became a "business" in the turbocharged consumer economy of the late 1950s, work by women artists wasn't considered as valuable as that of men, which meant dealers didn't show it, magazines didn't write about it, collectors didn't buy or donate it to museums, and art history courses failed to mention it. Gradually, most of the women who were part of the Abstract Expressionist movement were at best sidelined and at worst forgotten, despite the fact that they had been heralded before the "art business" took control of the art world and that they were pioneers, breaking down centuries-old cultural and social barriers.

Before the Abstract Expressionists, professional women artists were considered exceptional, either oddballs or "European" because they worked in a less hostile climate abroad. Beginning in the 1930s, however, women artists formed part of the New York art scene and by the 1950s, a handful of them had reached its very center. That history has been largely lost, leaving the chronicle of Abstract Expressionism half told, and robbing many aspiring artists of an awareness of a grand tradition.

It is true that art, while indebted to tradition, is usually at odds with it; art is about the thrill of mutiny. Young painters and sculptors are particularly unwilling to be hampered by the past, especially if that past is encased in the cement shoes of gender. But familiarity with tradition can be liberating for an artist because it provides a map illustrating the route other people have taken, which is especially valuable at the start of such a perilous journey. Male artists can inspire and instruct, surely. Artistic concerns are gender neutral. But there are social and personal issues a woman artist faces that cannot be found in the stories of men; these are the obstacles confronted and obstacles overcome. The poet Adrienne Rich wrote, "For spiritual values and a creative tradition to continue unbroken we need

concrete artifacts, the work of hands, written words to read, images to look at, a dialogue with brave and imaginative women who came before us."[1] It's instructive as well as comforting to know how other women have managed and what other women have dared. It's also gratifying to find in their stories an occasional energizing dose of inspiration. When Grace began her quest to become an artist, she faced two questions: How do I paint? and How do I live as a painter? She turned to Jackson Pollock and Willem de Kooning to help with the first. To answer the second, she turned to a woman, Elaine. I am ashamed to say that before I met Grace I would not have considered asking her advice on the subject. I was too indebted to a Western art tradition to imagine a woman artist had as much to teach me as a man. After my evening with her, I saw not only the value but the absolute necessity of learning from both.

I left Grace's studio reeling, my head filled with her tales—hilarious, tragic, edifying—and the question, why hadn't I heard this before? Why didn't I know that at the most thrilling moment in American art history, women were instrumental in its success and fruition, that men and women worked together as equals supporting one another in the greatest artistic experiment America had yet experienced amid a society arrayed against them and the art they produced. I decided to write a book to try to fill the void. Twenty years later, I finally began. *Ninth Street Women* is the result.

To tell the story as vividly and intimately as Grace told me, I decided to focus not on a single artist, but on a group of artists. I felt this would allow me to broaden the history and offer a truer, more vibrant portrait of the time. The avant-garde art community in New York at mid-century was tiny, but about one-third of the serious artists who formed part of it at any given moment were women—sometimes a dozen, sometimes as many as thirty. I chose a core five—Lee Krasner, Elaine de Kooning, Grace Hartigan, Joan Mitchell, and Helen Frankenthaler—based on the importance of their art or their personal significance to the movement. Also, because of the differences in their ages—a span of twenty years—each of these characters represented an important chapter in the development of Abstract Expressionism. During my years working on this project, I was aware of the irony of writing about these characters as "women artists" at all. None of them would have wanted to be characterized as such. The women among the Abstract Expressionists did not constitute a subgroup. They were painters. Period. As for their very real rebellion against a society that declared the best women to be those most easily ignored, Lee, Elaine, Grace, Joan, and Helen didn't rebel as much as ignore society's dictates. They didn't believe its rules pertained to them.

I went in search of their stories first through more than two hundred

interviews spanning sixty years, some of which I had the pleasure to conduct myself. I also pored through dozens of archives and collections belonging to libraries, foundations, and individuals, including several not previously open to the public, in a hunt for letters, journals, and notes. Those primary materials, written by the various characters, their friends, and their extended colleagues, helped me establish a clearer picture of their world as they lived it, as opposed to the way it has been interpreted over the past six decades. Finally, I spent years reading a mountain of general, women's, social, art, literary, and music history books pertaining to that period, as well as the many, many volumes describing the Abstract Expressionist artists, from the very first publications on the subject in the early 1940s to the most recent. What I was after was enough information to allow me to tell the full story, to introduce the reader to my artists in the society in which they lived. I chose to follow the path described by philosopher John Dewey, and art historians Erwin Panofsky and Meyer Schapiro, who taught that one is unable to understand art deeply without understanding the time and place in which a work was created, and without having a proper introduction to the artist responsible for the work.[2] The scope of my book expanded accordingly.

What I have come to write, through the biographies of five remarkable women, is the story of a cultural revolution that occurred between the years 1929 and 1959 as it arose out of the Depression and the Second World War, developed amid the Cold War and McCarthyism, and declined during the early boom years of America's consumer culture when the "latest" was inevitably the "best." Throughout the book, I have also described the ever-changing role of women in U.S. society, and the often overlooked spiritual importance of art to humankind. As I wrote, that last point became particularly relevant. The modern disassociation of the average person from art began at the very time when those who created it were most akin to them. The Abstract Expressionists were largely working people, the children of immigrants or immigrants themselves, men and women who lived a hard-scrabble existence. But because their art generally abandoned people, objects, and landscape—those elements most easily recognized by nonartists—it became difficult to understand and therefore easy to dismiss. Critics, art scholars, and museum officials often made matters worse. The formalist language that arose around art so obscured its meaning that art became removed from so-called real life. Gradually, society came to believe it didn't need art. And that is a tragedy, especially in an age such as ours.

Art serves a social function not unlike religion. For those who are open to it, it speaks directly to that aspect of man that is not beast-like, and stirs the part of modern man that is nearly calcified from neglect, his soul. I often thought, as I wrote, that our own troubled world is sorely lacking in

the nutrients that art provides. The stories told in this book might be a reminder that where there is art there is hope. Or, as Albert Camus wrote, "In the world of condemnation to death which is ours, artists bear witness to that in man which refuses to die."[3]

I would like to briefly explain my method to the reader so he or she does not feel cheated by a lack of traditional biographical detail. Because I am writing about five people during a period of a mere thirty years I had to be judicious in my choice of material, both for length and to fit the broader story line. I have used those elements of the five women's histories that are most pertinent to their lives as artists in the Abstract Expressionist milieu. For example, I don't dwell overly on childhoods and families except where doing so helps a reader understand essential facts that contributed to the artists' development. I don't spend time on specific dates that normally comprise and ritualize a person's life. I am interested less in a vertical history than a horizontal one, in other words, those experiences and people that influenced the artists, rather than their chronological development. Chronology is, in fact, a thorny issue in this book because memories about specific occurrences often conflicted, as did published accounts. Sometimes a letter appeared to help corroborate a date, sometimes a journal entry, but in other cases I had to rely on the logical preponderance of the evidence in placing an event at a particular time. Also, because the book ends in 1959, when the movement sputters and dies, I have, to my own frustration, offered mere snapshots of the characters' later lives. Those interested in full biographies of some of these women—dates and all—are lucky. In the past few years, biographies have been published on all but Helen Frankenthaler. References to the biographies of Lee Krasner, Elaine de Kooning, Joan Mitchell, and Grace Hartigan are included in the bibliography, as are many other wonderful biographies and books on the extraordinary characters with whom the Ninth Street Women lived and worked.

NINTH STREET WOMEN

And I am out on a limb, and it is the arm of God.
— *Frank O'Hara*[1]

Prologue

The Ninth Street Show, New York, May 1951

> I have come to the sad conclusion that there never was an age that was wholly civilized—that there was always the barbarism & savagery that we know to-day, with a few beautiful spirits who lit up their age.
>
> —*Janice Biala*[1]

THERE WAS NO shortage of ideas in the early morning as the artists who inhabited the Cedar Bar stumbled back to the ramshackle lofts where they lived illegally and worked without recognition from anyone outside their own minuscule community. But *this* idea gave them pause. As they said good night outside a derelict storefront on Ninth Street, they noticed the vast empty space within and agreed that, with a little effort, it would make a superb exhibition spot.[2] The painters and sculptors who lived just north and east of Washington Square Park had been largely excluded from the shows uptown, despite their well-publicized protests that no exhibition could be truly "modern" if it did not include the New York artists who were creating a revolution in paint and metal and stone. They knew, even if no one else chose to recognize it, that for the first time in history, the United States—New York—had become the center of the international art world. No longer would artists need to make the pilgrimage to Paris to absorb lessons from the masters. The masters were as close as lower Manhattan and no farther away than Long Island.

The men and women whose drunken laughter reverberated through the quiet street that April before dawn talked excitedly about the possibility of a salon des refusés in the nineteenth-century tradition and the opportunity to buck the uptown academy with their own artist-organized coming-out party. There was, however, a familiar impediment standing between their rebellious scheme and securing a space to house it: money. No one had the funds to pay the rent.[3] Milton Resnick, a battle-weary World War II veteran who was among the artists admiring the former furniture store, lived across the street with his painter girlfriend, Jean Steubing. He told her about the idea and went to bed. "In the morning she was gone," he said. While

Resnick slept off the previous night, Steubing met with the owner of the building that housed the storefront to negotiate a rental deal—fifty dollars for a month's use of the ninety-foot first floor and basement. The show had to be hung quickly, though. The building was slated for demolition.[4]

The news spread as a planning committee met to discuss the show in a studio next to the proposed exhibition site at 60 East Ninth Street, between Broadway and University Place in Greenwich Village. Painters John Ferren, Milton Resnick, Franz Kline, Esteban Vicente, Conrad Marca-Relli, and Elaine de Kooning, among others, considered the issues still to be resolved: Would it be an open show, or by invitation? Who would hang the works? Who should clean and paint the space? What about the lighting, publicity, and other costs? Even if everyone chipped in to pay the rent, more money would be needed, much more.[5] The discussions continued for days at another location, an Eighth Street loft known simply as the Club. It was a members-only meeting place where artists drank and danced but mostly argued about art, philosophy, music, religion, and poetry. Now the discussions focused almost exclusively on the show, which dozens of neglected painters and sculptors clamored to enter. The Club's guiding spirit, sculptor Philip Pavia, described the scene as "bedlam."[6]

The tight art community that gathered at the Club had arisen from the Depression-era Federal Art Project, which had paid artists a weekly survival salary to create. By 1951, its circle had expanded to include a younger generation. Those so-called Second Generation artists were resented by some Club members because they had not suffered—either financially or artistically—as much or as long as their elders, and some of the older men wanted to exclude them from the show. The younger women were especially resented by those who believed the women's works would diminish the strength and seriousness of the exhibition. Real art was a masculine domain, they argued. Women weren't innovators; their work was domestic, decorative. Yes, women artists were members of the Club—they livened up the place—but some of the First Generation weren't prepared to recognize *les gals* for anything beyond their pinup qualities: good figures, nice hair, great legs. After long and heated discussions, however, the strident old-timers were overruled. Unlike the museums and galleries uptown, the Ninth Street Show would strive to be inclusive. "The idea of the show was that we were equal...just all artists...no bullshit," Resnick explained.[7]

The work at the furniture store, meanwhile, proceeded briskly. Artists built dividers to increase the amount of exhibition space, scrubbed floors, whitewashed walls, and installed lights. Within two weeks the storefront was

ready. Given the acrimony over who might be in the exhibition, everyone agreed that the next step—hanging it—would require a diplomat. An artist would be accused of giving their friends the best spots in the show. An outsider was needed, and one was easily found.⁸

Leo Castelli had fled Europe in 1939, just before Paris fell to the Nazis, after mounting one spectacular Surrealist show in a building next to the Ritz in the Place Vendôme. He had arrived in the United States on forged papers with his wife and daughter, and quickly left them in New York to join the U.S. army in an intelligence unit in Bucharest.⁹ With the war's end, he became a "minister without portfolio," according to one artist, an "enabler" around the Village.¹⁰ The small, dapper, black-eyed gentleman with a cultured northern Italian accent preferred the company of artists to the textile manufacturers he associated with as a representative for his father-in-law's business. The artists weren't entirely sure what he did for a living—some thought he ran a T-shirt factory in Queens—but they knew he had art connections in Paris and that he hoped, eventually, to open a gallery in New York.¹¹

Castelli was their man. He was courteous—he smiled easily and spoke rarely—knew how to hang art, and he had money (less, in fact, than the artists believed, but more than they possessed). Painter Friedel Dzubas said Castelli was one of the few uptown people "with a little financial freedom that made themselves very available to the downtown roughnecks. Leo liked the whole thing."¹² The organizers asked Castelli if he wanted to oversee the hanging of the Ninth Street Show. His initial reaction was horror. "They'll kill me," he said, if he appeared to be biased in the placement of works. But Resnick advised him to make sure the biggest names weren't hung in the best locations and all would go well.¹³ In return for Castelli's services, and any money he could provide for incidentals, Bill de Kooning and some of the other artists would each give Leo one of their works.¹⁴ At that time, of course, none of the pieces had any monetary value to speak of, but it was considered an appropriate gesture of thanks for a man willing to embark on such an important and delicate mission. Leo agreed.

And so, the third week of May 1951, large paintings made their way along Eighth Street, Tenth Street, down Fourth Avenue, and up from the Lower East Side. Sometimes two legs, sometimes four legs were all that could be seen trundling below the slashing, screaming, color-saturated abstract canvases, or their equally expressive black-and-white brethren, created by artists who had stripped their work of the comfort of color to make gesture the dominant force in their paintings. Anyone lucky enough to have been on those streets at that time to catch a glimpse of

those traveling marvels would not have realized it, but they were witnessing nothing less than the future of modern art passing by.

Dazzling though much of that work was, it had been born out of nearly two decades of trauma resulting first from the Depression, and then from the devastation and sacrifices of the Second World War. Even those very few artists who were financially secure enough to have avoided the ravages of the economic collapse could not have failed to be affected by the social upheaval it produced. As for the war, it had been inescapable. "The war made everything different," recalled painter Mary Abbott, "and every*body* was different."[15] Mankind had unleashed its hidden beast and the result was not only the tangible horrors of Auschwitz and Hiroshima but a miasma of hatred, suspicion, and bigotry that lingered still. Under such circumstances artists continued to work, but they could no longer paint or sculpt the reassuring "things"—objects, landscapes, or people—that had occupied their predecessors for centuries. To do so would have seemed false, tantamount to nostalgia for an innocent past that had most likely never existed in the first place. The myths and themes of nationalism were also unworthy subjects in an age that had seen so many crimes committed in the name of the state. Religion? For many, it had been lost among the broken bodies piled up like cords of wood that had—for artists who had not witnessed them firsthand in war—appeared in newsreels at the cinema or in the front-page photographs of daily papers.

Artists who were able to, who *needed* to work despite the desolation of the times, had been forced to look deeper for a subject, to look inside the only thing they could be sure of—themselves. The result was abstraction free of anything but the material with which the art was made and the naked energy of the artist who produced it. These were individual, personal works, conforming to no school and utterly devoid of politics. And yet each piece, however unintentionally, did serve a greater social function. The work of the artists in postwar New York, like the work of artists during troubled periods throughout history, acted as a kind of beacon, a ping from hidden depths reminding those who searched for it that, all evidence to the contrary, civilization had not perished: If there is art, there is hope. Man is not a monster, because he yearns for truth and is capable of producing great beauty.

On Ninth Street, a greeting committee of sorts comprised of Castelli, Bill de Kooning, Franz Kline, and assorted other elder artists and show initiators occupied the makeshift gallery to accept and approve works submitted to the exhibition. Artists were allowed one piece and were encouraged to submit a small work to economize on space. Ultimately seventy-two art-

ists would be chosen to exhibit, including five women who would play pivotal roles in the movement born in New York. *ArtNews* editor Tom Hess, an important critic and champion of the group, would call them the "sparkling 'Amazons' who emerged in the flower of American painting."[16] They were as powerful as Amazons; as artists and as women, they were truly pioneers.

The veteran among them, Lee Krasner, had sent in a painting for the show from Long Island, where she was preparing for a solo exhibition in the fall. It would be her first since she had begun painting professionally sixteen years earlier. Independent, strong, and fiercely political, beginning in the late 1930s, Lee had been one of the foremost artists in New York because of the avant-garde work she produced, her leadership role in the art community, and her remarkable ability to recognize great art. Lee was credited with having one of the best eyes in the country for new work. But from the time she had begun living with her future husband, Jackson Pollock, in 1942, her art, indeed her life, was obscured by his formidable shadow. Lee Krasner the artist nearly disappeared. Colleagues whispered among themselves that she had stopped painting altogether, that Jackson wouldn't allow it. Neither assertion was true. Lee had continued working. With its myopic vision, the art world had simply failed to see it. "Back then there was so much extra-art garbage surrounding her work that it was an effort to move into the pure center and experience the painting for its own sake," playwright Edward Albee wrote of Lee years later. "These piles of garbage were named 'female artist' and 'wife of artist.'"[17] The year of the Ninth Street Show, Lee proudly and excitedly prepared to make a comeback devoid of the qualifying adjectives that had been attached to her name to diminish her achievements.

At twenty-two, Helen Frankenthaler was the youngest artist in the show and, with the chutzpah of youth, she had submitted the largest painting—more than seven feet long. With the help of friends, she had joyously hauled it across busy avenues, past buses filled with gaping passengers, through rows of cars backed up in traffic to Ninth Street from her studio nearby.[18] Would Helen have had advance permission to submit such a large work? Probably not. Would she have worried that it would be rejected? Not for a minute. Helen categorically refused to acknowledge artistic or social limits that were not self-imposed. She also had a deep reservoir of confidence in her ability as an artist that was unusual even for a more mature painter. It was not misplaced. Within two years she would produce a work of art so original it would spawn a new school of painting. But at the time of the Ninth Street Show, because Helen was not long out of Bennington, some of the older men grumbled that she was only in the exhibition because she was "Clem's girl"—the much younger consort of

the most powerful art critic on the scene, Clement Greenberg. Helen, who had been made mature beyond her years by painful personal experience, wouldn't have dignified that suggestion with anger. She would have dismissed it with a laugh. As she reminded an interviewer decades later, she wasn't "Clem's girl," she was "Helen's girl."[19]

Helen's close friend Grace Hartigan, whom New York journalist Pete Hamill called "fifty miles of trouble out of a film noir," had endured an unusually tumultuous period while finishing her painting for the show. Dead broke and in the midst of having her second marriage annulled, in late April she had listened to her nine-year-old son cry himself to sleep during a visit to her Lower East Side loft.[20] Grace had long before concluded that she could not be both a serious artist *and* a mother and had given Jeff to his grandparents to be raised in New Jersey. Now she saw her son only during emotionally charged weekends. The rest of her time was spent painting, or struggling to find the money to buy the materials to paint. The relationships she valued most were those that enabled or inspired her — with painters or poets, or lovers who were content to remain such. Anything else (especially that cumbersome attachment called a husband) was a distraction she could not afford and would not tolerate. She had worked too hard, sacrificed too much to be shackled by social convention. In fact, the most important man in her life would be the poet Frank O'Hara. Only he truly understood her. They understood each other. That he preferred men sexually didn't trouble Grace a bit. "I love men, why shouldn't he!" she exclaimed.[21] When Grace first moved to New York as a novice painter, she had stood outside the Museum of Modern Art, dreaming of seeing her work on its walls. Remarkably, within just a few years, she would. Grace would be the first of the Second Generation painters — male or female — to be so honored. She would also become one of the most celebrated painters of the 1950s.

Joan Mitchell had lately arrived in New York from Chicago, via Paris and the South of France, where she had turned the living room of a villa into a studio. There she had painted until her hands grew red and raw from turpentine, until her clothes were covered in paint, until all recognizable figures had been eliminated and replaced by the abstract markings that reflected both the inner turmoil that had engulfed her since she was a child and the soaring creative spirit that had managed to rise above her torment. Joan, too, had been embroiled in high drama before the show. In April, her painter boyfriend, Mike Goldberg, had forged a five-hundred-dollar check from an account belonging to Mitchell's husband, publisher Barney Rosset. Barney agreed to drop the charges if Mike disappeared into a mental institution for six months.[22] He did, and soon the sordid details began to filter through the small art community.

Castelli's concern wasn't the melodrama around the two artists, it was getting their work to Ninth Street. He walked around the corner to Joan's Tenth Street studio to help carry her painting and Goldberg's to the exhibition, but seeing the size of her work—six feet by six feet—he warned that it might be rejected. Castelli's hesitation would have unnerved her. Unlike Helen, Joan was insecure; her tough exterior hid an extremely fragile artist. However, she was lucky. The gatekeepers at Ninth Street when her painting arrived were Bill de Kooning and Franz Kline. They liked her painting and waved it through.[23] In fact, Joan was considered one of the most accomplished artists in New York. Soon, her reputation and influence would extend to Europe.

Finally, Elaine de Kooning brought in her piece. There was no question it would be accepted. As an artist, critic, and one-half of the most defiantly open and equal marriage on the downtown scene, she was a dominant figure among the group that frequented the Club and the Cedar. Elaine had appeared among the artists some thirteen years earlier, soon after graduating from high school in Brooklyn. It had been immediately evident that this willowy former dancer was not only beautiful, she was brilliant, too. Traversing the worlds of painting and writing, Elaine acted as a bridge between them and so helped introduce the greater world to the artists of the New York School. Like Lee, she was another "wife of," and her reputation as an artist had suffered by association. But Elaine's generous, exuberant spirit was so great that there was no possibility she would be confined to a subordinate role. "Elaine said," "Elaine's coming," "Elaine was there" were all repeated with excitement, if not awe, among the art community. Men notoriously loved her, and younger women aspired to be her.[24]

Indeed, all five of these artists formed part of a new breed existing unapologetically outside the mainstream of American life at mid-century. Each was as unique as the work she produced. What they shared was courage, a spirit of rebellion, and a commitment to create. Painter Elise Asher, who had arrived in New York in 1951, recalled meeting Elaine and Lee together on the street that year. "They seemed so knowing, so strong, so in it and of it, so absolutely sure, so central and in the center, I was overwhelmed and couldn't say a word in front of these powerful women."[25] Each would pay a price for selecting art over the life society would have prescribed for her. But it is impossible to imagine that any of them, despite the cost, regretted the decision. They simply had no choice. They were artists. There was no other path.

Under Castelli's direction (with assistance from Franz Kline), the installation and hanging of the show took three days. ("Hung the show! I hung it twenty times. Each time it was done, an artist would come and raise hell

about the placing of his painting," Castelli recalled with exasperation.)[26] By May 21 it was ready. Franz had designed black-and-white announcements in his singular style listing the show's participants. A huge banner was stretched across Ninth Street advertising the event. And, for dramatic effect, painter Lutz Sander hung a three-hundred-watt lightbulb from a flagpole on the second floor to illuminate the facade. Sixty East Ninth Street and the art therein was officially impossible to ignore.[27]

At nine p.m. on that warm spring night, the artists gathered to look at what they had accomplished.[28] Works by names that were then largely unknown but would become history burst from the walls: Bill de Kooning, Pollock, Kline, Motherwell, Frankenthaler, Hartigan, Resnick, and Rauschenberg hung alongside Krasner, Jack Tworkov, Elaine de Kooning, Joseph Cornell, Hans Hofmann, Mitchell, and Ad Reinhardt, with sculpture by David Smith, Ibram Lassaw, and Philip Pavia scattered elegantly around the space.

The artists had seen one another's work during studio visits, or on the rare occasions when one of them had an opening, but the Ninth Street Show was the first time the entire group had hung together. The effect was explosive and unexpected. As different as all the artists were aesthetically and personally, the unity in their work was striking. It wasn't a matter of copying one another; they had *influenced* one another and, judging from the art on display, were richer for it. Reverberating off the walls was a vibrant exchange involving diverse generations and nationalities, men and women, uptown and downtown artists.

The artists were overjoyed. Sculptor Ibram Lassaw said Ninth Street gave them "the first feelings of an identity." Castelli said it "proved that their art was new and important—and better than what was being made in Paris."[29] And to those galleries that had ignored or dismissed their work, painter Herman Cherry said the exhibition sent a message that was as direct as it was unmistakable: "Fuck you, we don't need you...the artist actually controlled the art world."[30]

The show's participants celebrated themselves, one another, and their creations, and then something remarkable happened. Cars began to pull up. Cabs appeared. "It was like, you know, the old newsreel pictures from a movie opening in Grauman's Chinese Theatre in Hollywood," recalled Sander. "And you know the strong lights that they used in those days that blotted out everybody? Well, that's what it looked like. There was this stark light hanging out front...and the jam of taxis pulling up, you know, five or six at a time. People getting out in evening clothes. Whoever they were."[31]

Among the arrivals was Alfred Barr Jr., the original director of the Museum of Modern Art and still considered the hand of God when it came to an artist's career. Though Barr and his closest associate, Dorothy

Miller (another powerful arbiter of artistic taste at the museum), had made many studio visits, the show would be the first time they would see the entire group hung together. It would be the first time they would be faced with the fact that something big, *really big*, was happening in New York. Barr stood stunned. He found Castelli and asked him about the origin of the show. "So, I went with Barr to the Cedar Bar while the show was still going on and told him a little bit about how the show came into being," Castelli explained. Leo showed Barr photos of the installation and recited the names of the artists as Barr took notes.[32] In a very short while, names from that list would become part of the Modern's collection alongside the European legends who had inspired them.

The Ninth Street Show was a success, much more than the artists anticipated or could have dreamed of. Among themselves, they had long experienced—albeit on a much smaller scale—the excitement on display at the opening. Now others, outsiders, some with real power recognized and applauded their art, too.[33] Philip Pavia wrote that the show made it clear that "no amount of blockage by uptown redcoat dealers and no pile of abstract nouns by the hostile critics would stop the avalanche.... It was the beginning of the end of modern art as shown in stacks of history books."[34] The triumph was capped, as were all openings in those days, with an afterparty at the Club.

The stream of artists and their vast circle of friends climbing the three flights of rickety stairs seemed endless and the scene behind the red door through which normally only members and their guests were permitted nothing short of riotous. Exhilaration gripped them all. In one corner of the smoke-filled loft, composers John Cage and Morty Feldman, and dancer Merce Cunningham, plotted collaborations. Off to the side, gallery owner Sidney Janis performed a "very suave tango," and in the center of the room John Bernard Myers, an outsize character whose fledgling Tibor de Nagy Gallery would become home to many Second Generation artists, entertained with extravagant sketches that left his audience weak with laughter. Amid all that, as copious amounts of whiskey were drunk from paper cups, a phonograph blasted Louis Armstrong's "I'm Not Rough," to which a surprisingly unrestrained Clem Greenberg jitterbugged "violently" with Helen. Everyone danced. They danced until the floor shook so hard that many feared it would collapse. Judith Malina, whose Living Theatre would be the prototype for the Off Broadway production, wrote in her diary after attending the party that the Ninth Street Show was nothing short of marvelous.[35]

In the weeks that followed, before the exhibition closed in mid-June, the artists took turns manning the door. One of them, Lewin Alcopley, was

born in Germany, where he'd studied philosophy with Heidegger and earned a medical degree before fleeing to the United States under threat of arrest by the Nazis for smuggling banned books. While in New York he learned that much of the family he had left behind had become victims of the Holocaust. He began to paint, and soon found himself among the avant-garde art community in the Village. They became his extended aesthetic family, and the Ninth Street Show was, in a sense, a celebration of those bonds—not just for Alcopley but for all the artists.[36] One quiet evening, while he was guarding the exhibition, an elderly black woman appeared at the door and asked if she could come in.

"Yes, come in," Alcopley said in his heavily accented English.

"How much is it?" she asked timidly.

"There is no cost."

"It doesn't cost anything?"

"No, come in and stay as long as you like."

The woman was only about sixty-four or sixty-five, but Alcopley said she looked much older, no doubt due to hard work and long hours in those days of segregation, when the only employment available to her would have been some form of manual labor. "She had a very sensitive face, and a kind of wonder in her eyes," he said. He decided to follow her to see what most interested her, and he found that she always stood in front of the abstract pictures he liked best. After studying a particular work for some time, she mused aloud, "The artist who did this must have known a great deal." He asked if she often went to art exhibitions.

"No, I never went to art exhibitions."

"Did you ever go to museums?"

"No."

Did she have paintings in her home? No, she said, but she had cut photos from magazines and hung them on the wall.

"Why?"

"I like to have pictures around me." The woman said she wanted to bring her family back to see the exhibition. "Is that all right?" she asked.

Alcopley replied, "Yes."

"Oh, this is such a beautiful show, so many shapes, and so much space," she said on leaving.

Alcopley was "flabbergasted" by her thoughtfulness about work that was still beyond the comprehension of most critics and museum officials. Through that modest woman, he said, he had "realized then and there that there is a certain aristocracy of people who understand art. This has nothing to do with education whatsoever." That "remarkable" woman had taught him that to be "knowledgeable about art and to really understand it

are two different things.... That's another reason I will never forget the Ninth Street Show," he said decades later, laughing deeply.[37]

No one who was involved with the show, least of all the women whose work hung alongside their male colleagues' in the most important exhibition of their time, would forget it.[38] Clem Greenberg said the reverberations from the show were felt for years.[39] In fact, they are still being felt. For the world of art, the Ninth Street Show changed everything.

PART ONE

1928–1948

Lee

1. Lena, Lenore, Lee

> Look, darling, I didn't give birth to myself and you inherit a lot of stuff right on your back from birth. You're given a load of shit at birth. Now I don't want to inherit: I want to choose my life and build it to suit me.
>
> —Louise Nevelson[1]

"How well I remember it, Lee Krasner arrived walking up to that second floor with her portfolio. How did she look and what effect did she have on me, Lillian Kiesler?

"She wore, she was dressed, in a black blouse, a black tight skirt, black knit stockings and high heel shoes... even walking in she had an animal magnetism and energy, a kind of arrogance that blinds, that makes waves happen."

Lillian, who was then Lillian Olinsey, encountered Lee in 1937 in Lillian's capacity as a volunteer registrar for the most advanced art school in the nation.[2] It was less a school, in fact, than an atelier run by a German painter whose true talent as a teacher lay in his ability to inspire. Hans Hofmann's name was legend among artists hoping to tap the vein that began with Manet and led through Kandinsky, Miró, Matisse, and Picasso. Lee had discovered those artists eight years earlier at the new Museum of Modern Art, but she still had not found a way to use their vocabulary in her work. The only teacher in town who could help her was Hofmann.

"I can remember myself, going into that small office and saying to Hans that there was a unique student upstairs, a girl by the name of Lee Krasner," Kiesler recalled. By way of introduction, Lee had shown her some drawings, things she had done as a student and in life drawing sessions around the Village. Kiesler was struck by their strength. They weren't just drawings of a nude model; the artist herself jumped off the paper. Lee's style was already distinctive, her lines dark, definite, determined. "They were so above all the work that was being done in that school.... I found her just a phenomenon that first day." Kiesler surprised herself by demanding that Hofmann give Lee a scholarship. He agreed on the force of her recommendation, without bothering to see the work himself.[3]

Several days later, when Lee returned to the school, Hofmann came into the studio during a life drawing session. Moving from student to student, he criticized their work in a peculiar English peppered with German

that was nearly impossible to decipher.[4] The tension during such crits was palpable. Hofmann's judgment was the judgment of Paris, of pre–World War I Paris, where he had painted alongside Matisse and Picasso. Coming to Lee during that first class, Hofmann lifted her drawing off the board it was attached to, tore the lower part of the sketch, and placed the torn piece on top of the intact drawing. Lee stood speechless. There had been no introduction, no discussion of what she was striving for in her work, just the sound of paper tearing and a jolly fat man blithely destroying and rearranging her work.

"I remember Hans later saying to me that yes...she was a most powerful student, one of the *most* powerful students, but that she, of course, needed criticism," Kiesler said.[5]

Lee would rise to the challenge and became one of Hofmann's stars. Years later, when Jackson Pollock was listed among Hofmann's celebrity pupils, the old man corrected the history, saying no, Pollock was not *my* student, he was a *student of my student*—Lee Krasner.[6]

The dynamic young woman who appeared at Hofmann's school came from a family of Russian immigrants who ran a fish, vegetable, and fruit stand in Brooklyn. She was born Lena, reinvented herself as Lenore, and would eventually settle on Lee. (Along the way her family name would also change: Krassner became Krasner.) Lee left Brooklyn in 1921 for Manhattan to study applied art at an all-girls' public high school and then enrolled in 1926 at age seventeen for two years at Cooper Union, which also offered a women-only program.[7] Despite the gender segregation, Lee was not cloistered in either school. She had moved to Greenwich Village, making a home there among intellectuals and bohemians whose political allegiances tended toward Trotsky and whose taste in art was thoroughly French. She lived an unselfconsciously liberated existence—not because she had read about such a life in books and aspired to emulate it but because that was who she was.

Lee had a long history of rebellion. As a girl, she had announced she was no longer a practicing Jew because she realized that, according to her morning prayers, God favored men over women. When her elder sister died, she refused to marry her brother-in-law and assume responsibility for his children, as was the custom in Orthodox immigrant families. (Lee saddled her fourteen-year-old sister with that burden, for which her sister never forgave her.) In school, she annoyed her teachers. (One wrote, "This student is always a bother...insists upon having her own way.")[8] Lee had charted an alternate course in a world that told her a woman's duty was to submit to her family, to the man she would marry, and eventually to the whims of her children. She wanted none of it. It was in daring to declare

herself an artist, however, that Lee positioned herself forever beyond the social pale.

At the start of the decade, women had won the right to vote and, in subsequent years, these newly empowered citizens made strides in some professions—medicine, law, and literature among them.[9] But the door had remained firmly closed to women who wanted to be professional artists. It wasn't just a matter of sex. America's hallowed work ethic rewarded those who kept their nose to the grindstone and eyes averted from the stars. Fine artists and their products were simply not valued, their activities seen as superfluous. It was almost unheard of for an American man in the first half of the twentieth century to call himself an artist and hope to live on the proceeds of his work, unless he traveled in cultured circles that embarked on annual voyages to Europe. For a woman, it was a near impossibility— unless, again, she had the means to resettle abroad.[10] For a working-class Jewish woman like Lee, it was unthinkable.[11] Many years later, she located the plight of the woman artist in the historic struggle waged by men against women that was as old as Judeo-Christian history. Handily brushing aside that heavy burden, Lee said, "There's nothing I can do about those 5,000 years."[12] She determined to be an artist anyway.

The phenomenon named Lena Lenore Lee Krassner Krasner was her first creation. "I came out of nowhere," Lee explained.[13] She had had no material help; her parents allowed her to do what she wanted as long as she didn't ask for anything. She was not inspired to be an artist by example; the only painting in the family home was a reproduction of Queen Isabella. And when she began to study art, she said she wasn't even sure what the word meant.[14] In fact, far from receiving encouragement on her chosen path, Lee was actively *discouraged*. She repeatedly received failing marks because she could not do the academic drawing required of students.[15] And yet, she persevered. She was driven from an early age by an inner force that was as undeniable and unstoppable as it was inexplicable.

Lee left Cooper Union in 1928, in search of something more serious, and enrolled at one of the oldest and best fine arts schools in the United States, the National Academy of Design. As part of her portfolio for admission, she submitted a self-portrait that she had painted outdoors by positioning a mirror on a tree. It was so good, and the plein air composition so unusual, that the admissions committee didn't believe she had done the painting in the location and manner she had claimed. Accepted on a probationary status, Lee took her place among the six hundred students receiving the Academy's traditional École des Beaux-Arts training. One of them was a tall blond Russian aristocrat who drove a yellow-and-chrome Lincoln convertible.[16] His name was Igor Pantuhoff.

While Lee's immigrant family had come from a Russian shtetl, Igor's

father had been a friend of the last czar, Nicholas (some accounts say he was the czar's cousin), and the family had lived in a town adjoining the Imperial Palace. Having chosen the losing side in the fight between the czar's army and the Bolsheviks, Igor's father swept his family to safety, eventually settling them comfortably into an apartment on Central Park West.[17] Igor was an accomplished portraitist and classical artist of the type the Academy championed. He therefore excelled at school, winning many of its prizes, including the coveted Prix de Rome.[18] On the surface, he was a veritable prince charming: talented, "startlingly handsome," exotic. But during the nearly ten years that he and Lee were lovers, he proved to be a cruel, anti-Semitic, and dishonest drunk. In his thick Russian accent, Igor once publicly stated in reference to Lee that he liked "being with an ugly woman because it makes me feel more handsome."[19] Their complex relationship would, in some ways, be an unfortunate template for her future marriage to Pollock. Igor and Jackson were both troubled men who represented for Lee a load that she would choose to bear out of respect for their talent and, despite their many flaws, out of love for the men. She believed her strength could save them. They did, too. "It never was surprising to me...that the most desirable men would be attracted to her, why not?" asked Lillian. "She gave them an ambiance that they would not have if it were not for Lee. She really did make the waves happen."[20]

Igor and Lee made a remarkable team, both in the Academy and around Washington Square. Voluble and outwardly self-assured, Igor made friends easily across the spectrum of society. His home, however, was in a more moneyed class; it was where he belonged and what he aspired to. He set out to teach Lee how to dress the part, selecting clothes to enhance a body that was often described as voluptuous, fantastic, "luminous"—and applying makeup, not to soften her strong features, but to accentuate them. Under Igor's tutelage, Lee wore multiple shades of eye shadow, dark kohl liner and heavy mascara to enhance her blue eyes, deep red to augment her sensuous lips, and rouge to increase the flare of her high cheekbones, which met at a prominent, somewhat haughty nose. Her auburn hair he had cut in a fashionable bob.[21] The Lee who emerged was not beautiful: She was striking. Her face and attire now complemented her formidable personality. It was a sign of her regard for Igor that she gave him free rein in helping her transform herself from a schoolgirl to the woman who would be Lee Krasner, just at the time that she was making her debut on the nascent modern art scene in New York.

During the first three decades in twentieth-century America, modern art largely meant European art. It was a delicacy reserved for the very rich and the hopelessly eccentric. In 1908, photographer Alfred Stieglitz had begun

showing the works of Rodin, Cézanne, Picasso, and Matisse at his small 291 Gallery in New York. For many years, it would be the only public place where vanguard art could be seen in America. That is, until the Armory Show of 1913 at Lexington Avenue and 25th Street. That show, which included sixteen hundred paintings and sculptures—Van Gogh, Munch, Cézanne, Picasso, Brancusi, and Matisse among them—assaulted American taste and artistic standards. The scale of the exhibition was so huge and the art it contained so new that modernism went from being a footnote in American cultural history to warranting a new chapter. As the Armory Show traveled to Boston and Chicago, it spread the message to visitors appalled and amazed by what they saw that it was no longer the duty of art to represent a recognizable person or place.[22] A painting could be enjoyed and appreciated for itself: for its colors, its shapes, the brushstrokes the artist had used to build it, and for what was omitted as much as for what appeared on the canvas. Photography had made realism unnecessary. An artist in modern society was free to create his own reality. That prospect, however, proved unsettling and aroused hostility in some quarters toward those Americans who dared to pursue the course laid by the European modernists.

After the Armory show, a few courageous collectors and gallery owners began to display the new art for audiences who were intrigued by the possibilities that had been revealed. In New York, Katherine Dreier and Marcel Duchamp formed the Société Anonyme in 1920, featuring rotating shows of modern works. J. B. Neumann exhibited the German Expressionists in his gallery in 1924. And the A. E. Gallatin Collection, which included Cubist pieces, was given a permanent home at New York University. The artists around the Village virtually lived in that gallery.[23] But as significant as those endeavors where, they were mere warm-ups for the big performance, the opening of the most important institution in twentieth-century American art culture—the Museum of Modern Art.

The idea for the museum was hatched in a surprising location: Egypt. There, Mrs. John D. Rockefeller Jr. met Miss Lizzie P. Bliss and discovered that they both dreamed of a museum "devoted to...rather outrageously advanced arts." On her return trip to New York, Mrs. Rockefeller bumped into Mrs. Cornelius J. Sullivan, who also expressed enthusiasm for the idea. "The ladies," as they would come to be known among museum trustees, put the plan into action.[24] Once they had agreed on the necessity for such an institution, their next task was to find the right person to run it. There was really only one candidate able to take on the project. At the time the ladies began their search, Alfred Barr Jr. was at Wellesley College, in Massachusetts, teaching the first course on modern art ever offered at an American university. Twenty-seven and a graduate of Princeton and Harvard,

Barr wanted nothing more in life than to become director of a modern museum. In accepting the ladies' offer, he wrote, "This is something I could give my life to—unstintedly."[25]

Barr looked like a "polite country vicar" out of a George Eliot novel. The son of a Northern Irish Presbyterian minister, he was ascetic: his clothes buttoned tight and without a wrinkle, his every hair in place above his small round spectacles. He exuded stern correctness and did not appear to have a passionate bone in his body.[26] But, in fact, he had a raging passion for modern art, and the energy to confront all the obstacles to a museum showcasing avant-garde work. And, indeed, there were many. The Metropolitan Museum of Art in 1921 had been denounced for displaying a "degenerate cult" of "neurotic ego-maniacs" who worshiped "Satan" after it dared to exhibit works by Manet, Cézanne, Matisse, and Picasso.[27]

Against that backdrop and ten days after the crash of Wall Street, the Museum of Modern Art opened on November 7, 1929, on the twelfth floor of a building at Fifth Avenue and 57th Street. Its first show was called simply *Cézanne, Gauguin, Seurat, van Gogh*. "It was like a bomb that exploded.... Nothing else ever hit me that hard, until I saw Pollock's work," Lee said of her reaction to the Modern's exhibition.[28] It was "an upheaval for me, something like reading Nietzsche and Schopenhauer. A freeing...an opening of a door"[29] that left her feeling "a little more at ease with what I was trying to do."[30] Lee's and her fellow students' immediate response to the show was revolt. They rushed into their classroom, ripped apart the classical backdrop upon which the male model they were to paint posed, and added elements from daily life—*they put clothes on the nude model*—in order to inject the modern world into the school's moribund traditions. Exasperated and appalled, their instructor threw down his brushes and stormed from the room.[31]

Two years later, sculptor Gertrude Vanderbilt Whitney opened the Whitney Museum of American Art on Eighth Street.[32] The artistic wealth in Manhattan had thus skyrocketed at the very time when all other riches had turned to vapor. Those first years of the Depression were desperate times. For Lee, access to the collections in the new museums would have helped to minimize—on good days, even trivialize—her material misery. Hunger was, however, an undeniable reality. Lee took any job she could to survive—painting china and hats, modeling nude for other artists. (In fact, Lee's fear of poverty born during that period would color her actions for the rest of her long life.)[33]

Using his Prix de Rome, Igor escaped the early Depression by setting off to study in Europe. During that same period, and though she would never use her degree, twenty-four-year-old Lee took the practical step of enrolling in a teachers college. "I wasn't counting on marriage to solve my

financial problems," she explained.³⁴ And at night, wearing silk pajamas, she waited tables in a basement nightclub called Sam Johnson's on West Third Street between MacDougal and Thompson in Greenwich Village in exchange for dinner and tips.³⁵

The club was run by the poet Eli Siegel and a former rabbi known merely as Deutsch. Siegel entertained by giving readings of his Gertrude Stein–inspired poetry and, when he and Deutsch felt generous, they would allow the artists and writers who congregated there to eat and drink for free. Because Prohibition had not yet been lifted, drink at that time meant coffee, and the mavericks who hung around Sam Johnson's drank it by the gallon.³⁶ One of the regulars was a giant of a man who had made the daring decision to abandon his law degree to write poetry and fiction. Lee said he talked of writing a novel "that's going to make Dostoevsky look like a dwarf." His name was Harold Rosenberg and everything about him was dramatic.³⁷ At six foot four, with coal-black hair, thick eyebrows above piercing eyes, and a large mustache, Rosenberg had a Byronic gait that caused him to swing his leg rather than bend it when he walked.³⁸ He was described by some as a "great Jewish prophet," and by others as a "buccaneer" who was "death to women."³⁹ Lee wasn't swayed by the romance surrounding Harold when she first met him. She thought he was cheap. Nearly a half century later she still recalled, "Harold and his brother Dave, they would come in and spend the night at a table and then leave no tip—especially Harold. That was so long ago and I'm still furious about it."⁴⁰ Though no doubt sincerely angry with Rosenberg, at some point she forgave him. Lee and Harold would become close friends, collaborators, even housemates. And, with her Russian aristocrat boyfriend abroad, Lee would receive her first lessons in political radicalism from Rosenberg and his coterie.

In the early 1930s, young Jewish intellectuals like Rosenberg from New York's outer boroughs swelled the Village scene. When they and their fellow artists and writers gathered in coffee shops, they didn't talk aesthetics; they talked activism amid the colossal failure of capitalism that began on Wall Street.⁴¹ The initial reaction to the cataclysm had been shock. It was inconceivable that so much could be lost so quickly and affect so many. Within three years of the first financial earthquake, nearly 25 percent of the U.S. population was unemployed, and a quarter of U.S. banks had been wiped out.⁴²

As the government tried to downplay the severity of the crisis, shock turned to anger. Strikes spread throughout the country. In lower Manhattan, Union Square seethed day and night with protests. People demanding jobs, demanding food, demanding an end to the suffering that had befallen them, but for which they were in no way responsible, clogged the avenues

with marches.⁴³ Despite newly completed architectural triumphs—the Empire State Building and the George Washington Bridge—that signified man's potential, New York at that time had for many an end-of-days aspect that transfigured the city and the people in it. Some adopted what one observer called a "coyote mentality," stealing and scavenging what they could from those who still possessed something. For most, however, the legendary New York bustle became a pitiful shuffle; enterprise was replaced by survival. Mercifully, respite was available. For the price of a ten-cent movie ticket, Depression-era audiences flocked to gangster films, cheering every successful heist, every well-placed thrust of a blade against authority.⁴⁴

The artists and intellectuals in the Village sought their relief at the John Reed Club, which was a cultural offshoot of the Communist Party. By the spring of 1933, two hundred artists and writers had become members.⁴⁵ "It wasn't a lack of love for the United States so much as thinking some other system would correct this blasting horror of hunger," explained playwright Jack Kirkland.⁴⁶ In 1934 in a loft on Ninth Street, the Artists Union was formed out of the John Reed Club. The Union's emblem featured a fist holding paintbrushes, and its goal was to protect that most abstract of concepts, "artists' rights," by trying to ensure that if jobs for artists arose, they would know about them.⁴⁷ Lee joined the Union, along with Harold and the "Picasso of Washington Square," Vosdanik Manoug Adoian, who as a child had watched his mother die of starvation while the family fled the Armenian genocide. Wearing a look of eternal suffering, he even changed his name to reflect his pain. He became Arshile Gorky: Arshile for Achilles, and Gorky, which meant "bitterness" in Russian.⁴⁸

A legendary figure among artists, Gorky worked, and worked, and worked at his studio on Union Square, painting all day, only to scrape the paint off the canvas at night because it was not enough; it was never *good enough*.⁴⁹ He seemed to be struggling to produce a work that would justify his having escaped the slaughter that killed his countrymen. Outside the studio, Gorky could be seen in a long black coat pacing off his angst in the company of two wolfhounds and two good friends: the Dutch painter Willem (Americanized to Bill) de Kooning and the mad Russian Ivan Gratianovitch Dabrowski, whom everyone knew as John Graham and who was acclaimed by that crowd as a genius.⁵⁰

Through the Artists Union, Lee began meeting that core of artists and quickly, according to Harold, became a "central figure" to whom they turned for help.⁵¹ Artist Irving Block called her a "big wheel." "In fact, whenever there would be committees formed for functions, the artists would make these great speeches—Gorky for example would say, 'What are we waiting for? There's an armory on 14th Street, man the barricade!'

You know, all this silly, crazy talk would go on and then they would have to form a committee.... It always fell on poor Lee Krasner's shoulders," Block said. "After they made these impossible addresses, someone would say, 'And I decline the honor of being on this committee in favor of Lee Krasner.... [Lee] became quite political, I don't mean in a narrow sense — in a broader sense. A real campaign manager."[52]

When Igor returned to the States in 1934, he found that Lee the artist had metamorphosed into Lee the champion of artists.[53] Having no interest in politics, and fresh from a tour of Europe, where artists were respected and lionized, he might have had difficulty fitting into the hard-bitten life that consumed his girlfriend. At some point, Igor began earning money by doing portraits of society women, which inevitably led to affairs between the artist and his muses.[54] For a time, however, he straddled both upper and lower Manhattan, and when an opportunity arose to share an apartment on 14th Street with Harold and his wife, May Tabak, Lee and Igor took it. The flat was so big, May said, the couples could have separate parties and not disturb one another.[55]

Living above Union Square — "Red Square," where a cafeteria's welcoming sign read "Where Comrades Meet" — they would have witnessed a carnival of protest.[56] Using megaphones to broadcast their chants and songs, agitated masses gathered there daily demanding from the government all the things they lacked. It is tempting to say that miraculously such relief came, but it was no miracle. In 1935, relief arrived in the form of the Works Progress Administration, and among its beneficiaries were the nation's artists. When told that painters were starving and needed federal help, President Franklin Delano Roosevelt said, "Why not?... I guess the only thing they can do is paint and surely there must be some public place where paintings are wanted."[57] With that simple concession, the Federal Art Project was born. It would be the greatest aid program for artists in American history, and a first step toward creating an environment that would revolutionize the history of art.

Most often, Lee painted scenes outside her apartment window, or she would head down to the docks with her paints. Her work was vaguely Surrealist: eerie, dark, brooding, architectural scenes devoid of people. The paintings were as bleak as the times. "New York had no atmosphere then, no ambiance. There was little support and few rewards," Lee explained. "I felt like I was climbing a mountain of porcelain."[58] Sometimes, she drew at Greenwich House, near Sheridan Square, which had a live model available for artists who wanted to come in and sketch. It was there one afternoon that a man appeared, asking if anyone wanted a job as an artist. The offer must have struck those assembled as a joke. It was year

five of the Depression. A job? As an artist? He didn't describe what was on offer, but Lee wasted no time thinking about it. Her hand shot up. The man looked at her drawing and wrote down her name. A few weeks later, she received notice to go to a certain address if she wanted work.[59] Lee had learned in the meantime that artists all over the city had heard the same offer. Harold had been at a life drawing class when "a guy came rushing in to say artists were being hired at the College Art Association. So, he said, 'Grab your paintings and go up there and get a job.'" Even people like Harold, with only a passing interest in art, raced to the CAA, which housed the Art Project in New York. "Every artist we knew seemed to be present at the sign-up," said May.[60]

Artists were lucky in the government's choice of leadership for the Project. The head of the New York effort was a woman well acquainted with the peculiar needs of that community. Audrey McMahon had administered a much smaller program to help artists in New York State under then-governor Franklin Roosevelt.[61] The overall director of the Federal Art Project was also an inspired choice. An unconventional man in the mold of Jack London, Holger Cahill (he preferred to be called Eddie) had run away from his Midwest home at thirteen, jumped a ship to China, and returned to the States to work ranches and ride the rails. At nineteen, he discovered Tolstoy and enrolled in school.[62] It would take a man with a vast amount of energy — during his first year, Cahill said he worked seven days a week from eight a.m. to three a.m. — matched by a sense of adventure, to manage the five thousand artists around the country who signed up for work on the Project in the first year alone.[63] Unlike many art administrators — indeed unlike most people — Cahill wasn't afraid of them (though he identified a few of the artists as "psychopaths") or the vanguard art some of the best in their ranks struggled to produce.[64] His most recent job had been as temporary director of the Museum of Modern Art while Alfred Barr was on leave. And, at the time of his appointment to the Project, he lived in Greenwich Village with his soon-to-be wife, Barr's assistant Dorothy Miller.[65] It would be Cahill's job to keep the artists in line *and* to protect them against conservative forces in Congress who wanted to eliminate the Project's funding because they saw no value in work made by "Hobohemians."[66]

For her first job on the Project, Lee was given the task of illustrating fossils. She was both thrilled by the work and the idea of being paid to do what she loved. Her next assignment teamed her with Harold assisting a rather prickly artist, Max Spivak, on a mural. Spivak didn't want them to touch his work but, under the Project's rules, they were required to turn up every day at his studio, so Spivak invented jobs for them. He called Harold

his "reader" and Lee his "research assistant."[67] Ibram Lassaw had a studio next to Spivak's and remembers seeing Harold stretched out in an armchair ridiculing a book by Stalin while reading it aloud, saying, "Did you ever hear anything so stupid?" When Stalin grew unbearable, Harold and Lee discussed poetry and their favored communist, Trotsky.[68] For their efforts, at the end of the work week, each was awarded a check for $23.86, as were hundreds of others on the same payroll in New York.

"You can't imagine how wonderful it was to get that money just to *paint*," said artist Mercedes Matter. "It was the most important thing that ever happened to me or to this country as far as art was concerned." The Project kept painters and sculptors alive, but it had other, unanticipated consequences. It created a community where none had previously existed. Suddenly artists who had worked in isolation began discovering one another. And it gave artists a sense of self-worth: For the first time, the government had recognized them as individuals with a talent that could benefit the broader society.[69]

After receiving their first Project payment, Lee and her friends pitched in and bought a bottle of liquor to celebrate the dawn of a new era.[70] Significantly, women were part of that dawn. Like the Roosevelt White House, which employed more women in high positions than any administration until the 1990s, the Project existed remarkably free of gender discrimination: About one-fifth of the artists on the Project were women who received the same pay as men. That acknowledgment—that women could be, that they *were* professional artists—elevated them to a position they had never occupied.[71]

As for the men, the Project "put an end to the idea that being an artist was somehow unmasculine," sculptor Ibram Lassaw said. In fact, the legendary image of the macho artist that came to define American painters in the 1950s first appeared in the Project. "We had no desire to look, live, or act like artists. We were, in that regard, anti-art," explained painter Jack Tworkov of those Depression-era days. "We even dressed like workmen.... And there was a complete lack of self-consciousness, which was rather unlike the traditional artist's attitude in this country."

Having found on the Project the acceptance they needed from the program's administrators and, most crucially, from one another, artists were unwilling to relinquish that newly won status or the much-needed paycheck the Project provided. In 1936, under pressure from reactionary forces in Congress, Roosevelt had hesitated to give the Project more funding. Artists took to the streets.[72]

Lee, who by that year had joined the Artists Union executive committee, was a veteran agitator. She declared proudly that she had seen the inside of some of New York's best jails.[73] The fight against injustice

energized her. In Lee's worldview, things were black or white, right or wrong. And to her, placing artists in the position where they had to choose between eating and painting was simply wrong and had to be prevented. One of Lee's jobs was organizing Union protests. She got to work.[74] In late November, members met at a Third Avenue beer hall to discuss a demonstration against reductions in Project funding. Men and women, even children, crowded the hall as the Union hatched an idea: They would occupy the Project's offices in a sit-down strike until the government agreed to withdraw plans to cut artists from the federal payroll.[75]

On Tuesday, December 1, 1936, four hundred artists marched up Fifth Avenue toward the Project building on East 39th Street, where they faced off against sixty policemen. Some of the artists pushed their way into the building and occupied Audrey McMahon's eighth-floor offices, while others outside formed a human chain and refused to move. As the standoff continued, police became agitated and tried to forcibly remove some of the artists.[76] "Two cops on either side of me got me by my arms and ran me out," sculptor Eugenie Gershoy recalled. "Everybody said it was so amusing because they lifted me off my feet, and I was still running while they were carrying me... my feet were going in the air, running in the air."[77] Others weren't so lucky. Women were dragged and beaten. Some were knocked unconscious after being hit on the head with clubs. As many as fifty artists were hurt, and two hundred others hauled off in Black Marias to the 57th Street Precinct to be charged with disorderly conduct.[78] One of those arrested was twenty-three-year-old Mercedes Carles.

Descended from art royalty, Mercedes was most often described as "grand" or "elegant" (and on one occasion "infuriatingly chic"). Her father, Arthur B. Carles, was a famous modern artist and her mother, Mercedes de Cordoba, a model.[79] The younger Mercedes's background was at once classically European (she was educated at finishing schools in France, Italy, and America)[80] and entirely bohemian. Through her parents, she had met everyone in the art world, which meant that when Mercedes began to paint she had both the comfort of understanding what it meant to be an artist and the burden of having to follow in the footsteps of a famous father. Mercedes, therefore, made herself what her adored father could never be: a femme fatale artist in the French salon tradition. She was helped greatly in that role by the fact that she was exotic and oozed sexuality during even the most banal encounter. And, if that wasn't enough, Mercedes was charming, intelligent, talented, and witty.

By December 1936, she had had a series of lovers in the New York art world, her most recent being Gorky, who had met her while they were collecting their weekly checks from the Project. Soon, Mercedes moved her easel into his studio and began painting next to the master, who also

expanded her education to include the writings of Marx, Lenin, and Trotsky.[81] It was this indoctrination that had led to her participation in the Union melee. Mercedes had heard at an Artists Union meeting that there would be a march on the Project headquarters. Inspired by her readings of Marx and his theoretical offspring, she rushed to Gorky's studio to say they should join the protest. Painting, he refused to go, so she set out alone on what would be her virgin act of political defiance. "I remember thinking as they took me up to the police station in a wagon, that I never could have imagined, just two or three years previously...that one day I'd be traveling up Park Avenue in such a fashion,"[82] she recalled.

Upon arriving at the precinct, police assigned artists to cells. Lee Krasner and Mercedes Carles found themselves locked up together. Remarkably, though they were both on the Project and part of the small circle around Gorky, they had never met. The two women had so much in common that their time in jail was as much introduction as reunion. When their cell door opened, they emerged as best friends.[83]

Thursday, December 3, the demonstrators were due to be arraigned. During their booking, the first artist who had been asked his name said loudly, "Jim Picasso." Hearing this, other artists, too, used the names of famous painters or writers to identify themselves.[84] "I think I was Mary Cassatt. I'm not sure. I didn't have a big selection," Lee said. "But it came to trial, the court clerk reading some of these names, my dear, you know, you'd hear Picasso and everybody's head would turn around to see who had said Picasso....It was great, just great."[85] Amid much pounding of the gavel and hilarious confusion in the court, a policeman whose job it was to call out names struggled to pronounce them—Henri Matisse, Georges Seurat, Cézanne, Rembrandt. "The judge by that time was wise, everybody was wise, and the whole place was roaring," said Spivak, who was also involved in the protest. Having been found guilty of disorderly conduct, "we got ten days suspended sentence...in spite of the fact that the judge was laughing and enjoying it."[86]

The following year, 1937, would be difficult and pivotal for Lee. Harold had begun work on the Federal Writers' Project, which suited him much better than the Art Project, and within a year he and May would move to Washington.[87] Lee and Igor, therefore, had to exchange their vast 14th Street apartment for a much smaller place on Ninth, which they shared with de Kooning's friend Robert Jonas and former Artists Union president Michael Loew.[88]

During that period, Lee's Project duties had become more administrative than artistic. "She became involved with the allocation of paintings, which was very important," Harold said. "She had to go around and convince

principals of high schools and officials of one kind or another that they would sponsor WPA art projects.... She was like the big art salesman of the art projects."[89] Her work with the Union was also increasingly vexing. The Communist Party's influence in the organization had grown, and favoritism was being shown to artists who were Party members and painted in a social realist style, depicting the suffering of the masses at the hands of corrupt capitalists. As much as Lee may have agreed with the premise, she considered such art to be mere propaganda, which placed her at odds with some of her closest associates and threatened the leadership position she had gained in the group.[90]

And, as if her professional problems weren't enough, life with Igor was a travail. Though on the Project, Igor spent most of his time on his portrait commissions, which meant enjoying the wealthy women he painted. He was also drinking heavily, and increasingly abusive to Lee. Rather than causing her to reject him, however, Igor's misbehavior seemed to make Lee love him more. She contracted what friends called a bad case of blind devotion. "She was so madly in love with him that she forgave him anything," said painter John Little.[91] Faced all around by unwelcome and changing circumstances, Lee reassessed her situation. During the previous two tumultuous years, she appeared to have produced very few drawings or paintings. In 1937, she was ready to regain control of her life by rededicating it to art — her own art. It was that winter that Lee made her dramatic entrance at Hans Hofmann's school.

Mercedes had been a student of Hofmann's (and the old man's lover) and often acted as an unofficial recruiter for his struggling enterprise.[92] Lee's friend John Little had also enrolled, and it may have been their recommendations that brought Lee to Hofmann. John said that as soon as she arrived at Hofmann's, Lee "raised hell," setting up her easel wherever she wanted, even if it meant displacing other students. Painter Fritz Bultman remembered her as a "*fervent* student, contentious, brilliant, and a general marvelous pain in the ass."[93] Though the weaker students grumbled, the stronger appreciated and absorbed her. Lillian said a group of "Lee watchers" developed at that time. "Even as a student [she] was taken seriously by the other students.... I mean she was considered a painter's painter, a professional artist."[94]

Lee had returned to her chosen path. She had asked herself what was the one thing she needed in life. The answer was art, always. With Hofmann's help, she would break through into abstraction as the world around her — as the world around them all — began a descent into chaos.

2. The Gathering Storm

> I found that I could say things with colors and shapes that I couldn't say in any other way—things that I had no words for.
> — *Georgia O'Keeffe*[1]

SINCE LEAVING THE National Academy ten years earlier, Lee had been bombarded by new art and new ways of thinking about art. The Museum of Modern Art had offered dozens of exhibitions that had included various flavors of European modernism: the Impressionists' light, the Expressionists' emotional confrontation with color and shape, the Futurists' fields of motion, the Cubists' reduction of nature to a series of angles and planes. And interspersed among those displays were shows of Mexican, African, and so-called primitive work—sophisticated in its execution and intellectually intriguing. Lee had returned time and again to see those shows and absorb the lessons on display there. What she found was that while all the pieces reflected distinctive cultures and eras, they shared a common, undeniable, and transcendent element: mystery.

Those discoveries at the Modern generated feverish discussion as the New York artists struggled to grab hold of the intangible so they could apply it to their work. At the same time, books and journal articles began to appear that sought to explain in words what had occurred on canvas. A new language for talking about art emerged, which fueled even more debate. What did Kandinsky mean by "necessity creates the form"?[2] Surely the Surrealists must be right in saying that the unconscious was the source of one's deepest thoughts, and therefore *it* was the wellspring of artistic creation. "If Gorky was there, he dominated the conversation," Lee said of nights at the Jumble Shop on Eighth Street in the Village, where she and a handful of friends sat at small tables in the red-tiled room, drinking beer and talking art. "And with Gorky, it was always Picasso.... You didn't get a seat at the table unless you thought Picasso was a God."[3] And lest the New York artists think they would never be worthy of their revered School of Paris because they were mere provincial nobodies, a Dutch painter whose life story reassured and consoled them appeared at the Modern in a burst of light.

In November 1936, Alfred Barr opened a huge Van Gogh show in the museum's latest quarters—a former Rockefeller family home on 53rd Street. The exhibition was perhaps the first ever museum blockbuster,

because of its scope and the number of people who saw it nationwide: 900,000. It was so popular in New York, where 140,000 people queued for entry, that police were called in to keep order.[4] What fascinated both the general audience and the artists among them was, of course, Van Gogh's work, which was as alive with radiant color as the day he had painted his small canvases more than a half century before. But the crowds were also attracted by his story. Van Gogh was the first modern artist whose biography was presented by a museum alongside his work. Suddenly a man, a mere mortal, was introduced as the author of painted masterpieces. Those who visited the exhibition learned that Van Gogh was the son of a shoemaker, that he had worked in obscurity, that he had given his life for his art. Van Gogh inspired because his story demonstrated that *anyone, anywhere* could be an artist if they were gifted and driven, and that art was a calling worth dying for if the humble artist's offering to humanity was a grand, new way to experience the world. Van Gogh's life, as much as his paintings, gave Lee and her fellows fresh hope and courage.[5]

A biographer of the Museum of Modern Art said that, during that fall of 1936, Alfred Barr offered nothing less than "a public course on the history of the modern movement, and his blackboard...was the museum."[6] The vicar of art followed his Van Gogh show with a survey called *Cubism and Abstract Art,* a compendium of all things abstract up to that moment: Impressionism, Fauvism, Cubism, Futurism, Expressionism. "For many [artists] it was the catalyst that served them as once the Armory Show" had served earlier artists, explained art historian Dore Ashton.[7] Those who sought a new direction in their work stood overwhelmed by dozens of possible pathways. But Barr wasn't finished. After the abstract show, he presented a massive (seven-hundred-object) *Fantastic Art: Dada and Surrealism* exhibit in December. It was the first comprehensive display of such art in America.[8] The speed with which Barr mounted those events was breathtaking, and perhaps intentional: Some museum trustees were terrified by the art on offer. Yes, they supported "modern" work, but not *this* modern. They had, however, not been given the time to digest, let alone reject it. Aware that he could not risk losing the confidence of those important backers, Barr sought to reassure them with the less than comforting explanation: If the art seemed insane, it was merely a reflection of the times.[9]

In 1937, the museum prepared to move to a temporary space for two years, while a larger facility was built. With the number of visitors far exceeding expectations, the Modern had outgrown its five-story home. Oddly enough, the Depression had produced a cultural flowering in America.[10] Social historians have suggested that because the occupations that had previously consumed society were suddenly absent, some people reevaluated their priorities and discovered that a rich life entailed more

than financial success—and that "more" involved creating works of art, whether they be paintings, poems, pieces of music, or plays. "When I lost my possessions, I found my creativity," said E. Y. "Yip" Harburg, the lyricist behind *The Wizard of Oz*. "I felt I was being born for the first time."[11]

Others have said that government funding of the arts through the WPA triggered the cultural renaissance not only by giving artists the means with which to create, but by making the arts part of mainstream American life. Music and painting were taught in school, theater groups established a presence in towns and cities where people had never seen a play. A young Larry Rivers remembered watching a Project mural being painted in his Bronx high school and awakening to the notion of art as a living thing.[12] Meanwhile, craving relief from their misery, Depression-era audiences flocked to the places where they might find it, if only for an hour or two. What they heard and saw was not just music and theater, but innovative work that created new sounds and fresh ways to communicate.[13] American literature, as well, experienced a golden era. The authors the New York artists read were less interested in *what* was written than *how* it was written.[14] By the mid-1930s, therefore, artists who worked with words and sound had made major strides into new territory. Lee and her friends recognized, however, that painting and sculpture in America lagged far behind. Rather than be depressed by that realization, they were exhilarated. "There was a tremendous spirit and belief in the future," said George McNeil, who would share a studio with Lee. And the future, they believed, belonged to abstract painters.[15]

For an artist, Lee was unusually pragmatic. Rather than struggle alone until she unraveled, with great pain and anguish, the complicated relations among lines, planes, and color as they appeared in the work of Europeans she admired, she chose to seek answers as close to the source as she could: at Hofmann's school. In his studio she could work independently, benefit from his criticism and that of her fellow students, and contemplate the insights he had gained among the greats in Paris during that city's heroic pre–World War I era.

There was, however, a problem. "At least the first six months that I was there I understood not a word of what the man said," Lee recalled. "I'd wait till he'd left and I'd call the monitor, George McNeil, over and ask him to tell me what *he* thought Hofmann said to me."[16] Hans's idiosyncratic "English" bewildered all his students. "We couldn't understand what the fuck he was talking about," said painter Nick Carone, "but you felt your life was at stake with every word he uttered. The atmosphere worked on you; it was serious, you were serious, and therefore you were an artist."[17] If *Herr Doktor* had known his students didn't understand him, it probably wouldn't have mattered. He himself admitted, "No one can give

a correct explanation of what art really is."[18] What *did* matter was what he imparted without words: spirit. The hulking, fifty-seven-year-old maestro was devoted to art. Hofmann believed that "to be an artist... was the most privileged existence available to man," according to Harold.[19] "He spoke... about the *'cray-ah-teef'* as if nothing else mattered."[20]

On a purely practical level, a Hofmann student needed an eraser, a box of charcoal, and two sheets of paper. By the end of class the charcoal would be gone and the student, if they had done their work, would be covered in it.[21] Hofmann offered three sessions a day: morning and evening, during which students drew from a live model; and afternoon, when they drew from a still life he had constructed. Hans visited the school twice a week to look at the work that had been done, and on Friday evenings he lectured. Free of charge and open to the public, such talks were traditional for professors in Germany, where Hofmann had established his first school, but they were entirely new in America.[22] Artists crowded into his sessions, as did literary types, two of whom would become the most polemical art writers of the Abstract Expressionist era: Harold Rosenberg and Clement Greenberg. Both were introduced to Hofmann and his theories by Lee.[23]

Those gathered for Hofmann's lectures were well rewarded. Hans treated them to a discourse on art theory and technique that amounted to a doctrine of aesthetic liberation. Nowhere in his ideas did fealty to an exterior subject intrude. Yes, he believed artists should work from something for inspiration—they should look at a still life or a figure or a landscape as they began their work—but they should then free themselves to go beyond simply recreating that grouping or person or scene.[24] The subject of a work of art should be—indeed could be nothing other than—the artist himself. As soon as the artist looked at an object, the object changed. It had become the artist's vision of the object. (Which is not unlike Heisenberg's uncertainty principle in science: Ours is an observer-created reality.) Likewise, as soon as the artist drew an object on paper it was doubly changed: It had become the artist's vision of the object, transformed into a new material reality. That was the mystery. Art, if it was true, reflected the artist's deepest thoughts and feelings made manifest. If it was stirring, it was because it was the artist's— *Van Gogh's*—beating heart. Said Hofmann,

> You cannot deny yourself. You ask, am I painting myself? I'd be a swindler if I did otherwise. I'd be denying my existence as an artist. I've also been asked, what do you want to convey? And I say, nothing but my own nature. How can one paint anything else?[25]

Those who attended Hofmann's lectures, who had abandoned the tumult of a Friday night in Greenwich Village for the rarefied atmosphere of the

artist's atelier, anticipated his pronouncements as if he were an oracle—an image he mischievously dispelled by ending his eloquent discourse with a giant belly laugh and the admonition *"Vurrruk, vurrruk, vurrruk...* find yourself!"[26]

Lee's drawings quickly began to show a real grasp of the principles Hofmann taught. The portfolio she had used to gain entry to the school had contained drawings of highly sculpted bodies, classic in their pose and execution. Under Hofmann's influence, and because she had studied so much advanced art in the years before she appeared in his studio, her work immediately shed its classicism. Whether Lee's drawing began as a person or a still life, it soon became a series of mere shapes that indicated objects or figures but went far beyond their literal description. She would later say how difficult the transition had been from her National Academy training to the Cubism espoused by Hofmann, and her paintings at that time did show this struggle. But in her drawings, the shift was as swift as it was accomplished. Hofmann himself said to her, "This is so good, you would not know it was done by a woman." Lee accepted the "compliment" grudgingly (it was, in fact, the same comment Degas had used in looking at Mary Cassatt's work the previous century, and would be used about women who painted or sculpted for generations to come).[27] Prior to Hofmann, Lee said she had never had *any* encouragement for her work.[28]

Hofmann didn't discuss his past, but his students had heard his story. He had opened his first school in a dingy room in Munich in 1915 after being stranded there at the outbreak of the First World War. Because he was German and technically an enemy of France, he was unable to return to Paris, where he had lived for a decade as a painter among the modern masters who were then still evolving in their work. He taught in Munich until 1933, when he was stranded again by world affairs—this time in America. Adolf Hitler had become chancellor of Germany and within months began a violent campaign against modern art and those who made it. Hofmann's wife, Miz, was still inside Germany, under threat and trying to keep his school there afloat. Hofmann was "not indifferent to world events," according to Harold, or attacks on his friends in Germany.[29] But somehow, he managed to sublimate those larger concerns and focus on his art. And in that way, too, he was an inspiration to his students. Hofmann taught them that the artist's responsibility to society, especially during dark times, was to preserve, nurture, and glorify the human spirit. His words resonated among the downtown artists who, with alarm and apprehension, watched the storm gathering in Europe.

Since 1933 reports had appeared with alarming regularity describing turmoil in Germany, Spain, and Italy, where rightist leaders used their military

and police to crush perceived enemies of the state as well as popularly elected governments. Not long after Hitler became chancellor, laws were enacted dismissing intellectuals who were found to be either too leftist or insufficiently Aryan to hold university positions. By May 1933, bonfires at the University of Berlin were fed the poems of Heinrich Heine, the fiction of Franz Kafka and Thomas Mann, and the scientific works of Marx, Freud, and Einstein. In April, New York papers began carrying reports of the murder, torture, and detention of Jews in Germany. The *New York Times* declared that month that Germany had gone mad.[30] By 1935, Italy had made headlines, too. Benito Mussolini, *il Duce,* was on the march in Africa, invading Ethiopia to settle an old score. It would have been impossible to ignore his exploits while roaming the Italian neighborhood bordering the Village. Small statues of Mussolini stood in windows, tokens of thanks to the proud *paesani* who had donated gold jewelry to finance the fatherland's aggression.[31]

At that time, discussions among downtown artists alternated between the subjects of art and the "crisis," which before 1936 had meant the Depression but now meant rising fascism. New York artists were largely immigrants or the children of immigrants with deep familial ties to Europe. They were also tied to that continent by the art and artists they revered, both of which were under threat. On September 11, 1935, Hitler had declared that art "forms the most uncorrupted, the most immediate reflection of the people's soul," and therefore it must above all present a "true picture." There was no need to ask whose truth. In Hitler's Germany, there was only one. During breaks at Hofmann's school, one classmate said, Lee harangued her fellow students about the situation.[32]

In February 1936, a three-day conference was held in New York attended by more than 360 artists, writers, designers, and photographers. "We are gathered together tonight for the first time partly because we are in the midst of what is plainly a world catastrophe," said writer Lewis Mumford as he opened the first American Artists' Congress. "The time has come for people who love life and culture to form a united front against [fascism], to be ready to protect, and guard, and if necessary, fight for the human heritage which we, as artists embody."[33] Stuart Davis, an abstract painter who spoke out of the side of his mouth like a gangster and was a leader among the Jumble Shop crowd, was chosen national executive of the organization.[34] His fellow artists lined up behind him, readily declaring themselves engaged in the battle. But what could they do? It seemed their first act was to argue among themselves.

Wednesday sessions at the Artists Union had long been dominated by talk of job actions, sit-ins, and government funding for the Project. In 1936, they shifted suddenly and violently to battles about the duty of the

artist in those troubling times. "They were hell-raising meetings," said George McNeil.[35] Artists affiliated with the Communist Party, those with social content in their work, accused abstract artists of being irresponsible elitists in the face of looming disaster in Europe. Lee and her allies shouted back that an artist could be politically engaged without producing propaganda, and that in any case "message" art was nationalistic, and nationalism was the father of fascism. "In theory," Lee said, "we were sympathetic to the Russian Revolution—the socialist idea as against the fascist idea." But, she added, "I, for one, didn't feel that my art had to reflect my political point of view."[36] Any unity that had arisen in poverty among the artists began to dissolve amid the threat of war—except where Spain was concerned. Spain was a romantic fight and artists rallied to it with an almost religious fervor.

"It would have been hard to find a writer or a painter who was not profoundly disturbed by the reports from Spain, or who did not have at least one friend who had volunteered for the International Brigade," wrote art historian Dore Ashton.[37] "In the 30s," recalled artist Harry Holtzman, "you couldn't walk down the street in the Village without someone saying, 'Are you going? Are you going to join?'" As Spain descended into full-blown civil war, three thousand Americans *did* join.[38] It was, to their minds, a noble cause with clear battle lines: An elected republic of leftists, who had overthrown a military dictator and who championed a vast underclass, were pitted against the military, big business, and powerful factions in the Catholic Church. Spain was also the birthplace of Picasso. It was an artist's duty, therefore, to protect. With Germany's entry into the Spanish Civil War, those convictions only hardened. Hitler had begun bombing raids on behalf of General Francisco Franco in what some saw as a training exercise for a future air campaign against targets of Berlin's own choosing.[39]

On April 26, 1937, Nazi planes bombed the Basque cultural capital Guernica during a crowded market day. Over a period of three hours, nearly fifty aircraft dropped one hundred thousand pounds of explosives and incendiary bombs and strafed fleeing civilians from the air with machine guns. Guernica's fires burned for three days. A third of its population, sixteen hundred people, was killed in the first "total" air raid in history.[40] Even those numbed by reports of outrages emanating from Europe were stunned. The coldness and cowardice of an aerial strike on civilians in a town with no military value beyond the fact that it was cherished by the Basque people showed that the world *had* truly gone mad. It was not just fascism versus liberalism, it was a war on humanity.

Spain became a vortex into which poured all the rancor, all the hatred that had gestated and mutated in the aftermath of World War I, and its people were the victims. Within two years, more than half a million Spaniards

would die. By the end of the conflict, some estimates say as many as a million perished. Among the first was the beloved poet Federico García Lorca, who had returned to Spain from New York in 1930 to celebrate his country's republic. He was executed by Franco's soldiers in August 1936.[41] George McNeil said that unless one had experienced it, it was impossible to comprehend the distress in the art community over the carnage in Spain. "You were dedicating your life to highly personal art, very self-centered, and here in Spain was a terrible, terrible crisis, which you knew was going to be a defeat for mankind. You were torn by your conscience, you had to do what you had to do in your art, but you knew what was going on."[42]

With a lack of response to growing fascist aggression, Europe descended into bloody chaos with remarkable speed. And there were fears among some that it would spread inside the United States. The Depression had rent the nation's social fabric, generating widespread anger and mistrust. "There was nothing theoretical about it," said McNeil. "No one knew where this country was going. There was fascism, neo-Nazi groups around. None of us would have been surprised if there had been a real Nazi movement in America."[43]

The tempo of life in lower Manhattan accelerated. Living meant so much more than surviving; art, too, had to have greater meaning. In the coming years, Bill de Kooning would tell his student and future wife, Elaine, that she should paint as if each stroke might be her last.[44] That sentiment was born in the late thirties. Amid Depression and inevitable war ("Some of us had lived with the conviction that it would come in one form or another from the moment we first heard Hitler ranting over the radio," said philosopher William Barrett),[45] artists felt in many ways that they were painting for their lives.

Artists on the Project had become expert at the art of stretching a dollar, but that was only possible if one *had* a dollar. In April 1937, President Roosevelt and Congress cut WPA funds across the board by 25 percent. In response, the Artists Union launched a month of protests, including the reoccupation of New York's Project offices, but no amount of noise could forestall the inevitable.[46] Artists marked the mass dismissals in July at the ACA Gallery with an exhibition, *Pink Slips over Culture*. The show would be Lee's first as a professional artist.[47] Fittingly, given the times and her fiery personality, her debut would be an act of protest.

Lee hadn't received a pink slip, but her already meager salary was reduced to about ninety-five dollars a month—even though her workload had increased. Igor, however, seemed unaware of the gravity of their financial situation or the times. Now driving a red convertible, he spent money frivolously. At some point, he also began work as a portraitist for

first-class passengers on cruise ships.⁴⁸ He and Lee were quite literally drifting apart. Unquestionably, Lee would have been saddened by their estrangement, and by the fact that the world Igor inhabited was one to which she had no relation. But in those trying days she may have felt that succumbing to personal sorrows or regrets would be self-indulgent and unseemly. In any case, she had too much to do.

During the summer of 1937, Lee was given the task of completing a mural that Bill de Kooning could not finish because he had resigned from the Project. (He feared deportation if it was discovered he wasn't a citizen.)⁴⁹ It was a sign of Lee's standing that she and de Kooning would be considered interchangeable on an important project. Lee accepted and began work in a studio on East Ninth Street, which she shared with Igor and George McNeil. "[Bill's] sketch was about four feet by six feet," she said. "They took it and turned it over to me to blow it up."⁵⁰

Lee tacked de Kooning's sketch on the wall and began measuring its forms, adjusting their scale upward, following the drawing's lines and shading as religiously as possible to retain de Kooning's original design. At the time, de Kooning painted recognizable figures—mostly men, flattened and simplified, with Picassoid eyes. For the mural, however, he had created something new. "It was hard-edged for de Kooning, and very abstract," Lee said. He would stop by periodically to monitor her progress as she transformed his incomplete idea into a painted reality that incorporated her own.⁵¹ The mural was a remarkable collaboration between two major talents and strengthened their friendship. De Kooning was part of what Lee called "a rather intimate group of painters and their friends" with whom she associated.⁵² "Maybe there were ten people." Many years later Lee would insist that this small grouping was nothing more than friends who looked at one another's work because no one else expressed the slightest interest in it.⁵³ In hindsight, however, it is clear that amid the deep anxiety and pervasive dread of that era, as she and her fellow artists struggled to find a way into their own work, the first signs were emerging of the movement that would redefine art and culture in America.

3. The End of the Beginning

The world about us would be desolate except for the world within us.

— *Wallace Stevens*[1]

FIRST LADY ELEANOR Roosevelt visited the East Side piers in 1939 to observe a mural project in action. A notorious champion of women's rights, Eleanor was responsible for much of the gender equality in her husband's administration, and would have been pleased by what she saw that day. Dressed in paint-spattered, rolled-up blue jeans and a heavy sweater against the cold, Lee led a crew of ten men at work on a six-foot-by-fifty-foot mural depicting the history of navigation—from the sailboat to the seaplane. "That mural seemed to be two or three miles wide," Lee recalled. "That whole experience introduced me to *scale*."[2]

It had only been four years since she was an assistant herself, but Lee's strength and seriousness had been recognized and rewarded by her Project supervisors, in much the way her fellow artists had turned to her when they wanted problems solved in the Artists Union. There was seemingly no project too large or too complicated for her to handle. But Lee was not a manager by choice; she was an artist. She demanded that, after overseeing the navigation mural, she be allowed to design and paint one of her own. *And* she believed she had earned the right to paint an abstraction.[3] At the best of times, Project managers had difficulty finding a business or public facility that would accept an abstract work. By 1939, it was nearly impossible. The Federal Art Project was in its dying days. No one knew how much longer money could be diverted toward art when the demands of war appeared imminent. Lee received a response that, under the circumstances, was probably all she could have hoped for: "Maybe."

For nearly two years, Lee had been studying with Hofmann (who had moved his school to 52 West Eighth Street, where it would remain for twenty years), and her work had evolved. At the age of thirty, however, she had not yet broken through. Her paintings, unlike her drawings, still felt very un-Lee-like, very tentative. Perhaps she hoped that a major piece, a "big wall" as the Mexican muralists called it, would be the challenge she needed to fully express herself in paint.[4] She was not alone among her artist friends in feeling there was an urgent need to do so. Quite unexpectedly,

they had found themselves thrust onto the international art scene and made the focus of extraordinary attention.

After the bombing of Guernica in 1937, the New York artists had received a direct appeal from Picasso himself. In a statement by telephone from Switzerland to the American Artists' Congress in December of that year, Picasso said he had hoped to attend their annual meeting but was unable to do so because the Prado Museum in Madrid had been bombed by the Nazis on behalf of Franco, and he was busy transferring art out of the facility for safekeeping. He wanted, however, to send the New York artists his greetings and a message:

> It is my wish at this time to remind you that I have always believed and still believe, that artists who live and work with spiritual values cannot and should not remain indifferent to a conflict in which the highest values of humanity and civilization are at stake.[5]

New York museums, collectors, and critics had not yet acknowledged the American artists working in their midst, *but Pablo Picasso had*. That recognition and show of solidarity with the New York painters and sculptors boosted spirits in studios from Eighth Avenue to Fourth Avenue, and in every bar and coffee shop in the Village. Six months later, the *Partisan Review*, whose editors mingled with the downtown artists, received a letter from Leon Trotsky. Yet again, a man Lee and her friends esteemed described the critical role they as artists played in the disintegrating world around them. His letter was called "Art and Politics," and in it he admonished American artists not to support Stalin's Soviet Union, as many Communist Party members in the Artists Union did. Trotsky accused the Party of championing a "socialist realism" in art that depicted "events which never took place" for the cynical purposes of propaganda. Likewise, he said, artists should not serve U.S. capitalists and their "decaying bourgeois society." Artists should work to satisfy only one patron, themselves.

> Art, culture, politics need a new perspective. Without it humanity will not develop. But never before has the prospect been as menacing and catastrophic as now.... In the face of the era of wars and revolutions which is drawing near, everyone will have to give an answer: philosophers, poets, painters as well as simple mortals....
> Art can become a strong ally of revolution only insofar as it remains faithful to itself.[6]

Accustomed to talking to one another, the New York artists were now part of a greater dialogue. New York was not a cultural backwater, as many artists feared, populated by provincial painters who would never be accepted by their counterparts in Europe. They were of enough significance to have caught the attention of Pablo Picasso and Leon Trotsky! For the downtown artists, "art began to be seen as a way to save civilization," Dore Ashton said. "Not political art but spiritual art in the sense of man's spirit."[7] Inside the front cover of the August–September 1938 *Partisan Review* containing Trotsky's "Art and Politics," Lee inscribed her name, "Lenore Krassner," as if enlisting in his cause. It was a cause she never abandoned. Some fifty years later when Lee died, that *Partisan Review* was still on her bookshelf.[8]

The artists' new way of looking at themselves and their work had occurred as forces in Europe openly declared their intention to destroy modern art. Hitler and his henchman Joseph Goebbels understood that to create a new society they needed to create a new mythology, and for that they had to employ art. They could not allow the existence of independent voices that might trigger thoughts and stir emotions counter to their plan for a "pure" Aryan Germany populated by easily manipulated people who conformed to the Nazi ideal.[9] From the beginning of his chancellorship, therefore, Hitler targeted for attack all art that did not reflect his aesthetic priorities. He further decreed that any artist who demanded the right of free expression be sterilized or "punished."[10]

In the summer of 1937, coinciding with the inaugural exhibition of Nazi-approved art at the Haus der Deutschen Kunst museum in Munich, Hitler proudly made that policy official. What he said ran contrary to everything the New York artists had come to believe. Hitler declared that healthy art was not international but national and should reflect the ideals of the country. Further, he said, it was not the job of artists to express or create for themselves, but to express the yearnings of the greater *Volk* and to produce art for its benefit. Finally, he said any work of art that could not be immediately understood and appreciated on its surface would no longer be allowed in Germany.[11] Examples of the types of works to be rejected—so-called degenerate art—were at that time on display at another location in Munich. Sixteen thousand pieces by nearly fourteen hundred artists were crammed into the facility, among them paintings by Cézanne, Picasso, Matisse, Gauguin, Van Gogh, Braque, and Max Ernst. On Goebbels's orders, the works had been gathered from various collections by the Nazi Party's favorite painter, Professor Adolf Ziegler (known by his critics as "The Master of the Pubic Hair," because of his excruciatingly detailed depictions of the naked body). After the show, those "degenerate" works

of international value were sold at auction, mostly in Switzerland. The rest were ordered burned.[12]

New York's Museum of Modern Art found itself in the rescue business, buying as much of the outlaw art as it could and helping the artists who had created it escape Nazi-held areas. The appeals from artists, indeed from all citizens who hoped to flee Hitler, exploded at the end of the decade when it became clear that as brutal as the Nazi campaign had already been it was only beginning.[13] November 9, 1938, changed everything. In towns and cities throughout German-controlled territory the sounds that night were the same: screeching tires, boots on pavement, breaking glass, gunfire, screams.

The Nazi government had repeatedly and vociferously denied reports that it had embarked upon a campaign of violence against Jews. After November 9, and the pogrom that would come to be known as Kristallnacht, the veracity of those reports was indisputable. "Every [foreign] newspaper correspondent in Germany and Austria could see and hear what was taking place," said one historian. The events that led up to that Night of Broken Glass had begun the previous month when a Polish Jewish family living in Germany had been forced out of their home and into an internment camp. Their seventeen-year-old son, who was in Paris, had heard the news and, in a rage, went to the German embassy in Paris intent upon assassinating the ambassador. Instead, he shot a lower-ranking embassy official who died of his wounds. Goebbels described that individual act of vengeance as part of a campaign by "international Jewry" to destroy the Reich, and unleashed a retaliatory mob. During the nights of November 9 and 10, thugs burned synagogues, destroyed Jewish businesses, and vandalized schools, leaving the streets filled with shattered glass, dead bodies, broken lives. The pogrom ended, not with the arrest of those involved, but with the detention of thirty thousand Jews. The German ambassador to the United States described the reaction in America as a "hurricane." Newspapers splashed the story across front pages. One thousand editorials condemned the attacks.[14]

After Kristallnacht, tight U.S. immigration laws were relaxed somewhat, allowing a trickle of people who wanted to leave Europe to enter the United States. Many of those given priority in a first wave of immigration were artists, writers, composers, and scientists, but even that very circumscribed immigration caused alarm. As late as 1939, 95 percent of Americans did not want any part of a European war.[15] And, with the country's economy still fragile, many people resented those fleeing it as needy hordes who would compete for scarce jobs and dwindling government support. Anti-immigration forces in Congress used fear as an excuse to deny foreigners entry. The House Committee on Un-American Activities was established

in 1938 to investigate newcomers suspected of being communists or spies.[16] Alarm and insecurity in some soon hardened into paranoia and hatred. In February 1939, twenty-two thousand people marched through Manhattan, giving fascist salutes and carrying U.S. flags as well as banners with swastikas, toward a pro-Nazi rally at Madison Square Garden.[17]

Amid that brewing crisis, the message to artists from the people who mattered most to them had been to focus on their art. Their job was not to fight, not to propagandize, but to create and so keep the spirit of what was best in humanity alive. That, however, was not the accepted message within the Artists Union. By 1939, it had come almost entirely under the control of the Communist Party. Not only did it show favoritism toward Party members in job placement, but it was unwavering in its support of Joseph Stalin, despite his having allied himself with Hitler. Stalin's supporters in the Union also seemed unconcerned by his crackdown on dissent. Beginning in 1936, "show trials" held to weed out Stalin's political enemies targeted Soviet intellectuals and artists. Trotsky had been one of the first victims; declared an enemy of the people, he was condemned to death.[18]

It was all too much for Lee. After years of being a major Union figure, she quit. "My experience with leftist movements in the late 1930s made me move as far away from them as possible," she explained. "Their primary emphasis, under the domination of the Communist Party, was a quest for political power and influence." Lee joined an alternative group, the American Abstract Artists, which had been formed three years earlier to promote abstract art and give the artists who made it an opportunity to exhibit their work.[19] "Ninety percent of the American Abstract Artists were young, and most were students of Hans Hofmann," said Mercedes, who had joined at the group's inception. A surprising number were also women.[20] Lee craved the apolitical purity of the abstractionists. She had tired of disputes and clamorous protests. Increasingly, she sought to rid herself of anything—personal or professional—that distracted her from her work.

In the early summer of 1938, Lee and Igor took a trip to Provincetown in his red convertible with Lee's painter friends Rosalind and Byron Browne.[21] They had chosen Provincetown for their holiday because Hofmann had a summer school there, which was infinitely more relaxed than his New York school. Provincetown was a business Hans operated to finance his Eighth Street atelier. It was popular among women from around the country, who were as interested in art as they were in escaping their tightly choreographed lives back home. It was thus, also, something of a private summer harem for Hofmann, who unleashed the force of his Dionysian character there. "He would praise the old ladies, and cut off the

balls of the young men," Elaine de Kooning said. "He was really like a bull elephant."[22] When his lady painters needed scolding, he was known to playfully pat them on the derriere. Sculptor Louise Nevelson, who had studied with Hans in Germany, was disgusted by his antics in America, accusing him of "kissing the asses of the rich ones." Another friend put it more bluntly: "He fucked everything that moved."[23]

In Provincetown, Hofmann was a cult figure whom the townspeople considered a "kook." He couldn't have been more different from the locals. Dominated by fishermen who worked out of shacks on the beach and lived in clapboard houses with peeling paint, the town enjoyed a relatively secluded life away from the mainland.[24] That was the environment — relaxed and safe — that Lee sought when she and Igor decided to leave New York and their myriad personal troubles. "The problem was that Lee was getting more and more attention," said her former flat-mate, the writer May Tabak. When Igor and Lee met as students, *he* had been a celebrity and he thrived in the limelight. But in the intervening years, he had not developed his talent. He was like a performer who had grown tiresome because he had not added any new songs to his repertoire. Lillian Kiesler said no one took him seriously as an artist anymore.[25] Lee, by contrast, was intensely dedicated and recognized among her peers. She may not have been able to understand — let alone live with — Igor's artistic complacency.

They rented a room near the water, and soon their party was enlivened by the arrival of Gorky and his friend David Margolies. The two men were ecstatic because they had won a windfall by Depression-era standards — four dollars — playing slot machines on the boat that brought them to the Cape. The legendarily melancholic Gorky shook off his blues, stripped down, and ordered everyone else to join him. They swam and sunbathed nude, the men wrestled in the waves, and they all listened and laughed while Gorky cracked jokes about their bodies. The trip was lighthearted; there was very little art (aside from sand drawings) and no politics.[26] But there was also no revival of the relationship between Igor and Lee. Back in New York, they fought for days at a time. Finally, in the fall of 1939, Igor sent Lee a postcard from the Pimlico Race Track in Maryland saying he was on his way to Florida and to say goodbye to their friends.[27] "He left one day without any quarrel," said May. "He took a painting he had made of her and took a bus or train. He couldn't understand the new art, and he was supposed to be a big artist. His brother had gone to Spain to fight in the civil war. Igor went to Florida where he could be in the social scene as a 'great artist.'"[28]

Lee was alone. Having been placed on temporary leave from the Project, she was forced to sell a radio-phonograph to pay her bills, and finally to move to a smaller apartment at 51 East Ninth Street. By way of decoration,

she asked Byron Browne, who was a talented calligrapher, to write in large letters across the wall of her studio a section of verse from Arthur Rimbaud's *A Season in Hell*.[29]

> *To whom shall I hire myself out? What beast must I adore? What holy image is attacked? What hearts shall I break? What lie must I maintain? — In what blood tread?*[30]

Browne wrote the poem in large black letters except for the line "What lie must I maintain?," which was written in blue. Lee said the lines "express an honesty which is blinding. I believe those lines. I experienced it. I identified with it. I knew what he was talking about."[31]

At that time, it was popular for artists to write poetry on their studio walls. It would be a point of discussion when other artists came to visit.[32] One day, Lee's friend Fritz Bultman brought an aspiring young playwright named Tennessee Williams to see her work. "They argued so much about [the poem] that I kicked them both out. I didn't like what they were saying so I said, 'Out,'" she recalled years later with unmasked pride.[33] Robert de Niro Sr. and his wife, Virginia Admiral, who were both painters, also saw Lee's Rimbaud verse. De Niro somewhat bizarrely thought it meant Lee was worried the Project was about to end and she'd need to find another job. But others saw in the selection something more telling: The perils of being an artist, and Lee's more personal story about the man she had just broken with after a stormy and burdensome relationship, and a prediction of the complicated life she would live with the painter who would succeed Igor in Lee's affections.[34] In fact, Lee had already encountered one side of Jackson Pollock at an Artists Union dance three years earlier when he stepped all over her feet and bypassed the niceties by drunkenly asking her, "Do you like to fuck?" Lee ignored the question and forgot the encounter until five years later, after she had met the other Pollock — the sober Pollock — in his studio on Eighth Street.[35] That time, she fell in love with him.

Nineteen thirty-nine was the year of Picasso. The Modern mounted a retrospective in the fall, encompassing forty years of his work. It was a show to which the New York artists returned repeatedly.[36] Picasso held an exalted status among them. They had come to regard his work as the pinnacle of what had been — possibly all that *could* be — achieved in painting. They also aspired to his life, which so completely fused who he was with what he did that the words "Picasso" and "artist" had become synonymous. But even those most familiar with Picasso and his work were unprepared for what they encountered in May 1939 on 57th Street.

The Valentine Dudensing Gallery hosted a fund-raiser for Spanish refugees sponsored by the American Artists' Congress. For the event, Picasso had sent over a very special painting, *Guernica*.[37] "It knocked me right out of the room," said Lee, who had rushed uptown to see it. "I circled the block four or five times, and then went back and took another look at it." At eleven feet high by more than twenty-five feet wide, the painting was unlike anything she had ever seen.[38] Picasso had followed in the tradition of his countryman Goya, who had used his art to document similar acts of state violence against civilians. But instead of employing Goya's more classical visual language, Picasso used modern vernacular and stripped his work down to the color of newsprint. Nothing else would have spoken so powerfully. "The presence of a great work of art...does many things to you in one second," Lee explained. "It disturbs so many elements in one given second you can't say, 'I want to paint like that.' It isn't that simple." Lee was so consumed with the painting, she followed it to Boston after it left New York.[39]

Gorky's response to *Guernica* was to call a meeting at de Kooning's 22nd Street loft. About ten artists listened as Gorky stood up and conceded,[40] "'We have to admit, we are bankrupt,'" Lee recalled, adding, "which *you* have to admit is a rather startling statement." She quoted Gorky as saying, "So, what I think we should do is try to do a composite painting." Hands shot up around the room as artists asked him what he meant by composite. "'Well,' he said, 'I think, like when you look around the room, one of us can draw better than the other, one has a better sense of color, one has a better sense of idea. We should pick a general topic and then all go home and the next time we meet, we all bring in our version of whatever this was.'" Laughing, Lee said, "I don't think I remember a second meeting on it."[41] Each artist had to confront the challenge posed by Picasso alone.

In the spring of 1939, the World's Fair was under way in New York, and the Museum of Modern Art timed the opening of its new building at 11 West 53rd Street to coincide with it. The inaugural exhibition was called *Art in Our Time*. Seven thousand men and women, in white tie, opera hats, dinner jackets, and evening gowns attended forty dinner parties arranged by museum trustees before descending upon the opening. Only ten years before, the museum had been a gamble. That evening, amid rustling silk and clouds of cigar smoke, it was evident that the gamble had paid off. "I saw New York's four hundred *en masse* in an awful crush," one guest remarked. "Evidently modern art has captured the attention of this group."[42] But maybe it wasn't the art at all, but the time. The event was so opulent it had a *Titanic* quality to it, as if everyone attending expected it to be the last big bash featuring that crowd in that city for a very long time.

President Roosevelt, whose Federal Art Project had helped create a new artistic culture in America, spoke to the gathering for fifteen minutes from the White House via radio broadcast.

> We are dedicating this building to the cause of peace and to the pursuits of peace. The arts that ennoble and refine life flourish only in the atmosphere of peace. And in this hour of dedication we are glad again to bear witness before all the world to our faith in the sanctity of free institutions. For we know that only where men are free can the arts flourish.[43]

In those days, it seemed impossible to talk about art without talking about war. As the president made his toast to honor the new home of modern art and the expressions of individual artists it contained, many hearing him — perhaps most who heard him — understood that the world as they knew it was about to change forever. And indeed, by the end of 1939, Spain fell to Franco, China and Japan were at war, and Italy invaded Albania. The decisive event that year, however, came in September, when Hitler's tanks rolled across Poland's borders as its planes bombarded the country from the air. Two days later, Britain and France declared war on Germany.[44] The global conflict that had seemed all but inevitable had begun. It was not less terrible for having been anticipated.

The day Hitler attacked Poland, a group of artists met at Isamu Noguchi's sculpture studio on 12th Street. Gorky had started drawing and invited the others to sketch on the paper with him. It wasn't a recreation of his earlier notion of a group painting. It was trauma therapy. As a child, Gorky had lived through war. He knew what the events unfolding in Europe would mean for those caught up in them. Together, the artists at Noguchi's studio drew until dawn, expressing "their heart out," one of them said, as their lines in pencil, charcoal, and colored pastels looped and slashed across each other until the paper was thick with coal, chalk, and graphite.[45] They drew as if they were afraid to stop. Who knew what would happen if they did? The prospect of the morning loomed uncertain enough.

Elaine

4. Marie Catherine Mary Ellen O'Brien Fried's Daughter

> When one is young and on the threshold of life's long deception, rashness is all.
>
> —*Françoise Sagan*[1]

Elaine called it a "transit encounter."

"I met a boy I had not seen since I was twelve years old.... And he said, 'What are you doing?' when I met him on 34th Street, carrying books.

"And I said, 'Oh, I'm going to Hunter College, and I have all these books and I have a lot of homework, and—'

"He said, 'Are you painting?'

"And I said, 'Well, I can't. I have all these, I have to, I'm studying physics and calculus, and German....'

"And he said, 'But you should be, you're an artist. You should be going to art school.... There's an art school called Leonardo da Vinci.... It's on 34th Street and Third Avenue.'

"That changed the course of my life. That meeting. If I had not met Larry Eccatani that day, I would never have heard of Leonardo da Vinci Art School. It was totally obscure," Elaine said. "It was through that school that I met this guy who introduced me to Bill. Because I might not have met Bill for twenty years, if ever. So, that one chance meeting—which is very terrifying in a certain way."[2]

The year was 1936. Elaine Fried was an eighteen-year-old college math major who commuted home each night by subway from Manhattan to Brooklyn.[3] But that did not begin to describe who she really was. Siren, saint, creative tempest, athlete, intellect, she could seemingly do anything better than anyone. And she was so socially adept that she could convince even those she had just bested that they had all had a wonderful time in the process. "She was a genius at life, accepting every one of its conflicting opportunities, juggling all chances, reckless with the love of it all," said her friend Rose Slivka. The painter Esteban Vicente called Elaine "a remarkable, perhaps sort of mad genius."[4] It was no wonder that Larry Eccatani expressed shock at seeing her engaged in such a pedestrian activity as going to college (which, in those days, was actually quite unusual for a young woman). The children who had grown up alongside Elaine in Sheepshead

Bay thought of her as a star and an artist.[5] She had considered her competition in that arena to be the Renaissance master Raphael and was briefly stricken when, at the age of ten, she discovered he had painted one of his best works at thirteen. Confident that she was up to the task, she thought, "Well, that gives me three years."[6]

By the time Elaine ran into Larry, she had in fact already decided she wasn't particularly happy at Hunter. "I didn't feel in control," she said. "*I wasn't choosing what to do.*"[7] Sometimes in telling a story Elaine collapsed the chronology to make it appear that things had happened more quickly than they did. In her memory, peripheral events didn't exist because they didn't matter. But it seemed in this case, her actions *were* swift and decisive. That very evening, after her encounter with her childhood friend, Elaine found the Leonardo da Vinci School, applied for admission, and was soon accepted.

Having dropped out of Hunter in the meantime, she entered what she called "a charmed circle"—her first fully artistic environment. "The atmosphere was free and easy, artists and students milling about in the hallways, sculptors carving stone or modeling clay in one room, students drawing from the nude in another." Years later Elaine described the "liberation" of seeing "a naked woman and everyone just taking it completely for granted."[8] Most of the instructors at the school were "mad" Italians, and some were employed through the Project. Elaine's first teacher was among those hires. His name was Corrado di Marcarelli—Conrad Marca-Relli. He was twenty-four and, according to Elaine, had a car "a half a block long."[9] Through Marca-Relli, who would become a lifelong friend, Elaine began to see what being an artist meant—the great joy of it but also the inherent sacrifices. "I was interested in the hard work of art," Elaine said of herself at eighteen. "I mean, just making drawings every day, all day long, and just completely being submerged in that activity."[10]

Tapping her penchant for costume, Elaine started to dress the part of the artist. "She seemed very dashing in a black trench coat and a beret. And she was very poised," recalled fellow painter Jane Freilicher. "She had bright red hair as a young girl, in a pageboy. And she had a strange accent that didn't make sense geographically. I don't think it was affected, but it was definitely not Brooklyn."[11]

During Elaine's commute into Manhattan she now carried a drawing pad, pencils, and charcoal, but she was also still laden with books. Her decision to leave Hunter did not mean that she had abandoned her studies. ("I'm a 'have your cake and eat it' girl," she explained.)[12] One day she sauntered into Marca-Relli's still life course and caught the eye of class supervisor Robert Jonas because she was carrying a thick book on schizophrenia. "She was very good-looking and very hip," as was made clear by

the fact that she was carrying a book on mental disorders when New Yorkers were discovering Freud, he said.[13] Elaine, too, recalled their first encounter, although slightly differently. "Well, this man came in and surveyed the class and I said, 'Oh, he's going to come over to me' after he looked around because I had [on] my little blue sweater. And he did. And he asked me for a date, and said he would take me to see a show of American abstract artists."[14] Elaine had spent many afternoons at the Metropolitan Museum and the Frick, looking at the art with her mother and siblings, and then later making copies of works in those collections on her own. She had come to assume that to have a painting in a museum or show the artist must be dead and European. The prospect of seeing an exhibition of modern art by living American artists had not even occurred to her.[15]

Jonas proved to be a competent guide for her initial foray into that world. At thirty, he painted small Surrealist works and was part of the downtown scene. He had even lived briefly with Lee and Igor that year.[16] As for the show he took Elaine to see, it was an important one: the annual exhibition of the American Abstract Artists. A *New York Post* critic who saw its first exhibition the previous year declared that he foresaw no future for the abstract movement. For Elaine, the 1937 show was a revelation. Two decades later she could still remember the placement of the paintings and the names of the artists.[17] Jonas told her that as good as the exhibition was, though, the best abstract artists — de Kooning and Gorky — weren't in it. In Elaine's retelling of the story, Jonas sometimes included himself among those omitted "best," a suggestion she dismissed out of hand. To be an artist, she said, "you had to be reckless." Elaine sensed that Jonas was terrified of life, a characteristic she could not countenance.[18] Brief though Jonas's involvement with Elaine was, he played a very important role in her story: He introduced her to Bill.

In the late 1930s, Chelsea around 22nd and 23rd Streets was a dirty, desolate patch of industrial wasteland. The area's Civil War–era buildings had once been fashionable homes, but when the families who had lived in them migrated uptown, the structures were occupied and deformed by small manufacturers. Then, during the Depression, those businesses left, too. What remained was a veritable ghost town: building after building of empty loft space, owned by landlords who despaired of finding anyone willing to rent in that inhospitable district.[19] Artists, poets, and composers, however, *were* willing. Edwin Denby, a poet who would be a central figure in Elaine's life, said the artists were thrilled to occupy a neighborhood that was "unknown, uncozy, and not small scale."[20]

Occasionally in those buildings, traces of what they had once been were still evident. A broom could uncover parquet flooring. Filtered light might

reveal an arabesque of metal railing along what had been an elegant staircase. Breaking out a wall often exposed a fireplace, which though no longer usable was still a nostalgic reminder of warmth. But generally, the structures were dilapidated, with cracked windows, faulty wiring, toilets without baths, cold water, and steam heat only during "working hours."[21] Though a few businesses had remained operative on the lower floors—laundries, bakeries, storage facilities—at night Chelsea appeared empty. "If you took a walk at midnight, all the buildings... would be all dark, but the top floors, where the skylights were, all were lit," Elaine said. "And that's where the artists were, and you would hear Stravinsky" floating from the open windows.[22]

One evening not long after the American Abstract Artists show, Jonas brought Elaine to the Artists Union hangout, Stewart's, on 23rd near 7th Avenue in Chelsea, to meet Bill. Lit up valiantly, the cafeteria appeared like a beacon along the darkened street on that cold evening, everything behind its massive plate glass windows made plainly visible to passersby. De Kooning sat inside, alone with a cup of coffee, reading a detective magazine. He was dressed in a thin jacket and a seaman's cap, and Elaine noticed that his hair was so blond it had an almost greenish tint.[23] "He had that limpid open gaze," she remembered. "Anyway, he was beautiful." Broke because he had just left the Project, Bill was nonetheless faultlessly polite, and bought the guests who sat down to join him a cup of coffee for five cents each. They nursed those drinks for hours until Stewart's closed and then, out on the street, continued to talk as they strolled a mile south to Washington Square. In the hours between her arrival at Stewart's and their journey back to 22nd Street and Bill's studio, Elaine had already decided that she was going to marry him.[24] She had been seduced by the man and his words. Now, inside his loft, she fell in love again—with his work. "Bill had a painting on the easel of a man, a bald man. It was a very quiet painting.... And I just knew that he was a genius. I mean.... Immediately."[25]

Through the years, as she repeatedly described that first encounter, Elaine frequently seemed as struck by Bill's vast studio as by his painting. Most probably she had never seen anything like it. She was a teenager from Brooklyn who shared a bedroom with her sister in the family home. She had only begun to meet "real" artists that year. Bill's studio was literally a new world for her, one in which the inhabitant's life had a single focus: art. Elaine would say later with admiration that Bill's studio struck her because it had "clarity." It was the clarity of a monk's cell—whitewashed, light-filled, immaculate. And in the kitchen, Elaine found "two cups, two saucers, two plates, and two glasses." A single suit hung in the closet.[26]

The Spartan severity of his studio, however, was deceptive. Bill's life was much messier than it appeared. For several years, he had been living

off and on with a dancer named Juliet Browner and the vaudeville performer Nini Diaz. The three had sometimes lived and slept together, or sometimes the two women lived apart from de Kooning but together, and at other times Juliet lived alone with Bill. He seemed to passively accept their presence when they appeared, and just as passively accept their departure.[27] Neither Juliet nor Nini were in evidence during Elaine's initial visit to Bill's loft. All she could see was a brilliant older man with an enormous talent. Bill placed a record on his phonograph. It was "The Rite of Spring," which he played at full volume as they sat looking at his latest work. Elaine was dazzled. "When I met Bill de Kooning," she said, "I just knew that I had met the most important person I would ever know."[28] For his part, Bill was besotted with Elaine. "There was nothing subtle about it," a friend of Elaine's recalled. "He told everybody."[29]

De Kooning had arrived in the United States eleven years earlier at the age of twenty-two by stowing away on the SS *Shelley* from Rotterdam. His interest in America had been born in movies he had seen as a boy. The people on the screen were lighthearted and enthusiastic, and the United States appeared a welcome alternative to what he viewed as a dark and tradition-bound Europe. When he arrived in the States, despite only being able to speak one word of English—"yes"—he planned to "be a commercial artist, make money and play tennis, and find those long-legged American girls" he'd seen in the pictures. He never did play tennis ("didn't really want to") but he had no trouble with women.[30] Bill was charming. A friend said he had an "innkeeper's mentality: you like everybody and get along with everybody." It was a trait he picked up from his mother, who ran a sailor's bar back in Holland.[31]

At thirteen, after being apprenticed to a house-painting and decorating firm, de Kooning had inadvertently begun his life as an artist. Its managers had recognized his natural talent and encouraged him to study at the academy in the evenings, which he did for at least six years. That meant that by the time he arrived in the United States he had been trained in all aspects of art—from the commercial to the classical—and immediately found work and acceptance among the downtown artists who traversed those worlds. By far his most important early encounter was with Gorky. They became "inseparable." Soon, the tall, dark, brooding Armenian and the small, blond, easygoing Dutchman were joined by Stuart Davis and John Graham in forming a core group of artists recognized around the Village as "modern."[32] All but Graham were part of the Jumble Shop crowd Lee met up with to talk art and politics. They were in no way remarkable, simply the latest iteration of the bohemians who had called Greenwich Village home since the mid-nineteenth century.[33] And like those predecessors, if

there were a genius or two among them, it would likely take decades or death before they were discovered.

Elaine's initial encounter with de Kooning had produced little more personally than an unspoken conviction on her side that they would meet again—and marry. Professionally, however, it erased any misgivings she might have had about art. In 1953, she would write about another artist in words that no doubt described her own first experience with Bill.

> Almost every artist seems to meet someone at the beginning of his career who profoundly and often inexplicably affects later decisions and attitudes, someone whose personal expression is identified with the peculiar glamour of art that hits certain people so hard that they are caught up with it for the rest of their lives.[34]

It was that glorious, albeit ragamuffin, glamour that drew her. She returned to the da Vinci School with eyes newly opened by the art she had seen in Bill's studio and the modern work she now sought in galleries and museums. She wasn't necessarily looking for abstraction. She was simply hungry for art that reflected the times, *her* times. Under those circumstances, the classical art taught on Third Avenue, which had been wildly exciting a few weeks before, felt tame. She began to look for a new school and, through another chance encounter, found one.

Elaine had volunteered to represent the da Vinci School at a meeting held by the John Reed Club, which was trying to form a students' wing of the Artists Union. At the organizational gathering, Elaine met a handsome, twenty-year-old Russian painter named Milton Resnick, who represented the American Artists School. He told Elaine *it* was the "center of the art world," and for a young artist in many ways it was. Located on 14th Street, the school stood at the crossroads where modern art met radical politics. Students not only learned about advanced art from Artists Union painters and sculptors who taught there, they were also fully indoctrinated with leftist ideology. The Communist Party dominated the school.[35] For Elaine, that environment was intoxicating. She enrolled. "I loved the conviviality of the school, the endless arguments over politics," Elaine said. "I had been brought up as a Roman Catholic, but I felt at home with members of the Young Communist League or the opposing Trotskyite groups. Our discussions would rage on and on, night after night."[36]

Elaine approached her new life with a freedom born of two assets that her elder in art, Lee, did not have: youth and money. Lee was ten years older than Elaine and, as an adult, she was self-reliant at a time when earning money was nearly impossible. By contrast, Elaine was a teenager living

off her financially well-positioned father. Not to diminish her commitment to art or politics, but life for Elaine at that point was a lark. As for life as an artist, in those early days Elaine had an easier path in that regard, too. She was a carefree young novice whose teachers (all male) were eager (if not thrilled) to encourage and guide her, while Lee was a contemporary of those instructors, with whom she interacted as equals. Still, as Elaine took her first steps into the world that she and Lee would share for decades, their differences were less significant than the many attributes they held in common: talent, strength of character, and audacity, among them.

Elaine immersed herself in the school, studying—she said, from ten a.m. to ten p.m.—not just drawing and painting but sculpture and lithography, too. She had also begun working as an artist's model. She became one of the naked women people took for granted, except in her case they didn't. Elaine was voted "most beautiful model" by members of the Artists Union. She and Milton Resnick, meanwhile, had become friends and then lovers. That tortured young romantic, with his chiseled face and deep-set black eyes, would be Elaine's first serious boyfriend.[37] "We sat in on stormy Artists Union meetings, listened to boogie woogie at Café Society Downtown... went to foreign movies at the Rialto on 42nd Street, went dancing at Webster Hall or to the dance halls in Harlem," Elaine recalled. "At last, every minute of my life was chosen by me. I was free of constraints."[38]

Soon the pair would be joined by a third, who would become Elaine's closest friend for life. A self-described "little girl from Louisiana," she was a painter from Shreveport who, like Resnick, could match Elaine prank for prank, passion for passion. Her name was Ernestine, which Elaine—having no time to spare on three-syllable formalities—shortened to Ernie.[39]

Nineteen-year-old Ernestine Blumberg had arrived in New York by train in 1934 with six hundred dollars from her father, who had told her she could stay until her money ran out and then come back home. (Eighty-one years later, she was still in New York.) Though she had come north to attend the Art Students League, Ernestine eventually found her way to the American Artists School, where she became friends with Milton and his girlfriend, Elaine. "At that time I thought she was one of the most beautiful and intelligent women I had ever met," Ernestine said. "She never disappointed me."[40]

Elaine quickly hatched the first of what would be many plans involving Ernestine: She declared they should rent a loft. "Milton and his friend were living way uptown somewhere and Elaine decided she wanted to have a place in New York, in the city away from family," Ernestine said, "and they persuaded me—I was the only one that had a job—to share a loft with them." Ernestine was "color editor" of the *Famous Funnies,* the first retail comic books. Earning a whopping thirty-five dollars a week, she was rich by

the standards of her Depression-era friends. Their first loft was at Fourth Avenue and 29th Street. "People came there, they couldn't figure it out, what this ménage à trois was," Ernestine said.[41] It was, in fact, less a ménage à trois than a ménage à deux, in several configurations. Milton and Elaine had wanted a place to work and meet without alarming her family, and so they invited Ernestine to join them as a cover. But Elaine didn't, in fact, live in the loft—her mother wanted her home by ten each night—and so Ernestine and Milton lived together. "Which made it very strange," Ernestine said. "Lots of people hung out there. We were young and kind of crazy."[42]

Greenwich Village was a place where it was difficult to attract attention. The denizens of Washington Square were connoisseurs of the unconventional. They were also a bit jaded when it came to pretty women; the Village was full of them. Elaine and Ernestine, however, made an impact. They were about the same height (Elaine slightly taller at five feet five), and the same shape (slender and boyish). What distinguished them was their hair: Elaine's was flaming red, Ernestine's golden blond. Together they made a ferociously vibrant team as they ran the streets in colored tights, outlandish shoes, and outfits cobbled together from bits and pieces purchased at a cheap department store on Union Square. "We were up to no good all the time," said Ernestine.

Once while walking on Ninth Street, they came to a doorway and "Elaine said, 'I hate that guy up there, Max Spivak.... Let's make him come down,'" Ernestine recalled. "We rang the bell and we ran way." Max wasn't there, but the artist he shared his loft with was. The infinitely patient sculptor Ibram Lassaw stopped his work, came down the five flights to find—no one. "That was the only time he came down and there was no girl waiting for him," said Ernestine of the man she didn't know at the time but would marry five years later.[43]

Elaine's and Ernie's lives were fast and free, lived at the tempo Elaine craved. "She was a daredevil," said Ernestine. "We used to go up on the roof at our loft to cool off in the summer, and Elaine would stand on the edge and walk around teetering. When we would cross the street, I wouldn't go across if it was a red light. Elaine would walk across right in front of onrushing traffic and dare them to hit her. She never admitted she was afraid."[44] In 1960, art critic Lawrence Campbell would write of Elaine, "She herself is like a figure out of Baroque history since she does not have a sense of her own boundaries. It's as though she could become all kinds of things, anything."[45]

By the second half of the 1930s, three styles dominated American art. Many painters clung to the reassuring message of the so-called regionalism promoted by the Project for its murals—happy farmers plowing rolling

fields or gangs of workers joined in common purpose. Others responded to the Communist Party's call for "socialist realism." Those paintings depicted the same farmers and toiling workers as their regionalist brethren but without a trace of the gladness. The realists felt it their duty to make society's problems the subject of their work, and so they painted hollow men and women in fields parched by drought, or laborers tormented by capitalist overseers. The third group of painters, the abstract artists, looked for something that transcended narrative. They did not want their work to tell a story but for their paintings to be appreciated *as painting,* the way a concerto is appreciated for its sound. Lee, Gorky, and Bill were part of the latter group. Elaine, Ernie, and Milton painted in the "socialist realism" vein. "I was swept along with it," Elaine said. "I began to paint scenes of the Spanish Civil War—women reaching toward the sky with blood running down their arms."[46]

Elaine must have been proud of her work because in 1938 she ran into Bill on the street near the new loft she shared with Ernie and Milton on 22nd and Fifth Avenue and invited him in to see her paintings. Elaine said the paintings she showed him were "gorier than ever.... He just stood there a while then said, 'Why don't you just paint a still life?'... He suggested I come and set up a still life in his studio and paint along with him."[47] Bill told her, "'If we both look at it then I can talk about it. When I look at this kind of painting there's no way I can talk about it. I can simply say I like it or I don't like it'.... And so, that's what I did."[48] Elaine soon began working with the person who would be the second greatest influence in her life. The first had been her mother. The phenomenon who would become Elaine de Kooning was very much Marie Fried's creation.[49] In fact, without an introduction to Marie, it would be impossible to understand Elaine.

Elaine's mother was born Mary Ellen O'Brien, but at some point she adopted the name Marie Catherine. It seemed to suit her better. She was an Irish queen like Grace O'Malley or Maud Gonne. She was meant to *be* someone in life. Marie's father had owned a bar on 28th Street and Eighth Avenue, and Manhattan was her kingdom. She knew every corner of the city and fed on it intellectually and culturally. By 1917, Marie was studying law at Hunter College, a remarkable achievement for a woman at the time, but she soon discovered she was pregnant by a young self-made businessman named Charles Fried.[50] They married, and for the next five years Marie was with child. (Elaine was the oldest of four children born in quick succession—two girls and two boys.) Marie may have assumed that once her years of indisposition ended she could return to her intellectual pursuits. She was mistaken. Out of concern for the children, Charles moved the family to a cultural backwater—Sheepshead Bay, Brooklyn.[51]

A good though remote man, Charles went off every day to his job in Manhattan as a CPA at a bread company, and when he came home his world revolved around the garden and the animals—some invited, some that had simply wandered into their lives. In 1920s America, meanwhile, a mother of four young children like Marie would have been expected to seek fulfillment in cooking and cleaning, washing and ironing, in making her home a castle for her husband and a sanctuary for her children. To Marie, that was all so silly, so beside the point. She wanted a life of the mind, of creation, as she had had in Manhattan. "She was contemptuous of Brooklyn," Elaine explained.[52]

While the children were young, Marie did her best to import her cherished culture into the house for them. That was *her* idea of mothering. She hung large framed reproductions of paintings on the walls—Michelangelo, Raphael, Rembrandt, Rosa Bonheur, Elisabeth Vigée-Lebrun. "I just grew up...from an early age, assuming that...half of the artists on the face of the earth were women," Elaine said. As soon as the children could hold them, Marie gave them "opulent art books."[53] Literature? "My mother was my chief reading guide until I was sixteen," Elaine said. Marie wouldn't just give her *a* book by an author, she gave her everything that author had written so Elaine could understand the scope and development of their talent. Dickens, Shaw, Proust, George Eliot, Jane Austen, the Brontës. Again, Elaine stressed, her mother wasn't making a point of introducing her to the works of women. "It was just the natural order of things."[54] When Elaine was five, Marie decided her daughter was ready to experience art firsthand at the Metropolitan Museum. "I remember it very vividly," Elaine said. "Immediately it grabbed me...but I never, it never occurred to me that people made [the art on the museum's walls]." This was the case until she was seven or eight, when her mother told her to stand still so she could draw her. "And she made a drawing, and as soon as she made it—it was very primitive—I immediately became competitive. I thought I can do better than that. And suddenly I realized that those little drawings that I was making" were part of a greater tradition.[55]

Marie gave all her children that education. She didn't support them, she challenged them. Elaine's brother Conrad remembered his mother announcing one day, "Now we all have to learn the Greek alphabet."[56] When Conrad was old enough, Marie enrolled him, during subsequent years, in the best high school in New York and the worst. "She thought that was an education for him," said Conrad's son, Charles Fried. (As an adult, Conrad would design the prototype for the ubiquitous bar code.)[57] Almost every week Marie brought the children into Manhattan to see a play, visit a museum, or scour the library. But she saved her special attention for Elaine. "She taught Elaine to dream very big. She once took

Elaine by cab to Canada. She was eccentric and she inspired a brand of eccentricity in Elaine," said her nephew Dr. Guy Fried, adding that Marie "was fabulous at high-end things, but she didn't have time for the kitchen."[58] Despite Charles's good salary, the children had to "scrounge for food."[59] Neighbors began to notice that the Fried children were dirty and disheveled, and that they seemed hungry.

In that middle-class district of neat homes, clothes flapping on the lines, cookies baking in sparkling kitchens, and pie recipes exchanged on porches, there is no doubt the neighbors were suspicious of Marie. She was obviously not one of them. Her face was caked in white makeup (one friend said it looked as though she had stuck her head in a barrel of flour) and then recolored with rouge. She wrapped her head in scarves, wore dangling earrings when most women wore discreet pearl clasps, and sometimes piled bracelets all the way up to the elbow.[60] That enigmatic figure could be seen riding her bicycle around the neighborhood.

When Elaine was six, while her father was in the city at work, police came to the house to take Marie away. They had received a complaint of child neglect because the neighbors said the children looked malnourished. Marie refused to leave. "So, they grabbed her and dragged her out screaming" as the children stood watching her kicking and clutching the banister in a futile effort to stay, recalled Elaine's brother Conrad. "She wasn't crazy," said Ernestine. "Marie was a totally frustrated woman."[61] Marie was institutionalized for a year at a psychiatric facility in Queens. "Institutions were for rich people who were not obeying their husbands," said Elaine's nephew Guy. "'For her own good,' the institutions would 'fix' them. In hindsight, you say, perhaps the institution was wrong."[62]

Marie was unchanged by the experience. Once released, she would remain just as eccentric as she had been prior to being locked up and continue to be a "bad" mother by educating her children rather than doting on them. But Elaine *was* changed.[63] As an adult, she would never allow anyone to take her freedom or in any way restrict or restrain her. She would do what she wanted without regard for the consequences. "Marie and Elaine were both free—then, it was revolutionary and unsafe," said Guy. "They were doing exactly what their hearts said, and society shifted to catch up with them."[64] Eventually, that is. But first, Elaine and her fellow women had a great many barriers to overcome.

5. The Master and Elaine

Life is discovery or it is nothing; life is adventure or it's jail.
— *May Natalie Tabak*[1]

ELAINE ARRIVED AT Bill's studio for her lesson. He gave her a random mix of everyday objects with which to build a still life—a coffeepot, a large shell, a yellow cup, a blue cotton shirt, an army blanket. Elaine's idea was to construct an arrangement that Cézanne might paint. Bill wanted her to try something different. A photographer friend who lived in the building next door, Rudy Burckhardt, had been doing a series of still life photos Bill liked. He positioned the objects apart from one another, like isolated individuals, rather than grouping them in an overlapping composition as was traditional for the genre. Bill pointed to the yellow cup and described how much more intriguing its shape would be if it stood alone. He found its contours remarkable against the space that it had "displaced."[2] "He'd say, 'Look how this sits there'... He'd use that term often, and it would be as if you'd never seen a cup before," Elaine said. It's unlikely de Kooning was consciously trying to train Elaine's eyes to see. The close observation he described was simply how *he* worked. Every aspect of the process mattered to him, and he was imparting what he knew to her. "When he talked, it was as if I were lifting weights. Not as if he were giving an opinion," she said, "but as if he were demonstrating something that was absolute and true, but that I had never seen before. As if he were telling me what $E = mc^2$ means. I had to strain. It was that kind of consciousness.... Not dodging things. It was making it as hard as possible."[3]

It was also an extremely intimate approach that would have heightened the physical chemistry between them as they stood side by side, quietly considering the pile of junk that had been transformed into precious artifacts as Bill described their unique visual and tactile qualities. Elaine would say that after she'd listened to de Kooning talk for an hour about a drawing or painting she would collapse on the bed "brain-tired."[4] She had been challenged to think in a new way, certainly, but her exhaustion went beyond the merely intellectual. She had been overwhelmed by an aesthetic experience almost sexual in its intensity and ability to transport. The Spanish painter Joan Miró would say, "Painting or poetry is made as one makes love—a total embrace, prudence thrown to the winds, nothing held back."[5] That is the world to which Bill introduced her. Elaine had

sought art. This was it. It required commitment, mind and body. It was spirituality and it was sensuality. It was life. Of her initial session with Bill, a sated Elaine said, "It was just absolutely terrific, and I really felt as though I could spend my entire life painting still lifes and express everything I wanted to express through them."[6]

Elaine's artistic world was now split between the American Artists School and Bill's studio. There she would spend days setting up still life compositions and months painting them on canvases he had stretched for her. She felt as though she was developing what she called "the wordless part of the brain,"[7] which made her antagonistic to the social realism taught at school. She began to argue with her instructors because she could not reconcile their lessons and Bill's, and she believed de Kooning's to be the "purer" approach. "Bill to me was *the* master," Elaine said, "and it's one of those attitudes that has prevailed throughout my life."[8] That student-teacher connection, however, was only part of their burgeoning relationship. By 1938, Juliet Browner had moved out (she would later marry photographer Man Ray), and Elaine had become the woman at Bill's side. "I don't think he had fallen in love with anyone before," said Ernestine. Women "had just sort of moved in on him and he accepted them.... He was very passive about it." Rudy Burckhardt agreed, saying, "Bill was incredibly in love with her."[9] Another friend expressed absolute shock over de Kooning's transformation after meeting Elaine, saying that Bill had suggested, "and I believe he was telling the truth—that he was prepared to be monogamous, that he didn't want any other woman. Just Elaine."[10]

In 1938, de Kooning was thirty-four and Elaine just twenty. As the "master" he appreciated the seriousness with which she approached her work and her evident respect for him and his art. As a man, he loved her vibrancy, wit, social grace, but most especially her thick red hair and, yes, her long American legs. Bill was also extremely proud of her. He had become the envy of his friends, who congratulated him on his "cute trick."[11] Gorky and his fellow Armenian, the sculptor Raoul Hague, often accompanied Bill and Elaine to the Metropolitan to savor a bit of vicarious happiness in those bleak times. Gorky would pontificate, his melodic voice echoing down the great halls. Then they might wander behind the Met for a stroll in the park. During one such journey, Elaine won the older men's hearts by offering to play gondolier, rowing a small boat around Central Park Lake while they relaxed. "They all loved it. Gorky said to Bill, 'That's very smart to have a teenager American girl. They're very strong.'" Elaine laughed at the memory. Hague recalled Bill's fury when he thought he caught Hague and Gorky trying to look up Elaine's skirt while she rowed.[12]

Gorky was Elaine's and Bill's near-constant companion at the Metropolitan. He considered it *his* museum. He could talk for an hour about the

corner of a tapestry or a portion of a Greek sculpture. Sometimes he would approach people who had stopped in front of one of his pet paintings and offer a lengthy, unsolicited explication of the piece. The painter Peter Busa, who occasionally went to the museum with Gorky, Elaine, and Bill, said the experience was "like going to church."[13] Such was Gorky's otherworldly presence that once, while sitting in the Met looking at a Rembrandt, "a woman stared at him and finally said, 'Pardon me, but you look like our Lord, Jesus Christ!' Gorky stood up. He was insulted!" recalled a friend. "'Madam. My name is Arshile Gorky!'"[14]

Having Elaine around boosted Gorky's spirits when he was at a very low point. An artist friend had recently starved to death in the Village. (De Kooning had also lost a Dutch painter friend in the Village to starvation.)[15] Gorky, too, was dangerously broke. He supplemented a meager teaching salary by offering private lessons at fifty cents an hour, which Barr's assistant Dorothy Miller and her husband, Project chief Eddie Cahill, took because they could not bear to see such a talented artist suffer.[16] And he had had a series of unsatisfactory love affairs—one that resulted in a six-week marriage to a woman he had only known for ten days. His friends said he married her because he thought she looked like a Picasso model. Gorky described the 1930s as the "bleakest, most spirit-crushing period of his life."[17] His agony might have been diminished somewhat by Elaine's tonic presence.

For her part, Elaine understood that she occupied a privileged position. Bill and Gorky were exceedingly generous in their attention and instruction. "Years later I asked Bill if I had been a seventeen-year-old boy, would I have been allowed to sit in and put in my two cents on everything. And he said, 'Are you kidding?'" They had offered her access to all they had learned and she diligently absorbed it.[18] "Their reverence and knowledge of their materials, their constant attention to art of the past and to everything around them simultaneously, established for me that whole level of consciousness as the way an artist should be," she said.[19] "I thought, I have come as the crow flies to the real artists in America.... I just knew there couldn't be anyone better than these guys."[20] That was Elaine's true academy of art. A third man, however, would be crucial to all of them by underpinning their work with theory. That man was John Graham.

In the great debate over whether the artists associated with Abstract Expressionism constituted a movement, it is often said that they did not because there was no manifesto that united and guided their work. In fact, there was: John Graham's *System and Dialectics of Art,* which was published in 1937, a full decade before discerning outsiders began to detect that something was happening in New York. Graham wrote his book in cate-

chism form, like the *Communist Manifesto,* by asking a series of questions, beginning with "What is Art?," "What is Abstraction?," and "What is the purpose of Art?"[21] He responded with concise and elegant statements that would become the spiritual, aesthetic, and social basis of advanced American art during the crucial first decade of its development. Those who read it when it was published—mostly Graham's artist friends—devoured it quickly and discussed it endlessly. And, in the meantime, Graham himself became a kind of celebrity seer for all things aesthetic in the Village. A former Russian cavalry officer (he could do somersaults while riding his horse at a gallop), he walked the Village streets like an aristocrat—dressed in a suit jacket, his back ramrod straight, his shaved head held disdainfully high.[22] Lee called him a "mad, wild, beautiful person." He once told her, "I was born to power and trained to rule."[23] Instead, he became an artist.

Graham held forth on a bench in Washington Square and in an Italian pastry shop on Bleecker Street called Pasquale's. There, Bill, Elaine, Gorky, and Milton Resnick, and later Lee and Pollock, among countless others, would gather to listen to him talk.[24] He was a true heir of the Russian intelligentsia, which was alienated from society long before such estrangement became fashionable with the advance of French Existentialism in the late 1940s. He loved women, wine, and art. Money, which he did not have despite his noble appearance, failed to move him. He even told artist friends that he would no longer associate with them if they were ever critically or financially successful.[25] For the New York artists, he was, like Hofmann, a well-traveled elder with links to Paris. He had known the painters there and made regular reconnaissance missions to France to check on artistic developments.

The message he brought back was not that the American artists should strive to be like their better-established European counterparts but that they should strive to be *themselves.*[26] Graham was one of the earliest advocates of the modern work being produced by painters and sculptors in New York. Whether he intended it or not, his *System and Dialectics of Art* became a theoretical guidebook for them as they began their struggle in a cultural environment that neither recognized nor encouraged their work. To survive, he said, they must reject the world that scorned them and forge ahead amid their tight colony of artists. But how and where to go? Graham's book was like a sign posted over a darkened doorway that read "Enter Here."

Graham defined art as a "process of abstracting" thought and emotion by use of paint or metal or stone. Because art was therefore intrinsically abstract, the duty of the artist would be to push abstraction "fearlessly to its logical end instead of evading it under the disguises of charm or being 'true to nature.'"[27] The artist created for society, he said, but if that society

didn't like what he or she had produced, the artist "does not trade his ideals for success. Martyrs and saints love luxury and success just as much as ordinary people, only they love something else even more." Graham said, if the artist is a true genius, he can *expect* to be misunderstood and alone. "The beauty of genius is frightful to behold, few can envisage it. Others find subterfuge in skepticism."[28] The abstract artist, he said, would be repeatedly challenged by such skeptics asking, " 'What does it mean?' . . . 'Is it a sky, a house, a horse?' " To which they should respond with confidence and honesty, " 'No, it is a painting.' "[29]

Finally, Graham said, of all the arts, painting was the most difficult because one false move on a canvas could mean the difference between a great painting and a failure. A writer could always resurrect a word, but a line or a shape was so ephemeral that, once changed, it was almost always lost for good. "To create life one has to love. To create a great work of art one has to love truth with the passion of a maniac. If society does not perceive this love, humanity perhaps will."[30] Graham's book also included a history of art — from prehistory to the twentieth century. It therefore not only consoled and encouraged, it instructed. The artists who read it came away, as they did from Hofmann's lectures, feeling as though they were not aberrations but part of a long and proud tradition of individuals who had ignored fashion to create culture.

Shortly after the Valentine Dudensing Gallery caused a sensation in the New York art world in the spring of 1939 by exhibiting Picasso's *Guernica*, a museum opened nearby that produced a similar commotion. The Museum of Non-Objective Painting reinforced Graham's ideas by featuring artists who had dared to push abstraction beyond Picasso and into the realm of pure spirit. Fittingly, Graham was an adviser to the director of the enterprise — the Baroness Hildegard Anna Augusta Elisabeth Rebay von Ehrenwiesen — known in New York simply as Hilla Rebay. A Bavarian-born painter, ten years earlier she had begun working with Solomon Guggenheim to build what would become New York's Guggenheim Museum collection. But until that facility could become a reality, Solomon had financed a museum in a townhouse on 54th Street to showcase the art Rebay championed: art that did not have an identifiable subject other than itself.[31] Cubists, Fauves, Impressionists, Surrealists, and German Expressionists all abstracted reality, but their works included *things*. People might be flattened and twisted, tabletops painted at rakish angles, the fruit resting on them distorted nearly beyond recognition — but not quite. They would remain discernible as objects. Rebay's museum featured works that went past that type of recognition. Her most important artist was Vassily Kandinsky, the first painter of modern times to employ pure abstraction *and* expressionism. For artists who had been fed a steady diet of Cubism and

were trying to find a way out of it, Kandinsky offered the key.[32] And in Rebay's museum, he was on offer in profusion.

Often the importance of Rebay's museum is downplayed in the history of the New York art scene because she was herself so controversial. Rebay employed many artists and had a reputation among them for being a "tyrant," although she also offered stipends to help support artists who worked in a nonobjective style. Because she was German, she was suspected of Nazi sympathies, though her personal letters showed that she abhorred Hitler and his cronies, whom she called "idiotic asses." (In 1937, when so-called degenerate art in Germany was at risk, Guggenheim, under Rebay's guidance, bought as many works as he could to save them.)[33] Some dismissed her as the manipulative lover of a rich old man, others as a middle-aged screwball. (The painter Peter Busa recalled that she often wore very loose pants, which would fall off while she was talking about a work of art. Undaunted, he said, "she'd leave them on the floor and move on to the next painting.")[34]

But her personal quirks and the museum's own "cosmic" atmosphere of piped-in Bach and silver and gray decor did not diminish the impact of the work it contained on the artists who saw it.[35] When the museum opened, those artists were trying to assimilate all the various directions in art to which they had been exposed in the previous decade. They were also, as were Americans in all fields, preparing for war. Kandinsky spoke with great prescience directly to artists in this position. In 1914, just as the previous global conflict was about to explode, he wrote, "When religion, science and morality are shaken, and when the outer supports threaten to fall, man turns his gaze away from the external and towards himself."[36]

By the beginning of 1939, Elaine was still living at home and still sharing a loft with Ernestine and Milton, who was still technically Elaine's boyfriend. Her life had become very complicated. Ernestine had never met Bill, and Elaine insisted that she do so. In fact, she thought Ernestine should take lessons from him, no doubt to give Bill a little extra income. "He had never had a show. He had never sold anything except to a friend to pay the rent," Ernestine said. "He did come to give me a lesson, but it didn't exactly turn out to be a lesson. So, that was the end of it. This is something I've never told. He made a pass and I was shocked because I knew," Ernestine's voice trailed off. "That was the end [of the lessons], not the end of my friendship—I adored Bill, he was our friend for many, many years. But in those days, that's what men did." His clumsy overture did not mean the situation between Bill and Elaine had changed. Ernestine said with absolute certainty, "He was in love with her."[37]

Indeed, Elaine and Bill had become lovers and, given Bill's jealousy and

her desire to meld her life with his, she had decided to break up with Milton. "Milton was devastated," said Ernestine. Not only was he devoted to Elaine, but he and Ernestine had both become part of Elaine's family in Brooklyn. Milton had abruptly left his own when he was seventeen and had gladly assumed the role of the eldest daughter's boyfriend, hanging around with her brothers, eating Sunday meals with the Frieds.[38] Undoubtedly, he had expected that their relationship would end in marriage and the eccentric and brainy bunch in Sheepshead Bay would be his family, too. "Elaine de Kooning was my sweetheart," Milton would say many years later, "and she kind of got seduced by him, and he said, 'I'll teach you to draw' and she went over and he screwed her, and then it became something between us. She couldn't leave me, and then it was back and forth." Milton finally met with Bill and, Milton said, after they realized Elaine "was a pain to both of us," the two men became friends.[39]

Milton moved out of the loft, and Ernestine and Elaine lived alone together on East 22nd Street between First and Second Avenues. Bill ostensibly lived in his place down the same street to the west but, with Milton gone, he increasingly used his studio for work and stayed overnight with the two women. "That was the first place they lived together. Elaine got the bedroom, I got the living room, and the kitchen was there and the hall," Ernestine recalled. "Bill painted the bedroom in different shades of that famous pink that he used in many of his paintings, and I cooked most of the meals. We had it for a year. We had fun.... Bill liked to cook potatoes."

Elaine made a pretense of going home for part of the week so the family didn't think she was living with Bill, but Ernestine said, "They laughed about Elaine. They knew her. Her brothers and sister.... I don't know what Marie knew."[40] Elaine's siblings — Marjorie, Conrad, and Peter — were intimately involved in all of her activities. Their closeness may have stemmed from the year their mother was institutionalized, when they had looked out for one another. Elaine and Marjorie were especially close. Eighteen months younger than Elaine, Marjorie was just as smart, just as feisty, and a favorite among Bill's friends. John Graham was "mad" about her. "He kept proposing to her," Elaine recalled. "He said, 'Teenage girls should always marry fifty-year-old men.' "[41] That was, coincidentally, an age Graham hadn't quite reached but was fast approaching.

It was evidence of the seriousness of their relationship that, after breaking up with Milton, Elaine brought Bill to Brooklyn for a Sunday dinner with her family. Bill was nervous about meeting Elaine's father, perhaps because he had never really known his own. His parents had divorced when he was a young child and his one attempt to live with his father and his father's new wife, when Bill was just five, had ended when she became pregnant. They didn't want him around when the new baby arrived. He

had, therefore, little experience with that creature called a father, and Charles Fried might have seemed a terrifyingly upright version of one. "They first shook hands. There was a pause. The silence began to lengthen. Then Charlie Fried reached over and put an arm companionably around de Kooning's shoulders." It was an unfamiliar expression of paternal affection that the younger man welcomed.[42]

Marie's response to Bill, however, was something else entirely. "She didn't care for him," said Ernestine. "He was old, she thought [and] had bad teeth."[43] Bill's friend Joop Sanders said Marie "absolutely loathed him. And it was reciprocal." Marie and Bill managed to hide their true feelings from Elaine, and Bill became Charles's "third son," helping him with chores, seeking his advice, and visiting the family home often. Eventually Bill began to see the area around Sheepshead Bay as a little Rotterdam where, instead of being the son of an abusive barkeep, he was a member of the kind of American family he'd seen in the movies.[44] Bill believed Elaine would give him the things he craved, including stability. Elaine imagined her life with Bill would be one of liberation. Both would ultimately discover they were mistaken, but by that time what they had hoped to receive from each other no longer mattered. They had found something better: a curiously abiding and unshakable love.

In 1939, the mayor of New York was that rarest of breeds, a Republican socialist. His name was Fiorello La Guardia. Elaine and Bill loved to listen to him on the radio as he delivered his favored oratory, the righteous harangue.[45] (Once when Gorky met La Guardia at a Project opening, the mayor declared, "If that's art, I'm Tammany Hall!" to which Gorky replied, "Do we ever really know ourselves?")[46] At that time the talk in the city—and from the mayor—was dominated by war and the New York World's Fair, which was scheduled to open in April on a plot in Queens the size of downtown Manhattan. Called "Building the World of Tomorrow," the event had been conceived as a bookend to a past that had seen a devastating First World War and a global economic depression.[47] But much had happened between its conceptual planning in 1935 and its inauguration. The future, by 1939, was ominous indeed.

La Guardia, who had successfully challenged New York's entrenched Democratic political machine, used the fair to poke a stick in the eye of an even bigger adversary, Hitler. The mayor declared there would be no German pavilion included (an easy stance to take, since Germany did not intend to open one) and called instead for a "chamber of horrors" for that "brown-shirted fanatic."[48] Bill, Elaine, and their friends cheered on the mayor, though conscious that this comic shadowboxing had little effect on the dangerous conflagration looming just over the horizon. The climate of

fear was so pervasive that the year before Orson Welles had been able to trigger a mass panic by broadcasting a mock Martian invasion on the radio.[49] Everyone knew war was coming—they just didn't know when.

In anticipation, President Roosevelt had ordered a large-scale upgrade of the U.S. military arsenal. And at the same time, a nationwide propaganda campaign began to condition the American public for battle. Through newsreels at cinemas and radio programs at home, Americans heard the repeated message that intervention was better than isolation, that America's duties extended beyond its shore, that if called its men would have to serve.[50] By the end of that most difficult decade, the 1930s, the drumbeat of war had reached a crescendo. There was no declared conflict involving the United States, but a war mentality pervaded the country. Want and fear had a new companion: urgency. And yet all one could do was wait—for the U.S. tanks to move and bombs to drop—while engaging in more modest personal activities. In this unsettled time, Elaine did just that. She had turned twenty-one that year and could make decisions on her own. Her first was to give up her studio. Her second was to move in with Bill.[51]

Art in War

6. The Flight of the Artists

"But many artists are like that. They're not sure of existing, not even the greatest. So they look for proofs; they judge and condemn. That strengthens them; it's a beginning of existence...."
"And what about you?" Rateau said. "Do you exist?"...
"No, I'm not sure of existing. But someday I'll exist, I'm sure."
— *Albert Camus*[1]

ARTISTS HUNGRY FOR news could find it in the cafeterias, in Washington Square, or on any number of street corners from Chelsea to Fourth Avenue. But on a cold winter's day, the best place was Leonard Bocour's paint shop on 15th Street. While he ground colors, artists basked in the heat of his powerful radiators, exchanging gossip. One day in early October 1940, the shop talk was about Mondrian. The Dutch master had fled Paris. Bocour said he was in town. "It was like reading about a sudden big reinforcement joining the allies at the war front," said sculptor Philip Pavia. Mondrian was only the latest European painter to seek safe haven in New York, but he would be one of the most important. Among downtown artists he was legend, though his work was difficult to find and most knew it only through poor-quality magazine reproductions. As for the man himself, Mondrian was an enigma. He had taken a place on 34th Street, and some who caught a glimpse of him described him as small and very thin. He looked "modest and unheroic," Pavia said, which only made him more intriguing.[2]

The events that had brought Mondrian and other artists, composers, philosophers, poets, psychoanalysts, and scientists to the United States in a great tidal wave of migration was Hitler's inexorable march through Europe. It has been said many times, but it is worth repeating because it is so remarkable, that countries fell like dominoes before Nazi tanks, troops, and planes: April 1940, Denmark and Norway; May 15, Holland; May 29, Belgium.[3] Germany had been rearming for years, to the great concern of its neighbors, but when Hitler finally made use of his weapons it was almost as if he had taken Europe by surprise. That was especially true of France.

After bombing Paris on June 3, Germany began moving its troops into France two days later. Within ten days, what remained of the French leadership was busily signing an agreement to divide the country in proportions that heavily favored Hitler. Three-fifths of France would be under German occupation and two-fifths under French control in what would become

known as the Vichy government. (Vichy would be "independent" but sympathetic to the Nazis, so, essentially, Germany had conquered all of France.) On June 23 Hitler entered Paris like an emperor, driving under a huge swastika that hung below the Arc de Triomphe. Though he loved the city, the exigencies of war meant he could only stay for one day. He therefore ordered that the best of Paris be brought to him. Hitler wanted all the city's art — that owned by the state and that held by French Jews — dispatched to Germany. Returning to Berlin triumphant aboard his train, *Amerika*, he was welcomed by one million people waving red swastika flags.[4]

For Germany, the capture of Paris was laden with symbolism. It had taken the French capital once before, in 1870, but had been unable to do so in the First World War. Much of Hitler's stated intention in launching his own attacks had been to remedy supposed wrongs and humiliations suffered by Germany in that earlier global conflict. In his mind, and perhaps in the minds of his countrymen, the conquest of Paris would help atone for that misadventure. But there was another, more profound reason to take Paris. Like Hitler's campaign to manipulate German mythology and culture in order to fashion the pure Aryan society he envisioned, controlling Paris would allow him to dominate the capital of *international* culture — what Harold Rosenberg called the "laboratory of the twentieth century...the Holy Place of our time."[5]

French, Italian, Spanish, Russian, German, Dutch, Belgian, and Swiss artists and their intellectual colleagues from around the world had been gathered in Paris for decades to work in an environment that stimulated both their creativity through its inherent beauty and their minds through a free exchange of ideas. It was from Paris that much of the "degenerate" art Hitler loathed emanated. If he could dominate that city, he could stifle the art that offended him at its source. He could also muzzle those individual expressions of liberty that took the form of words and pictures and were as dangerous to a tyrant as a resistance fighter's gun. If Hitler controlled Paris, he would take a step toward dominating not just geography, but thought itself. When composer Oscar Hammerstein saw Hitler on the Champs-Élysées, he wrote the lyrics to the song "The Last Time I Saw Paris."[6] Artists began packing up. They understood what Hitler was after and, as German loudspeakers mounted on trucks drove through the streets announcing a nightly eight o'clock curfew, they plotted their escape.

No place in continental Europe or North Africa was safe. The Nazis weren't alone in their aggression — Italy had invaded Greece and took the war to Libya, Eritrea, Ethiopia, and Somaliland. Britain, in turn, was bombing Genoa, Turin, and Italian bases in Africa. If an artist were inclined to go as far afield as Asia, parts of it, too, were on fire due to Japanese expansionism. England had not been invaded by land, but Nazi planes

engaged British aircraft almost daily over the British Isles during the summer of 1940. Then, on September 17, three hundred German bombers and six hundred fighter planes began hitting London in waves of attacks. On the first day, as church bells tolled throughout the city, nearly four hundred tons of bombs were dropped on London. And the bombing continued.[7] It seemed the only place an artist could be assured of the safety to live and work was across the Atlantic, in New York.

Alfred Barr and his wife, Marga Scolari-Barr, had lived in Germany in 1933 while Barr was on a mental health sabbatical, seeking relief from the stress of directing the Museum of Modern Art. They had seen Hitler's rise to the chancellorship that year and witnessed the widespread acts of repression that had begun soon after. "We saw the first yellow buttons. We saw the first department stores closed" in the Nazi campaign against Jewish-owned businesses, Marga said. "We became ferociously anti-fascist." The Barrs were also on hand to see the revolutionary art academy, the Bauhaus, closed by Hitler's followers and the growing clampdown on artists engaged in advanced work. In a rage over the dangerous cultural nationalism the fascists championed, Barr penned nine articles under the title "Hitler and the Nine Muses," describing the immediate threat faced by artists and intellectuals in Germany. No one in the United States would publish them, recalled Marga, who decades later still expressed shock at such willful blindness. Barr then did all that was within his power as a mere individual confronted by a regime determined to destroy modern art. He rolled up as many paintings as he could and smuggled them out of Germany in his umbrella.[8]

No one in New York, therefore, was better placed to help artists than Alfred Barr or better acquainted with the urgency of the situation. When artists trying to escape France began clamoring for assistance, Barr responded immediately. He was also quick to answer pleas from European museums that wanted the Modern to store precious works — Titians, Michelangelos, Donatellos, in addition to many avant-garde paintings — while the continent descended into chaos. Among the first to be sent for protection was *Guernica*.[9] How Picasso himself was faring in France, however, remained a mystery. "There was just no knowing what was happening to whom," Marga said. "We didn't know where they were.... We kept always thinking, would Picasso want to come?"[10]

Barr and Marga had set up an office in their Beekman Place home to coordinate efforts to rescue artists fleeing Europe.[11] Their counterpart in that effort was Barr's former Harvard classics chum Varian Fry. Armed with lists of names compiled by Barr and author Thomas Mann, Fry began operating the ad hoc Emergency Rescue Committee out of Marseilles, resorting to any means at his disposal (among them forgery, theft, and bribery) to smuggle out of France those artists and intellectuals who had

the most to fear from Nazi persecution. Clandestine work didn't come naturally to Fry. He said the only thing he knew about subterfuge on such a scale was what he had seen in the movies. But he accomplished it admirably, some might even say miraculously, given the constant surveillance and threat he was under. Fry stashed fugitive artists in homes and villas in the hills surrounding the Mediterranean port city, hiding them from the Gestapo and Vichy authorities, while Marga, Barr, and others worked on the State Department to secure U.S. entry visas. Each person entering the United States also needed a sponsorship pledge of three thousand dollars — about three times the average annual U.S. salary in 1940. That, too, was left up to the Barrs and their friends to secure.[12]

More than one thousand artists and intellectuals would ultimately be ferried to safety through Fry's network.[13] "In the artistic imagination these refugees represented everything valuable in modern civilization that was being threatened by physical extermination," said artist Robert Motherwell. "It had never been more clear that a modern artist stands for civilization." Painter Al Leslie called the refugee artists the "lean masters."[14] And there was none leaner than sixty-eight-year-old Piet Mondrian. Bypassing the Marseilles exodus, he had fled Paris for safety in London, only to find himself in the middle of German bombing raids there. He fled again, booking passage on a ship to the States. After a month-long journey, dressed in one set of clothes and a life jacket for the duration of his trip, Mondrian arrived traumatized.[15] But he fell instantly in love with that most vertical of cities, New York. "Mondrian saw New York as Gauguin saw Tahiti," said his friend Carl Holty. He even liked the noise.[16]

Since Lee's former lover Igor had left her in the dead of night destined for Florida, she had had only sporadic news of him. There was a report that he was working the southern aristocratic circuit as a portrait painter, and generally relying on his charm rather than his talent to steer him through life. In 1940 he wrote Lee a cheery letter, on which she scrawled the word "idiot." She was doing just fine without him. Lee lived alone in a small studio apartment on Ninth Street and, independent of Igor and released from her consuming Artists Union duties, she was thriving.[17] With the time to focus on herself and her art, she had finally begun to break through in her painting. Gone were the tentative daubs of muted color she had favored under Hofmann's influence three years before. Her shapes, outlined in black, now had clear definition, as did her colors, which tended toward primary blues, reds, and yellows. Her paintings were also completely nonobjective; there was not a recognizable vase, apple, or torso in them. That was due in part to Hofmann, who had been lecturing during

the previous year on Mondrian. He said the Dutchman had reduced painting to its ultimate purity with his lines and rectangles, open white spaces, and judicious use of color. Lee tried out his method.[18] Over a series of canvases, her former Cubist-inspired shapes became simpler, cleaner, more geometric until, finally, she had reached the point of producing "Mondrians." Ironically, she had no inkling that not long after she had completed those tribute exercises she would befriend the artist himself.

In January 1941, the American Abstract Artists had invited Mondrian and French artist Fernand Léger to join the group. Mondrian had just arrived, but Léger had been living in New York since 1935.[19] He was already a favorite among the American artists for his work, his lust for life, and his lack of pretense. Expecting to meet a "god" when he was first introduced to Léger, Bill de Kooning said, "He looked like a longshoreman.... His collar was frayed, but clean. He didn't look like a great artist; there was nothing artistic about him."[20] Bill and Mercedes had been assigned to a mural project with Léger, with Mercedes also acting as a translator. She and the Frenchman became good friends, and it was he who had introduced her to Swiss photographer Herbert Matter. In 1939 Mercedes and Matter moved in together, and in 1941 they were married. In addition to family, attending their wedding were Lee; Hofmann's wife, Miz (who had safely arrived from Germany); and two of Mercedes's former lovers.[21]

Unlike the voluble and reckless Léger, Mondrian quite simply *was* his art: stark and rigid. Critic Clement Greenberg would describe Mondrian's work as "passion mastered and cooled,"[22] and that described the artist as well. He had set up his studio in a Victorian house with curved arches, but in order to live among rectangles, he had squared them off with pieces of cardboard.[23] A dry and brittle little bachelor in wire-rimmed glasses, he wore his necktie knotted tightly and suit jacket buttoned top to bottom. His rather tired smile seemed a mere concession to civility rather than an expression of joy. Mondrian embodied restraint—physical and spiritual—but he had two secret vices: coffee (he hid his pot so this weakness wouldn't be discovered) and, inconceivably, dancing. He had a Victrola and a stack of Blue Note jazz records to which he danced barefoot in his studio.[24] Though he had taken lessons in Paris to learn the fox-trot and the tango, he preferred improvisation. One dance partner called him "terrifying."[25]

Léger and Mondrian accepted the invitation to join the American Abstract Artists group (Mondrian, who had no money, paid his dues promptly; Léger who had money, never paid) and the artists George L. K. Morris and Suzy Frelinghuysen gave an afternoon party in their honor.

Léger arrived with a gaggle of women on his arms, said his hellos in French, and left quickly. Mondrian arrived alone and stayed until ten that night. He "was the life of the party," said Morris.[26] In talking to Mondrian, Lee discovered that they both liked jazz, so they made a date to meet at Barney Josephson's Café Society.[27]

A Village version of a Harlem jazz club, Café Society flaunted its policy of racial integration during a time of segregation and leftist politics while the government busily hunted "Reds." In the foyer, an effigy of Hitler hung from the ceiling alongside "papier-mâché send-ups of well-known Manhattan society icons." It was a club for social anarchists.[28] For the painters, it was a place to dance, and that was what drew Lee and Mondrian. "I'm a fairly good dancer," said Lee, "that is to say I can follow easily, but the complexity of Mondrian's rhythm was not simple in any sense." No matter the music, Mondrian danced in a "staccato" manner with his head thrown back.[29] "It seems to me his movement was all vertical, up and down," Lee said, though she conceded, "maybe I had been too affected by his painting before I met him."[30]

They would have been a remarkable pair even apart from Mondrian's dancing. Lee was more than thirty years his junior and, in heels, several inches taller. She was also voluptuous, saucy, and stylish in net stockings and a tight skirt. Mondrian would have seemed a mere wisp of a fellow next to her as he bobbed frantically to the music inside his head. Lee found the bizarre experience exhilarating. "I loved jazz and he loved jazz, so I saw him several times and we went dancing like crazy."[31]

Soon after her initial date with Mondrian, the American Abstract Artists held their fifth annual show. Léger and Mondrian were among the thirty-three artists with paintings and sculpture in the exhibition.[32] During the opening, Mondrian escorted Lee as they walked around looking at each of the works on display. He didn't have much to say, but he offered a few words about every piece. "He asked, 'Who is this?' and then made his comments. Now we came to Lee Krasner and he says, 'Who is this?' And I say, 'Mine,' and you know, feeling queasy," Lee recalled of the moment. "He said, 'Very strong inner rhythm. Stay with it.' "[33] Those few words from Mondrian would have had great significance for Lee, and not just because a man of such artistic weight had uttered them. To an artist in those days, having "rhythm" meant one's painting had unity and "spirit," that it wasn't just a series of haphazard strokes on a canvas. Hofmann himself said that "the highest quality in a painting is always the rhythm."[34] Mondrian's recognition of that quality in Lee's work remained with her for the rest of her life "in a little corner somewhere," she said. "I try to stay with it wherever it may take me."[35]

Lee had stopped doing "Mondrians" at around the time she met the art-

ist, but the exercise had greatly strengthened her own work. The change was evident in her next series of paintings, which combined the influences of Mondrian, Picasso, Matisse, Miró, and Gorky. They were arresting in their exuberance over concepts understood and techniques mastered, which allowed her to make a purely individual statement. Lee herself, in all her brassy strength, was finally revealed on canvas in an intense palette of thickly applied paint and a liberal use of black line, with which she could slash a plane in two using a straight, hard edge, or pirouette into infinity in a whimsical curve. Lee was flying. It was thrilling to behold, not least because it had taken such a painstaking effort on her part to reach the point of being able to declare as a painter, "I am."

Lee's new work caught the attention of the Art Project officials charged with deciding whether an artist deserved the opportunity to paint their own mural. In 1941, the head of New York's mural division invited Lee to submit sketches for WNYC radio. She was one of four artists (among them the American abstract patriarch Stuart Davis) asked to paint a mural for the station's studios.[36] The work that had earned her such regard was due in large part to the education she had given herself, not merely by making art but by studying vast quantities of it. Lee understood that being a great painter involved more than hand and wrist. One had to be able to *see*, and that skill, like any other, took time and training. (Mondrian thought his eyes so powerful that he kept them downcast so as not to look directly at other people.)[37] Lee had developed her eyes to see like a master. Clem Greenberg said of her, "During the forties, Krasner had the best eye in the country for the art of painting."[38]

In early November 1941, Lee bumped into the Greek painter Aristodimos Kaldis outside her building at 51 East Ninth Street. Kaldis was an enormous mess of a man, with a potbelly and long uncombed black hair tumbling around his head. His companion that day was his physical opposite—a trim, elegantly dressed fellow with no hair at all. The trim man looked at Lee and said, " 'You are a painter.' " Lee recalled thinking, "My God, that man has magical insight, and I said, 'How do you know?' He pointed to my legs. I had specks of paint on them." Kaldis introduced him. The observant man was John Graham.[39] Lee had read Graham's *System and Dialectics of Art* and had been greatly influenced by it, especially his ideas on the unconscious as the source of images.[40] Remarkably, given the overlap between her artistic circle and his, they had never met. Lee decided to remedy that situation by inviting the two up to her studio to see her work. They saw, they talked, the men left, and that was the end of it. Until several days later when Lee received a note in the mail.

> *Dear Lenore,*
> *I am arranging at an uptown gallery, a show of French and American painting with excellent publicity etc. I have Braque, Picasso, Derain... Stuart Davis and others. I want to have your last large painting. I will stop at your place Friday afternoon with the manager of the gallery. Telephone me if you can.*
>
> <div align="right">*Ever GRAHAM*[41]</div>

"Whoo, big moment!" Lee said. "The fact that he invited me was overwhelming."[42] It was "big-time stuff. Graham is arranging a show of European greats and just a few Americans... and he wants to include *me.*"[43] Lee had learned that, in addition to Picasso and Braque, Matisse was also to be in the exhibition. "I felt pretty damn good about that... I was going to be showing with painters like Matisse... my gods."[44] When the initial shock subsided, Lee began to wonder which of her contemporaries Graham had selected. "I didn't write to ask Mr. Graham, whom I'd only just met... because that might have broken the spell." Instead she asked everyone she knew if they were aware of the exhibit or who was in it. "No, no, no" were the responses.[45] No one knew a thing. "Shortly after that I was at an opening at the Downtown Gallery and... I ran into someone called Lou Bunce who I knew from the Project, and we were chatting and he said, 'By the way, do you know this painter, Pollock?' And I said, 'No, I have never heard of him. What does he do, and where is he?' And he said, 'Oh well, he's a good painter. He's going to be in a show that John Graham is doing called French and American Painting.'" That was all the information Lee needed. "What is his address?" she demanded.[46]

At that time, Lee said, you could fit everyone in the downtown art world on the head of a pin. She had learned the names of the other Americans in the show: de Kooning, his ex-girlfriend Nini Diaz, Stuart Davis, Walt Kuhn, H. Levill Purdy, Pat Collins, David Burliuk, and Jackson Pollock. She knew all of them except the last. It irritated her that she had never heard of him, and even more so when she learned that he lived around the corner from her on Eighth Street, next to Hofmann's school.[47] She set out to find him. Years later, in an unpublished essay on Pollock, Lee described their first meeting:

> He and his brother Sandy [*sic*] and Sandy's wife had the top floor; each had a half. As I came in, Sandy was standing at the top of the stairs. I asked for Jackson Pollock, and he said, "You can try knocking over there, but I don't know if he's in." I later found out from Sandy that it was most unusual for Jackson to answer. When I knocked, he opened. I introduced myself and said we were both showing in the same show. I walked right in.

What did I think? I was overwhelmed, bowled over that's all. I saw all those marvelous paintings, I felt as if the floor was sinking.... I must have made several remarks on how I felt about the paintings. I remember remarking on one, and he said, "Oh I'm not sure I'm finished with that one." I said, "Don't touch it!" Of course I don't know whether he did or not.

He was not a big man, but he gave the impression of being big. About five feet eleven.... His hands were fantastic, powerful hands. I wish there were photographs of his hands. All told he was physically powerful.[48]

Through the years, Lee had often described the impact of seeing her first Matisse, saying that his paintings had been so new she had needed time to recover from the impact of her initial encounter with them. The same had occurred with Picasso's *Guernica.* Lee had been forced to leave the gallery because it had literally taken her breath away. Seeing Pollock's paintings stacked around his studio hit her the same way. "It was a force, a living force, the same sort of thing I responded to in Matisse, in Picasso, in Mondrian. Once more I was hit that hard with what I saw."[49] Looking with her expert eye at five or six of Jackson's paintings, Lee said, "I was confronted with something ahead of me. I felt elation. *My God, there it is.* I couldn't have felt that if I hadn't been trying for the same goal myself. You just wouldn't recognize it."[50]

Lee found his work to be an exciting combination of Expressionist and Cubist technique, which he used to tap the unconscious through Surrealist, mythological, and primitive imagery.[51] He, too, had read Graham's book. One painting in particular, *Magic Mirror,* stunned her. "We talked about this painting and the others and the conversation was totally easy and marvelous. He seemed happy that I liked his work so much. It was only later I learned that people didn't just walk into Pollock's studio... how guarded and tortured he was about his work, his person, his life."[52] Lee discovered that Pollock was, in a sense, working in a vacuum. He had been a student of the regionalist Thomas Hart Benton, and had worked with the Mexican muralist David Siqueros. He didn't, however, know many of the advanced artists who would be better equipped to understand his work and among whom he would be more apt to thrive. Lee determined to introduce the remarkable man she had discovered to her downtown world.[53]

Eleven years earlier, Pollock had followed in the footsteps of his older brother, Charles, and come to New York from California to study art with Benton at the Art Students League. Born in Cody, Wyoming, Pollock spent most of his childhood drifting around the southwestern United

States with his family in search of social and economic stability. As for academics, by the time he reached high school the only subject that really interested him outside the studio was, for a time, theosophy. It taught him that his inner thoughts were paramount and that, historically, "the wise men have lived apart from the norm." In 1929, Pollock was expelled from school for distributing protest literature. Though he was eventually reinstated, a break with formal education had been established in his mind.[54] He wanted to head east to be a sculptor like that first tormented modern artist, Michelangelo. On the long cross-country car trip, he and his brothers decided that if Pollock really wanted to be an artist, his given name, Paul Pollock, wouldn't do. It would be better if he used his middle name. And so, the man who within two decades would revolutionize the art of painting arrived in New York as Jackson Pollock.[55]

His start, however, proved discouraging. Pollock enrolled in the Art Students League on 57th Street, but he was so intimidated that he was left speechless and could not draw. Resorting to his preferred social crutch—alcohol—Jackson retreated to a speakeasy behind the League in search of his voice and the courage to be a new self, an artist like Benton. While Pollock studied with him, the most important lessons he learned were not about painting but about Benton's approach to life as an artist, and that approach was macho to the core: Benton was a fighting, cursing, woman-abusing drunk. He was also a staunch anti-communist.[56] Pollock grew to adore him.

Eventually, no doubt due to Benton's encouragement, Pollock overcame his fear of the League students and started to work again. His early paintings in oil looked like small, crude copies of his mentor's. As for his drawing, at a time when Lee was a student at the nearby National Academy drawing fluid, classical nudes, Pollock's sketches were agonizingly stiff and deliberate, giving no real indication that the artist had any natural talent. Perhaps partly because of that struggle, and because Benton announced that he planned to leave New York, Pollock's drinking turned destructive. After Jackson was arrested for assaulting a policeman, it became clear to his family that he couldn't live alone. He moved in with his brother Charles, who had a fifth-floor apartment on Eighth Street—the future Abstract Expressionists' "Main Street." With its nightclubs and jazz clubs, which bellowed music and emitted clouds of smoky air, Eighth Street would be Pollock's home until 1945.[57]

Pollock's integration into the New York art scene had been largely through Benton and certain California connections—the artists Philip Guston and Reuben Kadish—in addition to a League friend, Peter Busa.[58] People outside that group had heard of Jackson but mostly because of his drunken antics. Nineteen thirty-seven had been a year of binge drinking.

Nineteen thirty-eight was even worse. By June of that year, Pollock was admitted to an institution in White Plains, New York, that specialized in alcoholic psychosis and anxiety disorders. Meanwhile, the duty of caring for him had been transferred from Charles to their brother Sande and his new wife, Arloie, who had moved into the Eighth Street apartment when Charles took a job out of town.[59] Sande, like Jackson, was on the Project, but his full-time occupation was keeping his younger brother sane and healthy—a nearly impossible task. As soon as Pollock left White Plains, the drinking resumed. In January 1939, he had another breakdown.[60]

Two things would happen that year to help shift Pollock's focus from alcohol back to painting. He began therapy with a Jungian analyst whose discussion of the unconscious reminded Pollock of his prior interest in theosophy. And he met John Graham. Pollock had read an article, "Primitive Art and Picasso," that Graham had published in the *Magazine of Art* in 1937 and was so intrigued that he sought Graham out.[61] That was extremely uncharacteristic for Pollock, who was both intellectually insecure and excruciatingly shy when sober. But what he had read spoke to him directly, and when the two finally met—as different in every way as they were— their admiration was immediate and mutual. Graham entered the young man's life as a new mentor and father figure.

Artistically, Graham weaned Pollock from Benton's provincialism and introduced him to the School of Paris. Personally, Graham acknowledged but was not overly disturbed by Pollock's wild behavior. He believed that, to society, a genius always looked like an outlaw. Graham simply tried to help Jackson redirect his mad energy into his work. The sculptor David Smith said Graham kept a list of the most promising artists in New York and, by 1940, Pollock had topped it.[62] That was the Jackson Pollock whom Lee met in late 1941. She did not know about his troubled history. She only knew what she could see: an affable, humble man whose paintings she loved.[63] Lee went into action on his behalf—and then she stopped. Everything stopped.

In 1941, the economic crisis that had crippled the nation for more than a decade was over. The miracle was due to the massive government effort to upgrade its military equipment, and an arrangement with U.S. allies to supply the ships, tanks, and guns they needed to defeat Germany. The American economy had become a war economy.[64] For its part, Germany appeared unperturbed by America's support of its allies. Hitler had signed a mutual defense pact of his own with Italy and Japan and, by mid-June 1941, he appeared truly unstoppable. Germany controlled eight European capitals and territory from the Arctic Ocean to Crete in the Mediterranean. And still Hitler wasn't finished; he had set his sights east as well. On

June 22, Germany invaded the Soviet Union, and Moscow went from being America's communist foe to its anti-fascist ally. Stalin, too, would now receive U.S. assistance.[65] Responding to those events, the U.S. economy went from moribund to supercharged in a matter of months. Up and down the military supply line, the previously unemployed were working around the clock. Prosperity, which had been so long absent it was almost a forgotten concept, returned with a vengeance. For the first time in years, the average American's main occupation was not economic survival.[66]

The year before, Roosevelt had initiated the country's first peacetime draft—all the while promising Americans, as he ran for reelection, "Your boys are not going to be sent into any foreign war."[67] Such was the trust he had engendered among Americans for having guided the country through the Depression that he won an unprecedented third term. Everyone knew, however, that he wouldn't keep his word about the war. In New York, the streets were already filled with soldiers and sailors whiling away the hours in Broadway theaters or looking for a few nickels' worth of love in Italian brothels.[68] Most often they could be found slumped over any number of bars in midtown, uptown, or the Village as they waited for the news they knew would come—that they were shipping out to fight Hitler. Life had become a matter of acute anticipation. New York had become a "metropolis clouded by war."[69] But many Americans would have agreed with *New York Times* journalist Russell Baker, who described his youthful response to the war in Europe: "It wasn't my world that was on fire.... Sheltered by two great oceans, America seemed impregnable. I was like a person on a summer night seeing heat lightning far out on the horizon and murmuring, 'Must be a bad storm over there someplace.' It was not my storm."[70] On Sunday, December 7, 1941, it became America's storm.

New York was unusually warm and beautiful that day. For the first time in ten years the pre-Christmas bustle was not a mere ritual. People had money in their pockets and could afford to buy what they saw in store windows. Carnegie Hall was packed with families enjoying an afternoon concert.[71] A Sunday in December could not have been more cheerful. Until the whispers began at about two o'clock Eastern time.[72] *Did you hear the news?* The manager at Carnegie Hall walked to the center of the stage. The music halted. He said, "The Japanese have attacked Pearl Harbor."[73] While the stunned audience tried to comprehend his words, which were so incongruous with the festivities around them, the decorations, the furs, the pretty dresses, the polished shoes— *What is Pearl Harbor? Where is Pearl Harbor?*—the conductor spoke in hushed tones to his orchestra and waved his baton. The music that rose from their instruments was the national anthem.[74] It sounded like a funeral dirge.

Sports broadcasts and radio serials were interrupted regularly by the

phrase "More news from Pearl Harbor" until there was nothing *but* news from Pearl Harbor.[75] *Three hundred sixty-six Japanese planes hit American warships.* At Penn Station, New York, the loudspeakers squeaked and crackled with the bulletin for passengers coming out of their trains who didn't know that the world had changed during their journey.[76] People on the street looked into the blinding winter sun to see if the sky above them was clear, or if it, too, was filled with bombers. At 2:25 p.m., President Roosevelt announced the attack over the radio from the Oval Office.[77] It would take days to learn the full extent of the damage—twenty-four hundred people killed; seven battleships, three light cruisers, three destroyers, four auxiliary craft sunk or capsized; more than one hundred aircraft destroyed—but during those first hours the details didn't matter. Men who had already enlisted were mentally packing their bags. Men who hadn't yet done so made plans to volunteer the next day. Roosevelt called December 7 "a date which will live in infamy."[78] He declared war on Japan the next day. On December 11, Japan's allies Germany and Italy responded. They were at war with the United States of America.

Two years earlier, in 1939, *The Magazine of Art* had asked the wrenching question "Good God, how can you go on chattering about sculpture and painting when the children of Poland lie slaughtered by Hitler's bombs?"[79] In December 1941, for the artists in New York, that question had replaced all others. How could they continue to focus on art in a world on fire? In a letter that summer to Lillian Kiesler, Hofmann had written, "Our world has become so ugly that it is great to die as a simple man who can say before his end, 'I had nothing to do with this mess directly or indirectly.'"[80] But that was no longer enough. Absolving oneself of guilt generated a guilt of its own. In the great debate over an artist's role in war, the poet Archibald MacLeish had argued in *The Nation,*

> Artists do not save the world. They practice art. They practice it as Goya practiced it among the cannon in Madrid. And if this war is not Napoleon in Spain but something even worse than that? They practice art. Or they put the art aside and take a rifle and go out and fight. But not *as artists.*[81]

By early 1942, many artists had put down their brushes and as soldiers picked up guns.

7. It Is War, Everywhere, Always

Estragon: I can't go on like this.
Vladimir: That's what you think.

—*Samuel Beckett*[1]

THE PLANES AND ships heading west from Europe to New York were on rescue missions, their human cargo destined for a life free of fear from the indiscriminate cruelty of war. The planes and ships heading east from the United States to Europe, and the trains traveling west across the midwestern plains toward the Pacific, were on death missions. Their human cargo consisted of young men and boys terrified of the unknown that awaited them, and of the very real possibility that the vastness of their lives might be reduced to a daily bestial choice between killing and being killed. After Pearl Harbor, five million of them had volunteered. The decision had been easy—it was simply a "moral necessity," as painter Lutz Sander would say.[2] The ramifications of that choice, however, were monstrous. The person who enlisted would be but a distant memory to the person who returned home, if he returned home. "During the thirties, we were young and optimistic," said Lee's former studiomate George McNeil, "but then the war in Europe started and everything turned to dirt and grit. All the fantasy in life came to an end."[3]

The events that had led up to the bombing of Pearl Harbor had been a direct result of the turmoil in Europe. Echoing Hitler, the Japanese government that came to power in 1940 had announced its desire to establish a "new order in greater Asia" dominated by its own citizens as a "master race." Because European countries with territory in Asia were busy defending themselves against Germany, Japan's expansionism proceeded quickly until it came within range of U.S. interests in the region. The United States responded in July 1941 by imposing an embargo against Japan and seizing its assets in the United States. Britain did the same, and the combined action left Japan cut off from three-quarters of its overseas trade and 90 percent of its imports. Repeated attempts at diplomacy failed to ease the tensions. In December, Japan reacted by launching attacks against U.S. and British targets.[4]

As the headlines in daily newspapers began to focus on the Pacific, the names of places where soldiers and seamen were sent to fight and die were largely unknown. For the majority of Americans at the time, there was no

deep bond with Asia; their parents and grandparents had not emigrated from its lands. By contrast, many U.S. troops en route to Europe were heading home: they spoke German, Italian, French, Polish, or Dutch. They had extended family throughout the British Isles or Scandinavia, they understood the culture of Europe, they could blend in with its people. And yet that familiarity in no way diminished the threat those soldiers would face or the barbarism they were sure to encounter.

On the battlefront, Germany had shown in April 1941 that it was willing to murder on a mass scale to consolidate power when it bombed Belgrade as Orthodox Christians celebrated Palm Sunday. Seventeen thousand people died that day.[5] After Yugoslavia's surrender, Hitler turned his military on the Soviet Union, quickly taking its third largest city, Kiev, and by November arriving within sixty-five miles of Moscow. The cost on all sides was horrendous. In Leningrad, two hundred thousand people would die of starvation or cold, and untold numbers of other civilians would be slaughtered as the Nazi army first advanced through Soviet territory, and then withdrew in bitter defeat. Hitler would sacrifice two hundred thousand German troops in his mad attempt to take Moscow during the coldest winter in nearly a century and a half.[6] In both movements, east and west, the order of the day was butchery.

The other story emerging from Europe was even more chilling. It had begun to come into focus for Americans by the fall of 1941 when the *New York Herald Tribune* used the phrase "systematic extermination" to describe the murder of civilians. In August, reports of massacres—of Jews, homosexuals, Romanies, intellectuals—perpetrated by Hitler's forces and those allied to him had begun to appear in the press. Those initial reports were so beyond credulity that they were at first met with skepticism. But, in late October, after the *New York Times* confirmed the machine-gun murder of fifteen thousand Jews in Galicia, reports of similar atrocities began appearing with terrifying regularity. Alarming accounts emerged that Jews were being sent to "Jewish Reservations" in Poland. American reporters picked up a story from a Cologne paper that stated as dispassionately as if it were describing a mere transfer of commodities: "All the Jews in Luxembourg had been transported eastward."[7] It had become clear that the campaign against Germany's Jewish population, begun in the 1930s, had grown catastrophically to include Jews throughout Europe.

What was unknown at that point was Hitler's plan to accelerate the slaughter. On December 7, 1941, as the Japanese attacked Pearl Harbor, he had begun a secret program to gas Jews in the back of vans to stem outrage over mass executions that had previously occurred in public. The method proved so efficient and discreet that when the Nazi leadership met in January 1942 to map out a "Final Solution," they decided poison gas would be

an integral part of their plan to exterminate Europe's Jewish population.[8] Inconceivably, those men had come together and agreed that the preferred course at that point in twentieth-century history was murderous lunacy on an industrial scale.

The streets and cafeterias where artists had routinely gathered through the 1930s, the benches they had claimed as their own in the northwest corner of Washington Square, even Bocour's paint shop were eerily desolate after Pearl Harbor. One by one, the men who had roamed those streets and exchanged gossip in those cafeterias or stores had enlisted: George McNeil, Elaine's brokenhearted ex-boyfriend Milton Resnick, Ibram Lassaw, Conrad Marca-Relli, and Lutz Sander, to name just a few. Those left behind were deemed either too old (Gorky), or had a physical or mental disability that prevented them from serving. (Pollock had a "schizoid disposition." Bill had a bad knee.)[9] Lee had said before the war that the downtown art community was so small it could fit on the head of a pin. After the United States entered the war, that pinhead seemed positively roomy. The first official glimpse of what remained of the shrunken scene occurred at the opening of John Graham's *French and American Painting* show on January 20, 1942, at the McMillen antique furniture store on 44th Street.

Lee caused a stir by appearing on the arm of an artist who was also in the exhibition. Jackson Pollock was the first romantic attachment she had paraded before her fellow painters since Igor's departure in 1939. Like Igor, twenty-nine-year-old Pollock was movie-star handsome. Tall, blond, boyishly rugged, he flashed a beautiful smile that awakened three distinctive dimples.[10] Unlike Igor, however, Jackson appeared quiet, reserved, polite, deferential. For her part, Lee seemed deliriously happy, and not only because of her new man. As she surveyed the greats on display in McMillen's shop—Picasso, Bonnard, Modigliani, Rouault, de Chirico, Derain—she came to her own work and discovered Graham had hung her *Abstraction* between Matisse and Braque![11] Lee had not considered her own work "unique" at that point, but seeing it alongside two deans of the School of Paris she experienced it as if for the first time. The work she had created no longer seemed to belong to her, it was now part of a great tradition of art—*she* was part of that great tradition. And what was more, her painting held its own. "My own excitement around it was overwhelming," she said.[12]

Graham's show was curiously prescient about the art world that would emerge out of the war. In addition to Lee, he had selected de Kooning and Pollock for the exhibition. At that time, Bill had never been in a show and was virtually unknown outside a tight circle of friends, and Pollock was even less established. Lee admitted that Graham went "out on a limb" in

mounting the display. And yet, connoisseur that he was, he knew he was right. He had been able to see, in the works of those Americans he chose, the future direction of art. Graham had also understood that the painters in New York, even at that early stage in their experimentation, were beginning to nudge aside the well-established Paris masters. The latter had been artistic revolutionaries during their own great war in the first decades of the century. In 1942, there was a similarly changing reality and it would take a new generation of artists to describe it.[13] None but Graham and the artists involved, however, understood the significance of the McMillen event. It would generate only one review. In it, *The Art Digest* did not mention Lee's *Abstraction* or Pollock's entry, *Birth* (which he gave to Lee), but it did illustrate its article with a painting, *Portrait of a Man*. The *Digest* described the work's creator, "William Kooning," as a "strange painter" with "a rather interesting feeling for paint surfaces and color."[14]

De Kooning and Pollock had never met, so Lee introduced them. In fact, Lee made it her mission to introduce "this totally unknown" young artist to everyone.[15] It was not just that she thought he was a great painter. In that most inauspicious climate, when war clouded everyone's lives and dominated every conversation, Lee had fallen in love. "I resisted at first, but I must admit, I didn't resist very long. I was terribly drawn to Jackson...physically, mentally—in every sense of the word."[16] She joked that she was attracted to him because he was "one hundred percent American...at least five generations back." For weeks, she bragged to friends, "I've met a *real* American." (Milton Resnick said at that time the "guys... were all ethnics. When Pollock came along it was like an American among a bunch of ethnics."[17])

And what did Jackson see in Lee? When they met, Lee was a formidable figure in the art world as a *habitué* of the scene, as a respected leader in the fight for artists' rights, and as a talented artist.[18] Friends said that while Pollock was "riddled with doubt," Lee was "remarkably sure of herself." "She barely touched the floor and that effortlessness in her attracted Jackson," said Ethel Baziotes, who knew them both well. Lee was also an expert at the "mechanics of living," according to Ethel, while Pollock had demonstrated convincingly with his binge drinking and arrests that he was not.[19] Finally, Pollock's friend Peter Busa said Lee was "absolutely catalytic" in charting Pollock's future course. "Jackson got into modern art...through Lee."[20]

In describing Jackson's importance to her work, Lee once said that occasionally an individual "appears on the horizon and opens a door wide. We all live on it for a long time to come, until the next individual arrives and opens another door."[21] In fact, that would be *her* role in Pollock's life. Elaine saw Pollock's work for the first time at the McMillen show and felt

that of the two, Lee was much more "aware" as a painter. "Lee had a great, big, aggressive painting and Jackson's painting struck me as lyrical and it was almost as though Jackson took over something that Lee had had," Elaine said.[22] In other words, the formative Pollock drew from all of Lee's strength, even her strength on canvas. Lee, however, would never have acknowledged that Pollock had learned something from her paintings. Or perhaps she did know but didn't think it significant because her work was a mere drop in the sea of influences that helped create him. In any case, she insisted that theirs was not a "student-teacher relationship, but a relationship of equals."[23] She was simply willing to give him anything he needed to nurture his talent. "I had a conviction when I met Jackson that he had something important to say."[24]

Lee learned in the spring of 1942 that her long-planned mural for WNYC radio had become a casualty of war. The government was no longer interested in funding the Art Project. Instead, it had decided to employ artists in a new War Services Department. Furious about her mural's cancellation, Lee protested the decision and the War Services Department responded with a counteroffer. She would be a supervisor in what the artists called "the genius department."[25] Lee was asked to select a team of eight people to create war-related public service displays for twenty-one department store windows in Manhattan and Brooklyn, and, later, to make posters for navy recruiting stations. The jobs would last a year. Peter Busa, who would be on the navy crew, said it was "the most unregimented group of artists that you can imagine as far as carrying out a project."[26] Jackson was Lee's only hire for the duration of the work. In fact, through 1942 the pair was inseparable except while painting. "We shared the bedroom — there was no problem about that — but not the studio," Lee explained.[27] From quite early on, Ethel Baziotes said, Lee and Jackson became "psychologically embedded in each other."[28]

Lee had kept her studio on Ninth Street and Pollock his on Eighth but increasingly, he spent the night at her place. There were the usual domestic discoveries to be made. At the start of their relationship, Lee had asked Pollock if he wanted a cup of coffee. After he said yes, he was shocked to see Lee get up to leave her apartment. "You don't think I make it here?" she asked incredulously. Lee had never used her gas stove and wasn't even sure it worked. Coffee, to her, was something you bought at a cafeteria and sat drinking with friends. Coffee to Jackson was something you brewed yourself and sipped quietly at the kitchen table.[29] And then there was the question of books. Lee said she hadn't seen a trace of a book in Pollock's studio and asked him, "Don't you ever read anything?"

"Of course I do," he said.

"Why don't I ever see a book?"

"All right, I'll show them to you," he said, and took her to a back closet where he opened a drawer crammed with books.

"Well, Jackson, this is mad! Why have you got these books pushed away, locked up?"

"When somebody comes into my place, I don't want them to just take a look and know what I'm all about."[30]

But mostly their hours together involved endless discussions about art. "From the very beginning I found that we thought alike. In an uncanny sense, this was truly so," Lee said.[31] "We had a helluva lot in common—our interests, our goal. *Art* was the thing, for both of us."[32] Reuben Kadish, who had known Pollock since high school in California, said he was surprised at how easily Jackson expressed his ideas to Lee. And she, in turn, challenged him on them. As late as 1942, Pollock still used the language he had learned from Thomas Hart Benton to talk about art. It was a language Lee believed inadequate to describe what Pollock did or, more important, was capable of doing.[33] She became for him a new authority on art as he ventured into virgin territory on canvas and searched for diverse influences in exhibitions. Both had discovered Miró at the Modern, and both had read and looked at Kandinsky at Hilla Rebay's museum. They were also exploring the unconscious through Jung's writings.[34] After intense talk, intense lovemaking, intense "merging" of their lives, as Lee would say, they would return to their studios and apply what they had learned and felt to their canvases.[35] Pollock was eager for her reaction to his new work. "He did keep saying, 'Come and look, what do you think?'" Lee recalled. "That was a constant. So I take it that some part of my response was essential."[36]

The pair quickly became so intimate with each other's paintings that at times they took shocking liberties. Once, when Lee returned to her studio she felt something amiss. Looking at the painting on her easel, she said, "That's not my painting! And then the second realization was, he had worked on it. And in a total rage, I slashed the canvas... and I guess I didn't speak to him for some two months, and then we got through that."[37] Until the next time. Jackson noticed Lee's paintings weren't signed, and he insisted she do so. While she delivered a series of cogent pros and cons for signing or not signing, Pollock loaded a brush with black paint and wrote in large letters on the bottom of every painting in the room, "L. Krassner." He thought she was a "damn good woman painter" and wanted her to start claiming credit for her work.[38] Back in Pollock's studio, Lee got her revenge. While talking near his canvas, she gesticulated with a paint-laden brush dangerously close to the painting's surface. Jackson stood tormented watching the brush circle ever nearer until, finally, Lee made contact, leaving a red daub on the canvas. Storming out of the room, Pollock

shouted, "*You* work on the Goddamned painting." Peter Busa, who witnessed the tiff, said they "were like two kids."[39] Artist Fritz Bultman said Pollock and Lee "complemented each other, but it was almost like an antagonism."[40] In later years, their clashes would be truly horrific, but in those early days they were just having fun.

On meeting Pollock, some of Lee's friends were perplexed. They didn't know what she saw in him.[41] May Tabak recalled visiting Lee during a trip to New York from Washington. In the studio was a "silent looking man in dungarees.

> He just sat there and Lee didn't introduce him. She didn't say anything about him then, or at lunch afterwards. On the way out I said goodbye to him. I thought he was a janitor, or somebody who was deaf or half-witted, and she was giving him little jobs to do. When I came back the next time, I was shocked to find him there again. *Then* Lee told me that this was Jackson Pollock.[42]

But those fumbled introductions and puzzled reactions were minor compared with the famous "rough meeting," as Lee described it, between Pollock and Hofmann.[43] Lee had invited her teacher to see Jackson's work. "I brought Hofmann to Pollock's studio, as I knew Hofmann, I had studied with him, and I thought he would certainly, you know, dig this," Lee recalled.[44] "That wasn't quite what happened."[45] Hofmann's abstraction was rooted in nature; he believed an artist had to look *at* something as a starting point to trigger individual creativity. Pollock, however, didn't need outside stimulation for his work. His ideas were internally generated. "Well...[Hofmann's] response was, 'You are very talented, you should join my class, you work by heart, this is no good,'" Lee recalled.[46] He then looked at Pollock's palette and picked up a brush. An entire can of hardened paint came up with it. "With this, you could kill a man!" Hans exclaimed. Finally, glancing around the room and seeing no still life or model stand that would indicate Jackson ever worked from life, he warned, "You will repeat yourself, you should work from nature." Pollock positively growled his response, "I *am* nature."[47]

Other friends proved more receptive to Jackson. They liked him *and* his work. Among those were Mercedes and Herbert Matter. "We hadn't seen Lee for weeks; she had disappeared saying she 'really liked someone now,'" Mercedes recalled. "We had a lot of catching up to do, and I remember Lee having said Jackson should study with Hofmann. [Later] when I saw his things, I told her she was crazy: 'He's already made his own world. He doesn't need to study with anyone.'"[48] For his part, Jackson was taken by

the Matters. When they met, Mercedes was pregnant. Jackson fantasized about having a brood of his own and, voluptuously beautiful, Mercedes would have embodied his ideal of an earth mother. The two couples became close, and when in July Mercedes gave birth to Alexander Pundit Nehru Matter they celebrated together that new life born in a time of so much death.[49]

The friend, however, who would stimulate Lee and Pollock the most during their first year together, and who would be of critical importance to their life's work, was John Graham. After the McMillen show, they spent many afternoons in his company. Graham loved to host Saturday teas at his Greenwich Avenue studio, to which he invited different satellites of friends. There was a painters' circle with Hedda Sterne, Barnett (Barney) Newman, Mark Rothko, and Fritz Bultman, among others. Then there was a more eclectic group: the composer Edgard Varèse, the architect Charles Rieger, Bill de Kooning, Elaine, and her sister Marjorie. With Lee and Jackson, however, Graham did not invite any other guests.[50] From start to finish, the visit between those three was overwhelming in its focus.

Graham's studio was always freezing because he didn't believe in steam heat, but he walked around wearing only a towel as if he were in the tropics.[51] Cluttered with exquisite artifacts, the place was more museum than residence. African art, antiques, bits and pieces from his childhood in Russia, cooking utensils that he thought were as beautiful as sculpture covered surfaces and walls.[52] "Then, if he asked you for tea, he did it in the best Russian manner. He'd have the finest linen tablecloth, the best teas you can imagine, brewing in a samovar," Lee said. Once settled, the host soliloquized. "You didn't talk, you listened. There were so many marvelous things for the eye to absorb," she said. "Between that and the elegant tea and listening to what he had to say, it was quite enough."[53]

Graham spoke of Freud, Jung, and Marx, Surrealism, primitive art, and Picasso. He was also deeply involved in the occult. Part magus, part analyst, alternating between biting cynicism and wild humor,[54] Graham talked about the artist in society, saying that society would never recognize true genius, that the real artist would always be angst-ridden, that despite such torment he or she must nurture the creative spark within before self-doubt and the demands of daily life combined to snuff it out. "Fear automatically closes inner chambers of the unconscious mind,"[55] Graham explained, which is ruinous to an artist because the unconscious "is the creative factor and the source and the storehouse of power and of all knowledge, past and future."[56] To those who wondered how to access the unconscious, he advised simply, "Experiment wildly...only these explosions constitute art."[57]

Those words would have been a soothing balm *and* a stimulant for those

two artists, who were only just beginning to find themselves. Graham told Lee and Jackson they were at the most wonderful part of their artistic journey because they were unknown and therefore free, and that there was only one thing they had to dread: fame.

> How many men of great talent on their way to remarkable achievement in the present day are ruthlessly destroyed by critics, dealers and public while mediocre, insensitive hacks, who by intrigue and industrious commercial effort have gained recognition and success, will go down in history with their inane creations. Success, fame, and greatness coincide very seldom. The great are not recognized during their life-time.... Poe, Van Gogh, Rembrandt, Cezanne, Gauguin, Modigliani, Pushkin, Rimbaud, Baudelaire, and others could not make even a miserable living out of their art.[58]

As Graham described it, true art could never be *of* the world because it was always steps, decades, light-years ahead of it. Artists, therefore, had no need to be part of the world, either. Their only duty was to persevere. Humanity, he said, depended upon it.[59]

Lee and Pollock left Graham's studio in the exalted state of religious revelation. Indeed, everything associated with Graham was quixotic, even the most mundane encounters. Once, when Lee, Pollock, and Graham were walking on the street, they met a very small man in a very long overcoat who turned out to be the famous Viennese architect Frederick Kiesler. Graham introduced Kiesler to Pollock with a flourish, saying, "I want you to meet the greatest painter in America." The little man took off his hat, bowed low to the ground, and as he came up whispered, "North or South America?"[60]

For Lee, 1942 would be one of her most exciting years so far as an artist. By the spring, she had been in two exhibitions, hanging alongside the greats of modern art: the McMillen show in January and the American Abstract Artists annual in March, which had declared it a "privilege and necessity" to make and show abstract art as an affront to fascism. Lee exhibited there with Mondrian and Léger, as well as the Bauhaus master Josef Albers and Hungarian artist László Moholy-Nagy.[61] The significance of the show was personal but also political because it demonstrated that the language of art was universal and transcended national boundaries. Lee had also attended Mondrian's first-ever solo show, which was held at the Valentine Dudensing Gallery, where *Guernica* had been on display three years earlier.[62] And finally, Lee had met Pollock, which meant she had a new "cause" to fight for. In May, however, she discovered just how challenging that would be.

One morning in May, Jackson's brother Sande knocked on Lee's door to tell her that their mother was in New York and that Jackson was in the hospital. The arrival of Jackson's powerful mother, Stella, had sent him on his first epic drinking bout since Lee had come into his life. "He was in the Bellevue ward," Lee recalled. "He had been drinking for days. I said to him, 'Is this the best hotel you can find?'" Sande told her to take him to her place and sober him up in time for a family dinner. Though "shell-shocked" by the experience, Lee managed to make him presentable for Stella. No doubt expecting a family drama, Lee was surprised to encounter what appeared to be a lovely older woman who had prepared a "fabulous" home-cooked meal. "I thought Mama was a peach," Lee recalled.[63]

At that point, she had no understanding of the destructive bond between Pollock and his mother. What she did understand was that the man she loved possessed two violently opposing characters. The first was the charming, shy artist in whose paintings she could see the future of art. The second was the violent drunk who hated everyone but most especially himself. Another woman might have reconsidered their relationship. Lee, however, was not like other women. "She is at her best when she is fighting," said her friend Betsy Zogbaum. "She's a terrific fighter."[64] Eyes newly opened to what life with Jackson would entail, Lee moved in with him when Sande took a war industry job in Connecticut. The family was relieved that someone as competent as Lee had stepped in to care for Jackson.[65] Even his analyst was confident Lee could handle him. "She knew exactly what she was doing and she was exactly what he needed at that time," said Dr. Violet de Laszlo.[66]

Lee would use all the tools she possessed to save Jackson's life and help him develop his extraordinary art. She would call it "doing" for Jackson.[67] That, in addition to her own painting, would constitute her life's work.

8. Chelsea

If your everyday life seems poor, don't blame it; blame yourself;
admit to yourself that you are not enough of a poet to call forth
its riches; because for the creator there is no poverty and no poor
indifferent place.

—*Rainer Maria Rilke*[1]

A FELLOW PASSENGER admiring Elaine in the subway as she traveled to her job painting dials for airplane instrument panels would never have pegged her for an artist, much less a factory girl at a defense industry plant. She was positively *à la mode*. Her wavy shoulder-length red hair was cut in a "pageboy bob" and secured on either side by plastic daisy clips. She colored her lips red and plucked her brows into impeccable arcs. Her dress, too, reflected the latest style: a tight turtleneck sweater tucked into a wide belt over a ballerina skirt, accentuating her small breasts, thin waist, and lithe body. The look was lovely, charming, but conventional in a women's magazine sort of way. A surreptitious second glance might have given the traveler across the aisle pause; the young woman was not perhaps what she appeared. Her nose was buried in Proust's *Remembrance of Things Past* (Elaine would read all seven volumes during her year of commuting),[2] and when she swung her crossed leg in excitement over a beautifully crafted passage, any pretense of convention was destroyed. Instead of the regulation rayon stockings and sensible heels seen on the other women up and down the carriage, Elaine's legs were covered in startling blue tights, and on her feet she wore outrageous "all-encasing" purple suede high-heeled shoes.[3] Elaine's fellow "original Chelsea girl," Edith Schloss, called the look "downtown smart...street chic."[4] Elaine wore it well.

At twenty-three Elaine lived in the heart of Chelsea bohemia, a more eccentric world of artistic characters than even Lee's beloved Village. The two scenes overlapped for openings, performances, or nights at the cafeterias drinking coffee and arguing about art or Hitler. But the lofts between Eighth and Sixth Avenues, along 21st, 22nd, and 23rd Streets, housed an avant-garde that would have been an easier fit in prewar Berlin or twenty-first-century New York than lower Manhattan circa 1943. The neighborhood poets, painters, sculptors, dancers, composers, photographers, writers, and general hangers-on whom Elaine met through Bill had created a small, embracing community among the derelict lofts of the abandoned quarter.

Representing all ages, ethnicities, and sexual orientations, they were dedicated to their art and to helping each other enjoy life as much as possible in those dismal times.

This was Elaine's social training ground. Bill, Gorky, and Graham taught her about painting, but her friends in Chelsea during the war taught her lasting lessons about life. The woman who would later feed gossip and spark envy with her gregarious lifestyle was formed by two crucial experiences. The first was having watched her mother dragged off and institutionalized for failing to conform to the role society had assigned her. The second was discovering among the artists and intellectuals she loved that there *were* no assigned roles. Elaine's life, everyone's life, was theirs to create however they chose. If Lee's adult personality was born in Depression-era battles for survival, Elaine's was born during those heady days of absolute freedom and intellectual exchange in Chelsea. "She was university of the street, and the people she met as a young adult informed her," said Elaine's painter nephew, Clay Fried.[5] And though she was among the youngest of that crowd, she quickly came to dominate it. Edith Schloss called Elaine "the queen of the lofts."[6]

"I was just a cipher, a silent cipher," Elaine said of herself when she first met writer-composer Virgil Thomson, who was part of the educated, worldly, and distinguished cast of characters she would come to know. The chief music critic at the *New York Herald Tribune,* Thomson knew or had worked with the greats, including Jean Cocteau, Igor Stravinsky, Erik Satie, and James Joyce. He had also collaborated with Gertrude Stein on *Four Saints in Three Acts.* A teenaged Elaine had seen and loved that opera, and now the young adult Elaine was uncharacteristically intimidated to meet one of its creators, but only for a moment.[7] Though he was twice her age, she would later describe Thomson as among her close friends from that period. She loved his urbanity and wit (he described himself as "sassy but classy") and his defiance of social stricture (his companion was the painter Maurice Grosser).[8] But the main lesson Elaine learned from Thomson, which she would apply to her own life, was his ability to be many things—critic and journalist, among them—and still remain first and foremost an artist. There was life and there was art, and, happily for Elaine, who was eager to try her hand at *everything,* they were not mutually exclusive.

Fairfield Porter was Thomson's opposite. Whereas the latter grabbed life with both hands and devoured it, Porter observed it tenderly, thoughtfully, until he could claim a small portion of it to use in his art. He was the first "Harvard man" in Elaine's circle; not the first to have gone to that college but the first to look the part. Porter, his poet wife, Anne, and their five

children had recently settled in a Chelsea loft. Like Elaine, Fairfield worked a defense industry job during the day and, at night, taught himself to paint.[9] Having joined the steady stream of visitors shouting up to gain entry to de Kooning's studio, Fairfield came to Bill for trade secrets and to Elaine to share discoveries and talk. Tall, boyish, intense, and dressed in a rather threadbare herringbone jacket and tie (he even painted wearing a tie), this Ivy League renegade spoke to the "street chic" high school graduate from Brooklyn ten years his junior as an intellectual equal. Through her discussions with Fairfield, Elaine began to hone her ability to articulate her ideas. The two would remain friends throughout their lives and be crucial to each other professionally: Fairfield would introduce Elaine to her lifelong love of portraiture, and Elaine would recommend him for the job that launched his writing career.

But of all the wonderful characters who entered her life in those early years with Bill, the most important were Rudy Burckhardt and Edwin Denby. The two men had met by chance in 1934 in Basel, Switzerland, where Rudy, a Swiss medical school dropout, worked as a photographer. Edwin had quit Harvard, danced on the stage in prewar Berlin, and undergone analysis with Freud in Vienna. In need of a passport photo, one day he turned up at Rudy's doorstep. "A dashing cosmopolitan figure who had smoked opium with Cocteau, he was just what I was waiting for without knowing it," Rudy said. The two fell in love. When Rudy turned twenty-one, he followed thirty-one-year-old Denby to New York, where they rented a loft next to de Kooning.[10] For a while, Bill was known to them only through the classical music he played while painting. Then, by his cat, which liked to wander over to Rudy and Edwin's fire escape. And then through his art, which they saw—and by which they were astonished—when they returned the cat. The three men immediately became good friends.[11] "We stayed up most of the night," Rudy recalled of those days, "sat in Stewart's Cafeteria talking with Bill and his friends, watched the dawn on Madison Square, didn't get up till four or five in the afternoon." Bill and Rudy both spoke heavily accented English and charmed the patrician Denby (whom one friend called "the last civilized man") when they tried to sound more American by peppering their sentences with words like "swell" and "okey-dokey."[12] Denby counted Bill and Rudy among the three loves of his life, the other being the Russian dancer George Balanchine.[13]

When Elaine arrived on the scene she was immediately welcomed into their circle. "Men who usually did not care much for women adored you," Edith wrote to Elaine decades later. "Edwin was attracted to you most for your lively spirit, and also because he saw you as the guardian of Bill's perfection. He sat, eyes bright, all ears, listening to every word you had to say."[14] The two couples became extended family. Said Elaine,

> None of us lived a domestic life. We worked in our lofts and went to cafeterias and the Automat to eat.... But most of our talking was done while walking or even just standing in the street. The meetings were never prearranged; they just happened. And then we would all end up in one studio or another, to look at Rudy's latest photographs, or the painting Bill was working on, or Edwin would bring us a poem he had just finished.
>
> That was the way we got to know Edwin's poems, one at a time, as he finished them. I kept a copy of each of them and would learn them by heart from reading them over and over.[15]

During their nightly walks through deserted streets under a canopy of haze from coal furnaces, they were attentive to the wonderful sounds — the hooves of the milk truck horses, the shouts of deliverymen on early morning rounds, the clock at the Metropolitan Life Tower that marked the hours with a loud "Bong!"[16] Edgard Varèse, who was also part of their Chelsea group (he would record the sounds of Elaine and Bill kissing for use in one of his compositions), said New York had an orchestral music of its very own: clanging metal, the explosion of gas exhaust, the screeching of brakes.[17] Bill saw in the city shapes and colors, which he found "terrific." Rudy identified material for photos everywhere — water hydrants, manhole covers, empty streets — which Edwin duly noted for later use in his poems. Or, sometimes, when words were insufficient to express his feelings, Edwin would stop on the street and perform an impromptu ballet.[18] The three men thought New York thrilling. "Bill, Edwin, and Rudy loved it because they came from somewhere else," Edith wrote. "Elaine didn't have to love it, she *WAS* New York."[19]

And yet, through those meanderings, Elaine did discover a new way of looking at her native city. On Wall Street, she began filling her sketchpad with precise drawings of buildings.[20] Standing in the canyon of the street studying the structures around her, she recognized that those citadels of finance, so gray and austere, were not at all unlike Bill's yellow cup. The buildings were still life objects, too, each with its own marvelous qualities that could be appreciated if one looked hard enough. Art could do that to life — it could recalibrate one's very existence.

Elaine was soon absorbed by Edwin's and Rudy's wider social circle — Aaron Copland, Balanchine, Tennessee Williams, and later Kurt Weill and Lotte Lenya — until, she said, she "began to feel there was this long procession of geniuses that would keep unfolding themselves before my eyes. I didn't know then that I had somehow made my way to the red-hot center." Some of the people Elaine met came in pairs, and from them she learned by example that monogamy was not an essential ingredient in a marriage. It was "team spirit" that counted.[21] There were the Auerbachs — Walter and

Ellen, known as "Pit"—German photographers who had emigrated to the United States in 1940. At thirty-seven, Pit "was the admired 'older woman' to 'us girls,'" Edith said.[22] She was a product of those liberating days in Berlin before the war when women wore pants, smoked in public, and expressed themselves without reserve, socially and sexually. It was well known that both Auerbachs continued to have liaisons outside their marriage, but that did not seem to diminish their regard for one another.[23] Paul and Jane Bowles, another couple in their Chelsea circle, had a similarly unconventional relationship. At the time, he was still a composer, but Jane would publish her first book in 1943, *Two Serious Ladies*. It was a reversal of the wife as ball-and-chain scenario; in Jane's book, feckless men impeded the two ladies of the title. Elaine learned that the Bowleses lived in the same building but in separate flats. They were husband and wife, but more importantly they were good friends who spoke on the phone every night to tell each other about their days.[24] That, too, then, was a marriage.

Not all the relationships Elaine encountered, however, were so unorthodox. Painter Janice Biala had moved back to New York after a harrowing escape from Vichy-controlled France following the death of her writer-husband, Ford Madox Ford. She had since married Daniel Brustlein, an Alsatian who, under the name Alain, did cartoons for *The New Yorker*. The Brustleins and Biala's brother, the painter Jack Tworkov, and his wife, Rachel (known as "Wally"), would join Bill and Elaine for "endless coffee evenings" at Stewart's or dinner at the Jumble Shop.[25] Quite apart from the men in their lives, the women developed a bond of their own. When the "original Chelsea girls"—Elaine, Wally, Edith, and Ernestine—got together, "they all smoked like chimneys, cracking their gum, talking out of the side of their mouths," said Wally's daughter, the artist Hermine Ford.[26] Indeed, all of those people—Denby, Rudy, the Auerbachs, the Porters, Virgil Thomson, Maurice Grosser, the Bowleses, the Brustleins, the Tworkovs, Elaine and Bill—engaged in a wild, continual exchange enlivened by their love of art, tales of their extraordinary lives, and arguments about the war. ("We used to say paint was thicker than water," said Edith.)[27] That was Chelsea's old guard. A new generation, even younger than Elaine, had also begun to move in, and they would blast the scene wide-open.

Foremost among them was Nell Blaine. In 1942, at the age of twenty, Nellie had arrived in New York from Richmond with ninety dollars, of which she immediately spent twelve-fifty to rent half of what she called "a miracle of a studio with beautiful north light" on 21st Street. Her goal was twofold: She wanted to escape her past, which included a southern childhood with a furious mother and an abusive father.[28] ("Either you go under,

or you fight back," she said. "I reacted by doing wild things...fighting with boys, even though it would be three to one."²⁹) And she wanted to study with Hofmann. Stepping off the train, the compact young woman with thick glasses and short hair that always looked as if she had cut it herself marched—suitcase in hand—to his school to enroll. "Hans Hofmann had a chic lowercase sign in sans serif type discreetly mounted to the right side of the entrance. Eighth Street to me was Hong Kong, exotic ports, all things glamorous and colorful," Nell recalled. "This was my mecca, Hofmann, the master's street, the center of all things I longed to know, the gateway to abstract and all modern art, a holy place."³⁰ Back on 21st Street, she soon met the neighbors. In fact, Nell's studio became a new focal point for the group. By day she worked at an insurance company, and by night she ran sessions with a model so her fellow artists could get together and sketch.³¹

Not long after settling in New York, Nell met and married a French horn player from Brooklyn named Bob Bass, who was about to enter the army.³² Through him, Nell was introduced to Café Society Downtown, and to the 52nd Street jazz scene farther north. "We followed Billie Holiday and all those people in the clubs, you know, for the price of a beer," Nell recalled. "We were there to hear the first notes that Charlie [Parker] played at Carnegie Hall."³³ Through Bob she also met artist and jazz drummer Leland Bell and a scrappy sax player from the Bronx named Yitzroch Loiza Grossberg, who had started calling himself Larry Rivers.³⁴

Music thus entered the Chelsea scene in a big way. Whereas the streets had once been filled with Stravinsky and Bach floating from attic lofts, jazz suddenly filled the air.³⁵ There was also the persistent rhythm of drums. Nell had decided that, like Leland, she would be a jazz drummer in addition to being a painter. ("Handling the drumsticks affected to this day the way I use paintbrushes," she said.) Responding to the call of her music, the other denizens of the quarter would drop by. Soon, enough stragglers had arrived to make a party, and no one enjoyed *that* more than Nell. "Nellie danced by herself in wild improvised steps, or playing on the drums," Edith said. The parties "lasted for days until a group of people drifted apart from exhaustion." Jazz wasn't just a distraction for the painters, it was inspiration. "We painters were in love with the idea of creating new forms and rhythms related to the spirit we felt moving in this music," Nell said. "Like each improvisation in jazz, each color in abstract painting was to have a life of its own in the picture."³⁶ In that environment, Nell said she began to feel like a real artist.³⁷ Those around her couldn't help but be affected by her, too. Her escape from southern bourgeois bondage had produced an enthusiasm for life that was contagious and explosive.

One writer who knew Nell called her loft and the activity therein the "big bang."[38]

The Chelsea artists did their best to turn their industrial wasteland into an oasis of creativity devoid of war, but the war and its troubles found them, even there. Volunteers knocked on their doors, collecting material that might benefit the war effort: old pots and pans, tires, garden hoses, rubber raincoats—anything that could be melted down or converted into a weapon, a bullet, or gear for the troops.[39] Rationing had been instituted on goods including gasoline, coffee, canned food, and shoes.[40] "Sugar bowls from the Automat began to appear in artists' studios," Elaine recalled. "A major source of energy in diets that were skimpy elsewhere."[41]

Then, in January 1942, the war leaped from the headlines and reached America's shores. A British merchant ship was torpedoed off the East Coast of the United States. German "wolf pack" submarines had been aided in that attack by a backdrop of well-lit coastal towns and cities. By the end of January, forty-six merchant ships were sunk in the coastal waters between New York and Florida.[42] Immediate steps were taken to turn off the lights. Hour-long blackout drills were instituted in New York and other cities during which streetlights were extinguished, and people were ordered to draw their shades. Air raid drills began, their sirens blasting short bursts at random times, day and night, in preparation for a real attack. Even weather forecasts were halted in some regions so that enemy forces looking for a window during which to strike would not be aided by assurances of a clear night.[43] Since those first chilling hours after Pearl Harbor, when it became clear that the moats called the Pacific and the Atlantic were no longer sufficient protection against invaders, a generalized feeling of anxiety had become palpable. "For the first half of the decade, the war was uppermost in everyone's consciousness," Elaine said.[44] Ernestine called it "the cloud that hung over everything."[45]

The government had in many ways contributed to the panic by taking extreme measures domestically. In 1942, more than one hundred thousand Japanese Americans were uprooted from their jobs and homes and driven into "relocation camps" surrounded by barbed wire and secured by guards.[46] Meanwhile, public service announcements covered the walls in subways and on street corners warning that enemy spies were everywhere. "A slip of the lip may sink a ship." "Enemy agents are always near; if you don't talk they won't hear." "Wanted for Murder!" read one shocking poster featuring a cowering housewife who had supposedly "spoken one word too many" and cost a soldier his life.[47]

In fact, there were plots by foreigners within the United States. In June 1942, four Germans had been dropped from a submarine onto Amagansett

Beach on Long Island, and several days later, four others came ashore at Ponte Vedra Beach in Florida. All carried explosives, detonators, forged documents, and blueprints for rail stations and factories. Their arrests and trials were swift and decisive: Six of the eight were executed, and the other two imprisoned.[48] Coming after the "wolf pack" attacks, those cases confirmed people's worst fears that the war would not remain "over there." But incredibly, instead of blaming Germany for a spreading conflict, some in the United States blamed "the Jews." At the very time that Americans were dying fighting fascism, fascism in the United States was on the rise. Ugly language and ugly scenes were common enough that in one case the government silenced a popular radio preacher who had called for the removal of "Jews from the field of politics and government" because "Jews and commies" had "tricked" the country into war. That language of hatred infected some young minds. In Boston in 1943, gangs of teens tried to reenact Kristallnacht by breaking the windows of Jewish-owned stores and desecrating synagogues.[49]

Who was the enemy? Where was the enemy? Within the country, no one could be sure in those confusing times. Beyond the borders, their identities were clear, and what mattered most was to keep the war machine operating to defeat them. But that would require unity of purpose, and domestic control became paramount. Loyalty oaths were required of some government workers. Suspicious noncitizens were deported—a prospect that terrified Bill.[50] The government, too, had changed. During the Depression, the Roosevelt administration had been filled with reformers tasked with running the biggest social program in the nation's history. During the war, they were replaced by businessmen who oversaw the new national industry, conflict. They did their jobs well, funding the largest military campaign in history and managing to turn a profit from the costliest war the world had ever seen.[51]

At the end of 1942, the CBS broadcaster Edward R. Murrow, who for many was the most trusted voice delivering news of the war, declared, "The phrase 'concentration camp' is obsolete. It is now possible to speak only of extermination camps."[52] That statement was meant to put a stop to the debate over what was actually occurring in Hitler's Europe. Earlier that month, on December 2, half a million people in New York had stopped work for ten minutes to call attention to the massacre of two million Jews.[53] When first reported by the chairman of the World Jewish Congress in late November (and confirmed by the State Department), the mass slaughter received little press attention. The *New York Times* ran the story on page ten. National radio broadcasts had no story at all. The decision to ignore the staggering death toll was often explained away as a concern over "sourcing," but given

the State Department confirmation of the December announcement, the omission was difficult to comprehend. After Murrow's statement, and after near-constant reports of abuse and murder through the first months of 1943, there was no longer any denying that the Nazi regime was systematically killing Europe's Jewish population. In March 1943, seventy-five thousand people gathered in and around Madison Square Garden to hear political leaders, their thin voices echoing through the hall and the crowded streets via a public-address system, denounce "Hitler's decimation of the Jews."[54]

Eight days later, a bigger, more emphatic event — "We Will Never Die" — occurred at that same location. One hundred thousand people attended, among them Supreme Court judges, cabinet ministers, three hundred congressmen, senators, diplomats, and first lady Eleanor Roosevelt.[55] The groundswell witnessed in New York had taken years to build: ten years since Hitler had come to power and begun persecuting his people, five years since the world had stood shocked at the sight and sound of Kristallnacht. The crowds in Manhattan vowed not to forget. But many, many others would continue to ignore what was too horrible to contemplate, at least until the killing had stopped. Then they would comfort themselves by repeating like a mantra, "We didn't know." The truth was, they did.

The greater war — the soldiers' and sailors' war of battlefields and tanks and bombers and ships — was readily embraced as an American reality.[56] Patriotism in such an environment was not an abstract concept but an absolute duty. In the official art world, it was nearly impossible to find an exhibition that did not mention the conflict. War-themed shows filled the Museum of Modern Art's calendar: *National Defense Poster Competition, Britain at War, Wartime Housing, Camouflage for Civilian Defense.*[57] The biggest display of artistic patriotism, however, occurred in December 1942 when the Metropolitan Museum mounted its *Artists for Victory* exhibition. Presenting fifteen hundred works by "contemporary" artists, organizers billed it as a testament to the strength of the American spirit and a tribute to the troops.[58] But painter and writer Manny Farber, who reviewed the exhibition in *The New Republic,* said that the still lifes, portraits, and landscapes on display could have been done at any period. If *Victory* was meant to be a show about art and war, those pieces in no way reflected the gravity of the times. "These people are artists: They are supposed to have gone beyond the strictures of our culture. Yet there seems to be a definable fear behind the pictures in this exhibition — of exposing the emotions we do not talk of politely."[59] In the wake of massive demonstrations demanding the truth, and amid the recognition of what that truth was, the *Artists for Victory* show — in fact, all the museum war exhibitions — were wholly inadequate, if not dishonest.

The avant-garde artists in New York wanted no part of the "canned

culture" championed by official circles, which was meant to entertain and encourage but not enlighten.[60] "Every day the war news and photographic illustrations convinced us that we couldn't ignore reality for dreams," said Philip Pavia. "We were not ostriches closing our eyes and burying our heads in the sand at the approach of an ugly danger."[61] Clearly a new art was needed, one that expressed the actual world, and not with the painted words of the social realists or wistful images of nostalgia. The duty of the artist, in times of war as in times of peace, according to Elaine, was to "unleash a state of mind."[62] To do that, the New York artists required a clean slate. They could build on the past, but they would need to create their own visual language, one that reflected the world around them through the world inside them. Just when that realization had become clearest, New York was flooded by a bizarre troupe of exiled artists led by a French army psychiatrist-turned-poet who would help point the way. The poet was André Breton, and his message, which echoed John Graham's, was as elegant as it was simple: Risk all and let your unconscious be your guide.[63]

9. Intellectual Occupation

> Anybody can understand that there is no point in being realistic about here and now, no use at all not any... there is no realism now, life is not real it is not earnest, it is strange which is an entirely different matter.
>
> —*Gertrude Stein*[1]

OCCASIONALLY, THEY'D CATCH sight of him, Breton, in a green suit with green eyeglasses and medical books in his pockets, trailed by a gaggle of artists who "followed him like sheepdogs."[2] The New York artists watched with amused disbelief as the men whose names they had known from French art magazines walked and bicycled among them. There was Marcel Duchamp, just arrived from Casablanca, in Washington Square playing chess. And painter André Masson, from Paris, so terrified of New York traffic that he froze while crossing the street.[3] But most colorful of all was Breton himself, who, though possessed of no sense of humor whatsoever, was a magnet for the fantastically comical. One day, while Bill de Kooning was walking near the corner of 53rd Street and Seventh Avenue, he noticed a man across the street making wild gestures in front of his face. "It was Breton and he was fighting off a butterfly," Edwin Denby recounted. "A butterfly had attacked the Parisian poet in the middle of New York."[4] The Surrealists had arrived to make the already strange life in wartime New York stranger still.

Some had come in the late 1930s. Salvador Dalí had literally made a splash in 1939 by crashing through a Bonwit Teller window—along with a bathtub full of water—onto Fifth Avenue in a fit of pique over changes to a display he had designed. The outlandish Catalan's tantrum and subsequent arrest made headlines around the country.[5] But not until the early 1940s did the mass of Surrealists arrive to make their presence immediately felt. "All of a sudden we found these refugees surrounding us," Pavia said. "They were all over the place, like an occupation army."[6] Hitler's persecution of intellectuals and artists throughout Europe had intensified, which meant that the United States had become, seemingly overnight, the home of the most advanced thinking in the Western world. *Fortune* magazine declared solemnly, "The unprecedented exodus of intellectuals from Europe confers upon us the opportunities and responsibilities of custodianship for civilization."[7]

In the fields of science and philosophy, Albert Einstein, Enrico Fermi, Edward Teller, Claude Levi-Straus, Herbert Marcuse, Wilhelm Reich, Erich Fromm, and Hannah Arendt had arrived.[8] In music, Arturo Toscanini would take over the NBC Symphony Orchestra and Arnold Schoenberg would introduce atonal music to his students—among them John Cage.[9] In dance, Denby's beloved Russian, George Balanchine, would create the New York City Ballet by fusing classical tradition and American style.[10] Architects Walter Gropius, Le Corbusier, and Mies van der Rohe would transform the nation's skyline.[11] Psychoanalysis had been banned from the Congress of Psychology in Leipzig as a "Jewish science," and so America became the "world center" of psychology and psychoanalysis. One expert estimated two-thirds of all European psychoanalysts were driven to the United States by the war.[12] New York's New School for Social Research would establish a special department, "University in Exile," to employ eminent refugees. It was as if the school library had suddenly come alive and, instead of books by remarkable thinkers on its shelves, it had the remarkable thinkers themselves at the head of its classrooms. At New York University's Fine Arts Graduate Center, German scholars would revitalize the discipline of art history and come to challenge Europe's dominance in the field.[13]

Immediately affecting the artists in New York, however, were the arrivals of Stanley William Hayter, who had fled occupied Paris, and Tatyana Grosman, who had walked across the Pyrenees to Spain to escape France.[14] They would help spark a revolution in printmaking, elevating prints from the doldrums of reproduction to the realm of fine art. New galleries also benefited from the émigré influx. Dealers who had fled Europe with the remnants of their collections began opening galleries along 57th Street. Booksellers arrived as well, among them George Wittenborn, who had been a book merchant in Berlin but was badly beaten by Brownshirts because his shop sold "objectionable" literature and was frequented by homosexual artists. In New York, Wittenborn's bookstore would again be a favorite among artists. He would also, along with Bob Motherwell, publish invaluable English language texts on modern European masters, so that the artists in New York could not only see what their forefathers had done but read what they had written.[15]

ArtNews editor Tom Hess called the wartime intellectual flight to the States "the most amazing exodus in history.... Internationalism was thrust upon New York by Europe." Motherwell described the scene as "a kind of Istanbul...a great crossing place, a great bazaar" where ideas were the commodity of value and their exchange accomplished with gusto.[16]

Philip Pavia estimated the refugee artists who remained in New York after arriving in the States at only about thirty, but "they slowly...with

great skill, took over all of the 57th Street galleries and the museums." Said Motherwell, "They were not only famous for their art, now they were political martyrs, too, driven from their homes by the Nazis."[17] The New York artists, however, quickly abandoned their irritation over the ease with which the newcomers dominated the scene. They recognized in the refugees' careworn faces that their position in the art world had been hard-won.[18] "We saw them at firsthand and realized that they were great artists but that they were also men, and that we were men, and conceivably we could try to be great artists," Motherwell explained.[19] The downtown crowd walked a little taller by association. "This exposure," Pavia said, "did something to us."[20]

The New Yorkers observed their exiled counterparts from a new hangout on the corner of Sixth Avenue and Eighth Street, the Waldorf Cafeteria. Six nights a week, ten to eighteen artists met there. They were the men who hadn't gone to war and the women who dared to venture into that infernal "coffee-teria," as Gorky called it.[21] Police departments had emptied when their officers and recruits joined the military, and that meant fewer cops walking increasingly dangerous beats. "When women came [to the Waldorf] they left early," said Pavia. Elaine, however, stayed. "She, from the first, showed an independence that was copied and modeled later by many women," Pavia added. "She separated the woman from the artist and lived her lifestyle that way."[22]

The cafeteria that would be the artists' "club" until 1948 was one large room with a high ceiling and a wall of windows onto the street. Soldiers and sailors sat in one section, "sleazy characters—black marketeers" in another. "Ammunition loaders"—men who transported explosives for detonators onto ships—sat near the entrance. They impressed the artists the most. "Fear and tension was frozen on their faces," Pavia said. But those men were also government-protected "hoodlums" who could physically assault anyone they liked without fear of jail because their work was so valuable to the war effort that they were untouchable. The artists sat as far from the volatile loaders as they could, at the back of the cafeteria.[23] "The French refugees were always the topic of conversation," Pavia said. "What did we have?...Did we own a long tradition like our refugee visitors? These questions occupied the Waldorf crowd."[24]

The atmosphere in that wretched cafeteria in those days was electric. The avant-garde epitomized by the School of Paris no longer existed—Hitler had seen to that.[25] It seemed imperative that something original should come out of New York. The question was, what? And how? The *New York Times* had published a letter to the downtown artists from future art dealer Sam Kootz answering the second question: "Now is the time to

experiment," he said. "You've complained for years about the Frenchman's stealing the American market...all you have to do, boys and girls, is get a new approach, do some delving for a change."[26] Every day the artists worked in their studios, doing just that—delving, but not finding—and at night they went to the Waldorf to blow off steam.

"We'd have this big discussion—total fight," Pavia said.[27] Sometimes the arguments veered off into the absurd. De Kooning said Picasso was great. Gorky, considered a "king" by some of his fellow painters, couldn't come into the cafeteria with his two wolfhounds, so he shouted through the door that Picasso was on the way out.[28] John Graham came in to talk— and he expected them all to listen—but it was hard to take what he said seriously. Graham held his nose while he spoke because of the chokingly thick cigarette smoke in the Waldorf.[29] And then there were the odd visitors who added unexpected piquancy to the discussions. The Native American wife of Italian painter Oronzo Vito Gasparo settled among the Waldorf group one evening and proceeded to call them "white ass shitty painters" for stealing her people's images. Everyone was welcome, and all thoughts and comments noted.[30] "We had no program, we just felt a new vertical energy rising from the ground through our ankles, slowly upwards and finally making our minds restless and hungry," Pavia said.[31]

Had it been the 1930s, Lee would have been in the middle of the Waldorf discussions, as she had been in the Jumble Shop before. But by 1943 she had ceded that social territory to Elaine. Lee had a new preoccupation, Pollock. During their first months of living together, their influence on each other's art had been enormous. "Jackson helped her to be free and spontaneous and she helped him to be organized and refined," said art historian Barbara Rose.[32] After meeting Lee, Pollock painted his first masterpieces, *Stenographic Figure, The Moon Woman,* and *Male and Female.* They displayed a shocking leap in sophistication, both in terms of technique and imagery.[33] Jackson had had Lee to shield him from outside distractions and inner demons. He had also had her unassailable eye as a guide. Lee "knew more about painting than anyone in the United States, except John Graham," said future art dealer John Bernard Myers.[34]

For his part, Pollock had introduced Lee to an entirely new approach to painting, one that forced her to look inside herself for inspiration. *She,* the immensity of her own existence, was to be the subject of her work. "It's a full unity," Lee said of Pollock's idea. "With the advent of Pollock, there was no longer the separation of myself from nature."[35] Just as her association with Hofmann had caused her to abandon the academy, her association with Pollock caused her to take a second look at what Hofmann taught. She still revered her old teacher (which caused Jackson to be mightily jealous),[36]

but she loved Pollock. "Hofmann gave me enthusiasm. Pollock gave me the confidence to accept my own experience," she said.[37] In the fall of 1942, Lee had straddled both worlds, Jackson's and Hofmann's (with dashes of Matisse, Miró, and Gorky). By 1943, she had shed all influences but one. She was completely immersed in Pollock: her life with his life, her work with his. They freed "each other from the dogma of their respective teachers," Rose explained.[38]

They lived however they could. Lee's war project job had ended and she was given a federal stipend to take drafting classes, which would have prepared her for lucrative employment.[39] (Her instructor called her "one of the most brilliant students he had.")[40] But Pollock didn't want her to work. Unlike most of the male painters, who were financially supported by their wives or girlfriends, Pollock wanted to support Lee — *through the sale of his paintings!* The prospect was laughable. For someone as rooted in reality as Lee, the notion must have come across as a sweet, but deluded, act of middle-American gallantry. No one *sold* paintings, let alone lived off them. Pollock, however, had resolved to try. "He made a real issue of it," Lee said.[41] Eventually, she agreed. While awaiting an income from his paintings (which at that point had no gallery to show them), Pollock picked up odd jobs, until John Graham found him work in the maintenance department of Hilla Rebay's museum.[42] And, since their future depended upon it, Lee busied herself promoting Pollock.

On a recommendation from Hofmann, Sidney Janis, a collector who had made a fortune designing the two-pocket men's shirt, had come to look at Lee's paintings. He was writing a book to accompany an exhibition traveling to five cities called *Abstract and Surrealist Art in America* and was on the hunt for New York artists.[43] The book, which would also include Kandinsky, Picasso, Braque, Miró, and the important Russian painter Kazimir Malevich, along with all the major Surrealists then roaming the streets of New York, would be the first to showcase the new American talent. It was a phenomenal opportunity, in many ways more important than the McMillen show because the exhibition was larger and traveling, and because the book accompanying it would be a published record placing the younger Americans on par with their European elders.

After looking over Lee's work, Janis chose her thirty-by-twenty-four-inch painting *Composition,* which Pollock had signed for Lee and which Janis would display in a full-page plate in his book. In the exhibition, it would hang along with Gorky, Graham, Motherwell, Bill de Kooning, Mark Rothko, and Mercedes Matter.[44] The decision over her work made, Lee couldn't resist the opportunity to introduce Janis to Pollock. She took him into his studio, where, as Jackson stood silently in a corner, Lee described his ideas and his work. Janis was sold, eventually selecting Pol-

lock's *The She-Wolf* for the show. He then went well beyond what Lee or Pollock could have imagined: He recommended that the Museum of Modern Art buy the painting.[45] That purchase would eventually occur, though not immediately. In the meantime, the very thought that Janis found Pollock's work museum quality was enough to fill their empty stomachs with that most delicious food—hope.

Introducing Pollock to Mercedes and Herbert Matter had also opened important doors. Through them, a critic and future curator at the Museum of Modern Art, James Johnson Sweeney, became acquainted with Pollock's paintings. He loved them and brought them to the attention of a former California gallery owner who had arrived in New York via Paris.[46] A wonderfully generous character, Howard Putzel had a rare ability to home in on the best new art but was remarkably unlucky in business, had no money of his own, and was in general a nervous wreck.[47] "Howard was a very gentle man, he was big, fat, bloated, red-faced from drink, ate his fingernails so flat his fingers looked like twigs," said artist Theodoros Stamos. A chain smoker (he used a cigarette holder, which was no doubt well chewed), he once tried to quit by replacing cigarettes with a bowl of two thousand sour balls but it didn't work. Instead of replacing one habit with the other, he succumbed to them both.[48] At the fall of Paris in 1940, Putzel predicted that the United States would be the "new home of art," and when he arrived in New York, he set about meeting as many of its artists as he could.[49] With Jackson and Lee's address in hand from Sweeney, Putzel quickly made his way to Eighth Street.

"Genius."[50] Putzel uttered that word on seeing Pollock's paintings, full of symbols that hinted at a subject but never slipped into narrative. He told a friend, "This is going to be the major artist in this country." He also very much liked Lee's work. In fact, in his dealings with the Pollock-Krasner household, Putzel never treated Lee as a mere artist's girlfriend. She was an artist, full stop. But both Putzel and Lee agreed that Pollock was the one. He had already found himself in his painting, and what he had to say was extraordinary. They joined forces to spread the news. Putzel became a constant visitor to their apartment, dragging his large forty-five-year-old body up the five flights to the kitchen, where he would collapse at the table, often to share a meal.[51] Though just over a year ago Lee had not even thought to use her oven, in the brief time since she had moved in with Pollock she had learned to cook. (Putzel said she was a "Cordon Bleu chef.")[52] "I wanted that role," Lee said. "I couldn't suddenly not be a woman, not be in love."[53]

At some point, Jackson met Bob Motherwell, an extremely shy, thirty-year-old Californian who had studied at Stanford, Harvard, and Columbia and described himself as the "self-conscious son of a banker." Motherwell

had negotiated his way out of a career in law or business to become, despite the vigorous objection of his father, a painter.[54] By the time Pollock met him, Bob had studied art in Europe and lived among the Surrealists in Mexico.[55] He and Pollock would have seemed unlikely candidates for friendship, but many of their experiences and interests converged to make the early bonds between them strong: a commitment to painting (writer Lionel Abel said between 1942 and 1948 he never saw Motherwell without paint on his face), a deep appreciation of Mexican art (Pollock had just emerged from his Mexican phase), and perversely strong mothers (Motherwell called his a "psychopath").[56]

Motherwell invited Pollock to join a group of younger Surrealists who were breaking away from the Breton-dominated school.[57] The instigator of the rebellion was a charismatic Chilean painter raised in Spain's Basque country named Roberto Matta Echaurren. Small, with straight black hair and a wild exuberance about all things (especially himself), Matta captivated the young Americans. He acted like a master, demanding the attention and respect of a man twice his age, though he was just thirty-two. At the same time, he was fun: his laughter trilled upward, as one friend described it, "on soprano wings."[58] He proposed that the men meet to discuss art at his studio on Ninth Street, and that their "wives" be invited for social gatherings during which they would play Surrealist parlor games.[59] The distinction between the male artists and their wives deeply annoyed Lee. She had never been overtly sidelined because of her gender. Among Matta's Surrealists, she was supposed to accept the part of a grateful appendage.

For the Surrealists, women were muses, the embodiment of mystery, the angels, the erotic playthings, the objects of mad desire, the praying mantises. Both saint and sinner, a wife was sexually liberated but still the possession of her husband. Surrealist games often involved offering wives to other men, and the Surrealist "Notebook of Etiquette" said that a male guest was expected to eventually make love to the hostess. To the Surrealists, "woman" was a creature of imagination but never a creator. (Which was strange because there were many women Surrealist artists, and one of the most famous Surrealist works was by a woman: Méret Oppenheim's fur-covered cup, *Object*.)[60] Lee soon discovered that the Surrealists treated their women as "poodles" or dolls, "like something you dressed up and put on exhibition."[61] Ahead of a night out, the men dressed the women in elaborate outfits and fixed their hair. "And then when everyone got to the social event, which was possibly dinner at one of the houses, it was like who had done it best," Lee said. "Well, can you see Jackson trying to pick something for me to wear?" she asked incredulously.[62] "I could never put up with that sort of thing, never."[63]

Luckily for Lee, Jackson was also appalled and offended. He quit the group. But that brief exposure to the Surrealists tainted Lee forever. In a letter to Mercedes, who was living in California at the time with her husband and son, she described the movement as a "nest of snakes."[64] The revered émigrés had introduced Lee to the ugly reality of sexism in the arts, and she feared that the Surrealists' notion of art as a man's domain would take hold in New York. In fact, it did. Lee noted that some of the men began treating their female colleagues as lesser. "I am for the first time in my life aware of something about—a woman [being] in the way," Lee recalled.[65] "There were the artists and there were the dames. I was considered a dame even though I was a painter, too."[66]

The Europeans had given the New York artists license to be sexist by their example, but also, perhaps more importantly, the need to be so by their presence. The refugees were reminders that the New Yorkers, though grown men, were children by comparison, that they lacked painterly sophistication, that they were at best in mid-struggle. The nature of prejudice is such that when one feels mastered by another, one looks for someone to dominate in turn. Some of the male artists, though less experienced and less talented than the likes of Lee, would have embraced the European chauvinism to assuage their damaged self-esteem. They, too, could be "better" than someone. They could be better than a woman. Though disgusted, Lee didn't allow the changed atmosphere to interfere with her work. "I went about my business," she said. "I am painting."[67]

In discussions about the relationship between Pollock and Lee, the question often arises whether he, that most mythically macho of artists, ever asked her to stop painting. People outside Lee's inner circle said he did. But those who knew her and Pollock best in the early days said otherwise. Lee herself adamantly, repeatedly, and convincingly denied it, saying that if Jackson had asked her to give up painting, or hadn't respected her as an artist, they "couldn't have lived together for five minutes.... I think he knew it, I knew it, it was never discussed.... I painted and he painted."[68] Her unequivocal declaration, "I am painting," represented something much more fundamental than Lee's asserting her *right* to paint. Painting for her was not a right, it was a necessity. To deny an artist her ability to create would be tantamount to denying her air, water, food, or sleep. Lee could not do otherwise *but* paint. The ultimate proof that she continued to do so is the existence of works from that period.

Yes, Lee continued to paint, but she *did* relinquish something. She set aside her career.[69] As Pollock began to be singled out for recognition, Lee began to publicly occupy an unfamiliar lesser role. Her friend Lillian Kiesler said watching the process was like watching a "ballerina being

diminished, that here was this great star. Jackson was nothing to us."[70] Lee accepted her new position, out of love for Jackson, out of a belief in his work, out of sheer pragmatism because it would be his paintings that would keep them afloat financially if indeed he was able to sell them.[71] Lee Krasner the artist, therefore, retreated to the privacy of her studio. On the social scene, she became Lee Krasner, Jackson Pollock's manager girlfriend. She would commit herself to that role with the same energy—greater energy—than she had displayed on behalf of the Union.[72]

In a sense, the division of roles proved liberating for Lee. As a painter, she could experiment with the ideas she had learned from Pollock without observation from others. Taking herself out of circulation, she would be able to concentrate on the excruciating process of finding a new style, a new self, on canvas. Focusing on Pollock's career rather than her own had given her the time and space she craved and needed. But it wasn't easy. For three years, beginning in 1943, as Lee mined for inspiration within herself, she produced nothing but gray slabs—sometimes as much as three inches of thick, painted mud. "It wasn't clear what I was moving into," Lee said. "I went into my own blackout period... where the canvases would simply build up until they'd get like stone and it was always just a gray mess. The image wouldn't emerge.... I was fighting to find I knew not what, but I could no longer stay with what I had."[73] Filled as she was with an innate self-confidence and unafraid of hard work, Lee continued. The best she could say of her effort was, it was a start.

In the spring of 1943, a dozen Waldorf artists—Bill de Kooning, Elaine, and Philip Pavia among them—traveled to 57th Street to the opening of a show that, in retrospect, would be historic: the juried Spring Salon exhibition at Peggy Guggenheim's Art of This Century gallery.[74] The place was crowded with a bizarre mix of characters in full Surrealist regalia. Women dressed as Navajo Indians, headdresses and all, stood beside others clad and painted head to toe (including eyes, lips, and nails) in black. Some strolled through the crowd as movable mannequins showcasing works of art that doubled as jewelry. Worldly women, who wore a record of their travels in the form of Japanese silks, Indian needlework, and Moroccan fabrics, mingled with men in stiffly pressed military uniforms—blue, green, and white—for the gala that marked the uptown debut of works by the new downtown artists.[75]

"Art of This Century was... the first place where the New York School could be seen. That can never be minimized, and Peggy's achievement should not be underestimated," said Lee,[76] whose appreciation of Guggenheim's work on behalf of artists overrode her personal belief that Peggy was a misogynistic "bitch. There's no three ways about it."[77] Lee said Peg-

gy's "gallery was the foundation, it's where it all started to happen.... That must be kept in the history."[78]

It would, in fact, be tempting to dismiss Peggy's commitment to art as merely the preferred pastime of an eccentric heiress who collected excellent advisers and then, on their recommendations, collected great art. Historically, her reputation has in some cases suffered the same fate as that of her uncle Solomon's lover Hilla Rebay. Both dedicated themselves to collecting and exhibiting the most advanced art and financially helping the most advanced artists, but both were suspected of doing so for the wrong reasons. Somehow, they weren't considered serious collectors or patrons—and it wasn't simply because they were women. The Modern had been the brainchild of women collectors, as had the Whitney. No, there was something else at work. The women associated with those two museums were respectable; Peggy Guggenheim, like Hilla Rebay, was outrageous.

Born to one of New York's most prominent families, with all the wealth and social standing attached to that charmed entry, Peggy's secure path was derailed in 1912 when her father died in the sinking of the *Titanic*. Eight years later, Peggy took her inheritance, set off for Europe, and didn't return for twenty-one years. Her life abroad was bohemian (though she married and would have two children) and her preoccupation was art. Through her husband, the artist Laurence Vail, she had begun to meet painters and sculptors, and through one of *them,* Marcel Duchamp, she met all the others.[79] In 1937, the year Hitler declared modern art degenerate, Peggy decided she would start a gallery and buy one piece of art from every show she mounted. Two years later, as Hitler's troops advanced on France, her self-declared "rescue mission" accelerated: She would buy one work of art *each day,* aided by an American she described as a "big fat blond" whose conversation was "incomprehensible." The blond was Lee and Pollock's friend Howard Putzel, and he would be critically important to Guggenheim and to the Americans she would eventually support in New York. With the door closing on Europe, Peggy and Putzel embarked on a shopping spree, visiting artists' studios—Kandinsky, Klee, Picabia, Braque, Gris, Léger, Severini, Miró, de Chirico, Dalí, Magritte, Tanguy, and Max Ernst—and buying as much from them as they could.[80]

Somewhere along the way Peggy's marriage disintegrated, though she and Vail would remain friends, and she began a series of love affairs with a list of illustrious men. Her most significant relationship would be with Max Ernst, and she would make him her particular rescue mission. First, however, she had to save herself. Three days before the Germans entered Paris, she fled the city. The stream of cars, covered in soot from bombings, carrying millions of people to safety was so great that the four lanes of traffic that had previously run into and out of Paris were commandeered and

all travel redirected south. Taking that route, Peggy eventually made her way to Marseilles and Varian Fry's operation smuggling artists and intellectuals to America. There she reunited with Ernst, who had by then been in two concentration camps. Earlier, Peggy had given Breton and his family the funds they needed to flee to the States. Now she financed the exodus of her own family. In July 1941, Peggy, Vail, their children, Vail's lover, and Max Ernst set off for New York.[81]

In the relative calm of Manhattan, surrounded by the Surrealists she had known in Paris, and with Howard Putzel as adviser, Peggy reestablished her gallery. By the fall of 1942, the diminutive architect Frederick Kiesler had created for her a den of modernity in a former tailor shop above a fancy fruit vendor. More environment than exhibition space, it was unlike anything New York had ever seen. The gallery's walls were curved, with paintings hung not on the walls, but off them, mounted on baseball bats, or jutting out at right angles to promote viewer engagement with the work.[82] Peggy unveiled the space in October 1942 with a war benefit for the Red Cross, featuring works from her own collection. In the exhibition catalog she wrote,

> Opening this gallery and its collection to the public during a time when people are fighting for their lives and freedom is a responsibility of which I am fully conscious. This undertaking will serve its purpose only if it succeeds in serving the future instead of recording the past.[83]

The opening was a triumph. Peggy had managed to astound her guests with the gallery, the works on display, and with her own presence. Hair dyed jet-black, and with a small pile of a nose (the result of botched plastic surgery), she wore clothing that accentuated her best feature—her body. Throughout the opening Peggy glided resplendent in a white gown that left as little to the imagination as legally possible. In her ears, she wore one earring by Alexander Calder and another by Yves Tanguy.[84]

Peggy followed that event with a series of exhibitions showcasing Surrealists, but the more time she spent in her gallery the less she spent with Ernst. In early 1943, he left Peggy for the green-haired American painter Dorothea Tanning, who, to show her love for him, had created a blouse covered in his photographs. Peggy allowed herself a moment of grief before picking herself up and recommitting to her gallery—with a new focus.[85] Having championed the avant-garde of Europe, she would now champion the undiscovered of New York. She proposed a Spring Salon of artists under the age of thirty-five. To select the works, Peggy appointed a jury that included Mondrian, Duchamp, Alfred Barr, two art writers—James Thrall Soby and James Johnson Sweeney—Putzel, and herself. Each

artist was asked to bring in three or four pieces for possible inclusion in the show.[86] In studios throughout the city, artists scrambled to produce work for what could be their 57th Street debut.

Of the jurors, at least three were already well acquainted with Pollock's paintings: Soby, Sweeney, and Putzel. It is unclear whether Mondrian, through his friendship with Lee, had ever seen them, but it is likely that he had at least met Pollock. Lee and Mondrian had both continued their association with the American Abstract Artists and were included in the group's annual show that year.[87] Given the seriousness with which she took her job promoting Jackson, it is likely Lee introduced him to the Dutch master she so admired. In any case, it was Mondrian who tipped the balance in Pollock's favor for Peggy's juried show. When Peggy saw Mondrian looking at Jackson's painting, *Stenographic Figure,* she said, "Dreadful, isn't it?"

After coming back to find Mondrian still studying the work, she said dismissively, "It's so disorganized, there's no discipline."

"You're still standing here?" she exclaimed, returning yet again to find that Mondrian had seemingly not moved a muscle. "I think it's an awful work," Peggy declared definitively.

"I'm not so sure," the man of few words finally replied. "I think this is the most interesting work I've seen in America yet."[88]

Jackson Pollock secured a spot in that most significant group show, as did other American painters who were presences downtown: Bill Baziotes, Bob Motherwell, Virginia Admiral, Peter Busa, and Hedda Sterne. With that exhibition there was a sense "something was in the air," said Stamos. Possibility.[89] Significantly, Lee had not contributed work for consideration by the jury. She would never put herself into direct competition with Pollock. The Spring Salon was Jackson's show. In her new job as promoter, it was triumph enough for her that she had helped make it so.

10. The High Beam

> But no, we are two of a kind, allies and accomplices. In terms of grammar, I could not become the object or he the subject. I had neither the capacity nor the desire to define our roles in such a way.
>
> —*Françoise Sagan*[1]

FOR THE BETTER part of 1943 the easels at the de Kooning studio on 22nd Street stood inactive.[2] It was an unnatural quiet that, under any other circumstances, would have driven Elaine and Bill mad with creative anxiety and terrified their friends. An abandoned studio, especially *that* studio, was like a graveyard haunted by a sense of life interrupted and potential unfulfilled. The circumstances that stilled the brushes at Bill's that year, however, were joyous. Bill and Elaine had decided to marry. All their time and energy was going toward preparing a new home in another loft in their building. "I'll build her the most beautiful house in the world," Bill had told Elaine's sister Marjorie, as he described his plan to renovate a floor in their ramshackle residence. "It won't be the most expensive, but it'll be the most beautiful."[3] In the grip of wild romance, anything seemed possible. He and Elaine had been together for five years and nearly inseparable during four of them. For Bill, that wasn't enough. One afternoon in Brooklyn, he decided it was time to legalize their relationship. Elaine's brother Conrad had a twenty-two-foot racing canoe that he kept at a club at Sheepshead Bay. "Bill was terrified of the water," Conrad said, "but I finagled him into the boat." Arriving late to join them, Elaine hurried into the clubhouse to change into a bathing suit. When she emerged, Bill took one look at her from his bobbing perch and said, "We have to get married." Conrad added parenthetically, "She was kind of a knockout." Later, Bill explained to the young man who would be his brother-in-law, "When you meet someone you think you can't live without, then you get married."[4]

That decision made, and a party thrown to celebrate it, the two determined that though Bill's studio was suitable for a bachelor, a couple needed more space.[5] It was not that Elaine had any illusions about domesticity. Unlike Lee, she would never be a Cordon Bleu chef. "When we had no food and no money, and when the heat had been turned off in our building, we sometimes got into bed," Elaine recalled. "We had dinner in bed, but I didn't cook the dinner. I read aloud to Bill from the cookbook. And

we imagined what it would be like to eat fancy things, and that was our dinner."[6] Nor was she particularly interested in comfort. She and Bill both thought, however, that a private bedroom and a possible upgrade of the plumbing would be nice. Having discovered that a loft on the floor above had become vacant, they crept up to take a look. The space was breathtaking: one hundred feet by twenty-five, with soaring ceilings, a row of tall, north-facing frosted windows to filter the strong light in the front, and large skylights in the back. "It was really so much more desirable," Elaine said. "But we were about three months behind in the rent."[7] It seemed unlikely the building's owner would allow them to move into another of his lofts. Elaine, however, was determined that they should have it, and she set out to try, ultimately convincing the landlord, incredulous over her audacity, that he should ignore what they owed and allow them to move to the bigger space at the same rent.[8]

Every day, Elaine went off to her job, Proust in hand, and every night she returned to find Bill covered in plaster dust or twisted into a knot under a sink connecting pipes.[9] During his months of work, he patched the walls, installed a kitchen and bath, made painting racks, closets, and tables. He covered the floor with heavy, gray linoleum, and painted the studio walls and ceilings white. In the bedroom, he used colors that would later become well known in his paintings: pinks, grays, and yellows. Bill situated the bedroom in the middle of the loft and installed two windows, one toward the kitchen and the other toward the front studio, to allow light to flow through the interior space. Denby said the bedroom "seemed to float or be moored in the loft" like a ship.[10] Bill and Elaine had decided her studio would be in the back, under a skylight, surrounded by three-foot-high bookcases. Bill's would be at the front. For their living area, Bill made a library and sitting room, with a special spot for a prized phonograph he had purchased for the eye-popping sum of seven hundred dollars before he met Elaine. And, as if renovating the space wasn't enough, Bill even made furniture, which he built into the floor, saying, "I know she's not going to dust under it."[11] Friends who saw the loft were astounded. "It was basic and simple but glowed like a jewel box," Edith said.[12]

In that magnificent aerie, so full of light, so completely their own, Bill and Elaine began their life together. "We were spoiled. We were poor, but we were happy," Elaine said years later.[13] "We were walking once, Bill and I, on Park Avenue, and were stony broke. And Bill said, 'Well things could be worse.... We could be living in that place.' And he pointed to a place that had a doorman, and he said, 'Wouldn't it be horrible to have to talk to the doorman every day? You know, and say, how are things, how's the wife and family. And we'd have to get dressed up when we walked out.'"[14] Neither Elaine nor Bill equated happiness with money, nor would they

ever do so. What mattered to them was that they had sufficient funds and time to work.[15] For Elaine, Bill, and their friends, there was a heroism in being poor and on the other side of convention.

That tradition had begun in Western culture in nineteenth-century Europe when artists, no longer employed by the church, court, or aristocracy—and therefore without a patron to please—became an avant-garde. They pitted their talent and determination against long-established academies, salons, and a public with fixed ideas of what constituted good art. The nineteenth-century masters, beginning with Manet, were examples of the courage required to seek an alternative to commercial success or popular acclaim.[16] Elaine believed Bill was part of that tradition. Her passion for him as an artist hadn't wavered in the years she had known him. "I just thought he was great, which he knew," Elaine said.[17] What Bill did on canvas and what he said about his work, Elaine remembered and repeated until she died more than forty years later. But theirs wasn't a one-way communication.

Bill's education in Holland had been as an artisan, and though he had read widely, he did not come close to having Elaine's range of intellectual experience. Nor did he have a command of English. Edith said Elaine "found the poetry in his words" and in later years, when Bill delivered a lecture or wrote a statement, it would often be Elaine who crafted it. She made his "raw" words comprehensible to others but also, in a way, to Bill himself.[18] She articulated what he only vaguely suggested. "They were absolutely together on a beam in so many ways," said Elaine's nephew Clay Fried.

> She knew him as an artist and a man. She saw what he was doing. The fact that she could easily imagine it was big. "I speak your language. I show you what you're all about." None of the other women could bring that intellectual caliber that Elaine never stopped delivering. Bill was a teacher and a mentor for Elaine, but Elaine reached out for a place that Bill didn't even know existed, a Mount Olympus. She put Bill there—out of love for him, she put him there.[19]

Edith remembered walking by the Automat near the Chelsea Hotel on 23rd Street and through the window seeing Bill and Elaine inside with their heads turned face-to-face, deep in conversation. They were devoted to each other. Edith believed no woman had ever listened to her husband the way Elaine listened to Bill.[20] But that didn't mean they never quarreled. Elaine recalled "fantastic arguments.... And Bill used to be quite upset by it, and say, 'You son of a bitch.'" They argued about art and also about politics. "I felt this country was cracked," Elaine said. "I said this

country stinks, the way only an American could say it." Bill, whom she called conservative, told her, "'You know, you're always on the side of those guys behind bars'—which," she said proudly, "I am."[21]

Elaine and Bill challenged, loved, and respected each other. And everything they did seemed vital. Just mentioning that they might be at a party or a dinner—or even at the cafeteria—meant the evening would crackle and spark. Everyone wanted to be near them. "Bill was dynamite. And Elaine was dynamite too," Grace Hartigan, who would come into their lives in the late 1940s, once said. "The explosion made history."[22] People knocked on the studio door all day, shouting to be let in. "Sometimes, after one person left, there would be a knock ten minutes later, and someone else would come," Elaine said. "And sometimes people would double-up; while someone was there, someone else would come.... They'd begin to chat away. And if that went on too long, Bill would begin to get very angry. He'd build up a head of steam."[23] At those moments, Elaine steered their guests out to the street. Manhattan was her living room; its streets were where she entertained. A Sunday walk might bring her and her fellow travelers to a concert of Handel's *Messiah* at a church. If they craved Bach, they would head to Hilla Rebay's museum to listen *and* look. "We walked a tremendous amount," Elaine said. "We had our conversations as we walked."[24]

On the corner or during a stroll, she and Bill, their friends, and her family had some of their best discussions and oddest encounters. "Once Edwin and Bill and Rudy and my brother Peter and I were standing, during the war, at a street corner at 22nd Street and Seventh Avenue where there was a bar. And Bill told us that Belgians hung out there. And he said, 'They're very pugnacious.' Bill said, in Belgium people like to go out on Saturday night and get drunk and then they all start hitting each other. And we all were laughing at that. Well, a man came out of the bar, and went straight up to Bill, and started to try to hit him. Just a pure coincidence."[25] If those walking with Bill and Elaine were other artists, they might end up in a studio, where the painter or sculptor would present their work in an intimate display they all appreciated. "This was when the art world belonged to the artists," Elaine explained. It was also the birth of what she called a "brotherhood" that would ultimately make history under the banner "Abstract Expressionism."[26] In response to a question about the importance of an art community, Elaine once replied, "I was going to quote from the Old Testament, and say that 'a man sharpens his face on the face of his friends.' This is why important movements in art have always taken place where groups of artists could get together. And then something happens. It's some kind of electricity. A movement is never started by one; it's always give and take."[27]

Elaine's and Bill's relationship involved a continual exchange of ideas that wasn't restricted to conversations with friends. In the quiet of their studio when they were finally alone, they'd climb into bed and Elaine would read to Bill. Faulkner was a favorite. She also read Ambrose Bierce's Civil War tales.[28] And she would read Kierkegaard.[29] That nineteenth-century father of Existentialism wrote with great passion about the essential solitude and uncertainty of the human struggle. They were words of consolation for Bill and Elaine who, though confident in their path as artists, could not have been free of the nagging fear that they might spend their lives looking and never find what they sought in their work. Kierkegaard seemed to say that didn't matter, that it was the striving that counted, and he described the need to reconcile oneself to the unknowable that was man's fate. The artist, he said, had a crucial role to play in that regard. Like a religious figure who was an envoy from a realm most people could not access, the artist through his or her work revealed pure spirit so that men mired in the bitter reality of daily life might find the strength to continue.[30]

As often as two or three times a week, at the end of their workdays, Bill and Elaine went to the movies, which were preceded by looping, black-and-white images of war.[31] The newsreels were notorious for reporting only "good news" from the conflict that was tearing the planet apart, but in 1943 there was no need to dissemble. Hitler was no longer invincible. At the end of January, Germany had formally surrendered in Stalingrad after a disastrous battle that even Hitler, with his insatiable appetite for blood, declared "catastrophic." Nearly two million soldiers had died in seven months of fighting. The German defeat was so decisive that it would turn the tide of the war, not only on foreign fronts but inside Germany as well. Slogans written in large white letters began to appear on walls in Munich: *Freedom* and *Down with Hitler*. At Munich University, leaflets were distributed urging people to rise up against the "Nazi disgrace." Soon aristocrats, liberals, students, even some members of the army began protesting the regime. In the Warsaw Ghetto, the Jewish resistance, armed with only a few handguns, sent their German guards fleeing after twelve Nazis were killed. By April the Warsaw resistance had erupted into a three-week-long uprising. It was an act of suicidal defiance bred of desperation. None of the offensives against Hitler within Germany would be successful. But they were important because they showed that Hitler's mythical Reich was not impregnable. It was vulnerable to attack from enemies within as well as without.

In Italy, Mussolini, too, was losing support. In March 1943, his own people had brought the Italian war industry to a halt through a strike in Turin. By May, North Africa, which Italy had introduced into the battle,

was liberated from German and Italian forces. In July, the Sicilian city of Syracuse surrendered. Anti-fascist fighters throughout Europe celebrated as Allied troops prepared to begin their long march up the Italian boot. And in Asia, where U.S. forces were engaged in land, air, and sea battles against the Japanese and their allies, Tokyo ordered its men to evacuate New Guinea and Guadalcanal.[32] There was confidence among Americans at home that the tide was turning in favor of the Allies. They allowed themselves to think that the war, which had dominated their lives and thoughts, might one day, in the not-too-distant future, be over. Roosevelt announced in February that the great "invasion of Europe" would occur that year.[33] Surely *that* would bring an end to the madness.

Bill was one of the many Europeans in New York who had had no word of his family's fate. He had read with horror that the Nazis firebombed his hometown of Rotterdam in 1940 and that ten thousand people were killed.[34] But Bill was one of the lucky ones. He had been able to turn to Elaine's family for consolation. Elaine's father treated him as a son, and her siblings regarded Bill's studio as a Manhattan outpost of their family home. They were part of Bill's and Elaine's domestic life, social life, even their artistic life. Elaine's brother Conrad would be Bill's studio assistant and a model for Elaine. Marjorie was a favorite model for Bill's work, and the gregarious youngest brother, Peter, who would later pose for Elaine, was in and out of the studio as if he were Bill's little brother, too.[35] Even Marie would steal into their studio lives. One day while painting a grotesquely bejeweled woman, Bill announced to Elaine, "I'm painting your mother."[36] She, too, then, was inspiration. That eccentric family was a perfect fit for Bill. It provided all the benefits of love and security he had never had, without making demands that he, as an artist, could not tolerate.

Family. Ten years, even five years before, the word hadn't been part of the artists' vocabulary. Perhaps it was a matter of aging, or perhaps it was the war, which had made people want to hold fast whoever was near for fear they would be ripped away. Whatever the reason, a longing for family rather than casual coupling was in the air. Even Gorky had succumbed and, because it was Gorky, he had done so in a most dramatic fashion. Gone were his wolfhounds on leashes. Now when spotted in Washington Square the man in the long black coat who carried himself like a czar was seen pushing a baby carriage.[37] And it was all Elaine's doing.

In early 1941 Gorky told Elaine he wanted an American girlfriend. "They're so strong, these American girls," he said.[38] Elaine accepted the challenge of finding a mate for her mournful friend. She knew, however, that the person would have to be extraordinary. It wasn't just that Gorky would be difficult to live with; he was also highly critical. Soon, however,

a nineteen-year-old who had recently appeared in Elaine's and Bill's Chelsea circle caught Elaine's attention.[39] The daughter of a naval officer, Agnes Magruder had lived in the Netherlands, France, Switzerland, and China, and had "come out" as a debutante in Washington but imagined for herself something other than the life of a diplomat's wife for which she was groomed. She wanted to be a painter. Dragging with her a trunk full of satin gowns and fox furs, she left her family in Shanghai and returned to the States. Once in New York, she rented a room in a bedbug-infested flat and took a job working on a communist Chinese newspaper located around the corner from Bill's studio. Her father, meanwhile, cut her off financially for supporting Mao Tse-tung. With her brown hair dyed "Mata Hari" black, Agnes was tall, elegant, poised—superb. (Jeanne Reynal, a wealthy artist who ran a Village salon they all frequented, said, "Half the world was in love with her.")[40] Agnes was also worldly-wise and an unusual combination of hell-raising rebel and docile muse. "Oh, what a match!" Elaine thought when she saw her. First, she told Agnes about Gorky—that he was a great painter but a "terrible show-off who sings and dances and makes everyone dance in a circle with a handkerchief." And then she let slip to Gorky, "There will be a girl at a party we're going to whom you would like very much, so why don't you come with us?"[41]

At the party, Gorky stood on the lookout for what Bill incorrectly described as a "beautiful blonde" and Agnes scouted the room for a boisterous extrovert, per Elaine's description. Gorky found a blonde and sidled up to her, but Elaine grabbed his arm and said that was the host's girlfriend. "Not this one, *that* one!" she said, pointing to Agnes.[42] He sat down near her but didn't dare speak, and neither did she. She couldn't have imagined that the sad, silent creature beside her was the song-and-dance man she had been told to expect. Gradually, people began leaving the party, even Bill and Elaine had left, and still they sat. Finally, donning his porkpie hat, Gorky stood up. He and Agnes found themselves walking out the door together. As they did so, he turned to her and said in his purring accent, "Miss *Maguiger?*"

"Oh, Gorky," she replied.

"Would you like a cup of coffee?" he asked.[43] From that point on, Elaine said that Gorky and Agnes, whom he would christen Mougouch (meaning "little mighty one"), were a couple. They married, and in April 1943 their first daughter was born.[44]

Gorky's fortunes had changed fantastically. He had a woman who decided her "crusade" was to help him express his truth on canvas. He had sold a painting to the Museum of Modern Art and was featured in a show of young American artists there. And in a final triumph that fateful year, he met the collector Joseph Hirshhorn, who paid him three hundred dol-

lars for thirty small works. Gorky found himself in the unusual position of being loved and recognized outside his loyal circle at the Waldorf. Triumphant, he left New York for a summer in Virginia at Mougouch's family farm, where he would commune with nature for the first time since leaving Armenia as a boy.[45]

Elaine would have been happy for Gorky but annoyed that Bill still painted in relative obscurity. He had worked as long and as hard as Gorky, and to her mind was just as talented. She believed Bill deserved attention, too. It was a matter of ego, but not in the sense a nonartist might imagine. "What is necessary is a little recognition, even a little keeps you going," Elaine explained. "You have to have a few people see what you are doing once in a while or else you shrivel up."[46] Her frustration would have mounted further as she watched the career of a relative newcomer like Jackson Pollock soar. In 1943, after his work appeared in Peggy's Spring Salon, word spread that she had not only offered him a solo show but had agreed to give him a monthly stipend in exchange for paintings.[47] Just the year before, Pollock had declared he would live off the sale of his work and, against the most improbable odds, it appeared he would do it.

Lee and Putzel had conspired to win Peggy over to Jackson's cause. It wasn't easy. Peggy hadn't warmed to Pollock's paintings immediately. All her advisers, however, seemed to think Pollock was the best of the young Americans, and she agreed to see his work. Putzel and Lee, meanwhile, prepped Jackson for her visit.[48] Because of his self-destructive perversity, they feared Pollock would try to sabotage the encounter. Their fears, unfortunately, proved justified.

The day Peggy was scheduled to arrive, Jackson was to have been the best man at Peter Busa's wedding. But Jackson was so drunk that he passed out, leaving it to Lee to hand the ring to the groom. On the way home, she dragged Pollock into a cafeteria to try to sober him up with coffee—an agonizingly slow process. By the time they arrived on Eighth Street, a furious Peggy was storming out the door of their building with a dejected Putzel following sweatily behind. It took fifteen minutes to convince Peggy to make a second ascent to their fifth-floor flat.[49] Still seething on entering, Peggy first saw Lee's many paintings—signed "LK"—in her studio and railed, "Who is LK?...I didn't come to look at LK's paintings." Lee muttered under her breath, "What a bitch." Peggy "damned well knew at that point who LK was," she explained later.[50] Then Peggy looked at Pollock's work and, after returning to the gallery to consult with Duchamp, agreed to give him one hundred fifty dollars a month and a solo show in the fall. She also commissioned him to paint a mural in her new duplex. Peggy admitted she had only agreed to help Pollock because others

had told her to. "Strangely enough," she said, Jackson would become "the greatest painter since Picasso."[51]

Lee went into overdrive ahead of his show. At Putzel's request, she folded twelve hundred exhibition announcements. If Peggy wanted to communicate with Jackson, she did so through Lee. If Putzel had a lead on a collector, he told Lee. Day and night, Lee could be seen at the Waldorf pay phone making arrangements for the exhibition, scheduling visits to Pollock's studio, coordinating the transportation of his work.[52] The group assembled at the cafeteria's back tables watched with a mix of jealousy, admiration, and suspense as she put her organizational skills to work on the "cowboy" artist's behalf.

Lee performed the work of three people, and still it wasn't enough for Peggy. There were constant digs: Peggy asked Lee if she had posed for Pollock's painting *The She-Wolf,* to which Lee replied, "Of course I did." She abused Lee's time: Once when Jackson and Lee arrived for a dinner, Peggy asked Lee to cook the meal—for fifty people.[53] When Pollock complained about money, Peggy told him to send Lee out to work. The antagonism between the two women, however, may have been as much show as true animosity. Artist David Hare, who knew them both well, said they were very much alike and understood their relationship: It was all about furthering Jackson's career.[54]

The night of Pollock's opening, November 8, 1943, Peggy's gallery was packed. Even artists who were in the military had taken leave to see it. Ibram Lassaw was in from Fort Dix. Lee's friends John Little and George McNeil arrived in their navy whites.[55] The downtown art crowd—the men dressed in suits and ties, and the women in "nice" dresses from Klein's bargain basement on Union Square—found themselves rubbing shoulders with scores of Surrealists and the odd assortment of collectors and critics whom Lee, Putzel, and Guggenheim had invited. No one who knew Lee would have been surprised that she had been able to pull off such a stunning opening. But her work didn't end that evening. At the party after the show, Peggy slipped and broke her ankle, which sent Lee into a panic because she feared the gallery would be unmanned during Jackson's exhibition.[56] Lee stepped into the breach. She went to the gallery every day to sit at the front desk between ten and six. Every night she returned home with the same answer to Jackson's query, "Did anything sell?" "No."[57] The main thing, however, was that he had been introduced to a wider audience and that major artists like Mondrian and Marcel Duchamp, and even some critics, thought Jackson's work interesting.

"*No* artist wants to feel obliged to someone—they want to feel the work does it," Elaine said. "Well the work doesn't do it. What does it is the PR."

Elaine was naturally inclined to defend those she loved, and she embarked on a campaign of her own to help the man she loved most. She would not, however, be as overt as Lee.[58] At twenty-five, Elaine was a sophisticated, intellectual, beautiful artist, and she would employ all those attributes on Bill's behalf. In a strange way, Elaine might be seen as a model for the woman she stood in sharpest contrast to socially—that gold standard for women in 1950s America, the corporate wife. She understood a decade before corporate psychologists institutionalized the notion that a woman of charm, brains, and style could be essential to her husband's career. In the parlance of the country club bar, a guy who could snag a woman like that must have something going for him.[59] Elaine's campaign would be much less coarse, but she would be—and it would come quite naturally—a first line of seduction in promoting Bill's work. To her mind, the next step would be easy: People would see his paintings and recognize his genius as she had.

It was impossible to ignore Elaine. Even in a room full of people, slowly but surely the focus of attention and conversation would shift to her. Edith Schloss wrote to and of Elaine that she radiated "such femininity it wiped out the presence of any other female.... The men were flattered to think they held your interest, you knew how to behave with them.... But most everything then, as it was to the end, was spurred by your unqualified admiration of Bill."[60] Through Edwin Denby, who had become the dance critic at the *New York Herald Tribune* while its regular critic was at war, Bill and Elaine began to meet people uptown. A Viennese psychoanalyst and his wife "were quite taken with us," Elaine said, "and would invite us to lunch every Tuesday. Our whole week began to center around that one really good meal."[61] Elaine did her best to win them over because she enjoyed their company but also because they might support Bill's work. And then there was the opposite end of the social spectrum. The counterman at Stewart's Cafeteria at 23rd and Seventh set aside money from his paycheck to buy art from local painters. "Unfortunately, he had an unerring eye for the wrong people. He could have, at that time, and for the same amount of money, gotten *everything*," Elaine said, "the really good stuff." Some of the works he bought, Elaine thought, were poor copies of Bill's paintings.[62] "When I made some contemptuous remarks about the imitators, Edwin Denby said, 'Don't be an "artist's wife." If you want to help Bill, don't attack other artists. Talk only about the ones you like.'" His remark stopped Elaine short. "I took Edwin's advice to heart," Elaine said.[63] She must have hungered for more, because Denby, that most cultured of men, became Elaine's next mentor.

One of Edwin's friends called him "the ideal teacher." As a poet, dancer, critic, and actor, Denby knew everyone in New York worth knowing. His

intellectual, artistic, and social home was among the avant-garde, but he never tried to look or particularly act the part.[64] "There was a type of Chelsea attitude that Edwin Denby had which might have rubbed off on her, a kind of austerity about career," said the poet Bill Berkson of Elaine. "There was among that group like Denby and Burckhardt this attitude, and I wouldn't be surprised if that's how Bill and Elaine worked—it'll come if the work is good enough."[65] That attitude was pure Denby. Everything he did was subtle. He had "handwriting that can't be read and a voice that can't be heard," according to his friend Joe LeSueur.[66] And yet what he wrote was so beautiful that his friends gladly struggled to read it, as they also strained to hear the message conveyed in his whisper. Denby did not make a splash on a giant stage, though there is little doubt he could have if he had so wished, but he greatly influenced everyone whose life he touched, and many of those people *did* make a splash. For Elaine, Denby would become a sort of Henry Higgins who took her under his wing at a critical moment when she was becoming a bafflingly new creature named Mrs. Willem de Kooning. Denby helped her discover that she could still be Elaine, an even more glorious Elaine, while also being the guardian of the unique talent who would be her spouse.

 Elaine and Denby's relationship developed around the ballet. As the *Herald Tribune* critic, he often had an extra press pass to performances. Elaine became his favored companion. "She was a very beautiful young woman and it was very good for his prestige to be seen with somebody like Elaine," Rudy said.[67] They would have made a striking couple. Edwin exuded light—tall and elegant, with crystal-blue eyes and pale skin, he looked as though he walked without touching the ground. On his arm, dressed in borrowed evening clothes, Elaine was a perfect fit. She had studied dance from the time she was six, and she looked it: her back ramrod straight, her body lithe, her face contoured and taut as an athlete's. "I became a confirmed balletomane," she said of her evenings with Edwin. "I adored the excitement and glamor of opening nights.... I stood silently by at intermissions, admiring Edwin's quick, witty comments to people who sometimes struck me as dangerously sharp adversaries."[68]

 Denby was not a hack critic. He would, in fact, invent a new way of writing about dance, creating "a particular rhetoric, syntax, and vocabulary that was adopted by succeeding generations of New York School dance critics."[69] He also felt it his duty to see everything; not just the socially sanctioned performances with their lavish openings and recognized stars but also the most avant-garde productions in tiny venues, those his fellow critics might have considered amateurish. Denby ignored any missteps made in the cause of experimentation. It was a period in U.S. history when American ballet was being born and American choreographers

had begun creating a *modern* dance idiom—visceral and expressive, often as violent as the times. The dance world in New York during the war was moving into uncharted territory and Denby was there to record it.[70]

Elaine watched him interact socially and, after the performance, she would go back to the *Herald Tribune* office with him while he wrote his review.[71] If Edwin had asked Elaine what she thought of a performance, she might simply say, "Well the girl had green, nice green stockings." She was terrified to express an opinion that might contradict his. "You were a very youthful disciple," Minna Daniels, who at that time edited a small magazine called *Modern Music,* told Elaine. Edwin loved Elaine's guilelessness, Minna said, and the fact that she didn't feel the need to impress him by disagreeing.[72] On the contrary, Elaine happily consumed the wisdom Denby served. At first, she merely studied what Denby wrote, which was unlike the criticism she had read in magazines. "Poets," Elaine said, "use words very differently from let's say, critics, or from novelists who use words in a logical sense. Poets are much more involved with intuition and wild flights of fancy, and much, much closer to painters."[73] Denby's writing appealed to her; his words were familiar, as was his way of thinking. Soon, while he wrote his review, she would write one of her own, and when he finished his he would read and criticize hers. That education lasted for about three years.[74]

Elaine's work with Denby helped her develop a personality apart from Bill. She moved separately from him socially, had interests he didn't share, had talent and intrinsic value as an artist and a woman. Elaine had found room to breathe her own air, even within the confines of the tradition-bound relationship that she was about to enter. That meant that when the time came for her to be married, Elaine was ready to commit without fear of being consumed.

Bill and Elaine's relationship was a mystery to no one, and yet her mother acted surprised and dismayed at the possibility of their marriage. Twenty-five-year-old Elaine was too young, she said, and at thirty-nine, Bill too old. "She refused to believe that I would sink so low as to get married," Elaine recalled.[75] Recognizing that she was no longer a match for her headstrong daughter, Marie then forbade the rest of her children to marry until they were forty. She also put the equivalent of an Irish Catholic curse on Elaine by accusing her of having broken the Third Commandment by invoking God's name in swearing a false oath—marriage.[76] Marie's reluctance to see Elaine follow the path that had condemned her to a life of furtive intellectual pursuits and social alienation was perfectly comprehensible, and no doubt Elaine understood it clearly. Dismissing Marie's decision to boycott her wedding, Elaine offered by way of excuse that her beloved mother was "unhampered by sanity."[77]

On December 9, 1943—Elaine liked to say she was married two years and two days after Pearl Harbor—Elaine, Bill, Elaine's brother Peter, sister, Marjorie, and father, Charles, along with Bill's fellow Dutchman Bart van der Schelling, Biala and Daniel Brustlein took two taxis to City Hall for Bill and Elaine's wedding.[78] For the occasion, Elaine wore a navy blue dress and a necklace of thin blue beads. Presumably, Bill was dressed in the one suit that had hung in his closet. The couple's future, they discovered, rested in the hands of a humorless justice of the peace who operated a conveyor belt of matrimony. He had already begun the ceremony when Bill's friend the jazz aficionado Max Margulis (known as Max the Owl because of his thick glasses) burst in late.[79] The judge demanded, "And who's this?" To which Bill replied, "Our best man, of course!" The judge proceeded to read out the vows—"to have, to hold...in sickness..."—Bill answering, "I do," to each one. Annoyed, the justice told him to keep quiet. But when he finally finished the vows, Bill remained mum as ordered, annoying the justice still further. Turning to Bill in exasperation, he asked, "Well, do you?" "Sure," Bill genially offered. There were no tears of joy at their wedding, but there was plenty of laughter.[80]

Sporting a gold band that Bill had bought for nine and a half dollars, Elaine began her new life as Elaine de Kooning. The reception was an impromptu cafeteria lunch for the small wedding party, hosted by Biala and her husband, who had taken pity on the couple because their wedding would have otherwise involved no social celebration at all. Elaine also vaguely remembered a stop at a bar with her father.[81] "Actually, the wedding was kind of bleak," she recalled. "Oh, I guess it wasn't that bleak. It was kind of amusing. But it was not festive. I mean nobody rolled out the red carpet for us. And then we went back to Bill's studio on 22nd Street and we both continued to work."[82]

That was where Elaine usually finished her wedding story, but there was more to the day than she chose to describe. Later that night, she and Bill were invited to a stage designer friend's home for dinner, where they received their only recorded wedding gift: a box of pea green dishes.[83] The omission in Elaine's retelling of that day was significant. For Elaine, her relationship with Bill would always be about work—she had no interest whatsoever in domesticity and would have had little use for new dishes. Bill knew this when he married Elaine, but perhaps he had ignored it in the first flush of romance, or perhaps he had wrongly wagered that marriage would change her. "Elaine was irrepressible. Elaine was a dynamo of energy and whatever Elaine wanted, she did. She did it in a big way, and Bill didn't expect that," their friend Ernestine explained. "He expected to be catered to in the way women do when you get married, and Elaine had no such idea."[84] The differences in their understanding of what constituted

a home life, what it meant to be a husband and a wife, would become one aspect of the disagreement that eventually undermined their marriage, but never their love for each other.

On Christmas Day 1943, soon after their wedding, headlines carried the news that General Dwight D. Eisenhower had been named commander of a planned invasion of Europe.[85] The announcement seemed timed as a gift to war-weary citizens, who would interpret it to mean that the clock had begun ticking to the end of the conflict. Americans, who had previously been spared images of dead U.S. servicemen because such photographs were censored, had recently awoken to pictures in their daily papers of sailors floating like logs in the Pacific and bodies piled up on beaches after the Battle of Tarawa, which killed one thousand troops.[86] Roosevelt had even warned in his Christmas message that the country should expect to see more dead, that the casualty lists would grow as the war intensified. But the name "Eisenhower" stuck in people's minds. They believed he would be able to deliver the world from fascism. And so, with rose-colored glasses firmly in place, Americans exulted at the possibility that the nation would be out from under the cloud of economic depression and world war that had weighed so heavily for more than a decade.[87]

That season Irving Berlin's "White Christmas" as sung by Bing Crosby was the most popular song in the country. Its nostalgic remembrance of holidays past allowed listeners to imagine living in those gentler times again. But the soldiers at the front knew otherwise. James Jones, whose novel *From Here to Eternity* would be one of the most important of the war, said that while Americans at home eagerly believed the conflict was nearly over, the soldiers and sailors understood that the future might very well not exist and so had a growing imperative to seize each moment. *Their favorite song was Marlene Dietrich's bittersweet ballad of love and loss in war, "Lili Marlene."*[88] The coming years would show that the soldiers' reality had been the truer. Elaine and Bill's marriage, therefore, had begun in a confusing atmosphere of dreams and dread. They had vowed to remain together forever, but in the world they would inherit, the notion of forever would be just a memory. In August 1945 at Hiroshima, forever became another casualty of war.

11. A Light That Blinds, I

Have they destroyed enough yet?

—*Paul Goodman*[1]

IT IS DIFFICULT to comprehend the emotional, social, political, religious, and artistic tumult of 1945. How people could have absorbed such cataclysmic changes, coming one after the other, over a period of just a few months. How the exultation of spring, when it seemed that war had finally ended, would whipsaw into the horrors of summer when the incomprehensible human cost of that war became clear, and how, just when it seemed things couldn't get worse, they did. Unimaginably so. People all around the planet awoke on the morning of August 6, 1945, to learn that mankind in its brilliance had created a bomb which, when dropped on the Japanese city of Hiroshima, exploded with a heat ten thousand times that of the sun's surface.[2] People didn't die from such a blast, they vanished. Three days later, an American plane carried a second bomb to a second Japanese city, and the heat of the sun scorched the earth once again. The war that had proven so convincingly that man could kill like an animal proved he could also kill like a god. Man had harnessed the power to destroy the planet.

There was cheering. That decisive weapon had ended the modern world's most brutal war. But after the euphoria had subsided, many felt revulsion, and all had reason to feel fear. The people alive at that moment in history were the first to confront the possibility of global annihilation.[3] Under those circumstances, how did one go about one's life, with its small joys and disappointments, cherished goals and sacrifices made for the future? What future? Answers did not exist, only ambiguity.

Throughout the war, it had been easy to distinguish the good from the bad. It was a matter of uniform. But after the bombing of Hiroshima and Nagasaki, after the reports of the Allied firebombing of Dresden and Hamburg, and the carpet bombing of Tokyo, and after the world *knew* for at least two years that Hitler was killing Jews by the millions but did nothing to stop him—after all that, the black and white of good and evil became distinctly grayer. In the wake of Hiroshima writer Dwight Macdonald said,

> This atrocious action places "us" the defenders of civilization, on a moral level with "them"...and "we" the American people are just as much and as

little responsible for this horror as "they," the German people.... Can one imagine that The Bomb could ever be used in "a good cause"? Do not such means instantly, of themselves, corrupt *any* cause?[4]

The bomb's fallout produced intense moral confusion. The dancer Martha Graham once said of the war, "You do not realize how the headlines that make daily history affect the muscles of the human body." For an artist such as Graham, the response was visceral. A painter, too, would have been affected at that level.[5] Her work would *have* to change, as would her life. Elaine's and Lee's would change profoundly that year. The place where they would find themselves at the end of 1945 was very different from where they had been in January. The decisions each of them would make would come to define who Elaine de Kooning and Lee Krasner ultimately became, as artists and as women.

Diderot wrote in the eighteenth century that a woman artist needed youth, beauty, modesty, and coquetry, and that "one must...have good breasts and buttocks, and surrender oneself to one's teacher."[6] Two hundred years later, many people would have still considered that sound advice, Bill de Kooning among them. Elaine, however, would have seen the remark for the good joke it was. Far from surrendering or succumbing to her husband and artistic "master," after her marriage to Bill, Elaine became even more socially and creatively independent. Her year away from the easel in 1943 had been what *ArtNews* editor Tom Hess called a "year of stepping back in order to leap."[7] He had made that comment about Bill's creative hiatus, but it would have been equally true of Elaine. In 1944, she would make a breakthrough in painting, and the next year she would discover her writer's voice.

Elaine's painting discovery came during a visit to Fairfield Porter's loft while he was at work on a portrait of his wife, Anne. "I thought she had a terrific face, very strong and beautiful with wonderful shapely eyes. I made a very careful drawing of her that evening," Elaine said, "and then two small paintings from the drawings."[8] Intrigued by the idea of portraiture, she wanted to do more. Years later, when asked why she had chosen a seemingly traditional genre at a time when her fellow painters were struggling to move into pure abstraction, Elaine replied flippantly that it was because Bill wanted no part of portraits, which were to him "pictures that *girls* made," and so she would have that territory to herself.[9] Ernestine, however, scoffed at that explanation, saying, "Territory never daunted Elaine."[10] In fact, portraiture would have been a natural fit for her. Elaine was intensely interested in people, and portraits allowed her to probe deep into their nature. The challenge for her was to push portraits past the

merely descriptive. Elaine wasn't interested in making a photographic likeness. What she wanted was to use paint to express who the person *really* was. As the budding abstractionists in her midst looked inside themselves for inspiration, Elaine looked inside others.[11]

In 1944, she made a deal with a twenty-two-year-old Dutch artist she met at a Virgil Thomson concert: She would pose for him if he would pose for her. Elaine and Joop Sanders began a years-long collaboration that produced dozens of portraits. Elaine called hers the "Joop paintings." After spending a day drawing Sanders, she would work for a week turning that drawing into a painting. In the process, Elaine said, she became "hooked" on portraits, through which she melded those aspects she found most intriguing in her subject with elements of herself.[12] "Elaine de Kooning once said that painting portraits is an invasion of privacy, a bit like stealing someone's secret.... It's an uneasy transaction," Tom Hess recalled. "Of course, the privacy she invades most rigorously is her own."[13] Within two years of her first "Joop painting," Elaine moved well beyond the stylistic influences of artists she admired into her own territory of swift and broad brushstrokes that lustily defined shapes while economizing on the details. She was on her way to developing her own style of portraiture. In 1945, she received recognition for her effort in the form of a commission—from a friend.[14]

That same year, Elaine also began to write. The Museum of Modern Art had mounted a retrospective of works by the elder statesman of the downtown abstractionists, Stuart Davis. Though Elaine had seen Davis's paintings many times before, in the museum they struck her with greater intensity. "It was so clean-cut and without self-doubt," she explained. "His work had the energy and aggressiveness of billboard art but also a kind of lyrical inevitability that commercial art never achieves." Fascinated as much by what she saw as how she felt, Elaine returned several times to study the paintings and make notes. After each visit, back in her studio, she transcribed her fleeting impressions more formally.[15] Now, in addition to Mozart and Stravinsky and jazz, the residents of Chelsea could hear typing. With the window cracked open just enough so that the coal dust in the air floated in like black snowflakes, Elaine sat at a typewriter, pecking out her thoughts on Stuart Davis.[16]

Like Denby, who carried his poems in his pocket to show to friends, Elaine began carrying bits of her article to offer to her Automat audience.[17] She had found that she "liked the idea of putting into words my ideas about someone else's painting" and that writing about another's work helped clarify her understanding of her own.[18] After a month, she had typed out ten double-sided pages of text on Davis, which she promptly showed to Bill, and then Edwin, who sent her a one-word telegram: "Magnificent."[19] "I

was delighted with their response and put the piece away, not feeling the need or inclination to show it to anyone else," Elaine said. "When Edwin told Virgil Thomson about the length of the piece, Virgil said, 'I didn't know there was that much to say about Stuart Davis.'"[20] Elaine had proved that she could write, as she could talk, about anything.

Edwin had begun giving Elaine reviews to write if he couldn't cover all the dance performances he needed to on a given evening, and they would go over them at the Automat near the Chelsea Hotel. Elaine and Denby could spend hours together rewriting and editing, with Edwin always in the role of teacher. Bill, however, had become jealous of the time Elaine spent with Edwin, even though Edwin not only wasn't attracted to women, he hadn't even liked more than a handful in his life.[21] Elaine admitted to her friend Minna Daniels that Bill "attacked me violently for always going to the ballet with Edwin."[22] The phrase might have meant what it implied. Though outwardly charming, de Kooning harbored an intense anger (Edith said he could also be "ruthless") that was increasingly directed at Elaine. "Bill was very difficult," Ernestine said. "He had a terrible temper. When he got angry, he put his fist through the wall."[23] Some of the tales about Bill and Elaine through the years involved his taking a swing at her, mostly out of jealousy.

In early 1945, however, the source of his anger was most likely not so much Elaine as frustration with his painting. The desolate men de Kooning had created in the 1930s, and the calm and lovely women of the early forties were gone, and in their place was extreme anxiety, evident in both the way the paint was applied and in Bill's treatment of his subjects. According to Elaine, Bill jokingly blamed her, saying, "Before I met you, my paintings were all quiet and serene."[24] Whatever the cause, whether personal or a reflection of the angst in society at that time, his turmoil as he strove to find a new direction in his work was evident in every brushstroke. Denby called Bill's paintings of the mid-1940s "unfinishable."[25] They were extraordinary, he said, but never satisfactory to Bill. "You see, he'd get furious," Elaine explained, "and he'd be depressed, and he'd be angry with his work."[26]

Peggy Guggenheim made her appearance in Bill's studio during that tense period. She had come to see his paintings with Lee, Motherwell, and Clement Greenberg, who was making a name for himself as a critic. Peggy "kept yawning," Elaine said, "and that infuriated Bill.... He was working as usual on one painting and dissatisfied with it. And as she walked out she kind of said very grandly, 'You can bring that painting to my gallery. I like it, I'd like it for my next show.' And Bill may have assented, but when the time came he didn't send the painting."[27] Nor did he agree to a show George Keller had offered him on 57th Street. "He was struggling with his

paintings, wasn't very interested," Rudy Burckhardt recalled.[28] He was also starving, as was Elaine, which greatly increased the stress of their existence. Elaine's defense plant job had ended, which meant they were reliant upon odd jobs or on the sale of a work to someone they knew. Occasionally, they would find an envelope under their door containing one hundred dollars. They saw in the gift the benevolence of Edwin and Rudy.[29]

Bill and Elaine did their best to economize. If the kerosene heater ran out of fuel, they used the stove's gas burners for warmth. Thinking it might be cheaper to eat in than at the Automat, Elaine found a stew recipe, but she spent fifteen dollars on the ingredients, and they were so hungry they ate the entire pot in one sitting, though it had been intended for several meals. They reused canvas and tried to imagine as they did so that they were following in the footsteps of esteemed painters in history. "We never considered ourselves poor, just broke,"[30] Elaine liked to say. But that was her attempt to romanticize their predicament. In a more honest moment she said, "That devastating poverty seemed the most important thing in our lives together."[31]

Humor was a favorite tonic. Elaine collected eviction notices from their landlord, which she found amusing because they started with the word "Greetings" followed by "You are hereby required to vacate the premises." Indeed, their landlord was a frequent visitor, hammering on the door for the rent. When they didn't answer, he climbed up to the roof, came down the fire escape, and banged on the window, saying, "I see you, I can see you."[32] It became clear that one of them would have to find steady employment, and in the meantime they would borrow and barter away their financial woes. Bill traded paintings for doctor visits—earning the wrath of the medical man's wife, who said, "I'd like to see the de Koonings pay cash once in a while.... After all who does Bill think he is, Gauguin?"[33]

In her desperation, Elaine turned to Ernestine for help. By a strange coincidence, Ernie had met Bill's sculptor friend, the young, Egyptian-born Ibram Lassaw, at a breakfast counter in Provincetown. Just out of the army, he was celebrating with a trip to Cape Cod. Before the war, Ibram had visited Bill's studio several nights a week. He knew Elaine and was part of the Waldorf crowd, but surprisingly, he and Ernestine had never met. (In fact, they had, but neither remembered at the time. It was Ibram who ran down five flights to find no one waiting when Elaine and Ernestine played a prank during their early days in the Village.) After spending a day together on the dunes, Ibram took Ernestine to the bus for her trip back to New York. He told her he was going to marry her, to which she replied with her broad smile and Louisiana sass, "You're crazy."

On December 15, 1944, back in New York, they did get married, with Elaine and Bill as their witnesses. The two couples celebrated with a day of

feasting, which years later Elaine still recalled with laughter and relish. First Chinese food and a trip to the Metropolitan Museum, where they met up with sculptor David Smith, then a Swedish smorgasbord, which offered all the food they could eat.[34] "There was this round table and things went past us. You know, and all of us are the starving types," Elaine said. "There would be little tiny portions, some kind of meat.... Like black-hole meat.... Well, we ate, and we ate, and we ate, and they say as much as you could eat. We were going to do that.... Ernie would say, 'Oh you must try this, it's delicious'.... And then at home that night, lying in bed like a tube, absolutely stiff."[35]

Ernestine had discovered a fantastic loft on the top floor of a building on Sixth Avenue. With fourteen windows, it was bigger than any of the spaces the other artists had at that time. Of course it was neither suitable nor zoned for habitation, but Ibram got to work as Bill had done on 22nd Street and turned it into a home and studio that he, Ernestine, and their soon-to-be born daughter, Denise, would occupy for fifteen years. "We really lived in an alternative universe and I felt like a princess," Denise said.[36] It would also be a meeting place for artists when important discussions were held, and it would be a place of refuge for Bill and Elaine. After Ibram and Ernestine's wedding, Elaine asked Ibram if he could get her a job at the window display company on 46th Street where he worked. He did, and Elaine was back on the subway heading to a job making wire constructions for window displays at Bonwit Teller.[37] "Every morning, I would make Ibram a sandwich to take to work," Ernestine recalled, "and every day he would come home and say, 'Elaine ate half my sandwich,' so I began to make two big sandwiches for lunch, one for him and one for Elaine."[38] Despite her delight over a paycheck and Ernie's sandwiches, this life was hardly the one Elaine had envisioned for herself.

It was not that Elaine resented work. She was conscientious, punctual, and responsible, but she was an artist first, and the job kept her away from her *real* work just as she was beginning to find her direction.[39] Bill had had an offer from Lever Brothers to do an ad campaign that would have paid handsomely. In declining the offer, Bill argued that if he did a good job on the ad, he would have no energy left for his paintings.[40] Elaine believed she had the right to make a similar choice. "Male and female artists are not like the average person. They are people essentially who are rebellious. And women are just as rebellious as men," Elaine said.[41] "I know what I want, and [if] someone else wants me to do something different, I don't consider that rebellion. I just want my way."[42]

During that period, Elaine worked each day at her job with Ibram, painted when she could, and socialized as much as possible at night. She would leave Bill at his canvas, bundled up in his jacket and hat because the

heat in the building was turned off in the evening, while she visited friends around Chelsea.[43] Sometimes they drew from models, and sometimes they played. They might have concerts, using pots and pans for instruments. Edith recalled roasting marshmallows over the fireplace in her loft and playing parlor games, including a form of charades in which the person enacted poses from famous paintings. In one game, Elaine wore "a beret squished into the shape of a Phrygian cap...a broom held high in one hand, leading Rudy by the other. You were Marianne, the spirit of the French revolution in the painting by Delacroix, leading the French to Liberty."[44] On another night, composer Edgard Varèse, whom Elaine said "was very much taken with me," took her on an ice cream "bender." Their first stop was a gelato shop in the Village that Varèse told her had the best pistachio ice cream in the world. From there, the pair proceeded on a taste tour. "We went to five different ice cream parlors.... They were marvelous, all of them."[45]

Elaine's activities amounted to innocent fun. She had accepted a life of poverty, but she didn't feel she had to wallow in it. Bill didn't understand, however, and they began fighting often. As they did, the differences in their characters and expectations became clear. "At first, he did think that a woman was just, you know, her place was in the home," Elaine said. "And that once I got married I should drop my brushes and drop my books and get into the kitchen.... And no way was I going to change character."[46]

During one battle, Bill said to Elaine, "Well, if you think I'm so great, why didn't you get a job and support me?"

"I never asked *you* to get a job," she said. "I want to paint just as much as you do, and I'm willing to starve along with you."[47]

"I thought you'd give all that up when you married me," he countered.

"What gave you that idea? When you met me I was painting full-time. I had my own studio, and I was doing nothing *but* paint. You knew that when you married me."

"Well," he said, "I thought you'd make a nice pillow."

"I thought *you'd* make a nice pillow," Elaine retorted.[48]

That was the end of that particular argument, but it was repeated many times, though often with more humor. Once Bill accused Elaine of having "a very nice life for a young man." He said they were "like two bachelors shacked up.... What we two need is a good wife."[49] That line, which has become part of the de Kooning lore, may have been picked up by Bill at the movies. Spencer Tracy had used those same words in a similar domestic dustup with Katharine Hepburn in the 1942 film *Woman of the Year*. The fact that the dialogue had made it onto the silver screen illustrated that Bill and Elaine's creaking and groaning relationship was not so different from many others in those days. The status of women in society was in a

state of flux, and many couples were unsure how they should proceed in the midst of it.

The history of womanhood in America is one of radical change. Women have been called upon to be whoever society has needed at any given moment. Sometimes, within a single generation, a woman might be expected to accept the role of the humble dependent, to serve and obey her father and her husband, only to be encouraged—most often in times of national crisis and in great haste—to forget those limitations, ignore what she has been told, and to take charge, use her brains, show her strength. Colonial America, for example, needed women to abandon the guise of "toy wife" and work alongside men building homesteads and a new country. But after the War of Independence, when the fledgling United States sought to show itself worthy of its nationhood by displays of social refinement, white women were escorted back into the home.[50]

Through subsequent decades, women were confined to the kitchen, dragged out into public service, and then returned to the kitchen with almost comic regularity. It occurred again during World War I, when women were told to pick up the reins dropped by fighting men. But in that case, many women did not forget quite so easily that they had proven themselves immensely capable. When the battles in Europe had ended, women demanded recognition of their achievements. After having resisted for seventy-two years, the government finally acquiesced. In 1920, women were given a political voice in the form of a ballot.[51]

There was a new girl in town in the wake of that social earthquake. She had a "cigarette in her mouth and a cocktail in her hand" and often, she had employment outside the home—one out of four workers in 1920s America was a woman—which meant she carried the financial key to her independence. *Ladies' Home Journal* was appalled. It described that new phenomenon—the flapper—as a woman who "smoked, wore short skirts, performed obscene dances, listened to jazz, entered psychoanalysis, practiced birth control, and leaned toward Bolshevism."[52]

In fact, America's new woman was not as abandoned as the *Journal* suggested; many were quite serious. By 1929, 40 percent of all master's degrees and 15 percent of all doctoral degrees went to women.[53] Young women and girls growing up in the 1920s and 1930s witnessed women achieving big goals. In 1926 Gertrude Ederle swam the English Channel, becoming the first woman to do so and shattering the male record by two hours. In 1931 Jane Addams won the Nobel Peace Prize and Pearl S. Buck won the Pulitzer Prize (in 1938 she would receive the Nobel Prize in Literature). In 1932, Amelia Earhart became the first woman to fly a plane across the Atlantic alone.[54] That was the environment in which Lee came of age. She

had arrived in Greenwich Village as women began to feel capable of achieving anything they dreamed of. Elaine was still a child in the 1920s, but she, too, had absorbed those lessons. She would say she hadn't wanted to be a princess in the fairy tales—"That was always a limp figure, you know kissed, waiting to be kissed, and awakened.... I wasn't interested in her at all.... Women in action interested me." As a teenager, her hero, and the person she aspired to be, was the high-flying Ms. Earhart.[55]

Such women of action were also among the biggest draws of the film industry, which Dorothy Dix said in 1943 was the most influential educational tool in America. Female characters of that era were often depicted as strong, intelligent creatures who were equal to—if not sometimes better than—their cinematic male counterparts.[56] But that, too, was because society needed them to play those roles. The mass mobilization of men into the military that began after Pearl Harbor meant that women had to fill their places in the workforce—and not just any workforce, but a turbocharged war machine.

Enter Rosie the Riveter. Her face was plastered on posters around the country. Lipstick, feathery lashes, hair secured by a jaunty bandanna, and sleeve rolled up over an arm flexed to display her muscled biceps, Rosie became the face of womanhood in wartime America. Single women, married women, mothers, all were encouraged to apply for jobs. It was, quite simply, their patriotic duty. "If you've sewed on buttons, or made button holes on a machine, you can learn to do spot welding on airplane parts," War Manpower Commission recruiters offered. "If you've followed recipes exactly in making cakes, you can learn to load a shell." Six and a half million women would join the workforce between 1941 and 1945.[57] They drove taxis, repaired plane engines, operated cranes, and even replaced lumberjacks cutting down redwoods. They worked on Wall Street, in newspapers, and in hospitals.[58] For the first time in U.S. history, women were even allowed to join the military.[59]

The social revolution the United States underwent during those years was unprecedented, and as the number of Allied victories mounted and the end of the war seemed within reach, some began to fear that the revolution born out of military necessity might be irreversible. But that was impossible. There were not enough jobs to employ six million women *and* the twelve million men who would be returning home. Though surveys indicated that most women wanted to remain on the job after the war, they would have to be persuaded to leave the workforce. In 1945, the social machine that controlled the destiny of women was reactivated. Many institutions would be enlisted in the effort: government, church, schools, the law, but most of all media and film. Strong women characters would disappear from the screen and be replaced by "buffoons," passive sex

objects, or "thorns in the man's side." Medical practitioners, too, especially psychiatrists and psychologists, would be involved in convincing women that their accomplishments were unhealthy. "Once this bigotry has acquired the cachet of science, the counterrevolution may proceed pretty smoothly," wrote feminist Kate Millett. Even before the war ended, the stereotype of a woman's place being in the home had begun to resurface. Many men and women chose to believe it.[60] For someone of Bill's generation, life with Elaine would have been much easier if she had, too, but she was of the Earhart era and she couldn't.

The buildup to the Second World War had taken years. Some might even say it had begun with the ill-conceived treaty that ended the previous world war in 1919. Wherever one placed the start of the military campaign that would turn the planet into a battlefield, the war's beginnings seemed excruciatingly long compared with the swift descent toward its cataclysmic ending. June 1944 marked the beginning of a series of events that, during a span of fourteen months, would close the modern world's darkest chapter. They started with D-Day.

At six-thirty on the morning of June 6, 1944, the long-planned American and British invasion, involving millions of troops, began when the first U.S. forces landed on the French coast of Normandy. By midnight of that day, one hundred fifty thousand Allied forces had made shore. By the beginning of July, those numbers would grow to one million. By June 22, amid that push from the west, nearly two million Soviet troops had begun moving against Hitler's forces from the east.[61] Newspaper headlines screamed out each development, each portentous step, as Americans watched what looked very much like the start of a decisive battle to regain all of Europe. Towns and cities that just four years earlier had fallen one by one to Hitler's advancing army were recaptured. Then, on August 24, 1944, the bells of Notre Dame Cathedral began to toll and churches around the city answered in joyous communion. French Resistance forces had entered Paris. As that city had been the prize for Hitler, so it would be the prize for the troops that opposed him. French general Charles de Gaulle walked down the Champs-Élysées on August 26, reclaiming the capital of a united France.[62]

By early 1945, nearly all the territory gained by Germany since 1939 had been liberated. The advance had been steady, but the cost on all sides was great beyond imagining. The Allied firebombing of Dresden in February 1945 left the city covered in what one writer at the time described as a "carpet of corpses."[63] One hundred thousand people died in attacks launched by twelve hundred aircraft that set the city aflame with their bombs.[64] In Asia, too, Japan's empire was being slowly but surely eroded at

unthinkable cost. In March, sixteen square miles of Tokyo were incinerated and well over one hundred thousand Japanese civilians killed in the Allied carpet bombing of that city.[65] After a time, Americans at home became almost immune to the slaughter conducted in the name of peace. The numbers were staggering, the grainy images showing the aftermath of bombings numbing in their destructive sameness. But some news and images during that year still managed to shock, either by what they showed directly or by their power of suggestion.

In January 1945, Soviet forces finally entered Auschwitz to find 648 bodies and more than seven thousand still breathing skeletons. The Nazis had done their best to destroy evidence of what had gone on there, but the Soviets soon discovered six out of an original thirty-five storehouses still intact. Inside were more than eight hundred thousand women's dresses and three hundred thousand men's suits.[66] The people who had once worn that clothing no longer existed, not even for burial. The murder that occurred in Auschwitz was beyond reckoning, but it was just the beginning of a year of such discoveries. In mid-April, U.S. forces would enter Buchenwald to scenes of yet more horror. The photographs and film footage from the camps were published in newspapers and shown in movie theaters across the States.[67] People who saw them were horrified. Some coughed or laughed in embarrassment, according to writer Alfred Kazin, "It was *total*, the inescapable crime lying across the most documented century in history."[68] Americans had long known, even if they had allowed themselves to believe otherwise, that Hitler's forces were engaged in the systematic slaughter of Jews, Gypsies, homosexuals, and political opponents on a mass scale. The estimates, again, had become numbing. One million, two million, three million. For those who did not have loved ones in Europe, the deaths had been mere abstractions. After the photographs and footage, however, the crimes became undeniable. The images from the camps were seared into the psyche of every single right-minded person who saw them.

It was a moment of extreme moral vulnerability that required someone of great stature to explain how man could be capable of such atrocities and how mankind was to continue in the face of them. There was one such leader Americans might have turned to: Franklin Delano Roosevelt had been the voice of consolation and strength through the Depression and then again, as the United States sent millions of men and boys into battle in countries far from home. Elected president four times, he had been the steady hand during thirteen of the most trying years in modern U.S. history. But just when the country needed Roosevelt most, he was not there. He died on April 12, 1945, of a cerebral hemorrhage at his home in Georgia. "F.D.R. DIES!" "Death Shakes National Capital to its Foundation"; "President Roosevelt is Dead: Truman to Continue Policies: Ninth

Crosses Elbe, Nears Berlin."[69] Every headline in every newspaper repeated the message, and still it didn't seem true.

As a train carrying FDR's coffin traveled seven hundred miles north to Washington, DC, crowds on either side of the railroad tracks along the entire route said goodbye to him and his legacy. In the U.S. capital, citizens dozens deep lined the streets along which his coffin, drawn by a team of white horses and headed by military men marching in formation, moved slowly along Pennsylvania Avenue. Grown men wept, as did women and children of all races and classes.[70] It was too much to bear. America had been left to settle its most terrible conflict without the larger-than-life figure it had grown to trust. Just when it seemed the world might be pulling out of its dark days of mass killing, it was plunged into despair by the passing of one single heroic man.

Americans were given little time to mourn. By the spring of 1945, major events were happening too quickly.

April 21, 1945: Soviet tanks roll into Berlin with little opposition, as mere boys man German anti-tank guns. From the west, American forces also reach Berlin and link up with the Soviets.

April 27: Most of Berlin is in Soviet control.

April 28: Twenty-three years of fascist rule in Italy end when Mussolini is shot dead by Italian partisans along with his aides and his mistress.

April 28: American forces liberate Dachau and its thirty thousand inmates, and find fifty wagon trains of dead bodies.

April 30: Three-thirty in the afternoon, Hitler kills himself in a bunker in Berlin.

May 7: Germany signs an unconditional surrender on all fronts.

May 8: Germany's surrender takes effect.[71]

New York exploded with joy.

12. A Light That Blinds, II

> Modern politics revolves around a question which, strictly speaking, should never enter into politics, the question of all or nothing: of all, that is, a human society rich with infinite possibilities; or exactly nothing, that is, the end of mankind.
>
> —*Hannah Arendt*[1]

IT WAS IMPOSSIBLE to move in the city. It was impossible to hear. The screaming throngs radiating out from Times Square were so dense it was hard to imagine how they had all squeezed onto those streets and how they would ever be able to leave them. "A huge blizzard is raging outside, a paper blizzard," Mercedes's friend Janet Hauck wrote to her from New York on May 8, 1945. "The streets are knee deep in everything from toilet tissue to silver stars. People are wild with joy." The roar echoing up from the canyons of buildings was occasionally drowned out by the noise of airplanes.[2] In 1941, after Pearl Harbor, those planes would have sent crowds fleeing in fear. Four years later, the men and women on the street cheered and waved as U.S. military pilots flew their aircraft overhead in pride and jubilation. And, in case anyone in the crowd didn't know why that mass of writhing humanity had assembled in the heart of Manhattan that day, people held newspapers aloft: *"Nazis Give Up"; "It's V-E Day"; "The War in Europe Is Ended!"* All normal activity had ceased. Everyone joined the party. New York's joy was echoed in cities around the globe, though not as exuberantly in some European capitals whose people were too exhausted to celebrate. In those places, a subtler appreciation for peace expressed itself in small gestures: For the first time in years, streetlamps could be illuminated at night. There was no longer any fear that they might attract bombers.

There were many reactions to the end of the European war, but one was shared by nearly all: relief. The war, however, had not ceased for everyone. With Pacific battles still raging, civilians and soldiers were still dying. In fact, just as Hitler had accelerated his Final Solution in the face of defeat, so, too, the Japanese hastened their campaign in the Pacific. The Allied casualty count since mid-April had soared. President Harry Truman was advised that if his military tried to invade Japan, as many as one million U.S. troops could be killed. The American people would not tolerate such casualties, knowing that the war was effectively finished, if only the Japa-

nese would put down their guns. Japan's emperor had offered to stop the fighting, but he would not agree to an "unconditional surrender."[3] All that stood between war and peace were two words.

Americans had heard rumors of a bomb meant to end all wars, but the government denied the reports and so the public was not aware that a program to build just such a weapon had reached fruition. The government's most closely guarded secret had been tested in a remote part of New Mexico in July 1945. The atomic bomb had worked so "well" that it destroyed all life within a one-mile radius of its blast. Truman and his advisers concluded that only this, the most formidable weapon on the planet, would end the war.[4] "Never before have so few men made such fateful decisions for so many people who themselves are so helpless," wrote sociologist C. Wright Mills of the war a year before Truman's decision was reached.[5] Those words were even more apt in the summer of 1945. On August 6, an American plane dropped a payload that would change the course of human history. An atomic bomb exploded over Hiroshima, Japan, killing at least eighty thousand people instantly. "The eyes that actually saw the light melted out of sheer ecstasy," Bill said in a speech he and Elaine had written, referring to that unearthly blast. "For one instant, everybody was the same color. It made angels out of everybody."[6] Twice that number would ultimately perish as a result of that day, and 90 percent of what had been a city was left a charred, lifeless ruin.[7] Humankind had never seen such destruction. It wasn't the death toll that was so shocking; conventional bombing had killed as many people. It was the speed at which those tens of thousands of people had died—it had taken but an instant—and the extent of the devastation. Gorky's wife, Mougouch, would deliver their second child, Natasha, two days after that attack. "Imagine the horror," she wrote to a friend, "of lying in a maternity ward with every denomination of humanity & their little ones & hearing & reading of the atomic bomb."[8] August 9, 1945, the day after she wrote that letter, a second, more powerful bomb was dropped on the Japanese city of Nagasaki. Forty thousand more people died.[9]

As the news spread that Emperor Hirohito had finally agreed to the terms of surrender, normal activity in every town, every city, every street in every community in America came to a screeching halt. V-E Day had seemed tame by comparison. On Victory in Japan Day, August 14, the United States erupted in a bacchanalian orgy that belied the country's Puritan roots.[10] "If I had a uniform on, I felt I could have laid any woman on those streets," said poet Delmore Schwartz of that August day.[11] Twenty-year-old Larry Rivers was in midtown on the way to a music gig for the marines. "The streets were filled with happy, energetic drunks, sailors, soldiers, cops, et al., embracing, kissing, and trying to open the

doors of our cars to embrace and kiss us," he said. Theater producer Judith Malina, who was in the ecstatic crush at Times Square, said it seemed as though life could begin again, possibly even a better one.[12]

It didn't take long, however, for the realization of what had occurred during the previous six years to sink in and for questions to arise about the moral foundation upon which that new life would be built. Yes, the war had finally ended, but at what cost, not just in lives lost—*forty-six million*—or bodies maimed and minds left maddened.[13] Equally unsettling was the degraded state of humankind. "The reality is that the Nazis are men like ourselves; the nightmare is that they had shown, have proven beyond doubt what man is capable of," Hannah Arendt wrote in the *Partisan Review* that year.[14] And what of the threat to the very future that the bomb represented? Men of one generation were supposed to protect and improve the planet for the next. The bomb changed that. The next generation's inheritance would not be hope but fear of obliteration, and that knowledge would alter the way men lived. There was no longer an incentive to preserve and protect. Why bother? Beauty and bounty were no longer sustainable. Life had less value. It was now in the hands of fallible men who cloaked themselves in the mantle of God and could wipe out the planet. All one was left with (and even that was an illusion) was one's self. There was no longer a broad sense of "us," there was only "I." Anxiety "swept over us like a tidal wave when the first atom bomb exploded over Hiroshima, when we sensed our grave danger—sensed, that is, that we might be the last generation," wrote psychologist Rollo May. "At that moment the reaction of the great number of people was, strangely enough, a sudden, deep loneliness."[15] As artists and intellectuals discussed this dilemma endlessly, the sense of dread was pervasive. There had been a global trauma, a "break in the continuity of existence."[16]

Soul-searching seemed not only appropriate but vital. Yet almost as soon as the embers had cooled at Nagasaki and the full horrors of the death camps were revealed, the mass-culture machine began to mythologize the war. The memory of its victims was hurriedly buried along with the memories of the outrages that polite society—perhaps out of guilt, perhaps out of fear, hopefully not out of indifference—had decided not to dwell on. The mangled bodies of the military dead were neatly hidden under row upon row of pristine white headstones, remarkable only in the anonymity they bestowed upon the heroes beneath them. Magazine stories about the most horrendous crimes of modern times were thoughtlessly juxtaposed against ads of blooming youth enjoying a bountiful life, or beautiful women displaying the latest finery, which the reader, too, was invited to enjoy: *Go ahead, you've earned it*.[17] The United States had emerged from the

war the richest country on earth, and the men who controlled popular culture appeared to have decided that all the death, all the loss, all the horror leading up to that happy situation should be relegated to the department of "things better left unsaid."[18]

Those who had fought in World War II were remarkable for their stoicism upon returning home from battle. They were the generation that did not speak about what they had done and seen. Their reluctance to relive those experiences was understandable, but the larger society's reticence seemed like cowardice. Many returning GIs expressed shock and anger over the magnitude of wealth in the country and civilian triumphalism at the war's outcome. "There were moments when it seemed they were truly making it off our red meat and bone," wrote author James Jones.[19] "Used up" combat soldiers, those five hundred thousand who showed signs of psychological damage or physical injury, were referred to as "retreads" like secondhand tires. People were "repelled by" them, Jones said. "They did not want what he had caught to rub off, and they did not like it that they made him think of disaster."[20] The poet Archibald MacLeish, who had been assistant secretary of state in 1944, warned, "As things are now going, the peace we will make, the peace we seem to be making, will be a peace of oil, a peace of gold, a peace of shipping, a peace... without moral purpose or human interest."[21] "Moving on for the good of the country" was the justification. For some, however, it wasn't possible to move on, to paper over the truth with a Madison Avenue–created universe. Gino Severini wrote in the 1946 book *The Artist and Society,* which was popular among the downtown artists,

> It cannot even be said that peace has come after the war... or toleration after hatred. Few are the people nowadays who have faith in their fellow-men.... Ill will and superficiality are so widespread in the world that disbelief in men seems almost justified, and the truth is so twisted by private interests that one can hardly believe in Truth itself anymore....
>
> We need, therefore, to go deep down into ourselves, into the depths of our subjectivity, so as to search for a Truth that can revivify and strengthen our certainty that life is useful, beautiful and eternal.[22]

In the wake of war, artists in isolated pockets around the world would do just that, go deep into themselves. In New York, working individually but supporting each other collectively, men and women withdrew from the world to seek truth in the only place they could trust, themselves. Finding truth in one's art, truth in one's actions would not be easy—nothing is so difficult to recognize as oneself—but it was the only way

forward. As the war ended and the search began for a new path, Lee and Jackson would decide to travel together into Severini's landscape. They would begin by separating themselves from all they had previously known.

In August 1945, Lee and Jackson had been staying near East Hampton, Long Island, with their friends Reuben and Barbara Kadish. Just back from the war, where he had been stationed in Burma, Reuben was hoping to use his savings to buy a house in the nearby hamlet of Springs.[23] The Surrealists had had an outpost in Amagansett and, since the mid-nineteenth century, the South Fork of Long Island had been a favorite among artists. Springs, however, was still a closed community of fishermen and farmers surrounded by potato fields, pastures, dunes, and water.[24] The Kadishes' "summer rental" was a two-room shack on the bay at Louse Point, into which four adults and the Kadishes' two children squeezed for the season. It was without a single modern convenience—with a "leaking roof, a hand pump and no electricity,"[25] all of which appealed to Pollock. He had been born in the vast, open spaces of the West and was used to sleeping under its big skies.

Lee, however, at that point was city to the marrow. Everything she needed in her world was within a few blocks, as was *everyone* she needed (except Mercedes, who was still in California and whom Lee missed so much she frequently held "lengthy dialogues" with her in her head).[26] And yet, despite the lack of a subway and the unapologetically anti-Semitic environment in East Hampton, Lee found the serenity of Springs appealing.[27] The community seemed safe, a refuge from the mad world and from the uptown art scene with which she had unpleasantly engaged as Pollock's representative. That winter Lee wrote to Mercedes, "We've isolated ourselves in a sense—no openings no cocktail parties as little of 57th Street and all its shit as possible—Even at that some creeps through and the stench is terrific." Lee told her friend she had a strong desire to be alone.[28]

Amid the unrelenting reports of death in the world, three in particular shook Lee. Mondrian had died in late January 1944. The sadness surrounding his passing was not just over the loss of a great artist, it was also over the circumstance of his death. Mondrian had stayed up until four a.m. after an opening and had subsequently become ill. Though bedridden for several days, in his humility he hadn't wanted to bother anyone, and so he had remained alone in his stark white apartment with its myriad right angles until friends finally discovered he was sick and took him to the hospital. It was too late. He died five days later of pulmonary pneumonia.[29] Mondrian had had only one solo show during his lifetime, and that was in New York, where he said he had spent the happiest years of his life—because of the music. Lee had profound respect for her strange dancing

partner. His resolve to push himself to the limit in his art and in his life inspired her as he had inspired them all. Two hundred people—among them all the artists in New York—attended his funeral.[30]

The second passing that struck Lee to her core was her father's in 1945. He had been the great storyteller in her life, creating for her a fantastical world, and thereby training Lee's *mind* to see. Through his stories, which had not relied on books, she had learned that visualizations could pass from one person to another without ever treading that ground called reality, and that she was free to change those received images any way she liked to make them her own. As an adult she would pass her own rich imaginings along to others on canvas.[31] "In spite of the fact that I knew it was coming & in spite of his age (he was eighty-one)," she wrote Mercedes, "it pretty well tears you to pieces and is like some terrific eruption with everything being torn up from the bowels—everything and so I must wait until spaces are closed and time changes feeling."[32]

By the time Lee arrived in Springs that summer, she was depressed and exhausted, body and soul. Even her vast reservoir of energy had been insufficient to meet the demands of her changing life, most especially her life with Pollock. The recognition he received for his work through Peggy, though still minimal, had seemed to unhinge him. His drunken, boorish behavior had become increasingly outrageous and was often directed toward people Lee admired. During the summer of 1944, Lee and Jackson had been in Provincetown, where Pollock managed to offend Hofmann and his wife, Miz.[33] "Lee will have a hard time with him, but she stays with him and I respect her for this," Hofmann told Mercedes. "Lee says... it is easier to have five children as to be married with an artist. When he is talented then you can doppel or triple this number."[34] Howard Putzel had been able to help Lee both with Jackson and with Peggy, whose demands increased after she gave Pollock a contract. But Putzel had quit Art of This Century to open his own gallery, and that left Lee alone to act as go-between for the mercurial Peggy and the uncontrollable Pollock.[35]

Throughout all that upheaval, Lee did her best to preserve herself as an artist, even going so far as to rent space in Reuben Kadish's 12th Street studio. He attributed Lee's decision to distance herself creatively from Pollock to the competition between them.[36] But Lee, who denied any such competition ("that was not part of the game") complained to Mercedes that the traffic in and out of Pollock's place had begun to annoy her.[37] She had, however, managed to find the humor in one intrusive encounter. Lee had never met Pollock's early mentor, Thomas Hart Benton, because he had left New York before she began her relationship with Jackson. One day, the bell rang on the ground floor of their building. She poked her head out the window and saw Benton's face looking up at her.

He hadn't seen Pollock in quite some time so they had a big warm hello and then I was introduced. Benton said, "I hear you're a painter too." Now this is during the point at which my canvases were building up into gray masses and no image came through. It is not a good state of affairs. But I said, "Yes, I paint." Benton said to me, "I would like to see what you're doing." And I said, "I would love to show it to you" (knowing damn well that I had nothing but those gray slabs in there). And I took him in...[38]

Well for me to say there was astounding silence is the understatement of the century. And then Jackson generously changed the subject and we walked out and that's all that happened. But I must have felt pretty hostile to Benton or confident in myself to show him what I knew was in the studio.[39]

I was saying, "I paint. I paint every day. This is what's happening to me." I faced the issue very aggressively. I was having a rough time, and I didn't care who knew it.[40]

But Lee hadn't necessarily wanted to continue her struggles on canvas in public, so she moved her easel and paints into Kadish's space.

In the spring of 1945, Putzel opened his Gallery 67 with a provocative show called *A Problem for Critics*. Recognizing that something was happening among New York artists, he challenged the critics, whose numbers in those days were few, to decide what. Lee was the only woman in Putzel's show, which also included Gorky, Pollock, Hofmann, Mark Rothko, Picasso, and Miró, among others.[41] With Mercedes out of town, Howard had become Lee's confidant and friend, someone who both supported and respected her. But tragically, and perhaps predictably given how poorly he cared for himself, Putzel died, too. At the age of forty-six, he suffered a heart attack while Lee and Jackson were in Springs with the Kadishes in August.[42] Peggy wrote in her autobiography that Putzel had killed himself, and though his death was the result of natural causes, in a way she was right. In his final year, he had been in such a state of frenzy and despair (he slept in his gallery because he was so broke) that his obesity and bad habits had combined to kill him.[43]

Without Putzel, New York would have been a much less welcoming place for Lee, and much more difficult. While visiting the Kadishes, she concluded that removing herself and Pollock from that scene might help them both. They could work in peace, and there would be less opportunity for Pollock to drink. For someone as visually oriented as Lee, it is also hard to imagine that she wouldn't have been affected by the steady photographic diet of destroyed cities that she had been fed during the war, culminating in the ultimate destruction in Japan while she and Pollock were safely at the seaside. Cities had come to symbolize graveyards. Springs hearkened back to an earlier, less violent time. "The quietness of that land-

scape, the ocean being available in a few minutes. It seemed as good a place to try..." Lee stopped herself in mid-sentence, before adding, "I guess primarily what I'm saying is that there must have been a need, even if unconscious, to blow the city for a bit."[44]

She decided to try to sell Jackson on the idea. One night on the Kadishes' porch at sunset she said to him, "Why don't we rent [out] the place on Eighth Street for one winter and pack some canvas and books and try it out in the country?" He turned to her in shock. "Have you gone nuts? Leave New York?" Recalling that conversation, Lee laughed and said, "I thought, I must have gone nuts. I didn't even know where the thought came from.... He's right, leave New York, it's mad."[45] Back on Eighth Street, however, the suggestion took hold with Jackson, who considered it for two or three weeks before announcing, "We're going out there and buy a house and we are going to give up New York." Lee thought *he* had gone crazy. They only had about forty dollars between them.[46] Remembering a place he liked that they had seen with the Kadishes, he declared, "That's the house we're going to buy."[47] Lee phoned the real estate agent, but the property was no longer for sale. Undeterred, Jackson decided to return to Long Island to house hunt. Staying at a home Motherwell and his wife, Maria, had rented in East Hampton, they quickly found a two-and-a-half-story Victorian farmhouse on Fireplace Road in Springs with a barn and an acre and a quarter of land overlooking Accabonac Creek and Gardiners Bay. The price was five thousand dollars.[48] All they needed was $4,960 more, and it would be theirs!

As long as they were putting down roots—or dreaming of doing so— Lee decided they should also be married. Both she and Jackson had been adamantly opposed to the idea, but that year, amid so many changes, especially the death of her father, and because they were contemplating relocating to a community that wouldn't have understood or approved of the concept of "shacking up," Lee had warmed to the idea of matrimony.[49] "One day I confronted Jackson and I said, 'Here is the way I feel about things. Either we get married and continue as we are or we separate. I want very much to continue living with you. You will have to make the decision.'" Taking a few days to think about it, Jackson answered, "We get married." But not at city hall. "City Hall, that's a place to get a dog license. This has got to be a church wedding or else no wedding at all."[50] Lee was flabbergasted. Religion had played no part in their lives, other than as an interesting concept.[51]

Sometimes Lee said *she* had made the seemingly infinite number of calls to churches to try to find one that would marry a couple unaligned to any congregation — one of whom was Jewish and the other a lapsed Presbyterian. Sometimes May Tabak, whom Jackson had asked to be their witness,

said she had made the calls.⁵² It is likely that it would have taken both women to go through the Manhattan telephone book to find someone to perform the unorthodox ceremony Pollock demanded. Finally, May succeeded. Pleading with a minister at the Marble Collegiate Church on Fifth Avenue she said, "Unless these two are married in a church there will be no wedding, and it's a sin that they should continue living together without being married." The minister listened and then quietly replied that yes, he would officiate. "God would understand."⁵³

Lee saw a political opportunity in their nuptials. Having already decided to ask Peggy for an advance on Pollock's future work to help pay for the house in Springs, she invited her to be the other witness at their wedding, perhaps thinking this would soften her up for the financial transaction. Peggy's initial response was, "Aren't you married enough?" followed by "Who else is going to be there?"⁵⁴ May and Harold had just moved back to New York from Washington, and Peggy didn't immediately recognize May's name. Then it rang a bell. "'Is she married to a writer?' 'Yes.' 'Is she an editor?' 'Yes.' Peggy said, 'I will not be in the same room as that bitch.'"⁵⁵ She refused to witness the wedding, eventually saying she had lunch plans she couldn't change.⁵⁶ And so, on October 27, 1945, thirty-seven-year-old Lee Krasner (wearing a hat May bought her) stood beside thirty-three-year-old Jackson Pollock with witnesses May Tabak and the maid who cleaned the church while the Dutch Reform minister who had been bold enough to marry them described the wonder of love. May came away from the ten-minute ceremony "transformed" and took the Pollocks to lunch at Schrafft's.⁵⁷

Somewhat surprisingly, a bank agreed to give Lee and Jackson a mortgage for three thousand dollars. That meant to buy the house they needed to raise two thousand more and, with that in mind, Lee paid Peggy another visit. Sick in bed with the flu, Peggy sarcastically told Lee to ask rival dealer Sam Kootz, which Lee did.⁵⁸ He agreed to lend the money if Jackson switched to his gallery. A savvy negotiator, Lee returned to Peggy with the news. "How could you do such a thing and with Kootz of all people!" Peggy exploded. "Over my dead body you'll go to Kootz."⁵⁹ She agreed to lend them the money by rewriting Jackson's contract. She would double his monthly stipend to three hundred dollars (an added bonus Lee had not expected) and deduct fifty dollars a month to repay the loan—in exchange for which Peggy would have the rights to all of Jackson's work, minus one painting Lee could keep or sell each year.⁶⁰ The deal completed, Lee and Jackson spent the fall packing their things on Eighth Street, which involved Lee's scraping down her mud paintings so the canvas could be reused and destroying earlier works to lighten their load.⁶¹ They had arranged for the painter James Brooks, who was just back from the war, to

rent their apartment, along with Pollock's brother Jay and his wife, Alma, as placeholders in case they decided to return.[62] Then, in November 1945, Jackson and Lee left Greenwich Village with all their worldly possessions in a butcher's truck they had borrowed from May's brother.[63]

A ferocious "nor'easter" awaited them.[64] "I opened the door this morning and never touched the ground until I hit the side of the barn five hundred yards away—such winds," Pollock wrote a friend. In addition to wind, they had three solid days of snow and no one to turn to.[65] "I wondered what we were doing there. We had given up the New York place and burned all our bridges," Lee recalled.[66] "It was a matter of getting in the house. It was stuffed floor to ceiling with the contents of the people who had lived there.... The mackinaw of the man who had lived there was still hanging in the kitchen. It was a rough scene we walked into."[67] Despite the cold and the uninhabitable condition of the house, however, Lee felt there was a possibility they might be happy there. Walking on the snow-covered sand along the bay, she felt both calm *and* exhilarated.[68] On November 29, after they had been living in the house for about two weeks, Lee wrote Mercedes,

> Well here we be in Springs East-Hampton—3 hours from N.Y. and it might as well be 300 or 3000 miles—We've been here in this funny old Victorian bastard house.... We have a gigantic coal stove in the living room but haven't been able to get coal yet—I think it will be very comfortable when we do get it. A wood stove in the kitchen—running water (cold) and no bathtub—otherwise all the comforts of our Eighth St apt—Its very beautiful out here—the back of the house leads to a pond (inlet from the bay & with the house amongst other things is an old leaky row boat so we can get our own clams.... Our only means of transportation is bicycles—so as long as the weather permits we ride our sturdy steeds...
>
> Oh of course I forgot to mention that I am now legally Mrs. Jackson Pollock.[69]

Lee's life had taken her in the direction of relative stability. This had been her choice that year. During the same summer and fall, Elaine would make one fateful decision that would not lead to increased security. It would unmoor her.

In Goethe's *Faust* drama, Gretchen surrendered to Faust her love, her life. She was committed to him and died of it. Elaine was completely committed to Bill; she thought he was a genius and felt privileged to share his name and his work, to provide help and sometimes inspiration. But she wasn't prepared to sacrifice her life for him, either physically or spiritually. By the

summer of 1945, after a long winter of extreme poverty and creative struggle for them both, she needed a break. A young physicist by the name of Bill Hardy, who was a friend of Denby's, invited her to sail with him to Provincetown to celebrate the end of the war. She could crew the boat.[70] The offer—that kind of romantic adventure at such a portentous moment in history—was irresistible. Worn down by the daily struggle to survive, Elaine needed to engage life, a bigger life, completely. Sailing up the coast in Hardy's boat—the two of them against the waves—would have been just the ticket. Bill, not surprisingly, was furious. Ernestine said the notion that his wife would set off with another man, especially that man, insulted his masculinity.[71] Hardy had a job; Bill was penniless. Hardy sailed the open seas; Bill was afraid of the water. Hardy was a young wild Irishman; Bill a sulking forty-one-year-old Dutchman seemingly plagued in every aspect of his life. The anger Bill felt for Elaine as a result of that trip never really abated. Ernestine said Bill and Elaine's marriage was "essentially over when Elaine took off on the sailboat to Provincetown with another man."[72]

Years later, Elaine expressed what for her was a rare emotion—regret. The trip had not been what Bill imagined and had not been worth the pain it caused.

> I was cruel. It wasn't that I was cruel, I was totally inconsiderate which, you know, I have been at periods in my life, totally inconsiderate of Bill. I mean like that trip I took. The boat ride.... It was very high-handed of me to go off in a boat with this apparently lusty young man who didn't appeal to me at all. But, nobody would know that. Here I went off, stayed overnight, was on this boat....
>
> I went to bed while he kept sailing through the night. And I woke up on the floor of the cabin with water sloshing over my head. And I came up and there was this tremendous storm.... And I said, "How long have you sailed?" And he said, "I never sailed before".... We were going to sail up to see Edwin Denby. Because Bill Hardy and I, both of us had this crush on Edwin. And that was the reason we [set off].[73]

Elaine's liaisons with men other than Bill in later years would become well known and form part of her legend. Eventually, she and Bill would have a Chelsea-style open relationship, remaining a "team" but going their separate ways sexually. But in those early days, despite stories that later circulated about Elaine's having jumped into bed with various men, Edith Schloss said Elaine wasn't inclined toward promiscuity.

> Elaine had great pride in her body and would not give it easily, and...had rather more old-fashioned standards of behavior than the rest of us....

She could and did flirt outrageously with every male in sight, and used her feminine wiles full blast, but actually going all the way was another matter. Probably it was her very pride and peculiar girlish chasteness that were the main attraction.

In any case, Edith added, Elaine's relationships with other men were irrelevant "compared to her limitless lifelong devotion to Bill."[74]
Hardy left Provincetown, but Elaine stayed on for several months, and Bill traveled up to visit her. "I said to him... 'Why are you hurt, I think he's a pain in the neck,'" Elaine said, recounting her exchanges with Bill as she tried to explain away the Hardy disaster.[75] He wouldn't forgive her, and though he collected her from the Cape and brought her back to New York, he did not do so thinking they would remain bound together as they had been. "Bill was angry with Elaine. He was always angry with her," Ernestine said. "He resented the fact that she had not stayed in her position."[76] It was one thing that Elaine was not the domestic goddess Bill mistakenly envisioned but quite another for her to flaunt her lovers. Men could do that; Bill would do that. (Edith, whom Bill had made a pass at, said he was the type of man who "could always fit in a quickie.")[77] A wife most definitely could not.
Bill and Elaine returned to New York from Provincetown deflated in every respect, only to find that they had been evicted from their loft. The landlord told them the building was being sold and he wanted them out. Five months behind in their rent, they were in no position to argue.[78] The life Bill had carefully constructed, the vision of "most beautiful house in the world," where he had planned to live with his quiescent American bride, lay in ruins. It must have seemed to him that he had been singled out for unhappiness. But just when he was feeling most down on his luck, Milton Resnick came to see him. It was ironic that the man who had suffered a broken heart at Elaine's hands when she left him to move in with Bill would be the one to console Bill. No doubt their shared misery provided some comfort, and it might have been nice for Milton to have something as banal as a broken heart to consider. He had been in the army for four and a half years, during which he had survived five military campaigns. His last had begun on the second day of the D-Day landing.
Under General Patton, Resnick led a reconnaissance group that headed out before the rest of the troops moving deeper into France, scouting locations and checking for mines that would "blow your nuts off" if you stepped on them. (A rumor had started, Resnick said, "that even if you got your penis shot off, the Russians had already invented a way to give you a bigger one.... So that helped.")[79] His nerves strained by the work, they snapped completely during one mission when he was sent to a German

high command headquarters in an abandoned chateau. Milton entered through a window to avoid booby traps and then began a search for documents that took him into the cellar. As he descended, the steps gave way with a huge cracking sound and he fell, crashing to the damp floor below. "I leaned against the wall and knew I was dead. I couldn't move. There was nothing I could do. I was dead. I waited. Nothing happened.... After that, I was never the same. That was the beginning of me going down, down, down. My nerves were shot. That did it."[80] When Milton returned to civilian life, he could never again face the dark, even a darkened movie theater.[81] He became one of the walking wounded, the "retreads" who had been away too long and seen too much. In a journal entry after first meeting Resnick in those postwar years, Larry Rivers wrote, "You get the feeling that here is a person who has experienced life in its most tragic sense. Anything you say or do just makes him suffer more. He reeks with sensitivity. You might even think your breath is causing him to suffer."[82]

Bill told Resnick that he and Elaine were being evicted. Milton needed a place to live, too, so the two men set out to try to find an apartment or a loft. Real estate in New York was tight after the war. The flood of men returning home made finding any place nearly impossible.[83] Finally Milton discovered a flat on Carmine Street off Seventh Avenue. Bill still hadn't found anything. He told Milton, "Elaine needs a place to stay."[84] Milton agreed. "I let her have it," said the man who couldn't say no to his "first sweetheart." "Then [Bill] had no money so I loaned him two hundred dollars from the army pay my mother had saved for me while I was overseas. He never paid it back. I found another place on Spring Street." When Milton went home to get his things, his father asked him what he was going to do. "I'm going to do what I was doing before. I'm going to go back to painting." "Too bad," his father said, "I thought the army would make a man of you."[85]

Bill and Elaine would become his family. Arriving as he had, when they were deciding how or whether their marriage could be salvaged, Milton may have even helped them find a way. Seeing their friend's tortured face, which not long before had been so handsome and clear, they may have realized that their own problems paled in comparison. They loved each other—that hadn't changed. It was just different. Bill was frustrated and angry; Elaine wanted the freedom to conduct her life as she chose, which he didn't understand. But they could find a way to make it work. It wouldn't be conventional, but neither were they, nor were the people they cherished most. They were part of a larger circle of wonderful, damaged souls who did what they had to do to survive and create. Motherwell called it a "spiritual underground."[86] Writer Dwight Macdonald said its members spoke "modest meaningful truths to a small audience"—one

another—"[rather] than grandiose empty formulae to a big one."[87] The de Koonings would weather their early years of marriage in those confused postwar times, and though they would eventually have largely separate lives, everyone would still recognize them as a unit. Not as Mr. and Mrs. Willem de Kooning, the married couple, but as something much stronger: Bill and Elaine. Beginning in the mid-1940s, they would be one of two centers of gravity for much of the New York abstract art world as it was about to explode. The other would be Jackson and Lee.

The Turning Point

13. It's 1919 Over Again![1]

> We had no external limitations, no overriding authority, no imposed pattern of existence. We created our own links with the world and freedom was the very essence of our existence.
> — *Simone de Beauvoir*[2]

ARTISTS AND INTELLECTUALS old enough to have witnessed both world wars were struck by the similarities between post–World War II New York and Paris circa 1919, at the end of the First World War. "History never repeats itself, they say, but in this case...it might repeat the pattern if not the detail," wrote philosopher William Barrett, who plied his craft among the artists he counted as friends. "Surely some splendid and flourishing period lay before us even if we could not foresee what it would be like." A mood of "high seriousness" existed among artists and writers in 1946.[3] One couldn't help wonder whether the end of another world war would produce a book to rival Joyce's *Ulysses* or whether out of New York studios would come advances in art as great as the School of Paris. "There was a sense of coming back to life, a terrific energy and curiosity, even a feeling of destiny arising out of the war that had just ended," explained writer Anatole Broyard. "We shared the adventure of trying to be, starting to be, writers or painters."[4]

Those engaged in such activities generally agreed that an aesthetic response was needed to their tumultuous recent history.[5] It would not have taken much reflection to conclude that works of art created before 1940 were no longer appropriate to describe the postwar world. The broken planes of Cubism might have anticipated the destruction inherent in war, but they were made irrelevant by its onset. The dark terrors of the Surrealists were clever ruminations on the unconscious amid the rise of fascism. But as one visitor to a Surrealist exhibition said, "After the gas chambers... what is there left for the poor Surrealists to shock us with?"[6] Futurism, with its uncompromising exactitude that glorified the machine, would no longer do because those works could be interpreted as glorifying war. Poet Adrienne Rich wrote, "Radical change in human sensibility [required] radical changes" in artistic style.[7] That was where artists in New York found themselves immediately after the war, looking for a way to express their altered reality. "It was sort of an invitation to begin again," said painter Jack Tworkov. "It wasn't so much that you were against anything as you just

wanted to ignore what went before...to make a clean start.... You had to do it yourself, you had to find your own thoughts, your own way of thinking."[8]

Though there were some artists like Lee and Pollock working in distant outposts, members of the avant-garde art world after the war coalesced largely around the Village. Its clubs, bookstores, and cafeterias provided a welcoming environment for artists seeking both the solitude to work and the sociability needed to maintain their sanity. "Man needs relations with other people in order to orient himself," wrote Rollo May.[9] That would have been especially true of these artists because the territory they were entering was a vast unknown, especially to themselves.

Just as the New York art world had changed at the start of the war when arriving refugee artists crossed paths with departing artists who had answered the call to serve in the military, so, too, the end of the conflict produced another changing of the guard. With Paris beleaguered but secure, those European artists who had been waiting to return to France prepared to leave New York at the very time the American GIs began flooding back home. Ibram Lassaw, Milton Resnick, and Reuben Kadish had been among the first of the artists to return, but arriving quickly after them were Giorgio Spaventa, Ad Reinhardt, John Ferren, George McNeil, Conrad Marca-Relli, John Little, Philip Guston, Lutz Sander, James Brooks, and many more.[10] Almost comically they reclaimed Eighth Street—as soldiers retook territory—from the refugees who had promenaded in packs along that critically important stretch of pavement. "We would leave the cafeteria and walk the length of Eighth Street back and forth, exchanging big and small details for the new budding abstraction," wrote sculptor Philip Pavia.[11] The two Waldorf elders, Landes Lewitin and Aristodimos Kaldis, were no longer speaking to each other and so took up positions like bookends at either end of Eighth, awaiting the approaching procession to hear, when it finally reached them, what had been said along the way.[12]

Many of the artist soldiers and seamen used a higher education tuition plan under the GI Bill to pay for classes at Hofmann's or the Art Students League. "These were men who made a conscious choice to be artists after a life-altering experience," said Will Barnet, who taught at the League. Hungry for instruction, they seemed to be trying to make up for lost time.[13] Some of the GIs resented the artists who had avoided military service. They felt that those who had stayed in New York had an edge because they had been able to continue to paint during the years that their fellows had been away at war. There was also guilt on the part of those men who had *not* fought. A relatively young man who was free to walk the streets

during the conflict had been viewed as either mentally or physically defective, or a coward. The freedom he enjoyed came at a cost. But those fears and irritations evaporated amid the support the artists gave one another immediately after the war. A community developed that sustained them and gave them courage.[14] "You have to have confidence amounting to arrogance, because particularly at the beginning, you're making something that nobody has asked you to make," Elaine said. "And you have to have total confidence in yourself, and in the necessity of what you're doing."[15] That was much easier done in a group of like-minded individuals.

First more chairs and then additional tables were added to the artists' area at the Waldorf, as the GIs joined the nightly banter in that smoke-filled den, which had become so wretched its clientele had begun to call it the "snakepit."[16] "Once at the Waldorf Elaine found a mouse in the toilet swimming madly to survive. She fed toilet paper into the toilet so the mouse could run out," recalled her friend, Doris Aach. "It did, but ran in her direction so she, in turn, ran out of the bathroom, trailing a long piece of wet toilet paper along with her into the middle of the Waldorf."[17] The artists shared the place with pickpockets, two-bit hoods—"the boys from Sing Sing," as Lutz Sander called them. "There'd be all kinds of nuts, political nuts, ordinary Village bums," said George McNeil. "They used to clear the Waldorf out at nine-thirty.... They'd clear the whole damn place out...this was to get rid of all the creeps who hung out there."[18] Amid those thieves and thugs, the artists were engaged in discussions that would alter the very future of art. Already, historians like Herbert Read had begun to address in print some of the problems with which the Waldorf crowd grappled. In a 1945 book, Read wrote,

> Unless our civilization is to disappear completely, the postwar period must in all spheres of human activity be not less but more dynamic than any previous period known to history....
>
> The art which will then arise as a spontaneous expression of the spiritual life of such a society will bear no obvious relation to any art that exists now. It will incorporate...the eternal harmonies of great art; but it will be so original in its outward manifestation that its first impact must inevitably seem, and be revolutionary....
>
> It is a painful experience: creative work on this level is only done at a cost of mental anguish.[19]

Mercedes, who was back in New York and had moved with her husband and son to MacDougal Alley around the corner from the Waldorf, did her shopping at midnight and would stop by the cafeteria with her groceries for a cup of inspiration on her way home. "People just talked about

painting, about art," she said. "It was very important because the thing that existed then, a real climate that people existed in together...made them go past [as artists] where they would go alone."[20] Most of the artists were not equipped to entertain at home, and so the Waldorf became their communal living room. Pavia said at times as many as forty people would be sitting in their group, with another ten or fifteen clustered outside. "The meetings," he said, "were getting out of hand."[21]

The veterans had injected a note of defiance into the gatherings. Many had been in combat in Europe and the notion that Americans had saved the continent from Hitler had given them confidence they wouldn't have had before the war when comparing themselves to the French. That attitude was based in part on the art being produced in France, which under four years of occupation had largely stagnated when it could be produced at all. But mostly it arose from the perception that their country could get things done, that it represented the future. The artists began to think that this same country—that they themselves—could produce a heroic American art unlike anything that had existed.[22] If French art was no longer seen as particularly relevant, however, another French import was.

In 1946, Existentialism seemed designed to nurture and stimulate artists overcome with anxiety about their work and about living in a time when events beyond their control meant there was no respite from worry. Rooted in the nineteenth century in Kierkegaard, whom Elaine and Bill so admired, in the 1940s the philosophy was revived and reintroduced to Americans by a young French intellectual who had been part of the underground resistance to Hitler. His name was Jean-Paul Sartre, and when he spoke at Carnegie Hall in March 1946 at the invitation of a New York–based Surrealist magazine, *View*, the place was "filled to the rafters." All the artists were there to hear the philosopher, playwright, and novelist discuss his theories as they pertained to art.[23]

Sartre appeared a funny little man on that grand stage. His round face was a sickly gray, and the eyes behind his spectacles looked in opposite directions. Small and utterly professorial, he nonetheless exuded physical power, throwing his shoulder forward as he spoke, his voice rising strong and virile throughout the hall.[24] His presence was quite simply riveting. At Carnegie Hall that spring he discussed the theater, but his description of a stripped-down stage, characters revealing who they *were* instead of acting out stories, and the abandonment of time-worn theatrical traditions that were no longer adequate to express contemporary themes resonated with the painters. Sartre's theater would be distilled down to its essence, and that was exactly what the artists in New York hoped to achieve in their work. Unfortunately, Sartre spoke in French, which most of the artists did not understand, and so they looked for his meaning in translations of his writing.[25] Having sworn

an oath against dogma after their earlier faith in communism had been betrayed by Stalin, the New York artists were initially suspicious of yet another "ism." The more they learned, however, the clearer it became that Existentialism was a philosophy they could embrace because it asked them to do nothing but be themselves, as honestly as they could.[26]

Sartre's Existentialism began with the premise that man was not pure. In the full knowledge of war and the crimes of which man had proven himself capable, no other conclusion could be reached. He also pulled out from under civilization the social safety nets of religion and reason by saying that, based on six years of buildup to war and six years of full-blown conflict, there was no God, and man could not be trusted to act rationally.[27] Though Sartre did not paint a reassuring picture, he offered an alternative constructed not upon hope but upon truth. In *Existentialism and Humanism,* which was translated into English in 1946, he explained,

> If god does not exist, there is at least one being whose existence comes before its essence, a being which exists before it can be defined by any conception of it. That being is man....[28]

Man, however, exists as a veritable lump of clay until he does something or, as Sartre described it, until he makes something of himself.

> That is the first principle of existentialism....[29] There is no reality except in action.... [Man] exists only in so far as he realizes himself, he is therefore nothing else but the sum of his actions, nothing else but what his life is.[30]

A liberating notion, it meant men and women weren't limited by a preordained plan or a path assigned and approved by society. They were responsible for—and created—their own destinies.

> The first effect of existentialism is that it puts every man in possession of himself as he is, and places the entire responsibility for his existence squarely upon his shoulders....[31] You are free, therefore to choose—that is to say, invent....[32]
> Life is nothing until it is lived; but it is yours to make sense of, and the value of it is nothing else but the sense that you choose.[33]

As John Graham's *System and Dialectics of Art* was a manifesto laying out an aesthetic theory that formed the basis of Abstract Expressionism, Existentialism provided a philosophical footing for the movement.[34] As an artist stood facing a blank canvas, a block of stone, or a pile of metal, wondering how (though seldom whether) he or she should begin, the Existentialists said there was only one answer to that question—they must

act. They must travel to the deepest part of themselves, "where fear and trembling start," in the service of art.[35] And for those who feared such a perilous journey, Heidegger had an answer. Man is finite, he said, and if that is a given, there is nothing to lose by risking all on a life of one's own choosing.[36]

Lee's existential gamble involved a life in a barely habitable house in a hamlet with one saloon and one general store, among a community of several hundred people who viewed her and Jackson with suspicion. The nearest village, East Hampton, still had hitching posts along the main street for horses and wagons, and for entertainment a movie theater—open Friday and Saturday only—with hard wooden seats.[37] And yet, whether in spite of or because of those limitations, both Lee and Jackson would make major advances in their art by the end of the year. They had apparently needed the opposite of the emphatic camaraderie on offer in the Village. In the clarity born of isolation in Springs, an existence Lee described as "conservative and quiet," they were able to support each other as they jettisoned past influences and styles to create works that were uniquely their own.[38] For the first few months at Springs, however, their main task was transforming the house.

"We were so busy...tearing off wallpaper and burning up the contents of the house...that we didn't have time to do much else," Lee said.[39] Upstairs, Lee and Jackson cleared a room overlooking the creek for their bedroom. Another, smaller room would be used by Pollock as a studio, and a third (smaller still) functioned as Lee's studio and guest bedroom. During that first winter, because coal was still rationed, they couldn't afford to heat the entire house so they blocked off the upstairs during the day, warming only the ground floor and only for twelve hours.[40] Peggy had been among the first people to occupy the guest room. "We gave her an oil stove for warmth and she carried it around with her," Lee said. "She came down in one of her negligees with the oil stove and said, 'This reminds me of castles in England.'" In the morning, Pollock had to unfreeze the water in the toilet with a blowtorch so she could use it.[41] Friends expressed shock at the primitive conditions in which Lee and Jackson not only lived but apparently thrived.[42]

Bob Motherwell had purchased land near East Hampton on Georgica Road to build a house, and he and his wife, Maria, rented a place in Springs while the construction was under way. They were Lee's and Jackson's lifeline during those first few months.[43] Not only did Bob and Maria have a car, but having Motherwell as a neighbor would have been tantamount to living in close proximity to a library. Art theory, social theory, art history, philosophy, he knew it all, *and* he was a romantic who believed

in the noble mission of art. He also appealed to both Jackson and Lee personally. Like Pollock, he was excruciatingly shy. Like Pollock, he was from the West Coast. And like Pollock, he was viewed by the Waldorf crowd as an outsider. (The cafeteria set thought he was rich and overeducated.) Lee appreciated Bob because he was "somebody" in the greater art world. He had had solo shows at Peggy's and Sam Kootz's galleries, had two paintings in the Museum of Modern Art's permanent collection, and would be selected in 1946 for the Modern's prestigious *Fourteen Americans* show.[44] Lee, an expert at cultivating people she thought could help Jackson, considered Motherwell one of them. Bob's exotic young actress wife, Maria, however, became a growing source of anxiety for Lee.[45] Having embarked on her career as Mrs. Jackson Pollock, Lee was not inclined to have anyone around who threatened the life she was intent on building. Unlike de Kooning, Jackson wasn't in the market for a "quickie," but Lee assumed, because she was so in love with him, that other women would find him irresistible and try to tempt him away.[46]

Lee and Jackson had gone back to the city for a few weeks in April during Pollock's third solo show at Art of This Century. There was no indication that they felt nostalgic about the Village or regretted leaving New York to return to Springs after the exhibition closed. In fact, that spring and summer would be among the happiest in their lives. It was a season of gardening, cooking, canning vegetables, bicycling, and clamming. They got a dog they named Gyp and a "diabolical" pet crow named Caw Caw that learned to imitate voices at a party. (Mercedes said she awoke one morning in Springs to hear the bird at the window adopting various voices while reciting the previous night's conversations.)[47] They planted mimosa trees and made a deal by which Lee took care of the house and garden if Pollock did the planting and managed the grounds. Part of that chore included clearing out the old barn behind the house.[48] Both of them had grown as thin as the posts separating their property from the neighbor's, but in their rough workmen's clothing they looked happy—Lee, particularly so. "It was all a beautiful new experience," she said, "cozy, domestic, and very fulfilling."[49] Though difficult and remote, life overall was calm, a state that would be rare indeed for this couple. It would be something worth remembering later when their every waking moment was beset by trauma.

Patsy Southgate, who would be Lee's friend during her most difficult period in the mid-1950s, said Lee gave Pollock all the things he had wanted from his mother: "total devotion, exclusion of all others, complete primacy" and the added bonus of "sexual intimacy."[50] Lee admitted that in those early years she couldn't do enough for Jackson, and it seems that at this point the feeling was mutual.[51] There was a real sense of communion between them, a feeling that they were engaged in something larger than

themselves, together. "With Jackson there was quiet—solitude. Just to sit and look at the landscape. An inner quietness. After dinner, to sit on the back porch and look at the light. No need for talking. For any kind of communication," Lee said. "The fact that he drank and was extraordinarily difficult to live with was another side. But the thing that made it possible for me to hold my equilibrium were those intervals when we had so much."[52]

In June, after the barn was emptied, Pollock had the rickety structure moved to unblock the kitchen view out to the meadow and creek. Then he took up artistic residence there. Lee, meanwhile, moved into the room upstairs where he had painted.[53] Divided by a yard, inside two separate buildings, and absorbed by their own imaginations, they would begin paintings that were at the start remarkably similar. Both were without a trace of recognizable imagery and both were "all over," the action on the canvas extending to the very edge. Side by side, their works at times were mirror images, down to the calligraphic lines, even the frenzy of small swirls that made their canvases shiver and churn. "Unfortunately, when two people live closely together as Jackson and I did we affect each other," Lee explained.[54] It is impossible to know who did what first, or who influenced whom, but Lee would say repeatedly that Jackson "broke through" first, and so it can be assumed that she was following his lead. In any case, the paintings were a triumph for Lee. After three years of struggling with what amounted to mud, she had finally begun to produce pieces that excited her. "I felt fantastic relief that something was beginning to happen after all this time when there was nothing, nothing, nothing," Lee said.[55]

While her new works were a huge advance, they were only a step on her path of invention. Though she had climbed out of the mud, she still had a way to go before she pulled away from Pollock. He, however, was on his way to the stratosphere. The paintings he would create in his dilapidated barn would put him there, and Lee along with an art critic named Clement Greenberg made sure that the world recognized them for what they were: revolutionary, as demanded by the times.

14. Awakenings

> One has the impression—but only the impression—that the immediate future of Western art, if it is to have any immediate future, depends on what is done in this country.
> —Clement Greenberg[1]

FOR A PERIOD of about six years, beginning roughly in 1946, Lee, Clem Greenberg, and Pollock formed an enterprise, which, had it occurred in the early twenty-first century, might have been called Jackson Pollock, Inc. Lee and Greenberg both thought Pollock the best painter of his generation, even the best painter the country had ever produced, and they willingly, eagerly invested their time and energy to support him by essentially marketing Jackson. It was an extremely novel concept in those days. Other wives helped their artist husbands, but mainly by working at a job so they could paint or sculpt. And other critics had favorite artists, but few were willing to stake their reputations as boldly as Greenberg would on Pollock. Together, Lee and Clem would unwittingly create roles for future art world functionaries: manager and publicist.

Lee had met Greenberg at a literary party at May Tabak and Harold Rosenberg's flat in 1937.[2] Then thirty, Greenberg was a year older than Lee and, like her, the child of Jewish immigrant parents (his were Poles from Lithuania). Greenberg was born in the Bronx, but his father had moved the family to Virginia, where he established a clothing store franchise. That meant that when Clem returned to New York he arrived with a southern accent that fit his attitude and appearance like a mismatched suit. Prematurely bald, a cigarette always at hand, his brown eyes liquid as if reflecting the quicksilver movement of his thoughts, Clem was an intellectual of the type that could only be satisfied in Manhattan: intense, agitated, competitive.[3] As a teen, he had had an interest in art, but personal crises cut short his art training. He next tried his hand at poetry. His career in that field, however, ended when he plagiarized his first published poem. A life in business beckoned, but Clem wanted no part of a practical man's existence. Brilliant, belligerent, and at times emotionally sadistic, he pictured himself among creative people and believed the only life that would satisfy him was one of the mind. Through a cousin, he was introduced to Harold's circle of intellectuals, and through them, to Lee.[4]

The divorced father of one son, Clem worked at the U.S. Customs Service at the Port of New York and lived as a bachelor in the Village. He was, therefore, in proximity to artists but not part of their world. Lee changed that by introducing him to her artist friends. Most important to Clem was the introduction to Hans Hofmann and his Friday night lectures.[5] (Clem would call Hans "in all probability the most important art teacher of our time.")[6] Combining that intense immersion in New York's burgeoning modern art world with his own voracious reading, within two years Clem formulated the beginning of an aesthetic theory. He introduced it in a 1939 article he wrote for the journal that was home to the brightest stars in the city's intellectual universe, the *Partisan Review*. Called "Avant-Garde and Kitsch," it made Greenberg an instant celebrity among both writers and painters.[7]

In the piece, Clem described the avant-garde of mid-nineteenth-century Europe as having cut the "umbilical cord of gold" that connected it to art's greatest patron, the ruling class, in order to pursue an aesthetic ideal without regard to a paying public. He attributed to that radical sundering the subsequent generations of artistic innovators—Cézanne, Picasso, Matisse, among them—who derived their "chief inspiration from the medium they work in" rather than what they portrayed. Clem warned, however, of the existence of a "rear guard" in culture, which he called "kitsch," that was the opposite of the avant-garde. Produced by popular demand and based on tested formulas, a kitsch painting was one that did not challenge its viewer—its job was to please.[8] Writing as Hitler's troops began their push through Europe, Greenberg described the manipulation of citizenry by governments through the culture of kitsch. He said that once conquering forces—whom he called the "statue-smashers"—had destroyed what had been previously regarded as great and good, they would seek to reinvent culture to better control the vanquished people. Greenberg maintained that avant-garde art was offensive to the then-contemporary statue-smashers—fascist governments—not only because it was challenging but because it was "innocent."[9] There was a purity in such art that was beyond the control of anyone but the artist who created it.

Not long after "Avant Garde and Kitsch" was published, Greenberg became an editor at *Partisan Review* as well as an art critic for *The Nation*. The field was relatively new for such magazines. They had had music, theater, and literary critics but had largely ignored painting and sculpture, due in part to the fact that nothing in the United States had been deemed noteworthy in those areas.[10] With the arrival of the famous European refugee artists during the war, however, the art scene became vibrant. Museums, too, had new energy; they were suddenly flush with great works on loan for safekeeping. And then there were the New York artists, who looked in every respect

like the avant-garde Greenberg described. They had begun to attract attention, if only because the editors and writers from highbrow journals shared their Village haunts and had an excellent vantage point from which to chart their development. Clem knew the artists through Lee and was comfortable with their language, both what they said about their work and what they did on canvas. "I felt I knew art from the inside," he said.[11] For someone like Clem, who hoped to make a mark (he once told a friend he wanted to be a "great man" who would "dazzle instead of being dazzled"), modern art was virgin territory awaiting an intellectual pioneer.[12] In 1942, he became the full-time art critic for *The Nation* and, in a style that would inspire generations of future critics, began to write about the work being done in derelict lofts by obscure artists right there in Manhattan.

In the flurry of activity surrounding his new career, Clem and Lee had lost touch. In January 1942, however, a few days after the McMillen show, they ran into each other on the street outside the U.S. Customs Service, where Greenberg still worked (as critic jobs were either unpaid or poorly paid). It was a blustery winter afternoon. Lee, who was with a youngish man in a fedora and heavy overcoat, exchanged greetings with Greenberg and then said, "This is Jackson Pollock...he's going to be a great painter." Taken aback, Greenberg thought, "That's no way to size up a human being."[13] After that, their interactions seem to have been interrupted for more than a year. Clem was drafted and sent to a series of bases inside the United States — including a bizarre stint in Oklahoma guarding three hundred Nazi prisoners of war who were convinced Hitler would invade the country to free them. They routinely practiced goose steps, Nazi salutes, and shouts of "Heil Hitler" to properly greet the Führer when he arrived.[14] By the fall Clem had been transferred again, to a camp in Michigan where he suffered a breakdown. Greenberg's girlfriend Jean Connolly, whom he called the "great passion" of his life, had sent him a Dear John letter announcing she intended to marry someone else.[15]

Released from military service in September 1943, Greenberg was back in New York at *The Nation* in time to review Pollock's first show at Peggy's gallery that November. In his review, Clem "complimented" Pollock on his ability to get "something positive from the muddiness of color" but accused him of being pretentious in his choice of titles. He also remarked that Pollock "took orders he couldn't fill" by trying to paint large works. Despite his negative remarks, however, Greenberg seemed intrigued by what he had seen. Of Jackson's small paintings, Clem wrote that they were "among the strongest abstract paintings I have yet seen by an American."[16] That review was the first in a series of critiques penned by Clem about Jackson that would catapult them both into the public eye. In many ways, their careers developed in tandem: Jackson came into his own as a painter

as Clem did as a writer. By 1945 a more confident Greenberg would describe a more confident Pollock as "the strongest painter of his generation and perhaps the greatest one to appear since Miró."[17]

Greenberg was a demon for work. In 1944, he was writing for the *Partisan Review, The Nation, Politics,* the British publication *Horizon,* the Surrealist *Dyn, The New Republic,* and the *Contemporary Jewish Record*.[18] But, while Lee and Pollock lived on Eighth Street, he still found time to drop by occasionally to see what they were doing. The calls were professional; Clem had something to learn from Lee, and he was fascinated by what he saw in Jackson's studio. It wasn't until 1946 in Springs that the relationship became personal and the friendship among Lee, Clem, and Jackson intensified.[19] In fact, intense would not have been a strong enough adjective to describe their encounters. Theirs would be a historic collaboration, which belied its quiet beginnings. Greenberg recalled,

> Lee and I and Jackson would sit at the kitchen table and talk for hours—all day sometimes. Jackson usually wouldn't say much—we'd drink a lot of coffee. I know that this sounds like part of a myth. We would sit for hours and go to bed at three or four in the morning.... Pollock was a pure guy. He was. I'm not idealizing him. It was inconceivable for him to do something because it would get him somewhere. When he was drunk he was intolerable. When he was sober he was a pure guy and that was the real Pollock....[20]
>
> The most important person to his painting was Lee. She had this eye. She had a merciless eye. He talked about art with Lee, and with me when Lee was around. She was essential.[21]

Within two years of moving to Springs, Jackson had had paintings in exhibitions in New York, San Francisco, Chicago, Cincinnati, and Washington, DC, and had sold a work to the Museum of Modern Art, but he and Lee had no money to show for it.[22] In true loaves-and-fishes fashion, however, they still managed to assemble feasts for friends composed of clams Pollock retrieved from the bay, apple pies he baked, and Lee's vegetables from the garden.[23] Among the visitors to Springs that summer were Bill and Milton, who had come out to see what the Pollocks were doing. It was easy to see what Jackson was up to in his barn: He was busily preparing for what would be his last show at Peggy's gallery. Like the French artists with whom she had arrived in the States, she had decided to return to Europe. But before she did so, Peggy had agreed to give Jackson a show in January 1947.[24] As Milton looked around the house on Fireplace Road, however, there were no obvious signs of Lee's work. "I asked Bill, 'Why isn't she painting?'" Milton recalled. "He said, 'Pollock doesn't want her to.'"[25] While Jackson's reputation grew, the rumor spread in New York

that Lee had stopped painting entirely. It seemed that no one bothered to ask her if this was true. Lee explained,

> I resented [the rumor] but there was nothing I could do about it. Some of the paintings were hanging in view and if they didn't see them, there was nothing I can do.... I'm glad I had an inner strength that could carry me through.... I will say this, that if Jackson had let me down for one second along the line I don't know that I could have done it. It was because he never let me down in terms of his attitude toward me as a painter that I could...go right through.[26]

In fact, at the time that Bill had said authoritatively that Lee had put down her brush, she was on the verge of making her most important mark as an artist.

As the warm fall turned into a cool early winter, Jackson would bundle up in layers of clothes and head out each afternoon to the barn to paint. Lee had continued working on her paintings upstairs in the house, but it finally become too cold for her to do so comfortably and she was forced back downstairs. "I couldn't paint in the living room, it was open...you know, no privacy, you can't close the door, and so...I think it was Jackson who said, 'Why don't you try a mosaic?'"[27] During the WPA years, Pollock had done a mosaic and he had some fragments of glass and tile that he had collected for that piece but had never used. He gave them to Lee, as well as an old wagon wheel—forty-six inches around—which she used as a frame for a wooden board that would be her work surface. Lee began pasting broken glass and tile, keys and coins, pebbles, and finally, costume jewelry onto the board to create a vibrant, swirling mass of color that looked like one of her paintings.[28] On canvas, she liked to break up the space with lines and shapes. She did the same on her mosaic. On canvas, she set sections in motion with swirls. She did the same in her table. And on canvas, she often brought the marks of her brush to the very edge of the picture so the viewer saw not a painting *of* something but a painting pure and simple. Her mosaic table was completed in that very style: There was no beginning or end, no focal point. One had no choice but to get lost in its dynamism. Within a year, Lee would make a second mosaic table, but more importantly she would return to painting awakened by a new creative experience. The mosaic had given her a route into her paintings and, finally, beyond Pollock.

"They consisted of a kind of crazy writing of my own," Lee said of the paintings she began in 1947, "sent by me to I don't know who, which I can't read, and I'm not so anxious to read."[29] Lee began with daubs of

paint, thickly applied with a palette knife and built up to almost replicate the mosaic effect. She didn't work at an easel but placed her stretched canvas on a table (again, as if still working on a mosaic) so she could look down and paint across the entire surface.[30] Vigorous, tight, with small marks that produced a kaleidoscope of color, the paintings Lee would call "Little Image" were without reference to any recognizable object or landscape unless one imagined the microscopic writhing of life itself. "There was a fresh invention going through the whole thing—a kind of unconscious freedom," said painter James Brooks. "Stravinsky said, 'You can't really invent without limitations.' Lee had the limitations that come with a strong knowledge of the way paintings have to be put together, but she had the psyche to move through that with her imagination."[31]

Lee liked to think of those works she did during her first years in Springs as "controlled chaos."[32] She also thought of them as her own personal hieroglyphs. She had been fascinated by calligraphy—Persian, Arabic, Celtic—and often went to the Morgan Library in Manhattan to study manuscripts. Even as a child, though she could not read it, she had loved Hebrew "visually," and when it came time to paint her Little Image works, she did so as one reads Hebrew, from right to left.[33] The first paintings that emerged were jewellike, most only about twenty-four inches, and exquisite. They formed a bridge between ancient traditions in writing and art and a future in which the marks of an abstract painting would be as revelatory for a secular society as Renaissance works had been in the service of religion. Greenberg saw one of her early Little Images, *Noon,* which Lee said she "knew at the time was a good painting," and responded immediately saying, "That's hot. It's cookin'." "It took very little feedback to sustain me," Lee said.[34] She would ride high for years on that offhand remark from Clem.

Jackson's January 1947 exhibition at Peggy's Art of This Century sold well, but it would be his last with her before she left for Venice in May.[35] In her wake, it was difficult to find a gallery willing to show him. In addition to his art, into which Jackson began to insert cigarette butts, coins, tacks, string, and sand, there was the problem of his drinking. There were two Jackson Pollocks. One helpful, pleasant, respectful, poetic in his art and his person. The other a violent, coarse, spitting drunk. Sometimes it took only one drink and a matter of seconds for Pollock No. 1 to transform into Pollock No. 2.[36] As a result, the very, very few gallery owners who handled avant-garde work were unprepared to take a chance on either. In 1946, however, a finishing school graduate whose aristocratic family owned homes in New York, Newport, and Palm Beach, had opened a gallery on 57th Street, and she was brave enough to give Jackson a try.[37]

On paper, there would not have been a less likely candidate to enter into a relationship with Pollock than Betty Parsons. Betty, however, was neither a bluestocking nor a businesswoman. (She once declared, "I haven't really got a conventional bone in my body.") Like Peggy, she was a renegade from privileged society, but unlike the flamboyant man-eating Ms. Guggenheim, Betty was staid in her appearance (no makeup, flat shoes, tailored suits) and she loved women.[38] She was also a sculptor who had worked alongside Giacometti in Paris and could see that whatever the downside of representing Jackson might be, the upside was that she would have a chance to support an artist whose work she greatly admired. "I was born with a gift for falling in love with the unfamiliar," she said. "Actually, being an artist gave me a jump on other dealers—I saw things before they did. Most dealers love the money. I love the paintings."[39]

Betty and painter Barney Newman, who advised her, went to Springs to meet with Jackson and Lee. "At one point he sat on the floor and made a beautiful drawing for me which I call the *Ballet of the Insects*—it's so alive!" Betty recalled of Jackson. "I was fascinated and told him I would like to have him."[40] Peggy agreed to continue paying Pollock a monthly stipend for a year to ensure that he had the funds to paint, if Betty signed a contract saying she would represent and exhibit him. During that year, Peggy would receive all the proceeds from the sale of Jackson's old work, as well as any paintings that had not sold, while Betty could claim a commission on the sale of his new paintings. Parsons agreed.[41]

Betty's was not the only new gallery in town. The scene on 57th Street was changing. After the war, Americans were flush with cash but had no place to spend it because the industries that produced the consumer goods people craved had not yet been fully reconverted to civilian purposes. So, while waiting to buy that new car or refrigerator, some had decided to spend a few dollars on art. When asked why he and others collected, one Wall Street broker said, "It's just a fad...like those miniature golf courses."[42] Of course, there was more to it than that. During the war, the patriotic programs at museums had attracted new audiences. Museums began to be viewed as American institutions, not mausoleums for dead Europeans or warehouses of artifacts. The Modern was even rated the fourth most popular tourist attraction in a survey of soldiers on leave from the military.[43] Amid that increased attention, 1945 would prove to be a banner year for gallery sales, and while the majority of art sold was European, or American versions of European art, a few adventurers purchased paintings by artists working in New York. They were new collectors, generally under the age of forty-five, who sensed something was happening and wanted to "get in on the ground floor."[44]

Though most of the galleries that had opened after the war had no interest in advanced art, several showed a mixture of recognized names and a newcomer or two. It simply wasn't financially feasible to do otherwise. Sam Kootz had been able to show the likes of Motherwell because he made money selling Picassos.[45] Julien Levy took a chance with Gorky, but that was only after his gallery had amassed a client base of Surrealist collectors.[46] And if galleries were reluctant to show the avant-garde New York men, they were loath to show the avant-garde New York women. (Kootz said he would never show women because "they were too much trouble.") To collectors, and therefore to the dealers who depended upon them, "genius" was a word that could only be applied to a man.[47]

Women who had worked in New York in equality and obscurity beside their male colleagues since the Project had had a preview of the changing perception of women as artists with the arrival of the Surrealists, who revered and objectified them to better contain and control them. Some American men had adopted that attitude, but it hadn't pervaded the scene or had any tangible impact other than as an annoyance. Personal sexism could not keep an artist from expressing herself. Institutional bias on the part of galleries and museums, however, could. It would impede a woman's ability to show her work, and that would create a caste system: professionals who exhibited, and amateurs who did not, with women consigned to the disenfranchised latter category.

The critic who reviewed sculptor Louise Nevelson's first major show unabashedly illustrated the official art world's reaction to women: "We learned that the artist was a woman in time to check our enthusiasm. Had it been otherwise, we might have hailed these sculptural expressions as by surely a great figure among the moderns."[48] In that environment, it would take a woman made of tough stuff to continue. It seemed that the wider the art world grew, the fewer the opportunities for women in it. That meant that just as Lee began producing her best paintings, her hopes of exhibiting diminished. And still she persisted.

> I couldn't run out and do a one-woman job on the sexist aspects of the art world, continue my painting, and stay in the role I was in as Mrs. Pollock. I just couldn't do that much. What I considered important was that I was able to work... You have to brush a lot of stuff out of the way or you get lost in the jungle.[49]

Lee was not alone. Life for an artist, any artist, was difficult. There were few rewards other than the most important, which was satisfying one's need to create. But in the art world of galleries, collections, and museums that the avant-garde artists in New York would inherit in the late 1940s,

the difficulties experienced by the men who painted and sculpted would be nothing compared to those of the women. Society might mock the men's work and disparage them for being "bums," but at least they were awarded the dignity of ridicule. Women had to fight with every fiber of their being not to be completely ignored.[50] In a treatise on men and women in America published at the start of the war, author Pearl S. Buck wrote,

> The talented woman...must have, besides their talent, an unusual energy which drives them...to exercise their own powers. Like talented men, they are single-minded creatures, and they cannot sink into idleness, nor fritter away life and time, nor endure discontent. They possess that rarest gift, integrity of purpose.... Such women sacrifice, without knowing they do, what many other women hold dear—amusement, society, play of one kind or another—to choose solitude and profound thinking and feeling, and at last final expression.
>
> "To what end?" another woman might ask. To the end, perhaps...of art—art which has lifted us out of mental and spiritual savagery.[51]

Lee was that single-minded woman whose focus was art. But the art that preoccupied her was her own and her husband's. She lived and worked for two people, which was a natural course for a woman of her temperament and generation to take. Beginning with Elaine, however, some of the younger women coming after Lee—daughters of another time—would refuse to accept a similar place in the relative shadows. As much as they may have respected her, Lee would become an example of what they would *not* do. The New York art world was teeming and vibrant, the conversation scintillating, the work being produced wonderfully unexpected. They wanted to be part of it and, no matter the cost, would demand to be heard.

15. Separate Together

> The only way for a woman, as for a man, to find herself, to know herself as a person, is by creative work of her own.
> — Betty Friedan[1]

BILL, ALONG WITH Elaine's brother Conrad, struggled to lift a refrigerator up the five flights to the de Koonings' new apartment on Carmine Street. It was the only thing they brought with them—besides painting equipment, clothes, and linoleum—after being evicted from the loft on 22nd Street. The new place was city-rough: one and a half rooms, with hot water but no heat, a bathtub in the kitchen, and cockroaches scrambling over every surface.[2] Prayers to "Santa Kerosena" had produced a portable heating stove, but that and the fridge were the only items in the flat that provided a modicum of comfort or convenience. Given that his one attempt to construct a home had failed so miserably so quickly, Bill wasn't inclined to undertake renovations, though he did install a six-foot mirror to create the illusion of space.[3] Elaine, for whom the state of depression did not exist, put a brave face on their diminished circumstances by declaring that while the apartment wasn't great it did offer "a terrific view of Seventh Avenue."[4]

All the Fried children had a strain of the savior in them, and Conrad was no exception. Tall, exceedingly thin, and in no way a pugilist, he had been rejected by the military because he had lost his teeth in a fight coming to the aid of a passerby who was being set upon by a thug.[5] When Bill and Elaine made their move to Carmine Street, he seemed to have decided to try a similar rescue—of their marriage—by nudging his sister along the path of traditional wifely duties. Conrad would have known better than anyone that he had as much chance of success with Elaine as he did against the mugger, but he felt duty bound to try. Elaine's siblings had become close to Bill, and perhaps he feared they would lose him if the estrangement between Bill and Elaine over her Provincetown trip turned into a formal separation.

Conrad began his campaign by hanging a clothesline on the roof of the Carmine Street building so Elaine could wash clothes in the bathtub and hang them out to dry. Intrigued by a new experience, Elaine washed a set of sheets and hung them on the line. Six months later, Conrad was dismayed to find them considerably grayer, still flapping on the roof.[6] Elaine was who she was, consistently, no doubt maddeningly for those who wanted her at the age of twenty-eight to "grow out of it," to become a

responsible woman and a good artist's wife. She, however, could be neither, especially as such creatures were defined in those times.

After the war, in addition to abandoning paid employment, an American woman was supposed to forget any independence she might have enjoyed during the years of mass mobilization. Instead, according to *House Beautiful* magazine, she was to allow her husband to reassert his authority over her and their home. "He's head man again," the magazine cooed. "Your part in the remaking of this man is to fit his home to him, understanding why he wants it this way, forgetting your own preferences." Two psychiatrists, who wrote a best-selling guide for the postwar woman, suggested, "She should be ever ready, upon the homecoming of her husband, to be a spiritual companion, tricked out like a débutante for a cocktail party."[7] Irving Berlin's 1946 hit musical *Annie Get Your Gun* ridiculed women who had entered the world of men and wanted to stay there. His lyrics summed up the ideal "new woman": "A doll I can carry, the girl that I marry must be."[8]

As for being an artist's wife in the accepted mold, that would have required a self-abnegation of which Elaine was incapable. Lee said some of the women married to painters "never opened their mouths. You didn't know they had an opinion."[9] Others were assigned a "lesser" role of breadwinner. Yet the fact was that many of those women enjoyed their work outside the home. "They were kind of proud of the fact that they could make a decent living, it really wasn't a put down at all," said Jeanne Bultman, who was married to painter Fritz Bultman.[10] Those careers, however, didn't involve making art. And that was what Elaine wanted, even if it opened her up to criticism from friends who tut-tutted that she should have been doing more to support Bill. "What Elaine wanted was what [Bill] wanted, a studio and a career," Conrad said.[11]

Bill and Elaine each took corners of the Carmine Street apartment as "studios." There was not enough space to paint in separate rooms so they established privacy by facing in opposite directions. But it became impossible for either of them to work. Bill had memorized an aria from *The Magic Flute* and whistled it while he painted. (Bill's future assistant, Edvard Lieber, pointed out that the aria in question, "Queen of the Night," began with the line "The revenge of hell boils in my heart.") If things weren't going well with his canvas, Bill stormed around the studio, knocking over chairs, throwing brushes, cursing, and kicking.[12] Concerning Elaine, Bill had his own complaints. He said she painted like Gorky. While Bill worked for five minutes and looked at what he had done for twenty hours (according to Elaine), she stabbed and thrust at her canvas before stopping abruptly and rushing off to the next activity.[13] Once, Elaine pushed past Bill, saying by way of explanation, "I've got a deadline," to which Bill

replied, "Don't mention death in the house."[14] At such close quarters it was impossible for them to communicate. "There was a lot of conflict about who could work there and who couldn't," said Joop Sanders.[15]

Bill decided he needed a separate studio and managed to find a second-floor space across from Grace Church on Fourth Avenue. Conrad described it as "cold and dingy and decrepit." At thirty-five dollars a month, it was also expensive. With the Carmine Street apartment's rent of eighteen dollars, he and Elaine would be paying more for the two places than they had for the loft they hadn't been able to afford on 22nd Street. It was, however, a matter of creative sanity.[16] The new arrangement suited them both.

For the first time, Elaine had a studio of her own where she was able to lose herself in the process of painting. She could finally travel into that world outside reality where time was suspended, where all activity ceased but one, where the hand struggled with brush and color to record the imaginings of a mind that soared. With her newfound freedom, and faced with the six-foot mirror Bill had installed in their apartment, Elaine began to paint the most obvious subject available—herself. In 1946, she embarked on a year of self-portraits.[17] It was an important and liberating exercise. There was no need to concern herself with a sitter's response to the work; she could take as many chances as she liked while trying to make something new of the age-old art of portraiture. There was also something else happening, and it was most likely unconscious.

While Elaine studied herself in the mirror, interpreting what she saw on canvas, she may have also been searching for her identity as an artist. She had established a social persona independent of Bill, but creatively she was still very much under his influence. She unapologetically described herself as his passionate student, in the way artists historically were attached to and inspired by a respected teacher.[18] But that sort of relationship inevitably produced a gnawing creative discontent. Undoubtedly, she did not expect to surpass Bill—she had far too much regard for his singular talent—but she *did* want to produce "something unique." "I don't think artists ever say, you know, we're going to be making new art," Elaine explained. "But whatever each artist is doing in his studio, you always feel you're committed to doing something new, because if you do something that's already been done there's no point to it."[19] For a woman married to an artist, there was an even greater risk than mimicry. Germaine Greer described the phenomenon, which she called "as old as painting itself":

> Too often women must love where they admire, and admiring emulate, and by emulation are absorbed into the myth of the master, in which they are the most fervent believers. Only if the woman artist begins to count the cost, to jeopardize her sexual happiness by restless competition or struggles

for freedom, does the outside world even guess that an individual talent is at stake.... For every woman artist who struggled to assert herself against the power of love, there are literally hundreds who submerged themselves so willingly that their activity has left no perceptible trace.[20]

Submission, submersion, anonymity, retreat—perhaps another woman in her situation would have chosen those paths, but Elaine didn't entertain such possibilities. "She wasn't the type to say, 'Oh Bill, can I wash your brushes for you?'" said Elaine's friend Bill Berkson. "There wasn't a backseat character to her."[21] Elaine would assert herself. She simply had to find the right way. Conveniently enough, it was Conrad who would provide the avenue.

Elaine had been at Bill's studio one evening while he gave a private lesson on portraiture using a male model. Elaine liked the fold of the model's clothing. She liked the way the shirt and slacks, tie and jacket divided his body into halves and quadrants. "Then I began to make drawings of my brother, Conrad, and the paintings from them kept getting larger and larger until they were life-size."[22] What became important to her as she worked was the body dissected by clothing, and how a particular sitter appeared when at rest. She discovered that each person had a pose that was as revealing as a confession. "Some men sit all closed up—legs crossed, arms folded across the chest. Others are wide open," she said. "I was interested in the gesture of the body—the expression of character through the structure of the clothing."[23] Elaine's approach didn't rely on facial expression. In fact, she began eliminating the face altogether; it no longer seemed critical in describing a person.[24] "I worked on them for months with small strokes, and I wanted the action in the paint, and to be on the surface, the action of the strokes of paint," she said. "And I worked by canceling out, by painting over and over to find the contours."[25] Elaine's portraits succeeded because she augmented the painterly technique she was developing with a personal quality that infused all her endeavors: empathy. Conrad said that in approaching a portrait, Elaine developed a "psychological relationship with the model":

> In carefully studying the features, she would seek that beauty of individuality which she could admire.... She would try to generate in herself a certain sympathy, almost a love, a real intuitive, maternal-like nurturing feeling for him or her.... Other viewers could sense it too, in the work. Thus a portrait was created not only out of her expertise, but also out of expression of her true feelings.[26]

Amid her focus on the interaction of brush and canvas, and the personality of her sitter, Elaine initially had little time to consider her paintings in

the larger context of artistic tradition. But when she did, she was stunned by the realization that she was inadvertently engaged in an act of rebellion. "Men always painted the opposite sex," she said, "and I wanted to paint men as sex objects."[27] Elaine's men were hardly sex objects. Usually clothed in shirt, tie, and slacks, they looked as if they were sitting down for a chat (which was, in fact, how she began her portrait sessions and her secret for easing the sitter into his natural pose).[28] The point she was making was that she wanted to upend tradition. Historically (aside from exceptional cases like Artemisia Gentileschi and Rosa Bonheur) women had painted women, children, and sexually neutral themes because it was not deemed appropriate for a woman to be alone in a studio with a man if the woman were the dominant figure—the artist—rather than the muse. Society portraits and court portraits were often done by women, but again most of the subjects would have been women or children. Only men were deemed powerful enough to capture the essence of other men. Elaine defied that convention and claimed men as her subject, and she did so in a way that reflected not only the specific man in front of her but the status of men in general in the years after the war. Later, Elaine would call these paintings "Gyroscope Men."[29]

The reference to men and gyroscopes was not original to Elaine. It had appeared in a book that was so popular it was said to have changed American society. Called *The Lonely Crowd,* its author David Riesman described the isolated, terrified, impotent men of the postwar world. They were caught up, he said, in a revolution more profound than any since the birth of capitalism because American society was moving "from an age of production to an age of consumption."[30] Not only were men subject to a general anxiety arising out of the war, but they no longer understood their function in society. American men had been born to do, to make, to take initiative. But what was the role of a man in a consumer age when one did not make, one bought? The answer was to conform. And in conforming, in blending in, according to Riesman, men no longer needed an internal dictate—what he called a "gyroscope" and what others have called a "compass"—to keep them balanced and functioning within society. Fear and worry had replaced it. In the consumer society born out of the war, men did not lose their balance because they rarely dared to step out of line.[31] Elaine painted individual men who intrigued her because they had so dared, because they relied on their own internal bearings, because they were men who still had "gyroscopes." Not surprisingly, most of her subjects were artists.

Bill and Elaine considered Carmine Street to be Elaine's studio and their shared home. "We held to a kind of schedule," Elaine said. "We'd like to

get up late in the day, go to our studios, and then work until about eleven at night. Then we'd be beat and we'd stroll up to Forty-Second Street. We'd walk up and down the street and then go to a movie, and come out around three or four in the morning. Then we'd walk back home."[32] While theirs wasn't the "old-fashioned family setup" Bill had wanted, he had found part of what he sought: his own studio, even a wife who loved him deeply in her own independent way.[33] Dinner, however, would never be part of the equation. ("I found an egg in her fridge one time and it had been in there so long it was an empty shell," said Conrad's son, Charles Fried. "You would eat anything from her refrigerator at your peril.")[34] By the time Bill was established on Fourth Avenue and Elaine on Carmine Street, he seemed prepared to overlook that domestic failing. Bill and Elaine had found a way to continue as a couple who traveled together but not in lockstep.

After the war Bill had discovered that his family in Holland had survived those years of conflict and Nazi occupation. He wrote his father to tell him about the changes in his life in America while they had been out of touch. About his professional life, he wrote, "If I will ever be a great painter is something for other people to find out. I am content to just be a painter." About his personal life, he said he'd "married a beautiful woman and she sends you a big kiss." He enclosed two photos and Elaine kissed the letter, leaving a red lipstick print next to which Bill scrawled, "She says her lips are larger in reality."[35] Theirs was still a playful, sexual relationship. Around that time, Elaine became pregnant with Bill's child. "To get birth control you had to go to the Margaret Sanger Clinic. You felt like you were breaking laws," Elaine said.[36] She might have turned to her sister Maggie for help, but Maggie had taken work at U.S. consulates in Morocco, Turkey, and Belgium. Ernestine was the next closest thing Elaine had to a sister and, so, it was to her that Bill went to ask for a loan to pay for an abortion.[37] Bill wanted a child; it was simply a matter of not being able to provide for one. In the future, he hoped he could. Elaine, however, was deeply ambivalent about motherhood.[38]

The decision of whether to have children confronted almost every woman artist in their group, and the choice for most was wrenching. It was difficult enough to be taken seriously as a woman who painted or sculpted amid the increasingly powerful forces that had begun to assemble under the banner "art business" in the late 1940s. Adding the word "mother" to that already damning description would almost surely condemn her to a life of artistic isolation and indifference. There was also the practical factor of time. Elaine said that being a mother and being an artist were both more than full-time jobs. She would describe the moment when she realized she could not be both:

I decided to test out the idea. I borrowed a baby. It was easy. A friend had a baby, an adorable little baby. And she wanted to take a trip, so I volunteered to take care of the baby.... I thought it was just terrific fun.

So my friend left and I had this adorable baby in my studio. When I fed the baby, it closed its eyes and snuggled up against me. It smiled at me. And if I offered my hand, it kicked and gurgled and grabbed my fingers....

So I fed the baby and the baby went to sleep and I started painting.... Pretty soon, I started worrying that the baby might be too quiet. So I tiptoed over to check on the baby. It was just sleeping sweetly. And I went back to work.

After a while, I realized I was whistling while I worked and I stopped so that I wouldn't disturb the baby. Then, just as I would be getting really into my work, I would find myself worrying about the baby. The baby was just on my mind all of the time....

At the end of the weekend, I knew that I couldn't have a baby around and be a painter.... I would never be able to concentrate on my work. And that was that. No baby....

Well, a woman was just supposed to have children, and it took me a long time to say that that was not always a good idea, that it was not always the best thing for a particular woman.[39]

Her decision, however, was not Bill's, and she knew that there would come a time when she must either put aside her art and have a child or tell Bill she could not give him the family he wanted. In Springs, Lee and Pollock had already had that discussion and the result had been disastrous.

Like Bill, Pollock wanted to be a father. May Tabak said when she watched Jackson playing with her daughter, Patia, or the Kadishes' offspring, it was evident "he was crazy about children."[40] By the time Lee and Jackson had settled in their house, Lee was thirty-eight and her childbearing years were quickly slipping away. Jackson apparently thought the time had come to begin a family. When the subject arose, however, Lee's answer was a definitive no, which she stated in front of witnesses. Pollock went "berserk," May said. "The whole thing was to be married and have children."[41] He accused Lee of "tricking" him into marriage. "I think he was destroyed in part," May said.[42] Lee, however, felt she already had a child in her alcoholic, emotionally fragile husband, and another would have been more than she could bear.[43] Pollock's fantasy of a wife, children, and a farm had been a little like Bill's fantasy of a beautiful, compliant wife ensconced in the loft he had built for her—imagined without assessing whether the women they chose as partners would want the roles envisioned for them.

Lee and Pollock's bucolic life at Springs was disrupted by the dispute over children. They did not discuss it. Much more dangerously, it was allowed to

fester and mutate. Lee became gripped by the fear that if she didn't give Jackson a child, he might leave her for someone who would. The Motherwells would be the first to fall victim to a misunderstanding arising from her troubled state. One day after Lee had been out, she came home to find that Jackson had taken Bob's new MG convertible out for a ride with Maria Motherwell. Lee, no doubt aware that Motherwell and Maria were having marital problems, that in fact both were having affairs, responded in a jealous rage and "banished" the Motherwells from their home. Not knowing what had happened, Bob came over several days later to be greeted by an apologetic Jackson, who said, "Lee forbids me to see you anymore."[44]

Lee became a gatekeeper, restricting the types of people she invited to visit their house: only those who could further Jackson's career, friends who would not encourage his drinking, locals upon whom they depended, some family members, and Lee's friends. Her actions were directed toward a single goal, to create an environment in which the sole focus of their lives was painting, and under her control as much as humanly possible. That limited focus, that effort at greater discipline, however, only added to Jackson's distress (and no doubt her own), causing him to rebel against her. Pollock began taunting Lee with younger women. (He kept two pictures of Mercedes in his studio, one of which showed her nude on the beach.)[45] It is likely, given the intensity of Lee's and Pollock's personalities, that their relationship would have followed a tumultuous course even without the betrayal Pollock experienced when Lee told him she didn't want to have his child. But that decision would haunt them and ultimately become part of the drama surrounding Jackson's early death.

Bill and Elaine had been able to more easily weather their baby storm than Jackson and Lee, perhaps because they were in a larger community in the city and had separate, active lives. But for them, too, it was a subject that would resurface and ultimately drive them apart. That, however, wouldn't occur for another decade, and in the intervening years they reigned together as a couple over the downtown scene.

Elaine liked to think of herself as a modern-day version of the hetaerae of ancient Greece, a comrade to and companion of intellectual men, a woman who was equal to them and treated as such. "I thought that was a very nice role...women who were involved with intellect, and art, and so on, and in the company of men," Elaine said.[46] Such behavior had not raised eyebrows in Chelsea when she was younger because most of the men Elaine associated closely with then were gay. As a result, she hadn't risked alarming anyone's wife if her conversation veered, as it often did, into the realm of flirtation. But after the war, as the social circle emanating out of the Waldorf grew—in part with returning GIs (almost all heterosexual) who

had been attracted to the downtown art world—people unacquainted with Elaine didn't know what to make of her eagerness and accessibility, her open sexual charm. Once, during a dinner party Elaine attended, the hostess on leaving the room invited the women to join her so the men could stay behind at the table and talk. Elaine remained seated, engaged in conversation with the man next to her. The hostess came up behind her and said, "Come join us, Elaine."

"Oh, I'm perfectly happy here," she replied.

"You must come," said the woman, shaking Elaine's chair. "You can't stay, it just isn't done."

"Well, it *is* done," Elaine said. "I'm doing it."[47]

Elaine would have responded similarly as a child had she been told she shouldn't play hockey, or shoot dice, or play with the local boys at her grandfather's farm upstate.[48] But coming when it did, in the late 1940s, Elaine's preference for the company of men was viewed quizzically if not suspiciously. America's social upheaval had included the area of sex, and it was a most confusing time in that regard. No one knew any longer what was appropriate. Like the role of women in society, American mores had swung sharply one way—toward liberality—during the war, and just as violently back toward puritanism when the conflict ended.[49] Between 1941 and 1945, licentious behavior had been almost encouraged. Taboos against premarital sex, extramarital sex, and contraceptives existed but were largely ignored. At the end of the war, not only had veterans returned more sexually experienced than when they left, but living those many years in a community of men, in which the women they encountered were often viewed as mere sex objects, had changed them. Demeanor, manners, language had all coarsened.[50] Society could neither tolerate nor condone such behavior. Strict controls were introduced.

Red-light districts were closed. Books and movies were censored, women's fashions were designed to hide real curves under layers of false ones. Christian Dior set the pace for skirts, which flared so wide over a multitude of slips that there was no possibility a woman might be suspected of having legs underneath them. "When a girl took off her underpants in 1947," Anatole Broyard said, "she was more naked than any woman before her had ever been."[51] In addition to no longer having bodies, women were also expected to be without minds. An American Museum of Natural History exhibition in New York in 1945 described the ideal "normal girl" as one who exuded an "air of innocence" or "lovely puzzlement."[52] She was meant to civilize the returning soldier through her gentle naivety. And, to minimize sexual temptation, men's worlds and women's worlds were conspicuously separated. Each had socially proscribed spheres of activity inside and outside the home.

In the society of artists, however, those rules were neither observed nor necessary. There was an innocence among the Waldorf crowd in those early days. Alcohol hadn't yet become a factor—they mainly drank coffee—and many of the men of that First Generation were "old-school gentlemen."[53] Elaine was accepted among them, a full participant in all discussions and escapades. Slim in her fitted skirts and short-sleeved blouses, elegant despite her poverty, and oozing femininity, Elaine was considered one of the boys. "She was striking a new role for women," said artist Natalie Edgar. "It's risky stuff even if you were fully secure in yourself."[54]

Among the newcomers to the cafeteria was the charming son of a Scranton coal miner, Charles Egan. Charlie had begun selling art at Wanamaker's Department Store, before he found work at the very respectable 57th Street gallery J. B. Neumann. During the war, he had begun to hang around the Waldorf, frequently complaining to that crowd that he wanted to quit his job because of how servile he had to be to Neumann's clients to make a sale. And in any case, he wanted to show the kind of "real art" being produced downtown. The artists cheered him on, and when in 1945 he found a tiny space (two rooms and a closet on 57th Street), Resnick, de Kooning, and Isamu Noguchi helped him with everything from wiring to painting the walls.[55] Elaine, meanwhile, set out to organize artists to show with him. "I think Elaine was the real prime mover in a sense," said artist Peter Agostini, referring to Egan's gallery. Whoever was responsible, within three years of Egan's first show "the gates were opened up and everybody, the rebellious art crowd, became free," said Philip Pavia.[56]

In 1947 Egan was thirty-six, a bachelor, small, dark, intense, and irresistibly reckless. Pavia called him a "wild Fauve. Born and bred in the Waldorf Cafeteria."[57] Elaine, then twenty-nine, saw in Charlie a kindred spirit. Like her, he was continually "on." He and Elaine "gamboled at parties together, after they did handstands all over the gritty sidewalk at four in the morning, and stole freshly delivered strawberries waiting in front of the still closed gates of the A&P to distribute in the baskets to all the front doors of their still sleeping friends at five," wrote Edith.[58] Rumors began to circulate that Elaine and Charlie were lovers. Indeed, Egan was infatuated with Elaine and, eventually, they would have an affair. But at the start she appeared to be simply enjoying the company of a man who was younger and less complicated than her husband.[59] For his part, Bill may not have noticed or cared much about Elaine's new companion. He, too, had a new friend.

Though the group that would come to be known as the Abstract Expressionists formed a tight and supportive community, there was, especially in later years when fame and money became a factor, a strong undercurrent of sniping. Franz Kline alone escaped such criticism. He was routinely singled

out as the best among them, the warmest, the kindest, the funniest, even (and despite a bad leg) the best dancer! In his early years in the Village, before becoming part of the abstract crowd, he had worked as a street artist painting caricatures in bars and restaurants.[60] Many of his works depicted sad clowns. Kline *was* a sad clown. His life had been clouded by pain from the time he was a boy, and yet he had kept smiling, and the magic of his personality was that he was able to make those around him do so as well. "You see in his own way there was this kind of style, the way he danced, the way he lived, the way he dreamed," wrote Conrad Marca-Relli, who would share an old mansion with Franz on Ninth Street. "There was a very great poetry and I think that's what he brought into his painting.... This kind of romanticism—he was a great romantic."[61]

Like Bill's mother in Holland, Kline's immigrant father had a tavern in Pennsylvania, but he killed himself when Franz was seven. That began the future artist's odyssey of misery. His mother kept two of her children with her but sent her older children, Franz among them, first to an orphanage and then to a trade school for fatherless boys. Along the way he had exhibited a talent for art, and when he could finally choose his own course, he set out to follow the path so many artists had trodden before him—to Paris. Franz only got as far as London, however. There, while studying, he met and eventually married an artist's model and former ballerina, Elizabeth Vincent Parsons. They were back in New York in 1938 as Europe began its descent into war.[62]

Perhaps Elizabeth had not expected life in New York to be so difficult. Amid their poverty and with the full onset of war, she began to deteriorate mentally.[63] "The English being so besieged affected her. It upset her terribly. I think she had a nervous breakdown," Pavia said.[64] They moved to Brooklyn, Franz thinking a rural environment would soothe her. It didn't. As the news from Europe worsened, Elizabeth "began hallucinating, insisting that there were Nazis on the roof of the house in which they were living," wrote Kline's future companion, Betsy Zogbaum. "To reassure her, Franz climbed up to the roof. But it was useless. She began to withdraw." They moved back to the city—Franz, Elizabeth, and their dog—and into an apartment above a bar.[65] Kline began to draw her without any facial features. He told a friend, "She isn't there anymore." In 1946, Elizabeth was diagnosed as a depressed schizophrenic and institutionalized for six months.[66] It was during that period that Kline began obsessively drawing an empty rocking chair that, three years later, he would blow up into black-and-white masterpieces that became his signature works. He had also begun hanging around the Waldorf. "He'd come see us every night, that meant that his wife was locked up," Pavia said.[67]

Franz and Bill, who was six years Kline's senior, would develop one of the great friendships in modern art history. They were comically alike physically—both men were short and squarely built—but of opposite styles

and shades. Bill dressed in work clothes, his white-blond hair shaggy, his face clean-shaven. Franz sported a dapper mustache and had thick black hair that he oiled and meticulously combed back from his forehead. He dressed like a gangster, in loose-fitting secondhand suits and a black fedora. "Their talk moved back and forth between the present and the past as if there were no break between," recalled William Barrett, who watched them together as Kline sketched in the air with his stubby fingers to illustrate what he was saying.[68] They could also commiserate about women. Neither of their marriages had turned out as they had hoped. And they cracked wise, with Kline laughing harder than anyone at his own jokes. Tragedy, comedy, he wore them both well, and his spirit was contagious. He was a little like Elaine in that he always wanted to be at the center of the action. "Hell, half the world wants to be like Thoreau at Walden worrying about the noise of traffic on the way to Boston; the other half use up their lives being part of that noise. I like the second half. Right?" he famously told the poet Frank O'Hara.[69] Gradually, Franz would replace Gorky as the de Koonings' artistic brother. Kline's response to his tragic past could not have been more different from that of the Armenian friend whom they loved but whom they had drifted away from.

During the war, Gorky had been absorbed by the Surrealists around Breton and had begun to travel in a wealthy circle despite his own continued poverty. His first solo show, at Julien Levy's gallery in 1945, was panned by the critics but widely praised by fellow artists and the society around the Surrealists.[70] Gorky was ill-suited to the attention he had begun to receive. In November 1945, he was shocked to discover when he arrived at the Whitney Annual that he was viewed as a celebrity by younger painters. Gorky exhibited there "his *Guernica*." Painted during the summer of Hiroshima and Nagasaki, Gorky's *Diary of a Seducer* was done in the heavy gray color of nuclear ash. There were forms underneath the cloudy surface and forms trying to emerge from thick haze, but the overall tone was one of death and suffocation, of an age without a sun. Artists in New York had been disappointed by Picasso's response to the war. They had expected that he would produce a statement on the global destruction as strong as his statement on the Spanish Civil War. That had not happened. Picasso, they believed, had gone "soft." But wonderfully, perhaps predictably, the New Yorkers recognized that they no longer had to look to Picasso to speak through art. Harold Rosenberg called *Diary of a Seducer* a masterpiece. Other critics, including Clem, weren't impressed. Though he had only been a critic for three years, he flippantly disparaged the veteran Gorky as a Surrealist has-been.[71]

The Whitney show and Gorky's magnificent painting might have been a triumph for him. Instead they marked the start of a year of personal and artistic trauma. He and his family had moved to a Connecticut farm they

had rented, but in January 1946 the barn where Gorky painted caught fire. When the fire trucks arrived, Gorky was on the ground weeping as his work burned up inside. He lost twenty paintings—three years of work. Soon after the fire, Gorky was diagnosed with colon cancer. Operated on in March, he was given a colostomy bag and told he would be impotent.[72] By the winter of 1947, he was living alone in Connecticut because he was so out of sorts that everything his wife and children did annoyed him. He was also extremely jealous. "Gorky didn't live the sort of life that Elaine and de Kooning did," said his wife, Mougouch. Amid his mounting troubles, Gorky had stopped making Mougouch laugh. A young, free spirit, she decided to find someone who could.[73]

At the December 1947 Whitney Annual, Gorky finally received critical praise—even from Clem—and, appearing in fine clothes at the opening, seemed to have everything.[74] That, in any case, was how it likely looked to Elaine, who may not have known how hollow Gorky's life had become. She also could not have helped but wonder why Gorky and not Bill was represented by a gallery and heralded by critics. The problem, she knew, was not Bill's work. It lay with the painter himself, who Elaine said was born with "divine discontent." "There was once a masterpiece Bill had painted...and it was just fantastic. This red paint, and kind of poured all over the surface," Elaine remembered. "And the contour of that circle was just so tense. And when I came home that night, the painting was gone. And I said, 'What happened to the painting?' And he said, 'It looked too much like Miró.' Well it didn't. But he had that idea and so he painted it away, and I burst into tears, I mean, I just was brokenhearted."[75]

Elaine feared that Bill's mania for perfection would ensure that nothing he did would ever be seen outside his studio unless she intervened. Months before, she had begun plotting a way to force him to complete and relinquish his paintings. "I and this friend, this dealer Charles Egan, decided that the only way to get Bill to really finish a body of work was to give him a date for a show a good distance off," Elaine said. "So we set up a date in April of 1948....And then Bill somehow had that date in the back of his mind and [as] Samuel Johnson said, 'Nothing sharpens a man's mind like the threat of the gallows.'"[76]

Curiously, Elaine did not try to show with Egan herself. By the time she arranged Bill's exhibition, she had a body of work and could have easily mounted one, and without doubt Charlie would have been eager to do her that favor. But Elaine suffered from the same malady for which she chastised Bill: She was never satisfied with her paintings, they were never quite what she was after. Soon, they would be. Within the next three years, Elaine and all the artists of the First Generation Abstract Expressionists would find their style and, in doing so, give birth to a movement.

16. Peintres Maudits

> Under the circumstances, there is no use looking for silos or madonnas. They have all melted into the void. But, as I said, the void itself, you have that, just as surely as your grandfather had a sun-speckled lawn.
>
> —*Harold Rosenberg*[1]

IT WAS, IN fact, never intended to be a movement. It was a "Romantic revolution" as had occurred historically after other times of great upheaval, and it affected not just painting but all the arts.[2] Dancers, composers, poets, novelists, playwrights, painters, and sculptors in the United States and abroad had been handed a broken world and given the task of reconstructing its spirit. Someone was needed to write the symphonies and hymns to inspire, yes, but also to express the echoed memories of gunfire and screams. After years during which activity had been restricted by war and occupation, choreographers were needed to reinvent motion, liberated from tradition and unhindered by rules. Writers? Words were needed to make sense of what had happened and what was happening still. There were, of course, the daily reports in newspapers, but those words described events. Someone had to ascribe meaning. That would require poets to touch the soul, playwrights to stimulate the mind and eye, novelists to imagine new realms from which readers might emerge with a greater understanding of themselves and the world they had inherited.

Visual artists, however, had perhaps the most difficult task. They had to engage eyes dulled to near blindness by a decade of devastating images and a subsequent ad campaign that employed chipper illustrations exhorting them to forget that past, to "take it easy," to "cheer up."[3] "It was a question of finding your own reality, your own answers, your own experience," said artist John Ferren. "We tried to make a clean slate, to start painting all over again."[4]

That quest for an original vision and the means to execute it was a curse and a blessing. On the one hand, it "weighed heavily on them and, in some cases, brought them to despair," said art historian Dore Ashton, who at eighteen had begun living among the artists in the Village.[5] Bob Motherwell described the state as an "anxiety close to madness." On the other hand, the necessity to find something completely new was immensely liberating. Each moment, Motherwell said, was "focused and real, outside

the reach of the past and the future, an immersion in nowness that I think noncreative persons most commonly parallel in making passionate love... or perhaps in their dreams."[6] If they had been trying to paint a Cubist picture as Hofmann's students had done, they would have known the steps to take.[7] But in beginning anew, with only a notion that they wanted to convey their own deepest, wordless selves, there was no guide. There was only the void that Harold Rosenberg had described. "Some of us found monsters. Some of us found *a* painting. Some of us found painting," Ferren said. "These were 'real gone' times, and I do not recommend them without reservations."[8]

As a student at Princeton in 1950, William Seitz would write the first doctoral thesis on the Abstract Expressionists. (It had required the intervention of Alfred Barr to persuade Seitz's advisers to allow it.) In it, he described the artists collected under that banner as "astonishingly pure," concerned as they were with "creation over destruction, humanism and naturalism over mechanism, freedom over regimentation, truth and reality over falsehood and sham, inclusiveness over chauvinism."[9] As for the differences between the New York artists and those who preceded them, he wrote,

> The painter of the past, as a functioning unit of society, painted the public myth, ritual, and propaganda of his time, whereas the modern turns to his inner experience...not necessarily because he is so egocentric...but because private experiences have become the chief, and often the only, ones which he trusts.[10]

Seitz had said the artists were "pure," but they were also—quite without intending to be—courageous. The paintings and sculpture that would be produced in New York during those years were entirely out of sync with American society. Abstract Expressionism was "highly extreme art when the dangers of extremism—political and aesthetic—were widely and loudly decried," wrote art historian David Anfam.[11] To some in government, individual expressions such as theirs were interpreted as socially incendiary. In 1947, a book illustrating the dangers of modern art, titled *Mona Lisa's Mustache,* warned, "In 1914 Kandinsky arrived in Russia and three years later came the revolution." (A *New York Times* critic praised the book.)[12] Modern art had survived the "hot war" during which dictators and fascists had tried to silence its practitioners in Europe, only to become embroiled in a new conflict, the Cold War.

The guns of the Second World War were barely silenced when a new struggle between communism directed out of Moscow (said to be in

defense of socialism) and capitalism as directed from Washington (said to be in defense of democracy) began. It was a battle for influence between two ideological extremes and a race to secure the spoils of war, which at that time amounted to broken countries with shattered economies and people who craved nothing so much as peace. The United States had emerged from the war infinitely richer financially and custodian of the most powerful weapon on earth. But the Soviet Union had the larger standing army and had been able to occupy "every capital in Eastern Europe except Athens and Belgrade." British prime minister Winston Churchill had warned in a speech in Missouri in 1946 of an emergent Soviet bloc that would create an "iron curtain" dividing Europe.[13] The battle lines drawn, the first skirmishes were waged with "ideas instead of bombs," according to the head of cultural activities at the newly established CIA. Art became part of that campaign.[14]

In 1946, the State Department purchased seventy-nine "modern" works, which it planned to tour in an exhibition called *Advancing American Art*. Organized at the request of foreign governments, it was to travel through Latin America and Eastern Europe to celebrate expressions of democratic freedom.[15] The paintings were not the works of downtown renegades. In fact, they were mostly from a group of painters more closely associated with the avant-garde that worked in the decades surrounding the First World War, artists like Marsden Hartley, Ben Shahn, Edward Hopper, Reginald Marsh, and Georgia O'Keeffe. But even they proved too advanced for a vocal portion of the U.S. government. What some in the State Department's cultural program viewed as art representing the American spirit, the Hearst Press and some members of Congress saw as examples of godless, communist propaganda. *Look* magazine stated in exasperation, "Your Money Bought These Paintings."[16] Amid a cacophony of critical voices, the exhibition was recalled and its works were ordered to be sold as "surplus property." Secretary of State George C. Marshall further declared that henceforth there would be "no more taxpayers' money for modern art."[17] Even President Harry Truman weighed in. Replacing the mantle of president with an ill-fitting critic's cloak, he said,

> I am of the opinion that so-called modern art is merely the vaporings of half-baked, lazy people.... There are a great many American artists who still believe that the ability to make things look as they are is the first requisite of a great artist.[18]

Marshall's actions were merely the beginning of a government assault on artists, and Truman's criticism was mild compared with that of some

Republican forces in Congress. For the first time in eighteen years, they had won a majority in the 1946 election by campaigning as vigilantes against the "Red menace" (among the victors in that election was Joe McCarthy).[19] *Advancing American Art* amounted to a well-timed gift they could exploit for its propaganda value. Illinois representative Fred E. Busbey led the charge, exclaiming, "The movement of modern art is a revolution against the conventional and natural things of life as expressed in art. The artists of the radical school ridicule all that has been held dear in art. That is what the communists and other extremists want to portray."[20]

For a politician, there is almost no easier target to attack than art. The only people who care passionately enough to fight to protect it are the artists themselves, museum officials, collectors, and engaged factions within the art-appreciating public. But even combined, their voices are rarely a match for the righteous indignation of a government official fighting to protect Americans against "morally degenerate" creations. Many artists were known to have belonged to the Communist Party during the 1930s and that association could be used to tarnish them. It seemed odd that a government was allowed to shift allegiances but an individual, once committed, was considered to be a communist for life. That contradiction only added to the frustration and confusion of the times. Then-director of the Art Institute of Chicago Daniel Catton Rich described the artist's situation in a 1948 article in the *Atlantic Monthly*.

> It is ironic that at the very moment when our abstractionists and surrealists are being attacked as Communists, the Communists themselves are accusing such artists of serving "the selfish interest of the bourgeoisie" and "catering to their decadent and perverted tastes"....
>
> Meanwhile advertising, always on the lookout for new visual and psychological excitement, has discovered the dynamic core in abstraction and surrealism. Perhaps mass America is even now being favorably conditioned for advanced art through the medium of our railway posters and perfume advertisements.[21]

In fact, it was, but that subtle shift was lost on government zealots. The immediate years after the Second World War marked the start of a period that has been referred to as "the American Inquisition." Spy agencies and surveillance apparatuses proliferated.[22] The FBI, under J. Edgar Hoover, expanded its domestic franchise to root out "commies" wherever they were hidden. And in Congress, the House Un-American Activities Committee, which had been inaugurated in 1938 but was dormant during the war because the communists were considered "friendlies," roared back to life, targeting communist sympathizers in the film industry in the spring

of 1947.²³ Loyalty oaths, meanwhile, were introduced more broadly for federal workers, and the U.S government produced its first list of subversive organizations. According to one historian, the Truman government "codified the association of dissent with disloyalty and legitimized guilt by association."²⁴

Though the government had launched a propaganda war against modern art, the country's most advanced artists were so far underground that they largely escaped notice. In any case, they were not dissenters or disloyal or guilty of association with anyone but one another. Though they all possessed strong personal feelings about the state of the world, they had generally abandoned politics at the start of the war, and nothing that had happened during the postwar period had inclined them to return to that arena.

From the Soviet Union had come revelations that millions of people had died of violence or starvation under Stalin. Anyone willing to embrace Soviet communism would, therefore, accept mass murder as politically expedient. On the U.S. side, there was also little to cheer about. Internationally, under the banner of the Truman Doctrine, Washington had given itself the right — indeed, the duty — to intervene militarily anywhere in the world where it saw "liberty" threatened by communists (easily confused with merely leftist governments). And domestically, the country was riven with strife. Rampant inflation and unemployment combined with widespread strikes had sparked concerns that the nation might plunge back into financial crisis. Racial tensions boiled, too, triggered by the continued subjugation of black men lately come home from a war they had fought in the name of freedom. Looming over all that turmoil was the very real possibility of yet another military conflict.²⁵

In January 1947, Simone de Beauvoir arrived in New York from France and was shocked by what she called a "war psychosis" in the United States: "Day after day [magazines and newspapers] repeat that conflict is inevitable and that it's needed to repel Russian aggression."²⁶ The first coffins bearing the bodies of the hundreds of thousands of American soldiers who had died fighting in Europe and Asia had only begun to return to the United States that year, and yet already it appeared that plans were being made to send soldiers to a yet-to-be determined front.²⁷ The drumbeat to war was deafening in its insistence. *Again.*

The artists in New York decided that there was, therefore, no point in thinking beyond their studios, in participating in a society greater than the small group of individuals they called friends. It wasn't apathy that made them seek a world apart but disgust. And as they walked around the Village and began to see numbers tattooed on the thin arms of passersby, or visited the dance halls on 14th Street where women who had been in the camps

and were similarly numbered offered themselves for ten cents a tango, their disgust grew.[28] As did their feelings of anger and despair, hopelessness and powerlessness, and, most acutely, their sense of alienation. Those feelings permeated their work. "The painter was trying," artist Philip Guston said, "to fashion plastic images strong enough to hold the terrifying and contradictory spirit of the age."[29] One day, Bill told painter Peter Agostini that he was worried about the atomic bomb. Agostini said there was no use worrying because there was nothing they could do about it and no escape if one was headed their way. "Well," Bill replied with resignation, "there is nothing left to do but paint."[30] And that is what they did, all of them.

The owner of the Central Art Supply on Tenth Street had purchased at auction hundreds of rolls of fine Belgian linen, a prized but usually prohibitively expensive material on which to paint that hadn't been picked up at the customs house after the war. "He bought them for a song," Milton said. "He was selling it to the artists; a ten-foot roll by eleven yards for twenty-five dollars. A big bargain. If you didn't have twenty-five bucks, you could put five dollars down and they'd put your name on it."[31] Up until that time, most of the works the abstract artists had painted were relatively small—still very much the size reflected in the French easel tradition. But that quantity of fabric at such a low price meant artists could take chances on larger paintings. Meanwhile, out of economic necessity and to free themselves up to experiment, they had also begun scrounging around for nontraditional materials to work with. (Elaine, who had resorted to covering cardboard with white primer to fashion a "canvas," said an entire tube of costly cadmium red could be used up in one brushstroke.)[32] Bill and Franz located a store on the Bowery that supplied sign painters. Each bought a five-gallon can of commercial black paint and a five-gallon can of white enamel, as well as heavy paper they mounted on Masonite.[33] Other painters followed suit, picking up house paint, sign painters' enamel, paint used on cars. Freed from tradition (material and aesthetic), freed from social responsibility, freed from dogma, they lugged their supplies back to their studios and prepared for a voyage of discovery.

Artists recalling those early years frequently say how lucky they were that they received so little attention from the greater art world. Like Elaine and her self-portraits, or Lee painting her Little Images in the seclusion of her small room in Springs, the community of abstract artists in New York had been able to mature and develop largely free from public scrutiny. They had removed themselves so completely from society and become, in their poverty and perceived eccentricity, so irrelevant to anyone in power, that they were practically invisible. That began to change, however, in the fall

of 1947, when a pair of little magazines devoted to new art, music, and writing began publishing, and when Harold Rosenberg and Clement Greenberg took it upon themselves (though not in consultation with one another) to begin creating the myth that would grow into the Abstract Expressionist legend.

Tiger's Eye, edited by writer Ruth Stephan, and *Possibilities,* written and edited by Bob Motherwell, Harold Rosenberg, and composer John Cage, gave American artists a forum in which to express in words the ideas that concerned them on canvas. Their pieces became part of the near-constant dialogue among artists, who were often criticized by outsiders for being insufficiently verbal, insufficiently well-read. In fact, they did little but talk, work, and read. Seeing themselves suddenly published, albeit in journals read almost exclusively by their own community, codified their ideas. Those journals were short-lived (*Possibilities* lasted for only one issue, *Tiger's Eye* just nine) but they helped establish a culture around the artists. Rosenberg and Greenberg, meanwhile, introduced that culture to a broader audience in tales of pure romance. Interestingly, both articles were first published in Europe.

Rosenberg's writing appeared in Paris in the spring of 1947 as a catalog essay for a show at the Galerie Maeght called *Introduction to Modern American Painting* and would be reprinted in *Possibilities:*

> It would almost be correct to say that Art is the country of these painters.... From the four corners of their vast land they have come to plunge themselves into the anonymity of New York, annihilation of their past being not the least compelling project of these aesthetic Legionnaires. Is not the definition of true loneliness, that one is lonely not only in relation to people but in relation to things as well?... Each is fatally aware that only what he constructs himself will ever be real to him.[34]

Harold's piece would be followed by a breathless account by Clem for the British journal *Horizon.* After declaring Pollock the "most powerful painter in contemporary America" and sculptor David Smith the "only other American artist of our time who produces an art capable of withstanding the test of international scrutiny," he described the community as follows:

> [It is] below 34th Street, that the fate of American art is being decided—by young people, few of them over forty, who live in cold-water flats and exist from hand to mouth. Now they all paint in the abstract vein, show rarely on 57th Street, and have no reputations that extend beyond a small circle of fanatics, art-fixated misfits who are as isolated in the United States as if they

were living in Paleolithic Europe.... Their isolation is inconceivable, crushing, unbroken, damning.[35]

Those two articles, coming as they did after the well-publicized condemnation of the State Department's *Advancing American Art* show earlier that year, created what in modern parlance would be called a buzz.[36] Not that editors of mass culture magazines had become overnight converts to avant-garde art or concerned about its practitioners, but they knew a good story when they saw one. In December 1947 *Time* magazine ran an article mockingly titled "The Best?" showing reproductions of works by Pollock, David Smith, and Hans Hofmann.[37] The wider world had started to awaken to the existence of the New York artists. It was not necessarily what the painters and sculptors wanted, but it had begun. The cost would be more than what a good number of them could bear.

17. Lyrical Desperation[1]

Every so often a painter has to destroy painting. Cezanne did it. Picasso did it with cubism, then Pollock did it. He busted our idea of a picture all to hell.

— *Willem de Kooning*[2]

THE SNOW NEARLY brought New York to a standstill on New Year's Day 1948.[3] It had begun falling as the clock struck midnight and continued until the morning. Because it was a holiday, those people who did venture out onto the streets were mostly merrymakers, children playing in the drifts in Washington Square, churchgoers in boots and heavy coats streaming into services to pray for a better year amid so much anguish. The snow seemed a cleansing omen. The city positively glistened. Lee and Pollock were in town at Lee's sister's apartment on Fifth Avenue, just north of Washington Square.[4] It wasn't, however, the holiday that had brought them to the city. Jackson's first exhibition at Betty Parsons's Gallery was scheduled to open on January 5, and it would take several days to stretch and hang his canvases because some of the works were seven and eight feet long. Pollock had had many solo shows since his debut in 1943, and none of them had been easy for either him or Lee. First, there was the pain of exposure. An artist like Pollock would have put everything he had onto his canvas, which meant that if people didn't like what they saw they were rejecting who he was. And then there were the very real financial concerns. Every show began with the promise of a sale that might keep Jackson and Lee afloat for a few months, and nearly every show had ended with that promise falling far short of their hopes and expectations. In any case, because of Jackson's continued contract with Peggy, she received whatever he earned to repay his monthly stipend. With his paintings priced at between one hundred fifty and twelve hundred dollars, Pollock would have to sell out an entire exhibition — multiple exhibitions — to pocket any proceeds from the sale of his work.[5]

The show that January, however, was even more than usually unsettling. The previous summer, Jackson had tried something new. He had begun to lay unstretched canvas on the floor of his barn and, pacing around it like a panther, allow paint dripping from sticks and hardened brushes to fall onto its surface. It was not a random process, no more random than that of a painter

whose brush touched the canvas. The difference was that Pollock created distance between himself and the surface; he painted in the air and tracings from the movement of his arm in space appeared below on the canvas where the paint fell. As he worked, as his movements became a dance, he grew more comfortable with the process, manipulating the sticks, the paint, the cans the paint came from, the speed and direction of the flow, the way the paint puddled and spread, and all the while he experimented with materials—oil paint, enamels, aluminum plumber's paint, any bit of detritus within reach.[6] Over and over, around and around the canvas he poured and dripped until the layers became dense, until in order to see the painting one had to look deep inside, through its veils, past its multitudinous lines. There was no door, no obvious point of entry, but Pollock beckoned the viewer to come in.

At the same time, the paintings were about surface, exploding outward in cosmic strings, shivering across the canvas like fields of grass in the wind, frolicking unpredictably in rhythmic abandon until finally the chorus of color and line he created in his barn shouted *Hallelujah!* That was because painting had been reborn. Did he know what he had done? Marcel Duchamp said, "When you tap something, you don't always recognize the sound. That's apt to come later."[7] Even Cézanne wasn't sure of his own work. He thought perhaps he had eye trouble rather than talent.[8] No, Pollock wasn't sure what he had done, and so he asked Lee.

By the summer of 1947, Lee and Jackson's routine at Springs was well established. She rose at eight and painted until she heard Jackson stirring. "He always slept very late. Drinking or not, he never got up in the morning. He could sleep twelve, fourteen hours, around the clock. We'd always talk about his insane guilt about sleeping late," Lee said.[9] While he had breakfast, she ate lunch. "He would sit over that damn cup of coffee for two hours. By that time it was afternoon. He'd get off and work until it was dark"—until seven, when they met at the table for dinner. Lee and Jackson had reached an agreement that neither would enter the other's studio uninvited.[10] "When I asked him to come to my studio and look at the work, I must say I had to ask him many more times before he responded than when he asked me," Lee said. "Generally I would preface it with a big belly ache about something, 'I want you to come up and look at what I've done, it's bothering me like hell.' And then I'd list what was bothering me. And when he'd come into the studio, he'd say something like 'Oh, forget all that, and just keep painting.'"[11] For his part, at the end of the day Lee might ask, "'How'd it go?' Although I could tell before I asked the question," she said. "And on occasion he would say, 'Not bad.'"[12] But other times when he came into the house he announced quietly, "I have something to show you."[13]

Walking across the yard to his studio, listening to their steps through the grass, filled Lee with anticipation. She had no idea what she was about to see except that it was something that had never before existed. When Jackson unveiled a new painting for her, what he wanted to know was quite simple: "Does it work?"[14] And that was what he asked her about the paintings he had done during the summer and fall of 1947, works that would not only become synonymous with the name Jackson Pollock but would add a new chapter to the history of art. Did those paintings, which would be credited with opening "entire new terrains of possibility for creators in every medium," which "profoundly altered or even obliterated the concept of painting handed down within the Western tradition," *work?*[15] The understatement inherent in that question was matched only by Lee's response. Asked many times through the years what her first reaction had been when she saw Pollock's "drip" paintings, Lee often said she didn't remember, except that she was enthusiastic. "And I think he very much appreciated that enthusiasm. Because if you remember at that time at which this so-called drip painting came about it was way out on a limb.... These were coming in as, you know, shockers."[16]

Perhaps Lee was so close to Jackson's work that she, like him, couldn't "recognize the sound" of his "tap." The other artists around Pollock, however, did. When his show opened that January, all of them—even the most cynical—came away changed. The unending space that Pollock created "was to our time what perspectival space was to the Renaissance," said painter Charles Cajori.[17] Through the door that Pollock opened they saw endless possibilities, all of which led into themselves. Painter George McNeil explained,

> The movement of color, movement begetting movement, color invoking color, the whole idea of process, painting coming from the act of painting. It was very exciting. Pollock was the most important American painter. I don't know if he was best, but in the sense of a liberating force. He made it possible for other people to break through conventions.[18]

Said Philip Pavia, Jackson "was a one-man art movement. Fusing the art currents of the postwar years, plus his own temperament, he was both heroic and revolutionary. His aggressive forward-moving space changed everything."[19]

Pollock wasn't the first painter to "drip," and he wasn't the first painter to eschew traditional fine arts tools and paints in favor of more plebeian materials. He wasn't even the first painter to do "all-over" paintings, or completely nonobjective works, or mural-sized canvases.[20] But he was the first painter to combine all those elements and, with the intensity of vision

born of genius, create mad, marvelous, massive statements that embodied himself—his gentle poetry *and* his violence—and the world as it was, a world destroyed but not irrevocably so. In Pollock's paintings there was hope because there was life. Decades later, long after his works had been trivialized through repetition, their original impact could best be experienced not in another artist's paintings but in the awe-inspiring images of space and time sent back to earth by the Hubble Space Telescope. Breathtaking, heart-stopping, humbling images full of portent that the intellect alone was incapable of apprehending. Those who walked into Betty Parsons's gallery in early January 1948 were faced with just such a mystery. Pollock had created it, and in so doing, he had revealed something deep and rich—reflective of himself, of the moment, of the future. He had done what the artists of his generation had set out to do. He was the first to journey so deep into himself that he discovered a universe.

Parsons's walls were covered in seventeen paintings by Pollock—*Full Fathom Five, Cathedral, Lucifer, Phosphorescence,* and *Alchemy* among them. The effect was overwhelming. A work of art, if it is art, is not an end but a beginning. It is a challenge to the artist who produced it and to the artists around him to take the next step, to answer the questions raised by the work, to achieve what he or she has yet to accomplish. It also represents a challenge to the nonartist, who is offered a fresh vision. But Betty, to her frustration, said collectors could not "see" the new painting because they had only just learned to "see" works done in the late nineteenth century.[21] "Modern" for many in America still meant Cézanne, while Jackson had "exploded the easel painting, the wall painting. His paintings *were* walls—whole worlds. Expanding worlds," Parsons said. The show "was a sensation. A total sensation," she added.[22]

Clem came through for Pollock in *The Nation*. Naming him as a successor of Mondrian, Picasso, and Braque, he predicted that Jackson would "compete for recognition as the greatest American painter of the twentieth century" with the then-recognized holder of that designation (according to Clem), John Marin.[23] That comment, which in the hyperbolic twenty-first century might seem mild, stunned readers at the time. No one before had dared to use the word "greatest" in association with a modern American painter. In fact, it would not have been used in describing any American painter without many qualifications. "Great" was reserved for European artists.[24]

Lewin Alcopley said Clem's almost crude impertinence "startled" those who read it. "In one way, one has to give him credit, because he never could have, no one could have...[made] the American public aware that something important is going on in America" without shocking them into that realization, Alcopley explained.[25] But the rest of the critical world in

New York hated the show. *The New Yorker* described "unorganized explosions of random energy" that were "therefore meaningless."[26] *ArtNews* remarked on the works' "monotonous intensity."[27] The public reaction was also fiercely negative. "Wallpaper" was perhaps the gentlest description of Pollock's painting by nonartist visitors to the exhibition. A more decisive gallery-goer scrawled the word "shit" on the wall.[28]

Jackson, Lee, and his family went to the Hotel Albert after the opening. Pollock immediately threw back three double bourbons and proceeded to take the fancy hat his sister-in-law had worn to the opening and crush it in his hands.[29] He had left his soul hanging on the walls of an uptown gallery, to be alternately disregarded and abused by ignorant strangers. If that weren't wrenching enough, he knew that all but one of whatever paintings he didn't sell would go to Peggy in Venice. He would emerge from the show poorer in every way than he had been back in his barn while he was creating the works. It seemed that the only peace and dignity an artist could find was in his solitude.

Lee could see in real terms just how dire their situation had become. Pollock's contract with Peggy would expire in February, and that left them entirely dependent upon the sale of his work. It was only "natural and logical," Lee said, that she should expend a certain amount of energy in making that happen by promoting his paintings.[30] Facing another winter in Springs in a house that was only slightly less rudimentary than when they bought it, her enterprise became a matter of survival. They didn't have the money to pay for coal.[31] They had little by way of furnishings. There was still no bath—no warm water. They also continued to rely on bicycles to get around. They weren't looking for enough money to change those conditions, simply enough to heat their home and fill their stomachs.

By the end of Jackson's show at Betty's gallery, only two paintings had sold, and the proceeds of both went to Peggy. Lee became a kind of secondary dealer, trying to find someone to buy Jackson's work. After the exhibition, the sister of fellow artist Fritz Bultman bought one, and Betty tried to sell others at a discount or to "guilt" clients into buying on a "charity basis." In April, she managed to sell one for seven hundred dollars, and, knowing how much Lee and Jackson needed the money, refused to take a commission on the sale. The Pollocks lived on the proceeds of that transaction for a year.[32] But living was frugal in the extreme. Because of the heating situation, they were forced again to close off the second floor, which meant Lee, bundled in heavy sweaters, long johns, and blue jeans, was back in the living room working on another mosaic table instead of painting.[33] Jackson, meanwhile, unable to work in the barn for lack of warmth, descended into what Lee called manic "grooves," blasting jazz from the phonograph in the living room so loudly it could be heard across

the snow-covered fields. "Day and night, day and night for three days running until you thought you would climb the roof! The house would *shake*," she said.[34] It was a howl from a drunken man stranded between creations. Pollock once told Lee, "There's no problem painting at all; the problem is what to do when you're not painting."[35]

While Lee and Pollock existed—merely existed—in Springs, Pollock's work had sparked a major debate in the official art world and among the artists at the Waldorf. He may have quit New York in a depressed funk, but he had left a tempest of talk and creative action in his wake. Pollock had thrown down the gauntlet and other artists felt compelled to do the same.[36] Nothing less than ultimate freedom, ultimate risk accomplished on a large scale, would ever do again. Historically, large paintings, grand European paintings, had been *important*. They were the prizewinners in the salons and the academy, and they made the greatest statements— *Guernica* being the most recent example.[37] Many New York painters had accomplished large works in the form of murals while on the Project, but none of them before Pollock had brought that scale into their studios, not even those who had availed themselves of the customs house linen. Perhaps they had been afraid to be so presumptuous. Pollock gave them license to do so.

"After 1948 and Pollock, everyone started to work larger," explained George McNeil. "Everyone exploded and became other people when they painted larger."[38] Said Motherwell, "The large format, at one blow, changed the century-long tendency of the French to domesticize modern painting.... We replaced the nude girl and the French door with a modern Stonehenge, with a sense of the sublime and the tragic.... What a gesture!"[39] But scale wasn't the only issue Pollock had raised. He had shown by example that a unique statement existed within each of them, a statement whose discovery required persistence bordering on, sometimes tipping over into, madness.

Elaine and Bill had been caught up in the furor surrounding Jackson's work, and it had only made their situation more complicated. Bill was trying to finish a group of paintings to be shown at Charlie Egan's gallery in April, and because he was naturally competitive—a trait that wasn't always apparent under his seemingly easygoing exterior—Pollock would have been a distraction and a goad. Gorky, too, had a show scheduled in February. The pressure on Bill became overwhelming because he measured himself against those two artist friends, and they had both already produced great works while he still struggled. Like Pollock and Lee, the de Koonings were flat broke that winter. Once while seeing off some friends who were leaving the country for a few weeks, Bill said to Elaine, "How

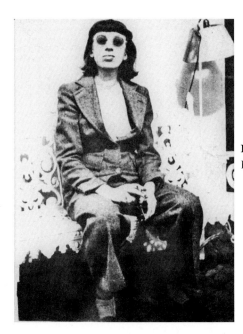

Lee Krasner, ca. 1938
Photographer unidentified.

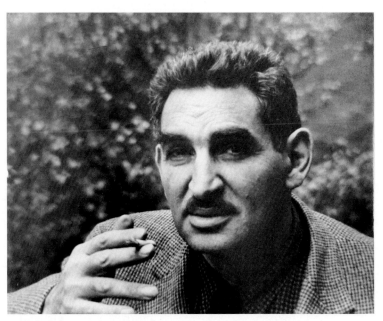

Harold Rosenberg, ca. 1950
Maurice Berezov, photographer. Harold and May Tabak Rosenberg Papers, Archives of American Art, Smithsonian Institution, Washington, D.C. *Copyright Madelyn Berezov, A.E. Artworks, LLC*

Willem de Kooning and Elaine de Kooning, 1944
Ibram Lassaw, photographer.
Copyright Ibram Lassaw, Ibram Lassaw Estate

Arshile Gorky and Willem de Kooning, ca. 1937
Oliver Baker, photographer. Rudi Blesh Papers, Archives of American Art, Smithsonian Institution, Washington, D.C.
Artwork copyright 2018 the Arshile Gorky Foundation / Artists Rights Society (ARS), New York

Jackson Pollock, 1944
Bernard Schardt, photographer. Jackson Pollock and Lee Krasner Papers, Archives of American Art, Smithsonian Institution, Washington, D.C.

Class at the Hans Hofmann school, Provincetown, Massachusetts (Hofmann seated, center), ca. 1945
Photographer unidentified. Hans Hofmann Papers, Archives of American Art, Smithsonian Institution, Washington, D.C.

Robert Motherwell, 1957
Hans Namuth, photographer. *Courtesy the Center for Creative Photography, University of Arizona, Tucson, Arizona. Copyright 1991 Hans Namuth Estate*

Lee Krasner and Jackson Pollock at Springs, New York, 1949
Wilfrid Zogbaum, photographer. Jackson Pollock and Lee Krasner Papers, Archives of American Art, Smithsonian Institution, Washington, D.C. *Copyright 2018 the Estate of Wilfrid Zogbaum / Artists Righ Society (ARS), New York*

Lee Krasner on porch at Fireplace Road, Springs, New York, ca. 1946
Photographer unidentified. Jackson Pollock and Lee Krasner Papers, Archives of American Art, Smithsonian Institution, Washington, D.C.

Clement Greenberg, 1959
Phillippe Halsman,
photographer.
Courtesy Magnum Photos

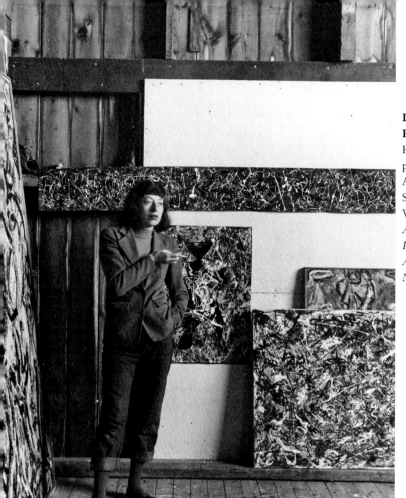

Lee Krasner in Jackson Pollock's studio, ca. 19
Harry Bowden, photographer. Harry Bowden Papers, Archives of American Art, Smithsonian Institution, Washington, D.C.
Artwork copyright 2018 the Pollock-Krasner Foundation, Artists Rights Society (ARS), New York

Tom Hess in his *ArtNews* office, 1961
Fred W. McDarrah, photographer.
Premium Archive / Getty Images

Buckminster Fuller's architecture class constructing the Venetian Blind Strip Dome, with Buckminster Fuller, Elaine de Kooning, and Josef Albers, among others, 1948, Black Mountain College, North Carolina
Beaumont Newhall, photographer. *Courtesy of the Western Regional Archives, State Archives of North Carolina. Copyright 2018 the Estate of Beaumont and Nancy Newhall. Permission to reproduce courtesy of Scheinbaum and Russek Ltd, Santa Fe, New Mexico.*

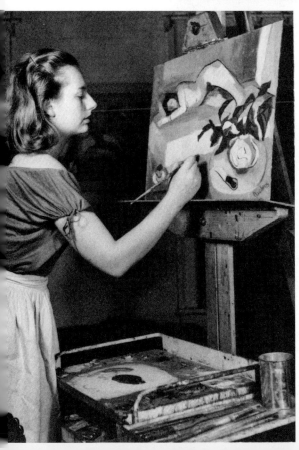

Grace Hartigan painting, ca. 1947
Photographer unidentified. Grace Hartigan Papers, Special Collections Research Center, Syracuse University Libraries, Syracuse, New York.

Larry Rivers, ca. 1950s
Walter Silver, photographer.
The Walter Silver Collection.
Copyright Photography Collection, Miriam and Ira D. Wallach Division of Art, Prints and Photographs, the New York Public Library, Astor, Lenox and Tilden Foundations

Jane Freilicher, ca. 1950s
John Gruen, photographer.
Photograph courtesy Eric Brown Art Group LLC. Copyright Estate of John Gruen

Jackson Pollock and Lee Krasner amid Pollock's paintings, 1949
Lawrence Larkin, photographer. Jackson Pollock and Lee Krasner Papers, Archives of American Art, Smithsonian Institution, Washington, D.C.
Artwork copyright 2018 the Pollock-Krasner Foundation / Artists Rights Society (ARS), New York

Grace Hartigan on the roof of the studio she shared with Al Leslie, ca. 1951
Photographer unidentified. Grace Hartigan Papers, Special Collections Research Center, Syracuse University Libraries, Syracuse, New York.

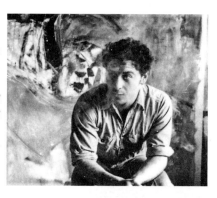

Alfred Leslie, ca. 1960
Walter Silver, photographer.
The Walter Silver Collection.
Copyright Photography Collection, Miriam and
Ira D. Wallach Division of Art, Prints and
Photographs, the New York Public Library,
Astor, Lenox and Tilden Foundations

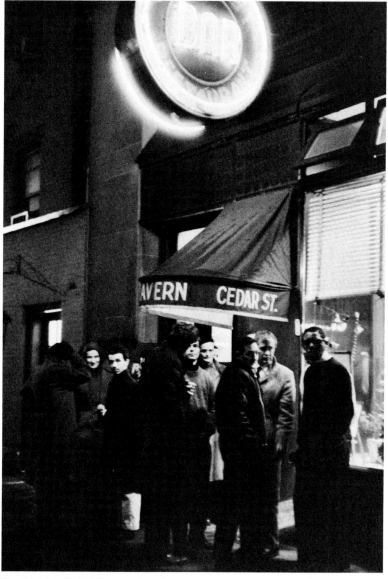

Outside the Cedar Bar, undated
John Cohen, photographer.
Hulton Archive / Getty Images

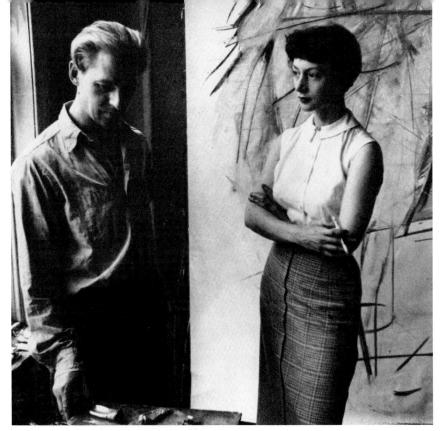

Willem and Elaine de Kooning, 1950
Rudy Burckhardt, photographer. Elaine de Kooning Memorial Portfolio.
Photography Collection, Miriam and Ira D. Wallach Division of Art, Prints and Photographs, the New York Public Library, Astor, Lenox and Tilden Foundations. Copyright 2018 the Estate of Rudy Burckhardt / Artists Rights Society (ARS), New York

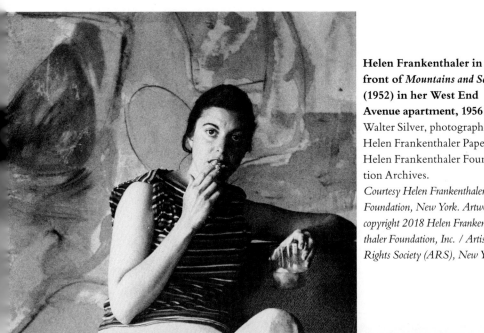

Helen Frankenthaler in front of *Mountains and Sea* (1952) in her West End Avenue apartment, 1956
Walter Silver, photographer. Helen Frankenthaler Papers, Helen Frankenthaler Foundation Archives.
Courtesy Helen Frankenthaler Foundation, New York. Artwork copyright 2018 Helen Frankenthaler Foundation, Inc. / Artists Rights Society (ARS), New York

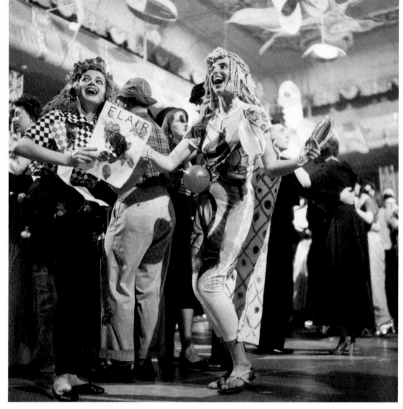

Helen Frankenthaler (right) and her friend Gaby Rodgers at the Beaux Arts Ball, Astor Hotel, New York, May 19, 1950
Walter Sanders, photographer. Photograph appeared in *LIFE* magazine, June 12, 1950.
The LIFE Picture Collection, Getty Images

From left: Lee Krasner, Clem Greenberg, Helen Frankenthaler, and Jackson Pollock at the nightclub Eddie Condon's, New York, January 1951
Photographer unidentified. Helen Frankenthaler Papers, Helen Frankenthaler Foundation Archives, New York.
Courtesy Helen Frankenthaler Foundation, New York

John Bernard Myers, ca. 1940s
Photographer unidentified. John Bernard Myers Papers, Archives of American Art, Smithsonian Institution, Washington, D.C.

Seated, from left: Elaine de Kooning, Lee Krasner, Jackson Pollock, and Willem de Kooning (facing away) at the Museum of Modern Art, ca. 1950
Photographer unidentified. Jackson Pollock and Lee Krasner Papers, Archives of American Art, Smithsonian Institution, Washington, D.C.

Joan Mitchell, ca. 1952
Walter Silver, photographer. The Walter Silver Collection.
Copyright Photography Collection, Miriam and Ira D. Wallach Division of Art, Prints and Photographs, the New York Public Library, Astor, Lenox and Tilden Foundations

Barney Rosset in the military, early 1940s
Photographer unidentified.
Joan Mitchell Papers, Joan Mitchell Foundation Archives, New York

Joan Mitchell and Barney Rosset under the Brooklyn Bridge, ca. 1947
Photographer unidentified.
Barney Rosset Photographs, Joan Mitchell Foundation Archives, New York

Franz Kline (center, foreground) at the Cedar Bar, 1957
Burt Glinn, photographer.
Courtesy Magnum Photos

Mike Goldberg, ca. 1959
Photographer unidentified.
Courtesy Estate of Michael Goldberg

can those people afford to go to Europe? We can't even afford to stay here."[40] They had resorted to selling blood to get money to buy kerosene.[41] Bill's upcoming show with Charlie Egan had been Elaine's idea, so she couldn't risk diverting his attention from painting by suggesting he pick up commercial or house-painting jobs to bring in some cash. It was up to her to earn their living while he prepared for his exhibition. "Money came in just in little globs, and I finally had the idea of writing," Elaine said.[42]

In addition to dance reviews, Elaine had written magazine articles — among them pieces for *Seventeen* and *Mademoiselle* — and she was confident she could do more. Serendipitously, she met a woman named Renée Arb, who had written about Elaine and Nell Blaine in a 1947 article for *Harper's Jr. Bazaar* entitled "They're Painting Their Way."[43] Discovering that Arb also wrote for *ArtNews,* Elaine told her the magazine's critics "didn't know anything about the contemporary scene, that they were art history majors, you know, who just learned from people who also didn't know anything about the contemporary scene.... It was ridiculous to have them covering shows."[44] Renée told the new *ArtNews* managing editor about Elaine's complaints, and he said, "Tell her to come in and see me about writing some of her own." That invitation initiated Elaine's next important chapter: her career as an art writer. She would also meet the man Ernie said was the most important in her life besides Bill: Tom Hess.[45]

A cross between a patrician Humphrey Bogart and a Jewish-American Marcello Mastroianni, Tom was born in the wealthy enclave of Rye, New York.[46] He was educated in Switzerland, until he enrolled at Yale to study French art and culture. Handsome, beautifully spoken (in several languages), elegant, and at the same time tough, after graduating from Yale in 1942 Hess had begun working with Alfred Barr and Dorothy Miller at the Modern but joined the army air forces as a pilot during the war.[47] Still wearing paratrooper boots, as soon as he was discharged from the military he returned to the New York art world, though not to the museum. Instead, Tom joined *ArtNews* as an editorial associate to the main editor, Alfred Frankfurter, who was also just back from the war in Europe, where he had formed part of a team recovering art stolen by the Nazis.[48] Frankfurter had "historical" art well covered. He needed someone to investigate the rumblings in the magazine's backyard. Tom was that man. Named managing editor, he began to introduce articles about that terrifying phenomenon, "modern art," into a journal that had been dominated by the works of dead Europeans. In the process, Hess turned *ArtNews* into the most influential art publication of its time.[49]

In trench coat, tuxedo, or trench coat over a tuxedo, Tom mingled easily with the art crowd around 57th Street. Before he met Elaine in 1948, however, he had not ventured into the heart of bohemia.[50] He was eager to

do so. The new art intrigued him, as did the artists who created it, men and women. Indeed, Tom championed women writers and artists. He seemed oblivious to the fact that social convention dictated that women be treated differently than men either personally or professionally. In any case, what society sanctioned didn't particularly interest him. Tom had a wry, cynical, worldly attitude that belied his age.[51] When Elaine met him she was thirty and he just twenty-seven.

During their first encounter in February 1948, Hess gave Elaine a list of shows to review as a test of her abilities.[52] Not only was Elaine not an art historian—as were the other writers on staff—she had no formal education beyond high school. All she had, from what he could see, was beauty, charm, and self-confidence. He didn't even know she was married to one of the stars of the downtown art world. In fact, Tom was one of the few people Elaine met at that time independent of her husband, and she protected that relationship, referring to Hess as "my friend" Tom rather than "our friend" and going so far as to correct an interviewer who had the temerity to call him a "family friend."[53]

Among the shows Hess asked Elaine to review was an exhibition at the Pierre Matisse Gallery of thirty sculptures and a group of paintings by the Swiss-born artist who worked in Paris, Alberto Giacometti. For some of the New York artists, his work had a greater impact than Pollock's two weeks earlier. Philip Pavia called it a "turning point."[54] "Everyone talked about this show," Mercedes recalled. "Bill said one second after seeing Giacometti's work, everything was changed." Mercedes herself was so moved that she wrote the artist a letter saying his work represented a "change of epoch." She had planned to have everyone she knew sign it but didn't.[55] Instead, she paid him an even greater tribute: She went home to paint.

While Jackson had explored an internal landscape on canvas, Giacometti in his sculpture created a true and unparalleled outward vision of postwar man. Ranging from life-size works to pieces so small he could carry a bundle of them in his pocket, his figures in bronze and plaster were battered, thin, powerless, stripped of their humanity, stripped of their dignity, and yet surviving still. Diminished, even made ridiculous (very much like the characters being created at the same time by a writer in Paris, Samuel Beckett), they refused to disappear. Though Giacometti had not intended to make a philosophical statement, his figures were the ultimate Existential works. (Sartre wrote the catalog essay for Giacometti's Pierre Matisse show.) No sculptor had ever portrayed humankind in such a way, and no one—sculptor or painter—had portrayed the human figure in the wake of war as honestly as he did.

The Irish painter Francis Bacon (one of whose works the Modern had just purchased) had ripped the body wide-open and splashed it across his

canvas, but that act of painterly brutality was oddly personal and had been seen in the works of an earlier artist, Chaim Soutine. Giacometti's sculptures represented mankind. They were not of *a* man; they were *everyman*. In addition to speaking to larger issues, Giacometti also represented a practical direction for artists like Bill and Elaine, who did not feel compelled to abandon the figure but knew it could no longer be portrayed as it had always been. Giacometti sculpted and painted men and women not as they were but as he *perceived* them, and he rendered that perception through the expressive use of his materials.[56] Elaine raved about the show in her review, breaking with the professional critics, who generally did not like it. (Clem, for example, called Giacometti's new works "a sad falling off from his previous standard.") Luckily for Elaine, Hess liked Giacometti, too. In the review he would write, Tom called the exhibition "one of the newest, most exciting shows of sculpture this reviewer has ever seen."[57]

He also liked what Elaine had written, but he had reservations. "They at first were afraid to hire an artist, because they said, 'Well, you might favor your friends.' And I said, 'They were all my friends, I know everybody. So, there's no possibility of favoritism.'"[58] When Tom continued to hesitate, asking, "How can I hire you, you know all these people?" Elaine declared, "That's exactly why you *should* hire me."[59] Having convinced him, she also had to convince Bill, who "was very against it," she said. "He felt it was like being Joe DiMaggio, after you hit a home run, going back and sitting on the sidelines, and criticizing the other guys. He felt that I shouldn't do it."[60] As an artist herself and as a person guided in all things by empathy, Elaine was not about to criticize her peers to aggrandize herself or Bill. "My idea was that to write a review was simply to illuminate what the work was.... I didn't feel one had to sit in judgment," she said. "And so, my reviews tended to be descriptive.... What I tried to do was to cast some light on it that a person might not have seen at first sight."[61] Her sensitive approach was essential in those days. Her fellow artists were only just beginning to be covered by art journals. She knew that every word mattered, as the artists would scrutinize them all.

Hess hired Elaine to write twenty reviews at two dollars each for the April issue.[62] She approached her writing with extraordinary diligence. "I would go, and climb five flights of stairs, and see some old artist—with four kids and something on the stove—and so, I saw not only paintings, but also all the travail that went with it," she explained. Each such studio visit would take at least two hours.[63] In the two paragraphs she was allotted for each review, she might be required to condense four years of an artist's life and work. "I treated it very seriously, I wanted to put everything into those two paragraphs, so I'd really sweat over them. But it was very, very good discipline," she said. "Before that when I would walk into a show, if I

didn't like it I'd say 'Ugh,' and then walk away. But if I had to cover it, then I'd have to say, well what do you mean by 'Ugh'? And I'd have to analyze. And I found analyzing a painting that I thought was bad was just very illuminating."[64] She began carrying small notebooks to jot down her thoughts as they came to her. ("The right word was as vital to her as breathing," her sister Maggie said.)[65]

Elaine's dedication surprised Tom. One evening at about five she sat down at a typewriter in the *ArtNews* offices, saying she wanted to make a few changes in a piece she was writing about the artist Reuben Nakian. It was his first one-man show in many years. She knew how much the review would mean to him. Soon the office around her emptied, and she realized she was alone in the building. "When Tom Hess came in at nine in the morning, just as I was leaving, he said suspiciously, 'You haven't been here all night, have you?'" Laughing by way of answer, Elaine fled and left him guessing.[66]

Artists came to view Elaine's role at *ArtNews* as "fundamental" to the expanding understanding of American avant-garde art. In a very short time, she would change the way Tom and by extension all other reviewers at *ArtNews* approached criticism. Mirroring her philosophy, he told an aspiring critic, "You can knock the famous, you can knock the dead. But the little ones you leave alone." To another he said, "No comparisons, no art history jargon, no name-dropping. The artist was the star."[67] "Elaine was the inside connection explaining things," said artist Paul Brach. "She brought Tom into our world." Soon Tom began showing Elaine things he had written and asking her advice.[68] "He, usually so skeptical when listening to others, took in her talk with an attentive adoring air," recalled Edith Schloss, who also wrote for *ArtNews*. Elaine's relationship with Tom deepened when he finally met Bill after de Kooning's first show at Charlie Egan's. Tom was stunned by Bill's work.[69]

Elaine's belief in 1946 that a deadline of two years hence would be sufficient time and enticement for Bill to finish his paintings had proved correct. Three days before the show was scheduled to open, on April 12, 1948, Charlie, Elaine, and Bill sat together on Carmine Street to come up with names for the nine black-and-white and one color abstractions he was prepared to exhibit. The rule was that no title would be affixed to a painting unless all three agreed. *Light in August*—in recognition of Bill's love of Faulkner but also perhaps an acknowledgment of the light in August 1945 that Bill had said made everyone into angels. *Orestes*, the tale of an avenging son who killed his mother and her lover. *Black Friday*, a reference to the darkest day on the Christian calendar. *Zurich. Painting. Black Untitled*, and so on.[70]

In the wake of Pollock's show, Bill's work seemed relatively small. It

also seemed more muted, inhabiting that noir world of grainy images from the police gazette or the inaccessible secrets of exposed negatives. In fact, it was that very subtlety, that mysterious restraint which was so intriguing. Pollock exploded and grabbed attention. Bill's paintings whispered, but the effect was just as strong. When the show was hung, de Kooning was immediately recognized for the brilliant artist everyone had long believed he was. Tom Hess called the show Bill's "emergence from the artists' underground."[71] Said Jane Freilicher, "Everybody was talking about him."[72] Nearly forty-four years old, he had finally arrived. There was no opening at Egan's because there was no money to mount one, but the Waldorf crowd gave Bill a party that evening.[73] "It had happened," Pavia said. "We felt de Kooning had deepened the visual experience."[74]

Pollock's show had been embraced by his fellow artists but not the critics. De Kooning's was generally heralded by both. Renée Arb from *ArtNews* (who no doubt had become a friend of Elaine's—nearly any young woman who met Elaine became attached to her) was so enthusiastic in her praise for Bill's work that Tom asked Renée if Bill was her boyfriend. In *The Nation,* Clem declared Bill "one of the four or five most important painters in the country."[75] It's likely Elaine enjoyed such praise much more than de Kooning did. Artists often dislike and mistrust acclaim because, as James Lord wrote about Giacometti, "satisfaction is the artist's enemy."[76] And, again like Giacometti, Bill desired cash rather than compliments. Nothing sold from the Egan show, however, even though Charlie kept it up longer than scheduled (until it became embarrassing, Elaine said; "It made things seem more hopeless").[77] Elaine could take on more reviews— one month she wrote thirty-eight—but they had borrowed so much from friends, in addition to their monthly obligation of two rents, that even seventy-six dollars wouldn't cover all their expenses.[78] For Elaine and Bill, their salvation was the odd dinner invitation. And after Bill's show, one came from an unexpected source: Lee.

She and Pollock had spent an evening that spring with Elaine and Bill at Clem's West Village apartment. Leo Castelli was not long back from the war, and Clem had arranged a cocktail party to introduce him to artists he knew. Castelli's first professional adventure in that area—a gallery in Paris—had ended with the onset of war.[79] In New York he was employed in his father-in-law's sweater factory, but he was aching to get back into art. "I have always been guilty of hero worship," he said. "For me, great artists and great writers are in the same class as great warriors and great statesmen."[80] In 1948, he considered himself a "collector" and a conduit for sales from Europe. Through Clem, Motherwell, and the Chilean Surrealist Matta, Castelli was also getting to know the New York scene.

(Clem took Castelli to Bill's studio in 1947, which confirmed in Leo's mind his suspicion that Picasso and Braque were "dead ducks.")[81] The gathering at Clem's brought the de Koonings and the Pollocks together in an unusually convivial setting. By the end of the evening Lee—perhaps in recognition of Bill's show, perhaps to court Elaine as a critic—invited the de Koonings to Springs. That trip would be the first time Elaine had ever been to East Hampton, a place she and Bill would one day call home.[82]

If they were hoping to relax, however, the situation they walked into on Fireplace Road was tense in the extreme. Without Peggy's monthly stipend, Pollock and Lee had endured their most difficult winter.[83] Despite the brilliance of Jackson's output, it became increasingly clear that living on the sale of his art was an impossible goal. That spring, Lee had one hope: The Museum of Modern Art's James Johnson Sweeney, who had supported Jackson's work since he saw it in 1943 at Peggy's gallery, was on the board of Pittsburgh's Eben Demarest Trust, which gave grants to artists. She appealed to him for help. It worked. In June, Pollock won a fifteen-hundred-dollar award, to be distributed in quarterly installments.[84] But that sort of infusion of cash was a mere Band-Aid. Lee needed to make something happen that would ensure an income. She needed to make Jackson Pollock, the phenomenon, happen. Jackson, however, had spun dangerously out of control.

After Gorky's show that February, Pollock had stormed into a restaurant on Eighth Street where everyone was celebrating. Bill and Elaine were there, but Gorky's wife, Mougouch, was not.[85] Gorky was already out of sorts because of that, and because his life seemed to be falling apart around him—the fire in his studio, his colon cancer, the fears that his young wife was planning to leave him. Pollock chose that night of clouded celebration to pick a fight with Gorky. Ethel Baziotes, who knew Lee and Jackson well, said Pollock "came in like a cannon. He lashed out at everyone, and no one could say anything to please him. He was insulting to his good friends in a way I'd never seen before. Everyone was white with fear."[86]

Jackson made the mistake of planting himself in front of Gorky, close to his black-with-anger face. "You're a lousy painter," he growled at Gorky. "Gorky didn't bat an eyelash," according to de Kooning. The Armenian already despised Pollock over an earlier drunken night at Gorky's studio when Pollock had verbally abused Mougouch.[87] The two men stood glaring at each other, Pollock muttering obscenities and barely coherent insults as Gorky sharpened a pencil with a knife. With each stroke, he brought the knife closer to Jackson's throat. Not until painter Bill Baziotes told Pollock to shut the hell up was the situation defused.[88] Everyone had seen Pollock drunk, but few had seen this violence in him, which appeared, despite his outward aggression toward Gorky, to be strangely directed

inward. Now that he was "somebody" among his small circle of painters, it seemed he no longer knew who he was.

Against that backdrop, the de Koonings' weekend in Springs did not go well. Bill and Pollock got along fine. But Elaine later recalled, "Lee misconstrued little things that happened during the visit—which I will not go into—but I remember it all very clearly. Anyway, six months later, at Clem Greenberg's apartment...Lee said to me, 'You have the heart of a tiger,' which I took as a great compliment, but it was really an attack. Yes—she misconstrued some whole things at that weekend—where, by the way, Charlie Egan was present."[89] Lee later said she had been "scornful" that Elaine, as an artist, traded on her husband's name.[90] But it is likely the dispute ran far deeper.

On the surface, Elaine and Lee had much in common. Both were serious artists, both left-wing politically with mutual friends going back to the Union days, and both were rescuers. Lee had fought on behalf of any artist who needed her, before she began focusing her missionary zeal on her husband. Elaine, too, helped any needy person who crossed her path and was devoted to helping Bill. That similarity, however, might have been the root of the animus Lee felt for Elaine. Lee likely believed, and no doubt Elaine recognized as well, that in promoting their spouses they were competing for the attention of a minuscule pool of collectors and museum officials. The "competition" between Elaine and Lee ultimately produced two camps and a fissure in the community. Ernestine said,

> There was kind of a joke that went around. You were friends of the de Koonings or friends of the Pollocks. There was definitely a split. Everyone tried to compare Elaine and Lee, but actually there was nothing to compare. Elaine got along with everyone, but Lee was totally different. Elaine was very strange, I remember a little thing...somebody hit Elaine and she kissed their hand. That's Elaine, typical of Elaine. If you spit on her, she would kiss you. She had no animosity. Lee was the opposite.[91]

The problem of competing interests would have been aggravated on Lee's side by the topic that was on everyone's lips that spring: sex. Alfred Kinsey's *Sexual Behavior in the Human Male* had been released in April and, despite all its charts, graphs, and dry commentary, it became an instant best seller. It was impossible to ignore the Kinsey Report, as it came to be known. Cartoons, newspapers, magazine articles, radio programs all featured discussions about the study and its findings.[92] Americans awoke to the knowledge that people just like them were engaged in sex, of all kinds, all the time. "Professor Kinsey and his coadjutors drag forth into the light all the hidden actualities of sex so that they may lose their dark power and

become domesticated among us," wrote Lionel Trilling in the *Partisan Review*, an issue Lee and Jackson owned and on the cover of which Pollock had doodled.[93] Based on eighteen thousand interviews, the Kinsey Report neither judged nor encouraged, but the effect was *permissive*. It was as if the "doctor" had concluded that sex in all its forms was normal, healthy, even necessary, and that individuals satisfied their desires in many ways.[94] In its wake, men and women examined their own intimate lives and cast questioning glances at one another.[95]

The Kinsey Report coincidentally appeared at a time when Lee's paranoia about Jackson's interest in other women had become acute, and when she began to suspect that Elaine's extramarital dalliances were politically motivated—the men she seduced all seemed able to benefit Bill. Sex was a weapon Lee could not and would not deploy. She had turned forty that year, a milestone she did not mark because she had begun to lie about her age.[96] (Elaine, who was thirty but claimed to be twenty-eight, did as well.)[97] Actually, Lee had never looked so good. Confident, sexy, and centered, it was as if her exterior and interior selves had found harmony. Apparently, that wasn't enough. Since her quarrel with Pollock over children, Lee had tried to minimize the kind of temptation a woman like Elaine posed. That summer she would banish Mercedes in a dispute over Jackson's attentions to her and another young woman with whom they socialized. "It was a painful shock to me," Mercedes said. "I had never thought of Jackson as anything but my best friend's husband. But he himself must have brought about the contrary idea."[98]

In fact, Lee's anxieties were unwarranted. Without doubt Jackson tormented her with the idea of other women, but in truth, he wasn't that interested in sex. His concerns existed elsewhere: in his studio, in his own head. Lee knew that.[99] And if it wasn't clear to her in the spring of 1948 that he loved her, it would be by the end of that year. No amount of therapy, medication, or self-loathing had been powerful enough to keep Pollock away from alcohol. But the pain he would cause Lee during a boorish, drunken performance—epic even by his standards—in the fall of that year would. After deeply hurting her, not as a woman but as an artist, Jackson would stop drinking. Cold.

18. Death Visits the Kingdom of the Saints

> There are hardly any exceptions to the rule that a person must pay dearly for the divine gift of the creative fire.
>
> — *Carl Jung*[1]

IN LATE JUNE, Elaine, Bill, and Gorky's sister-in-law, V. V. Rankine, rattled south out of New York in a driving rainstorm en route to Asheville, North Carolina. The night train was crowded with soldiers sleeping on the floor.[2] Though the war had ended three years before, many trains still functioned as utility vehicles, not meant to provide passengers with relaxing rides but to transport goods and troops. Rudimentary repairs using coarse lumber had been made to reinforce the seats, but the results seemed only to make things worse. Jagged edges snagged clothing and scraped bare arms and legs, making a walk in the aisle, while swaying to and fro through the narrow cabin, a dangerous journey.[3] Elaine and Bill, however, were no strangers to primitive accommodations and they accepted the trip for what it was, a wonderful adventure. They were headed to a foreign country — the U.S. South — and awaiting them at the end of their ride was what they considered a fabulously generous paycheck. Bill had been offered two hundred dollars, plus room and board, and two round-trip train tickets to teach for the summer at Black Mountain College.[4] The offer had been nothing short of a godsend.

By that spring they had been down to their last few cents and, because galleries were closed for the summer, Elaine had no prospect of earning more money by writing. Friends who themselves didn't have two nickels to spare took pity on them, especially after Bill's show. Everyone knew he'd sold nothing, and yet his works, the result of so many years of tortuous effort, were magnificent. He had therefore joined the long and exalted list of martyrs for the cause of great art and, as such, was considered in need of extra succor and protection.

The Greek painter Kaldis intervened to make sure Bill and Elaine had food to eat. Bringing them to an Automat that employed Greeks, he distracted the attendants by regaling them with stories in the language they shared while telling Elaine and Bill to eat as much as they could from plates along the food line before they got to the cashier. "Eat, you sons of bitches, eat!" he whispered before returning to his role as carefree Hellenic raconteur, holding the young countermen in his thrall.[5] The doctor and

painter Lewin Alcopley literally gave Bill the shoes off his feet because Bill's were falling apart.[6] And Ernestine fed Elaine and Bill on a regular basis. "If you invited her to dinner, she'd be the first one there," Ernestine said. "They ate with us a lot."[7]

The de Koonings had desperately wanted to get out of town for the summer, away from the heat-baked concrete and the air that hung heavy with humidity, capturing the city's soot and darkening even a bright summer's day. Many friends went to Provincetown for July and August, or rented a place on Long Island. Both options were cheap, but anything requiring money, no matter how little, was out of the question for them. Bill tried to look on the bright side. Once, while he was leaning out the window smoking cigarettes, Elaine asked him what he was thinking about so intently. "Look at all those poor dumb sons of bitches," he said. "*They* have to go to work. We're so poor it doesn't matter. We can do what we want to do."[8] But poverty eventually robs even freedom of its splendor. They were in dire need of an occupation that involved cash payment. Incredibly, one arrived unbidden. After a series of scheduling mishaps, the reproduction of Bill's paintings in art magazines, and a reference from John Cage, Bill was invited to teach at the most avant-garde educational institution in the United States.[9] "All of our problems were solved," Elaine said of the offer. "We were overjoyed at the prospect of a vacation in the mountains."[10]

Elaine paid the rent on their studios for the summer, which left them ninety-four dollars to live on for the season. They then packed brushes, paints, jeans, bathing suits, a "good" suit for Bill, and two dresses for Elaine and caught the train to North Carolina. V. V. Rankine, who was heading to Black Mountain to take classes, joined them as they settled in for a long and most uncomfortable trip. Elaine recalled the journey:

> At ten p.m. a porter came around with pillows he was renting for fifty cents apiece. Bill and I looked at each other and a silent agreement was instantly reached: If we had only ninety four dollars for the whole summer, a dollar for pillows for one night was a disproportionate luxury which we felt we should not allow ourselves—a decision we regretted as the night dragged on and we found hard surfaces and jutting corners where we twisted and turned to rest our heads. We finally gave up trying to sleep and read the mystery stories to which we were addicted at that time, all through the night.[11]

She was referring to the works of Dashiell Hammett and Raymond Chandler. "We thought they were hilarious," Elaine explained.[12]

At sunrise, they could see through the train's windows the foggy moun-

tains and lush green hillsides around them. Everything seemed bathed in a clean, fresh dew. Even the air tasted sweet as they descended from the train. It was as if they had traveled back to a time before industrialization, before exhaust fumes and the clanking of machines. They could hear *birds chirping!* Their initial enthusiasm was tempered, however, when they arrived at the campus. The college itself was a disappointment. The buildings were shabby and small, the grounds littered with Coca-Cola bottles and, among the debris, students lay on the grass "looking, we thought, peculiarly listless and forlorn," Elaine said.[13] Having never encountered a southern summer, Elaine and Bill didn't understand that what they took to be sloth was a strategy for survival. But one man didn't seem to be affected by the heat at all. As they pulled their bags from a student's station wagon, Josef Albers rushed toward them, saying, "Ach so! The de Koonings." He embraced them as old friends.[14]

Albers, like Hofmann, would be remembered not only as a painter but as one of the most important art educators in U.S. history. He had taught at the Bauhaus in Germany until 1933, when it was closed by the Nazis and it became imperative that he and his weaver wife, Anni, who was Jewish, leave the country.[15] Black Mountain College was being formed that year, in "revolt and rebellion" against traditional institutions of higher education, and Albers was recommended as a perfect fit.[16] After being offered the opportunity to bring his Bauhaus lessons to North Carolina (a place he had never heard of) to head the art department, he replied by telegram, "I do not speak one word of English." To which the college replied, "Come anyway."[17] By the time Bill and Elaine arrived, fifteen years later, Albers still spoke little English but made up for that deficiency with warmth and enthusiasm.[18] In any case, language wasn't important to him because, he said,

> [Art] is concerned with something that cannot be explained by words or literal description...art is revelation instead of information, expression instead of description, creation instead of imitation or repetition....Art is concerned with the *HOW,* not the *WHAT;* not with literal content....The performance—how it is done—that is the content of art.[19]

No matter how broken the English, those were words Elaine and Bill understood well.

In any studio, Albers would have seemed an odd sort of artist. At sixty, he looked more scientist than painter in his starched linen smock, rimless glasses, pink skin, and straight white hair.[20] But in the rustic Carolina hill country, he appeared nothing short of a wizard surrounded by a flock of equally eccentric and outlandish characters. There were so many faculty

members that Elaine and Bill couldn't remember their names. "We'd refer to people by profession and build," Elaine said, "'that tall photographer' or 'that fat weaver.'"[21] As she and Bill surveyed the grounds to see who had joined them as visiting instructors, they recognized familiar faces, and soon began to feel as though they hadn't left the Village at all. Composer John Cage and dancer Merce Cunningham were there, as were sculptor Peter Grippe and his painter wife, Florence Grippe. Sculptor Richard Lippold had arrived with his wife and two young daughters in a hearse with a wire sculpture on the top. (The family slept in the hearse for the summer.) Rudy Burckhardt showed up for a while to take pictures. Also on hand were the young painters Robert Rauschenberg and Kenneth Noland, future film director Arthur Penn, artist Ray Johnson, and most delightful of all to Elaine's mind, Buckminster Fuller. Arriving with an aluminum trailer packed with mathematical models, he immediately attracted a coterie of Harvard engineering students who were in North Carolina to work with another professor but who hung on Bucky's every word.

More than seventy students had enrolled in the summer program, many of them former GIs.[22] "Anything went, and did between the students," Lippold said. "I mean anybody slept anywhere with anybody. There was no condemnation, no criticism, no evaluation of them. The only demand that was made... was that they had to perform in their field."[23]

Bill was there to work (he had ten students, six of whom were so enamored of him that they would quit school and return with him to New York), so Elaine threw herself into study, greedily enrolling in every class she could find. "I just loved all of this, because I did not have that collegiate experience," she said.[24] First was Merce's two-hour dance class, six mornings a week. She had known him since his solo debut in 1944.[25] Like the painters who were developing the new abstract art, Cunningham wasn't interested in telling a story. He wanted dance to be appreciated and understood on its own merits, as movement through space.[26] Next, from ten to noon, Elaine sometimes took Josef Albers's color theory class, "fascinating to me both for content and for Albers's authoritarian style of teaching," she said. (At night, she entertained Bill by parodying Josef's lectures.)[27] Once, after Albers had stood before the class tearing up a collage Elaine had done, fellow student Pat Passlof quit the course in protest. Elaine stayed. Though she poked fun at him, Elaine deeply valued his teaching. And, on the days she did not study with Albers, Elaine attended Buckminster Fuller's courses.[28]

At first, she had thought of Bucky as a stuffy little man in a bow tie, with eyes magnified behind small but very thick glasses. She said she fell in love with him, however, after hearing a three-hour lecture he gave to the college. Using "teaching tools" he gathered at the five-and-dime—bobby pins

and clothespins among them—he made geometric mobile constructions to illustrate his ideas of "energetic and synergetic geometry based on the tetrahedron." "Then he began making diagrams on a blackboard," Elaine recalled. "He drew a square, connecting two corners with a diagonal line. 'Ah,' he said affectionately, 'here's our old friend, the hypotenuse.'...That did it." Turning to Bill, she announced, "I'm taking his classes."[29] Elaine became the only woman among what she called "a tight little clique of architecture and engineering students from Harvard—elegant, businesslike young careerists."[30] For his summer project, Fuller planned to attempt one of his first geodesic domes. Elaine eagerly joined his crew. "If I had been eighteen, not twenty-eight, I think I would have dropped painting and gone into engineering because Bucky made it so entrancing."[31]

Finally, Elaine worked with and listened to John Cage, who was uncharacteristically tanned and freckled, and sporting a new crew cut. She had met him in her Chelsea days, and later Cage and his wife, Xenia (who had a crush on Bill), had been among the few brave souls to visit their apartment for dinner after Elaine and Bill moved to Carmine Street. (The de Koonings could only invite two people at a time because they had just four chairs.)[32] Their evenings together occurred during a difficult period for Cage: His marriage was disintegrating, he was acknowledging he was gay, and he was blocked in his music.[33] At Black Mountain, the circumstances were happier. Released from personal problems, he was consumed by the music of Erik Satie. During the course of that summer he would give twenty-five concerts of Satie's music, but he wanted to perform an even greater tribute. Cage had discovered a play by Satie called *The Ruse of Medusa*, which had only been produced once before, in Paris. Cage wanted Bucky to play the main character, Baron Medusa ("a kind of W. C. Fields aristocrat who talked constantly in nonsequiturs," said Elaine); Elaine to play his daughter, Frisette; and, in Elaine's words, "the handsomest student on campus, William Shrauger," was chosen to play her suitor. The cast, writers, and the play's twenty-four-year-old director, Arthur Penn (whose future films would include *Bonnie and Clyde*), worked on the production all summer.[34]

Elaine had not been so *free* since her marriage five years earlier. Accommodations were small and bare, the cafeteria food barely edible (Bill greeted one frankfurter-and-banana salad by saying, "Looks like something Elaine would make")[35] but her mind was firing, she was learning, and she was also painting. During her stay at Black Mountain, Elaine completed eighteen abstract enamel paintings on paper.[36] The forms were flat, clean, and curvilinear; the color appeared dry and lacked passion. Though accomplished, the works were not Elaine. These were passage paintings, the results of a door that had been opened by Albers and through which

she had to travel to produce artworks that would become her signature.[37] By the fall, after she returned to New York, Elaine's paintings would erupt in slashing brushstrokes of thick, saturated color whose unequivocal message was naked energy unleashed.

Black Mountain seemed to be exactly what Elaine needed at that moment in her life. It recharged her creative batteries and immersed her in a scene of limitless experimentation. Elaine's closest friends on campus were Cage and Cunningham, but the time she spent with them began to irritate Bill. "He got quite hostile to us as a little group. He called us the gigglers," Elaine said many years later. "I would sit with them at lunch, and we just laughed the entire time. And Bill would be sitting elsewhere. You know, and I kind of threw myself in. I was hanging out much more with the students."[38] In retrospect, she realized she had made Bill, who was conscious of being a foreigner, feel even more of an "outsider."[39] If Elaine knew this at the time, however, it didn't cause her to scale back her activities. Likewise, Bill didn't sulk over being deserted by his intellectually voracious wife. He became involved with his students and one painting, a masterpiece he would call *Asheville*. Life continued that summer for both Bill and Elaine with a kind of glorious sameness, until the outside world intruded and broke both their hearts.

Gorky had killed himself. There are several versions of the story as to how Bill and Elaine first heard the news, but it doesn't really matter, the effect was the same—utter devastation—although perhaps, after the shock had worn off, not surprise.[40] One fellow artist described Arshile as a kind of John Barrymore acting a Shakespearean tragedy "seen through the eyes of Dostoevsky."[41] Even acknowledging that there had been warning signs, though, his friends felt robbed by his death. Gorky had been the heart and head of the downtown scene during the Depression and into the early years of the war.[42] During times of greatest trouble, fellow artists turned to Gorky for inspiration, for guidance, and—despite his well-known proclivity for autobiographical invention—for honesty. Honesty in art, honesty in life. And just when Gorky had painted his greatest works, when he finally had the money to buy the best materials and devote himself entirely to his art, the disappointments he experienced outside his studio had proved too great. The painter could not survive the dilemmas of the man.

During the two years since Gorky's paintings had burned and he had received a diagnosis of cancer, he had been half crazy, according to David Hare, who lent him his Connecticut home for a time and was part of the Surrealist circle in which Gorky traveled. "He would close himself up and work for two or three weeks, or maybe not work, and have someone bring him sandwiches in through the door and not see anyone," Hare said.[43]

Mougouch had come to believe she was living with a lunatic. Gorky had hit her, and Mougouch fled with the children to the safety of her parents' home (some said at Gorky's request), while she tried to determine if their marriage was salvageable. According to John Bernard Myers, she was "terrified" of Gorky and consequently "began a liaison with Matta."[44]

The Chilean was the opposite of Gorky. Small, giddy, filled with a sense of his own greatness, he was immersed in the grand role he was writing for himself in art history. Gorky's dealer Julien Levy described Matta as a "rather pudgy little Rimbaud, assuming that Rimbaud was as his photos seem, rather beautiful and perversely angelic." Matta had been married but left his wife when she became pregnant, which he considered "a form of half castration."[45] She had twins, which presumably meant he would have been castrated twice over if he had stayed. Newly freed, he offered the lovely Mougouch a ticket out of her troubles, and she accepted.[46] In June 1948, she told Gorky she was going away for two days, and when she returned, Matta spread the word that they had been together. Gorky became aware of their affair at a party when he found Mougouch and Matta together in a bathroom. Meanwhile, everyone around the dinner table regaled each other with cuckold jokes.[47] The proud Gorky writhed in agony. He had come to despise the Surrealists and their sex games. "You know...I made a terrible mistake getting in with these Surrealist people," he told a friend. "The husbands sleep with each other's wives. The wives sleep with each other. And the husbands sleep with each other. They're terrible people. I never should have let Agnes get mixed up with them."[48]

On June 25, 1948, Gorky read Mougouch's diary. Some accounts say he discovered she was planning to leave him.[49] Whether she had used those words, or he simply read that intention into what she had written, Gorky believed his worst fears were confirmed. He spent the day with his dealer Julien Levy and went to a dinner party that night with Levy and his wife, Muriel. Despite a driving rainstorm, Gorky insisted on going home in case Mougouch, who was in Virginia with her family, telephoned. Muriel, their new puppy, and Gorky got in the car—a drunken Levy behind the wheel and Gorky beside him in the passenger seat.[50] Muriel described what followed:

> It was now pelting with rain. We couldn't see a thing. We went around this curve on a steep hill and there was a stake on the right-hand side. Chicken Hill. It was notorious. Downhill curve. Treacherous at best. Julien hit the stake. The car turned over on Gorky's side. Turned upside down, once or twice. The car was smashed up. Julien's dog was yelping.[51]

Julien suffered a broken hand and collarbone. Muriel had a mild concussion. Saying he was fine, Gorky refused to stay at the hospital to receive

his X-ray results. The next day, however, while he was at Levy's home, the hospital called to say he had a broken collarbone and two fractured vertebrae. Hospitalized and placed in traction, Gorky looked crucified.[52] Mougouch heard about the accident and rushed to see him, but Gorky's physical pain was nothing compared with his mental anguish when she arrived. Matta had brought her to the hospital.[53] Gorky thereafter seemed to lose his mind. He informed hospital staff to "make way for the throngs" who would visit him. "He says he is a famous genius," an intern told Julien. "Is he?" "Possibly," Levy replied. "Quite possibly a genius."[54]

In July, Gorky was discharged and given an iron and leather neck brace to support his head. Painting for Gorky was an extremely physical act, and it would have been nearly impossible for him to continue to work at his easel until he had healed. All that remained for him was the weight of his despair over his marriage and the mystical belief that the forces that had deprived him of happiness from his childhood onward were not done with him yet. Almost incredibly, shortly after Gorky returned home from the hospital, Mougouch decided to confess that she *had* been with Matta during her two-day absence the previous month.[55] Gorky felt a surge of energy but it was for only one activity, revenge. He made an appointment to meet Matta in Central Park. Carrying a heavy Irish walking stick, Gorky gave chase when he saw Matta in order to bludgeon him to death, but Matta managed to calm Gorky to the point that the two could sit on a bench and talk. No doubt crushed that he was not even capable of murdering Matta, Gorky told the Chilean that he would "make him a gift." He then took his leave, though he did not return to Connecticut. Gorky began to roam around New York.[56]

The figure who once strode through the Village triumphant, head held high, the Picasso of Washington Square, was now battered physically and beaten spiritually. He lurched like a madman. Two days after his meeting with Matta, Gorky went to the studio of his old sculptor friend Isamu Noguchi and stood outside howling, *"Isamu! Isamu! Isamu!"* Noguchi recalled, "I thought I was dreaming, and then the calling came again like a song." He looked out the window to find Gorky, who, after crying "Nobody loves me," asked for a lift back to Connecticut.[57]

Once home, on July 20, Gorky put a knife through his most recent painting and then called friends, asking each for some sort of help. Levy speculated that Gorky had really just wanted to hear their voices one last time.[58] Earlier in the day, he had hung several nooses around the property he was renting, one of which was suspended from a rafter in an open-sided shed where he sometimes went to read or think.[59] Around midday on July 21, Gorky scrawled one line in white chalk on an old painting crate in the shed— *"Good-by, my loveds"*—and from a noose dangling next to it hanged himself.[60]

"The last time I saw Gorky," Edwin Denby said, "not long after the war, he was sitting with Bill and Elaine in a diner that used to be at Sixth Avenue... and I went in and joined them for a coffee. I told them I had just read in the paper that when the war was over there were 175,000,000 *more* people in the world than before it began. He looked at me with those magnificent eyes of his and said quietly, 'That is the most terrible thing I have heard.'"[61] Gorky could not bear the thought that more children had been born into betrayal, violence, and despair. He did not love the life of men. He had existed during his forty-four years on the planet as a creator. His place had been among the gods.

When Bill heard the news in the Black Mountain cafeteria, he "recoiled as if struck." Elaine, Bill, and the artist Ray Johnson immediately left the campus to walk off their sadness and recapture their memories.[62] In those past few years, while Gorky was feted by his new Surrealist friends, he and the de Koonings had grown apart, but Bill and Elaine still revered him as an artist and loved him as a brother. In the coming days, Bill would be seen infrequently around the school.[63] He retreated to his studio to mourn his friend. With Gorky's passing, an era had truly ended. It was as if their innocence was gone.

19. The New Arcadia

> "What is it?" It is as difficult for him to explain what his art *is* as to explain what he himself *is,* but, since he paints with the question and not with the answer, explanation is not an issue.
> — Elaine de Kooning[1]

AT THE END of the term at Black Mountain, Bill boarded the train north carrying the one painting he had completed and Elaine's eighteen works.[2] He had become tired of both the parties and the proximity of nature. One evening, he turned to Elaine and said, "Let's take a walk." They did so for about ten minutes until they found themselves surrounded by velvet mountains under a diamond-studded sky. Bill suddenly said, "The universe gives me the creeps. Let's get back."[3] What finally drove him away, however, was an epic end-of-season celebration. Coming so soon after Gorky's death, the wild revelry grated on Bill. And so, accompanied by a twenty-year-old painting student from Georgia named Pat Passlof, Bill left for Manhattan. Pat was the perfect traveling companion. A confirmed de Kooning disciple even before she met him, she had quit college to follow him to Black Mountain after seeing his paintings at Charlie Egan's.[4] After a summer as his student, Pat's admiration for the man and his art had only grown. Elaine, meanwhile, had volunteered to stay behind to help put the school back together after the big bash. In fact, she may have been reluctant to relinquish her creative sanctuary by the lake.

Elaine's career as a student at Black Mountain had been a triumph. Cage's production of Erik Satie's play, in which she was one of the three main actors, had been so good he considered bringing it to New York for a performance.[5] She had also valiantly come to Bucky Fuller's defense when his grand finale, his geodesic dome, collapsed during its unveiling one rainy afternoon, much to the hilarity of his skeptics. "It was like Fulton when he first tried out his steamboat," Elaine said. "I just knew that Bucky was right—and they were all wrong."[6] During the end-of-term party, she waltzed with Fuller, who complimented her dancing, saying, "You're a terrific performance per ounce!"[7] He might have been describing her entire tenure at the school. Elaine had been everywhere, studied everything, and performed admirably "per ounce" throughout. Life impinged, however, and in any case, she was a guest at Black Mountain, not a student. Not long after Bill left campus, Elaine did, too.

The New York she returned to had changed during her two-month absence. Personally, she was surprised to learn that her favored consort, Charlie Egan, had married a woman he met at a nude beach on Martha's Vineyard. Even as he proposed, though, he had told his future wife he would always "adore" someone else. He hadn't mentioned the woman by name, but her identity soon became clear. "Charlie's brother called me Elaine and Charlie called me Elaine," said his wife, Betsy Duhrssen. "This was a pretty serious thing in my life."[8] Together again in New York after her return from Black Mountain, Elaine and Charlie appeared not to have let his changed marital status interfere with their relationship. He often accompanied Elaine home from dinner (which Betsy had prepared) only to disappear until the next morning. Betsy found lipstick on his undershirt, and once she "told him, 'I saw Elaine's shoes in the gallery.' And he said, 'They're my shoes.' And I said, 'But you don't wear high heels.'" Betsy was shocked that Bill, though seemingly aware of the affair, wasn't overly concerned.[9] She hadn't been on the scene long enough to understand that this was simply the way Bill and Elaine's relationship had evolved. "It was not one-sided, believe me," said Ernestine. "If Bill went out with somebody to have a cup of coffee, he might never come home.... They had no sense of fealty, or whatever you might call it. It was just a mutual disability, as it were."[10]

More significant than that minor alteration of her personal landscape, Elaine recognized major shifts in the art scene. While she and Bill were away, the community had consolidated, even as its numbers grew with the return of former soldiers and sailors who had been studying abroad on the GI Bill. They had gone to Paris in search of bohemia only to discover that the real bohemia, the home of the avant-garde, had relocated to New York. Soon, they did, too. Most wanted to settle around the Village, but the buildings on Eighth Street with fifth-floor studios that were prized by artists were being sold and artists were no longer welcome. "Genius Row," along the south side of Washington Square, had been torn down to make way for New York University's expansion. And all around the periphery of the Village, century-old buildings had been replaced by vacant lots.[11] A search for suitable quarters, therefore, forced artists to look slightly farther afield—north and east—to Tenth Street, where they discovered that a group of commercial structures between Third and Fourth Avenues had been vacated by their munitions factory tenants and the rents were ridiculously low.[12] One by one the artists began to move in, poetically replacing the production of bullets with the production of art.

Philip Pavia and David Hare were among the first. Then Bill, whose studio was around the corner on Fourth, found Pat Passlof an incredible space with a skylight on Tenth for fifteen dollars a month. There she could

continue her private studies with him (which she did for two years) and meet the neighbors. "To my surprise, many of [Bill's] cohorts were curious to see what I was doing," she recalled of those early days on that famous street.[13] Within a short time, ten, twenty, and eventually more than thirty artists would be living and working there, a territory they happily shared with its native inhabitants.[14] "Tenth Street was like an annex of the Bowery. It had these employment agencies for dishwashers and it had bars that catered to derelicts and there were at least twelve or twenty bums who lived on the street," said Ray Spillenger, who had also studied with Bill at Black Mountain and followed him to New York.[15] Soon the artists who lived in derelict buildings and the derelicts who lived on the street were on a first-name basis.

The same GI Bill that had swelled the ranks of the artists had created not just new painters and sculptors, but a newly educated audience to appreciate such work *and* a vibrant avant-garde scene across all the arts. Actors, poets, novelists, dancers, and composers who had been given the opportunity to study whatever they chose by the government they had served signed on to a new mission: the movement to change the face of the arts in America. Larry Rivers, who had used an army pension to study at the Juilliard School of Music before he transferred his artistic affections to painting, credited the GI Bill with "unintentionally producing more artists per hundred thousand civilians than ever before." Elaine said that for the artists, the GI Bill "in the forties [was] what the WPA had been in the thirties."[16] And, like the earlier generation of artists who had come of age during the Depression, the GI generation was content to paint and perform for no audience other than one another. Said Rivers,

> You could be poor and think your life was worthwhile—the dance of the mind, the leaps of the intellect. If you made art that did not sell immediately, or ever, you could still be involved in a meaningful, inspiring activity that was a reward in itself, and you could show it to the people you dreamed of thrilling with your efforts; your friends were your audience. They were sitting on your shoulder watching you work. That was the opera of the time.... Pursuit of a career and commercial success was *selling out*, losing one's soul. In painting, writing, music, and dance, nothing could be more shameful.[17]

Clem had worked overtime to ensure that the work being done in the city was acknowledged for what it was: romantic and revolutionary. And that was catnip for a young artist trying to break out of the conformist culture of postwar America. Columbia University sociologist C. Wright

Mills described that straitjacketed existence as "organized irresponsibility.... More and more people are becoming dependent salaried workers who spend the most alert hours of their lives being told what to do."[18] By contrast, Greenberg described the New York artists as a veritable resistance movement, part of a long and proud tradition, not just in art but in Western society. In a 1948 series of articles in *The Nation* and the *Partisan Review,* Clem wrote in his most aggressive mode, attacking anyone who criticized the new art. More than a critic, he was an *agent provocateur*.[19] In those days, he believed in art with the passion of first love. Clem had matured as a critic along with the artists he reviewed and believed he understood them as no other critic did or could. Make no mistake, he was not a mere cheerleader. The Greenbergian intolerance and insensitivity that would make generations of artists shrivel were on display in many of his reviews. But for the work and artists he respected, he stood his ground and batted off detractors. Writing in the *Partisan Review,* he stated dramatically,

> The myth that is lived out here is not a new one; it is as old as the Latin Quarter; but I do not think it was ever lived out with so little *panache,* so few compensations, and so much reality. The alienation of Bohemia was only an anticipation in nineteenth-century Paris; it is in New York that it has been completely fulfilled.[20]

To have such impassioned commentary in a journal that was considered a must-read by the nation's intelligentsia (Larry Rivers called the *Partisan Review* "a neon sign over the gateway to the fields of measured thoughts and thrilling argument") signaled that something of note was happening in New York.[21] It meant that "the 'mad geniuses' were creating works [viewers] might not understand but that they should at the very least acknowledge," said Dore Ashton.[22] What was more intriguing still was that while Clem and a very few other critics—notably Tom Hess and his staff at *ArtNews*—lustily praised the new work, some art institutions just as vociferously denounced it. In February 1948, the Institute of Modern Art in Boston changed its name to the Institute of Contemporary Art so as not to be associated with the "double-talk, opportunism, and chicanery at the public expense" of the "cult of bewilderment founded on obscurity and negation" then arising out of New York. The *New York Times* identified Pollock and Gorky as members of that "cult," and in an article that summer would suggest Pollock in particular was party to a "hoax" being cynically perpetrated on the public.[23]

Such a challenge could not go unanswered and so, in a resurgence of activism that quickened the hearts of the old Artists Union members,

abstract artists held a symposium at the Museum of Modern Art titled "The Modern Artist Speaks." Just under 250 people attended, among them Pollock and Lee, to hear familiar voices like that of Stuart Davis again issue a fist-thumping defense of artists' rights from behind a podium. The difference, however, between 1938 and 1948 was that instead of defending the artists' right to earn a living on the Project, he was defending their even more basic right to create whatever they pleased.[24] Later, in the fall, there would be yet another gathering at the Modern: a symposium sponsored by *Life* magazine of fifteen eminent art historians, critics, and educators (Clem among them). They were to address and "clarify the strange art of today," which was "ugly," "looked wrong," and was "difficult to understand" but appeared to be the "dominant trend...of our time."[25] *Life* considered the symposium of such value that it reprinted the transcript for mass consumption in its October 11 issue. Nestled among the ads for Goodyear tires and Hunt's peaches were reproductions of works by five contemporary Americans, among them Jackson and Bill.[26]

After being blissfully ignored for so long, and thereby allowed to develop their own styles, their own culture, their own social system, the avant-garde artists in New York were not about to allow themselves to be defined by others—for good or ill. They had a publication at their disposal, *Tiger's Eye*, in which they could produce written statements, and in the fall, they would open a school in a loft at 35 East Eighth Street.[27] Its awkward name, the Subjects of the Artist, indicated just how unused to such formal endeavors the artists were. And yet that school would be crucial to the development of modern American art. It wasn't the classes that were so important; the students attending were few. What was significant, even groundbreaking, was the decision to hold Friday night guest lectures.[28] At first, the talks were mostly by Surrealists with whom two of the school's four founders, Bob Motherwell and David Hare, were friendly. By the end of the year, however, the artists invited to lecture at what became known among them as "Motherwell's School" were mostly the New York abstractionists who had previously spoken only to one another about art and life.[29] Now, addressing a broader audience across the artistic community, they began to give voice to a movement (which, in the best anarchistic tradition, the artists would forever insist did not exist) that had been named in an offhand remark by a *New Yorker* critic struggling to describe their work. In 1946, Robert Coates had borrowed a phrase used by Alfred Barr in a 1929 book on Kandinsky. He called the new work "abstract expressionism."[30]

Pollock's paintings had provoked much of the tumult and chatter in New York that year, but he and Lee had carried on in Springs as they always had, working, entertaining, and fighting each other with increased feroc-

ity. Evenings or weekends with friends often ended with curses, insults, and plates flying. In one case during a dinner party Pollock toppled a cupboard full of dishes. That outburst was occasioned by the surprise appearance of Lee's old beau, Igor, who sported a split lip after an unwelcome encounter with Jackson's fist.[31] Meanwhile, Jackson tormented Lee by flirting with other women. Most often, the women involved knew it was nothing more than a hurtful game he played to aggravate Lee.[32] (Actually, he was so timid with women that when May Tabak came to the house when Lee wasn't home Pollock insisted on sitting with her outside so no one would suspect anything was "going on" between them.)[33] But if the subject of Jackson's attention wasn't part of their inner circle, she might respond—and face Lee's wrath. After one such battle between Lee and a woman who had fallen for Jackson's charms during an evening of cards, Jackson stormed out of the house, flailing his arms and shouting at Lee, "Get out of here, you bitch. I hate your guts." According to Lee's sister Ruth Stein, "[Lee] sat there with her arms around him, kissing him until all that anger dissipated."[34] Jackson recognized that his actions were aberrant and that his drinking was "rough" on Lee. "I can't say I'll stop," he told her, "because you know I'm trying to. But try to think of it as a storm. It'll be over sooner or later."[35]

Among the guests arriving at Springs that summer was a gallery owner named Bertha Schaefer. She was one of the few visitors more struck by Lee's work than Jackson's. Schaefer had scheduled an exhibition that would incorporate modern art into the modern home. Lee's work perfectly married that idea of art and function. Schaefer asked Lee if she would like to show two of the tables she had made—one a mosaic and the other topped with a Little Image painting covered by glass—as well as a Little Image painting that she would hang on the wall. The opportunity to exhibit on 57th Street would have been Lee's first in three years, since before Howard Putzel's death in 1945. Lee answered Schaefer's invitation with an eager yes.[36]

The show opened on September 20, amid a glowing pageant on Fifth Avenue. New York was celebrating its Golden Jubilee. It had been fifty years since the city's five boroughs were consolidated. The town was literally bathed in gold: Golden lights illuminated the exterior of the New York Public Library on Bryant Park, store windows along Fifth featured gold dresses, gold jewelry, gold accessories.[37] It seemed that all of New York was uptown drinking in the glamour, and that meant more people strolling through galleries like Schaefer's. Amid such excitement and activity, Lee's show was a success and her work was singled out for praise— a first for her—in the *World-Telegram,* the *New York Times, Architectural Forum,* and the *New York Herald Tribune,* whose reviewer called Lee's

mosaic table "magnificent" and also featured a picture of it in the newspaper.[38] Lee was elated.

Schaefer invited Lee and Pollock to her well-appointed apartment to celebrate after the opening. Predictably, Jackson began drinking. One bottle of wine, a second bottle, and when he made for a third, Schaefer tried to take it away from him. Jackson snarled imbecilically, "What does an old lady like you do for sex?" He then went on a rampage, destroying valuable antiques. Terrified, Schaefer reached for the phone to call the police, but by the time she started to dial, the beast Pollock had collapsed, his rage spent, the destruction he had caused scattered around him.[39]

It is not hard to imagine the magnitude of Lee's anger, hurt, and mortification. Her big night, *her* opening, not his, had been ruined. After all she had done to make sure his career was a success, he had not reciprocated. Such behavior reeked of jealousy from a man who had been called "the greatest." Upon returning to Springs, Lee forced him to send Schaefer an apology. Jackson wrote,

> *Thank you so much for being so nice to us while we were in New York. I hope you will forgive me for my inconsiderate behavior and the inconvenience I caused.*[40]

Schaefer did not forgive him. She threatened to file charges, to sue for damages, to have him thrown in jail. Clem, Betty Parsons, Lee, and the Pollocks' neighbor Roger Wilcox all pressed Schaefer to drop the case. Eventually she did.[41] But everyone involved in that disaster came away from it shaken, not least Jackson. He had come very close to landing in jail, and he had deeply hurt Lee. It is impossible that the sober Jackson failed to recognize the injury he had caused her. *That* Jackson was gentle, considerate, and loving. He knew what she had done for him, and he could not have escaped feeling remorse and guilt over how he had thanked her. The only way to make amends would be to calm his storm, to lay off the booze. Lee had already spoken with a local doctor about Jackson's drinking, and when, not long after the Schaefer debacle, Pollock fell off his bicycle and needed medical treatment, Dr. Edwin Heller quietly broached the subject with him.[42]

Heller was a plainspoken man who told Jackson he was being poisoned by alcohol, that his body simply could not tolerate it. For a rural doctor, that approach to treating an alcoholic patient was remarkably advanced. Drinking had been accepted as part of American life since the repeal of Prohibition in 1934 and had come to dominate the social life of adults during and after the war. By 1948, however, some physicians recognized that excessive drinking was not a moral weakness but an illness.[43] That is what Heller saw in Pollock, and he approached him as he would any other ill

patient: calmly, directly, pragmatically. He did not blame him for his bad behavior, but neither did he condone it. Heller simply said that there was a way to change, but only one: Pollock had to stop drinking. Heller gave Jackson tranquilizers to smooth the rough edges as he eased off alcohol.[44] He also gave Jackson his phone number, telling him to call whenever he felt the urge to drink. Finally, he scheduled weekly appointments.[45] It wasn't therapy, it was just two men talking. Praising Heller as "one doc with no shit in his bag,"[46] Jackson soon declared that he had "quit [drinking] for good."[47] His decision was transformational for Lee *and* Pollock. She could breathe again. He was a new and better man. Maybe the storms that had rocked the house on Fireplace Road were over.

In late October 1948, sound trucks drove slowly through the Village streets, urging people to vote for the antiwar, socialist-leaning candidate Henry Wallace in the November 4 presidential election.[48] Many artists and intellectuals saw Wallace and his Progressive Party as the only alternative to the establishment candidates—Harry Truman and Thomas Dewey—who were sure to follow the same paths of political crackdowns domestically and confrontation globally. On the third anniversary of V-J Day, there was a sense that the war was not yet over.[49] In fact, by 1948, the seeds of future turmoil that had been planted during World War II had sprouted. Israel had been declared a state that year, and efforts to reach a truce with the Palestinians who resided within its borders dominated the news in the spring and summer. Mahatma Gandhi, a symbol of peace, had been assassinated in India. Amid the massive postwar transitions in Asia, he had helped win his country's independence from Britain. Meanwhile, riots had erupted in Italy and Czechoslovakia, civil war continued in China, and throughout the world the Cold War between Washington and Moscow had escalated dangerously. In June, the Soviets instituted a blockade of Berlin.[50]

The tensions around the world exacerbated tensions at home. Nineteen forty-eight saw violent attacks on Communist Party members in New York. One of its leaders was stabbed to death in the street, and members of the Boys Club broke up a Party meeting in the Village, shattering the windows of the local headquarters. The mobs were not just anti-communist, they were also racist and anti-Semitic. While attacks on them went unprosecuted, Party members were dragged into court. In July, twelve communists were indicted on charges of conspiring to overthrow the U.S. government. Not that they had taken any steps to do so, but prosecutors said they were *thinking* about it. That anti-Red fervor only increased when allegations surfaced that communists had penetrated the U.S. government. The country was transfixed during the summer by a drama playing out before the House

Un-American Activities Committee, which historian David Halberstam said was comprised of "the most unattractive men in American public life—bigots, racists, reactionaries, and sheer buffoons."[51] At issue were charges that a former State Department official named Alger Hiss had been a communist when he worked for the government, and that there were others like him prowling those hallowed halls.[52]

The situation would have been comical if its consequences for society had not been so grave. Even nonpolitical intellectuals and those who merely deviated from the accepted social path were being arrested, often on trumped-up charges. It had become so dangerous and socially unacceptable to voice political opinions that many people simply stopped having them. Conveniently, a wonderful new device appeared in homes that greatly helped in that regard. The television age had dawned in America. By 1948, Milton Berle and Howdy Doody would become pioneers at the frontier of living-room entertainment, offering jokes and gags as a respite from worries.[53] Even politics became entertainment. For the first time in history, the presidential election count was televised and, much to the surprise of most prognosticators, Truman won.[54] Americans had chosen the steady hand of a man who promised not a "New Deal" (which by 1948 was viewed as tantamount to communism) but a "Fair Deal."[55] That was enough for that new generation of Americans fortifying themselves in prefabricated homes in freshly sprouted suburban developments. There, polished cars were parked alongside newly mowed lawns, and houses were filled with the latest time-saving gadgets so the inhabitants could forget themselves and the world as it was in favor of a televised universe of make believe.[56]

The artists and intellectuals in New York felt more estranged from that greater world than ever. They were what Bob Motherwell called "spiritual beings in a property-loving world."[57] Somewhere along the way, their lives had diverged completely from the mainstream. But wasn't that always the way with the bards and minstrels of bohemia? *They* had not made an issue of their outsider status, they had simply wanted to be left alone. The critics who observed and chastised them, however, wouldn't allow it. In an end-of-year message in the *Atlantic Monthly,* the director of the Metropolitan Museum of Art, Frances H. Taylor, accused America's avant-garde of humiliating and patronizing the public through unintelligible paintings that aroused "antagonism" and "indignation."[58] If that was the case, said the abstract artists, so be it. They had a duty to the greater society—not the society of their day, which had rejected them, but the society of tomorrow for whom they spoke.

Before his suicide that spring, the French poet and playwright Antonin Artaud had written a kind of memorandum to artists trying to navigate

their way in a hostile world that neither appreciated nor understood them. He said,

> THE DUTY
> Of the writer, of the poet
> Is not to shut himself up like a coward in a text, a book, a
> magazine
> from which he will never emerge
> But on the contrary to go out
> Into the world
> To jolt
> to attack
> The mind of the public
> If not
> what is he for?
> And why was he born?[59]

As a blizzard dropped twenty inches of snow on New York in mid-December 1948, making seamless domes of out of stranded cars, outlining black tree limbs with glistening fairy dust, softening the emphatic green, yellow, and red of stoplights into mere hazy suggestions, the lights in studios from Chelsea to Third Avenue burned bright. The artists inside them were creating Artaud's jolt, and it would change the way people saw art, the way they saw life, the way they *lived* their lives. The artists would not have to go out to attack the world; the world would come to them. Soon, everyone would want to be part of it. Elaine called the years between 1949 and 1959 "a ten-year party."[60] Among those attending would be three younger women who would help blow the scene wide-open.

PART TWO

1948–1951

Grace

20. The Call of the Wild

What am I? Nothing. What would I be? Everything.
— *Marie Bashkirtsev*[1]

A YOUNG WOMAN with shoulder-length blond hair who was so conventionally feminine, so reassuringly lovely that she could have been the face of an ad campaign for nourishing breakfast cereal, stood in late October 1948 in front of a dingy abandoned storefront at 85 Fourth Avenue on the rough edge of the Village.[2] As incongruous as the location was with her appearance, the block was familiar to her. She had enrolled her son in the school across the street until that spring, when she made the most wrenching decision of her life. She sent her seven-year-old boy to live with his grandparents in New Jersey so she could stay in New York and paint.[3] She had abandoned everything—job, husband, lover, son—to be an artist, and she wasn't even sure what that meant. All she knew was that she *had* to do it, and she was looking for someone to tell her how. The woman rang the bell and a head looked out the window. She called up:
"I'm Grace Hartigan, here to see de Kooning. Jackson Pollock sent me."
Bill invited her in.[4]

Grace had been plotting her escape from the world into which she was born from the time she was a child. It wasn't a particular path that drew her—she didn't care where she went as long as it involved adventure. For a time, she was content to listen to the tales spun and sung by her beloved Irish grandmother and maiden aunt who had lived upstairs in the family's Bayonne duplex.[5] That is, until her parents moved their brood to the New Jersey countryside and Grace discovered a Gypsy encampment nearby. "I used to climb in my apple tree and hide and watch them for hours," she wrote a friend many years later. "I knew they were thieves but so free and so beautiful like art. I learned a lot watching them. I guess I wanted the free and beautiful part."[6]

Grace's parents seemed to have recognized that they had a "changeling" on their hands because they didn't treat her, the eldest of four children, as mothers and fathers were supposed to treat a daughter. They *expected* something from her. "They always asked me, 'Who are you? What are you going to do with your life?'" There were no limitations just because she was born a girl. Tellingly Grace once said, "I always thought I was a *person*." At ten

she wanted to be a detective.[7] She also loved poetry and considered becoming a writer. Then she discovered the movies, and from that moment, stardom beckoned. The women of the silver screen easily matched the scale of her dreams. No doubt Grace had never heard the word "diva," but that queenly status was what she aspired to.[8]

Young Grace's fantasy life was so vivid in part because her home life was so tense. Her mother lived in her own illusory world of distinction as the descendant of French aristocrats and English colonialists. She believed she had married beneath her when she accepted the son of a blacksmith as her husband. When he became an accountant, she still considered him lesser, and the strains arising from her discontent only increased through the years. Grace's mother grew more rigid (she never used the phrase "I love you"), and eventually showed signs of mental instability.[9] As the children left the house in the morning, they did so at times to their mother's threat, "When you come home from school I might be dead."[10] She also hoped to commune with the dear departed. "For about the first seven years of my life," Grace wrote, "I was awakened the night before my birthday by my mother walking the house in her nightgown waiting for her mother (in spirit form) to appear."[11] Grace tried to ignore the acrimonious and bizarre happenings around her by retreating into the arts, but they, too, became a zone of conflict. "My mother was so antagonistic to anything like that that if I would listen to an opera on the radio she'd come in and turn it off," Grace recalled. "It's interesting because it made me feel as though I had a private life, something to fight for.... it was forbidden, maybe kind of magical."[12]

The Depression years were difficult for the family and instilled in Grace what she called "a horror of owing or being without money" (which is ironic given that she would pursue a life offering the assurance of only one thing—poverty).[13] Those years also meant that when it came time for her to decide what to do after high school, college would not be an option. Her aunt had graduated from Columbia as an aspiring writer, and Grace, who had been expected to follow her, had scholarship offers from various schools. But even with that help the family couldn't afford the "incidentals" to send her to a university.[14] At eighteen, Grace therefore had two options: work or marriage. She settled for work (possibly to augment the family finances) at a Newark insurance company.[15]

A twenty-year-old accountant at the firm, Bob Jachens, was also a creative refugee in that sterile environment. He had gone to Columbia but was forced to drop out during the financial crisis and had washed up like Grace in a job for which he had no real interest.[16] Discovering each other, they began to date. Previously, Grace's only trips into New York City had been shopping excursions. Bob introduced her to something new. He took his

eighteen-year-old girlfriend to the Metropolitan Museum. It was the first time Grace was surrounded by art, the first time it broadcast off the walls to her, the first time she saw the millennium reflected in the works that mankind had created. She said it was the first time she was "conscious of art" and... it didn't really move her.[17] She was, however, interested in Jachens. In May 1941, shortly after Grace turned nineteen, they were married. She liked to explain her decision later by saying, "I married the first boy that read poetry to me."[18] What may have actually attracted her was his willingness to break free from the confines of their lives. She and Jachens had decided to quit their jobs and move to Alaska. They were going to be "pioneers." Purchasing two one-way bus tickets for twenty-five dollars, they set out on the first leg of their journey: New York to Los Angeles.[19]

They had not reckoned, however, on the cost of their stopover in California and were soon out of cash. "Bob pretended to know how to ski and got a job selling ski equipment in a department store," Grace said.[20] Being in L.A., she might have tried to make inroads into the movie business. Her high school triumph was being voted "best actress" of her graduating class. But by the time she was in a position to try acting professionally, Grace had soured on it. She discovered she "hated to be an interpreter of someone else's expression."[21] In any case, she was pregnant, which put a full stop to that fantasy. To any fantasy. Grace came to the bitter realization that independence from her family hadn't elevated her existence. It only seemed to bury her under fresh layers of conventional drudgery. Grace wasn't interested in children; she didn't even particularly like them.[22] She had considered having an abortion but was afraid of the procedure, which was illegal and often dangerous. Instead, she decided to try to accommodate her condition, to accept that major setback in her sprint toward liberty. She mused, "That's all right. Pioneers have children... in the fields and tuck them under an arm and go on."[23] Grace's attempt at self-reassurance, however, didn't convince her. Married, pregnant, stranded in California, she summed up her condition in one word: hopeless. Bob must have sensed her despair. He began to ask her the questions her parents had posed when she was a child: "Who are you? What are you going to do?"

"I can't be a composer, it's too late," Grace replied. "I've written," she offered, though they both admitted that she wasn't very good.

"How about being a painter?" he asked.

"I can't paint."

"Oh, come on," he goaded.[24]

And so, they enrolled in an adult education class at a local high school. "The minute I picked up a pencil just to draw a vase I started to sweat. I began to suffer while he was pretty good. He made a drawing and there I was crying and sweating with this pencil in my hand," she said.[25] "I never

cried. I didn't know why I was crying."²⁶ "Something just felt as though it was very important to me."²⁷ Grace bought watercolors, an exceedingly difficult medium to which many beginners mistakenly turn, and though she struggled and failed, she did not quit. She returned to charcoal and pencil. "All during that time I was pregnant and then after the baby was born, I drew, all on my own," Grace said.²⁸ A young mother having given birth to her first child would have been expected to be preoccupied with her new responsibility, if not her new joy, but Grace's attention was divided from the start. Her son, Jeffrey, would always look upon art as "the competition" for her affections and, increasingly, it became evident that art would win out over motherhood.²⁹

Shortly before Jeff was born, the Japanese attacked Pearl Harbor. The panic on the East Coast was mild compared with that in California, which was within range of Japanese aircraft. The state changed almost instantly to a war footing and, just as quickly, hordes of servicemen began pouring in from small towns and military bases across the United States. Bob, who was twenty-one, knew he would be drafted and so he, Grace, and the baby packed up and headed back east to Bloomfield, New Jersey, where they moved in with his parents. They lived together in those crowded quarters for a year, until April 1943, when Bob received his draft notice. Believing, as many men did, that he was heading to the front to die, he told Grace, "Go ahead and make a life."³⁰ At twenty-one, Grace was alone, with a baby she did not particularly want, living with her in-laws. What life? The only one that interested her—the life of an artist—was one she could not have. To Grace's mind, she had hit rock bottom.

Like Elaine and Lee, Grace became one of the millions of women who answered the call to work during the war—an example of what *Life* magazine called the "heroine of a new order."³¹ But unlike those two, her reasons were dictated less by the necessity of earning a living than by the desire to escape from her in-laws' home. Patriotism had given her cover for rebellion. Fibbing, Grace called herself an experienced "tracer" to get a job at an aeronautical factory north of Newark. She ended up in the drafting department and was so gifted that her foreman authorized her to take night classes at the College of Engineering to become a professional mechanical draftsman.³² She did, and found herself among like-minded souls. Drafting was a refuge for artists who needed work. In fact, in those days "art school" for most meant "mechanical drawing."³³ Once, during a coffee break, talk turned to "real" art and a coworker asked Grace if she, too, was a painter. She was trying, she said. What did she think of modern art? he asked, to which she replied, "I don't know what that is." He brought her a book of Matisse's work.³⁴ "I got fascinated, and I said, 'Could I borrow that? Because I think I can do that.' I brought it back to my room at my

in-laws' and found out I couldn't do that," Grace conceded.[35] The coworker told her he studied with a local artist, Isaac Lane Muse, and that if Grace wanted to paint like Matisse, Ike was her man. She enrolled in a weekly night class.[36]

During the first life-drawing session at his studio, Ike stood behind Grace and said by way of gentle criticism, "You've been out of it for a while, you'll do better when you get back into it."

"I've never drawn from a model," she admitted.

"In that case, you're doing fine."[37]

Grace's confidence soared.

In the small studio she had created in the bedroom she shared with her son, and in Ike's classroom, Grace felt alive. Elsewhere—in her job, in her roles as mother, loyal war wife, and dutiful daughter-in-law—she was sleepwalking. All her thoughts were focused on art and that most basic of questions, *how to do it*. "It was terrible because I had no facility. I was a terrifically good draftsman but I had no art facility because I hadn't done it when I was a child. Nothing was given to me in that realm," Grace explained. "I was a very clumsy artist." Crucially, however, she knew that she *was* an artist. It would just be a matter of hard work to help her arrive at that "sweet triumph" when she could call herself so.[38]

Not long after she began working at the aeronautics plant, Grace discovered that she earned half the pay of male colleagues doing comparable work. Having demanded and received a raise, she saved enough money to rent a place of her own in Newark where she could live with Jeff, out from under the watchful eyes of Bob's parents. She would also be closer to Ike. Though married and nearly twice her age, he had become her lover. "He taught me more to do in bed than he did about painting, actually,"[39] Grace said. "After sex with Ike, I was aching from head to foot." "So *that's* what it's about!" she recalled thinking after their first encounter.[40]

With the end of the war in 1945, the ground shifted under American society. Before the war, during the war, and after the war; in that very short time span, from 1940 to 1946, the fabric of life in the United States changed, changed, and changed again. Massively. Marriages that had been sworn eternal on the eve of battle fell apart in peacetime—five hundred thousand in 1945 alone. Millions of families uprooted for work in war factories never returned to their hometowns. Millions of women who had been self-confident and fulfilled in the workplace shuffled back to the kitchen.[41] There they faced angry and increasingly delinquent children who psychologists said were, improbably, the result both of women who had neglected them in favor of outside work *and* of women who had stayed home and were thus overbearing.[42] Society was unraveling, and many

were eager to believe women alone were to blame. The postwar best seller *Modern Woman: The Lost Sex* stated in its denunciation of those dangerously confused creatures that they had moved "into a blind alley dragging all of society with them."⁴³ In late 1940s America, the creaks and groans that threatened the structure of the family were given a name—the Woman Problem. The topic was discussed endlessly across society with the "expert" conclusion disseminated by the popular press: If women were brought into line, if they accepted the role for which they had been created—helpmate and mother—all would be well.⁴⁴

But there were counterarguments to that formula from women who knew a snow job when they saw one. The Woman Problem had conveniently arisen when men returning from war wanted to displace women in the workplace. Said Simone de Beauvoir in her groundbreaking book *The Second Sex*, written after she toured the United States in 1947,

> Just as in America there is no Negro problem, but rather a white problem; just as "anti-Semitism is not a Jewish problem; it is our problem"; so the woman problem has always been a man's problem.... Men have always held the lot of women in their hands; and they have determined what it should be, not according to her interest, but rather with regard to their own projects, their fears, and their needs.⁴⁵

America was not suffering a "woman problem," it was in the midst of a social revolution. During those years, it was the rare family that was *not* changed, and it was clear to those involved in the often tragic consequences that it took at least two to destroy a home. Grace's was an example. Bob had written her to say he had fallen in love with a brewmaster's piano-playing daughter in Holland and planned to stay in the Netherlands to work for her father. Taking the news in stride, Grace called it "a natural parting after five years for people who were that young." She and Ike, meanwhile, had decided to leave provincial Newark and move to the heart of the U.S. art world, New York, where they would live as a couple despite his marriage to another woman and her child by another man.⁴⁶ Was Grace afraid of the social opprobrium attached to such a move? "I don't think she gave that a thought. She just did it," said Grace's longtime assistant and confidant, the painter Rex Stevens. "You've got to realize that this is a very intuitive and impulsive person."⁴⁷

Having lived in New York previously, Ike Muse had been part of the downtown scene, painting Cubist-inspired works that were apparently interesting enough that the Whitney purchased one in 1943. He was also

in the collection of the Museum of Modern Art. Ike felt comfortable in that world and knew his way around, which helped them find accommodations quickly: an entire house for rent on 19th Street and Seventh Avenue. Grace, Jeff, and Ike moved in.[48] At twenty-three, Grace had never known a professional artist other than Ike. She knew no one in the art scene in New York and was entirely dependent upon him socially. But financially, he depended upon her. Ike expected that Grace would perform the traditional role of "artist's wife" and support him by working at a job while he painted. At first, she did just that. Grace enrolled Jeff at Grace Church School and commuted to a drafting job in White Plains where she earned a salary large enough to pay their bills. And when she wasn't working, taking care of Jeff, or attending to Muse, she painted "as much as she could" in a small room they had designated as her studio. Grace considered herself Muse's student, but she began to recognize that what she was being schooled for was something other than life as an artist.[49]

Muse organized life-drawing sessions for some of the artists he had known previously in New York—Mark Rothko, Milton Avery, and Adolph Gottlieb among them.[50] They were all Ike's age (forty or older), all established artists. Grace became friendly with them and their wives, who she discovered supported their husbands emotionally and financially. Grace recoiled from such a future, and yet that was where a life with Ike inevitably led. Grace would be indulged in her painting until she eventually gave up the idea of being an artist altogether. "Slowly, I realized the terrible unfairness of it all," she said.[51] Grace's relationship with Muse continued uneasily until January 1948. That was when Grace saw Pollock's first show at Betty Parsons's gallery.[52]

Grace stood "mesmerized and fascinated" before his drips and skeins of paint. It wasn't that she liked the work, what attracted her was its undeniable power.[53] "It was very confusing," she said. "You can't imagine what it is like to see, for the first time, something that has never before existed."[54] "Avant-garde" to Ike meant Matisse and Picasso. They were the pinnacle toward which he strove. Grace, however, was fascinated by Pollock and, after the show, she and Muse fought about the work, a fight that culminated in Ike's instructing her "not to paint abstractly."[55] "Not to" were words that rang in Grace's ears like a fire alarm. "I didn't think Ike was a *REAL* artist," she said.[56] How could he be if he willfully closed off entire avenues of discovery? Grace returned to look at Pollock's paintings again and again— they had become as delicious as the opera she surreptitiously listened to as a child.[57] In the meantime, she focused more on her own efforts, trying to incorporate what she saw in his vast canvases into her small works. And that caused a fatal rupture with Ike. Grace recalled the moment:

One time we gave a party and I'd just done a painting and Ike condescendingly allowed me to hang it in our living room. All the people congratulated him on the best painting he'd ever done. You see the handwriting on the wall there, can't you? From then on it was just a battle. It was...him really wanting me to give it up.[58]

"It became a huge issue. It was rough," Rex said. "After the party, they started arguing and she thought, 'I don't need this shit.' She moved out."[59] Many years later, after the hurt and resentment had dissipated, Grace said calmly, "I left Isaac still loving him but realizing I could no longer be the adoring student and support him with nothing left for myself."[60] Grace was twenty-six when she left. Her husband, Bob, had come home from the war and sued for divorce on the grounds of desertion.[61] Grace felt liberated. Freed from all male attachments that might have confined her to a supporting role, she was ready to begin her life as an independent artist. Having decided she would paint "every day of my life," she asked her boss at her drafting job to fire her so she could collect unemployment insurance for a year. He agreed. Next, Grace found an apartment for herself and Jeff—a seventh-floor walk-up—at 330 East 33rd Street.[62]

Grace did her best to be an artist *and* a mother. After bringing Jeff to school, she would rush home to paint, but that focus on her work resulted in constant quarrels with her son. Jeff resented vying for his mother's attention. When he returned in the afternoon, he confronted her, saying, "I know you have been painting again." The situation, Grace said, "was extremely difficult....Jeff, my son, bitterly opposed my painting."[63] For his sake and hers, Grace realized she would have to decide between her son and her life's calling. Grace chose art. When the seven-year-old's school term ended, she took him to stay with his paternal grandparents in New Jersey, ostensibly for the summer, promising to see him on the weekends. "From then on there was never any doubt" that she would be an artist.[64]

If Grace's decision had been made by a man, it might have been forgiven. As feminist writer Cindy Nemser said, when a man abandoned his family to paint or sculpt, it was "incorporated into the art myth....In the end society excused him as the great artist who did what he had to do."[65] But for a woman in 1948 America, turning her back on her child to pursue art was scandalous. Grace lived at the time of the ideal mother as created by Dr. Benjamin Spock, whose book on babies and childcare sold one million copies each year for fifteen years after its publication in 1945. Spock's prescription for a mother who wanted an occupation outside the home was "seek psychological counseling."[66] Grace was aware of the massive step she was taking and yet she took it anyway. "It wasn't a *bad* thing; it was a necessary thing," explained Rex Stevens.

If you look through history at people who are pioneers, they don't have a guilt chip. They're forced to have a guilt chip, and act like they have one, *but they don't have one*. There's no guilt. It's a "me" thing.... I think Grace is one of those people who does what she needs to do.[67]

Still, Grace's niece Donna Sesee, who like Rex was very close to Grace, said, "Her big regret was Jeff. There was always a certain level of pain. But she felt as though she had to make a choice, she had to choose the work over the child."[68]

Grace spent the summer getting to know the new city that would be her home, the first she had ever had on her own, and she did so as would a true New Yorker: on foot. As an aspiring artist, she might have been expected to spend her time roaming the city's bountiful museums. Grace, however, chose to roam the street, which would always be her primary inspiration. She consumed its sights and sounds—the markets, the store windows, the faces rushing by in the crowd—sucking it all in and making its heady brew of color and expression, its movement part of her work. New York would become her muse. It was to its life that she most fully and joyously responded. After having been in a state of suspended animation from the moment she left school, driven by possibilities but restrained from realizing them, Grace was finally in charge of her existence. She had nothing. She had *everything*. Standing on 54th Street outside Alfred Barr's museum, Grace predicted to herself, "Someday my painting will be in the Museum of Modern Art."[69] She could not have known at that moment that her naive and outlandish prediction was in fact correct. Someday for Grace would arrive remarkably soon.

The muse, the New York, that Grace set out to discover was not an "American city."[70] Statistics told that story. In 1948 there were eight million people in New York's five boroughs, among them two million Jews, nine hundred thousand Russians, half a million Irish and half a million Germans, four hundred thousand Poles, more than two hundred thousand Puerto Ricans, and one hundred and fifty thousand Britons.[71] The remainder were immigrants in smaller numbers from every country on the planet—in addition to native-born Americans. On the Lower East Side, signs outside shops and delicatessens featured Hebrew script and, after 1948, proudly displayed the Israeli flag. In Little Italy, on the southern border of the Village, signs, newspapers, and books were all in Italian dialect, and life was lived there as it had been an ocean away in Naples and Palermo and Rome. Nearby Chinatown, with its beckoning "chop suey joints," was a world apart, dominated by the elevated trains that intersected at Chatham Square, creating a dark cave of filigreed shadows.[72] On a stroll

through the Syrian quarter on Greenwich Street, one was immersed in Arabic. And along Eighth Avenue in Chelsea, the Greeks dominated with their language, their food, and their song.

As for New York's stark social contrasts, they were a matter of real estate. In the glittering oasis uptown, along Fifth, Madison, and Park Avenues, and radiating off from Central Park, luxury was not a dream, it was a given. A little north existed an alternate universe: Harlem, where half a million American, Caribbean, and African blacks lived, some in aristocratic and artistic dignity, but many others in squalor. Several miles south, another face of the city was on display. The Bowery. In that New York, men lay on the street like discarded rubbish, mocked by the beckoning neon of bars that had promised them paradise.[73] Those rumpled bodies were so much part of the landscape that people walked around and over them, without stopping to check if the person inhabiting that space was even breathing.

Between those extremes of wealth and want was the carnival of midtown. For a painter like Grace, it was a pulsing palette of color and life. Times Square with its blaring jukeboxes and moving billboard advertisements: the Corticelli Kitten, which played with a ball of silk on Broadway; spearmint soldiers who performed military drills on behalf of Wrigley's chewing gum. *Chevrolet, Kinsey Blended Whiskey, "Make Mine Ruppert," Pepsi-Cola, Budweiser, Yonkers Raceway*—it was impossible to think amid the multitudinous lights blinking for attention, screaming to be recognized and read.[74] But it was the movie theaters that dominated the scene. *"Stupendous!"* announced nearly every poster plastered on the facades of theaters.[75] For artists, the midnight features were favorites. After the show, they joined other movie patrons pouring out to neighborhood restaurants, bars, and food stands. "Eating a hot dog in Times Square at one in the morning at one of Grant's twin bars was like being in an enormous cacophonous operatic chorus," wrote Larry Rivers, for whom Grant's was an "after-theater boîte" made glamorous by the beggars and pickpockets who also ate there.[76]

Grace took it all in, stored it away for future reference, and finally made her way to the Village. Like the museums, it should have been a first destination for an artist in New York. But she was at heart and in appearance a product of New Jersey's suburban middle class, and her artist friends had so far been relatively staid middle-aged men and women. With her neatly brushed hair and slightly "arty" Mexican blouse and skirt, her fresh-faced eagerness would have unquestionably marked her as a rube. She was simply not prepared for the subterranean intellectual and artistic world south of 14th Street, where, by 1948, "hipsters" owned the streets.[77] These were the young men and women whom Milton Klonsky in *Commentary* that

year called "the spiritually dispossessed," "the draft dodgers of commercial civilization" who believed in three things: Benzedrine, marijuana, and jazz.[78] They, too, had their own language, jive: *nowhere, in there, solid, gone, sad, dig, far out, crazy, flip, with it,* and that serviceman's contribution to American vernacular, the ubiquitous *fuck*.[79] Beyond language was the hip attitude, which Grace most certainly did not possess. It involved exhibiting as little emotion as possible: A greeting might be a mere movement of an index finger. That was recognition enough for a Village "cat" standing apart from the crowd, eyes narrowed, mouth slack, ever observant behind requisite dark glasses.[80] The Village would have seemed an impenetrable other world for a woman of the bourgeoisie like Grace during her first months alone in the city. And yet she needed entry there, to find her way onto the scene, to become a part of it.

During the hours when she wasn't painting, Grace began visiting coffee shops where painters and actors congregated. She also knew about Motherwell's school on Eighth Street because Ike's friend Rothko taught there. Art students from Brooklyn College had studios in the building, and GIs flooded Hofmann's school across the street. There was, therefore, a constant flow of young people along that stretch. Grace began to socialize with them. "She kept her mouth shut at first," Rex said. "She listened to what the conversations were and that's when she really started to realize she had to read.... To read a lot more."[81] Grace also learned to her great relief that she was not the only young artist newly arrived in New York, that nearly all the people she met were or had been in her outsider position. This went a long way toward putting her at ease in that intimidating environment, as did her budding romance with a complicated painter just out of the military.[82]

Harry Jackson, like many New York artists—from Gorky to Pollock to Larry Rivers—had reinvented himself by the time he appeared in the Village to take his place among the abstractionists. He was born Harry Shapiro in Chicago and had had a love affair with the far west from the time he was a boy working around the diner his mother ran near the city's stockyards.[83] Sturdy, small, and dark-haired, at fourteen he went to Wyoming to work on a ranch and adopted a new identity: Harry Jackson, the painter cowboy. During the war he was a sketch artist for the marines and was wounded in a battle in the Pacific. He returned to the States having been awarded a Purple Heart and having discovered a reproduction of Jackson Pollock's paintings in a Surrealist magazine.[84] Harry arrived in New York painting like Pollock and wanting to be part of the scene that had forged him.[85]

His apartment on the Lower East Side was near a tenement building where John Cage, composer Morty Feldman, sculptor Richard Lippold, and Swiss painter Sonia Sekula lived or had studios.[86] Sonia showed with

Betty Parsons along with Pollock, and during an evening at Cage's she asked Harry and Grace what they thought of him.[87] Both leaped at the question. Seeing one of Pollock's works from the early 1940s had changed Harry's life. Grace had literally abandoned her former self after seeing his show — fifteen times — the previous January.[88] "Why don't you call Pollock up and tell him?" Sonia asked. "He has just moved to the country and is very lonely. No young artist has ever said he is any good, practically no one has."[89]

Harry called Pollock, who invited him and Grace to visit. Several weeks later, in early November 1948, they did, hitchhiking to Springs to meet the master.[90] On the way to Long Island, Grace said Harry swore her "to secrecy that I was a painter because *he* wanted to be the painter!... It was only when... I was alone with Lee, and she said, 'Confess. You're a painter, aren't you?' So we two women painters sat and talked about my work. Women artists sniffed out each other, sort of. She was awfully nice about it. And then Jackson was wonderful about it once he found out."[91]

The young artists had arrived at Springs shortly after Pollock's drunken debacle at Lee's opening and as he was trying to give up alcohol. Perhaps he had slowed down already, because the visit proceeded without any of his usual outbursts. In fact, Grace described him as exceedingly shy, and the scene delightfully domestic: Jackson baked an apple pie and Lee cooked "wonderful, big fat hamburgers."[92] But there was a purposefulness to such simple country pleasures. They seemed, in retrospect, to be designed to prepare the visitor for the work being done in that humble location — not Lee's work but Pollock's. "I thought Lee's paintings were fascinating and remarkable.... I thought of them equally as artists but she was working against a barrier of ego," Grace said. "She deliberately submerged her personality to his genius, if I can use that word."[93]

Like a gallery owner for a client, Lee had constructed an introduction to "Jackson Pollock, the artist," with which she regaled each new visitor to the house. "She went over everything. She showed us [Jackson's] earlier paintings, things that [James Johnson] Sweeney had written," Grace said, "and talked about their hopes of Jackson being able to get recognition. It was quite a presentation."[94] Inside his studio, however, the flimflam aspect of Lee's promotion dissipated in the face of the artistic marvels that amply justified such a carefully laid foundation. Lee wasn't just promoting, she was conditioning the visitor for what was to come. "I can't describe the experience of seeing wet drip paintings in the studio," Grace said.[95] "I spent day after day staring at those paintings in the barn," she said. "And I was astonished and stunned and couldn't understand. The allure was enormous."[96] Grace emerged thinking that the most important thing about them — their most significant lesson — was that "the paintings and the

person who painted them were one and the same. Painting was not an activity but a total life. And you would do anything to keep painting, even if you starved. You were the paintings and the paintings were you."[97]

She was also struck by Pollock's humility. After she looked at his work, Jackson asked, "'Grace, do you think this is a respectable thing for a grown-up man to do?' I said, 'I don't know how to talk about them, Jackson, but I think they're remarkable.'"[98]

Before leaving Springs, Grace asked Pollock who else was worth looking at.

"Everybody's shit except for de Kooning and me," he said.

"Who's de Kooning?"

Pollock gave her his address.[99]

Back in the city, Grace made her way to Fourth Avenue, where she rang the bell at Bill's studio, introduced herself from the street, and was invited up. She was searching for a source, a starting point from which to set out on her own long path of creation. It wasn't Ike Muse. And it wasn't Harry Jackson. She had been blown over by Pollock's work, which challenged and electrified her, but she couldn't embrace or absorb it; it was too much his own. Looking around Bill's studio, however, she saw art that she could draw from to evolve. The moody black-and-white paintings he had shown at Egan's gallery that spring were stacked around the studio against the walls, as well as his new works, among them the giddily colorful *Asheville*, which reflected so well the time he and Elaine had spent in North Carolina that summer. De Kooning's paintings resonated with Grace because they were part of a tradition she understood, albeit just barely: a European tradition. Where Pollock's work evoked a life force that man and the universe shared, in de Kooning's paintings, human life—tangible flesh and blood—were in evidence. That sensuality appealed to Grace. It was immediately clear to her that she had found the living teacher who would inspire her work.[100]

As she had from Pollock, the first lesson she learned from Bill was that art was not something one *did,* it was who one *was*. It required total commitment. Only if she was prepared to relinquish all would she find herself in her work. Grace had already done that, had cleared her life of everything that would distract her from painting. Poised on the threshold of self-realization through art, and after having been in the incredible position of consulting the two most important painters of her day, Grace was converted. "Meeting with and seeing the work of Jackson Pollock and Willem de Kooning changed my life—I understood what it meant to totally identify oneself with one's art."[101]

As Bill talked about his work in that grotty studio and described his

decision to abandon traditional materials in order to experiment, a woman appeared. "Vivacious, saucy, and beautiful. She was the most beautiful and most sexy woman I had ever seen," Grace said. "Red hair, pale green eyes, a perfect body, that slightly husky voice with the residue of Brooklyn and the overlay of rubbed-off-from-Bill Dutch accent."[102] At twenty-six, Grace was an artist in embryo, not only struggling to discover herself creatively but trying to determine what "personal style to present to the world." When Bill and Jackson said artists must *be* their art, she understood what that meant when applied to the work, but what did it mean personally for a woman? What did an independent woman and artist look like? How did she conduct herself? Grace had observed the wives of artists, but none was bold enough, free enough for Grace's liking. "Then one day in Bill's studio in 1948, I met Elaine," Grace said.[103] "There she was—beauty, charm, wit, sexiness, intelligence.... She was fearless and honest.... I had my model."[104]

The Abstract Expressionists' in-house philosopher, William Barrett, wrote,

> The man who has chosen irrevocably, whose choice has once and for all sundered him from a certain *possibility* for himself and his life, is thereby thrown back on the *reality* of that self with all its mortality and finitude. He is no longer a spectator of himself as a mere possibility; he is that self in its reality.[105]

By the end of 1948, Grace Hartigan had found her calling and, through Elaine's example, had found herself. She was no longer a mere possibility. From that point on her name would be accompanied by the word "painter." Her existence prior to that moment had been a preview of her life to come, but through it all she would have two constants: her art and the great adventure of her life. It had taken her a while, but Grace found herself back among the Gypsies.

21. The Acts of the Apostles, I

> For a long time everybody refuses and then almost without pause almost everyone accepts. In the history of the refused in the arts and literature the rapidity of the change is always startling.
> — *Gertrude Stein*[1]

AT FOUR-THIRTY in the afternoon on January 8, 1949, Grace Hartigan Jachens and Harry A. Jackson stood before a justice of the peace in the small living room of the Pollock home vowing to love and to cherish unto death. "Lenore Pollock" and Jackson Pollock signed the marriage certificate as witnesses, and Pollock baked a pie to celebrate the nuptials.[2] Harry had gone into the relationship full of hope, imagining Grace to be a supportive artist's wife in the mold Lee had created, with himself a cowboy painter like Pollock. Writing in his journal after the ceremony he said,

> I met Grace in June of 1948 and we have certainly had our ups and downs together.... We have often thought of marrying but never seriously and were just on the verge of a split up when we upped and married and started planning a trip to Mexico. I love Grace more each day....
> With the inspiration of men like Jackson P., Tamayo and Bill De Kooning and a wife like Grace I cannot fail to produce something worthwhile.[3]

Grace, however, saw the marriage as another "call of the wild," which was more about the allure of Mexico than the man with whom she would travel there.[4] Harry's former Brooklyn College teacher Rufino Tamayo had told him about the once-grand central Mexican mountain town of San Miguel de Allende, which had fallen on hard times. In its dereliction, it had become a magnet for foreign students, and an art school was founded there that was a favorite among GIs.[5] Faced with the prospect of a long, cold winter in New York, Grace and Harry decided to enroll and to do so as a married couple, which increased the veterans' benefits Harry could receive under the GI Bill.[6] While organizing their journey from New York to Mexico, which would follow a path well trodden by artists in search of an exotic life, they volunteered to help Lee and Pollock prepare for Jackson's second show at Betty's gallery.

The exhibition would be the result of Pollock's most productive season ever. Despite a summer and fall of drunken benders and violent outbursts,

he had finished thirty-two paintings.[7] But the show was going to be difficult. The opening would be the first Jackson had to face sober, and the display would include some of his largest (one painting was eighteen feet long) and most experimental works. Viewers who had not had time to digest his drips and pours would be confronted by a wooden hobbyhorse head attached to the surface of one painting, another with shapes cut out of the canvas, and yet another with the imprint of Pollock's hands slapped across the top of the painting. Anyone struggling to understand his latest works through their titles would discover to their dismay that even that final sop to the literal-minded had been reduced by the artist to a mere number: *Number 1A,* for example, or *Number 13A.* More descriptive titles, he decided, only added "to the confusion."[8] Jackson would need to surround himself with friends to face the hostile reception that was sure to come when Betty opened her doors on January 23.

Grace had offered the Pollocks the use of her 33rd Street flat while they were in town for the show. Having accepted her invitation, they arrived in Jackson's "new" Model A Ford on January 21. Just a year before, Grace had been on the outside of the art world dreaming of finding its center after seeing paintings by Pollock. Now she was cooking dinner and talking art with her new painter husband and their good friends Lee and Jackson.[9] "Her transformation from a New Jersey mother to a professional painter was lightning quick," said art historian Robert Saltonstall Mattison. "Especially for a woman without real connections."[10] Grace's speedy entry into that world was evidence of the small size of the art community and the fact that no one in it thought of themselves as a celebrity. But Grace herself was also a factor. Under the flipped hair and peasant blouse of the woman at the stove there existed a formidable character—tough, single-minded, at times even ruthless.

Later that evening, after Pollock had looked at Grace's work and turned one rudimentary abstraction upside down much to her satisfaction, everyone got busy at the gallery. The crew of four was augmented by a few of Jackson's friends.[11] Gallery assistants, professional picture hangers, even professional art handlers to move the works did not exist at their level and most especially not at Betty's gallery. She was barely scraping by financially. As was the tradition in those days, therefore, hanging a show involved a gang of artists building stretchers, repainting gallery walls, and positioning the paintings to interact visually. Usually, payment arrived in the form of a bottle of whiskey or a case of beer. But for Pollock's second show, Lee wouldn't allow any alcohol during the installation or the opening. When the gallery's doors opened at five, she wanted to be free of the worry that a drunken Jackson might cause a scene. He did not. Wearing a suit and tie, he smiled genially, said little, and counted the minutes until

his performance as "creator" could come to an end. Lee, on the other hand, was ebullient. Quite apart from celebrating his art, she happily announced to whomever she saw that Jackson had stopped drinking, that Dr. Heller had found a "miracle cure."[12]

Among the artists, another opening night tradition involved a dinner that was, depending upon the show's reception, meant to congratulate or console the artist. That night, Lee, Jackson, Grace, Harry, Bill, Elaine, Milton, and three hangers-on invited by Elaine went to a Japanese restaurant on 29th Street for a meal.[13] That group had no idea how the greater world would respond to Jackson's work, only how they themselves saw it: magnificent and bewildering, and therefore exciting. Jackson and Lee returned to Grace's apartment, but the rest continued their revelry, walking across the lamplit paths of Washington Square to the Minetta Tavern on MacDougal Street, where they drank and talked until just before dawn. Six days earlier, Harry's doctor had told him not to drink any alcohol at all and to see a neurologist.[14] He suffered from epilepsy due to a traumatic brain injury he had received during the war and had landed in a psychiatric clinic in 1947 after a seizure.[15] Harry, however, had not told Grace about his troubles.[16] He was a physical time bomb, and doing his best to ignore it.

Pollock's dinner party had, in the end, been celebratory. His show was widely reviewed, including in the *New York Times, Art Digest,* and the *New York World-Telegram.* In *ArtNews,* Elaine had given him three inches of ink as opposed to the usual two.[17] The comments in general were positive. Only the *World-Telegram*'s Emily Genauer was openly hostile. She wrote that the paintings "resemble nothing so much as a mop of tangled hair I have an irresistible urge to comb out."[18] Clem's piece in *The Nation,* however, easily nullified her remarks. He said the latest works were "more than enough to justify the claim that Pollock is one of the major painters of our time."[19] And if the critical response wasn't enough proof that appreciation was coming Jackson's way, nine of the works would sell, two to important collections: the Museum of Modern Art and Alfonso Ossorio, an artist and heir to a Philippine sugar fortune. Using the proceeds, Lee and Jackson finally installed heat and hot water in their home.[20]

In looking at the new work coming out of New York, some people that year had begun to follow up the question "What is it?" with a second query, "Who *did* that?"[21] Among the American avant-garde artists, Pollock's life was the first to be scrutinized by a press corps trying to find out. On February 7, 1949, *Time* magazine published a picture of one of Pollock's new works and identified the painter as "the darling of a highbrow cult which considers him 'the most powerful painter in America.'"[22] About a week after the *Time* article appeared, Jackson received a request

from *Life* magazine, which wanted to send a photographer to take his picture in his studio and to photograph him standing beside his eighteen-foot-long painting *Summertime*. *Life*'s circulation exceeded five million, more than any other magazine in the United States. "We went back and forth on the decision to 'chance' the *Life* article," Lee said. "We discussed the advantages and the disadvantages."[23] Jackson was raw, exposed, especially so early into his sobriety. He wasn't accustomed to being singled out for media attention. The prospect, however, excited Lee. She understood what it would mean to their lives. The *Life* article could be the break they had worked for since Jackson unilaterally decided they would live off his paintings. She hadn't blamed him for his decision or accused him of being unrealistic even as they froze during the winter. But given the chance to live with a modicum of security if publicity produced sales, Lee wanted to take it. Besides, she believed Pollock deserved it. She went one further than Clem. She didn't think Jackson was one of the best painters in America, she thought he was *the* best. Lee lobbied in favor of *Life,* and Jackson—to his subsequent dismay—agreed.[24]

A thirty-year-old freelancer named Arnold Newman came to Springs to take pictures of the artist in his lair for a story to run that August. He followed Jackson (with Lee following them) around the house, through the grounds, and into his studio. There, Newman snapped away as Jackson, dressed in a paint-splattered jacket and jeans, crouched tensely over a canvas, demonstrating how he poured paint and sand onto his work.[25] Next, Newman shot Pollock standing in Betty's gallery in front of *Summertime*. There Pollock relaxed. Assured, strong, even arrogant, his denim-clad body blended into the traceries of paint so that his person became just another element he had introduced into his work.

The photo spread also required Jackson and Lee to sit through an interview with editor Dorothy Seiberling. "He talked," Seiberling said, "but you felt it was agony for him. He twisted his hands."[26] Lee would "step forward and speak for him, kind of amplify what he said. She didn't try to dominate or talk for him, just to make it easier for him and sometimes to explain. They were a very good combination."[27] Some of the Pollocks' friends believed that Lee had saved Jackson, that not only had she taught him ("Lee Krasner was a vanguard mentality, probably before Pollock was himself," said the Modern's William Rubin)[28] but she had nurtured him into the powerful painter he became. Said artist John Little, "As for Jackson, without a Lee, it would be like American painting had there been no Hofmann."[29] But others complained that she had become overbearing, demanding more of Pollock than he was able to give. Artist Fritz Bultman explained sadly, "In a way, Jackson was Lee's creation, her Frankenstein; she set him going. And she saw *where* he was going, aside from the talent

and all that, but he was devastated by fame coming to him."³⁰ And *Life* was only the beginning.

Everyone could feel the sands shifting in New York. There was an excitement, a freshness, a verve. There was a new cast of characters on the scene. Young people had appeared who not only liked the work being done, they admired the men and women doing it. They wanted to emulate them, from their style of painting—suddenly New York was full of "little Pollocks"—to the way they dressed. Young women, Grace foremost among them, saw in Elaine the audacious freedom they craved. In Bill's case, some newcomers were so enamored of him that they mimicked the way he talked. For no organic reason, Dutch-accented English proliferated in the Village.³¹ After working in obscurity, with only one another as an audience, the older artists received a much needed boost to their egos. Even if the official art world didn't recognize them, a new generation of artists did.

The center of the action was, as it had always been, Eighth Street. Younger artists coursed between Stanley William Hayter's print atelier and the two schools: Hofmann's and Motherwell's. The number of students attending the latter, the Subjects of the Artist, had not increased. In fact, one had died, reducing the already small student body.³² But interest in the school had grown because of its Friday lectures. When they began in the fall of 1948, the school rented just fifteen chairs for the audience. Word spread, and twenty-five seats were required.³³ By the beginning of 1949, the lectures had become so popular that an additional artist was recruited to oversee them. Barney Newman, the theoretician of the art community who in his suit and monocle looked every bit the part, took the job.³⁴ "The evenings were a fantastic success," recalled Annalee Newman, Barney's wife. "I used to take the tickets.... I turned away this guy and it turned out to be [Alfred] Barr. Because there just wasn't room. The place was just so crowded. Mostly artists. People were so hungry."³⁵

Bill was invited to be the first speaker of the 1949 term. "I remember he came over to the house with Elaine, and they wrote out a speech," Annalee said. As with many of Bill's lectures, it fell to Elaine to weave his random observations into a structured delivery.³⁶ By 1949, they had been together for ten years and had talked art nearly every day. Their ideas had become synchronized. Even when apart, they quoted each other, assuredly giving voice to one another's thoughts. The speech they came up with at the Newmans' and over several subsequent days of writing was more riff than lecture, but the audience hung on it because it was by Bill. Artists young and old, even critics like Tom Hess, wanted to hear what that underground hero had to say.

Bill began by stating, in his accented English that made everything he said seem vaguely comical, "I am surprised to be here this evening reading my piece, for I do not think I am up to it.... Barney Newman decided it really and he even gave the evening its name, 'The Desperate View.' "[37] He went on:

> My interest in desperation lies only in that sometimes I find myself having become desperate. Very seldom do I start out that way. I can see of course that, in the abstract, thinking and all activity is rather desperate....
>
> In Genesis it is said that in the beginning was the void and God acted upon it. For an artist that is clear enough. It is so mysterious that it takes away all doubt....[38]

After his introduction, Bill was so terrified that he couldn't continue. "In the end, Bob [Motherwell] read it," Annalee said, and then the floor was opened to questions.[39] Everyone had questions, and not just in the school that night. If the new art was there to stay, if art lovers, art students, museums, and collectors were to accept it, they wanted to know what it was about. Though the artists were *able* to explain what they sought in their work, they did so in their own language. It wasn't jive (though some did speak the lingua hipster) and it didn't involve abstruse terminology. It simply required an open, unfettered mind, that little-exercised faculty at a time when intellectual freedom was discouraged. "Artists don't talk about art like critics or historians trying to construct a theory or prove a point," Elaine said. They expressed themselves without affectation "briefly, directly, simply, and often humorously."[40] Still, the art and its explication confounded most people.

The day after hearing Motherwell deliver Bill's lecture at the Subjects of the Artist, Grace and Harry piled into a car Harry had bought for one hundred dollars and set off for Mexico. Grace was anxious to begin the first year in her life that she could dedicate exclusively to painting.[41] She had been overwhelmed during the past months with new visual information—from the city, from the artists she had seen and met—and she, herself, had changed greatly. But she was not yet the artist she hoped to be. That had become painfully clear before they left New York. Bill had looked at her work and said it showed "a complete misunderstanding of modern art."[42] He suggested she do what Elaine did. "I tell Elaine to use the finest pencil in the world, and to make an exact and perfect pencil drawing of a still life," he explained. "And then she shows it to me and it is perfect and I tear it up and I tell her to do it again."

"And does she?" Grace asked.

"Yah. She does," he replied.[43]

Grace's response was a "three-day crying jag" but she knew what he meant.[44] She had work to do. Grace needed to see how the person she had become would filter the information she had received, with the added spice of doing so amid the deep purple, yellow ochre, and azure blue of Mexico.

On March 6, Grace and Harry finally arrived at San Miguel. By May, they had moved into a villa in the middle of town where they lived, according to Grace, like a "prince and princess" on about twenty-five dollars a month. Under the stress of relocation and their intense effort to create, however, Grace and Harry's relationship began to show signs of strain. "We do not belong together for many reasons," Harry admitted in his journal the first month after their arrival. He may have finally realized that Grace wasn't the lesser half of a married couple. She was one of a kind.[45]

22. The Acts of the Apostles, II

> The heart of any artist is a mystery at the core. And I think to the artist it remains mysterious.
>
> —Jane Freilicher[1]

BACK IN NEW YORK, Elaine and Bill were also in trouble. Their heralded "team spirit" had failed them utterly during one booze-fueled evening at a loft on West Broadway where their group had arrived in elaborate hats for a wallpaper-stripping party. "After a while it was a pretty wild-looking scene," said Charlie Egan's soon-to-be-ex-wife, Betsy. It became evident that among the partygoers three were missing. "I heard Bill yelling upstairs. Elaine and Charlie were locked in the bedroom and Bill was beating on the door.... This was in front of everybody, of his friends," Betsy said.[2] Elaine's affair with Egan was news to no one, least of all Bill. But relations had been discreet until 1949, when alcohol replaced coffee as the drink of choice for artists. Under its influence, according to Elaine, everything changed. Life became frenzied, freer, more *fun*—but also more destructive.

The appearance of alcohol coincided with the slowly emerging recognition of the group. As the number of galleries willing to show the new work grew (that year there were still only four), artists began attending more openings and availing themselves of the liquor on offer. That trickle of alcohol at openings became a flood at parties and soon no social event could be considered a success if it were dry. "There were openings every week," Elaine explained,

> and it was free liquor and everyone was still broke. So, you kind of had the feeling that every drink you downed you saved a dollar. And so definitely a lot of the extremes of emotion and also the whole exhibitionistic thing had to do with drinking.... Everyone drank, it was kind of a communal thing.[3]
>
> If there was one bottle, we drank that. If there were ten bottles, we emptied them.[4]

Elaine's public romp with Egan wounded Bill in the way her trip to Provincetown had four years earlier. The earlier incident had been a willful act that might have been excused by Elaine's age, as well as the tumultuous times. With Egan, thirty-one-year-old Elaine's behavior could be blamed on alcohol, but it could not be easily forgotten or forgiven by Bill.

He responded in two ways. He found a vibrant new girlfriend, and he began shredding the image of women on canvas, turning them into hideous, twisted shrews.

Bill's twenty-eight-year-old girlfriend was a painter named Mary Abbott. Petite and blond, she glowed so bright she was nearly effervescent. Mary had been "*the* debutante" when she came out in New York in 1940 and had modeled for *Vogue* and *Harper's Bazaar*. She was also American blue blood, a descendant of Presidents John Adams and John Quincy Adams, and her family remained well placed. Mary's father, Henry Abbott, worked at the State Department; her cousin was secretary of the navy.[5] But if the men in Mary's life were pillars of society, the women were artistic and eccentric. Her mother, Elizabeth Grinnell, was a poet, her aunt a sculptor, and her grandmother a big-game hunter.[6]

After a brief wartime marriage in California that ended in divorce, Mary was back in New York in 1946, living in a loft near Broome Street and making her way into the downtown scene by way of sculptor David Hare. Years later she laughed at the contradictory individual she was then. After her marriage disintegrated, she drove cross-country alone in a convertible with an Afghan dog she picked up in a pound in Denver, living off the generosity of people along the way who fed them both. And yet that free spirit was so bound to the milieu in which she was raised that she still curtsied when meeting someone ("I was taught to curtsy. I think I eventually stopped"). On one hand, her family didn't know how she was living, she said. As for the art community, "Heavens, I wouldn't let people know I was a debutante." She existed in a state of perpetual rebellion, and yet it was all done in the spirit of enormously great fun. She was also open to all and any adventure. "David Hare gave me some mescaline, peyote, Indian things, so I used those things sometimes," she said matter-of-factly. "Once I took it by myself and walked down the middle of Fifth Avenue. I didn't do that again."[7]

Hare had introduced Mary to Motherwell's school, and she easily absorbed its lessons. "Abstract painting came naturally to me, much more so than the other," she said. "When I did it, I thought, 'Aha, that's it. Now I've found it. What a relief!'" Soon, she began meeting other artists in that abstract orbit, including Grace, who became a close friend, and Elaine, who took Mary under her wing.[8] But it was not until the aristocratic Miss Abbott moved to that infamous stretch among the derelicts, Tenth Street, that she met Bill.[9] Mary found him "magnetic," and, of course, a great painter. Soon he and this much younger woman, who had Elaine's spirit without her complicated intelligence, became lovers. It was a casual relationship, warm and easy. Elaine so approved that she told Mary she sometimes wished Bill had married her![10] But she never wished it so much that

she considered divorce. Elaine would remain Bill's wife, confidante, most loyal fan, and effective promoter. They loved each other, though their bond confused those around them. Bill once tried to explain it to Lewin Alcopley, saying, "We have no life together but I'm psychologically attached to her."[11] For her part, Mary would be Bill's companion in the ways Elaine no longer could be. Their affair would continue off and on for years. Even after Mary wedded someone else, Bill remained the love of her life.[12]

By June, with Bill occupied and her critic duties settled for the season, Elaine left New York for what she thought would be a weekend in Provincetown. After arriving at the Cape, however, she discovered a renegade colony of New York artists not unlike the scene she had loved at Black Mountain the previous year. The latest group was centered around Hofmann's Provincetown school. "I went up for a weekend...and I just stayed on and on, because I liked it so much," she said. "I was sharing a place, right on the ocean, with a girl named Sue Mitchell.... I was painting very well, so I just kept on till December '49."[13] Mitchell, who was Clem Greenberg's painter girlfriend, was studying at Hofmann's.[14] Also attending the maestro's school that summer was Nell Blaine, Elaine's artist and drummer friend from Chelsea who had, since those days, created such tremendous paintings that she had been called the "hope of American painting" by the late Howard Putzel. In her personal life, Nell had, in short order, had a miscarriage, annulled her marriage, and come out as a lesbian, all the while continuing to be an inspiration for artists who ventured into her studio.[15] Among them were two young painters in Provincetown that season who would be central figures in the emerging New York art scene: Larry Rivers and Jane Freilicher. Brought together initially by jazz, their relationship would grow through a shared love of painting and poetry, and lives lived not on the edge, but well over it.

Larry had no need to adopt hipster ways; hip was in his blood. He had played the baritone sax in jazz bands since he was a teenager, acquiring the language, the look, and the drug habits of that three a.m. culture. His life in those early days straddled two worlds: the beating heart of jazz on 52nd Street in Manhattan, and the Bronx, where his family lived in an apartment block full of Eastern European Jews.[16] By night Larry played music, and by day he helped his father with his neighborhood hauling business and courted a local woman who had a small son. Soon, they married, had their own child, and Larry the junkie sax player became Larry, head of household, with a wife, two sons, and a saintlike mother-in-law named Berdie.[17] In the annals of unconventional domestic arrangements, his through the years would be among the most bizarre and yet, strangely, also among the most harmonious.

During the summer of 1945, Larry had been offered a job playing for three weeks in a band at a resort in Maine. (The single audition question was "Do you or don't you get high?" The correct answer was "Yes.")[18] There he met Jane Freilicher, the wife of the piano player, and through her discovered one of the greatest passions of his life, painting.

> [Jane] was nineteen, an artist, very funny and very smart. I caught that intelligent thing about her right away.... She was valedictorian of her graduating class....
>
> If someone asked me was I attracted to Jane I would have said no. But I kept watching her paint. We went for long walks, and we talked about literature and art....
>
> One day as the rest of the band was playing cards, I was lying in the sun trying at least for a tan. Jane was painting. It impressed me. I became curious....
>
> Jack [her husband], who was also using the paint, said "Why don't you try it, man? I think you'll dig it."
>
> Jane pushed some paper in front of me and handed me a brush.
>
> "It's not music," said Jack. "But it's fun."
>
> Every day after that, when the boys in the band would sit down to an afternoon around a card table, Jane, Jack, and I nearby, on one of those picnic-bench tables, laid out paint and paper, and with one brush each, spent a few hours painting....
>
> After a week or two I began thinking that art was an activity on a "higher level" than jazz. The blue romance that haloed jazz was still strong.... I had been caught up in this romance with jazz, blues, drugs, and night.
>
> Now I began to have pleasure in the daylight.[19]

When they returned to New York from Maine, Jane introduced Larry to Nell, whose 21st Street loft and life appeared to him a paradise. "Nellie was very messianic," Jane said. "She was terribly sure of what she believed in."[20] Larry and Jane joined the artists who drew there and began to meet the neighbors—Bill, Denby, Fairfield Porter.[21] The activity in Nell's studio was continual and moved seamlessly from the concentrated silence of a room full of people with pencils scratching on paper to that same crowd in a frenzy of dance, abandoned to the blasts and cascades of a saxophone. Describing twenty-six-year-old Nell, Larry said, "She was the first swinging lesbian I knew.... She seemed to be dealing with a world that I thought was much more dimensional in certain ways than music."[22] Larry and Jane considered her a wise elder of the art world, so when she told them about Hofmann's school they enrolled immediately, together. Larry would say, "In a way, everything is through Nell."[23]

Jane was an excellent student and followed Hofmann's abstract prescriptions. "Without feeling that I had any specialized talent, I thought I might do something in art, not for fame or achievement, but out of a romantic inclination to beautiful things," she said. "A free-floating feeling that something was creative *in me*."[24] Twenty-three-year-old Larry, on the other hand, showed up for class wearing his jazzman zoot suit and promptly rejected all of Hofmann's principles.[25] (Hofmann was big enough to accept rebellion. "The concepts of my school are fundamental," he would say, "but a true artist could violate them all.")[26] Soon, after Larry left his family (the separation would be brief) to move downtown to a building filled with artists, writers, dancers, and prostitutes, he began looking the part of a Village cat in extremis—clad in black, all black, even his cap. "Larry was always coming home in his long overcoat with his strange haircut, saying a lot of things no one understood, telling weird jokes without a punchline, and using a lot of 'hey man, you dig, man, go man,'" his sister Goldie recalled. His friends, she said, were even less comprehensible. "They all wore costumes. You'd see a guy in a doctor's uniform, you knew he wasn't a doctor. He even had the stethoscope around his neck."[27]

Larry began to feel conflicted about his drug use. He shot up in the bathroom at Hofmann's school, but he only did so a few times a week because it made him so sick and because he believed that, traditionally, painters weren't junkies, they were drunks.[28] Though treatment didn't work, he eventually gained control of his habit as his obsession with painting and his entanglements in the art scene grew.[29] Jane was one of them. Her marriage had broken up and Larry fell—in his own way—madly in love with her. "With him it's hard to say because he had so many sexual projects going on. He was married to a woman, and he was trying to seduce his mother-in-law, and he was on drugs, and he was kind of a mess," Jane recalled. Jane had been studying for a master's degree in art education at Columbia, working as a cocktail waitress in a bar across from Macy's, and trying to paint.[30] Larry was not what she needed. But people tended to indulge him because he appeared almost poetically damned. "He was only a beginner, but already he had this incredible myth developed around him," Nell said. "Whatever it was that made his hands shake, he blew it up into some fatal disease and he would tell us he only had a few years to live; and so everyone...let him get away with murder half the time!"[31]

Elaine had met Larry that spring while reviewing his first show at the Jane Street Gallery, an artists' co-op Nell was involved with.[32] Larry's work was not what one would have expected from such an outrageous fellow. It was *impressionistic,* and yet as both Elaine and Clem noted in their reviews, his paintings were so original that they reawakened the genre.[33]

Clem called Larry an "amazing beginner" and a "better composer of pictures than was Bonnard himself in many instances."[34]

In Provincetown, with its soothing Atlantic breezes and the waves caressing the sand outside her beachside cottage, Elaine settled in with her odd assortment of friends, whose numbers swelled as the summer progressed. Ernestine, Ibram, and their daughter, Denise, arrived. So, too, did Joop Sanders. Rudy Burckhardt—who had married Elaine's "original Chelsea girl" chum and fellow *ArtNews* writer Edith Schloss—turned up to shoot a comic movie, *The Dogwood Maiden*. He cast Elaine as a sorceress.[35] Amid personal projects and grand schemes, the summer was shaping up in every way to be a repeat of 1948, with even wilder cavorting. Said painter Anne Tabachnick, "We were all pretty brazen and really pretty innocent."[36]

Larry and a young woman named Tess held a dinner party to launch the season. The two were roommates and, to hide the fact that they were having sex, Tess told her husband that Larry was gay. (Larry took the ruse to its logical conclusion by offering to give Anne's husband a blow job when he visited. The husband, Larry recalled, pretended not to hear.) At their dinner party, Elaine appeared "without Bill, looking like a Ring Lardner escapee, rouged cheeks, red lips, short skirt contrary to the long new look, talking a mile a minute," Larry wrote. Also on hand was Jane and her estranged husband, Jack. "They brought some Basie records and bruised tomatoes." And, though it had been Larry's party, painter John Grillo cooked the meal. "He made a delicious dinner for us," Larry said, "something between chicken, pork, lobster, and pâté, which he later announced was...whiting!...At these shindigs you felt part of a happily beleaguered community."[37]

By day, Elaine attended Hofmann's classes. Though she didn't respond to him immediately, she soon found him "extremely illuminating."[38] Hans was particularly alive that season. He had just returned from Paris, where he had gone for the first time since 1930. The occasion had been an exhibition of his work, and while there he had visited with his old friends, Picasso, Braque, and Miró.[39] They were the wise men of modern art, the revolutionaries of the First World War, and Hofmann counted himself among them. Returning to the States, he declared, "This visit to Paris has been a tremendous inspiration for me, I am made to feel I have roots in the world again."[40] It was a rejuvenated Hofmann his students encountered that summer.

For Elaine, what he said about *a* painting wasn't as important as what he said about all art, the grand sweep of it.[41] She became part of the new generation, along with Larry and Jane, that hung on his words as Lee's had done a decade earlier, absorbing the artistic tradition he represented while

struggling to decipher his message. ("Componize" meant "composition." "Fize" meant "face.")[42] And when he spoke about an individual student's work during critiques, the seriousness with which he approached the art raised it to a historical plane that the aspiring artist could only dream of. "Hofmann made art glamorous," Larry said, "by including in the same sentence with the names Michelangelo, Rubens, Courbet, and Matisse, the name *Rivers*—and his own, of course. It wasn't that you were a Michelangelo or a Matisse, but that you faced somewhat similar problems. What he really did by talking this way was inspire you to work."[43]

During her previous summer in North Carolina, Elaine's paintings had become more abstract, but they were extremely controlled, almost statically designed. By early 1949, her work was energized. "I used to see newspapers when I would walk past a newsstand and I would see a terrific composition," she said. "And then go up close and look and it was always a sports photograph." She started to collect the pictures and hang them on her wall. "And I began to work from them, but purely in terms of, you know, the abstract forms, and so on."[44] Those paintings were all about action—the thrust of her brush striking up the canvas, the vibrations of colors, which she allowed to exist without their having to define anything but their relationship to one another. Under Hofmann's influence, Elaine reintroduced a bit of restraint into that mix. Part of his genius was that, like a fortune-teller or a priest, his message was broad enough that any artist listening to him could take what he or she needed. Elaine did just that. She did not come away a Hofmannite. She came away a little surer of being Elaine.

With no *ArtNews* income that summer, Elaine had set up some freelance writing jobs, among them an article for *Mademoiselle* magazine about her experience with art schools. The project required that Elaine study women in art history. Contrary to what she had believed as a child, Elaine discovered that though there had been fascinating women who painted and sculpted through the centuries, those who had been recognized by history were very, very few. Even into the twentieth century, she found there had been almost no avenue for a woman to become a "real" artist.[45] That had not been her experience, but as she looked, she could see the evidence all around her at Hofmann's summer school, where the rafters and balcony were literally filled with talented women who would not have dared to consider themselves professional artists. Her research raised questions that went to the heart of the position of women not just in art, but in society. Elaine gave up on the article because she had found so much "profound information" that she decided it wasn't appropriate for a fashion magazine. Instead she would give a talk that summer during an artist-organized event

called Forum '49. Elaine's offering was called "Women Fill the Art Schools, Men Do the Painting."[46]

Bill had been in East Hampton but drove up to the Cape with Motherwell, "both of us with devastating hangovers, he to meet his wife Elaine," Bob said.[47] Beyond the hangover, Motherwell was in a bad way personally. His wife had left him for another man because Bob was "preoccupied with his work." Not long after, Motherwell had found himself alone during a three-day snowstorm. It "was the only time in my life I seriously contemplated suicide," he said. Instead, he painted the first work in his *Elegies to the Spanish Republic* series: *At Five in the Afternoon,* his tribute to the murdered poet García Lorca.[48] Adrift not only because of his wife but because his school had closed after just nine months, Bob happily accepted an invitation to speak at the Forum '49 gathering in Provincetown.[49] It was in the lecture he delivered there, "Reflections on Painting Now," that Motherwell coined the phrase that perhaps most aptly described the group of artists with whom he, Bill, and Elaine were associated. He called them "The New York School."[50]

Motherwell got down to business, and Bill moved in with Elaine to join the summer culture of alcohol-infused mischief. Joop said it was the first time he saw Bill drink heavily, and in one case his overindulgence landed him in jail. Stopping by Elaine's cottage, Joop found her frightened because Bill had gone to the ocean with a friend, both were drunk, a storm was approaching, and Bill couldn't swim. "They were unbelievably drunk and were still drinking," Joop, who had found them, said.

> Bill's companion actually fell down and passed out. I said to Bill, "He's so big that we have to get him into the ocean to sober him up."... There was nobody to be seen, and we didn't have bathing suits with us, so Bill and I took our clothes off. We dragged him into the water and he started to sober up and said, "I'm going to kill myself"—and walks right into the waves. I got a stranglehold on him by the neck and Bill was kind of prancing around in the water. I'm dragging him back to the beach and he flops down and we start to laugh. I'm looking down at him and then I look sideways and see these boots. There was this state trooper. He said, "You're under arrest for exposing yourselves where women and children could see you." The guy with us started to shadowbox with him. So there we were, resisting arrest and indecent exposure.[51]

Ibram appeared to bail them out—five dollars each—and they were freed without further ado. The naked shadowboxer, however, was in more

serious trouble. He was released on bail—forty dollars, which Hofmann provided—and ordered to reappear in court.[52]

Beginning on July 3, 1949, two hundred people, many of them artists who had traveled from New York and around New England, streamed into an old Ford garage that had been converted into a gallery for sessions of high seriousness under the auspices of Forum '49. There was also an accompanying exhibition featuring fifty artists. One of the pieces Jackson offered to the show, *Number 17*, would become famous by early August.[53] *Life* magazine's article on him had appeared, and it included a reproduction of that work.[54] There were many ideas discussed in Provincetown that summer, including Elaine's lecture on women, but by the end of the season one topic dominated the conversation: Pollock. Specifically, the question *Life* asked in its headline: "Jackson Pollock: Is he the greatest living painter in the United States?"[55] It wasn't just Pollock or Lee who would be affected by the question. "The whole balance of things changed," Elaine said.[56] The artist as celebrity was born.

23. Fame

> Rodin was lonely before his fame, and perhaps the fame that came to him has made him still lonelier. For fame is actually only the sum of all the misunderstandings that gather around a new name.
>
> —*Rainer Maria Rilke*[1]

ARTISTS JAMES BROOKS and Bradley Walker Tomlin walked into Lee and Jackson's house in Springs carrying the magazine. Jackson turned away, too embarrassed to look, but Lee eagerly grabbed the copy, flipping through it until she saw her husband in full color looking like Brando on Broadway—tough, sexy, unapproachable, undeniable—leaning against his painting, the image spread out over two pages.[2] The design was fantastic—clean, stark—following, as it did, dozens of pages of black-and-white war photographs, cheery ads, and a full-page *Li'l Abner* cartoon. Clearly, Jackson represented something new. The future. It was impossible to look at those two pages and see it any other way. The article described Pollock's unusual working methods and included a bit of Pollock lore, explaining that he was thirty-seven, born in Cody, Wyoming, and that five years earlier he was an unknown. Since then, *Life*'s Dorothy Seiberling wrote, he had "burst forth as the shining new phenomenon of American art," his work hung in five museums and forty private collections, and he had "stirred up a fuss" in Italy.[3] Beyond the biographical details, however, the piece contained almost nothing of Seiberling's conversation with Jackson and Lee earlier that year. Rather, the article relied on a piece Pollock wrote in 1947 for the journal *Possibilities,* in which he said, "When I am *in* my painting, I'm not aware of what I'm doing." That became clear later, he said, during a "get acquainted" period. Finally, he described his painting as having "a life of its own."[4]

Any artist reading his words—and they had all done so when they were first published in *Possibilities*—would have understood exactly what Pollock meant. But, according to the response *Life* received for its Pollock article, the majority of its readers were horrified by what he did and said. One reader-critic submitted a photo of her young son standing before his own "Pollock." A reader from Florida said Pollock's work looked like the garage door he used to clean paintbrushes. The magazine even referenced Forum '49 on its "Letters" page, saying that a box had been installed next

to Jackson's painting in Provincetown with ballots asking whether he was the "greatest." The tally: 13 yes, 153 no.[5]

In April, *Life* had published photographs of so-called communist sympathizers: Norman Mailer, Leonard Bernstein, Marlon Brando, Arthur Miller, Charlie Chaplin, and Albert Einstein among them.[6] A week after *Life*'s article on Pollock appeared, Michigan representative George A. Dondero took to the floor of Congress and added avant-garde artists to that infamous list, warning of the "germ-carrying art vermin" out to destroy artistic traditions and peddle "communist-inspired and communist-connected" work.[7] What terrified the likes of Dondero was not that the new American artists were communist but that they were beyond his—or anyone's—control. "The dangerous people are those who think for themselves," Elaine said. "Abstract art in no way comments on the absurdity of bureaucracy and yet they are ten times more afraid of it than they are of left-wing painters who can be bought for a dime a dozen."[8] In their art and their lives, the abstractionists rejected the consumer society arising out of the war in favor of the two elements lost in that world: truth and freedom. And wouldn't it be dangerous if the youth of America made that choice, too?

Lee had been in that fight against reactionary forces before and wasn't intimidated. In fact, she was "in ecstasy" over the attention being paid Pollock, said her friend Betsy Zogbaum. "She was just enchanted with his fame."[9] Lee's joy was that of a fellow painter thrilled that someone as courageous as Pollock had become the focus of a national debate that was sure to elevate the conversation and shine a spotlight on the work of those around him. As an artist's wife, she embraced his celebrity because it had been won at great cost. But Lee was more than a fellow artist or artist's wife. She was Pollock's manager, and as such she cheered *their* success in garnering recognition for his art.

If Lee was jubilant, however, Pollock felt exposed by the article. He described himself as being "like a clam without a shell."[10] "That shit isn't for a *man*," he told his neighbor, Jeffrey Potter. "People don't look at you the same any more—maybe more, maybe less. But whatever the hell you are after that, you're not your you." James Brooks, who had delivered the magazine to the Pollocks' house, said, "I think right then Jackson saw what was coming and was scared to death."[11] What was coming was a tidal wave. The rural postman delivered mail from around the world. In the driveway, cars lined up full of strangers who wanted to see or meet him. An East Hampton socialite couple sent over a truckload of antiques to furnish the Pollock home.[12] Suddenly the hamlet oddballs were local celebrities.

Among the small community of New Yorkers whose idea of a Saturday

afternoon well spent included a stop at the 57th Street galleries showcasing modern art, the perception of *all* the artists changed after the *Life* article. It wasn't that the art public understood the work any better, and most still didn't like it, but they wanted to be part of whatever was happening. They could burnish their cultural credentials by saying they had been at Sam Kootz's show, *The Intersubjectives,* in early September, where they had seen the work of all the new big names—Pollock, de Kooning, Hofmann, Rothko, Motherwell—and had met some of the fire-breathing artists themselves. "It was a first attempt by either a gallery or a museum to define who were the potentially best men in the Abstract Expressionist movement," said Kootz of the show.[13] Visitors could even be intrigued and amused by Harold Rosenberg's exhibition essay, which stated,

> The modern painter is not inspired by anything visible, but only by something he hasn't seen yet. No super-lively kind of object *in* the world for him.... Things have abandoned him, including the things in other people's heads (odysseys, crucifixions). In short, he begins with nothingness. *That is the only thing he copies.* The rest he invents.[14]

Savvy gallery-goers could read the reviews and parrot the critical comments with an air of authority. And when, wearing their new badge of connoisseurship, they came upon Sidney Janis's October show, *Artists: Man and Wife,* they could sniff haughtily along with the critics over the women's offerings. Lee and Jackson, Elaine and Bill, Max Ernst and Dorothea Tanning, Picasso and Françoise Gilot had been selected by Janis to demonstrate artistic partnerships.[15] But the critics did not see in the exhibition the remarkable work of talented couples. They saw artists, some of whom might be modern masters, and the wives of artists, who also dabbled in paint. That narrative was built into the title of the show. It wasn't *Artists: Man and Woman* or even *Artists: Husband and Wife*. It was a show about creative men and their personal chattel. Under those circumstances it wasn't surprising that the *New York Times* would declare the men in the show "adventurous" and idea-driven while describing the women as restrained and interested in "design or color." That was "noticeably true" of Jackson and Lee, according to the *Times* critic, and "in exactly the same relationship are Willem and Elaine de Kooning."[16] An *ArtNews* reviewer accused Lee of wanting to "tidy-up" Jackson's style. "Lee Krasner (Mrs. Jackson Pollock) takes her husband's paints and enamels and changes his unrestrained, sweeping lines into prim little squares and triangles."[17] That review was probably the first time the adjective "prim" had been used to describe any aspect of Lee's personality or work. She responded with a characteristically unladylike fury.

The criticism based on sex came naturally, no doubt even unconsciously, in the patriarchal, Freud-obsessed society of late 1940s America.[18] In artistic partnerships, Germaine Greer wrote, "The male was always the predominating figure, the innovator and the initiator, with the woman following as his emulator."[19] And that relationship was not confined to artistic couples. In a book published that year, 1949, titled *Male and Female,* Margaret Mead wrote that man was aided in his success by being able to always vanquish at least one other person—a woman; that a man weighing his own value might conclude that even if he wasn't all he could be, he was better than his wife.[20] The men in Janis's show had no interest in besting their artist wives, but visitors to the gallery could use the social formula Mead described to bolster their confidence when grappling with the new art. They might not know much about new painting, they would admit, but they were sure of one thing: The men in the show were better than the women. Sidney Janis, who had come up with the idea for the show, has been credited with making "the art business a business."[21] Did he cynically elevate the value of the men in his show by exhibiting them opposite works by women he identified as "wives"? Whatever his motives, the effect was the same. At the moment when Lee and Elaine were introduced to a broader art public as painters, they were presented as inferior beings.

Lee dismissed the show as "gimmicky."[22] Elaine, who was initially excited by the opportunity to show uptown, eventually did so as well. "It seemed like a good idea at the time but later I came to think that it was a bit of a put-down of the women," Elaine said. "There was something about the show that sort of *attached* women—wives—to the *real* artist."[23] However, she more easily ignored the show's inherent slight than Lee did. Lee had expected more. A veteran of many group shows, she had never been so singled out for public diminution. She also knew how different her work was from Pollock's at that point. "It couldn't be any other way," Lee explained. "Two individuals, even if they are married, are still two individuals."[24] Her painting in the exhibition had been a brilliant Little Image work, entitled *Junk Dump Fair.*[25] That and works like it were the result of her difficult development beyond classicism, beyond Hofmann, beyond Pollock, and yet they were still not seen as sufficiently her own.

Lee reacted by making a radical break in her work—again. She would produce her last Little Image painting that year and head off in a new direction.[26] "For Jackson, 1949 was a good year; for Lee it was less so in terms of work: She was doing rather Matisse-like color field abstractions... all but two of which she soon destroyed," said Jeffrey Potter. "For their marriage, this was the best year by far due to Jackson's victory over alcohol."[27] Lee was nothing if not pragmatic. She would tackle her latest artis-

tic quandary, consoled by a life free of the drunken domestic tempests that had caused her so much grief.

While Lee and Jackson were in town for the *Man and Wife* show, Lee had bumped into Grace on the street. It was the first time she had seen her since Grace and Harry had left for Mexico the previous February, and Lee was hungry for news of their exotic journey.

"How's Harry?" she asked a tanned and visibly changed Grace.

"Harry who?" the younger woman replied bluntly.[28]

Creatively, the trip had resulted in a real advance for Grace. Ostensibly in Mexico to attend school, she hadn't found the classroom stimulating enough to hold her attention. As she had in New York, she turned instead to the street. Grace searched for inspiration amid the Baroque colonial architecture that rose as a historic backdrop in San Miguel, its decayed ornamental opulence contrasting markedly with the simple beauty of the Indian folk art and everyday goods she found in merchants' stalls. She sought new color combinations, new shapes, new textures she could apply to her canvas. She had even begun to appreciate the fact that she hadn't been formally educated in art because it saved her the distress of having to break the rules. Blissfully, she didn't know any.

Though still unresolved, Grace's work in that environment began to move toward a richer, more complete abstraction. Her brushstrokes wide, her paint thick, the shapes sensuous, there was not a hard edge or recognizable image to be found within her picture plane. "It was not until 1949 that any of my paintings began to give me hope of eventually reaching a full expression," she explained.[29] The size of her work changed, too. Big would always attract Grace and that was what she found in Mexico. One of her paintings from that trip, *Secuda Esa Bruja,* reflected her shift in scale. Vaguely resembling a Surrealist-inspired Pollock, its lush cadmium yellow and orange covered a canvas nearly six feet tall.

Personally, however, the trip was a disaster.[30] Harry was in a bad way in Mexico, and Grace experienced for the first time the depth of the problems he had hidden from her. He suffered a series of epileptic attacks during their stay, culminating in one in which Grace found him unconscious on the floor of his studio. Over the next twenty-four hours he would have multiple seizures, during which he slipped in and out of consciousness. When he finally did come around, physically and psychologically spent, he succumbed to days of complete "lethargy."[31] Grace had a helpless lump of a man on her hands, one who had known of his condition but had not had the courtesy to warn her. At about the same time, the U.S. government cut its accreditation for the school at San Miguel because students complained

that they wanted more and better classes. "So there we were," Grace said, "no GI Bill." They had no choice but to head back to New York.[32] Therein, however, lay another problem. Harry couldn't drive because of his physical condition, Grace didn't have a license, and the car wasn't in working order. "The gears didn't work on the damn car and they *backed* their way out of Mexico," Rex Stevens said. "The forward gears didn't work anymore.... They didn't have any money."[33]

Through the heat, the dust, and the scrub of Mexico they swerved unsteadily until they met up with friends, repaired the car, and started their journey east with Grace driving most of the way. They would arrive in New York on October 1 as husband and wife, but in name only.[34] As she indicated to Lee, Grace had decided to abandon husband number two. She no longer signed her paintings Grace Jachens or Grace Jackson. She was Grace Hartigan and always would be. All that remained was to find a place of her own and to make their separation legal.

The decision suited Grace, as had her trip. She had returned stronger. Amid unexpected adversity thousands of miles from anyone who might have comforted her, she had nonetheless persevered with her painting. To continue, however, Grace needed money, and for that she turned to Hofmann's school, where she offered herself as a model and was eagerly accepted. Grace settled into her work as artist and muse amid the ever-vibrant Eighth Street scene.[35]

The Village she returned to pulsed with expectation after the *Life* article on Pollock. It wasn't just that Jackson was now famous, or that his work was breathtakingly new. His photograph had caused tremendous excitement, especially among returning GIs and young men scattered across the country who aspired to be painters. To their astonishment, Pollock looked like them, like a *man,* an *American workingman.* His lined face and rough hands were like those of men on farms, in machine shops, even on fishing boats in communities throughout the United States where toil was a way of life. What Brando had done for acting, with his stained army-issue undershirt and world-weary sneer, Pollock did for painting.[36] He destroyed the traditional image of the artist in America, snatching it away from the elites and claiming it as an occupation for "real" men. Those who recognized themselves in his image flooded into the city relieved and grateful to answer his call.

Some found their way to a new undertaking in the Eighth Street space Motherwell's school had abandoned. Pollock's friend Tony Smith and two other teachers from New York University's fine arts program had taken over the loft and offered part of it to students for use as studios.[37] Grace quickly fell in with that circle of artists, living what she called a "double life with

people my age and the older artists." The younger artists drew together, ate together, drank together, but most importantly looked at one another's work, offering support and encouragement. Soon the bare walls of what became known as Studio 35 were used by Grace and her friends to mount exhibitions so visitors from all corners of the art world could see their work.[38] That new generation comprised an assortment of idealistic men and women whose goal was to paint so well, to create something so new, that they could "pay back" the artistic elders who had shown them the "moral grandeur" of another way of working and living, according to painter Al Leslie. When he came out of the military, Al said, the United States was "the embodiment of moral squalor. There was no courage to be had. I believe they [the First Generation artists] brought courage, the possibilities of dignity, the possibilities of people raising themselves up out of this terrible disaster, this holocaust.... As a young artist, I can only say that it was thrilling."[39]

Alfonso Ossorio, the sugar fortune heir who had bought one of Pollock's paintings and become friends with Jackson and Lee, had a mural project in the Philippines and was planning to be away for several months. He offered the Pollocks the use of his MacDougal Alley carriage house (which Pollock christened "Nine Mac") while they were in New York for Jackson's upcoming show at Betty's.[40] The place was fantastic with its two-story northern skylight and balcony laden with flowers. Ossorio's partner, the dancer Ted Dragon, would be in residence, too, but he was busy rehearsing for a Balanchine production and would be away most of the time.[41] Lee and Jackson accepted and would remain in the city for three months, their longest stretch since they had moved to Springs four years earlier.[42] Part of the reason for their extended stay was increased social demands. Pollock's celebrity—and his sobriety—had produced invitations to dinners, parties, and openings.[43] Nothing made their altered circumstances clearer than his own opening at Betty's gallery on November 21.

All the artists were there: Elaine with Bill and Milton, Waldorf stalwarts, Grace and the Studio 35 crowd. But there were many new faces in the crowd, too, people anxious to meet the *Life* artist.[44] In the entire avant-garde art world in New York at the time, there were no more than one hundred people, including artists, dealers, collectors, critics, and museum officials. (Clem put the figure at half that.)[45] They weren't all friends, but they recognized one another. These new people crowding the gallery—cultural New York with its wealth, elegant dress, and formal manners—felt like guests for whom the artists should be on their best behavior. Milton said,

> The first person I met at Pollock's opening in 1949 was someone I knew and he stuck out his hand so I shook it. I thought it was kind of funny. I know

the guy, why is he shaking my hand? I'd probably see him the next day on the street. Then another person; same thing. So I asked Bill what all the hand shaking was about, "What's going on here?"...

"Look around," Bill replied.

"Why?"

"Do you know these people?"

"No."

"They're the big shots," Bill said. "Pollock broke the ice."[46]

Collectors roamed the smoke-filled gallery trying to decide not whether but which of Pollock's twenty-seven dazzling sprays and splashes they wanted to buy. Collector and stockbroker Roy Neuberger bought one for one thousand dollars. Mrs. John D. Rockefeller purchased another. Even the actor Vincent Price, who had made his name in horror films, purchased a Pollock. Art directors from magazines surveyed the works for graphic ideas. The Modern's Alfred Barr was on hand as the presiding minister of art, offering advice and direction.[47] Jackson had joined the major leagues. It was, for some, exciting to see; the downtown artists had a love-hate relationship with money. "Friends watched Cadillacs coming up from Wall Street on Fourth," David Hare recalled, "not liking it, but liking it."[48]

Seeing that type of wealth close at hand, however, mingling with it in a gallery, and watching its possessors exchange banknotes for paintings was confusing and unnerving. Was that why they painted? A true artist would have said no. "Whenever Hollywood does a movie on artists they don't know how to deal with what drives an artist," Elaine said. "They always think an artist works toward fame. They can't imagine the thrill of the actual work, it doesn't occur to them. That, they feel, is just on the side, and fame is the aim. Whereas it's exactly the opposite. [Work] is the aim, and fame is a byproduct."[49]

Regardless of what the artists wanted, however, the juggernaut had commenced. After Pollock's success, selling a painting was suddenly neither an abstract concept nor merely a matter of survival. It had become a destabilizing measure of achievement. "He had a success with that show," Resnick said of Pollock, "but we were anxious for him."[50] Every day Pollock and Lee went to Betty's gallery to answer questions and bask in the unexpected critical acclaim and attention Jackson was receiving.[51] Even those critics who nine months earlier had been skeptical of his work had been won over. It all seemed a little unbelievable. "Lee and Jack would sit around [the gallery] all day. It meant so much to them," Clem said. "Or maybe they had nothing else to do."[52]

Carrying a batch of new work, Elaine returned to New York from Provincetown in December. She had been in and out of the city that fall,

accompanying Bill to the *Intersubjectives* opening, to *Artists: Man and Wife*, to Pollock's show, and to work on two pieces for *ArtNews,* one on the artist Edwin Dickinson, who split his time between studios in New York and the Cape, and the other on Hans Hofmann, who did likewise. Those articles were significant because they marked the start of a new phase in Elaine's writing career, indeed in art writing in general.

In 1949, Elaine and Tom began writing feature-length articles that brought the writer—and thus the reader—into the artist's studio for several sessions of observation and talk while a particular work of art was being created. The result was a vivid piece on the artist and his or her working life that they believed would help the reader understand the process of creation and therefore the marvel of the art produced. It was a novel way of writing that focused on what the artists considered to be the most important aspect of creation: the *act* of painting or sculpting.[53] The articles also allowed Elaine to introduce *ArtNews* readers to the contemporary scene as she would have if she were bringing them to visit a friend's studio. The tone was conversational and the articles naturally revealing. Elaine *wrote* portraits in the same way she painted them—intimately, compassionately, and with great respect for her subject. For the community more broadly, the launch of those articles at that moment was fortunate. Artists needed someone on the inside to explain the work being done because the world, newly awakened to their existence, seemed already to be missing the point.

While Elaine's younger friends were busily occupied at Studio 35, the Waldorf crowd had found a home several doors down on the same side of the street at 39 East Eighth Street. After years of talking about renting a space, they finally had, forming what would be known simply as the Club. The downtown art scene had outgrown the Waldorf, which in any case had become too seedy even for the artists who had spent nearly a decade there in smoky banter.[54] "There were a bunch of toughies at that cafeteria. They'd start beating people up," Philip Pavia said. "When there was a big fight among them we'd get scared and stand outside—and we'd talk and talk.... That's when the club idea was born."[55] The Village was rich in the club tradition, with some grouped by interests—the Tile Club, the Liberal Club, the Music Club—and others by ethnicity. Pavia's idea was to have a "man's club like the Italian idea of the men getting together in the cafe," Ernestine said.[56] Bill explained it even more simply: "We just wanted to get a loft instead of sitting in those god-damned cafeterias."[57]

As with nearly all the significant events involving the history of the New York School, the exact circumstances surrounding the beginnings of what would become one of America's most important artist-inspired and artist-organized societies vary depending on who is telling the story. What is generally agreed, however, is that a space on Eighth Street had been

found and a meeting of fewer than twenty artists was convened at Ernestine and Ibram Lassaw's loft to discuss the idea of renting it and what such a club might entail.[58] A commercial artist from New Zealand had the lease for the loft and was willing to turn it over for five hundred dollars in "key money" and a monthly rent of eighty dollars to be paid to the landlords. That was an enormous sum for that ragtag bunch but the loft was perfect, as was its location. "I remembered that I had $22 in my pocket, of which I put $20 on the table," recalled Alcopley. "Others followed my example, but we collected only about $50."[59]

Philip Pavia, who was introduced to the avant-garde by writer Henry Miller in Paris in the 1930s and who saw the club as a future center of such activity in the New York,[60] agreed to advance the rest—four hundred and fifty dollars—so they could take possession of the loft. "We were all overjoyed," Alcopley said. Pavia would, from that point until he left the Club in 1955, function as its manager, director, treasurer, and guiding light (its Machiavelli, according to painter Pat Passlof)—with all the joys and headaches that job entailed. He was up to the task. As an Italian stonecutter's son, Pavia said, he had learned "you have to move mountains."[61]

The money problem solved, the meeting at the Lassaw loft continued with Ernestine taking notes, but they were hardly necessary. There were no formal rules, no agreed charter, in fact the first organizational meeting was mostly concerned with how to remain unorganized. "It was anarchistic, it came out of the soil," said painter Natalie Edgar, who would marry Pavia.[62] It has been said that some at that initial meeting wanted to create an artists'-only membership that excluded women, communists, and homosexuals. If those exclusions were ever actually discussed—and that is also an area of dispute in the Club's history—they were almost immediately ignored.[63] Elaine, whom Esteban Vicente said "no one could keep out of anything she wanted to be part of," was involved in the Club from the moment she returned from Provincetown.[64] (She did not become a full member until 1952, however, in an act of protest because her friend Aristodimos Kaldis was not given immediate membership.)[65] Painters Perle Fine and Mercedes took part even before Elaine, with Mercedes paying dues from the start.[66] "Certain ones fought [to be members]," Ernestine said. "Mercedes fought."[67]

The so-called restriction on gays quickly fell by the wayside as well. John Cage was eagerly absorbed into the Club; the artists considered him "sort of a saint, a sort of guru."[68] As for the ban on nonartists, Charlie Egan, Harold Rosenberg, and Tom Hess—a gallery owner and two art writers—also formed part of the early group.[69] Communists per se, however, did *not* make an appearance, nor was communism discussed. It wasn't that the Club was anti-communist, but amid government witch hunts and persecutions no one felt so passionately about the ideology that it was

worth the risk of an official visit from the feds. And when FBI agents or police did climb the three flights to knock at the red door, Philip would send Elaine out to talk to them. "We never had a problem," Pavia said.[70] "She smiled and laughed them down the stairs to the street," added Natalie.[71] In any case, Club members "had no political views above the present," according to Lutz Sander. "They had sort of romantic notions of [the revolutionary periods in Europe] 1849 or 1917. It was nice, it was all very honorable and well-intentioned. To them it still had its purity, you know, for the good of man and so forth."[72]

Spirits were high during that formative meeting, and opinions strong and varied. On one item, however, everyone agreed: There would be no art displayed on the walls, and there should be no sponsorship, no dependence upon a gallery owner, critic, or curator.[73] The Club was a protected zone established at a critical moment when the influence of outsiders threatened to taint the pure creativity that had flowed unrestricted through the New York School. The community spirit that had formed in the Project and survived the war in the Waldorf had found a base from which to flourish in a small factory building in the Village between University Place and Broadway. Remembering years later that third-floor space, Mercedes said,

> The Club was marvelous. It brought together in one place, at one time, the greatest diversity of artists—as nothing had done before or has since. One could be in a room with... Franz Kline, Willem de Kooning, Philip Guston, Bradley Walker Tomlin, Barney Newman, Harold Rosenberg, Dylan Thomas, Edgard Varèse, John Cage, Morton Feldman—the list could go on and on—and there was extraordinary warmth and camaraderie among artists then. The end of that marvelous time came when American art became big business. Success seemed to spoil the climate.[74]

Happily, that would not occur for many years, and in the meantime the artists supported one another in their difficult individual journeys. It is almost certain that they would not have been able to achieve as much as they did had they been on their own. "The Club created a kind of spirit that transcended normal social contact among artists," explained painter Jack Tworkov. "There was great mutual concern and respect for one another. It was a joy to live in such a society. We drank, and danced and liked each other's company." As for the influence artists had on one another, "Critics raise a storm about 'influences,' but artists know they are constantly interacting."[75] The Club gave them a near-perfect forum in which to do so. Leo Castelli, who would become an early member, called it a "mystical fraternity.... It was like almost something we had great faith in, something that we relied on to perform all kinds of miracles for us."[76]

But before the mythmaking came the cleaning, and during the first months all the artists involved took part. "The loft had a fireplace, three windows facing Eighth Street and one window at the back. It was crowded with partitions and the many walls were covered with drawings of pinup girls and pornography," Alcopley recalled. The charter members got to work tearing down the walls in the thirty-three-by-sixty-foot space.[77] Milton, with his wartime horror of the dark, insisted on painting the Club "Sing-Sing" white and using bare bulbs as lighting.[78] Giorgio Cavallon installed a sound system and record player on which they often played operas—*Don Giovanni, Così Fan Tutti,* and *The Magic Flute.*[79] "The place was actually full of artists listening to the recordings," Ibram said, with commentary provided by Rudy Burckhardt. Ibram made a large table, which served for both dining and discussions.[80] The group had comfortable furniture for a while, but Milton decided it was too bourgeois, so he threw it out. The artists then pooled their money to buy wooden folding chairs.[81] Lutz Sander and Bill, meanwhile, took charge of scouring the small kitchen. They disassembled the old oven, boiled each part, and reassembled it. Finally, the space was ready and keys were distributed to charter members, who numbered nineteen and within weeks would grow to thirty-seven.[82]

During the first official meeting inside the new space, the artists discussed the relationship between art and poetry. Sitting in front of the fireplace into which they fed orange crates scavenged from local shops, the group drank coffee and discussed Baudelaire and Cézanne, and Cézanne and Mallarmé.[83] After the hubbub of the cafeterias, the quiet of the Club felt protected. Ibram said, "The first months of the Club were almost too good to be true."[84] They decided to celebrate by inviting their families to a Christmas party. "For a few evenings the Club became a workshop where most charter members made one or two giant collages, covering the walls and ceilings with them," recalled Alcopley of the preparations for the gala. The Christmas gathering proved such a success that members left the decorations in place for an adults-only New Year's Eve party.[85] Sitting at a row of bridge tables, enveloped by music, the artists at that event were "well behaved," Lutz Sander recalled. "Everything was a little high but quiet, sort of glowing." Until after the dinner, that is, when the dancing began and the wood floor of the old factory shook with a manifestation of their joy. The Alpine mountain climbers' meeting hall one floor below would have reverberated with the sound of an avalanche.[86]

Sometime during what became a three-day party that ushered the artists into 1950, Philip Pavia stood to make a toast. "This is the beginning of the next half century," he said. "The first half of the century belonged to Paris. The next half century will be ours."[87] It was a bold statement, but

there was a sense that anything was possible. As the 1940s ended, many of the First Generation artists had created not just new works but new worlds. They were floating, free, and it was wonderful and terrifying and painfully difficult. "Doing the best there is...in you to do, it's got to go beyond the point where it's comprehensible," Lutz explained. "Music, you know, it's just scratching on the strings until it's transposed into music and then the strings and the bow are no longer there, but are dematerialized.... The excellence is somewhere beyond explanation."[88] And that was where the new decade found them, quietly confident, even defiant, alternately incomprehensible and a source of intrigue to those around them. It was a blissful state while it lasted.

24. The Flowering

> In a painting, I try to make some logic out of the world that has been given to me in chaos.... The fact that I know I am doomed to failure—that doesn't deter me in the least.
>
> — *Grace Hartigan*[1]

SOMEWHERE BETWEEN MEXICO and Manhattan, Grace had exchanged her loose skirt and peasant blouse for an army surplus jacket, jeans, and boots and had chopped her blond hair roughly, Nell Blaine–style, to just below her ears. By the start of 1950, the look she had worn when she first arrived in New York as Ike's quiescent lover no longer suited the person she had become: intense, independent, but most of all inspired. Grace and the younger painters with whom she associated were on fire. "We were in love with paint," she explained, and enthralled by the lives of the people they knew who dedicated themselves to pushing it around on canvas.[2]

After just a year of marriage, Grace and Harry officially separated in January 1950.[3] Despite their disappointment with each other, they remained friends, socializing together within their small community. Grace, in particular, didn't waste time on recriminations. By February, she was living with Al Leslie in a fourth-floor loft without electricity or heat at 25 Essex Street on the Lower East Side.[4] "A lot of people have said, 'Oh, wasn't she beautiful?' I never thought of her as beautiful or not beautiful," Al said of Grace. "I just thought of her as a remarkable person whose force of personality and radiance of self came before anything else. She was very smart and very devoted to her work."[5] Al was the perfect partner for Grace at that time. He wasn't looking for a long-term attachment—he, too, had just separated from his wife.[6] They were comrades in art. It didn't hurt that Al was also quintessentially macho—dark, compact, muscular (one writer called him the "pin-up boy of the avant-garde"[7])—the type Grace was most drawn to sexually. Or that he, like she, had burst onto the scene a relative artistic neophyte. They communicated easily because they were the offspring of the same artistic parentage: the First Generation artists of New York. "I had no formal education and held only a high school diploma," Grace would say years later. "I learned by listening a lot and looking."[8] For his part, Al said he was literally "hatched out of Abstract Expressionism."[9]

Unlike Grace, who had no interest in art as a child, Al had wanted to be an artist—or alternatively, Mr. America—from the time he was a boy in the

Bronx. His father was in engineering and had taught him mechanical drawing. Though talented enough to be awarded special instruction at school, Al rebelled against the teacher's rules, and the sessions ended quickly.[10] That pattern of false starts continued when he was a teenager. Between bodybuilding (he would be named Mr. Bronx)[11] and an interest in shooting movies, Al had continued to draw and won a scholarship to the Pratt Institute to study art. But Pratt's admissions officer, sizing Al up in his zoot suit and silk "blouse," said he wouldn't be happy there and rejected his application. Al's next stop was the coast guard. That career ended in just nine months.[12] After Hiroshima, the likes of Al were no longer needed.

Sitting in Washington Square one day, he saw a coast guard friend who was going to college. "'Why don't you go to the university and you can collect more benefits from the GI Bill?'" Al recalled him saying. "He suggested NYU."[13] Al wasn't interested in art school—he had modeled at art schools and knew what they had to offer—but the idea of a university intrigued him because he recognized that he didn't have the "intellectual resources" to be an artist. An early visit to the Metropolitan Museum, he said, "scared the shit out of me." Seeing centuries of art on its walls, he thought he couldn't possibly compete with what had already been accomplished. Then, as a teenager, he was chased out of the museum by guards who didn't think his dress displayed the respect due such a hallowed institution. That was enough, he said, to put him off high culture.[14]

Al had been fortunate, however, to enroll at NYU's Fine Arts Program as it shifted its emphasis from art history and traditional teaching methods to contemporary art and a more relaxed style. At the time, he had a job waxing floors for a man who made lamps with marbleized background effects and figures dancing on them. Al tried to copy the technique at home, using the material he had at his disposal: wax paper and floor wax, which he poured to create his images. One of those works had formed part of his admission portfolio to NYU and was hung in a hall at the school. Al's teacher, Tony Smith, spotted it and exclaimed, "Jesus Christ, that looks like a Jackson Pollock."

"Who's Jackson Pollock?" Al asked.

"Clement Greenberg thinks he's the greatest painter in America."

Al burst out laughing. He thought Smith was joking, not because of what he said but because the "names for a lower-class kid were so funny, ridiculous," Al recalled. Tony told him to see Jackson's and Bill's paintings, that he was in for a shock. When he did, Al said the work didn't surprise him at all. He intuitively understood where it came from.[15] He also appreciated his position and that of his fellow young painters, who were trying to follow in the footsteps of the First Generation. Al believed he and they

had it much easier than their elders. The veterans had asked the difficult aesthetic questions; all the younger artists had to do was learn to execute the answers and find their own way.[16] In 1950, Al was twenty-two (five years younger than Grace) and had tremendous respect for artists like Bill, who at twice his age had been painting for longer than Al had been breathing. Most of that older generation hadn't even had a show, "or those who did show didn't believe in exhibitions. Only shitheads showed," Al said. "The idea was simply to make the works, and the works through their own moral splendor reached out into the world."[17] Those Romantic ideas energized the likes of Grace, Al, Larry, and all the artists whom Tom Hess would identify as the Second Generation.[18] They venerated their elders and sought to inherit their mantle in art and in life.

On February 10, 1950, Al signed a lease for the Essex Street loft, which cost about a dollar a day, and he and Grace moved in.[19] It was the dead of winter. By mid-February the temperature had plunged below zero, where it would remain until March.[20] They had essentially paid for the privilege of camping in the city. For lights they used lanterns, and for heat a propane stove until they could afford a coal stove.[21] Like the lofts their friends occupied around the Village, the Essex Street space was zoned commercial, so Al and Grace made it appear that they didn't live there by hiding anything remotely domestic. Al also purchased a one-dollar permit that allowed him to serve food to his "employees," thereby avoiding any questions that might arise about their rudimentary kitchen and what exactly they were up to in that space.[22] And those questions did arise, from both official and unofficial visitors.

One night, their suspicion aroused by dim lights on the fourth floor of the otherwise deserted building, police knocked on the door. Al and Grace invited the uniformed men in. Walking around the place, looking at the paintings, which were made more bizarre in the flickering lamplight, the officers laughed. "What is this?" one of the policemen asked.

"This is our work," Grace said.

"You don't have electricity? Who lives in New York without electricity?"

The police left them in their shabby splendor and didn't bother with them again.[23] Another evening, however, when Grace was alone, there was another knock on the door. "There are these two guys," Rex Stevens related, recalling Grace's telling of the story. "You can visualize it like in the movies, some big dudes in coats and hats...and they say, 'So, honey, what'da you got here?' and walked past her into the space. 'What kind of business you got here?'"

"I'm an artist. I'm a painter," Grace replied.

"Do you sell these paintings?" they asked incredulously.

"No," she admitted, she didn't.

"Oh, honey, we got you, we'll take care of you, don't worry about it.... You're protected."

"They were the dudes shaking the businesses down," Rex said. They gave her "a pass because it's so pitiful.... They left, and nobody ever bothered her again about that stuff. She didn't have to pay any fees like the butcher or the pickle dude or the bagel man."[24] For the next decade, Grace made Essex Street her home and artistic safe haven. The Lower East Side had long been the fountainhead of dreamers who struggled and hoped with an eye to a better future. One historian called the neighborhood the first stop of the "Tenement Trail," a path followed by generations of people who worked their way out of the ghetto and into a more prosperous borough across the river.[25] Grace didn't want to work herself up or out. The neighborhood was her vast studio and she loved it.

Life there was lived on the street and in the air, where layer upon layer of clotheslines fluttered above crowded roads and walkways like the unfurled sails of schooners, and where women carried on a near-constant shouted exchange in Yiddish from window to window. The scene below was no less cacophonous. Merchandise was sold and bartered in basement shops and out of ground-floor storefronts but mostly curbside, where everything imaginable was spread out on tables, carts, and crates. It was nearly impossible to walk on those teeming sidewalks, and so women alone or with children, grandmothers hunched and slow, and men with black hats, black coats, and long beards took their chances in the street, dodging and pivoting through the rush of oncoming cars, carts, bicycles, even horses.[26] Writer E. B. White recalled that on hot nights, after the business day had ended, whole families laid claim to the pavement outside their buildings, sitting on the ground or on orange crates that served as couches and chairs.[27] There were no private living rooms in the heat of the city in that quarter; privacy—like the English language—was an American habit that hadn't quite taken yet.[28]

Grace's building was famous as the home of a pickle vendor whose wooden barrels, filled to the brim with a fabulous variety, stood in two rows from deep inside the shop out onto the street.[29] The smell of dill and vinegar was so pungent that it rose all the way to Grace's fourth-floor loft. In fact, all around her were a myriad of delicatessens, bakeries, kosher butchers—each recognizable by the rich, distinct aromas of their offerings.[30] Grace, however, lived on "oatmeal, bacon, bread, and tomatoes for two years."[31] That didn't, however, discourage her. As David Hare said, artists "might starve, but they don't starve because they *want* to be artists. They starve because they can't *help* being artists."[32] And in any case, hunger was part and parcel of their glamorous tradition. Matisse himself, when his family was hungry in Paris, had refused to allow them to eat the fruit he used in his still lifes.[33]

Grace and Al both worked as models, she at Hofmann's school and the Art Students League. The pay was low but employment steady, and it introduced Grace to an academic side of the art world that she herself had never experienced. From the model stand, her nude body still as a statue, she allowed her eyes to roam as various teachers traveled from student to student offering instruction. Greedily absorbing everything she could, when Grace returned to her studio she applied those lessons to her own canvases.[34] Grace's life was full and devoted to painting. Every relationship she had, every activity she engaged in, revolved around it. Except, that is, her relationship with her son. At eight, Jeff still lived in New Jersey with his grandparents, sharing Grace's bohemian existence on the weekends. Each of the toys left strewn around the loft after his visits acted as a sad and nagging reminder that her decision concerning her son's welfare was only half resolved.[35] Like all children, Jeff needed stability, and that was something Grace could not offer. "Some people would say that it is not human for a woman or for a man to put their work before everything," Grace said. "But I don't see how you can create and not have the feeling that it is the most important, all-consuming thing."[36]

As Elaine and Lee had experienced, the decision to be an artist often meant having to forgo—or in Grace's case, abandon—children. It was an excruciating dilemma. Were they really so "unnatural" that they would choose art over childbirth, the destiny biology and society had assigned them? And if they did, could they live with themselves amid the inevitable disapprobation, the scandal-tinged questions that would be attached to their names? Throughout her career, Grace was loath to acknowledge any difference between the sexes when it came to making art—except in the case of children. Women, she said, "are facing a special circumstance which does have to do fundamentally with the fact that they bear the children. If a woman gets a man who is a lover, a good friend, and is mutually supportive, that is a very human and creative situation, but I don't know how society can solve the children part of it."[37] For her, the issue was not theoretical. Every weekend she looked at her son, recognizing what she must do but lacking the strength to admit it. Grace understood that giving Jeff up entirely would be "very cruel, very harsh, and very difficult."[38] And yet one day she would. Only other artists—only other *women* artists—might have fully understood her predicament. And on any given night, when she needed to find someone to talk with or simply to recharge her batteries, Grace knew where to go.

That year, 1950, a nondescript bar without a jukebox or television on University Place between Eighth and Ninth Streets had begun to serve as a gathering place for the downtown artists. With its "bile green" walls (Mil-

ton said they were the color of subway bathrooms), white lights, and forgettable Hogarth prints, the Cedar Bar was an environment without the barest soupçon of style.[39] Even the bar's name was an afterthought; its circular sign that read, "The Cedar Street Bar Restaurant" had been claimed from the rubble of a defunct saloon.[40] Said Mercedes,

> There was never any kind of music, nothing, it was just a dirty dismal quiet bar that never had any daylight, always twilight. It was always night there. There was a huge clock in the back of the room and every once in a while the clock would go backwards... and I thought that was just because there was something about a continuum of no time at the Cedar Bar.[41]

The Cedar was a blank canvas that the artists animated each night between ten p.m. and four a.m. with talk, laughter, and the occasional brawl. During those hours, that dreary place was magical and—for the artists who nursed a fifteen-cent beer at the bar or sat at a booth in the back eating a dollar meal of spaghetti—a much-needed refuge, sometimes the only refuge where they could enter burdened and feel immediately relieved.[42] It wasn't because of the alcohol—at the start, not much was consumed. It was a matter of friendship. The Club, around the corner, was primarily a forum of ideas. The Cedar was where the artists gathered for fun. "If someone were to ask me where I did my post-graduate work, I'd have to say the Cedar Bar," said Joe Stefanelli, who was among the returning GI artists. "The camaraderie that existed was electric.... The impromptu encounters and the wonderful exchanges would be the envy of art journalists, a place where the camaraderie was like a brotherhood."[43] George McNeil said the bar was—not in appearance but in function—similar to the nineteenth-century Latin Quarter cafés, where a young Monet might sit at a table and listen to his elder, Courbet.

> Something like that was true of the Cedar Bar. If you believed in the future, an exciting art, that was the place to be. There weren't any big shots around, there weren't any collectors or big critics. [Artists] came there for all the exuberance, comradeship and all the excitement, and then you go home and do your own work. No one held forth, no one bullshitted about "This is what art is."... Everybody knew it was the place to be.[44]

Elaine was the "mother" who presided over the Cedar family and a draw for artists like Grace in need of a sympathetic ear, a bit of advice, or merely a laugh. And then again, especially for the younger women, it was sometimes enough to simply sit back and watch her in order to be strengthened and encouraged. Elaine was considered a principal player on the New

York art scene, based not on the fact that she was Mrs. Bill de Kooning but on the strength of her own formidable personality and achievement.[45] By early 1950, Elaine's name had appeared prominently and regularly over major articles in *ArtNews*, which everyone in their circle and beyond in the greater art world read. In February her piece "Hans Hofmann Paints a Picture," with photographs by Rudy Burckhardt, appeared as a lengthy exchange of wisdom and wit between her and the revered maestro.[46] ("Hofmann enjoyed the idea of painting a picture for a camera and for Elaine," Rudy said. "He talked and talked and made advances to Elaine. Called her *Elainechen*. He was a character.")[47] At that point, Elaine's was a singular voice in New York's art community; she was the only artist writing for *ArtNews* and therefore the only one able to broadcast her colleagues' travails with the sensitivity and understanding of one who also struggled alone in a studio.[48]

Additionally, through her relationship with Tom Hess, Elaine had helped redirect the magazine's focus: It would become the house organ for the Abstract Expressionists and in so doing become the "most influential art trade publication of the 1950s and early 1960s."[49] Said future Museum of Modern Art curator William Rubin, "Hess and Elaine were very close. They constituted a party and they had the power of *ArtNews* at their disposal."[50] Naturally inclined to seek the center of the action, Elaine had found it. She *was* the center, the point of intersection for the painting, writing, and socializing associated with the New York School. Everyone knew her and she knew everyone. Everything interested her, and she made sure she was involved in it all. "Some people have only four threads, connections," Ernestine said. "Elaine had thousands."[51]

Painter Jane Wilson and her writer husband, John Gruen, met Elaine in the Cedar that year. "She was sitting there with her husband, Bill, and I went right over to their booth to tell her how much I liked her writing," Gruen said. "The thing you noticed about Elaine was her tremendous vitality and wonderful wit.... You knew she was a person of substance, but you also knew that she wasn't pretentious and didn't take herself all that seriously. The point is, she made you feel comfortable."[52] Younger artists may have emulated Bill's art, but they found inspiration in Elaine's life. Art critic Rose Slivka recalled her first impression of Elaine:

> It was a spring evening and I was drawn to the figure of a young woman in black with a black lace shawl over her red-blonde hair, with large, flashing eyes, luminous white skin, and bright red lips, walking rapidly toward me.... She did not see me as she passed, eager, avid, radiating the energy of her excitement.... I was so new to the art world that I did not yet know who

she was. The friend I was with saw me staring and said, "That must be Elaine de Kooning."⁵³

It was at that time, during that first season at the Cedar, that Elaine became what poet Frank O'Hara would call "the White Goddess: she knew everything, told little of it though she talked a lot, and we all adored (and adore) her."⁵⁴

However grudgingly, the official art world seemed to have accepted the fact that "modern art" was not going away. On January 1, the front page of the *New York Times* announced that the Metropolitan Museum had decided to embrace the new in art by mounting a show and competition featuring American work from the beginning of the century up to 1950.⁵⁵ Artists' hopes soared and were just as quickly dashed as they read the names of the judges who would select the work and award the prizes. They were all conservative. Avant-garde to them meant pre–World War I. It appeared that the Met was willing to accept the concept of modern art but not the most advanced examples of it.

That realization was especially demoralizing because it reflected a trend in the broader art world. A few uptown galleries had dared to show the work being done by the New York School, a few collectors had even dared to buy it, but the paintings and sculpture by the majority of artists in and around the Village had never left their studios. Most of the time, that state of isolation wasn't an issue. They enjoyed the freedom to experiment; it was an advantage anonymity conferred upon them. But the Met show was a warning that they risked being defined and condemned to oblivion by outsiders who feared what they did not understand. There was little doubt among the advanced artists that they were making history, that the works being produced among them were revolutionary and extraordinary. They had to ask themselves whether they wanted to keep it "their secret" or make a concerted effort to demand attention as a group—if, that is, they *were* a group.

In its March 20 issue, *Life* magazine reignited that debate with a feature on what its editors determined were the nineteen best modern painters in the nation under the age of thirty-six. Four hundred fifty works had been submitted for consideration and nineteen chosen for acclaim and reproduction. Though most of the artists in the country lived in New York and 90 percent of the most advanced painting was being done there, only two artists from the Club and the Cedar crowd were featured among the *Life* nineteen: Hedda Sterne and Theodoros Stamos. And most of the so-called abstract works reproduced in *Life* were Cubist or Surrealist knockoffs.⁵⁶

The article was one more insult directed at the downtown crowd, one more example of the New York School's having provoked a dialogue without being allowed to be part of it.

The young artists at Studio 35 responded with a protest show entitled *Fourteen Under Thirty-Six,* which hung for two weeks in early April at that artists' space. Grace, Al, Elaine, Franz, Larry, and Milton were among those in the show, whose criteria for entry was that the artist was advanced, young, had been omitted from the *Life* article, and had no gallery representation.[57] The exhibition was an act of defiance, but those in it also hoped to attract the attention of their elders, who might offer advice and comment on their work.[58] What happened was much better; "incredible," according to Grace.[59]

Motherwell had had a show scheduled at Sam Kootz's but cancelled, leaving an opening on the gallery schedule. Kootz turned to Clem Greenberg and Meyer Schapiro "to dig up some young artists for him to exhibit," Grace said.[60] Clem and Schapiro, respectively the most important art critic on the scene and the art historian most admired by the downtown set, had seen the Studio 35 show and made "mental notes" about the artists. Next, they visited the various artists' lofts to make selections for a show. Ultimately twenty-three artists were presented in *Talent, 1950,* among them Grace, Elaine, Al, Larry, and Franz.[61] "I was only twenty-eight then, that was pretty good, to be in the Kootz Gallery with that company," Grace recalled.[62] Sam didn't scrimp on the costs. The red, faux-velvet invitations to the opening were a playful take on salon traditions. And Greenberg and Schapiro provided an essay for the show, describing the "robustness, the enthusiasm... of Young American Art."[63] Beyond its vibrancy, the exhibition had historic significance: It officially launched the "Second Generation" of the New York School.[64]

The show opened April 25 to "a great deal of attention," Grace said.[65] "The results surprised Kootz as much as anybody."[66] Instead of crowding a gallery to see Bill or Pollock or Rothko, those older artists walked from painting to painting looking at and discussing the younger generation's work. Greenberg and Schapiro had selected Grace's painting *Secuda Esa Bruja* for the exhibition. She wasn't satisfied with it, but she conceded that at least it had a "full voice."[67] All the works at Kootz had new, clamorous voices, which indicated that something undeniable was happening in American art, something so established that a first generation had given birth to a second. For the older artists, that realization was exhilarating and frightening. Some had never been in a show, and already their artistic offspring had been given that opportunity. Many believed it was time to assess the situation.[68]

By the spring of 1950, after only a few months in operation, Studio 35 on Eighth Street had gone the way of Motherwell's school at that same loca-

tion. It was forced to close. But before it did, a three-day symposium convened on April 21 to examine the issues confronting the artists in New York.[69] Participants varied each day, but a core of about twenty-three artists attended most sessions, which were moderated by Motherwell, sculptor Richard Lippold, and the Modern's Alfred Barr.[70] There was no set agenda. The issues discussed ranged from the aesthetic to the mundane. Some ideas, however, resurfaced, and one of those was whether the artists constituted a movement, and if they did, whether it should have a name. Barr appealed to the group to call themselves something. "We should have a name for which we can blame the artist—for once in history!" he said.[71] But none of the participants could agree on one, and few were inclined to renounce their right to the pronoun "I" in order to be submerged into the "we" of a movement. "I think we are craftsmen, but we really don't know exactly what we are ourselves," Bill said. "We have no position in the world, absolutely no position except that we just insist upon being around."[72]

The symposium would have ended on that note of irresolution if not for an afterthought by painter Adolph Gottlieb. On the last day, he suggested that the artists draft a protest letter to the president of the Metropolitan Museum over the planned *American Painting Today* show.[73] The announcement of that event had been the catalyst for the recent anxiety about where the New York artists stood in the art world, and a letter would give them the opportunity to voice their dissent publicly because it would be distributed to newspapers, in addition to being sent to the Met. The artists agreed. Over the coming weeks, Gottlieb, Motherwell, Barney Newman, and Ad Reinhardt wrote a denunciation of the show, which was signed by eighteen painters and ten sculptors.[74]

> The undersigned painters reject the monster national exhibition to be held at the Metropolitan Museum of Art next December and will not submit work to its jury.
>
> The organization of the exhibition and the choice of jurors by Francis Henry Taylor and Robert Beverly Hale, the Metropolitan's Director and Associate Curator of American Art, does not warrant any hope that a just proportion of advanced art will be included.
>
> We draw to the attention of these gentlemen the historical fact that, for roughly a hundred years, only advanced art has made any consequential contribution to civilization.
>
> Mr. Taylor on more than one occasion has publicly declared his contempt for modern painting; Mr. Hale, in accepting a jury notoriously hostile to advanced art, takes his place beside Mr. Taylor.
>
> We believe that all the advanced artists of America will join us in our stand.[75]

Barney Newman delivered the letter, dated May 20, to the *New York Times,* which ran it two days later on the front page under the headline "18 Painters Boycott Metropolitan: Charge 'Hostility to Advanced Art.'"[76] The following day, the *New York Herald Tribune* denounced the denouncers as "The Irascible Eighteen," saying the artists were unfair in their criticism of the Met. The brushfire that had begun at Studio 35 quickly spread through the national press.[77] Ironically and unintentionally the artists who could not agree during three days of talks on whether they constituted a group had been identified as such due to a not very artfully crafted five-paragraph letter to a museum bureaucrat.

Twenty-eight artists had signed the letter, but twenty-nine came out publicly in support of it, and the circumstances surrounding those signatures involved a slight that Lee remembered bitterly for the remainder of her long life.

Neither Lee nor Jackson had much time to devote to painting during the winter they stayed at Ossorio's carriage house. Jackson complained that he had gone to so many parties and hadn't held a brush in so long that he didn't even feel like a painter anymore.[78] That overfull dance card was the price of his fame, and because of that fame the artists drafting the protest letter very much wanted his endorsement. Thanks to *Life,* Pollock had become the face of new art and the only name among the New York artists that a general audience of readers might even remotely recognize.[79] He and Lee had returned to Springs before the symposium was held and knew nothing about the discussion or the letter being drafted until one day in mid-May when Barney Newman called. Lee answered the phone and chatted for a while with her old friend, who then asked to speak with Jackson.

> While we were talking he, Jackson, walked in the house and I said, "Hold, here he comes." Jackson picked up the phone. I could only hear what Jackson was saying.... I heard Jackson say, "Yes, I'll certainly go along with it, you can put my name down." When he hung up he told me what it was about. They were getting up a petition of protest.[80]

Lee was stunned that Barney, who had known her from the Artists Union, who was aware of her history of activism on behalf of artists, not to mention her history as a painter of the advanced school, had not had the courtesy to ask if she might like to sign the letter, too—or even to mention what her fellow artists were doing. He had treated her as a disinterested bystander. "Angered me?" Lee said. "That's stating it simply. He just bypassed me totally."[81] Lee helped Jackson draft a telegram, in lieu of a sig-

nature, in support of his fellow artists' position, and left her name off the message.[82] Instead, she nursed her wounded pride and began to reevaluate her position as an artist and an artist's wife.

Slowly but surely, as Pollock's notoriety grew, Lee's very existence had become eclipsed—not just among the newcomers to the New York art scene, as one might have expected, but more painfully among those who had known her for decades. "Now come on, that's a big load to carry," she said. " 'The wife paints too? And she's good?' ... That's almost unreasonable."[83] As her friend Betsy Zogbaum had said, Lee was a fighter, and after the letter incident she began to think about herself again, *her* identity as an artist in that expanding community.[84] Pollock's career was doing just fine. Alfred Barr had selected him to be among six artists represented in the American pavilion at the Venice Biennale that June, and Peggy, who was living in Venice, planned to mount a show of twenty-three Pollocks from her collection during that event.[85] Jackson's paintings would, therefore, receive a powerful introduction in Europe. "[Lee] was a great artist in her own right," said Ted Dragon, "but she was determined to take that husband and make him. It was her obsession. Then, when he made it, living through him wasn't enough. She wanted it for herself."[86]

That spring Lee initiated her own petition to a museum official. At a meeting in Springs, she proposed that the abstract artists who had moved to the area write a letter to the director of the Guild Hall in East Hampton asking him to give them a show. The artists wanted two of the museum's galleries, but the director agreed to make only one room available.[87] That, in any case, was a victory because the show would be the first abstract exhibition in an artistically conservative enclave for whom the Impressionists still embodied the cutting edge.[88] Lee had proven she had not lost the ability to organize. If her activist past had been forgotten by the Manhattan art crowd, in East Hampton she was celebrated. Said fellow Springs artist Josephine Little, "In the beginning there was Lee."[89] That year, the painter Lee Krasner would start her long climb back from obscurity. She may have reckoned that she could relinquish some of her responsibilities for Pollock to Betty Parsons and to Jackson himself. He was sober and calm and, now back in Springs, in the midst of his most productive painting season ever. Lee could not have anticipated how quickly that happy state would unravel.

25. Riot and Risk[1]

> It seems to me that the modern painter cannot express this age, the airplane, the atom bomb, the radio, in the old forms of the Renaissance or of any other past culture. Each age finds its own technique.
>
> —*Jackson Pollock*[2]

WHEN THE POLLOCKS returned home from their winter in the city they learned the devastating news that Jackson's doctor, Edwin Heller, had died that March in a car accident. They grieved his loss on two levels: because a good man had passed too young, and because he had been the only person on the planet who had been able to keep Jackson away from alcohol. Heller's calm intervention had changed their lives immeasurably for the better and Lee, especially, would have been apprehensive about what his death would mean for her husband. But at the start of that spring and summer, Jackson appeared strong.[3] It may have been that he hadn't noticed his loss as much because he was so eager to get back to painting after a long stretch outside the studio. He began pumping out not just paintings but masterpieces.[4] At that moment he seemed possessed by a drive greater than willful self-destruction.

For her part, Lee was riding high. Because Jackson's work had sold well at his last show they had money to make improvements to the house and enough remaining to live on without undue worry. That rare combination freed her to focus unencumbered on her art. Lee had completed her last Little Image painting, with its tight hieroglyphic notations, and had begun to expand those shapes in her new work. Rather than hundreds of tiny swirls and angles vying for space in a canvas as crowded as the night sky, she might represent only two large squares floating on a background of short, similarly hued brushstrokes. The result was subtle and serene. Lee seemed to be in a period of creative purification. She had even taken a cue from a show at Sam Kootz's that year and begun a series of black-and-white works.[5] There was a sense that she was trying to eliminate elements in her paintings she no longer thought necessary so that when inspiration struck she would be free to follow wherever it took her.

The start of the summer was thus blissfully about painting. What few interruptions did occur were social. Some were uncomplicated and brief—guests out for the weekend to escape the city's heat. There were also bizarre gatherings. Once, a bus loaded with art enthusiasts appeared in the driveway

on Fireplace Road as part of a field trip to Pollock's studio organized by a local art patron. (Lee cordially capped off the group's intrusive arrival with a cocktail party.)[6] Another visit, however, proved disruptive before, during, and long after it occurred. For the first time in seventeen years, Jackson, his three brothers, their mother, and all the various wives and children would be together. As with many family gatherings, the Pollock reunion didn't survive the day before hurt feelings and suppressed anger over past incidents surfaced. Jackson had had trouble sleeping in anticipation of the event. Both he and Lee were on edge. Each had something to prove to the Pollock clan: Jackson that he had made it as an artist, Lee that *she* had been the one to help him.[7] Emotions on the side of the arriving guests also ran high. Some believed that Jackson had not done enough to support his widowed mother and had never adequately thanked his brothers for their sacrifice and care during his difficult first years in New York.[8]

As car after car pulled up to the house on that Saturday in July, disgorging three generations of Pollocks, greetings were warm, the games that followed light and fun, the meal delicious. But throughout the day tensions rose as Jackson repeatedly described the fruits of his success in the form of money earned, articles written about him, and exhibitions in his name.[9] By evening, the tensions erupted into full-blown discord.

That day, Jackson and Lee had received an Italian review of the Pollock show organized by Peggy in Venice.[10] Only two words were comprehensible—Pollock and Picasso. Sitting alone, hunched over the article in the kitchen, Jackson obsessively tried to decipher the language. He dialed friends to find an Italian speaker. He and Lee repeatedly and with bizarre urgency asked Jackson's family if any of them read Italian, and then, ignoring their answers in the negative, returned to the piece to try to decode its meaning. His guests, annoyed by Jackson's and Lee's disregard, finally had enough. "Is Picasso more important than your family?" Jackson's sister-in-law Alma, who lived in their old Eighth Street apartment, demanded. Lee and Jackson responded with "outraged stares." Some family members, especially the women who had witnessed the drunken disorder of Jackson's youth, came away from the outing confirmed in their belief that he was and ever would be a self-centered bastard.[11] Unfortunately, that is how an artist often looks to their family. But in many cases, it isn't a matter of being self-centered but of being in a world apart. Jackson and Lee had lived in that world for so many years that they likely no longer remembered there was another in which art was not the center of the universe. If not art, then what? The question was to them unanswerable.

The same month that the Pollock family descended upon Springs, a happier occasion occurred nearby, a veritable storming of the Bastille in East

Hampton. Guild Hall, where the art of pastoral landscape had reigned supreme since its opening in 1931, and where tea-sipping patrons could rest assured that the untoward and the distasteful would never intrude, was the scene of the revolt. The exhibition that Lee had helped initiate, *Ten East Hampton Abstractionists,* had opened. It was the first completely abstract show in Guild Hall's history.[12] Since Lee and Jackson had moved to Springs five years earlier, a community of artists had grown up around them, but until the show at Guild Hall the group's work, for the most part, had been available to and acknowledged locally only by each other. The July show changed that. On the walls that usually featured paintings of potato fields or expansive skies over gentle seascapes, nonobjective works by the likes of Lee, Pollock, James Brooks, and Motherwell, among others, assaulted the senses of gallery-goers. The patrons of Guild Hall discovered that walking and working among them were some of the most advanced artists of their day. Since the *Life* article on Pollock, most Hamptons residents would have known that there was one outré painter in the vicinity. The Guild Hall show alerted them to the fact that there was a troupe of them, and they were proliferating. It was terrifying. It was invigorating. It was a lot to digest—but there was a history of artistic innovation on the South Fork of Long Island dating back to 1870. The New York School would eventually be accepted, even embraced, as its latest, albeit indecipherable, variant.[13]

The show's opening swelled with summer residents—fellow artists, writers, actors, and theater directors—and those nonartist citizens who lived in the area year-round. Among the temporary visitors at the event was a thirty-five-year-old German photographer named Hans Namuth.[14] He and his family had rented a house in the Hamptons that summer, and he was pleased to discover that an artist he very much wanted to meet lived and worked there.

> Pollock had a few paintings there. And he was present also. I took my courage in two hands and approached him and very timidly asked him if I could come to his studio some day and photograph it. I mentioned to him that I felt encouraged to ask him because of [photographer Alexey] Brodovitch, whom he knew. And immediately that broke the ice...Jackson said yes, and we made a date. I asked, "May I bring my camera and take some pictures?" And he said, "Sure."[15]
>
> He promised he would start a new painting for me, and, perhaps finish it while I was still around.[16]

Hans's photos of Jackson would become iconic images, perhaps *the* iconic images of the Abstract Expressionist era. They would also be the first of many portraits of those artists by a man who understood their work

because, in many ways, he had been buffeted on the other side of the ocean by the same historical storms that had influenced the artists in New York.

The path that led Namuth to New York had begun in Essen, Germany, in 1933, when he listened on a homemade radio to Hitler's election as chancellor. Hans was arrested not long afterward for anti-government political activities but freed due to the intervention of his father, a local Nazi Party leader. Immediately, eighteen-year-old Hans fled Germany for Paris with dreams of being a theater director. Instead, he landed a series of photo jobs that put him in Barcelona in 1936 at the start of the Spanish Civil War. He became a war photographer documenting the conflict the artists in New York cared about so deeply. The changing situation in Europe eventually forced him back to Paris. After the Germans invaded, and after being interned twice by the French, Hans went south to Marseilles and made his way to the States through Varian Fry's network.

Namuth arrived in New York in April 1941 amid the flood of refugee artists. But unlike those refugees, who were content to sit out the war in safety, Namuth said, "I wanted to combat the forces that had driven me out of Germany and Europe—Nazism, Hitler.... The only way for me to do that was to fight and to enter the war." He joined the U.S. Military Intelligence Service and was part of the D-Day invasion in France. He and his division worked their way through Europe, eventually arriving in Germany, where Namuth helped arrest wanted Nazis.[17] Back in New York in October 1945, Namuth's stated goal was to earn a "huge amount of money." Instead, he enrolled in courses at the New School with photographer and legendary *Harper's Bazaar* designer Alexey Brodovitch, who told him about the "importance" of Pollock.[18]

By the time Hans encountered him in July 1950, both Jackson and Lee had grown wary of journalists and photographers. It seemed that the non-art press in America—especially *Time* magazine, which was the "semi-official" organ of the right wing—couldn't resist mocking him and belittling his work. Writers who focused their articles on Jackson's and Lee's life together did so with the typeset equivalent of a snicker, portraying Jackson as a brush-wielding aw-shucks cowboy and Lee as the subservient little missus.[19] A *New Yorker* piece that summer was especially egregious in that regard. It described Lee as "the former Lee Krasner... bent over a hot stove, making currant jelly" who laughed "merrily" in answer to a question from her husband. The article conceded that Lee was "also" an artist but all references to her by the author and by Jackson merely glorified her domestic talents.[20]

In a letter to Grace, Elaine once wrote, "I really have come to the conclusion that the only way to avoid being misquoted is to remain silent—a

total impossibility for me."[21] That was a conclusion Pollock and Lee had also reached, but, as it was for Elaine, silence for them was impossible. Pollock's show in Venice had generated more interest in him at home, while expectations built for his next exhibition at Betty's. Amid all the chatter about performance, Lee was conscious that Jackson was vulnerable without Dr. Heller's counsel. Namuth, of course, didn't know any of that background when he arrived at Springs to take pictures of Jackson at work. He was stunned, therefore, when Jackson greeted him saying, "'Sorry, I've just finished the painting,' and that was that," Namuth recalled. "He had obviously changed his mind — or perhaps Lee, his wife, had decided against it. I was absolutely crestfallen and asked if I could go inside and photograph him with the new work. He agreed reluctantly."[22]

Jackson in his T-shirt and Lee in a housedress and bedroom slippers walked with Namuth to the barn. Inside on the floor was an enormous wet painting. That summer, Jackson was painting huge works — as large as eight feet high by seventeen feet wide. Excited by what he saw and disappointed at not being able to shoot Pollock in action, Hans was about to ask Jackson if he could come back again.

> Suddenly [Jackson] looked at the painting and started to correct something. Before I knew it he had a pot of paint in his hand and a brush and then he started to paint and he destroyed what he had made before and a brand new painting emerged.... In the meantime, I started taking pictures.... I shot roll after roll.... From that day on I was accepted. Especially after he saw what I had done, you know, a week or two later I brought him some of the pictures and that sealed our relationship.[23]

Lee, who had been perched on a stool in the studio while Hans photographed Pollock, later told Namuth "until that moment she had been the only person who ever watched him paint."[24] Hans had earned the trust of both because he did not speak, he merely recorded. His collaboration with Pollock would continue and deepen into November, during a period when the pressure on Jackson would become so great and so distressing that he could finally no longer hold himself together; when Lee's cherished freedom to work without undue care would vanish; when the world all around them descended into fear and paranoia and men again would don uniforms to die in distant lands.

Of the Spanish Civil War Namuth had said, "Like in other periods of history, the artists and the intellectuals sense more" the troubling events of their day.[25] By late summer and fall of 1950, the world felt nearly as bleak as it had in 1945, and the artists of New York responded with horror.

"There's a mass depression such as I have never witnessed," wrote Judith Malina, who frequented the Club, in her diary that August. "Everyone says, 'I can't stand reading the newspapers.' 'I dare not listen to the radio.' "[26] The news was pure madness: domestic arrests and inquisitions, and discussions among supposedly sane men concerning which capital would make the best target for an atomic strike. On 42nd Street outside a theater a man turned to a woman and asked, "Do you think there will be a war?" "There *is* a war," she responded. It was once again a time of "mourners and...murderers."[27]

Nineteen fifty had begun inauspiciously with a decision by President Truman to proceed with the development of a hydrogen bomb. The perceived necessity to take that step had increased in urgency after the Soviets successfully tested their own atomic device.[28] In January, a British scientist named Klaus Fuchs, who had worked in the United States at Los Alamos and who had had access to the most sensitive aspects of the American nuclear program, confessed that he had passed secrets about atomic weaponry to Moscow. The president's advisers told Truman that it was only a matter of time, therefore, before the Soviets built not just an A-bomb but an H-bomb. As news spread about the monstrous new weapon, experts speculated that it would make the bomb that hit Hiroshima seem like buckshot. A hydrogen weapon would kill people by the millions. For Washington bureaucrats, however, it wasn't a question of death toll but of who would obtain that unholy capacity to annihilate first.[29]

Amid the increased nuclear threat and revelations of spying by Fuchs, the investigation into alleged espionage on the part of the ex–State Department employee Alger Hiss had finally resulted in a conviction in January. The crime was not that he was a communist spy but that he had lied to Congress. The Hiss case handed the Republicans a win and whetted their appetite for more. Communism was their stated adversary, but many believed their true enemies were Roosevelt's New Deal legacy, their Democratic opponents, East Coast intellectuals, and American-style liberalism.[30] On February 5, 1950, less than a week after the Fuchs spy story broke, and fresh from the Hiss conviction, Senator Joe McCarthy addressed the Republican women's club in Wheeling, West Virginia, launching one of the darkest chapters in modern U.S. history.[31] "I have here in my hand a list of 205 [State Department employees] that were known to the Secretary of State as being members of the Communist Party and who nevertheless are still working and shaping the policy of the State Department," he declared.[32] Within six days, however, McCarthy's list of hundreds had dwindled to fifty-seven, and then the list disappeared altogether. He said he had misplaced it while drunk in Nevada. When asked by the incredulous press whether the list had ever really existed,

McCarthy snarled, "Listen, you bastards, I'm not going to tell you anything. I just want you to know I've got a pailful of shit, and I'm going to use it where it does me most good."[33] The McCarthy era was born.

No matter that the man who launched four years of domestic intimidation and terror was a drunk and a liar, McCarthy's fearmongering was accepted as fact, his wild allegations front-page news. Soon, he became head of a Senate committee charged with investigating the "Red Menace," which the U.S. attorney general shrilly declared in April had infiltrated all aspects of American life "in factories, offices, butcher shops, on street corners, in private business—and each carries in himself the germs of death for society."[34] Those words gave McCarthy and his cohorts carte blanche to go after alleged communists anywhere, anytime, anyhow. Indeed, any*one* deemed out of the ordinary, any activity that deviated from conservative, white, middle-American values, could trigger an investigation.[35] Such activity might be political, but it could just as easily be aesthetic ("communist art" was a pox on the land), moral (homosexuals were a favorite target of the "red" witch hunts), or social (said one historian, "The feminine mystique [of the domestic goddess] was the gendered form of McCarthyism").[36]

Fear was the order of the day in America: Fear of war, fear of the bomb, fear of one's neighbor, fear of false accusation and arrest—fear, finally, of oneself. The social conformity championed in the late forties became, in 1950, a veritable straitjacket. "At the height of the paranoia of the McCarthy era, the New School was searching for somebody to teach a course on Marxism," painter Pat Passlof said. "Harold [Rosenberg] was the only one brave enough to take it on. Three students attended: Elaine de Kooning, and two FBI agents."[37]

There were more pronounced acts of civil disobedience in New York than Elaine and Harold's academic defiance. But come June 26, domestic concerns were eclipsed by Truman's announcement that the United States was obliged to come to the aid of South Korea, which was under attack by Communist forces from the north. Events from that point moved quickly. On June 28, the South Korean capital Seoul fell. On June 30, avoiding the loaded word "war," Truman announced that U.S. forces would join a "police action" to free it. Whatever its name, the campaign was costly. By August, during what one historian called "one of the worst periods in American military history," six thousand Americans and about fifty-eight thousand North Koreans had died.[38] Posters appeared on Village lampposts, in the subway, and on mailboxes, reading "Answer War Gandhi's Way," "War Is Hell: Resist It."[39] But for the majority of Americans, judging from the elections that autumn, which swept a large number of Red-baiting candidates to power, communism had to be defeated, and many

felt it was better that the battle happen in Asia than at home.[40] In July and August a reminder of alleged domestic treachery had again made the news. A Lower East Side couple, Julius and Ethel Rosenberg, were arrested and charged with conspiracy to commit espionage. They were accused of being party to the plot to give the Soviets U.S. nuclear secrets. Writers and artists were appalled at their detention.[41]

No one was immune to the depressing news and oppressive atmosphere in the United States that year. Even in Springs, Lee and Pollock were under siege. Henry Luce's right-wing magazine *Time* appeared to have adopted a policy of deliberately distorting news about Jackson's work. In late August, it ran a piece saying, "U.S. painting did not seem to be making much of a hit abroad last week. At Venice's 'Biennale,' the U.S. pavilion (featuring the wild and woolly abstractions of Arshile Gorky and Jackson Pollock) was getting the silent treatment from the critics." *ArtNews* reported on the contrary that "the Italian press have been vociferous in their opinions—some good, some nasty." The *New York Times* also begged to differ with *Time,* saying that Pollock in particular was generating notice and controversy.[42] But the *Time* article grated because it appeared in a widely read, national publication, because it was part of an ongoing attack on modern art, and also perhaps because of its timing. With Jackson's next show at Betty's gallery scheduled for late November, he and Lee were both extremely anxious. Their livelihood depended upon its success, and in the climate of panic that prevailed at that moment, collectors and institutions might be reluctant to be seen embracing, let alone buying, politically suspect art that had failed to impress a critical audience in Europe.

Hans Namuth and his camera appeared a welcome relief, almost akin to therapy. "I knew how not to abuse his time and I didn't intrude too much," Namuth said. "I just worked so that I was not a nuisance. Actually, we both looked forward to our sessions as it happened."[43] In late August or early September, Namuth expressed frustration that he was not able, despite having taken nearly two hundred photographs, to adequately capture the magnificent ballet that was Pollock painting. "To make a film was the next logical step," he said.[44] It was, in fact, a project that would be much truer to Jackson's art, which was primarily about action. It would also, like Elaine's articles in *ArtNews,* introduce the reader to the all-important process. A first attempt at a black-and-white film, however, didn't do either the photographer or Jackson justice. "My aim was to show, if possible, the man not just in the act of painting, but what's happening inside, what takes place in his face. How could I show that?" Namuth asked himself. "One sleepless night I suddenly hit on the idea of showing him through glass. And when I suggested this idea to him he jumped on it.

He said it was a great idea." Jackson got to work building a structure on which to rest a sheet of glass that he would use in lieu of canvas.[45] The light in the barn wasn't adequate and so they had to shoot the film—which would be in color—outdoors.[46]

The pair worked on the project over many weekends, at a time when Jackson was finishing the paintings for his upcoming show and as the temperature began to dip. Again and again, Namuth's camera hummed and Pollock went into action, only to be told to stop, then start, then stop. In the process, Jackson said he "lost contact" with one glass painting and wiped the pane clean.[47] He began another under those restrained and inhibiting circumstances with Namuth lying on the ground, filming up through the pane of paint, recording Jackson's movements and facial expressions as he created. The process was grueling. Pollock told his neighbor Jeffrey Potter that he only continued because Lee pestered him to do so. "A camera whirring away is easy compared to that," Jackson grumbled.[48]

Toward the end of November, *Time* struck again. An article entitled "Chaos, Damn It!" appeared after the Venice opening of Jackson's work from Peggy's collection.[49] *Time* augmented its own "reporting" with grossly distorted translated excerpts from the Italian article that Lee and Jackson had obsessed over during the Pollock family reunion in July. That *L'Arte Moderna* article was written by a twenty-three-year-old bookshop owner and critic named Bruno Alfieri, who had ably and sensitively grasped Pollock's paintings and placed him "at the extreme apex of the most advanced and unprejudiced avant-garde of modern art."[50] Alfieri declared,

> Compared to Pollock, Picasso, poor Pablo Picasso, the little gentleman who, since a few decades, troubles the sleep of his colleagues with the everlasting nightmare of his destructive undertakings, becomes a quiet conformist, a painter of the past.[51]

In *Time*'s editorial hands, Alfieri's article was butchered, with only snippets of sentences that could be construed as negative quoted. The magazine also implied that Pollock had been in Venice and Milan for the show, hobnobbing with European glitterati (thus proving he was not the workingman artist young painters revered).[52] The response from Jackson and Lee to *Time*'s latest outrage was ferocious. Life as an artist was difficult enough in America without also having to confront a concerted campaign of abuse. "What they want is to stop modern art," Pollock told Potter. "It isn't just me they're after, but taking me as a symbol sure works. And taking myself, I'll let you in on something: Maybe that sheet of glass

is unbreakable...but I'm not." Lee and Jackson covered the kitchen table with drafts of a response,[53] which they eventually composed and sent as a telegram to *Time:*

> NO CHAOS DAMN IT. DAMNED BUSY PAINTING AS YOU CAN SEE BY MY SHOW COMING UP NOV. 28. I'VE NEVER BEEN TO EUROPE, THINK YOU LEFT OUT MOST EXCITING PART OF MR. ALFIERI'S PIECE.[54]

Three days after that *Time* article was published, and a day before Thanksgiving, Pollock and James Brooks took the train into Manhattan, where a *Life* photographer had assembled fifteen of the artists who had signed the protest letter against the Metropolitan Museum earlier that year.[55] So soon after the *Time* slight, Jackson would have been ready to be part of any protest in opposition to the powers arrayed against avant-garde art. Lee would have been eager to join such a protest, too, but because she hadn't signed the original letter to the Met, she wasn't invited to be in the photograph. Only one woman was, Hedda Sterne, and she called the experience "in terms of career...probably the worst thing that happened to me." Hedda said her fellow male painters "were very furious that I was in it because they all were sufficiently macho to think that the presence of a woman took away from the seriousness of it all." Hedda had been showing her work since she arrived in New York as a refugee from Romania in 1941.[56] That was not sufficient experience, however, for her colleagues. It seemed there was more than enough prejudice—on all sides of the canvas—to make each artist's life a trial.

Somewhat miraculously, Pollock managed to remain sober during that long and emotionally difficult late summer and fall. But in the final days before his show was scheduled to open on November 28 his nerves frayed. At one point, he called Lee in to look at his more than seven-foot-by-nine-foot masterpiece *Lavender Mist* and asked, "Is this a painting?" "Can you imagine," Lee recalled years later. "Not 'Is it a *good* painting,' but 'Is it a painting?'"[57] After so many months in his studio and so much clamoring confusion, Pollock couldn't see his own work anymore. Clem had come out to look at the pieces Jackson had selected for the gallery and predicted that the show would be Jackson's best. But he added, "I didn't think it was going to sell. He didn't want to hear that."[58]

The final day of shooting for Namuth's film began the Saturday after Thanksgiving, three days before Pollock's Parsons show was to open. Lee had planned a dinner party that night to celebrate.[59] She had been supportive of Hans's project, but she could not have anticipated how taxing it

would be for Jackson. The demands of filmmaking were antithetical to Pollock's style of painting. The former was staccato, the latter fluid; filming involved restraint, painting release; the filmmaker directed the action, Pollock was only happy when free. It was a testament to Namuth's and Pollock's relationship that they had been able to work together under such stressful conditions for so long. But that work was over. Pollock couldn't take any more. He felt empty, absolutely depleted. "Maybe those natives who figure they're being robbed of their souls by having their images taken have something," he said.[60]

Lee had help from Ted Dragon preparing the meal. He and Ossorio had rented a house in the area. At twenty-six, he was much younger than the rest of the Hamptons crowd and, as the relatively impoverished lover of a powerful and wealthy man, he felt doubly ostracized. When he and Lee had first met the previous year, they became friends instantly. "We were from two different worlds, but somehow we just clicked. Part of it was that we were both hitched to the stars in the family," Ted said. The summer of 1950, Dragon's friendship with Lee grew. "We were both lonely. Those macho artists weren't interested in me very much, you know, but Lee showed me around town and introduced me to people. Lee really cared."[61] The group coming to dinner that night included Ted and Ossorio; Hans and his wife, Carmen; John Little; the architect Peter Blake; their neighbors Penny and Jeffrey Potter; and Betsy and Wilfrid Zogbaum. "Everybody was sick of turkey, so I went to the supermarket and bought a large roast beef, and Lee and I cooked up a feast," Ted said.[62]

The warmth of the house, which by 1950 had heat *and* hot water, and the smell from the kitchen were enveloping in their comfort. The windows steamed over as the temperature outside dropped and the wind began to howl. A storm had moved in that would sweep across the island and into Manhattan, blowing streetlights from their posts and carpeting the pavement with shards from broken windows.[63] The evening began as an uncomplicated gathering of friends who shared love of place and love of art, who were pioneers in that outpost away from the city. Outside, it was already dark when Jackson and Hans shot their final take of Pollock's glass painting. "It was a bloody cold day," recalled Peter Blake. "I was near the dining table...all set full of stuff by Lee. Hans and Jackson came in literally blue—you know, frozen." He watched Jackson enter the back door, walk across the room to the kitchen sink, reach down, and pull out a bottle of whiskey. "He filled two water glasses and said to Hans...'This is the first drink I've had in two years. Dammit, we need it!'"[64]

Lee was also in the kitchen. The color drained from her face as she watched Pollock down a glass of poison. She had done everything she could for him (Ted said her love for Jackson was "like a madness").[65] She had

cared for him and fought for him, but she could not fight against him. With that drink she knew she had lost. "The look on Lee's face. *God*," Ted remembered.

> So I whispered, "Why are you so upset? It's only one drink." She was furious with me. She gave me *some* look. "You don't know what you're talking about!" she snapped. In the year and a half we had known Jackson, we'd never seen him take a drink. But thinking back on it, he wasn't really sober that whole time either. He was on the edge of the trigger. He was what alcoholics called "dry"—he wasn't drinking, but all of his inner demons were waiting to come out, a walking time bomb.[66]

Potter recalled that Jackson had another drink, and then he grabbed a heavy strap of sleigh bells the Potters had given the Pollocks and swung them at Namuth's head. Potter said,

> Hans ordered him to put them down, but his wife, Carmen, told him to leave Jackson alone. There was tension in the air, which Lee broke by saying we should sit down for dinner. Jackson dropped the bells on the floor and... dropped in the chair. As we sorted ourselves out, Lee's seating arrangement was ignored and Hans ended up on Jackson's right.[67]

No doubt Lee hoped Jackson would act up and pass out so she and their guests could proceed undisturbed with dinner. But then again, Jackson hadn't been drunk for so long that she had no way of predicting the course of events. "Lee was at the far end and we worked hard at pretending nothing was going on with our host, now glowering at Hans," Potter said. "Then an argument in low tones between Hans and Jackson began.... It was clear a process over which we had no control had begun." The last word anyone heard in their dispute was the word "phony" before Jackson stood up and said, "*Now?*" while holding his hands under the table and looking at Hans. "Hans started to rise," Potter said, "but, on Jackson's stiffening, thought better of it and came out with a drill sergeant's command, 'Jackson—no!'" Jackson asked more loudly, "*Now?*" to which Namuth shouted with his German accent, "Jackson—this you must not do!" Jackson replied again with the same, ever more threatening question, "*Now?*"

"At the same time he heaved the table upward," Potter said.

For an instant, there was danger it might be upended on top of Lee, but Jackson didn't get it beyond a forty-five-degree angle before it tipped to his left and rolled over. When a plate on the floor finally stopped spinning, the silence was complete. It was broken by tension-released laughter I recognized as

mine; I had gone over backward under the avalanche of food and wine. I lay helpless in the gravy, laughing, as Jackson crunched through the broken glasses and china on his way to the back door. He slammed it behind him, we picked ourselves up, and Lee announced that coffee would be served in the front room.[68]

Lee was "heartbroken," Ted said. "We never saw him sober again. Never. He was a completely different person after that."[69]

Years later, Kirk Varnadoe, the Museum of Modern Art's chief curator, would call that day in November a "moment of poignant high tragedy. On the eve of the greatest exhibition of his life, after a season of spectacular achievement, a self-destructive act sends the artist off the edge of a spiritual sinkhole from which he will, in essence, never reemerge."[70] But Lee did reemerge. She was made of infinitely tougher stuff than Jackson, and she would survive. In time, she would even thrive.

Helen

26. The Deep End of Wonder

> Creating a great painter is not only a question of being a great painter—it is a thing that is achieved by a number of factors working together for that end—Practically a miracle when it happens.
>
> —*Janice Biala*[1]

HELEN FRANKENTHALER WALKED out of the elevator with Clem Greenberg and into the Betty Parsons Gallery to see Jackson's November exhibition. "Now you're on your own," Clem said, before heading back to Betty's office. "Look around the show and tell me what you think of it."[2] He left Helen in the midst of Pollock's paintings, whole walls of explosions in color and line, vast depths of beckoning space, "the endless webbing"[3] of what one visitor likened to a meteor shower.[4] Helen felt as though she had been "blinded, as if he had put me in the center ring of Madison Square Garden.... It was so new, and so appealing, and so puzzling, and powerful, and real, and beautiful, and bewildering."[5] One or two other people wandered through the gallery, but they were invisible to Helen, surrounded as she was by works so alive it was as if the dance Pollock had performed to create them continued still.[6] "I was overwhelmed. His work simply seemed to resonate. It captured my eye and my whole psychic metabolism at a crucial moment in my life," she said. "I was ready for what his paintings gave me."[7]

At twenty-one and a year out of Bennington, Helen had been searching for a way to release the gift she knew existed inside her. She believed she was capable of something big, something grand, something utterly original. Something *like Pollock*. It wasn't necessarily *what* he had done on canvas that inspired her that day but the fact that he had done it, that he had created something so new, his own universe, and that meant she could, too. "He opened the way for me and freed me to make my own mark," she said decades later, still remembering the exhilaration she experienced that day.[8] "I mean, I wanted to live in this land, and I *had* to live there, but I just didn't know the language."[9] Part revelation, part provocation, Helen called her initial encounter with Jackson's work "a beautiful trauma" that set her on a path of technical innovation and bold creation that would inspire others as he had inspired her.[10] Within a few years, her work would be seen as a bridge between Pollock and what was possible in his aftermath.[11] Helen

would, in other words, represent the future. It was a dangerous and demanding position; Pollock himself bore the scars of life on the artistic frontier. And yet it was a role for which Helen had been groomed and which, without a trace of braggadocio, she believed to be her destiny.[12]

In recalling early memories, many people mention a pet, or a person, or even a place. Helen remembered a line. As a child in New York, she played in Central Park behind the Metropolitan Museum. One day, armed with sticks of chalk, she made a mark on the sidewalk behind the statue of Adonis and, stooping all the way with her nurse walking haltingly beside her, drew one continuous line from 82nd Street and Fifth Avenue, across streets, up curbs, and past apartment buildings where doormen watched in amused disbelief as a tiny creature bent at the waist trailed a single thread of color until she arrived at the canopy of her family's building at 74th and Park. "It's a story of determination really more than drawing," Helen recalled.[13] It was a precocious act of willfulness that contributed to the label Helen wore among her family: "special." Her birth on December 12, 1928, had been announced with a headline in the *New York Times*.[14]

The youngest of three daughters, Helen was raised in the rarefied climate befitting the family of a New York State Supreme Court judge. "She came from a German-Jewish upwardly mobile bourgeois family," said her nephew, Fred Iseman. "Her parents had a box at the opera. Her father was a judge, a successful lawyer. [Her mother] Martha was glamorous, a beautiful woman.... They lived in influential circles.... He knew everybody in politics in New York, and they would come by the house."[15] The children were so accepting of the family's social standing that on St. Patrick's Day, when they trundled into the section reserved for the mayor during the city's annual parade, they thought the event was in honor of their mother, whose birthday was March 17.[16] For the Frankenthaler children, life was lived on the grand stage their parents had erected and enlivened by the romance that existed between them. "It was a marvelous marriage," Helen recalled from the perspective of her own adulthood.[17]

Helen's parents had met during World War I, when Martha Lowenstein, a German immigrant who had arrived in the States via Ellis Island, was discovered selling Liberty Bonds on the steps of the New York Public Library by one of Alfred Frankenthaler's friends. He hired her and subsequently introduced her to Alfred.[18] More than six feet tall with thick dark hair, she was majestic, strong, handsome, intelligent, and wild. "She was sensational, really a sort of Valkyrien, lively, youthful, earthy peasant with class," Helen said. "In a way very vulgar and in another way [she had] very great taste."[19] Martha also painted abstract watercolors the size of post-

cards.[20] She was beauty, sensuality, and art.[21] What *he* was, Alfred, was a powerful lawyer and workaholic who, during the Depression era of Helen's youth, spent his days helping to rescue the many people whose savings were in jeopardy. Judge Frankenthaler felt the weight of his duties heavily. He considered all of New York City his responsibility—block by block, bankruptcy case by bankruptcy case. When he went to the opera, he would retire to a restaurant to read if the performance had an unhappy ending. "He had unhappy endings in court all day," Fred said. "They would meet after the curtain at Sherry's."[22] In general, he didn't want to be apprised of anything negative outside his working hours. Even at home, he chose to enjoy his daughters rather than discipline them.[23]

Alfred's many eccentricities were accepted as by-products of his brilliance. Germophobic, he washed his hands constantly, was petrified of dogs, and cared not at all about his appearance. "In family lore there is a story that my grandfather fell on the icy steps of the State Supreme Court one winter day while wearing his judicial robes and people passed him by, not helping him, mistaking him for a bum," said Helen's nephew, artist Clifford Ross.[24] He was a classic eccentric intellectual, and Helen adored him. As an adult, Helen would gravitate toward men like Alfred and in some ways, she would herself become like him. "His own eccentric behavior likely sanctioned Helen's ability and willingness to follow her own path, different from the norm," Clifford said.

> One of the things that was handed down was an impulse to live life according to one's own rules—which I know is a bit strange coming from a sitting judge. Whether it was social behavior or an attitude to her chosen profession, Helen got the message that it was fine to be different—an attitude she deployed to make breakthrough art.... Helen was born into an environment where there was respect for the rules as well as encouragement to reinterpret them for herself.[25]

Helen, who was five and a half years younger than her next oldest sister, became a pet project for Alfred. She once overheard him say to her mother, "Watch that child, she is fantastic."[26] When she was nine (at the height of the Depression), Helen won an honorable mention in a drawing contest at Saks, for which her father rewarded her with a trip to Tiffany's and a gold charm in the shape of an artist's palette.[27] At ten, he took her to Atlantic City to buy a *real* palette.[28] Anything Helen did creatively was saved in manuscript form or framed and heralded by her parents, especially Alfred.[29] "Helen was the favored child, she was encouraged, and I have no doubt that having parents who confirmed her specialness helped her inner strength

and resolve," Clifford said.[30] But to Helen's mind, the attention was at times confusing. "I was a special child, and I felt myself to be," she said.

> All my infancy and childhood, my parents treated me this way, I had the genes...intelligence...talent...the "gift." Who knows what it is, really? But it was a positive thing. The condition was my destiny.
> On the other hand...the child is alone, isolated. The child cannot know, at first, that the gift is *creative within*. So there was this constant state of potential crisis, of excitement, of things driving toward perfection, of impatience with the obvious, easy solutions....
> But the truth is, you are different.[31]

In 1939, as the world descended into chaos, with Spain falling to Franco, Hitler driving his tanks into Poland, and France and Britain declaring war on Germany, Alfred had begun to sense that he was ill. He thought he had cancer but would not see a doctor; so many people depended upon him in those darkening days as the economic crisis looked ready to grow into an even larger one, global war.[32] For a time, he worked despite his illness. But by the fall he was bedridden, and the Frankenthaler apartment became a place of whispers. On December 12, when Helen turned eleven, her father lay dying. The man who had embodied joy to her, who had in a sense created a character named Helen Frankenthaler, a child so exceptional she did not have the capacity to disappoint, was not able to help her celebrate. His life had been reduced to a single element: pain.

The Jewish holidays and Christmas passed without anything resembling the usual festivities. The strong Frankenthaler women now existed in a state of vulnerability. It was Alfred who had placed them in society—they were Judge Frankenthaler and his family. Without him, who were they? Especially Martha. She would no longer be half of one of the most prominent couples in New York. She would be a widowed Jewish mother in a world being destroyed by a fascist whose message had begun to resonate in her adopted home. A smattering of bigoted American voices had swelled into a chorus that boldly stated that Jews themselves were to blame.

It was at that terrifying moment that they lost him. On January 7, 1940, at age fifty-eight, Alfred died.[33] Helen's glorious childhood ended abruptly. She would never be the same.

"Financially," said Fred Iseman, "they coped. There were two Irish trustees of my grandfather's estate who put them in railway stocks and other investments that did very well for them."[34] Socially, Martha took steps to ensure that her daughters remained well placed in their milieu. Her eldest, Marjorie, was headed to Vassar, and middle daughter Gloria was still in

high school but leaving soon for Mount Holyoke.[35] And then there was Helen. She was in elementary school and, unbeknown to her mother, on the verge of collapse.

"After he died I was very depressed, but of course a child of eleven doesn't know she's depressed," Helen explained.[36] Describing herself as "really a wreck," she had begun to have migraines but didn't know what they were.[37] "The war had just started," she said,[38] and she was at home with her mother amid "coupons and meat rationing and gas rationing, air raid drills in the middle of the night and terrible loneliness and terrible fear."[39] Years later, Helen said it was still painful to revisit those times. Even as an adult she was reminded of them when she looked at the early morning light with a "feeling that the war is on" and thought with dread as she had then, "ahead lies the day."[40] As a child, Helen was in pain emotionally and physically, "and yet I was still carrying on as if none of this had happened—going to school and going to birthday parties and having my teeth straightened."[41] Fearing her mother's reaction, she hid her suffering.[42]

Things grew worse for Helen when she transferred to a new school, Brearley, which her mother had chosen because it was *the* society school at that time. Brearley had a quota on the number of Jewish students it would accept, and those few who were admitted, according to Helen, were "a couple of rungs" higher on the social ladder than even the Frankenthalers. Among that crowd, Helen failed miserably.[43] "I was all over the place, I wanted to do everything, I was not listening," Helen explained. "To this day I have trouble listening. I am in my own head and going faster than my head."[44] Her migraines worsening, she began to think she had a brain tumor. In class, Helen spent hours testing her side vision, and when she discovered floaters, she believed her worst fears were confirmed: she was dying.[45] And in a way, she was. Helen was suffocating. When the school year ended, she had failed. She was put back a grade, and failed again. At times, she was so incapacitated she couldn't speak or even see. In retrospect, she suspected she had had a breakdown. A doctor diagnosed her as merely "high-strung." Brearley wouldn't allow Helen to return unless she attended a summer French camp. She did so but failed there, too. In pain and ignominy, she was sent home to an apartment that had once been full of family life but now bustled only with uniformed staff.[46]

It seems hard to imagine that Martha was not greatly concerned about her youngest daughter, but at that time Martha had other things on her mind. Her uncle and two cousins had been trying to leave Germany since 1939. By 1942, the roundups in their town of Giessen had intensified. It was clear that the doors out of Germany for Jews were closing fast. In September of that year, with no longer any hope of escaping deportation to Poland, Martha's two cousins drowned themselves and their father took an

overdose of sleeping pills. They were among the last of the Jews in Giessen. By the end of that month, all the rest had been sent to extermination camps.[47] "It's a terrible story of our family trying to rescue relatives and sending money," explained Helen's nephew Fred. "They were the ones they were trying to save, Martha's first cousins, I believe."[48] Compared with those grave concerns, Helen's ongoing saga may not have registered with Martha. It is also unclear to what extent Helen was aware of the cause that preoccupied her mother, though it is unlikely she was entirely in the dark. The household was small, the situation in which it was embroiled dire, and Helen was on an emotional knife edge. "We weren't bombed, but personally I was bombed," Helen said of those years, before adding in words used by many survivors, "Out of those times come both the scars and the strengths."[49]

Toward the end of the war, in 1944, Helen's mother finally recognized her daughter's profound unhappiness and enrolled her in yet another school, the progressive Dalton. Helen said it saved her life.[50] Lavished with the encouragement she had lacked since her father's death, her battered self-esteem began to be restored in part through the intercession of a teacher, the Mexican muralist Rufino Tamayo. Helen called Tamayo the "first real artist" she had ever met.[51] Importantly for Helen at that crucial moment, the forty-five-year-old painter treated his fifteen-year-old charge with respect, sincerity, and—most essential to Helen—humor. They developed a "real relationship," during the course of which Helen began to understand what it meant to be an artist, the seriousness of it, the attitude an artist needed to have toward his or her work. And of course, Tamayo helped her through the initial technical problems of learning to paint. Having no medium of her own, Helen adopted his: "A third turpentine, a third linseed oil, a third varnish," and began producing "Tamayos." Tamayo also encouraged her to work big.[52] Equipped with those tools, Helen took off, intellectually and creatively. For the first time, she began to consider being an artist—either a painter *or* a writer. "Writing was just as important. I valued the written word, the book, the conversation, the making up of stories," she said. "I would get lost in the worlds of words and paint in every conceivable way. After adolescence, I knew that I had something I wanted to investigate and never stop doing."[53]

Dalton had ignored Helen's failing record from Brearley and accepted her as a senior.[54] That meant she would graduate at sixteen and face the prospect of yet another school. Having no intention of going to a conservative women's college, she set her sights on Bennington in Vermont.[55] The most progressive (and expensive) women's school in the United States, it had a roster of instructors from the highest ranks of international intellectual circles.[56] That was a territory into which Helen had already begun to

venture. At fifteen she liked to sneak off to the New School in the Village to listen to poets, "which was somewhat unusual for a fifteen-year-old Park Avenue Jewish girl," she recalled. Torn between those two worlds— bohemia and the Upper East Side (which she called the "country club"), gradually, Helen recognized that bohemia "was very much more my thing. Bohemia was where I lived and had fun and the rest was where I belonged with my family." Bennington, therefore, was a perfect fit. Its students had a reputation for doing "wild things," she said. "They write things you can't understand, they paint things you can't [understand]." But the prospect of that school terrified her mother. "If it involved her losing face in her social setting she might deliver an hysterical monologue," Helen said. "Somebody might think I was sleeping with somebody, or hated my family, or went with communists."[57] Eventually, Martha relented. "If she wanted face-saving she'd say with great pride, 'My Bennington girl,'" Helen said, "because she already had a Vassar and Mount Holyoke girl."[58]

Helen often spoke of herself in those days as a "girl," but she was very much in that confusing period of becoming a woman. Between 1940 and 1945 she had experienced traumas that destroyed her childhood innocence, and yet despite these scars, she had not emerged bitter or cynical. Her art, too, would be largely free of overt darkness. Helen, like her father, didn't dwell publicly on the disagreeable. She had learned as a child to hide even her deepest pain, and as an adult and as an artist she would continue to do so. "I'm always surprised when people say you must have been in a very happy mood when you painted that. Sometimes they're right, sometimes they're dead wrong," she explained. "Often when I'm my angriest, I'm my funniest."[59] It could be, as her nephew Clifford suggested, that Helen's early years before her father's death were so grounded that even the devastating loss and emotional tempests she experienced after his passing only temporarily derailed her.[60] Once restored, Helen was both stronger and *lighter*. And, most importantly, she was no longer afraid.

Helen was accepted at Bennington in 1945, but because she was only sixteen she couldn't enroll until 1946, and so she spent the fall studying with Tamayo on her own and looking with ever more sophisticated eyes at paintings in galleries and museums.[61] She learned her lessons well, so well that by the time she arrived in Vermont for the 1946 winter term her art teacher, Paul Feeley, "recognized something she had," according to her classmate Nancy Lewis.[62] It was one year after the end of the war, and thirty-six-year-old Feeley was just out of the marines.[63] He was in every way someone Helen would have considered dishy. "He was extremely intelligent, well read, knew literature, politics, the fighting world," Helen said, "was a husband, father, very complex, drank like a fish, was a real

narcissist, very handsome, very giving, very humorous."[64] Feeley became Helen's next important guide into both modern art and her own expression. He also became a lifelong friend.

Feeley's classes were small—only ten or twelve students.[65] In them he taught not only technique but how to analyze a painting. "We would really sift every inch of what it was that worked; or if it didn't, why," Helen explained.[66] He also introduced his students to a wide range of art history, the full menu of artistic tradition from which they could draw to develop themselves. Helen's own visual vocabulary expanded accordingly. Said Nancy Lewis, "Helen started turning out great stuff."[67] It was a matter of talent but also a willingness to commit to the hard work and intense focus required of an artist.[68] Feeley, like the other professors at the school, encouraged his students to go their own way, to think for themselves, and above all, as artists, to look.[69] After all that individual searching, there would be an all-important exchange of ideas in which each related what they had discovered. "Everything that went on within that community was shared experience," Lewis recalled.[70]

In that environment, Helen could be herself, which was not always the case at home. "While I conformed to the protocol and fine, upper-bourgeois manners and proper window dressings of the social environment and schooling in which I was raised, I was also a renegade and a maverick, and capable of great humor," she said.[71] One aspect of her rebellion that Helen rarely described was how being a woman made it more difficult still. In the world the Frankenthalers inhabited, a girl or a woman declaring that she wanted to be an artist was worse than her saying she was going on the stage. Art for a woman was encouraged as a hobby, but to *be an artist,* with the loose morals and mixed society that life implied, was not done. Which was another reason Helen found it so attractive. "She always referred derogatorily to 'the shoulds,'" said Fred. "I quote her often, 'You *should* marry this person, you *should* do that.' I hear Helen's voice describing the 'shoulds.'" Yet what she joyfully advocated was their opposite.[72] At Bennington, Helen was surrounded by equally rebellious young women who exchanged social acceptability for self-realization and adults who encouraged them along that bold path.

Helen and a group of friends started a newspaper—Helen was named editor—to raise discussion about college concerns above the level of gossip, and to allow students to read about political and cultural events occurring nationally. From the first issue in April 1947 the tone was politically left. *The Beacon* criticized President Truman's support for an "extreme right-wing unrepresentative and undemocratic government in Greece," and in 1948 the newspaper ran a front-page piece supporting the leftist

third-party presidential candidate, Henry Wallace.[73] The newspaper, however, formed only a small part of Helen's busy campus life.

She waited tables in the faculty lounge, where she served the poet W. H. Auden ("He ate cold cereal at every meal," she said).[74] She played poker "a couple of times" at the home of author Shirley Jackson and her literary critic husband, Stanley Edgar Hyman[75] (who in 1949 became the first person to buy a Frankenthaler painting).[76] It was during a game of poker there that she met thirty-four-year-old Ralph Ellison, who was writing his seminal book on the alienation of black men in America, *Invisible Man*. He and Helen became friends.[77] Helen studied with the poet Stanley Kunitz; the psychologist, philosopher, and Marxist Erich Fromm; and the literary theorist Kenneth Burke, whom she credited with changing her life by introducing her to the meaning of symbols in art and language.[78] Helen matured emotionally, intellectually, and artistically. When, during a winter term she took a job writing for *MKR's art outlook* in New York,[79] she cogently took on the Chrysler Corporation for organizing a show of artists that she said represented a "step—backward—for art." . . .

> These twentieth-century Medicis appear to have smothered potential artistic expression by limiting the painting field to one subject: Significant War Scenes. For this reason, the paintings exhibited at Chrysler's International Salon have merely a literary quality. . . .
>
> Because all emphasis has been placed on the story-telling angle, the artists have neglected color and composition. However, if the purpose of the show is to report battlefront horror—and to disregard "art"—then by all means, the show is successful. . . .
>
> It's too bad this had to happen. The Chrysler Corporation might have done active good by furthering the painting careers of young veterans. Instead, it has wound up with a memorial—a monument—to World War II.[80]

The critic, Helen Frankenthaler, was eighteen.

Helen's assuredness was partly the result of class and wealth, but more particularly in her case the fact that she knew who she was. She was Alfred Frankenthaler's "fantastic" child. If Grace lacked a guilt chip, Helen lacked a self-doubt chip. She had enormous confidence; astonishingly for an artist, even with regard to her work. She was also competitive to the marrow, and audacious.[81] The same year that she took on Chrysler, she met a challenge offered by, in her words, an "irritating and wincing" Williams College lad who had mocked Marlon Brando after seeing Helen and a friend mooning over him in *Life*. The young man asked, "What's he got that I

haven't got?" Helen and her friend, Cynthia Lee, decided to find out. "Looking attractive, alluring and aesthetic," they headed into the city to see Brando on Broadway in *A Streetcar Named Desire*. At the end of the play they scribbled a note to Brando and asked the stage manager to hand it to him. The man returned a few minutes later and said with a wink, "He'll see you on Saturday at two." Helen and Cynthia had a date with twenty-four-year-old Marlon Brando.

Back in the city the next Saturday, they met him backstage before his two-thirty matinee performance. Brando hurried them out of the theater, walking between them with his hands on their elbows across the street to a "dingy cafeteria," where, as he inhaled a plate of eggs and rye toast washed down with coffee, he explained that he had just woken up. In a plaintive half whisper, he described his frustration with American films (in which he had not yet appeared). He confessed to having been expelled from military school for building a bomb. He described digging ditches as his only paid nonacting job. He discussed Stella Adler, with whom he was studying, and disclosed that he might marry a woman who weighed just ninety pounds. More incredible to them than what he was saying was the fact that he was talking at all. With Helen and Cynthia, the notoriously reticent actor was *chatty*. He topped off their encounter by inviting them back to his dressing room, where he "unabashedly" stripped down to get into his stage gear. The two women left (Helen "accidentally" forgot her gloves in his dressing room and was forced to return to retrieve them), having long forgotten the reason for their mission.[82]

It was not until her senior year that Helen decided to be a painter. Her experiences and influences had been so broad that she had continued to be torn between the pen and the brush. But in the end the "thrill and ambiguities of painting" drew her.[83] As a young woman, Helen would always tend toward freedom—no rules, no restraints, no conformity, no "shoulds"—in her life and in her art. "I think Helen viscerally understood that she would have to rebel against the straighter parts of her upbringing," said Clifford.[84] After graduation, she headed downtown. It was that fateful year, 1949, when the abstract artists were hitting their stride.

During her last winter at Bennington, Helen had used the school's nonresident term to take classes on 14th Street with Wallace Harrison, a Francophile Australian painter who taught Cubism.[85] While studying with Harrison, Helen and her best friend from Bennington, Sonya Rudikoff, rented a third-floor cold-water railroad flat on East 21st in the Gramercy area to use as a studio.[86] "We were both embarked on some artistic kind of life and then it made sense that we shared this place and she could write and I would paint," Helen said. "It was fourteen dollars a month, we each put in

our seven bucks."[87] Sonya had been a year ahead of Helen at school and was much more intellectual than Helen's other Bennington friends. "She thought before she spoke," one friend said tellingly in describing Sonya.[88] It was a sign of Helen's seriousness that she chose Sonya as her studio mate.

After graduation, Helen continued to paint on 21st Street.[89] She had had three years of training from various sources that had all seemed to converge at one point—Cubism. And so, back in New York in her shared studio she began churning out Picassos. "I had it under control. It looked good. But it was student [stuff], and it wasn't satisfying to me or to the thing itself," she explained.[90] She was also dissatisfied about dividing her time between painting and studying. Helen had enrolled in an art history master's degree program at Columbia, studying with the abstract painters' favorite academic, Meyer Schapiro. "I did it largely because I wasn't sure about painting myself," she said,[91] but also because "I didn't have the guts to say, 'I'm leaving home and I'm going to paint.' "[92]

Having turned twenty-one in December 1949, in January she decided to declare who she *really* was—sort of. Helen moved out of her mother's apartment and into a place on West 24th Street with Gaby Rodgers, an aspiring actress studying with Stella Adler. She and Gaby had traveled together in Europe during the summer of 1948,[93] a difficult trip not least because the quays where transatlantic ships docked in Europe were full of the coffins of American servicemen whose bodies were still being sent home three years after the end of the war. In fact, Europe looked as though the war had only just ended. Rationing was still in effect, the rubble from years of bombing had not yet been cleared in the capitals they visited, and the faces of Europeans they met remained haunted by the horrors they had endured.[94]

Helen and Gaby emerged as close friends from that difficult journey. So, when they found themselves in New York, wanting to begin their lives as artists and yet unable, because of social strictures, to break away from their families, they decided to make the leap together.[95] "In order to do what I wanted to do, which was leave home and paint, I shared an apartment with another 'nice girl,' " Helen said.[96] ". . . If we did it together it looked legit. . . . Our parents would commiserate about [their] renegade, terrible children."[97] Within weeks of moving into London Terrace, Helen also abandoned the pretense of Columbia. "I would do what I did and take it from there."[98] From that moment on Helen painted, and for the next sixty years, she rarely stopped.

In late 1949 or early 1950, Helen received a call from the Jacques Seligmann Gallery on 57th Street, which was interested in mounting a show of works by Bennington alumnae. It was a boon for the school's art program,

and for Paul Feeley, who had been named head of the department.[99] Helen agreed to organize it, which she did with all the thorough correctness of her uptown training. As a downtown girl, however, she knew how important liquor would be to the artists and their guests, and so she secured the services of the best bartenders she could find. Next, she created a master list of invitees and, from a command center she created at her mother's apartment, picked up the phone and called everyone she knew in the worlds of art, literature, and academe as well as everyone she didn't know but who she thought would be important to have at the event.[100] Among that latter group was *The Nation*'s art critic, Clem Greenberg, whom she had been reading since his days at the *Partisan Review*. After describing the exhibition, Helen invited him to the opening. Clem said, "Oh, I love Bennington! I love Bennington girls. But I'll only come if there are drinks."

"It just so happens that we have enough money to have a lot of liquor and we're not only going to have drinks but we're having both martinis and Manhattans," she said.

"Then I'll come," he replied in his slow, deliberate voice with its hint of Virginia.[101]

May 15 was opening night. "The entire art and literary world of the New York avant-garde showed up for this Bennington show," Helen said.[102] "Everyone got plastered."[103] Clem appeared as promised, giving the event the critical imprimatur of the art writer whose pieces were almost as daring in style and content as the paintings and sculpture he described. All eyes were on him as he moved around the room. People wanted to see what works he stopped to scrutinize with his signature squint, furrowed brow, cigarette dangling from his lips, and sometimes fingers pressed beneath his eyes to focus his vision. Pavia called Clem the "king critic of the forties" who, at that point, artists heralded for his bravery. Back at the Cedar, said John Bernard Myers, the artists discussed "every damn article" Clem wrote.[104]

It was only natural that Helen would gravitate toward him. He was *the* intellectual power figure in the avant-garde art world, and she never wasted her time with anything but the best.[105] Having introduced herself, she took him in hand and directed him painting by painting through the show. They made a striking couple. At six feet tall in heels, she was the same height as Clem. Like her mother, Helen had thick dark hair, which she wore shoulder-length and permed into a Lauren Bacallish languid wave. Her eyes were large, round, and dark. Her mouth was not particularly large, until she smiled—broadly, joyously, and without a hint of restraint. Forty-three-year-old Clem, with his bald pate and intellectual reserve, only made Helen appear more spontaneous, more vital. The dynamic between them was not unlike that of young Martha and Alfred.

Perhaps Helen recognized it, too. But Clem was not like her father. He had a brutal streak that surfaced during their very first encounter.

While walking through the show they came upon a painting, *Woman on a Horse*. It was a Picasso-inspired figurative abstraction painted in intense primary colors and with a liberal use of black to create negative space. The *New York Times* and *Art Digest* both remarked favorably on the painting in their reviews of the show.[106] But Clem declared, "I don't like that one," to which Helen replied, "That's mine."[107] This man who was an expert at looking at art could not have failed to see her name clearly inscribed in yellow on black at the bottom right corner of the painting. He had therefore known what he was saying and to whom he was saying it. Later, laughingly recalling that day, Helen said, "He finally let me know that he thought my picture was the worst one in the show."[108] In retrospect, his comments seemed to be a trial. Not only was he, like any bully, attempting to rattle her, but he seemed to be assessing Helen's maturity to see how much she could take. Helen barely registered his remark (she was no longer satisfied with the painting herself),[109] and if Clem's criticism was a test, she passed it. By the end of the opening, he was enthralled with Helen. And the feeling was mutual.[110]

Helen returned to the gallery to collect her painting at the end of May and was told that Clem had called to get her phone number.[111] She hadn't been pining away for him. She and Gaby made such a splash at a Beaux Arts Ball fund-raiser for the Artists Equity Association four days after the Seligmann opening that their picture appeared spread across a full page in *Life* magazine.[112] But she *was* interested in him. Though Clem had her number, he hadn't called (he was involved with two other women at the time).[113] Helen decided to give him a nudge. On June 4, 1950, she wrote,

> Dear Mr. Greenberg,
>
> Theodoros Stamos advised me to write to a Mr. William Levy at Black Mountain College about a job on the art staff during the summer session. He warned me that the administration was somewhat disorganized, and not to expect an answer. And I didn't receive an answer but am still anxious to find out about the job.
>
> I have since learned that you are connected with the college, and wondered if you could give me the name of someone who would consider my application!
>
> (I trust you have recovered from the Bennington exhibit.)
>
> Sincerely,
> Helen Frankenthaler[114]

Not long afterward, Helen was at her mother's watching a baseball game on Martha's new TV.

The phone rang and it was Clem and he said would I have a drink with him.... And we had a long phone call in which it was very clear that we shared a certain humor and interest. And we made a date for drinks. And that was the beginning of a five-year relationship.[115]

Short of Pollock or Bill, Helen could not have picked a better male escort to conduct her into the avant-garde art scene. That was where Clem lived, and as soon as she began dating him she, too, became part of it. People she had only read about in art magazines or literary journals became friends. Her nights were spent at soirees at Clem's Bank Street apartment or his favorite Village hangout, the San Remo. They appeared together at the Club and the Cedar (though Clem hated that bar). On Saturdays, they did the gallery circuit with the *Partisan Review* crowd, or with Elaine and Charlie Egan.[116] Helen couldn't quite believe it herself. She described her early social life with Clem as "heart pounding."[117] "It was a whole new world and I couldn't get enough of it," she said.[118] Through the years, some would suggest that Helen used her relationship with Clem to open doors that would have otherwise been closed to her. When confronted with that theory, Helen would point out that she and Clem took pains to stay out of each other's professional lives. They had an understanding that he would never write about her work or promote her, even decades after they had stopped dating.[119] As for opening doors, Helen's nephew Clifford said,

Sure. But those doors could have been slammed back in her face...if she didn't have the strength and talent to push forward.

So I think her liaison with Clem has to be understood *not* as some crudely opportunistic move, but as part of her genuine fascination to be near a brilliant mind and be exposed to the best art of the time—to learn. She was deeply drawn to him by his intelligence and the fact that he was in the middle of a rich artistic brew. It was not about careerism as much as it was about gaining access to ideas. It's important to note that Clem never wrote anything significant praising Helen's work. Her relationship with him was consistent with her ambition as an artist to be close to the smartest people around, and that included Clem—even if his behavior could be really objectionable.[120]

And what did Helen give Clem? The companionship of a woman with youth, beauty, brains, and social stature. Clem's *Commentary* magazine colleague Irving Kristol said that the Frankenthalers "occupied a near royal position in the hierarchy of Jewish-American society."[121] And Clem's romance with Helen (his first long-term relationship with a Jewish woman)[122] coincided with a debate he was engaged in over Judaism in

America, Jewish nationalism, and Jewish "self-hatred" in the wake of Nazi atrocities. After the founding of the state of Israel and amid growing calls to embrace one's Jewishness in a collective—a nation—as a matter of pride *and* security, Clem offered a counterargument. Seeing the dangers inherent in any kind of rabid nationalism, he proposed coming to terms with the war's slaughter not as members of a group, but by confronting the causes and effects of the trauma as individuals.

> The main struggle, at least for us in America, still has to be fought inside ourselves. It is there, and only there, that we can convince ourselves that Auschwitz... was not a verdict upon our intrinsic worth as a people.... What I want to be able to do is accept my Jewishness more implicitly, so implicitly that I can use it to realize myself as a human being in my own right, and *as a Jew in my own right*.[123]

At the moment that Clem was wrestling with those profound issues, he met Helen. They discovered in each other exactly what they needed. It was a relationship upon which both would continue to depend as the First Generation, which Clem had chronicled and alongside whom he had matured as a writer, made room for its offspring, the Second Generation, among whose company Helen would thrive and grow as an artist.

27. The Thrill of It

> Our way of life was so exactly what we wanted that it was as though *it* had chosen *us*.
>
> —*Simone de Beauvoir*[1]

BILL DE KOONING had recommended Clem for a summer teaching job at Black Mountain, which meant Clem would be spending the summer away from New York.[2] Helen had also hoped to be in North Carolina working at the school, but apparently that offer hadn't materialized because she found herself at the end of June without plans to escape for the season.[3] And that meant Helen would have nothing to do and no one to do it with because the art scene in the city shut down for July and August. Galleries closed. Museums generally mounted crowd-pleasing shows that fell under the heading "mass culture" and were shunned by *real* artists. Even art magazines shuttered their offices. As a result, there was an annual migration of painters and sculptors east to Long Island, south to North Carolina, or north to upstate New York, Maine, Vermont, or Massachusetts. From among all those possibilities, Clem suggested the last to Helen. He told her she should study with Hans Hofmann in Provincetown. The German master had been crucial to his own understanding of art, and he was sure Helen would benefit from his instruction as well. Partly on the strength of Clem's recommendation, but also because a brief turn in Hofmann's studio was a rite of passage for an aspiring New York School painter, Helen enrolled.[4] It was, in her words, a "necessary bridge."[5]

With great anticipation, in July she headed north to the Cape. Once there, Helen was excited and charmed by Hofmann.[6] ("He was a tough geezer but very human, very straight, very bright," she said.)[7] The accommodations, however, proved disastrous. By the time Helen arrived, all that was available by way of lodging was a wooden shack, to be shared by Helen and four other students, run by Hofmann's "severe alcoholic secretary" and her "alcoholic boyfriend."[8] In the summer's heat, that discomfort grated and, as the days passed, it may have added to Helen's growing impatience with Hofmann's teaching. It wasn't that she didn't enjoy his lectures, but she felt she had already learned the lessons he offered. She was also frankly tired of being in school. Helen wanted to follow her own artistic instincts, to make her own discoveries, independent of a teacher's influ-

ence. One day, she wandered away from Hofmann's studio and began to paint Provincetown Bay on her own.[9]

Setting up an easel on the porch of her shack, Helen looked out over the bay, not knowing what she intended to do except that she wanted to somehow transform the scene before her so that the humbling infinitude of sea and sky would become hers.[10] An artist is a conduit for a vision that is as uniquely her own as a fingerprint, and unrecognizable until it appears. "Every picture tells you what to do," Helen said, "that's the glory of it."[11] Helen began painting and gradually, over many days, what emerged was more than a painting of the bay. It was a perfect marriage of who Helen was and what Helen saw. She had captured a feeling.

Helen's bay was abstracted: A line that could be interpreted as the horizon dissected the top quarter of the painting, but it did not do so emphatically. It, like everything around it, appeared liquid, in motion, not just what a viewer could assume to be water, but the sky, the clouds, the dunes, even the rocks. And within that fluid image Helen had been able to convey the summer's heat rising off the shoreline and the quiet calm one experiences when faced with such beauty, knowing that this moment of unity with the immensity of creation was reality, frozen and profound, but also sadly fleeting. In cerulean and cobalt blues, grays and blacks, ochres, reds, burnt umbers and browns, and without a trace of recognizable object, Helen had gotten all of that into her small painting. When she was finished, she looked at her work and wasn't at all sure what she had done.[12]

Helen brought *Provincetown Bay* into Hofmann's famous Friday critique. It was a heart-stopping moment.[13] Students hung from the rafters and others stood in a pack around Hans, rapt as he spoke about each of the paintings produced that week. After critiquing several students' pieces, Hofmann came to Helen's and placed it on an easel. He discussed her color choices and how they impacted the space to create depth, how she had extrapolated from nature to make something new and uniquely her own, how she had captured the essence of the bay and her own sensations upon viewing it. Hofmann then offered what amounted to his highest praise: "This works." Helen's face flushed and her breath shortened. She was suffused with the impulse to paint again.[14]

While in Provincetown, Helen's fellow students watched her run to meet the mailman each day to see if Clem had written.[15] Finally, after three weeks, she decided she would rather be at Black Mountain than on the Cape. She could paint just as easily there and do so in the company of her new man. "There was this electricity between them. I think a lot of it was sex," her future friend Cornelia Noland said. "They just had everything in common."[16] In order not to alarm her mother by announcing she

was going to stay with her older lover, Helen made her journey under the guise of a trip to Virginia to see Gaby, who had won an acting scholarship in Abingdon.[17] Nursing a toothache, Helen left Provincetown for a "discreet tour" of Black Mountain.[18]

Clem had been hired to teach art history and theory, and had arrived in early July with his fifteen-year-old son, Danny. The boy had been in and out (mostly out) of Clem's life since his birth, and when father and son were reunited, Clem allowed Danny to hang around, provided he did not interfere with his lifestyle. Danny, in turn, responded to Clem's indifference with bad behavior. He had been expelled repeatedly from school and presently refused to comply with Clem's many demands, which all involved Danny's transforming himself into someone Clem might approve of.[19] Injecting Helen into that relationship did not make it easier.

She was only six years older than Danny and was not prepared to play the role of surrogate mother to any child, much less an irate teenager. And in any case, resolving domestic discord had not been part of her plans. Helen thought she was en route to a gathering of artists and intellectuals. Besides Clem, John Cage was there that summer, the writer Paul Goodman (one of the early speakers at the Club), and painters Theodoros Stamos and Robert Rauschenberg. Helen expected to find "a sort of southern version of Bennington."[20] That, in any case, was her pre-arrival fantasy. The reality she encountered was a bitter disappointment.

Unlike Elaine, Helen found Black Mountain charmless. It was "so depressing and nobody had a car... and there was a swimming hole.... And nobody had any money or largesse or freedom, including myself," she said. She found the place "dreary," the food "terrible," the barracks "unspeakable," "the personal situations were nightmares" and, to top off her misery, "there were snakes."[21] Clem might have contributed to her wretchedness. The previous month the woman he had called the love of his life, Jean Connolly, had died (she whose Dear John letter while he was in the military contributed to his breakdown). Clem greeted the news with a prolonged bender.[22] His preoccupation with past dramas, some of which were embodied in his son, coupled with the dismal environment in general were more than Helen was prepared to tolerate. She remained at Black Mountain for less than a week before deciding she couldn't stand another minute. She packed her bags, grabbed a ride to the train station, and left North Carolina, stopping to pay her visit to Gaby in Virginia, and then rumbling up the East Coast to New York.[23] Her relief was evident in the postcards she sent Clem along the way as she left behind the South and a train full of "crying southern babies."[24]

"To my surprise, the trip from Va. was nice, & I wrote some not-bad

poetry on the train, & drank beer with stock-brokers."[25] The discussion with her fellow travelers was about the so-called U.S. police action that had begun that summer on the Korean Peninsula. "All the war news is horrible, & the further east you go, the more scared the people seem," she wrote.[26] Of her trip to Black Mountain she added an oddly tepid, "In all, last week was good. Thanks. Much love, x Helen."[27] That was all she *could* say and even that was an exaggeration. At that point in her life, the patch of territory Helen was most interested in was Manhattan. She had lived there all her life, but she realized that she knew only a small part of it.

> I wanted to feel New York, even though I was a New Yorker, I hadn't known it as a young adult, or as a member of the avant-garde, or as somebody hooking in with young comrades. And then Clement introduced me to Grace Hartigan, Harry Jackson, Larry Rivers, Bob Goodnough, Al Leslie—Al and Grace were living together then and they were making money as nude models at the Art Students League. And they used to eat Wheatena, at periods three times a day. I mean they had nothing.... Larry was playing in a band.[28]

The young artists to whom Clem introduced Helen were sometimes referred to as "Clem's stable" because Clem and Meyer Schapiro had selected them for the *Talent, 1950* show and because he had then absorbed them into his social circle. Clem loved the company of younger people.[29] With the Second Generation, he acted as a wise elder, offering advice on the scene and, more crucially, their work. "It was Clem Greenberg. Period," said Al Leslie. "What Clem said was enough for anybody."[30] Some of the older artists had begun to call Greenberg "Pope Clement."[31] Not only did artists hang on his every word as if it were gospel but, with the Second Generation, he had found himself a flock.

The deeper she moved into the downtown scene, the more furiously Helen painted. "Work was pouring out of me, painting after painting. The more I painted the more I wanted to paint," she said. "I had so many ideas I couldn't get them out quickly enough."[32] She thrived on the stimulation of seeing other artists' work and having them see hers, and delighted in the near-constant dialog about art. Helen called the group of artists she came to know that year "a young, lively, moving nucleus art family."

> I think the luckiest thing at that moment was to be in one's early twenties with a group that you could really talk with and argue pictures about and it's something that you can't delay and something that you don't need later on.... It was very trusting. Oh, it was beautiful.... There was judgment but not the judgment that goes with power or with moralizing. It didn't have to

do with self-righteousness.... It was more a question of, "Why didn't you fill the upper left of the picture?" Or will you help me size and prime this cotton canvas. Or come for dinner. Or let's go to a Greek dance hall... daily I would either see or talk to or think about Pollock, de Kooning, Hofmann, Charlie Egan, Elaine de Kooning, the whole environment of the Cedar Bar, the Friday night artists' thing which we went to, I would say every Friday—the Club—I was very close then to Al and Grace.[33]

Sonya Rudikoff had married that fall and moved to New Hampshire, which meant Helen had the studio to herself.[34] Alone on 21st Street, she began "knocking out paintings that were pretty terrific.... I was off on my own. I had my own history. I was developing." Bill and Elaine were frequent visitors, and Helen in turn saw their work.[35] Both had begun important paintings, pushing themselves further than either had gone into a territory that Helen had only begun to experience, the unknown.

That year, 1950, Elaine launched a series of portraits of her eccentric friend the Greek artist Aristodimos Kaldis. He was such an intriguing character that she would paint him repeatedly until his death in 1979. (In fact, the only person she would paint more than Kaldis was President John F. Kennedy in the year before his assassination.) Elaine was an expressionist painter and Kaldis—a man of raw nerve endings, bombast, and tatters—was an expressionist's dream. "He was a fantastic figure, a brilliant man, always wore several brightly colored scarfs," Elaine recalled. "Everything he owned, he was wearing.... He looked to me like Rodin's Balzac."[36] In life-sized paintings, she represented him in long thick strokes, quickly applied, which captured his mercurial personality, and simultaneously gave him weight—physical and intellectual. Many artists have a subject to which they return time and again because the familiarity frees them to concentrate on the act of painting. Cézanne had fruit, a mountain range, and his wife. Elaine had Kaldis. For her, painting his portrait was like playing a favorite piece on the piano. Each time she did, she added a flourish or a deeper note. Elaine's portraits up to that point had felt restrained, either by a sense of fealty to subject or by her search for a style that would raise portraiture above convention and make it her own. Kaldis helped her achieve that. In him and through him, she combined the technical and stylistic discoveries that came to define her portraits.

For his part, Bill was also working on a favorite, well-rehearsed subject, and out of it would come a masterpiece. In June, he had begun painting *Woman I,* which he would continue to work on until 1952.[37] It would be, along with Pollock's major paintings, among the most important in the history of Western art. Never before had a woman been as brutalized by

brushstrokes on canvas nor seemed so amused by her thrashing. Never before had an artist painting in America created an expressionistic work of such power. Graham, Hofmann, Schapiro, Camus, Kierkegaard, Trotsky, John Dewey, and Sartre had all dared artists to paint their reality through the prism of their own deepest vision. De Kooning, like Pollock, had done that. Bill's *Woman* reflected his own inner turmoil and suppressed rage, as well as the violence and insecurity of the age. And at the same time, his painting playfully mocked the hypocrisy of 1950s society, in which women were exalted as queens in order to make their social and domestic servitude more palatable.[38] With eyes wide-open to her hideous reality, a grotesque smile frozen on her face, Bill's *Woman I* writhes upon the throne where she sits, demurely clutching the pocketbook (her passport to independence) that rests on her lap.

He had begun by tacking a seven-foot-high canvas to a frame with the intention of painting a seated woman. It was an image to which he had returned countless times since meeting Elaine. Of the 1950 painting that turned into a series, he said, "I always started out with the idea of a young person, a beautiful woman. I noticed them change. Somebody would step out—a middle-aged woman. I didn't mean to make them such monsters."[39] Elaine was quick to silence whispers that she had driven Bill to such madness, declaring that she was neither model nor inspiration for the work. (On the contrary, she said, it was Bill's mother!)[40] No matter who or what had inspired *Woman I,* however, the artists who visited Bill's studio, Helen among them, watched its long gestation with amazement. It was a painterly tour de force that was so taxing to the artist he had begun having heart palpitations. After one such episode, struck by fear, Bill banged on Conrad Marca-Relli's door on Ninth Street at two in the morning, saying, "Jesus Christ, I think I'm going to die."[41] He was terrified that any undue exertion would cause a heart attack, and yet the nature of his work involved intense and prolonged physical labor, and continual mental and emotional stress. Doctor and fellow painter Lewin Alcopley advised Bill to take a drink now and then to widen the arteries around his heart, thereby easing his palpitations. Bill bought a bottle of whiskey and began taking sips when he felt his heart racing. Then he began to drink a bit throughout the day to settle his nerves. Finally, he began drinking in the morning, to better "'sneak' into the day."[42] That was the year that painting and drinking became intertwined for Bill. Both, he believed, were a matter of survival.

As powerful and important as was *Woman I,* however, another painting Bill began that year, an abstraction titled *Excavation,* spoke much more directly to Second Generation artists like Helen. In it, Bill allowed color (it seemed almost grudgingly) to creep back into his previously black-and-white

abstract work. And, in the wake of Pollock's mural-sized paintings, Bill's, too, grew in size. *Excavation* was more than six and a half feet by eight feet, and every aspect of that vast surface was worked, reworked, scraped bare, and built up again into a frenzy of shattered lines. What color he used—an odd patch of red, yellow, or rose madder—worked as mere random highlights. In fact, *Excavation* is more a drawing than a painting, despite being created in oil paint and enamel. That painting, in that style, resonated with Helen. She began to look at color differently, not as something that had to be "clear and bright and a nameable," but as something that could also be a "noncolor." Color was just one element among many; it could even be a minor element and still have great impact.[43] After seeing *Excavation,* Helen began eliminating the rich Kandinsky-like colors and sensibilities that had emerged in the wake of *Provincetown Bay,* replacing them with whispers of ochre, white, and thinly veiled reds.[44] Her paintings became completely abstract. The subject *was* the painting.

To stimulate the all-important dialogue between artists, especially the newcomers among them like Helen, Elaine had begun to use her platform at *ArtNews* to introduce the methods and ideas of veterans who were not immediately accessible to the New York crowd and who did not paint in the abstract mode most often seen in their studios. In March, she traveled to Pennsylvania to interview painter Andrew Wyeth, whom most would label a realist but whom Elaine, in a tribute to his talent, elevated to the category *"magic* realist."[45] During the summer, she also contacted her old Black Mountain teacher Josef Albers and asked if he, too, would be interested in being a subject of one of her *ArtNews* features. *"Ach so,"* he replied, adding, "I will do a series of color demonstrations and will call it *Homage to the Square.*"[46] It would become his most celebrated series and engage him for the next twenty-six years.[47]

Having left Black Mountain to head the new art department at Yale, Albers invited Elaine and Rudy Burckhardt to New Haven to see him.[48] "He had about a hundred paintings on the floor, with one color against another color and always the same size," Elaine said. "I thought, he can paint forever and not think of anything else, because he's dealing with this particular infinity."[49] As she interviewed Albers, Rudy took photographs. Sixty-two-year-old Albers, meanwhile, gamely chased Elaine around a table trying (unsuccessfully) to kiss her, "much to Rudy's amusement," said Elaine's sister, Maggie.[50] There was no antagonism in his defeat, however, because that fall Albers invited Bill to come to New Haven as a visiting teacher. His pay would be a generous sixteen hundred dollars. Bill rushed to tell Elaine.

"Guess what?...I got a job teaching. I got a job teaching at jail!"

"That's nice," she said and continued painting.

"But aren't you excited?" he asked. "It's a job at jail!"

She wasn't particularly interested until he said slowly, *"Jail University."*

Finally understanding what Bill meant, Elaine was excited indeed.[51] But Bill's time at Yale didn't last. During his first class, his students were so unused to being in the presence of a working artist that they mistook him for the janitor because of his painting clothes. He in turn thought them "lousy," a waste of his time. "I can't see myself as an academic," he conceded. "I think of myself as a song and dance man."[52] Despite the generous pay, Bill quit after the fall semester and recommended Franz Kline for the post.[53] It was a natural choice. That fall, Kline was the talk of the art world.

In October and at the age of forty, Franz had his first solo show and astounded everyone.[54] Seemingly overnight, he had gone from being an interesting painter of mostly pathos-laden traditional themes to a powerful master of cutting-edge abstraction. Of course, his development wasn't overnight; it was the result of many years of hard work. But his conversion to abstraction was, according to Elaine, "total and instantaneous."[55] And what did his new work mean? When asked that question Kline would reply, "I'll answer you the same way Louis Armstrong does when they ask him what it means when he blows his trumpet. Louie says, 'Brother, if you don't get it, there is no way I can tell you.'"[56]

In 1948, Franz's wife, Elizabeth, had finally been committed to a psychiatric institution. She existed for him artistically as a faceless figure or an empty rocking chair.[57] Soon after she left, Franz was at Bill's place with Elaine one evening while Bill was enlarging his own drawings by projecting them onto the wall using a Bell-Opticon. A person Elaine identified as a "friend" asked Franz, "Do you have any of those little drawings in your pocket?"[58] Kline made sketches on telephone book pages and his pockets often contained one or two of them. He handed over a drawing of an empty rocking chair, and it was placed on the projector. The effect was astonishing. Franz's chair, Elaine said, "loomed in gigantic black strokes."[59] Said artist Peter Agostini, "I think Franz had no idea of doing big black-and-whites until Elaine de Kooning suggested one day that [he] should blow up one of his drawings and see what it looked like. So when he saw what it looked like, she said, 'Well, why don't you do that?'"[60]

Excited by the discovery, Franz returned to his Ninth Street studio, where he lived with two dogs (that urinated through the floor into John Ferren's studio below) and painted all night, often playing Wagner (which greatly added to Ferren's annoyance).[61] Placing a beer crate on the floor at the base of a large canvas tacked to the wall, he leaned a plank on the crate to make a ramp so he could reach the top of the painting. Racing up and

down, Franz began to replicate the desperate black slashes that had exploded out of his drawings through the magical light of the Bell-Opticon.[62] At about five-thirty in the morning, Elaine and Bill were on Carmine Street sleeping when they heard a knock on the door. Elaine looked through a crack and saw Kline.

"Is everything OK?" she whispered.

"I just finished a painting and haven't been to sleep," he said. "Come over and see it."

Bill and Elaine got dressed and went with him to his studio. There, they were confronted by a wet painting that combined power and passion in black and white.[63] It was as solid as a steel girder and as lyrical as a poem dashed off with a quill pen and India ink. The three friends looked at and talked about the work for an hour and then went out for breakfast to talk some more as the sun rose over a still waking Manhattan.[64] For Franz, for them all, it was in every way a new day. With that painting, Kline became what writer Pete Hamill called "the third glittering star in the Big Three constellation" along with Pollock and Bill.[65] It was evident that this was major, that these were the paintings Kline had been born to do. Elaine told Charlie Egan about Franz's breakthrough, and Charlie offered him a show.[66]

Everyone in the avant-garde art scene turned out for the opening on October 16, partly out of love for Franz but mostly out of excitement over his work. That event was followed later by a massive party at the Club, which Franz couldn't properly enjoy because he had had a tooth pulled, so the party was repeated with just as much gusto two weeks later.[67] For once, the critics were generally in agreement about the power of the paintings. Manny Farber, writing for *The Nation,* cheered Kline on: "A heroic artist achieves a Wagnerian effect with an almost childish technique."[68] Clem would call Kline "the most important painter to come out" in the past three years.[69] But Frank O'Hara best described the sensation of seeing Franz's work from that period:

> To see some of the paintings shown at the Egan Gallery...is to take part in one of art's great dramas...a drama which has the added poignance of meeting again someone you once loved and who is more beautiful than ever.... Kline is one of those lighthouses toward which Baudelaire directed our gaze: what is thrilling is that they are shining here, in our very time.[70]

Helen's arrival on the scene coincided with an unprecedented creative acceleration within the New York art world. By 1950, a host of First Generation artists—Pollock, Bill, Mark Rothko, and Bob Motherwell among them—had found their signature styles.[71] (In Lee's case, she had found a

unique style with her Little Image paintings but had abandoned it for a new direction.)[72] Those considered (whether appropriately or not) Second Generation, including Franz and Elaine, had also begun to make breakthroughs into artistic maturity. In response, galleries that just a short time before had been reluctant to open their doors too widely to the new artists began to take more chances. Sam Kootz, who had hosted the *Talent, 1950* show with Grace, Elaine, Franz, and Larry Rivers, had decided to allow First Generation artists (Motherwell, Hofmann, Baziotes, David Hare, and Adolph Gottlieb) to select newcomers for a similar exhibition to be held in December. Twenty-one-year-old Helen Frankenthaler would be among them.[73] While under a hair dryer at the women's fitness "tomb" MacLevy's Slenderizing Salon, Helen scribbled a breathless letter to her friend Sonya announcing the news:

> Remember my writing you about Clem, Adolph Gottlieb & the Kootz show? Well, Gottlieb saw my paintings at Clems, and along with several others (I'm not bragging, just relatin') went wild over them. He selected <u>me</u> as his other choice for the Kootz show, & of course I'm pleased about it. The show, "Unrecognized Talent" is in Dec.... I've been painting a great deal. One, 6' x 8'— with sand, enamel & plaster of Paris. Have been working in a good kind of exhaustion....
>
> <u>Shit!</u> Just realized I've been under this hot thing for 40 min, & forgot to take my heavy kerchief off. Groan.[74]

Helen had been in the New York art world for less than six months and already her work had been selected for a show at the prestigious Kootz gallery. Her life was moving at such speed that she sometimes had difficulty fathoming it. It was as if she were starring in the film version of her own story. Weekends often involved dinners with celebrated literary critics and authors Lionel and Diana Trilling, or the broader *Partisan Review* crowd at the home of the journal's editor William Phillips and his wife, Edna.[75] At one such gathering, Helen shared the table with philosophers William Barrett and Sidney Hook, poet Delmore Schwartz, authors Vladimir Nabokov and Arthur Koestler, "and ALL the Wives," Helen wrote Sonya. "Hook was clutching Fromm's new book *Psychology and Religion* most of the night; Delmore looked nuts, Will threw me a flirty 'serious talk' line. Oh it was something! If our friend H. James had to report the scene, it would've meant his exhaustion and death."[76] Helen didn't take such company for granted; quite the contrary. "I often felt sort of—when I met the Trillings for example, I would sort of gulp and feel the way I felt at fifteen meeting Cary Grant. Sort of 'I can't believe I am in this presence.'"[77]

By the fall, among the painters and sculptors in New York, however,

Helen had begun to feel she was in the company of kin. Clem's Bank Street apartment was in some ways their home. With a neon liquor sign shining through the window, and furnished like a studio with a six-foot-high easel; a card table covered with paints, brushes, and rags; paintings (mostly his own) stacked along the wall; a preponderance of white bookcases; and two "weary" Windsor chairs, it was one of the spots where they would gather once or twice a week for an evening of cocktails and talk.[78] "The hors d'oeuvre was slim but the booze was heavy," Helen recalled.[79] Bill and Elaine were part of that inner circle and, when they were in town, Jackson and Lee were also invited. In fact, Helen met them at Clem's in the early summer of 1950. "At that time [Pollock] was on the wagon and he sat on the floor in Clem's apartment and was sober and totally silent, withdrawn, probably very depressed," Helen recalled. "Affable, pleasant, but noncommunicative, and not the image I had of him later."[80] Nor the image she had had of him before. "I remember as a college student, when *Life* magazine came and we all rushed for our copies," Helen said. "And they had a spread on Pollock in *Life*. And that struck me...and I thought...I'd sort of like to see more of that." At her near-weekly dinners at William and Edna Phillips's home she had. A Pollock painting from the 1940s hung in their dining room where Helen sat staring at it, "mesmerized."[81]

Meeting Jackson in person was a "huge moment," she said, but also something of a disappointment because he was so remote.[82] Aware of Jackson's and Lee's importance to Clem, Helen did not force herself into their relationship or try to accompany Clem at that point to Springs.[83] But when the Pollocks were in town, she joined them as Clem's youthful date (Lee was twenty years older than Helen). In fact, the night before the opening of Pollock's important November show at Betty's, Helen and Clem had dinner with Jackson and Lee. Of the evening, Helen told Sonya that Pollock behaved as "a very 'American' charming grump. Prima donna but nice, & looks as if he <u>ought</u> to speak with a foreign accent."[84] That encounter occurred just after Pollock's table-tossing episode in Springs, which meant he would have been drinking again.

Helen and Clem didn't go to Jackson's opening, perhaps because Clem had already seen the work in his studio or perhaps because Clem felt the event could—likely would—turn into a circus with Jackson as its main attraction.[85] And that was precisely what happened. People poured into the gallery, less interested in the reeling galaxies on the wall than the painter who had caused such a stir in the press.[86] What pained Jackson more than the focus on him personally was the fact that he had had to endure it sober. As soon as he could, he left the opening and started to drink.[87] Catastrophically. Making his way back downtown, Pollock roamed the Village streets

like a wounded beast, literally howling in his drunken agony.[88] Poet John Ashbery wrote that at that time,

> To experiment was to have the feeling that one was poised on some outermost brink. In other words if one wanted to depart, even moderately, from the norm, one was taking one's life—one's life as an artist—into one's hands. A painter like Pollock for instance was gambling everything on the fact that he *was* the greatest painter in America, for if he wasn't, he was nothing.[89]

It is certain that when, sometime after that November opening, Helen stood amid Pollock's paintings for the first time, experiencing their wonder, she knew the show was a critical and financial disaster. Betty Parsons called it "heartbreaking."[90] Clem had predicted it, despite the fact that "the show was so good, it's unbelievable.... It was *there,* that something in Jackson that was so pure, so *right.*"[91] Yet no one wanted the work. It was too large (who had eighteen-foot walls?), too advanced, and in that conservative political climate where abstraction was viewed as dangerously subversive, too provocative. Only one painting, *Lavender Mist,* sold, to Lee and Jackson's friend Alfonso Ossorio, in whose carriage house they were staying.[92] Knowing that Jackson had been mistreated by the critics and misunderstood by the public would have made Helen feel even more a part of that privileged world of artistic insiders who could recognize truly great art. For herself as an artist, Helen had found in Pollock's work an invitation to "let it rip, let it [be] free, try it, run with it, fool around." There were no rules. He had torn them to shreds. Helen returned to the show to look at his work again and again.[93] But unlike her experience with de Kooning, she did not return to her studio to make little "Pollocks." Rather, Helen returned to her studio freed to make very large Frankenthalers.

Helen and Clem's favorite spot in the Village was the San Remo, the writers' equivalent of the Cedar. Dark, crowded, it was home to a mixture of hipsters, literati, aging bohemians, and gay men who represented all of the above. The front bar had wooden booths, a black-and-white tiled floor, a jukebox, a massive espresso machine, and draft beer. In the back was an Italian restaurant from which the smell of various sauces managed to penetrate the dense and ever-present cloud of cigarette smoke.[94] Helen and Gaby had gone there often before Helen met Clem but only as observers of a scene that revolved around "heavy drinking, loose sex" and intellectual exoticism. They had watched the ultra-hip Anatole Broyard—"jazzy, tuned-in"— and his writer friend Milton Klonsky as if the two men were on stage.

"When they cruised it was not for our square kind; their sometimes girls were swingy... tiny, often elegant, sexy," Helen wrote years later in a piece on the bar. "Some were blond tall numbers from the Vassar belt slumming, or *petites vicieuses* loaded with makeup or none at all.... The aura of The Intellectual that haloed these two young men implied an atmosphere, the cast of which I was yet to learn."[95] After dating Clem for a few months, Helen was not only part of that crowd but had met said Broyard (though she remained too intimidated by his command of cool to speak with him).[96] It was impossible to sit at the San Remo with Clem and *not* have guests invite themselves to the table. The talk involved writing, current projects or controversies (personal, philosophical, and literary), and, of course, the Cold War. The most worrisome talk of all, however, was about the bomb. President Truman had made known the month before that he was considering using it in Korea.[97] Helen wrote Sonya, "The news is so horrible and scary... people murmuring about leaving the City."[98]

Quite often, though, it would be a refugee from the Cedar who would slide into a chair at Clem's and Helen's table to talk art. One of them appeared during the fall of 1950. A tall man—over six feet—with dirty-blond hair, wearing a blue blazer, gray flannel pants, and Brooks Brothers oxfords asked to join them.[99] He wasn't part of the *Partisan Review* tribe, though he spoke cleverly and well. He was too exuberant, wore his emotions too close to the surface, and was too obviously and unselfconsciously gay.[100] Clem introduced that unusual fellow to Helen as John Bernard Myers. Myers had leased a space on 53rd Street near the Third Avenue El with the intention of opening a gallery.[101]

John "described the most chi chi fag impossible enterprise in which he was going to have shows of lace and paintings that light up in the dark, it was going to be wild camp," Helen recalled.[102] "Clem that evening convinced him that it would be much more important... to gather up some of the young painters around and show them."[103] He said there were "lots of kids around that are talented and worthy of a show."[104] When John asked who, Clem rattled off a few names of painters: Grace Hartigan, Larry Rivers, Al Leslie, and Harry Jackson, among them. In fact, it was a list John had heard before just that summer at Springs from Lee. During lunch at the Pollocks', John had told Lee he wanted to start a gallery but complained there weren't any good artists who hadn't already been snapped up. She shot back, "I can give you at least twenty names of terribly exciting young American artists who are working new and fresh... and they're very talented." Her list, like Clem's, included Grace, Al, and Larry.[105] The advice became impossible to ignore.

During an earlier career as a puppeteer, John had called himself "the

puller of strings and the master of fanciful destinies."[106] Beginning in January 1951, he put those same talents to work on behalf of the Second Generation New York artists and their poetry-writing friends. Through his gallery, Tibor de Nagy, and a combination of will, work, and whimsy, he would stage-manage an entirely new scene that reflected not where art had been but where it was going.

28. The Puppet Master

> I believe life consists of epiphanies.
> —*John Bernard Myers*[1]

IN THE NEW York School canon there are the periods BJBM and AJBM— Before John Bernard Myers and After John Bernard Myers. Aside from Peggy Guggenheim, no single gallery owner would have a broader impact on the movement. He didn't merely exhibit and sell art; he changed the culture. He was like Betty Parsons in that he was driven primarily by the love of art, not the potential for riches from its sale. He was like Charlie Egan in his willingness (indeed his eagerness) to take chances on the undiscovered. And he was like Peggy in his propensity to think big. Both he and she were producers who staged events—their lives were events—not simple exhibitions. But John went beyond his fellow art dealers by using his gallery to showcase poetry and theater as well as painting and sculpture, and to invite artists, poets, and playwrights to work together. Tibor de Nagy was not an art gallery—under John Myers's direction it was an *arts* gallery. The artists from all fields who were engaged there flourished as a result of what Elaine called the "tremendous ferment" he inspired.[2] In 1950, this thirty-year-old puppeteer from Buffalo, whom the poet James Merrill described as "an ageless, hulking Irishman with the self-image of a pixie," became a steward of the mid-century American artistic Renaissance.[3]

Everything had been in place for years in New York for a cultural and artistic rebirth across disciplines. It had begun to happen with the Club. Before Tibor de Nagy, however, no organization or gallery had provided a space where artists could break the confines of their genres to better reflect the creative unconscious of their time. What had been lacking was a person wise enough (or mad enough) to see both the potential and the need for such a space. John Myers wrote,

> It is Imagination, man's power to imagine, that makes living in society, any society, possible. I think what Paul Goodman says about doing away with "intolerable biological deprivation and spiritual impoverishment" through what he calls "creative cooperative production" is the right and humane solution to our social woes.[4]

With that mission statement in mind, John got to work. He knew and loved the First Generation artists, but it was the Second Generation who would become his family. For them he would be father, mother, priest, (jealous) lover, friend, fixer, and, most passionately of all, defender.

John had arrived in New York in 1944 after discovering André Breton's manifesto on Surrealism while working in an airplane plant in Buffalo during the war. At the time, he had been editing a small journal with a tiny circulation entitled *Upstate*. In that dreary environment, Breton's message that only the "marvelous" was worth pursuing in life struck John as an unarguable truth. Serendipitously, that revelation coincided with an invitation from the Surrealist magazine *View* to be its managing editor. John wasted no time. At twenty-four he boarded a train to Manhattan, where he was met by his Buffalo friend and future roommate, the chemist and poet Waldemar Hansen. Between them they had almost no money, but they were expert performers and quickly learned to "sing for their supper," garnering invitations based on their entertainment value. Said John, "Waldemar is good for at least an hour of laughs and I am an inveterate gossip."[5] John's arrival at *View* occurred during the peak of Surrealist activity in New York.[6] His days revolved around Breton, Masson, Duchamp, and Matta—the men and their art. "I thought they were incredible, enchanting, marvelous creatures. I really did. I mean why should I kid myself?" he said. "I thought they had glamor, excitement.... Everyone was after them." In comparison, he considered American artists "crude" provincials.[7]

View's offices were located above the swanky Stork Club on 53rd Street off Fifth Avenue, but the magazine itself was a shoestring affair. John's job was to correct proofs, get advertising, and collect photos. Much of his work, therefore, involved going to galleries, Peggy's among them. Through her he met some of the new abstract artists, including Jackson and Lee.[8] "Within minutes after talking with Lee, I found both of us laughing wildly. As for Jackson," he said, "the impact of his personality was almost completely chemical. Shall I call it sex appeal, personal magnetism, inner radiance?"[9] It was via Peggy's network that John also encountered Clem, though they didn't interact meaningfully until 1946 after a chance meeting in Central Park that ended with drinks at the Hotel Vanderbilt.[10]

Clem was the opposite of the elegant Europeans to whom John was drawn, but John liked him because he exuded big-city élan and was without pretense. He was so comfortable intellectually that he didn't try to impress with his way of speaking. Clem casually dropped the "g" on words ending in "ing." And he was so completely *of* the art world that, unlike the Surrealists, he didn't need to dress the part. Clem was interesting, John

concluded, though "quite far removed from the world I move in." That meant that when Clem told him, "The place where the money is, New York" would replace Paris as the center of the art world, John listened but didn't believe.[11] Until 1947. That was the year Peggy closed her gallery, joining the Surrealist exodus from New York after the war. It was also the year *View* ceased publication. "It was a breakup of the whole world. It was the end of Surrealism," John said. "It was the end of French painting too, in a very funny sense."[12]

John scrambled to make a living on his own by publishing poetry and performing puppet shows until one evening in early 1948 at the ballet when he was introduced to a Hungarian who, if not an aristocrat by birth, looked every bit the part (John thought he was a baron).[13] His name was Tibor de Nagy and he had arrived in New York in December 1947, a self-described "disillusioned, spoiled Hungarian romantic, with memories of prison and the loss of people dear to me fresh in my mind." Tibor said he was "desperate to find new values and a new life."[14]

Through the war years, Tibor was imprisoned three times, once by the Nazis and twice by the Russians. During his second Russian detention, which occurred while he was head of the National Bank of Hungary, his wife divorced him so she could enact the stratagem of marrying a Dane and fleeing to America on a Danish passport with Tibor's daughter. The hope was (in those days it was always hope; plans did not realistically exist) that Tibor would rejoin them later. In the meantime, however, his wife fell in love with the Dane and Tibor's marriage ended, as did any desire on his part to salvage the remnants of his life in Hungary. Escaping his Russian captors, he made his way to England, where his family had stored what he believed were valuable jewels he could use as currency. The jewels, however, turned out to be worth much less than he expected. Tibor arrived in New York with his past in ruins, his future uncertain, and his pockets nearly empty.[15] He called himself "*nouveau* poor."[16]

"While I was waiting for a post in the World Bank, a young man persuaded me to invest in, of all things, a marionette company," Tibor said.[17] In a most bizarre conversation, the man told him "that with very little money we could make something big in television because at that time Howdy Doody was popular... and his roommate is a brilliant puppeteer who lost his job on *View* magazine."[18] The roommate was John Myers. After being introduced to him at the ballet, the forty-year-old Hungarian banker, who possessed an unusual sense of adventure, agreed to fund the Tibor Nagy Marionettes. The two men became business partners. Tibor provided the money and John the artistry. "It is said of Astaire and Rogers that she gave him sex and he gave her class," Grace wrote. "Of the partnership of John Myers and Tibor de Nagy, I might say that Johnny gave Tibor

permission to be mischievous and John's excess was tempered to a finer style under Tibor's influence."[19]

The impish John and the elegant Tibor performed their puppet shows in schools for children and in clubs for adults (during which they included some stand-up comedy).[20] Through photographer Cecil Beaton and the Russian prince and socialite Serge Obolensky, who allowed them to perform several times daily at his Hotel Sherry-Netherland, they were also invited to stage their extraordinary show privately.[21] Puppet theaters were well established in Europe, with thousands of professional troupes touring the continent. But in the United States the phenomenon was relatively new, with only about one hundred professional groups plying their craft by performing the classics.[22] What set John's and Tibor's shows apart was the contributions of artist friends who supplied original scripts, musical scores, and wonderfully crafted marionettes. "Even Jackson Pollock made a carved hand puppet for John," recalled Tibor.[23] Though they were no rival for Howdy Doody, Tibor Nagy Marionettes soon became famous. "There were big articles in the *New York Times* and so on," Tibor said.[24]

By 1949, John had moved to an apartment on Ninth Street and had begun to hang around the Cedar and the Club. He had entertained its members and their guests with a puppet show that Christmas during their inaugural holiday party, after which he was "taken up" by Bill and Elaine.[25] His travels deeper into the downtown art world occurred at the very time that he and Tibor were growing tired of pulling strings. "It was terrible, terrible physical work and no money, and misery," Tibor recalled.[26] John was anxious to return full-time to the milieu in which he had lived while at *View;* not that he necessarily yearned for the Surrealists, but he wanted to work with artists again. He explained that on one level his desire to be involved with painting and sculpture was "inexplicable" and "so deeply psychological that one better stop right there. But let's put it on the art level."

> One summer [1949] I was visiting with Lee and Jackson, I had not understood one single thing about American art up till this point. But one day, Jackson said that I could go out [to the barn] and just sort of look around, nosy around. I went out by myself. I had been friendly with the Pollocks up to that point but had never—I hadn't the slightest idea what he was all about. And things were lying around. And things were pinned up on the wall. And all of a sudden, I just saw it. I got what the idea was. I saw what he was doing. I understood it.... [F]or the first time in my life I realized that there could be such a thing as American art.[27]

John hit upon the idea of starting a gallery as a way back into art. In fact, there had been a general buzz among the avant-garde artists and their

supporters about the need for a gallery that showed the younger generation.[28] Tibor had had an art collection in Hungary (which was destroyed, along with his villa, by a British aerial bomb), and John had been involved with the Surrealists and so, to a group of wealthy art champions the pair seemed prime candidates to run a gallery. Based on their rich friends' offer to put up money for the venture, Tibor rented a first-floor railroad flat at 206 East 53rd Street and hired an Italian interior designer to spruce it up.[29] When it came time to collect the money from the gallery's backers, however, the funds weren't forthcoming, and all seemed lost—most especially Tibor's remaining pittance. "Out of nowhere, Dwight Ripley appeared, an absolutely brilliant person; poet, artist, botanist, and a great collector of art," Tibor said.[30] He agreed to pay the rent—which he continued to do for six years.[31] The British-born, Oxford-educated Ripley, who "looked and acted like a handsome international playboy," lived upstate with fellow botanist Rupert Barneby. He had been thinking about opening a gallery (and had discussed it with Clem) since Peggy left town in 1947.[32] Funding John and Tibor saved him the trouble of doing so.

The gallery was rented and ready, but neither John nor Tibor knew quite how to proceed. John sought advice from both Clem and Lee, and on at least one occasion Clem and Lee together in Lee's kitchen.[33] "It was Lee Pollock who said to me, 'Look John, the most important thing you can do *now* is show the artists who really need to be shown, and who are available and who show the most talent.... Don't try to take on people that have already made some sort of name.'"[34] John didn't listen. "I absolutely went ahead and made mistakes." After several "disasters," John went back to Lee and Clem for advice and heard the same refrain: Show younger artists.[35] John got the message. The Tibor de Nagy Gallery would become the home of the Second Generation of the New York School.

In histories of the New York School, a question has often arisen as to whether the designations First Generation and Second Generation are valid. Many of the younger artists bristled at the label "Second" because of the implied connotation of being somehow lesser. They also argued, correctly, that those kinds of clear generational divisions were simply not recognized among the artists at that time. De Kooning in 1950 was forty-six, Pollock thirty-eight, Larry Rivers twenty-five, Al Leslie twenty-three. Lee Krasner was forty-two, Elaine thirty-two, while Grace was twenty-eight, and Helen twenty-one. And yet all of them worked together, socialized together, and formed a community.[36] But there *was,* in fact, a clear and undeniable difference between, say, Lee and Bill's generation, and Grace, Helen, Al, and Larry's. This difference informed their art and therefore justified—for art history's sake if nothing else—a distinction.

The elder artists were immigrants or the children of immigrants. They had experienced the Depression as adults and had been part of the foundational Federal Art Project. They had been stirred to political idealism by the Spanish Civil War and had been introduced as young men and women to the Communist Party, not as the villainous group portrayed postwar but as an (at least for a time) heroic alternative to capitalism. They had begun painting when the Museum of Modern Art and the Whitney did not exist; when art was a product of Europe, like French wine or Swiss chocolate, and they were introduced to it through pictures in French journals they could not read. They had had to convince themselves and the greater art world that there could *be* such a creature as an American avant-garde artist. They had, in other words, started at zero, creating their own artistic expression and a community in which to keep that expression alive.

By contrast, Grace, Helen, Al, Larry, Nell Blaine, Jane Freilicher, Pat Passlof, Harry Jackson, and Bob Goodnough, among others, were American by culture and temperament. They tended to be better educated; some had even gone to college. Their version of the Project had been the GI Bill. European art had been accessible to them from the start in museums and galleries. They had been children during the Depression, and while their lives had been difficult, they had not been responsible for their own survival. Their generation's social trauma had been the war. They were the cannon-fodder generation. The elder artists who had gone to war did so mostly as officers, intelligence men, illustrators, mapmakers—roles that largely kept them off the front lines. (Milton Resnick was the dramatic exception. But he, like Elaine and Franz Kline, straddled the two generations and didn't fit exclusively into either.) The younger generation had been in combat and, having dodged death (and lost friends), they had returned both more serious about what mattered in life and less burdened by the cares of bourgeois existence. All of them—men and women—had experienced war-related rupture to varying degrees: dislocation, divorce, despair, disillusionment. And, of course, fear. Fear because they had reached adulthood at a time when they could not be sure of tomorrow. Their general attitude when the war had ended, and the horrors and sacrifices associated with it had been swept under the rug, was "fuck it." Fuck all of it.[37] In a journal entry during that period, Elaine wrote,

> For the bureaucrat, reality is found in...the radio with the advertisements that make claims that he accepts as false. Reality is the baseball game, Hollywood, Washington, D.C. Reality is conspicuous consumption. All of this, in short, is the reality that someone else has made for him.
>
> This to the artist is unreality...

The bureaucrat submits to, and if he's clever, learns to control forces outside himself. The artist doesn't fight them. He doesn't have to. He can ignore them.... He didn't rebel against the world. The world rebelled against him and he didn't notice, except as one notices a fly that stings.[38]

The younger artists had the energy and idealism to make the most of their brave new landscape. "They weren't at all like the older generation, who were much more sober," said John Myers. "[They] were totally opposite, much more swinging."[39] And that suited him just fine.

In the fall of 1950, John set out to find the artists on the lists Clem and Lee had given him. "I had a phone call at my Essex Street loft from John Bernard Myers, talking like a manic typewriter about a new gallery," Grace recalled.[40] He described it as "'a rather small space, but you'll *love* it. This wonderful Italian architect, Roberto Mango, designed it. *It's heaven!*'"[41] John's words "art," "color," and "beg pardon" emerged as "aht," "culuh," and "beg pahdon." He spoke precisely but dramatically. His sense of urgency precluded the possibility of answering no to his request to come and see her work. Not that Grace would have said no anyway. "In 1950 I had shown my paintings to Kootz, Parsons, and Egan, none of whom, though encouraging, would exhibit me,"[42] she explained.

Grace had painted feverishly during that year, and her art had lost the timidity of her Mexican abstractions. In the vast studio she shared with Al, Grace's paintings had grown in size and expression, despite the fact that she couldn't afford good paint or fresh canvas. It was a testament to her determination that she found a way to paint regardless of her poverty. Wearing a man's army jacket, blue jeans cinched at the waist with a man's belt, and work boots, Grace trawled the streets looking for other painters' discarded canvases and stretchers, which she pulled out of the garbage, repaired, and painted over. She used house paint instead of artists' oils because she couldn't afford to be as free as she had to be with costly tubes.[43] "Most of her waking hours were spent painting large, dashing canvases," John said later. "*Not* painting bored her to distraction."[44] Indeed, by the fall of 1950 "not painting" for Grace was no longer an option. A look around her studio was evidence of that.

Months and Moons, a four-and-a-half-foot by nearly six-foot painting from that year roiled with thick black brushstrokes that swerved and dodged on the surface to contain bursts of white, red, pink, ochre, gray, and violet, and then dove back into the canvas to create depth and space. *The King Is Dead,* also from 1950, was Grace's tribute to Pollock's having "slain" Picasso.[45] At five and a half feet by eight feet, it was her largest painting to date. It was not a copy of Pollock but an adaptation. "I never

removed my touch from the canvas the way Pollock did with the drip," Grace explained. "But I went into the all-over concept, the continuum, no central image, no background—all the revolutionary ideas that were in the air."[46] *Kindergarten Chats,* a playful painting also from that period, was much calmer. Its green forms were blocklike, its hints at lettering childlike, its circular shapes recollected balls. *Kindergarten Chats* looked, much more than any of Grace's other paintings at that stage, like a reference to the joyful childhood her son might have had under more normal circumstances.[47]

To John's question, therefore, Grace replied yes, he could see her work. She had plenty that she was proud to show him. "I took a big gulp," Grace said. "I invited him the next day at noon."[48]

John was in a foul mood when he climbed the many flights at 25 Essex Street to visit Grace that first day. "Oh God, I was saying to myself, another female painter whose talent will belie her appearance." But when he reached the top of the stairs and saw Grace waiting for him, he was shocked. She was "tall, as 'fresh as in the month of May,' with what people used to call clean-cut, American good looks. She smiled and put out her hand to pull me up the last step."

"Isn't it a heavenly spot to live in!" she said. "Have a dill pickle."[49]

John entered to discover that Al Leslie, who was also on his list, was in residence and had just baked bread. "John was absolutely enchanted and proceeded to eat lots of bread right out of the oven," Grace recalled.[50] Instantly the three became friends (to John she became "my darling Grace" and "Grace Sublime"),[51] but more important than that, John loved their work. "Their pictures entered my brain so immediately and I felt such enthusiasm for who they were as people that I was certain their art would arouse other people in the same way," he said.[52] John had his initial gallery recruits, and he offered Grace the opening show: a solo exhibition on January 16, 1951. She would be the first of the Second Generation artists to be so honored.[53]

Grace decided for her initial exhibition to identify herself as "George Hartigan." The name, she said, was part of the "extraordinary" camp culture at John's gallery, where some of the men called each other by women's names. For herself, she settled on "George" as tributes to writers George Eliot and Georges Sand.[54] But John Myers found practical poetry in her decision. Helping her select her *nom de brosse,* he had declared triumphantly, "darling you won't have to change your monogrammed sheets!"[55] Grace embraced the sexual playfulness and openness that she experienced at the gallery. In a letter years later, she said that the "wit, 'secret life,' and courage" of John and her other gay friends "appealed to everything in me that the bourgeoisie had tried to repress. Here were men having FUN.

And making gay (the word had the original meaning then) life in the middle of poverty."[56]

That John had selected Grace for his first show indicated that he had no qualms about exhibiting women.[57] In fact, his decision was a matter of gut. "I don't know who's going to turn out at all. All I know is I can identify with something that's alive and kicking and might be going someplace," John said, adding, "I can't get involved in the future. First of all, there may not be a future."[58]

Given John's attitude, the strides Helen had made in her work, and the fact that he and Clem had discussed artists for his gallery in front of her, it was curious that Helen was not among the artists Myers initially recruited. The reason was that Clem had discouraged him. He didn't think Helen was ready, and in later years she said she was "very grateful" to have been excluded. "I hadn't been painting out of college long enough," Helen explained. "I also met John through Clem, so that both Clem and I didn't want me to enter any art world situation that was in a sense connected with him."[59] That changed, however, after John saw Helen's oil, sand, plaster of Paris, and coffee-ground painting *Beach* in Kootz's *Fifteen Unknowns* exhibition in December. Defying Clem's wishes, John went to Helen's studio on 21st Street, looked at the stacks of paintings around her, and recognized that "Clem's girl" was a courageous artist, even at the tender age of twenty-two. During that first visit he did not invite her to join his gallery, but by February he would.[60]

The year Helen became a Tibor de Nagy artist, 1951, would be the New York School's "coming out" year. It began with an introduction to the public—once again—in the pages of *Life*. The American people (or at least *Life*'s five million readers) had been aware of the existence of an American avant-garde since 1949, when Pollock first leaned against his painting *Summertime* in a two-page spread, daring readers to enter the place where his soul resided. But it wasn't until January 15, 1951, that a wider cast of New York artists was introduced to subscribers. The group picture a *Life* photographer had shot the previous November of fifteen painters was finally published under the name the *New York Herald Tribune* had assigned them: the Irascibles.[61] The timing of the publication was to coincide with the Met show of so-called modern art that had sparked the artists' protest in the first place. As predicted, that exhibition did not reflect the true state of contemporary American art because it failed to include those painters and sculptors at the cutting edge of it. *Life* readers may have been shocked to finally see the individuals identified as "irascible," whose works were supposedly so outrageous they weren't fit for popular consumption and might very well be a national security threat. The artists—

among them Pollock, Bill, Rothko, Motherwell, and Hedda Sterne—looked positively benign. Dressed in suits and ties, with Hedda in a coat, prim hat, and carrying a purse, all of them were middle-aged and, though most wore a scowl, seemingly normal, if not slightly dull. But even that reassuring portrait did not bring them acceptability, much less respect.

Luckily for the downtown artists of both generations, a show opened in early January that put their lives and their work in perspective. It honored the first man among them who had been martyred to their cause. The Whitney on Eighth Street had opened a Gorky retrospective that bathed them all in his wonderful, crazy, heroic light. It was as if an old friend had returned to remind them to ignore the world outside their studios and small community. They were part of a grand tradition: They were *artists,* and it was their curse and their blessing that their work would be abused and ignored. "Gorky reduced personal tragedy—his own or anyone else's—to the level of discomfort or irrelevancy," Elaine wrote, "and in the light of his lack of sympathy, any misfortune lost its magnitude."[62] Celebrate ignominy, Gorky's work shouted from the Whitney's walls. Embrace alienation. If it ultimately kills you, no matter, the most important part of oneself survives, one's art, and it speaks to generations. As Gorky's friend John Graham had written, a great artist is "an enemy to the bourgeois society and a hero to posterity.... Humanity loves its heroes served dead."[63]

Gorky's show drew all the artists. For the younger painters who had known only his legend, seeing dozens of works by the man was overwhelming. They, who were at the beginning of their careers, could see where an immediate ancestor had been at their age and where he had gone. It was almost like time travel. They could be in his studio in 1938, 1943, 1945, and at his side for his tragic end in 1948, all the while watching the steps he took until he was able to produce his masterpieces, works like *Diary of a Seducer,* or *How My Mother's Embroidered Apron Unfolds in My Life.* Helen was particularly affected by the exhibition, returning time and again to the works, which resonated with passion and pride and agony, and were replete with what Helen was not afraid to seek in her own work: beauty. Helen would always mention Gorky, a man she had never met, as one of her greatest influences. Later that year in a letter to Sonya she wrote, "I'd say that Jackson P. & Gorky's paintings are the only ones of a particular school that give me a real charge that might compare—somewhat—to the excitement I now get from seeing a really great old master."[64]

For those artists who had known Gorky, the exhibition was no less full of wonder. So much had happened since his death and being surrounded by his work again had a clarifying effect. It brought them back to the Jumble Shop, the Waldorf, to afternoons at the Met. Elaine, who wrote a long

tribute to Gorky in *ArtNews* to accompany the show, said every now and then when she walked through Union Square she caught herself looking for him, "for his long stride and dour face," forgetting he was gone.[65] The Whitney exhibition had brought him back, along with all the unrestrained love his friends had for him. Elaine returned to the show several times to "visit" Gorky. While walking through the exhibition one day, she had a battle royal with Fairfield Porter. Elaine tried to convince her old Chelsea friend of the importance of the man and his art. Fairfield couldn't see it and argued just as vehemently against Gorky. "We had a complete, thorough disagreement," he said.[66] But in typical Elaine fashion, rather than be angry over the dispute, she found Fairfield's argument so cogent that she told Tom Hess he should hire Fairfield to write for *ArtNews*. Hess did, launching Porter's long career as an art critic.[67]

Lee and Jackson, who had been in town since Jackson's show in November, also attended the January 5 opening.[68] There, Jackson came face-to-face with great works that, like his own, had been underappreciated and misunderstood in their time (even by Pollock himself) and had cost the artist who created them his life. Pollock believed that during Gorky's last years, when he was crippled by despair and ill health, he "was on the beam" and had painted his best works.[69] Still battered by the poor reception of his own last show, which had included some of *his* best paintings, Pollock may have seen himself in that same place personally and artistically.

That winter was Pollock's first season in the Cedar, and there was no better place for him to drown his sorrows than among his fellow painters in the sanctuary of a workingman's bar. (Lee despised the place and refused to set foot in it.)[70] He would stumble out each morning after a night there, poisoned by booze and furious over the hand that fate had dealt him. Jackson's favorite revenge was making three a.m. phone calls to Clem or to gallery owners, taunting them, threatening them, until he finally collapsed from the sheer exertion of his rage.[71] "I really hit an all-time low," Pollock wrote Ossorio that month, "with depression and drinking. NYC is brutal. I got out of it about a week and a half ago. Last year I thought at last I am above water from now on in—but things don't work that easily I guess."[72] If Jackson had hit an all-time low, that meant that Lee had, too. Her trip to Gorky's show would have taken her back to a better time. By that winter, though she socialized often, she was in many ways alone. She had been reduced to being the full-time minder of a stone drunk and was struggling again like a beginner to find herself in her work. That struggle required strength, and in those first months after Jackson fell off the wagon she didn't possess it.[73]

At the end of January, the Museum of Modern Art opened an exhibition, *Abstract Painting and Sculpture in America,* which included paintings by

Jackson and Bill. The show was in part an answer to the Met's "contemporary" exhibit, featuring works the Met curators had shunned and giving the artists who had created them the opportunity to express their ideas in a symposium titled "What Abstract Art Means to Me." In November, Alfred Barr had written a letter to the chairman of the Princeton University Art Department saying that the Abstract Expressionists had produced "some of the most original and vigorous painting ever to appear in this country. In fact, I would say that for the first time American painting is as good, if not better, than painting anywhere in the Western world."[74] Barr's ringing endorsement was not generally known. At that time the avant-garde artists considered themselves only slightly more accepted by the Modern than they were by the Met. It was Barr's reserved nature that was to blame for any misreading of his appreciation of their work. The January exhibition was evidence that if he was not fully converted, he was well on his way.

The show's private opening in the museum penthouse included a who's who of art world figures. Most importantly for Lee, some were the very people she and Jackson needed to secure their future. Elaine and Bill were also there. His 1950 abstract painting, *Excavation,* had been selected for the show, and he was to deliver a speech (on which he and Elaine were busily working) at the symposium the next month. The tension and excitement among the artists was palpable, and apparently too much for Pollock. He drank so much that he fell off his chair, and when he was asked to say a few words to the gathering he responded by fleeing the building.[75] Elaine watched as Lee, dressed in her best clothes, chased her loping and weaving husband through the museum and out to the street.

In the midst of all that drama—around Pollock and within Pollock—Lee was losing control. She said she felt as though she was "holding a comet by the tail."[76] Said painter Nick Carone,

> Lee saw from the beginning that he was something strange; she saw he was some kind of genius. This was a woman who would have staked her life on that; she fought the whole art world defending what she knew he was and what contribution he was making.... A woman taking care of such a man is not just feeding him and darning his socks; she's living with a man who might flip any minute. Think of the tensions she lived under! Lee knew she was dealing with a powder keg.[77]

Lee was not about to allow Jackson to go to an early grave like Gorky without a fight. She hunted around Manhattan for a therapist she hoped would be as effective as Dr. Heller and discovered a woman named Ruth Fox, who specialized in treating alcoholics.[78] However, neither Jackson

nor Lee had complete faith in her ability to help him or his ability to help himself. While they were in New York that winter, Jackson wrote out a will stating that in the case of his death everything he possessed, including all his work, would go to Lee.[79] Maybe that act was a result of the Gorky show, too. Gorky had also been in a downward spiral, and then, in a moment, he was gone.

January 16, the day after the Irascibles photo appeared in *Life,* and on the margins of events great and small affecting the First Generation, Grace's show opened at Tibor de Nagy Gallery.[80] Much to Grace's delight, a reviewer acknowledged that the ten works on display had "progressed a long way" since her first appearance in the *Talent, 1950* show. "Rhythms are faster, more complicated. Each work now seems surer, more self-contained."[81] The opening did not draw a huge crowd, or even a big one, but it did include Grace's artist friends and family, and people from John Myers's extended orbit.[82] Among those was Living Theatre director Judith Malina, who wrote in her diary that Grace's "brush work is bold and her compositions complex. Her sensitivity is female, but she paints with a vigor that men claim as exclusively masculine." Malina also noted that Grace showed as "George Hartigan," and attributed that decision to the "prejudice against women painters."[83]

The suggestion that Grace adopted the name "George" to hide the fact that she was a woman, which has been repeated by historians through the decades, annoyed Grace until her dying day.[84] "That never entered my head," she fumed.[85] Grace was in no way ashamed of being a woman, nor was she fearful that she would be discriminated against if she was identified as one. Anyone coming to the show and looking for "George" would not have confused Grace with a gentleman. She wore men's work clothes when she painted, but she prided herself on being "all woman" when she went out at night. (She was so successful that John said men's "nostrils flared" when she entered the room.) And the only critic writing about her show referred to "George" by the pronoun "her" in his piece.[86] "To be truthful I didn't much think about being a woman. I thought about how difficult it was to paint," Grace said.[87]

> You know, you don't go into the studio and say, "Oh here I am this marvelous heroine, this wonderful woman doing my marvelous painting so all these marvelous women artists can come after me and do their marvelous painting." There you are alone in this huge space and you are not conscious of the fact that you have breasts and a vagina. You are inside yourself, looking at a damned piece of rag on the wall that you are supposed to make a world out of. That is all you are conscious of. I simply cannot believe that a

man feels differently.... Inside yourself, you are looking at this terrifying unknown and trying to feel, to pull everything you can out of all your experience, to make something. I think a woman or a man creating feels very much the same way. I bring my experience, which is different from a man's, yes, and I put it where I can. But once that is done, I don't know if it's a woman's experience I'm looking at.[88]

The gallery's nurturing atmosphere helped Grace overcome whatever disapprobation she experienced socially and whatever disappointment she felt personally when her show came and went with just one sale—that was returned! A young man had purchased a painting for seventy-five dollars, but his mother wouldn't have it in the house so his parents came back to the gallery and asked for a refund.[89] "The thing about all this is that John's style made everything witty and wonderful: there was never any room for self-pity," Grace said.[90] "John Myers and Tibor not only exhibited me but believed in me."[91] To an artist like Grace, at the start of her painting life, that was as good as a sold-out show.

In fact, nothing at that point could douse the spirits of the younger artists coalescing around John's gallery, the Cedar, and the Club. Even the dramas of their elders only made their endeavors seem more romantic. "It was mostly the osmosis of being around everybody and the excitement of the tremendous energy that was going on and the tremendous achievements," Grace said. "That was what was in the air."[92] Though Helen essentially lived with Clem on Bank Street, the apartment she now shared with Gaby Rodgers at 470 West 24th Street had become a hub for the fledgling Tibor group and their older First Generation friends.[93] Helen's building had a swimming pool, and so a motley assortment of art world figures would gather two or three times a week to "swim and tell stories, bad jokes and have dinner," according to Al.[94] And when they weren't at Helen's or Clem's or the bar or the Club, they were in one another's studios, talking about their work. And when they weren't talking about their work, they were doing it. Their lives had meaning. They had each other. It was, to quote John Myers, simply "marvelous."[95]

Joan

29. Painted Poems

> I don't think I've gone anywhere. It's all with me. Sort of packed in the suitcase. Only, the suitcase gets bigger.
> —Joan Mitchell[1]

BARNEY ROSSET WAS not a patient man. He was too aware of time, of its passage and its demands. He had too much creative energy.[2] As he looked out the second-floor window of the eleven-room villa he and Joan had rented in the French Riviera village of Le Lavandou, he didn't see the aquamarine Mediterranean lapping in the distance, or the mimosa and palm trees that had animated generations of painters from Utrillo to Matisse, and fed the imaginations of writers like André Gide and Jean Cocteau. He was nearly blinded to the area's charm by his isolation, and the feeling that life was passing him by. When they had arrived at the seaside from Paris, Barney had vaguely thought he would write, that he would try for a style like Hemingway's, and he sat at his typewriter day after day tapping out words until he had three hundred pages of them. But mostly, he spent his days looking out the window, thinking about New York. That was where he believed he ought to be, making movies.[3] The frustration he felt only increased because he knew Joan was downstairs relentlessly pursuing *her* passion. "She couldn't stop herself," he said with a mixture of awe and exasperation. "*She could not stop.*"[4]

Joan had taken over the living room on the floor below and turned it into a studio where she painted works Barney neither understood nor appreciated.[5] He was consumed with notions of social justice and politics. For entertainment, they had a radio and listened to the news out of the States. It was 1949, and government cold warriors were raiding libraries for suspect material. Books that had been considered classics were being removed because they were thought to contain subversive messages. Energized by outrage, Barney wanted to be able to do something—fight the system, expose the lie. From his perch in a Côte d'Azur villa, however, he was impotent. But Joan wasn't. She could be, she *should* be more political in her painting. "I tried to make Joan into a Socialist Realist," he said. "Then I began to understand that I didn't understand what she was doing. She was very powerful, believe me.... You couldn't keep her down."[6]

The year before, after graduating from art school in Chicago, Joan had moved to Paris in search of a way into the abstract art practiced by the

European masters she admired. But the dislocation from the States had unnerved her, as had the postwar miseries of rationing and strikes. Most of her time was, by necessity, spent trying to survive, with any residual energy dedicated to painting.[7] She needed more, though, than warmed-over vitality and scraps of time. Joan needed to be able to work unimpeded by life's demands to make the changes on her canvas she could feel but not yet execute. "I had painted terribly that year in Paris, semi-abstract stuff," she said. "I remember the last figure I did. I knew it was the last figure I would ever paint. I just knew. There were no features, and her arms were...rudimentary. I knew that was it."[8] Eliminating the figure, however, would be the easy part. With what would she replace it? That involved internal exploration that Joan didn't have the strength to begin. The penetrating damp of her Latin Quarter apartment had finally made her sick. A doctor told her the only way she would recover was if she quit the city for someplace warm.[9]

After much soul-searching about leaving the States, Barney had arrived in Paris in November 1948 to be with Joan. They had been lovers for two years, and the intensity of their relationship, especially on his side, had only increased with time. By leaving New York and his film projects there, Barney had essentially declared he would take whatever road Joan needed to travel and, within two months, that meant heeding her doctor's advice and heading south. With Barney behind the wheel of his Jeep station wagon, the pair set off for the Mediterranean coast.[10]

As they approached the sea, they felt a mistral wind blowing, its violence seeming almost a sign, almost a welcome.[11] Once, Joan and two painter friends in Paris, Zuka Mitelberg and Shirley Jaffe, had asked one another what in their lives had first made them aware that there *was* such a thing as art. Shirley said it was the stenciled wallpaper in her apartment. Zuka recalled an icon of St. George in an Orthodox church. Joan said it was the wind she felt and watched from the balcony of her family's apartment overlooking Lake Michigan. "That was the first time she ever thought about art, the clouds and the sky and the wind," Zuka said. "She wanted to paint it."[12] Joan would often say she carried landscapes within her and that was what she had brought from her Chicago childhood to France: blowing wind and roiling water. Finding that combination at Le Lavandou would have made Joan feel comfortably at home. Only the color was different. Unlike gray Chicago, Le Lavandou exploded in rainbow hues. The scene around every corner was a painting, as if a great designer had created a space whose sole function was to inspire. Materially, thanks to Barney, Joan had what she needed to live. She felt restored. Joan set up her vast studio, stretched her canvases, and began to paint.

At the start, the only avenue into complete abstraction she recognized

was through Cézanne and Cubism, and so she began a series of what she called "Cubed up" landscapes.[13] Barney said he watched, first with dismay as Joan moved away from realism and deeper into what he considered to be frivolous abstraction, and then with fascination as those paintings increased in size and brilliance.

> So we were there all alone, and she was painting, and I gradually saw the forms began to change, it became less recognizable, and it was very exciting. I became aware of the importance of space in paintings, of the difference between a narrowing of the horizon going into infinity and...of trying to make the background come up to the foreground. Problems like that, which became much more important to her than any message, political message, whatever. And the culmination was that she was painting the boats, fishing boats, that were beached on the water, little rowboats, whatever, dinghies, and they gradually didn't look like boats anymore...and I thought it was marvelous.[14]

Relieved that Joan hadn't taken his advice and made her work overtly political, Barney exclaimed, "I mean, I almost destroyed her, made her into a Communist."[15] He had come to realize that abstraction made much more of a political statement than any literal story Joan might have told on canvas. In an age of repression, she had declared her freedom, even from his influence. Barney also recognized, in her intense struggle and in its results, Joan's genius. From the moment he first saw her, when she was an obnoxious fourteen-year-old and he a high school senior, he had suspected she possessed it.[16] Ten years later, watching her paint confirmed his hunch. And so, as Lee had done for Pollock, Barney, unbidden, assumed the role of Joan's protector. He knew her outward toughness masked an extreme fragility, and that the talent she possessed was as beautiful as it was rare. He had not written his Hemingway novel there in the dappled sunlight along the Mediterranean, but he had found himself a mission. Barney Rosset would watch over and provide for Joan Mitchell.

Having made the advance into abstraction that she sought, Joan realized it wasn't complete. She had eliminated a story from her canvas, but if one looked hard one could still recognize elements of real life: a boat's mast, a bicycle wheel. The work was still rooted in the world outside; it did not reflect the complicated young woman she was within. Yet she couldn't go any further on her own. Joan needed to be in a community of artists, looking at art—avant-garde American art, not the "Frenchy" stuff she'd studied since she was a girl.[17] While Barney was living in Brooklyn in 1947 making his first movie, Joan had seen the work of downtown artists, albeit

from the distance of a timid outsider poking around the edges of that world. Since then, however, she had heard more about the fervor around the Village.[18] Joan began to join Barney in dreaming about life in New York.

"It's time to go home," Barney finally declared.

"How will I carry all these paintings?" Joan asked.

"I will," he replied. "If we get married."[19]

They had talked about marriage for years. Joan had even fantasized about a Barney Rosset III whom she would simply call "III," but now that he was asking, she wasn't at all sure.[20] It wasn't that she didn't love Barney. She did and always would. He was the one man who understood her deeply. But she had once told her sister that before a woman married she should be certain that she had sufficient self-confidence and internal fortitude to make it on her own, and "only then is it safe to lean on someone else."[21] Joan hadn't reached that level of maturity. There were, however, practical considerations of which Joan's mother reminded her. In August she wrote,

> You said in another letter a short while ago that you didn't think you were ready for marriage "in the deep sense"... perhaps however, it would take more strength than you have to do without B. The alternatives would be drab. You don't want to live here and your allowance is too small for you to live comfortably in New York. You have become accustomed to B's companionship. Even the idea of another emotional entanglement must be at present distasteful.[22]

Joan told her mother that she might "close [her] eyes and do it quickly,"[23] which is exactly what she did. To Barney's proposal of marriage, Joan responded with a tepid "OK."[24]

On September 10, 1949, the mayor of Le Lavandou pronounced twenty-four-year-old Joan Mitchell and twenty-seven-year old Barnet Lee Rosset Jr. man and wife. Perhaps as a gesture of thanks to the Americans who had not long before helped free France from Nazi occupation, the mayor added an untraditional coda to the wedding ceremony: *"Vive Chicago!"*[25] In fact, Barney and Joan were New York–bound. They had too much baggage to fly, so Barney booked a first-class suite aboard an Italian ocean liner sailing out of Cannes.[26] "The paintings went out by rowboat, and then we were brought onto the ship," Barney recalled. "All those god-damned paintings."[27] Actually, the adventure thrilled him.[28] He was pleased that their cargo comprised books and paintings rather than the trunks of mementos their fellow passengers had gathered during European tours. While others swanned around the deck in elegant dress as if attending a nine-day party, Mr. and Mrs. Barnet Rosset played chess, drank and smoked excessively, and made love.[29] Meanwhile, gossip columnists back home in Chicago

worked overtime to rush into print the news that a local socialite had been married along the Med.

"Riviera Romance for Joan!," a *Chicago Sun-Times* headline read nine days after the marriage. Joan, it said, might be "the secret bride of Barnet Lee Rosset Jr."[30] "The Smart Set" columnist, Cholly Dearborn, explained the unusual marriage away from friends and family to readers in the rival *Chicago Herald-American:* "Joan never cared for society, being an independent and spirited young woman with plans of her own that included none of the social butterflying of her contemporaries in the young crowd to which she was born."[31] That air of mystery and rebellion made Joan great copy. She had been in the headlines in Chicago since she was a child. The city had watched her grow. It had, however, never understood her. Chicago was a city of eccentric individualists, but even in that environment Joan stood out as unique. In a letter to Joan after their relationship began, Barney described his regard for her.

> *You reduce, by comparison, almost every other girl I have known to a sort of a state of nonentity, triviality, and shallowness.... People like you are so rare that I don't think that they could compute any law of probability about finding anybody else like you kicking around in these here United States.... It is not every day that you find a new element in the firmament.*[32]

Joan was, and always would be, a star. But her light and her life would be forever shadowed by her sad and strange beginning.

Like Helen, Joan had grown up in an atmosphere of wealth and privilege. Her parents were both national figures: her mother, Marion Strobel, had been an editor of *Poetry* magazine, which was the country's foremost publication for the genre,[33] while her father, James Mitchell, was a medical doctor, renowned expert on syphilis, and the head of the American Dermatological Society. Evidence of her family's prominence in Chicago was visible in the very fabric of the city: her engineer grandfather, Charles Strobel, had designed bridges over the Chicago River, as well as the Chicago Stadium, which was the largest indoor stadium in the world.[34] Joan and her older sister, Sally, reigned as princesses within Chicago's white, Anglo-Saxon, Protestant community. They quite literally lived apart from and above the rest of society, especially after 1940, when Joan's father bought the tenth floor of a building on North State Parkway on Chicago's exclusive Gold Coast overlooking Lake Michigan and the glistening yachts docked at marinas along its shore.[35] When the family relaxed during the summer, their residence was an eight-bedroom villa at Lake Forest, Illinois, nestled among the estates of other upper-crust Chicagoans.[36] Materially,

Joan had everything she could have wanted. But unlike Helen, who was similarly well-situated, Joan had neither expressions of love nor, at the start, encouragement from her father. To Alfred Frankenthaler, Helen could do no wrong. To James Mitchell, Joan could do nothing right. His disappointment in her had begun with her very birth.[37]

James, or Jimmie as he was known, had been so sure his second child would be a boy that he wrote the name John on the birth certificate on February 12, 1925. His mistake acknowledged—but never accepted—he changed the name to Joan and then proceeded to ignore her.[38] For two years after Joan was born her mother (who had also wanted a boy) was ill and also largely disengaged, and so Joan's father hired nurses to take care of Joan and her elder sister, a cook and maid to feed them, and a driver to chauffeur them around town.[39] Joan's nurse was an abusive German woman who terrified her by her rigidity and by the horrific stories with which she filled the child's head.[40] Joan was born into the Chicago of Al Capone, when lawlessness in a city famous for its criminality was at a peak and was not confined to the gangster class. With disconcerting regularity, headlines featured stories on the kidnapping of children from prominent families.[41] Little Joanie, her large eyes framed by spectacles from the time she was three, was made aware—thanks to her good nurse—of the possible danger that existed for her and her sister.[42] (Joan said her father, his head covered in a black hood, had been taken to treat Capone's syphilis, though it is unclear if she learned that later or if she knew of it as a child.)[43]

When Joan's mother finally recovered sufficiently to attend to her children (with household help), there was still a large gulf between them. Joan's mother had emerged partially deaf and had to use an "ear trumpet" to hear.[44] "I felt she was very alone," Joan said. "I was very aware of that. I often tried to imagine what kind of silence must be inside a deaf person.... Have you been North, in the snow? In that silence you can almost hear?"[45] Quiet lines of verse seemed to compose the most important noise in her mother's existence. In fact, communication with Joan's elders in general was strained to the point of nonexistence. Joan said she didn't talk as a child, that at times she felt as though her mouth wouldn't work. And even among those who dared to speak, Joan remembered the whispered admonition *"Don't tell."* When her famous grandfather appeared at their apartment on Sundays, he and Joan never spoke at all. "He was very shy, I guess," Joan remembered. "He liked me. I didn't speak either."[46] Amid all of that silence, Joan began to express herself in two ways—in writing and in art. Her mother represented one of those activities, her father the other.

Marion Strobel's professional social circle included some of the best-known poets and writers of the day. "Everybody who was a poet of any

kind, or writer who came to the United States from Europe or anywhere, would always go to...Miss Strobel," said Joan's friend, Zuka.[47] The sumptuous living room of the Mitchell apartment and the family's dinner table might on any given night include Robert Frost, Carl Sandburg, Edna St. Vincent Millay, or Thornton Wilder (who read Joan and her sister, Sally, stories).[48] The poets' banter (they talked!) was wonderfully refreshing. There were none of the dark undertones that normally overshadowed the Mitchell table. Inspired by their presence, Joan tried her hand at poetry.

> *The last red berries hang from the thorn-tree,*
> *the last red leaves fall to the ground.*
> *Bleakness, through the trees and bushes,*
> *Comes without sound.*

The stanza was from a poem entitled "Autumn," which was published in *Poetry*. Joan wrote it when she was just ten.[49]

That same year Joan would also begin painting in oil using what she called a "violent" high note. "I never painted so bright again," she said. "All those reds and yellows."[50] The visual artist in her was nurtured, if one could call it that, by her father. Jimmie Mitchell was an amateur painter who Joan said drew like Toulouse-Lautrec.[51] Given his contradictory and antagonistic relationship with Joan over her interest in painting, it is possible that he was frustrated at not having been able to pursue art professionally. On one hand Joan's father introduced her to Chicago's outstanding museum—Joan saw the first major Van Gogh exhibition in the United States at the Art Institute of Chicago when she was eleven, after it had left the Modern in New York.[52] Jimmie also brought Joanie to the zoo to paint watercolors of the animals, or outside to draw alongside him from nature.[53] On the other hand, he denigrated what she produced, as if he had introduced her to art to have someone against whom to measure himself—triumphantly.[54] He had not reckoned, however, on either Joan's talent or her resolve.

Whatever Jimmie challenged her to do, she did and excelled. But there was never a congratulation, simply a new and higher bar. When Joan was eleven or twelve she felt "pressured to become, quote, a professional," to choose between writing and painting. Her father said if she were a "jack-of-all-trades" she would be "master of none."[55] Perhaps seeing in the choice an opportunity to please him, Joan chose painting. But Jimmie shot back, "You can't draw! How can you be an artist?"[56] In his litany of abuse he shouted, "You'll never speak French as well as I. You can't draw as well as I. You can't do anything as well as I because you are a woman." And, in the next breath, he accused her of acting like a boy, of moving like a boy.[57]

Emotionally battered and undoubtedly confused, Joan's need for her father's love was so great that she was prepared to do anything to earn it. Boy, girl, whatever he wanted her to be, she would be, and she would be the very best.

It was around this time that Joan's name started appearing in Chicago newspapers. No doubt the columnists who covered society were friends of her mother's and reported what Marion told them over lunch. For example, Joan's tenth birthday was marked with a lead in a gossip column that said, "Joan and [Abraham] Lincoln celebrate birthdays on the same day."[58] When she was thirteen her birthday was mentioned in the paper again, along with a list of her achievements and plans for her party.[59] But by the time she was fourteen the papers had something genuinely newsworthy to report about Joan. She had become a rising star on the competitive figure skating circuit. "Joan Mitchell is a name that someday we may all conjure with, for she's easily one of the most talented young figure skaters in this part of the country." The article also mentioned that Joan was an artist, a champion diver, and a champion tennis player.[60] Was Jimmie satisfied? Perhaps, but there was always the next competition ("I won plenty of athletic prizes for my parents," Joan would say) and in art, unending struggle.[61] Gradually, however, as Joan showed her father how terrific she could be, his esteem for her grew. Jimmie began taking Joan to the symphony once a week. He woke to take her to six a.m. skating lessons. He encouraged her and drove her with an intensity that bordered on brutality. She was not just Jimmie's child, she was his obsession.[62]

Joan's mother acted as a counterpoint. She saw in Joan what she herself might have become had she not married at twenty-seven a man eleven years her senior. When she met James, she was in the midst of an affair with the poet William Carlos Williams, and working as associate editor of *Poetry* under its legendary founder, Harriet Monroe.[63] It had been a free and poignant existence during those heady years in the early 1920s, when women's long fight for the vote had finally been won and flappers celebrated that occasion with new social and sexual freedoms.[64] As an adult, Joan would blame the men in her mother's life for stifling Marion. In an unsent letter to her sister, Sally, Joan wrote,

> *If she married for anyone at all it was for her father who couldn't bear her being a poet, working at Poetry & being unmarried & "bohemian." This is the side of Maw I have always felt you didn't understand & the side that both encouraged me & went frantic. To get out of the house & do it—i.e. painting—not society—& not marriage—she wanted for me & was terrified at the same time.... Maw gave me a lot.*[65]

When Joan was young, Marion tried to encourage her to relax, not to strive so hard—in short, to be a child. Joan recalled her mother saying, "'Why don't you have a good time, Joanie, why don't you just skate and have a good time?' It seemed very boring to me to do something for a good time because I didn't know how to have a good time."[66] Joan knew she was different from other children, and they frightened her. She hadn't been allowed to play games with them before entering school. Her activities had always been directed. "I wasn't allowed to waste what I got," she explained.[67] That constant sense of competition made her a social outcast. Feeling inferior to those around her, despite her accomplishments, Joan developed a shield of belligerence. By the time she was in high school, angry defiance had become her signature trait, as had foul language. Joan favored those words considered most unbecoming for a young lady— "fuck," "piss," "penis," and "balls" among them.[68]

Joan and Sally had attended the same school—the city's progressive Francis W. Parker—until Sally reached high school age. At that point Sally was enrolled at her mother's alma mater, Girls' Latin, the kind of school a young woman of their class would be expected to attend.[69] With nods of approval all around, Sally thereafter spent her time thinking about boys, parties, and what to wear. When Joan reached high school age, however, she remained at Parker. Barney, who was also enrolled there, called the school the home of "crazy maverick revolutionaries."[70] Joan couldn't have fit comfortably anyplace else, and even there she courted expulsion. Joan baited teachers, was thrown out of classes, cheated on tests, and bragged about it.[71] But with teachers she liked, she was an angel. She loved her French teacher, an actress named Helen Richard, who Joan said saved her life because the elder woman taught her passion.[72] But most especially Joan loved her art teacher, Malcolm Hackett. Hackett was in the mold of Pollock before anyone had heard of Pollock. He dressed like a workman, drank far too much, and fought hard and often. He had perfected the snarling disregard for society that Joan had only begun to practice. Hackett taught his students about technique and also about the life of an artist. Among his rules: Artists should only allow themselves to be influenced by the greatest artists. Art is not a career, it is one's essence. And an artist, if serious, should expect to suffer and be poor.[73]

Barney Rosset was a senior at Parker and embodied all the things Joan was not. He was gregarious, engaging, interested in everything—not for the sake of mastering it but because of a voracious appetite for knowledge. A star athlete in track and football, Barney was class president, as well as a member of the radical national American Student Union and editor of a publication called *Anti-Everything*.[74] He was also successful with women,

the classic "great guy," who was good-looking but not handsome, athletic but not buff, bookish behind his horn-rimmed glasses. In addition, Barney was the only child of a very wealthy man. His father was head of Chicago's Metropolitan Trust investment bank, but he had other less upright business ventures, including being co-owner of the Hotel Nacional in Havana, which was a favorite among movie stars and mobsters.[75] He was also involved in business adventures with FDR's eldest son, James "Jimmy" Roosevelt, who operated at times on the edge of propriety (sometimes along with Joseph P. Kennedy Sr.) and was accused of having links to the Mafia.[76] Perhaps what would have been most objectionable to Joan's parents was that Barney's father was Jewish. The Mitchells were anti-Semites. Jimmie, in particular, was an equal opportunity bigot: anti-Jewish, anti-black, anti-communist, anti-liberal, anti-intellectual.[77] Surveying his own parents and Joan's, Barney would later say, "Can you understand why I became a communist for a while?"[78]

Barney's high school world was fully occupied and yet he had noticed Joan. "She was in eighth or ninth grade, and I was four years older. Although I was very involved with the people in my own class, in every way from athletics to love, I still was always very aware of Joan—you had to be. She was a very strong force in every way...she came across as a highly unusual, very beautiful young woman."[79] The Rossets lived in a penthouse on Lake Shore Drive two blocks from Joan's family's apartment, and he kept track of her from that near distance.[80]

After Barney graduated and went off to college, he summoned his courage during a visit home to ask her out. There are two versions of their first date. Joan said Barney took her to see *Citizen Kane*. He said that was possible, but he recalled taking her to see *Gone with the Wind,* which had arrived in theaters in 1941. He and his friends had decided the film was racist "so I took her to see [it] as sort of a protest. We stood outside the theater with a kind of placard or something, which totally confused her."[81] Indeed it would have. Joan was a personal renegade but had not yet developed a political consciousness; she was still very much a child of the Gold Coast.[82] Part of the reason she was chauffeured around town was to spare her "contact with another 'race' on the bus," a precaution she apparently accepted.[83] Barney called Joan "reactionary politically."[84] After the film, he invited her for a ride in his father's speedboat on Lake Michigan. Their relationship, however, didn't jell. "She just seemed absolutely at a distance. I couldn't really converse with her," he explained.[85] Barney left town for UCLA intending to study film. Instead, he went to war. The Japanese had attacked Pearl Harbor.[86]

The impact of the conflict was felt almost immediately, even at the Parker School, where desks emptied as the older boys enlisted to fight. Joan's boy-

friend in 1941 was a classmate, Timothy Osato, whose father was interned in the "security" roundup of Japanese citizens. Distraught, Timmy abruptly left Joan and school to join the U.S. military and fight in the Pacific.[87] "I was very moved by it; all the kids going off," Joan recalled. "It was a *real* situation."[88] New faculty with foreign accents had also begun to appear, the men and women of the intellectual exodus from Europe. As elsewhere, life changed drastically in Chicago, even for one as insulated from reality as Joan.[89]

In January 1942, during Joan's last year in high school, her competitive skating career earned her the title "Figure Skating Queen of the Midwest" and a chance to try for the national title. The U.S. Figure Skating Championships were held in Chicago, and she was the hometown star.[90] The pressure could not have been greater. Not only would Jimmie be watching, but everyone who had followed her career in the Chicago newspapers and seen her pictures splashed across those pages would be waiting for her crowning triumph. During the second stage of the competition, however, Joan fell and injured her kneecap. Her power and poise evaporated. She couldn't recover. When the event ended, Joan finished a disappointing fourth.[91] At seventeen, her skating career was over—as was her life in competitive sports. Given her drive to win, it's impossible to imagine that Joan deliberately sabotaged herself. But at that critical moment, when the world around her had grown very dark and when she herself was moving into adulthood, her days of performing—primarily to please her father—had conveniently come to a crashing halt. Her public shame had freed her from being jack-of-all-trades, master of none. She told Jimmie, "I've won my last medal for you, Daddy."[92] Joan would now do one thing, and do it well. She would paint. Though she had hoped to attend art school, her father said she was too young. "I wanted to go to Bennington, but [he] said that was too arty." Joan enrolled at Smith College and left for Massachusetts in the fall of 1942.[93]

Two thousand women were on the Smith campus, and many had donned navy uniforms. They were being trained for the newly formed all-female unit called WAVES.[94] The aura of privilege that normally pervaded the campus had changed into one of purpose. Smith women were not to be frivolous at such a time but were to serve their country in any way they could while still getting their education. Some volunteered to dig potatoes at local farms. Joan volunteered at a hospital for the mentally ill.[95] Smith would help her mature as a woman amid that national crisis, but she found to her dismay that it would be of no help whatsoever in her development as an artist. Joan had to declare herself an English major because there was no major in visual arts, and during her only art class she struggled to draw in the classical style being taught. She received a B-plus for the course, which she deeply resented.[96]

Stymied and disappointed, Joan took out her frustration on those around her, annoying and antagonizing her teachers and fellow students, and ridiculing others—particularly their appearance—as mercilessly as her father had done to her. In addition to denigrating Joan's art, Jimmie Mitchell had disparaged the way his daughter looked. And, if he had not dissuaded Joan from painting, he succeeded brilliantly in convincing her that she was ugly.[97] Of course, she was not. Irving Sandler, who a decade later would be the first writer to publish an important piece on Joan, called her "gorgeous."[98] After her skating days ended, her body became at once lithe and voluptuous. She had a slim, boyish figure and full, magnificent breasts. Wearing her favorite costume—a trench coat—Joan had an aura of toughness and glamour, like a gun moll or a spy. Her eyes were penetrating and her expression stormy, pensive, deep. Until she smiled. When joy cracked her troubled surface, Joan was glorious. But she didn't believe it, and so she viciously attacked the women around her for their physical imperfections to draw attention away from what she perceived to be her own.[99]

Joan's time at Smith was unhappy. She was not where she wanted to be or the person she had hoped to become—a committed artist. That was perhaps part of the reason her summer sojourn at an art colony was so liberating. Joan would remember it as one of the happiest periods of her life.[100]

Oxbow, in Saugatuck, Michigan, was an outpost of the Art Institute of Chicago, which offered a mix of drawing and painting from a live model, and drawing and painting from nature. But what intrigued Joan most was painting from a live model *in* nature. "We painted outdoors in the field with the trees behind," Joan said. "A very strange experience, painting the nude outdoors. Exciting and beautiful. There was a model, Cleo, with a marvelous body, like a Renoir. She posed by the lake." It was a midwestern version of Manet's *Le Déjeuner sur l'herbe*.[101] Immersed as she was in the one occupation she truly enjoyed, Joan did not attend what should have been a major event in her young life: her coming out as a debutante. Though Joan's name appeared on the list of young Chicago girls who were to make that feted transition into womanhood, she was AWOL.[102]

The workload at Oxbow was intense—up to nine hours a day—and all the students and teachers were in it together. At Smith, the interactions among the women on campus and the young men at nearby Amherst had been courtship rituals. At Oxbow, the men and women were art students who viewed each other as equals. If an attraction developed, as in the case of Joan and a fellow named Dick Bowman, it was because they admired each other's paintings. If they had sex, it was because it felt good.[103] There was one higher goal, and it was not marriage but art. Oxbow was Joan's

Lee Krasner, *Self Portrait,* ca. 1930
Oil on linen, 30⅛ by 25⅛ inches (76.5 by 63.8 cm). The Jewish Museum, New York; Purchase Esther Leah Ritz Bequest; B. Gerald Cantor, Lady Kathleen Epstein, and Louis E. and Rosalyn M. Schecter Gifts, by exchange; Fine Arts Acquisitions Committee Fund; and Miriam Handler Fund, 2008-32. *Photo credit the Jewish Museum, New York / Art Resource, New York. Copyright 2018 the Pollock-Krasner Foundation / Artists Rights Society (ARS), New York*

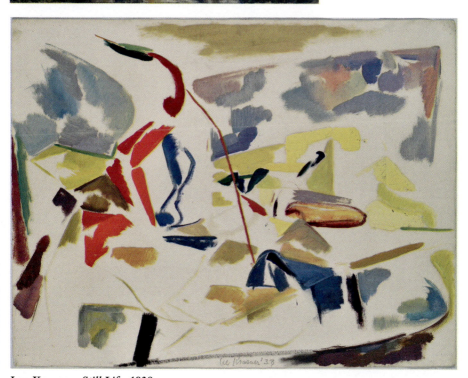

Lee Krasner, *Still Life,* 1938
Oil on paper, 19 by 24¾ inches (48.3 by 62.9 cm). The Whitney Museum of American Art, New York; Purchase in honor of Charles Simon, with funds given by his friends from Salomon Brothers on the occasion of his seventy-fifth birthday, and with funds from an anonymous donor and the Drawing Committee, 90.19. *Digital image copyright the Whitney Museum of American Art, New York. Copyright 2018 the Pollock-Krasner Foundation / Artists Rights Society (ARS), New York*

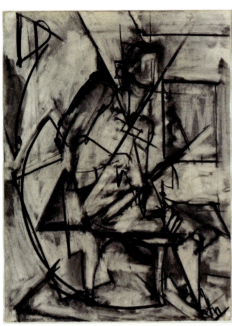

Lee Krasner, *Seated Nude,* **1940**
Charcoal on paper, 25 by 18⅞ inches (63.5 by 48.0 cm). The Museum of Modern Art, New York; Gift of Constance B. Cartwright, 134.1976.
Digital image copyright the Museum of Modern Art, New York / Licensed by SCALA / Art Resource, New York. Copyright 2018 the Pollock-Krasner Foundation / Artists Rights Society (ARS), New York

Lee Krasner, *White Squares,* **ca. 1948**
Enamel and oil on canvas, 24 1/16 by 30⅛ inches (61.1 by 76.5 cm). The Whitney Museum of American Art, New York; Gift of Mr. and Mrs. B. H. Friedman 75.1.
Digital image copyright the Whitney Museum of American Art, New York. Copyright 2018 the Pollock-Krasner Foundation / Artists Rights Society (ARS), New York

Lee Krasner, *Untitled,* **1948**
Oil on canvas, 30 by 25 inches (76.2 by 63.5 cm). The Metropolitan Museum of Art, New York; Gift of Mrs. Donald T. Braider, 1986 (1986.354).
Image copyright the Metropolitan Museum of Art, New York. Image source: Art Resource, New York. Copyright 2018 the Pollock-Krasner Foundation / Artists Rights Society (ARS), New York

Lee Krasner, *Black and White,* **1953**
Oil paint, gouache, and cut and torn painted paper, with adhesive residue on cream laid paper, 30 by 22½ inches (76.6 x 57.1 cm). The Art Institute of Chicago, Margaret Fisher Endowment 1994.245.
Image copyright the Art Institute of Chicago. Copyright 2018 the Pollock-Krasner Foundation / Artists Rights Society (ARS), New York

Lee Krasner, *Milkweed,* **1955**
Oil, paper-and-canvas collage on canvas, framed 84 by 59 by 1½ inches (213.36 by 149.86 by 3.81 cm); support: 82⅜ by 57¾ inches (209.23 by 146.68 cm). The Albright-Knox Art Gallery, Buffalo, New York; Gift of Seymour H. Knox, Jr., 1976.
Image courtesy the Albright-Knox Art Gallery / Art Resource, New York. Copyright 2018 the Pollock-Krasner Foundation / Artists Rights Society (ARS), New York

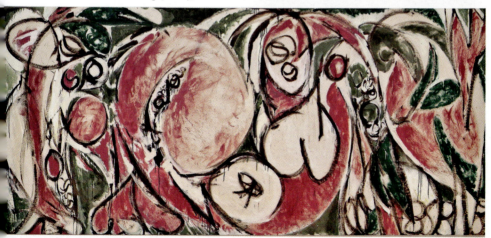

Lee Krasner, *The Seasons,* **1957**
Oil and house paint on canvas, 92¾ by 203⅞ inches (235.6 by 517.8 cm). The Whitney Museum of American Art, New York; Purchase with funds from Frances and Sydney Lewis by exchange, the Mrs. Percy Uris Purchase Fund and the Painting and Sculpture Committee, 87.7.
Photograph by Sheldan C. Collins. Copyright 2018 the Pollock-Krasner Foundation / Artists Rights Society (ARS), New York

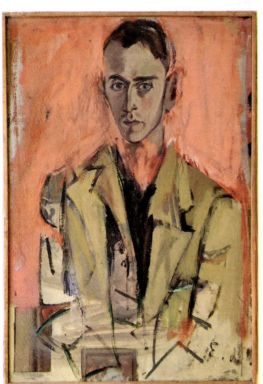

Elaine de Kooning, *Joop Pink,* **1946**
Oil on board, 33 by 23 inches (83.8 by 58.4 cm). Collection of John Sanders.
Image courtesy Timothy Greenfield-Sanders. Copyright Elaine de Kooning Trust

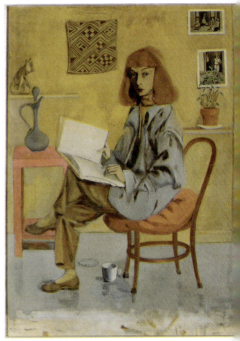

Elaine de Kooning, *Self Portrait,* **1946**
Oil on Masonite, 29¾ by 22⅝ inches (75.6 by 57.5 cm). The National Portrait Gallery, Smithsonian Institution, Washington, D.C.
Photo credit National Portrait Gallery / Art Resource, New York. Copyright Elaine de Kooning Trust

Elaine de Kooning, *Untitled, Number 15,* **1948**
Enamel on paper, mounted on canvas, 32 by 44 inches (81.3 by 111.8 cm). The Metropolitan Museum of Art, New York, Iris Cantor Gift, 1992.22.
Image copyright the Metropolitan Museum of Art, Image source: Art Resource, New York. Copyright Elaine de Kooning Trust

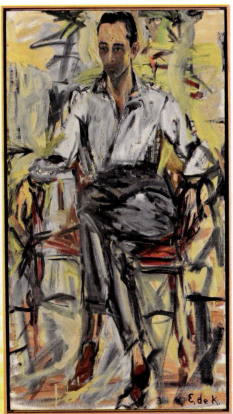

Elaine de Kooning, *Leo Castelli*, 1953
Oil on canvas, 54 by 30 1/16 inches (137.2 by 76.4 cm).
Nina Sundell Collection.
Photographer Larry Beck. Image source: The National Portrait Gallery, Smithsonian Institution, Washington, D.C. Courtesy Estate of Nina Sundell. Copyright Elaine de Kooning Trust

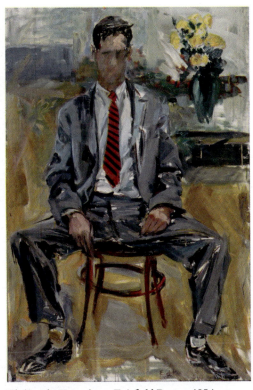

Elaine de Kooning, *Fairfield Porter*, 1954
Oil on canvas, 48 by 31 7/8 inches (121.9 by 81 cm). The Kemper Museum of Contemporary Art, Kansas City, Missouri; Bebe and Crosby Kemper Collection; Gift of the Enid and Crosby Kemper Foundation, 1995.22.
Copyright Elaine de Kooning Trust

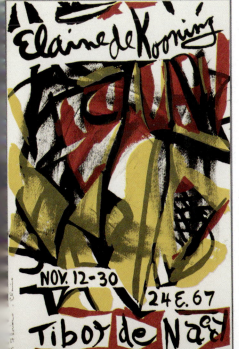

Elaine de Kooning, *Untitled* (poster for Elaine de Kooning exhibition, Tibor de Nagy, New York, November 12–30, 1957)
Screenprint with hand coloring on cream wove paper, printed at Tiber Press, New York, 20 by 13 inches (50.8 by 33.02 cm). The Frances Lehman Loeb Art Center, Vassar College, Poughkeepsie, New York, Dexter M. Ferry Collection Fund, 2007.22.
Image courtesy the Frances Lehman Loeb Art Center. Copyright Elaine de Kooning Trust

Elaine de Kooning, *Farol,* **1958**
Oil on canvas, 54 by 77 inches (137.16 by 195.58 cm). The Mint Museum, Charlotte, North Carolina.
Courtesy Levis Fine Art. Copyright Elaine de Kooning Trust

Elaine de Kooning, *Juarez,* **1958**
Oil on Masonite, 35¾ by 47⅞ inches (90.8 by 121.6 cm). Anonymous gift, 1983. The Solomon R. Guggenheim Foundation, New York.
Photo credit the Solomon R. Guggenheim Foundation / Art Resource, New York. Copyright Elaine de Kooning Trust

Grace Hartigan, *Six by Six,* 1951
Oil on canvas, 60 by 65¼ inches (152.4 by 165.73 cm). The Frances Lehman Loeb Art Center, Vassar College, Poughkeepsie, New York; Bequest of Agnes Rindge Claflin, 1977.23.5.
Image courtesy the Frances Lehman Loeb Art Center. Copyright Estate of Grace Hartigan

Grace Hartigan, *The Persian Jacket,* 1952

Oil on canvas, 57½ by 48 inches (146 by 121.9 cm). The Museum of Modern Art, New York; Gift of George Poindexter, 413.1953.
Digital image copyright the Museum of Modern Art, New York / Licensed by SCALA / Art Resource, New York. Copyright Estate of Grace Hartigan

Grace Hartigan, *Venus and Adonis, after Peter Paul Rubens (Flemish, 1577–1640),* ca. 1952
Oil on canvas, 40 by 40 inches (101.6 by 101.6 cm). The Frances Lehman Loeb Art Center, Vassar College, Poughkeepsie, New York; Gift from the Roland F. Pease Collection, 1997.11.7
Image courtesy the Frances Lehman Loeb Art Center. Copyright Estate of Grace Hartigan

Grace Hartigan, *Grand Street Brides,* 1954
Oil on canvas, 72 9/16 by 102 3/8 inches (184.3 by 260 cm). The Whitney Museum of American Art, New York; Purchased with funds from an anonymous donor, 55.27.
Digital image copyright the Whitney Museum of American Art, New York. Copyright Estate of Grace Hartigan

Grace Hartigan, *The Masker,* 1954
Oil on canvas, 72 by 41 inches (182.88 by 104.14 cm). The Frances Lehman Loeb Art Center, Vassar College, Poughkeepsie, New York; Museum purchase, 1954.9.
Image courtesy the Frances Lehman Loeb Art Center. Copyright Estate of Grace Hartigan

Grace Hartigan, *Interior, 'The Creeks,'* **1957**
Oil on canvas, 90⁷⁄₁₆ by 96¼ inches (229.7 by 244.5 cm). The Baltimore Museum of Art; Gift of Philip Johnson, New Canaan, Connecticut, BMA 1983.45.
Photograph by Mitro Hood, courtesy the Baltimore Museum of Art. Copyright Estate of Grace Hartigan

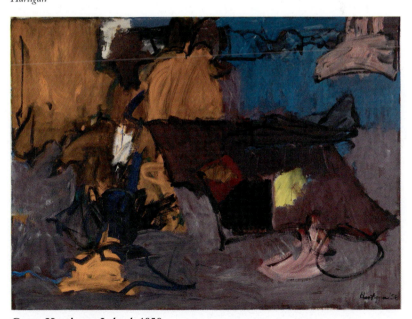

Grace Hartigan, *Ireland,* **1958**
Oil on canvas, 78¾ by 106¾ inches (200 by 271 cm). The Solomon R. Guggenheim Foundation, Peggy Guggenheim Collection, Venice, 1976, 76.2553.182.
Photo credit the Solomon R. Guggenheim Foundation / Art Resource, New York. Copyright Estate of Grace Hartigan

Joan Mitchell, *Untitled (Self-portrait),* **ca. 1947**
Graphite on paper, 10⅛ by 7¾ inches (25.72 by 19.69 cm). Collection of the Joan Mitchell Foundation, New York.
Image courtesy the Joan Mitchell Foundation. Copyright Estate of Joan Mitchell

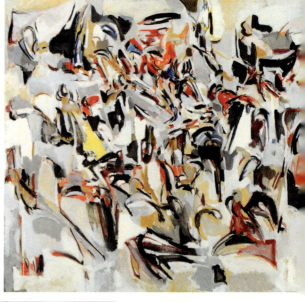

Joan Mitchell, *Untitled,* **1950**
Oil on canvas, 52½ by 54⅝ inches (133.35 by 138.73 cm). Collection of the Joan Mitchell Foundation, New York.
Image courtesy the Joan Mitchell Foundation. Copyright Estate of Joan Mitchell

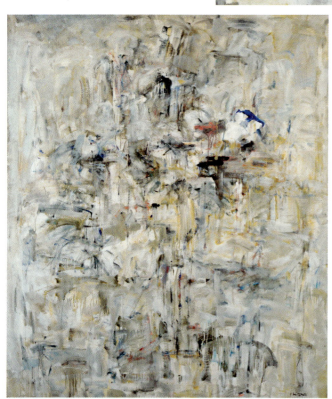

Joan Mitchell, *Untitled,* **1953–1954**
Oil on canvas, 81 x 69 inches (205.74 by 175.26 cm). Private collection.
Image courtesy the Joan Mitchell Foundation. Copyright Estate of Joan Mitchell

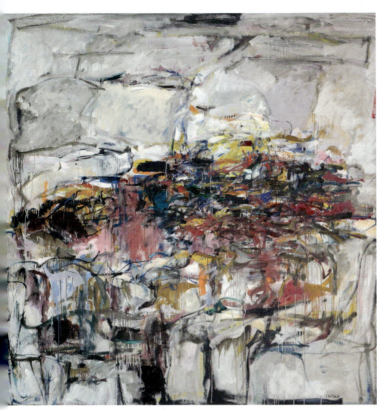

Joan Mitchell, *City Landscape,* **1955**
Oil on canvas, 80 by 80 inches (203.2 by 203.2 cm). Collection of the Art Institute of Chicago; Gift of the Society for Contemporary American Art, 1958.193.
Image courtesy the Art Institute of Chicago. Copyright Estate of Joan Mitchell

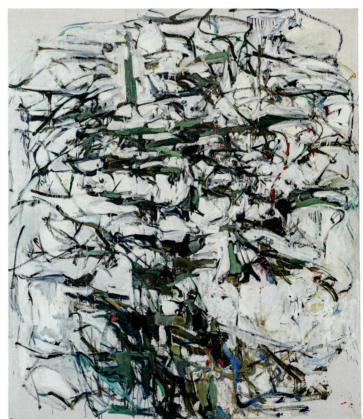

Joan Mitchell, *Hemlock,* **1956**
Oil on canvas, 91 by 80 inches (231.13 by 203.2 cm). Collection of the Whitney Museum of American Art, New York. Purchased with funds from the Friends of the Whitney Museum of American Art, 58.20.
Digital image copyright the Whitney Museum of American Art, New York. Copyright Estate of Joan Mitchell

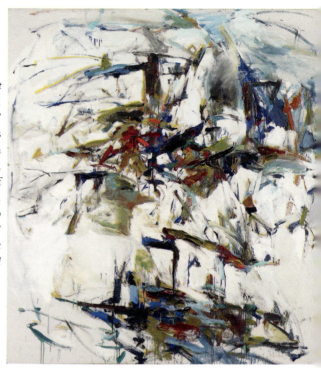

Joan Mitchell, *George Went Swimming at Barnes Hole, but It Got Too Cold,* 1957
Oil on canvas, 87¾ by 78¼ inches (222.89 by 198.76 cm). Collection of the Albright-Knox Art Gallery, Buffalo, New York; Gift of Seymour H. Knox, Jr., 1958. *Photograph by Biff Henrich. Photo credit the Albright-Knox Art Gallery/ Art Resource, New York. Copyright Estate of Joan Mitchell*

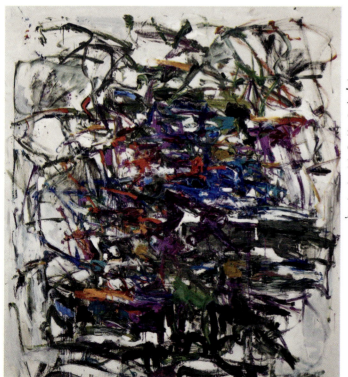

Joan Mitchell, *Cercando un Ago,* ca. 1958
Oil on canvas, 94¼ by 87⅝ inches (239.4 by 222.57 cm). Collection of the Joan Mitchell Foundation, New York. *Image courtesy the Joan Mitchell Foundation. Copyright Estate of Joan Mitchell*

Helen Frankenthaler, *Untitled,* **1951**
Oil and enamel on sized, primed canvas, 56⅜ by 84½ inches (143 by 214.6 cm).
The Crystal Bridges Museum, Bentonville, Arkansas.
Image courtesy Helen Frankenthaler Foundation. Artwork copyright 2018 Helen Frankenthaler Foundation, Inc. / Artists Rights Society (ARS), New York

Helen Frankenthaler, *Ed Winston's Tropical Gardens,* **1951**
Oil, enamel, and pencil on paper mounted on board, 37¼ by 191¼ inches (94.6 by 485.8 cm). Helen Frankenthaler Foundation, New York.
Image courtesy Helen Frankenthaler Foundation. Artwork copyright 2018 Helen Frankenthaler Foundation, Inc. / Artists Rights Society (ARS), New York

Helen Frankenthaler, *Mountains and Sea*, 1952
Oil and charcoal on unsized, unprimed canvas, 86⅜ by 117¼ inches (219.4 by 297.8 cm). Helen Frankenthaler Foundation, on extended loan to the National Gallery of Art, Washington, D.C.
Image courtesy Helen Frankenthaler Foundation. Artwork copyright 2018 Helen Frankenthaler Foundation, Inc. / Artists Rights Society (ARS), New York

Helen Frankenthaler, *Scene with Nude*, 1952
Oil and charcoal on sized, primed canvas, 42¾ by 50¾ inches (108.6 by 128.9 cm). Helen Frankenthaler Foundation, New York.
Image courtesy Helen Frankenthaler Foundation. Artwork copyright 2018 Helen Frankenthaler Foundation, Inc. / Artists Rights Society (ARS), New York

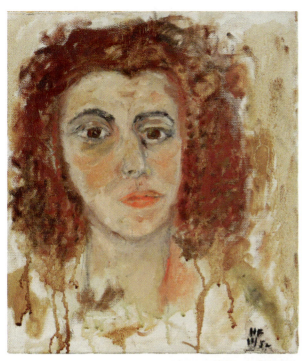

Helen Frankenthaler,
Self Portrait, **1952**
Oil on canvas, 16⅛ by 14¼ (41 by 36.19 cm). Helen Frankenthaler Foundation, New York.
Image courtesy Helen Frankenthaler Foundation. Artwork copyright 2018 Helen Frankenthaler Foundation, Inc. / Artists Rights Society (ARS), New York

Helen Frankenthaler,
Trojan Gates, **1955**
Oil and enamel on sized, primed canvas, 72 by 48⅞ inches (182.9 by 124.1 cm). The Museum of Modern Art, New York; Gift of Mr. and Mrs. Allan D. Emil, 189.1956.
Digital image copyright the Museum of Modern Art, New York / Licensed by SCALA / Art Resource, New York. Artwork copyright 2018 Helen Frankenthaler Foundation, Inc. / Artists Rights Society (ARS), New York

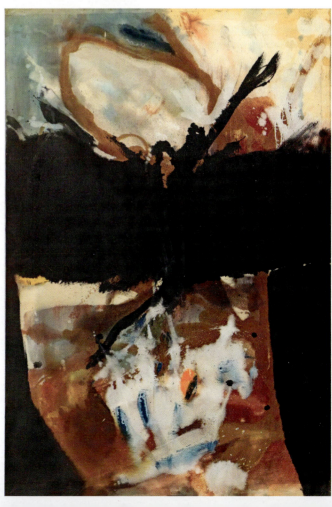

Helen Frankenthaler, *Hôtel du Quai Voltaire,* **1956**
Mixed mediums on paper, 15⅜ by 23¼ inches (39.1 by 59.1 cm). Helen Frankenthaler Foundation, New York.
Image courtesy Helen Frankenthaler Foundation. Artwork copyright 2018 Helen Frankenthaler Foundation, Inc. / Artists Rights Society (ARS), New York

Helen Frankenthaler,
Jacob's Ladder, **1957**
Oil on canvas, 113⅜ by 69⅞ inches (287.9 by 177.5 cm). The Museum of Modern Art, New York; Gift of Hyman N. Glickstein, 82.1960.
Digital image copyright the Museum of Modern Art, New York / Licensed by SCALA / Art Resource, New York. Artwork copyright 2018 Helen Frankenthaler Foundation, Inc. / Artists Rights Society (ARS), New York

first foray into such a supportive and free community, and the first time she was able to dedicate herself exclusively to painting. Predictably, she thrived there, though she had much work to do.

Joan had chosen painting as her "profession" when she was still a girl, but by the time she arrived at Oxbow at eighteen her works still had a Sunday-afternoon hobbyist feel to them: timid, representational, small, and pretty. They were modern, but in a late-nineteenth-century sort of way. Joan had seen enough great painting to know how far she had to go before she could dare to call herself an artist, and as the summer ended and she prepared to return east to college, she understood that Smith would not help her get there. One of her instructors at Oxbow, a one-legged German World War I veteran named Robert von Neumann, often talked about decisions, those made within a painting and those made in life. Joan made one that summer: "My decision to leave college was the decision that time is short. Time to become a painter.... One paints by painting full time."[104] Joan returned to Smith for one more year, during which she negotiated her return to Illinois and her enrollment in the School of the Art Institute of Chicago. She entered it as a second-year student in September 1944.[105]

Joan learned quickly. She spent hours, days, months roaming the Art Institute's superb galleries, which housed works of Western art representing periods almost up to that very moment. It was, Joan would say, "the real inspiration" for her development.[106] And when she wasn't looking, she was doing. During day-long classes, Joan worked from plaster casts and still lifes in studios as large as ballrooms, where, for almost a century, others had done the same, using the same tools—pencil, charcoal, or oil paint. In that environment, an aspiring artist could feel part of a grand continuum, as well as sheltered from the vagaries of the outside world. Joan found safety in the studio from life, from death, even from her father. (She would say that when she began doing abstract work she freed herself from her father. "He couldn't even criticize it," she said. "And then I felt so protected.")[107] Still, her situation was not ideal. Joan lived at home and was subject to Jimmie's tirades and attempts at control.

Not surprisingly, he did not approve of the woman she was becoming. By the time she was in art school, Joan was ashamed of her family's wealth, and yet so inured to it that she made only token gestures of rebellion. A chauffeur still drove her to school, but she made him drop her some distance away so no one would see. She favored wrinkled men's shirts and jeans—but wore them under a fur coat.[108] It was a confused and transitional time for Joan *and* her family. Perhaps realizing he could no longer dictate Joan's professional path, Jimmie tried to take charge of her social life. Joan was still seeing Dick Bowman from Oxbow. That scion of the middle class, even though he had had a show of paintings in New York,

was the type of man Jimmie loathed. He suspected Dick of being a mediocrity and told him Joan would not marry an artist "unless he was of the reputation and stature of somebody like Picasso."[109] Jimmie needn't have worried; Joan wasn't interested in Dick. Unbeknownst to her father, she had met someone else.

One night in late 1945, Barney was back home from the war and in his favorite Chicago bar, Tin Pan Alley. It had "Baby Dodds playing the drums and Laura Rucker, a blind woman, playing the piano," Barney recalled.

> You had to fall over them to get past them, the blind pianist and the old drummer. But they were wonderful. And at the end of this long bar, in the middle of it, was a staircase. And I was there, and I think it was around New Year's Eve. I saw this girl walking down the staircase from the ladies' room, and it was Joan. And this weird idea came into my head that I was going to get married to her. All I remember is I went up and I spoke to her that night, and that was it.[110]

Barney was not only not Picasso, he was objectionable to Jimmie Mitchell on every level. But importantly, not to Joan. He would be her bridge, a connection to her past that led to her future. In that future both of them, separately and together, would make history. Barney would become one of the most important American publishers of the twentieth century and Joan would be ranked among the greatest artists the United States had ever produced.[111]

30. Mexico to Manhattan via Paris and Prague

> Painting isn't about reality. It's about life.
> —*Elizabeth Murray*[1]

IN 1945, NOT long after the war ended in Europe, Joan packed her bags for a train trip to Mexico.[2] Her mother sent her off with good wishes for a safe journey—and a bribe. Marion told Joan, who was then twenty, that if she returned to Chicago without having contracted syphilis or become pregnant, she would give her a copy of that filthy book, *Lady Chatterly's Lover*.[3] Before Jimmie said his grudging farewells (he had been against the trip), he loaded Joan up with a veritable pharmacy: a duffel bag full of medicine, bandages, and purified water. Joan and her twenty-one-year-old companion, Zenaida Gourievna Booyakovitch Polonsky Omalev, known simply as Zuka, also carried easels, paints, and turpentine. "We traveled heavy," Zuka recalled with great understatement. Thus encumbered, and dressed in skirts, ankle socks, and saddle shoes, the pair boarded the train for a two-day journey through the midwestern plains and the southwestern desert to Mexico. The difficult trip offered no assurance of comfort at their final destination.[4] Joan, however, wouldn't have minded too much. She was thrilled to be traveling beside Zuka.

Joan had met her friend during her summer at Oxbow and was instantly intrigued by the tall, dark young woman. Zuka's parents had escaped Russia during the revolution and had settled in Hollywood. There Zuka's father worked as an extra in movies and formed a Russian theater company. At the University of Southern California where Zuka studied art (it was the nation's first university fine arts department), she met a teacher from Chicago who told her about Oxbow. Zuka decided to go. Nearly seventy years later, she still remembered the first time she saw Joan during a life drawing class there.

> We were sizing each other up because we were sort of the same age...to see if we were good enough to talk to. We decided we were. Then after the class, she said let's go swimming....She came out in her dark, gray, drab swimming suit and I was from Hollywood...I had a baby blue, two-piece bathing suit and we went into the water. She swam, I don't know how many yards, in perfect stroke. I went in, I could swim certainly but I wasn't out

to—she acted as though she was in a race or something.... You don't fool around. That was the beginning of our friendship.⁵

Joan's businesslike approach to swimming aside, she was captivated by Zuka. "I grew up in the theater practically," Zuka said, "and so that's what attracted Joan in me, my Russian side.... I could sing Russian songs and dance and... I was fun and funny." For her part, Zuka was fascinated by Joan. The Mitchells struck her as very sophisticated. Even the shocking language Joan and her sister used reminded Zuka of the British upper class, the kind of "snobbism" practiced by those so elevated they could say anything, secure in the knowledge that their stature would be undiminished. "And then they would drink. Here we were, twenty, nineteen, eighteen, I don't remember exactly, but we would have dry martinis, two dry martinis every night before dinner," Zuka recalled of visits home with Joan. "I would be absolutely on my ears... every night in this beautiful apartment overlooking the lake."⁶

Zuka told a story that illustrated the differences between the way she and Joan had been raised. When Joan's father taught her to ride a horse, he told her to hold magazines under her arms to keep her elbows tight at her sides so she would appear rigid in the saddle. When Zuka's father taught *her* to ride, he told her to keep her left hand on the reins so the right would be free to hold a saber.⁷ That wild daughter of the Russian steppes and that constrained child of American high society became best friends.⁸

The young women's first stop in Mexico was Mexico City. Joan had a letter of introduction to the famous muralist José Clemente Orozco. "It was pretty much a fiasco," Zuka recalled.

> He wasn't in the least interested in two young American girls in our saddle shoes.... My Spanish was pretty bad, but it didn't stop me. Joan only spoke in English, which he didn't seem to want to use. We did not try to see Diego Rivera nor Frida Kahlo, I'm embarrassed to say, because we had adopted the dumb attitude that they were NOT good or great painters at all, particularly Frida, who... we didn't even understand.⁹

Slightly shaken by their cold reception, they continued to their destination: the colonial-era town of Guanajuato in the mountains of central Mexico. Its draw for an artist would have been its mix of natural beauty and magnificent architecture. As Joan and Zuka soon discovered, Guanajuato was also a university town with a heady literary and artistic scene. They spent their days painting in rooms they had found in a former palace that functioned as a hotel, and at night they shared secrets, until they met

two young men who became their local escorts. "Hers was a darling poet, small and blond," Zuka said. "My boyfriend was a law student.... A group of professors and students would meet in the center of town at *'el estudio.'* The boys brought us there."[10] Joan indulged in a holiday romance with her young man, while Zuka's grew into something more serious. But both women fell in love equally with Guanajuato. For Joan, the experience was rich because she was independent. It was her world, hers alone.[11] She was in a constant state of excitement, and her work changed drastically in that new environment.

Joan began to absorb the landscape, the art, and the culture around her, and combine it with the European tradition she had learned so well. She didn't leap into abstraction. On the contrary, in Mexico Joan's paintings were very much in the "Socialist Realism" vein Barney would champion. Her work combined color and stylistic elements from the Mexican muralists; subject matter from the American Ash Can School; figurative expression from the German artist Käthe Kollwitz; along with Van Gogh's, Oskar Kokoschka's, Kandinsky's, and Cézanne's painterly interpretation of landscape. And, near the top of Joan's list of figurative influences was Picasso's Blue Period. Joan painted misery as beautifully as she was able. Her figures' heads and limbs hung in despair, her landscapes writhed in agony like the trees at Golgotha, or melted like a mirage. Those mutable landscapes may have also been influenced by events well beyond her Mexican sanctuary. She and Zuka had traveled to Oaxaca in August 1945. "I remember walking in the morning to the market," Zuka said, "and the newspaper vendor was running very excited on the street shouting *'La bomba atomica! La bomba atomica!'* "[12]

The 1945 trip proved so stimulating artistically and socially that Joan and Zuka did it again the following summer. The women began to feel integrated in Mexico. They had a circle of friends and a second, sunbaked home where they could be whomever they chose. Joan became a carefree version of herself, a character she named Juana.[13] That young lady had left Jimmie Mitchell's insecure Joanie far behind, though not her competitiveness. "Even though she hated competition, she was the most competitive person I knew," Zuka said. "She couldn't stand being at a dinner if she wasn't the most important person there. I was prettier, but men liked her better. Men always gravitated to her because she was daring and flirtatious."[14] In addition to Joan's Mexican poet boyfriend (who the gossip columnists in Chicago hinted was Joan's secret husband), Dick Bowman turned up in Guanajuato that summer, as did Barney.[15] Driving nearly two thousand miles without stopping to rest (though he did occasionally doze off dangerously behind the wheel), he had come to whisk Joan back home.[16]

Joan had been seeing Barney since they met again at Tin Pan Alley. It was a torrid affair that involved the backseat of Barney's Olds, late-night communications by walkie-talkie from the Rosset penthouse to the Mitchell suite, and flights through snowstorms in the small plane Barney owned with a friend.[17] There were also excursions into a world of jazz under the metallic canopy of Chicago's elevated trains. Barney had introduced Joan to that world in all its rich diversity: black, white, Jew, Gentile, man, woman, gay, straight. He was unlike any other man or boy she had known. He had experienced life. He was passionate. His every decision involved adventure. And he had anger to match her own (although in his case, it was not self-directed). They became that headiest of combinations. They were lovers *and* friends.

Barney's film studies at the University of California Los Angeles had been cut short by the reality of war. After Pearl Harbor, he had enlisted in the infantry, hoping to go to the front line. His superiors, however, had other ideas, and he was admitted to Officer Candidate School, from which he transferred as Lieutenant Barnet Rosset Jr. to the Signal Corps photo school in Flushing, New York.[18] Camera in hand, Barney was sent in 1944 to the conflict zones in China and India. Like any photojournalist, his job was to dispassionately document the war as it was being fought, and the terrible aftermath of those battles. Image after image recorded the horrors of which man was capable. In China, Barney's black-and-white pictures captured the largest and most intense Japanese land campaign of the war, Ichi-Go.[19] It was impossible to prepare psychologically for the magnitude of the destruction in a country the size of China: the pillaged villages, the streets strewn with bodies, the children wandering like stray dogs through hell.

Barney's military duty is often written about as though, because he was a photographer and not a fighter, he was somehow spared the fear and anguish of battle. He was not. Embedded among advancing Chinese troops meeting the Imperial Japanese Army, Barney went beyond his photographer's duties to smuggle Chinese guerrillas inside Japanese-controlled territory.[20] He told his parents in a letter from the front, "When you get orders you obey them/ and you don't let the enlisted men take all the chances. My outfit is the only ground forces Photo outfit in China and the pictures that we take will be the only historical record in existence when this thing is over."[21] The images he saw through the lens of his camera were seared into his brain, and when he returned to the States he showed signs of what would later be called post-traumatic stress. It remained with Barney into adulthood: He couldn't sleep, he didn't eat; eventually he would turn to alcohol and drugs. "He drank rum and coke, and martinis," said his future wife Astrid Myers Rosset. "Sometimes one drink in one

hand and another in the other. He also took amphetamines."[22] But that was in the future. When he arrived back in Chicago after demobilization in 1946, he sought solace in social justice and in Joan.

Barney had enrolled at the University of Chicago and became embroiled in political groups on campus and off, among them the American Veterans Committee (a pacifist alternative to the American Legion and Veterans of Foreign Wars) and the Communist Party. Gradually, he saw the futility of such endeavors, especially the Party. Though he subscribed to Marxism, he viewed its practitioners as ineffectual. "It drove me crazy!...Each member of the Party was supposed to sell fifty copies of the *Daily Worker* a week. I would take mine and throw them in the garbage can!" he said. "I mean, the idea of going through the South Side of Chicago among all these black families, and selling them the *Daily Worker*.... So I threw them away." Barney paid for the five-cent copies himself. "And then I was voted the *Daily Worker*'s best salesman. I had the best record."[23]

Barney's patience with organized protest exhausted, he became interested in using film to give voice to his own. Coming out of the military, he was shocked by the mistreatment of black veterans and the general discrimination against blacks in America. The war, he said, had been fought in the name of liberty, democracy, and rescuing humankind from its darkest self. And yet in America an entire race was oppressed and exploited, and expected to bear its heavy load if not with joy, then at least with gratitude. He decided to make a film about racial discrimination in America, which he would call *Strange Victory*.[24]

Barney's other occupation was converting Joan to radical politics. "Joan took from me a lot of political ideas and actually became quite politicized and eventually became a begrudging Communist," he recalled.[25] Joan's conversion would not have sat well with her parents. Perhaps Marion found the "Handbook of Marxism" Barney gave Joan, or realized her daughter was spending an inordinate amount of time in all the wrong places with a Jewish GI and social activist.[26] Marion was so concerned that Joan's relationship might be headed somewhere unpalatable that she called the principal of the Parker School to inquire about Barney. "Joan told me...that Herbert Smith said to the mother that I was the best student speaker he had ever encountered," Barney recalled, "but that I was a lame duck or a wounded duck, a wounded bird, or something, and would always be so. So, although again, it was very complimentary, it was also damning."[27] Her parents were frantic, but at twenty-one Joan could do what she wanted, and she wanted Barney. The Mitchells decided to invite the young man to dinner.

For Jimmie, having a Jew at his table was gut-wrenching, and he apparently decided to make the evening as unpleasant as possible.[28] Barney described the scene:

At dinner that night, [there occurred] one of the most peculiar table conversations that I've heard in my life, before or since. What I think he was doing was telling us about a cadaver.... It could have been about a live person, a man, I think, a patient, who had put lots of perfume on his pubic hair. And he went on at great length about it. About what kind of perfume it was. It was a hair tonic that you'd use on your head. And this guy had it on his pubic hair and it was very strong smelling and you know, we're all eating dinner.

That was the way he sort of spoke. It was out of context. It was insane, I thought. But in a very calm voice and nobody had any comments. What are you going to comment on?...Joan didn't have any strong reaction, so in other words, to her it was normal....

He was a strange man. So brutal, I thought, in a way with that conversation.... It was offensive to the people sitting there, including me. And forget me, but the others, his wife and her brother.[29]

Jimmie would never accept Barney. Even as Joan later prepared to marry him, her father wrote, "He constantly reminds me of the Duke of Windsor—plenty of money and nothing to do. He has not finished anything—college, business or what have you? His sole aim in life seems to be in pursuit of you—a very pleasant avocation but hardly to be considered a vocation."[30] But if Jimmie didn't approve of Barney, Marion soon did. She went to the Rosset apartment to meet Barney's parents and developed a surprising attachment to his roguish Russian-Jewish father. "I thought her mother hated me because I was half Jewish, but on the other hand, her mother loved my father—so it confused me," Barney said. "The truth was, she liked him better."[31]

In her final year at the Art Institute of Chicago, Joan painted intensely. She was back in competition mode. The school term would end with a series of awards for members of the graduating class and the "Figure Skating Queen of the Midwest" wanted to rack up as many of those prizes as possible. The figurative style of painting she had begun in Mexico not only reflected her current, more politicized consciousness, but it earned her applause when it was exhibited in January 1947 at a gallery in Rockford, Illinois.[32] In those postwar years, Joan's paintings of the downtrodden were acceptable on several levels. As a daughter of the upper class, she would have been congratulated on her aesthetic charity in recognizing and depicting the sufferings of others. As a "modern" artist she would have occasioned nods of approval because she had not crossed that incomprehensible threshold into nonobjective abstraction. And as a skilled practitioner of an ancient art form, Joan would have been awarded respect. She had worked hard—methodically,

tenaciously—to learn to paint, to master technique so she could free her mind to create. By 1947, her work had a facility and sophistication that far exceeded what might have been expected from a twenty-two-year-old.

When her school term ended, she won a traveling fellowship, worth two thousand dollars (a huge sum in those days, when the average annual salary was about three thousand),[33] and in June, a print prize in the Chicago and Vicinity Annual art exhibition. That award earned Joan her first mention in *ArtNews*.[34] Joan's college years had ended triumphantly. She was back in the spotlight in a way she hadn't been since before her tumble on the ice five years earlier. Joan wanted to use her prize money to go to Europe, but it was too soon after the war. Instead, she went to New York to be with Barney, who had moved to Brooklyn.[35]

One Fulton Street, where he lived, was a rooming house used by the city to shelter poor, unwed mothers. Gradually painters, poets, and actors had also found their way to the building, located in an evocative setting on the waterfront in the shadow of the Brooklyn Bridge.[36] The four-story corner structure was decorated with a latticework of fire escapes, and on the ground floor the Franklin Bar and Grill Restaurant beckoned with a sign wearily missing a few of its letters. Joan had visited Barney in his apartment above the Grill during her spring break from school and had come away changed.

> *I don't know where or how to begin and so soon it's all squashed together— the little boat—the tremendous curve of the bridge and you—semi yellow against the blue walls making eggs—naked and with big slippers—the night noises—the bus—the fog horns and train whistles, and always so damned warm against me in this little white room was Barney...the car waited like a horse below glad we had found a bed at last....Rosset you were wonderful—I love you—I love you and I got in that plane and wanted to crawl under the seat and cry—it was all so much more than I knew existed....When you and painting are both in the white room the world will be at the end of Fulton Street. You leaning on the typewriter.*[37]

Joan had also awoken to a new way of painting. Soon after returning to Chicago she wrote cryptically, "Painting is leaning abstractly in my mind in a semi-idea where to go."[38] Two weeks later she declared her paintings had taken "an abstract leap...haven't come up for a breather."[39] No doubt during her New York holiday, Joan and Barney had visited galleries, and that month, March 1947, powerful shows were on display: Gorky at Julien Levy's and Rothko's first solo show at Betty Parsons's among them. Joan had absorbed the art and the ambiance, and wanted more. Her return to Illinois, therefore, was brief—just long enough to collect her end-of-term prizes and say goodbye. With no ties to Chicago beyond tradition and no

place she would rather be than New York, Joan and a painter friend, Francine Felsenthal, left by car in the dead of night for Brooklyn.[40]

Joan's early days were spent making up for lost time with Barney. During their courtship in Chicago and their brief visits since he had left home, their sex life had been intense. Barney was not Joan's first lover, but he was her first long-term partner. One has the sense that for the first few weeks, most of their time was spent in bed. Barney took a series of nude photographs of Joan during that period, stunning pictures as sensual as any classical odalisque. In that Fulton Street apartment, cut off from the life she had known, Joan's focus was directed toward the two things she desired most: love and art. In fact, years later Joan would say her art *was* love.[41]

Barney, at work on his movie, gave Joan time alone to paint, but she was finding it difficult. Each new location in her life — whether it be Oxbow, Chicago, or Mexico — had resulted in a new direction in her work. In New York she headed ever deeper into abstraction, but she was only able to take baby steps in that regard. Something was lacking. In Mexico, she'd had the people on the street for inspiration. At Oxbow, she had nudes in the landscape. In New York she had only miles of concrete, the right angles of buildings, and herself. And that self was a mystery. She was Joan wrenched from the safety of her milieu, Joan without an identity. She had been a prodigy in Chicago; in New York she was nobody, a young person with dreams and ambitions in the city where such hopes were more often dashed than realized. "Maybe someday in the brave new world they'll sell self-confidence in bottles," Joan had written to Barney earlier that year.[42] Until that happened, Joan had to summon her own. She couldn't do it alone, so she did as so many other lost artistic souls had done before her. She made her way to Hans Hofmann's school.[43]

Joan dutifully climbed the well-worn steps to his atelier, but she wasn't even prepared for that. "I couldn't understand a word he said, so I left, terrified," she recalled.[44] In fact, she understood some of his words, but she hadn't agreed with his message.

> He was talking about the push and pull, and he was erasing people's drawings and saying: "This goes this way." The nude was sitting there, "and this angle is there and that angle is there," he said. I could see that, but did I have to make that nude into that angle?...I wondered why and why and why.[45]

Joan quit his class and didn't return. She was back in Brooklyn, alone. She had looked at the new art being done in New York. She had seen, as had Grace, Jackson's first drip show at Betty's in January 1948. (It didn't move her.)[46] She had read the magazines: *Possibilities* and *Tiger's Eye; Time*'s first attack article on Pollock; and Clem in the *Partisan Review*

declaring the ascendancy of American painting and the "decline of Cubism." Joan was a bystander to a revolution that she wanted desperately to join. The main impediment was the most difficult to overcome: herself. She could not do what she wanted to with her paintings, and she was not bold enough to inject herself uninvited into the scene where the new art was being created. Of her mother, Joan once wrote, "One thing that fucked her was her inability—fear, timidity & puritan ashamedness of her feelings & therefore to show her work to her peers & accept criticism.... She had no belief in herself as a poet."[47] Joan was in a similar position, except that she *did* believe in herself; it was simply a matter of breaking through.

The close quarters where she painted and Barney wrote became, over time, confining. Joan had also begun to experience a feeling greater than physical claustrophobia. She sensed she was being subsumed, or what her analyst later described as "engulfed."[48] Joan had not intended to trade her father's dominance of her life for Barney's, and yet that is what was happening. It wasn't that Barney wanted to control her, it was that Joan feared he would do so anyway. Normally her response would have been to fight. In this instance, she chose to flee. She had her ticket to independence in the form of her traveling scholarship and an incentive to use it. Zuka was in Paris. Joan decided to go to France.

Barney didn't understand why she wanted to leave, but neither did he try to stop her. "I do not say that it was wrong for you to leave in any way, it was what you had to do," he wrote Joan. "I just happened to be on the other end of the line which got cut off."[49] And if their separation meant the end of their affair, he said,

> *There is no doubt but that those things I have within me now which belong to you will prove to be one of the most intense and real experiences of my life—if I could say coldly and objectively—I knew Joan, we were together, and now we are separated, and this is what she gave to me—emotional understanding, a deep sincerity and honesty of thought which somehow I partook of, an insight into the creative processes of a fine human being, then having taken these things from her I should say—this is all one can expect to get from another, this is more than is permitted to most, now let her go her way and you go yours.*[50]

Joan set sail for Europe in late June.

"It was awful leaving you—walking that long space between you and the boat," Joan wrote Barney upon arriving in France on July 3, 1948, nine days after her departure from New York. "Not wanting people to see my face—wanting to turn around—I miss you." Her entrance onto the ship

was memorable. A bottle of bourbon she carried in a paper bag broke through the bottom and crashed onto the deck.[51] (She had another bottle in reserve, and when that ran out, the "nice" crew supplied her with more.)[52] "It was rough the first five days—stormy etc. Women bitching and puking in the hold—we slept on deck—Now I'm brown—sort of and salty—the girls above me read the Bible all day—really—the males are all eager—so eager & dumb."[53]

On the ship Joan had a first intimation of the former war zone into which she was headed. Some of the passengers had concentration camp numbers on their arms. But when the ship neared the French port at Le Havre, the war's devastating impact truly hit her.[54] Half-sunken ships lay scattered, abandoned along the coastline. Bombed out shells of buildings, their facades ripped open, stood amid empty blocks where houses and shops had once been. And everywhere debris, fragments of twisted metal, ragged chunks of charred wood—monuments to death's lingering presence. The Marshall Plan was established that year to help countries rebuild, but its signs were not yet visible. Le Havre looked like a vast graveyard. "I'll never forget it," Joan said. "The sun was setting and there was all the devastation.... Maybe other people didn't think about it, but it's all I thought about."[55] Her longing to be in Europe only deepened when she realized the cradle of Western art had nearly been destroyed. "For one crazy moment I wanted to touch the ground—I wanted to touch the continent where Mozart had composed," she said.[56]

Joan arrived in Paris to a warm welcome from Zuka and an Illinois friend, Nancy Borregaard, who had won the Art Institute of Chicago's traveling fellowship two years before Joan. After presenting Joan with beautiful orange and blue flowers, they spirited her away to Zuka's Pigalle apartment, where she lived with her new husband, Louis Mitelberg, a Polish-born political cartoonist for the Communist newspaper *L'Humanité*.[57] Their swift intervention saved Joan the initial shock of discovering that, though she had studied French, she did not speak it, and though France was ostensibly at peace, it was racked by social conflict.[58] French poet Antonin Artaud described life in France that year:

> We are not yet born, we are not yet in the world, there is not yet a world, things have not yet been made, the reason for being has not yet been found.[59]

Joan grappled with life in a country where strikes made even essentials impossible to buy, protests regularly brought traffic to a standstill, and reprisal attacks against Nazi collaborators occurred regularly and sometimes publicly. Women who had been branded for consorting with the enemy could be seen bearing swastikas tattooed on their foreheads. The

hostility toward those who had aided the Germans, expressed in the whispered phrase "They will pay," had given the French Resistance the strength to continue even when victory seemed impossible. And yet, Simone de Beauvoir said, once "they" had been made to pay, joy did not replace hatred or anger or fear.[60]

Adding to those wrenching problems *within* French society was the concern about influences from without. France found itself in the tug-of-war between the Soviet Union and the United States, with many intellectuals fearful that an American postwar protectorate of Western Europe would mean the demise of local culture; that American music, film, literature, and even painting would suffocate the barely breathing art scene the war had left for dead. Those fears were embodied in the GIs who had returned to Paris flush with government money, and the hordes of U.S. civilians who arrived to see what remained of its glory. As in the 1920s, dollars bought a wealth of French francs. "A communist newspaper said, 'You are lucky if you can hear French spoken in the streets of Paris.' "[61]

Zuka and Louis helped Joan get her bearings until she rented a place of her own, a second-floor studio in the Latin Quarter at 73, rue Galande, near Notre-Dame Cathedral.[62] Both excited and frightened, she told Barney, "There are so many feelings in me—I don't know where they came from or how to separate them—I feel like I've been here before and felt lonely and it was all a long time ago."[63] Ration tickets in hand, she slogged through the hot city to gather what she needed, even the supplies to paint.[64] But the misery around her was depressing. Paris was beautiful until one looked at its weary people. Joan wrote,

> They don't seem to laugh at all—only walk with their heads down with the brown bread under their arms because there is no white bread. In fact the Lower East Side is luxurious compared to all of Paris. The children look old and everyone looks dried up and sick. I think so much of the war when I'm not thinking of you—of people with courage and no stockings, of the collaborators that are all over now, of the confusion....[65]
>
> I think I am not made of the stuff these people are made of—I think I couldn't go through a war like they did—suffer like they have.[66]

Joan had only been in France a week before Barney began making plans to visit.[67] "Bring blankets...& don't be depressed like you sound," Joan wrote to him. "Just finish the thing and come quickly and we'll go swim in a blue sea & fuck on yellow sand—without your letters I'd go crazy."[68] Joan had managed to find stretchers and rabbit-skin glue to size and stretch her canvas, and she commenced the operation factory-style, preparing eight large canvases at once in her one-room studio with its enormous

windows and north light.[69] She took solace in the mechanical prelude to creation, which was all she *could* do. Joan had walked the length of the Seine in search of inspiration and had come away empty. Paris was not hers, the landscape and the light hadn't become part of her.[70] "I thought, Why don't I quit this stuff, be strong enough to kick this," until she admitted "there wasn't any other way." Painting "was the only thing."[71]

Barney had finished his film to the point that he could send it to trade publications and distributors, but the initial news was uniformly negative. *Variety* called *Strange Victory* "hardly the sort of film to achieve more than a cursory interest." A "semi-liberal" distributor told him it would be a hopeless task to try to sell a film on racism in America in 1948.[72] Reluctant to abandon the project, Barney decided that if there was no audience in the United States, there might be one in Europe. And so, in August he decided to travel to France. His visit was planned for a moment when Joan's spirits needed more than the usual amount of boosting. She had submitted work to an annual European show of new talent called *Momentum* and was rejected. Joan tried to brush off her disappointment.[73] Barney, however, was "furious" over the news. "I was absolutely positive of her talent, her genius—at all times, whether we were fighting or loving or whatever," he said years later. At the time, he wrote to her before leaving the States, "I have more faith in you as a straightforward, uncompromising, honest, artist than anyone else I have ever known.... In myself I have much greater doubt...and perhaps that will be my saving."[74]

Barney was a magnet for absurd situations, and one such arose involving his quick trip to France to see Joan. In a bar, he had met a man who had an airplane he used to fly Italians who wanted to emigrate to South America across the Atlantic. On the way back, he would stop in New York to collect cargo so that his return trip to Europe wasn't wasted. When he discovered that Barney was headed to France the man said, "I'll take you!"

> Now I had a Jeep station wagon, which was a clumsy, big thing, not to be confused with a real Jeep.... So I brought it out to an airfield in Connecticut and they started putting it on the plane and it wouldn't fit in the door of the plane. It got wedged, sideways. It took them two days. After it was in, I sat at the steering wheel. We went to Geneva...Joan had gone to meet me in Geneva. When we got to Geneva, a terrible storm came up. A plane was knocked down and on the ground they thought it was us, because our plane had been hit by lightning and our instruments all went out, including the radio—but our plane itself was all right. Finally they got a hand-operated radio to get the beam from Paris. We flew back to Paris, declaring ourselves an emergency. There were fire engines and whatnot and they wouldn't let the pilots and whatnot off the plane because they didn't have visas. I did

have one, so I got off the plane... [but] I had a terrible fight with the French government, trying to get my car off the plane, which I finally did. Joan thought I was dead.[75]

Having made a mournful trip back to Paris believing Barney and his plane had been lost in the storm, Joan found him waiting for her on the rue Galande in the Jeep he had ridden in across the ocean.[76] Their visit was short, but it was enough to pull Joan out of her funk. Days after Barney departed, leaving his car behind, Joan painted a landscape. "I think [it's] too complicated... very, very abstract—but it's a beginning."[77] Within a week she announced, "I paint with a real interest again—it's so wonderful. I had forgotten—no I'm not happy or anything so sudden but just while I stand there putting paint on life is maybe wonderful & beautiful after all."[78]

In the fall, however, the situation in Joan's unheated studio grew difficult. The damp cold penetrated the layers of clothes she wore even indoors. When she needed to warm up, she went to the movies or the Louvre on her own.[79] She had a few friends from Zuka's circle, but Joan was essentially alone. Her mother had arranged for her to see Alice Toklas, and repeatedly suggested that Joan see Marion's colleague Sylvia Beach, who was a great friend of James Joyce's and could introduce Joan to writers. She even contrived a way to force the meeting by asking Joan to deliver a letter to Beach.[80] But Joan was paralytically shy during those early days. At times, she would go to the Café de Flore and stare through the window at Sartre and Simone de Beauvoir without daring to go in.[81]

Joan had met her upstairs neighbors, three gay men: Tony, Fred, and Eldon. Recognizing Joan's melancholy after Barney's departure, they "put on a costume show," she said, "in fantastic dresses & hats & made me laugh a little, but I don't want to laugh." Their next enterprise was to make her place feel homey. Fred sewed curtains, and Eldon fixed the curtain rods.[82] And gradually, various New York artists began passing through her place. Amid all that activity, she soon declared that her studio had gone from being a monk's cell to feeling "sometimes like Grand Central Station." Importantly, though, Joan was painting. Barney had sent her a cigarette holder, which extended from her mouth at all moments except when she was sleeping.[83] But she didn't do that often. Having been in a creative drought for so long, she began to work around the clock. In one letter, she told Barney that she had drawn for two nights and painted for two days with only three hours of sleep. "Fuck everybody—I want to work if it kills me—so I'm unhealthy and neurotic and all of those things but I don't care." She added, "It's as though I had turned all of myself off except the part that paints."[84]

Joan believed she could "learn about color" in Paris and be sufficiently divorced from life to work freely and well.[85] "I'm where I've always wanted to be—stove—bread & wine & canvases—I'm not depressed even—just arrived at a real knowledge of where I don't belong which is everywhere."[86] In that state Joan was able to declare, "I have confidence like I never had before."[87] Her high, though, did not extend to those moments when she wasn't painting. At those times, the "bottom drops out," she said, and she succumbed to regret, about leaving New York, about leaving Barney.[88] She called her choice to do so "strange & stupid…[and] expensive [emotionally]."[89] Barney heard in her letters that old cry for help and, as luck would have it, he had to go to Europe anyway. He had an offer to show his movie in Czechoslovakia. Barney flew to Paris, after which he and Joan would make their way to Prague.[90]

Surrounded by apparent peasants dressed in black, the women with babushkas over their heads and toting baskets, Joan and Barney flew aboard an Air France plane to a land entirely unknown to either of them except from what they had read in the newspaper.[91] Through a series of maneuvers, the Communist Party had taken control of the government the previous spring, making the country a single-party state and firmly within the Soviet orbit. The anti-American sentiment there ran deep, even among moderates, who believed a punitive U.S. decision to terminate a critical loan to the war-ravaged country had facilitated the Communist takeover. Barney and Joan were not guaranteed a hospitable reception, which was why the response of the customs official who reviewed their passports at the Prague airport came as such a surprise. After asking Barney if he had his film with him, to which Barney replied yes, the official's face cracked into a broad smile. "We have been waiting for you."[92]

Barney and Joan boarded an unheated bus for an hour-long ride in the pouring rain to a hotel they had been directed to. They expected a similarly warm welcome, but when they arrived, the porter said there were no vacancies and meals required a ration ticket, which they did not possess. Barney had been given the name of a man he was told would help them through any difficulties. His name was Dr. Kafka! But they couldn't find him and no one they spoke to had heard of him. Stranded, wet, and cold, they eventually found a man named Kafka at the Ministry of Information, but he wasn't the Kafka they sought. "Our little Kafka was extremely amused…about the error," Barney recalled.

They wandered the streets, past empty window displays and shops that were nearly so, finally finding a room at the Grand Hotel, which offered shelter, heat, and hot water. They believed their problems were over. They were not.[93] The next day they awoke to a summons to attend a meeting on

a subject they didn't understand with a professor they did not know. When they reached his office, the man asked what he could do for them. "I was bewildered," Barney said. "I didn't know what to say." He was apparently an authority on Prague, and after being told that Barney and Joan were interested in the city, "he screwed up his face, and said that he really was not qualified to tell us anything." Dismissing the experience as communist "bureaucracy at work," Barney carried on with his film business (even winning a prize) while Joan visited museums. But the longer they stayed, the more they wanted to leave. Denied visas to visit Hungary and Poland, they decided to return immediately to Paris.[94] "We didn't say anything, we just got the hell out and went back to France," Barney said.[95] With a "sense of relief" they landed "back in our familiar, dirty old bourgeois, capitalist world" in time for Christmas.[96]

Joan had produced eighteen paintings during her first six months in France.[97] Her working conditions had been difficult, though far from unusual for artists in Paris at that time. Coal for heating was impossible to obtain, and so she resorted to less efficient wood. She also drank quantities of coffee, which she boiled on a single-burner hot plate to give her body the illusion of heat.[98] Her large windows, so lovely in summer, were a problem come winter. The icy air rushed through the thin panes as if there were no glass at all.[99]

The gossip columnists back home in Chicago, meanwhile, romanticized her plight: "Joan writes that she paints in 'three sweaters and ski pants' to keep warm during the present Paris heat crisis. Joan has a studio next to Picasso's."[100] The reality was that she was very ill and the combination of worsening weather, a disinterest in food, an addiction to cigarettes, and a refusal to relax only made her worse. The holiday season abounded with heavy drinking and days of seemingly endless parties. A New Year's Eve bash that Joan and Barney attended at American artist Herman Cherry's was such a blowout, Barney said, "I had to stay there for two days. Not just me, it was like a ward in a hospital." In January, Joan's doctor said that the only way she would recover from the bronchitis that had taken hold of her was to leave Paris.[101] That diagnosis precipitated the series of decisions that began with the rented villa and culminated in their marriage and return to the States.

"Dr. and Mrs. James Herbert Mitchell and the Barnet Lee Rossets were on the dock in New York when the newlywed Joan Mitchell and Barnet Rosset Jr. disembarked on Saturday," reported Adele Fitzgerald in her "At the Moment" column.[102] At least one member of that greeting party was thrilled by the nuptials. When Barney's father first learned that Barney and

Joan were considering marriage he had summoned Joan's mother for a meeting. Marion described the encounter to Joan:

> He came right out and said he wanted you as a daughter-in-law; you were brilliant, a "good kid"; he wanted grandchildren....
>
> When I said that I thought you were seriously interested in painting, which made a decision about marriage more difficult than it would be ordinarily, he said, "You mean at present, painting comes before sex?"[103]

As Mr. and Mrs. Barnet Rosset Jr. stepped off the ship, Rosset Sr. had a rare reason to be proud of his boy. Barney never did what his father wanted, except this one time. The Rossets offered to give Joan and Barney their penthouse on Lake Michigan if they moved back to Chicago.[104] Naturally, Barney and Joan had other ideas. They headed to the Chelsea Hotel on West 23rd Street.[105] While their deflated parents returned home to the Midwest, Barney and Joan prepared to meet the residents of the demimonde that would become their new family.

31. Waifs and Minstrels

> My idea of being an artist was to be everything [except] what a bourgeois girl like me was expected to be.
> — Hedda Sterne[1]

WITHIN A VERY short time, Joan and Barney moved out of the Chelsea and into what he called a "dollhouse" in the tangle of streets comprising the West Village. Two sixty-seven and a half West Eleventh Street was a one-room house and basement in the middle of a garden behind a brownstone. "Maybe it had been meant for a maid or a children's playroom, but it was our living space, including Joan's studio," Barney said. "Some agile carpenter-type friends from Chicago helped us put up protective walls in the basement, keeping out the dampness a bit, and there we were."[2] The house was nearer to where Joan wanted to be, but not quite. The great advantage of the location, however, was its proximity to the woody writers' hangout the White Horse Tavern and the Village Vanguard. Joan and Barney spent hours there listening to Pete Seeger, Mariam Makeba, Lenny Bruce, Miles Davis, and even a drunken Jack Kerouac (whom Barney, in his next professional incarnation, would publish). The Rossets were such regulars that they became friends with the bar's legendary owner Max Gordon and his jazz aficionado wife, Lorraine.[3]

Indeed, during their first months back in the city the Vanguard served as a nightly refuge from their daytime travails. Joan had undertaken the painful task of trying to flog her work to galleries. For someone as insecure as she, there could have been no activity more soul-destroying. But some part of her, perhaps the part that was in rebellion against her profound timidity, needed to be on display. And so, against the odds, Joan carried her more portable paintings to East 57th Street and the satellite of galleries leading off from that discerning stretch. The one response she would remember from that initial foray was, "Oh, Joan, if only you weren't a woman and American...I'd give you a show."[4] No one wanted to exhibit her work. Luckily, neither she nor Barney had to rely on themselves to survive. Joan received an allowance of two hundred dollars a month from home, and Barney's reservoir of Rosset family funds seemed unlimited.[5]

One day in January 1950, while Joan roamed through the Whitney's annual exhibition of modern American artists, she turned the corner into

one of its galleries and saw a work that changed her life. There on the wall was Bill's painting *Attic,* which he had completed in 1949. Years later Joan remembered it as a large black-and-white painting, but its immediate impact at the time would have been less its starkness than its depth and ambiguity, or what Edmund Burke identified as a property of all great art: obscurity rather than clarity.[6] *Attic* exploded in shards and slashes of black enamel projected over a background of ochre that had been muddied by newsprint applied to wet paint. Over the entire five-foot-by-six-and-a-half-foot surface only two small splotches of red interfered with the thrusts and jabs of Bill's line. That color defined nothing and everything, the way a single note struck on a piano in an empty hall fills the space with the poetry of sound. Consciously or not, *Attic* may have resonated with Joan for another reason as well. The lines—some quick, some sharp, others gracefully looping—looked like nothing so much as scores on the surface of ice made by a skater's blades. She had made marks like those and he had painted them. Joan was stunned by the work.

To be astonished takes only a second, but the artist who produced the painting had worked long and hard. Joan knew that, if not from her painting, then from her skating, and she knew that she had much to learn from the mind and hand that had painstakingly created *Attic*. "I'd never heard of him, but I wanted to meet him. Who is he? I thought; I have to find a way," Joan recalled.[7] She inquired at the museum how she could find Bill. "I was given an address in the Village, which turned out to be Franz Kline's."[8] The mistake, however, would be auspicious.

There would have been no better person for Joan to meet during her initial encounter with a member of the New York School than Franz. Climbing the winding staircase to the top floor of the decrepit mansion where he lived, which had once been owned by the actress Lillian Russell, she entered the lair of a wonderful wizard.[9] Franz had just made his own breakthrough into his black-and-white works and was on fire with the love of discovery. His talk, a little like Hofmann's, didn't distinguish between past and present. Then was now, which, to an artist like Joan, would have been thrilling because it made her part of that glorious procession called the history of art.

> [I] went to his loft on Ninth Street to see his work. I walked in and there were brick walls with paintings, not on stretchers, tacked all over them and all over the floor. And those drawings he made on telephone book pages. I was overwhelmed.... I thought they were the most beautiful things I'd ever seen in my life. We talked... or he talked... until about seven-thirty in the morning. Double-talk.... What about? Oh, one never knew exactly what Kline was talking about.[10]

Kind, generous with his time, because he possessed nothing materially—
"he was practically starving," Joan said[11]—Franz was a better talker than a
listener, but in his flow of words he made the people around him feel he was
on their side. Like many damaged souls, he oozed empathy. The women
who knew Franz loved him for many qualities, but during that heyday of
machismo, they highly prized the fact that he was not a sexual aggressor.
He was as gentlemanly as his secondhand suits and fedora implied. Twenty-
four-year-old Joan could talk to that thirty-nine-year-old painter all night,
drink with him all night, without fear that his attention came at a price. She
left his loft the next morning stumbling with exhaustion and floating with
joy. The world that had so far been closed to her had opened. In Paris, Joan
said she belonged nowhere. As she walked home along Ninth Street that
morning, Joan's heart would have beat a little faster because that was no
longer the case.

Franz had given Joan the address she wanted—Bill's studio on Fourth
Avenue—and she went to see him. Like Grace earlier, Joan discovered a
painter whose work amazed her and whose dedication inspired her.[12] That
was the year Bill had started his masterpieces *Woman I* and *Excavation*. Under
Bill's generous tutelage and after many visits to his studio to watch the works
take shape, Joan began fresh experiments of her own on canvas. (Years later
she would say to a young artist who feared being influenced by a more expe-
rienced painter, "Do you know how many de Koonings I've done?")[13] Joan
was so affected by Bill, whom she considered a "hell of a nice guy," that she
told a friend she had begun to think of him as her "father."[14]

In those early months of 1950 when Joan met them, Franz had not yet
had his first solo show and Bill had had only one, at Charlie Egan's. Despite
their brilliance and years of work, they were still largely ignored by the
official art world. But the two men told her that showing and selling were
beside the point. It was all about creating. In a pair of cold, derelict lofts
Joan discovered purity of purpose. The drive to win that had been
ingrained in her since she was a child was, in that world, irrelevant. She
had fallen upon a community of beautiful losers, the type she had first rec-
ognized in the person of her beloved high school art teacher, Malcolm
Hackett. The scene was so far away from the world of salons and ladies'
teas and philanthropic support for the arts that had existed in Chicago that
Joan positively rejoiced. "You had this feeling of a group against the world,
against dealers, even against Artists Equity," she said. "This seedy, exciting
group of people."[15] And, most importantly of all, their work was not
merely arresting, it was *alive*.

Barney had enrolled at the New School to finally get his bachelor's
degree, and in the spring he began volunteering at the American Associa-
tion for the United Nations. He was also, amid McCarthy's clampdown,

defiantly back in the realm of "Red" politics, working for the Socialist journal, *The Monthly Review*.[16] Barney was occupied. And so was Joan. After meeting Franz and Bill, she had begun to hang around at the Cedar and the Club, all the while pushing herself ferociously in her studio. Charles Baudelaire once wrote that the frenzy of the artist

> is the fear of not going fast enough, of letting the phantom escape before the synthesis has been extracted and pinned down; it is that terrible fear which takes possession of all great artists and gives them such a passionate desire to become masters of every means of expression so that the orders of the brain may never be perverted by the hesitations of the hand and that finally... ideal execution, may become as unconscious and spontaneous as is digestion for a healthy man after dinner.[17]

In 1950, Joan was in the midst of such a frenzy. Day after day in her studio, her fingernails outlined in dark pigment, paint encrusted in the cracks of her hands and extending up her arms, even finding its way onto her ankles where her skin was exposed between her pants and her socks, she marked the canvas, stood back as far as she could to see what she had done, then moved forward and marked it again.[18] Back and forth, back and forth, Joan fenced with her creation. In a canvas full of seemingly random brushstrokes, each one had, to Joan's mind, a purpose. "The freedom in my work is quite controlled. I don't close my eyes and hope for the best," Joan told the art historian Irving Sandler. "If I can get into the act of painting, and be free in the act, then I want to know what my brush is doing."[19]

Working day and night in her new, supportive milieu, visually inspired not by works on museum walls but by works-in-progress in fellow artists' studios, Joan would produce her first mature, nonobjective painting. The influence of both Gorky and Bill was clear in her more than four-foot-by-four-foot *Untitled* of 1950—Bill's black shards and slashes, Gorky's coloration and whimsical shapes. But the dominance of white, which both rested on the surface of the canvas and served as background, was pure Joan. Bill's hints at color, his small splotches of red, in Joan's hands had also evolved. Her colors fractured throughout her canvas, intense pigments—oranges, reds, blues, yellows, pinks, ochres, and a menu of grays. After many years of struggle, Joan had broken through. On canvas, she had become someone new.

Back in Chicago, Joan's well-meaning mother had arranged for a show of Joan's early work to be held at a gallery in that privileged Social Register enclave of Lake Forest, Illinois.[20] Wrote the effervescent Cholly Dearborn in the *Chicago Herald-American*,

Joan, however, will not be at the "varnissage" [sic]...She's much too busy painting and keeping house for her bridegroom of last September in their little Greenwich Village studio...to come west for the show.

Besides, her husband, Barnet Rosset Jr., can't get away from his job with the United Nations, and Joan isn't one to let him shift for himself.[21]

Cheery Cholly really didn't have a clue. At the time she penned her "insider's" account of Joan's life, the Rosset marriage was already disintegrating.

On May 30, 1950, Joan's painting activity came to a halt when she had an acute attack of appendicitis in the middle of the night. A doctor friend of Barney's, who had helped create the first mobile medical units in the Spanish Civil War, rushed her to the hospital, after which he "looked in on her a few hours later," Barney said, "and then went to jail to begin his sentence for refusing to answer questions for the House Un-American Activities Committee."[22] Barney, himself, was suffering from hay fever, and so when Joan was finally well enough to travel, they left town for a working holiday: He had an assignment for the U.N. and planned to set aside time for a film project, and Joan would use the escape to recuperate. Their first stop was Cuba. Barney's "father knew [dictator Fulgencio] Batista," Joan said, and they were treated like minor royalty at Rosset Sr.'s Hotel Nacional, until a hurricane forced them to flee the island for Haiti and the decadent Hotel Oloffson in Port-au-Prince.[23]

> I remember Haiti so well & that Hotel & the room Edmund Wilson stayed in—the crocodile in the pool—the whore thrown out the window—the black outside the door sabers—oh joy—voo doo-handshake for good fucking etc. jeep in jungle.[24]

Joan's freestyle recollection of that visit described just how far they had traveled from Chicago. No longer were they two young adventurers in search of themselves. They had broken from their pasts, but only one of them—Joan—had found a future. Barney was still wandering. Their next stop, Mexico's Yucatán Peninsula, reawakened the passion Joan had felt for that country, but when Barney suggested they continue on to Mexico City she said, "To hell with it." She wanted to be in New York. "I was starved for painters," Joan said. Barney stayed, and she alone left for Manhattan.[25]

Part of the reason Joan was drawn back to the city was a new group of friends she had met shortly before she and Barney left for Cuba. Joan's old Oxbow boyfriend, Dick Bowman, had told two acquaintances from the Midwest, young artists named Paul Brach and Miriam "Mimi" Schapiro,

to contact Joan in New York.²⁶ They had just arrived in the Village to work at Stanley William Hayter's print studio on Eighth Street. It was an open atelier where artists from all generations gathered to use Hayter's equipment and learn from a master. Joan decided to work there, too, hoping to hone her printing skills and, of equal importance, meet other artists. "And that's where I met Mike, and so on," she related breezily of her first encounter with a man who would be a major figure in her life.²⁷

Born Sylvan Goldberg, Mike became for a time Michael Stuart, before Michael Goldberg finally emerged.²⁸ He was hardly alone among the artists in choosing a new name, but his inventions went far beyond that: Mike's persona was constructed of an intricate web of lies. Even his obituary in the *New York Times* carried a correction: He was not, as he had stated, a member of a fabled and decorated fighting unit in Asia during the Second World War.²⁹ At one point, Mike claimed to have a degree from Princeton and a brother who played football for Notre Dame. Both claims were untrue.³⁰ And he told volumes of stories of violent antagonisms and derring-do in which the dark hero was always the same: himself. Who was he in fact? A fascinating scoundrel who also happened to be an extremely talented painter. "Mike Goldberg, it turned out, was having a little career in crime at the time. He was a thief, he was cheating people," recalled art historian Dore Ashton, who made Tenth Street her home. "I didn't for an instant let him in my house. We all knew what Mike was, everybody around here."³¹ A future wife would call him a "psychopathic personality...he didn't have a conscience."³² Those who disliked or feared him, however, were outnumbered by the people who loved him despite his many faults. "Mike was a rascal but charming and he was a good painter, and that was all that mattered," said artist Natalie Edgar. "That and you had to be entertaining."³³

One narrative that seemed to have stuck, and may have been true, was that he had run away from home at the height of the Depression in 1938 at age fourteen and begun taking classes at the Art Students League.³⁴ "I think I really got turned on to modern art by Picasso," he recalled. "It seemed to be more important to be Picasso than to be, say, Joe DiMaggio....Picasso was really very inaccessible, at least in a lot of the Bronx...and it was kind of like a myth and because it was a myth it seemed like it had some sort of oh, challenge, mystery about it....So I made it my business to find out." At the same time that Mike discovered art, however, he discovered drugs. "I was a stone junky when I was a kid," he said, living any way he could, supporting himself and his habit.³⁵ That his early life did not end in incarceration or death may have been due to the war. Mike did serve in Asia, but not with the full degree of romantic heroism he claimed.³⁶ At the end of the

fighting, he resurfaced in the Village as one more veteran taking advantage of the GI Bill at Hofmann's school.

Mike was one of the few painters (Larry Rivers was another) who was both artist and hipster. His dress, his speech, his outlaw irreverence, his view that the future did not extend beyond the day and so anything was permissible, were all "down." Mike was also "sexy, that is: he exuded an extremely masculine yet by no means macho sexuality with which he was so comfortable, and about which he was so secure," wrote his friend Joe LeSueur.[37] While Barney was lean, bespectacled, intellectual, his hairline receding, Mike had thick black hair and black eyes. Not quite handsome, Mike could best be described as raw, which only made him more attractive to the unconventionally inclined. He was also a lodestone for rich, educated women. Joan became one of them.

For her, Mike embodied New York and was so distinct from her own history (as Barney was not) that, through him, Joan could bury Jimmie's Joanie once and for all. Joan and Mike became lovers. She had been starved for the company of painters, and he was one. She had wanted her own group of friends, and he, Mimi, Paul, and the younger artists they knew comprised it.[38] "Painting could change the world then," Mike said. "And within that climate, Joan and I . . . existed. . . . [Her] vision of what life could be was a helluva lot broader than most of us had."[39] While Barney was away, Joan tasted a life of independence in New York and she was not willing to relinquish it.

Before Barney and Joan left for Cuba they had been told they would have to leave their dollhouse on 11th, which had never suited them anyway. They had found a fabulous apartment in a brownstone at 57 West Ninth Street: the entire top floor and attic, with a vaulted ceiling, a large fireplace, and glass doors out onto the terrace at either end.[40] When Joan returned alone from Mexico, Paul, Mimi, Mike, and a few other people helped her move their belongings into her new home.[41] Its location put Joan in the heart of the action. She was closer to the bar, the Club, to Franz and Bill, and much closer to Mike. He, too, lived on Ninth. "I got very involved in the Cedar Bar and the whole thing," she said. "And, of course, less involved with Barney."[42]

If Joan had been unwilling to relinquish her independence, Barney was unwilling to relinquish Joan. Arriving from Mexico not long after Joan had moved into their new flat, he, too, began hanging around the Cedar and the Club, hoping to remain part of Joan's life but also imbibing the ambiance and the ideas.[43] "The painters were much more important to me than any authors whom I knew," Barney said. "The lifestyles of the painters seemed so much more open, free."[44] Others who had been exposed to

the downtown artists had had the same response, especially the men in New York who wrote music.

During the first few months of 1951, ideas flowed among the artists at the Cedar as freely as beer. They were busily articulating who they were in response to the many slights they had received from the press, from the Metropolitan Museum with its contemporary exhibition that had ignored them, from the numerous "best of the new art" shows from which they had been excluded. They might have been demoralized by such official disdain had it not been for the Friday night lectures at the Club. Those lectures caused the artists to think well beyond their art world grievances, past painting and sculpting, into the very nature of creation itself. "It was like belonging to a church," Larry said of the gatherings.[45] "These discussions gave me the sense that there was a whole array of aesthetic choices — an aesthetic spectrum — and what you were doing in your work had a place in it."[46] The Club's legendary sessions had begun by chance, due to a casual invitation extended by Elaine.[47]

Hofmann, Motherwell's school, and Studio 35 had all offered Friday night talks, but the founding members of the Club had wanted no part of them. They were too institutional. The very point of the Club was to have a place to share one another's ideas informally among friends.[48] One evening in the fall of 1949, when a few Club members were sitting around in front of the fireplace doing just that, Elaine arrived with philosopher William Barrett (who called her "the liveliest spirit of the group, perpetually concocting possible programs and entertainments").[49] His specialty was Existentialism, a subject the downtown painters were vitally interested in. They asked Barrett a few questions, he answered and proceeded to talk. As a professor at NYU he was used to speaking to a group and so he addressed the gathering in what became a lecture. The artists listened as he described the ideas he was working on at the time.

> Our technological civilization has become even more involved with elaborate apparatuses to catch and smother the individual. We have gone beyond the nineteenth century in the development of a fantastic mass culture — in radio, movies, and television — that stamps out all individual differences. Modern society has become more and more a mass society.... [T]he individual is threatened more than ever by the anonymity in the mass.... Amid this general purposelessness of life, this mass driving, we set ourselves the task of recapturing the sense and meaning of life.[50]

"I don't think I've ever spoken to a more attentive audience," Barrett said. "Yet I wasn't sure they heard what I said."[51] He may have had his

doubts because when he finished the artists asked if he would like to come back to deliver his message again to a larger group. Eventually he did, in June of 1950, but by then the Friday night lectures and panel discussions arising from his initial encounter were well under way.[52] The list of speakers, each invited by a member and promised nothing in payment other than appreciation and perhaps a bottle of liquor, would have inspired envy in the heart of a university dean.[53] These were eminent scholars on subjects that fed the imaginations of the eager students sitting amid clouds of cigarette smoke in rows of folding chairs. Philip Pavia said the speakers "added new life to the Club."[54] Their words gave the artists a sense that they were part of not just a larger artistic tradition but an intellectual one as well, and that realization gave them courage.

During the early months of 1951, the lectures were both intellectually stimulating and a form of intensive therapy for the artists bombarded by the mass-culture machine that Barrett had described. In addition to Hannah Arendt, who spoke on art and politics; Joseph Campbell, fresh from publishing his famous *Hero with a Thousand Faces,* who discussed art and myth; and the mathematical logician Jean Louis van Heijenoort, who had been Trotsky's personal secretary and who talked about space, math, and modern painting, composers addressed the Club.[55] Virgil Thomson opened that year's series. He was soon followed by a newcomer to the scene, Morty Feldman, and then by John Cage, who introduced Zen to the group with his famous "Lecture on Something." (Zen would be discussed there over the years even more than Existentialism.)[56] Pavia called the composers part of "the foreign legion wing" of the Club.[57] They had fought their own battles against "European neoclassicism," which prized tradition over innovation, and were back to offer field reports.[58] For their part, the composers sought out this audience because it was the only one that valued their work. "I could get one hundred artists to come to listen to a concert that I would give," Cage once told an interviewer. In answer to the question, how many musicians would attend, Cage replied, "None."[59] "My work was strange to musicians, and thought even not to be music by musicians," Cage said. "The visual artists didn't feel that same difficulty toward my work, since they had already done similar things visually."[60]

It was as impossible to describe avant-garde music in words as it was impossible to truly describe abstract art, and so Cage's talks at the Club often involved stories. One, which Edith Schloss remembered, illustrated in very visual language the music that Cage and his fellow composers were after. The story involved a road trip he took with dancer Merce Cunningham.

> Once Merce and I were driving through Vermont. We stopped at a roadhouse. We went to swim in its pool. Teenagers splashed and yelled around

us, there was the wind in the trees, cars whooshed by on the road. From inside the roadhouse came some dance music.... So here we were in the dark, wet up to our necks, our heads in the air hearing everything around us — snatches of pop song from the Wurlitzer, the bells of the pinball machine, the kids' laughs, cars, wind, water — all at once and the same time. We were inside it all. We were inside this mix, it was a piece of music.[61]

Like an abstract painter engaged in capturing a landscape, Cage was not interested in the individual elements, but in the *feeling* produced by all the elements simultaneously. It was that sense of rapture that encompassed him. This was language the painters understood. The development of avant-garde music in New York was remarkably similar to the development of avant-garde art there, down to its chronology. There was a first generation of composers, men like Edgard Varèse and Stefan Wolpe, who had arrived in the United States from France and Germany respectively, bringing evolving notions of sound with them. Varèse and Wolpe soon became friends with the New York painters and a pollination occurred across disciplines.[62] "I learned mostly from the painters," Wolpe said. "From the musicians I really learned only to liberate myself from my teachers."[63]

By 1950, the "heroic" generation of composers like Wolpe and Varèse had found their way to the Club.[64] But also on the scene was a second generation of composers, men like Cage, Morty Feldman, Earl Brown, and Christian Wolff (who was just sixteen). "[We] were getting rid of glue. That is: where people had felt the necessity to stick sounds together to make a continuity," Cage said, "we four felt the opposite necessity to get rid of the glue so that sounds would be themselves."[65] Music and painting were traveling the same paths. Pollock's work, said Earl Brown, "*looked* like what I wanted to *hear*."[66]

Feldman and Cage went to the Cedar nearly every day for five years, between six in the evening and three in the morning.[67] Cage knew everyone in the bar, but it would be Feldman who would be most closely associated with the Abstract Expressionists. "Morty," said Edith Schloss, "was one of us."[68] He had been a student of Wolpe's at the composer's Contemporary Music School in New York. (One expert said Wolpe was to music what Hans Hofmann was to painting.) By 1950, however, twenty-four-year-old Feldman had "hit a wall" and could not write music. It was the courage of the abstract painters that inspired him to continue.[69] In what he called the protected "cul de sac" between the Cedar, the Club, and his Village studio he found the security to risk everything.[70] He explained,

> There is that doctor who opens you up, does exactly the right thing, closes you up — and you die. He failed to take the chance that might have saved

you. Art is a crucial, dangerous operation we perform on ourselves. Unless we take a chance, we die in art.[71]

Morty was adopted by all the painters. He resembled a bookish teddy bear in need of rescue: He weighed three hundred pounds, wore thick tortoise-shell glasses, and already had deep worry lines striating his brow. "One evening when I was still a newly arrived immigrant at the Cedar Bar," he recounted, "Elaine and Willem de Kooning casually took my arm as they passed, and said, 'Come on over to Clem Greenberg's.'"[72] Even Lee and Pollock sought Morty out. In 1951, Namuth's movie of Pollock painting was being edited and Jackson hated the "exotic" music that had been chosen as the score. Lee asked John Cage if he would write something for it, but he was otherwise occupied (and he didn't like Jackson personally). Cage recommended Morty, who agreed to do it in exchange for a drawing. "It was the beginning of my life, really," Morty said. When the film premiered at the Modern, Jackson said the only thing he liked about it was Morty's music.[73] Like the younger painters, Morty learned from and appreciated the First Generation, but his nights in the Cedar were spent in the company of artists of his own generation, among them Joan and Mike.[74]

Though Joan was still living with Barney, her time was spent increasingly with Mike. As a couple, they made a bold statement—young, hip, aggressively "outside." Jane Freilicher had seen the pair huddled in a booth at the San Remo looking "very French new wave."[75] But even without her streetwise companion, Joan attracted attention. Grace Hartigan, who was three years older than Joan, had been altogether shocked by her arrival on the scene.

> When I first hit the artworld in the late forties, I was the only woman [of the younger generation] and I liked it. So the first blow was in comes Helen Frankenthaler with Clem Greenberg. I reluctantly made room for Helen and we actually became very good friends. Then in comes Joan Mitchell. Oy vey! Now we've got three women. So I reluctantly made room for Joan. She really impressed me in her ability to swear[76].... I've never heard anyone swear like that. Male or female.[77]

Joan was in every way unique. Fearful that coming from a wealthy family would tarnish her bohemian credentials, Joan dressed down: worn men's clothing covered by a light brown leather trench coat comprised something of a uniform.[78] "Wiry, intense, angular, restless and blunt," Joan appeared to make no real attempt to look feminine, to powder her nose from a discreet compact as did other women at the time, to trouble

herself about the wave of her hair. That was due in part to the fact that she was so insecure physically that she was embarrassed if anyone caught her primping or looking in the mirror.[79] The irony was that Joan didn't have to try to be beautiful. At a time when women's fashions were designed to render one "passive and helpless"—with girdles, stiletto heels, and delicate nylons—Joan, in her tousled, unembellished state, exuded sexuality.[80] She was a gorgeous, tough broad, tougher than most.

The common narrative among writers describing the women artists in the Abstract Expressionist movement is that they were "trying to be like the boys," to act macho so as to be taken more seriously as artists. That observation, which is actually criticism, is made regarding Grace and Elaine because of their heavy drinking and their many sexual liaisons. And it is made about Joan because of her appearance, her drinking, her brawling, and her language. But in each of these cases, the character traits the woman supposedly assumed to fit into a male universe developed out of the person she was *before* she arrived on the scene. These three were not reacting to an environment and engaging in role-playing for career or social advantage. They were strong women, and they had no need to act like less-than-convincing men. In fact, they had gravitated toward the downtown scene in part because they believed they could be themselves there without censure. And for the most part, among their peers, they could. Especially Joan. Once, in the Cedar, the veteran artist and Club éminence grise Landes Lewitin, who was notorious for undressing women with his eyes, came up behind Joan and cupped her breast in his hand. "Without missing a beat," Joan's biographer Patricia Albers wrote, "she swung her arm down" and grabbed him by the balls. The bar went silent. And then it exploded in laughter at the stunned old man's expense.[81] It was a new day for those women who dared to seize it, and woe to those men who were too slow to recognize the change.

In the few months during which Joan had been seeing Mike, her life with Barney had unraveled. It was impossible to hide her passion for another man, and she felt guilty about living under Barney's roof, where he paid the bills. However, she was not prepared to leave Barney entirely, and so, with money her mother had set aside for her, Joan took a step toward separation by renting a "marvelous clone of a Paris studio" to paint in on Tenth Street.[82] "I went over there and tried to break the door down, but I didn't succeed, which is just as well," Barney said sadly. "Joan and I were sinking, much as I desired to stay with her."[83] Finally, in mid-April 1951, the situation deteriorated dramatically. Mike had forged one of Barney's checks and withdrawn five hundred dollars from his account. Said Barney,

Chase Bank called me and said my account was overdrawn. I knew that was not true. I knew I had three hundred dollars and this guy wrote a check for five hundred dollars.... I knew that whoever did that was about to be arrested. I guessed who it was and I guessed right. And what did we do? We set out to save him. Turned around totally. Totally for me because I realized how much she was in love with this guy and the police are after him. We have to get to him first. We didn't make it. The police beat us by an hour, arrested him.[84]

Mike, who had been out on probation for another crime when he was arrested for forging Barney's check, was jailed in Manhattan's notorious Tombs pending a grand jury hearing.[85] Receiving the news, Joan fell apart, shaking, crying, blaming herself for not being able to "stop it"—without elaborating whether "it" was Mike's arrest or the fact that he had needed money so badly that he was prepared to steal.[86] She quickly learned just how much money he *did* need. As word of his arrest spread, creditors came out of the woodwork to shake down Joan for the cash. His debts, however, were too great even for her ample purse. She decided to get a job, to get a master's degree so she could teach, anything to help him and to earn her financial independence from Barney.[87] Unable to see Mike, and their letters censored (on one side by his jailers and on the other by Barney), Joan couldn't sleep. Neither could she paint.[88] She was in full meltdown.

In April, Joan began seeing a psychotherapist named Edrita Fried, a figure who would become one of the most important in her life.[89] Fried was a warm, uncritical, nonjudgmental woman who exuded calm strength and who believed that "love and sexuality moved the world," that they were "indispensable for survival."[90] Joan could tell her anything, and did, and Fried never registered surprise in response. She had heard much worse. Fried was born in Vienna and had arrived in the United States during the great migration of psychoanalysts fleeing Hitler. While the war raged in Europe, she worked at Princeton analyzing the psychological content of Nazi propaganda. After the fighting stopped, she formed part of a Nuremberg team interviewing high-level Nazis.[91] Joan's problems would have been minuscule by comparison but, by 1951, Fried was involved in the very issues Joan represented. She was interested in freeing her patients from the sexual and emotional distress that plagued and paralyzed them.[92]

Barney, meanwhile, had been called to appear before the grand jury that was convened to hear the case against Mike. "His father and brother were there," Barney said. "They started berating me." Barney didn't respond to their pressure, but when he went before the grand jury he had both Mike's irate family and Joan's broken heart uppermost in his mind. He decided to

try to keep Mike out of jail. After being asked routine questions, he interrupted the district attorney and said, "This is ridiculous. This man is insane. You can't arrest him for this. What you have to do is give him hospitalization." The district attorney was furious that the victim appeared to be siding with the defendant. He told Barney, "You shut up. If you say one more word, I'll have you arrested. Get out of here." Barney left. The next day the DA called him and said the grand jury had been persuaded that Mike *was* crazy. He would be sent upstate to a hospital for the mentally ill.[93]

By that time, Barney had himself gone half mad. Like an amateur detective, he spent days, weeks sorting through Mike's lies and shadowy history. "I was gradually, gradually zeroing in on him and Joan wouldn't believe any of it," Barney said.[94] She didn't *want* to believe any of it, even as she found herself sucked deeper into Mike's dangerous life. One night, when she returned to her studio after a fight with Barney in a bar, a man, obviously high, demanded to see Mike because Mike owed him money. Putting his foot in the door, he unzipped his pants and hit Joan over the head. Joan let out a piercing scream. Barney, who had followed her home, rushed to the building and the man fled. Later, during a visit to Rockland State Hospital to see Mike, Joan was raped by an attendant there. She didn't press charges. She called the attack "the dark side of being with Mike."[95]

Barney loved Joan deeply and was livid that she allowed herself to be "brutalized" by Mike and the hoodlums around him. But, he said, "There was no way of getting her away from it. No way. I mean, I couldn't believe it." Barney's response was to become more violent himself in his relations with Joan.[96] He and Joan fought continuously with words, with objects, with shoves and swings. Once, writer John Gruen and his painter wife, Jane Wilson, invited Barney and Joan to dinner. Gruen and Wilson had just moved to Bleecker Street and had painted their walls white. Gruen said,

> Things started out smoothly enough, until Barney noticed that Joan was ready for a second helping of food. "I wouldn't eat that if I were you," interjected Barney. "You're getting fat around the middle." With that, Joan took a ripe tangerine out of our fruit bowl, stood up, and aimed it with enormous violence at Barney's head. Barney ducked, and the tangerine landed with splattering force on our virgin walls.... At the beginning of our friendship with the Rossets, our function was to bear witness to their endless fights. It was like a game in which a naïve audience was needed for "the performance."[97]

Amid all of that tumult, the dapper and unsuspecting Italian Leo Castelli had come by Joan's place on Tenth to look at her paintings. The artists, he said, were putting together the Ninth Street Show and he wanted to see what she had to offer.[98]

PART THREE

1951–1955

Oh, to Leave a Trace[1]

32. Coming Out

> Society is jealous of those who remain away from it, and will come knocking at the door.
>
> —*Joseph Campbell*[2]

STUDENT EASELS STOOD thick as a forest around an upraised platform bearing a naked model lounging still and submissive, the way women through the millennium had posed before men using paint and charcoal to recreate their beauty. In early 1951, the woman on the model stand was Grace Hartigan. Her first solo show at Tibor de Nagy that January had not produced a single sale; it had only added to her parlous debt, and so she was obliged to return to work for ninety-five cents an hour[3] to supplement what she laughingly called her income. But whereas a year before she had listened with reverence to instructors as they wandered among the easels, commenting on their students' efforts, now, as a more seasoned artist herself, she was attuned to the false notes in the teacher's performance. One day, in painter Will Barnet's class at the Art Students League, Grace could not sit a minute longer listening mute while he, to her mind, misinterpreted the past and denigrated friends she admired. Artist and future critic Lawrence Campbell was in Barnet's class and recalled that day.

> The painter Grace Hartigan was working as a model and she was posing while Barnet was lecturing. As usual he began to talk about Ingres, and said something slighting about Delacroix. I noticed that Grace Hartigan was looking angry. Then the lecture began to turn to what was happening on the current scene, and the name of Willem de Kooning (who at that time had a largely underground reputation) came up. I don't remember now what it was that Barnet said about de Kooning, but whatever it was, it disturbed Grace Hartigan, who all at once spoke out and contradicted Barnet from the model stand. This was the first and only time that I can recall a model contradicting the instructor. Of course Grace was not a regular model.... She was extremely beautiful and a really marvelous model to work from. She was also a strong feminist and an ardent admirer of de Kooning.[4]

As Grace explained the incident, "It was just too embarrassing to be standing there, nude with an instructor arguing with you about your art, so I thought, I can't do this anymore."[5] Grace put on her clothes and quit.

Lee had said of the Village of the mid-1940s, "there were the artists, and then there were the dames."[6] In Grace's world there were the artists (meaning men *and* women employed in creating works of art, from painting to music to literature) and everyone else on the planet. She was part of the former group. Her act of defiance, which left her penniless, declared it so. In any case, she couldn't have done otherwise. Grace no longer had time for a half commitment. The arrival of her Second Generation friends had injected new energy into the scene the way children force parents and grandparents to join their frenzy of youthful discovery. Everything was faster, wilder, more fun.

As if to launch the season and celebrate their expanding group, Helen had decided to have a 1920s-themed party because of an F. Scott Fitzgerald revival then under way.[7] Young Americans of an intellectual or artistic bent once again felt themselves members of a postwar Lost Generation.[8] While Helen planned her party, she also made room for a new studio mate, Lee.[9] In town for the winter, the Pollocks had once again taken up residence at Ossorio's place on MacDougal Alley, but Lee couldn't work there. Jackson's benders were frequent and lasted for days, during which time Lee had to be constantly on guard against disaster.[10] "The more Jackson's fame grew, the more tormented he felt," Lee explained. "My help, support, and encouragement didn't seem to be enough."[11] It was no way to live, let alone work, and so Lee took artistic sanctuary with Helen on 21st Street.

A hardscrabble street fighter old enough to be Helen's mother, Lee, with her Brooklyn background, could not have been more different from Helen with her gilded childhood, and yet each might have been just what the other needed. In many ways, Helen was the woman Lee had been before she met Pollock: fearless, independent, thriving in a community of artists, joyously expanding her artistic boundaries. Lee had misplaced that young woman in herself and through Helen, perhaps, she would be able to rediscover where she had been headed. As for Helen, she had no experience with a powerful woman artist. All her mentors had been men. And as good as they were, there was something none of them could teach her. In Lee, she could see that it was possible, despite official prejudice, to be both artist and woman with commitment and dignity. True, Lee wasn't exhibiting, but many of her male contemporaries had not had shows either. True, she was obscured by Pollock's shadow, but that had not diminished her drive. Lee had remained fierce, and Helen admired her for it. "She is a strong aggressive 40 yr. old Bennington type and I must say it makes me assert myself," Helen wrote Sonya. "However, I don't think it will harm to have someone around (and she is pleasant & a good critic, I understand) for awhile."[12]

Having scrubbed and waxed the studio ahead of Lee's arrival, Helen considered having her Fitzgerald bash there.[13] But in the planning, the party "which started out to be a little joke" had become increasingly elaborate. A larger space had to be found. "It's going to be in a huge studio that I got hold of through David Hare, a sculptor friend," Helen wrote Sonya, "and between the people and the general decor, it really ought to be a show. The twenties really have taken over in my 'milieu'; a sad commentary on our time, but also rather amusing."[14] Located at 79 East Tenth Street, Hare's studio nestled among at least a dozen other artists' spaces. After the party, to which everyone came in costume, drinking and dancing until they stumbled out onto the street at dawn, Helen decided to sublet the space when Hare went to France later that spring.[15] "It's really huge and beautiful and I'm thrilled," she wrote Sonya on May 7.[16] It was a *real* artist's studio, and at twenty-two, Helen was a real artist. On the day she told Sonya about her move, Helen had appeared in her first show at John Myers's gallery, a group exhibition called *New Generation,* along with Grace, Al, Harry Jackson, and Bob Goodnough. "I'm pleased, surprised, scared, flattered about the whole business," Helen wrote.[17]

> *The show at Tibor's is made up of five painters... all of them have "something"... I have three paintings in the show—a very large oil, a smaller oil, and another painting done on paper. I was surprised, amused, and pleased at the reviews. God knows all those critics don't know their ass holes from their Roger Fry, but even so....*[18]

It had only been a year since Helen had been painting "Picassos" and organizing a Bennington show with a series of cold calls to critics and literati almost as a schoolgirl lark to see if any would respond. Now many of them, through Clem, had become her friends. But her most intense relationships were those she had formed on her own with other artists, especially the nucleus around Tibor de Nagy. Helen dubbed that "posse"[19] "the Tibor Five": Grace, Al, Harry, Bob Goodnough (who was soon replaced by Larry Rivers), and herself.[20] Being in Hare's studio put her closer to them, which meant they would have easier access to one another's work. And Helen considered that essential. She explained,

> If you're the only person on the block making something—and there's nobody across the street or down the hall competing with you in a positive way and attempting to outdo your work—then it's an isolated and often stale situation. Art is such a lonely business anyway, so fragile and unpredictable, and it often comes out stillborn. Having other artists you respect "out there" is very important.[21]

Sometimes they simply wandered from studio to studio looking at one another's paintings and offering suggestions. "I loved what I just saw in your studio, I'm going back to mine and I'm going to knock your eyes out" was one of the reactions Helen recalled.[22] Sometimes their gatherings served a practical purpose. "We would buy canvas remnants together and have stretching-sizing parties," Helen said. "And Al Leslie and Harry Jackson and Grace, and we'd all get in on the act. It was a matter of money but it was also a matter of fun."[23] Beyond the artistic support, however, Helen found working in a community critical to overcoming the alienation she and they felt in the greater society. For artists just beginning their careers, it was necessary to find a place in *a* society, a group of individuals in whom they could trust in order to grow. "I think artists are often very comfortable with each other because they assume a common denominator," Helen said.

> Even if they're artists of different persuasions, a recognition and mutual honoring, we're all in this war together, or at this wonderful party together.... I think there's a lot of mood and often depression and apartness, apartheid, that goes with being an artist, and given the rules of society... it's often very difficult for artists to meld in with the rest and cope.[24]

Though filled with nostalgia while packing up the 21st Street studio that she had had for three years, in May Helen moved her operation to Tenth Street, where she could live among her artistic tribe.[25] The same motivation had brought Joan to the same street that month. It was an act of self-preservation, a search for safety in numbers. It was simply too difficult to become an artist alone.

On May 10, the local newspaper cheerily announced that Mr. and Mrs. Pollock had arrived back in East Hampton.[26] After a difficult winter in New York, they were home to celebrate a new season and a fresh start. Jackson's wild gyrations between insecurity and certainty had swung toward the latter that month. One of the Second Generation kids, Bob Goodnough, had written a long piece, "Pollock Paints a Picture," which had appeared in *ArtNews*. It took a painter to understand Pollock's work, and Goodnough did. Bob wrote that when looking at a Pollock, "one is not earthbound."...

> The experience Pollock himself has had with this high kind of feeling is what gives quality to his work. Of course anyone can pour paint on a canvas, as anyone can bang on a piano, but to create one must purify the emotions; few have the strength, will, or even the need, to do this.[27]

The Pollocks considered *ArtNews* to be a de Kooning vehicle because of Elaine's role at the magazine, her relationship with Tom Hess, and Tom's regard for Bill's work. They were thus paranoid that a large part of the New York art world was arrayed against them. Goodnough's article and the photographs of Jackson by Rudy Burckhardt came as a pleasant surprise. Bill had not yet received such expansive treatment in the magazine's pages. Lee took that as a sign that her husband remained, as she often called him, numero uno.

Against that comforting backdrop, Jackson was anxious to return to his natural abode, according to Goodnough, outside Earth's orbit. Lee, likewise, was eager to get to work. At the studio she had shared with Helen that winter, she had begun an exciting new direction moving her—she was thrilled to admit—toward a style she did not yet recognize. Prior to that, Lee had lunged from canvas to canvas, one seemingly disconnected from the next. In the paintings she produced in the early months of 1951, all the elements with which she had toyed separately—large blocks of color, sharp and thick vertical lines, spatial divisions that established a rhythm across her canvas like a film reel—came together and *worked*. Paintings such as *Untitled* and *Ochre Rhythm* were utterly original, created by an artist who had never been so free. "Lee is doing some of her best painting," Jackson told Ossorio, in a rare written expression of admiration for his wife. "It has a freshness and a bigness that she didn't get before."[28] He was so excited by them that he called Betty Parsons and asked her to look at Lee's work for a possible solo show.[29] Quite remarkably given her long career, it would be Lee's first.

"Delighted" was how Lee described her reaction to Jackson's stepping in to promote her. After she had spent eight years working on his behalf, Pollock had decided it was time to reciprocate. More than any words of praise or mumbled encouragements, this would have confirmed to Lee that she was on to something. "That, to my knowledge, is the only place that he made that sort of gesture, which meant a great deal to me," Lee said.[30] Betty, however, was less than thrilled at the prospect. "I didn't believe in having husband and wife in the same gallery," she explained. "Jackson knew this...but for Lee he could be persistent. And I felt if I didn't show her, there would be problems."[31] Betty came out to see Lee's bold new work and agreed to give her a show in October.[32]

It was to this scene—productive, peaceful, portentous—that Helen arrived in the spring of 1951 for her first visit to the Pollock household.[33] Perhaps the trip had been the result of an invitation from Lee, extended by way of thanks for Helen's studio hospitality that winter. Whatever its genesis, by the end of her stay Helen would be transformed as an artist. The

house on Fireplace Road was all about painting. "His mood permeated the ménage," Helen said. "But one was fully aware of Lee's interest and seriousness in relation to her own work."[34] Whereas in the past visitors would not venture up into Lee's studio, that spring they did. Self-confident over her upcoming show and buoyed by Jackson's approval, Lee proudly displayed her new paintings.[35] That happy state of affairs changed abruptly, however, after a mean-spirited jibe from Clem.

During one visit, while he was supposed to be looking at Lee's work, Clem instead studied the splattered wall around where her canvas was tacked and said, "Gee, that's fascinating."[36] Coming as it did from someone with an eye Lee respected, a dismissive remark like that—essentially declaring what Lee had intentionally painted to be inferior to the flotsam and jetsam she had not—would have been devastating. If it had been anyone else, she would have thrown him out on his ear after berating him with a cascade of choice epithets. But Jackson needed Clem, and therefore so did Lee. Swallowing his cruelty, she saved her response for a later day. The damage, however, was immediate. Lee began to second-guess her new direction. At some point that spring or summer, she abandoned the style of painting that Jackson had liked so well and that Betty had seen when offering her a show. Sadly, Lee's canvases turned timid.[37]

Helen may not have been aware of the undercurrents of conflict between the old art colleagues, mesmerized as she was by what she saw in Jackson's barn. Of course, she had known he painted on the floor, and she had been "rocked" by the results she had seen on the walls of Betty's gallery.[38] But there was something fascinating about seeing his actual studio: the stillness in which such chaos was produced; the cans of paint, rags, cigarette butts, and sand scattered around the room; the smell of solvents and oil, which to a painter are as evocative as the scents in a chocolatier's shop are for a child.[39] With streams of sunlight filtering through its cracked wooden siding, that humble barn was the scene of a revolution.

Soaking it all in, Helen realized something she had not understood when merely viewing Jackson's work on a gallery wall. Pollock didn't paint with his hands or wrists or even his arms, he painted with his whole body. Helen saw the potential for her own work in his method. She, too, wanted to engage her entire person in her paintings, not merely the delicate extremities that held a brush.[40] She did not want to paint *on* canvas, she wanted to paint *in* it. Helen was also one of the early witnesses to a new style Pollock had been trying. He had begun to allow his paint to seep into the canvas's weave rather than build up on top like a second skin. Pollock *stained* his canvas. The process intrigued Helen. "My concern was always, where would one go from there?" she said.[41]

Helen soon returned to Springs with a member of her "posse," Larry

Rivers.⁴² Jackson "was very gracious," Larry recalled. "It was exhilarating to meet him in that studio with all the trappings of the very foremost artist."⁴³ Fifteen canvases lay stacked on the floor like carpets in a showroom. Jackson lifted the corners so the younger artists could have a "peek," Larry said.⁴⁴

> There were huge canvases, like piles of them, and all so *serious*.... And then at lunch in his house—Lee was gracious too—there was heavy talk. Afterward, Helen and I walked by the sea: We were going to be great painters, really devote ourselves to art because of the guy—move to the country, even be what he looked like...⁴⁵
>
> Helen and I were standing on a deserted beach with drawn faces looking into the ocean which by now had become the ancient abyss, promising to devote ourselves even more determinedly and forever to ART.⁴⁶

In Pollock, Larry, a twenty-seven-year-old sax-playing, jive-talking, dope-shooting son of the Bronx, had found inspiration, while his twenty-two-year-old, elegantly dressed, beautifully educated Upper East Side companion had found a mentor. Their rumbling train ride back into the city was laden with a sense of destiny. In fact, destiny was in the air that spring. The underground artists had decided to show their cards, to announce themselves to the world. To have an exhibition.

Everyone downtown, First and Second Generation, men and women, had one occupation during the third week in May 1951: getting their work ready for the Ninth Street Show. The bustle in the Village and its surrounds was palpable. There were battles over who and what should be allowed in. Must all the work be nonobjective? Should only the First Generation be represented? Those artists had worked in obscurity for so long—didn't they deserve it? After much discussion, concessions were made to allow for "Clem's stable," artists like Helen, Grace, Larry, Al, and Bob Goodnough.⁴⁷ (Even Clem himself was allowed to show a work.) Bill liked Joan Mitchell. What about her boyfriend, Goldberg, who showed as Michael Stuart and who was mysteriously "away" for a period? "They didn't want to let in the whole Tibor de Nagy and other enclaves," Helen said. "It was sort of, who are these young whippersnappers...hauling these huge pictures across 10th Street to put in this big loft barn?"⁴⁸ Leo Castelli rejected one white-on-white painting. It went *too* far. But Lewin Alcopley argued that they couldn't refuse it; the show was meant to demonstrate everything that was going on. "This was Rauschenberg. He didn't want to take it in," Alcopley said. Castelli eventually did, but it was too late for Bob's name to be included in Franz's soon-to-be famous announcement.⁴⁹

During those weeks leading up to the show, Grace had struggled doubly—with her painting and with her son. Jeff, now nine, had come to stay with her and Al in their Essex Street loft while Grace wrestled with her Ninth Street Show contribution, *Six Square*. No matter how many times she reworked it, the painting eluded her, and she couldn't finish.[50] That creative turmoil only increased the distance she felt from her son, a boy who was well attuned to such disregard. In her journal Grace wrote, "Jeff cried himself to sleep after I brought him home.... It was heartbreaking to hear him, there was nothing to be said that could soothe him."[51] But, Grace had made her choice between art and motherhood, and would not allow her son's tears to melt her resolve. "He has his tragedies defined for him at an early age," she continued.[52] The coldness of that entry was evidence of the shield Grace had constructed to protect herself from the suffering of others, even her only child's. She had had to become that tough to survive. Opening the door to compassion or remorse at that point, when her entire being was directed at self-discovery in art, would have been a costly distraction.

At twenty-nine, she believed she had already wasted too much time. She was prepared to sacrifice everything. Grace lived hand to mouth, with all extra money (those funds others might have used to make life bearable) going toward painting supplies. Her bread was days old, her fruit bruised and overly ripe, her cheese aged but not intentionally so. In the days before and after the Ninth Street spectacular, in addition to painting, Grace juggled temporary office jobs to pay the bills.[53] That was all the time outside the studio she could afford. But that was how most of her friends lived.

Elaine and Bill were broke as well. He had had a second show that spring at Charlie Egan's and had sold three drawings and two paintings, but the money for the works found its way into Charlie's pockets and never reemerged.[54] Elaine said they were so poor that Bill sometimes ate catsup in hot water—"tomato soup"—at the Automat as he had during the Depression days.[55] Her earnings from *ArtNews* weren't enough to support them. Elaine and Tom Hess saw Egan as a big part of the problem and began pressuring Bill to leave his gallery for one that attracted better collectors and, more importantly, promised to pay. No matter Elaine's relationship with Egan, which by that time was largely over, her priority was Bill. She knew Charlie was no longer able to give him the help he needed and deserved.

When the lights went up on Ninth Street, however, with its banner announcing the show and a floodlight hung from a second-floor window acting as a beacon, *all* the artists forgot their plagues of daily concerns. What appeared was not a few abstract paintings by a couple of New York

artists but a symphony of color and line, a wall of noise so declarative it could no longer be denied or ignored. Even to an aficionado like Alfred Barr it was obvious that history hung on the makeshift gallery's walls. "It was sort of an outburst of pride in their own strength," Castelli said. "We considered this almost as the first Salon des Independents; this is what I called it as a matter of fact.... I thought that never before anything of the kind had occurred in America."[56] Sculptor James Rosati said the show was "probably the biggest event, I would say the biggest event since the Armory show" that introduced modern art to U.S. audiences in 1913.[57]

Nothing sold, but no one cared. The exhibition had earned the artists attention on their own terms. In the weeks that followed, the Cedar swelled with tourists: art students from the outer boroughs and New Jersey, gallery owners who had previously been loath to venture downtown, young women bored to death in their clerical day jobs looking for some nighttime excitement with an artist. "After the Ninth Street Show," said Mary Abbott, "the scene became a scene."[58] Indeed, it became almost a carnival. Visitors felt compelled to look the part of the artist, not realizing that the real artists dressed conservatively when they ventured out for an evening: in jackets and ties for the men, and for the women (aside from Joan), skirts or dresses. The only hint that they were artists was the telltale scent of turpentine they wore like a perfume and the odd splotch of paint on their person or clothes.[59] One night an unfortunate newcomer decided to try to seduce Joan with a discussion of "abstraction paintings." She listened and looked and, according to Elaine, finally said, "Shove off. There's something wrong about you—you look too much the part."[60]

The artists' nightly home had been invaded, as had the Club. Suddenly members were bombarded with requests to be invited for a Friday night lecture and the dancing afterward.[61] ("It was like Roseland!" exclaimed Harold Rosenberg.)[62] Eventually word spread as far as Europe. When artists or writers from the Continent arrived in New York, they made their way to the Club and the bar. Museums seemed like mausoleums in comparison to that throbbing scene. Even *Life* magazine wanted in on the action. Its editor tried to schedule a photo shoot and story on the Club. The artists, grown wary of such exposure, said with one resounding voice, "No."[63]

33. The Perils of Discovery

> Some artists have never received any recognition.... I've not received very much, but there is not enough bitterness, anger or resentment to make me stop working.
>
> —*Lee Krasner*[1]

ON JUNE 28, a new air-raid system blasted its first test in New York. Though this was not its purpose, the siren acted as a city-wide alarm announcing the annual summer exodus of artists (for those lucky enough to have the wherewithal to leave). Lee was already in Springs, preparing paintings for her show. Elaine had accepted invitations to visit friends outside the city whenever and from whomever they appeared. Helen and Clem had gone to Vermont for the season with his sixteen-year-old son, Danny. There they painted watercolors and Clem taught Helen to drive.[2] Grace had had her most "fruitful month of work" ever by the end of June.[3] But that fluidity in her studio had been achieved because she had not taken any temporary employment. The summer's start, therefore, found her penniless. In addition, Al had decided to leave their loft.[4] Grace responded to that natural parting between friends with deep sadness, even "heartbreak." If anxiety amplified her loneliness, it was because she was entirely on her own when it came time to pay bills. Though Grace had made a deal with the building's owner to clean the roof in exchange for a lower monthly rent, that only put a small dent in her financial obligations. In July she began working three days a week at the Savoy Plaza travel bureau.[5] Helen had invited Grace to join her in Vermont, but arranging other people's vacations at the Savoy was as close as Grace got to an extended holiday that season, that and a short stint at the Jersey shore with her son and family.[6] As for Joan, she would find herself in East Hampton for the first time that summer. And because it was Joan, her path there was not without drama.

She was doing the best work of her life and, while her fellow artists praised her (Clem shook her hand approvingly at the Ninth Street Show), Joan had been excluded from what would have been her obvious home at Tibor de Nagy with her fellow Second Generation artists. The trouble was, John Myers didn't like her work.[7] Years later, Joan said she wouldn't have joined the gallery even if she had been invited to do so because of "those two bitches," by which she meant Grace and Helen.[8] The response was classic Mitchell. It was also undoubtedly not true. Barney may have

sensed that her exclusion from Tibor de Nagy rankled because at the moment when John was assembling his stable of artists, Barney offered to help Joan find representation elsewhere. Using Illinois connections in the form of powerful Chicago gallery owner Katharine Kuh, he initiated visits by important people to Joan's studio: Betty Parsons (who was enthusiastic but whose gallery was full), the Modern's Dorothy Miller (who did not respond to Joan's work), and Kuh herself, who wrote to the Whitney on Joan's behalf and invited her to be in a show in Chicago the next winter.[9] Those visits had the opposite effect one might imagine. The attention left Joan feeling "uneasy" and "dirty." She sensed that when her guests discussed her work they did so "like I'm in a coffin & they're talking at a great distance."[10]

Joan had begun working toward an MFA at Columbia and taking French classes at NYU in order to earn a living when (not if) she and Barney split.[11] She had reached a point of despair over her tangle of personal crises: the difficulty of sorting out Mike's complex affairs, the emotional strain of her guilt over Barney, the horror that she might be pitied at home. Joan had told her mother about the mess her life had become, and while Marion responded with understanding, her tone had a patronizing "there, there" quality. She had even suggested Joan return to Oxbow for the summer to think things through.[12] At around that time, Mike asked a young pianist named Evans Herman to deliver a message to Joan. Evans had met Mike at the psychiatric hospital after being institutionalized for draft dodging. Joan fell madly in love with him. He represented a creative quiet that she had known as a child in the presence of her mother and grandfather but which had eluded her as an adult. Evans lived in the Chelsea Hotel with a grand piano. "She relaxed by coming up to my apartment without sex and listening to me play," Evans said.[13] Soon, however, that relationship, too, became complicated. Evans and Joan became lovers. Now there were three men vying for Joan's attention.

In midsummer, a gentlemanly Columbia graduate student named Eugene Thaw came into Joan's life to solve her New York gallery dilemma. Thaw and a partner had an exhibition space on the top floor of the Algonquin Hotel, and Gene had been directed to Joan by Conrad Marca-Relli.[14] Gene had no track record, no reputation, no real place in New York's art world. All he could offer was a love of art, *new* art for his New Gallery. Joan invited him to her studio, liked him, and he in turn offered her a solo show the following year.[15] The gallery question thus settled, Joan was eager to leave the city, too. Her old Chicago Art Institute friend Francine Felsenthal had invited Barney and Joan to join her in Long Island in her portable shack on Sammy's Beach.[16] (In town she had an orgone box in her flat. Barney called her "a little on the psychotic side.")[17]

Somewhat remarkably, given the state of Joan's and Barney's relationship, they agreed.

It was the first time either of them had been to the Hamptons, and they were struck by its beauty: the turbulent water visible across its flat expanses, the white mountains of dunes, those elements that reminded them of home and yet were unique enough to be transporting. Everything about the weekend was salubrious and, when it came time for Barney to muse about his future, which he had decided would not be in film, Francine mentioned a friend who might be interested in selling a small publishing house. Though Grove Press had produced just three books, its owners were losing interest because their money flowed in one direction—out.[18] In a gesture that Barney called "a rather beautiful final act" in their moribund relationship, Joan told him to do it, to buy Grove. "Failing as a husband, perhaps becoming a self-employed entrepreneur was the next natural step," Barney said. "Publisher" was an occupation he could live with. For three thousand dollars, Barney inherited the name Grove Press and unsold copies of each of its three books: Melville's *The Confidence Man*, the *Selected Writings of Aphra Benn* (the first professional English-language female writer), and the work of a seventeenth-century British metaphysical poet named Richard Crashaw.[19] Under the direction of Barney Rosset, Grove Press would go on to publish Samuel Beckett, Jean Genet, D. H. Lawrence, Henry Miller, Frank O'Hara, William S. Burroughs, Allen Ginsberg, Jack Kerouac, Malcolm X, Che Guevara, Alain Robbe-Grillet, and Nathalie Sarraute, among many others. At the start, however, Barney approached his new business cautiously. One of the first books he acquired was at Joan's suggestion: Henry James's *The Golden Bowl*, a novel about adultery and doomed marriages.[20]

Nineteen fifty-one was one of those pregnant years, filled with many beginnings. It was not just the year of the "Irascibles" photo in *Life* magazine, or the Ninth Street Show, or the debut of the "Tibor Five," or the rebirth of Grove Press, it was also the year three Abstract Expressionist women would have their first solo exhibitions. Grace had had hers in January, Helen's would be in November, and on October 15 Lee would mark her debut at Betty Parsons's gallery. Lee always referred to the event as a solo show. In fact, it wasn't. She shared the Parsons space during her exhibition with the collage artist Anne Ryan.[21] Lee didn't quibble. After watching her First Generation colleagues have their day in the limelight, she, too, was coming out.

But something had happened between the time Betty saw Lee's paintings several months earlier, in Springs, and the fall when Lee and Jackson hung her work in the gallery. It was so different it might have been done

by another artist. The paintings Betty had seen in Lee's studio made statements and were remarkably confident in the power of her line and dark masses of undulating color. By contrast, the fourteen paintings Lee brought in for her show were pastel-hued and controlled to the point of boredom. They appeared almost as student work, not the paintings one would expect of a veteran of the long war of abstraction.[22] Sometime during the summer, perhaps as a result of Clem's heartless comment about the wall on which she worked being of more interest than her painting, Lee had lost her nerve. She had collapsed into that netherworld of "pretty" things. Pollock may have recognized the show's weakness. Normally, when threatened by Lee's accomplishments, he punished her with a drunken outrage. On the occasion of her Parsons exhibition, his sense of competition was unaroused. As soon as people began arriving, he told a friend, "This is *Lee's* show" and escaped to the street.[23]

Nothing about the show rang true. Even in the brief biographical details printed to accompany her paintings, Lee's age was given as thirty-nine, when in fact she was forty-three. Insecurity about her work and her person defined the event.[24] Clem had not reviewed it, but pieces in the *New York Times, ArtNews,* and *Art Digest* were gentle, as if the critics were being intentionally kind.[25] Lee was, in other words, a critical charity case. If she had been made to defend paintings she was proud of against critical disdain or misunderstanding, she would have been able to hold her head high. That would have been a noble fight. Instead she found herself in a position she abhorred: she was pitied. "It was worse than I feared," said Betty. "I felt badly for Lee."[26] Lee later admitted she didn't like the work herself. Just two of the fourteen canvases she had shown would survive. The rest she destroyed or recycled.[27]

Lee's debacle of an exhibition had only been down a short while when Helen hung her first solo show.[28] Lee believed bitterly that her generation's struggle had made it easy for the Second Generation to find their own style and gain acceptance. "They may think it's rough for them but it is pie compared to what we went through," she fumed. "We broke the ground."[29] "We had to create all this. The next generation had an open door."[30] In any case, that was how it appeared to Lee and to other First Generation painters. One veteran said of Joan that it took her only eighteen months to accomplish what he had struggled with for eighteen years.[31] But that thinking neither acknowledged the difficult personal histories of the younger artists they dismissed as gate-crashers nor the difficult artistic position into which they had been placed *because* they came after the major discoveries had been made. In some ways, all Second Generation artists were treated like "wives who also painted." They would always be compared with their distinguished elders and, until they made original statements, viewed as lesser. That was the Second Generation's

burden, and it weighed on them each time they entered their studios. As Helen prepared for her show, Grace noted in her journal, "Helen, Al and I are all going through a crisis at the same time—Helen to such an extent that she wants to give up painting entirely."[32]

One of the differences between a person who played at being an artist and the real thing, however, was that the latter did not stop, no matter the difficulties. By the time her exhibition opened at Tibor de Nagy on November 12, Helen had eleven works ready to be hung with the help of John Myers, Grace, Al, and Gaby.[33] Helen's mother and sisters, meanwhile, held preshow envelope- and stamp-licking sessions, spending hours preparing invitations and planning a post-exhibition party.[34] The result was a packed show and a party for seventy people that lasted until five a.m. Reviews appeared in *The New Yorker,* the *New York Herald Tribune, Art Digest, The Nation,* and *ArtNews.* "While I'm pleased," Helen wrote Sonya, "I think I have a fairly sound outlook on the whole business."[35] What mattered most was her own opinion and that of her fellow artists. Neglected First Generation painters were no doubt astonished by the reception young Helen's work received, but John Myers wasn't. Helen, he said, "from the beginning, and even in this, her first show, was an original."[36]

Two days after Helen's milestone show closed, Grace, Lee, Jackson, Clem, Barney Newman, and a painter friend of Clem's named Friedel Dzubas were gathered at Helen's apartment when Clem proceeded to disparage the very idea of "women painters."[37] The year had, in fact, begun with a scandal over an early nineteenth-century painting by a woman that had mistakenly been attributed to Jacques-Louis David. When the work at the Metropolitan was believed to have been by David, it had been considered a masterpiece, "a perfect picture, unforgettable." But after it was discovered that the portrait of Charlotte du Val d'Ognes was not by a Frenchman but most likely by a Frenchwoman, possibly Constance Marie Charpentier, it fell from grace. Of course, the painting itself had not changed one stroke, but the scholars who had previously heralded it as the finest example of the French master David's powers admitted, on second thought, that it really wasn't very good. One wrote with a sniff that it had the common aroma of a "feminine spirit."[38]

This controversy at the Met, which had shown itself to be so reactionary with regard to modern art, might have been dismissed as one more example of the backward attitudes of its scholars and administrators if not for comments by intellectuals that seemed to support such thinking. One of the Club's favorite speakers, Paul Goodman, had said that fall, "There are no women artists because a woman is too much concerned with her own body."[39] And then there was Clem's discourse that evening at Helen's on

the genetic improbability that a woman could ever become a great artist. He delivered his "lecture" with the comfortable assurance that everyone would agree with his premise, as well as utter disregard for three of his listeners who were women painters. Or *was* he unaware of the injurious nature of his remarks?

Clem was calculating in his so-called honesty, which he increasingly employed as a weapon as his lone occupancy of the throne of avant-garde art critic came under threat. New voices could be heard, articulate voices provocatively describing the scene. Tom Hess had just published *Abstract Painting,* the first book on the new work coming out of New York, and its ideas were "thrashed out...like early Christianity," according to Philip Pavia, at every spot where artists gathered.[40] Hess's opinion was on everyone's mind that season; for the first time in years, Clem's wasn't the intellect through which the reading public gleaned its greatest insights into American avant-garde art.

Coming as it did so soon after Helen's first solo show and a month after Lee's, Clem's tirade could only have been intended as a calculated affront to the women gathered at Helen's place by an angry man looking to do harm. An artist—regardless of whether his or her show had been a success—was nearly always left feeling drained and delicate afterward. Clem knew that, and yet he had chosen that moment to declare, according to Grace, that women artists were "too easily satisfied" and that they "finished" and "polished" pictures into mere decoration, that they made "candy." He said that Second Generation artists like Al, Larry, and Bob Goodnough struggled, implying that Grace and Helen did not. "Am I to scream at him, 'I struggle too, I do! I do!'" Grace wrote in her journal. "He said he wants to be the contemporary of the first great woman painter. What shit—he'd be the first to attack."[41] It would take a great deal of strength for an artist to listen to Clem's expression of culturally sanctioned sexism and not be brought low by it. But if Clem's aim had been to intimidate, stifle, or discourage the two younger women, he failed utterly. Neither Helen nor Grace could ever be persuaded that they were secondary painters because of their sex. They were not *women painters,* they were *painters,* and they got to work at the end of that important year with renewed vigor despite Clem's reminder that the official cards were stacked against them.

The winter had come on full blast by mid-December, making the studios in which artists worked nearly unbearable with their lack of central heat. Grace repaired broken windows with a papier-mâché paste to keep out the arctic gusts and painted in ski clothes while working on a five-and-a-half-by-six-foot canvas she called *Woman.*[42] As for Helen, she wrote to Sonya, "It's been freezing, snowy, icy in the City for the past few days.

So cold, that my two gas heaters do hardly any good in my big drafty studio. I've been stomping around there in blankets to keep warm. What irony: wearing my luscious seal coat in such surroundings!"[43] Helen said later of that period that creatively, she had had so many ideas she wasn't sure she had the "wherewithal physically [to get] it all down as fast as my head is moving towards it."[44]

Both artists were pushing beyond themselves and their detractors. They were young and easily able to bounce back. Lee, however, was not. She had been crippled by disappointment, mostly in herself, after her fall show.[45] Debilitated and directionless, she wasn't prepared when Jackson's exhibition at Betty's gallery on November 26 was more disastrous still, if only because the spotlight shone much brighter. Crowds had gathered to see the "drip painter" and were sorely disappointed to find instead black-and-white canvases, some of which contained *figures*.[46]

The reaction was incredulous. Clem, who had attended the opening with Helen, did his best to praise Jackson's show in print, writing in *Partisan Review* that if "Pollock were a Frenchman...people would already be calling him *'maitre.'*"[47] Instead, some who had only just been converted to Jackson's previous painting style murmured knowingly that he had "lost his touch."[48] Lee recalled a dealer saying to her of Jackson's new direction, "'It's all right, Lee, we've accepted it.' The arrogance, the blindness was killing," she exclaimed.[49]

Anticipating Jackson's reaction, Lee brought him back to Springs to try to reduce his access to alcohol and friends with whom to drown his sorrows.[50] It was a spiral she had seen before, but not so violently or so maniacally as it manifested itself that season. On December 28, the East Hampton police investigated a report of a car accident in Springs. Driving a 1941 Cadillac convertible, Jackson hit three mailboxes, a telephone pole, and a tree head-on. Blind drunk at the time, he escaped uninjured.[51] But the accident terrified Lee. From that year on, she said, "I never knew if he would come home unhurt."[52] She wasn't just afraid for her husband, she was afraid for the artist Pollock. He was hers to preserve and protect, and she feared that she had failed him.

One morning Jackson said to Lee before going into his studio, "I saw a landscape the likes of which no human being could have seen."

"I guess he was talking about a sort of visionary landscape," suggested Lee's friend, B. H. Friedman, to whom she recounted the story.

"Yes, but in Jackson's case I feel that what the world calls 'visionary' and 'real' were not as separated as they are for most people," she responded.[53]

Indeed, those two realms coexisted without boundaries for most of the

New York School painters. As long as they were only speaking with one another, that didn't seem in any way strange or noteworthy. But the Ninth Street Show and the increased gallery representation had exposed avant-garde artists to a broader audience. Jackson had been the first to face the onslaught of outsiders—as he had been the first to break through in his painting—and it was driving him mad. Soon they would all feel the pressure and shock of what the world called "success." Wasn't it wonderful, then, that arriving on the scene at that moment were writers to elucidate the painters' worlds and in so doing remind them of the singularity of their purpose. Two of them were old hands on the scene: Tom Hess and Harold Rosenberg. But more important still was a group of young poets. They, too, would become a New York School.

34. Said the Poet to the Painter

> Simply to live does not justify existence, for life is a mere gesture on the surface of the earth, and death a return to that from which we had never been wholly separated; but oh to leave a trace, no matter how faint, of that brief gesture! For someone, some day, may find it beautiful!
>
> —*Frank O'Hara*[1]

THE PERSON WHO seemed to be enjoying the New Gallery opening least on that snowy fourteenth of January 1952 was the artist herself. Joan was blinded by terror.[2] It had been many years since she had been the focus of public attention, and she may have lost her knack for performance. In any case, having dozens of artists discussing one's paintings was much more traumatic than pleasing an audience or a panel of judges from the center ice. The entire Club had turned up for her opening, as had the younger generation of artists (except Larry, who was sleeping off a bad shot of heroin).[3] Though Joan knew all these artists socially, and though many had seen her work in her studio, declaring oneself with sixteen paintings in a first New York solo show was almost more exposure than she could bear. What made it more difficult still was the fact that Joan had decided for the occasion to wear the costume of the respectable young lady she was not: dress, corsage, and hair combed into submission. She was as comfortable as a longshoreman in a corset and heels. Joan's attire might have been a gesture to her parents, who subsidized her painting life with a monthly allowance and had flown in to celebrate their talented daughter's achievements.[4] That clash between Joan's two worlds only added to her anxiety. The girl she had once been came face-to-face with the woman she was, and the meeting was not easy.

Luckily, Joan had had support before and during the show: from Barney, who even as he threatened to divorce her, paid for her exhibition catalog and arranged for poet and critic Nico Calas to write the exhibition essay;[5] from Leo Castelli, who helped Joan hang her show to best advantage;[6] and from her fellow artists, Paul Brach, who reviewed the exhibition for *Art Digest*, and Bob Goodnough, who wrote about it in *ArtNews*.[7] There was also support from veterans like Elaine, whose praise pleased Joan immensely.[8] The fact that Elaine had come to her opening at all was a testament to the loyalty she felt for Joan. Elaine had broken her leg badly after slipping on the ice out-

side the Empire State Building in November. Her leg encased in a heavy plaster cast, she arrived at the gallery in a wheelchair. (Ernestine was her "pusher" and, when necessary, Johnny Myers carried Elaine up stairs.)[9] Such immobility in the dead of winter might have kept others apartment-bound. Not Elaine. Her condition was an impediment to be dismissed with the wave of a hand and a flick of ash from her ever-present cigarette. She wouldn't have missed Joan's debut for the world.

In painting after painting, the work that covered the walls of the New Gallery looked like detonations frozen in space and time. They didn't expand like Pollock's into infinity or reside masterfully on the canvas's surface as did Bill's. Joan's pictures were as contradictory as she was. The violence of her sharp shards of color combined to create an image that was surprisingly pleasing. Her paintings were both in motion and utterly still. Vast numbers of seemingly random brushstrokes had in fact all been very deliberately applied. Joan's paintings also showed an exuberance that the elder artists, who had already arrived at a style, lacked. At twenty-six, her development was far from complete; her work wasn't resolved—it wasn't yet *there,* as she and her fellow artists sometimes confessed in moments of frustration—but she was on her way and the passion of her search gave her canvases life. Joan's paintings also had power—*she* had power, in her arms, in her vision. No one seeing that show would have questioned her right to call herself a painter.

Except Grace. Glamorous in a flapper-style necklace knotted at her breasts, Grace arrived at the opening with Helen (who appeared to be having the most fun of them all), declaring Joan's work "a fantastic display of youthful talent and virtuosity, without the real thing."[10] Grace was engaged in an epic struggle with a large canvas she called *The Massacre* and may not have been in the mood to be generous.[11] If Grace's sour note had made its way to Joan's ears, however, she would have ignored it. Despite opening-night jitters, Gene Thaw said that Joan "already knew she was a star." And, to confirm her position in the New York galaxy, by the end of January Joan was elected a member of the Club.[12]

Joan's admission to that artistic conclave occurred amid a brewing controversy that Philip Pavia called "The Hess Problem."[13] Tom Hess had published his book *Abstract Painting* the previous November. It was the end of that critical year of the Ninth Street Show, after which the attention directed toward the New York painting scene was no longer limited to a few artists like Pollock, or even the "Irascible Eighteen," but applied to the entire group that had, until that point, lived and worked largely below the radar of official culture. The new attention had energized the artists, but it had also made them self-conscious, and Hess had identified a general tendency toward reevaluation. In his book, he set out to help by describing

the roots of modern art, and the loose aesthetic that bound together its practitioners in mid-twentieth-century America. But that seemingly modest mission aroused a disproportionately passionate response from the artists who were his subject, particularly Tom's linking—as had Kandinsky—the notions of abstraction and expressionism.[14]

In a historical portion of his book, Tom wrote very simply and clearly that modern artists working mostly in Europe during the late nineteenth and early twentieth centuries painted primarily in two veins after the Impressionists. There was the abstraction evidenced in analytical Cubism, Futurism, Constructivism, and in the singular work of the New Yorkers' revered friend, Piet Mondrian. The European abstractionists had developed styles based on formulas and painted within those rules. The paintings were largely flat, clean, divorced from reality, though not always devoid of things. They represented ideas, not about life but about painting. Developing at times simultaneously was another painterly landscape, expressionism. Its practitioners included artists like Van Gogh, Gauguin, Kandinsky, and Chaim Soutine, whose paintings writhed in glorious agony and had been featured in a major show at the Modern in 1950.[15] Like their abstract brethren, the expressionists were interested in painterly ideas, not in replicating the world as it was. Their struggle involved *expressing* the world they experienced. Whatever formula they may have embraced was personal, and generally employed vivid colors, thickly applied paint, and brushstrokes as individually identifiable as a signature.

Tom's leap (and what some Club members believed to be his crime) was to suggest that the New York avant-garde artists married abstraction *and* expressionism in their work, that they represented both veins that ran through Europe.[16] They were pure abstractionists *and* expressed their visions of the world as individuals. It seemed an innocuous enough thesis, but it was met with a roar of disapproval and cries of anguish from some of the artists. After reading the book, Jackson bounded up the steps of the Club, threw his copy at Philip Pavia, and shouted at Bill, "Who wrote this book? Your wife?"[17] He saw in its pages a treatise promoting the European style of painting most visible, among the First Generation artists, in Bill's work. And Pollock wasn't alone in his criticism. He and others feared the encroachment of expression, of what they considered a less-than-pure form of painting, and of a return to a subservience to Europe. The very idea appeared to them regressive. "What was the chief objection—the point of friction?" Philip Pavia asked.

> It was the implication of a sinister collaboration of the Abstract artist with the representational artists, making the near abstract more important than the abstract.... Instead of proud, pioneering abstract artists, they were to be

nothing but bastardized near-abstract artists with hybrid experiences. A bastard word, a bastard idea and a bastard artist would be a compact paraphrase of complaints.[18]

To "prevent riots," Pavia organized a series of seven panel discussions on "Abstract Expressionism." The first discussion was held four days after Joan's opening.[19] By the fourth session, Joan took a seat among her Second Generation colleagues on a panel of their own along with a poet who had arrived on the scene in late 1951 and whom Elaine had invited to the Club.[20] His name was Frank O'Hara and he would be the fractious group's Apollinaire.[21]

In a letter to Barney Rosset's secretary in 1957, as Barney prepared to publish a book of Frank's poetry, Frank provided an abbreviated version of his history: born in Baltimore in 1926, raised in Massachusetts, enlisted in the navy at seventeen, served in the Pacific, received a degree in English from Harvard, studied music, and "worked in a textile mill during the summers and read Rimbaud."[22] As to his physical description, he would say that he was made "in the image of a sissy truck driver."[23] All of that was true, but it didn't come near to capturing the man who would be the greatest inspiration, the favorite painterly subject, the most exuberant cheerleader, the guiding light, the best friend, and cherished lover in varying degrees to many of those who considered the Cedar and the Club home. His close friend and fellow poet John Ashbery said no one knew the scene was missing something until Frank arrived, and then everyone realized he was what they had been waiting for.[24]

Francis Russell O'Hara was indeed born in Baltimore, but it was only to mask the fact that his mother was pregnant before she was married. The O'Haras had deep roots in Grafton, Massachusetts, to which his mother and father returned eighteen months after Frank's birth and where he would stay until he left for the navy sixteen years later.[25] Cultured in a small-town New England sort of way, his family was just dysfunctional enough to provide material from which a grown Frank could draw, and protective enough that he learned to express himself without fear. The oldest of three children, Frank was coddled by aunts and a granny who adored him.[26] How could they resist? He was slight, freckled, dark-haired, blue-eyed: a perfect Irish angel, until his nose was broken in a schoolyard fight and never properly set.[27] That crooked nose didn't rob Frank of his beauty, it became him.

Frank had wanted to be a pianist and was taking classes at the New England Conservatory of Music when the call to duty that his generation felt compelled to answer beckoned.[28] Immediately upon graduating from

high school Frank enlisted in the navy. It was June 1944 amid the drama of D-Day, but Frank wasn't bound for Europe. He was dispatched as a radarman to Asia, where the war seemed endless and a resolution out of reach.[29] Miserable during basic training, Frank said,

> I reread *Ulysses,* needing to throw up my sensibility and Joyce's art into the face of my surroundings; I found that Joyce was much more than a match. I was reassured by [the discovery that] what was important to me would always be important to me.... I found that I myself was my life.[30]

Outwardly in every way a wisp of a seventeen-year-old boy, inside he became an independent man. Though he formed part of a group, and was intrigued by those around him, he was essentially alone, observing, absorbing, not with a sense of angst but with a limitless freedom. The comprehension that each man is as free as the restrictions he imposes upon himself meant that anything was possible. On that destroyer heading to Asia, Frank came to understand who he was. He was an artist.[31]

Because of his broken nose, which suggested that Frank was a pugilist, Frank's shipmates called him by the macho nickname Butch—until they got to know him. Then he became Butchie.[32] Frank had had his first gay experience a year before enlisting and had never bothered to try to pass as a straight man.[33] In any case, in those days when the question was not how one lived one's life but whether one would live at all, there was no need. Though in society homosexual acts were still considered a felony, with only murder, kidnapping, and rape garnering harsher penalties, the military had been desperate for recruits and largely turned a blind eye to gay volunteers.[34] Said one historian, "For many gay Americans, World War Two created something of a nationwide coming out experience."[35] Frank's, or anyone's sexuality, was least among the worries onboard his ship. They were sailing toward what they had expected to be a land invasion of Japan. Instead, Frank and his mates formed part of a rescue mission searching for POWs after so many years of war. The bombs that had incinerated Hiroshima and Nagasaki had made a land campaign unnecessary.[36]

By the summer of 1946, Frank was back in the States, joining the mass migration of veterans from the battlefield to the classroom. That fall, he enrolled at Harvard, where 71 percent of the student body was on the GI Bill. His plan had been to study music, but after his father died suddenly in 1947, Frank switched to writing.[37] Another new chapter in his life had opened, one that proved so daunting he thought of killing himself because he feared he would not have the strength to create something truly beautiful. And yet that difficult quest promised such great rewards that he refused

to succumb to the impulse to die. Writing in his journal in October 1948, Frank said,

> If life were merely a habit, I should commit suicide; but even now, more or less desperate, I cannot but think, "Something wonderful may happen." It is not optimism, it is a rejection of self-pity (I hope) which leaves a loophole for life.... I merely choose to remain living out of respect for possibility.[38]

At Harvard, Frank's early roommate was a rangy fellow from Chicago just out of the coast guard named Edward St. John Gorey, or Ted. Having been Joan's mischievous friend and fellow art student in high school, Gorey was by college a budding illustrator whose comically macabre drawings would eventually appear in books, on Broadway, and even on television.[39] But long before he had attained popular acclaim, he was showing his work around Cambridge, and it was at a bookstore exhibition of Gorey's watercolors that Frank met the poet John Ashbery.[40] "There was a sort of legend about Frank," Ashbery said. "That he was this brilliant young writer who talked sassy. Someone who looked like he was going to be famous someday."[41]

The two became friends, and when John graduated in 1949 and moved to New York, Frank decided he would go there, too, after his own graduation the next June. A community of young poets waited to receive him. Like him, they were dedicated to writing a new kind of poetry, one that celebrated words for their own sake without regard to grand themes or traditional storytelling, that declared the existence of the poet as he or she was, at that moment, in the world, without the trills and flourishes of language borrowed from the past. Like the painters and composers who had made their home in New York, the poets were interested in a revolution modestly waged among themselves and for one another.[42] "You could fit the people I write for into your john, all at the same time without raising an eyebrow," Frank would write Jane Freilicher in 1951.[43] At the start, Frank's readership included a handful of painters and his fellow poets John Ashbery, Kenneth Koch, and James Schuyler.

At twenty-seven, Jimmy Schuyler was the oldest of the group and the only one among them who hadn't gone to Harvard.[44] Born in Chicago, he looked like a 1940s film star of the James Cagney variety—boyish but potentially deadly. During the war, Jimmy was on a naval destroyer in the North Atlantic occupying a most existential position: He was a "ping jockey" operating in a virtual cone of silence, listening intently for sounds arising from the deep sea indicating the presence of enemy submarines. Near the end of the war, he worked at Voice of America radio and was in

the studio on the day the United States tested its first atomic bomb. "A lot of people were afraid it would set off a chain reaction that would destroy the world," he said. "I was to take this record, if the world wasn't destroyed, and run with it down to the studio."[45] His fragile mental health shaken, Jimmy abandoned his life of listening for imminent death. He went to Italy for a spell and worked for the poet W. H. Auden as a secretary before eventually making his way to New York, where he found a job in a bookstore and met Frank at a party in 1951. Frank and Jimmy moved in together as roommates, sharing a wretched East 49th Street sixth-floor walk-up with filthy walls and rivers of roaches.[46]

Kenneth Koch was the only straight poet of the group, though Larry Rivers said he "talked and acted gayer than any gay friends."[47] Kenneth had made the mistake of telling Frank that during psychoanalysis he had been told he had "homosexual dread." Forever after he was teased about his affliction, which was abbreviated to HD, and about the fact that he was by his own admission "a little squarer than they were. Obviously I was, since I was not forced by my sexual preferences to lead the life of a semi-outlaw."[48] Born in Cincinnati, he was a rail-thin, curly-haired, country-club boy who had grown up on tennis, swimming, and lazy summers trying to seduce nice midwestern girls. He had an uncle who ran the family furniture store but had wanted to be a poet. When Kenneth was fifteen, his uncle introduced him to that world of words, opening the store safe to reveal poems he had written when he was a teenager *and* the complete works of Percy Bysshe Shelley. Koch immediately equated poetry with escape—from his genial home and from the retail furniture future that lay in wait for him.[49]

What actually awaited him was the army. Kenneth was drafted and sent to the Philippines as a rifleman. His military career became an unmitigated nightmare. During one march through the fetid jungle, he fell and lost his glasses, without which he was nearly blind. "The only person behind me in the company was a hillbilly corporal from Oklahoma. 'C'mon Cock'—they all pronounced my name *Cock*—'get your fuckin' ass outta here...or you're dead.'" Having miraculously survived that ordeal, Koch turned to the company's commander and explained that he was useless without his glasses. He wondered if he could stay out of combat until he got a new pair. His request denied, he was sent out to the battlefield with a rifle he couldn't fire to fight an enemy he couldn't see. On his Harvard application he listed his interests as "creative writing," "peace," "philosophy," and "psychiatry."[50] Mostly, he wanted to forget the Philippines.

Slender, clear-skinned, and patrician, John Ashbery was the youngest of the poets and the only one who did not serve in the military. Larry Rivers described him as hilariously and delightfully well-spoken.[51] John had been

raised on his father's fruit farm on Lake Ontario and, like Joan, recalled the sound of snow, that feathery silence that covered the landscape and everyone in it. His escape as a child had been the library at the home of his maternal grandfather, with whom John lived for a period as a boy. His grandfather introduced him to literature as well as the redemptive notion that John could be anything he chose.[52] The child's first love had been painting, but through high school he became increasingly immersed in poetry. In 1945, at seventeen, he had two poems published in Joan's mother's magazine, *Poetry,* in an issue that also featured poems by a young soldier named Kenneth Koch.[53] The two aspiring poets, whose backgrounds were so different, would meet as students at Harvard, where Ashbery was a year behind Koch. That friendship continued when they both moved to New York to attend graduate school at Columbia and inadvertently form the nucleus of a new school of poetry.

It was initially through Jane Freilicher that the poets of the New York School were introduced to the painters of the New York School. "I was living in this kind of, it was a building that wasn't exactly a tenement but it was ... on Third Avenue and it was a walk-up, four flights," Jane recalled of their meeting. Koch also lived in the building, and he and Jane shared a kitchen. "And we became very friendly and it was very strange because Kenneth ... liked to put on a mask, a lion's face, and sit in the window and scare people on the Third Avenue El."[54] Soon he began going to galleries with Jane and Larry. He met Nell Blaine. He made his way to the Cedar.[55] And when John Ashbery came to town to stay at Kenneth's place, he, too, became part of that circle.[56] It was a world of words and pictures; it was Leonardo da Vinci's "painting as 'silent poetry'" and "poetry as 'speaking painting.'"[57] Frank entered that world as if he were born there.

In John's furnished room on West 12th Street in December 1950, a crowd gathered for a party that included literary types he had met on various jobs, and a few of the artists he had lately befriended. The dress was conservative, the tone highbrow, the music classical.[58] Twenty-four-year-old Frank was in town during a holiday break from graduate school in Michigan and appeared at the door wearing his usual look of high expectation and his veritable uniform: a Shetland sweater with no shirt underneath, army pants, and tennis shoes.[59] His was a heart-stopping entrance. "Compared to him everyone else seemed a little self-conscious, abashed, or megalomaniacal," Koch explained.[60] Said Jimmy Schuyler,

> Frank O'Hara was the most elegant person I ever met, and I don't mean in the sense of dressy, for which he never had either the time or the money. He was of medium height, lithe and slender (to quote Elaine de Kooning, when she painted him, "hipless as a snake"), with a massive Irish head, hair receding

from a widow's peak and a broken, Napoleonic nose.... He walked lightly on the balls of his feet, like a dancer or someone about to dive into the waves.[61]

Friends often remarked on his walk. One called it "light and sassy.... It was a beautiful walk. Confident. 'I don't care' and sometimes 'I know you are looking.' "[62] Frank's fluidity and grace of movement were matched by his social prowess. "He had perfect manners, and he was a real gentleman," said Koch. "Everything he did made you happy. When I was around Frank I felt like a better person. I was more generous, I was a little more inspired."[63] Composer Morty Feldman called Frank "a Fred Astaire with the whole art community as his Ginger Rogers.... [He treated] the whole thing as if it were some big frantic glamorous movie set."[64]

By the end of that evening at John's, Frank had fallen in love.

With Jane Freilicher, who said they became friends in about "six seconds. It was a bond such as I never had with anyone else. It was instant intimacy.... It was very flattering to have somebody who would sit and look at you in wonderment. Every word that you said he would think was sort of a profound utterance. And he meant it."[65]

With Larry Rivers. They talked for two hours before finding a "quiet spot behind a window drape" to kiss.[66] "I saw two pairs of shoes protruding from the drape," John said, "one of them being Frank's usual white sneakers and the other being Larry Rivers's shoes."[67] The two men were nearly the same height, same build, same intensity. "I liked his Ivy League dirty white sneakers, he liked my hands full of paint," Larry said. "He was a charming madman, a whoosh of air sometimes warm and pleasant, sometimes so gutsy you closed your eyes and brushed back the hair it disarranged."[68]

With New York. Frank wanted to stay but he had to finish his studies in Michigan during an endless winter, and a summer made bearable only because it had included a visit from Jane.

Frank finally settled in New York in August 1951 and gripped its pavement, daring anyone to force him to leave. He, like that first "poet of the city" Baudelaire, didn't want solitude to create.[69] He needed life. In the nineteenth century, when a poet was a kind of priest in a lofty tower, writing beatitudes, Baudelaire had challenged his confreres to open their eyes to the poetry of daily life. He admonished them to establish themselves "in the heart of the multitude, amid the ebb and flow of movement, in the midst of the fugitive and the infinite," to enter "into the crowd as though it were an immense reservoir of electrical energy."[70] That is what Frank sought and did. In the company of poets and painters.

In December he took a job on the front desk of the Museum of Modern Art. Frank said he wanted to be able to see the Matisse retrospective on

display there whenever he chose, but later he stayed on at the Modern because he so loved being surrounded by and in service to art.[71] "The first time I dropped by to see him," Jimmy Schuyler said, "I found him in the admissions booth, waiting to sell tickets to visitors and, meanwhile, writing a poem on a yellow lined pad (one called 'It's the Blue!'). He also had beside him a translation of André Breton's *Young Cherry Trees Secured Against Hares*."[72] John Ashbery said at that time "there was nothing like a basis for the kind of freedom of expression that Frank instinctively needed."[73] Not in poetry, but it did exist in the visual arts, and Frank found himself drawn to the people who created it. Because of the risks they had taken in their lives and work, Frank was awed by the New York painters he was coming to know.[74] He explained,

> Then there was great respect for anyone who did anything marvelous: when Larry introduced me to de Kooning I nearly got sick.... [I]f Jackson Pollock tore the door off the men's room in the Cedar it was something he just did and was interesting, not an annoyance. You couldn't see into it anyway, and besides there was then a sense of genius.[75]

Like the composers, the young poets had no home among official literary circles.[76] They were another group of artistic orphans whom Elaine invited to the Club. "Elaine was a great enthusiast for the new poetry, also a born strategist, and she knew this was very important," said Natalie Edgar. "She brought in the poets."[77] Years later Elaine described why, telling an interviewer,

> Poets can look at a painting and understand it without having it spelled out [and] painters can read poetry.... People say, I don't understand what it means, about John Ashbery's poetry. Painters would never say that.... The idea of "I don't understand what it means," looking at abstract painting and saying, "Explain it to me, what does it mean?" You don't say that, and you don't ask people to explain music. And so, poets, painters, composers don't need explanation. Explanations are for other people...burdened by logic.[78]

It was not until March 7, 1952, however, that Frank made his debut on a Club panel. When he did, it was during a discussion on Tom Hess's book, moderated by John Myers, with co-panelists Joan, Grace, Jane, Larry, and Al Leslie.[79] It was not just Frank's coming out at the Club, it was the Second Generation's. The event was the first to feature the young painters, to give them a chance to express their ideas about art. And it was a disaster. No doubt, the calamity was partly due to their case of nerves when faced with elder statesmen and -women. "These people were like your parents,"

Larry said. "You couldn't really argue with them."[80] Appearing before that crowd, Larry became uncharacteristically tongue-tied and "very conservative, the arch enemy of the modern spirit." Grace reacted pretentiously. Asked if she might paint an "Ingres" someday, she said unabashedly that she was open to the possibility.[81] (It took her days to recover from the mortification she felt over her response.)[82] But it was Al's appearance that everyone remembered.[83]

Liberally peppering his rant with "shit"s and "fuck"s, he announced that he was the only artist of value, that he owed nothing to anyone, that he had "sprung full-blown out of the head of Medusa," that he had "invented painting."[84] (By which he meant that everyone should feel that way when they approached a canvas, but all anyone remembered was his apparent declaration that he was the root, the forefather.)[85] He also proclaimed that everyone was his enemy, which Larry said "of all his ideas was at least possible."[86] In the middle of Al's exposition, a drunken Charlie Egan rushed the panel, shouting, "Let's kill that little fucking bastard," though he didn't manage to get in a swing.[87]

By then thoroughly abused and amused, the audience turned to the old wise man who invariably ended the discussion portion of the Club's Friday nights, Aristodimos Kaldis. His shirt pitted with burns from cigarette ash, his vest and many scarves stained with liquor and food, Kaldis effected calm by summarizing what had been said and stating that "artists were always in conflict and art always won out in the end."[88] "It was," recalled Al, "the only unarguable point of the night and meant it was over. Everything would stop after Kaldis talked."[89]

A hat having been passed, someone was dispatched to buy liquor. And then the dancing began.[90] The younger generation enlivened that aspect of the Club, too. Whether the soundtrack was Viennese dance music, or polkas, or Larry's band, the response from the dancers seemed to have no relation to the music being played.[91] Some of the "girls" did the cancan, some couples the fox-trot. Some jitterbugged as best they could or tried the Lindy. Franz and Joan would dance "until they rolled on the floor dancing horizontally," Philip Pavia recalled.[92] It was group therapy, a release of energy primal in its intensity, "something wilder coming from each pair of feet bouncing vertically into non-history."[93] Frank, who in some ways would have fit more comfortably in early nineteenth-century England, wasn't so stylistically abandoned. "He was such a superb dancer he made you feel like one too when you moved with him," Edith Schloss said. "It felt as if I had never danced before, it felt sexy and elegant. Once when we were gliding cheek by cheek, he breathed, 'Ah, dancing with you like this it's like a night with Lotte Lenya.' Dazzled, I stammered, 'When did you

meet her?' 'Never,' said Frank."[94] They were all gliding in a world of make-believe and Frank had the words to describe it.

The arrival of wordsmiths on the scene had a curious impact on the artists of the New York School. The poets appeared just as the younger generation was searching for its own direction. They had been raised in the absolute abstraction of the First Generation but were not necessarily wedded to such aesthetic purity. Both the young painters and the young poets saw themselves as part of the world and were playing with the notion of borrowing elements from it to enliven and enrich their work. Perhaps not surprisingly, those artists who were most enmeshed in Frank's life—especially Larry, Grace, and Jane—were the quickest to absorb the poet's lessons and become more literal and literary in their paintings. Frank gave them the courage to change direction, to move beyond the elders they so admired. And that was exactly what Grace, in particular, needed to hear at that moment.

She was afflicted by what she has described as a "bout of conscience" for having launched directly into abstraction without having studied the lessons of the past that informed the First Generation's work.[95] "I thought I was a robber, that I had taken from people older than I, who had struggled tremendously for years to find this breakthrough," she said.[96] Grace feared she had followed a path that led to acceptance within her community but not the original achievement she sought.[97] "If you were a *real* artist, there's no one like you," Milton Resnick said. "To the extent that you were *like* Picasso, you were *less* than Picasso."[98] Grace felt herself less than the artists who came before her. "I decided I had no right to the form," she said. She went on a killing spree, destroying a batch of paintings she felt weren't any good.[99] Then she enrolled in a school of her own devising.

> I started to paint through art history and I spent almost all of 1952 painting from the masters—Rubens, Velásquez, Goya. I didn't do exact copies, rather I worked freehand, trying to understand where I really came from.[100]

Some of her friends thought using old masters for inspiration, and even worse allowing the odd bit of figuration from a master study to appear on canvas, treasonous.[101] Helen and Joan "felt that I had lost my nerve," Grace said. "I was reactionary.... We liked each other a lot, but yeah, we'd just fight. But I had to do it."[102] Larry was a fellow artist who understood why. He, too, was looking to history for answers because, like Grace, he had not been raised on art. "You set yourself up as some kind of special agent for handling these supposedly different things," Larry said. "But somewhere

sneaking underneath all this was the idea that I wanted to identify with the history of art. I wanted to have some of the abilities of the best to really prove to myself that there was something of the artist in me."[103] While visiting the Metropolitan Museum with John Myers, Larry and Grace made a deal. She said, "If you spend twenty minutes with me so I can look at all those crazy kings and queens and mad princesses and everyone, I'll go with you to look at English landscapes."[104] And that is what they did, again and again, until those images became part of their own vocabulary, until they understood the line that had created a leg in motion or the subtle shading that breathed despair across the face of a saint.

Visitors to Grace's studio who were used to seeing her abstractions were shocked by what they saw: *The Massacre,* a seven-foot-by-twelve-foot canvas based on sketches from Delacroix; *Portrait of W,* which owed its composition to Cézanne's numerous portraits of his wife; *The Horsemen; The Hero; Paris, 1920*—all echoing themes that had occupied artists throughout the centuries. In her paintings the horses were there, the cityscapes, too, but the exactitude, the striving for naturalism had been abandoned. She recreated those earlier paintings from the perspective of one who had been trained first in abstraction; she approached the past having already mastered where it would lead.

Grace would say of her old master studies, "I always said that all of the Madonnas were the artists' girlfriends or their wives, and that Jesus was one of their kids. You draw from the visual material around you."[105] With that idea, Grace hit upon the direction she would pursue in her art. The "formal basis" of her work would be Abstract Expressionism, but the subjects would be a near-complete departure from the artists who had looked within for inspiration.[106] Grace began to consider the possibility that the people and things that constituted the world around her did not have to be rejected outright, because they, too, formed part of her artistic existence.

Grace's second show at Tibor de Nagy was scheduled for March 25. In addition to finishing enough paintings to fill the space, she had to come up with money for stretchers, invitations, a catalog, and liquor for the after-party. Although much sought after, exhibitions for artists who had no private income were costly affairs. Grace had been forced to take a three-week clerical job "that was a miracle of stupidity" to cover the necessary expenditures, and still she was broke. Neither she nor her new studio mate and lover, a war veteran and photographer named Walt Silver, had a spare nickel.[107]

Grace had met Walt shortly after Al moved out of their Essex Street loft the previous summer. Turning up in the Village, his life shattered after the death of his two-year-old son to leukemia and the subsequent separation from his wife, Walt had not been on the scene long when Grace hired him

to photograph her paintings.[108] "Grace thought he was a good-looking guy," Rex Stevens said, and she liked his work. Though introverted and lacking charisma, Walt was Grace's type physically—small, dark, stocky—(what Rex called "little dudes, big hands").[109] Walt was also steady and undemanding, which was all Grace needed: a sexual companion who didn't interfere with her work. It also didn't hurt that Walt adored her. "Most of her men acted as if devoting themselves to her was more than enough to live for," Larry said.[110] Walt became one of them. He had lost his old life when his son died, and he had found a new one with a beautiful, blond powerhouse named Grace Hartigan. "Found Walt and peace and freedom to begin working intensely," Grace announced in her journal after Walt moved into her studio.[111] Some of Grace's friends suspected she only tolerated him because she needed someone to share the bills and support her when necessary. But Rex scoffed at that notion.

> I don't think she had the thought, *I need to be supported.* If she was going to do that, there were many more men around for Grace Hartigan to be hooking up with than these shrubs on the bottom-feeding rung. It was about art.... Walt Silver had a really good eye.... And she likes company.... If Frank was straight, she would have been with Frank.[112]

Indeed. Grace would have many men in her life—a few of them she would even marry—but *the* man, the love of her life, would be Frank O'Hara. When Grace died in 2008 there were only two photographs on her desk. One was a picture of Grace with Frank, and the other, his portrait.[113]

They met in the fall of 1951 at a Thursday night salon at John Myers's apartment shortly after Frank settled in New York, but they didn't discover each other until several months later.[114] Before that both were otherwise occupied, especially Frank. His social calendar had been filled to capacity and his love life was byzantine in its complexity. There was Jane, whom he was in love with and to whom he wrote poems. She was the goddess for all the young New York poets, who fell for her warmth, her wit, and the fact that she was so modestly understated and yet so brilliant in every conceivable way.[115] Larry was in love with Jane and Frank. John Myers and Frank were both in love with Larry.[116] And they were all part of a group of artists who roamed into and out of each other's lives. Said Nell Blaine,

> We saw each other all the time, especially in the evenings at Jane's, Larry's, the San Remo, the Cedar, at my place, and later on at Grace's and John's.

> We had sketch groups at my place, at Grace Hartigan's, different artists' studios.... We were a roving pack, traveling about to movies, plays, exhibitions, parties.... [E]verything interested us.[117]
>
> We'd go, six or eight of us, to hear Judy Garland together. Very late at night frequently we'd go out, walking from my place down to the Village.... There was a lot of dancing. Then when it got very late, one or two at night, the gay boys would go off to a bathhouse.... That was in the early 1950s. We were all very young, very wild, and very innocent.[118]

Frank's romance with Grace began in February 1952, after he returned from his family's home in Massachusetts, where he had gone to attend his aunt Grace's funeral. She was one of the women who had nurtured him as a child and had continued to do so when he was in college, even helping to pay his Harvard bills. Frank's sense of loss over her death was exacerbated by the state in which he found his mother. In the five years since his father's death, Frank had tried to help his mother get sober. That February, finding her drinking heavily, he realized his efforts had been for naught. When he left home after the funeral, he told his younger sister, Maureen, he wasn't coming back, and he suggested she leave, too.[119] To his brother, Philip, he wrote, "As you know I don't give a fuck for families. I think that people should treat each other as they feel. I consider our mother to be one of the most mean, hypocritical, self-indulgent, selfish and avaricious persons I have ever known well."[120]

Grace. Perhaps the name was a comfort after having buried another Grace who was so dear. Whatever the reason, it was to Grace Hartigan that Frank turned when he reappeared in New York, shaken by the rupture with his mother.[121] She was, in many ways, the perfect choice. Grace, too, had walked away from family. She, too, had made the difficult decision to live her own life rather than succumb to the needs of others to whom society and biology said she was bound. Grace listened without judgment, and the two became close. "Frank would call and say I have a can of pea soup, do you have a can of chicken soup, we can mix it together," Grace said.[122] He began posing for her, and she appeared in his poetry. "Frank was crazy about her," said his friend Joe LeSueur.[123] "Grace brought a kind of gutsiness and toughness," said Kenneth. "And Frank was like her wings of language."[124] Grace described their relations more simply: "We fell in love. If a homosexual and a heterosexual could be in love, it was a falling in love."[125]

John Bernard Myers was ecstatic. He had his stable of artists, for whom he worked tirelessly. He introduced their work to collectors, demanded attention for them in the press, implored Dorothy Miller and Alfred Barr to see

their work, and arranged any financial support he could with the help of whoever offered. The spring of 1952, Elaine and John (neither of whom had any money themselves) teamed up to try to find Larry seven hundred dollars to support himself and his family because the soles of his shoes were "thin as paper."[126] Under the name "Jack Harris, Quick Sketch Caricaturist," Larry had had a job at Bloomingdale's doing drawings as a perk for people who bought a certain brand of ballpoint pen.[127] That sort of employment would no longer do, however, if he were to be taken seriously as an artist, which Larry may not have cared overly about but John did. Myers had a grand and glorious vision, which that season began to include poets.[128] The gallery had produced its first chapbook of poetry, a thirteen-page publication called *A City Winter and Other Poems,* written by Frank O'Hara with drawings by Larry Rivers. Tibor de Nagy Editions was born. The book was sold in the gallery and in the Club, where the New York poets gave their first reading that spring.[129]

The pressure on Grace to have a fantastically new show was great in that environment. Advice and assistance came in from all quarters, especially from Frank, who Elaine said "had a sense of what painters are after, he helped you see what you wanted to do."[130] Grace felt alternately overly confident and extremely nervous. Her paintings represented a big departure from those of the previous year when all her work was abstract. Ten days before her opening, Bob Goodnough arrived at Grace's studio to look at her nine paintings for his *ArtNews* review.[131] The private viewing for a critic, even a friend like Bob, was often more frightening than a show because every raised eyebrow, every utterance was magnified in importance and interpreted (usually misinterpreted). Grace was, therefore, annoyed when Harry Jackson appeared for the viewing (their divorce was still not final). But then Clem and Helen arrived later, and their response was heartening. Clem liked *The Massacre* and *Portrait of W,* and Helen was "mad about" Grace's painting *The Widow.*[132] Clem's praise, even if private, trumped what other critics might say in print, and obliterated Grace's concerns about Harry. And then something peculiar happened.

Four days before her show, Helen told Grace she couldn't help her hang it.[133] Her decision was highly unusual because the tradition among the Tibor de Nagy artists, especially between Helen and Grace, was to help one another with their exhibitions. That was part of the fun. Grace's disappointment turned to shock and then rage after her opening. Taking a second look at her new direction, Clem told Grace she was losing her way. "Clem told me to stop doing it," she recalled decades later with still fresh anger. "Don't do it, stop doing that, that's not what you do. You have to stay avant-garde."[134] "He said it was not modern. Can you imagine that?"[135] Clem didn't explain where she had gone wrong, but Grace understood his

criticism to be based on her return to semi-abstraction, to what Tom Hess had described in his book as the marriage between abstraction and expressionism. "I was furious and screamed at him that day in my studio, and when he left, I remember breaking some cups and saucers or glasses or whatever—hurling them after him when it was too late to hit him."[136]

Clem was used to being the last word on an artist's work. But his power and influence didn't extend to de Kooning's circle, which was under the protection of Hess and his magazine, nor did it penetrate the Club as it once had. Grace was one of the younger artists who comprised "Clem's stable." He had given her her first break in 1950, and he might have expected her to listen passively and respond compliantly to his aesthetic dictates about her work. She did not. "When Clement Greenberg told Grace Hartigan not to paint the way she was any more, that was a fucking nerve," said Mary Abbott. "That wasn't very popular. You don't say that to Grace."[137] Whether rashly or bravely, Grace cut relations with Clem and, much to her regret, with Helen as well. They had been best friends in that community, but Helen had picked sides and had apparently chosen Clem.[138]

Despite her hurt and anger, and the inevitable self-doubt that Clem had planted in her artistic conscience, Grace remained steadfast. "I must be free to paint anything I feel," she declared in her journal.[139] It was a simple formula that required all the fortitude she possessed. In 1920, T. S. Eliot had written, "The more perfect the artist, the more completely separate in him will be the man who suffers and the mind which creates."[140] Grace was trying to construct that barrier between her life and her work in order to continue. She had just turned thirty. So far all she had to show for herself were psychic scars, fantastic aspirations, and a studio full of paintings that she had decided by the end of her exhibition at John's gallery in April she no longer liked.[141] Her reaction was hardly surprising. For an artist, satisfaction is antithetical to creation. Though her show was well received (the *New York Times* critic called her work "ebullient" and "handsome"), Grace knew she was just beginning. She was "facing the unknown again."[142] Except that spring there was a difference. She had Frank. He boosted her spirits with his presence and with his poems. His "Portrait of Grace," written during that turbulent period, moved her with its understanding of who she was to the marrow. "This poem makes me have an existence," Grace said.[143] Fresh sustenance in the form of words renewed her, *and* she was no longer alone.

35. Neither by Design nor Definition

> If then, this art is about something, what is it about? Each artist has his notion; so does every spectator.
> —*Elaine de Kooning*[1]

DOROTHY MILLER WAS of the generation of women who accepted that they would always be in the background, whether in the shadow cast by a father, a husband, or, for the "feminists" among them, a male boss. In her case, during the Depression years she was known as the wife of Federal Art Project director Holger Cahill and, from 1934, as assistant and rumored lover of the man who embodied the Museum of Modern Art, Alfred Barr.[2] What that meant was that Dorothy would rarely be awarded—or claim title to—the recognition she deserved for being what she *was:* the Modern's early expert and prime mover on avant-garde American art.[3]

When Barr hired Dorothy, he told her, "There are dozens of things I want you to do to help me, but the first one is to interview all these artists that are on my neck. I can't get any work done because they're coming in droves."[4] By "these artists," he meant American artists, mostly in New York, who were starving because they had not yet received a lifeline from the Project. With the energy and efficiency that had first brought her to Barr's attention, Miller dove in. She doled out money where she could, bought paintings herself if she had a few extra dollars, but most important of all she looked at the neglected artists' work tirelessly, fearlessly. ("There'd be the occasional crazy one and I'd have to run screaming '*Help!*'" she said.)[5] She loved art with the passion of the painter she had once hoped to be. She also loved artists, especially eccentric geniuses like Gorky (whom at one point she considered a best friend) and Pollock (who she feared was so fragile he would break without tender care).[6] Over the course of three decades, during the rise, at the sensational height, and amid the eclipse of the Abstract Expressionists, Miller's life was consumed with artists for whom, during much of that period, no one else at the museum had any time. Painter Paul Jenkins explained,

> If it hadn't been for Dorothy Miller, it might have taken longer for Pollock to become acknowledged, also Rothko and [Clyfford] Still. They felt they had a patrician goddess, mother, who saw to their needs. She was very brave.[7]

Art historian Irving Sandler said, "Dorothy was really second in command, next to Alfred Barr, and in many ways, she was in advance of him."[8] Some observers of the scene and the Modern's relations to it credit Dorothy with introducing the museum-going public to New York's avant-garde. "These artists were relatively, some completely, unknown when Dorothy singled them out," said art historian Russell Lynes. "In retrospect, these exhibitions were of the utmost importance not just to the artists but to the rest of us."[9] And yet, you won't find Dorothy's contribution in most history books. Through the years, she and her work have been relegated to mere footnotes.

By 1952, when Miller mounted what would be the Modern's most controversial exhibition since Barr's inaugural shock-and-awe campaign to acquaint American audiences with the advanced work coming out of Europe, she had probably been in more artists' studios than almost any museum official in America. During the Depression, she had traveled coast to coast, week after week, with her husband, visiting artists and seeing the work that was being done, mostly in obscurity, throughout the United States.[10] In New York, she lived for decades in a two-room apartment on Eighth Street—the New York School's Main Street. A devotee of the Cedar, she never missed going to the Club. ("We all went like going to a prayer meeting," she said.)[11] And she was a familiar, if somewhat incongruous, Village figure.

At forty-eight, Dorothy reeked of good breeding. Tall, thin, elegant, immaculately groomed, gracious *and* graceful, she was, in a word, lovely. She appeared in every way as though she belonged uptown, ensconced in the upholstered protection of a women's club. All of which made the image of her jauntily climbing five flights of stairs in heels to a studio on Ninth Street, Tenth Street, or Fourth Avenue, while gripping the railing in one gloved hand and patting her chignon into place with the other, both comical and remarkable. She lived for this journey into wretched buildings to see art. *Real* art. The discoveries in the form of paintings and sculpture that awaited her were, to her, treasures. "I mean, doesn't one learn everything one knows from artists?" she once asked an interviewer. "Certainly, that was my experience. If I hadn't known any artists I wouldn't know a damn thing about art. You simply have to know the people and see them working and let them tell you about their pictures."[12] It was that sense of wonder, which matched their own, that put the artists at ease with Miller and helped them forget that she was looking at their work on behalf of that citadel of culture, the Modern.

In 1929, Barr had exhibited American artists in a show called *Nineteen Living Americans*. It was fairly unremarkable except that the artists were not European (though it wasn't obvious from their work) and that he had

deigned to exhibit them. More than a decade later, in 1941, perhaps as an act of patriotism at the start of the war, the idea of mounting a show of contemporary Americans arose again, and Barr handed the project off to Miller, his most trusted colleague.[13] Borrowing the format Barr had used in 1929, she allowed each artist their own gallery so that visitors could experience the exhilaration of entering an artist's studio.[14] Her first such show opened as *Americans 1942: 18 Artists from 9 States*. None of the artists was from New York, which generated considerable grumbling in her neighborhood. As for the critics, the response was mostly tepid; the world was otherwise occupied.[15] In 1946, however, Dorothy returned with *Fourteen Americans,* and that produced a "shift in taste toward new work by Americans," according to John Myers.[16] Though it included mostly artists who were acceptably, even fashionably, "modern," Miller had also selected artists on the cutting edge: Gorky, David Hare, Isamu Noguchi, and Bob Motherwell, among them. The jolt through the art crowd, which at the time still gathered at the Waldorf, was tremendous, as was the subsequent news that the Modern had bought a Motherwell (a purchase Museum trustees greeted with disapproval).[17]

It would be another six years before Dorothy, as curator of museum collections, received approval to mount a third American show, and during that period the revolution in art had been waged and won. The paintings that had caused such consternation among museum trustees in 1946 were absolutely tame compared with the *15 Americans* show she curated in 1952. Abstract Expressionism, the New York School, whatever one wanted to call the insurgency arising from New York studios, dominated the exhibition, and many of the works were massive. "I had a twenty-foot wall filled with one Pollock," she recalled.[18] *15 Americans* appeared a year after the Ninth Street Show. While the latter had been organized by the artists themselves, this exhibition had the imprimatur of the most important modern art museum in the nation. That one-two punch delivered the message that artists in New York not only demanded to be seen but *deserved* to be seen.

"Everybody said, 'Congratulations Dorothy! You've done it again. They hate it. Isn't that wonderful?'" she laughed.[19] Among the critics, only one—eighty-five-year-old Henry McBride—expressed real enthusiasm for the show, telling Dorothy, "It's like a trip to the mountains. It's like a great breath of fresh air. It's marvelous."[20] In *ArtNews* he wrote, "A few American artists, at long last, seem to have gone completely native, and for the first time since these wars, it has not been necessary to stumble over references to Matisse, Juan Gris, Picasso, Léger." *15 Americans,* he said, had begun a "new cycle."[21]

The Modern had in previous years sent paintings by Pollock, de Kooning, and Gorky among others to Venice to represent the United States in

the important Venice Biennale. European audiences were sophisticated. They expected to be shocked by artists and understood that much great art at first appeared ugly because it was so new. But audiences in the country where the works had been created, the United States, had not been exposed to the force of gallery after gallery of avant-garde work. *15 Americans* was their introduction on a grand scale, and they were neither impressed nor inspired. Letters of protest poured in to the museum.[22]

The reasons for the outrage were both aesthetic and political. For the average museum visitor, the works required more patience and a greater leap of faith than most possessed or were inclined toward. Disdain, dismissal, incredulity, hilarity were some of the responses from those who walked among the canvases on the Modern's walls. Politically, mounting the show during the McCarthy years, when avant-garde art was considered un-American, was shockingly brave. Authors, actors, and film directors had all been called up by Congress for intense public scrutiny and in some cases professionally silenced for past communist affiliation. Up to that point, though artists were a favorite rhetorical target of the right, they had not been physically harassed or impeded in their work, but that was because they were so obscure that the public who might have been "infected" by their "communist propaganda" was minuscule. They were quite frankly not worth the trouble. The Modern show, however, moved them dangerously into the spotlight in what could have been interpreted as an act of provocation. Without doubt, the show's intention had not been to make a political statement, but for those looking for one, this message could be easily found.

It is likely that many outside the museum would have attributed the daring exhibition to the Modern's trailblazer, Alfred Barr. Though women founded and funded a number of American museums, at that time, aside from the notable exception of Grace McCann Morley at the San Francisco Museum, they rarely occupied positions of operational control.[23] In Dorothy Miller's case, it was difficult to identify where her contribution lay. She and Barr worked so closely together, wrote future Carnegie Museum of Art director Lynn Zelevansky, that "it is virtually impossible to tell where his ideas ended and hers began. Undoubtedly because of Barr's stature, and also because Miller rarely wrote for publication, there has been a tendency to give him credit for what she accomplished."[24] Dorothy was also "extremely beautiful and extremely feminine," said the Modern's former director of painting and sculpture William Rubin, and that contributed to the perception that she did not have the strength or brains to be "the boss."[25]

In the American shows, however, she was. "I could ask as much advice as I wanted, but I wasn't troubled with 'No, you can't put that person in,'

or 'Put this one in,'" she said.²⁶ The exhibitions were hers. For *15 Americans,* Dorothy could have picked safer paintings. Instead she selected the artists she thought best told the story of where American art was at that moment. Interestingly, people associated with the museum were excited by what was on its walls. Before the show had even opened, trustees bought sixteen works in an act one writer called "speculative investment." This was the first time Abstract Expressionist art had been considered a risk worth taking.²⁷ As Henry McBride said, it was a "new cycle" indeed.

Dorothy had asked Bill to be in the show and had even gone so far as to select the work she wanted to exhibit, but he withdrew at the last minute.²⁸ During the winter and spring of 1952 he was so involved in his work that he couldn't be bothered. The previous year he had received letters from the Art Institute of Chicago asking him to submit his painting *Excavation* for its 60th Annual American Exhibition. The show involved a competition that awarded a "purchase prize," meaning the museum would buy the winning work for a whopping four thousand dollars. Bill ignored the letters, telling Elaine's brother Conrad, "What do they think I'm going to do? Pack up the painting and ship it to Chicago and get it shipped back and told you got an honorable mention? So to hell with it." But one day a representative from the museum knocked on Bill's door and essentially told him if he submitted his painting to the competition, he was guaranteed to win. "That changed everything," Conrad said. "We packed it up and sent it off." Hans Hofmann was on the jury. Bill's painting won the prize.²⁹

The check for four thousand dollars received and cashed, Bill stuffed the wad of money into his pocket. He had never had so much. He didn't even have a bank account.³⁰ Newly flush, Bill moved out of the dingy Fourth Avenue studio he had occupied since he and Elaine had been evicted from their Chelsea loft, and shifted his painting operation to East Tenth Street. "He found a terrific studio there with skylights and windows along both sides of it," Elaine recalled. "I mean it was just a fantastic place."³¹ Philip Pavia lived in the building next door and shared a fire escape with Bill, but it was as if they were in the same space. "Pollock used to come through my studio to visit de Kooning," Philip said. "I could hear Elaine typing."³²

In addition to her *ArtNews* articles, Elaine was corresponding with Josef Albers about a book she wanted to write. She also fantasized about traveling to Tangiers to see her sister, Maggie, who worked in the U.S. embassy in Morocco.³³ Perhaps it was Bill's flood of money, perhaps it was a reaction to the heavy cast and crutches with which she had been burdened, but whatever the reason, Elaine's dreams soared that spring. Bill was flying, too. He had good paint, a beautiful new space, and was temporarily free of financial worry. Those were the best working conditions he had had for

five years. The only thing he wanted to do was remain on Tenth Street and paint.

By mid-June, however, the heat of Manhattan, which had hit ninety-five degrees and continued to climb, had penetrated his studio and corrupted even that paradise. With the windows opened to catch the breeze, the smells from trash cans, the sickening aroma of urine from doorways, and the dirty taste of fumes and dust from the Third Avenue El tainted the space and even entered the spirit of Bill's work. Outside was worse. Hoodlums had appeared on Tenth Street and along Third and Fourth Avenues, where they preyed on the local mendicants as a kind of summer's eve entertainment.[34] The neighborhood became dangerous and unbearable. Bill had reckoned he would be stuck there, until Leo Castelli intervened. He and his wife, Ileana, had bought a shingled house in East Hampton across the road from Motherwell's place and invited Bill and Elaine out for the season.[35] Also in residence was the de Koonings' old friend and spiritual guide John Graham, who had married Ileana's mother.[36]

Since his early days in the Village, Graham had soured on man's ability to create, saying, "Only Divine Powers or Forces can create something from nothing. Man, at best, can imitate, adopt, interpret, elucidate...." He had also become disgusted by the commercialism of American postwar life and its infiltration into the world of art. "I always thought that the art world was divided into two groups: those who seek success at any price offering people nothing and those who seek success only on bases of real effort and significant results." But, he continued,

> I came to learn that this world is divided into two groups: those that seek success at any cost and get it and those who seek success at any cost and don't get it. The true creators are as scarce as white elephants. Even Jesus could find no more than twelve apostles and even some of those turned out to be fakes.[37]

Bill and Elaine jumped at the chance to spend the summer outside the city in the company of what she called their "satyr-like, Machiavellian... cynical... [and] wickedly funny" old friend.[38]

The inspiration for Castelli's invitation had been both personal and professional. Leo worked in a semi-official capacity with gallery owner Sidney Janis and had recommended to Sidney that if he were going to select any of the new American artists for his gallery he should pick Bill. In 1951, Janis began giving Bill a small subsidy to help him buy supplies with the understanding that when Bill was ready, Janis would give him a show.[39] Elaine and Tom had encouraged Bill to make the move because, at forty-eight, having had only two solo exhibitions at Charlie Egan's, he had

struggled long enough.⁴⁰ Castelli's invitation was, therefore, a way to keep Bill working in a healthy environment and, more crassly, a way to protect Janis's investment. But the greater motivation for Castelli was personal.

> For me, actually...the point was to be with these people, to live their lives....I wanted to be part of it, was part of it, there was a real hero worship of artists, or some artists in particular....I think my hero, too, at that time probably was de Kooning.⁴¹

After unpacking their painting gear, Bill made a studio for himself in an enclosed porch at the Castelli house while Elaine took a portion of the porch outside to work.⁴² She was hoping to have a show in the fall after a productive winter but told Kaldis she would probably postpone it, "since the best paintings are the ones one hasn't made yet."⁴³ Unlike some artists who worked during bursts of inspiration, Elaine's painting did not stop and start. It flowed like her conversation. "I thrive on work, you know," she told a friend. "It's its own exhilaration."⁴⁴ One rainy day, having been driven off her porch, Elaine set up her studio in the bedroom she shared with Bill. She wanted to do a portrait and told Leo to come in and sit down. Soon, the entire household had crowded into the bedroom, laughing and talking while Elaine, though fully engaged in the gaiety around her, retained her focus, her large eyes nearly unblinking as she painted Leo, legs crossed, shirt open, relaxed and elegant in his chair.⁴⁵

Even amid such cacophony, Elaine was as absorbed in her subject as she would have been if she had spotted a lover across a crowded room. "Painting a portrait *is* like falling in love," she explained, "because you become terribly fascinated with this one particular human being's unique aspect; that is the element of likeness, that you are you and nobody else and so your beauty becomes just your uniqueness and this is what is so exciting."⁴⁶ When the work was finished, the only indication of the party that had formed around her was the painting's background: a riot of brushstrokes that quavered and sang like an excited chorus. Leo's would be only one of many such portraits Elaine painted that summer. She succeeded in capturing the cast of characters in East Hampton on canvas the way others might document the friends they had encountered on their holiday in snapshots or on film.

Bill, too, had a productive summer, making hundreds of studies for his women series.⁴⁷ It became something of a sport to watch his work pile up, and to guess who, if anyone, from among their group Bill had depicted. Mercedes came by while Bill was painting *Woman on a Bicycle*. "It was a portrait of me, absolutely myself, like no photograph could be. It was me!" she exclaimed years later. "The next day it wasn't at all, it was somebody

quite different."⁴⁸ Of course the dominant rumor was that Elaine was Bill's subject; the more ferocious the figure, the more friends recognized a likeness. Feigning offense, Elaine asked Hans Namuth to take a photo of her in front of one of Bill's women to show that there was no resemblance whatsoever. Hans complied, but unbeknown to her positioned Elaine before the painting as though she were the subject's daughter, with a painted hand (or claw) appearing to rest on Elaine's shoulder. Elaine appreciated Namuth's picture for the good joke it was.⁴⁹

Harmless hijinks were the rule that season, which had not always been the case when the artists were invited to share a home outside the city. Just that spring a German professor of philosophy named Fritz Henzler, who had wanted to discuss Heidegger with Bill, invited a group of artists to his New Jersey farm for an intellectual weekend. (Mercedes recalled that the moon was full, which she said may have accounted for the disastrous consequences.)⁵⁰ "What the painters did that night was to make a Jackson Pollock out of Henzler's dining table and living room," wrote Lionel Abel.⁵¹ In addition to Abel, the party included Bill, Elaine, Mercedes, Franz, Philip Guston, Milton Resnick with a girlfriend, Conrad and Anita Marca-Relli, and twin sisters newly arrived on the scene, Nancy and Joan Ward.⁵² The group, Abel said, brought Cedar-like shenanigans to New Jersey.

> They ate Henzler's roast lamb, poured his Moselle wine on the floor, drank his Scotch and bourbon, broke his crockery, made love in his bedrooms, and left on foot at four in the morning. Elaine de Kooning, in fact, walked with one leg in a cast all the way back to New York, leaving Henzler's dining room, and his whole house, like a disaster area.⁵³

Elaine clarified a few of Abel's points: The group misbehaved in direct proportion to Henzler's pomposity, and she did not walk all the way to New York. She was spotted by Bill hobbling across a field before she could do so. In any case, she said Henzler "was totally without a sense of humor."⁵⁴ But Leo wasn't, and so the artists who were drawn to his home by the de Koonings' arrival were, by comparison, well behaved, though always in motion. "If anything," Elaine said, East Hampton was "even more hectic than New York."⁵⁵ "We painted all day and then every night went out to a party."⁵⁶

Writers May Tabak and Harold Rosenberg had a summer place in Springs even before Lee and Pollock moved there in 1945. As the number of artists who made the seasonal migration to Long Island grew, Harold and May were there to greet them. In the summer of 1952, the de Koonings joined their circle.⁵⁷ Bill and Harold's friendship deepened, but even more

important was the intellectual kinship Harold felt with Elaine. She spoke his language in art, in leftist politics, in the sheer joy of loud and contentious discourse. And Harold had a lot to get off his chest.

As early as 1947, when Simone de Beauvoir was in New York, he had offered to write an article on the New York painting scene for the French magazine *Les Temps Modernes,* which was edited by Sartre, Beauvoir, and Maurice Merleau-Ponty. Beauvoir accepted the offer, but by the time Harold finally finished the piece he had become angry with Sartre, whom he accused of misusing an article Harold had written criticizing the Communist Party. Harold refused to submit "The American Action Painters" to *Les Temps Modernes.* Instead, he showed it to Elaine.[58]

She and Bill had stayed in East Hampton long after the rest of the summer invaders left.[59] Therefore, she had time to concentrate on Harold's writing. He was a master manipulator of words—both as a poet and an advertising man (he created the character Smokey the Bear)[60]—and had a tendency to get caught up in their rhythm. But the piece he gave Elaine had a much greater value than mere clever style and literary flourishes. Elaine was struck by the depth of Harold's ideas. In fact, his theory of "Action Painting" would come to define for many the essence of the New York School.

Unlike Hess, whose book earlier in the year had detailed the European roots of American art, Harold described a more recent social history of New York artists from the time they had warded off starvation by collecting wages from the Project. He distinguished between the "modern art" being created in their studios and the many commercial objects—from bracelets to vacuum cleaners—produced under the postwar "modernist" umbrella.[61] He dispelled the notion of a "movement" arising out of the work being done in New York because its essence was its individuality. It amounted to a man (he wrote only of men) and a canvas on which the man "acted." In a now famous passage he wrote,

> At a certain moment the canvas began to appear to one American painter after another as an arena in which to act rather than as a space in which to reproduce.... What was to go on the canvas was not a picture but an event.
>
> The painter no longer approached his easel with an image in his mind; he went up to it with material in his hand to do something to that other piece of material in front of him. The image would be the result of this encounter.[62]

The painting represented actual moments in the artist's life and was "inseparable from the biography of the artist.... The new painting has broken down every distinction between art and life."[63] The goal, Harold said, was simple:

Just TO PAINT. The gesture on the canvas was a gesture of liberation....
On the one hand, a desperate recognition of moral and intellectual exhaustion; on the other, the exhilaration of an adventure over depths in which he might find reflected the true image of his identity.[64]

At the moment when the art public began to see the advanced art in America as the product of a group, Harold reminded them that the work was the product of individuals who had struggled mightily through perilous times. He argued that this effort should not be forgotten, that to do so would rob the work of its meaning.[65] Years later Harold explained that he had stressed individualism and identity because he feared that critics and art historians would look at a work of art as a mere object divorced from the life of the artist who had created it, that an "arid professionalism" would substitute analysis for understanding, and that this *analysis*—rather than the artist's own words or experiences—would become the filter through which younger generations were introduced to the New York School.

To forget the crisis—individual, social, esthetic—that brought Action Painting into being, or to bury it out of sight...is to distort fantastically the reality of postwar American art. This distortion is being practiced daily by all who have an interest in "normalizing" vanguard art, so that they may enjoy its fruits in comfort.[66]

The loss, he said, would be society's, which would be deprived "of the self-awareness made possible by this major focus of imaginative discontent."...

Who would suspect this inception of their work from the immaculately conceived picture-book biographies and the gasping-with-admiration catalog notes, in which personalities have been "objectified" to satisfy the prudery of next of kin and the prejudices of mass education?[67]

In a world of mass production and soulless acquisition, according to Harold, art had to be made inviolable. A painting was not a thing. It was a person.

When Bill and Elaine returned to New York, she showed Harold's piece to Tom. "By return mail I got a proof," Harold recalled. "She brought it up to Hess and he set it in the approved file. I don't know how he got it that fast."[68] Tom didn't agree with the idea of "Action Painting," which he feared implied a thoughtlessness on the part of the artist and dealt only with the process of painting, not the finished work. But he said, "It was a

very well-written article which I was happy to publish, over the dead body of the then editor [Alfred Frankfurter], I might say, who objected violently to it."[69]

The article would not appear in the magazine until December, but its effect was immediate. Out of it emerged what Irving Sandler called "a formidable art world power base" composed of Elaine, Tom, and Harold.[70] Said one writer, "In time this triumvirate became so formidable that it influenced curators, shaped collections, and affected the short-term course of artists' careers."[71] Elaine recalled their times together as "highly drunk, but intellectually roaring."[72] Their base of operations was *ArtNews*.

Editors adept at their work are often referred to warmly as "writers' editors," meaning that they know how to bring out the best in their writers. As managing editor, Tom was one (Clem said he was one of the best he'd ever known),[73] but he was also, importantly, an "artists' editor." "He was one of the few editors that got involved with the artist," said painter Herman Cherry. "Anybody could reach him.... He was very, very important, I don't think people realized how important."[74] "He had the whole damn magazine behind him, then he published a book around that time on abstract art," said artist George McNeil. "You can't tell what might have happened if Hess hadn't been publicizing them. Nothing would have happened."[75]

Though he lived in a townhouse on Beekman Place that the artists considered a palace, Tom was completely embedded in their downtown lives. "He felt enthusiasm for what was happening, and tried to stir things up," Larry said. "Tom figured out that artists needed rewards. If they weren't selling anything, they at least knew someone was looking.... He himself actually bought art and hung it on his walls. Okay, he was a rich man but who else did it?"[76] He also literally fed the artists. In his office Tom kept a few spare neckties push-pinned to a bulletin board in case an artist showed up at lunchtime unsuitably dressed for a midtown restaurant.[77] Hess provided the platform, and he, Elaine, Harold, and a growing cast of poets and painters who wrote for the magazine filled it with ideas, images, and words. There were accusations that *ArtNews* engaged in a "conspiracy" to promote the Abstract Expressionists at the expense of other artists. But Fairfield Porter defended the paintings and sculpture the magazine featured. "The conspiracy was, as far as I can see, that [Tom] recognized that they were the best painters around and deserved to be publicized."[78]

Harold and Tom had not known each other prior to Tom's having received "American Action Painters" from Elaine. Harold was closer in age to the First Generation artists—he was fourteen years older than Tom and twelve years older than Elaine—but the age differences disappeared during their vigorous exchange of ideas. The relationship was fluid and

easy intellectually but complicated personally. Tom and Elaine had been lovers for years and held each other in the highest regard. There was not an article in which, given an excuse to do so, Hess did not mention Elaine's paintings or writing. Even in his book *Abstract Painting,* he slipped in a reference, calling Elaine "one of the most perceptive writers on modern art" in America."[79] For her part, she quoted Tom only slightly less often than she quoted Bill. Breaking in on that pas de deux was the larger-than-life Harold, with whom Elaine had a fleeting sexual affair. Tom and Elaine's comfortable situation for a time was destabilized.

But of far more importance was the intellectual relationship among the three. Tom and Elaine both deferred to Harold, who possessed a backlog of ideas about society and aesthetics much richer than their own. In fact, historically part of the reason Tom's contribution to the Abstract Expressionist canon is often overlooked is because of the deference he showed to Harold. "He gave his page [in *ArtNews*] to Harold all the time," said Natalie Edgar, who in addition to painting wrote for the magazine. "Harold was older, a powerful personality, commanding. Tom was shy, he wasn't like Harold or the others.... He listened."[80] Soon the three settled into their respective roles, which played to each of their strengths. "Hess, wealthy, urbane, and well educated, was an insider accepted by artists and collectors alike," wrote Clem Greenberg's biographer Florence Rubenfeld. "Rosenberg, quicksilver intellectually, had the panache of a guerrilla fighter."[81] And Elaine? Said writer John Gruen,

> Elaine is a fighter and she has always known how to fend for herself and others. Although she was a good deal younger than the famous painters of the fifties, she was their equal insofar as struggles, setbacks, and achievements were concerned. She was accepted by them not only because she became a spokesman for the movement, but because she was a terrific companion.... And she could hold forth with greater verbal virtuosity than many of that crowd.[82]

And so, their conversations continued, day and night. Tom, Harold, and Elaine could often be seen stumbling toward home just before dawn after an evening together, still talking.[83]

At thirty-four, Elaine thought, perhaps mistakenly, that she could have it all. She could paint, write, and have a husband she admired as well as lovers she enjoyed and with whom she engaged intellectually. She could have the life her mother had longed for, a longing that an earlier generation had thought so insane that Marie was institutionalized for even considering it. In the new era in which Elaine lived and worked, especially among the

people with whom she associated, she had presumed to think that society had moved beyond petty cruelty. But just as love and generosity are human attributes that transcend the ages, so, too, do jealousy and suspicion. And Elaine encountered both as her power within the art scene grew. First in whispers, then in full-throated discourse, some asserted that Elaine was sleeping with Tom and Harold, the way she had with Charlie Egan, to benefit Bill.[84]

Ironically those very people who had criticized Elaine for living apart from her husband, for being part of a team but not part of a marriage, also accused her of devoting herself so thoroughly to his work that she would be a whore for the cause. All her actions, they said, were designed toward one end—to promote him—and that story line became part of Abstract Expressionist history. Painter Basil King said some people were "jealous" and called Elaine a "bitch" for supposedly using her power at *ArtNews* to help Bill. "And she was sleeping with Hess. Everybody knew that because it was talked about," he said, adding, "but that's not really the point, the point is that she promoted [Bill]. I think she truly loved his work, she loved him."[85]

Indeed she did, but she was not a slave to him or his painting. She had her own life, her own friends, her own interests, her own art. "Elaine worked very hard for Bill, but she wasn't a 'wifey,'" said Natalie. "That was a real marriage that started out with high hopes. She had a high ambition. She dominated the room when she was in it with flair, brilliance, charm, good looks, and laughs."[86] In any case, Bill didn't need Elaine to promote him; he was already a leader among his fellow painters when she met him, and he had scant interest in commercial success, as evidenced by his lack of interest in showing his work. "But," said painter Hedda Sterne, "that doesn't mean that her intelligence and sustained enthusiasm didn't inadvertently help his career. There's no doubt about it. Her devotion was endless."[87]

As her involvement with Tom and Harold deepened, Elaine's life became even more hectic. "I think it's one of my failings that I am interested in everything," she once told an interviewer.

> I would really prefer to just have blinders on, like Willem who exemplifies, I think, the statement by Kierkegaard, "Purity of heart is to will one thing." I would love to will one thing, but I have a great many interests. I met a minister up in New Hampshire...and he said, "Being married to you must be like being married to twenty women." And I thought, is that a compliment?[88]

Elaine's devotion to Bill hadn't wavered, but her attention had. Gradually, other women began to fill the spot she had vacated. For the previous seven years she and Bill had each had lovers while maintaining their

unconventional union. In 1952, however, in part because Elaine's life had grown much larger and in part because of the influx of eager young women onto the scene, the de Koonings were increasingly seen in the company of other people. Bill had so many girlfriends that he installed a special bell system at his loft to indicate which one was ringing for admission. Those who had been on the scene for years—women like Mary Abbott—knew his situation and were well acquainted, if not friends with his increasingly powerful wife. But the younger women who had begun to fill the Cedar after the Ninth Street Show were either unaware of Elaine's importance in Bill's life or deluded into thinking they could somehow change it.

Among the latter was a young woman in her twenties who had grown up on army bases and come to New York with her twin to study at the Art Students League just after the war. By the time they appeared in the Cedar in 1952, Joan Ward and her sister Nancy were working as commercial artists and ready for adventure.[89] Petite and voluptuous, they made quite a splash at the bar. "They were startling to see, in the way identical twins always are," recalled John Gruen. Franz Kline claimed Nancy, and Joan Ward claimed his best friend, Bill. He didn't resist. Joan was uncomplicated, smart, but anti-intellectual.[90] She was a raucous, small-town girl half Bill's age, and she was good for his ego. Seeing them together, however, struck some friends as curious. In body type and coloring, *she looked like Elaine*.[91] It was as if Bill had found an understudy to play the part of his wayward wife. And, like every understudy, Joan had her heart set on snagging the leading role.

For the first time since the end of the war, politics intruded into the New York School in the fall of 1952. Audrey Hess, Tom's wife, was a leading figure in the Democratic Party in New York, and she, along with Leo Castelli, had organized Club artists to make posters on behalf of the party's presidential candidate, Adlai Stevenson.[92] It didn't take much persuading. The Illinois governor was what one writer called a favorite of "the new GI Bill intellectuals."[93] He took on the anti-communist fearmongers. In an era when the majority of Americans wanted to raise the moat and ignore the rest of the world, he was an internationalist. He spurned the new televised marketing of candidates, saying he objected to "selling the presidency like cereal."[94]

As enlightened as Stevenson was on some issues, though, he was conventionally sexist. He would tell a graduating class at Smith that a woman's role in politics is as wife and mother: "Women, especially educated women, have a unique opportunity to influence us, man and boy."[95] But despite that attitude, he was surrounded by adoring women and notorious

for his affairs at a time when that still worked in a politician's favor as an indication of his virility (especially as the conservative right tried to insinuate that he was gay).[96]

Stevenson's Republican opponent was a moderate, General Dwight D. Eisenhower, hero of the Second World War and commander of NATO. Though Ike, as he was known, despised McCarthy, he couldn't admit it because his Republican Party was already torn apart by factional fighting. To appease the ranks, Ike had to accept as his running mate a McCarthyite favorite, Richard Nixon.[97] In the minds of artists and writers who frequented the Club, Eisenhower and Nixon represented Red-baiting, corporatism, crude provincialism, and militarism. Stevenson was, they thought, their only hope, and they became passionately involved in the campaign.

"I can't remember any of the writers or painters or myself... ever being so engrossed in a political campaign," wrote poet Barbara Guest, who had arrived on the scene to become the only woman among the early poets of the New York School. She told her family in California, "It was very amusing that most of the painters had never voted before and were all busy taking literacy tests, which are required here for a first voting!"[98] After casting a ballot, Grace noted in her journal, "I have never been so involved in an election before—I'm almost superstitious." Grace feared that if Stevenson lost, the next four years would be "dark & discouraging" for her and fellow artists.[99] Grace's prognostication would soon be put to the test. The election had come down to a question of stability. Ike won by a landslide, and Joe McCarthy launched two years of communist witch hunts that grew so maniacal eventually even his supporters were appalled.[100]

The *Partisan Review* declared the "death of bohemianism," as disappointed artists retreated to the bar and their studios.[101] They would not dabble again in politics for years to come. But were the Eisenhower years as bleak as Grace feared? Not at all. Within their mutually protected universe, the artists' pace of life actually quickened. There were more artistic advances resulting from new influences, more opportunities to show, more openings and parties as painters, sculptors, poets, and composers celebrated their adventure. These would be the glory years. For most, there was no better time to be an artist, and no better place to do so than in the birthplace of Abstract Expressionism, New York.

Discoveries of Heart and Hand

36. Swimming against a Riptide

I find that the subject of discrimination is only brought up by inferior talents to excuse their own inadequacy as artists.
— *Grace Hartigan*[1]

Any woman artist who says there is no discrimination against women in the art world should have her face slapped.
— *Lee Krasner*[2]

HELEN ONCE SAID that in the course of an artist's life a "certain magic" happens once, maybe twice, which produces a breakthrough.[3] Her first came in 1952 when she was just twenty-three. In a Ford Clem borrowed from his father, Helen and Clem drove out of the city in late July, northbound toward Cape Breton Island in Nova Scotia.[4] They had a month with nothing on their schedules except absorbing the splendid coastal landscape, swimming, and painting side by side from nature. Watercolor was their preferred medium.[5] It traveled best and was most in harmony with their idyllic surroundings. The violence of the North Atlantic and the rugged coastline seemed in the summer to be positively tamed, as if some great hand had softened the latter's craggy strength and the former's fury. For their studio, Helen and Clem had the windy highlands, the vast green mountain valleys that had been carved out by glaciers, the expanses of sandy beach where land and sea became one. It was altogether impossible to do justice to the scene around them; their work amounted to little more than exercises. But limbering up in such a setting did them both good, especially Helen. When she returned to New York in late August, she brought those landscapes with her, not just in the small works she had painted, but deeply and internally. She said she could feel the magnificence she had been part of in her arms.[6]

Helen had moved her base of operations to 23rd Street between Seventh and Eighth Avenues in Chelsea after David Hare returned from Paris to reoccupy his Tenth Street place. Her studio mate in the new space was a thirty-seven-year-old Berliner named Friedel Dzubas.[7] Friedel had fled Nazi Germany in August 1939 when he was seventeen. "I ran," he said, "because I had no notion of getting myself killed for Hitler. I ran because I am a coward. I hate physical pain."[8] Making his way to New York, he

found a German acquaintance-in-exile known as "the Red Prince"—Prince Hubertus zu Löwenstein—who was feted in high society circles for having been chucked out of Germany for outspokenly opposing Hitler. "He knew everybody and everybody knew him," Friedel said of the Red Prince. "I had no money, but I was invited to fancy parties, uptown in the sixties, beautiful townhouses."[9]

When outside Löwenstein's orbit, Friedel lived in a Brooklyn rooming house, subsisting on Oreo cookies he bought for six cents a pound and studying English at the movies. "I learned to speak like Humphrey Bogart, Jimmy Cagney," he said. "I would sit there for about three or four hours." As to paid employment, he did what he could: manning a bakery pushcart on Seventh Avenue, painting radiators and walls in brothels on Coney Island. During a party he attended with Löwenstein, however, his fortunes changed. Friedel met a publisher who learned he had studied art in Berlin and offered to relieve him of his Oreo diet by giving him a job in Chicago on a magazine. Friedel took it and did not return to New York for four years.[10] When he did, the war had ended and Friedel became part of the ferment in the Village.

Even from the distance of Chicago he had felt part of that scene because he had religiously read the *Partisan Review* and *Commentary*. When he finally met the men and women who wrote for these publications, they already felt like friends. Especially Clem, whom he encountered when Greenberg posted an ad in *Commentary* saying he was looking for a summer home near New York. Friedel had just rented one in Connecticut and offered it to Clem as a share, saying, "I've been reading your articles for the last four or five years, and I've seldom understood what you were writing about."[11] Several years later, Friedel was again sharing a place, this time with Clem's girlfriend, Helen.

The differences in their age and experience might have created a gulf between them, but Friedel's German roots may have reminded Helen of home. Their artistic sensibilities, too, were similar. In that increasingly bipolar world where it had begun to feel necessary to pledge allegiance to either de Kooning or Pollock, they were among those who remained loyal to Jackson.[12] Even their reasons for doing so were similar. Both saw him as a jumping-off point. "Jackson never provided you with something you wanted to imitate or be like," Friedel said.

> What he provided you with, if you were sensitive, was an image of unheard of freedom.... There's also a certain desperation about it. If you want that kind of freedom, then you pay for it with a constant feeling of discomfort—you can't lean on anything.[13]

The respectable life Friedel had begun to construct during his years working in Chicago was in shambles. He and his wife were divorcing, and she had taken his three children and their house. The 23rd Street loft became his home. Friedel built a wall to demarcate the arrangement he and Helen had reached: He would live and work on one side of the space while she painted on the other.[14] Then, ignoring the wall, they roamed back and forth freely "moaning and groaning," as he recalled—he about his life, she about her art. "She would come with little doubts, but the little doubts, I mean, hide...a huge, absolute drive of self-righteousness, that she's not doing wrong, she's doing right," Friedel said.[15] In other words Helen asked Friedel's advice but, despite her relative youth and his greater understanding, she didn't really need it. However, Friedel was valuable as a second set of eyes, and so one October day, she asked him to look at a painting she had done.[16] "I think I was puzzled by it. I didn't realize that I had done something enormous or profound or necessarily beautiful," Helen recalled. "And I knew that it was a new kind of gesture because I had never seen anything like it before, but it puzzled me and I wasn't sure what it was but I knew that it had to rest."[17]

After returning from her trip with Clem, Helen had ordered a bulk of raw cotton duck from a sailing supply store and tacked a seven-foot-by-ten-foot piece of the canvas on the floor.[18] "I had a summer of making small, careful, after-nature watercolors and got into my own place on 23rd Street and felt sort of, letta rip," she said. "So I left the stuff on the floor and I mixed paint in hardware store pails and coffee cans, and...first made the gesture in sort of blocking out the picture that I didn't know was about to happen."[19] Helen had thinned her oil paint to such an extent that it was liquid, and when she poured it onto the raw canvas it didn't form a skin, it soaked into the weave of the cotton duck. "I had no plan; I just worked. The point was how to get down the urgent message I felt somehow ready to express, in the large, free scale it demanded."[20]

Kneeling on the floor and reaching across her canvas, sometimes climbing onto it, she pushed the paint pools and watched the pastel colors change as they bled into one another or spread out more thinly into and across the fabric. Like Pollock, Helen engaged her whole body in her work. But instead of Pollock's constellations, she created oceans, her paint forming seas of color that ebbed and flowed. Very few lines appeared on the surface, and those that did were mere traceries of a brushstroke, existing not to demarcate a shape or space, but for their own sake. Helen had not felt compelled to cover the entire surface of the work; parts of the cotton duck remained untouched. The raw fabric that was usually painted into oblivion

was to be appreciated as art, too. The painting was massive, but the overall effect was weightless. She had opened her arms and unleashed nature, allowing it to merge with the threads of the canvas to create shapes that defined nothing but felt like a world.

Helen saw the work as "something that I had to do that naturally evolved.... I didn't finish the picture and think um, something terrific has happened. I didn't think that at all. I thought I made a picture that looks like no other picture I've ever made and I feel I should leave it and take it from there."[21] Friedel came over to Helen's side of the loft and looked at her work, startled and more than a little resentful. He had thought her use of unprimed canvas was a sign of "laziness.... I mean she would slosh into the studio about two o'clock in the afternoon and then...she would paint for three hours, and then she would have to go home to her bottle of sherry, to make dinner or get ready for dinner, and the unprimed canvas was a great thing."[22] But that afternoon, he realized that what she had done was profound. She had created not only a new painting, but an alternative to the tradition of the painted surface. *And* she had taken what she learned from Pollock and moved beyond him—in one afternoon.[23]

"I called Clem to arrange evening plans and Friedel got on and ebulliently told him to come on over and look at the picture I'd just made," Helen said.[24] When Clem arrived he looked at the painting and told her it was terrific, that she was "red hot" and should keep at it.[25] They all agreed the work was "'finished' and shouldn't be touched."[26] Helen then took the unusual step of dating her piece in the lower right corner: 10/26/52. "I usually don't, but I remember wanting to do so with the picture that day," she said.[27] She called the work *Mountains and Sea*. Helen, Clem, and Friedel had a few drinks while looking at it, and then thoughts turned to dinner.[28] It was just another evening. But art would never be the same. Helen had planted the seed for a new school of painting. The critic Hilton Kramer would say that her *Mountains and Sea* was to the Color Field School that emerged later in the 1950s what Picasso's *Demoiselles d'Avignon* was to Cubism.[29] It provided an opening for an entirely new way of thinking about and making art.

No artistic advance is ever without precedent. Even the most rebellious among New York's avant-garde acknowledged they were indebted to the artists who preceded them. But faced with an innovation that alters the direction of art, a lively, sometimes acrimonious debate can erupt over whether the person who made it was really the first to have been so bold. The debate over who dripped first lasted decades after Pollock's death. In Helen's case, the question debated among the painters themselves and then by generations of scholars was an equally silly one: Who made the first *stain*?

There had, indeed, been other contemporary artists who had allowed

their paint to seep into the weave of the canvas and spread of its own volition. The most notable of them was James Brooks, alongside whom Helen had studied in Wallace Harrison's class in 1949 while she was on a break from Bennington.[30] Pollock himself had soaked and stained his canvases in the black-and-white series Helen had seen in his studio in the spring of 1951 and later at Betty's gallery. Therefore, just as those who had investigated the genesis of the drip discovered that Pollock had not been the first painter to employ that technique, those on the trail of the prime stain could find its use among painters before Helen. But those discoveries do not in any way rob Jackson or Helen of their status as artistic innovators. Both pushed the boundaries beyond anything that had been done before. What made their work so unique and brilliant was that intangible element—self. Great painting, great art in general, is not about materials used or methods mastered or even talent possessed. It is a combination of all these factors, and an individual driven by a force that seems outside them, toward expression of an idea they often do not understand.

That is what Helen felt. She returned to her studio, excited to see what she could do next with her discovery. "I couldn't try them out fast enough," she recalled.[31] On the other side of the loft they shared, Friedel started to paint like Helen, too.[32]

Early in the year, Lee had arranged for Jackson to begin seeing a new doctor who made and sold an elixir that was supposed to rebalance Pollock's body chemistry to counter the effect of alcohol.[33] Not only had Jackson smashed his car while driving drunk the previous December, but his work was suffering. His best painting years had been those during which he was sober, and since then he had had only short spurts of productivity. In anger and frustration over the waste of such a talent, Clem remembered Lee shouting, "When you were off booze in '49 and '50, look what you did! But since then, back on booze, do you do *real* pictures?"[34] Pollock did not have the strength to reply.

In the past, he had kept his work and his addiction separate. By 1952, however, his disease had overtaken even that part of himself he most protected. His studio was littered with empty bourbon bottles among the cans of paint.[35] A man who had been hired to work on the Pollock house during that period remembered Jackson as "a mess, a real pain in the ass." All he did was "spit, drool, sneeze, cough, snot, and piss."[36] Lee and Jackson had tried many therapies to wean him from alcohol, with the most effective one having been the simplest—talk. That year they tried the most outrageous (and expensive at two hundred dollars a month).[37] The man Lee had found to help was a biochemist named Grant Mark (Alfonso Ossorio said he looked like "something out of a horror movie" and called

himself a "business manager," not a doctor) who instructed Jackson on his diet. He was to stay away from any fowl that could not take flight at fifty miles per hour (it also should have been killed within the previous two hours), bathe in salt, and receive shots of copper and zinc.[38] But most importantly, Jackson was to drink a quart each day of Mark's own "total well-being emulsion." Mark claimed that his elixir would allow Pollock to drink as much liquor as he wanted without ill effect.[39] The treatment was a failure. Pollock felt like hell and was drunk day and night. Under Mark's regimen, Pollock told Alfonso, he felt as though he had "been skinned alive."[40]

Ossorio had purchased the most prestigious property in East Hampton, a seventy-acre estate called the Creeks, and now lived near the Pollocks year-round.[41] It was primarily Ossorio who kept Lee and Jackson afloat through purchases of Jackson's work and whose personal support through their many crises became increasingly important. Despite Pollock's growing fame, he and Lee had started the new year destitute.

By spring, in part to remedy their dire financial situation, Jackson joined an exodus of artists leaving Betty's gallery. Amid the rise of the "businessman" dealer, they believed she was an anachronism. The new dealers thought of artists as investments, and they were prepared to spend money—from subsidizing an artist's work to buying advertising space—to ensure those investments paid off. What Betty offered her artists was love, and as much as they appreciated that support, after so many years of poverty, selling had begun to feature in their fantasies.[42] But it wasn't easy for Pollock to find another gallery. Between his personal reputation and the questions that had arisen about his continued ability to create, Jackson was too much of a risk for the few enterprises that showed the avant-garde. There was also a problem of size. The pool of possible collectors for his work was tiny: They would have to be wealthy visionaries with eighteen-foot walls.

In desperation Lee paid Sidney Janis a visit.[43] Nine years earlier, she had introduced Janis to Pollock. At that time, she tried to sell Sidney on the idea of including Jackson in a traveling show and book he was assembling, in which she was also included. Several Pollock masterpieces later, she was back asking him to give Jackson another chance.

"You know Jackson is not with Betty anymore and he's looking for a gallery," she said.

"You've come to the right place," Janis said, before expressing one concern. "I want to ask you, Lee, Jackson's had a show every November and don't you think that his pictures have reached a certain saturation point where the public is concerned?"

"The surface hasn't even been scratched" was her confident and prescient reply.[44]

Jackson signed on with Janis, who also represented Gorky's estate and Bill de Kooning. That was a club of "pros" Pollock wanted to join.[45]

Janis's space occupied the same floor as Betty's and she watched brokenhearted as the artist she had rescued five years earlier left her for a businessman.[46] Almost immediately, Betty informed Lee that she was no longer a Parsons Gallery artist either. "It has nothing to do with your painting," she told Lee. "I still respect you as an artist, but it is impossible for me to look at you and not think of Jackson and it's an association that I cannot have in here."[47] Reminded in the cruelest way that she was not an independent artist, but Mrs. Jackson Pollock, and that his fate dictated hers, Lee left, stunned. Coming so soon after Lee's miserable first show the previous fall, Betty's dismissal proved devastating. In the spring of 1952, Lee closed the door to her studio and did not reenter until the next year.[48]

Under those depressing circumstances, the summer festivities in East Hampton centering around the Castellis were torture for Lee. It was as if the Cedar she loathed had come to Long Island. Jackson was drawn away from his work to drink with "the boys." He didn't even have to drive to do so. Conrad Marca-Relli, who hadn't known Jackson before arriving in Springs but who was close to Elaine and Bill, had bought the house next door to the Pollocks.[49] The traffic of artists up and down Fireplace Road thereafter moved in a steady alcohol-infused stream, and as the summer progressed the parties along that route swelled and grew wilder.

Bob Motherwell's house, a Quonset hut designed by a French architect (which was the bane of the native Hamptonites), was not far from the Creeks and across the road from Castelli's.[50] One night, Motherwell and his second wife, Betty Little, were at a party at Leo's with Bill and Elaine when he noticed Jackson reaching the point of drunken explosion. "While I'm not cowardly—I was always ready to strike back if he struck me—I didn't want to be around," Bob said. The Motherwells left in Bob's MG convertible, which he parked each night in his circular driveway.

> As we were getting ready for bed I thought, "I wouldn't put it past that bastard Pollock to come zooming in in that Model A, and with the circle blind there wouldn't be a chance not to smack into my beautiful MG." In my shorts—this is unlike me, a passive, inactive man—I got out and put the MG around the corner of the house. Then, just getting into bed—bang! Pollock was tearing around the driveway in the Model A and my MG would have been demolished. There was in it—I don't know, five years' savings—and Pollock would have been apologizing the next day.[51]

Jackson was having a wonderful summer making mischief; he had also tried to run over a sculpture of Larry's that stood on Castelli's lawn. His

attention to pranks, however, came at a cost. Pollock's studio stood empty except for a seven-foot-high-by-eighteen-foot-long painting that haunted him. Everything about the painting spoke of defeat. Before Pollock had begun to rework it that season, it had been a kind of group effort involving Tony Smith and Barney Newman, who had tried to coax Jackson back to work by making marks on the canvas themselves.[52] During rare moments of lucidity and sobriety, Pollock again faced his canvas. "This won't come through," he complained to Lee as he endeavored to find *something* in that space.[53] Eventually he did, by painting eight "poles" across the length of the painting at equal intervals. It was a painting of energy restrained, of Pollock in a cage. In some ways, it marked the end of the artist he had been. But it was a masterpiece.[54]

Pollock had eleven paintings ready for his inaugural show at Sidney's gallery on November 10, with *Blue Poles* his most important. He was so terrified ahead of the exhibit that he was afraid to drive on his own and asked a neighbor to give him and Lee a lift into New York.[55] The Pollocks' financial future depended on the exhibition, as did both his and Lee's mental health. They were in a worse place in nearly every regard than they had ever been. Lee had been rejected and dismissed as nothing more than the lesser half of a package deal. Jackson was wallowing, artistically speechless, in that dark place reserved for those who have been granted celebrity and then cast off. The Janis show could set things right. But it didn't. Though the press praised the show, with *ArtNews* calling it the second best solo exhibition of the year after Miró, almost nothing sold.[56] *Blue Poles* was removed from its stretcher, rolled up, and eventually returned to Pollock's barn.[57] Two years in a row Jackson's exhibition had been a flop. Even Clem, the critic who had been Jackson's most vocal supporter, whose own career had risen alongside the painter he once anointed as "the greatest," had apparently lost interest. He didn't even bother to review the show.[58] Jackson's "inspiration," he concluded coldly, "was flagging."[59]

November 17, a week after Pollock's show opened at Janis, the first retrospective exhibition of his paintings was scheduled. Clem had organized the show at Bennington College, selecting eight magnificent works from between 1943 and 1951.[60] The exhibition was significant because of the caliber of faculty associated with the school as well as the wealthy, liberal families who sent their daughters to study there. Both could be receptive new audiences. Jackson and Lee should have, therefore, approached the event with excitement. Instead, they were tense and wary. The very idea of a retrospective felt loaded for Jackson because it implied that his painting life had already ended.[61]

In a station wagon Alfonso had loaned them, Lee and Jackson collected Helen and Clem in Manhattan en route to Vermont.[62] Their first sched-

uled stop, however, was upstate at Bolton Landing, where sculptor David Smith and his girlfriend, a recent Sarah Lawrence graduate named Jean Freas, awaited them with dinner and a place to sleep. A member of the First Generation and veteran of the Project, forty-six-year-old Smith was a welder from Indiana.[63] He was a hard-drinking, violent bear of a man whose abstract sculptures used material most often found on a building site. His work was, therefore, as difficult to sell to collectors interested in "fine art" as were Pollock's paintings. When his sculptures were finished, Smith planted his steel creations totem-like around his property and went back into his studio to make some more. His first wife, artist Dorothy Dehner, had walked out on him in 1950 after a fight that left her with several broken ribs and after years of keeping her own interest in sculpture a secret for fear of his jealous reaction.[64] Freas, whom Smith would marry in 1953 and with whom he would have two children, was a former student two decades his junior.[65] Smith had nothing materially; he and Jean were so broke they had taken out a bank loan to pay for the dinner they prepared for their guests.[66] But to Jackson's mind it may have appeared that David had everything: freedom to work, freedom to drink, and an adoring young girlfriend, not an older woman in whose eyes he could see only the reflection of his failings.

Helen and Clem had wanted to see David and suggested the overnight stop. When Helen met him the previous year, she was taken with both the man and his work. In fact, she bought a sculpture and became one of Smith's earliest patrons.[67] Clem and Helen had made frequent pilgrimages to the shores of Lake George to visit their friend, but the trip would be a first for the Pollocks, who would have had much to discuss with their fellow veteran. When they arrived, however, forty-four-year-old Lee was relegated to the company of twenty-three-year-old Freas, while Helen and the men retreated to the studio to talk art.

Clem described Lee as having had a "tantrum" at Smith's, which he attributed to her fear that Jackson was in the studio drinking and that Smith was the center of attention.[68] No doubt worry about liquor was part of it, but that was a constant concern and rarely provoked the kind of rage Lee exhibited that day. Her fury was the response of Lee the artist, not Lee the wife. Her paintings were a disaster. She had lost her gallery. The art world she had sought to corral was moving toward de Kooning and, try though she might, she could not control her husband's drinking. That day at Smith's, being consigned to the kitchen while the *real* artists talked, would have felt like pointed disrespect. She had known Smith from the Project. She had been, and to her mind still was his peer, and yet even among colleagues she had become inconsequential, just a wife. Lee positively roared and demanded they leave Bolton Landing immediately.

Shocked into action by the violence of her command, Clem, Helen, and Jackson piled back into the car and set off for Vermont. The dinner Freas had prepared for them sat abandoned.[69] "She was very nasty, to me," Freas recalled, "and I know why she was nasty: because I was young and pretty, and she was—I think she may have been the ugliest woman I've ever seen."[70] At that point Freas had no idea what motivated a woman like Lee, or the depths of her torment.

At Bennington, Jackson's paintings—masterpieces like *Pasiphaë, Totem Lesson 2, The Key,* and *Autumn Rhythm,* among them—were hung high and haphazardly from a balcony inside a barn on campus. The installation was surprisingly amateurish. Viewers couldn't "walk into" the works as Pollock had intended. The show, therefore, lacked the sense of enveloping wonder that one felt when encountering them in Jackson's studio or in a gallery. Jackson was also annoyed that Clem hadn't selected any of his recent work for the show. The choices seemed designed to illustrate Clem's contention that Pollock's best paintings were behind him.

Visitors to the exhibition, however, weren't aware of those tense undertones or the artist's dissatisfaction. The exhibition went off well. Jackson, trim and well-groomed in a suit and tie, appeared quietly cordial throughout.[71] And, after the show, Helen's former teacher Paul Feeley held a small reception for faculty and some students. Somewhat surprisingly, the guest of honor's wife volunteered to act as bartender during the gathering.[72] Feeley wouldn't have known Lee's reason, but Helen and Clem did: she was taking control of the liquor to keep Jackson sober. Her plan worked until nearly the end of the party when someone offered Pollock a drink.[73] Clem overheard the offer followed by Jackson's eager acceptance. "The last thing I wanted was for him to be drunk at Bennington," Clem said. He told Pollock to put down the drink and "lay off."[74] Embarrassed that others had heard Clem's command, Pollock turned on him and said in an equally audible voice, *"You're a fool"* and lustily downed his whiskey.[75]

The next morning, breakfast passed without visible rancor, but relations between Clem and the Pollocks were ruptured. Pollock dropped off Clem and Helen at the train station to return to the city, while he and Lee drove to Springs.[76] "When he called me a fool, I was furious," Clem said, "and I was off him for a couple of years. I didn't say it but Jackson sensed it.... Besides, he had become, if not famous, at least notorious, and I suppose the battle had been won."[77]

Harold's "Action Painters" piece finally hit the stands shortly after the Bennington trip, appearing in the December issue of *ArtNews*. Lee practically shrieked when she saw it. She and Pollock read into the article a deliberate attack on Jackson by a de Kooning acolyte, one that insinuated

an emptiness in Jackson's art (which could be seen as merely action).[78] Lee scrawled comments across the article and along the margins, arguing with the printed page as if Harold were in front of her.[79] The painter Bradley Walker Tomlin was at the Pollocks' when the magazine arrived. The discussion around the kitchen table intensified. "At some point a car drove in," Lee recalled. It was Bill and Philip Pavia, who liked the piece. "The house began rocking and rolling.... We were all arguing about it." After Bill and Philip left, another car appeared and more discussions. "So that was quite a day," Lee said. "I dare say everyone had some...form of objection."[80]

The primary objection, however, came from the paranoid and embattled residents of the house on Fireplace Road. The year had opened with Tom Hess's book and ended with Harold's article. Lee saw Elaine's hand at work in everything. The de Kooning cabal was in the ascendancy at the moment when, having become estranged from Clem, she and Jackson had no critic to take their corner. At the approach of the new year, Jackson told a friend he was hanging by a "hope rope." To a genial greeting, "How's it?" Jackson replied with one word into which he slowly breathed the essence of his anguished existence, *"Sh-i-i-t."*[81]

37. At the Threshold

> Always (it was in her nature, or in her sex, she did not know which) before she exchanged the fluidity of life for the concentration of painting she had a few moments of nakedness when she seemed like an unborn soul, a soul reft of body, hesitating on some windy pinnacle and exposed without protection to all the blasts of doubt.
>
> — *Virginia Woolf*[1]

ALL ARTISTS SUCCUMB to self-doubt; it is the handmaiden of creation. For a woman, however, whether in Virginia Woolf's early twentieth-century England or Joan Mitchell's 1950s New York, that doubt would have been the result of forces both creative and social. Of the latter, Woolf wrote,

> The indifference of the world which Keats and Flaubert and other men of genius have found so hard to bear was in her case not indifference but hostility. The world did not say to her as it said to them, Write if you choose; it makes no difference to me. The world said with a guffaw, Write? What's the good of your writing?[2]

Many decades later, Joan would put her own salty spin on that same sentiment.

> How did I feel, like how? I felt, you know, when I was discouraged I wondered if really women couldn't paint, the way all the men said they couldn't paint. But then at other times I said, "Fuck them," you know.[3]

The obstacles faced by women who hoped to leave a mark on humankind have, through the millennium, varied in height but not in stubborn persistence. And yet, a great many women have just as stubbornly ignored them. The desire to put words on a page or marks on a canvas was greater than the accrued social forces that told them they had no right to do so, that they were excluded by their gender from that priestly class called artist. The reason, according to Western tradition, was as old as creation itself: For many, God was the original artist and society had assigned its creator a gender—*He*.[4] The woman who dared to declare herself an artist in defiance of centuries of such unwavering belief required monstrous strength,

to fight not for equal recognition and reward but for something at once more basic and vital: her very life. Her art *was* her life. Without it, she was nothing. Having no faith that society would broaden its views on artists by dethroning men and accommodating women, in 1928 Woolf offered her fellow writers and painters a formula for survival that would allow them to create, if not with acceptance, then at least unimpeded. A woman artist, she said, needed but two possessions: "money and a room of her own."[5] By 1953, at the age of twenty-eight, Joan would have both.

After Joan moved to Tenth Street, Barney waited for her to return to him on Ninth. "I said, 'Joan, you've got to come back — if you don't come back, I'm going to get divorced,'" Barney recalled. Joan assured him that she would, and Barney waited. For one year. "I finally said, 'I'm going to Chicago.' In Illinois they have extremely liberal divorce laws if you're a resident, which we were not exactly. But, her father, my father.... So I went to Chicago, that was my last bluff. I went. I called her. I said, 'Joan, I'm getting divorced tomorrow.' I charged her with desertion. And it was true. She agreed."[6]

The news that Joan had left Barney for another man elicited gasps along Chicago's Gold Coast, where residents learned the sordid details of the split from the same gossip columnists who had gleefully announced the Rossets' marriage.[7] In reality, Joan and Barney's divorce was less a scandal than a sad parting of friends. Though there had been plenty of fights, there was little acrimony. Joan hadn't even wanted a divorce; she had hoped for an open arrangement like Elaine and Bill's.[8] But Barney needed more, and in the end, he prevailed.

The state required that Barney present two witnesses to attest to the fact that he and Joan had not lived together for the previous two years. One of them was his disappointed father. "He had gotten drunk. He called the judge and ordered the judge to have the trial in his chambers so nobody could see he was drunk. He was upset — he hadn't wanted me to be divorced. The judge wouldn't hold it in his chambers because he thought it would look suspicious to all the reporters."[9] A gaggle of them sat poised to record the history of Joan's betrayal, but they came away disappointed. In open court, the proceedings were as antiseptic as they were brief. The judge warned Barney, "You know if you lie under oath it's a crime, it's perjury."

"Yes, I know," Barney replied.

"Have you lived in Chicago these past two years?" the judge asked before a courtroom of people who knew Barney lived in New York.

"Yes, I have," Barney replied. In a city where the power of a man like Barney Rosset Sr. carried more weight than the law, Barney Jr.'s blatant lie was accepted and recorded as fact.

"So he divorced me," Barney said.[10] "One paragraph... and one other sentence: She had the right to use her maiden name. That's all she wanted!... That was the whole settlement."[11]

Within two years, Barney's father would die, and Barney would inherit a bank and government bonds worth fifty million dollars.[12] Joan hadn't claimed any of it. She didn't have to. Despite their intense early sex life, she and Barney had always been more brother and sister than husband and wife, and he would continue to take care of her when she needed him. In fact, that spring just before he left to obtain the divorce, Barney paid for Joan to abort a child she had conceived with another man.[13]

The discovery of her pregnancy and the procedure to end it had occurred around the time Joan joined the Second Generation artists in their debut panel at the Club with Frank O'Hara.[14] Frank and Joan's friendship began in earnest from that point. Having constructed a formidable protective wall to separate her interior and exterior lives, Joan required great tests before deciding to reveal her true self to another. Frank, with his infinite capacity for empathy, passed. He would be admitted into Joan Mitchell's life because he had seen through her aggressive posturing. He had met the vulnerable persona Joan sometimes referred to as "Little Joan." She was an artist, and Frank not only understood her, he liked her. She liked him, too.[15]

During that season of quiet sadness after their divorce, Barney retreated to Paris to hunt for books, relieved that his difficult marriage had ended, though his love for Joan never would. One day, on the Champs-Élysées, he spotted a chocolate-brown poodle puppy and thought of her.[16] Barney had the dog shipped back to the States. When it arrived, he drove Joan to the airport, telling her that he was going to introduce her to a young Frenchman she might like. When she saw the dog, she took him in her arms and fell in love.[17] "Music, poems, landscape, and dogs make me want to paint," Joan would say many years and many dogs later. "And painting is what allows me to survive."[18]

Now officially single, Joan found a fourth-floor studio on St. Mark's Place in a tree-lined enclave of Russians, Ukrainians, and Poles where she could do just that.[19] With fourteen-foot-high ceilings, parquet floors, and northern light, Joan's vast room — there was only one — gave her the space to step back as far as she needed to see what she had done and where her brush should take her.[20] Joan's previous studio on Tenth had been in a building crowded with other artists and had, like her early Paris flat, begun to feel too much like Grand Central Station.[21] To paint she required very little in the way of special materials or conditions, except for solitude. Solitude, that is, as well as linen, stretchers, paint, books, and music, which she blasted on a high-fidelity record player to signal that she should not be dis-

turbed. "I have to be without myself to do something," she explained. "When you are really involved in writing or painting you are someone else.... You are the what I call, 'no hands,' the riding a bicycle. You do not exist."[22] At St. Mark's Place, a studio she would keep for thirty years, Joan could achieve that transfigured state because it was a room of her own. The only creature she allowed to enter while she was painting was her new puppy, Georges du Soleil.[23]

It had been almost two years since the Ninth Street Show, and the artists who had been involved in it were anxious for another. The commercial galleries willing to exhibit avant-garde work still amounted to fewer than five.[24] That meant that the vast majority of artists from the Club and the Cedar, whose studios were filling up with hundreds of canvases, had no opportunity to exhibit. Women were finding it especially difficult. "The galleries had quota systems," Joan explained. "Two women to a gallery, if they were lucky.... Janis didn't show women."[25] And then there were the critics. Clem was not alone in his hostility to women who painted or sculpted. Unless the reviewer was a friend, the woman artist could expect the writer to employ feminine adjectives that functioned as a code indicating that the work was not *serious*. In her book *Of Men and Women,* Nobel laureate Pearl S. Buck explained the phenomenon.

> American men critics may often show some respect to a foreign woman artist, feeling that perhaps the foreign women are better than their own. But they cannot believe that anyone belonging to the species they see in department stores, in the subways and buses, or running to the movies and lectures, or even in their own homes, can amount to anything in the arts.[26]

And what of the artists? Those men who painted, drank at the Cedar, and discussed art alongside women at the Club? "When I was in New York in the late '40s," said Grace, "everyone was poverty-stricken—there was no fame, no money, no galleries, no collectors. That's when you have equality. Men have no objection to women as creators. It's only when they're all scrambling for recognition that the trouble begins."[27]

The "heroic" generation, men like Bill, Pollock, and Hofmann, wouldn't have thought twice about a woman's right to be an artist. They had enough to trouble them inside their own studios to bother worrying about anyone else's.[28] But in the early 1950s, a creeping resentment began to appear among some lesser talents who watched the stronger women appear in solo shows at John Myers's gallery or Betty's place, and take their seats on Club panels, *as if they were men.* Joan's friend Paul Brach, for example, once described with bravado, "The fifties was a 'boys' club,' but some

of the women painted *almost* as well as the boys so we patted them on the ass twice and said keep going."[29] The women who dared to be artists at that time would have found his comment unremarkable. "If we were ill, we'd get a man doctor, if we needed legal advice, we went to a man," said sculptor Louise Nevelson. "I recognized that, but I also felt that men were no challenge to me personally."[30] And that was how most of her female contemporaries survived: by believing in their work and ignoring the ludicrous machismo some male artists wore like body armor. (Historically, Auguste Renoir may have taken top honors in that contest by declaring, "I paint with my prick.")[31] Elaine's friend Doris Aach said of the 1950s, "In those times everyone knew women were at a disadvantage, but it was the reality and you carried on. If you live in a time when women wear veils, you wear veils. That was reality then."[32] But it wasn't easy.

The artist-selected exhibitions were mercifully free of gender bias, according to Elaine, largely because women artists sat on the selection committees.[33] All that mattered was the quality of the work, and there was a lot of terrific painting and sculpture by women *and* men languishing unappreciated. In late 1952, Conrad Marca-Relli and Nick Carone convinced a new gallery owner named Eleanor Ward to allow them to use space she had rented in an old livery stable on Seventh Avenue and 58th Street for an exhibition along the lines of the Ninth Street Show. Marca-Relli and Carone had been in her first exhibition, which featured contemporary Italian painters, and were overwhelmed by the location: two floors of unobstructed space large enough to accommodate huge paintings. Elaine said the Stable had "the best wall space of any gallery in New York bar none." Ward agreed to the show, which was disingenuously called the Second Stable Annual (the first "Stable Annual" being the Ninth Street Show).[34] With that, Ward and the Stable Gallery entered the history of American art.

Affluent, stylish, and as much at home in Paris as New York, at forty-one Ward had been encouraged by her friend and former employer Christian Dior to pursue her dream to open a gallery.[35] In a letter to Larry, John Myers described Ward as "an upper class, ex-beauty with a lot of pretensions to gentility and a kind of tough, stubborn determination to have exactly her own way. When you rubbed up against her honey—you rubbed up against pure sandpaper."[36] The opposite of a nurturing Betty Parsons or Johnny Myers, Ward was an uncompromising businesswoman (Joan eventually called her a "crook").[37] But she provided an opportunity for undiscovered artists to show, and they in turn ignored any perceived high-handed tactics. Marca-Relli, Carone, and a committee of four others set about organizing the Stable Annual, inviting more than one hundred artists to participate in the January 1953 show.[38] The only stipulations

were that the artist live in the New York area and be engaged in avant-garde work.[39] Clem agreed to write an exhibition essay.[40] Soon, the art poured in.

As had occurred with the Ninth Street Show, the work reflected the full range of artists then creating in New York: in age, from the veteran Hans Hofmann to Helen, who was again the youngest painter of the group; and in notoriety, from Pollock to Robert Rauschenberg, then a nearly complete unknown.[41] Bill, Elaine, Motherwell, Franz, Alfonso, Joseph Cornell, Grace, Joan, Jane Freilicher, Larry, Mercedes, Philip Guston, Bradley Walker Tomlin, Perle Fine, Fairfield Porter, Al Leslie, Bob Goodnough, William Baziotes, Milton Resnick, and many, many others delivered their paintings and sculptures to the Stable. The entire space, as well as the ramps leading between floors, gradually filled with their work.[42] (Notably absent was a painting by Lee, who had still not recovered from Betty's dismissal.) Ward recalled the scene:

> It was absolutely smashing.... I'm certain you could have bought out the entire show for $10,000. But nothing sold!... Nobody bought *Blue Poles*. No one bought a de Kooning, no one bought a Kline, no one bought a Motherwell, no one bought anything.[43]

When the Stable Annual opened on January 11, 1953, artists packed the gallery to get a first glance at how far they had traveled since their initial coming-out party on Ninth Street in the spring of 1951. Grace, who had offered a small self-portrait to the show, thought the exhibition even better than that earlier adventure. (Somewhat surprisingly, given her competitiveness, she wrote in her journal the next day that she thought Joan's painting one of the best of the abstract works.)[44] Also craning to see the work in that vibrant space was a new breed of collector—doctors, dentists, professionals—who, while not willing to part with cash just yet, studied the work on hand with future purchases in mind.[45] The show was a triumph. Eleanor and the artists agreed that the Second Stable Annual should be followed by a third, and twenty-five artists were selected to sit on the planning committee, among them, Elaine and Joan.[46]

Their early easy relationship, when Joan had first arrived on the scene, had become more difficult because of Joan's unattached marital status.[47] Elaine had grown conscious of the extent to which she was being crowded out of Bill's life by younger women, who swarmed around him like gnats.[48] It wasn't that Elaine had become territorial at the age of thirty-five, it was just that relationships could become so confusing. Elaine and Joan reached an agreement; they would be friends and allies if Joan promised not to join the queue of women waiting to ring Bill's bell.[49] The pact

was similar to ones Elaine would make with other women she enjoyed and admired.[50] And if Joan readily accepted, it was because she not only respected Elaine's strength and stature, she aspired to be like her: to be exactly who she was without regard for who society thought she should be. But there was likely another reason for Joan's easy acquiescence. Joan believed women artists did not support one another. "I suffered from that," Joan said. "Men actually helped me more and would back me more than women." Joan's was a commonly stated observation.[51] The belief that a woman artist was somehow lesser was so pervasive and culturally ingrained that even women themselves subconsciously accepted it and primarily sought the approval of male colleagues. "Most women were Uncle Toms," said painter Hedda Sterne, "and would rather be loved and accepted than admired and feared."[52] Elaine was an exception. She encouraged other women, not because they were women but because they were artists. In turn, they sought her out for help, knowing it would be forthcoming without a hint of competitive self-interest. Joan gladly agreed to Elaine's terms in order to be that trailblazing woman's friend. The deal struck, together the two plunged into their work for the Stable.

Soon, Joan would reach another agreement with another strong (though less genial) woman, Eleanor Ward. Eleanor had selected a few artists to exhibit with her regularly as part of the Stable Gallery group. The eclectic assembly included Rauschenberg, Joseph Cornell, Marca-Relli, Carone, Isamu Noguchi, Jack Tworkov, James Brooks, Richard Stankiewicz, and Joan.[53] The fact that Joan had been selected was proof that Grace hadn't been the only person to admire her painting. Seeing her work in the Annual, Charlie Egan told Joan she was a "brilliant" artist. Hans Hofmann congratulated her as well. Like many artists, Joan greeted praise with a mix of gratitude and suspicion—suspicion because she feared she must be doing something wrong if her work was suddenly so accessible that it garnered compliments. But Ward's offer came genuine and heartfelt. Elaine said that Eleanor had an advisory committee of about six people who could never agree on any new artist, except Joan.[54] And, as if that weren't encouragement enough, Hal Fondren, Frank's roommate at Harvard and again in New York, had joined the gallery to assist Ward. Though Joan's relations with Eleanor were difficult, Hal had become a friend.[55] Eleanor offered Joan a solo show in April and she accepted.

Since the previous October, when Helen had painted her work *Mountains and Sea,* she had been pushing the technique as far and as fast as she could.[56] Sometimes at night, she said, she saw an entire painting in her mind and she would try to "write it down" on the canvas the next day.[57] At other

times, she came into her studio, walked up to a piece of canvas or paper "with a feeling in my head, my mind, my heart, my arms, all synchronized to know exactly what might pour out, what I want to do."[58] But just as often, she labored over a work until it was beyond redemption, until the spontaneity she strove for was lost for good.[59] Helen believed those moments were important, too, that the successes and the failures were one. "Painting is a constant process of renewal and discovery," she said. "You know it when you see it."[60]

The freedom that came from painting in a visual language she alone possessed allowed Helen to take radical chances. Shortly after completing *Mountains and Sea,* she returned to the figure after seeing a work by Grace called *Venus and Adonis.* Using her new technique of pouring thin paint onto the surface of the canvas, Helen responded with a nude so bold it is shocking even today. Legs splayed wide-open across the nearly three-and-a-half-by-four-foot canvas, a patch of dark pubic hair arresting the voyeur's attention, Helen's painting was an assault on the High Victorian culture then abroad in the land. Within a year, the Kinsey report on female sexuality would be published and twenty-seven-year-old Hugh Hefner would launch *Playboy* (which he offered as "a little diversion from the anxieties of the atomic age"),[61] but when Helen painted her *Scene with Nude* in 1952, censorship was still very much the rule. A few salacious words might cause a book to be banned. Cleavage in film was encouraged, but bare breasts could halt a production.[62] If an intimation of a woman's sexuality did make it past the morality police, it was woman's sexuality as conceived by male writers, directors, and producers. Pervading popular culture, therefore, was a man's notion of who a woman was and what she wanted. Women were largely mute on the subject and were expected to remain so. Helen, apparently, hadn't received the message.

If a man had painted Helen's *Scene with Nude,* it would have been scandalous. For a young woman to have done so was incomprehensible. And yet there it was, unabashed in its raw sexuality, unflinching in its depiction of the most intimate parts of the female form. Helen had even sprinkled splotches of red paint between her figure's legs, violating yet another taboo by apparently glorifying menstrual blood, or lost virginity, or the blood of childbirth, or an abortion. Whatever it was, *it simply was not done.* Not in 1952. Of course, Bill was also busily painting women at that time, but next to Helen's nude his ladies seemed positively prissy.

Often, when displeased with a painting, Helen destroyed it, which is another indication that her *Scene with Nude* was not a fluke.[63] She not only kept it, but selected it for inclusion in her second solo show at Tibor de Nagy.[64] She was proud of her painting, and rightly so. It was magnificent both aesthetically and in the shocking strength of its image. For those who

had ever murmured that Helen's paintings were "pretty" and that she herself was just a "lady painter," her nude served as a reality check. She was no lady; she was an artist. Perhaps not surprisingly, when *Mountains and Sea* and *Scene with Nude* appeared among thirteen works at the gallery on January 27, 1953, the reaction ranged from embarrassed silence to open hostility.[65] The *New York Times* critic called the exhibition "imprudent." Even Fairfield Porter in his *ArtNews* review failed to understand the significance of Helen's invention, writing that while her smaller works were fresh and airy, "in the large pictures fresh air and good luck are not enough: she does not seem to be deeply involved."[66] Through the years, Helen would hear people ask of *Mountains and Sea,* "Why enlarge paint rags?"[67] At some point, someone stuck bubble gum on the painting, and another "critic" scrawled a four-letter word.[68]

Helen weathered the criticism ably. "She believed in herself," John Myers said. "Once she decided to do it, she absolutely believed in her marks on canvas. And this, I think, took an awful lot of courage to do. I really do."[69] What Helen could not countenance was the disregard shown her work by the artists she had considered her friends.

Since Clem's rupture with Grace, and amid the growing divide between the Elaine-Tom-Harold-Bill camp, and the Clem-Jackson-Lee trio (which in any case had been disbanded after the Bennington fiasco), Helen felt herself shunned at the Cedar, the Club, and even among the "Tibor Five."[70] Grace had not bothered to attend her opening, declaring afterward that Helen's new work was "terribly depressing, detached, and uninvolved."[71] Helen was a talker. She wanted to discuss her work, to argue about it if her friends disapproved or failed to understand, not to hear thirdhand what had been said. She had taken her biggest step — her biggest artistic leap — and yet the silence among those whose opinion she respected was deafening. That was often the way with art that voyaged into the realm of the profoundly new. Such art was confusing, frightening, often offensive to those who saw it, even to other artists, sometimes *especially* to other artists because it challenged them to reconsider their own direction. While Helen understood that, it was little consolation for the disappointment she felt. Which was why Helen appreciated Larry's response to her show.

Nearly a month after her opening, a long letter from Larry arrived at Helen's studio. His thoughtfulness — the considered intelligence of what he had to say, which he only trusted himself to detail in writing — was the reaction Helen had hoped for. That it had come from an artist who was himself in the midst of a radical change made it more valuable still. Larry told her he had a "very complicated reaction" to her show because he could not divorce her work from the person he knew her to be, nor from

the people (presumably Clem) whom he believed influenced her. He said it was "very sophisticated" of her to realize that it was not essential for biography to appear in one's work, but he said biography almost always intruded nonetheless. He recognized in Helen's new abstract paintings traits both personal and artistic that he thought detracted from the work: particularly, an avoidance of conflict and struggle.

> *I am not saying your days are not torturous. Or that doubt is never at you. But all of that has no way of finding its way onto your canvas when you decided to paint. Maybe it shouldn't. You are a master at the canvas, at the moment of action and later at home with no immediate demands you become a confusion of ideas. Others are opposite....*[72]

Helen scrawled notations over the envelope in which Larry's letter had come.[73] In more than a dozen comments, she reacted quickly, no doubt as she read, and then, after more consideration and with a voice of great calm, she wrote,

> *Dear Larry,*
> *I was happy to get your letter. It touched me that you should write to me about my show, and I read what you said seriously. My answer isn't going to be just an answer but more of an out-pouring; for despite my poised air of nonchalance I've been thinking and brooding (to a point of depression) over a lot of the things you talked about.*
> *What moved me most of all was what you implied in saying that my style is, out of necessity, an echo of the manner in which I've solved my present life — i.e. seeming to be without conflict or struggle or rather, refusing to show conflict... but I don't think struggle as you use the word, is part of the formula for good or strong painting. If I can strip the wordiness out of both our letters for a moment, I think you feel that just because a painter... goes at and finishes a painting in say two hours, never erasing or smearing out or going over what he puts down, — that something is lacking. Is the alternative to show work, layers of ropey paint, struggle, conflict?... aren't you placing too much emphasis on the amount of romance or the historical importance behind painting that should just be looked at and judged as a painting whether there be ten strokes to an inch or just a whisper of a stroke to a foot?...*
> *However, there's something else. I don't think you mean merely how the paint is applied but also what does it apply to... — therefore abstract painting versus subject matter. As you could see from my show, I am not one to outlaw subject matter per se, but I see only repetition and backwardness in the middle road of Corinth and Soutineish paintings done in 1953. It's neither new nor imaginative nor adventurous nor challenging, and it can be done by many*

(some far superior to others).... Abstract or realistic, it's too bad that at the moment so many painters paint so well and have caught on to the vocabulary like good students. The level is high and mature but oh so even and dull....

The atmosphere stinks lately and I want out. In the face of a "front" I become frustrated and cannot bother to keep score like some of the personalities on the local scene (not you)....

When are you going to the country? Maybe we can have a slaughtering or a love-fest or a cup of coffee before then. Love Helen[74]

Several weeks after their written exchange, Helen and Larry were indeed engaged in a "love fest," making a date to go to the Metropolitan Museum together for talk and "visual excitement."[75] She was not annoyed by his criticism. What would have irritated her was ostracism and the silent disapproval she felt from her gallery mates. That and her difficult show contributed to her taking what could only be described as a precipitous step for an avant-garde artist at the start of her career. Helen quit the gallery. She had been a member of one of the few serious galleries that risked showing unknown artists. She had been absorbed, embraced, and coddled by its eccentric director.[76] Though just twenty-four, she had had two solo shows, whereas many older painters had never had a *single* solo exhibition.[77] Helen had had it all, but chose to walk away from it. She needed space and time to think.

The night of April 4, Clem invited a group of people to his Bank Street apartment for drinks. Several artists from Washington, DC, were in town, among them a former student of Clem's at Black Mountain, Kenneth Noland, and his painter friend Morris Louis.[78] He asked the group if they would like to see something new. He noted in his appointment book that day: "At 6 pm Louis & Noland, along with Chas. Egan, George McNeil, Franz Kline, Leon and Ida Berkowitz & Margaret Brown and I visited Helen Frankenthaler's studio, where some of us stayed until 11." Helen wasn't there. Clem chose that moment to introduce his guests to her painting *Mountains and Sea*.[79]

Helen had hauled it back to 23rd Street after her Tibor de Nagy show ended. Though its price was just one hundred dollars, Helen said, "Nobody wanted it."[80] Three months later, however, as Clem and his friends viewed it privately, the value of the work became apparent—at least to Noland and Louis. The Washington artists experienced a jolt not unlike the one Helen felt on seeing Jackson's work at Betty's gallery in 1950.[81] "It was as if Morris had been waiting all his life for [this] information," Noland explained.[82] "We went back to Washington high."[83] Morris Louis called *Mountains and Sea* a "revelation,"[84] "a bridge between Pollock

and what was possible."⁸⁵ " 'Yes, and they walked right over that bridge' meaning they walked right over me," former National Gallery of Art curator E.A. Carmean Jr. recalled Helen saying.⁸⁶ Which is what happened, with Clem's help.

Inspired by Helen, Louis and Noland returned to Washington to work on their own for several years until they produced paintings that successfully incorporated Helen's discovery. Their style of painting soon had a name, the Color Field School, and a vociferous champion in Clem Greenberg.⁸⁷ Significantly missing from his many writings about the school was Helen's place in it. Not until the early 1960s did Clem finally mention Helen in relation to the artistic development that so intrigued him in others but that he had not registered publicly when she made it.⁸⁸ Though Helen did not dwell on that omission, which she attributed to his policy of not writing about her because they had been lovers, it was at the very least a distortion of history.⁸⁹ In truth, Clem robbed Helen of her rightful place in it. "She was the fount of it," said art historian Irving Sandler of Helen's role in the Color Field School. "There's no bones about it."⁹⁰

After her year of intense work capped off by disappointment, Helen decided to go to Europe. Alone.⁹¹ She needed a break from the New York scene she felt had grown so petty, and a break from Clem, who she had come to believe was riddled with neuroses and with whom she increasingly fought.⁹² For the first time since her schoolgirl trip in 1948 with Gaby, Helen decided to board a ship crossing the Atlantic. Her destination was Spain.⁹³

38. Figures and Speech

> I'm not a pastoral character. I'm not a — how do you say that? — "country dumpling."
>
> — Willem de Kooning[1]

GRACE WAS AT her best in a defensive position. Not defending herself; that most often resulted in shouts she regretted or, worse, embarrassed tears. Rather, she was ferocious when defending someone she loved or respected, which was why, amid the crush of people at the opening of de Kooning's first Janis Gallery show, Grace came out swinging verbally in defense of Bill. Her opponent was the staid *Art Digest* critic James Fitzsimmons, who stood overwhelmed and repulsed by the twenty-six paintings and drawings of women who screamed and writhed in infernal glee on the gallery walls around him. These were Bill's women, from the series he had begun working on in 1950, and the critic's response was not unusual. Tom Hess said the work made "a traumatic impression on the public." People came out of the gallery "reeling," according to *Time*.[2] Fitzsimmons's mistake was to express his opinion that the paintings represented "blood goddesses" and "hatred" within earshot of Grace.[3] Sizing him up as "frighteningly restrained" and probably "deeply and violently emotionally disturbed," Grace employed the full force of her one-hundred-and-fifty-pound, five-foot-ten-inch frame (in heels) to confront him.[4] Nose to nose she told him menacingly that, on the contrary, she thought the work was funny. Who wouldn't laugh at a painting of a woman riding a bicycle in high heels, a yellow dress, and a necklace of teeth? "Jim pointed to one of the women who had alizarin crimson slashed across her breast, and said, 'Look, he stabbed her. That's blood,'" Grace recalled.

She turned to Bill. "Jim Fitzsimmons says you stabbed that woman."

"Blood, gee, I thought it was rubies," Bill replied in bemused innocence.[5]

Shaken by the exhibition and perhaps by Grace herself, who appeared a living incarnation of a de Kooning Fury, Fitzsimmons left. But he would return to look at Bill's work eight more times, until he could say that while he still didn't like it, and considered Bill's women the "ugliest and most horribly revealing that I have ever seen," at least two of them were "probably great."[6] By that time, he was also deep into an affair with Grace (she couldn't resist a challenge), and Bill's paintings had made history.[7]

* * *

Sidney Janis had expected to mount a show of Bill's abstract work. Instead the artist delivered a revolution.[8] Benignly called *Paintings on the Theme of Woman,* the exhibition was to the New York art scene, to art in general, as significant and unsettling as Pollock's first drip show had been five years earlier.[9] It wasn't just the unrestrained violence with which the works were painted, but that one of the deans of American abstraction had returned to the figure. Bill had poked his head out of the tent of nonobjective art and discovered it was safe to revisit the pictorial world of things and people. In truth, many of his fellow artists were already working in that world. Pollock's black-and-white paintings had included figures of a sort; Elaine had long been involved in portraits; and younger painters—most notably Grace and Larry—had incorporated recognizable imagery in their work. But a giant in their community like Bill having made that transition was—however unintentionally—a statement.

The nonobjective abstraction that he and his fellow painters had struggled to master during and after the war had reflected the time: the age when things, even people, were seemingly without value because they could be destroyed with great efficiency on a scale never before imagined. By 1950, certainly by 1953, the times had changed. That year, the Bible topped nonfiction best-seller lists, but the real American religion was consumption, and the most important figure in that belief system was a goddess called wife.[10] Shopping was her creative expression and owning the latest "stuff"—purchased with money her husband had given her—a manifestation of her achievement. Because she was discouraged from expressing herself on a stage larger than family, she had little choice but to become a conduit for the accomplishments of others. And she was to prettily pretend that the world she inhabited was the world she wanted.[11]

Bill was not a propagandist. He was not in the business of making social or political statements in his work. But artists are barometers of their time, and their paintings and sculpture, consciously or not, reflect the world in which they live. Bill's paintings did just that. They shined a light on the creature "woman" as featured in popular culture and advertising in the early 1950s, a period one sociologist at the time described as the dawn of the "married mistress."[12] It was also, coincidentally, the dawn of the phenomenon called Marilyn Monroe.

The famous shot of twenty-two-year-old Marilyn lounging fully nude had made its first appearance in a calendar in 1952 and soon hung in men's lairs around the country, where, glorious in her supple surrender, she existed heartbreakingly out of reach. By 1953 Monroe was a movie star, breathing sensuous life into that fantasy. She didn't disappoint. Marilyn became the new woman for both sexes.[13] In a book called *How to Be a*

Woman, wives were instructed to be a little more like her: "endlessly intriguing... alluring, captivating, admiring, yielding, desirable, and desiring, a creature of infinite promise and infinite delight," in addition to being a perfect "wife, mother, and homemaker."[14] It was a scripted part that left little room for a genuine personality.

While Bill's paintings have been seen by some as anti-woman, Tom Hess argued that they were actually a mocking commentary on the role and treatment of women in American society of that era.[15]

> De Kooning had recognized and accepted the pinup as part of the anonymous American mid-century urban environment. Although it was highly stylized—like the erotic photographs that had appealed to [French painter Édouard] Manet—it also expressed with extraordinary candor a hidden social condition—the debasement of women, their inferior social status, their exploitation as sex objects and their simultaneous elevation, "on a pedestal" as the cliché put it, to a pantheon of goddess-dolls....
>
> Both the de Kooning and the Manet created public scandals, not only because they allude to nonart, despicable, illicit sources... but also because they comment on a general, shameful, social hypocrisy—Manet on the double-standard and the degradation of the prostitute by nineteenth-century society; de Kooning on the dehumanization of American women, one hundred years later. Manet's *Olympia* offers to the spectator the skin of an issue, so to speak; de Kooning's *Woman* reveals the anxieties inside.[16]

Bill's paintings captured the essence of this modern woman—this lesser Marilyn—caged within the frame of his canvas as she was in her life. Grinning hideously in her tattered finery, lying agape in a bed of viscid paint, her very being was reduced to pearly pointed teeth, mad wide eyes, and pendulous breasts. She was what had emerged out of the rubble of war. She was America's *Marianne*—its goddess of liberty.

Many artists recalled seeing Bill's women in progress; it would have been difficult for anyone who knew him *not* to have seen them. Bill worked on *Woman I* for two years, scraping it down to the surface "at least fifty times," said Tom, until it was wrenched away from him for the Janis show.[17] (Harold said Bill had wanted to spend the rest of his life painting it.)[18] But as happened with Pollock, and with many artists, the power of their creation was not truly recognized until it was allowed to envelop the viewer from all sides. All Bill's friends had met his women, but until they saw them at Janis they did not truly know them. Their reactions ranged from confusion and disappointment to exhilaration. Elaine said Bill was "quite pleased to discover he had shocked the avant-garde."[19] And, as she wandered

around the gallery overhearing snatches of searching conversations, she was delighted, too.

"The show is conclusive proof that de Kooning is a homosexual," said one observer.
"Why?" his companion inquired.
"The bullet holes of course."
"What bullet holes?"
"The bullet holes in the girl's chest."

"Hm. I feel sorry for Elaine," artist Herbert Ferber said to Bill.
"Oh, now I get it. Bill is painting Elaine," exclaimed Bob Motherwell, recognizing a resemblance between one of Bill's paintings and his own memory of Elaine in a bathing suit.

Grace to Elaine: "That one's you. That one's me. That one's Jane Freilicher."
Mercedes to Elaine: "That one's you. That one's me. That one's Jane Kootz."
Elaine to Edwin Denby: "That one's you. All the rest are me."[20]

There was one aspect of Bill's work upon which nearly everyone agreed, however: The show was the result of that rare gift, genius.[21] Among the artists, dealers, and collectors who packed the gallery were luminaries from the Museum of Modern Art circle: Alfred Barr, Dorothy Miller, and Mrs. John D. Rockefeller III, among them.[22] Dorothy had wanted Bill to be in her *15 Americans* show the previous year, but he had declined. Now she had a chance to see what a de Kooning gallery might have looked like. By the end of the show, Barr and Miller had selected *Woman I* for the museum, and Mrs. Rockefeller—Blanchette—had purchased *Woman II*.[23] When introduced to her, Bill, the "country dumpling" star of the evening, said guilelessly, "You look like a million bucks."[24]
Edith and Rudy Burckhardt, meanwhile, had been busily taking pictures at the opening, and Bill invited them to join him and a group of friends for dinner afterward at a "steak joint."[25] The dinner, paid for by Janis, included Bill and Elaine, Edith and Rudy, Philip and Musa Guston, Wilfrid and Betsy Zogbaum, Franz Kline and Nancy Ward, and Bob Motherwell. After dinner, Bob invited everyone back to his place.[26] He had just purchased a townhouse off Madison on Ninety-Fourth Street, where he lived with his wife, Betty; her daughter by a previous marriage, Cathy; and their own infant daughter, Jeannie.[27] While serving coffee, Bob told them the story of Rodin's assistant and lover Camille

Claudel, who he said had probably made some of the statues signed by Rodin. The group assembled in his living room had never heard of her, or of her tormented life and the fact that, instead of being heralded as an artist, she was considered insane by her family and institutionalized. Bob called her sculptures brilliant because they showed not only the outer person, but also her subject's inner turmoil. Claudel's sculptures sounded a lot like Bill's women. After pondering how little the world had changed, aesthetically or socially, over the centuries, the group snapped back to life. "We got up and danced, the way painters did, any old way, bumping into the Motherwells' chic plump couches, bumping into each other," Edith said. Afterward they all felt much lighter.[28]

Bill sold a whopping nine thousand dollars' worth of work through Janis in 1953. Elaine, too, had what for her was a banner year: She had earned more than four hundred dollars from her writing and from the sale of drawings.[29] But after the gallery's commission, the cost of supplies, repaying debts, and daily incidentals, they were quickly back where they had started: broke.[30] At one point, Bill had an eviction notice attached to his door, while inside artists danced and drank. He had thrown a party. Hats were regularly passed at such gatherings, artists contributing what they could to help pay the rent.[31] And if those parties didn't produce enough cash, other friends contributed. "I helped them out," said Pavia. "I wasn't rich, but I just had more than they did. It wasn't much money—five bucks, ten bucks.... Every time someone couldn't pay the rent, I would get a call. I used to go to Tom Hess, or I'd go to about three other people, and I'd get the money for the rent."[32]

The notion of paid employment didn't really occur to most of the artists, unless it was necessary to save up for a month or two of uninterrupted painting. When a fellow artist seeing him on the street asked Joan's boyfriend, Mike Goldberg, whether he was working, he said, "No, I have a job." (Both understood that "work" meant painting.)[33] Jane Freilicher quit her job as soon as John Myers offered her a solo show. She decided she didn't have time to earn a living *and* paint, and that painting well was more important than eating well.[34] Grace took temporary jobs when and where she could, borrowed money from her sister, and anticipated the windfall of a sixty-seven-dollar tax refund to help pay for the coal she carried in buckets to her Essex Street loft to stave off the chill.[35]

The scramble after funds had become part of the rhythm of their lives. "One time, Franz Kline was in my studio," Grace recalled. "He didn't have any money to pay his rent, but he had a collector, who was going to meet him by a bank.... Franz didn't have the money for the subway. So, I cashed in some soda bottles for the subway, to meet the collector to get the money to pay his rent."[36] They had all been at it for so long that the struggle for

survival was no longer a struggle. It, too, had become a form of art. It was New York art, practiced by those who were not brought low by their squalor because they existed in a higher state of expectation. Writer Joan Didion said the belief in the possibility "that something extraordinary would happen any minute, any day, any month" was peculiar to the city in which whole populations existed on dreams.[37] E. B. White described them:

> There are roughly three New Yorks. There is, first, the New York of the man or woman who was born here, who takes the city for granted and accepts its size and its turbulence as natural and inevitable. Second, there is the New York of the commuter—the city that is devoured by locusts each day and spat out each night. Third, there is the New York of the person who was born somewhere else and came to New York in quest of something. Of these three trembling cities the greatest is the last.[38]

That "trembling city" is where Grace and her artist friends lived. In her journal entry on March 6, 1953, she wrote,

> On the way to the laundry I passed the stale bread store and the little stands that sell penny tomatoes, that foul market that has meat for 15 cents a pound, and I remembered how I lived three years ago with Al, that steady endless poverty, when I felt bloated with bad food—could I ever go through it again?[39]

The fact that Grace no longer lived quite as roughly as she had was due in part to her having mastered survival techniques but also to Frank O'Hara's ability to help her and all his artist friends rise above their material misery and focus on their work. "You couldn't wait to have Frank see the painting," said Grace. "It was a party, it was incredible."[40] Friends watched his face for signs of excitement, which often arrived in an "involuntary" snort of cigarette smoke streaming from his nostrils. "When Frank snorted, ears perked up," said novelist Lawrence Osgood.[41] His joy in seeing what his painter friends had done was enough to pull them out of a pit of self-doubt or the mire of their daily concerns.

"What really matters is to have someone like Frank standing behind you," said composer Morty Feldman. "Without that your life is not worth a damn."[42] Larry agreed, albeit more colorfully: Frank "talked a lot of artists into thinking that they were terrific. That's why he was so popular and so sought after. He had you on his mind. And if twenty percent of it was horseshit, so what? With most people ninety percent of it is horseshit."[43] Frank fed Grace's spirit with his company and his poems, and he gave her what she needed to find herself in her paintings. She had searched for her own style through the old and the contemporary masters, and she finally

found it, not in their images but in Frank's words. A woman who knew the poet Rainer Marie Rilke once said,

> If someone were to ask me what kind of man Rilke is, I think I could only answer: he is not a man, he is an apparition, a being from another world who has come into our midst.... For although he is in the world, he personally stands outside this world, which he recognizes and understands like no one else; he belongs to it on another plane.[44]

That could have been Grace describing Frank. He had arrived in her life at a creatively crucial moment, and under his influence she flourished. The years 1952 and 1953 marked the real birth of the painter Grace Hartigan. She had discovered her style, and the world would discover her.

The influence of the poets infected the entire circle around the Tibor de Nagy Gallery. Having already studied the paintings of their elders, those artists now plunged into the works of the classical and modern writers who had influenced their poet friends. Grace read Hawthorne, Melville, Rilke, Joyce, biographies of Byron and Chopin, poetry by William Carlos Williams, Auden, Wallace Stevens, and as much Virginia Woolf as she could lay her hands on.[45] Larry became a self-confessed "nineteenth-century freak.... In 1953 alone, I think I read twenty-one novels of Balzac. I read Stendhal, all the Russians."[46] The results for both Grace and Larry were the same: Stories entered their paintings. Grace began posing friends as costumed characters from which to paint, though there would be barely a trace of them left on her canvas when she had finished. Walt became a matador for one work. Frank appeared in the cinematic-sounding painting *Frank O'Hara and the Demons*. "He became your art," Grace said. "I don't know anybody who was doing anything remotely realistic who didn't use Frank. Of course, he was marvelous looking...that broken nose."[47] Frank became Grace's model of choice, and she, in turn, his poetic muse.

There was a lightness to their volleys, from her paintings to his poems. The early culmination of that relationship occurred in November 1952. Frank and Grace had been looking for a way to collaborate. One day, over breakfast, Grace said, "he showed me some surrealistic poems called *Oranges* in which the word oranges does not appear once—that was his kind of wit."[48] Frank had written nineteen of them in 1949, not with surrealism but with Rimbaud's *Illuminations* in mind.[49] He gave most to Grace, saying, "How about a dozen oranges?"[50] She accepted. "I took these very bad pieces of paper, which is all I had, and I did oils."[51]

Turning Frank's poems into paintings occupied her for months.[52] It was the first time Grace's work was not merely influenced by words but directed

by them. As she painted, Frank's writing did not appear *on* each painting so much as in it. In *Oranges 6 (The Light Only Reaches Halfway)*, for example, Grace covered half the paper with shadowy blues and grays and half with "light"—a mix of whites, yellows, and golds—on which she painted in reckless lettering the poem Frank had given her. Emphasizing those words that encapsulated the meaning of Frank's piece—"The light only reaches half way across the floor where we lie.... I have ripped your... We know each other better than anyone else in the world. And we have discovered something to do"—she applied her paint thickly, creating blocks of color, patches of pigment that might resemble a small face, a doll's or a mannequin's.[53] The words, too, burst forth and in the next line faded into the canvas to become just one more element of the painted surface, no more or less important than the color into which they were submerged.

Larry had provided black-and-white images for Frank's book of poetry *A City Winter and Other Poems,* but Grace's paintings were the first among the Tibor de Nagy gallery group to include poetry. The collaboration significantly deepened the relationship between Frank and Grace. (He would keep one of Grace's *Oranges* over his bed until his death.)[54] They emerged from it as lovers in all ways but the physical. For Grace, the project also had profound artistic implications. "One of the most difficult things of all is not to have the painting be a depiction of the event but the event itself," Grace said. "That is the difference between great art and mediocre art. Most art looks like it is talking about something that happened some other place."[55] Painting Frank's poems forced Grace to close the gap between *what* she painted and painting itself. She succeeded. One didn't go to Grace's paintings to read a poem but to see the startling convergence of painting and words. Soon afterward, Grace stopped at a five-and-dime and bought a bouquet of artificial flowers.[56] She had had the most inspiring material from which to work, poetry, and now she would turn to the least: kitsch. Grace came out of her *Oranges* series convinced she could paint anything and make it art. In her journal on December 6, 1952, she wrote,

> I believe I am the first woman of major status in painting, and I feel that given a long life and sufficient courage and energy, I may become a great artist.... I want to compose the world in my canvases. God give me strength and time.[57]

On March 31, 1953, two weeks after Bill's show and still using the name "George Hartigan," Grace's new work appeared at Tibor de Nagy. It was her third solo show. Each of the ten paintings on the gallery walls were in her new style, which combined thickly applied, saturated color abstraction with figurative elements: people, things, poetry, references to old master

works, references to her life at that moment. For the first time, the force of Grace's bold personality appeared on the canvas. She had not bothered to make her paintings beautiful, nor even to make them seem finished. She had loaded her brush and slapped it on the canvas in a riot of color obscured by darkness. Grace's early abstractions had exhibited a youthful vigor and searching. The work she showed at John's gallery that spring retained that vigor—in fact surpassed it—but replaced wonder with conviction. The paintings even *looked* like Grace: large, beautiful, blustery, strong, impossible to ignore upon encountering, impossible to forget once gone. But the artist herself was nearly paralyzed with fear. "The last few weeks have been indescribable, and I brought myself so close to madness that it almost terrified me," she wrote before her opening. "Having a show is deeply unsettling to me."[58]

Grace's closest friends recognized the symptoms and literally covered her with flowers to boost her spirits for her opening night. "Jim Fitzsimmons sent a huge box of gladiola anonymously—later confessed—Jane brought blood red tulips," Grace wrote in her journal. "I wore Larry's long stem rose and Frank's anemone, drank half a pint of scotch, and signed books of Oranges."[59] John Myers had had the idea that Grace and Frank's collaboration should be copied and bound in time for the show. "Now darling," he said to Grace, "why don't you do some nice covers for them— twenty, two dozen perhaps—and we'll just sell them for a dollar." On the eve of her opening, Grace surrounded herself with folders from the five-and-dime, "and I sat down on my studio floor and did twenty-four individual paintings on the covers and we sold about four of them. I remember we sold two to the de Koonings."[60]

The crowd at her opening was larger than ever. It was as if the excitement from Bill's show had not yet abated. "I felt really glamorous," Grace recalled.[61] A United Press reporter named Roland Pease, who had stumbled upon John's gallery two years earlier and became an instant convert to the art on display, had been the only collector up to that point to have purchased one of Grace's paintings uncoerced.[62] He was on hand to help the artist he admired celebrate her third outing at Tibor de Nagy. He called her "Grace the idealist" and said she had "the breeziness and good looks of a young Ingrid Bergman with the brain of an articulate feminist."[63] In honor of her new show, which Grace's lover-of-the-month, Jim Fitzsimmons, characterized in *Arts & Architecture* as "Dionysian,"[64] Pease threw a "marvelous cocktail party" at which Grace confessed she "got completely plastered and came near making a fool of myself over some emotional opportunist.... I must remember what a serious girl I am and not think I can flirt with impunity." Grace's show ended with accolades, but it left her with a gnawing sense of dissatisfaction. She had to get back to work.[65]

On the last day of her exhibition, April 18, 1953, the phone rang. It was Frank, calling from his post at the front desk of the Modern. A taxi had just pulled up outside the museum and two people had emerged carrying a painting. "Alfred Barr and Dorothy Miller have just come through the revolving doors with *The Persian Jacket* under their arms," he told Grace excitedly.[66] Frank watched, breathlessly, as they struggled with Grace's four-and-a-half-by-four-foot painting. That struggle meant everything, it meant Grace's future. She had sold only one painting as a professional artist and it looked as though the second would be to the Museum of Modern Art—if Barr and Miller could get it through the door! They couldn't, but they soon found a side entrance large enough to accommodate it. Grace's painting was in.[67] Word spread like wildfire among the artists—no doubt thanks largely to Frank and his telephone.[68] Grace was the first Second Generation artist—male or female—to have a piece in the Modern. In 1948, as a novice, she had stood outside that hallowed place and dreamed of her work being in it one day. Astonishingly, a mere five years later, with Grace having just turned thirty-one, it was. Her triumph was not hers alone; it was celebrated by all her friends as a harbinger of things to come. Wrote Al Leslie from California as soon as he heard the news, "I'm pleased as hek that the Museum of Modern Art bought your picture. I think 'now those fucking museum directors won't ignore us' Wow—Sow—Socko its swello—really—I mean it from way down—gal."[69]

Within two days, the vicar of art, Alfred Barr, called to say he had been studying her painting and felt "disturbed by the upper left area." He wondered if she would come to the museum and do something about it.[70] He asked her to bring along her box of paints. She did, and worked in an office on the troublesome corner until she—and Barr—felt it was improved.[71] The next day, after dining the previous evening with Frank in her studio, where she showed him her latest painting, *River Bathers,* and he read her his latest (and sensational in every sense) opus, "Second Avenue," Grace received word that the final hurdle to having her painting in the Modern had been removed. As was the practice, a collector was found to purchase *The Persian Jacket* for the museum.[72] The first Hartigan would officially enter the Museum of Modern Art collection.

By 1953, John and Tibor's gallery was still not able to support itself. Tibor considered a good year to be one in which they hadn't incurred an outright loss.[73] The stipend from Dwight Ripley was not enough to keep the two men fed and the gallery running, and so they tried various schemes to bring in extra cash. They had opened a record shop on Lexington Avenue that quickly failed. Next, Tibor went into the import-export business but lost his shirt. Finally, he returned to his original métier, banking. He

worked in finance during the day, and sat at the gallery at night and on weekends.[74] The rest of the time, John held sway with the help of painters he corralled into watching the shop while he visited galleries, lunched with collectors, drank with critics, and generally buzzed around town promoting his artists, whom he loved far more than he loved himself.[75] Writing to Larry, he said,

> For me every Triumph consists of publicity—and I'll admit—I've become publicity hungry. People buy names; ergo—we must create names. Names create myths and the art public adores names and myths....
>
> I feel strangely exalted at the thought that maybe in this little gallery near the 3rd Avenue El—American art will be transformed, and find a place in world art.... Success is my siren! I should not listen to her song! She's just a painted old queen who leads too much trade down rosy alleys and gives only a momentary blow job that proves quite evanescent. But who hasn't been tempted?[76]

John Myers was *everywhere,* which made artists who weren't part of his stable grumble that they were at a disadvantage because their dealers (when they had galleries to complain about) weren't willing to sacrifice themselves to the same extent for their art. (At one point, John announced that he had "strained his testicles posing for a statue" by Larry.)[77] Poet James Merrill said,

> John never lost his old liberal starry-eyed sense that things could be done. Spanish War refugees could be helped, so could a painter down on his luck.... Books could be issued under his own imprint.... Critics could be shamed into taking note.... He was a lifelong, passionate impresario [with] crusader standards.... A warm heart and a sharp tongue.[78]

Though he was a large man, when John sat at his gallery desk, which was big enough to be used as a dining table and had on it only a telephone, he looked small in an *Alice in Wonderland* sort of way. That was where he thought. In 1953, John had a new idea to earn the gallery publicity while also advancing the cause of art. He had assembled artists and poets to make paintings and poems, but he hungered for more. Serendipitously, his love life provided the answer.

John met a director named Herbert Machiz, who had operated a Paris theater that used artists, musicians, and poets to mount shows.[79] John found that sort of endeavor irresistible. Having all the components he needed—poets to write the plays, artists to design sets, composers to write scores—John and Herbert created the Artists' Theatre. It would, Machiz

said, operate "with no eye to the box office and no desire to flatter a vast public."[80] As might be imagined, the competition for such an enterprise, whose expressed aspiration seemed to be commercial failure, was nearly nonexistent.

"Off Broadway" did not exist at that time. The only theaters even approaching Machiz's idea were Judith Malina's and Julien Beck's Living Theatre in New York and the Poets' Theatre in Cambridge, Massachusetts.[81] The reason was simple: Though French audiences existed for the Theatre of the Absurd, Americans were as wary of experimental theater as they were of avant-garde art. In the years immediately after the war, Broadway had at times addressed man's search for meaning by presenting cutting-edge plays. Sartre's *The Flies* and *No Exit* were performed on the Great White Way. But, as anti-communist congressional investigators lambasted Broadway as the "Great Red Way," and as audiences shook off their postwar alienation, they looked for something less provocative than philosophizing during an evening out.[82] Many sought entertainment in the form of musicals. Others, according to Machiz, wanted to see themselves reflected in characters confronting life's challenges.[83] And though some of those productions were by writers of genius — Eugene O'Neill, Arthur Miller, Tennessee Williams, and Lillian Hellman, for example — John Myers believed their efforts wasted.[84] Theater had become just another "diversion which supplies people with after-dinner conversation before the bridge table is brought out."[85] By contrast, Myers and Machiz had in mind productions that bypassed "an exhausted naturalism in favor of a fresh approach to the individual in the coils of modern society...a world where everything has become incredibly difficult to understand."[86]

The Artists' Theatre's first production was *Auto-da-fe*, by John's friend Tennessee Williams, followed by the melancholy tale of a postwar love triangle, *Try! Try!*, by Frank O'Hara (set by Larry Rivers); *Presenting Jane*, a play about Jane Freilicher, by Jimmy Schuyler (set by Elaine); and an allegory on sex, *Red Riding Hood*, by Kenneth Koch (set by Grace).[87] "Up until rehearsal I didn't think there were going to be any plays the way everyone screamed at each other," Grace said.[88] Larry's set, she felt, was the most inventive of the early productions. For *Try! Try!* he "bought a lot of pipe and twisted it all together and had an empty stage with all this pipe sculpture in the center of it."[89]

The audience, unsurprisingly, loved the plays. It was the same audience that turned out for the artists' openings; for lectures, readings, and panels at the Club; for Living Theatre productions; and for concerts by John Cage and Morty Feldman. "I remember a night when Lionel Abel had a play produced" at John's theater, Mercedes recalled. "We went to this play by Lionel and then we all went to the Cedar Bar afterwards, and half an hour

later he came into the bar and everyone stood up and clapped. There was that warmth and that support."⁹⁰ The audience traveled as a preassembled, appreciative package. At one Cage-Cunningham performance, the group was settled in its seats when Harold Rosenberg looked around to survey the crowd. "Here it is almost curtain time and the Lassaws aren't here yet!" he boomed, as those gathered around him exploded in laughter. Then he spotted a newcomer in the third row. "Throw him out!" he demanded.⁹¹ Avant-garde theater, music, and art was *their* world.

The Artists' Theatre would produce sixteen plays between 1953 and 1956, when it died its inevitable death.⁹² But in the meantime it not only helped expand the scene, it breathed fresh life into it by giving artists yet another way of looking at their art: multidimensionally on a stage even larger than their biggest paintings. Under John Myers's guidance, boundaries between the arts ceased to exist. It was all one great work—paintings, sculpture, poetry, music, plays—created by a large and very eccentric family.⁹³ Anything was possible. Everything was done. And all of it was, according to *le cher maître* Johnny, extraordinary.

39. Refuge

> Our tragedy today is a general and universal physical fear so long sustained by now that we can even bear it.
> — *William Faulkner*[1]

THE PREVIOUS FALL, the artists at the Club had broken Philip Pavia's one rule—no politics—by embracing Adlai Stevenson and working on his presidential campaign. Perhaps not surprisingly, their vision of what the United States could and should be diverged significantly from that of most voting Americans. The "egg-headed liberal" Stevenson lost, and the artists came away from the experience disillusioned, confused, and possibly in danger. Emboldened by the election and protected by Vice President Richard Nixon, Senator Joe McCarthy's inquisition accelerated.[2] Though conducted under a banner of anti-communism and a fight for individual liberty, his investigations looked very much like broad assaults on liberal ideals. By 1953, the number of congressional probes into suspected subversives and traitors conducted during four years of Republican-controlled Congress nearly equaled those held during the previous one hundred thirty years of U.S. history. The net was so wide that a person could be placed under scrutiny or even jailed for simply knowing someone else on the list.[3]

Some of the targets were what today would be called "soft." Immigrants, that vulnerable constituency that is most easily attacked during times of national crisis, were among the first. Eisenhower's attorney general ordered twelve thousand immigrants deported as "subversives" and put ten thousand more under investigation.[4] The vast majority of Americans whose lives revolved around work, faith, and family, however, had largely been spared by the purge. But in the early 1950s, even that tidy world began to feel the encroachment of anti-communist crusaders. A third of all corporations in the country had begun administering personality tests to determine whether employees were sufficiently loyal to company and country, and conformed to the American way of life.[5] Among those who began to arouse suspicion were union members. The wealth gap during the early 1950s was relatively small, due in part to powerful labor organizations. But those groups were increasingly viewed by corporate leaders as impediments to growth. Big business began a campaign to paint unions Red. The National Association of Manufacturers spent millions each year trying to convince the public that "right to work" laws

were part of a Soviet campaign to disrupt American business. Even the Chamber of Commerce warned that the Red menace had infiltrated the workplace through labor.[6] Unions, those mainstays of the American workforce, became tainted by insinuation.

The twin threats of communism and of being suspected of communism existed like white noise in the background of American life during that period—until June 1953, when that white noise blasted like a thousand bugles. New Yorkers learned in a dinnertime radio and television bulletin that Ethel and Julius Rosenberg had been electrocuted on June 19 at Sing Sing for conspiracy to commit espionage. An otherwise unremarkable husband and wife with two small children became the first U.S. civilians to be sentenced to death and executed for such a crime. No matter whether one believed in the Rosenbergs' guilt, the case sent a chill through the land. Writer Sylvia Plath said that in New York, on every corner and at every subway entrance, headlines about the case confronted passersby.[7] The Rosenberg executions raised the question, was anyone safe? In the land of FBI director J. Edgar Hoover, whose lodestar was suspicion, the answer was no. Only anonymity and conformity ensured security, but these were impossible for artists. Their very being set them dangerously apart. In that climate, amid those dark clouds, their annual summer migration out of the city had greater purpose. Studios emptied as the denizens of the Cedar and the Club left to regroup together on Long Island, where they could be themselves in all their glorious otherness.

Elaine and Bill were back at Leo's place. Bill had bought spackle, wallboard, and screening to build a proper studio. And in the meantime, he rented Motherwell's studio across the street.[8] Elaine used Castelli's house as a base at which to paint and from which to travel—to the beach ("The whole *Art Digest* crowd...is going...and they're a fairly merry clan," she wrote a friend) and farther afield.[9] On one outing, a carload of artists drove up to Boston to see Merce dance.[10]

But primarily, Elaine's focus was portraits, and that summer she returned to her source. Nine years earlier in Chelsea she had fallen in love with the idea of portraiture after walking in on Fairfield Porter painting his wife, Anne. Since those loft days, he and Anne had moved with their five children to Southampton, where they had a two-and-a-half-story, shingled colonial with seven bedrooms, five bathrooms, five fireplaces, and a porch that wrapped around the front of the house. They had done little to repair its signs of aging; they had simply filled it with life and art. The result was so lovely, so otherworldly that, over the years, it would serve as a sanctuary for poets and artists in the midst of mental or physical crisis.[11] Elaine sought out the Porter house that summer as a break from the

"horrendous" social scene (by which she meant drinking).[12] She went there for days at a time to paint alongside Fairfield, that quiet man whose works, unlike her own, were so very still. She also painted portraits of him. To his complaints that she made him look like a Harvard man, Elaine replied, "Well, you are!"[13]

Larry had also moved his family (consisting at this point of his mother-in-law, Berdie, and his two sons, Steven and Joe) to Southampton, and Grace and Frank left the city in mid-June to see him. Grace had given Jim Fitzsimmons the "bum's rush," according to Frank, and had spent the spring after her show "not terribly upset and painting like a fiend."[14] After learning she had sold another painting, she pocketed the cash and left the heat of the city with Frank for "luminous" Larry's.[15] Theirs was a complicated relationship, and yet none of the three treated it as such. Grace and Frank were in love, and Frank and Larry were lovers (Frank called himself "Larry Rivers' sons' stepmother"),[16] and Larry was so smitten with Grace that he told Frank, "I think I will marry her." He thought she was one of the three best painters in New York (the others being Bill and Joan).[17] They wandered in and out of the deepest recesses of one another's lives, even when things became messy, which they frequently did. By midsummer, Frank and Larry had broken up and Frank began seeing the classical pianist Bobby Fizdale.[18] But that change of romantic allegiance didn't overly disrupt the trio. Nor did Grace's live-in boyfriend, Walt, who hovered in the background of her life like an extra on a film set.

In July, with Frank otherwise occupied, Grace returned to Long Island with Walt. She had begun to paint landscapes during her visit in June, inspired by Jane's belief that she had been reborn as an artist the previous summer by painting outdoors. Hoping for the same, Grace set up her easel on the Castellis' property to try to absorb what she saw around her.[19] The results, however, were disastrous. She didn't know what to do with what she saw. It was too vast, too *beautiful*.[20] For Grace, landscape meant cityscape. In fact, she had been so anxious to return to Manhattan that as she and Frank approached it by car after leaving Long Island in June, Grace said, "Where's that damned skyline?" Frank recalled, "Suddenly there it was looking wonderfully squalid and dirty and dull, putting it to the sky as usual."[21] Grace, however, could not abide the concept surrender and she returned to Long Island with Walt to give landscapes another go. They stayed at Rose Cottage, a two-bedroom home Joan rented at Three Mile Harbor along with Mike Goldberg, Paul Brach, Mimi Schapiro, and Joan's dog, George.[22] Entering it was like walking into a cyclone.

After Joan and Barney's divorce, Joan had had her wish. She could be with Mike. Almost immediately, however, he began to annoy her. Barney's virtue,

which had ultimately contributed to their divorce, was his willingness to give Joan the social space she needed to be who she was. (Who she was, unfortunately, was someone other than the wife he had envisioned.) Mike was much more controlling. A charter member of the snarling, brawling fraternity of machismo, he considered women to be broads who required domination. That was simply not possible with Joan. She had an innate and violent hostility, born out of her relations with her father, toward anyone who tried to control her.[23] (Grace said that in any case Joan was too smart and too aware of her worth to be subsumed by the likes of Mike.)[24] They fought, often. A composer living near Mike in the city overheard their violent quarrels, after which Joan would emerge black and blue.[25] Those fights, with fists and kicks and a torrent of obscenities, continued on Long Island. Though Joan no longer loved Mike with the passion she had just two years earlier, she could paint with him and so, in their own dysfunctional way, they remained a couple.

In early April, a few days after Grace's show, Joan had her first solo exhibition at the Stable Gallery. Since her New Gallery show the previous year, Joan had eliminated from her work the flat areas of broad color reminiscent of Analytical Cubism and replaced them with pure activity. One could almost feel the arc of her brush as she repeatedly swept it down and across the canvas, leaving a thin trail of paint. One could also sense the hesitation she felt before making small but important notations of black that worked to balance the painting. Joan once said she "loved the idea that painting never ends, it is the only thing in the world which is both continuous and still."[26] That was exactly the feeling she captured in her new work. Not unlike Pollock's paintings, Joan's exploded, but her explosion was freer, brighter, less night sky than the expectant crest of a breaking wave. In reviewing Joan's show, Jim Fitzsimmons aptly described her ability to harness chaos. "Paintings like these suggest a new concept of the artist's studio: we see it as an atomic age Vulcan's forge, with bundles of energy glancing off the walls and ricocheting into space."[27] For a young painter, Joan received considerable positive attention from the critics: *Art-News, Art Digest,* the *New York Herald Tribune,* and *Arts & Architecture* all reviewed her show.[28] Everyone thought it was a success except Joan. It wasn't that she didn't like the work. She did. But seeing her paintings on the gallery walls, she felt she no longer knew them, that they belonged to someone else. When the show ended, Joan felt not pride but relief.

She hadn't been sleeping well for months, and in the weeks before her show and before she left Manhattan for Rose Cottage, she fell into a deep funk. Barney, who was still very much in her life and had thrown a party in her honor after her opening, had begun dating other women. They were so different from Joan that his intention seemed to be to erase her. One of his early girlfriends was a Ford model named Patricia Faure. Speak-

ing of Barney and Joan, Faure said, "He was actively looking for some replacement and she was actively looking to disparage any choice he'd make." Faure and Barney had considered marriage, but she took offense when Barney didn't invite her to a dinner he had prepared for Margaret Mead. It was a dinner to which he *would have* invited Joan. "They were both rich kids from Chicago—she could afford to paint and he could afford to buy a publishing house," Faure said.[29] She left him, but a publisher worth millions didn't lack for companionship for long.

His next girlfriend was an attractive immigrant named Loly Eckert, whose only child had died of malnutrition in Germany during the war.[30] The circumstances of her life had made her as tough as Joan, but she was more conventionally womanly. She was, in other words, prepared to be a wife. Though Joan did her best to compete with Loly, she couldn't dent Barney's affection for her or intimidate Loly into leaving.[31] Joan was losing Barney. She didn't want him, but neither did she want to be replaced by a woman who occupied that girly space so foreign to her from the time she was a child. Writer John Gruen recalled a Thanksgiving dinner at Barney's where Joan and Loly were both present.

> There was much cheerfully aggressive banter and gossip during dinner, and later we put on records and danced.... I danced with Joan....[32]
>
> She was in my arms. And we glided. And she was pleasantly high, I guess.... During our dancing she had her eyes sort of half closed, and we were dancing to a slow beat... and her head was very back. And at this moment she looked wonderful... and I said, "Joan, you look beautiful!"... And she suddenly opened her eyes wide, stopped, stopped dancing, left my arms, and walked into the next room.... I followed her into the bedroom. And she sat down where all the coats were.... And she sat there at the edge of the bed looking down...
>
> "*What* is your problem?"...
>
> "First of all, I'm not beautiful," she said.
>
> "Well, you seemed beautiful at that moment."...
>
> "Well, that was your imagination. I am not and don't ever say that to me ever again."...
>
> "OK."...
>
> "And fuck you too.'"[33]

Gruen's comments, no matter how sincere, felt like pity to Joan.

Barney was preoccupied not only with his busy love life, he had discovered a new playwright, an Irishman in Paris named Samuel Beckett. Barney had gotten hold of a copy of his play *Waiting for Godot,* which had opened to jeers in Paris in January 1953 and played in London to nearly

empty theaters. "My immediate response was," Barney said, "here was a kind of human insight that I had never experienced before." He began planning a trip to Paris to meet Beckett.[34] When he did later that year, he was accompanied by his new bride, Loly. Joan, who valued words nearly as much as paint, could only watch the excitement over his monumental literary discovery from the sidelines. Her life was simultaneously empty and chaotic, yet when she was painting in her studio on St. Mark's Place or working under the eaves at Rose Cottage she found sanctuary. She could breathe again. She was completely present, until she wasn't, and that was the state she was after: oblivion.

Grace's arrival at Rose Cottage at that moment, fresh from her sale to the Modern and riding a wave of recognition, proved particularly annoying to Joan, who neither spoke of herself as part of the great continuum of painters as did Grace, nor sought a place among the art stars. "I was quite satisfied looking up to my elders," Joan said. "A lot of painters are obsessed with inventing something.... All I wanted to do was paint."[35] Joan needled Grace, saying she admired Grace's courage to paint ugly pictures. ("I make them as beautiful as I can," Grace wrote defensively in her journal.)[36] She also implied that the sale of *The Persian Jacket* to the Modern meant nothing "because they have purchased so much mediocre work."[37] Paul Brach must have felt it was open season on Grace because at one point he sent her running from the cottage in sobs when he questioned her tipsy contention that Larry was the Picasso of their day and she the Matisse.[38]

Grace had made herself an easy target for such arrows, especially from an expert antagonist like Joan. By the end of the summer, long after Grace had left Rose Cottage, she found herself still so rattled that she questioned everything about herself. She was in the midst of her most successful year—artistically and commercially—and yet she barely knew who she was anymore, and she feared that uncertainty had found its way into her paintings. "The pictures ask 'What are we doing here?' and 'what do we mean to each other?'" Grace wrote in her journal in August.[39] About herself personally, she was equally plagued by doubt and confusion. "I do have a picture of myself as pale & willowy & poetic instead of this big strapping creature that I am," Grace confided to her journal. "I've been struggling to lose weight but I can't seem to get below 150, even though I haven't touched bread potatoes or anything sweet for two weeks."[40]

Others, however, saw in her something quite different. Lila Katzen was an art student just entering that male-dominated scene and trying to find someone to give her hope that she could find a place in it. One night at the Cedar, she saw Grace. "She was very beautiful, blonde, quite gorgeous, and very vivacious," Katzen recalled.[41] She was also serious and taken seriously. From the point of view of a younger woman, Grace's was a life to emulate.

* * *

The scene around Rose Cottage that summer was one of hipster bacchanalia. Bonfires at night, swimming nude (Joan refused to participate), painting, jazz, drink, and drugs. Hash and pot, and Benzedrine, sucked off a cotton ball or dropped into a Coca-Cola or tea, had begun to infiltrate the scene, especially around Jungle Pete's, where Larry's band played.[42] Cool jazz, which had arrived via Miles Davis to slow the tempo, was Second Generation music, a Second Generation scene.[43] Larry *was* that scene and succumbed to it completely. "Heroin, powder to make him king, dust to rain dreams...to close the eyes without closing them," he wrote in a piece called "The Heroin Addicts."[44] Frank vomited whenever he saw Larry "take the needle."[45] Larry tried to stop but couldn't lay off entirely.

Back in New York in September the entire crowd turned up for Nell's opening at Tibor de Nagy. It was a huge gathering to support Nell but also to launch the raucous new season.[46] Larry had decided to shoot up for the occasion, but he overdosed.[47] There was no question of calling a doctor. It fell to Grace to nurse him through his ordeal, feeding him chicken broth and ice cream all night and into the next day until he showed signs of what, for Larry, was life.[48] He had been in similar need of nursing the previous year after he slit his wrists in a bizarre act he cryptically called "literature," which none of his friends took seriously.[49] The ostensible reason for the gesture was that Jane had had the temerity to fall in love with someone outside their circle—Joe Hazan—which reawakened Larry's early passion for her. "Larry's cutting his wrists...came out of a fantasy that he was mad about me," Jane said. "It was an exhibition of his exhibitionism, only it was based on voyeurism....It was a gesture, a confrontation, it was in the realm of taking a chance on an enormous shot of dope."[50] Elaine called it a "thespian act."[51]

In fact, Elaine said that much of the Second Generation—Larry, Grace, Joan, Mike Goldberg, even Frank—was on a stage of their own devising for all the world to see. Unlike the First Generation, the Second bared everything. "You know, the interpersonal relationships, and this coarse sexuality....I mean the whole AC/DC. You know, flirting. Homosexuals being attracted by women....Private things were made public," Elaine said frankly but not critically. "It was the temper of the times."[52] Jane called that period *Disorder and Early Sorrow* after Thomas Mann's novella.[53] In the case of Larry's suicide attempt, Frank bandaged him and packed him off to the Porters', where Fairfield preserved Larry's rash act for posterity by painting him with bandages wrapped around his thin bare arms.[54]

Grace's job in the fall of 1953 after the overdose was much simpler. Having tapped what she called her "latent Florence Nightingale instincts," Grace merely had to rescue Larry from too much dope. "Grace Hartigan

was so wonderful marvelous everything to me I'm going to leave her my entire estate except what I leave you," Larry wrote Frank about the incident. "She fed me held my hand gossiped told me sweet things about myself. Finally I got up enough strength to get out of bed at 5 and Lordie. Kiss her for me."[55] When Frank received Larry's letter, he was with Grace at Bobby Fizdale's, where Bobby and his professional partner Arthur Gold practiced the music of Poulenc. As a treat, before Frank and Grace returned to the city, the pianists performed a private concert. Grace said,

> So we went into this empty drawing room, empty except for two pianos and a Victorian love seat. Frank and I sat on the love seat and they threw us a blanket because we were both kind of cold, and we sat there for the first time listening to two professional pianists play Poulenc for us, the Poulenc thundering in this room with just me and Frank huddling together under a blanket.[56]

All the dramas, high and low, personal and political, disappeared when the painters returned to their studios and when the poets began to write. Their lives were so much larger than petty grievances, wounded pride, broken hearts, even the occasional overdose or bender. That was all background noise. Art was their only reality. When art was denied them, their lives became unbearable. And that was what was happening on Fireplace Road in Springs.

Part of the reason Lee and Jackson had moved to Springs in 1945 was to escape the social scene in the Village, because it was literally killing him. For a few years, they had relative solitude and a glorious spell of sobriety during which both had thrived. Now, just at the moment when each of them was profoundly uncertain about where to go in their work, and when Jackson was drinking with a suicidal vengeance, the art scene came to them. The arrival of legions of artists, writers, and hangers-on from the city was a constant reminder of what the Pollocks were not doing artistically as well as a constant temptation to Jackson to play the drunken cowboy.[57] That buffoon was not the person Lee had married, but it was the one with whom she shared her home in 1953. And though she loved him and hoped he would recover the man he had once been, she was not willing to be a martyr to an unworthy cause.

In late May, Lee and all the artists were reminded of the transience of their lives. The painter Bradley Walker Tomlin had been at Lee's and Jackson's for a party but left at about midnight, feeling ill. By seven in the morning, Tomlin had had a heart attack and was dead. He was just fifty-three.[58] The entire community paused to think of him, of their loss, of the

brevity of their own existence, of what they had not yet accomplished. Lee was especially struck because Tomlin had been one of the artists who always acknowledged and respected her as a painter. In handwritten notes Lee scribbled around the time of his death, she wrote, "I want to talk about my self-destruction, my disgust and stupidity...(waiting and trapped.)"[59]

Since her dismissal from Betty's gallery the previous year, Lee had been trying to coax her creative self back to life by working on paper with black ink. She had been deeply wounded by Betty's rejection and, in its wake, she had to discover if she could ever paint again. She started by going back to drawing, tacking each work to the wall until, one day, her entire studio was covered floor to ceiling. But the drawings suddenly looked to her like sheer madness. In a rage, she tore them off the wall and threw them on the floor. "It was a couple of weeks before I opened that door again," she recalled. "When I opened the door and walked in, the floor was solidly covered in these torn drawings that I had left, and they began to interest me."[60] Lee frequently said her work was biographical if anyone cared to read it, and those shards of paper piled on the floor, their ripped edges jagged, their painstakingly constructed compositions torn to shreds, described Lee at that point in her life with terrifying accuracy. She picked up a few pieces, and began to place them next to each other on a table. The juxtapositions were dynamic, unexpected, "marvelous...miraculous, if you will," she said.[61] "I became very excited about what was beginning to happen there. Then I started going through a lot of work that dissatisfied me with the same process...destroying in order to recreate."[62]

Lee had found her artistic pulse beating amid the debris of her studio. She began turning her drawings into collages. Then she started cutting old paintings to incorporate them into her work. In a state of exhilaration, she went to Pollock's studio and asked him if he had anything she could use. He gave her some drawings and paintings, which she duly tore and cut to pieces. They, too, were integrated, resurrected. At the start of their relationship, when Lee was painting mud, she had scraped down her paintings so Jackson would have canvas to work on. Now they had come full circle. Jackson was the impotent artist, sacrificing his work to help her.[63]

Vertical and small, her initial collages were only about thirty by twenty-two inches, but they had a depth and energy that gave them power much greater than their size. Like Jackson's *Blue Poles*, Lee's collages were often restrained, in her case by strips of torn paper positioned over the surface of the work like cell bars or scratches made by an anguished hand. Behind them, the real activity occurred. Writhing and thrusting, the varied textures and markings of the multitude of torn and cut shapes made Lee's collages deep, inexplicable, exciting. There was a moody intensity to them that had not previously existed in her work: aggression, even violence.

Fairfield Porter would say that they depicted a "subtle disorder greater than he might otherwise have thought possible."[64] One writer called her collages songs "torn from the throat of a blues singer."[65] Their soulfulness was their strength.

Lee didn't question the work. It was, she said "sufficient for me that I was involved with it."[66] But neither did she take it for granted. Having made her life-saving discovery, Lee put everything else aside. "I sleep and eat, that's about it," she said of her work cycle.[67] During that period, she became an instrument of nature. The power to create something original was hers for a moment. Her occupation was sweeter still because if she had not been able to lose herself in truly good work, she might have imploded.

The public had expected masterpieces from Jackson seemingly so that they could ridicule and dismiss them. Time and again, he had gone so far out on a limb that he was airborne, but the world and its small-minded ingratitude and jealousy had dragged him back down to earth. And that was a place where he could not survive. Day after day, he went out to his barn willing something to happen that would send him off again into a universe of his own. Nearly always, he came out of his studio at the end of the day empty. Over the winter he had begun to travel into the city to see yet another doctor to try to stop drinking, but he left each of those sessions and headed straight to the Cedar.

The poison had a hold on him. In the summer of 1953, he and Lee began to grow apart.[68] *Her* work and her life became her primary concerns. She had long asked Jackson for a proper studio. That summer, they bought a piece of land on which to build one.[69] She had refrained from showing after her debacle at Betty's, but during the summer of 1953 she was in three shows—two at Guild Hall in East Hampton and one in Amagansett.[70] She began developing a life apart from Jackson's. "He tried to talk to me about getting closer," Lee wrote in diary-like notes, "said he appreciated my staying with him."[71] She would not abandon him, but neither would she be bound to him anymore.

The disappointment Lee felt in Jackson was directly proportional to her expectations. She had seen something in him, a combination of talent and personal complexity so great it was certain to produce something marvelous. And he had. Jackson had made paintings that rocked the very foundations of art. No one after him could ever approach the canvas the same way again. And then he squandered it. The attention had been too great. The pressure intolerable. The reaction too cruel. Dorothy Miller said Lee and Jackson came by her apartment one evening in 1953 and Pollock was drunk. His hands over his face, Jackson said to Lee, "Don't look at me like that—don't look at me like that!" Dorothy added, "I think she hated him."[72]

Lee needed help taking care of Jackson, and so in August they invited his

mother, Stella, to live with them at Springs. Stella Pollock was perhaps the only person who could influence her son, even when he was drinking. In September, she arrived but stayed only twenty-six days. Even she could not tolerate the insanity in that household.[73] Shortly after Stella's departure, Sidney Janis canceled the show he had scheduled for Jackson in October. Pollock had done ten paintings that year, including *Portrait and a Dream,* which contained his only known portrait of Lee. Janis, however, didn't think the 1953 works were good enough to warrant a show. It would be the first time in a decade that Jackson did not have a solo exhibition in New York.[74]

The White Horse in the West Village near Clem's was the hard-drinking, straight writers' bar. It was as if a Dublin pub had been flown over the Atlantic and reassembled, patrons and all, in New York. The Clancy Brothers even played there. The Welshman Dylan Thomas felt so at home at the Horse that after discovering it during his first visit to the States in 1950, it and the Chelsea Hotel became his second homes during three subsequent New York sojourns.[75] The final trip, in October 1953, proved the most raucous and the most desperate. Like Pollock, Thomas had spun out of control with drink. When he came to the Club, he could barely stand. "He was very loaded," Ibram Lassaw said. "I remember seeing Ernestine and Dylan dancing around the floor there."[76] Thomas was in town to see his "play for voices," *Under Milk Wood,* performed at the Poetry Center, but all anyone remembered about that season's visit was the fact that he never appeared sober and was always unwell. He began his day with barbiturates, stayed on his feet with the help of Benzedrine, and ended the evening with sleeping pills washed down with whiskey. In between he was literally mad with drink, raving, shouting obscenities at strangers, lunging at them on the street and in bars.[77]

On October 27, his thirty-ninth birthday, he came to his senses long enough to declare himself "a filthy, undignified creature." On November 3, unable to sleep, he slipped out to the Horse at two in the morning and had, he later declared, "eighteen straight whiskeys."[78] Two days later he was at St. Vincent's Hospital on West 12th Street. Some accounts say a doctor who had treated him before his hospitalization had tried to stabilize him with three shots of morphine, which put him into a coma. Other accounts say he was given a shot of cortisone.[79] Whatever had occurred, the damage was done. No amount of medical intervention, however responsible or bizarre, could improve his condition. There were complicating factors, like pneumonia, but the primary and undeniable cause was booze. He had poisoned his body with alcohol. When Caitlin Thomas, his wife, arrived from Wales, she asked, "Is the bloody man dead or alive?" He was just barely breathing. And on the afternoon of November 9, he stopped.[80]

"Habitual drunkenness" had been recognized as a "disease" in America as early as 1870, and the term "alcoholism" introduced even earlier—1849—by a doctor in Sweden.[81] But the American experiment with Prohibition had left a bitter taste, and anyone after its demise appearing to advocate limiting alcohol consumption was seen as joyless and retrograde. Even research conducted prior to Prohibition that dispassionately described the perils of alcohol was ignored as "wet-dry" political propaganda. Though Alcoholics Anonymous was formed in 1935, it was not a force able to counter the allure of drinking, especially during the war and postwar years, when alcohol was cheaper than psychoanalysis and available around the clock.[82] Gradually, however, the miserable alcoholic who destroyed himself and his family began to appear as a character on the silver screen. Magazines, too, devoted dozens of articles to the issue. There was, therefore, an awareness of alcoholism. Lacking was a depth of understanding about the disease.[83]

The day after Dylan's death, the White Horse overflowed with people drinking in his honor.[84] His funeral on November 13 at St. Luke's Chapel was similarly packed with a "full roster of writers and artists," according to Judith Malina. "It might be a mass in any church where all the parishioners know one another, nod, and afterward stop in the winter sunlight to exchange a few benign words."[85] But over the next week, as the details of his death began to sink in and people examined their own behavior, many began to question how much they, themselves, drank. For a while, there was a greater consciousness when a painter raised his or her glass. How many have I had so far? Which one is this? Writer James Agee, for one, declared he had come up with a plan to curb his consumption of alcohol. He would limit himself to five drinks a day.[86] Well, something had to be done—people risked killing themselves with the stuff! That message hadn't reached Long Island. Two days before Christmas, Jackson was found lying on the sidewalk outside the East Hampton Police Station.[87] He wasn't dead, but he was getting there.

40. A Change of Art

> As we all know deep down, it is not by submission, coolness, remoteness, apathy, and boredom that great art is created, no matter what the cynics might tell us, the secret ingredient of great art is what is most difficult to learn: it is courage.
> — Boris Lurie[1]

"OH SHIT, IT'S my night!" Grace thought with alarm as she opened her studio door to find a smirking Larry Rivers, gardenia corsage in hand, ready to collect her for the ballet. "Larry had a theory that you were supposed to go to bed with everybody you know," she explained. The flower was a signal that he believed the time had come for them to consummate their friendship. Grace shuddered at the prospect. "He had this beat up car. On the way he asked if I minded if he smoked a joint. I said, 'No, that's OK.' He parked the car, smoked some marijuana, and fell sound asleep. I tiptoed out of the car and took a cab home. I never got a gardenia again. The moment had passed." Years later, as Grace laughingly recounted that episode, she still expressed profound relief that nothing had happened.[2]

In a way, though, Larry's bungled seduction at that moment was a sign of his respect for Grace as a fellow artist. In the fall of 1953, Larry was on top of the world. He had just painted his first masterpiece, a nearly seven-by-nine-foot work that he said gave birth to "the idea of Larry Rivers."[3] He called it *Washington Crossing the Delaware* and described it alternately as a "bomb" thrown by an "aesthetic anarchist" against both the tradition of nonobjective abstraction and "corny public school patriotism," and as a painterly tribute to *War and Peace,* which he was reading at the time.[4] It was also the painting Larry had been waiting for. It referenced all his influences, as well as his indebtedness to music and words. And, it allowed him to indulge his powerful drawing skills without seeming academic. Startling, funny, aesthetically challenging, employing realism and abstraction, the painting surprised no one more than Larry himself. "If you knew what goes on inside of me when I work you'd dismiss me in a minute as just a lucky freak," he wrote Grace while painting it.[5]

As his December show at Tibor de Nagy approached, worry over the potential reaction to his art supplanted any joy Larry may have felt at accomplishing it.[6] In turning to Grace, he had actually been looking less for sex than support.[7] After he returned to Southampton following their

misadventure with the ballet, Grace wrote him words of reassurance from the perspective of bitter experience. "You'll of course be viciously bitched and dished and knifed but everyone knows you are 'someone' to contend with and if they don't know it then the work will show it to them."[8] Indeed, after Larry's show opened the first week in December, his painting was the talk of the town.[9]

Some, Grace among them, were so intrigued by his use of narrative subject that they scrambled to find a way to employ it themselves. "This whole idea interests me more than anything since I 'discovered' Spanish painting," Grace wrote in her journal on the eve of Larry's opening. "What I must do is find *my* world of reference."[10] Larry had resurrected an artistically tired theme—America's War of Independence—to manifest his novel vision. What interested Grace was the notion of finding a theme, rather than the odd object or old master work, through which she, too, could express herself *in a series*. She listed possible ideas: "Haute monde? Opera, ballet... restaurants—diners in evening clothes. Elegant homosexuals.... High fashion world... dancers—Spanish." "This of course will take *years* to digest, discover and express," she added.[11] Instead, it took mere weeks for Grace to begin a painting inspired by Larry's *Washington*. Hers would be a six-by-eight-foot work called *Grand Street Brides,* and it, too, would be seminal.

Grace's studio was "two blocks from Grand Street, where there is one bridal shop after another," she recalled years later.

> I am very interested in masks and charades... the face the world puts on to sell itself... [and] in empty ritual. I thought of the bridal thing as a court scene, like Goya and Velázquez and I posed the bridal party in that same way.... I bought a bridal gown at a thrift shop and hung it in the studio. Every morning I would go out and stare at the [bridal shop] windows and then come in and paint.[12]

At thirty-one, with two failed marriages behind her, Grace's choice of subject was intriguingly autobiographical (though neither of hers had been white weddings). Publicly, however, she didn't make the association between her own "empty rituals" and her art. Nor did she see her painting as an overt statement on the role of women in 1950s America, when after having been feted as queen for a day during her wedding, the new bride was expected to accept a lifetime of servitude and submission. Grace's subject was at once broader—"loneliness, alienation and anxiety"—and more aesthetically pragmatic: "By then I had found that my best work had some roots in the visual world."[13]

Larry's painting had been done in the relative isolation of Southampton, but Grace worked in the city, where her painter friends watched as she

trampled the hallowed ground of pure abstraction. "I remember the year she painted *Grand Street Brides* [there was] an energy," Al Leslie said, "talking about those things and thinking there was a future to painting outside of the metaphysical boundaries, that could include figuration."[14] The majority of the New York School painters, however, were still wedded to pure abstraction. They saw in works like Larry's and Grace's a dangerous return to a public art, an acceptable art, which they implied was inherently mediocre (an opinion inflamed by jealousy after *Washington* was acquired by Gloria Vanderbilt for the Museum of Modern Art).

The hostility to figurative abstraction among New York painters seemed sadly ironic because those very artists who disparaged the new work for breaking with abstract orthodoxy had spent their careers defending their own right to paint anything they pleased. Painters like Larry and Grace had broken their rules, but hadn't the point been that there were no rules? Or as the Club began to ask in a series of eight panels in 1954, "Had the Situation Changed?"[15] The question was artistic but could have been applied to society as well, and the answer on both counts was yes. Life in America itself had changed, and therefore, by necessity art had changed. A large part of an artist's subject matter, Elaine said, was beyond the artist's control, often even beyond their consciousness. "This is the social or historical element. Not *How* or *What* the artist paints, but *When* and *Where* and *Why* he paints is involved here."[16] And at that time, in both American society and American art, a rebellion was brewing.

Fear is greatest when its source remains in the shadows. Until 1954, Americans existed in a state of fear based on residual anxieties left over from the war, economic concerns rooted in the Depression, and the narrative of dread purveyed by cold warriors internationally and at home. All those fears felt tangible and weighed on society until they became part of the fabric of American existence.[17] The great postwar American reservoir of foreboding began to evaporate that year, however, due in part to televised congressional hearings that showed the source of much of the disquiet to be a sham. While Joe McCarthy's committee investigated so-called communist infiltration based on "secret evidence given in closed session," it had held the nation spellbound.[18] Not only was the top-secret hunt for domestic treachery reported in the daily papers, but it had pervaded mass culture in films, books, and radio serials. That spring, McCarthy's investigation of alleged disloyalty turned its attention to members of the military, and the decision was made to televise thirty-six days of testimony and grilling over whether army brass had gone soft on communism.[19] The result was remarkable.

Caked in "cream-colored makeup" under the glare of lights in sessions

broadcast live to black-and-white screens across America, the bold anti-Red crusader from Wisconsin was unmasked: McCarthy often seemed drunk and comported himself like a bully.[20] In the face of his alternately hostile and paradoxical questioning, the suspected communist sympathizers before him appeared as pillars of virtue. When the army's chief counsel finally asked McCarthy, "Have you no sense of decency, sir?" those in the audience, many of whom wore military uniforms, erupted in applause.[21] The shadow McCarthy had cast over the land began to dissipate. As that levelheaded species known as the "average American" saw McCarthy at work, it came to recognize the eight years of anti-communist witch hunts for what they were, the triumph of zealotry over reason. By the fall, McCarthy had earned a censure from the Senate and been stripped of his power. The spell was broken. Americans emerged to celebrate. It was V-M Day, victory over one of the nation's darkest chapters, McCarthyism. Some saw in 1954 the long-awaited dawn of a liberal America.[22]

A life lived in fear is not living, it is merely surviving, and the realization that precious years had been lost to unfounded panic caused many Americans to wonder what they wanted from life. There was no longer an event greater than themselves dictating their behavior and requiring a sacrifice for the common good. The individual, one's family, and the company for which one worked became the extent of one's responsibility, the boundary of one's concern. America became *self*-centered. For most, security, prosperity, and health comprised the formula for happiness. For some younger Americans, however, who had seen their parents surrender to conformity, religiosity, and thrift in dark times—parents who had grown so habituated to restraint that they seemed prepared to accept it forever—there arose a profound yearning for change, for *chance*. That younger generation had accepted the fact that the world could end tomorrow; the realization was their birthright. Under those circumstances, there was no rational basis for caution. When Marlon Brando's leather-clad character was asked, in the 1953 film *The Wild One,* what he was rebelling against, he answered for a generation: "What've ya got?"[23]

Music was the most accessible art form for young people hungry for new experiences and ways to express them. The first pocket-sized transistor radio hit the market in 1954 and quickly became the biggest-selling consumer product of all time.[24] Young people carried with them a device that broadcast anthems of insurrection—R&B, rock and roll—music that crossed the previously unbridgeable racial divide by making available (and celebrating) artists white *and* black.[25] The pace was fast, the music hot, the reaction wild. It was the spirit of the time. The artists in New York represented that time. They, too, were caught in its headwinds. Beginning in

1954, their parties became more elaborate, their painting life more intense, their love affairs more destructive.

"Sometimes there would be three parties in one night," Elaine said. "We'd go from one to another and they were kind of arranged to synchronize."[26] Harold Rosenberg called the scene a "flying circus.... You'd say 'good-by' and a half hour later you'd be in some other house and all the same people would be there."[27] The only description applicable was "incestuous." One night at Edith Schloss and Rudy Burckhardt's loft author Jane Bowles sat up and said, "Wait a minute.... Everybody be quiet. Let me think. I have a strange feeling about all of you here." There were twenty people in the room, and she said, "I know that everyone here has slept at one time or another with someone or another in this loft." Those assembled, among them Bill, Elaine, Edwin Denby, Fairfield, Larry, Milton Resnick, and Nell, looked at one another. "It was uncanny," Edith said. "It was true."[28]

Also at the gathering at Edith's that night was a small, dark-haired woman who had appeared on the scene like a bird signaling a change in the weather.[29] She rarely spoke, and when she did it was in monosyllables, mostly a whispered yes or no.[30] On one memorable occasion, she came to the Club wearing a mask. Someone called out, "Take it off!" and soon the entire gathering began to chant "Take it off!" Finally acquiescing, she silently removed the mask to reveal a second mask underneath it. "Shock, then uncontrollable laughter" followed, according to Irving Sandler, who witnessed the unveiling.[31] Her name was Marisol. In 1954, she was twenty-three, glamorous (some called her the "Latin Garbo"),[32] and in full rebellion, a state in which she had long resided and which resonated strongly that season among her agitated friends.

Born Maria Sol Escobar in Paris in 1930, she came from a wealthy Venezuelan family that encouraged her gift for painting.[33] After her mother's suicide when Marisol was eleven, the child stopped speaking. She explained,

> I really didn't talk for years except for what was absolutely necessary.... I was into my late twenties before I started talking again—and silence had become such a habit that I really had nothing to say to anybody.[34]

There was never a time in her life, however, when she had not communicated through art, and when it came time to attend high school and beyond, she studied painting in Paris and Los Angeles, and then in New York and Provincetown with Hans Hofmann.[35]

Aside from her silence and her privileged background, Marisol's artistic sensibilities and experiences were very much like Larry's. Both revered the

old masters, history, and the tradition of painting, and both were equally steeped in the culture of hip. "I was high for about four years," Marisol said. "I used to know a group in the Village who used to turn on with drugs. That was a very friendly time for me. We sort of lived together. Property wasn't so important. It wasn't important to own your own bed or your own spoon."[36] Her artistic training had been in painting, but in 1954, when she began hanging around the Cedar, she switched to sculpture. First clay, then wood.

> Everything was so serious. I was very sad myself, and the people I met were so depressing. I started doing something funny so that I would become happier—and it worked. I was also convinced that everyone would like my work because I had so much fun doing it. They did.[37]

Like Larry's *Washington Crossing the Delaware* and Grace's *Brides,* Marisol's sculpture—totem and fetish-like, which grew from tabletop- to life-sized—drew from daily life, political life, and popular culture, and recreated it with bemusement. (It was Kierkegaard who said that the deepest modern seriousness must express itself through irony.)[38] One had the impression that Marisol was peopling her world with silent figures like herself: delightful to behold, impenetrably mysterious. They were also remarkably accomplished. From the moment she began sculpting, she had a singular style that commanded attention, both for her technique and her vision. Those few people who saw her sculpture at that stage knew they were in the presence of a rare talent whose work broke from the sculptural Abstract Expressionist tradition the way Grace and Larry had departed from the painterly First Generation pack. Maybe it was a case of zeitgeist, maybe it was a necessary evolution—like those teenagers, transistors hidden in their shirt pockets, breaking inevitably, inexorably away from their parents.

That was how Frank saw the development of his younger artist friends as they moved out from under their elders' abstract umbrella. "The artists I knew at that time knew perfectly well who was Great and they weren't going to imitate their works, only their spirit," he said.[39] In other words, theirs wasn't a rejection of those who had come before but the necessary culmination of a search for oneself, in art and life. Elaine said an artist "traditionally seems to find something new (if he finds it at all) by passionately *following*—until there is nothing left to follow but himself."[40]

In the spring of 1954 Marisol was introduced to then-fifty-year-old Bill, and the two became lovers. "He was the most romantic man I ever met," she said years later. "A big idealist.... He was my hero, actually, he is still my hero and I learned a lot from him."[41] One of the unfortunate lessons

she learned, however, involved drinking.[42] With a few coins in his pocket from the sale of paintings, Bill had begun drinking Scotch, bourbon, and martinis in addition to beer. He had always been volatile when his work wasn't going well (which to his mind was continually), and liquor only made him more so. Under its influence he ranged from wild gaiety at the bar to brooding and battling in his studio, alone or in the presence of the women who always seemed in residence there. The twin from Scranton, Joan Ward, was one of them and, for a time, Marisol was, too. She was attracted to the darkness in Bill.[43]

Elaine, however, was not. She had begun to feel that Bill's "pugnaciousness" under the influence of hard liquor amounted to hostility toward her. Later she would say "it was not Bill talking, it was booze talking," but at the beginning his cruelty seemed intensely personal.[44] And that was due in part to the fact that her own judgment was clouded by liquor. "You know, *Who's Afraid of Virginia Woolf* was not about a married couple," Elaine once said. "It was about two glasses of liquor conversing with each other."[45] Drunken melodrama became the medium through which she and Bill communicated. "I was sitting nearby as Bill and Elaine started to argue," Pat Passlof recalled. "Each time one spoke, the other would knock something off the table with a deliberate flourish: a knife, a fork, a spoon, salt, pepper—all went flying."[46] Elaine, however, had the sense to realize that she could do nothing to help Bill, and that the only way to help herself was to put distance between them. She had an aversion to aggression and ugliness, and an ability to circumvent most obstacles.[47] "Rather than face a fact that I don't like," Elaine said, "I prefer to dodge it if possible and it often is possible. Maybe frankness saves time but dodging saves feelings."[48] Bill had become one such obstacle to avoid. "And so I had my own life, which was very fulfilling," she said. "And it wasn't just that I went off and became a nun, you know. I just was living exactly the kind of life I wanted to live."[49]

At thirty-six, Elaine had been at the center of the New York School for half of her life. While she was a powerful critical voice, and though her importance in the community was undisputed, as yet her painting—which she believed to be the core of her existence—had not been recognized or for that matter even shown in other than group exhibitions. Amid all the changes and excitement of 1954, she decided she was ready to exhibit alone. She had built a body of work that included not just abstract paintings and portraits but a series that struck many as oddly out of step with what a "serious" artist would paint. Elaine had chosen sports figures.

She had begun the series in 1948 after her return from Black Mountain. At that time Elaine used pictures of basketball players in newspapers to inspire her canvases. But that method lacked the immediacy she craved, so she

went directly to the source, attending games to sketch from life amid thousands of cheering fans.[50] According to Elaine's friend the art historian Helen Harrison, she would go back to her studio and conjure it from her memory, bringing with it her own emotion, as well as the excitement, danger, and sheer energy of what she had observed. "Those elements certainly appealed to her," said Harrison. "The painting itself is static but the image is not. It's very difficult to convey that."[51] Soon the paintings grew to eight feet high, and she began to combine divergent, even seemingly irreconcilable elements: the razzle-dazzle of the pop culture sports figure iconography with the masterly sensibilities of El Greco; the freedom of the Abstract Expressionist brushstroke with the precisely drawn arc of an arm in mid-toss.

Grace had been regarded with suspicion for allowing old master references to appear in her work. Larry had been called reactionary for employing a historical theme. Elaine's paintings of pitchers and batters and basketball court skirmishes were so outside the realm of acceptable New York School subject matter that they were nearly beyond comment, just as her Gyroscope Men had been when she began painting those. Both series, along with Grace's, Larry's, and Marisol's work, however, foretold the direction of art in those years before Pop. And both were true to who Elaine was as an artist. It wasn't who or what she painted that interested her, it was what those subjects allowed her to do. "I want gesture—any kind of gesture," she said.

> Gentle or brutal, joyous or tragic; the gestures of space soaring, sinking, streaming, whirling; the gestures of light flowing or spurting through color. I see everything as possessing or being possessed by gesture. If the gestures are inhabited by landscapes, arenas, bodies, faces, animals, or just colors, it makes no difference to me.[52]

She was guided in her work by two elements: trust, which she called "the key word," and courage.[53] "'Throw caution to the wind,' that was the advice she would give any artist," said Elaine's painter nephew Clay Fried. "'Your best work is what you think is the worst. Put it out there.' She believed in a genius inherent in every person. 'Get out of the way and let the genius out.'"[54] Elaine lived her own advice with difficulty. In 1952, she had hoped to have a show but was so uncertain of her work that she postponed it.[55] It took nearly two years before she felt strong enough to try again. When she did, the first gallery she approached was Betty Parsons's, but that exhibition didn't occur because of a series of miscommunications. "After she didn't pick me up, then I just spoke to...Conrad Marca-Relli," Elaine recalled. "I said, 'I'd like to be in the Stable Gallery, do you think she'd be interested?' And he said, 'I'll find out.'"[56] Eleanor Ward was, and

she offered Elaine a solo show in April 1954. "And now I'm preparing (surely the wrong word)—I'm staggering and blundering toward my show Apr. 5. I get an idea a day each one better than the one before," she wrote Larry that spring, "each one proving that every painting I ever made was all wrong but this is it. In other words, a charming picture of disorganized energy. But organized energy is repulsive. All it leads to is money mainly thereby creating bigger and angrier problems."[57]

Elaine's preparations came amid a season of high expectations. Remarkably, Grace's exhibition at Tibor de Nagy at the end of February had sold out. Six of the ten paintings were snapped up, and the four that remained without a red dot were already in collections.[58] One large painting—*River Bathers*—was purchased by the Museum of Modern Art for one thousand dollars (Alfred Barr said the work showed "genius"),[59] and the Whitney Museum acquired a smaller painting called *Greek Girl*.[60] "It would be impossible to describe my feelings so I won't even try," Grace wrote in her journal as news of the sales came in. "All that I can think of is the time it gives me, freedom to work without the pressures of financial worry.... I think I have some good pictures in me. I'm going to get a roll of linen!"[61] Frank, who was the model for many of the paintings in the show, wrote the entirely biased review of Grace's exhibition that appeared in *ArtNews*.[62] Her *unofficial* defender against any criticism that came her way was Larry, who in his characteristically elliptical style wrote to Grace after her opening:

> Ban, Bunhole, Bullshitte.... What the fuck did they know about New York and the Twentieth Century and 3d and Television and the boredom the masses would feel for anything that didn't scream, fly, fuck, or murder....
> Have there been any remarks that shake the house. Point em out Ill kill em. Have you got the Cedar blues. Stay out of there George si vous voulez venir Chez Rivers don't even phone, just walk. I'll pick up the pieces in Smithtown. Bring a bottle of white tempra and a knife.... Visit me and we'll make history together.[63]

There was, happily, no need for violence. Grace's exhibition was very well received by all but the stalwart abstractionists. All the works in Grace's show included figures, objects—if not the real world, then at least a veiled reference to it—painted into, not on top of, a field of abstraction. One would be wrong to conclude that because the works contained traces of reality they were easier to digest than fully abstract paintings. They were in some ways more difficult because the objects and people Grace painted were never reassuringly present; she forced the viewer to hunt for them

within the paint, as if searching amid a crowd in the dark for a missing friend. The paintings left one vaguely uneasy, wondering whether what was lost would be found and, if it were, whether it would be as one remembered. Grace's works on display in 1954 were born in her *Oranges* series with Frank and energized and aggrandized by her own relentless drive and talent. Said Tibor, Grace "was like a volcano which erupted regularly and frequently. She was the heart of our gallery from the beginning.... Her everyday life was difficult and colorful, and all this was transposed into her paintings."[64]

While Grace's friends celebrated her exhibition, filling her studio with violets, carnations, and daffodils, her twelve-year-old son Jeff had been hospitalized in New Jersey and was to undergo an appendectomy. Grace's nights were spent at the gallery, and her days at Orange Memorial Hospital.[65] Guilt, fear, and depression concerning her estranged son overcame her. Amid the most successful show of her career Grace began doubting her work. She thought it "half-hearted" and without "magic."[66] It was one of the rare occasions when the love of her child interfered with, even superseded, love of her art. Frank noticed a sweetness in Grace during that period that he had never seen. Having quit his job at the Modern to write for *ArtNews,* he was momentarily away from the city. He wrote Grace, "Are you working or brooding? Don't worry about anything till I get back and then we'll worry together."[67] Grace had agreed to split the cost of Jeff's procedure with her ex-husband. Therefore, despite her many sales, she emerged from her show with only seventy-five dollars to live on.[68] Life had intervened to knock Grace off the course she had charted for herself—but only for a moment. Jeff recovered, and she did, too.

Luckily for Grace, a charming older gentleman collector who had made a fortune in New York real estate had taken a shine to her.[69] A recent widower, Alexander Bing had generously, and with few strings attached other than companionship, opened his ample purse whenever Grace asked for help.[70] Bing was well-known among the artists as a benefactor. John Myers described him as "brilliant, bright, delightful...a real Jamesian character" whose early support boosted the painters' spirits.[71] He not only enjoyed and collected their work when few others of his social ilk did, he appreciated their company.[72] His uptown, Fifth Avenue apartment was a vast, gloomy affair filled with servants, but he enlivened it from time to time with the Cedar crowd.[73] "He'd invite a group of artists like Franz Kline, [Jack] Tworkov, Bill, me, Giorgio Cavallon, and Charlie Egan," Elaine said. "He'd make this great dinner party for us, and after dinner we'd all go up to a room, and he'd have the most fantastic art books—you know, the kind that cost thirty bucks apiece.... And then Alexander Bing would

serve us Scotch-and-soda, plus the most ridiculous cakes. I mean, to have Scotch-and-soda with some very plushy cake that cost a fortune!"[74]

Grace, however, was his special artist friend. In his chauffeur-driven limousine, he took her to the ballet where, rather than sitting in the balcony, she joined New York's high society in orchestra seats. "For the first time, I could see the strain of the hard work in the faces of the dancers," Grace recalled. "A drop of perspiration actually fell on my wrist."[75] Bing took her to dinner at restaurants where one meal likely cost as much as Grace lived on for a month.[76] He invited her to accompany him to Europe, an offer which, after some soul-searching, she declined. Fearing the corrosive effect of an affair based not on love but on what Bing could give her materially, Grace blamed her reluctance to travel on her need to paint.[77] Bing gallantly accepted her decision, saying she deserved a younger man to make her happy.[78] He was apparently content merely occupying her glorious orbit, because his support for her work did not end when she spurned his advances. It was Bing who bought *River Bathers* for the Modern. In thanking him, Alfred Barr wrote that Grace "is one of the most talented painters of her generation now working in New York."[79]

As Grace's involvement with the Modern deepened, Dorothy Miller tried to persuade her to declare herself a woman professionally by using her own name. "John Myers says you do not want yet to come out from behind that masculine false front," Dorothy wrote her that spring. "I do wish you would let us call you Grace Hartigan some time soon in print."[80] It had become silly. Everyone associated with the gallery knew that "George" was a woman and anyone who read reviews saw them peppered with the pronoun "she." By July, Grace agreed.[81] It was, in fact, an easy decision. George Hartigan was a character from an earlier life, a remnant of her artistic infancy, like a childhood nickname. As an artistic force to be reckoned with, Hartigan was finally prepared to be Grace.

Elaine's exhibition opened several weeks later at the Stable Gallery, on the same night as an exhibition by First Generation veteran Adolph Gottlieb across town and a week before Franz Kline's third outing at Charlie Egan's. Both men were, by then, grandees of abstract painting, purists whose styles were so recognizable there was no need to hunt for the artist's name on their canvases. On April 5, those who had previously seen Elaine's work represented by one or two paintings in a group show would have been surprised, in seeing it covering the walls of the Stable Gallery, just how instantly recognizable it also was, despite the fact that Elaine switched from portraits to full abstraction to action figures as her mood dictated.

The show was a revelation. Everyone had read Elaine's words, but few

had been exposed to the intensity of her paintings. They simply had not had the opportunity. She had not shown them, out of humility, disinterest, and that rarest of emotions for a confident creature like Elaine: timidity. Perhaps knowing how vulnerable Elaine was at that moment, Tom assigned her trusted friend Fairfield Porter the job of reviewing her show for *ArtNews*. "Her construction is rapid and blazing; the color flashes out of the plane, but not out of the fire," he wrote. "This exhibition, which reveals a stubborn, clever personality, may well prove to be the most original of the season."[82] Across two columns and over half a page, the magazine reproduced one of Elaine's Gyroscope Men.[83] It was both a sign of respect and a show of support for an artist who had remained too long in the shadows.

In a piece on Renoir, Elaine had written, "There are two images the spectator gets from every work of art: one while looking at the work, the other—the after-image—while remembering the work.... The artist creates the after-image, the painter makes the painting."[84] Elaine's show, which everyone attended (Larry made a special trip into town from Southampton), did not have the commercial success that Grace enjoyed. (Elaine sold only one small painting, to fellow artist Jack Tworkov.)[85] Nor did it generate the kind of heated critical debate that Bill's shows had. But it did establish her presence as a painter. The after-image her work left with those who saw it proved distinctive, undeniable. And when she appeared at the Cedar or a party with some of the athletes she had collected in her travels, men like baseball player Eddie Robinson or the heavyweight champion Ezzard Charles, the artists around her froze in fascination.[86] It was as if Elaine's paintings had come to life. The thrust of her brush was recognizable in their movements.

Was Elaine disappointed that her show hadn't received as much attention as the exhibitions of some of her peers? Probably not. She was quoted as saying that "she became an artist to paint, not to receive recognition." (To which Grace replied, "I have this overpowering ego. You're dealing with two different types of women.")[87] In any case, Elaine was preoccupied with personal matters outside the studio that threatened to change her world.

While preparing for her exhibition, Elaine had learned that Joan Ward was pregnant by Bill. "Have you ever had a bomb shell drop on you?" she asked Larry in a letter on which she drew four bombs. "Well I did, today."[88] Elaine had decided years before that it would be impossible for her to be both artist and mother, and the issue of children for her had been closed. Or closed as much as it could be for a woman when inadequate birth control meant pregnancy always loomed as a possibility. But it had never been closed for Bill. Early in their relationship, he had wanted children, and it remained a source of conflict for them. Now it seemed that

one of his girlfriends would give him the child Elaine had not. "And still life goes on, nest-pa," Elaine continued in her letter. "And everything that happens makes one more intelligent In The Long Run. So here's a toast to the long run."[89]

In the short run, Joan did not give birth to Bill's child from that pregnancy. She had an abortion, and afterward succumbed to a year-long depression.[90] For her part, Elaine didn't have time to register anything but momentary emotions over the episode. Shortly after she learned of Joan's pregnancy, she also learned that Bill's mother had decided to visit them from Holland.[91] It would be the first time Bill had seen her since he was a teenager, and the first time "Oma," as Cornelia de Kooning was called, laid eyes on his American wife.[92] Elaine was thus called upon to play a part that had never suited. It was a tragicomedy that would become legend.

41. Life or Art

> I am an artist of paint, making discoveries.
> —*Helen Frankenthaler*[1]

ONE OF THE main differences between the young girl who drew a line in chalk from the Metropolitan Museum all the way to her home on Park Avenue and the young woman who drew lines on canvas and paper twenty years later was that the latter understood the willfulness that drove the child. She was facing "the monster," the consuming need to create, which was beyond her control but no longer beyond her comprehension.[2] Helen had long understood that her gift set her apart, and that it would be nearly impossible to describe how and why without sounding arrogant or cruel. "It's saying I'm different, I'm special, consider me differently," she explained years later. "And it's also on the other side, a recognition that one is lonely, that one is not run of the mill, that the values are different, and yet we all go into the same supermarkets...and we all are moved one way or the other by children and seasons, and dreams. So that art separates you...."[3]

The separation she described was not merely the result of what one did, whether it be painting or sculpting or writing poetry. Helen said the distance between an artist and society was due to a quality both intangible and intrinsic, a "spiritual" or "magical" aspect that nonartists did not always understand and were sometimes frightened by. "They want you to behave a certain way. They want you to explain what you do and why you do it. Or they want you removed, either put on a pedestal or victimized. They can't handle it." Helen concluded that existing outside so-called normal life was simply the price an artist paid to create.[4]

At twenty-four, she no doubt believed she could accept it, that she could live with the often excruciating solitude that accompanied a life in art. Painting was *the* priority for Helen, or as she said, "painting and health, because one needs that."[5] Art was her essence. She engaged the world in relation to it. While some saw from an airplane window the vast distance between themselves and the earth, Helen saw an unsigned canvas bleeding out color and shapes.[6] And because everything applied to her work and fed future paintings, Helen existed in a state of heightened receptivity, hungering for experience. "There is so much I want to do, see, hear, fulfill, find out about, run to, investigate," she said.

I want to look up and see when that Verdi was written, I want to read that recipe to see if I can make it, I will travel someplace, I want to meet somebody, any number of things... and that's an enormous problem, but it's also part of the beast.[7]

Only artists really understand other artists—Helen said they were a "club unto themselves"[8]—and, in cutting herself off from the Tibor de Nagy crowd, Helen had denied herself membership in that important group of like-minded spirits with whom she had no need to explain herself—her art, yes, but not herself. During the months since she left the gallery and traveled to Europe alone that summer of 1953, she had not been starved for inspiration. She found it in front-row seats at a bullfight, wandering through the Prado, and especially in the Cave of Altamira. "This was worth the whole trip," she wrote Clem after seeing it. "It all looks like one huge painting on unsized canvas; in fact it all reminded me of a lot of my pictures."[9] Nor had she lacked artistic companionship. In France, she met up with Lewin Alcopley and Frederick Kiesler, dining with them in what she called a "dream of cognac."[10] She had also been introduced to Marc Chagall.[11]

What she craved, though, was the vibrant exchange with artists of *her* generation, painters who were also finding themselves and whose every work, good or bad, meant discovery. By the time she arrived home, tired and "as wrinkled as my clothes," she was anxious to allow the colors, sights, and feelings she had absorbed during her journeys flow out onto her canvas, and to talk about it with the "Tibor Five."[12]

Helen was on good terms with one of them: Grace's ex-husband, Harry Jackson, had offered her the use of his Broome Street studio while he and his new wife were in Europe.[13] Helen needed one because Friedel, with whom she had shared a space on 23rd Street, had stopped painting after his first solo show. Despite "reputational" success, he felt he was a failure, entered psychoanalysis, and (temporarily) put down his brush.[14] The lease on the studio he and Helen shared was nearly up, and she didn't want to keep it on her own. Harry's place was one possibility.[15] Helen was also on relatively good terms with John Myers (though she was suing him for the return of a painting he couldn't find).[16] Significantly, though, she was still estranged from Grace—and by extension Larry—and that was because of Clem. He had seemed to go out of his way to disparage Grace's work, insinuating that she had soared so high so quickly by means of seduction. Grace wrote in her journal that Clem accused her of wooing Alfred Barr "because I know who is 'important.' It's so absurd—I would woo him if I could, because he *is* so bright, *so important,* and admires my painting. A delightful combination. But I've met the man only three or four times in

my life."[17] Unfortunately, this dispute tainted Grace's relations with Helen, who seemed to be taking Clem's side. After her return from Europe she was always in his company. Yet even at a distance Helen and Grace were in agreement on art and life.

In a letter to her school friend Sonya in February, Helen had recommended "a marvelous play... 'In the Summer House.' I think it's the best contemporary bit of play-writing I've come across in years—not at all arty or schmaltzy, and yet full of really felt drama and meaning."[18] Grace had seen Jane Bowles's play on Broadway as well, writing in her journal, "I don't think I've ever been so moved in the theater. When the daughter cried 'don't leave me, I love you!' Frank, Larry & I all burst into tears at once."[19] And then there was their reaction to that year's Stable Annual, which Grace found depressing and Helen called "dreadful. It gives me the impression that finally everyone has learned the skills of modern art. The general level is so low, and there are few exceptions."[20] The problem, according to both Grace and Helen, was that so few artists seemed to take chances. Many in the First Generation had found their styles and settled into them, while many younger artists had studied those styles so carefully that they were able to recreate them to the last brushstroke.

In fact, later that year a show in New York of student work from colleges and universities around the country demonstrated just how pervasive Abstract Expressionism had become—about 80 percent of the work replicated the First Generation painters of the New York School.[21] That imitation as adulation was still limited to a very small segment of the population, but it signaled a worrying possibility: The avant-garde risked becoming mainstream. Helen, Grace, Al, and Larry in painting, and Frank and his poet friends in words, were part of a *new* scene that was as yet relatively undiscovered and therefore entirely free. But such freedom felt fleeting. By mid-February 1954, after not painting for weeks, Helen told Sonya she was "anxious to get to work—very anxious, as a matter of fact." She had something original to say.[22]

The U.S. crime rate, which had been on the rise since the war's end, peaked in 1954, especially in large cities.[23] The streets of New York, in particular, had become desperate places. Society's castoffs, some crazed, some criminal, others merely perennially unlucky, seemed to gravitate there. But when it came time for those unfortunate individuals to take what they did not possess their chosen victims were most often nearly as destitute and disenfranchised as themselves. Around the Village, in the "Bird Circuit" midtown gay bars, and north of Tenth Street, men preyed on those who trusted strangers because to society they were strangers themselves.[24] In quick succession, in February and March 1954, crimes—a double homicide and a

shooting—hit the community of artists and writers in New York, destroying their belief that they were protected by a shield of poverty; that they had nothing anyone with a weapon would want.

On February 10, poet Max Bodenheim and his journalist wife, Ruth Fagan, were murdered by a deranged young man. Bodenheim had been a character in the Village since the thirties (he was a denizen of Sam Johnson's when Lee, clad in silk pajamas, waited tables there) and was known to everyone who had frequented the Waldorf and the San Remo. Though he had published a number of books, by 1954 Max was reduced to panhandling, going from table to table at the bar offering individual poems for sale. Some said he also pimped out his wife in order to buy them a night's stay in a flophouse. Undoubtedly Bodenheim's star had long since waned, but he was, for better or worse, one of them, which was what made his death so terrifying. Some said a man named Harold Weinberg had invited the Bodenheims to stay at his place on Third Avenue. Others said the couple had offered Weinberg a bed. Whichever the case, by morning Max was dead from a bullet to the chest and Ruth lay stabbed to death beside him. "I ought to get a medal. I killed two communists," the murderer reportedly told police.[25] Communist, poet, it was all the same to those who didn't understand the Village culture. Within two days, a wake was held at the San Remo that Helen said everyone attended, murmuring over drinks about Max's and Ruth's brutal and unexpected end.[26] With the memory still fresh of Dylan Thomas's wake at the White Horse just three months earlier, Judith Malina said of Bodenheim's passing, "The ranks of the dead poets swell."[27] Indeed, the poet who was most important to them all nearly joined those dearly departed several weeks later.

Frank had been out buying groceries and was at the door of his wretched building on East 49th Street one evening when some young thugs demanded his money.[28] "So I gave them my wallet, but then they wanted my keys, and that was a bit much," Frank said, according to Kenneth Koch, to whom he later recounted the incident. Frank told them to "go rob somebody else" and ran up the stairs.[29] As he moved, he felt a sharp pain. Not stopping to investigate, he made it up five flights to his apartment and called the police. Paramedics and police arrived, B-movie style, in a flurry of flashing lights and blazing sirens.[30] Frank told them he had been stabbed, but an examination showed he was shot. Wrapped in his trench coat, he was placed on a gurney and whisked away to a hospital on Welfare Island that specialized in bullet wounds.[31] Frank's first phone call when he arrived there was to Grace, who raced to the hospital, where she found him lying on a thin hard bed in the hall waiting to be admitted to a ward. The bullet had entered near his right hip and couldn't be removed. "It was too close to a vital organ," Grace explained.[32]

Word sailed through the community that Frank had been shot. Gasps of amazement greeted the news as much because Frank had been the victim as because potentially deadly violence had once again hit so close to home. His poet friends and those who knew him best, however, weren't entirely surprised. Frank had a self-destructive streak that he masked with his optimistic demeanor. He seemed to taunt fate to see how far he could go and still remain in its good graces. "Frank really lived life. Which, as you know, is not so easy," said his friend Joe Brainard. "You can get hurt that way...it's hard to be that uninhibited."[33] Said Koch, "We all worried about him. He would get drunk and go to sleep in construction sites. He seemed to be careless about his safety."[34] During that period, Frank also had a penchant for picking up strangers—in bars, on the street, in the subway, in public toilets.[35] It seemed, however, that the young men who shot him had seen Frank only as a mark.[36]

Grace visited Frank every day, as did Jane Freilicher. (Jane brought him poems by Mallarmé, Grace movie magazines.) His poet friends, too, filled the hospital ward.[37] Those educated young men who lived on words formed a remarkable assembly in that facility, filled as it was with victims of crime for whom warmth and clean sheets were almost worth the price of admission. Having been assured that the bullet that remained lodged near his hip wouldn't interfere with his famous gait, Frank seemed almost chipper, as if hosting a private party.[38] Once discharged, he stayed with Larry in Southampton to recover, writing to Grace, "How is my favorite dancing singing and looking girl? Do you think this opening makes me sound like one of Teddy Roosevelt's Rough Riders?...Write me and think of me all the time, that's all I ask."[39]

In the wake of such violence, all the artists seemed to draw a little closer to one another. The outside world appeared hell-bent on interjecting itself into their circle. The only way the artists and poets could face it securely was together. Soon, even their absent friend Helen, who would suffer an emotional blow mightier than a bullet, would rejoin the pack.

By mid-March, Helen had found a new apartment, uptown, overlooking the Hudson on West End Avenue, where she could live *and* work.[40] The spot was nearly as far from her previous abodes as she could be while still residing in Manhattan. On 94th Street, she was miles north of the Village and Chelsea. On *West* 94th Street, she was the width of Central Park away from where she had been raised. While the distance might not seem significant, socially it was tantamount to a move to Newark. Her address left family friends aghast. Gossip spread that she was living on the West Side—with a man.[41]

In fact, Helen's rebellion *was* only geographical. She was not living with Clem. Her apartment was, intentionally, at great remove from his Bank Street flat. Though she had spent nearly every night with him at the beginning of the year, that had ended abruptly on February 7. By the spring, she appeared to be distancing herself from her lover, whose efforts to dominate her socially and intellectually were becoming troublesome.[42] They had met nearly four years before and Clem, now forty-seven, seemed happy enough to have their relationship continue forever as it was. Helen was not. Though they fought often, the logical step for someone of Helen's age and class would have been marriage, and Helen had suggested as much. Writing from Europe the previous July, she said, "I think we should get married in September." She even scouted honeymoon spots as she traveled.[43] But Clem was aware that Helen's mother disapproved of him because of his age, and he refused to discuss it.[44] By the time Helen moved to West End Avenue, the topic had become an irritant for her, too. She wasn't used to being told no. She was also not sure she wanted to be Mrs. Clement Greenberg. She would still see Clem, but she needed time to collect herself, alone. On March 15, she wrote Sonya,

> *The apartment is coming along, getting settled.... I have a great desire to get everything done at once, but of course one can't, so I am still curtainless, bookshelfless, and sitting on chairs borrowed from Jerry Cooke. Despite all this, I do love the apartment, feel cozy here, have started to paint in the studio.*[45]

Helen was painting furiously. One after the other, she pumped out works that tested new possibilities. She was not thinking about who might see them or what they might think. "I knew what they were," Helen said of her paintings, "that was enough audience."[46] She was in that blissful period when her art was *for herself alone*. Not for long, however. Johnny Myers came by to see her new place and what she was up to in the studio. Struck by what he saw, he immediately asked her to return to the gallery.[47] Helen accepted. Her initial decision to leave Tibor de Nagy had been in part due to exhaustion after a year of intense work and breakthroughs that might have taken another artist a lifetime. By the spring of 1954, she had clarity about her art and herself, a sense of independence that made her better equipped to stand her ground among her peers, who in fact seemed eager to be once again in her company. In early April, she and Larry began communicating: Helen brought a sculpture of his to her studio for safekeeping after an exhibition.[48] And, ahead of Helen's return to Tibor de Nagy, Grace went so far as to fire an epistolary shot at Clem that was spirited even by her standards. On April 1 she wrote:

Dear Clem,

John tells me he has asked Helen to return to the gallery. This increases the possibilities of meeting you socially, and I feel I must say a few words about the polemic that exists between us. I have no real quarrel with Helen. Each time I see her I am reminded of the affection I had for her, and it makes me sad.

Admittedly my attitude toward you is loaded way beyond the point of intellectual disagreement. I had unreasonable respect for you and your judgment. Plus whatever complications always exist between a man and a woman. Even understanding this, there is something to be said.

In your discussion of me and my painting I think you have been flagrantly irresponsible. You must know that your remarks have been repeated to me, and that I, helplessly fuming, hear you think I am "not even a painter." ...

Whatever opinion you have of my work, you must respect my seriousness and energy. When an artist presents a show he backs it up with his life. You are a coward because you back your words with more words. Conversation is not criticism.

I must ask you to "put up or shut up." To undertake in writing the responsibility of your ideas or to accept the consequences of "being condemned as frivolous" a "cocktail critic."[49]

No doubt, Clem would have dismissed Grace's letter as the rantings of a "hysterical" woman, but she spoke for many of the artists who had grown tired of Clem's pronouncements. A decade earlier, when he had begun his critical writing, Clem had attempted to learn from the artists what it was they hoped to achieve before he then wrote or commented on their work. It was an exchange based upon mutual respect along the lines of Baudelaire's observation that "the duty of criticism should be to seek to penetrate deep into the temperament and activating motives of each artist rather than to attempt to analyze and describe each work minutely."[50] By 1954, however, Clem trusted *his* intellectual judgment, *his* ability to understand art, *his* "eye" more than he trusted the judgment, the ability, or the eye of the artist at hand.[51] At that time, Grace was one of the few in her circle bold enough to take Clem on, using his weapon of choice — words. She wasn't as eloquent as she might have been, but news of her letter spread through the community and the younger artists especially nodded approvingly at her moxie.[52]

In a way, her letter was also a defense of Helen. Grace knew what Clem said about women who painted, and she had been distressed by it from a distance. How much more would Helen have withstood at such close range? *How could she?* Helen, it seemed, did what strong women (especially those as competitive as she) have done through the ages when faced with hurtful prejudice.[53] She tried to ignore it. "A woman has no place as an art-

ist until she proves over and over that she won't be eliminated," explained another veteran of that particular war, sculptor Louise Bourgeois.[54]

Helen returned to the gallery with a year's worth of new work, and a new apartment in which to entertain friends who happily made the journey uptown to bask in a bit of luxury. Helen also returned with an air of sophisticated confidence. It was as if she had left in Europe the remaining traces of the Bennington girl she had been. Helen was a more mature, independent young woman dedicated to her painting and acknowledged by her peers. But at just that moment, as had happened when she was a child of eleven, her charmed life came crashing down around her. On April 23, 1954, Helen learned that her fifty-eight-year-old mother—a woman who had been vibrant and vital, much like Helen herself—had committed suicide. Helen was away with Clem when she did so.[55]

As an older woman, Martha Frankenthaler was still ravishing, even appearing glamorous when surrounded by women half her age. "Tall and gorgeous," Fred Iseman said. "My father said she was one of the most attractive women he'd ever known."[56] Martha also enjoyed physical pursuits—like fishing or trudging alone through Central Park during snowstorms—activities that might not have been expected of the doyenne of an Upper East Side family.[57] But she had developed Parkinson's disease, and when it began to limit her ability to move and act, *to live*, not surprisingly it began to affect her mentally as well. Doctors and hospitals became her life. It was too much; it was not enough.

In February, Helen told Sonya that she had seen her mother and reported her "better."[58] But better under those circumstances was relative. In 1950s America, medical experts had no means by which to slow, let alone counter, the decline associated with that terrible disease. In mid-March, Helen's two sisters, Gloria and Marjorie, each left New York for a break with their husbands.[59] Helen had been left alone in the city with household staff to watch over the extended Frankenthaler family. While they were away, Helen's young nephew Peter developed meningitis and was hospitalized in critical condition. In a panic, Helen called her pregnant sister Marjorie back from the Virgin Islands to attend to her son. Soon Peter improved and things "calmed down," as Helen told Sonya. "What relief. This has been a winter of sickness and hospital visits for me!"[60] According to Clem's daily appointment diary, he and Helen had not seen each other from February 7 to April 20.[61] Between her family affairs, her new apartment, and her return to the gallery, she had apparently not had time for him. On April 22, however, Clem had a lecture scheduled in Albany and Helen agreed to join him on the trip.[62] This was where she was when she learned her mother had killed herself.

With Martha's tragic death, long-held resentments on the part of Helen's family surfaced. Her sisters believed that Helen had not done enough to help, that she was not present for the family, that she was selfish. Helen would have been aware of those accusations, even the anger, because in fact she was *not* there.[63] She could not be present in the way they would have wanted. Many years later, Helen heard a quote by poet Joseph Brodsky, who said, "No, a person who deals with such things has two subjects to handle: one is life and the other is art, and you cannot be successful in both. Sooner or later you realize that you must fake one." Helen told the woman who read her that quote that she agreed with Brodsky "One hundred percent!" But rather than "fake" life outside of art, Helen chose to accept that the "problem exists and try to handle it."[64]

> ...I think for a long time, for a number of reasons, very complicated...that I thought one could handle both and I learned that one can handle the *problem* of both; but cannot simultaneously, with equal love and gift, handle (the cliché) of a "full life" and make beautiful and original art. That's impossible....[65]

Still responding to the Brodsky quote, Helen explained,

> I think that if one is in the grips of the torment in the gap between art and life, that your very survival is threatened because you can't handle it. And rather than pretend, you will settle on just the art, or you will try to settle on just the life, which is impossible if you are a real artist....[66]

Helen was a real artist, hence her apparent remove. But how to explain that to a family ripped apart by grief? She could not.

The difficult funeral and official events associated with it ended by five p.m. on April 25, after which Helen and Clem had dinner alone.[67] At that time of loss, Helen may have hoped to find friendship if not comfort in Clem's company. But Clem, with nearly unimaginable cruelty, reacted to the news of Martha's desperate death by saying, "I never liked her anyway."[68] Out of all the words he had said to Helen, words that often demeaned who she was as a woman and an artist, those five echoed in her mind most damagingly. The seed that would destroy Helen's relationship with Clem was well planted and would grow over the coming months.[69]

Helen prepared to go to Europe again for self-restoration through travel and art.[70] "There's always something sort of gloomy about the Fourth of July spent in empty New York City," Helen wrote her poet friend Barbara Guest, who was in Reno arranging her divorce.[71] The entire art crowd except for Grace and Frank had pulled up stakes for the Hamptons. She

continued, "Saw Joan Mitchell last week. She reports Jackson broke his leg & ankle, drunk at de Koonings in Easthampton. The horrors of L.I.!"[72] Helen had been painting, and though she thought three or four of her pictures were good, she didn't think anyone else would like them. "They look quite ugly, really," she told Sonya in early July.[73] Helen's usual exuberance was gone, drained away. During a weekend with Clem at Woodstock, where he was lecturing, Helen described herself to Barbara as "sulky.... I behaved like a three year old, tired and cranky, and not getting enough attention.... I have a funny on and off rash on my face, general angst about leaving."[74] Helen had expected to travel alone, but by the time she wrote that letter from Woodstock Clem had decided—insisted—that he would accompany her on her trip.[75] He had long enjoyed believing he controlled her, but that summer Clem may have feared he was losing his grip.[76] Helen was back among her artistic compatriots, many of whom no longer feared or even particularly respected him, and she had inherited a substantial amount of money.[77] She did not need him. But he needed her.[78]

Clem had not been to Europe since 1939, before the war. Europe had become Helen's turf, and she led the way as they traveled through Spain, Italy, France, and England during two and a half months.[79] In fact, they traveled well together because they had a strong professional relationship that revolved around art. (Clem would say he most enjoyed Helen's company while looking at paintings.)[80] Their itinerary was quintessential Helen, keeping them busy nearly from dawn to dawn. In Madrid, where they stayed at the Ritz, they visited the Prado, dined at the Jockey Club, danced until 1:30 a.m., went back to the Prado in the morning, relaxing with champagne in their room before returning to the museum, and then on to a bullfight.[81] On August 2, they arrived in Rome, took in the sights of the Eternal City, rented a car, drove to Naples (with side trips to Capri and Pompeii), Salerno, Positano, and finally, Florence.[82] That city mesmerized Helen with its riches. "The Uffizi really has every museum beat," she wrote Sonya.[83] And if the art on its walls weren't enough, Helen and Clem had tea with the legendary historian of Renaissance art Bernard Berenson at his summer villa in nearby Consuma. "He is really fantastic. He's so old that the sense of his age really penetrates the atmosphere," she told Sonya of the eighty-nine-year-old scholar. "I don't mean at all that he's doddering, but he has such a manner! Actually, he's very energetic, witty, bitter, & very much alive." Helen was surprised to find in Berenson's study copies of *ArtNews* and to learn that he had been following the development of art in New York.[84]

One of the curious discoveries Helen made during her trip was just how closely her small world in New York was watched by those in Europe. Helen felt alternately like a feted ambassador from an exciting capital and a

scientist offering a progress report on a groundbreaking experiment. "All the English painters (French too) dote on 'the word' from America," Helen explained. "They really look to us, for the 1st time in history."[85] In Venice, the U.S. Pavilion at the Biennale was generating great debate. The Modern had organized the U.S. entry, and Bill had been given two rooms to display his work. While Helen didn't think the show his best, and she was appalled that another artist in the U.S. Pavilion was the social realist Ben Shahn, she said that none of the other countries' offerings were better.

"More interesting in Venice is Peggy Guggenheim's palazzo on the Grand Canal," Helen wrote. "She is as strange as she's cracked up to be: generous & selfish, attractive & ugly, interesting & boring."[86] Though Clem had known Peggy in the 1940s, Helen had been a child during Peggy's reign in New York. Their encounter in Venice was their first, and they got along famously, so much so that when Clem and Helen left for Milan, Peggy traveled with them.[87]

Europe always revived Helen, in part because she was under no obligation to remain anywhere or with anyone she found unpleasant. She had the energy and the means to alight where she wished, when she wished. Generally, she returned to the States reluctantly, and the fall of 1954 was no exception. Writing Sonya on October 15 after an unpleasant journey across the Atlantic, Helen said,

> New York is so ugly, <u>hot</u>, and frantic, I hate being back. It's taken three days to really feel that I'm home again.... It was either a matter of staying on, in London or Paris, for a long time or getting the hell home. The latter path was taken, obviously.[88]

That season's reentry was particularly difficult because Helen returned to face the sadness and pain that she had tried to escape abroad. Having been away only made the anguish more acute. One Sunday afternoon, not long after she had returned, she met John Myers for a beer. "Although she was considerably shaken by her mother's suicide, Helen's essential seriousness was fortified by a strong will and huge ambition," he wrote years later, recalling that autumn, which was why he was surprised by what she told him that day. "I have the very strong feeling," she said, "that it is unlikely that I'll live past thirty-five." Helen was only twenty-five "and already had a sad view of life."[89] It was a side of herself that she rarely allowed the world to see and a sign of the trust she had in Johnny Myers that she allowed him to look under the veneer of her radiant, often hilarious public persona.

Almost immediately, she set about burying her melancholy in manic activity. Two weeks after her return from Europe, Helen told Clem she

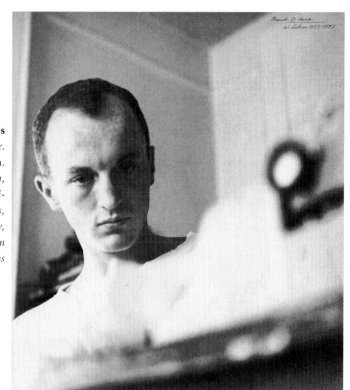

Frank O'Hara, ca. 1950s
Walter Silver, photographer.
The Walter Silver Collection.
Copyright Photography Collection, Miriam and Ira D. Wallach Division of Art, Prints and Photographs, the New York Public Library, Astor, Lenox and Tilden Foundations

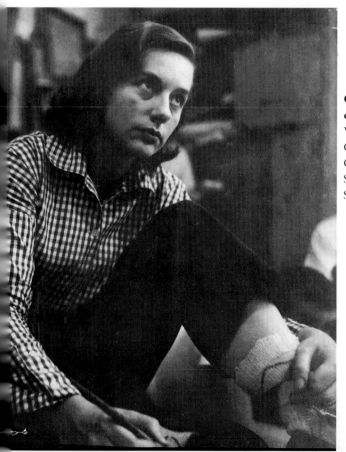

Grace Hartigan sketching, ca. 1952
Walter Silver, photographer. Grace Hartigan Papers, Special Collections Research Center, Syracuse University Libraries, Syracuse, New York.

Dorothy C. Miller, ca. 1938
Soichi Sunami, photographer.
Dorothy C. Miller Papers,
Archives of American Art,
Smithsonian Institution,
Washington, D.C.

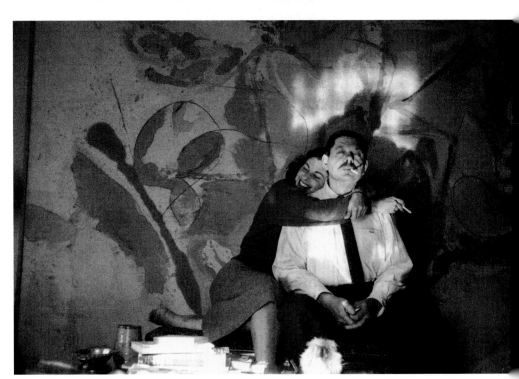

Helen Frankenthaler and David Smith in front of *Mountains and Sea* (1952), in her West End Avenue apartment, 1956
Burt Glinn, photographer.
Courtesy Magnum Photos. Artwork copyright 2018 Helen Frankenthaler Foundation, Inc. / Artists Rights Society (ARS), New York

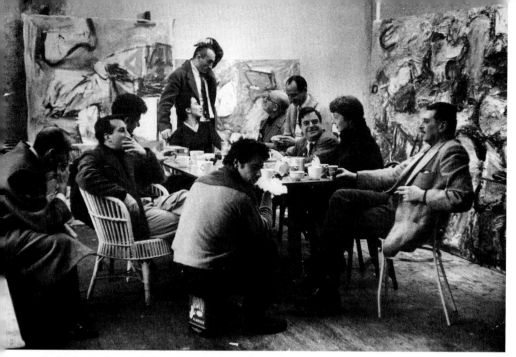

Artists' meeting at Milton Resnick's studio on Tenth Street
Clockwise from center foreground: Al Leslie, unknown artist, James Rosati, Giorgio Spaventa, Pat Passlof, Milton Resnick (standing), Earl Kerkam, Angelo Ippolito, Lutz Sander, Elaine de Kooning, and Al Kotin. James Burke, photographer.
The LIFE Picture Collection, Getty Images

Grace Hartigan with self-portrait, 1953
Walter Silver, photographer. Grace Hartigan Papers, Special Collections Research Center, Syracuse University Libraries, Syracuse, New York.

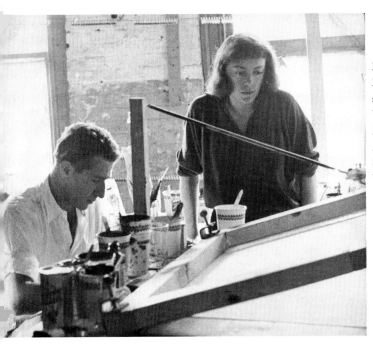

Mike Goldberg and Joan Mitchell at Tiber Press studio, ca. 1958
Walter Silver, photographer. Michael Goldberg Papers, Archives of American Art, Smithsonian Institution, Washington, D.C.

Grace Hartigan painting *The Bride and the Owl*, ca. 1954
Walter Silver, photographer. Grace Hartigan Papers, Special Collections Research Center, Syracuse University Libraries, Syracuse, New York.

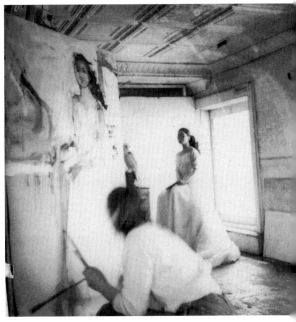

Elaine de Kooning with basketball painting, ca. 1950s
Walter Silver, photographer. The Walter Silver Collection. *Copyright Photography Collection, Miriam and Ira D. Wallach Division of Art, Prints and Photographs, the New York Public Library, Astor, Lenox and Tilden Foundations*

Joan Mitchell and dog, Georges de Soleil, in East Hampton, New York, ca. 1953
Barney Rosset, photographer. Barney Rosset Photographs, Joan Mitchell Foundation Archives, New York. *Copyright Joan Mitchell Foundation*

Grace Hartigan and Frank O'Hara, ca. 1954
Walter Silver, photographer. The Walter Silver Collection. *Copyright Photography Collection, Miriam and Ira D. Wallach Division of Art, Prints and Photographs, the New York Public Library, Astor, Lenox and Tilden Foundations*

Jean-Paul Riopelle, 1963
Heidi Meister, photographer. Joan Mitchell Papers, Joan Mitchell Foundation Archives, New York. *Copyright Heidi Meister*

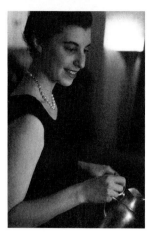

Helen Frankenthaler in her London Terrace apartment in New York City, ca. spring 1951
Jerry Cooke, photographer. Helen Frankenthaler Papers, Helen Frankenthaler Foundation Archives, New York. *Copyright 2018 Jerry Cooke Archives, Inc.*

Grace Hartigan at *12 Americans* opening, 1956
Walter Silver, photographer. Grace Hartigan Papers, Special Collections Research Center, Syracuse University Libraries, Syracuse, New York.

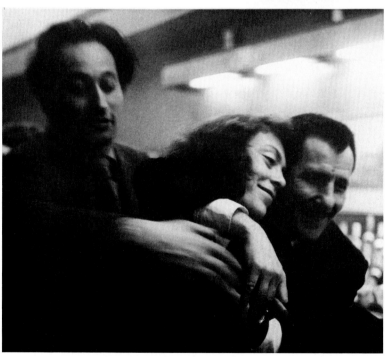

From left: Norman Bluhm, Joan Mitchell, and Franz Kline at the Cedar Bar, ca. 1956
Arthur Glenn Swoger, photographer. Thomas Hess Papers, Archives of American Art, Smithsonian Institution, Washington, D.C.

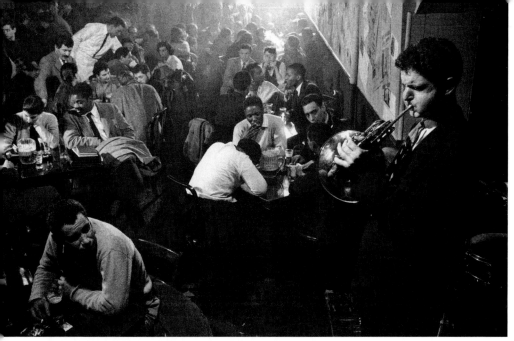

David Amran playing at the Five Spot, 1957
Burt Glinn, photographer.
Courtesy Magnum Photos

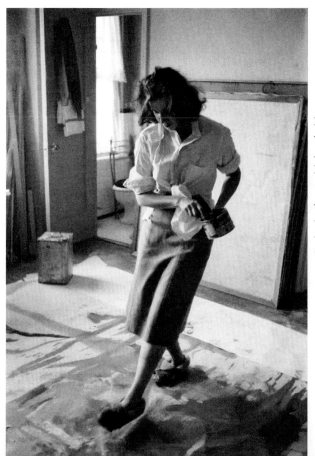

Helen Frankenthaler working in her West End Avenue studio, 1956
Burt Glinn, photographer.
*Courtesy Magnum Photos.
Artwork copyright 2018 Helen Frankenthaler Foundation, Inc. / Artists Rights Society (ARS), New York*

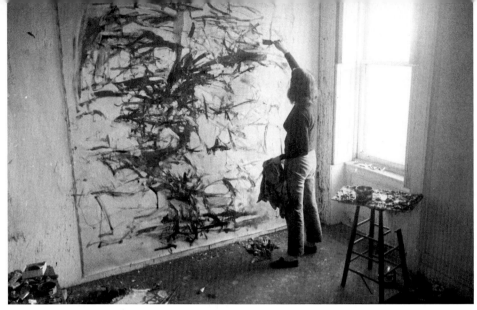

"Mitchell Paints a Picture," for *ArtNews*, 1957
Rudy Burckhardt, photographer. Joan Mitchell Papers, Joan Mitchell Foundation Archives, New York.
Copyright 2018 the Estate of Rudy Burckhardt / Artists Rights Society (ARS), New York

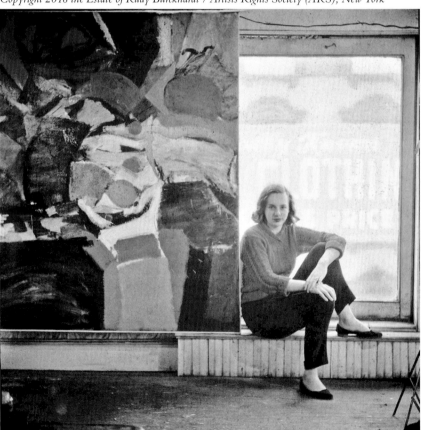

Grace Hartigan in her Essex Street studio for *LIFE* article "Women Artists in Ascendance," May 13, 1957
Gordon Parks, photographer.
The LIFE Picture Collection. Getty Images

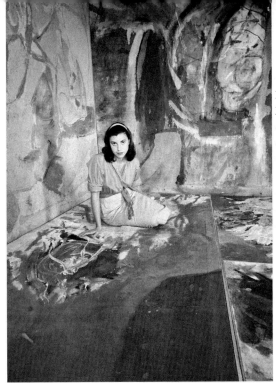

Helen Frankenthaler in her West End Avenue studio for *LIFE* article "Women Artists in Ascendance," May 13, 1957
Gordon Parks, photographer.
The LIFE Picture Collection. Getty Images. Artwork copyright 2018 Helen Frankenthaler Foundation, Inc. / Artists Rights Society (ARS), New York

Joan Mitchell in her rue Daguerre studio in Paris for *LIFE* article "Women Artists in Ascendance," May 13, 1957
Loomis Dean, photographer.
The LIFE Picture Collection. Getty Images

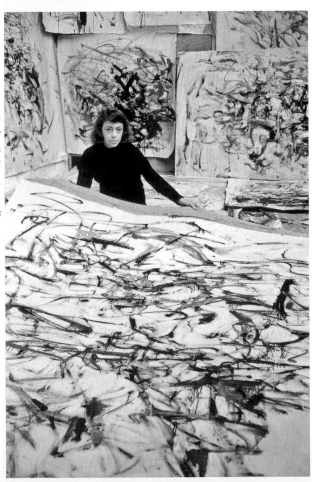

Elaine de Kooning and Herman Cherry, East Hampton, New York, 1957
Ibram Lassaw, photographer.
Copyright Ibram Lassaw, Ibram Lassaw Estate

The Five Spot, 1957
Rear table, clockwise from left: Helen Frankenthaler (holding drink), David Smith, Frank O'Hara, Larry Rivers, Grace Hartigan, Sidney Rolfe. Burt Glinn, photographer.
Courtesy Magnum Photos

From left: Joan Mitchell, Helen Frankenthaler, and Grace Hartigan at Helen's solo exhibition opening at Tibor de Nagy Gallery, New York, February 12, 1957
Burt Glinn, photographer.
Courtesy Magnum Photos. Artwork copyright 2018 Helen Frankenthaler Foundation, Inc. / Artists Rights Society (ARS), New York

Helen Frankenthaler and Robert Motherwell on their honeymoon in Saint-Jean-de-Luz, France, summer 1958
Photographer unidentified.
Helen Frankenthaler Papers, Helen Frankenthaler Archives, New York.
Courtesy Helen Frankenthaler Foundation, New York

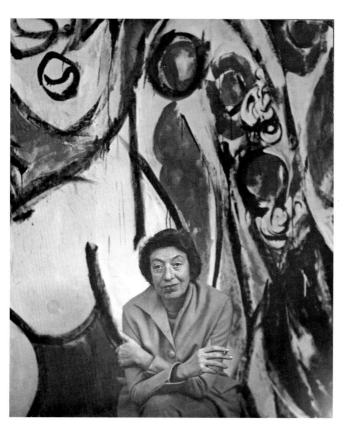

Lee Krasner in front of her painting *The Seasons*, ca. 1957
Hans Namuth, photographer.
Jackson Pollock and Lee Krasner Papers, Archives of American Art, Smithsonian Institution, Washington, D.C.
Copyright 1991 Hans Namuth Estate. Artwork copyright 2018 the Pollock-Krasner Foundation / Artists Rights Society (ARS), New York

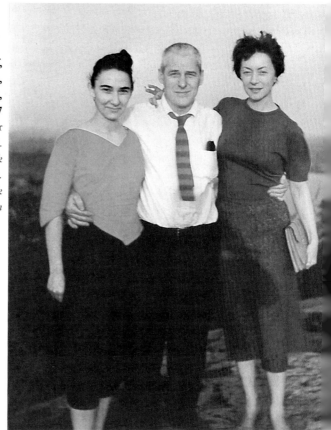

From left: Pat Passlof, Willem de Kooning, and Elaine de Kooning, 1957
Photographer unidentified.
Courtesy the Milton Resnick and Pat Passlof Foundation. Copyright the Milton Resnick and Pat Passlof Foundation

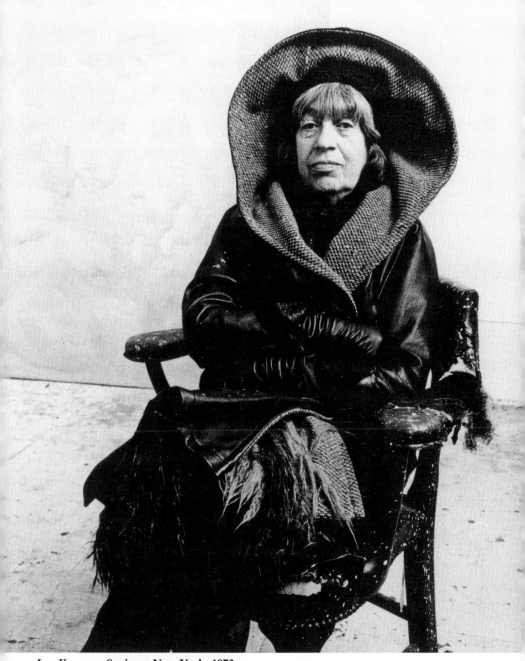

Lee Krasner, Springs, New York, 1972
Irving Penn, photographer. The Jackson Pollock and Lee Krasner Papers, Archives of American Art, Smithsonian Institution, Washington, D.C.
Copyright the Irving Penn Foundation, New York

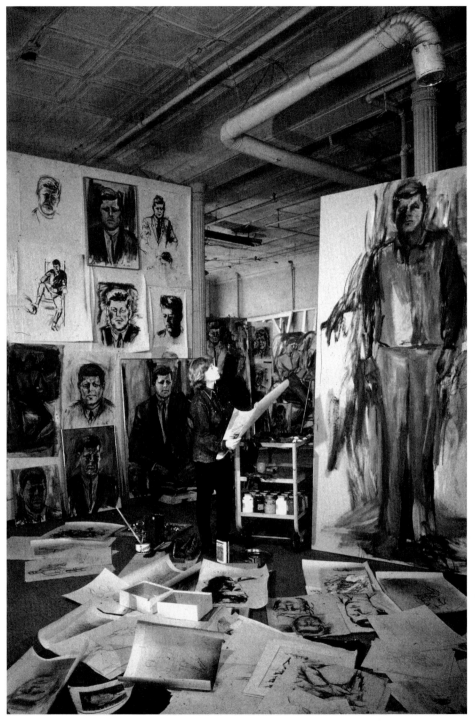

Elaine de Kooning in her studio with John F. Kennedy paintings, ca. 1963
Alfred Eisenstaedt, photographer.
The LIFE Picture Collection. Getty Images.

Grace Hartigan in front of her Fells Point studio in Baltimore, 1990
Walter P. Calahan, photographer. *Copyright 2017 Walter P. Calahan. Courtesy Walter P. Calahan Photography, Inc.*

Joan Mitchell walking with her dogs at Vétheuil, France, 1984
Édouard Boubat, photographer. Joan Mitchell Papers, Joan Mitchell Foundation Archives, New York. *Copyright the Estate of Édouard Boubat*

Helen Frankenthaler in front of *Guiding Red*, first shown at Expo '67, Montreal, then later at the World Trade Center II, New York, from 1977 to 1978
Dan Budnik, photographer. Helen Frankenthaler Papers, Helen Frankenthaler Foundation Archives, New York. Artwork: *Guiding Red,* 1967, acrylic on canvas, 30 by 16 feet.
Photograph copyright Dan Budnik, All Rights Reserved. Painting copyright 2017 Helen Frankenthaler Foundation, Inc. / Artists Rights Society (ARS), New York. Photograph courtesy Helen Frankenthaler Foundation, New York.

wanted a trial separation.[90] Next, she arranged with John the dates of her third solo show: November 16 to December 4. The old Helen was back. "One reason, I think, is because I jumped into the business of a show right away," she wrote Sonya,

> *& that puts you in contact with very New Yorkish attitudes and events.... Getting these damned envelopes addressed, having "Art News" jerkies come here & review the show, stretch two large canvases & other dirty chores. But I look forward to the exhibit & feel some of the paintings are good. I expect that many people will find them "ugly" or shocking, or won't get them at all.*[91]

That wasn't a concern, however. It was a badge of honor. If critics, collectors, and the general public, which had begun ever so tremulously to venture into exhibitions of avant-garde art, didn't understand or like her work, she could live without them. She was a species apart. Helen had seen others like herself on the walls of museums across Europe. She and her fellow painters formed part of a hallowed tradition. That was, in any case, the face Helen presented to the world, and it was what she had to believe to continue. In private moments, she struggled in the valley between doubt and dreams. If only one truly could exist solely in one's work. If only there were no internal regrets or external recriminations. If only life did not impinge.

42. The Red House

Let's play it all the way—you live & I'll live—going to be a fucking long tennis game.

—*Joan Mitchell*[1]

WITH THE VISIT by Bill's mother looming, Elaine assessed their combined finances and determined that she and Bill had three hundred dollars between them on which to survive the summer.[2] The sum was paltry even by their standards and would most certainly not cover the expenses related to Oma's extended stay. Over the years, when letters from his mother arrived, Bill invariably tossed them aside, saying, "She never wants to let go." And, just as invariably, Elaine retrieved the discarded missives and wrote her own in reply, filled with news of their life and invented messages from Bill.[3] Because those letters were largely creations of Elaine's vivid imagination, whose subject was an artist she revered, they no doubt made Bill's success seem material as well as creative and their life together one of harmony and cheer. Now the mother Bill still feared would be apprised of their true situation unless, of course, something remarkable happened.[4] And in a way, it did. Lutz Sander learned of a one-hundred-year-old, oxblood-red house in Bridgehampton available for six hundred dollars for the season.[5] If the de Koonings, Lutz, Franz, and his girlfriend Nancy Ward all pitched in on rent, food, and alcohol, it would be cheaper than staying in the city. It would also, Bill and Elaine agreed, relieve them of the difficulties associated with Oma's possible residence in Bill's Tenth Street studio. They accepted, and immediately went to Long Island to see the soon-to-be infamous Red House.[6]

The place was enormous and seemed even more so because it didn't contain a "stick of furniture," Lutz said. It also had troublesome plumbing. "There wasn't enough water, ever, to take a bath on the second floor—just enough to flush... with so many people in the house, that one john upstairs didn't flush too well."[7] (An outhouse helped ease the bathroom congestion.) Inadequate plumbing, however, seemed a minor concern compared with the home's potential. It was perfect. The housemates set to work establishing a comical order to their new lives. Lutz agreed to cook, Elaine offered herself as salad maker, Bill said he'd do dishes, and Franz volunteered to watch Bill toil at the sink.[8] Next, Elaine, Lutz, and Franz claimed studios in three rooms on the first floor, while Bill chose the garage for his

work space.⁹ That left a parlor, dining room, kitchen, five bedrooms, and an attic vacant. A call went out for donations of furniture.¹⁰ "Everyone seems to be loaning a little something," Frank wrote Larry. Bill "was delighted that I'd help him move it around, since he thinks one has to have a particular temperament to move furniture and be happy doing it."¹¹

The donations appeared designed to create less a living space than a set for a performance piece. "We had a mixture of the best and the worst. For instance, we had sterling silver sconces to hang on the wall, and our only chairs were folding chairs." The legs of the dining table they received had been shortened to make the table the correct height for children. "It was a full thing with leaves and everything," Lutz said, "you could pull it way out." But an adult could not sit at the table with any degree of comfort. Like the plumbing, however, the table wasn't a deterrent to their enjoyment of the place. "Sometimes there'd be fifteen for dinner," Lutz recalled, adding, "well, it was a meal of some sort."¹²

As the house took shape, the group decided that the wallpaper clashed with their eclectic furnishings, so they covered the walls with graph paper Philip Pavia had found in New York.¹³ For entertainment, a friend loaned them a television that broadcast one channel, which featured mostly Charlie Chan movies. Like children, they whooped in delight, appreciating not only the comedy but the fact that the actors' figures were often elongated into abstractions due to the poor reception.¹⁴ The result of all that domestic activity was that by the time Bill's mother walked off the ship that carried her from the Netherlands to New Jersey, the house was fully, however bizarrely, equipped and awaiting her.¹⁵

A small, round woman with white hair and crystal-blue eyes came toward the strangers assembled to meet her at Hoboken, one of whom was her now grown son. "She's only five feet tall, but to me she looms ten," Bill whispered to Elaine and her sister, Maggie, who formed the greeting party.¹⁶ It was hard to imagine why. Oma appeared the picture of maternal love. Because she only spoke Dutch, few besides Bill were the wiser as to her true personality. "Everybody thought she was wonderful," said Joop Sanders.¹⁷ Elaine, however, had heard Bill's stories of violence and neglect at the hand of that seemingly harmless woman. And, knowing the years of resentment that had built up inside him, she was fully prepared for an eventual eruption. In the meantime, however, their friends provided a salutary buffer between volatile mother and resentful son. Lutz spoke to Oma in German and a smattering of Dutch he had picked up during the war, and Franz invented a language that became known as "Kline Dutch." *"Passen die budder, please.... Wansen ein bier?"*¹⁸ His every attempt at communication was greeted with wild hilarity. Even Oma appreciated the joke.

Quickly she found her place within that eccentric household, sharing cooking duties with Lutz, and awaking each morning at six to scrub the stairs.[19] That was the source of one of her early quarrels with Bill. "Mrs. De Kooning wanted one thing: a scrub brush with which to wash the stairs," recalled Pat Passlof. "Bill let it be known in no uncertain terms that she wasn't going to get one."[20] Oma prevailed. But rather than be quelled by her victory, the quarrels continued. Elaine's brother Conrad said that, on one occasion, Oma threw a full cup of coffee at Bill's head.[21] Far from horrifying the Red House residents, those familial dramas made the place seem more like a home. Said Joop of Bill's mother, "She fitted in beautifully in one sense."[22]

Conveniently located as it was on Montauk Highway, the main road coming into the Hamptons, the Red House was easy to find. And soon it became party central. Elaine said the house "attracted people like a little pile of honey attracts flies."...

> It was a kind of pleasant but nightmarish summer, parties every night, entertaining in the way a nightmare could be entertaining, if you know what I mean....I mean a tremendous amount of social life. An artist needs his isolation even if you enjoy people's company: There is such a thing as too many friends, too much talk, too much booze, too much of a good thing. These are problems of the City and the City was brought to the Red House in Bridgehampton.[23]

But not immediately. At the start, the antics involved innocent fun. "We played a lot of croquet," said Lutz.[24] And softball. Elaine lived large in people's memories for being able to run the bases—and score—in heels, and for a prank that became legend.[25] She had stayed up one night carefully painting two grapefruit white with black stitching, and adding a replica of the Spalding trademark. The next morning, as Philip Pavia strode to the batter's box, Franz, who was catching, walked out to the pitcher (Esteban Vicente) and exchanged the ball for a grapefruit. Everyone was in on the joke except Philip, who positioned himself for a swing as Vicente hurled the object toward him. The bat connected and the grapefruit splattered, perfuming the air with the scent of citrus. Good joke, very funny. Philip now prepared to swing at the real ball, as Vicente wound up and threw. Philip made contact and again a grapefruit burst in the air. "All right," Pavia said, as he looked out over the infield where the players wandered weak-kneed from laughter and out to center field, where Bill was doubled over, shaking with delight. "Let's play."[26] The game proceeded uneventfully but was never forgotten.

* * *

One of the flies seeking Red House honey was Pollock. Since he had begun drinking again at the end of 1950, he had proclaimed each year to be his worst ever, and yet sadly it was always topped by the next. Nineteen fifty-four Jackson hovered just above rock bottom. By the end of the year, he would finish only one painting, and he hadn't sold a single work from his February show at the Janis gallery.[27] After surveying the ten paintings on Janis's walls, Clem shook his head and told the friend he had once declared a genius that he'd "lost his stuff." Pollock responded with a half promise, half warning: This time, he told Clem, "he wasn't going to come out of his drunk."[28] Lee said he went to the barn every day and lit a fire in the old stove, hoping that would be the day he would be inspired to paint again.[29] It never happened. Defeated and full of rage at himself, at the people who demanded too much from him, at his wife who some of the men in their circle grumbled had pushed Pollock too hard, he returned to the house at dusk seeking the consolation he could count on from a bottle.

Luckily for Lee, she became friendly during that difficult year with a twenty-six-year-old woman who had moved from Paris into a remodeled barn in Springs with her husband and two young children. Patsy Southgate was a writer whose husband, Peter Matthiessen, had cofounded the *Paris Review*.[30] Now settled on Long Island, she had pushed her baby stroller up Fireplace Road to meet the neighbors. One of them was Lee, whom she found "in a state of collapse."[31]

> I took Lee's side strongly from the point of view that This Woman Is Not Being Treated Fairly. I mean literally, Lee had two pairs of britches to her name, was trapped in the house, and didn't know how to drive. Jackson didn't want her to, but he had mobility. He would go off, had his large studio, this person making delicious food, and pretty much what he wanted.[32]

Patsy initiated a mission to save Lee, visiting her almost every day and teaching her how to drive in exchange for painting lessons. Soon it became clear that Patsy couldn't paint, and she gave up trying. Lee couldn't drive, but she persevered.[33] After a few attempts, she passed her driving test and got her license. "She was liberated: She could go shopping, see friends, be on her own," Patsy said. "Jackson didn't like my teaching her at all; if you give people a car and a license, they have independence. I don't think he wanted that."[34] Patsy was uniquely qualified to confront Jackson on Lee's behalf. Tall and willowy, she was described by one writer as "blond to her eyelids" and by Frank as the "Grace Kelly of the New York School."[35] With "cornflower blue eyes" and a scrubbed complexion, she was so fresh,

so naturally stunning that she was disarming.[36] She was also a mother, a species Jackson revered. Before her, he stood defenseless. Though he didn't approve of her interventions on Lee's behalf, he didn't interfere to stop her. Patsy changed the dynamics in the Pollock home. Lee had the excitement of her studio, where she was still engaged in collage, and now she had an expanded social life, thanks in part to a young woman who, far from pitying Lee, came to look upon her as a role model.[37]

Patsy worked at a new bookstore in East Hampton, the House of Books and Music, which was run by Don and Carol Braider.[38] They had supplied much of the furniture for the Red House and had become friendly with the artists who migrated to the area for the summer.[39] At a party at Ossorio's, Joan and Alfonso had persuaded the Braiders to use a small carport next to the shop as a gallery featuring art by the summer émigrés—among them, Bill, Elaine, Franz, Joan, Larry, and Conrad Marca-Relli—whose works would be on offer for less than three hundred dollars apiece.[40] The Braiders did, and with Patsy's help, Lee arranged a one-day solo show there on August 15.[41] It would be the briefest of exposures at the smallest of venues, but an important step because it would be Lee's first solo appearance since her disastrous Betty Parsons show three years earlier, and also because the audience would be almost exclusively her fellow artists. Lee's health had deteriorated—stress had developed into ulcerative colitis—but she was working and developing a circle of friends who appreciated her as Lee Krasner rather than as Mrs. Jackson Pollock.[42] Sometimes, she even felt free.

With Lee thus occupied, Jackson was left on his own to prowl the neighborhood in his Model A. One day in June, Elaine was alone in the Red House and heard the sputtering sound of Pollock's jalopy outside. When Jackson came in, she told him that Bill and Franz had gone to the Braiders' bookstore with some of the stock Don and Carol stored in the basement of the Red House. Pollock helped himself to a beer and offered to carry books upstairs, but Elaine, afraid he'd break something, told him it wasn't necessary. Maybe he was irritated that she didn't trust him to lend a hand, maybe he had decided to take out his troubles on the wife of his rival, maybe he was plain bored. Whatever the reason, Jackson challenged Elaine to what he called a wrestling match.[43] It was his latest imbecilic attempt at seduction. "I hated Pollock," said Mary Abbott, who had herself been attacked by him. "His way of making friends was to knock you down and get on top of you."[44] Elaine had witnessed the assault and remarked at the time how well the petite Mary managed to fight him off. "A remarkably strong girl, she held her own," she recalled.[45] But Elaine wasn't about to let Pollock test her strength in a similar position. She ran. "I was very impressed by the top of his eyes," Elaine said. "They were very straight...like a bull ready to charge."[46]

He was kind of drunk and he was chasing me all through the house. And that was also an act because I personally never thought Jackson was interested in women.... So he was chasing me around and I called Bill at Don Braider's bookstore... and Bill and Franz came over and threw their arms around Jackson. They all began to horse around.... Suddenly Jackson was on the ground with his ankle broken. Jackson was absolutely indignant. He said he had never broken a bone.[47]

Carol and Don Braider, who had driven Franz and Bill back to the house, loaded Jackson, cursing and writhing in pain, into their station wagon and took him to the East Hampton clinic. Once there, he proceeded to insult the unfortunate duty nurse with a medley of obscenities.[48] It was left to Philip Pavia and Franz to take Jackson home, but they were so terrified of Lee's reaction that they left him next door at Marca-Relli's.[49] Their instincts were correct. When Lee learned what happened, she stormed across the field, livid. "I know those people, they're trying to kill him, they're trying to kill him," she repeated, threatening to call the police.[50]

Jackson was immobilized. Even if he had wanted to, there would be no dancing around a canvas for the immediate future. "I've been watching flies in the studio, the way they try to get out of spiderwebs and never make it," he told Jeffrey Potter. "Like me, they push right to the edge... that edge where death is. All you know about is death in the War, not *dying*. There's no death in dying—it's all pain."[51] Through June and into July, Jackson did virtually nothing. He smoked cigarettes, grew a beard, and developed a paunch from too much beer and too little activity.

Lee became ever more furious over the fact that Jackson did not even make a pretense of trying to paint and also over the incident that had put him in that sorry state. That his accident had occurred at the de Koonings' was unbearable. "Around Lee we were taught nothing but derogation of de Kooning; she knocked him all the time," said her friend Cile Downs.[52] For his part, Jackson didn't criticize Bill, though he appreciated Lee's spunk in doing so. "What's good about Lee is she doesn't take any shit from anybody—even me," he told Potter.[53] Lee was strong, especially when angry, but Cile could see in her figure, which had been made gaunt by illness, that the constant fighting, the constant financial struggle, the constant uncertainty had taken an alarming toll.[54] Everyone assumed Jackson was out to kill himself, but her friends recognized that it was Lee who risked dying.

Before Jackson appeared at the Red House hoping to "wrestle" Elaine, he had been drinking gin at the Bossy Farm cottage, which Joan, Mimi Schapiro, and Paul Brach had rented that summer near the Pollocks' house.

("We feel almost responsible" for Jackson's condition, Mimi told Grace.)[55] Joan didn't arrive until the third week of June, after the incident.[56] The previous year, Mike had been part of the Rose Cottage ménage, but this season Joan arrived solo to take up residence in a duck shed behind the main house. The landscape—fields dotted with wildflowers and surrounded by trees—set Joan's heart racing and her hands reaching for her brush. With her poodle, George, at her feet, Bach on the "machine," a shot of gin at hand, and a small blue car to help her escape when she needed to, she began to work.[57] But she did so haunted by a sense of dislocation. "I feel on the edge of my life and I'd like to get back into it," she wrote Mike.[58]

Joan felt unloved and alone. Her relationship with Mike had devolved into near-continual antagonism. Earlier that year, Mike had met a playwright and poet named Bunny Lang at a costume party given by Larry. Within a very short time, the two decided to marry.[59] Joan, who was far from monogamous, had no interest in that kind of relationship with Mike, but she had confided to her mother that she dreamed of having "one small child."[60] Whether she envisioned Mike as the father was unclear, but his publicly declaring himself attached to another reawakened Joan's interest in him. It was similar to her reaction to Barney's courtship of Loly.

In fact, that summer was a continual nagging reminder of Barney's seemingly idyllic new life. Barney and Loly had purchased Motherwell's place near Castelli's in East Hampton, which became another center of frenetic social activity. "We found ourselves in the midst of a wonderful social scene," Barney recalled decades later. "I've never experienced anything like it before or since. It was not quite the Cedar Bar, but it was as if the bar had suddenly added several new layers of personality."[61] Though Joan had stopped pretending she was interested in being Barney's wife, that did not minimize the pang she felt in speaking with him about his work (he had signed a contract to publish Beckett) or hearing him express rare contentment with his lot.[62]

Amid all that happy coupling, Joan also feared that her favorite poet, Frank, would be lost to her. Bunny had been Frank's first lady love in 1949 at Harvard, and Frank was smitten with Mike.[63] To Joan's mind Mike, Bunny, and Frank formed a tangled threesome of fierce creativity and intense sexuality from which she was excluded. In what she called a "letter from a duck shed," Joan wrote Mike, "I would like to be loved or destroyed by you but not left crippled like an insect."[64]

It's unlikely that Joan would have liked Bunny even if they had met under other circumstances, but she might have secretly admired her quirky strength and independence. The youngest of seven girls, Violet Ranney Lang was born to a Boston Back Bay family that clung to its gentility while

growing noticeably short of the cash required to support such a life.⁶⁵ Perhaps being part of a family that pretended to be something other than what it was instilled in Bunny a theatrical bent. She didn't dress, she wore costumes: hair extensions, fake curls of many colors, falsies, false eyelashes, artificial fingernails, theatrical makeup, men's cotton jerseys or sweatshirts, torn blue sneakers that showed her garishly painted toenails, and an old trench coat that had once been white but was "soiled to brown" and so threadbare it no longer repelled the rain. Or, alternatively, under the same trench coat, she might be sheathed in a strapless evening gown or barely covered in a nightie.⁶⁶ Bunny was "rather heavy, with firm, fair, heavy flesh. Her hands were broad, with short fingers.... There was something childish too in the full pout of the mouth and the placing of the rather round eyes," wrote her friend and biographer Alison Lurie.⁶⁷ "To be with Bunny was like alcohol: at first exhilarating, but in the end destructive."⁶⁸

After attending the University of Chicago and serving in the Canadian Women's Army Corps during the war, by the age of twenty-six Bunny was published in Joan's mother's *Poetry* magazine and the *Chicago Review*.⁶⁹ In 1950, she would become the only woman in the avant-garde Poets' Theatre in Cambridge, Massachusetts.⁷⁰ Recognizing her limitations onstage, Bunny focused on writing plays. And to earn money, she took a series of jobs that satisfied her theatrical tendencies. Using invented names and clad in appropriate costumes, she worked as a journalist, a bridal consultant, and most famously as a chorus girl at a burlesque house.⁷¹ In January 1954, arriving in New York, where her play *Fire Exit* was being performed at Johnny Myers's Artists' Theatre, she stayed with Frank on 49th Street and met his circle of friends.⁷² One of them was Mike, and the two became lovers.⁷³ Bunny returned home to Boston in March, announcing that she planned to move to New York to marry a Jewish painter who worked in a box factory.⁷⁴ Preparing for her latest role, she wrote Mike, "You are going to be very pleased with me, I am going to be a joy and a delight to you and keep the bathroom exquisitely clean and keep the icebox full of iced fruit with brandy on it."⁷⁵

Bunny's companions weren't surprised by her announcement until they met the man himself in April when he came to Boston to ask Bunny's anti-Semitic father for her hand. Friends were perplexed by Bunny's attraction to him. "He said almost nothing at all and moved everywhere with a quiet, catlike walk" in paint-spattered sneakers. Though there were enough chairs to accommodate everyone, he chose the floor, where he sat cross-legged. Asked what he thought of Boston, Mike said, "I think it is very ugly." He exuded a sense of "suppressed violence" that Lurie noticed made Bunny nervous. The couple left the gathering early and as they did, "he propelled her in front of him with his hand on her neck, as is seldom done

in Cambridge, and she let him do it." Mike's talk with Bunny's father went even less well. Mr. Lang refused to countenance their engagement. The lovers left Boston immediately, returning to New York intent on marrying anyway.[76]

Bunny had been ill since the previous summer with what physicians in Boston thought was pleurisy. That spring in New York, a doctor told her she didn't have pleurisy, she had Hodgkin's disease and needed radiation treatment. Bunny was dying.[77] Rather than sympathizing with or comforting her, Mike dispassionately told her he couldn't handle illness and broke off their relationship.[78] That, however, was not the end of their affair. Through the late spring and early summer, while Joan was in East Hampton, Mike and Bunny (often with Frank as mediator) carried on a blistering epistolary and telephonic exchange during which neither was prepared to let go or give in. By summer's end, Bunny had tired of the drama, declaring the situation "feeble and psychopathic."[79] She sent Mike an angry letter calling him a "pig" and threatening to "write a long letter to *ArtNews* or *Time* denouncing non-figurative painting and sign your name."[80] Next she shut herself up for a month to write a play that would be called *I, Too, Have Lived in Arcadia,* which she described as a denunciation of Mike and everything he stood for. Having expunged Mike from her life, and with the sands of her own future running out, Bunny was Florida-bound. She announced that she planned to join the circus.[81]

Bunny's play featured a temptress trying—ultimately successfully—to lure the character based on Mike away from Arcadia. That temptress, who had a dog named George, was Bunny's depiction of Joan. Actually, throughout that spring and early summer Joan had been only halfheartedly interested in Mike, and then more out of a sense of competition than love. She was otherwise occupied with an older married sculptor, Wilfrid Zogbaum.[82] By midsummer, however, that relationship had evolved into mere friendship, so when Mike sought reentry into her life (as his prospects with Bunny diminished), Joan succumbed as one would to a bad habit.[83] Though creatively supportive, personally Joan and Mike brought out the worst in each other. That summer, as a result of their reunion, the volatility index at Bossy Farm went off the charts. "The two of them were scary," recalled artist Hermine Ford, who as painter Jack Tworkov's daughter had met Joan and Mike as a child.[84]

Excruciatingly shy when sober, Joan became a brawling, cursing, destabilizing demon when drunk. The year before, she had chased gallery owner Martha Jackson off the grounds of Rose Cottage for asking what Joan considered to be "stupid questions."[85] The summer of 1954, she brought a din-

ner party at the Braiders' to a standstill by interrupting Don with the unanswerable question, "What's so sacred about your asshole?"[86] At other times, she publicly ridiculed ex-lovers' penises and berated "lousy lays."[87] Fellow artists got off lightly if Joan merely dismissed them as hacks.[88] But her most delicious torment that summer, in which Mike was complicit, was reserved for her housemates, Mimi and Paul. The nightmare occupants of the duck shed on one occasion thought it a great joke to slip into the Brachs' room and try to plant lice in their bed. On another occasion, Joan performed a lewd and mocking dance for the couple with Mimi's Egyptian necklace, wrapping it around her head, her breast, and finally dangling it like a penis from her groin. The display went beyond playful to what the Brachs considered "disturbed."[89] Paul said Joan acted as if he and Mimi were a "bourgeois couple...and she was the one going into uncharted waters."[90] In fact, she was already truly well in them.

The only artist on the scene whose behavior came even remotely close to Joan's was Jackson, just down Fireplace Road. She wasn't *trying* to be him, she *was* him. The French critic Yves Michaud once described Joan as "a burning sensibility, one that is skinned alive."[91] Like Pollock, Joan harbored two personalities: one an intensely private artist struggling to release the magnificent images that lived inside her, images without which she could not survive; the other a Fury, whose rage was hideous and unpredictable. That such behavior came from a woman, who it was generally accepted in 1950s America had been designed by nature to be nurturing, was even more unsettling. What could one do with such an abomination? As the summer progressed, Paul grew too frightened to look at Joan. He stared nervously at his feet when encountering her. Mimi tried to avoid her altogether by hiding.[92] Joan recognized what she did and said during spasms of drunken violence, and how impossible she had become. She despised who she was at those moments.[93] In reality, though, her outrageous behavior—to employ a tired expression—was a cry for help. Joan was in a treacherous downward spiral.

She found she couldn't paint at Bossy Farm. Joan associated painting with love, and it was in short supply that season.[94] "I've been painting continually and destroying continually," she wrote. "My hand doesn't always feel and my eye sees just clichés."[95] At the end of July she confided to Mike, "The pressure of the summer has been unbearable....I feel in a gold fish bowl.—I want to pull the shades down—I want to hide."[96] Strangely, she was troubled by the thought of using color on her canvas. She said it created a new kind of pressure that she wanted to "deny."[97] In the middle of a field of wildflowers, Joan inhabited a very dark place. She was taking amphetamines and drinking and listening to Bach and reading Dostoevsky.[98]

The country life ain't for me I guess.... I'm sick of showing pictures...one paints finally for a show and I have nothing that belongs to me anymore.... I can't make the rat race.... My painting natch is horrible.... This summer has perhaps been the worst so far because it should have been the best.[99]

Decrying the "absurd chaos—the fucking emotional bankruptcy"[100] of that summer, Joan gave George to Carol Braider, put a recording of *Don Giovanni* on the phonograph, and took an overdose of Seconal, which she washed down with gin.[101] "We have no new beginnings the way you had always hoped," she wrote to Mike, "& never even clean endings—we just drag ourselves along & if we're lucky there's a nice blue line someplace."[102]

Joan did not die. Weak and sickened by the pills she had taken, she awoke to the unwelcome dawn of the failed suicide. There was only one word for it. "Fuck."

Joan's suicide attempt followed a legendary blowout at the Red House. It had been billed as a simple afternoon gathering, and Nancy Ward designed the invitations:

> Willem de Kooning, Elaine de Kooning, Ludwig Sander, Nancy Ward, Franz Kline invite you to a croquet party at the Red House, Montauk Highway, Saturday, August 7, 3:00–7:00
> Refreshments, Bridgehampton[103]

But nothing related to the Red House was simple. The preparations could not have been more elaborate if they had been for a production at Johnny Myers and Herbert Machiz's Artists' Theatre. In this case, Elaine was the director. She asked Franz, Bill, and Lutz to make hundreds of large paper flowers to distribute around the property.[104] Bill marbleized the outhouse's three-holed toilet seat in red, black, and white (an item that was decades later offered unsuccessfully at auction for sixty thousand dollars), and installed shelves on its walls for votive candles.[105] Two hundred dollars' worth of liquor was purchased and set out on a long table (during the party a heavy woman sat on it, causing a cascade of precious bottles). Nancy made one hundred cream cheese and cucumber sandwiches, while Elaine made potato and tuna salads. Fresh fruit was placed in a washbasin, and wheelbarrows were filled with hardboiled eggs. The morning of the event, Bill planted the croquet course on the lawn, and Nancy and Elaine hung the paper flowers from bushes and trees. Suddenly, Elaine had another idea. Flowers must *smell* good. And so, she rushed into town to buy bottles of cheap perfume, which she sprayed on the paper petals.[106] All that work accomplished, Nancy, in a little black dress, and Elaine, attired as a coun-

try hostess in thrift-store ruffles and billowing skirt, awaited their guests on the lawn of their home that beautiful afternoon.[107]

Soon they arrived. Cars lined both sides of Montauk Highway, as people streamed along the busy road on foot toward the Red House. There were the invited—artists, writers, critics, collectors, gallery owners, family, friends—and strangers drawn by the clarion call of competing phonographs (one inside the house and one outside) and the curious fair under way on the grounds of the Civil War–era residence.[108] The only requirement for admission was leaving one's inhibitions at the door. It was a rule with which everyone happily complied.

Grace was among them. She had arrived in Southampton in late July to spend the summer at Fairfield Porter's with Frank, occasionally Walt, and Fairfield's son Lawrence, while the rest of the Porters vacationed in Maine.[109] During the first part of the summer, she had worked in the deserted city on major paintings in her new figurative style.[110] Being able to concentrate in the relatively deserted city was liberating. (Frank felt the same about his poetry. "'The City Summers of Hartigan and O'Hara' would be an ideal thesis for some graduate student at Millstone University I should think. About 1980," he wrote Grace.)[111] She had made events of each painting, enlisting those friends who hadn't already left Manhattan—Frank, John Ashbery, Jane Freilicher, and the writers behind the avant-garde publication *Folder*—to model in costumes she found in secondhand shops: a black hooded cape, a harlequin shirt, a red hunter's coat, and a beaded dress from the 1920s.[112] Grace was in creative overdrive, serenaded by the records of pre–World War II singers—especially Marlene Dietrich and Zarah Leander—whom she had come to adore.[113]

Grace appeared at the Red House with a relatively triumphant Southampton contingent of poets and painters. Larry had achieved celebrity status that spring when *ArtNews* featured him in "Larry Rivers Paints a Picture."[114] And Grace had achieved notoriety of her own that helped her hold her head a bit higher. "They are burning up about the new Museum show that's going out," John continued. "They" were the abstract purists at the Club. The exhibition in question was at the Modern, and included Grace and Al.[115]

Also attending the party were gallery owners Sidney Janis and Sam Kootz, and the latest addition to the still small coterie willing to take a chance on the American avant-garde, Martha Jackson. The heiress to a chemical fortune, Martha planned to open a gallery on East 65th Street and was prowling Hamptons studios as if sifting through store racks for summer sales.[116] Martha pillaged the Braiders' gallery, taking work off the carport walls after making deals on her own with the artists.[117] "She went with cash in hand—greenbacks—and there were few artists who could

resist the sight of greenbacks," John Myers said. Though some did. "Joan Mitchell was one... but then, she was rich herself."[118] Another was Pollock. Martha had been trying to no avail to convince him to sell her some of his work. Finally, she offered him something that meant more to him than money that summer: mobility. She would trade her 1950 green Oldsmobile convertible for two 1951 paintings. Pollock agreed, and she left the shiny Olds parked in his driveway.[119]

Among the guests who arrived with considerably less fanfare was Joan Ward, though her impact on Elaine would be the greatest. Bill had been estranged from Joan since she vanished from the scene several months earlier, gravely depressed by her decision to abort his child. Joan reappeared at Bridgehampton that August, suitcase in hand, prepared to stay for two weeks, ostensibly to see her sister.[120] By the end of her visit, her affair with Bill had been rekindled and Elaine would say in retrospect that this is when her marriage to Bill reached its end.[121] "What marriage could survive what theirs did?" Grace said. "And it doesn't matter how conventional or unconventional it might have been.... After a while... there was no marriage.... Both of them must have known that."[122]

The invitations to the Red House party had said three to seven, but as night fell the number of attendees only grew. People danced inside the house and out, stood in clusters engaged in drunken banter, or crawled off into the bushes after experimenting with the mescaline making the rounds that summer. Elaine finally gave up and went to bed at three a.m. after a long and raucous game of charades in the living room.[123] As dawn approached, the crowd dispersed, too, though many only had the strength to crawl into a corner or curl up under Oma's immaculately scrubbed staircase. ("Three days later, they found a couple still in the attic," said Joan Ward.)[124]

In the morning, the housemates arose to a state of chaos. Lutz ventured outside to begin gathering up the debris from the night before—glasses, food, bottles, a shoe, a stocking. "I found it in the backyard under this bra, soaked in a pool of gin," he explained to his fellow residents.[125] A moan from the bushes meant he had discovered not just pants or a shirt but the unfortunate person attached to them. Elaine and Nancy's flowers hung limply from the trees. Flies and bees swarmed around the sandwiches, salads, fruit, and eggs exposed to the elements for nearly twenty-four hours. Chairs that had been toppled by too vigorous dancing lay scattered.[126] It was as if a hurricane had struck Bridgehampton. And then one did. Three weeks after the party, a monster storm hit the Hamptons.

Hurricane Carol slammed ashore on August 31 with one-hundred-mile-per-hour winds.[127] Joan's duck shed was destroyed and, along with it, some of the paintings that she herself had not already ruined. Having retrieved

her dog from the Braiders', she had to risk her life to save him. "It was a very devastating experience. Trees fell over. It seemed as if the wrath of God fell upon East Hampton," Joan told Irving Sandler. "The hurricane is a ghastly symbol of a frightening period in my life."[128] Wires loosened from electrical poles lashed across roadways, roofs blew off homes and garages. A massive tree hit Bill's summer studio, crushing it along with "almost the entire summer's work." The only pieces that survived were those he had brought into the house as party decorations.[129] But the tremendous wind was only half the problem. On such flat terrain, flooding was a real concern.

As the storm abated, Jackson limped across the field to Conrad Marca-Relli's.[130] The sun had burst through the clouds, blazing brighter than ever, as if a sign that Hurricane Carol had done her worst. Pollock, however, looked up at the sky and said to Marca-Relli, whose property was on lower ground, "I'm not going to get flooded, but you are." He told Conrad to move his paintings off the floor and his jeep into Jackson's driveway. Marca-Relli thought he was exaggerating, but within minutes his house was engulfed in a flash flood. Wading through four feet of water, with Marca-Relli's jeep submerged, Jackson told him, "Open all the doors, come back to my house for coffee and in a couple of hours we'll be back and the water will be gone."[131] Not just Marca-Relli, but all the artists in the area converged upon Lee and Jackson's to ride out the storm. After it subsided, Jackson, Franz, Nick Carone, and Bill, among others, patrolled the area, helping people trapped in cars, freeing those caught inside their homes or too frightened to leave. That day would prove to be one of the best of Jackson's year. Though still cast-bound, he was a fully functioning man, able to contribute something to the effort. He felt whole again.[132] For Lee, however, the hurricane was the last straw.

From the time she was a child, Lee had an irrational horror of storms and this one, coupled with her illness and Jackson's physical, mental, and artistic decline, caused her to snap. Shortly after Carol, she and Jackson accompanied their artist friends James Brooks and Charlotte Park to survey the damage to their home in Montauk. Theirs was a winding road, and Lee harassed Jackson as they drove slowly along, "hollering at him, treating him badly— nagging," James recalled. "He was so upset, he said, 'I'm going to hit you with a brick if you don't shut up.' But she just kept after him until we all got out of the car and looked down from the bluff at the wreck of our studio. After looking at it for a while—nobody was saying anything—[Jackson] started crying."[133] Lee refused to get back into the car with him. She decided to leave Long Island, returning with James and Charlotte to New York.[134] As strong as she was, she didn't have the fortitude to absorb the shocks around her any longer. And she wasn't alone.

Within a year, Elaine, Joan, and Helen would all examine their tumultuous personal lives and determine that they could no longer continue as they had done if they hoped to survive. Only Grace was immune to that soul-searching, and that was because she had long before determined she would not allow herself to be in thrall to anyone but herself and anything but her work. Her early reward for such determination would be stardom.

Five Women

43. The Grand Girls, I

> In my case, I had no uncertainty or lack of conviction as far as art was concerned. That is my life. Society, personalities, and problems are quite another story.
>
> —Louise Nevelson[1]

ON OCTOBER 9, 1954, Grace discovered her *River Bathers* hanging in the Museum of Modern Art as part of an exhibition, "unprecedented" in scope, of four hundred works by major artists.[2] *Paintings from the Museum Collection* inaugurated a year of celebration marking the twenty-five years since "the ladies" and Alfred Barr had opened their improbable museum. During that period, the Modern had organized more than eight hundred exhibitions, and had gone from five employees to two hundred.[3] Upon learning that the show had been hung, Grace rushed to the museum and, bypassing the twentieth-century European masters, into the galleries housing the newly minted American greats—Gorky, Bill, Jackson, Franz, and Rothko, among them. It was within that constellation of talent that Grace found her work, and she felt, as she looked at it, that this was where she belonged. "It is a beautiful picture," she confided to her journal the next day.

> It has everything that is young in me, and ecstatic, but I pray that I am capable of much more, greater depth of message and emotion as well as a more profound and original painting form. I am proud that Barr feels what I know myself, that I am the equal—and more—of most of my American contemporaries.[4]

With an uncharacteristic acknowledgment of her sex, Grace continued,

> I regret sometimes that this great gift has been born to me, a woman, with the countless flaws of vulnerability, worldliness, fears—what all! I have.... So be it, I try to live the life that is necessary for it to flow. If fame is to come to me, it will require great strength to continue to work and keep the proper distance, the correct understanding in regard to my inner or spiritual self and my outer or worldly one.[5]

From the time she had sat enchanted as a child watching Hollywood stars in the movies, Grace had anticipated fame. Seeing her painting in the

Modern—and at one point watching a father with his child stand before it and explain the figures she had painted—filled her with pride over what she had accomplished on canvas and who she had become in life.[6] Grace had crossed the threshold. She was now the person she once dreamed of.

> To think of that picture in the world, with thousands of people seeing it, while I am safely here in the studio with Walt, listening to Ravel, and drinking the last of the Cointreau, all this is new, heady and confusing![7]

For an artist, the rush accompanying the first intimation of fame most often lasts a moment. It is a suspect sensation bearing scant relation to the work at hand. For Grace, it lasted ten days, until she strode triumphantly into the exhibition's opening, dressed to the nines and ready to receive accolades, only to discover that she was nobody. "No one knew who I was, so we wandered around like anonymous spectators," she wrote in her journal the next day, downcast that the event had not fulfilled "my dreams of glory on such an occasion."[8] Within a week, she suffered another disappointment. The Whitney Museum opened on October 25 at its new location on East 54th Street, but Grace discovered that her *Greek Girl*, which the museum had purchased from her last show, wasn't on display.[9] "Apathy, mediocrity, indifference—these are the things we meet everyday," she wrote petulantly of herself and her fellow artists, "not hostility which is easier to fight.... The whole thing plus my own state of confusion depressed me terribly."[10] "I don't know which is more frightening, failure or success," she confessed in another entry.[11] "Who am I?" she asked herself finally, and to no avail.[12]

Her confusion was justified. Few artists, especially young ones, can accommodate the vicissitudes of career and the demands of creativity. (Grace had turned to Virginia Woolf, who identified the problem as "living in two worlds at once.")[13] But her depression was unwarranted. Despite Grace's bruised ego over her museum disappointments, by the fall of 1954, at the age of thirty-two, she occupied an exalted position in terms of recognition and commercial success. Among her generation of artists Grace stood alone at the pinnacle of such achievement. No one else had sold out a show or had works in two of the three New York museums that featured modern art. Even compared with most First Generation painters, Grace was doing quite well. Using sales as a barometer of success, Grace had sold fifty-five hundred dollars' worth of work in 1954, just short of Bill's seven thousand during that same period.[14] Her ascent was remarkable, and it did not go unnoticed. Her phone began to ring with interview requests, *Newsweek* and *Glamour* among them.[15] "For the last few days I have been work-

ing on this painting with one hand, and trying with the other to keep my door closed against the outer world—phone calls!" she wrote in November. "Good God, how do the Famous ever find time to do any further work?"[16] Within the span of a few weeks, in addition to a group show at Tibor de Nagy, she had been asked to send five paintings to an exhibition in Minnesota, another to the Whitney for its important annual exhibition, and fourteen more to Vassar. The college wanted to mount a solo show of "Grace George Hartigan's" work.[17]

The attention had come Grace's way not only because of her talent, but also because she proved to be a fascinating phenomenon, one that embodied a previously nearly unimaginable combination: a successful, young, independent American woman and artist. (Omitted from that portrait, painted in large part by Johnny Myers, was how she had achieved that state: by eliminating all entanglements from her life, including her son.) Just as Pollock (minus the alcoholic psychosis) represented a new breed of American man, the sanitized-for-public-consumption version of Grace exemplified a new breed of woman. Strong and self-made, she was free of both the inaccessible gentility and the incomprehensible eccentricity many had come to expect from the rare woman who dedicated her life to paint or stone. As Jackson had looked like everyman, thereby proving that social pedigree was not an essential ingredient in making art, Grace personified a liberated version of everywoman. She even spoke with a New Jersey accent!

When Grace addressed an assembly at Vassar during her show, she inspired her audience from the moment she crossed the stage. One student recalled being struck by her confident, unfeminine stride. Another by her ease at the podium: She spoke conversationally, peppering her comments with language that would have been unremarkable at the Cedar but shocking at a Seven Sisters assembly.[18] "I was just dazzled," said future art historian Linda Nochlin, who heard Grace as a student, "because you know we all wore skirts and she came up in her paint-covered blue jeans and smoked all during her talk. And she was just marvelous. I mean she was a true artist." For Nochlin, a "light went on." Grace was further proof that a woman "could do everything, anything."[19]

Though Grace's struggles in the studio continued, socially the attention she had begun to receive made her feel powerful. Frank's friend Joe LeSueur met Grace around that time, and though he was somewhat alarmed by Frank's attachment to her ("It became clear to me that his love for her was so great that he was physically drawn to her, as a mass of steel is drawn to a magnet," he wrote),[20] Joe, too, acknowledged her charm. "Yes, I really thought she was something," Joe said. "To begin with, I never knew anyone, male or female, who appeared to have more self-confidence and determination."[21] LeSueur witnessed Grace at her most imperious one

night as he, she, and Frank walked across Eighth Street toward the Cedar. A "wimpy little guy" had followed them from a party, Joe wrote,

> He was unsteady on his feet, slobbering slightly, and slurring his speech from having drunk more than he could hold. Do you think Grace felt sorry for him? No way. Without warning, she hauled off and hit him so hard on the side of the head that he landed in the gutter. Frank stopped to help him to his feet as Grace, eyes straight ahead, continued walking briskly, with me keeping apace, eager to know what had gotten into her. "Hey, Grace," I said, "why'd you do that?" "I can't stand a man who doesn't act like a man!" she said furiously.[22]

Appalled by Grace's assault, Joe complained about it to Frank, but the ever-loyal O'Hara defended her, saying, "What are you talking about? The guy was asking for it."[23]

At the end of Grace's marvelous year, Joe was privy to another, less violent but no less surprising example of her strength. She had thrown a "roaring" New Year's Eve party at her loft. Her hair cut to slightly below the ears and tousled Marilyn-style, she wore velvet matador pants and a backless top that knotted at the nape of her neck.[24] She, her artist friends, and all the poets—Frank, Kenneth Koch, and Jimmy Schuyler among them—drank and danced, encircled by her paintings to usher in the auspicious-sounding 1955. If 1950 had been the start of the First Generation's decade, 1955 would be the beginning of theirs. Her party was a sensation. Grace was at her most glamorous, and then "much to my delight and every one else's astonishment," she wrote the next day, Alfred Barr appeared.[25] *He* was at *her* party. The mountain had moved. It had come to Grace.

Grace's celebrity occurred at the dawn of a "gold rush" in the New York art market. The United States was now a full-fledged consumer economy (the credit card had been born), with business and consumer confidence indexes stable.[26] In addition to that salubrious environment, the U.S. tax code had been changed to allow art collectors to take a deduction on art purchased with the intention of one day, even posthumously, donating the work to a museum.[27] That bureaucratic change had two immediate effects for the buyer: Wealthy individuals had an incentive, beyond a love of art or the acquisition of the ultimate status symbol, to buy paintings and sculpture. And they were more focused in their pursuit, increasingly purchasing works on the advice of a small number of "experts" who directed them toward the art most likely to be accepted by a museum.

For the nation's more than two thousand museums, the change produced a bounty in promised donations of paintings and sculpture they

could not otherwise afford.[28] For galleries, the impact was obvious. What had been a few sales to a small pool of collectors became a relative flood. In 1955, "the scene opened up suddenly. Detroit and Texas money began feeling that this was a prestige item," said gallery director Nathan Halper.[29] And for artists? Even the New York School painters reaped the benefits. Paintings by Europeans cost a fortune: A Vermeer sold in 1955 for three hundred and fifty thousand dollars; a Matisse might be purchased for seventy-five thousand.[30] But a Pollock or a de Kooning could be had for a relatively paltry sum, and some people hoping to get in on the art market saw the Abstract Expressionists as a more affordable pathway.

Fortune would publish a lengthy feature that year advising and educating its readers on art as investment. Describing a Vermeer as that seventeenth-century Flemish master's work had never been described, the magazine called it "one of the world's most highly valued surfaces... at $1,252 per square inch" and compared its worth with that of the land under the House of Morgan on Wall Street, which was valued at just over two dollars per square inch. Art, the magazine concluded, "can be the most lucrative investment in the world." And, it reported, the time was right. "Today this art market is roiling with an activity never known before."[31]

Its readers were told that the market could be divided into various categories based on style, history, and quality, of course, but also on price. There were the "Old Masters," a limited pool of works by long-dead artists, which for those with pockets deep enough to purchase one, were an investment "as good as gold."[32] Next were "blue-chip" paintings and sculpture—a category *Fortune* defined as "you can't possibly lose." These included nineteenth- and twentieth-century Europeans: Monet, Manet, Degas, Van Gogh, Matisse, Picasso, and Gauguin.[33] Finally, the article described the "speculative" or "growth" market. Sometimes work in that category was the result of changing taste—an artist might come back into vogue and sell well. Of more importance for the New York School, however, "growth" art could also include work by newly discovered artists. Near the bottom of *Fortune*'s list appeared the names Bill de Kooning, Motherwell, Pollock, Rothko, Kline, and Rivers. Their prices ranged from only a few hundred dollars to several thousand. Though the risk to investors was high, the potential reward for the "shrewd and lucky" speculator could be enormous.[34] Some among America's postwar nouveau riche heeded that advice and took a chance on the new art.

Because of increased leisure time in a culture dominated by labor-saving devices and the advent of shorter work weeks, by the mid-1950s fifty-five million people visited museums nationally each year. While that was still about the same as the number of people who saw a movie each *week,* it was double the visitor figures for 1935.[35] The annual attendance at New York's

Metropolitan Museum, for example, went from seven hundred and fifty thousand before the war to nearly three million between 1954 and 1955.[36] At the Modern during that same fiscal year, a record high of nearly seven hundred thousand people sought out the newest, most challenging work; sometimes thirty thousand visited on a single day.[37] The Modern had made such art both chic and relatively safe. Harold Rosenberg described the newly changed climate in the country:

> By the middle of the 1950s the pervading acridity of the years immediately following the war, brought on by memories of the war dead, the return of the mutilated, the images of death camps, of Hiroshima, had been largely dissipated. The feeling of crisis was no longer pressing, no longer *popular*....
>
> The art world [nationally] had swelled to include hundreds of galleries, collectors large and small, contemporary arts councils in major cities....
>
> The challenging "But what does it mean?" or the verdict "He's nuts!" is heard no more.[38]

After 1955, said gallery owner Sam Kootz, it was "no particular struggle for any of the good men to exist because we sell enough of their pictures to have them make a very respectable income."[39] Everyone felt the shift. In her diary on January 10 of that year, Judith Malina wrote that she had gone to a "self-conscious little East Side party full of painters and people who talk about 'who has the money.'"[40] The conversation had changed. When one talked of art, one spoke of wealth.

Notably absent, however, from either the *Fortune* list or Kootz's summary of the health of the art market was any mention of women—other than a passing reference to Georgia O'Keeffe. Larry's name had appeared in *Fortune* as an interesting bet, while Grace's was omitted. Kootz had spoken of the rosy future for "good men," slamming the door on women who painted, too. "The abstract movement made no distinction between men and women in judging the work itself so long as society ignored it," explained author May Tabak Rosenberg. "But once accepted as respectable, then all the sexual prejudices of bourgeois society began to divide the art world and women can be *accused* either of painting like women or of painting like men." One way or another, May concluded, sex rather than merit came to define a woman's art.[41]

And yet, at the start of the age when American art would be appreciated for its price as much as its quality, women *were* selling and showing. Grace was evidence of that. Her annual solo show at Tibor de Nagy in 1955 was widely acclaimed by critics and sold out. Poet James Merrill paid two thousand dollars for her *Grand Street Brides,* which he donated to the Whitney. Nelson Rockefeller bought her smaller *Peonies and Hydrangeas* for the

Modern. The Chicago Art Institute purchased her large 1954 painting *Masquerade*.[42] As for her fellow painters, Joan and Helen would be invited along with Grace to exhibit work in the important 1955 Whitney Annual.[43] Joan, Elaine, and Helen were chosen in 1955 to show in the prestigious Carnegie International in Pittsburgh.[44] In fact, the invitation to include Helen's *The Facade* had arisen out of her third Tibor de Nagy solo exhibition the previous November, during which the painting was purchased for the Carnegie Institute.[45] In 1955, Helen's work entered a museum collection. She was just twenty-six.[46]

What such recognition ultimately meant was that if a gallery director defied ingrained sexism, as did John Myers, Betty Parsons, and Eleanor Ward, and showed work by talented women, those artists had as much chance as talented men to become part of the national art dialogue, to be included in museum exhibitions and collections, and finally to have their art seen by the public. Unfortunately, there were not enough daring dealers to make that possible, and so women remained largely off the commercial and museum radar. Grace, Helen, and Joan were the exceptions. "I used to refer to them as 'The Grand Girls,' Hartigan, Mitchell, Frankenthaler," art historian Dore Ashton recalled decades later, smiling at the admission that she had felt slightly intimidated by those painters. "But I never let them know it! They had élan." As for their elders, Elaine and Lee, Dore said, "I was a little afraid of Elaine. She had aplomb. She was the queen. I didn't really like Lee, but later I got to be much more tolerant of her. All of my Grand Girls were interesting people. There's no question about it."[47]

As the art world began to cleave into two camps—those who responded to art regardless of the artist's gender and those who saw only men's work as serious—Dore's "girls" stood out. "Those women paved the way for me," said Marisol of that group.[48] They would pave the way for generations of artists. "In the 1950s, with the emergence of Grace, Joan, and Helen, it was a new ball game," said art historian Irving Sandler, who knew them all well.

> They opened it up for women, in part because they were stronger than any of the [Second Generation] men.... In order to be a woman on the scene, you either had to remove yourself as Helen did, she went uptown... or you had to be tough, you really had to be tough, and they didn't come tougher than Joan or Grace. I once asked Grace, "Has any male artist ever told you you paint as well as a man?" And she said, "Not twice".... Also you know Lee and Elaine were intellectually brilliant. They all were really smart, and you don't mess with that.[49]

The women of the New York School put their foot in the door that was being closed against them, not as an act of feminist protest but because

inside was where they belonged. It is interesting to note, however, that at the time those women established what art historian Eleanor Munro called their groundbreaking "working presence" among the artists in New York, the social sands were shifting once again regarding women in general.[50] A faint chorus had even begun encouraging them to emerge from the confines of their homes.

By the mid-1950s, women who had long been schooled in subservience were given a new goal: they should also strive to be mediocre. Popular magazines, films, television serials, books, and even some university courses advised women, no matter how intelligent, to downplay their abilities.[51] In a 1952 *Life* article called "The Wife Problem," women were told that the same self-restraint that had helped them win a husband was to be employed to advance his career. A good wife, the article said, was not to be "*too good*" for fear of drawing attention to herself and envy toward her husband. "One *can* move ahead, yes," the article read, "but slightly, and the timing must be exquisite."[52]

There was, however, one area of "liberation" for women as the 1950s approached its midpoint. The Kinsey report on female sexuality had been published in 1953 with as much fanfare as his report five years earlier on men. Women, the report concluded, engaged in all kinds of sex, a good deal of it pre- and extramarital.[53] While there was some ambiguity as to whether women achieved orgasm or had sex because they enjoyed it (if they did and the goal was not pregnancy, their orgasm was called "malicious"), that very confusion made the findings more palatable to mid-century readers.[54] As a *Reader's Digest* article concluded, "'What Every Husband Needs' was, simply, good sex uncomplicated by the worry of satisfying his woman."[55] Betty Friedan, who as a young housewife during that period witnessed firsthand the strangely one-sided sexual revolution (which she called a "counter-revolution"), wrote in her 1963 book *The Feminine Mystique* that sex became

> the only frontier open to women....In the past fifteen years, the sexual frontier has been forced to expand perhaps beyond the limits of possibility, to fill the time available, to fill the vacuum created by denial of larger goals and purposes for American women....
>
> For the woman who lives according to the feminine mystique, there is no road to achievement, or status, or identity, except the sexual one: the achievement of sexual conquest, status as a desirable sex object, identity as a sexually successful wife and mother.[56]

And yet, Friedan wrote, neither the man nor the woman in that society was particularly happy with the ubiquity of libidinous relationships. After

reaching the saturation point in books, magazines, films, and in reality, such activity felt hollow. Sex had grown dull. "This sexual boredom is betrayed by the ever-growing size of the Hollywood starlet's breasts, by the sudden emergence of the male phallus as an advertising 'gimmick,'" Friedan wrote. "The frustrated sexual hunger of American women has increased, and their conflicts over femininity have intensified."[57] For those college coeds who had decided to skip "Mate Selection" or "Adjustment to Marriage" classes, or those housewives grown tired of a steady diet of courtesan tips in magazines, intelligent women's voices had begun to surface that questioned the status quo.[58]

Simone de Beauvoir and Margaret Mead had studied the cultural history of women and discovered that while Western society had advanced in nearly every measurable way, its treatment of women had not. Their books, Beauvoir's *The Second Sex,* published in English in 1953, and Mead's *Male and Female* in 1955, made for challenging reading. Mead's anthropological research had taught her that, contrary to the theories of Freud and his disciples, gendered behavior was cultural, not biological, and therefore entirely subject to change.[59] Beauvoir had said as much earlier, writing, "It is not nature that defines woman; it is she who defines herself."[60] Historically, however, that had not been possible in societies dominated by men, she wrote, except among "women who seek through artistic expression to transcend their given characteristics."[61] Beauvoir was speaking of women in the performing arts, but she acknowledged the strides women were attempting to make in literature and visual art. In those areas, she warned, the forces of tradition might be insurmountable unless a woman was prepared to reject everything she had been taught about herself and her so-called limitations, and was ready to risk potentially crippling social disapprobation. For the woman writer or painter to succeed beyond mere reproduction or homage, she must trample "upon all prudence in the attempt to *emerge* beyond the given world....

> The free woman is just being born; when she has won possession of herself perhaps Rimbaud's prophecy will be fulfilled: "There shall be poets! When woman's unmeasured bondage shall be broken, when she shall live for and through herself, man—hitherto detestable—having let her go, she, too, will be poet! Woman will find the unknown!"[62]

In 1955, a twenty-year-old French author named Françoise Sagan arrived in the States, a manifestation of Beauvoir's social philosophy and Rimbaud's words. Her book about a young woman's affair with an older man, *Bonjour Tristesse,* had just been published in English and she was on a book tour. Sagan's picture appeared everywhere, her escapades described

in starstruck detail. "She seemed...to have taken possession of her fame with great aplomb, living it up the way young male writers were supposed to," recalled author Joyce Johnson, who was nineteen at the time. "She had a predilection for very fast driving in expensive sports cars.... There was something in her speed, her coolness, that seemed...totally new."[63] With her gamine pout and Parisian ennui, Sagan had made that leap to liberation seem easy. The women of the New York School knew otherwise. They were well acquainted with the pain of achieving and maintaining their freedom, of finding Rimbaud's "unknown."

During the third Stable Annual, young Marisol sold a sculpture and was so alarmed by the attention she received that she fled first to Mexico and then to Paris.[64] Grace, too, was experiencing that disequilibrium. On her thirty-third birthday, in March, she wrote, "Trying to think of a message for myself...but the only one that occurs to me is 'courage!' "[65] The nearer she approached the paintings she felt were truly her own, the more she sought isolation in the studio, and yet, isolation at that moment was impossible. Grace had discovered it was no longer just her work that was for sale. She, too, had become part of the transaction.[66] In response to a letter from Grace about her depressed confusion that spring, Mary Abbott tried to help her refocus, writing, "despair is not in you, I don't believe.... You momentarily feel nostalgic for what now seems your former innocence your romantic feelings about being an artist etc. but that must pass too because *it* has passed."[67]

Grace was incapable of accommodating the change. She tried to confine her inner turmoil to Essex Street, but it was beyond her control. In May she burst into tears in the presence of Larry and Frank, leaving them stunned and confused. "Did either of us say anything that began a long discussion with yourself that quickly led to the road of Who Am I Why Am I or such song.... I didn't know what to do to make you feel better," Larry wrote her the next day. "I never saw you like that.... Go see the Rodin and DON'T commit suicide. Goodbye baby I'll call. Papa."[68] Just as often, Grace's fear surfaced among less supportive friends. "I went through another of my nervous crises two nights ago, much to my humiliation Joan was with me to witness it," she wrote that same month. Grace called the spring of 1955 "a terrible time for me, I am lost and floundering—and worse of all, I can't even flounder on a canvas, it is all in me, I can barely force myself to work. I don't know what I want to paint, or how."[69] Quite unexpectedly, an opportunity arose for Grace to escape New York, her studio, the art world, even herself, and she took it.

Jane Freilicher and Joe Hazan had decided to marry, but before they

could Joe needed to divorce his wife, and he had decided to do so in Mexico.[70] By mid-May, poet John Ashbery, Grace, and Walt had all signed on to the trip southwest in Joe's convertible, leaving New York on May 28 for a three-week, four-thousand-mile tour of Americana.[71] "This motel is like a Hollywood B glamor film—I'm half in it and half laughing at it—Giant cheese burgers, kidney shaped pools, green flood lights," Grace wrote three days into the trip from Texas.[72] After a week of heat and discomfort on the road, however, tempers began to flare. Receiving conflicting reports from the various occupants of Joe's car, Frank feared the travelers had turned on one another and that Grace and Walt might have been murdered, their bodies "dumped" into the Rio Grande.[73] Wrote Jimmy Schuyler to Kenneth Koch, "it would be more soothing to the nerves to drive a load of TNT through the Rockies" than take a trip to Mexico in that company.[74] It came as no surprise when, having crossed the border, the group split up for a spell. Grace, with Walt, went in search of the country that had inspired her when she lived there with Harry on the GI Bill, while Joe, Jane, and John headed to the coastal resort of Acapulco to have some fun.[75]

Walt followed Grace reluctantly into the Mexican hills, to Guanajuato, the colonial city Joan and Zuka visited when they were students.[76] "The first night we entertained every mosquito in Mexico," Grace admitted. Despite her discomfort, she felt happy, absorbing the culture and the characters around her for use in her work. "I must remember...the Padre and good spirited middle class Mexican businessman," "the respectable looking pimp and his little girl," she busily noted in her journal. Even on vacation, Grace was preoccupied with painting. She couldn't turn it off.[77] And, as with her son, Jeff, who had always felt second to art in her affections and attention, Walt felt a distant third, if not fourth in her life. There was art, there was Frank, there were Johnny Myers and Larry. Walt may have realized he would never breach that inner circle to reach Grace. During their Mexico trip, he apparently decided he'd had enough, though Grace seemed too busy to notice.[78] Back in New York in mid-June, with ears newly pierced, Mexican rum in the cupboard, and "cha-cha-cha" records on the phonograph, she returned to work, free of the worry that had plagued her before she traveled, free of confusion about who she was.[79] Then Walt announced he was leaving.

Stunned and admittedly afraid, Grace struggled with the possibility that she might never have a permanent relationship, and questioned more deeply whether she needed or wanted one.[80] For Grace, a lover was not an end but a means. "I have this fusing with another or the loss of self only in the love act—then, having loved and been loved I rush into myself with new

strength," she wrote.[81] Love, or lovemaking, was one more ingredient she needed and used to be in the right frame of mind to paint. Relationships and commitment were burdens she could not carry. "Until recently, women kept thinking that somehow they had to settle the man thing; somehow it was paramount," Larry told an interviewer in 1979. Recalling that earlier time, he said,

> That wasn't true for Grace, I think. She was just as interested in a career, in her work, and men were like dressing—a little bit of spice in life. She seemed to boss them around—like, "Don't bother me, I'm doing my work, you can call between five and six." That would seem very normal today.[82]

Said Grace's close friend Rex Stevens,

> Her attitude was modern... it was, they'd have a little special time together and then she'd say, "Well, you have to go." They were so shocked at that because they'd brought a fifth of whatever. Now the fifth is gone, they had their time, and now she's telling them they're not sleeping over, they're not staying. She's got work to do.... She was surprised by how shocked they were... every time she dropped that on them.[83]

Walt had not been a casual relationship. They had lived together for four years. He had asked very little of her, and yet Grace was not able to deliver. She believed, as André Gide had written, "One should want *only one thing* and want it constantly."[84] That one thing would never be a man. Grace let Walt go, with the agreement that they would see each other more casually. "Now my days alone have a certain shape to them," she wrote on July 1, 1955.

> I wake about nine, turn on the symphony and have juice, fruit and a pot of black coffee. Read a bit (still Gide's Journal), talk on the phone.... Then three or four, sometimes five hours on this canvas....
> Then a few domestic chores for myself, a cold shower, a cold hard boiled egg and one or two rums with Rose's lime, more reading, some records. Tonight I meet Frank at the Cedar for dinner, then to the late showing of *East of Eden*. I feel sharp, my reading is concentrated and not "escape." I have thoughts, ideas.[85]

Such solitude, however, did not make painting any easier. Grace wept with rage and "hurled" herself at her work, "using the brushes like clubs, the wall shaking with the blows," because the image she sought would not surface.[86] "My life has been so often in turmoil, why can I not find in my

art the peace, the refuge the form and order that life doesn't seem to have for me?" she asked herself.[87] Grace believed she finally understood why Walt had left her—he couldn't bear her life. "Why should he—how could he when I can scarcely bear it myself," she concluded.[88]

Having slept off her despair and anger, Grace returned to her canvas, consoled by the notion that despite the difficulties, she was "sure and decided," not in her bond with another, but in herself and her work.[89]

44. The Grand Girls, II

> I have often fought, fought and won, not perfection, but an acceptance of myself as having a right to live on my own human, fallible terms.
>
> —*Sylvia Plath*[1]

IN 1955, ELAINE moved to a second-floor studio at 80 St. Mark's Place, several doors away from Joan's.[2] "Mine was right over a kind of a night club bar. And I didn't realize it," Elaine said.

> My brothers helped me move in.... We moved in with wheelbarrows, practically carried the stuff by hand, because I didn't have that many possessions then. And we kept moving stuff in until about nine o'clock at night. Suddenly this tremendous blast of music came through the floor. And we all dropped everything, and my two brothers burst out laughing. They thought it was the funniest thing... and they said, "This is a wonderful studio for an artist to go mad in"....
>
> My studio was like the inside of a sounding box. From nine o'clock every evening till four every morning, that was what I would live with. It became kind of fascinating. Also, the music was God awful, it was not good, you know, jazz or anything, it was medleys, like... songs from the thirties.[3]

On the positive side, the studio was cheap and nearer her colleagues. She was, therefore, in a protected environment as she began her first year estranged from Bill.[4] Their relations had been familial in the months after the Red House, in part because Bill's mother had extended her stay when they returned to Manhattan and was very involved with Elaine's family and friends.[5] But after Oma's departure, the false facade of a semi-traditional marriage evaporated. Bill returned to his studio, his women, his drinking. Elaine described the evolution in their relationship as "I'm doing what I damn please, and he's doing what he pleases."[6] That had largely been their modus operandi for years, but Elaine had become aware that her early experiment with autonomy hadn't amounted to real independence. "When I read Simone de Beauvoir, *Second Sex*, I began to realize there were all sorts of things that women, even liberated women, totally take for granted in the way of, you know, being this way. Submerged," she said.[7] Though Elaine had never joined the ranks of women

overshadowed by their spouses, she had been associated with Bill in the minds of their friends from the time she was a teenager.[8]

For some, when Elaine spoke, it was assumed she did so on behalf of her husband. Similarly, when she attended an uptown party, or was seen in the company of a writer or collector, the cynic saw in her socializing a strategy to benefit Bill. By 1955, he was doing quite well without her, and personal issues had made the continuation of their "team" painfully difficult.[9] Therefore, at thirty-seven, still carrying herself like a dancer, her thick red hair cut short to frame her face, a thin cigarette employed as reliably as an eleventh finger to emphasize or enlighten, Elaine began building a life wholly apart. She approached her project in two ways. First, through breakneck socializing with her Second Generation peers—"Joan and I were always having parties," she said—and second, through intellectual engagement.[10] Elaine waded directly into a battle that had been raging among the New York School artists for years but had erupted into full-blown warfare that season.

The discord over whether a painter could be truly modern while allowing objects or figures to appear in their work had only intensified as a result of the critical and material success of artists like Grace and Larry. Accused of selling out, of polluting the pristine waters of abstraction, they had come under attack from fellow artists who had been reborn through nonobjective painting and still believed it was the only method worthy of the name "art."

Frank had stoked the tensions the previous fall by writing in the small publication *Folder* an essay called "Nature and New Painting." In it he argued that including a reference to so-called real life in a painting did not make it less abstract than a painting covered in only swirls or stabs. A painting was, intrinsically, an abstraction. And if one believed, as did Hans Hofmann, that all painting derived from nature, then cityscapes, window displays, and people were all fair game because they constituted "nature" in mid-century New York. Frank included work by Grace, Larry, Elaine, and Jane Freilicher to illustrate his thesis.[11] He might have also included his own poems, which he had begun filling with the minutest details of his life: casual mentions of friends, nods to popular culture, snippets of daily news—references, in short, to subjects never before deemed worthy of a serious poet. "This is me and I'm poetry—baby," Frank's work boldly declared, according to John Ashbery.[12] Painters, Frank argued, should be able to do the same. Pursuing that idea, the Club held three nights of panels in 1955 with nonartists like Barr, Clem, John Myers, and Tom Hess, as well as artists on all sides of the issue.[13] Far from settling the matter, the panels only exacerbated antagonisms.

During the early months of 1955, while those rancorous discussions

were under way, Elaine in her St. Mark's Place studio formulated her own thesis on the new painting, with the intention of publishing it in *ArtNews*. Previously her articles for that magazine had been about specific artists and their work, as well as the odd book review. While some of the pieces were important, and many quite long, they fell loosely into the category of art criticism. The article Elaine wrote in response to the controversy about "less than pure" painting, however, was a work of art theory, a terrain previously occupied by well-educated, intellectual men. Despite her mere high school education, Elaine felt comfortable residing there. She had lived, talked, practiced, and written about art in all its manifestations for nearly twenty years. Few were better able than she to address it theoretically, but she hadn't done so until now perhaps because any polemic she might have published would have been immediately associated with Bill. In a piece on the new art, Elaine would have been seen as his mouthpiece because Bill—like Elaine—had strayed from the purely abstract to accept figuration. Now, speaking only for herself, Elaine was freed to produce a seven-page essay she titled "Subject: What, How, or Who?," which rebutted Clem's *pronunciamenti,* ridiculed the hand-wringing by the abstract purists, and validated, with a mixture of erudition and humor, a fresh direction in art.[14]

Elaine argued that the concerns that had given birth to nonobjective abstraction during and after the war no longer applied. And to those who clung to the notion that only pure abstraction could be avant-garde, Elaine pointed to the legions of imitators who had mastered the style and in so doing reduced the artists' abstract revolution to mere convention.

> The "taste bureaucracy"—museums, schools, art and architecture as well as design and fashion magazines, advertising agencies—all freely accept abstraction....
>
> There is, however, still a prevalent belief that abstract art is, per se, revolutionary; that representational art is, per se, reactionary. Clement Greenberg recently wrote: "It seems as though, today, the image and object can be put back into art only by pastiche or parody."... This, if true, is a half-truth. The same claim can be made for the opposite.[15]

True art, she said, is that which reflects an individual creator in a particular time and place, and by its very nature must adapt and change.

No artist who paints abstractions today can possibly have the same motives as the artist of thirty, forty or even ten years ago. A Crucifixion by an anonymous Gothic artist has a completely different subject from a Crucifixion

signed by a Renaissance or Baroque artist. The difference is not only the obvious one of style, but it is the relationship of the artist to his subject....

The desire of all artists for independence, for newness, for originality is really the desire for revolution—for its own sake. If he did not desire to change all art he would never get past his love for the artist who first inspired him and be able to paint his own pictures.[16]

Tom Hess published Elaine's piece in the April 1955 issue of *ArtNews*, prompting more nights of discussion at the Club and deepening the rift between the two camps in part because the article had come from such influential sources.[17] When Bill had exhibited his *Women* paintings for the first time at Janis's gallery, the shock the art community experienced upon seeing them was due as much to who had painted them as to what appeared on the canvas. A veteran of the Waldorf, the Club, and the war of abstraction had *returned to the figure*. Elaine's article was similarly received. She, too, was a battle-hardened soldier of the avant-garde. And though her own paintings had long followed an independent course, her words had been used to promote understanding and acceptance of fellow artists whose work was so new it had required what amounted to an interpreter. Now Elaine was telling those artists to accept that the cause they had been fighting for was no longer pertinent. Unless they were prepared to explore once again to find a new vision, they would become like old warriors the world over, reliving their glory days for an audience grown weary of their tales.

Elaine's article also showed her taking a step away from Bill. It is impossible to read her statement "If he did not desire to change all art he would never get past his love for the artist who first inspired him" and not see a declaration of independence from her spouse and mentor. Elaine had found a new home among a more aesthetically and socially sympathetic group: the Second Generation and their poet friends. At that moment, she counted one of them, Joan, among her closest companions.

Joan was in the midst of her own wrenching transition. She had survived the summer madness of Bossy Farm, the Red House, her suicide attempt, and the hurricane—though her beloved dog had not. George was hit by a car on Long Island.[18] Joan's memories of him proved so raw that once, when she found herself doodling his image on a letter to Mike, she crossed it out furiously and scrawled, "I can't bear to draw him." Late that August, Joan had had to return to Chicago because her father was dangerously ill.[19] December 1954 found her back with her family for the holidays, amid fears that Jimmie's health had not greatly improved.[20]

It was in many ways the worst and the best environment for her at the

end of a year during which she had spiraled out of control. She could assess her miserable present from the place where her life's torment had started. She could comprehend with the intellect of a woman the family dynamics that had made pain and delight, abuse and devotion indecipherable to her as a child. She could also see the climate from which her paintings had arisen: the violence of the windswept lake upon which she gazed from a home stultifying in its silence. "Everybody sneaks around," she wrote Mike on December 27.

> *I can see how living here would force anybody to paint. Through successive vacations I've covered all old nostalgia and now it's drained—fuck the lake—and fuck my reactions to it & the past—shit it's depressing....*
>
> *Everything here is so couched & phrased & put in boxes—worse than a post office with combination locks....*
>
> *Father terrifies me—really. And tells me what to do every five minutes until I almost scream the way I used to "Leave me alone"—& my mother can't hear. It's so hard to keep breathing here....*
>
> *My father gave me a book for Christmas entitled "A Guide to Drawing"....*
>
> *Mother becomes increasingly generous ie Europe (1st class) & leopard fur coats discussions....*
>
> *Wish I were there listening to so much Billie Holiday—falling down with FO'H & you picking me up.*[21]

Joan amused herself in massive drinking bouts with Barney and Loly, who were in town to see Barney's mother, and with Ted Gorey, who had also returned home for the holidays.[22] But none of that socializing helped. "Man I can almost not take it," Joan wrote in a letter so disjointed she had undoubtedly written it while drunk.[23] A day later, however, her usual tone of aggrieved disdain for her parents changed dramatically. Her father had had a heart attack. "The adjoining doctor found him & rushed him to the hospital under oxygen," she wrote. "He's comfortable now & my mother's flipped."[24]

The Joan Mitchell who wrote that letter, dated December 29, 1954, was the child she had never allowed herself to be. The angry exterior she wore like a shield had vanished to be replaced by confusion, sadness, pity, and even love.

> *I've been there three times to see him—keep changing clothes to please him...he's so collapsed &...sweet the way he isn't otherwise....*
>
> *They're both so damned withdrawn.... She just lives in a closet in an enormous apartment & literally asks nothing from anybody and if he dies, what the fuck will become of her.... And if he lives as an invalid, it will be too cruel. All*

> day long I've been like Gibraltar and with all my problems about him... I've imagined that damn hospital scene for years & his saying— "you've never cared" and holding my hand....[25]

Each night, Joan returned to the family apartment alone, something she realized she had never done.[26] Her parents had always been there, entombed in their separate lives. Joan wandered around that vast space, which though devoid of people was ironically no longer quiet; each corner clamored with noisy memories. "The mixture of feelings is almost impossible," she confessed.[27] Nineteen fifty-four had been a year of death and depression. Even her paintings had become ghostlike, drained of color, or alternatively as angst-ridden as a Giacometti, whose lines described the impotence that afflicted humankind. Joan had lost her way. But standing in her parents' tenth-floor apartment, surveying the city's dazzling lights beside the dark turbulence of Lake Michigan, believing that the man who had taught her the shame of failure lay dying, Joan reset her internal compass. It was a defining moment from which she would emerge forever changed, as would her work.[28] She had broken free of the baleful influence of her father and of her childhood self. The result would be magnificent.

While Joan was in Chicago she read Rilke.[29] Back in New York after the new year, when it became clear her father would survive, she took the advice the poet had given to a young artist: "Be happy in your growth, in which, of course, you can't take anyone with you." "What we call fate does not come into us from the outside, but emerges *from* us." Seek, he said, "Solitude, vast inner solitude. To walk inside yourself and meet no one for hours...that is what you must be able to attain."[30]

Joan cranked up the music in her studio, tacked an eighty-inch-by-eighty-inch piece of linen to the wall near a window, and began to paint. Her hands covered in cerulean blue, rose madder, and burnt umber, she stood on her toes, stretching her arm and brush high above her head, then dropped into a crouch, brushes and rags strewn on the floor around her.[31] She painted deliberately, assuredly, filling the canvas with the scene she recalled from her parents' balcony. "I paint from remembered landscapes that I carry with me," Joan explained, "and remembered feelings of them, which of course become transformed. I could certainly never mirror nature. I would like more to paint what it leaves me with."[32] The landscape Joan worked on at St. Mark's Place became color—luminous, dense, cacophonous, impenetrable—massed in a stormy, swirling central plane that read "city." Hovering above that furious activity, Joan painted gauzy white, gray, and pale ochre shapes that had little to do with clouds but could be interpreted as nothing else. Across the bottom third of the painting, the same elements Joan had employed to say "sky" became "water,"

reflecting and distorting the life lived on its shore in smudges, drips, and wash. And yet, if one didn't know that Joan had just returned from Chicago, one wouldn't recognize a sky, a city, or a shimmer of lake. One would simply appreciate and admire Joan's work as a painting, which was, in fact, the point. That was all she was after.

In describing her technique, Joan once said, "I don't go off and slop and drip. I 'stop, look, and listen!' at railroad tracks. I really want to be accurate."[33] One can imagine every stroke applied, every drizzle of pigment—both those visible in the finished work and those buried beneath its many layers—being the result of just such consideration. The majesty of Joan's painting, which she would call *City Landscape,* was a quality it shared with all great art—the sense that it had always existed, and that during one inspired moment it had been dredged from the subconscious depths by a hand and mind graced with the talent and vision to retrieve it for the rest of us. That revealing work, so exuberant, so deep, so masterful, and so unlike the shards and violent explosions that had been her signature, was the result of Joan's having survived a personal hell and her own imperfections. It was her prize for having persevered, and all who saw it were the beneficiaries.

Joan poured out new paintings ahead of her second solo show at Eleanor Ward's Stable Gallery on February 22, ten days after her thirtieth birthday. She was predictably nervous about their reception. ("Never do I think of myself as a genius," she said years later, "because I don't have that kind of egotism.")[34] Joan's mother had tried to boost her confidence before the event, writing in a letter (which included a five-hundred-dollar check to buy a fur coat), "Now please don't worry about the show. You're having one! Whether you sell anything is secondary."[35] Because of her father's health, Joan's parents didn't travel to New York for the opening or the after-party at the Club in her honor.[36] They would not, therefore, be on hand to see the best show of Joan's young painting career. *ArtNews* reviewer Dorothy Seckler said her "wall-sized, landscape inspired abstractions...marks her as one of the most vital of the younger New York artists.... She has seen that color can be used not as light but as pure energy."[37] By the end of the year, Joan would be invited to participate in seven major group exhibitions, including the aforementioned Carnegie International and Whitney Annual, as well as the important national traveling show, *Vanguard 1955.*[38] Long seen as one of the more interesting members of an outsize pack of painters, after 1955 Joan took her place among the very top.

As glorious as Joan's painting life had become, however, her personal life was a shambles, and her analyst, Edrita Fried, pressed her to leave the culture that had nearly destroyed her the previous year.[39] Her relationship with Mike had long since stopped being a love affair (she said she used him

"like a garbage pail for my sickest feelings"), yet they remained connected.[40] Bunny had left the picture entirely and married a wealthy eccentric artist and theater man she met in Key West.[41] In her absence, Frank and Mike had become closer, with Joan occupying the unacceptable position of third wheel. "She began to feel neglected, jealous, then suspicious," Joe LeSueur said.[42] Drink didn't help. As Elaine described, the liquor flowed freely along St. Mark's Place, and Joan drank more than almost anyone. Under the influence of alcohol, she did not possess a filter. On one occasion, Elaine recalled a drunken party during which Joan burst into the bathroom to find Frank and Mike.

"Well, what were they doing?" an interviewer asked Elaine.

"You guess! I mean...I have a feeling it was something interesting. And, but Joan came out, you know, announcing it to everyone."

"And what did everyone do?"

"Just shrugged their shoulders and went on drinking and conversing. You know, and saying, 'Oh that's just like Joan'...and it wasn't shocking," Elaine said. "I mean, just Joan's desire to drag intimate matters out into a public arena, which is one of Joan's things."[43]

Said LeSueur, "The only conversation [Joan] deemed worth having was one with a high anxiety potential."[44] But that was Joan drunk. Joan sober knew she was destined to descend into the black hole of self-loathing from which she had lately emerged unless she changed her life. "Nothing comes with guarantees & nobody is more destructive than I," she said that year.

> *There are times, so seldom, when the world is meaningful—drunken states when you remember why you paint &...why you live so differently from everyone else—so seldom....*
>
> *There is nothing so crazy as painting & so lonely—& at all wrong hours so exciting—*
>
> *Are all artists unhappy like they say—*[45]

Edrita Fried told Joan to leave town, to get away from Mike and the person she became when she was with him. Joan considered Alaska but Fried told her to ask her mother for the money she needed to finance a trip to France.[46] Somewhat surprisingly, given that Joan still had friends in Paris, she hesitated to travel there alone. She offered to use some of her mother's money to pay Elaine's way if Elaine escaped with her. But Elaine said the timing wasn't right.[47] Tom had been made executive editor of *ArtNews*, the conversation she had helped initiate was shifting the art world, and he was prepared to take the magazine along with it.[48] Tom was also considering curating an exhibition in which Elaine was involved, featuring the younger generation.[49] Joan's trip would have to be solo.

On the eve of her departure in late May, Helen threw a bon voyage party at her apartment.[50] Joan didn't expect to be away long, just long enough to put some space between herself and Mike and to determine a course once she achieved that elusive state, emotional independence. Things didn't go according to plan. "I went to Paris in the summer of '55 to get away from personal things," she recalled. "Of course [I] ran into other personal things."[51] Joan's life became more complicated still.

The sunken battleships that had lined the coast when Joan arrived in France seven years earlier were gone, the battered buildings repaired or replaced, the previously downcast citizens revived. Spring in Paris 1955 was as wondrous as it had been before the war, when writers, philosophers, and painters filled cafés resonating with chatter and smelling of acrid coffee and cigarettes. War had come and gone, and Paris had survived. There was, however, one notable change among the artists of that city. They now worked with one eye turned toward New York because it was no longer they who represented the advance guard. The month Joan arrived in Paris, a major exhibition organized by the Museum of Modern Art, *Fifty Years of American Art,* was on view at the Musée d'Art Moderne.[52] Individual members of the New York School had had exhibitions in that city, but the *Fifty Years* show was the first survey presented to Europeans that displayed through more than one hundred paintings and twenty-two sculptures where American art had been and where it was going.[53] Grace's painting *River Bathers* was among them.[54] "Tell Grace that several people have remarked on her painting and that I say proudly I am a friend of hers," Joan wrote Mike, who was at that moment engaged in a friendly fling with Hartigan.[55]

American culture invaded France that summer, not just in visual art but in music, theater, and dance. It was part of a Cold War counteroffensive designed to blunt what Washington perceived as Moscow's aggressive cultural propagandizing.[56] "An artist who went to Paris was not an exile or an expatriate," said painter Paul Jenkins, who lived in that fabled city.

> You were put to task at the cafés on every single controversial American policy that was coming down the pike. There was a furor over the Rosenberg trial. You represented the good and the bad. In fact you found yourself a walking representative and realized just how American you were the longer you stayed.[57]

Joan fell in with an art crowd comprised mostly of Americans who socialized in the cafés along the boulevards Saint-Germain and Montparnasse.[58] One of her most important early connections was painter Shirley

Jaffe, who had rented space in Mike's studio in 1951 during a stay in New York. "Of course, I met Joan often because of Mike," Shirley recalled sixty-six years later from her home in Paris. She had also noticed Joan's work in the Ninth Street Show prior to meeting her. "I remember Rauschenberg was in the same show. They were the two people who stood out."[59] As soon as Joan arrived in Paris, Shirley prepared to introduce her to her friends.[60] Joan tried to beg off, saying she was in the Hotel Montalembert and going to bed. "So she called me...and she said, 'Oh, no! I'm sitting in a café in Saint-Germain, and I'll wait for you,'" Joan recalled. "And I got there and then I met...[painters] Sam Francis and then [Norman] Bluhm....A day or two later I met Saul Steinberg. There were a lot of people in Paris."[61]

At first, with her tousled hair, face free of cosmetics, worn leather trench coat, and espadrilles, Joan appeared among them shy, humble, watchful.[62] Paralyzed in her timidity among that new group, she felt "horribly ugly."[63] She didn't possess the confidence to muster the kind of drunken snarl or pithy retort that had helped her establish herself in New York. Early-Paris Joan would have been unrecognizable to her friends in Manhattan. "Yes I'm changed, but not enough & maybe never will be," she wrote Barney in June. "I live a curious unreality—like being on ice...anyway I'm not flipping but I am a little confused."[64]

Joan thawed quickly. Among the first significant relationships she established upon arrival was with Samuel Beckett. No doubt it was Barney who connected the two. On May 23, Joan wrote him to say, "Beckett called—he lives in the country but will come in this week. His voice is very elegant."[65] From the moment Barney had introduced Joan to Beckett's work, she was deeply moved by it. Beckett's ability to convey meaning with a few carefully chosen words—words, which although part of a whole, were to be appreciated individually—was very much like Joan's painting.[66] She, too, struck single, deliberate notes in her work.

Barney said the "rapport between Beckett and Joan was fantastic."[67] Though nineteen years her senior, the gaunt Irishman respected Joan's painting, enjoyed her company (he liked shooting pool with her), and appreciated her reluctance to speak when sober.[68] (Joan recalled Beckett saying, "Why stain the silence with words.")[69] Wrote his biographer, Deirdre Bair,

> Beckett...found this an appealing quality, especially in a young American woman so unlike any he had ever met before. She and Beckett became companions at this time, and it was to Mitchell that he turned when life in Paris became too hectic. She was the one person with whom he could drink, relax and talk, and her friendship became a crutch he leaned on heavily.[70]

Though Joan said she was in love with Beckett, their relationship was not primarily physical.⁷¹ Once he and Joan checked into a hotel to have sex, but Beckett lost his dental bridge and spent their time together looking for it.⁷² Theirs would be an enduring friendship, not a mere affair.

As she moved from hotel to borrowed apartment, café to café, man to man, Joan's life in Paris seemed pure romance compared with the violent nightmare she had left behind in New York. Joan's day began late—she described drinking "Martini blanc" all day, playing pinball, and consorting with friends who yakked endlessly—and ended early, mostly at jazz clubs, where she heard that quintessentially American music sweetened by the melancholy of Paris.⁷³ "I've never quite lived the kind of life I'm living now," Joan wrote to Mike, "so completely, completely by myself—with my eyes I meet people—*c'est tout*—Sometimes I think of Van Gogh—intensity & alone. The night is short here—it gets blue at 4 a.m."⁷⁴

She loved Paris at that hour, when the demimonde laid claim to it. "The whores gather at dawn across from the Dôme—at the Rotonde—the blonds sit on one side—the red heads at the other—all colors—wild—& the jazz musicians stare talking 3 language bop talk."⁷⁵ Soon, Joan's circle broadened to include some of the New York crowd—Mary Abbott, Marisol, John Ashbery, and Kenneth Koch were all in town—as well as people who had been in New York whom she had not met. One of them was Gorky's nemesis Matta, another was composer Leonard Bernstein.⁷⁶ "I guess I've met many famous people," she wrote Barney in June.

> *Giacometti etc but so what. I walk endlessly with David Hare—eating couscous & sitting like clochards under bridges. At night I see a variety of Time-Life-Unesco types. Dull, dull... at late night... I go jazzy listening—and I see my French horn man—young—sexy—horribly talented. Mornings I crawl to coffee at Deux Magots—if there's sun it shines there. Think of studios—read Le Monde & the Tribune—walk—blistered to the Louvre—[see] the Picasso, Pignon, Degas, Derain, shows or whatever....*⁷⁷

Joan wasn't painting much. She had managed only a few small "Klines" and a few faux "Mitchells."⁷⁸ She didn't stop socializing long enough to produce anything of significance and hadn't found the right abode in which to work. But her time wasn't wasted. Joan was gathering landscapes she could use when she did begin to paint again. "I am neither happy nor unhappy," she told Mike.⁷⁹ "Except for you I really don't want to go back—same bloody life—or is it me."⁸⁰ As the time passed, however, and as her two-month holiday neared its end, Joan felt pressed to make a decision. About something!

"Maybe I should get a studio like Grace's in NY," she offered. "I think of

Grace here." Joan had begun to understand Grace's distress and confusion that spring. The very thought of that changed scene, where one no longer strove simply to make a good painting but was also supposed to court success, unnerved her. "They make something of you & want something from you & natch I withdraw," Joan wrote.[81] "I'm afraid to go back—I do nothing with my life there & here it doesn't matter."[82] At other times she considered abandoning painting altogether. "I'm not much good but god knows not much else is either—and so to have a baby instead—no—just grow old & ugly—why not—& keep proving myself to everybody—too much effort—better to get drunk."[83] Amid those ruminations, Shirley invited Joan to "another boring party," this one with French Canadians. Among them was the painter Jean-Paul Riopelle.[84] He would be Joan's lover, and therefore her affliction, for the next twenty-four years.

Riopelle craved danger, especially speed.[85] He raced cars and boats, flew planes, and drove motorcycles—not to move from point A to point B, but for the thrill of it. Though his Bugattis (he would eventually have five) had a maximum speed of about one hundred fifty kilometers per hour, he drove two hundred on small roads.[86] He also liked to save people, but ordinarily those he chose to help were so far gone that his mission was doomed before it began.[87] And he loved life, everything it had to offer in the greatest quantity possible. He loved it the way a poor boy from Montreal, who had been thrown out of furniture school only to become the richest painter Canada had ever sired, could love it.[88]

When Joan met him, he was thirty-two, married, the father of two young girls, and a leader in the budding nonobjective abstract community in Paris. He knew or had known everyone of any importance in the art world. His work was shown in France, New York, Germany, England, Switzerland, and Japan. The Modern and the Guggenheim in New York, the Philadelphia Museum, and the Art Institute of Chicago all owned his paintings.[89] He was also handsome in the way that most appealed to Joan: dark, strong, masculine, unkempt, alternately brooding and reckless to the point of self-destruction. *And* he was a bit of a con man. Like Mike, Riopelle had invented much of his past, but he conducted himself with such dash and had achieved such acclaim that the mystery surrounding his actual beginnings only made him more attractive. "He had style," Joan said simply.[90]

As for why he was attracted to her, beyond the fact that she was as dangerous as a hairpin turn at two hundred, Joan said with similar understatement, "I impressed him because I was a WASP." In fact, Jean-Paul saw in her the first woman he considered his equal. He "recognized right away Joan of Art," said his biographer, Hélène de Billy.[91] Joan, she said, could

teach him about painting at a time when Parisian artists didn't want to paint better than Picasso, they wanted to paint better than de Kooning. Joan was also the first woman whose company he enjoyed as much as his male companions. "It's great," Jean-Paul told one friend. "I have met a woman who drinks as much as I do."[92]

Through Saul Steinberg, Joan found an apartment at 26, rue Jacob.[93] With its high ceiling, parquet floor, and large garden out her window, it was a miniature version of St. Mark's Place. It even had a phonograph on which she played borrowed records of Baroque music and the one Billie Holiday 78 she owned, *In My Solitude*.[94] By the time she moved in, almost all the summer artists had left Paris.[95] "My life is terribly simple — the trees out my window and my painting," she wrote. "I haven't been out for 3 days." Joan had covered the wall with white paper, "bought out," she said, the art supplier Lefebvre-Foinet "and la vie en rose begins — and so I come all the way to Paris to tack some canvas on the wall & step back & swear."[96]

The canvas had come from Riopelle. In lieu of flowers or candy or perfume, Jean-Paul's first gift to Joan was a role of "sumptuous" linen.[97] Though they had just met, he understood her. She would not be wooed like other women but would only respond if Jean-Paul recognized her first and foremost as an artist. "I'm getting more and more involved with the man with the car," she told Barney, who periodically sent her "Grove Press earnings" (possibly in exchange for the pure Dexedrine she sent him). "This section of my life is not rational entirely and he's the kind of person who says 'You won't return' or 'I'll follow you' — his English is awful... and so it has charm & unreality & all those things that still appeal to me & get me no place and I ain't getting younger."[98] A strong indicator of Joan's health and happiness, however, was her artistic output, and after meeting Riopelle she described herself as "painting madly."[99]

Joan hadn't intended to stay in Paris past the summer, and frequently debated returning to New York. At times, she longed for the city and her friends there, but she agreed with Jean-Paul who believed Paris was the only place in the world where one could call oneself a painter and not be questioned as to what that meant.[100] It was an idea that appealed to Joan, who had a horror of explanations and very little interest in the business of art. She merely wanted to be left alone to paint in the most congenial setting possible. And then, one day, a ride in a taxi helped her reach a decision. A postcard of Van Gogh's *Irises* was attached to the cab's sun visor. She told the driver, "Vinnie is my favorite." The cab driver looked at her and said, "Do you know why the iris is so white? Because it makes the others look so blue."[101] In a city where the understanding of art ran that deep, Joan could make a home. She decided to stay.[102]

* * *

Joan was happy. Though Jean-Paul was married and though she said she was not the kind of woman who destroyed marriages, the two became inseparable.[103] They played pool, she accompanied him to the racetrack, and even to the Italian mechanics' where he spent hours working on his cars or motorcycles with the same passion and attention he brought to his art. Riopelle's friends resented the time Jean-Paul spent with Joan and couldn't comprehend what he saw in the outspoken woman who comported herself with the freedoms reserved in France for a man.[104] "Women didn't talk," Shirley said of French society at that time. "At the table French women didn't talk, only the men talked."[105] Those who came to know Joan in Paris were struck by this "amazon" who used "bad language" and had an animal magnetism and sensuality "which was never as evident as when she lit a cigarette. Joan Mitchell possessed the charm of Lauren Bacall," Billy wrote, "and a very singular elegance."[106] Joan's smile, which she held in reserve, was so disarmingly radiant that it was engraved into the memory of those who saw it. And Joan was smiling a lot in those days.

In October, she had moved again, west of Montparnasse, to an apartment she could occupy through November. Her world, as she described it, was painting and Jean-Paul.[107] "I have become more committed," she wrote Mike, "in ideas in what I like & don't like—in what I am & am not & I think it would be easier to live the life of a painter here—the continual working & not showing for years—it's accepted & has a dignity."[108] She began establishing a life there. It was what she wanted and so it became what she feared. She told Barney,

> My love affair which—I wrote Fried about is very disquieting—no security again—emotional I mean—except he's very strong for a change—& talented—& wild & if I were 5 yrs younger it would be fine—but I think of time slipping by and wonder & wonder—age & death—God I've got that anxiety now and I used to laugh at yours—it's like a lump in my throat, a hurt in my stomach.[109]

The more important Riopelle became to her, the more Joan felt she had to leave Paris, at least for a while. She did not want to be dependent, adoring or adored, especially of and by someone as personally encumbered and unpredictable as Jean-Paul. She told Barney she would leave Paris on December 2 but return the next spring because she had found a studio and had been invited to exhibit her work in an important group show.[110] As an aside, Joan wrote, "I heard that DeK. had knocked up Joan Ward & she refuses to have [an] abortion & wants him to marry her—it all sounds very messy."[111]

★ ★ ★

Elaine had called the news of Joan Ward's first pregnancy by Bill a "bomb," but it had not destroyed her. When she learned, by word of mouth, that Joan was pregnant again and intended to have the child despite Bill's objections, the news nearly did.[112] Elaine was a "fabulous survivor," but even someone as adept as she possessed a vulnerability.[113] And that child was it. Elaine had lived apart from Bill, but she had still retained a unique place in his life and he in hers. They were family. His becoming a father would change their relationship forever. "I just knew that Bill would feel responsible for a baby.... He was just that way, and he had this incredible respect—honor—for the role of father," Elaine said.[114]

Friends noticed that Elaine and Bill suddenly seemed embarrassed in each other's company.[115] Something profound had come between them, something greater than infidelity, excessive drinking, or even violence. Elaine tried not to show her pain. "No matter how jealous or hurt she was, she never spoke ill of him," said Elaine's nephew Clay Fried. "Bill was permitted in Elaine's world to do what he had to do."[116] But everyone who knew her sensed she was suffering. "Even though Elaine and Bill weren't much for monogamy, I knew how close they were," Grace said, "and though Elaine never inspired pity, I saw how she struggled to deal with Joan's pregnancy."[117]

Over the years, Elaine had had several abortions, but at one time she had thought she was pregnant and decided not to end it.[118] Fascinated, she watched her body change and develop until she believed she might be as far along as seven months. Finally seeing a doctor, she was told she had had a "psychological pregnancy." "She was very, very affected by that," said her friend, the poet Margaret Randall. "A very sad moment."[119] In the fall of 1955, not long after Elaine learned of Joan Ward's pregnancy, a child of her own became an impossibility. She was told she needed a hysterectomy. "And that did it. No children," Elaine said, making light of the surgery that added a sad coda to that terrible time. For his part, rather than be happy about the prospect of fatherhood, Bill appeared depressed and angry.[120] Though he had thought he could go on painting women forever, Bill stopped painting them that year, turning instead to the less emotionally charged subject of landscape.[121]

The exhibition of younger artists Tom Hess curated at the Stable, *U.S. Painting: Some Recent Directions,* was held in October. Elaine had four works in the show, but she was too ill to help with the planning.[122] Whether she was in depressed seclusion or convalescing from her surgery is not clear, but she was out of the picture for an event she had helped inspire and when she should have been celebrating her entry in the important Carnegie International that fall. Elaine was an expert at surmounting obstacles.

"You know, they're not something that stops you, they're something that you get over," she would say.[123] But there was also another saying that preoccupied her. " 'For better or worse,' and in certain periods I felt, well this is for worse. Sometimes it is for worse."[124] Elaine had begun the year plotting her path to independence. She had not reckoned that her course would be so dramatically decided by another person, or that she would have to devise a radically altered plan.

45. The Grand Girls, III

> I am married to madness! I need some space between myself and—a man raging in the dark!
> — *Tennessee Williams*[1]

HELEN DECIDED TO rent Conrad Marca-Relli's house next to the Pollocks in August.[2] She had been in and out of the Hamptons that summer (partly as an excuse to drive her new convertible), and her visits had proved to be so refreshingly lighthearted that she had wanted more.[3] She needed a place to mend after a "long period of seclusion" and a "troubled spring." She was also anxious to be near friends on the island for "painter-talk," as she told the poet Barbara Guest, with whom she had stayed at Fairfield Porter's during one of her weeks in Southampton.[4] The weight of the previous year since her mother's death had not lifted. If anything, it had settled on her like a shroud. Her twenty-sixth birthday in December "was rather gloomy and lonely and it made [me] feel old to celebrate my Birthday without any 'celebration'; unlike the festas of my youth!" she wrote Sonya. "The better part of last week was spent trying to sell or give away and divide up all the furniture etc in storage, from my mother's apartment. It was a horrible job, and all done now, thank God."[5] In renting Conrad's place, Helen anticipated a break from the sad reality of her recent past, as well as greater distance from Clem.

Out of the five years in which Helen and Clem were recognized as a couple, only during two of them had the relationship not been on the verge of collapse. But following Clem's cruel reaction to her mother's death and after their return from Europe in the fall of 1954, their affair had been more off than on. They did not make an appearance together at any of the myriad New Year's Eve parties that year and, in January, Clem had turned up at a party at John Myers's in the company of another woman.[6] Helen, in the meantime, had begun seeing men her own age. Previously, whenever she had suggested they try a separation, Clem had made light of it, convinced she would be back.[7] In late May 1955, however, when Helen announced she wanted nothing more to do with him, that she was ending their relationship, it sounded final.[8] But rather than accept the news with the spiteful arrogance one might have expected, Clem became needy. He had surprised himself by discovering after Helen's rebuff that he was in love with her.[9]

The breakup came at a particularly difficult period for Clem. His now college-age son had reappeared in his life exhibiting signs of what would be diagnosed as schizophrenia.[10] Professionally, Clem was also out on a limb, having managed to annoy just about everyone with his piece "American-Type Painting" in the *Partisan Review* that spring.[11]

Nineteen fifty-five was a year of summing up and critical surveys, and Clem had weighed in with his own. After reviewing the history of the New York School, he high-handedly assigned gold stars to those artists he determined to be the new geniuses, particularly the First Generation painter Clyfford Still, whom he described as "perhaps the most original of all the painters under fifty-five, if not the best."[12] He also demoted those he had previously championed, most notably Pollock, whose last show he described as "forced, pumped, dressed up."[13] Artists saw in Clem's essay a lack of understanding of what they had done or were doing, according to Fairfield Porter, and proof of the high esteem in which Clem held not art but himself. In a letter to the editor of the *Partisan Review* rebutting Clem's piece, Fairfield wrote to humiliating effect, "Sometimes he says 'we' when 'I' would be more accurate."[14] Even Clyfford Still, the beneficiary of Clem's praise, wrote to Jackson and Lee, saying, "May I add that I wish [Greenberg] had never seen my work or heard of it?"[15] Pope Clem, Clem the Terrible, Clem the Kingmaker was still *somebody,* but his power had begun to wane.

Clem couldn't sleep, and he began taking a mixture of prescription and over-the-counter drugs. On June 2, Helen called him and found him "disoriented." Concerned, she told him to contact her analyst and, through this circuitous route, Clem found a young psychotherapist named Ralph Klein.[16] Klein had no medical training but was a follower of the "father of American psychiatry," Harry Stack Sullivan.[17] Klein's generation of analysts adopted Sullivan's notion of psychic problems being rooted in the family but proposed their own radical solutions to deal with them.[18] The way to overcome even the most debilitating problems, they said, was to break restrictive bonds—familial, marital, social—and adopt the Sullivanian notion of freedom. Family ties were out, monogamy was out, any kind of self-censorship or restraint in speech or act was out, too. Clem thought Klein terrific.[19] He reinforced Clem's natural inclination toward self-absorption. "He didn't think about other people. He thought about himself," Clem's future wife, Jenny Van Horne, said. "Clem didn't try to figure out what anyone else was feeling."[20]

After Clem began his therapy, Helen and he met for drinks and dinner. Though Clem did his best to be "nice," Helen declared tearfully but firmly that they would never again be a couple. As he had many years earlier after receiving the Dear John letter from his lover while on a military base in

Michigan, Clem responded to Helen's rejection with a nervous breakdown.[21] "Clem was in over his head with Helen," said Jenny.[22] This was a remarkable statement, given that she was talking about one of the most powerful and terrifying men in the New York art world, one who was two decades Helen's senior. But, in fact, Clem was devastated to the point of incapacitation by her loss. Clem's younger brother helped him gather his things from Helen's apartment, then took him to his home on Long Island, where he nursed him for several weeks. "He was kind of sleepwalking," Martin Greenberg recalled. "He had a 'high' quality.... He wasn't manic in behavior but manic in thought." Ironically, Martin added, "He was better at that time to be with, more human, more open, than he ever was before or since."[23]

If Marca-Relli's place in rural Springs looked to Helen like a refuge, she couldn't have been more mistaken. Not only would her own crises follow her with Clem's arrival in the area, but her neighbors, Lee and Jackson, fought so violently that the house shook first with his screams—"Bitch, bitch, bitch, bitch, bitch!"—and then with her bitter replies. After ten years of marriage, Lee had begun to consider a radical option: divorce.[24]

For the Pollocks, 1955 had started inauspiciously. In February, a drunken Jackson broke his ankle a second time while wrestling with a friend in his living room.[25] Again out of commission, he drank from morning to night, alternately wallowing in self-pity and erupting in fury, mostly over what he had become. Swollen, unshaven, bearing scant resemblance to the man he had been, in moments of clarity Jackson saw himself as a failure. "Shit! All I am is my art," he told a friend.[26] And yet he confided to another that he had not "touched a brush" for more than a year.[27] He was drained, ruined, left pacing the floor dragging his cast and shouting, "What more do they want from me, what do they *want?*"[28] Yet the real question was, what did he expect from himself? Unable to reach the purified mental state needed to produce the work that lay dormant inside him, all Jackson was left with was his rage.

The adventurous collectors who dallied in the "growth" area of avant-garde American art had begun considering Jackson's work. That year he finally sold *Blue Poles* to a collector on Park Avenue for six thousand dollars.[29] It was a stunning amount. "The gossip spread like a forest fire," Helen said, "from the beaches of the Springs to the art world and beyond that. Unbelievable news."[30] Six thousand dollars was more than most painters had made in a lifetime of trying to sell their work. Once again, it looked as though Jackson had broken the ice. But while those kinds of sales thrilled Lee, they meant little to him. Paul Jenkins described an evening in the professionally decorated apartment of a private art dealer who was try-

ing unsuccessfully to interest the Modern in a new work by Jackson. In the midst of the gathering, Jackson looked around and said, "This is a windmill...going no place fast." He repeated the phrase several times.[31] Was he commenting on the sale of his painting? The plush environment? Was he philosophizing, or getting ready to blow? During earlier drunken episodes, Jackson had been able to control his outbursts when among people he needed. By that spring, he no longer possessed an off switch.

Curator Sam Hunter and his pregnant wife, Edys, had come to Springs for a weekend that May. Edys said Jackson "played the hi-fi at decibels that would give you an earache, and Lee screamed at decibels that would give you an earache." Jackson also treated his guests to a hair-raising ride in his Olds during which he seemed to enjoy their realization that he could kill them all if he wanted to. Sam came away convinced Pollock was "a real psychopath."[32] As much as Jackson frightened or hurt those around him, however, it was nothing compared with the pain he caused himself. He was being ripped apart from the inside. He was going down, and he wanted everyone to know it. His tragic act could almost qualify as performance art.

Lee's friends watched her struggle with ill health, with a fiend of a husband, with her work.[33] Before he broke his ankle the second time Jackson had actually been worse, if only because he was mobile. Nick Carone, who had a house near the Pollocks', recalled receiving a call from Lee at about two a.m. during this period asking for help. Jackson had been drinking all day, she said, and had disappeared. "Their house was so cold, I kept my coat on in the kitchen where I sat with her," Nick said.

> So we sat there, waiting, and drinking coffee in the cold of that kitchen. Lee would get up and look out a window every now and then; whispering "Where is he?" Or when a car would pass, she'd say "Maybe he's in it."

After about an hour, Jackson finally appeared, wearing a wool hunting hat and a halo of lunacy.

> And he looks at me, "What the fuck are you *doing* here?" I thought, my god—the way he was acting—he's come and he's going to kill me. Lee wanted him to sit down because she was nervous about how drunk he was and his mental state, and she was right to be. He was *violent*—making a scene—and then in a rage he was yelling and screaming, and you'd think he was losing his mind: "I've done it, I've done it, you fucking whore!"...I've never heard a tirade of profanity in my life like that, never—but with *violence*. Try to understand the intensity of that moment in winter, three o'clock in the morning, and his coming in—wham! I saw us there being killed by a madman.

And here was Lee babying him, offering him milk, then more of his profanity. And he was standing there, losing his mind, yelling and screaming. Then he jumps up, grabs at that chandelier in the ceiling, and it came down on him. He goes over on his back against a big flower pot. He hurt himself and he was lying there on the floor with Lee asking where it hurt, was he bleeding? Maybe it was the shock, but he calmed down—exhausted, almost out. Then she wanted to try giving him milk and told me to go, it would be all right now. She'd take care of him.[34]

At the start of their relationship, Lee's caring had been an act of love, but by 1955 it was mere survival. Like many who learned to live with an alcoholic or addict, the choreographed steps required to talk them out of a rampage had become rote. Remarkably, though, during that season in hell, as Jackson roamed the house looking for someone or something to destroy, she was focused on her art. It seemed that the worse Lee's domestic situation, the more beautiful her shattered images became. That was where Lee found peace. Her colitis had made her so weak that she had trouble climbing the stairs.[35] But in her studio she could direct what remained of her energy toward something more productive than anger.[36]

At the end of July, Clem turned up.[37] Though he had not been on good terms with the Pollocks since the Bennington show fiasco three years before when Pollock had called Clem a fool, he wanted to see them. In his own demented state over Helen, Clem said he "preferred going to them than to anybody else."[38] Clem was under no illusions about the state of affairs on Fireplace Road. He knew that Lee bore the brunt of Jackson's abuse. But the scene he found in Springs was so horrendous that he was afraid for Lee's life.[39] "Before Lee got sick she was pretty intense," Clem said. "She was formidable; made of steel. And so competent at everything.... Then when she was soft after her colitis, she didn't give a shit anymore....Jackson couldn't stand it." Lee had been Jackson's staunchest defender. She had believed in him when he wasn't sure of himself. Now that she was debilitated by illness he erroneously reached the conclusion that she had abandoned him, and that was more than he could tolerate.[40] "Jackson was in a rage at her from morning till night," Clem said. "He had a sharp sense of how to find someone's sore spot and he was out to wreck her."[41]

Clem said he wondered why Lee didn't "get out." "She had this drunkard on her hands. I don't like calling Jackson a drunkard, but that's what he was. He was the most radical alcoholic I ever met, and I met plenty."[42] Clem took Lee's side. Very little shocked Lee, but Clem's uncharacteristic gallantry may have. She was still angry with him over his "American-Type Painting" article that spring, in which he had denigrated Jackson so pointedly.[43] She also resented him on her own account, over his belittlement of

her work. But Clem either was not aware of her feelings, or he didn't care. He adopted what for him was a most unusual role—a defender of women. "And there'd be the two of us fighting Jackson," Clem said.[44] His intervention gave Lee a reprieve. Jackson had a new foil in his kitchen.

Clem's by now beloved therapist Ralph Klein was vacationing near Springs in August, and Clem suggested Lee see him. Jackson wanted to go, too, and so the three trundled along in a car filled to capacity with neuroses to pay Klein a visit. Klein accepted Jackson as a patient and referred Lee to a Sullivanian colleague, a Dr. Leonard Siegel. Clem had full faith in the therapy, which he believed was helping him turn his life around.[45] But friends doubted either "doctor" would help Jackson or Lee. Patsy Southgate called Klein a "thirty-year-old sort of nonregulation shrink.

> I recall how Klein thought he could understand Jackson, but I don't think he understood him in the slightest; he was a callow youth. Jackson was in despair and doing a lot of weeping, which I never minded except when I felt they were sort of crocodile tears and he'd be peeking through his fingers to see if you noticed him.[46]

As for Siegel, a young relation of Lee's called him "insane, off the wall." Lee's friend Cile Downs said that far from helping Lee, Dr. Siegel "wanted Lee to coddle him." Clem said Siegel came to Lee to be "comforted." He, like his colleagues, believed therapists should sleep with their patients.[47] That meant that instead of lightening her burden of woes, Lee had attracted another dependent. She was in such desperate shape, however, that she continued the therapy. Lee may have been intrigued by one aspect of Siegel's technique: He had patients keep diaries of their dreams.[48]

The notations she took of them were, in fact, revealing. Many of her dreams involved shopping for food or clothing, from which she had forgotten to remove the price tag. Her anxieties born in the Depression surfaced in those dreams because she was never sure of being able to find or afford what she needed.[49] Others revealed her jealousy. In one she dreamed that Jackson announced he was going to have an affair with Joan Mitchell. Some nightmares concerned her worry about Jackson's drinking.[50] But mostly Lee's dream notations involved self-analysis.

> From whom did you inherit your greed—Must you have all—Why not learn to live with the fragments that are meant for you—Do you really think you can harness the sun?[51]

Toward the end of her notebook Lee copied a portion of T. S. Eliot's poem "Four Quartets," which described a quest that returned the explorer

to his beginning.⁵² That was all she sought. Herself. It had been a long, long time since Lee had encountered her.

That summer, Lee and Jackson drove with Marca-Relli and his wife, Anita, to Riverhead to apply for passports.⁵³ Sometime in late 1954 or early 1955, Clem and Helen had introduced Lee and Jackson to the British art dealer Charles Gimpel,⁵⁴ whom they had met in Europe. Jackson had had a solo show in Paris and had been included in numerous group shows in France and Italy, but broader Europe, especially England, was an untapped market, and Lee was anxious to get his work into an important gallery there. Gimpel Fils, which Charles; his wife, Kay; and his brother Peter ran in London, was just such a gallery. Lee saw a trip to Europe as both good business and possibly restorative for their marriage.⁵⁵ The journey, however, would have to wait. Jackson wasn't ready to travel. He told Conrad he was afraid if he got drunk in a foreign country and needed help no one would understand him.⁵⁶ As the Marca-Rellis left for Europe, the Pollocks returned home to do battle in Springs.

That was the bucolic scene into which Helen arrived on July 29. Blithely unpacking her bags, she made ready to socialize and immediately organized a chowder fest with Barbara Guest for the next day.⁵⁷ By the end of Helen's first week, however, Clem was in her social circle—staying with Barbara—and the storm clouds literally descended. The sea had turned green and wild as Long Island awaited yet another summer hurricane.⁵⁸ Amid the howling wind and rain, Helen had a dinner party (one is tempted to say bravely) to which she invited Clem; her screaming neighbors from across the fence, Lee and Jackson; her old studio mate Friedel; Barbara; and the collectors who had purchased her painting *The Facade* for the Carnegie Institute, Rebecca and Bernard Reis.⁵⁹ Helen was an excellent hostess, and went to great lengths to make sure every aspect of an evening was exquisite.⁶⁰ That night was no exception, but she had overlooked (or possibly not understood) the combustible combination of personalities at her table. "Terrible, hostile evening of enemies," Barbara wrote in her diary of August 6, 1955, describing the event.⁶¹ From there, the situation only deteriorated, like the weather.

Hurricane Diane, which at the time was one of the three deadliest on record, was a tropical storm when it hit Long Island, but its prodigious rainfall caused flooding, and high winds threatened power lines and roofs.⁶² Storms made Lee frantic, and in her already unraveled state she became insensible. Clem was on hand, ostensibly to see his analyst, but in his frequent visits to the Pollocks he also crossed paths with Helen.⁶³ Evidence of just how disturbed Helen was in that environment came on August 25, the day of her end-of-season bash, to which she had invited her

friend Sonya Rudikoff and all the artists on the island.[64] "When we got there, she hadn't bought the food," recalled Ernestine. "She sent the boys out to buy it."[65] Helen, for whom no entertaining detail was too small, had failed to cook. The lunacy that emanated from the Pollock household was contagious.

There was, however, one bright spot that dark summer. Eleanor Ward had offered Lee a solo show at the Stable Gallery in September. It would be Lee's first in the city since 1951, and she would show the collages that had been building up in her studio like diary entries. Eleanor came out to Springs to select the work she wanted for the gallery. "*You* select *my* show?" Eleanor recalled Lee's howled outrage at the notion. "*I* am selecting my show and I am hanging it on both floors," Lee demanded. Ward threatened to call off the event entirely unless she picked the work. Somewhat surprisingly, Lee agreed.[66] In fact, there was little risk that Eleanor would select badly. Lee's collages were consistently good, so good Clem would say years later that Lee's exhibition that fall was one of the great art events of the decade. Recalling her show many years later, Lee said simply, "I felt something positive was happening between myself and the outside world in that '55 exhibition."[67] She must have known it was exceptional. At the age of forty-six, instead of signing her work "LK" as she had since her Ninth Street days, she had begun to sign her full name: *Lee Krasner.*[68]

On September 26, Clem, Jackson, and Conrad Marca-Relli drove into the city for Lee's opening.[69] In the past when Jackson was jealous of Lee's work, he mounted a scene-stealing tantrum. For the Stable show, however, he cleverly staged a new act. Well-groomed in a pinstripe suit, tie, and dress shoes, Jackson appeared disarmingly normal. "All the women moved in on him and he was shaking hands," said Lee's nephew Ron Stein.

> That transformation meant it was no longer Lee's show; he had ended it then and there on his entrance. He knew what would happen, so it was a sonofabitch thing to do: to come in sober, no breaking things up, no punching people in the nose. He was feeling his power, and Lee lost control.[70]

Though furious, Lee wasn't about to allow him to ruin her night.[71] She mounted her own act, implying that Jackson was so well-behaved because he was "proud as a peacock" for her. It was she, however, who was proud. Nineteen fifty-five was *her* year.[72]

In addition to being challenging and inspired works of art, the pieces on the walls of the vast Stable Gallery were a testament to an artistic spirit that would not die despite unimaginable psychic chaos and physical pain. Dated from 1953 to 1955, Lee's collages charted her transcendent journey

of self-*re*discovery and her mastery of a technique popularized by the Cubists that she had transformed as much as her Abstract Expressionist colleagues had transformed their predecessors' handling of paint. Lee's initial collages, which she constructed using the drawings she had torn from her walls in a fit of pique, were small and muted, with an overall sense of restraint. Soon, however, once Lee felt comfortable with the medium, her joy in the process became evident. It was as if a light in a darkened room had been switched on. As if *she* had been switched on. One writer described Lee's work as bluesy, and much of it was soulful, while other collages possessed the spark of visual jazz.[73] Gallery-goers moving from collage to collage would have seen that Lee's relatively timid work of two years earlier had grown in size—to nearly seven feet—and boldness in brilliant reds, cadmium oranges, and violets. Covered in paper, fabric, bits of discarded paintings and drawings, Lee's work vibrated and pulsed. It was impossible to miss the message that Lee Krasner had been reborn.

Everyone came to see what Lee had been doing in her studio. Many who had wrongly assumed that she had given up expressed admiration for her collages—Betty Parsons bought one (it would be Lee's sole sale)—and reviews were favorable.[74] *Arts* magazine remarked on Lee's having moved collage into the realm of painting.[75] Fairfield saw in her work Lee's regard for and transcendence of nature.[76] But it was Clem who recognized the show for what it was: powerful, unexpected, groundbreaking. (Of course, he didn't tell Lee. She would have to hear what he thought of her show thirdhand, many years later.)[77]

Helen had arrived at Lee's opening late on the arm of a thirty-three-year-old, switchblade-carrying Beat writer from Idaho named Chandler Brossard.[78] He was, in every regard, the opposite of Clem: a western WASP hipster. Clem began seething. Bob Friedman, a childhood friend of Helen's and heir to a real estate fortune, threw a party for Lee after the opening at his Sutton Place flat.[79] He had written an article on Pollock (calling him "the Rubens of our time") and visited Springs for the first time that year.[80] Well supplied with liquor, everyone who gathered at Friedman's posh place expected that on the emotionally charged night of Lee's show Pollock would provide the fireworks. And, indeed fireworks came like clockwork—but not from Jackson. Sufficiently oiled to release the pugilist within, Clem lunged at Helen's date. "The next thing I knew, Clem and Chandler Brossard were swinging at each other and rolling around in my hall," Friedman said.[81]

About a week later, on October 4, Helen's former Bennington teacher Paul Feeley had an opening at Tibor de Nagy.[82] Both she and Clem were involved in preparing the exhibition: Clem helped Feeley hang his work,

and Helen hosted a post-opening party for Paul and his wife at a friend's place in the Village.[83] With Miles Davis and Charlie Parker on the phonograph and the apartment crammed with the usual Tibor de Nagy ensemble, the evening proceeded in a haze of cigarette smoke, Scotch, and the warmth of close friends. A twenty-one-year-old guest, Jenny Van Horne, who had just graduated from Bennington, sat shyly on the couch watching characters she had previously read about in magazines. Even amid that intimidating group Helen, to her mind, stood out. "She was unmistakable," recalled Jenny. "She was so alive, people gravitated to that.... She was shamelessly open."[84] Helen had come to Paul's show with another writer beau, a poet-playwright friend of Larry's named Howard Sackler.[85] Clem saw Howard as yet another young man trotted out to torment him. At some point during the evening, a Frank Sinatra record was placed on the phonograph—Helen's favorite.[86] She began to dance. Tall, "good-looking and cool," her thick hair shoulder length, her lips red without lipstick, her swaying skirt emphasizing a near perfect figure, she dared everyone to free themselves.[87] "Electric," Jenny said. "She was so beautiful."[88]

Clem loved to dance, too, and did so often with Helen.[89] The music and her movement were further reminders of what he had lost. John Myers saw an opportunity to make mischief and "sidled up to Clem... raving about the youth and beauty of Helen's new paramour," according to Larry.[90] Standing in the kitchen, John implied to Clem that Helen was madly in love. "Clem's legendary ire exploded. He punched John Myers, the cheerful messenger of the tidings; then he made his way across the room to where Helen was talking to the new boyfriend," Larry said. "And before she could answer his spittle-strewn questions [Clem] slapped her."[91] Knocking her down, he then went after Howard, who landed a punch that sent Clem to the floor.[92] John, meanwhile, ran out of the kitchen shouting, "Clem's crazy! He's crazy! Get him out of here!" Crying, Helen had fled to the bedroom, where she curled up in a chair surrounded by friends as Clem stood across the room.[93] He tried to say that he hadn't slapped Helen, that he merely pushed her, but that distinction was lost on her friends.[94] Slapping women was part of the macho culture of the time. Heroes like Bogart did it in the movies; Mickey Spillane novels—the most popular in the country—were rife with it (or worse); frustrated husbands did it to their submissive wives.[95] *Nobody,* however, did it to Helen Frankenthaler.

Only two people watched those dramatic events unfold with a sense of detachment. One was John Myers, who saw the gossip gold to be mined from the evening and his own clever role in its unraveling. "I was so lucky," he told Grace the next day on the telephone. "As I was falling, I grabbed some steak tartare and clapped it to my eye and I don't even have a black eye today!"[96] The other was Jenny Van Horne. Amid the chaos, she had moved

next to Clem in the bedroom and offered him her phone number, which he dutifully jotted down.[97] Earlier that night the two had talked. "Clem was so nice and he looked at me and talked to me and took my measure," she said. Shocked and pleased by her bold gesture during what she called a "grown-up" party, Jenny left.[98] Having stuffed her number in his pocket, Clem quickly forgot about Jenny and returned his obsessive focus to Helen.[99]

While in New York, the Feeleys stayed with Helen on West End Avenue and witnessed the contretemps between the former lovers. A contrite Clem came by the next day and asked Helen to marry him. She requested time to think it over, but when he returned for her answer it was an unsurprising no. Clem flew into a rage and came after her, but Helen managed to lock herself in the bathroom. While he beat on the door trying to break it down, Helen Feeley summoned Ralph Klein, telling him to come over immediately to "stop Clem from killing Helen."[100] After that dramatic performance, Clem made a show of having moved on. He called Jenny and the two began dating. But privately, he was consumed with Helen. Clem sent her six imploring messages in the days after she rejected him, and his journal entries during that period ranged from simpering to murderous.[101]

While Clem vented his rage, Helen relied on sleeping pills and therapy to get her through the worst of the crisis. She also found herself surrounded by friends who made sure she felt safe and supported.[102] In fact, the more Clem raved, the more isolated he became. Friends Helen had met through Clem began to shun him to socialize with her.[103] Clem experienced that changed reality firsthand when he nervously attended the November 28 opening of Jackson's show at the Janis Gallery and encountered hostility all around, especially from the women.[104] He had arrived at the opening with Jenny, as he had arrived at Pollock's show in 1950 with Helen.[105] The difference between those two occasions did not just involve the women on his arm. Clem was another man. The scene had moved beyond him, and in his dogmatic rigidity he had been unable to move with it.

Jackson was another man, too. In that exhibition five years earlier, he had created a universe and was reviled for it. In 1955, Janis was forced to call the show a retrospective because there was nothing new in it. Jackson had completed just one painting the previous year.[106] And though some of the works on Janis's walls were wonderful, they felt old, so old that critics in the general press and a growing portion of the public felt *comfortable* with his work. Even *Time* magazine, which had mocked Jackson cruelly during his most productive years, now called him "The Champ."[107] Clem, however, walked the gallery shaking his head in melodramatic dismay. Grace looked at Pollock to see if he had noticed. Jackson had and was "devastated."[108] They all were—Jackson, Lee, even Clem. But before that year was out, Clem had one more shot to take.

On December 28, *Vanguard 1955,* an important traveling show that had first opened in Minneapolis, reached New York and the Stable Gallery. Joan and Helen had been selected to be among the twenty younger artists featured from around the country. The event was that year's crowning achievement for Second Generation artists, who were being recognized as something other than "followers of" de Kooning or Pollock. They were now respected for the quality of their own work and innovations. Though the opening occurred three days before New Year's Eve, it felt in every way like a celebration of a new beginning. The Stable, despite its ample space, was packed. Jackson and Lee were among the few who were absent. But Joan was there, back from Paris. And Elaine had come, too. Friends watched to see how she comported herself in a crowd that would surely put her in close proximity to Bill. She did so as she did everything, with aplomb, except that she drank more heavily than usual.[109]

And so it was that Clem had a full house when he decided to do his best to ruin Helen's show. Helen was accompanied again by Howard Sackler, and even though Clem was with Jenny, the idea that Helen would parade her new young man among their old crowd awakened the jealous monster within.[110] The "next thing I knew," Jenny said, "Clem had pushed the man over a bench. For me, it was a replay of the night we had met. Except then it had been strange and interesting. Now...it was awful."[111] Howard righted himself and took a few swings at Clem.[112] People stopped looking at the art and began watching the fight. Jenny moved to the back of the gallery, blaming Clem but also thinking "Damn Helen!...Suddenly, there was Bob Motherwell, whom I barely knew, standing next to me," she recalled. "He handed me a drink, said soothing things, and gave me a handkerchief for the tears that his kindness had set to flowing."[113] Bob was an elder statesman among that crowd and had seen far worse than Clem and Howard's scuffle over Helen. So had Helen. She had no fears for Howard, who could handle Clem. But Clem was frightened by the depth of his rage.[114] He had to move on. Having convinced himself that he was through with Helen, within weeks he asked Jenny to marry him. She said yes.[115] Helen was free. She could breathe—and paint—again. She was on her own.

The end of 1955 was truly the end of an era. Friendships dissolved over aesthetic arguments and money. Marriages and relationships born in poverty and obscurity could not withstand the onset of fortune and fame. Even the institutions and architecture associated with the New York School changed. The last portion of the Third Avenue El was demolished and, while the artists along Tenth were not displaced, the homeless residents who lived among them were. "It was much nicer when they were with the bums," Mercedes said of her fellow artists.[116] As for the Cedar, it

had become so crowded with art tourists and painter wannabes that the regulars found themselves a new bar, a Bowery dive called the Five Spot.[117] And, after six years, the Club left Eighth Street and moved to a space on 14th.[118] Philip Pavia, who had kept the Club afloat financially (and bloodshed within it to a minimum), resigned as its director-by-default, passing control to a new generation.[119] It was their time now and it looked nothing like the past. Creaking and groaning, America in general was awakening to an uncertain dawn.

James Dean, who had showed movie audiences that a boy did not have to be a brute to be a man, died in his speeding Porsche in California.[120]

Ten years after Hiroshima, nuclear annihilation had become entertainment. Helen's former roommate Gaby Rodgers played a luscious villain who set off a nuclear explosion in the film *Kiss Me Deadly,* one of dozens of movies that thrilled audiences with celluloid visions of mass destruction.[121]

Thirty-four-year-old Charlie Parker died of heroin and booze after sparking the bebop revolution that had changed the way people heard, made, and moved to music. But by then, white men had learned the black man's rhythm, and twenty-year-old Elvis Presley topped the music charts.[122]

Racially the nation was at a crossroads. A 1954 Supreme Court decision desegregating American schools had forced the country to confront its history of racism. It was a decision by men in black robes that was ignored in municipalities where men wore white robes. They responded, as they always had, with violence, but the reaction they encountered was no longer fear. The August 1955 murder of a black fourteen-year-old named Emmett Till in Mississippi, and the defiance of Rosa Parks on a bus in Alabama, gave rise to the civil rights movement and gave voice to a young leader, the Reverend Martin Luther King Jr.[123]

And, across the country in San Francisco, Allen Ginsberg became a voice for another population when he gave the first public reading of his poem *Howl*.[124] "I saw the best minds of my generation destroyed by madness, starving hysterical naked / dragging themselves through the negro streets at dawn looking for a fix...."[125]

This was the new world, one of confusion and discord, and of course art. Artists continued, no matter the world around them. The New York School would, too. But after 1955, it would be different.

PART FOUR

1956–1959

The Rise and the Unraveling

46. Embarkation Point

> I wonder if this new reality is going to destroy me.
> —*Barbara Guest*[1]

A BIRTH MARKED the start of 1956. On January 29, Joan Ward delivered Bill's daughter, Johanna Lisbeth de Kooning—Lisa. Franz had taken Joan to the hospital because she wasn't able to find Bill. He appeared the next morning at her room "like the white rabbit," Joan said, in a state of "total shock." Bill hadn't necessarily wanted the child, but when he saw Lisa through the nursery window he fell in love.[2] She was his very best and most unexpected creation. As soon as Elaine heard the news, she, too, made her way to the hospital with a bouquet of flowers for Joan.[3] She had had several months to process the fact that Bill would be the father of someone else's child and had made peace with it. "She did not like everything the world dealt her," said her nephew Guy, "but she was not bitter.... This is the die that's been cast so I'll make the best of it. She wouldn't complain. She'd say this is what I must accept."[4] Looking at the hospital register, however, and finding not Joan Ward's name but her own—"Mrs. Willem de Kooning"—listed in the maternity ward, Elaine stood dumbstruck before what felt like a cruel joke.[5] Elaine would never be the occupant of that happy ward because she could not bear children. The wound reopened, Elaine arrived at Joan's room announcing with sarcastic cheer, "How wonderful, Bill and I always wanted a child." And, upon seeing Lisa, laughingly remarked that the baby—though blond as Bill—looked like Pollock![6] Elaine had gone to the hospital with magnanimous intentions, but by the time she arrived at Joan's room hurt had gotten the better of her.

Inevitably the question of divorce and marriage would arise as a result of the birth. Joan wanted Bill to divorce "that nag" Elaine so she, Lisa, and Bill could be a family.[7] That did not happen, and there are many competing theories to explain why. "He wanted a divorce, or he said he did," recalled Ernestine, "and Elaine backed out, she kept backing out. She wouldn't divorce him. She wanted to stay as Mrs. de Kooning."[8] Elaine, however, said she offered to divorce Bill after Lisa's birth, but it was he who said no. Rudy Burckhardt explained that being married to Elaine saved Bill the trouble of legally committing himself to another woman.[9] As much as Bill may have loved Lisa, he had no deep feelings for Joan and was, in his very

strange and estranged way, still bound to Elaine. "They never physically or emotionally left each other," said Elaine's nephew Clay.[10]

Joan had a small apartment where she lived with the baby, while Bill continued to live on Tenth Street.[11] It soon became clear that, though he tacked a picture of Lisa on the wall of his studio and brought friends to Joan's place to see her, he had no intention of being a traditional father.[12] Contrary to Elaine's expectations, his life changed very little after the baby's birth. He painted, he drank, he cavorted with women. He even grew closer to Elaine. She began to occupy a place familiar to many Western European wives whose husbands had mistresses, even separate families. Elaine became the person Bill could count on and return to because of their shared history. She and her family were his family. Later that year, when he moved Lisa and Joan to a house in Springs, it was to a property owned by Elaine's brother Peter.[13] From Elaine, Bill could expect unconditional forgiveness and acceptance. (An extreme illustration of that had occurred once after Bill struck Elaine in public: She took the hand that hit her and kissed it.)[14] It isn't clear, though, whether Elaine could similarly depend on him. But she must have believed so. Elaine's life of professional and personal independence was lived as Elaine de Kooning, wife of Willem de Kooning, whose $9.50 wedding band she still wore.

Elaine had given up her noisy flat on St. Mark's Place that year for a large loft on Broadway at Tenth Street. She had begun a new series of paintings in preparation for a second solo show at the Stable that spring.[15] On Broadway, without hours of percussive disturbance from below, she could concentrate on what her paintings said. Sometimes, she'd sit alone with her work and think, "'Gee, it's crowded here.' It's the sense of being open to a great many possibilities at once."[16] Elaine had begun a series of drawings she called "cocktail portraits...done over martinis."[17] More exercises than finished pieces, the drawings took a very short time. Often, however, a particularly intriguing sketch—either because of the pose or the person—became a painting. Some were of Bill, some of Tom, some of her favorite muse, Aristodimos Kaldis, but the most significant that year was Elaine's portrait of Harold Rosenberg. "That was the largest painting I had done up until that time," Elaine said.[18] "And it was the only painting in my life I ever did on the floor. I had made a drawing of Harold...and then working from the drawing. I did the painting on the floor and I utilized washes, in color, and then contours going through it."[19]

Elaine called the painting a breakthrough and it was.[20] Previously Elaine's work was characterized by its thick impasto, her strokes having built up layers of paint until her surface appeared dense and textured. In the massive portrait of Harold, slouched in a chair with a can of beer in one

hand and a cigarette in the other, Elaine applied paint almost as if she were working on a mere eight-by-ten-inch sheet of paper with watercolor and India ink. The overall effect was simple and weightless. White had never before been so important to her painting, and when it had appeared it was as thickly applied as the other pigments. In Harold's portrait, Elaine allowed the primed canvas to act as her white. Harold's exquisitely rippled shirt, for example, was comprised of little more than canvas and a loose dark line of paint flowing effortlessly between his chin and his belt. Nothing more was needed to describe fabric and the body beneath it. The overall impact of the painting was light, bright, quick, and masterful. The fact that it was seven feet tall made that result more remarkable still.

Clearly Elaine was experimenting with new influences. For the first time her work dripped, employed paint thinned to the consistency of turpentine, and included horizon lines to split her canvas into large blocks of color. At that time there might have been two possible sources of Elaine's inspiration. On January 31, Helen's latest show at Tibor de Nagy had opened with fifteen paintings done during the previous year. Amid the complicated events surrounding her deteriorating relationship with Clem, Helen's paintings had become "simplified and simplified and simplified," she said, though they appeared anything but.[21] The thinly applied paint in her new work had mass and structure; though the paint had been poured, it no longer felt liquid. Helen's handling of paint may have given Elaine the idea that the human figure could be formed of a similar wash and still have density. Friedel had reported to Clem that everyone attended Helen's opening and that she was receiving accolades from the greater art world for her work.[22] Clem was significantly absent from the party, but it is likely Elaine had been among the throngs. Helen's opening occurred two days after Lisa's birth, when Elaine, raw and wounded, would have sought art and the company of artists as an emotional balm.

If Elaine's portrait of Harold showed Helen's influence, it also showed the influence of a much older artist, Mark Rothko. Elaine had begun visiting him with an *ArtNews* article in mind and felt reassured in his company because of both his manners and the turmoil he, too, was experiencing in his life.[23] Rothko was selling, and that fact, which should have been a comfort, pained him because he believed his art had nothing to do with commerce.[24] In the art-as-investment environment that gripped New York, Elaine found him refreshing. An old-school Russian intellectual, Rothko had no time whatsoever for appearances: His shirt hung untucked, his fly was often open, and smoke from a seemingly perpetual cigarette rose to create a barrier between himself and whomever he addressed.[25] Nonetheless, Elaine said she found Rothko "dignified privately and dignified publicly."[26]

When she visited him in his small studio on 61st Street, they might sit from ten in the morning until five in the evening talking art.[27] Surrounded by canvases covered in veiled paint so thinly applied that the works felt translucent, their discussions were just what Elaine needed at that moment. Elaine would write, "Hung in a room, a painting by him immediately affects everything in the room. His canvases have a curious way of transforming the people standing before them."[28] And while his work was "reduced to about as close to nothing as a painting can be and still exist," they exuded meaning.[29] "I take the liberty to play on any string of my existence," Rothko told her. "Everything is grist for the mill."[30] Elaine absorbed his lesson in her portrait of Harold. She used as close to nothing as she could materially, infused it with her own existence, and created a man. Elaine's work felt clarified and, after her ordeal with Bill, so did she.

Around the time of Lisa's birth, Bill had begun binge drinking.[31] Whether it was due to the strain of fatherhood and the associated emotional entanglements or his newfound wealth is unclear because both occurred around the same time. In April, Bill's second solo show at Janis's gallery was a tremendous success.[32] In addition to his being listed as a "growth" artist in *Fortune,* two other things combined in 1955 to make Bill's work irresistible to collectors. He had stopped painting his terrifying women in favor of much more salable abstractions, and he had been made notorious nationally in an attack ad run by an angry husband. The previous May, large-circulation newspapers in the country carried a full-page advertisement paid for by the millionaire Huntington Hartford. Its catchy title: "The Public Be Damned." "It was the usual Sanity-in-Art screwball pitch," Tom Hess said, "but with the difference that de Kooning was singled out for special attacks."[33] Hartford's wife was a painter whose show had been dismissed by an *ArtNews* reviewer in the same issue that carried a long article by Tom on Bill's *Woman I.* "Mr. Hartford seems to have fixed on this glaring injustice," Tom said, "and, quoting liberally from the essay on de Kooning, proceeded to give him the kind of national publicity that politicians dream about."[34] Just as mocking articles in *Life* and *Time* had counterintuitively propelled Jackson's career, so did Hartford's attack propel Bill's. "It's sort of a private joke that this perhaps 'made'" Bill, Tom added.[35] Whatever the cause, collectors rushed to buy his work.

Bill's fellow artists helped him celebrate, first at a dingy bar on Tenth Street and then at the Cedar. Arriving late at Tenth, poet Selden Rodman found that the only people who hadn't already left for the Cedar were Larry, Franz, and Jackson. Dancing alone in a beat-up fedora, his face scratched and disfigured, Pollock was enjoying his own private celebration. Jackson had sold a painting to a collector for eight thousand dollars, and he had a new young girlfriend who, like Bill's, could give him a baby, too.[36]

* * *

The screams emanating from the Pollock household during the summer of 1955 had subsided by late fall. Now discussing their problems with their respective analysts, Lee and Jackson no longer felt the need to vent their rage at each other. Lee's successful show had also helped. She was back in the art game. The collector Roy Neuberger was considering buying her collage *Burning Candles*.[37] After more than twenty years as a professional artist, it would be Lee's first big sale, but more crucially, it would give Lee a taste of independence. She had relied financially on Jackson, not by her choice but by his, for more than a decade. In late December, Clem and Jenny had begun visiting Springs about once a month and that, too, boosted Lee's spirits.[38]

Sitting at the small kitchen table, the two couples drank coffee, smoked cigarettes, and gossiped. "Who was doing what, which shows were good and which bad, which paintings worked and which didn't and why, which reviews and reviewers passed muster and which were full of shit, who had sold what, for how much and to whom, who said what about who, who was being fucked over by their dealer and who was just plain fucking who," Jenny said. "In that house, with Lee at the helm, no matter how mundane, there was always an impending drama to be hashed over. Lee was a master at fanning the flames of injustice."[39] Jenny implied "we," but it was Lee talking, Lee and Clem. Jenny recalled sitting quietly while they "bat[ted] the ball back and forth for what seems like hours."[40] Jackson appeared preoccupied by something else entirely. Slumped against his hard-backed kitchen chair, he watched his coffee mug and the clock until it was time to switch from caffeine to alcohol.[41] "There was that tension, that desperate wariness," Jenny said. "The alcoholic sunken into himself with defeat.... The tiger in his cage, always the dead center of attention, making the room seem too small."[42]

Lee had lived with Jackson's "schedule" for so long that she was as aware of the clock as he. At noon, Jackson was ready for his medicine—the day's first drink—which she delivered punctually. "She always refers to Jackson as Pollock," Jenny said, "whether he is across the table or on the moon."[43] Lee often spoke of Jackson as if he were absent. Even while visiting collectors, if Jackson caused a scene, she told those witnessing his antics to ignore him, that he would collapse and then they could enjoy the evening without him.[44] Lee had stopped apologizing. She had emerged from the previous terrible year harder, with what Jenny called a "'fuck everyone' arrogance.... Lee is a loaded shotgun armed with black and white opinions... all delivered in her inimitable gruff New York-ese."[45]

Each Monday, Lee and Jackson traveled into New York to see their therapists, returning the next day to Springs, though not always together.[46]

Lee's dream analysis had opened a new avenue in her work. She had abandoned her collages for large paintings that explored complex subconscious themes. Jackson's therapy, however, had not gotten him back into the studio.[47] Instead, it steered him personally on a path away from Lee. Jackson "loved" Klein and told Clem he was "overjoyed" with his therapy.[48] Patsy Southgate, who often rode back in the train from the city with Jackson after his session, said Pollock considered Klein supportive in the way Lee no longer was.[49] In fact, Klein saw Lee as an anchor weighing Jackson down, and he suggested Pollock find a new woman, as many as he wanted, to free himself by acting out "his sexual impulses."[50] Unfortunately for Jackson, his efforts at seduction were so repellent that women usually fled. In the Cedar one night, Jackson stumbled over to a twenty-year-old artist named Audrey Flack. "All I wanted to do was talk art with him—I was passionately involved with art," Audrey said. Jackson, however, was beyond discourse.

> This huge man tried to grab me, physically grab me—pulled my behind—and burped in my face. He wanted to kiss me, but I looked at his face: a stubble and a debauched, very sick look. There was a desperation, and I realized that this man whom everybody adored, idolized, was a sick man. An artist like him was like a movie star to me, but this beeline he made for me at twenty scared me. He was so sick, the idea of kissing him—it would be like kissing a derelict on the Bowery.[51]

Jackson's friends had come to believe he didn't really want a sexual relationship. In his sorry state, what Jackson really wanted was love.[52] And in February, a Liz Taylor look-alike appeared in the bar to offer it. Ironically, it was Audrey Flack who had sent her there.[53]

Twenty-five-year-old Ruth Kligman had moved to Manhattan from New Jersey in search of "great men who sense my needs, my unharnessed ambitions." The quintessential mid-1950s woman, Ruth was intelligent but chose to rely instead on another asset—her beauty—to get ahead. And by "ahead" she didn't mean a career or even a marriage. Ruth aspired to be the mistress of an important man.[54] After finding a job in a minor commercial gallery and having caught the art market fever, Ruth naively set her sights on an artist.[55] She asked Audrey the names of the most important Abstract Expressionists. Audrey told her: Jackson Pollock, Willem de Kooning, and Franz Kline, in that order. She then drew Ruth a map to the Cedar, and Ruth set off for the bar carrying a small piece of paper that read "Pollock, de Kooning, Kline."[56]

Her dark hair styled and sprayed, her makeup expertly applied, her

clothing "a little black dress and a perfect white linen coat," Ruth was a "touchy-feely, a come-hither, good-time girl with brains that didn't show," not the type of woman who often made an appearance at that bar.[57] By 1956, the young women who drank there were cut from the Grace, Joan, and Elaine mold. They had watched those older women and adopted their audacious ways just as the younger men emulated Jackson or Bill. Ruth, on the other hand, looked like a starlet hoping to catch the attention of a Hollywood director. She had mastered a look of vulnerability and sexual openness that she used as bait, but in reality she was tough. Jenny Van Horne called her "willful and ballsy."[58] Ruth was a girl on a mission: to find a man who was "somebody."

Sitting quietly at the bar, Ruth ran into an artist who showed at her gallery. He invited her to a table at the back from which she could survey the scene while half-listening to the conversation around her. The place smelled "faintly of stale urine." There was no music, no soft lights, just an ugly bright glare, and boisterous chatter. "The sounds were the people, poor and mangy and excited from one another and booze," she said.[59] Until Jackson arrived. *"Pollock's here."* "People transformed dramatically in seconds, expressions came alive," Ruth recalled. "Everyone got quiet and active at the same time."[60] She had been waiting for that entrance but so had everyone else. Word had spread through the extended community of younger artists and hangers-on that Pollock made a weekly appearance on Mondays, and they flocked to the Cedar to catch the show. They wanted to come away from the evening with a story of how *outrageous* Pollock had been. Aware of the eyes that watched his every move, Jackson at times pretended to be drunk so as not to disappoint.[61] But most often he *was* drunk. To Ruth, he appeared a large, tired man who nonetheless exuded enormous energy. "A genius walked in, and we all knew it, felt it, each and every one of us," she explained.[62]

"Jackson, Jackson... Hiya, Jackson." All around her she heard strangers trying to get his attention. In Ruth's telling of their first encounter, she felt Jackson looking at her from the bar and then watched as he walked back to her table, sat down, and waited to be introduced. "Jackson, this is Ruth Kligman.... She's terrific... isn't she pretty..." her companion offered, to which Jackson replied, "You sound like a goddamn ass!"[63] Ruth said they didn't need an introduction. She felt she already knew him through his work. They looked into each other's eyes, she recalled, and knew they were in love.[64] It is hard to take seriously a history by one so hopelessly romantic, and yet that is how she chose to recall it.

Pollock's biographers Steven Naifeh and Gregory White Smith described Ruth and Jackson's courtship differently: Jackson didn't take the bait. Only after two months of her persistent phone calls and entreaties did Jackson

agree to go to Ruth's apartment and then drunkenly slept through their first big night. Jackson, however, thought they had made love and was thrilled. He began parading his beautiful conquest around the bar. And that was fine with Ruth. "I wanted everyone to pay attention to me and when I was with Jackson, they did," she said later.[65] *Time* magazine that year had called Jackson a "wild one" and "Jack the Dripper." The magazine equated him with Brando and James Dean.[66] With Ruth on his arm he even looked the part. He was a real bad boy! "He felt good about her— you know, a pretty, voluptuous gal, thinking he was the greatest man in the world, and in love," said James Brooks.[67] For a time, Ruth gave Jackson joy, partly because she was a delicious secret he could keep from Lee.[68]

In March 1956, the painter Paul Jenkins, based in Paris at that time, visited Springs.[69] Paul had had previous encounters with Jackson and seen him at his worst, but because of his own history with an alcoholic father, he understood Jackson's rage. "I immediately felt a sympathy because I realized that not just his persona but his psyche was leading him down a one-way tunnel, at the end of which was not necessarily light but darkness for him personally." When Paul and Jackson talked about painting, however, that person disappeared. He was replaced by a gentle man who knew art to his marrow.[70] Jackson felt a connection with all artists who had gone before him, and he made others feel it, too. "All I can say is that it left me with a lasting impact. I had met a man who had laid his life on the line," Paul said. "I felt that in this man resided a notion of a human being whose vigil I could respect." Paul added, "Jackson was something of a human catalyst. He would constantly go out and break dirty windows so you could see through better."[71]

For the younger New York crowd, Jackson had become more of a character than an artistic innovator, and he was no longer used to receiving the respect for his art that Paul displayed. Jenkins's weekend in Springs, therefore, had a salutary effect on both Jackson and Lee. They were reminded of what Jackson really was through the admiring eyes of the younger man. "At one point Lee and Jackson were talking nostalgically when we looked over at a huge plant," Paul said. Howard Putzel had given it to them years before. "At the mere mention of his name, they warmed and told how kindly and encouraging he was." Jackson told Jenkins, " 'If just five people understand what you're doing, it's worth it.' And I believe sincerely that at that time he felt a conspiracy of misunderstanding and dismissal from [the art world]," Paul said.[72] Having Paul at their table and discussing Jackson's art for the love of it was almost like being with Howard again. Jackson was sober during Jenkins's visit, which made his final act all the more bizarre. Before Paul left, Jackson shot an arrow into the kitchen wall.[73] Out of con-

cern and with a touch of humor, Paul sent Jackson the book *Zen in the Art of Archery*.[74] He returned to Paris having extended an invitation for the Pollocks to visit any time they chose.

In May, Alfred Barr offered Jackson a solo show at the museum in the fall. The Modern had decided to launch a new series featuring artists at midcareer, and Jackson was to be the first.[75] It was another retrospective, another summing up, indicating that the founders of the New York School were no longer its primary innovators. And if there were any doubts that a generational shift had occurred in the New York art world, they were unequivocally dispelled that same month. Dorothy Miller had chosen her next bellwether *Americans* show, and the Second Generation was the headline act.[76] John Myers had worked overtime to make that happen, writing an appeal to Dorothy.

> *All I do these days in the face of complete ignoring by the New York Times, Herald Tribune, and The Arts Magazine... is think about whatever is going to happen to my artists whom I'm so crazy about.... Particularly I think about Grace H. and Larry R. and that some time in the future you are going to be deciding on Fifteen Americans. What worries me is that perhaps you and Alfred have forgotten us since last year.... [T]he new work is better, the impulse is forward going. I know it's awful to try to influence you this way. But we are all so forgetful (I am at times)—and since both artists are in the Museum of Modern Art's collection—I would feel so much better if there was a continuity of faith shown.*[77]

Dorothy hadn't needed prodding. When her *12 Americans* opened in May highlighting what she called new directions in art, Larry and Grace were both in it.[78] Dorothy had been an early supporter of Grace's work, but she hadn't liked some of her 1955 canvases and selected Grace as the last artist to be in the show. "I was so glad that I put her in," Dorothy said the following year, "because she responded to the invitation with two or three magnificent new canvases. One of them, which I think is perhaps her best to date, was bought from the show by Nelson Rockefeller." That painting, *City Life*, had been the object of a bidding war between the Metropolitan Museum and Rockefeller.[79] Grace's six-and-a-half-by-eight-foot painting was a snapshot of the activity outside her Essex Street window—the colorful canopies, the bustling street vendors, the carnival of shoppers below. She did not search for idylls either within or without to inspire her, but took life as it came to her. Fruit, dresses, pickles, pots. Years before Pop artists fetishized the mundane, Grace embraced the familiar and made it art.[80]

Grace received fan mail from a prisoner on a Florida chain gang who had

somehow obtained a copy of the *12 Americans* catalog.[81] But professional reviews were mixed. Dorothy had come to expect that. Of the *Herald Tribune's* Emily Genauer, Dorothy said, she "hates me and has only two techniques of dealing with any exhibition I organize—to pan it or to ignore it."[82] Whether the critics liked the new work, however, was irrelevant. The story that spring was youth: *New Talent, Recent Directions, Forecasting the Future*. Dorothy Miller also curated a *Young Americans* show that included two works by Elaine, who though part of the First Generation scene was associated with the Second aesthetically. "Suddenly the magazines were filled with news of the new generation," wrote Dore Ashton, "although the old generation had scarcely had time to be inscribed in history."[83]

Galleries, also, began to see the value of the new work. Martha Jackson had a show that spring called *New Talent in the U.S.A.*[84] Even Sidney Janis, the blue-chip dealer for the First Generation, mounted a show in late April called *Four Americans*. It featured Mike Goldberg, Bob Goodnough, Paul Brach, and Joan. The show had, in fact, been built around Joan after a meeting she had with Janis's son in Paris, but one senses Castelli's hand in the exhibition as well.[85] At the time, Leo acted as a scout for Janis, and he had been actively engaged in Joan's exhibitions since 1951, when he fetched her painting for the Ninth Street Show.[86]

After returning from Paris, Joan had reentered the New York scene where she left it, amid high personal drama and intense creativity. Though she had painted in Paris, and believed in some cases that she had painted well, back in her studio on St. Mark's Place she was able to release all the images she had stored from those significant months abroad. The result was fury. Joan's paintings of that winter are, each and every one, a storm. Her brush slashed across the canvas, whipsawed back on itself, and rained down along the surface to settle near the base in a cluster of paint that anchored her freewheeling motion. Color had become less important to her. *City Landscape* from the previous year had been a veritable bouquet. Joan's paintings of 1956 were about speed. In works such as *Hemlock,* one has the sense that she could not record her memories quickly enough.

Joan's personal life was just as frantic. On one hand, she had Jean-Paul in Paris imploring her to return, saying that no one understood him as she did, that she belonged in France. And on the other Mike, who remained in Joan's life as a lover, friend, and colleague but whose influence in all areas but the last was pernicious. Joan was never more self-destructive than when she was in his orbit. Indeed, in the days before the Janis show, which was to be one of the most important exhibitions of her career and quite unusual for Sidney because he never showed women, Joan did her best to sabotage it.

The night before the paintings were to be moved to the gallery, Joan and

Mike were drinking together at St. Mark's Place—he a bottle of bourbon and she a bottle of Scotch. It was a drama they had enacted many times that nearly always ended in violence. This night was no exception. Having decided she hated one of the paintings she planned to send to Janis, Joan attacked it with a razor blade. Mike pushed her aside to stop her, but Joan shoved back and the two launched into a fight that only ended when Mike "knocked her out cold." Mike spent the rest of the night trying to repair the damage to the painting so Janis wouldn't notice it had been slashed. It didn't work. Sidney refused to accept the piece. Wearing dark glasses to hide from that most genteel and important gallery owner the black eye she had received during her scuffle with Mike, Joan appeared at Janis's and replaced the torn painting with another.[87] Was she mortified that an important dealer like Janis had witnessed her messy personal life? Perhaps, because rather than wait to see what might come her way after the exhibition, Joan began plotting a return to Europe. Riopelle's nearby show at the Pierre Matisse Gallery acted as a kind of signal, reminding her of that other, seemingly less destructive and perhaps richer life awaiting her in France.[88]

In later years Joan dismissed the allure of Paris.[89] But it's hard not to see in her protest the old Mitchell inclination toward dissimulation. She hated to reveal herself in anything other than her work, and most often answered direct questions about her life with riddles or ridicule. Paris, however, *did* draw Joan—the city itself, what it represented in the history of art, the people she knew there, the woman she could be in their company. As a younger woman in that city many years before, Joan had stood looking through the windows of cafés along the Boulevard Saint-Germain, too terrified to inject herself into the conversation of the famous writers and thinkers there.[90] Now she was one of them. Joan met Beckett nearly every night in the Dôme on the Boulevard Montparnasse for drinks and talk. Giacometti was also there, as was Beckett's friend the painter Bram van Velde, and of course Riopelle.[91] "Riopelle, a vibrant personality, often became angry with conversations he found deliberately depressing, and stormed out through the revolving door into the Paris night," wrote Beckett's biographer, Deirdre Bair.

> On one occasion Mitchell tried to stop him. Beckett followed Mitchell into the door but was too drunk to extricate himself. Round and round he whirled, while Giacometti, like a giant, brooding toad with hooded eyes, sat and watched and said nothing, and while tourists pointed at the poet of nothingness and despair [trapped inside a revolving door].[92]

The scene in Paris was hard-drinking, but the drunkenness did not necessarily result in blows. Apparently, it was where Joan believed she

belonged. Having thrown herself a party after her Janis opening, she immediately left New York to return to France.[93]

Helen was headed to Europe, too. Her trip would be a celebration after an exciting winter. For the first time, one of her paintings—*Trojan Gates*—had entered the Museum of Modern Art collection.[94] And like Joan, she had breached the walls of an important uptown gallery that was loath to accept women. Helen had received a commission through Kootz to make a tapestry for a synagogue in Minneapolis that would form part of a show later that year.[95] The prospect of working with new material thrilled her, presenting as it did fresh possibilities for her paintings.[96] On the personal front, her life had opened up in every way. She had resumed her friendship with author Ralph Ellison, socialized with her former Bennington teacher poet Stanley Kunitz, and added other new writer friends to her circle, including Saul Bellow.[97] She had also begun hosting evenings with important art figures.

Among her guests that spring was the London art dealer Charles Gimpel, who may have thanked her for her hospitality by inviting her to visit him in France because within a month of their encounter Helen had finalized her summer travel plans.[98] She would leave for Europe in early June, attend the opening of the Biennale in Venice, and then head to the south of France to see the Gimpels—Charles and his wife, Kay.[99] Having left her convertible with Clem and Jenny (who as of May were officially man and wife), Helen hitched a ride to her ship from Barbara Guest. "The voyage is delightful," she wrote her during the sea journey. "I milk the boat for all its services; go swimming, 'decking,' boozing...sleep 10 hours a day. It's great! I'm having a good but rather quiet time."[100] Helen was preserving her energy for what would be three months of whirlwind travel that she hoped would take her as far east as the Soviet Union.[101]

Lee watched Helen's departure with interest if not envy. While New York seemed fixated on the work coming out of the Second Generation, European audiences were awakening to the First. Across the Atlantic there existed as much excitement and controversy about that painting as there had been in 1948 in the States. As Pollock's astute manager, Lee wanted to get his work to Europe to become the center of the dialogue. As an artist, she craved that atmosphere of discovery. Lee asked Jackson if he wanted to go, but he hesitated.[102] He had been sick that spring. Milton said, "his liver was shot."[103] He had also spread himself too thin emotionally.

At first the affair with Ruth was enlivening because of the attention it brought him and because of the excitement inherent in the forbidden.[104] Composer Morty Feldman had invited Lee and Jackson to a concert he was giving with John Cage that February. Lee turned up, but Jackson didn't. After taking Lee to dinner, Morty dropped her off at the Earle

Hotel, where she and Jackson stayed when they were in town for therapy, and then headed to the Cedar. When Morty arrived, Jackson and Ruth were just leaving. "He looked happy," Feldman recalled, pleased for his otherwise tormented friend.[105] Accustomed to Jackson's disappearing during their city stays, Lee didn't suspect the involvement of another woman. And though everyone in their circle had seen him flaunting Ruth, no one dared tell Lee.[106] It was just as well. By the spring, Jackson had broken up with Ruth. It was too much. He wasn't painting. Pollock was lost. "There was a sodden air about him," said his neighbor Jeffrey Potter. "His mouth seemed always wet from the last sip and the eyes about to produce tears."[107]

Around that time, Jackson asked Ibram Lassaw to teach him to weld.[108] As a boy he had wanted to be a sculptor, and perhaps he felt that if he had nothing left to say in paint he might find a way to express himself in metal. But Ruth wasn't about to let her "genius" slip back into his life and studio on Fireplace Road with Lee. She followed Jackson to Long Island, taking a job at an art school in Sag Harbor for the summer. (She said she didn't know it was close to Springs.)[109] Again her persistence paid off. Jackson resumed their relationship. It was, for a man with barely the strength to continue, the most pleasurable path of least resistance. His studio remained closed.[110] Seeing Milton in the bar one night, Jackson asked him what he thought of his going to Paris.

"Why ask me about Paris?" Milton said.

"Well, you were there."

"I didn't like it. What do you want to go to Paris for? What are you going to do there?"

Pollock didn't know. The idea was crazy. Jackson dropped the subject, saying, "I hate art."[111]

The next time Lee asked Jackson about Europe, he had an answer. He said no.[112]

By late June, Jackson had begun spending two or three nights a week with Ruth. He fantasized that he could have both women, that the studio he had planned to build for Lee on their property could be made instead into her dwelling, and he would live in the main house with Ruth.[113] He even proposed bringing Ruth to the house to meet Lee, perhaps thinking that if Lee met her she would accept her as Elaine had Joan Ward. He had even begun telling people Ruth was pregnant (which she wasn't).[114] He was quite literally delusional on many fronts but most especially about Lee.

Lee, meanwhile, had been busy with her work that spring. Her painting was both exciting and frightening because some of the subconscious images that appeared were shockingly unexpected, especially a figurative painting she would call *Prophecy*. "That one terrified me when it happened. I had to learn to live with it and accept it," Lee said.[115] The painting resembled one

of Jackson's from 1953, *Easter and the Totem,* but by comparison to Lee's his was decorative. Hers was dominated by a large central figure or figures, flesh tone in color but more animal than human. Most disturbing of all, however, was an eye she had scratched into the upper right corner of the painting. It stood apart from the work, as if done by a hand other than the artist's. Jackson advised Lee to get rid of it. She ignored him.[116] Lee was looking for just such images to emerge in her work, things she couldn't explain but could learn from.

It is likely that Lee's focus prevented her from noticing that something had changed in Jackson's life. One day, however, she found Ruth's scarf in Jackson's convertible. He confessed. Lee demanded that he choose between them. But that required more strength than Jackson possessed. Opting to let the women decide, he brought Ruth to Fireplace Road to meet Lee. They didn't get past the driveway. Ruth refused to leave the car, and Jackson was so drunk he feared he couldn't drive any farther. He suggested they stay the night in his barn.[117] Ruth described leaving the next morning as they attempted, unsuccessfully, to do so without disturbing Lee:

> We ran hand in hand through the field... the air sweet and the sun radiant.
> Halfway toward the car we saw Lee on the back porch. I had never seen her before, nor she me. I was surprised by her appearance and attitude. She wore her bathrobe over a nightgown. She was white with rage. Her face distorted with anger, her body shaking. She stared at me, trying to utter something coherent, stuttering and finally screaming at us, calling out, "Get that woman off my property before I call the police!"
> Jackson started to laugh. "In the first place it's not your property, it's mine, and in the second place stop making a god-damn ass of yourself."...
> We ran to the car laughing like two children being scolded by the big bad mother. It was the funniest scene, at her expense; all the way to Sag Harbor we were laughing hysterically.[118]

One can only imagine Lee's pain in those moments. That house had been a place of struggle toward the noblest of goals. Now the tawdry scene that played out before her threatened those memories. It may have even destroyed that life.

Jackson returned to the house to find Lee as livid as she had been when he left. Again she told him to choose between them. Again Jackson could not.[119] Lee went into the city to talk with Clem. He told her to go to Europe, to Paris. To get away from Jackson.[120]

On July 12, 1956, Barney and Annalee Newman, and Day Schnabel took Lee to the pier to board the *Queen Elizabeth.* Halfway up the gangplank,

Lee decided she couldn't leave. "Jackson needs me," she said and ran to find a phone to call him. When he answered, Lee pretended she was calling because she had lost her passport. But during the conversation, brief though it was, she must have remembered why she had left. She abruptly told him she had found her passport and said goodbye. There was another attempt to call, ship to shore, and a final effort to convince him to join her. He refused.[121]

Lee was terrified at the prospect of Jackson trying to survive on his own. But, unbeknownst to Lee, he wasn't alone. The very afternoon that she sailed for Europe, Ruth had moved into Fireplace Road.[122] Hanging her clothes in Lee's closet, Ruth recited her own version of the "married mistress" motto: "I must look beautiful all the time and smell beautiful, and be beautiful every minute of every day and always be desirable for him," Ruth told herself, "and he will love me always because I will be so irresistible and will love him."[123]

Within two weeks, Jackson's relationship with Ruth would be all but ended. Within a month, Jackson would be dead.

47. Without Him

> To die early—before one's time—was to make the biggest coup of all, for in such a case the work perpetuated not only itself but also the pain of everyone's loss.
>
> —Morton Feldman[1]

RED ROSES AWAITED Lee in Paris.[2] On the ship, she had had seven days to think about her decision to leave. She had weighed his needs against hers and ultimately decided that hers were the more pressing. She needed a vacation from the continual crisis of her life with him. "*To be by myself,*" she exclaimed.[3] By the time she settled into her cabin as the *Queen Elizabeth* left New York harbor, Lena Lenore Lee Krassner Krasner, the powerhouse who had stormed the New York art scene, barely had a pulse. She had given everything to Jackson, and if she had stayed it would have killed her. But those roses melted away her anger, as well as her fear. They were a sign that the life she remembered happily, before the fall of 1950, when Jackson began his terrible decline, was not over. They were his way of telling her "I love you," "Have fun." Maybe even "Forgive me." Again. Though Lee and Elaine were very different, they shared two traits: a commitment to art and a commitment to very fallible husbands. Lee would always forgive Jackson, for his abuse, his ingratitude, his inability to overcome his addiction, even for the humiliation and betrayal she had suffered because of Ruth.

Paul Jenkins and his wife, Esther, helped Lee navigate Paris until she booked into a room at the Quai du Voltaire, a hotel across the Seine from the Louvre and a favorite for more than a century with guests for whom art was a priority: Baudelaire, Wagner, Oscar Wilde, Rilke, and Gertrude Stein among them.[4] From that central location, Lee immediately set about meeting gallery owners.[5] She did so on Jackson's behalf, but also to see what passed for modern art in Paris. "Indescribably bad," she concluded, and abandoned its pursuit in favor of the past. In her first letter to Jackson, dated July 21, she wrote excitedly,

> About the "Louvre" I can say . . . it is overwhelming . . . I miss you & wish you were sharing this with me. . . . It all seems like a dream—The Jenkins[es], Paul & Esther, were very kind, in fact I don't think I'd have had a chance without them. Thursday nite ended up in a Latin quarter dive, with Betty

Parsons, David, who works at Sidney's, Helen Frankenthaler, The Jenkins[es], [sculptor] Sidney Geist & I don't remember who else, all dancing like mad— Went to the flea market with John Graham yesterday....

Jackson would have recognized in that letter the woman he met in 1941: Lee at her most vital, strong and completely alive. After telling him to kiss their two dogs for her, she wrote, "It would be wonderful to get a note from you.... Love, Lee (How are you Jackson?)"[6]

Also in residence at the Quai du Voltaire during Lee's stay was Helen.[7] She had been in Europe for several weeks, part of that time with Howard Sackler, using Paris as a base for travels, mostly south.[8] One of those trips had been to see Peggy Guggenheim in Venice. Helen regaled her friends with stories of rides in the divine Peggy's gondola, dinner at her home on the Grand Canal, late nights in that magical city with a painter "who has the most beautiful studio" she'd ever seen, dancing with scions of storied Venetian families, invitations from said gentlemen to grouse hunts in Scotland ("which I declined") and to the Palazzo Mocenigo ("the one of Byron"), which she accepted. "My dear!" Helen wrote Barbara Guest. "Actually I don't believe any of what I'm saying but it's happening.... Tante bella cose!"[9] On July 25, she planned a trip to Kay and Charles Gimpel's home at Menerbes in the South of France.[10] It had been decided that Lee would meet her there three days later.[11]

The trip would be the first time since the two women shared a studio in 1951 that they would be together for an extended period without their respective partners. Though twenty years separated them (that summer of 1956, Lee was forty-seven and Helen twenty-seven), their insatiable curiosity, their desire to engage life to the fullest, made them remarkably sympathetic traveling companions. Far from settling into a lazy life in Menerbes, a salubrious village that had been home to generations of artists (including Picasso), Helen and Lee set off each day touring by car: to the chateau of British art historian Douglas Cooper outside Avignon to see his collection of twentieth-century modern European masterpieces; to Aix-en-Provence to experience the pastoral beauty captured by Cézanne; to Marseilles to soak up the vibrant color of a Mediterranean port city; and to St. Remy to savor its provincial opposite and marvel at the nighttime canopy Van Gogh immortalized in his *Starry Night*.[12]

"The country is unbelievably beautiful," Lee wrote Jackson. "So much happens in one day that I don't see how I can start again the next."[13] Before she left New York, Lee was plagued by more than a year of ill health that had robbed her of her energy, forcing her at times to drag her body from place to place, yet in France she felt revitalized. By the end of her week with the Gimpels, Lee's face was tan and freckled, her posture erect, her

outlook optimistic. In a postcard to Clem, Lee wrote, "Leaving in a few days for Peggy's then back for another touch of Paris."[14] Helen's description of Venice had whetted Lee's appetite for the detour to Italy.

She had not seen Peggy since 1947. They had, therefore, nearly a decade of news and gossip to share, which actually amounted to several lifetimes because so much had changed in New York. Lee may have also been anxious to see Peggy's collection. Under the deal Peggy had made with Lee in 1945, giving Jackson a stipend and the funds to buy their home, Peggy owned most of Jackson's early work—more than two dozen paintings. Lee had not seen those pieces, which represented some of her best years with Jackson, for a very long time. Each one told a story of shared love and accomplishment that she ached to revisit. Peggy, however, had no desire to see Lee. Hearing from Kay Gimpel that Lee was headed her way, old antagonisms Peggy harbored were rekindled and new ones exacerbated. Peggy had come to believe she was being written out of the history of the Abstract Expressionists, that her essential and early contribution had been ignored in the many treatises about the New York painters published since her departure for Europe. She also believed that Jackson himself had forgotten her importance to his career. Thinking him ungrateful, when Lee called to ask if Peggy could find her a hotel in Venice, Peggy said no, there was not a room to be had.[15] Disappointed (though, knowing Peggy, not entirely surprised), Lee wrote Jackson to say that she planned to return to Paris on Sunday, August 5, adding, "You can reach me in care of Paul Jenkins. Please write."[16]

During her years with Jackson, Lee had certain dreams that she remembered for the rest of her life. One of them she described like this:

> Jackson and I were standing on top of the world. The earth was a sphere with a pole going through the center, I was holding the pole with my right hand, and I was holding Jackson's hand with my left hand. Suddenly I let go of the pole, but I kept holding onto Jackson, and we both went floating off into outer space. We were not earthbound.[17]

That was the state in which she and Jackson existed during the best of times, but in the previous few years they had been sunk neck-deep in life's muck. "The marriage couldn't have been more rough. Sure it was rough. Big deal," Lee said. "I was in love with Pollock and he was in love with me. He gave an enormous amount, Pollock. Of course, he took, too."[18] Lee was anxious to grab Jackson's hand again so they could fly off into the stratosphere where pure art existed. Her remaining time in Paris would amount to a busy winding down until she could set sail for New York in late August to see him.

Helen's energy had been far from spent in Menerbes so, after leaving the Gimpels, she traveled to Vienna, Munich, Amsterdam, and The Hague, while Lee returned to Paris alone.[19] When Lee arrived, however, it was difficult to find a room, so the Jenkinses offered her a sofa in their Montparnasse studio. "We were overjoyed because she could stay with us," Paul recalled.[20] He knew all the artists in Paris, especially the expat community with whom Joan socialized. For her part, Lee introduced him to her generation—men like John Graham—and related the story of the heady early days in New York.[21] While they talked, Paul had the feeling that "Jackson was by her side for her in a curious sensitive way.... It wasn't the fact that she was thinking of him all the time; it was just that everything she saw, she saw also in relation to sharing with him."[22] Once when Lee and Paul were with friends at a café, Lee burst out laughing, saying, "My God, at this point, Jackson would do something utterly outrageous, like break a chair!"[23] Life seemed so predictable without him.

On the morning of Sunday, August 12, everyone in the Jenkins house was fast asleep when the phone rang. Esther answered. It was Clem on the line, asking to speak with Paul. "Stay calm," Clem told him, before relaying the news: Jackson had died in a car accident and taken a young woman with him. "She could tell from the way we were talking," Paul said of Lee. "All of a sudden she screamed, 'Jackson is dead!'... And then Lee was, for a period of about a half an hour, time is so deceptive in crisis, she had uncontrollable grief. I just kept an armlock on her. I didn't let her go. We lived on the top floor and there was a balcony outside. We were in a very strange place."[24] As shock turned to realization and pain to guilt, Lee said, "I have to go back."[25] Paul called Darthea Speyer, the American cultural attaché, to solicit help in getting Lee on a flight to New York that night.[26]

Helen, meanwhile, had returned to Paris and was back at the Quai du Voltaire. She planned to stay for a while—her friend Sonya Rudikoff and her husband were in town—before leaving for what she ambitiously hoped would be a two-week trip to the Soviet Union.[27] Finding herself free that Sunday morning, she called Paul to see what they had planned for the day. "Hi, how are you doing?" she said when Paul answered. Thinking Helen had heard the news from Clem, he replied, "We're doing as well as might be expected."[28] The artists on both ends of the line were puzzled. He soon realized that Helen's call was simply the "wildest coincidence." She had no idea what had happened, that the giant whose work had transformed the art world and been the catalyst for her own discoveries was gone.[29]

Painting would always be the truest way for Helen to express her feelings. She opened a dresser in her hotel room and pulled out the lining paper. Her small watercolor kit, however, proved inadequate—it was insufficiently

red—and so she reached into her bag for nail polish and lipstick.[30] Quickly sketching lines to make what looked like a window on the gold paper, within its frame Helen painted a wash of blue-gray—maybe water, maybe sky—and then "inside" the room from which the artist looked out over the Seine, she created raw emotion. Jabs of red lipstick left marks like knife wounds on a field of pinkish nail polish. Furious brushstrokes made streaks of blue and green, perhaps indicating an arm angrily sweeping away everything in its path. Whatever order had existed inside that pictorial space before that moment of creation lay in tatters. Helen signed the work, which she would call *Hôtel Quai du Voltaire,* and dated it "8/56."

Having told Paul that she would do whatever was needed to help, Helen quickly made her way to the Jenkinses. Once there, she immediately began drafting telegrams, using her French as best she could, and generally undertaking those peripheral jobs that were too difficult for Lee to consider.[31] Then Helen and Paul decided to get Lee out of the studio, to try to distract her during the long hours before she boarded a plane home.[32] "I had a car, and we drove around and just kept time moving," Paul said. They drove to the Luxembourg Gardens and the Bois de Boulogne. They stopped at cafés along the way.[33] Coffee, cognac, cigarettes, talk.[34] "We had a tacit understanding that we wouldn't talk about it," Paul said. "It" being the troubles Lee and Jackson had had prior to her departure. At that moment it was not the details that led to Jackson's undoing that preoccupied them but the enormity of his life.[35] "He painted the whole sky," cried Franz when he heard the news. "He rearranged the stars."[36]

Paul and Helen delivered Lee to her flight that evening, explaining to the man seated next to her what had occurred and asking the stewardess to give Lee a sedative to help her sleep through the fourteen-hour journey.[37] Lee could not. When she stepped off the plane at Idlewild Airport into a bright August morning, her eyes red from fatigue and grief, her face aged and tense, she found a party of worried friends there to meet her: Patsy Southgate, Lee's nephew Ron Stein, Alfonso Ossorio, and Ben Heller, the young collector who had purchased Jackson's painting earlier that year for eight thousand dollars. He was on hand to speed Lee past customs.[38] Having seen her through her arrival, the others headed back to Springs on their own while Lee settled into Alfonso's limousine, finally able to ask the question she had rehearsed all night. How did it happen? Recognizing her fragile state, Alfonso, a gentle man and true friend, fibbed and said he didn't know.[39] They continued quietly along toward Long Island.

Everyone knew. They had been watching Jackson's tragic drama unfold in a very public way for a month, since the day Lee left Springs. At first Jackson paraded Ruth around the Hamptons, taking her to parties, driving in

his convertible with his arm draped around her shoulders.[40] A big man, a big car, a real babe. For her part, Ruth "brought a let's-pretend wifely bustle into the house," Jenny said, "despite the fact that she was cooking for someone who couldn't/wouldn't eat and smiling at someone who had forgotten how."[41] Ruth looked at Jackson starry-eyed. He mostly returned her gaze with the blank stare of a man whose life existed in a bottle. If anything, after Lee left, Jackson drank more.[42]

Within two weeks, Ruth had begun to annoy him. Her fussing around the house. Her cat. Her declaration that she wanted to be an artist.[43] As she set up shop in Lee's studio, where *Prophecy* stood facing the wall, Jackson howled, "Why the hell do you want to be a painter?"[44] Soon, he was as abusive to Ruth as he had been to Lee, though Ruth didn't possess the strength to respond in kind. To counter his verbal violence, she mustered only confusion. She didn't understand where her "matador, the conquering hero" had gone.[45] "Why have you turned against me, Jackson?" she pleaded. Amazed at her naivety, he shouted, "Are you a psychotic?"[46] If Ruth was bewildered, none of the Pollocks' friends were. Ruth "seemed to have no idea of the bond between those two amazing painters, who had stuck it out and grown up together, in a sense," Jenny said of Jackson and Lee.[47] Explained Nick Carone, "He went through the act of getting rid of Lee to bring in Ruth with the romantic notion of filling in a moment in his life, an interlude, then realized it was shit. Also, he realized that he *needed* his wife, so he'd staked all on a move that didn't have any substance."[48]

Ruth needed something as well—a break from the life she was living in Springs.[49] She had been unprepared for the depth of Jackson's madness and his lack of resolve concerning their future together. She told Jackson that she planned to go to the city to see her family and her shrink. Ruth left on August 9 and returned the morning of Saturday, August 11, with a friend in tow, a twenty-five-year-old awestruck beauty salon receptionist from the Bronx named Edith Metzger. Edith was partly a buffer against Jackson's reaction to Ruth's having deserted him and partly a way for Ruth to see the glories of her life through fresh eyes.[50] In her florid and perversely false narrative, Ruth had told Edith about the "purity, the elegance" of Jackson's home. "He has riches that I never dreamed of," she said. "The best of everything. He has opened my vision to another life, a life I never thought possible." As Ruth spun her tale, she imagined that she and Edith were like "Joan Crawford and Ava Gardner."[51]

The two women arrived at East Hampton by train. Along their route, Ruth had filled Edith's head with the intoxicating goings on of important art world figures on the island and her boyfriend's central role in the action. She had portrayed Jackson as charming, handsome, fun, rich.[52] The heavy fellow who gathered their bags and grunted hello to Edith, however, was

not that man. Tired and dressed in dirty clothes, Jackson stank of liquor. Though it was morning, he drove to a bar where he drank beer while the two women sat in their city clothes anxious to get to the beach or to a party or anywhere but a darkened dive with a man who barely spoke and stared at them malevolently when they did.[53]

Back at the house, the scene didn't improve. Ruth's cat had disappeared. The sink was full of dishes, beer and liquor bottles lay scattered, the air hung heavy with the stale smell of cigarettes.[54] In Ruth's stories of East Hampton, the beach had loomed large, but though both women had changed into bathing suits, Jackson made no effort to drive them to the sea. He took a nap and awoke to continue drinking—gin. It wasn't his usual drink, but it did the trick: Jackson got good and hammered.[55] The day passed with the women confined to the house and the yard. Finally, Jackson announced that they had been invited to Ossorio's for a concert. Ruth and Edith changed, and Jackson staggered to the car to await them. Edith noticed his trouble walking and wondered if he was sober enough to drive. "He's a very good driver," Ruth assured her.[56]

In fact, in his stupor, Jackson drove so slowly he eventually rolled to a full stop in the road. A policeman approached. He recognized Jackson and asked if everything was all right. Jackson assured him he was fine, that they had only stopped to talk and were out for the evening to visit friends.[57] A neighbor, Roger Wilcox, also pulled over to check on them. They had made it nearly to Ossorio's driveway. "Jackson told me he wasn't feeling well and might not go to the concert after all," Wilcox said.[58] Edith, meanwhile, had become increasingly nervous.

Jackson turned the car around and headed back in the direction of the house, but when they arrived at a bar called the Cottage Inn he stopped again. Edith jumped out.[59] A child of the Holocaust, she had a firmer grasp on reality than her friend. She had watched her father in Germany ruined by the Nazis. She knew what danger felt like, looked like, and at that moment it looked like Jackson Pollock.[60] She said she would call a cab, that she didn't want to get back into the car, that Jackson was too inebriated to drive.[61] Ruth knew he was, too, but she was also conscious of the possible repercussions of upsetting Jackson in that state. She hoped for the best and suggested they drive on. Jackson shouted for Edith to get back in the car. Eventually, she did, climbing into the front seat between them.[62]

When drunk, Jackson fed on fear. It gave him power, which he exercised that evening by driving faster and faster as Edith's complaints turned to screams. "Stop the car, let me out!...Ruth, do something," she hollered. Jackson pushed the gas pedal to the floor. As they drove down Fireplace Road, Edith struggled despite the wind and the speed to get out of the car. Jackson began laughing. He squealed around one curve and

approached another. That time, he lost control. The big Olds swerved to the left, hit some saplings, and overturned with a thud.[63]

All was still, except the car's horn, which sounded at regular intervals. A mechanic who lived on Fireplace Road could see lights shining up into the trees. He ran over and found the car and a woman in front of it, "crawling on her elbows. She was cussing me, every word in the book—state of shock, seemed to me," the neighbor said. The woman repeated "Jackson's there, Jackson's there!" and mentioned a girl.[64] From under the convertible, he saw a woman's leg, eventually an arm, a blue party dress, and a foot buried in dirt up to the ankle. "Well, she wasn't going to come to any harm now," said a second neighbor, who had come up in a car and turned his headlights on the scene. The lights also caught the woman in a white dress lying across the road. She had stopped crawling. Her head was bleeding like hell, he said, and covered in dirt. The horn made communication difficult. He asked if she was with anyone else. "Two more," she said. The neighbors set out to find the third victim of the wreck.[65]

Cars pulled up along that busy stretch. People gathered to see what was happening. Gasoline poured out of the overturned vehicle and, with the growing crowd around it smoking, an explosion was a real possibility. The onlookers stepped back. Someone among them recognized the car as Pollock's, but no one had seen Jackson.[66] A neighbor and a policeman began searching the woods, moving deeper, improbably deep until they came across what looked "like an old dead tree lying in the brush." "We near fell over him." Pollock was "thrown a good fifty feet from the car. It was like he was planing in the air, elevated about ten feet off the ground, because it was that high on the tree trunk his head hit," said patrolman Earl Finch. "I knew he was dead from the look of him."[67] A coroner arrived, looked at Jackson and said "Jesus!" and pronounced him dead. Edith as well. Ruth was taken by ambulance to the hospital, severely injured. Someone finally had the sense to rip out the wires to the car horn, but it had been sounding for so long it seemed in everyone's ears to be sounding still.[68]

At Ossorio's, a maid took the message from Conrad Marca-Relli, who had identified the body, and came into the concert to tell Alfonso. He told his partner, Ted, to stay at the event in order not to alarm the group, then he motioned Clem out to the terrace and told him the news.[69] "I remember taking my glass, my glass of booze, and throwing it into the woods, and saying 'That bastard, he did it,'" Clem said.[70] The two men, Jenny, and Marisol headed to the scene.[71] Conrad was there amid the flashing lights of the police cars and ambulances. Clem saw a woman's arm sticking out from under the car, and Jackson's body, his forehead caved in. "I couldn't look," he said.[72] Alfonso did. Reaching down, he closed Jackson's eyes and covered his friend's battered face with a handkerchief.[73]

Someone had to tell Lee. That job fell to Clem. No one knew where she was. She was supposed to be in Venice. Unable to track her down, at three a.m. New York time Clem finally called Paul Jenkins to see if he knew where to find her.[74] Paul said Lee was there, sitting beside him in Paris.[75]

The women who gathered at the Pollocks' the morning of the twelfth, while Lee was en route from France, did their best to expunge Ruth's presence from the house. No one was sure if Lee even knew Ruth had moved in. Cile Downs, Josephine Little, and Charlotte Park cleaned, put fresh linens on the bed, and made piles of Ruth's as well as Edith's belongings. They rearranged the house to ensure it looked as Lee would have wanted it. Patsy Southgate discovered a few delicate items that had been overlooked: several dresses and Ruth's diaphragm.[76] Clem noticed Edith's bathing cap. "How pathetic it was. It was lying on the floor, she never got to the water," he said.[77] Sidney Janis had called to ask that someone lock Jackson's studio. Lee's friend Lucia Wilcox, disgusted by his focus on property at such a moment, said, "But Sidney, no one's going to steal anything. There are no art dealers around."[78]

Ossorio's big car pulled into the driveway that Monday to find a house filled with friends and family, busily making work the way one did when trying to ignore pain or forestall darkness. No one could be sure what state Lee would be in. She surprised them all. "I was astonished at her control," said Ron Stein. "For Lee the more severe the crisis, the better she was." On seeing Cile Downs, Lee approached, said, "Don't say anything," and put her arms around Cile as if to comfort *her*.

> She seemed to be in total command of herself—we'd been breaking down and crying—and she was making graceful statements about things to the Brookses and a whole group. I remember thinking, "Golly, that woman is amazing. She's just come home and this terrible thing has happened, yet the grip she has on herself." Well, it's what Lee was like.[79]

On the flight home, Lee had focused at least part of the time on Jackson's funeral. She wanted Clem to deliver a eulogy. He went home and thought about it and, as he tried to imagine what he would say, he realized he couldn't say anything without mentioning Edith Metzger. "I thought it was improper. This guy got this girl killed. I was indignant. I wasn't going to stand up and put a face on it," Clem said. "I was sore at him."[80] He told Lee the next morning, "If we talk, we talk about her." Lee, he said, had a fit. "I knew enough of the story by then, about the way he thwarted this poor girl," Clem said.[81] "Her terror. He heard her scream."[82] He couldn't forgive Jackson. Clem suggested other possible people to speak at the

funeral, but Lee said, "It's you or nobody." Clem refused.[83] Lee proceeded with the arrangements. The funeral was to be held the afternoon of August 15 at the Springs Chapel. No one would speak on Jackson's behalf.

Though the art community was dispersed for the summer, the news of Jackson's death spread through it like lightning. Some heard it by phone. Those at the bar spread it by "Cedar-gram" (which Tom Hess said was like a "convicts' grapevine").[84] Some farther afield had to read about it in the newspaper. Johnny Myers was on a train en route to Florence when he opened the paper to find that Jackson was dead. Startling his fellow passengers, he let out an anguished wail. Joan heard about it through the Paris expat community and immediately began a painting called *Sunday, August 12th*.[85]

Elaine was in the Cedar with Franz when word came in from Long Island. They had all accepted, she said, "Jackson's own self-evaluation of invulnerability. He'd had quite a few little accidents and he always walked away and I think we thought he always would." The bar that day "was like a wake," she said. "Like after Roosevelt's death. Everyone . . . was conscious of one thing and that was the subject of conversation everywhere."[86] Every inch of the bar told a story about Pollock. The men's room door that he had torn off its hinges. The front window, against which he pressed his face begging admission after being barred. Even Franz's hat, which Jackson more than once knocked off his head in a friendly scuffle. "Jackson's image had been so strong," said Marca-Relli. "Suddenly you felt this hole, this silence; as time went on it got more and more."[87]

For those who knew him as an artist, though not as a friend, the loss was great, too. "We felt not only sadness over the death of a great figure, but in some deeper way that something of ourselves had died too," said artist Alan Kaprow.

> We were a piece of him: he was, perhaps, the embodiment of our ambition for absolute liberation and a secretly cherished wish to overturn old tables of crockery and flat champagne. We saw in his example the possibility of an astounding freshness, a sort of ecstatic blindness.[88]

In life and in death, Jackson represented a challenge to his fellow artists: to go all the way in the name of creation, over the cliff if you dared. It might kill you, but we all pass that way eventually. Better, once you have done so, to have left in your place not just memories but miracles. He was an "artist who was totally conscious of risk, defeat, and triumph," said Frank of Pollock. "He lived the first, defied the second, and achieved the last."[89]

Wednesday afternoon was clear and hot. By four, the parking lot at the Springs Chapel was half filled with the cars of artists, locals, gallery owners,

museum officials, family, and friends. The attire on that beautiful day was incongruously dark and formal, as were the grim faces in the crowd.[90] Grace had driven in from the country with her son, Jeff, Dorothy Miller, and Dorothy's husband, Eddie Cahill.[91] It had been almost a year since Grace agreed that Jeff should move with his father to California.[92] Now, she saw him only during holidays when he came back east to see his grandparents. Dorothy had invited Grace to bring him to her home outside the city for their reunion, a visit that was interrupted by Jackson's passing.[93]

Bill had been staying on Martha's Vineyard with Joan Ward and Lisa when he heard the news. He and a group of artists on the Cape chartered a plane to Long Island for the funeral.[94] Bill and Elaine attended the service together, after which she accompanied him back to the Cape to hole up at her friend Rose Slivka's with painter Herman Cherry to work on a movie script about that weekend.[95] Jackson's death had brought the de Koonings together as husband and wife, as did all momentous events. Lee, however, was alone. Dry-eyed, she sat apart from the Pollock family at the front of the chapel as a minister who did not know Jackson officiated before his closed casket.[96] There was very little obvious reaction to his words except from Jackson's old California friend Reuben Kadish, who let out a wail.[97] "No mention was ever made of his name either at Chapel or cemetery," Theodoros Stamos wrote Paul Jenkins. "No one made any attempt to say a word for him as artist etc. <u>Wow</u>!"[98] But some among the Pollocks' friends felt the service appropriately subdued. They didn't need a minister to mention Jackson by name. Silence, somehow, befitted his send-off.[99]

The group made its way to the small Green River Cemetery, where Lee had bought three plots in the "biggest and highest section," then to the Pollock house for drinks and remembrances.[100] Barney Rosset hosted a children's event at his house so the parents needn't worry if their grief gave way to excessive drinking, which it did.[101] The Pollock party began respectfully, but soon the restraint that had weighed on the group at the chapel lifted as the liquor flowed.[102] "We all got drunk," said Herman Cherry. "We all danced like mad until we couldn't move."[103] The mood brightened so quickly that someone joked "Jackson had to be spiking the drinks."[104] "Everybody said there had never been such a wonderful party there," Jenny said.[105] "What made it such a *joyous* occasion," added Philip Pavia, "was the realization that this man was loved." Even "Lee agreed it had been great," said Jeffrey Potter. He remarked to his wife, Penny, as they left that the party involved a "lifting of burdens: for Jackson the weight of his art and his agony; for us the powerlessness to help him other than by our presence; for Lee the release from having to take care of him and the anxiety that brought."[106] Clem spoke with Jackson's mother, who sat stoically in a chair. "Well his work is done," she said of him.[107]

Lee's, however, was only beginning. The will Jackson drew up in 1951 made her executor of his estate. Even after his death, she would still be caring for him. "Dozens of meetings with dealers, collectors, curators... all these impositions reminding her that she is still Mrs. Jackson Pollock and all still provoking guilt for not being there when he died," wrote Lee's friend Bob Friedman. Lee would say, "I had to realize that things would have happened in the same way even if I had been sitting right here in my living room." It took many years, however, for her to absolve herself of the blame.[108]

It wasn't a conscious decision to abandon the Cedar after Jackson's death, but the place felt haunted without him. The crowds that had come to see him still appeared, looking for the next wild man or woman to put on a show. "That was... the big problem at the Cedar Bar because you couldn't sit there and have a conversation without some drunk or nudnik... tourist from the boroughs [who had] come to see the animals," Harold Rosenberg said.[109] The previous year, Herman Cherry, who lived on Bowery, had come into the Cedar and told Al Leslie that he and David Smith had "found a bar with music and Jesus, the beer is only 10 cents or 15 cents, they play jazz." The main attraction, though, was that no one in search of a scene was in it. A typical skid row gin mill, the Five Spot had nothing to do with art, and was so small and dingy that it made the Cedar feel posh. Al had a pickup truck he called Rosebud and offered anyone who wanted to go to the Five Spot that night a ride. By two a.m., he had made so many trips back and forth transplanting friends to Third Avenue that he'd "emptied the Cedar Bar," said Herman.[110] "Where the fuck are all you guys going?" asked the Cedar's owner, Sam Diliberto. For the first time in years, his barstools at closing stood empty.[111]

The First Generation would remain loyal to the Cedar, but the Second Generation and the poets began considering the Five Spot home.[112] After Jackson's death it became the new old place to find him. No physical memories of him existed there, but the music was as close to his art as one could get without watching him make it. Ralph Ellison, a onetime jazz musician himself, wrote,

> Jazz is an art of individual assertion within and against the group. Each true jazz moment (as distinct from the uninspired commercial performance) springs from a contest in which each artist challenges all the rest; each solo flight, or improvisation, represents (like the successive canvases of a painter) a definition of his identity: as individual, as member of the collectivity and as a link in the chain of tradition.[113]

Jackson's tradition had ended; theirs would continue. They would not do so like him, but because of him.[114]

48. The Gold Rush

> It would be nice if we all got fabulously rich, and I don't mean wealthy.
>
> —*Frank O'Hara*[1]

The "artist in mid-career" exhibition the Museum of Modern Art had planned for Jackson in December became, after his death, a memorial show.[2] The Jackson Pollock chapter in the history of art had abruptly ended. The paintings that hung on the museum's walls would be his last. Perceptive collectors took notice. Nothing drives commodity prices higher than scarcity. The death of an artist means the number of their available works is finite, and that number will decrease as every sale removes another piece from the market. Lee recognized the value of scarcity as well, though from a different perspective. Aside from memories, she had little left of her husband except his work. Each painting sold would be an irredeemable loss.[3] True, she needed money. Though Jackson had earned a record amount for a painting in 1956, by the time he died the Pollocks had about three hundred dollars in their checking account.[4] No matter. Lee was unwilling to sell fragments of her spouse to fill her purse. Her hesitation, which was largely sentimental, affected how she approached the inevitable and unavoidable matter of business.

In discussing Jackson's work with Sidney Janis, Lee spoke of "economic symbolism," by which she meant a market price as opposed to a painting's true value.[5] The market price was imposed on a work by outside forces and limited to a specific time and cultural climate. It reflected the dealer's eagerness to make a sale and the buyer's appetite for risk. Lee identified a painting's "value" as intrinsic. She believed that with a painter like Jackson dealers and buyers had not had enough time to evaluate his work and attach the appropriate "economic symbolism" to it. Nor did they have the proper perspective on the movement within which he developed. Lee did. She had been there from the beginning and recognized the value of *all* their work. She refused to think "in terms of a current market, only a future market," said Bob Friedman, who observed Lee's discussions with Janis.[6] She also refused to take anyone's advice. "Unlike most women, she had no trouble asking for what she wanted," said Jenny Van Horne. The masters of the art trade were "a tough bunch, but they met their match in Lee." After assessing the situation, Lee calmly instructed Janis to quadru-

ple Jackson's prices and impose strict controls on how many of his works could be sold and to whom.[7] Her directive stunned the art world. One could argue that it has not been the same since.[8]

Before Jackson's death, Alfred Barr had been interested in buying Pollock's painting *Autumn Rhythm* for the Modern. Told at the time that the price was eight thousand dollars, Barr couldn't raise the funds. A few weeks after Jackson's funeral, he came back to Janis and said the museum was still interested in the painting and would now consider paying that price.[9] Eight thousand was the most Pollock had ever received for a painting, and that had only happened once. The Modern sale would be significant. Lee, however, said no. She told Janis to raise the price to thirty thousand.

"Do you think that's the right thing to do?" he asked. The amount was unprecedented for a contemporary American. While alive, Jackson had not made that much from all his sales combined.

She responded with three words: "Jackson is dead."[10]

Lee's seemingly reckless decision was not simply a grieving widow's roll of the dice. Though untrained in the business world, "she was a businesswoman on the DNA level," said gallery owner John Lee Post, who worked for Lee one summer.[11] Janis wrote Barr saying that if he was still interested, the painting's price had risen. "Barr was livid," Janis said.[12] "He was so upset that he couldn't answer the letter."[13] He grew angrier still when the Metropolitan Museum agreed to Lee's terms. The transaction represented the first time a major museum had purchased an Abstract Expressionist work for the price it might pay for a European painting. "We didn't believe anyone would spend that kind of money on a painting. Thirty thousand dollars?" recalled Irving Sandler.[14] That single sale reset the entire market for modern American work. "We had a little less trouble selling a de Kooning for $10,000 than we had a month earlier trying to sell one for $5,000," Janis said.[15] The Stable's Eleanor Ward said Lee's "handling of the estate was the most brilliant thing that's ever been done—without her those price levels never would have happened."[16]

Perhaps it *was* Lee's action alone that raised prices for American artists, but she and they were fortunate that she did so at just the right moment. In 1957, purchasing power in the United States had reached new heights, tax laws favored investment in art, and the number of galleries in New York had quintupled between 1947 and 1957—even Leo Castelli had finally opened one—with the majority joining the contemporary bandwagon.[17] Most important, however, was the appearance of a new sort of collector, who Tom Hess said was "as interested in sharing the artist's social life as in hanging pictures on their walls."[18] The change in fortune for the artists was dizzying. "There was a carnival atmosphere," recalled Elaine, "a general

euphoria as artists' sales began to catch up with their reputations. Everyone was encouraged."[19]

Mike Goldberg, who had limped along as an artist making ends meet with odd jobs since he returned from the war more than ten years before, said that previously it hadn't been fashionable for an artist to have money.[20] Those who had been born into it were often resented, and those who made it from their art shamefacedly joked that they must be doing something wrong if their work had become acceptable enough to buy.[21] But when the money stream turned into a mighty river flowing toward them all, few at first questioned such bounty. After years of deprivation, who would blame them?

That winter of 1957, Mike had been on unemployment when Joan's friend from Paris, the painter Norman Bluhm, came by his studio with collector Walter Chrysler.[22] Mike was wild, violent, and charming, just the kind of artist collectors not wanting to miss out on the "next Pollock" sought. Chrysler looked through Mike's paintings and said he'd take ten thousand dollars' worth. "In one fell swoop. He said that he'd come back the next day and make the final selection," Mike said. "So he leaves and I'm thinking, he's full of shit, he's not going to come back. So I borrowed a couple bucks from Norman." Chrysler *did* return and offered to pay Mike in four installments. "Ten thousand bucks at the time was a lot of money," Mike said. "I'm holding $2,500 of it in my pocket, and I said, 'You know, I want to buy an electric blanket'.... I bought an electric blanket and I spent the weekend in bed, under that blanket, just holding the money." But that wasn't the end of his good fortune. "About a week later, I hear this loud voice hollering up from the street—it's Martha Jackson. She found out that Walter had bought my paintings, and she wanted to take a look. She'd never given me the time of *day* before. So *she* proceeds to buy ten thousand dollars' worth of art. So I rented Elaine de Kooning's [brother and sister-in-law's] house in East Hampton for that summer and took Norman out there and bought him a used Ford."[23]

Now flush and carrying a contract from Martha Jackson's gallery in his pocket, Mike also asked Joan to marry him. She refused.[24] While her painting life had largely remained in New York, where she spent the winters, her love life had relocated to Paris. Jean-Paul was there, beseeching her to return with romantic Gallic overtures such as, "I cannot think of anything but you." "I have never seen Paris so sad. I am a veritable Robot.... Once and for all I do not want anything but you."[25] If their affair had not been complicated by the fact that Riopelle was already married, Joan would have happily accepted an offer of marriage from him. But for the moment she would remain single.[26]

Mike's life-changing experience was far from unusual that year. Rothko sold nineteen thousand dollars' worth of work—*after* the gallery's one-

third commission.[27] Philip Guston, who showed with Janis, said of his own sales windfall that it was "the first taste I had of having money in the bank." He thought he might "stop teaching... spread my wings, put in a toilet in [his home in] Woodstock."[28] Eleanor Ward said she noticed the change in the artists' fortunes when they suddenly started going to the dentist. "The artists had teeth!" she exclaimed.[29] They also had the funds to buy the best supplies, and the freedom to focus on their work. (Bill once said that the trouble with poverty was that it took so much time.)[30] But after the money had been used to upgrade studios and buy cars, better clothes, and Scotch instead of beer, the wealth became disorienting. "They lost their minds," Harold Rosenberg said. "They found themselves with that big bank book and they didn't know what the hell to do with themselves. They began getting into fights with their wives, they did all sorts of things. It was the money. Just like schmucks in Hollywood. This hit them much too strong and much too organized."[31]

In the rush of excitement over the art market, there was also enthusiasm and real astonishment over the women in it. Readers of art magazines were already acquainted with the names Frankenthaler, Mitchell, and Hartigan but in 1957, readers of mass-circulation newspapers and magazines were introduced to them as well.[32] What they discovered was that the art world wasn't just exciting, it was glamorous. Grace had been photographed posing in front of her painting *City Life* for *Mademoiselle* and would be interviewed that year for *The Saturday Review*.[33] Under a fetching photo of her relaxing in East Hampton, the caption read, "Grace Hartigan— 'remarkable talent and work.'"[34] (Grace had demurred about the photograph of herself rather than her painting, but in a letter told James Thrall Soby, who conducted the interview, "I think there is a certain amount of curiosity in the public about how I look (what kind of a woman would paint like that?), so showing them is quite to the point.")[35] Meanwhile, *Esquire* featured Helen in a spread as a representative of "hep... Upper Bohemia." The piece included three photos of a disheveled Helen at work in her studio, and one of her paintings at an opening. "Helen Frankenthaler, young abstract expressionist, has recently sold paintings to Whitney Museum and the Museum of Modern Art," the caption read.[36]

Joan, whose prices had tripled during her solo show at the Stable that spring and nevertheless sold to important collectors and the Whitney, grumbled, "Helen's all over the place in *Esquire*. And wherever Helen isn't Grace is."[37] But she herself would be featured in a major article that year.

Over more than five pages, Irving Sandler described Joan and her work in "Mitchell Paints a Picture" for *ArtNews*. In the first paragraph he announced, "Miss Mitchell is reticent to talk about painting."[38] In fact,

Miss Mitchell was reticent about participating in the article at all. "When asked what she felt about the word 'nature,' she replied: 'I hate it. It reminds me of some Nature-Lover Going Out Bird-Watching,'" Sandler wrote.[39] During the first session with Irving, Joan proved so provoking that Frank, who was on hand to witness her behavior, told her to "cut the bullshit."[40] She did. The result was an unprecedented window into her work. Joan demonstrated the artist's struggle, belying those critics who believed that all an abstract artist did was throw paint at a canvas.[41]

> She sketched in charcoal a central horizontal stroke about which she composed an over-all linear structure. Turning almost immediately to tube paints, she attacked the chalked areas with housepainters' and artists' brushes, her fingers and, occasionally, rags.... She worked rapidly. A full range of color was used....
>
> The picture was allowed to sit for a day. The artist resumed painting the next evening and worked through the night.... She painted slowly, studying the canvas from the furthest point in the studio (23 feet away), simulating in a way the panoramic view of memory. She spends a great deal of time looking at her work.

Indeed, she made marks, but they went nowhere. She studied her work but could not proceed. Joan grew so dissatisfied with it—it was "not specific enough," not "accurate," she told Sandler—that she abandoned it and started another.[42] Depressed by the seemingly closed door her new blank canvas represented, Joan tapped a memory she loved: her dog, George, swimming at Barnes Hole on Long Island.[43] The second painting she began under Sandler's watch was as warmly hued as her memories of the pet she had received from Barney. Her brushstrokes frolicked in the center of the canvas, creating a splash of activity like a figure jumping out of a wave. But because she worked on it during the winter, "the painting developed and it got bluer and colder and that's the story of the title," she said. "It's absolutely true."[44] The painting Joan ultimately finished would be among her most famous: *George Went Swimming at Barnes Hole, but It Got Too Cold.*

Rudy Burckhardt had been assigned to take photographs as Joan's painting evolved, which would have meant that each time Irving was in Joan's studio, Rudy would also be there. That, however, was an intrusion too far. "Joan Mitchell did not want to paint for the camera but she was willing to fake it," Rudy said. "I set up the camera, showed her how to turn on a couple of lights and take the picture.... She took a picture every day after she finished painting for, I think, two weeks."[45] Joan most definitely did *not* think, as did Grace, that it was "quite to the point" for a reader to be

treated to a photograph of the artist. The annoying issue arose again, however, in May when *Life* magazine published a feature called "Women Artists in Ascendance." The women painters *were* the story. The contents page featured a picture of Joan under the tagline "Laurels for lady artists, LIFE presents the vigorous and colorful works of a group of women who have made American art history by establishing themselves as notable artists."

The same *Life* editor who had written the original feature on Pollock asking if he was America's greatest artist was behind the latest story. Dorothy Seiberling wrote,

> In the art-filled centuries of the past, women rarely took up serious careers as painters or sculptors. Of the daring few who did, barely a handful achieved any lasting stature.... Today the picture has changed. A sizable and remarkable group of young women is resolutely at work and their art is being sought by leading museums, galleries and collectors....
>
> On these pages LIFE presents five of the outstanding young women painters in the U.S. None over thirty-five, they work in the varied styles that characterize the lively American art scene and have won acclaim not as notable women artists but as notable artists who happen to be women.[46]

Pictured with their work, Helen, Grace, Nell Blaine, Jane Wilson, and Joan occupied four color pages of the most widely read magazine in America. The biographical text was scant; for *Life* it was the picture that told the story. Just as Pollock in his *Life* debut had destroyed the image of an American artist as a beret-wearing elitist, so these five women destroyed the image of an American artist as a man. Their work was serious and challenging, and they themselves were beautiful. "It was a real shock to see them," said future art historian Barbara Rose, "with their huge paintings, standing there confidently in paint-splattered jeans when their [nonartist] contemporaries were all wearing tweedy classics in the suburbs, terrorized by the 'feminine mystique.'"[47] Not everyone was pleased with the display. Joan had sent Dorothy Seiberling a telegram asking "urgently" that she withdraw her image from the story.[48] Seiberling apparently ignored her. Dark and stormy, Joan appeared in *Life* surrounded by her thrashing paintings, a testament to the creative power of a woman.

Obscurity for her was no longer an option. *ArtNews* would call Joan's Stable show one of the ten best of 1955. A book on the modern movement published in 1956 identified Joan as one of the "new leaders."[49] And in 1957, as far away as Germany, writers had discovered the women who were making a mark in New York.[50] Joan and all her female Abstract Expressionist colleagues would have to get used to their celebrity. They were *phenomena,* and that was what the new market was all about.

★ ★ ★

Grace had been identified by *Life* as the "most celebrated of the young American women painters."⁵¹ She adored the attention. The role of diva came quite naturally. "I had as much fame in the fifties as anyone can," she remembered. "I sold everything I painted."⁵² The Tibor de Nagy Gallery had moved from Third Avenue to an old mansion on the corner of 67th Street and Madison Avenue.⁵³ That spring, Grace's annual solo show there sold out.⁵⁴ The new collectors who had discovered the virtues of modern American painting had discovered Grace, too. Among them was Larry Aldrich, who had been buying work by major European artists but took a chance on an American after seeing Grace's 1957 show. Meeting Grace and finding her "very tall and very, very attractive," Aldrich said, she "didn't look anywhere near as attractive as she could have looked." She, in turn, had discovered from Johnny Myers that Aldrich was a fashion designer. Grace pulled him aside.

"You know, I've been working for a long time and living in poverty really. I have a couple dollars now and do you think I could get some clothes wholesale?" she asked.

"Why, of course," he replied.

They made a date for Grace to come up to his warehouse. When she arrived, surrounded by row after row of women's wear, she wanted so many things from his collection that she realized she would never be able to pay for them. Larry proposed a swap: clothing for paintings. "I let her take anything she wanted, and then I went down to her studio one night and selected several things in exchange for clothes, and we did that for quite some time," he said. "We became fairly close friends."⁵⁵ Grace made a similar arrangement with a furrier, and her friends noticed her transformation.⁵⁶ One told Aldrich, Grace "looks like a different person since she's been getting clothes from you."⁵⁷

Joe LeSueur recalled going to a Chinese restaurant on Second Avenue with Grace, Frank, Philip Guston, and Guston's wife, Musa.

> I remember [Grace] fussing with the enormous fur coat that enveloped her ample body, the coat having only just that week been acquired through one of the bartering deals artists used to make.... As we were getting seated, I was struck by how self-satisfied and haughty she seemed that night. Then this: "Musa...you should talk to Philip about getting you a fur coat. How about it Philip?" Before Philip could reply Musa said sweetly... "I'm happy with the cloth coat Philip bought me."⁵⁸

Later, when Joe complained to Frank about Grace being a "tad bitchy," Frank defended her, saying, "It's bitchy of you to think she was." Joe was

stung, though not surprised, by Frank's "usual blind loyalty to Grace, about whom he brooked no criticism."[59]

In fact, Frank may have understood Grace's comment in a different light. Musa was one of those artist wives who dedicated her life to her husband's genius while asking for little in return.[60] Philip was selling and could make a deal with a furrier just as easily as Grace had, providing his wife with a coat that would not only warm her on that "uncommonly cold winter night" but also serve as a gesture of thanks for her sacrifices during years of hardship.[61] (Mercedes, the opposite of a retiring wife, was one of Guston's lovers.)[62] Perhaps it wasn't haughtiness that compelled Grace but the defense of a woman who did not have the will to defend herself.

Frank also knew that Grace's new fine clothes were part of an act as important to an artist's survival in those years as a steady output of paintings. If collectors wanted to be able to socialize with their artists, the glorious Grace of *Mademoiselle* and *Life* had to appear in something other than the creatively cobbled together secondhand attire she had worn since arriving on Essex Street. "It has nothing to do with being a woman. It has to do with power," Grace said.[63] One had to look the part, act it, exhibit the strength inherent in the painter Grace Hartigan and those working on her behalf. Frank had become just such a powerful figure at the museum, and he did everything he could to promote her and his Second Generation friends.

In 1955, Frank had returned to work at the Modern in its International Program.[64] His time at *ArtNews* had not been an entirely happy one. He found that writing for a living to feed his stomach interfered with writing the poetry that fed his soul. He also found that *ArtNews* didn't pay enough to accomplish even the former in any reliable way. The Modern welcomed him back. He would be part of a new team charged with promoting American art abroad.[65] Some have called the International Program an extension of the U.S. propaganda war.[66] No doubt as the government sought to counter Soviet cultural influence in Europe, officials in Washington were happy that the Modern had begun sending exhibitions abroad. But it would be ludicrous to think that Frank's motivation was political. It was entirely personal. The exhibitions gave him the opportunity to share his friends' groundbreaking work with audiences in far-flung places.

As he had when first employed at the Modern's front desk, Frank considered the museum his home, an extension of the small two-room apartment he had moved into that year with Joe LeSueur. At work, "he would stream in good and late and smelling strongly of the night before," Jimmy Schuyler, who briefly worked with Frank at the Modern, recalled.

He read his mail, the circulating folders, made and received phone calls....
Then it was time for lunch, usually taken at Larré's [a faux French restaurant with meatloaf "paté"] with friends. When he got back to his office, he rolled a sheet of paper into his typewriter and wrote a poem, then got down to serious business.[67]

The museum's operator, exasperated by the number of personal calls Frank received, once exclaimed *"Good God!"* when she heard Jimmy's voice on the line before putting him through to Frank.[68] In Frank's inimitable way, he was able to juggle it all, even when his job required that he leave his desk and his phone and travel the world as an ambassador of the avant-garde.

In 1957, he was asked to select paintings for the Modern's entry to the Fourth International Art Exhibition in Japan. He chose fifteen paintings by fifteen artists, among them works by Grace, Helen, Joan, Elaine, Al Leslie, Mike Goldberg, and Larry.[69] Next, Frank was asked to help select work for the São Paulo Bienal in Brazil. The American entry was to have two parts: one a Pollock retrospective, on which Frank worked closely with Lee, and the other a show of works by five painters and three sculptors. The selection committee of five consisted of three die-hard Hartigan fans: Dorothy Miller, Frank, and James Thrall Soby. Grace was included in the exhibition.[70] Artists, meanwhile, began grumbling about Frank's perceived bias, but if he heard, he didn't care. His attachment to—and more significantly, respect for—Grace was so strong it would have been unnatural *not* to promote her. The result of Frank's support was that Grace reached a level of notoriety few artists of either gender ever achieved. As long as Frank was involved in the selection, the biggest shows produced by the Modern nearly always included the name Hartigan.

Through the years, to counter the baking heat of a summer's night in Manhattan, Grace often slept on the fire escape, trying to catch whatever breeze might blow her way from the river.[71] Unless she received invitations from friends, she had not been able to afford a week or two in the Hamptons. In 1957, however, she had enough money to rent a place of her own for the season, and she took the Gate House on Alfonso Ossorio's vast Creeks estate.[72] It would prove to be an entertaining and strategic move. Ossorio, along with artists John Little and Elizabeth Parker, decided that year to open the only commercial art gallery in East Hampton dedicated to advanced work.[73] They each contributed five hundred dollars to lease a space in the center of town for the Signa Gallery.[74] It was not a cooperative and it did not show "members'" work. It showed *great* work by the artists who had redrawn the cultural map of the world. Grace was offered star

billing. Hers would be the gallery's first solo show, on July 28.⁷⁵ At the Creeks she began a new series of paintings that reflected her changed environment. Gone were the scenes of bustling city life. Amid so much space and natural beauty, Grace's paintings breathed. She returned to pure abstraction.

On most weekends, Grace was not alone at her Creeks cottage. She shared the place with her boyfriend-of-the hour, sculptor Giorgio Spaventa.⁷⁶ Giorgio had been, like Milton Resnick, damaged by the war. Serving for the duration of the conflict, he had emerged extremely sensitive, complicated, and introverted.⁷⁷ "He went through too much hell," explained Natalie Edgar. "You felt inside he'd seen too much."⁷⁸ Giorgio let birds fly freely around the Tenth Street studio where he worked and slept, but his real home was the Cedar, where he sat nearly every night until last call.⁷⁹ Beloved by that crowd, he was, as Elaine described, "a man of eloquent silences."⁸⁰ He was also friends with the Five Spot gang, drinking and doping with Larry when the opportunity arose. Though Grace had long seen him at the bar, it may have been at Larry's in Southampton that Giorgio finally came to her attention. Verbal and outgoing as she was, she preferred her lovers to be literally strong, silent types. Giorgio was that. Spaventa's "only compensation for the attention he wasn't receiving from the art world was the hot and heavy he was having with Grace," Larry said.⁸¹ During one such sexual storm at the Creeks, neighbors called the police because Grace and her quiet man were making so much noise.⁸²

While Grace painted that summer, both Giorgio and Frank came and went between her cottage and the city, though Grace never looked forward to Giorgio's return as much as she did to Frank's. No matter whom she romped with in bed, Frank was the man in her life. Their relationship, during that past year, had solidified not so much because of her needs as because of his. Frank's thirtieth birthday the previous June had been celebrated at Grace's, but it was a hollow festivity. He had a fatalistic attitude toward aging, one that was reinforced in July 1956 by the death of Bunny Lang, who had finally succumbed to Hodgkin's disease at the age of thirty-two.⁸³ Two weeks later Jackson died, inspiring Frank to write "A Step Away from Them," a moving poem about loss in which he asked, in reference to his dead friends, "But is the / earth as full as life was full, of them?"⁸⁴

That poem was perhaps the first of Frank's "I do this, I do that" poems, in which he recorded his thoughts and actions, the various people and things he experienced during the course of a moment, a lunch, or a day. It was as if, in preserving those details, he was declaring that all of life had value, because it was so fragile, that life itself was poetry.⁸⁵ In the wake of that terrible summer of loss, all Frank's relationships had become more important, especially his friendship with Grace.⁸⁶ She negated the sadness

around him. She had no time for sadness. In a poem called "For Grace, After a Party," Frank wrote:

> You do not always know what I am feeling.
> Last night in the warm spring air while I was
> blazing my tirade against someone who doesn't
> interest
> me, it was love for you that set me
> afire.[87]

Frank's feelings for Grace had become so strong that "he was ready to try to push past the strictures of his homosexuality," wrote his biographer Brad Gooch.[88] Joe LeSueur witnessed a night at the Creeks by a blazing fire when Frank had eyes "only for Grace."[89] As the group's thoughts turned to bed, Frank said to Grace, "We should sleep together," she recalled.[90] Fearing sex would end a relationship that had outlived countless partners on both sides, she said, "And ruin this? No way!"[91] Frank saw the wisdom of Grace's rejection. "It would take more than that to end their friendship," Joe explained.[92] Though he swore Joe to secrecy about the episode, Frank immortalized the moment. The next year, when he selected paintings for what would be the most important show of Grace's life, he chose a beautiful work she did that summer. Bathed in red, it was called *Interior, 'The Creeks.'*[93]

Nineteen fifty-seven was a strange summer. Out of habit, everyone was on the lookout for Jackson. He had cruised those streets in his Oldsmobile, injecting himself into any gathering, stopping to help with any project, and in so doing—depending upon one's level of tolerance—making of himself either a nuisance or a friend. It was difficult to get used to the first summer without him.[94] For Lee, it was difficult to get used to *life* without him. Terrified of nights fraught with memories, she could not sleep at her home alone. Initially after Jackson's death a group of friends who dubbed themselves "Lee's Night Ladies" stayed with her in rotating shifts. Then relatives filled the roster, or young artists, or even the children of friends.[95] Alfonso had been so concerned about Lee's welfare that he took the extraordinary step of asking her to marry him. It wasn't a matter of love (he was in love with Ted) but simply that he had always protected the Pollocks and he felt marriage would be the best way of continuing to do so.[96] Lee, however, recoiled at the notion that a man thought she needed protection, answering with an emphatic no.[97] She could take care of herself—and Jackson's legacy. Lee's time was split as it had always been between her work and his. All that was missing was the companionship and the shouting.

After the funeral, Lee had been faced with the very real question of whether she could continue to paint. It wasn't just a matter of grief.[98] She realized that when Jackson was alive, "it's very possible that I was appeased by the idea that he was getting all the attention," she said. "That was enough. Then when he died came the realization I had to do it myself, deal with myself."[99] She did not expect to be under the kind of pressure Jackson had felt, but now that there was only one painter in the household, it was her or no one. She didn't know if she could do it. "I had to, is the only way I can put it, and it was not easy," she said.[100] Her first step was to confront the painting she had left turned to the wall on leaving for Europe. *Prophecy*, with its mysterious eye, frightened her even more than it had when she painted it. She had no desire to look at it, but to move ahead she knew she must. One day, with great trepidation, Lee turned the canvas around and faced an image stained by the horrors of those last months, painted by the woman she had been then. She discovered she was no longer that person.[101] She could continue. "A suicide I'm not," she said. "So that's that, you know, you stay with it. You keep going."[102]

After painting for more than a decade in a small upstairs bedroom, Lee had moved her studio out to Jackson's barn, where she could finally spread her arms wide and her imagination with them.[103] Friends knew she was out there working. She had entered a cycle in which she painted without stop and with little socializing.[104] After several months, those few invited into the barn were astounded. In 1956, after Jackson's death, Lee had painted autobiographically laden pictures—*Embrace*, *Birth*, *Three in Two*. Dominated by flesh tones, and a recurrence of the eye motif that had made *Prophecy* so dangerously intriguing, they writhed in an agony one might expect from a painter who had lost so much.

By the early summer of 1957, though, the paintings Lee produced in the barn heralded a rebirth. The tones were bright, the shapes open and free, her previously anguished images replaced by expressions of joy. It was no longer man who occupied her canvas but nature—quite surprisingly, a woman's nature. Breasts, wombs, flowers, and vines. "No one was more surprised than I was when breasts appeared," she said.[105] The life in Lee's paintings was irrepressible, rhapsodic. Where once she had created prisons within her powerful collages, in the series she would call "Earth Green," she painted escape—from her past, from Jackson. And, Lee allowed those images that she did not completely understand to grow. *The Seasons* became seven feet high and seventeen feet wide. One can imagine Lee's arms swooping, swinging in a playful swirl to create voluptuous forms suggestive of a woman's body across the length of the massive canvas. The *New York Times* critic John Russell would call *The Seasons* "one of the most remarkable American paintings of its date."[106] Jackson had said, "I am nature." In

her paintings, Lee recognized nature as within us, without us, before us, and after us. As a continuum. As a religion. Humankind formed a part of it, but not nearly so significant a part as it imagined. Nature is "my God," she would say.[107] For the rest of her long life, it would be her inspiration.

Standing in that studio filled with sunlight amid Lee's ecstatic paintings, one might have assumed that she had recovered from the trauma of the previous year. Far from it. "I am depressed and about as far down as you could go," she recalled of that period.[108] "When I was painting *Listen* [in 1957], which is so highly keyed in color...I can remember that while I was painting it I almost didn't see it because tears were literally pouring down."[109] Lee said her work did not always "coordinate with emotion."[110] But she accepted "magic" when it came through in her work. The surprises a canvas held for the artist who painted it were, she believed, what sustained them.[111]

By midsummer, the season on the island was in full swing. Any artists or associated characters who hadn't been there previously were in residence by that point. "If you wanted to find Harold Rosenberg, you'd go to the beach at Louse Point at 4:30 pm," said Dore Ashton. Bill could be spotted around town riding his bike.[112] Elaine and her writer friend Rose Slivka liked to skinny-dip off Georgica Beach.[113] In the evening, artists drove the Hamptons' wooded roads until they found a driveway filled with cars or excessive lighting coming from a bungalow deep in the trees.[114] Both heralded a party. Baseball games still fed competitive spirits. Picnics on the beach became elaborate affairs attended by dozens. Dore called the summer social life "informal...clannish and colorful."[115]

The Signa opening on July 13 on Main Street in East Hampton, however, showed just how much the scene had changed and grown. Five hundred people attended the event, among them Grace, thin and striking in a black dress with a plunging neckline. Mary Abbott was at her side, cigarette holder between her fingers, her shoulders bare in a strapless number.[116] Not five years before, the painters and sculptors of Long Island had been social outcasts, many without indoor plumbing. Now they were sought after, written about, in some quarters treated like stars. Of course, they all knew who they *really* were. But the entire scene had become so strangely alien, at times they had to wonder.

That May, Larry had made his debut on the nationally broadcast CBS television show *The $64,000 Challenge*.[117] Was that who these iconoclasts had become? The program had been a sensation from the time it began airing because no game show had ever offered so rich a reward.[118] The idea was that ordinary people who possessed a vast amount of knowledge would compete against one another by answering questions worth increasing

amounts of cash. The show's producers had approached Elaine to see if she wanted to be a contestant, but she declined, worried that if she appeared she wouldn't be taken seriously as an artist. She suggested Larry, who had no such scruples. He was also, she said, the best showman she knew.[119]

Larry made the cut and was scheduled to compete against a jockey in a category called "Painting 1850–1950." How could he lose? Larry knew *everything* about art history. But just in case, he and Frank studied together before each show in the Modern's library. Everyone in the New York art world made sure they were in front of a television set on Sunday night to watch Larry perform.[120] His first question, for eight thousand dollars, had been howlingly easy: "Who was the Spanish painter whose name begins with P who painted *Guernica?*"[121] Having answered that question correctly, Larry battled his self-taught art expert jockey opponent week after week, and week after week he prevailed. Before the final question on June 16, he had told his friends, "Meet me if I win at the Cedar. If I lose at the Five Spot."[122] The jackpot question was, how did French artist Pierre Bonnard sign his prints? Larry knew the answer, but so did the jockey: None of Bonnard's prints was signed, he initialed them.[123] They split the jackpot, and Larry showed up at the Cedar with a check for thirty-two thousand dollars. "It was like a movie scene," he said. "The check was grabbed from my hand and passed around the entire bar so that everybody could take a look at what I'd won."[124] He used the cash to buy an eight-room house in Southampton.[125] Previously infamous, Larry was now famous, too. *Life* magazine profiled him as a "wonder boy."[126]

For a time, Larry was his fellow artists' favorite celebrity—until he was upstaged by a celestial being. Marilyn Monroe entered their lives.[127] She of the ubiquitous calendar, she whom all other women were expected to emulate, she whom painters (Bill and Grace among them) glorified on canvas. Vacationing at Amagansett with her new husband, Arthur Miller, *she* had stepped into the Signa to buy a sculpture.[128] Her teacher Stella Adler knew all the Abstract Expressionists and may have suggested that Marilyn meet some while she was in the area. An unsuspecting Philip Pavia, who had rented Wilfrid Zogbaum's house in Springs, picked up the phone one day. Monroe was on the other end asking if she could bring her basset hound to his place because their dogs were from the same litter, and Pavia's had had puppies. She also wanted to see Philip's work.[129]

Word of that improbable pending visit spread among the artists. By the time Monroe, Miller, and their dog drove down the bumpy road to Zogbaum's house a small group had assembled to meet her. Nick Carone, Franz, Al Leslie, and artist Diana Powell greeted their hosts' new friends "the Millers." If the Queen of England had appeared it would have been a less awkward social situation. But Marilyn was an expert with fans, and

she, Diana, and Philip kept the conversation going—on pets and art. Marilyn, in white slacks, sat during part of the visit on the floor, "fantastically beautiful" without a hint of makeup, playing with the dogs.[130] When Monroe and Miller finally departed, the group left behind sat silently, staring at her empty chair. Franz finally got up and sat in it. He said it was still warm.[131] Maybe they hadn't been dreaming.

That kind of competition in such close proximity made Grace uneasy. "Grace was complaining that she'd like to be a real star," recalled painter Paul Brach.

> We were in the supermarket, she was pissing and moaning to Mimi [Schapiro] that...none of us was famous.... It was the Marilyn Monroe summer, because stardom was on her mind. We were in Bohack's and this young woman came up to Grace and said, "Are you Grace Hartigan?" Grace said, "Yes," to the young woman and she said, "May I have your autograph?" She signed it and Grace floated through the checkout line.[132]

Money, fame. It was funny, it was confusing. It was the end. The purity was gone. "I vividly experienced the change of climate which occurred with the financial boom in the art world," Mercedes said. "The change from taking poverty and obscurity for granted to competing for a place in the spotlight. At the Cedar one began hearing many talking about galleries over their bourbons instead...[of] about art as before over their beers." Artists had become entertainers, selling themselves and their gifts for a piece of paper, the almighty dollar, emblazoned with a new motto, "In God We Trust." Paul Brach said 1957 was the last year that artists made other artists' reputations.[133] From then on, they were made by a machine called "the art establishment." "Career, the nemesis of our past, had crept up on all of us," Larry said.[134] It was like a virus, something all of them had but none of them wanted. At least in the abstract.

49. A Woman's Decision

> The realization of my first strong desire to choose, to decide, to find, to move myself consciously in a chosen direction gave me for my whole life, as I now see it, a feeling of victory not over someone else but over myself, not bestowed from on high but personally acquired.
>
> —*Nina Berberova*[1]

BACK IN THE city in late July, Grace, Larry, Mike Goldberg, Frank, Joe LeSueur, and Elaine were sitting together as they often did at the Five Spot. "It was after hours," Elaine said. "They weren't serving any more drinks, and the band was just playing in a very desultory fashion, and everyone was kind of tired and winding down."[2] The smoke-stained walls of the bar above the wooden wainscoting were, by that time, plastered with notices about openings, poetry readings, plays, and performances. Those who wanted to talk sat away from the area designated for musicians (it couldn't quite be called a stage).[3] But those who wanted to be *in* the music sat at small tables a few feet from the pianist, who beginning that month was thirty-nine-year-old Thelonious Monk, accompanied by John Coltrane on the tenor sax.[4] When the artists first began hanging around the bar, owners Joe and Iggy Termini had hired mostly white musicians who played like black jazzmen. Larry was one of them but thought it a shame that they should settle for second or third best when the greats were looking for jobs.[5] Monk had lost his cabaret card allowing him to play in nightclubs because he had taken the rap on a drug charge to spare a friend a long prison sentence. "Through a very convoluted grapevine he heard that if he wanted it, he had a three-month gig right here in New York City," Larry said.[6] Monk accepted the offer.

A hip maestro in his cape and sunglasses, Monk performed for an appreciative audience comprised mostly of derelicts and artists. He played the way the artists painted. Each night when he walked in he knew what he wanted his music to do, but he had no idea what notes he would strike to achieve it or whether the men who played with him would be able to follow his lead.[7] "I always had to be alert with Monk, because if you didn't keep aware all the time of what was going on you'd suddenly feel as if you'd stepped into an empty elevator shaft," Coltrane said.[8] Sometimes, though, they both caught the music, and then Monk stopped playing and

let Coltrane carry it alone while his large body danced, transported.[9] The artists who listened sat mesmerized. No one had heard such music before and might never again. They witnessed at once its birth and its death. Unlike their paintings, when Monk's miraculous music stopped it was gone forever. It was not written down, it had not been recorded, it existed like cool air filling the hot night and sweetening their memories.

Soon word spread through the 52nd Street jazz community about a new dive downtown. Men who would be legends began showing up to play. Cecil Taylor was among the first, then Charles Mingus, Miles Davis, and later Ornette Coleman, who described his music as "something like the paintings of Jackson Pollock."[10] Not only the performers, but also the audience became more racially mixed at a time when racial tensions in just about every other part of the country were at the boiling point.[11] The Five Spot became a creative and social sanctuary, protected by its decrepitude from the meddling world beyond.

In the wee hours of that July morning in 1957 when Elaine and Grace and the gang were seated in their regular corner of the half-empty bar, a thirty-year-old musician named Mal Waldron arrived with a singer he had recently begun accompanying on the piano.[12] "What I do remember, very distinctly, was the excitement that ran through the place when word got around that Billie Holiday had just come in," Joe LeSueur said. "The table where she sat with Mal Waldron wasn't far from ours."[13] There were few people living whom the artists in that bar respected more than Billie Holiday. In fact, Joan, Mike, and Frank had stayed up until three a.m. that June to hear her sing at a nearby movie theater.[14] Billie embodied the artists' struggle. She had paid the price for her gift from the time she was a child, burdened by the fact that she was not only a woman, but a black woman. At forty-two, after a lifetime of hard work, bad men, worse drugs, and cruel discrimination, her health and her finances were poor, but she had retained her dignity. Lady Day stood majestic. Tall, slim, her hair pulled back tight from her face, her eyes large and weary, it seemed as if pain had only made her more beautiful.

Frank, who had once called Billie "*better* than Picasso," had gotten up to use the men's room by the musicians' platform and then stopped just outside the door.[15] Mal Waldron was at the piano. "Suddenly we heard this voice whispering," Elaine said. "It was Billie Holiday, you know, after she had been told she couldn't sing anymore. And she was just whispering a song."[16] The session that none of them would forget, and many others claimed to have witnessed, continued until morning when the rising sun painted a line of blue along the horizon.[17] They had barely dared to breathe during those sublime moments while Billie sang and Mal played. Everyone felt it. The kid from East Harlem who was allowed to listen from the

phone booth because he was too young to sit in the bar.[18] The painters and poets and writers and musicians who sat shoulder to shoulder, knee to knee around small tables crowded with empty beer pitchers and overflowing ashtrays. The drunks for whom life held little that could qualify as beauty. Hearing her gave them all courage; by dawn their faith was restored.

Elaine, in particular, was in need of such courage. Every aspect of her life required changing. Drink for her had become something more than a way to pass an evening with friends or shake off a day in the studio. She had begun taking a shot in her morning coffee and continued through the day, until her clever musings devolved into slurred nonsense.[19] Of course, no one around her was sober enough to notice. Her reliance on alcohol was the norm among her artist friends. One night as she and Franz sat alone at the Cedar, a waiter came by to announce last call.

"We'll have sixteen Scotches and sodas," Franz said, affecting the voice and pose of a proper English gentleman.

"Sixteen?" the waiter asked, looking at the dwindling crowd and seeing only Franz and Elaine.

"That's right," Franz said. "Eight apiece."

Elaine and Franz would have done their duty and drunk all sixteen but luckily weren't put to that test. Joan and Frank appeared to share the bounty. In the minutes before the barman shouted, "Time's up, out of here," they downed what they considered a much more moderate four drinks each.[20] While that kind of excess was rare enough to become a favorite story, it demonstrated how little Elaine and the other artists understood the ravages of alcohol and how much they were in its thrall. "That's what you did then," she said. "I did not think that I was an alcoholic, and I didn't really know what an addictive personality was. But I was addicted to alcohol, and so was almost everyone else on the scene at that time."[21] And that made them easy marks for predators.

The Village no longer belonged to the artists. A woman staggering alone back to her studio on Broadway wasn't safe. One morning, Elaine had a close call at her door. A man had followed her from the Cedar and, as she stopped to find her keys, pressed himself into the entryway of her building. Grabbing Elaine, he covered her mouth to silence her and, holding her by the throat, began banging her head on the stairs. Elaine pointed at her neck and whispered "laryngitis." She wanted to assure him she wouldn't scream. He removed his hand and she gave him her purse, which he grabbed like an animal. An artist in the building, who had heard a scuffle, called down to ask if Elaine was all right. She shouted that she was fine, that she had trouble finding her keys. Standing up unsteadily, this woman who had once tried to resuscitate a mouse she had regretfully poisoned, said to her assailant,

"You look cold. Come on upstairs and I'll make you some coffee." He tamely followed her into her loft. "He was just a poor defeated junkie who needed money for a fix," she concluded. After their initial encounter, the man occasionally stopped by Elaine's place. "He's very interested in painting," she said.[22]

That response was typical of Elaine. "She was such an unusual person," recalled her friend Doris Aach. "She appeared not to judge you. She didn't blame you for your excesses."[23] Elaine's complicated life, during which she had made her own share of mistakes, had resulted in a seemingly boundless empathy toward others.[24] In an irrational world, she banked on sanity, believing that "people who know that you will not harm them will not harm you.... And besides, I just will not live in fear of other people."[25] Elaine began collecting stragglers who often misunderstood her generosity and returned her kindness with deceit.[26]

And then there was Bill. In the year after Pollock's death he had seemed obsessed with Jackson, as if he felt it necessary to compete with a dead man, to claim title to the celebrity Jackson had achieved. At Jackson's grave, looking at the forty-ton boulder Lee had chosen for his headstone, Bill boasted to Franz, "You see that stone? The rock Elaine is going to put on my grave will make it look like a pebble."[27] On the street and at openings, he carried himself like a star, posing as an "isolated genius" at galleries for the benefit of the eyes that followed him, awestruck.[28] Young women adored him (in that way he *did* best Pollock). Bill could be smooth, charming. Critics, museum curators, and gallery owners loved him, too. Unlike Jackson, he knew how to behave.[29] From the sale of his work, Bill now earned enough to pay Elaine about twenty-five hundred dollars a year (in addition to emergency money) and Joan Ward double that figure.[30] And still he had plenty to spend on painting supplies and booze.[31]

Those who had been his friends before he attained mythical status experienced the de Kooning who didn't know what to do with his money and fame. They tried in their own inexpert ways to help. At times, Bill turned up at Joan's St. Mark's Place studio to listen to Mozart and eat ice cream, which she administered as an antidote to drink.[32] Dore Ashton, by then an art critic for the *New York Times,* said, "I would see [Bill] on the street, usually drunk." Once she discovered him sitting on his stoop, too inebriated to navigate the stairs.

> So I said, Bill I'll help you.... I dragged him up three flights.... When we get there, he's suddenly alert and he gets his key and he opens his door, moves in quickly, and pushes me in, slams the door behind me and turns around and says, looks at me and says, "You little American bitz."[33]

On another occasion while visiting Esteban Vicente, who lived in Bill's building, Dore passed de Kooning's studio and heard a ruckus. Joan Ward was inside screaming at Bill, who was holding their toddler daughter, Lisa, out the window. "That was Bill," Dore said. "Bill was scary when he was drunk.... I was young but I had some sense. I sensed the violence in his character and I was careful around Bill."[34]

Bill's harem had grown exponentially after Jackson's death, but in the fall of 1957 he had begun seeing one lady he deemed special: Jackson's girlfriend, Ruth Kligman. Friends who had remarked on Bill's metamorphosis into Pollock shook their heads, half in dismay, half in amazement over the woman he wore on his arm like a trophy. Elaine called her "pink mink." Franz christened her "Miss Grand Concourse." Bill didn't seem to care about the mutterings. He told his friends, "She really puts lead in my pencil."[35] Though Elaine had nothing against Ruth, and would eventually become her friend, it was too much to bear. She had stepped out of Bill's life to make room for his daughter. Bill, however, had not become the father she imagined he would be, which made her angrier than she had been over Lisa's conception and birth. "The only time when I know I could kill," Elaine once said, "is anyone who does anything to children. I can kill, easily. With a hatchet, I could do anything."[36] As an adult, Bill had the right to make a cock-up of his own life, but he had no right to ruin his child's.

Bill's bizarre behavior formed an unsettling backdrop to a time when Elaine was at a professional crossroads. She, like many of the painters she had worked beside for years, felt creatively stagnant in the changed environment that had brought them acceptability. The extremists among them called for a "new academy" to counter the advance of commercial success. Ad Reinhardt was that group's high priest.[37] In the fall after Jackson's death he had exhibited his first black cruciform painting—black on black. In a complete repudiation of the new scene, he called his work a "free, unmanipulated, unmanipulatable, useless, unmarketable, irreducible, unphotographable, unreproducible, inexplicable icon."[38] In May 1957 he threw down the gauntlet in *ArtNews,* challenging his fellow artists to similarly purify their work to repel the invading hordes.[39] (Ironically, in the coming years those hordes would flock to Reinhardt.) Elaine sought something more modest than a grand new vision for art. She wanted to break out of the "prison" of her own palette, but within the environment of New York she could not.[40] She needed refreshment, inspiration, renewed energy.

Her solo show at the Stable the previous year had received favorable attention from *Arts* and *ArtNews,* but beyond that the response was tepid.[41] More importantly, Elaine didn't feel she had the support an artist needed from her dealer to mount another show.[42] While John Myers cajoled,

praised, and incited his artists to do more, to reach higher, Elaine believed Eleanor Ward at the Stable was ignoring her. And so, in the spirit of housecleaning in preparation for a new beginning, Elaine severed her ties to the Stable. Writing Eleanor, Elaine said she did not feel "properly represented" by the "minor" pictures Ward had chosen to keep as examples of her work. She also objected to Ward's

> thinking I had "slapped out a show" or, as you suggested, that I might "slap out" future pictures. And if I object to your thinking in regard to my work, it seems to me our situation is untenable.
>
> I certainly can't ask and wouldn't want to ask you to think any differently, but there is no sense in my being represented by a dealer who is not convinced by my work and I'm sure that, on your side, you would prefer not to be saddled with an artist whose work doesn't meet your taste. I see no reason for either of us to compromise. There's room for both of us in this world on our own terms, let's hope.[43]

Elaine's decision was daring. Like many of her colleagues, she was in a state of eclipse. Earlier that year, the artist-run Tanager cooperative gallery had decided to organize an ambitious exhibition coupling new and older artists. "We met, meeting after meeting after meeting, and votes were taken as to who was to be included and who was not," said Irving Sandler. "They did not include Elaine, which meant de Kooning would have nothing to do with the show, which meant the whole thing collapsed."[44] Elaine had been invited to participate in every major artist-inspired group show in the past, as well as many museum and gallery exhibitions. But the younger generation apparently didn't regard her work highly enough to include her in their show. At that moment of uncertainty, her decision to cut ties with her gallery took courage. At the same time, the artist in her "cherished" her freedom from commercial endeavors.[45] It was as if she knew she would not be in New York for long, that the politics and competition that had replaced camaraderie would no longer concern her.

In late 1957, quite unexpectedly, Elaine received an invitation to teach at the University of New Mexico beginning the next fall. A sculptor named Robert Mallary, who had read Elaine's pieces in *ArtNews,* had extended the invitation.

"Oh, I thought there would be prejudice against women teachers," she said.

"There is," he responded, "but I'm not prejudiced."[46]

Elaine was right to express surprise at the offer. "It was kind of an honor to be asked to go and impart your knowledge to the people in the poor benighted hinterlands," said art historian Helen Harrison. As universities added art departments, due in part to the popularity of Abstract Expres-

sionism, they sought "wise men" from New York to help form them.[47] Based on Elaine's writing, Mallary considered Elaine one of them. Proclaiming like a nineteenth-century pioneer that she had never been west of the Hudson River, she eagerly agreed to Mallary's terms.[48] The desert Southwest was her ticket out of the parched earth—personally and professionally—that New York had become.

In November, the third solo show of Elaine's career, which would be her last in New York for three years, was held at Tibor de Nagy. It felt like a retrospective, displaying as it did the various techniques she had used through the years across an array of her portraits, abstractions, and exuberant sports paintings.[49] In his review, Jimmy Schuyler praised Elaine for her willingness to take chances.[50] He meant in her art, but as her friend he may have also been speaking of her life. In heading to Albuquerque, she would leave behind whatever benefit she still enjoyed in New York as Mrs. Willem de Kooning. At thirty-nine, she would set off westward alone as a missionary for modern art.

Helen, who was considerably younger than Elaine, longed not so much for adventure as for stability. Her only long-term relationship having been a largely dysfunctional one with Clem, at twenty-eight she had begun to hunger for a mutually supportive attachment that might perhaps result in marriage. She was prepared to try the life some believed impossible for an artist, especially a woman artist. The possibility was made real one evening in mid-February as she watched a fellow artist take just such a step.[51] The least likely host for the occasion, Joan, had thrown a party at her St. Mark's Place studio for Jane Freilicher and Joe Hazan, who had finally decided—two years after his Mexican divorce—to marry.[52] "They went [together] for years," Helen wrote to Sonya. "It's odd to have a marriage for once in this crowd—not a split-up or ménage!"[53] Publicly, Joan wasn't sentimental about the gathering, announcing beforehand, "I'm serving cognac and nothing else, and I don't want to hear any bitching."[54] But all of them were moved by Jane's portentous decision. In honor of the occasion, Frank wrote his famous "Poem Read at Joan Mitchell's."

> *... Yesterday I felt very tired from being at the FIVE SPOT*
> *and today I felt very tired from going to bed early and reading ULYSSES*
> *but tonight I feel energetic because I'm sort of the bugle,*
> *like waking people up, of your peculiar desire to get married....*
> *we peer into the future and see you happy and hope it is a sign that we*
> * will be happy too, something to cling to, happiness*
> *the least and best of human attainments*[55]

Helen came away from that evening hopeful and yet uncertain.[56] Since she had broken up with Clem, she had had many dates, some of them blind (engineered by Grace), mostly with writers. At times she had even felt like "a young chick on the town again."[57] But that wasn't what she was after. Jane's marriage reminded her that she was on her own, which exacerbated the loneliness Helen often felt in the studio. From late 1956 through the fall of 1957, Helen's mention of the men she dated often hinted at the girlish question: Is he the one?[58] The question was directed at herself, but she was open to any help her friends might offer.

If, however, Helen's personal life felt impoverished, her creative life had never been so rich. Beginning in 1956, she produced some of the most daring work of her young career. Critics before that period had complained that Helen was not sufficiently present in her work, and they were suspicious of the apparent ease of her technique. Helen answered those criticisms by laying it all out, by risking everything. It was as if she were asking, as Jackson had in his painting and Frank did in his poems, "Can I do this? Can *art* do this?"

Eden, with its exaggerated symmetry symbolized in a pair of numbers—"100"—felt both lyrical and disturbing. The lines were spirited and brisk, until the viewer encountered a red hand that stopped the eye's journey around the canvas the way a road sign stopped a fast-moving car.

New York Bamboo (black and gray on unprimed canvas) and *Jacob's Ladder* (a brilliant patchwork of color) each played with the question of balance: Can a mass of brushstrokes or bed of color at one end of a painting be made to weigh the same as a line or a smudge at the other?

Seven Types of Ambiguity, a pale painting with undefined white-gray shapes floating lightly on the surface like a gauzy veil, beckoned the viewer to look more deeply into what might be a purely abstract painting, or might be a work filled with playful symbolism: a heart with a sword struck through it; the numbers one to six, similarly skewered by a line; a man and a woman embracing.

Or *Giralda,* a nearly eight-by-seven-foot painting, which could be a tribute to the bell tower of that name at the Seville Cathedral, or a massive hard-on emerging from legs splayed open.

Something emboldened Helen during that period. Perhaps it was merely a matter of maturing as a woman and an artist. Or perhaps she found the freedom to explore that she might not have had under the judgmental eye of Clem Greenberg. Helen attributed the change to Jackson. She said that after his death she began investigating a side of herself she had recognized in his 1951 black-and-white painting *Number 14,* which breathed freely between, under, and around black traceries of poured enamel paint. "In fifty-six and seven I think I let a lot of things come out in pictures," she

explained. She didn't want to experiment with style, Helen said, but with herself.[59] The response to Helen's new work was enthusiastic. John Myers wrote,

> I think all this past year you've been coming into your own steadily, at times, brilliantly. By which I mean an increasing depth and authority in your work.... Strange—perhaps the largest gift your work has given me is its peculiar power to make me <u>see</u> other pictures better. All kinds of pictures—old as well as new. What better proof of their power....
>
> Do I compliment you? Well I mean to. A good artist simply can't ever receive enough (What was it Rilke loved to repeat, "I praise"...) So.[60]

Beginning with her solo show at Tibor de Nagy that February, Helen's exhibition calendar in 1957 was full— *Young America 1957* at the Whitney; *Panel's Choice 1957* in North Carolina; *Artists of the New York School: Second Generation* at the Jewish Museum in New York; *New Talent in the U.S.A.* traveling exhibition; *American Paintings: 1945–1957* in Minneapolis—and those were only the shows through May of that year.[61]

On the last weekend in May, Helen boarded the train to Long Island with Frank. She was bound for a weekend with Grace at her Creeks cottage, and he to an attic apartment he had rented from Larry for the summer.[62] Though Frank and Helen had known each other for years, they had not been as close as Frank was with other painters. Clem had been a major impediment in that regard. This had changed, however, during the previous year partly through poet Barbara Guest's intervention. She and Helen were in constant contact, and Barbara was one of Frank's regular lunch partners at Larré's. By late 1956 Helen had joined them there, too.[63] Frank soon named a poem after Helen's painting *Blue Territory,* a sign that she had become part of his world.[64]

During Helen's girls' weekend at the Creeks with Grace, Frank formed part of the cast at the events that filled their evenings: drinks with Gaby Rodgers, dinner at Alfonso's, a late-night bash at Barney Rosset's, who that year would publish Frank's book of poems *Meditations in an Emergency* with a cover designed by Grace.[65] The women's days were spent sunning on Grace's terrace in the morning and swimming with friends come afternoon. Most important to Helen, however, was the time she spent talking with Grace over glasses of chilled vermouth.[66] The topics ranged from art (their struggles), to life (where were they going), to the drunken ridiculous. Fantasizing about what they would do if they weren't artists, Grace decided she'd be a "glamor puss, who finds a film god with his opera cape flung over the puddle when she steps out of a stretch limo." Helen said she wanted to be a Rockette.[67] They also discussed men. Uniquely qualified to

understand Helen's angst on the subject, Grace, too, felt the strains of being an artist and a woman, and wondering whether or how to fit a permanent relationship into that mix. Jane's wedding had started them all thinking.

The artists' weekend together had been better than a spa. Helen left feeling "fancy free and floating in a nice unanalytic way."[68] Upon her return home, she wrote Grace,

> The three days I spent with you were very full and mean a great deal to me. I look back on all sorts of mutual revelations and moods and feel very happy that you are my friend and that we can share such complete and different moods and times together. I know you experience this as I do. <u>Knowing a friend</u> is very rare these days in our crowded and active "milieu" and understanding, rapport, pleasure, helpfulness are rich things. Despite the fact that my eyelids look like pink balloons, my sunburn fits well over my winter skin. The air, the booze, the rage, the low-moods, the wonder of homos, the dressing-up and dressing-down—all made me feel very wide awake today.[69]

Responding in kind, Grace answered, "So often affection is never expressed verbally between friends because it is assumed that it is 'understood.' I too am glad we are friends, glad as much for the ease in it as for the confidences."[70]

Back in New York, Helen was painting, had met a "bright nice lively sweet doctor with a sensuous face," and was generally happy enough to be spending a few weeks in the city. "New York is quieting down," she wrote, "and I look forward to quiet strolls, 9 pm on Madison Avenue. Somehow that's my dream of freedom."[71] Gregarious as she was, however, Helen couldn't reside in such solitary bliss for long. In July, when Hans and Miz Hofmann invited her up to Provincetown, she jumped at the chance.[72] The artists who congregated there were a different set from the Hamptons crowd—older, more staid. Helen enjoyed both groups, but she was drawn to the company of the old man of art, Hans. Though she had only studied with him briefly, he treated her as a favorite student, a favorite child. Amid her uncertainty over her personal life, she may have relished the security she felt and the attention she received in the Hofmann home behind its white picket fence.

As well as still being a draw for students from around the country, the Hofmanns were favorites among the established artists who had driven north from New York. The Rothkos were there that season, as were the Motherwells: Bob, his wife, Betty, and their children.[73] Helen had, in fact, spent New Year's Eve with the Motherwells, along with Lee, and Philip and Musa Guston.[74] It was a particularly poignant moment: Lee's first New Year's without Jackson. Host Bob Friedman noted in his journal the next

morning that though Pollock was not with them, his "ghost" had been."[75] While that night had been warmly melancholy, the nights at the Cape were about fun. The Motherwells invited Helen to their place for drinks.[76] They were acquaintances who felt like old friends.

Sometime that summer, Helen became involved with a thirty-three-year-old pipe-smoking painter named Reggie Pollack.[77] The son of Hungarian Jewish immigrants, he had fought in the Pacific in World War II and used the GI Bill to study in Paris. When Helen met him, he split his time between New York and Paris, where he had worked in a studio next to Brancusi until the Romanian's death that March.[78] Reggie appealed to the part of Helen that craved Europe. They became a couple, despite his marriage to a woman in France. He had promised Helen that he would divorce his wife, and she considered herself engaged.[79] That bit of life's business taken care of, by the fall, Helen told Grace she had "stretched about ten new pictures and I feel some of them are really 'there.' I don't know when I've had such a sense of one-ness and solid, sure, strong feelings about what is mine and what I do that's right and me.... I'd like you to see them. Which brings me to the next point: When?"[80] When was a question Grace couldn't answer. While Helen was enjoying the Cape, Grace had taken an important step in a new direction in her art and found a new fellow of her own in the Hamptons.

Somewhat surprisingly for a woman who craved the city, Grace had fallen in love with the life on Long Island. The paintings she completed at Ossorio's, and later that fall while renting Zogbaum's house in Springs, were the landscapes she had tried but failed to produce in 1952 on the Castellis' summerhouse lawn.[81] In the works from 1957, she discovered a way into the vastness of nature: Grace married mankind at its most vulgar to nature at its most sublime. Mid-twentieth-century man had cut a new swath through nature and called it a highway. Grace celebrated that "advancement," which had inspired artists from the Beat writers to Bill, in huge abstract paintings that looked like the view through the windshield of a car traveling at one hundred miles per hour. "I wanted every section of the final image to vibrate with life, with inner automobile feelings, the soul of a car, so to speak," she explained.[82] "Our highways are fantastic: I like nature as imposed on by man."[83]

The massive paintings—*Montauk Highway* was seven and a half by ten and a half feet—were among Grace's best and most beautiful. Larry called *Montauk Highway* a "masterpiece." They retained the playfulness of her city works, but not at the expense of an overall elegance of technique and design. Grace's city paintings had been the result of a years-long artistic struggle to find her original voice. The works she would call her "Place Paintings" were the magnificent result of having achieved that. They were relaxed, joyous,

masterful. "I used to think I needed the tension and anxiety of New York," Grace explained. "Now I have enough of my own. I want to rediscover hackneyed truths. Three years ago I found nature bewildering. Today I think I can learn some of her lessons, and translate them in my studio."[84] She had found a new muse and wanted to remain near it. This being Grace, that also meant finding a man to help her enjoy her time outside the studio. Mary Abbott introduced her to an intriguing possibility: the owner of a bookstore and gallery in Southampton named Bob Keene.[85]

Between the closing of the Braiders' shop and the opening of the Signa, Bob's bookstore was the only place in the area to show the new work. He was an unlikely candidate for such an endeavor. A local playboy, Bob organized "mixed sex boat trips" as part of a "bachelor's club." He was also politically conservative. But his store attracted the writers who lived or summered in the Hamptons, and Larry persuaded him to give local artists a place to hang their work. Everyone came away pleased with the arrangement. Not only did Bob serve champagne and martinis at his openings, but he paid artists who sold through him in cash, on the spot.[86] He endeared himself still further to the New York School when he dared to show Larry's full-length nude portrait of his teenage son. Outraged locals demanded Bob remove the obscenity and the local newspaper ran a story on the scandalous display. Bob capitulated to a point but largely stood his ground on the side of the artist: He posted a sign on his door saying the work could only be seen by request. People lined up to view it.[87] Bob seemed like the kind of man Grace could enjoy—strong, funny, in his own way iconoclastic. By the end of the summer, he had become her latest paramour,[88] which caused Grace to shed her previous lover, the sensitive Giorgio. Brokenhearted, he was not prepared to go easily.[89] One night in the Cedar, well into his cups, Giorgio announced that was going to "pay Grace and her bookish lover a surprise visit," Larry recounted.

> Scouring the bar, borrowing money for the one-hundred-mile drive to Southampton from his fellow artists, who were glad to bankroll such a good cause, he climbed into a taxi and told the driver where to go and how fast to get there. Two hours later the taxi stopped outside the apartment back of Keene's bookstore.... George banged on the door and demanded entry. Asked by big Bob Keene, naked in the doorway, what he wanted, George leaped and threw a roundhouse punch. Bob, an ex-marine sergeant, stopped the punch in midair, grabbed the looping arm, and wrapped it around George's neck. George found himself in the position of having traveled a hundred miles to give himself a half nelson. He began to make gurgling noises. Grace appealed with Bob not to hurt him. Bob shimmied George

back to the cab, piled him into the backseat, and told the driver where to go and how fast to get there.⁹⁰

When he returned to the Cedar, his expectant friends still waiting, Giorgio told them his tale of humiliation. Bravo! they said. It was, as always, the act that counted.⁹¹ But Grace remained with Keene.

The Great Neck Adult Education program on Long Island had hired an incredible roster of artists to teach its students: Louise Nevelson, Nell Blaine, Larry, Grace, and Helen, among them.⁹² Helen wrote Grace in October 1957, after her second night, "...to my delight and surprise [I] have enjoyed teaching very much.... The class is so hopped-up and abstract-happy that I often feel I'm running a group psycho-therapy class rather than [an] art course."⁹³ Helen's life was full—she was excited by her painting, happy in a job, engaged to a painter in Paris—which is perhaps why one December night after teaching in Great Neck she declined a dinner invitation to the Friedmans'. Helen protested that she couldn't—she was on Long Island, it was too late, she was too busy. It was an answer the Friedmans didn't want to hear. They told her they'd pick her up at the station when she arrived back in Manhattan.⁹⁴

Among the guests at their table was Bob Motherwell, who, between Helen's Provincetown encounter with him in July and the Friedmans' dinner in December, had separated from his wife. Bob's marriage had been in trouble for nearly two years after a very public affair he had conducted with a nineteen-year-old student. Several attempts at reconciliation having failed, his wife left him and took their two children to Virginia near her family.⁹⁵ At the Friedmans', Helen found herself listening to his side of the story and boldly challenging him on the decisions he had made that had ruined his marriage. Helen recounted,

> After a real exchange we went out and had a drink around the corner. He was teaching at Hunter and had two bucks in his pocket. He had support to pay. And he was in bad shape and I thought his psyche, his ego, his total ambiance needed...a real perspective to shake it up eye to eye directly. And for some reason, probably enough beer, and the hour, and a real interest in this person, I let him have it saying "Why do you think you're doing this?" "Why is that?"...I put it in such a way and what came through was this passionate interest, not just a stupid kid wanting to attack.

Not long after that conversation, Helen and Bob would meet again. "And then all kinds of things happened," Helen said.⁹⁶

* * *

At forty-two, Bob was a First Generation grandee, one of the originals who had been party to the Surrealist invasion of New York, who had translated and published some of the first documents in English by the French artists who had made art modern. He was also one of the first writers to articulate the changes occurring in art in America during the war, and he was one of the first New York School artists to have a painting in the Museum of Modern Art collection and form part of Dorothy Miller's *Americans* shows. Finally, Motherwell's school, however short-lived, had inaugurated the tradition of Friday night lectures that was expanded upon in the Club. He had, in other words, been at the heart of the movement from the beginning.

But amid the emergence of the Second Generation, Bob had retreated from the scene somewhat. He had a growing family—two small daughters of his own and a daughter from his wife's first marriage—a house on the Upper East Side, and a job on the faculty at Hunter College.[97] It was a comparatively secluded existence, which, in fact, suited his personality. "He was painfully shy," said his daughter Jeannie Motherwell. "Before he could answer the phone he had to light up a cigarette."[98] And he had scant interest in small talk. "In many ways, social occasions caused him a lot of anxiety because he didn't really know what to do with himself until he got to know someone well enough to have a deeper conversation," said his younger daughter, Lise Motherwell. "His work was his primary relationship."[99]

Without making any real connection, Helen and Bob had occupied the same social orbit since she appeared amid the art crowd as Clem's consort in 1950, and the same artistic orbit since the 1951 Ninth Street Show in which both participated. For Helen, Bob existed primarily as a name on paintings she admired. As early as 1950, she remarked in a letter to Sonya, "Good Robert Motherwell exhibit at Kootz."[100] And later, when she had begun to detect a sameness in the work on display in group shows, she had singled out Bob's as among the few worthy of regard.[101] If Bob had not noticed Helen earlier, he would have certainly done so in 1955, the year of her breakup with Clem. It was Bob who had comforted Clem's girlfriend Jenny Van Horne as she stood crying in humiliation while her date, overcome by jealousy, scuffled with Helen's at the Stable Gallery.[102] That evening, it would have been impossible for Bob to miss the magnetic young woman who was driving Clem mad.

Leo Castelli had finally opened his gallery in February 1957. It took him more than a decade to take that step, but the time could not have been more auspicious, and he was, in any case, tired of collecting artists for Janis. Castelli's first New York gallery was a "shoe-string operation," run out of the fourth-floor apartment on East 77th Street that he shared with his wife and daughter. "We devoted the living room—actually it was a combina-

tion living room–dining room, 'L' shape—to be the exhibition space," he said. His daughter's room served as office and storage facility, and the family lived in the front of the apartment in two rooms and a kitchen.[103] The roster for his first eight shows included familiar names: Bill, Jackson, David Smith, Léger, Mondrian, Giacometti, Paul Brach, Friedel, Marisol, and Norman Bluhm among them. The last show of the year, which he called *Collector's Annual,* included Helen's work.[104]

The opening was scheduled for the evening of December 16. Earlier that day, Helen had had what she called a "very neurotic drama" with Reggie Pollack as he left New York for Paris.[105] He was to go back to Europe to divorce his wife, and Helen was to join him in France soon afterward. Helen had even taken the precaution of giving her studio key to her lawyer and alerting John Myers of the arrangement.[106] But after her talk with Reggie, nothing seemed certain. Upset and confused, she dressed to go to Castelli's and was nearly out the door when the phone rang. It was Bob Motherwell, asking her to dinner. She told him she was on her way to the opening. He offered to escort her.[107]

The gallery was suffocatingly hot and the scene—the people, the smoke, the fun—proved too much for Helen. She began to cry. "I want to get out of here," she told Bob. He suggested they go someplace for a drink. In her troubled state she didn't want to see anyone, even waiters. She asked him to take her home. "And we sat and talked all night long," Helen said,

> about what life is like in a way that most people would think profound adolescents might. But it was a sort of very accurate and real but fantasy night of this is the way life is, this is the way I think it could be made, these are the problems, these are the things I don't know about…there was a fantastic recognition and a permanent road into each other. And it developed from there.[108]

Helen had always been drawn to writers. In Bob, she had both a painter and a writer, a man who understood the sensuality of paint and who could explicate that sensuality in words, not in judgment as a critic but out of love for the medium as an artist. In Helen, he would have seen a vibrant young artist committed to her work. "He really respected artists, just for being artists…for choosing that life, knowing how difficult it was," Lise said. "Helen was a serious artist, that's what she was devoted to. And he got that."[109] Apart from the fact that Bob was thirteen years her senior with two failed marriages and two children and that, as a profoundly introverted man, his personality was the opposite of Helen's, they had everything in common: art, intellect, a love of luxury and beauty.[110] Helen would not marry Reggie Pollack. Within a very few months, twenty-nine-year-old Helen Frankenthaler would add "Motherwell" to her name.

50. Sputnik, Beatnik, and Pop

> The question of how and why an artist achieves and retains recognition in contemporary America is as complicated as it is tragic, comic and boring.
>
> — *Thomas B. Hess*[1]

JOAN WASN'T IN New York for the publication of "Mitchell Paints a Picture" in the October 1957 issue of *ArtNews,* or to see her spring show named one of the year's ten best by that same magazine. In August she had fled New York for Paris, a city toward which it seemed the balance of her life had shifted.[2] Edrita Fried, the analyst Joan depended on, told her that after seven years of therapy, their work together was ended.[3] Joan's schedule of wintering in New York had served two primary purposes: It allowed her to remain part of the scene and paint without interference in her St. Mark's Place studio, and it allowed her to consult Fried.[4] She needed both. She had come to think of Fried as a mother, one stronger and more understanding than her own. Joan demanded that their sessions continue but, as with any relationship, the desire of one party to withdraw meant the end was already a fait accompli.[5] Joan had to prepare for that severance.[6] Distance was one way of doing so. Jean-Paul was another.

By 1957, he had become one of the most famous younger artists in France. The genius hunt that consumed New York's art world had crossed the Atlantic, and Riopelle was declared one. A cultural prognosticator on French television gushed that year, "Make no mistake, fifty years from now the work of this man will be classed as masterpieces, and we are fortunate indeed to be living in the same moment in history as one of the masters."[7] Writers in Europe described his work hyperbolically, even though the type of abstraction Jean-Paul produced would have been ranked, had he been working in the States, as second-tier Second Generation—interesting but in no way original. As a representative of Europe, he was, however, given extra credit for being a leader of the continent's nonobjective movement as it struggled against the dominance of New York. *And* he made a great story. Magazines like *Vogue* and *Life* had discovered the handsome, thirty-three-year-old painter, with his fleet of sports cars and motorcycles, and requisite disdain for the mannered life of the bourgeoisie.[8] He looked and acted like a character out of the French New Wave cinema that was all the rage.[9] Money

poured in. Jean-Paul responded by churning out paintings "like *petits pain* at the bakery."[10]

Though she despised the spotlight herself, Joan secretly loved that kind of success. (Mike's lack of competitiveness had been one of her chief complaints against him.) Leaving behind Fried, who had spurned her, and New York, where fame had proved so disorienting, Joan flew to Paris to be with a celebrated wild man who was obsessed with her.[11] On the ride back to Paris from Orly, Jean-Paul stopped his speeding car alongside a field, pulled Joan out of the vehicle, and made love to her.[12] That memorable greeting set the tone for their time together. Nothing less than high drama, fueled by massive amounts of alcohol, would do. ("They drank so much bad Ricard and smoked so many Gauloises without filters they should have had twenty heart attacks," Barney said.)[13] Joan and Jean-Paul shouted boisterously through the early morning streets after stumbling from their favorite bars, drove horrified guests from a rural auberge with their antics, and crashed respectable Parisian parties in the company of nefarious characters they had picked up along their merry way. A friend of Riopelle's declared that it was at times "terrifying to be with them."[14]

Jean-Paul lived with his wife and two daughters, which meant Joan had to find a studio of her own for her time in France. During previous Paris stays, she had moved from apartment to apartment, and sometimes into hotels because she couldn't find anything even semi-permanent. It made life difficult and painting nearly impossible. In 1957, however, not long after her arrival, Joan met Paul Jenkins, who wanted to return to New York. Joan proposed an exchange: her St. Mark's Place studio for Paul's atelier on the rue Decrès, the same studio where Lee had been staying when she heard the news of Jackson's death. Paul agreed.[15]

In 1958, Joan took possession of his sixth-floor flat, where she sunbathed nude on the balcony and painted beneath a massive skylight that placed her amid the stars.[16] It was perfect, as was its location, close to the Dôme. There she could find her friend "Sam" Beckett, when he was in town, and Alberto Giacometti each evening, smoking, reading a communist newspaper, and enjoying the same meal—a veal cutlet, spaghetti, and a glass of Campari.[17] Though a famous sculptor, he was not disarranged by his acclaim. In fact, he ignored it.[18] All her associates in Paris did. They lived their lives as they always had, only in Jean-Paul's case more vigorously. Joan stepped easily back into what she called her "little world" of Parisian friends who congregated around the Boulevard Montparnasse.[19] Until, that is, Barney's arrival that fall, when her little world expanded.

Earlier that year, Barney and his associate Don Allen had started a literary journal, *Evergreen Review,* devoting the second issue to a group of writers

called the Beats.[20] The name was the result of an offhand remark made by Jack Kerouac comparing the post–World War I Lost Generation and his own, which had matured under the mushroom cloud of World War II. Kerouac said his generation wasn't lost, it was "beat," and his friend, the writer John Clellon Holmes, immortalized the label in a 1952 *New York Times Magazine* article introducing the "Beat Generation."[21] While the image and the name became well known, the Beats' work largely languished unrecognized until 1957. *Evergreen* became the first national publication to print it.[22]

Allen Ginsberg's poem *Howl* was tied up in an obscenity case in San Francisco and could not be published, so Barney produced an expurgated version, along with work by Kerouac (whose *On the Road* would be published that September by Viking) and poet Gregory Corso.[23] Though City Lights in California would ultimately publish *Howl* in its entirety, Barney said *Evergreen* and Grove Press "became, in a way, the official publishers of the Beat Generation."[24] When Barney arrived in Paris to see Joan and Beckett, Ginsberg and Corso were already there. They had taken up residence in a fleabag hotel near the Place St.-Michel to escape Ginsberg's *Howl* celebrity.[25] (By the end of 1957 it would sell ten thousand copies.)[26] To Joan they weren't literary celebrities, merely Barney's latest discoveries.

To stave off homesickness for her friends in New York, if not the city itself, Joan began hanging around with Ginsberg, his lover Peter Orlovsky, Corso, and William Burroughs.[27] Burroughs was just up from Tangier and working on a seemingly unpublishable book called *Naked Lunch,* which Ginsberg was trying to peddle to Barney.[28] All but forty-three-year-old Burroughs were of Joan's generation and shared her attitude. The Beats made their art with words but lived their lives as statements. Much more so than the New York School, they had mastered a street theater that was disruptive, abrasive, indignant. It was a little like Joan's own.

The boys also made her feel connected to Mike, who was in every way (short of a pledge of allegiance) a Beat, as well as to Frank, who was not. Though their poetry was unlike his, and though he felt their style tended too much toward the confrontational, Frank had befriended Ginsberg and Corso in the States, and so built a bridge between West and East Coast avant-garde writers. The Beat boys had begun turning up at the Five Spot and occupying tables at the Cedar.[29] (That fall, Helen had a "No Beatniks" sign hung in the bar after Kerouac urinated in the sink outside the men's room.)[30] The spillover world of poets enlivened Joan's life. During her first months in Paris, while struggling in the studio to make the transition to a new environment, and while wrestling personally with the ill-suited role of a married man's mistress, Joan reveled in the outré existence of her new

friends. Ultimately, however, she would disassociate herself from the "let's howl school" and the "too too sneakered poets."[31] Though it may not have been by choice. The Beats were an exclusively male club, far more impenetrable for a woman than the New York School.[32] Joan, in any case, had neither the time nor the patience to try. She already had enough complications with the men in her life.

Joan considered Barney "family," someone for whom she had "undying forever loving loyalty," and he, in turn, cherished her.[33] Joan still received money from Grove and, in an almost paternal way, Barney kept an eye on her affairs.[34] Inevitably in Paris he met Jean-Paul. Predictably, he didn't like him. "A little better than Mike," he concluded, "but not that great.... He was French-Canadian, who didn't speak French or English.... You really couldn't understand him." Barney said, as he had of Mike, that Jean-Paul was "brutal," and worse, that he copied Joan's work and made a fortune from it.[35]

In fact, it was Joan who had tried some of Jean-Paul's language on her canvas during that year. His work had evolved from Pollock-like drips to more thickly applied, distinct brushstrokes, sometimes so thick that they formed blocks of paint. In 1957, Joan's brisk strokes had started to become thicker, too, until instead of spinning or thrashing on canvas, they became static building blocks. Where previously, her paintings leaped and danced, they now appeared dead. She had gone too far into another artist's realm. In late 1957 and early 1958, in preparation for her next show at the Stable, Joan found a way back to herself, maintaining the denser lines but once again setting them in motion.

She was under intense pressure to finish her work and get it to Eleanor Ward by February. For perhaps the first time in her adult painting life, Joan's show was anticipated because of her previous year's success.[36] She was not just another painter, she was one of *the* painters. The strain was nearly overwhelming. She tried, unsuccessfully, to have her show postponed.[37] If she had been in New York she would have understood Eleanor's insistence that she abide by the schedule. The art world was changing again, drastically. In January, a reproduction of a painted target below four plaster faces appeared on the cover of *ArtNews*.[38] It was a work by a twenty-seven-year-old artist named Jasper Johns. With his arrival, Joan and her generation faced fresh competition and the possibility of something infinitely worse, irrelevance.

Two years before, Johns had been designing windows at Tiffany's with Bob Rauschenberg.[39] But in early 1957, Leo Castelli had seen his work at a Jewish Museum show of Second Generation artists. Castelli recalled,

In this show there were all the people that we knew—the Leslies, the Joan Mitchell and Mike Goldbergs and so on, plus Rauschenberg...and one painter that I did not know. I stumbled while I was walking through the show on a green painting...a green square painting done in a strange way, collage type and I was terribly impressed by it. For me it was <u>the</u> painting in the show, and I looked at the name plate and it said Jasper Johns...and I asked myself who the hell can that be—I've never heard of him. It almost seemed like an assumed name.[40]

A few days later Castelli visited Johns in his studio and invited him to appear in a group show at his gallery.[41] Since the end of the war, Castelli had been immersed in the Abstract Expressionists' world. He believed the first "turning point" for that group occurred in 1948 after Gorky's death, when Clem wrote in the British magazine *Horizon* about the genius Pollock. Castelli identified the second turning point as the emergence of Jasper Johns. "He really sounded the death knell for the previous movement as it existed," Castelli explained.[42] It happened so quickly, it was nearly unfathomable. In January 1958, *ArtNews* featured Johns's *Target with Four Faces* on its cover; that same month Castelli gave him his first solo show, and the Modern bought three of his works for its collection.[43] It had taken years for the museum to accept Abstract Expressionism, but just months to anoint its youthful successor. "It was like a gunshot," said critic Hilton Kramer. "It commanded everybody's attention."[44] Irving Sandler called Johns's appearance the beginning of a "bloodbath."[45]

In October 1957, the American people learned that the Soviet Union had launched a satellite the size of a beach ball into space. By November a second satellite, Sputnik II, was orbiting the planet. It was heavier, flew higher, and carried a dog.[46] The U.S. citizenry, many of whom had been lulled into complacency during the Eisenhower era by a combination of television, tranquilizers, and martinis, suffered an electric shock.[47] The father of the hydrogen bomb, Edward Teller, called Sputnik "a technological Pearl Harbor."[48] Those humiliating orbiting beach balls changed U.S. society—from the study halls of schools in rural Tennessee, where math and science suddenly became priorities, to the halls of Congress, where thoughts of war no longer involved dusty battlefields but the crisp vastness of outer space.[49]

Jasper Johns was the New York School's Sputnik. Even before his appearance, artists and writers meeting at the Club had begun to criticize the art world's complacency, the sameness that was increasingly evident on the walls of galleries showing abstract work.[50] "It's like jive talk," John Myers said in a letter to Helen about the art on display at that time, "amusing when first used by, say, Louis Armstrong—irritating when picked up

by everyone.... One seems to be seeing parodies of what started out so seriously."[51] Alfred Barr demanded a revolution. Tom Hess sounded the alarm in *ArtNews,* declaring "Abstract-Expressionism has died!"[52] But no one within the New York School other than Ad Reinhardt with his black-on-black paintings had offered an alternative. Jasper Johns embodied one.

His *Target* and American flag series served as both a direct challenge to the New York School artists to awaken from their somnolent self-absorption, and a rebuke for the seemingly impenetrable images they continued to produce. In comparison, Johns's work was direct. It went well beyond the references to daily life that Grace had daringly embedded in her abstractions. Johns seemed to ask, why the subterfuge? If it is life and its symbols you are embracing, then do so. If it is truth you seek, then here it is. Basing his work on the most recognizable of images, he gave viewers a choice: One could appreciate it for its familiarity, albeit cleverly transformed, or one could see it for what he had created, a new type of art, a new aesthetic.

Johns's paintings immediately captured the American imagination.[53] Writing in 1957, philosopher William Barrett explained why. In an age when people nightly "journey[ed] into untruth," surrendering themselves to a pretend reality on their television screens, they were no longer capable of probing and participating, as both life and abstract art required. They had reached the point where they were only able to passively regard that which had been prepackaged for their approval.[54] Brilliant though Johns's art was, it reflected the time. It was a time largely lacking in romance. It was an era of production-line, advertising-directed culture.[55] Self-expression had devolved into Think alike. Look alike. Buy alike. What one owned came to define who one was, but everyone purchased the same things.[56] In 1958, the British critic Lawrence Alloway identified a new movement in England that mirrored—though more crassly—what Johns was doing. It used the cheap iconography of mass culture and declared it fine art. Alloway called the movement Pop, and like the Beats, it was an all-boys' club.[57] That was what the Abstract Expressionists were up against, especially the women among them, a change in sensibility so radical it was nearly irreconcilable with what had come before. One movement had been born of man's search for his soul, the other sprang from the terrible corruption of his spirit.

There is no one more aware of the passage of time—the loss of life implicit in each tick of the clock—than the elderly. In 1958, Hans Hofmann was seventy-eight and had been teaching younger artists for more than forty years.[58] During that time, he had been called a master, but it was not necessarily for his work. He had not had time to paint as much as he would

have liked because he had spent so many of his waking hours helping others understand the majesty of art and the gift of making it. He had watched his students thrive, paint masterpieces, win acclaim, and he had been proud of his role in their achievement. But he was not prepared to be a footnote in someone else's biography. That year, when a young man as talented as Johns would have illustrated to an old man as perceptive as Hofmann that there was still so much to be done in art, Hans decided to close his school. He had no more time to lose if he wanted to leave his mark as a painter, not merely a teacher.

After 1958, artists who wandered into 52 West Eighth Street did not find students standing amid an array of easels. They found one easel and one artist, the old man himself.[59] Harold Rosenberg once said of Hofmann, "the 'message' of this man was, above all, enthusiasm for the artist as a human type and for art as a style of feeling."[60] Both type and feeling had changed radically in America between 1934, when Hans opened his New York school, and 1958, when he closed it, because society had changed. As one historian of the fifties wrote of that shift, "It seems in retrospect not so much that the dream was betrayed. It was trivialized."[61]

At the moment when some in New York were playing a funeral dirge for the Abstract Expressionists, however, the world beyond awakened to their importance. European curators had watched the Museum of Modern Art organize exhibitions of the latest American art for events in Brazil and Tokyo, and requested that it produce a similar traveling show for Europe.[62] The Modern agreed. The exhibition would be in service to both art and state. Twelve years earlier, a similar traveling show of "modern" art sponsored by the State Department had been so controversial that it was abruptly withdrawn, with the U.S. government vowing never again to spread that demon doctrine under its banner.[63] But by 1958, as the United States feared losing the technology war to the Soviets, it unleashed avant-garde art as a secret weapon in the cultural war against its Cold War foes. No matter how inexplicable to those in power in Washington, the kind of art being produced in New York was evidence of the freedom of expression a democracy afforded its people. An exhibition like the Modern's was therefore encouraged, while not overtly supported; there were still too many conscientious objectors to abstraction for the government to fund such an enterprise.[64]

The benefit to art itself was incalculable. Artists working in America had created a revolution comparable in importance to that of the nineteenth-century modernists in Europe—Cézanne, Manet, Monet, Van Gogh—who had changed not only the way art was made but how it was perceived. Now the results of that revolution would be on display for

audiences in eight European cities, places where Americans were caricatured as either GIs armed with guns or tourists flaunting money.

The exhibition, *New American Painting,* would be the most significant of the many traveling exhibitions that the Modern had mounted. It was to be organized by Dorothy Miller with the assistance of Frank O'Hara.[65] Both were well acquainted with the artists able to represent the previous two decades in art, and the exhibition came together quickly. Pollock would be its foundation, as he had been in Brazil, with sixteen additional artists who had been part of Miller's past *Americans* shows completing the roster. They included artists like Gorky, Philip Guston, Bill de Kooning, Franz Kline, Motherwell, Rothko, Barney Newman, and Jack Tworkov, as well as three Second Generation painters, one of whom was Grace.[66] Having painted professionally for less than a decade, she would take her place as the only woman artist in the most important American exhibition of its time.

The weeks leading up to the show's departure for Europe were exhausting for everyone involved. With Frank's help, Grace selected her paintings *River Bathers, City Life, Essex Market, On Orchard Street,* and *Interior, 'The Creeks.'*[67] Averaging about six feet by eight feet, they spanned the years 1953 to 1957, and represented her city period and her return to abstraction on Long Island. It was as close to a Grace Hartigan retrospective as was possible within the five paintings allowed her.

On March 10, those involved in the show gathered for a private viewing and cocktail party at the Santini Brothers Warehouse on West 49th Street. Alfred Barr, Dorothy Miller, Frank, Leo Castelli, Lee, Grace, Tom Hess, Nelson Rockefeller, Eleanor Ward, Bill, Elaine, and Clem, among others, stood amid some of the paintings that had changed history.[68] They were all so familiar it was as if those assembled were surrounded by past friends— even Gorky and Jackson were there. Now those friends were being sent out to the world. The artists and art lovers gathered at Santini Brothers raised a glass, and then went home. The paintings were crated. The warehouse stood dark. Two weeks later, the head of the Modern's International Program, Porter McCray, sent out a memo: "The exhibition left New York on March 28" aboard the SS *America.*[69] It sailed on Grace's thirty-fifth birthday.

With the first opening not scheduled until May 19 at the Kunsthalle in Basel, Switzerland, those who had worked so hard to make *New American Painting* a reality believed they had time to relax.[70] And then, on April 15, just before noon, a fire broke out on the Modern's second floor in an area undergoing renovation.[71] It began either because of an electrical fault or a

cigarette dropped onto painters' cloths next to thirty-five gallons of paint. Whichever the cause, with that amount of accelerant on hand, the fire spread and smoke quickly poured from the gallery into the main staircase and air-conditioning ducts that snaked through the building. Five hundred visitors in the museum required evacuation. But on the upper floors and on the roof, scores of people were trapped. Three women were so terrified that they prepared to jump from the sixth floor, before being rescued by firefighters on a ladder. Alfred Barr and a colleague smashed a window and climbed out onto a neighboring roof. Meanwhile, thirty museum staff members, from guards to curators, formed a human chain down the stairwell, ignoring firemen's hoses and the choking smoke to pass artworks to safety. At the time of the fire, there were more than two thousand paintings in the building.[72]

The true cost of the blaze became clear after the fire was fully extinguished an hour later. An electrician, Rubin Geller, had died of smoke inhalation, thirty firemen were injured, and a Monet *Water Lilies* mural had been destroyed.[73] Among the other works ruined or badly damaged were two of the most important paintings to come out of the New York School: Larry's *Washington Crossing the Delaware* and Jackson's *Number 1* of 1948, with his hand prints slapped along the top of the work.[74] Larry's piece was eventually repaired to his satisfaction, but Jackson's iconic painting "remained extremely fragile." The museum itself had suffered so much damage that it would be closed to the public until the following October.[75] As news of the fire spread around the world, it became clear that during those months the *New American Painting* exhibition in Europe would be more than a show. It would be an ambassador keeping the spirit of the Modern alive.

In May, the initial reviews from Basel were good. Zurich's *Die Weltwoche* stated,

> It is not only the imposing size of the canvases but the dynamic and vital events which take place there which fascinate us. Seventeen painters, among them Pollock and Grace Hartigan...open a very new experience of the expanses of limitless space.[76]

For Grace, being singled out for mention alongside Pollock was only the latest affirmation of her special status among her peers. She was *the* woman artist on the scene. She had been selected in January for a *Mademoiselle* award as one of ten women in various fields whose achievements in 1957 had been significant.[77] *Newsweek* and *Time* magazine were planning to run pieces on her, the former with a photograph by Cecil Beaton.[78] Earlier,

Grace had been merely exasperated and inconvenienced by such exposure, but by 1958 the continued onslaught had begun to deeply disturb her. "I felt that I was being devoured," she said years later of that period. "Artists aren't actors and actresses. They are mediums for the work. I felt that everyone wanted to eat me up and it had nothing to do with my work.... It was a very confusing time."[79] While maintaining a foothold on Essex Street (which she called "Les Girls Storage Company"), Grace began spending more time in Bridgehampton with Bob Keene.[80] It was a faster, wealthier crowd than she was accustomed to, one whose cocktail hour began at noon and who had few concerns more pressing than where to go and what to do that evening.[81]

Some of her old friends began to think Grace had gone over to that other side — the conventional. Back in the Cedar, there were whispers about her haughtiness, her arrogance, her free sexuality.[82] These were mostly expressions of jealousy at Grace's having "made it," but they were also due to the fact that, unlike Elaine or Joan (who exhibited a surprising tenderness toward younger artists), Grace made no effort to bring anyone along in her success.[83] Grace was not a "woman artist" and felt no obligation to help others succeed simply because they were linked by gender. She had become who she was on the strength of her own will, personality, and talent. She expected that anyone hoping to become an artist would recognize that they needed similar fortitude.[84] As a result, for some, Grace came to occupy that familiar berth reserved for women who ignored their supposed genetic predisposition to nurture: They thought she was a bitch. It was an appellation shared by all of Dore Ashton's "Grand Girls" at some point.[85]

The confusion Grace felt was such that she needed to escape New York for a bit. She did so with Mary Abbott. Looking like film stars in violet sunglasses Mary's husband had bought them in Europe, they traveled to the Virgin Islands in February for what they hoped would be a period of relaxation under lush green palm trees and brightly colored cabanas.[86] Instead Grace was bitten by fleas as soon as she stepped out of the plane and found the palm trees brown and tattered by the wind. "The poster gets you there, and then you do nothing but sweat," she complained.[87] Back in New York, pink and disillusioned, Grace returned to her studio and Bob Keene, but that romance provided as little comfort as her trip.[88] (Grace compensated for its shortcomings by embarking on casual relationships with Franz as well as Five Spot owner Joe Termini.)[89] Mary suggested that perhaps Bob was too "normal," by which she meant a nonartist.[90] Perhaps. Grace had not been romantically involved with anyone outside the creative world since she left New Jersey. But there seemed to be something else disturbing her: She may have feared that what she craved from Bob was not love but protection.[91]

It would have been a reasonable response at that point in her life. Many women who had accomplished more than they thought possible reacted to success with fear—especially in the 1950s, when society told a woman who dared to make her own way that she was unnatural, unlovable, a freak.[92] Author Kate Millett described the syndrome as "the offense of going too far."[93] Standing at the vertiginous pinnacle of achievement, feeling that all of society was arrayed against her, a woman might experience a subtle tug, "a reflexive withdrawal from freedom when suppression has so long been the rule."[94] Not just Grace, but others in her circle seemed struck by this need to question the course they had set themselves on so assuredly.

It had begun the year before, after Jane Freilicher's marriage to Joe Hazan. The question of commitment, especially among Second Generation artists who were nearing or into their thirties, hung heavy in its wake. Was it possible for an artist to be happily married? Weren't family life and artistic life mutually exclusive? For Grace, Joan, and Helen, the question was profound, and the considerations both biological and social. But for all the "Grand Girls," even Lee and Elaine, the future was uncertain. A young woman artist could be viewed as bold, fascinating, intelligent, desirable. An older woman artist no longer possessed of those attributes, whose life did not include a husband or children, risked bitter exile. No matter how much attention or success she had experienced in her youth, she faced the real possibility that her work might fall from favor, that the scene which already revolved around men would entirely exclude her, that she would be alone. Men could recover from such a fate. The opportunities available to them were many. For women they were frighteningly few.

When Lee, Elaine, Grace, Joan, and Helen began painting, theirs had not been a choice but an imperative. How they would continue amid a radically changed social and artistic landscape would involve careful decision. The fact *that* they would continue was never in doubt.

51. Bridal Lace and Widow's Weeds

> Well, I guess I'm opinionated. It's not that I tell people what to do, it's that I tell them not to tell me what to do.
>
> —*Lee Krasner*[1]

THE MORNING THEY were to board a ship setting sail from Le Havre to New York, Bob Motherwell, dressed in white flannel trousers and blue blazer, instructed Helen to put on her best "Great Gatsby" clothes, too. They had to appear to be rich Americans ending a season on the Continent whose baggage included nothing more than trinkets of little interest to customs agents on either side of the Atlantic. One piece of luggage in particular was sure to attract attention. Unable to find a crate to hold the dozens of paintings they had done during their honeymoon in France's Basque country, Bob and Helen had purchased a coffin. Carefully rolling their work, they placed it inside with Helen's nearest to the top, then sealed the coffin for transport and hoped no one would open it. In the event that they did, however, Bob had planned a performance in which both he and Helen played a part.[2]

Arriving at the dock tanned and glamorous, Helen flashed a magnificent smile and sailed past officials stationed there and onto the ship. The couple's friend E.A. Carmean Jr. said Bob stayed behind with their baggage watching as it, too, made its way on board. All went well until an inspector came to the coffin and demanded to look inside. Pretending to speak confidentially, Bob explained that his pretty wife was a painter and though she was not very good, he had agreed to ship her work home to please her. Its value, he explained, was entirely sentimental. That was all very well, the customs agent said, but added, "Monsieur, I will have to see." The casket opened, one of Helen's large paintings was unrolled on the dock. "Oh Monsieur," the agent exclaimed, "you are wrong. She is *terrible. Horrible!*" With a look of sympathy for the American husband's plight, he ordered the painting rolled up, the casket resealed, and its contents declared utterly without value.[3] The box containing works by two of the most important painters in New York made its way onto the ship and, ten days later, off the dock in Manhattan. Meanwhile, Bob and Helen relished the voyage home even more due to their successful ruse. They made a good team—in art, in love, and apparently in the confidence racket.

* * *

After their first date in December, Bob and Helen were rarely apart. Much to their surprise, they had discovered that though they were separated by a generation and had entirely different temperaments (she lively, self-confident, relentlessly social; he bookish, insecure, and socially awkward unless intellectually engaged)[4] they were in the most important ways the same. Both had art as the driving motivation in their lives, and both had come from privileged backgrounds that had at times been scorned by their peers.[5] With each other, they had no need to apologize for either their appreciation of the finer things in life or their focus in the studio.[6] Helen would also be spared the difficult task of explaining her creative storms. Bob understood them. When their relationship began, however, it was he who needed understanding. He had hit bottom.

Bob's marriage had been in turmoil for two years and he was teaching full-time to support his family. Gradually, drinking had come to occupy the hours he should have spent in the studio.[7] After seventeen years of producing a steady flow of work that had earned him a place in major museums around the country and exhibitions around the world, the number of paintings Bob was able to create in his drained and depressed state had been reduced to a trickle. Two days after Christmas, he officially separated from his wife. Helen, who had just turned twenty-nine, stepped into the breach to rescue him.[8] "Though she was almost fourteen years younger," wrote art historian Jack Flam, "it was she who took him under wing." During their first months together, while Bob painted into the early morning, Helen sometimes slept in his studio to keep him company and away from alcohol.[9] Helen's role in Bob's life was to pull him out of himself, to inspire him by her energy—that heightened state she occupied in which every event was an adventure—not by her submission.

That would have been impossible in any case. Helen was soaring. Her paintings of that period exhibited the new "one-ness" she felt with her medium and a joyfulness in the application of paint, which was not poured or brushed or veiled or spotted, it was all of that: an assortment of techniques employed without a whiff of restraint.[10] Where Helen's earlier stained paintings had appeared spare, her 1957–1958 works were rich and abundant. Those pieces and Helen's highly experimental paintings from the previous year had been included in exhibitions at Castelli's, the Tanager Gallery, and a major traveling show from the Whitney called *Nature in Abstraction* in which Joan, too, appeared. Helen had also been invited to be in a group show in Nebraska, and the Osaka International Festival in Japan.[11] It had been some time since Bob was similarly in demand. Watching Helen, listening to her fresh and passionate perspective on painting, he began to shake off his rust and regain his purpose.[12]

At Helen's January 1958 annual solo show at Tibor de Nagy, Bob made his official debut as her beau. News of their romance made its way along the phone lines from Manhattan to Provincetown, and by post to Paris. "Flash the greatest love affair in New York art world Helen Frankenthaler and Bob Motherwell," painter Norman Bluhm wrote Paul Jenkins.[13] Bob and Helen's relationship moved equally quickly. Bob's divorce having become final on March 20, eight days later the *New York Times* announced his and Helen's engagement. A week later, on April 4, Grace assembled a group of women at her Essex Street loft. She had organized a wedding shower for Helen.[14] At a very respectable five p.m. Elaine, Mimi Schapiro, May Tabak, Musa Guston, Barbara Guest, Sonya Rudikoff, Helen's sisters Gloria Ross and Marjorie Iseman, and assorted other friends drank and ate, surrounded by large paintings in Grace's bright two-story studio.[15] Eight years earlier, when Grace had moved into the space without electricity or heating, that sort of gathering would have been unimaginable. It's true, Grace had had bridal gowns and women dressed as brides in her studio, but only as inspiration for paintings. Now the women who had contributed to an artistic and social revolution gathered to engage in the most conventional of feminine rituals. Of course, their version of a wedding shower was laden with irony and humor, but it was not mocking. There was a sweet solemnity to the occasion.[16]

Two days later, at Helen's sister Gloria's Park Avenue apartment, Bob and Helen were married.[17] The weather could not have been worse; one guest remembered that it rained "cats and dogs."[18] But that didn't dampen the moment. Helen's high spirits were contagious as the wedding party moved to L'Armorique on Second Avenue and 54th Street. "It was a French restaurant, very decidedly French," recalled Helen's friend the collector Rebecca Reis.

> We must have been twenty or more guests at that wedding lunch. And it was one of the most charming events you ever want to know because... Helen was there in a great big hat and full of the devil. And everybody was in great humor. It was one of the events I shall never forget because it was so...it was marvelous.[19]

Even before the wedding, Helen had moved into Bob's brownstone on East 94th Street and begun entertaining.[20] It was something Helen did naturally, but it was also part of her effort to stir Bob back to life. His closest artist friends were by his own admission "square" married men—painters like Rothko, Barney Newman, and Adolph Gottlieb.[21] Helen began introducing him to her friends, the painters and poets with whom she felt the greatest connection—Grace, Barbara Guest, Al Leslie, the

Washington painter Kenneth Noland, who had been so inspired by Helen's work—and two men Bob would grow especially close to: Frank O'Hara and sculptor David Smith.[22] Frank became one of the writers Bob most admired and with whom he collaborated. David became his best friend.

It must have been reassuring to Bob that his new wife's taste in company so precisely mirrored his own. "The arts were definitely where he resided and where most of his friends came from," explained Bob's daughter Lise. "He really loathed professional people, or professions—finance people, lawyers—he hated that whole world, those who cared more about making money than making art or a difference."[23] Helen knew from her own experience how important it was for an artist who worked long hours alone (in Bob's case from eleven at night to two or three in the morning) to discuss, if not their art, at least *ideas* with other artists.[24] Creative soil required fertilization. Helen's prescription and attention worked. By the spring, Bob was painting more and drinking less.[25]

In early June, "the Motherwells" boarded a ship for a three-month honeymoon in Europe.[26] Having as a young man chosen a life in art partly to repudiate the forces that had denied Spain its rights as a republic during the Spanish Civil War, Bob wasn't interested in visiting the Spain that the victor, General Francisco Franco, had created.[27] But Helen convinced him that he had to see the wondrous art of that country—both in the Prado, a collection she knew by heart, and in the cave at Altamira.[28] Arriving at the port town of Alicante on June 12, they made their way through Andalucía and La Mancha en route to Madrid.[29] Helen and Bob had timed their trip to coincide with the opening of the Modern's *New American Painting* show there. Bob had six paintings in the exhibition.[30]

Since its arrival in Switzerland in May, the show had traveled to Italy, where it received mixed reviews from critics who had covered the Venice Biennale and were thus already acquainted with the latest in American painting.[31] Spain, however, had not previously been exposed to the work and was so unused to paintings on the American scale that when the show arrived in Madrid, logistical problems compounded the usual critical concerns. Two of the canvases—one by Jackson and another by Grace—were so large that the main entrance at the Museo Nacional de Arte Contemporáneo had to be altered to accommodate them.[32]

Politically, it was a painting by Bob that caused a stir. In mid-June, while staying at the Ritz, Motherwell received a cable from the Modern. The Spanish government said it would only allow Bob's painting *Elegy for the Spanish Republic XXXV* to be hung if he changed the name. He refused. The U.S. embassy, meanwhile, learned that Bob had been declared persona non grata in Spain. "Franco has decided that he doesn't want a Moth-

erwell anywhere near Madrid or Spain," said Carmean. U.S. officials strongly suggested that Bob and Helen leave the country.[33] Bob, meanwhile, instructed the Modern's Porter McCray, who was in Madrid organizing the show's installation, to remove all his paintings from that portion of the touring exhibition.[34]

On the eve of their forced departure from Spain, consumed by anger over the censorship imposed upon him by a government he despised, Bob felt an urge to work. Helen had done a mixed-medium piece on cardboard that she had tacked to the pitted plaster wall of their hotel room and that she considered a "wedding portrait." She similarly hung several sheets of paper for Bob, who, in an uncharacteristically spontaneous approach, attacked the white paper with pencil.[35] The drawings displayed his marks deformed by the aged wall beneath and its myriad imperfections, which inadvertently symbolized Bob's experience in Spain and inspired a new series he called *Madrid*. Amid the remarkable circumstances that had inspired them, he and Helen may not have noticed that Bob's drawings could have been done by Helen. They looked remarkably like hers.[36] The next day, Bob and Helen packed the car with their belongings—among them the first of what would be many works of art produced by them in Europe—and drove across the border to safety in France.[37]

In the French fishing village of Saint-Jean-de-Luz they found a "fantastically beautiful & enormous beat up villa" that they were able to rent for the entire summer. "With loads of room to paint, a view of the water and the town and a short walk to our beach. It's our dream come true. The town itself is our thing: simple & civilized, cafes & good bistros, nice people," Helen wrote Barbara Guest.[38] They so loved the place and the region that they considered buying the villa at the end of the summer. Helen set up her studio in a large room off the kitchen with French doors leading to a veranda. Bob took a suite of small rooms on the third floor.[39] Having plenty of time and a shared sense of purpose, they next went in search of canvas. It was in short supply, so they bought bed sheets of Basque linen to paint on instead.[40] They couldn't be bothered to wait for canvas. Especially Bob. After years of relative idleness, he had begun painting large works exhibiting a vigor and freedom that he attributed to Helen. Writing to his friend Eugene Goossen he said,

> Being with her has released something pent up & frustrated in me for years, & I feel an endless stream of things in me for years to come—it's rather staggering in a way, our whole enterprise together, & for me who has a sharply existentialist view of reality, surprising to be in such optimistic circumstances... I can hardly keep up with the changes.[41]

Helen, too, was amazed, as well as both relaxed and incredibly busy. Writing Grace she said,

> I'm sitting on the porch, sipping a 5 pm vermouth, in a bathing suit, listening to jazz-hot on the portable.... We've both been working a great deal. I'd thought after so many months not working that I'd suffer real birth pains, but somehow in three days I started and kept going like one possessed.... All the feelings and ideas I'd been storing up poured out and I couldn't get the materials to fly fast enough. Some of the results look just that way, and now I'm more apt to stand back, take a look, think, revise, try again.... The walls of the wrecky villa are slowly being covered, inch by inch on all floors with our work. It's been a beautiful and thrilling experience for us to share... to watch, talk, encourage. Joy....[42]

Despite Helen's relative isolation, news of Grace's career successes had reached her during her travels. "We saw your issue of *Time* while sitting on a veranda in Granada," Helen wrote. "What a crazy experience. It looked good... what was the reaction? They seemed to quote you in that destructive *Time* manner, but what the hell—it's the picture that speaks & counts."[43]

Grace, also drinking a vermouth "by the Essex window watching a noon summer rainfall on my orange marigolds—I've become a fire-escape gardener," told Helen that though she rarely left her studio, she enjoyed the melancholy that came with a summer in the city. And, in the meantime, Grace, too, was planning a trip to Europe to see the *New American Painting* show. She would travel with Bob Keene. "I love him in a way, need him and depend on him," she confided to Helen. "How wise you were to have waited for Bob and how mysterious an instinct it was to wait when it might have been so comforting to settle for less at certain points in your life."[44] As Grace wrote, she was pondering "settling" herself, swapping mystery for comfort with someone she cared about only halfheartedly. At the height of her career, Grace's survival instincts directed her toward a safety net.

Only two clouds marred Helen and Motherwell's idyllic holiday. Bob turned melancholy when he thought of his daughters living with his ex-wife in Virginia, so much so that for a period Helen would not allow anyone to visit if they had children.[45] The other was the Spanish trouble. It grated on Bob to surrender to Franco just when he had fallen in love again with passionate, tortured Spain. The Spanish reviews of the *New American Painting* show (which did in the end include Bob's paintings minus his *Elegy*)[46] demonstrated a profound appetite for the work and a willingness to search for the message behind it. Wrote the critic from *Revista* in Barcelona,

Upon entering the room, a strange sensation like that of magnetic tension surrounds you, as though the expression concentrated in the canvases would spring from them. There are other myths, other gods, other ideas, different from those prevailing in Europe at present....

Each picture is a confession, an intimate chat with the Divinity, accepting or denying the exterior world but always faithful to the more profound identity of conscience. The present painting is a mystery to many who wish to understand its significance without entering into its state.[47]

Not only had Bob and Helen been cut out of that important dialogue about modern art and modern society, but they had been denied access to Spain's past riches. Unwilling to accept such defeat, by mid-July Helen told a friend that they had plotted a route back into Spain. A month later, they secretly made their way to the cave at Altamira.[48] It was late when they arrived, after the public tours had ended. A small amount of money exchanged, the guard on duty allowed them to enter. Once inside, the guide gave Bob a candle, and left them alone. Transported back thirty-five thousand years, Helen and Bob stood in that domed space that felt in every way like a chapel, covered not with Michelangelo's figures but with animals that were equally awe-inspiring.[49] Though they shared no language with those who had created that work, in the flickering flame those anonymous artists felt like brothers and sisters, speaking to them from the place where it all began.

Their lives transformed by their journey, Bob and Helen left Europe from Le Havre in late August with their coffin full of paintings. Helen's delight over her new life with her husband did not abate when they arrived in New York. "I feel so much <u>myself</u>, so well, growing, alive—and still (forever) more in love everyday," she wrote Barbara.[50] Having been alone together in an intense atmosphere of creativity, the couple felt they knew each other completely. There was, however, a large part of Bob's life that remained a mystery to Helen—until Thanksgiving, when his two daughters, Jeannie, age five, and Lise just three, came to New York for a visit.[51] Helen, a newlywed still glowing from her honeymoon, stood face-to-face with two confused little creatures who did not understand what role she played in their lives. They were certain of one thing, though, Helen was not their mother. She was not even like any other women they knew.[52]

"She didn't appear very maternal," Jeannie recalled, "mainly because she was clueless, I think, because she wasn't expecting to have children quite so quickly, so it was kind of traumatic for everybody.... She was as good as she could possibly be, especially under the circumstances, which were sort of thrust upon her."[53] Bob was a loving father, but he didn't

know how to communicate easily with children too young to discuss art or psychoanalysis.[54] Helen, however, did and, after the initial shock of realizing she had married not just a husband but a family, she warmed to the idea of having children around. She wasn't equipped to be a "normal" mother, just as she was ill-equipped to be a 1950s-era "normal" woman, but she could be Helen with them—and so she was.

Helen invented bedtime stories, which she told in installments, and comforted the girls with sugar-and-butter sandwiches if they had nightmares. She also set about introducing them to the New York of her childhood—the Plaza for lunch, skating and dinner at Rockefeller Center, the theater, the Rockettes, carriage rides in the park.[55] "She just had a sense of delight about her," Jeannie recalled.[56] One of Jeannie and Lise's earliest memories of Helen is of her dancing with them in her studio, or alone in the living room in front of the record player after dinner until the girls (though never Bob), drawn by her laughter and the music, joined her.[57] The children returned home after that first visit still confused and wary but maybe a little less afraid.[58] Helen, for her part, had fallen in love. Two years later when Jeannie and Lise came to live with her and Bob, she would discuss their adoption.[59] She had not given birth, but she had two little girls.

It wasn't possible for both Helen and Bob to paint in the house, so she took a studio around the corner in a storefront between 94th and 95th on Third Avenue.[60] However, for the first two months after her return from Europe, Helen was unable to paint. There were too many changes for her to shut the door and focus with the depth that painting required.[61] She was also perturbed by a decision she had reached. After seven years, she planned to leave the Tibor de Nagy Gallery for good.[62]

John Myers's artists all grumbled about him and had from the very start of the gallery, but that was the nature of the business (dealers, no matter how enterprising, can never do enough to satisfy their artists) and no one took it too seriously. By the late 1950s, however, he gave them what they thought was a significant reason to complain—they felt he was distracted. While Helen had been in Europe, John had traveled to Venice for the Biennale, sending back letters in which he mused over the role of a gallery in the modern market, his future in it, and of course gossip about the many notables with whom he had dined, drunk, and danced. He wrote Helen,

> Venice, my dear, is the Provincetown of Europe—full of these, those and them. The only difference is that it's international and there are a lot of principessi floating around with extraordinary hairdos and black circles around their eyes.... Also—there's no Harry's bar in Provincetown.[63]

It appeared to some of his artists—Grace and Helen among them—that his heart was no longer in his work, and yet it very much was. What he lacked was enthusiasm for the turn the art world had taken.

John Myers was at his core an artist. He had never been in it for money and was disgusted by how the enterprise around art had been diminished by those who saw painting and sculpture as commodities. Calling the art establishment figures he encountered at the Biennale "pigs," he told Larry,

> When I see such a big exhibition as the one at the Palazzi Grassi I feel everything under me crumble. I wonder what the hell I'm doing there. All that crap, all called by deep and clever names; and there (at the opening) all the shysters, speculators, publicity hounds, art tarts, hangers on and face loaders... making markets, making prices, making their living.
>
> It's such a nightmare. And yet I'm caught up in the contradiction of really liking my gallery and the work I show. I can't seem to assign a decent philosophical reason for doing it.[64]

The artists he and Tibor had showed from the beginning feared that John's purist approach no longer sufficed. These artists were approaching middle age. They had outgrown the desire—in most cases the capacity—to live without heat in wretched dives in order to remain part of the blessed Romantic tradition. They wanted more. Galleries had begun giving their artists stipends between shows. They provided help with framing and packing. They financed openings. John did none of that.[65]

In addition, Helen had long felt neglected by John. Even as he coddled her personally ("I've wanted to rock you in a lovely cradle of affection," he wrote, when he saw her "sad or suffering"),[66] spent holidays with her and her family,[67] or acted as a compassionate listener during times of tragedy,[68] she believed he had not done much to promote her work.[69] Grace and Larry had more commercial success than Helen, and she believed that was due to their complicated personal relations with John, which had developed while she was entangled with Clem. Helen showed her work every year at John's gallery and was included in dozens of group shows (that fall she would be in exhibitions at the Whitney, the Carnegie Institute, and the Albright Art Gallery in Buffalo),[70] but her work had not yet found its way into many museum or private collections.

One night in early October she called John to tell him she would no longer be part of his gallery. When he asked why, she answered, "Of course you understand why."[71] She thought it was perfectly clear. He had what she called his "first-class citizens"—Grace and Larry—and the rest, whom he let languish in steerage. She felt lost among the latter.[72] John *didn't* understand. After Helen's call, he didn't sleep for four nights. Frank

told John Ashbery, "He also cried a lot."[73] Writing to "Mrs. Robert Motherwell," John told Helen he would return her paintings immediately because to look at them "at this point is too painful for me...."

> *I think of art dealing as a profession, a vocation, a way of life, a commitment. I do not see it as a "business" in the usual sense.... An art dealer of any stature first works to create an ambiance for his artists, a milieu; he attempts to set up standards of taste; he promotes that which is excellent. He does this because he is the friend of artists, the friend of intellectuals and the protector of poets....*
>
> *I am not interested in being "business like"—nor shall I <u>ever</u> conduct that sort of gallery. I leave that to the cream skimmers. I'd rather be principled like Betty Parsons and go down with a thump than adopt the Madison Avenue airs....*[74]

John could not accept what he perceived to be hurtful disloyalty from one of his artists, and he blamed his rupture with Helen on Bob. "A mutual friend...told me that Motherwell didn't approve of his wife being in the gallery of someone with my kind of private life," John wrote in his memoir.[75] Even he would have known that was silly. John's "private life" at that stage was as risqué as an aging spinster's. No doubt Helen had consulted Bob—and Clem—about her decision to leave Tibor de Nagy, and both likely encouraged her. But her choice of dealer appeared to be her own. The gallery she turned to was run by an old friend, Gaby Rodgers's cousin André Emmerich,[76] who had fled Germany in 1941. Building on his family's art-dealing roots in Paris and having been a protégé of Clem's, Emmerich opened a New York gallery in 1954.[77] He could give Helen the support she believed she needed, and his style suited her new uptown life. "There is a phrase someone used, 'upper Bohemia,' that certainly is my world," he would say.[78] That was Helen's world, too. John, meanwhile, gleefully belittled Helen's choice by saying that Emmerich expanded his empire by marrying the heiress to the Tootsie Roll fortune.[79]

By early December, feeling her "break" with John a "dead issue," Helen was finally able to work.[80] She tried her hand at sculpting and began painting the images she had absorbed in Europe.[81] In every aspect of her life, Helen was beginning anew. Ironically, given the fact that she had traveled the world to reach that point, it occurred on the Upper East Side not far from where she had started.

Lee, too, had returned home in a sense. After living on Long Island for twelve years, in 1957 she rented an apartment in the city on East 72nd Street and only spent the summers in Springs.[82] Even when she was alone, that house felt too crowded, its rooms too full of memories.[83] At forty-nine, Lee needed a place of her own to begin again, as two people: Lee

Krasner the artist and Lee Pollock, executor of the Jackson Pollock estate. Lee controlled how Jackson and his work would be viewed by history, and it *would* be part of history, she had always been certain of that. She had been working with Frank and the Modern to send Jackson's paintings around the world.[84] The response they received convinced her that while some might see his work in terms of financial investment, a greater audience saw him the way she did—as an artist who risked everything to give a shattered world a new means of expression. Lee had come to believe, however, that Sidney Janis valued Jackson only in terms of sales. During a second posthumous show of Jackson's work, which involved mostly small paintings, Janis had fought Lee over prices. He wanted to sell the works for less than three thousand dollars each. In the end, Lee relented, and forever regretted that decision. The show sold out.

Panicked that Jackson's work was slipping away from her, Lee began to wonder whether she should pull the estate from Janis's gallery.[85] As it was, Lee was plagued by Pollock-related meetings and correspondence.[86] Why not take control of his estate entirely? Her friend Bob Friedman believed that Lee was driven in part by guilt. She had not forgiven herself for having relinquished control of Pollock's life during the summer of 1956, for being in Europe when he died. She would not make that mistake again.[87] In 1958, Lee decided to do it: She would manage Jackson's estate without a gallery. Her move was enormously risky. "Lee had no formal organization, no place of business, no permanent employees," said James Valliere, whom Lee hired several years later as a research assistant. "She also had no background in business and lacked a formal education beyond art school. Her advantages were that she knew the New York art world, she had street smarts, she was well-connected, and nurtured her relationships. Above all, she was determined to succeed."[88]

Having made up her mind, Lee's next step was to inform Janis. But that tremendously strong woman lacked the courage.[89] "Janis at this point represented the gallery that handled *the* artists—it was dead stop," Lee said. "Where would one have taken the Pollock estate if one pulled out of Janis? There was no place to go."[90] Repeatedly she made appointments, and canceled each one. Finally summoning her strength, she walked into Sidney's office "determined that I would simply go in and say, 'I'm taking the estate out of here' and leave immediately, as I didn't trust myself to be swayed," Lee recalled. "I did just that." Lee told Janis she wanted control of all of Jackson's work and didn't explain why.

> He then was in a state of shock, and said well let us TALK about this thing. And I never wear a wrist watch—I have a thing about it—I kept looking at my blank wrist and I said I'm terribly sorry but I have an appointment and I

must leave. He never questioned that there was no watch on my wrist. I got up and left. I went into the elevator and went down, and I was so in my own state of mind, incidentally I had no appointment. I found myself out on 57th Street and hailed the first cab that came along and the driver said where to?... I remembered a friend of mine had said something about going to Vic Tanny's in a gym on Lexington Avenue and the upper 40s and I gave that address, don't ask me why.... He stopped in front of the hotel and I got out and there were lots of red arrows that said Vic Tanny—I'd never been there before. I followed all these red arrows and landed in somebody's office... [I] said "I want to take out a membership—I want to use the gym" and she directed me to an office and there was a man seated at a desk and he went on about rates. If I wanted to use it for a week or a month or a year but finally there was the lifetime membership, and I said "I'll take it".... The next I knew I was in the gym looking it over and I was told to get leotards... and come in the next day, all of which I went out and bought leotards and appeared and when I was in the gym I thought to myself, what am I doing here? How did I get here?... And then I thought well, I know psychologically what's happened. I've pulled the estate out of the Janis gallery and what I needed above everything else now is muscle.[91]

Lee only went to the gym three or four times before it closed. But, in the meantime, she found the strength she needed. "I just did what I saw fit to do, which was offensive to many people who would have preferred that I do what *they* would have preferred," Lee said. "It is offensive enough to have said, 'Hands off.' But from a female it is inexcusable."[92]

Lee once said, "All my bitches, all my beefs, all my antagonisms, all my hatreds, which I cling to desperately, they do something for my adrenaline, which is good."[93] Amid the Jackson-related aggravation in her life, artistically Lee was having one of her best years ever. In February she had a solo show that covered two full floors of the Martha Jackson Gallery, which featured the works she had done since Jackson's death. Writing the essay for the show's catalog, Bob Friedman declared, "Lee Krasner has made three glorious, heroic, and temporarily unprofitable 'mistakes.'" He listed her marriage to Pollock, which had required great sacrifice; the fact that she had never "asked for any concessions as a woman," insisting only that she be judged as an artist; and finally, that Lee had come on the scene too early. She was part of a new "lost generation," artists in their mid-forties "which lacks drama and novelty from the point of view of the popular press. Despite the fact that Lee Krasner can paint and collage rings around many of her juniors, she is not 'news' in the sense that they are. She has been around."[94]

Friedman noted that the work at Martha Jackson's gallery was done "entirely during the past year and a half, during a period of profound sorrow after the sudden and shocking death of her husband."[95] It was Pollock and his death that initially drew the press and gallery-goers to the exhibition. Writers from nonart publications were drawn to the show as voyeurs to see how Lee was getting along without Jackson, and critics from art publications did their best to interpret her work in relation to him. Each writer seemed to see what they wanted to see. Though Lee's "Earth Green" series burst with color and life, *Time* noted the paintings' "somber blacks and grays" that "seemed to express death-haunted themes." *ArtNews* inexplicably discovered in her sensual swirls and depictions of a woman's erotic nature "Pollock motifs."[96] The *New York Times,* however, was struck by her "bravado."[97] Lee embraced such controversy. It was silence that offended her, and her show that year sparked a lively debate. Lee celebrated her opening with an after-party at the Five Spot.[98]

Friedman, like Ossorio, had been among those who had watched over Lee (albeit from a respectful distance so as not to incur her wrath) after Jackson's death. Both men bought Lee's work (Ossorio purchased the famous *Prophecy*), and both encouraged her in her life post-Pollock.[99] In 1958, Friedman gave Lee a massive boost—the biggest project of her career. His family owned a new thirty-story building at 2 Broadway, and he commissioned Lee to make two mosaic murals for its exterior. One of the murals was to be eighty-six feet long.[100] The project would combine two artistic episodes from Lee's past: the mosaic tables she made after moving to Springs, and the murals she did under the Federal Art Project. In 1941, she had been given her own to design and execute only to have that opportunity snatched away from her when the country's resources were redirected toward war. Friedman's job gave her the opportunity to finally execute murals, and not just in a radio studio but in a part of the city that would ensure they were seen by people from all walks of life, every day of the week. Lee would be leaving her mark on the great canvas that was Manhattan.

Lee's friend Charlotte Park said, "Lee was her own woman before and after Pollock, but not during." By 1958, Lee seemed to have come full circle, back to the years before she met Jackson. She was once again a power in the art world, engaged in an important public project, and invited to submit work to an international art exhibition in Japan.[101] She was also socializing in downtown dives as she had during her Jumble Shop era. Lee hated the Cedar and only visited the Club once—in December 1956 for a Pollock memorial where she sat uncharacteristically silent while everyone else in the room shouted about her dead spouse.[102] But as a jazz fan, she loved the Five Spot, and went there with Clem and Jenny, and even Bill.

Their friendship made his decision to rent Marca-Relli's place next door to Lee that summer all the more hurtful. Ruth Kligman was suing Lee to cover the cost of her accident with Jackson, and Bill had invited Ruth to join him there.[103] The continued drama emanating from that sad chapter could have engulfed Lee if she had let it. She did not. Lee made the circuit with old friends and a younger generation as well: Frank, Patsy, Mike Goldberg, and Kenneth Koch among them.[104] They respected Lee—intense, funny, often aggressive and abrasive, while at the same time disarmingly humble—as one of the originals, and yet she had only just begun.

To mark the end of that summer season, which itself signaled the end of an era, Barney Rosset threw a "party to end all parties."[105] He had been on a buying spree, snapping up coastal property in the Hamptons and reselling it just as quickly. While his publishing house struggled along producing avant-garde writing, it seemed he could not lose in the property game. The relatively quiet outback along the South Fork of Long Island had been discovered by people from the city willing to pay a fortune to develop it. All Barney's transactions produced a profit, and so during the month of August he decided to spend some of those "earnings" on an outrageous party for his friends.[106] Building a dance floor on pontoons in the waters of Three Mile Harbor, he had a narrow arched bridge constructed to reach it.[107] He also hired a barge for jazz musicians—among them, Larry on the sax—to float offshore so the music could carry across the water.[108] Next, he sent out invitations to nearly four hundred people representing all strata of society.

In late August, they arrived as summoned, outfitted in everything from furs to painters' rags, streaming in through the scrub and across the sand toward the ethereal scene that Barney had stage-managed at twilight. "The place was lighted by about one hundred flares and five enormous bonfires," Ernestine said. She had arrived with Ibram, their teenage daughter, Denise, and Elaine and Bill.[109] The de Koonings had been together for a week at Elaine's brother's house with Bill's daughter Lisa. He had cut short his stay at Marca-Relli's when Ruth left for Venice in a huff after Bill refused to travel with her to Europe. He had since decided he would go, later in September. That was when Elaine would also leave for a year to teach in New Mexico.[110]

Indeed, Barney's party had an end-of-an-era feeling to it for them all. The marvelous ten-year bash that Elaine described was coming to a close. But not just yet. As the night turned into morning, rather than abating, Barney's blowout grew in size and frenzied activity. The musicians' barge had been anchored next to the dance floor, where the greatest cluster of revelers had gathered. Denise Lassaw climbed onboard to help the musi-

cian striking the keys of an upright piano that had been made sluggish by the mist. "My job was reaching inside the piano and lifting the hammers that the keys controlled," Denise explained. "As fast as the piano player played, I had to be just as fast on the inside of the piano."

From her spot she heard screams and a monstrous splash, and looked up to see the happy carnage a mere six feet away. Barney's bridge had broken under the weight of the crowd.[111] Women in fancy dresses and men in suits, who had been chucked into the harbor, paddled madly for safety amid shrieks and howls.[112] One man on shore, wrapped in a fur, who was obviously accustomed to taking charge, surveyed the scene and said with calm authority, "Why don't you all stand up?" They did. The water, it turned out, was about four feet deep for the most part.[113] With that discovery, the screams turned to laughter, and the party moved *into* the water. "Elaine and my mother took off their clothes and jumped in," Denise said. "I jumped in and swam after a high heel shoe that was floating out to sea. A great summer night!"[114] It was a worthy send-off.

52. Five Paths...

> The time will come when no one will speak to you at all, not even complete strangers. (Pause.) You will be quite alone with your voice, there will be no other voice in the world but yours. (Pause.) Do you hear me?
>
> —*Samuel Beckett*[1]

IN 1959, PEGGY Guggenheim returned to New York for the first time in twelve years. She had been invited to the opening of her uncle Solomon's museum.[2] The Frank Lloyd Wright–designed structure that Hilla Rebay had commissioned, before being dismissed from her position as head of the Guggenheim Collection after Solomon's death, was finally finished.[3] For Peggy, however, the museum's unveiling was little more than an excuse to revisit the city where the art that continued to dominate her life in Venice was born. When she left New York in 1947, Jackson had not yet exhibited his drip paintings, Gorky was alive, the Club did not exist, the Cedar still belonged to the workingmen who drank there in downtrodden silence. As for the artists, at that point the notion of selling their work *for a living* was laughable. Upon her return, Peggy discovered that the New York she remembered no longer existed. "I was thunderstruck," she said, "the entire art movement had become an enormous business venture. Only a few persons really cared for paintings. The rest bought them from snobbishness or to avoid taxation.... Prices were unheard of. People only bought what was the most expensive, having no faith in anything else." The scene, she concluded, had "gone to hell."[4]

In the booming economy of late-1950s America, when the "latest" was inevitably the "best," the race to create something new and to be the first to buy it propelled both maker and market.[5] "The alienated rentier or retailer or stock-exchange speculator seeks a culture that will echo the rhythms of his own manic-depressive way of life," wrote Tom Hess. Because that life did not encourage reflection, art became valued for its most superficial quality: its newness.[6] Novelty replaced quality, gimmickry replaced vision. The market lapped it up. Buyers descended upon the galleries that handled modern art.[7] Many purchased work not on the basis of the artist but of the dealer. Just as some early collectors had enjoyed socializing with the artists whose work they bought, some buyers now sought out the company of the cultured men and women who sold the work.

A "cult of personality" had begun to form around a number of them, most notably Castelli.[8] It made sense. For those new collectors intimidated by the old money exclusivity of the museum world, or the indecipherable mutterings of the artist, the most comfortable access point would be a "businessman" who was eager to accommodate because he wanted to sell what they wanted to buy. Everyone came away feeling good about the transaction. Dealers gave commerce the veneer of sophistication. So, too, did auctions, which had become "high-class entertainment."[9] In 1958, Sotheby's in London held the first black-tie evening auction. Dressed as if for a night at the opera, guests gasped in wonder at a new kind of spectacle — a *sale*. Seven works by Cézanne, Van Gogh, Manet, and Renoir brought in a staggering two million dollars.[10] The drama during those moments before the gavel sounded was shared by all. Collectors *and* artists wanted in on this thrilling game of refinement and riches. The event proved a turning point. The question became, according to Elaine, "How do I *make it,* versus how do I make art."[11]

By 1959, the year Harold Rosenberg published an article in *Esquire* declaring New York's Tenth Street "Main Street of the Art World," that Main Street was almost a memory. The artists who had lived there illegally in shared industrial lofts were either forced out by city regulations or had the means to move into bigger ones, if not out of the city entirely. The artist-run cooperative galleries that had sprung up along Tenth in white-washed storefronts were closing, too. They had once been the only option for new artists who wanted to show their work. Now, commercial galleries were clamoring to represent newcomers to feed the appetite of buyers who wanted something modern, but not at too high a price.[12] They did not, however, clamor for women artists. "Women were slowly squeezed out," explained editor and art critic Elizabeth Baker, "first from galleries, and then also from museums, since museums rely heavily on dealers." And as women showed less, their names and work gradually disappeared from magazines and museum publications.[13] Their names were likewise absent from the classroom, where the history of the Abstract Expressionist movement as taught spoke *only* of men.[14] Some artists joked that "women had more balls than the men" because theirs was a harder road.[15] Harder, though not impossible, as demonstrated by a determined few.

On January 13, 1959, the *New American Painting* show opened in Paris.[16] By then it had been in Switzerland, Spain, Italy, and Germany, but its presentation in the French capital would be the most significant. Paris was where Western art had begun its modern journey. New York was where it went. Nineteen Parisian publications carried stories about the show, most of them disapproving, as summed up by *Le Figaro,* which asked, "Why do

they think they are painters?"[17] The fact was, good or bad, American art was *the* topic of cultural conversation on the Continent. Not without cause Porter McCray called the show a "sensation."[18] Grace's name appeared often in the European press. Journalists seemed fascinated by the "abstract and ecstatic" "young lady of the group."[19]

Grace herself arrived in Paris in September before the opening, while Frank was there overseeing details of the show. It was her first trip to Europe, and she and Bob Keene used their two months to make the grand tour—Spain, Italy, Austria, Switzerland, and north to Grace's ancestral homeland, Ireland.[20] After "slushing" through the back streets of Dublin, she told Barbara Guest that the city was "more sad than any city in Europe."[21] And yet Grace fell in love with its misery, so much so that it would inspire six major paintings.[22] But if Ireland was the most artistically important destination during her travels, Paris proved the most important personally. It was almost as if her whole life since arriving in New York had led to that point. It was the culmination of one period and the beginning of something radically different. One day while Bob remained behind at the hotel, ill, Grace and Frank wandered along the Left Bank of the Seine alone and stopped for a meal.[23] When they began their friendship in 1952, neither could have imagined they would be in that city together—she in the biggest art show on the planet, he one of the people responsible for organizing it. But rather than celebrate their incredible good fortune, there was a sadness about the day.[24] Grace blamed it on Frank's work with the museum—he had too much responsibility.[25] In fact, their relationship was changing.

Frank believed that Grace was becoming someone he could not abide.[26] He wouldn't have told her so at the time, but several months later during a drunken episode at the Cedar his disappointment over the direction Grace's personal life was taking boiled over. Standing on a table, he shouted at her that she had become "*bourgeois!*"[27] He believed that now, at the pinnacle of her career, she was exhibiting a failure of courage. He had loved her defiance of everything society expected of a woman, and her paintings, each of which declared unapologetically and demanded unequivocally her right to exist and create. She had done as a woman and painter what he had done as a gay man and poet. And now he saw in her embrace of a life with a man like Bob Keene signs of surrender. For once, however, Frank had misunderstood Grace. He didn't grasp that the confusion caused by celebrity that had killed Pollock threatened to destroy her as well. Several years later, Grace confided to Dorothy Miller, "I had been seriously mentally ill those last two years in New York."[28] At the time, she had seen the signs and sought shelter. She was still Grace, still wild, still

driven, still hungry. She just needed a bit of time and space away from the scene to recollect herself. Frank didn't see that. He thought she was afraid.

But during their Paris visit no such anger was expressed, just bittersweet memories. At another lunch later in the week in Montmartre, Grace, Frank, and Barbara Guest drunkenly reminisced about their early New York days. Then Barbara suggested they pay a visit to the Bateau-Lavoir in tribute to Picasso and the artists who had once worked in similar obscurity there. Everyone agreed but Frank. "That was their history," he said, testily, "and it doesn't interest me. What does interest me is ours, and we're making it now."[29] Someday, people would make pilgrimages to the places where *they* had worked and played. "Oh Barbara! Do you think / They'll ever name anything after us like / Rue Henri-Barbusse or / Canard a l'Ouragan?" Frank playfully wrote in a poem he called "With Barbara in Paris."[30] By 1959 it wasn't an outlandish question. Some of the artists and poets who had formed a community of exiles in the Village had become famous. Some of their histories were already being inscribed.

The *New American Painting* show had one last stop before returning to New York: London's Tate Gallery. While British critics called the work "emotional anarchy" and "a joke in bad taste," a record number of people — nearly fifteen thousand — streamed in to see it.[31] At the time, that was the highest paid attendance for a month-long show in the history of the Tate.[32] "I have never seen so many young gallery goers sitting down in a silent daze," wrote one critic.[33] During the last hour of the closing day, three thousand people crowded in to see it.[34]

The show's New York homecoming was, therefore, triumphant. On May 25, 1959, the night before the exhibition was to open to the press at the Modern, dinner parties, attended by the artists in the show and some of the people who inspired them, were held throughout the city at the homes of New York's finest citizens and the museum's most generous benefactors. The guests, once finished, traveled on foot, by taxi, and in limousines to the exhibition.[35] It had been a little over a year since some of those same people had gathered at the Santini Brothers warehouse for a send-off, not knowing how the work would be received. Now they knew, and they had reason to celebrate.

Audiences around Europe had awakened to a new direction in art that would affect not just painting but fiction, poetry, theater, and film (French director Jean-Luc Godard cited Pollock as a major influence on his work) — in short, the way people thought, saw, and expressed themselves.[36] But New York had already moved on. The art those gathered at the Modern that evening championed had become passé. ("If everybody

loves the avant-garde," explained David Hare, "it's not avant-garde.")[37] Even Dorothy Miller, with expert eyes directed toward the future, believed it was time for new visions. That year she would produce another *Americans* show. Of the sixteen artists included, only two—Al Leslie and Landes Lewitin—were part of the old crowd. Dorothy had considered including Helen and Joan but crossed them off her list in favor of men like Bob Rauschenberg and Jasper Johns, and hard-edged, geometric work by new painters like Ellsworth Kelly and Frank Stella.[38] In September, the new chief art critic for the *New York Times,* John Canaday, pounded a final nail into the Abstract Expressionist coffin. In his opening letter to readers, he validated the "modern art hoax" theory, declaring that while there were some talented "men" in the New York School, others were "freaks" and "charlatans" who perpetrated a fraud on the public.[39] "It was quite depressing in a way because it was almost like getting mugged," said painter Giorgio Cavallon.[40]

It was to that unsettling scene of wild commercial success and utter spiritual devastation that Elaine returned in the spring of 1959 from New Mexico. She would be one of the few artists who could accommodate the changes. Elaine arrived back in New York having discovered her way forward as a mature artist and woman. She had, in effect, become whole.

When Elaine left in the fall of 1958 to teach at the University of New Mexico, she was forty years old and had about twenty-three dollars in her checking account.[41] Not that she ever worried about money. She lived by the rule that the more one gave the more one received, but the visiting professorship was a welcome boon in the form of a steady paycheck.[42] It also spared her from witnessing Bill drunkenly playing the leading man in the delusional drama that was Ruth Kligman's life. In every way the trip west was for Elaine a fortunate journey.

Elaine had been one of those East Coast residents for whom the only stop after Pennsylvania was California; nothing in between had registered much in her imagination. New Mexico was, therefore, an utterly foreign landscape, one she found "overpowering." "The ruddy earth, the naked musculature of the Rockies, the brilliant colors of the sky behind them at the twilight."[43] "Twilight that scoops up the ground under my feet and turns it purple."[44] "It was autumn when I arrived," she recalled, "and the cottonwood trees and aspens had turned an overwhelming gold."[45] Albuquerque itself had a mere handful of tall buildings, none of which could remotely be called a skyscraper. Less a city than a town, it had experienced a mini building boom due to activity surrounding the development of the hydrogen bomb.[46] Elaine had never lived in a place that size. "I asked a lumber salesman named Rocky about the population of Albuquerque.

'The second floor of my apartment house in the Bronx had more people,'" he told her. But, while the general population was small, it contained a thriving community of good artists—a large percentage of whom, Elaine noted with pleasure, were women.[47]

Elaine rented a small adobe house at the foot of the Rockies and began to teach.[48] She had always been generous with her advice to fellow artists, but New Mexico was her first formal teaching job and the role suited her perfectly. "I can't imagine ever having been a real mother," she said. "But I love having the power to change things, to give something that will change a life. Someone makes a wish, and magically the fairy godmother makes it come true. What could be better?"[49] Her idea of teaching, which she had learned from Hans Hofmann and Edwin Denby, was simply to inspire. She encouraged students to join the life—an artist's life—which was the "greatest thing in the world." Think big, paint big, be wedded to nothing, neither landscape nor abstraction, paint nor stone.[50] And all the while she moved around the room like a dancer and talked, about New York, about how artists there lived and worked, about what they had discovered, about the glory of it all—"it" being art and "all" being life.

Poet Margaret Randall, who was then twenty-two, newly divorced, and fresh from a job writing copy for a firm that worked on government missile programs, had started modeling for the university's art program. One day the job brought her to Elaine's class. Margaret didn't want to be an object on a model stand, she wanted to draw, but that was not her role. Elaine tore off a piece of paper, handed it to her, and said, "Do it, draw." "She immediately became the greatest mentor of my life," Margaret said fifty-five years later, expressing undiminished admiration for Elaine. "Looking back, I think she was my first model of a strong woman who did what she wanted to do, all else be damned. Remember, this was the fifties. She opened my eyes to all kinds of things, to the world of art."[51] Elaine, Margaret said, "redrew my interior map. Her identity in art, and attitude toward its process and practice, realigned my creative energies.... Elaine believed in freedom. Freedom of gesture, risk in everything she touched. She showed me that abandon long practiced becomes skill."[52] Within a very short time, Elaine awakened and enlivened the entire art scene in Albuquerque.[53]

Not long after her arrival, Margaret and painter Connie Fox began taking Elaine to bullfights six hours south of Albuquerque in Ciudad Juárez. The trip itself was wonderfully exotic. During each visit, they stayed in the same charmingly ratty hotel and drank tequila at the same woebegone bar.[54] Yet as much as that ritual of travel would have appealed to Elaine, it was what she found in the bullfighting arena that truly thrilled her: color, motion, strength. Over the course of twelve trips to Mexico, Elaine absorbed what she witnessed, making sketches on paper, and then returned

to her studio to paint it.⁵⁵ The paintings, all horizontal, grew gradually in size, from a few square inches (in *Juarez,* one of the earliest and best of her Bullfight Series) to a mammoth ten by twenty feet.⁵⁶ Her colors changed, too. Shedding the mud that sometimes appeared even in her portraits, Elaine's pigments clarified and intensified to reproduce the heraldic hues of the matador's cape and clothing, the crisp blue of the sky above, the golden sand of the arena's surface, and the jet-black of the sweating beast. Her brushstrokes thrust and dove like a bull as it charged. They spun as that mere man, the matador, face-to-face with thundering muscle, pirouetted elegantly to safety.⁵⁷ Elaine captured it all abstractly, with barely a hint of man or animal, only the passion that united them. The result was stunning: the most compelling abstract work she had ever done. She had had to travel more than halfway across the country to find a subject big enough and powerful enough to satisfy her.

Elaine's life in New Mexico was much healthier in every way than her life in New York had been. She had a group of friends she enjoyed, students and fellow artists she could help, and sculptor Robert Mallary, who had recruited her for the job, as a lover.⁵⁸ True, Elaine still drank too much. "She got drunk one night and drove her car practically into her living room," Margaret, who was in the car, recalled. "The car was half in the yard and half in the living room. Elaine started laughing."⁵⁹ In Albuquerque, Elaine was having the time of her life.⁶⁰ But that life had a prescribed ending in the form of a limited contract. As Bill had at Black Mountain, Elaine invited those people she could not live without back to New York. Margaret, who was one of them, went on ahead of Elaine. "She gave me a list of people to look up," Margaret said, as well as the names of men she should avoid because "they were Elaine's."⁶¹ Bob Mallary would also go east. Though each was married, he and Elaine would be lovers for years. Connie Fox went, too, eventually settling on Long Island, where she remained Elaine's friend for the rest of her life.⁶² And then there were the students who had listened to Elaine's fabulous tales of New York. They followed her to see if any of them were true. They were not disappointed.⁶³

"When I returned to New York ten months later, I felt like Rip Van Winkle," Elaine said. "Greenwich Village was full of coffee shops I hadn't noticed before. The openings and the parties were still going on but the guest lists had burgeoned to a point that made the studios and galleries inhumanly crowded."⁶⁴ Elaine slipped back into that life, but occupied a somewhat new position. She was no longer an agitator, neck-deep in the internal controversies surrounding the art world, but a comforter, a queen mother, what a young priest she met on her return called "a patron saint of the whole scene."⁶⁵

Elaine had a steady income from teaching, augmented by money from Bill, and disbursed it freely.⁶⁶ At one party when John Cage was broke and unable to pay his way back to Long Island, Elaine gave him the three dollars she had in her purse. Realizing a few days later that his plea for cash was a symptom of a wider problem, she mailed him a check for one hundred dollars with a note, "Dear John, I hereby commission you to write a piece of music. Love Elaine." In return, he would present her with the remarkable sixty-three-page *Concerto for Piano and Orchestra (1957–58),* which he dedicated to her.⁶⁷ She added it to her "inadvertent collection." Whenever she made money on art she spent a portion buying someone else's work. That practice, picked up by Elaine from Denby, was antithetical to the attitude pervading society in the late 1950s.⁶⁸ Elaine did it out of friendship, appreciation, solidarity—and defiance. "As far as I'm concerned," she said, "out of the seven deadly sins there's only one, and that's greed. And that's what is doing in the human race."⁶⁹

Elaine had a large studio on Broadway across from Grace Church. By then she had so many paintings and had begun to work so big that she needed a greater area to be able to see them all at once to understand them.⁷⁰ She broke through walls, back into another building, creating a space she later likened to the Grand Canyon.⁷¹ Elaine's niece Maud said that to go from one end to the other was like "taking a walk.... It was a place you could play in all day, and never get tired."⁷² Pigeons flew through Elaine's "canyon" and nestled on the windowsills. White columns rose up from the rough wooden floor to the tin ceiling high above.⁷³ There was no possibility of making that expanse homey in the traditional sense, and Elaine didn't try. Black soot seemed to cover every flat surface, but the walls were lined with floor-to-ceiling bookcases, stuffed with texts and magazines.⁷⁴ While Elaine had fashioned a small kitchen as well as a perfunctory living room and bedroom, it was the front half of the space that was most important.⁷⁵ Overlooking Broadway was where Elaine worked surrounded by art—her own and her friends'.⁷⁶ She opened that studio to everyone: "Thieves, politicians, prize fighters, basketball players, football players, drug addicts, priests, composers, poets, the lumpen proletariat of the world, including scoundrels and angels," recalled Herman Cherry.⁷⁷ Her nephew Charles Fried said, "She'd meet a delivery man or a cop [and say,] 'Oh, look at that face'" and invariably invite them to her studio to sit for her.⁷⁸ But the nearly permanent occupant in the place was Kaldis.

That old veteran had been in the hospital so often and was so poor that he lost the room he rented. Elaine offered to let him stay with her until he found a place. Six months later, having fallen in love with a sofa covered in orange fabric by Elaine's sister-in-law Paula Fried, he was still there.⁷⁹ He was a good, if eccentric chef (he cooked "by ear," listening to the hiss of

the grease). And he hovered over Elaine protectively, even eavesdropping on her phone calls, the contents of which he announced to the rest of the New York art world. Mostly, however, he talked, doling out advice about art and money.[80] "He was obsessed with monetary success, the opposite of Elaine," said Doris Aach.[81] Painter Pat Passlof said that Kaldis and Elaine finally reached an agreement: He could stay as long as he stopped talking. "Next morning, they crossed paths," Pat said. "Kaldis emitted a 'Good morning,' and Elaine shot back, 'There you go again!' "[82] She let him stay anyway. He was part of her scenery.

Elaine's young niece and nephews saw him as a grandfather figure, occupying Elaine's magical kingdom.[83] "We used to climb up to her third floor, two flights of marble and one wooden," recalled her nephew Clay. "There at the top would be Elaine in a red light. She'd say, 'You can do it, you can climb.' "[84] And not just physically. "She wanted us all to be like Elaine," her nephew Luke Luyckx said. "She felt that art in general—music, dance—was the higher path," the only worthy path. That kind of encouragement represented her philosophy of life.[85]

"If you came to Elaine with a problem, before you finished telling her about it, she was actively involved in its solution," said Margaret Randall. "If you wondered whether to go this way or that, Elaine laughed and asked, 'Why choose?' "[86] The negative side of such generosity, however, was that some people took advantage of her. A drug addict she tried to help (one among many) stole from her. She knew, and didn't stop him. Another young man, who was an "around-the-clock drunk" borrowed money. "He'd want one hundred dollars and she'd scold him but give him more," Clay said. "She was endlessly empathetic with people. The drowned rats were the ones she would take in."[87] Elaine's friends recognized her charity as part of her nature and a sign of her strength, but some outside her inner circle misinterpreted her kindness as evidence of weakness. "People who can't be as open, who can't be as generous, suspect anyone who is as putting it on," explained painter Sherman Drexler.[88] Murmurs had always surrounded Elaine and her unconventional life, and yet she had managed to challenge and inspire those around her anyway. In the late 1950s, by deed and word, Elaine issued a new challenge—to resist wealth and fame and, if it came, to avoid its corruption by putting the fruits of such fortune to good use in helping others.[89] But the artist closest to her, the one most in need of her message, was beyond help or hearing.

On May 4, 1959, Sidney Janis opened an exhibition of Bill's latest work. The line to get into the gallery for the five o'clock opening had begun to form just after eight that morning. By noon, nineteen of the twenty-two paintings had sold. By the end of the week, all of them had. After Janis

deducted the gallery's one-third commission, Bill walked away with eighty thousand dollars. He was rich.[90] In jest and resignation, he told a reviewer, "I'm selling my own image now."[91] He had become, said Fairfield Porter, the face of Abstract Expressionism.[92] "Walking with de Kooning in downtown New York was like walking with Clark Gable in Hollywood," Edith Schloss said. People stopped and stared, some shouted his name. Diminutive though he was, he appeared huge on those crowded streets.[93] Bill had moved into a new studio at 831 Broadway and prepared to renovate it to a standard befitting one of the richest artists in the country.[94] With a faux Elizabeth Taylor at his side and money in his pocket, he seemed to be on top of the world. Instead, he was miserable and he drowned that misery in alcohol.

Around that time, Elaine had a knock on her door. Presciently, she feared it was a representative from Grace Church engaged in a neighborhood outreach trying to "get their hooks in me."[95] She opened, and indeed it was. But the representative of that church was "the most beautiful man I'd ever seen in my life, Steve Chinlund, the minister," Elaine recalled. "He was fantastic. And I said, 'Step in.'"[96] Grace Church was Chinlund's first assignment just out of the seminary. The war had made him a priest, and in its aftermath he had wanted to "alleviate suffering." In the Village he did so through "the interface of pacifism, art, and religion." He had made his way to Elaine's while trying to find local residents who might want to become part of a dogma-free Bible studies class rooted in social justice.[97] Elaine was open to just such a message.[98]

Taken by Chinlund's sincerity, Elaine began attending his Bible classes and then offered to host discussions of biblical passages and literature at her studio with about a dozen friends.[99] "They were more interested in the biblical rather than the secular," Chinlund recalled. Bill came once or twice. In fact, Elaine had hoped Chinlund might counsel him to stop drinking. "She was nuts about him, thought he was a genius," Chinlund said. "She didn't ask for help except in how she could handle Bill, and she was upset about him and his daughter." Bill had still not become the father Elaine had hoped he would be. Agreeing to do what he could, Chinlund spoke with Bill, but found him to be a "nasty drunk.... By the time I met him he was not offering much for anybody to hang their affection on." Elaine was. Chinlund discovered in her a remarkable spirit. "She was extraordinary in many ways," he said.[100] The two would work together on numerous future projects helping the nearly hopeless.

The world in which Elaine had immersed herself was the opposite of the world of fame and fortune engulfing Bill. To her, showing, much less selling one's art, no longer mattered. Recognition had bred destruction. Two years before, Elaine had become part of the March artist-run cooperative

gallery. In 1959, as nominal leaseholder of the space, Elaine turned over the keys to artists Boris Lurie and Sam Goodman's "NO! Art" movement, advising Tom Hess that their work represented "an important new trend."[101] It was a trend toward social dissidence in art. Lurie, who told Hess that he got his art education during four years in Nazi concentration camps, "rejected the coupling of art and commerce, art and career," wrote one historian.[102] "Instead of adaptation, Lurie called for resistance and protest, courage instead of passivity, and remembrance and vigilance instead of suppression and oblivion."[103] Dore Ashton said it had become clear that a "sub-culture of dissent was emerging."[104] Elaine would be part of it. Amid the commercialization and corporatization of art, and on the eve of the most radical decade since the 1930s, Elaine found herself again at the forefront.[105] She chose society over self, and employed her art and her efforts for its benefit.

53. ...Forward

> But the balance is shifting, and the day is close at hand when a woman will only have to have qualifications equal to a man's to get the job, win the election, or get the retrospective at the Museum of Modern Art.
> — *Barbara Rose*[1]

IN MARCH 1959, HELEN had her first solo show at André Emmerich's gallery. Large, striking canvases, some as long as thirteen feet, covered the walls—works like *Madridscape, Before the Caves,* and *French Horizon*—all inspired by the scenes she encountered during her summer abroad and infused with the feelings she experienced while remembering them.[2] Every painting made a statement in Helen's singular language and exhibited the assured hand and eye of an artist in full stride. Without doubt Helen had searched and struggled while she painted, but as in any accomplished work of art, the pain of execution was evident only to the creator. Visitors to Emmerich's gallery found themselves encircled by the declarations of a spirit on fire. Thirty years later, author Kurt Vonnegut would write after seeing an exhibition of Helen's drawings, "I am so glad to see the beginnings of her work because she rehearsed the whole history of modern art."[3] On Emmerich's walls, Helen took her place in that history.

And yet critics at the time saw in her paintings the influence of her new husband (Motherwell was mentioned in the *Arts* and *New York Herald Tribune* reviews of her show).[4] Others noted her tendency to "dress up a canvas," her "narcissistic" yielding to the "temptation of finding every spot significant," and her use of "decorative colors" that created an overall sense of "boudoir elegance."[5] (*ArtNews* by contrast called her work "frightening" and "crazy looking.")[6] The tone of the coverage of Helen's work had changed drastically from that of her earlier shows at Tibor de Nagy when, though younger, she had been taken more seriously. It may have been the times—the fact that women artists were no longer, as *Life* had declared just two years earlier, "in the ascendance"—or the socially reflexive assumption that Helen's marriage to an older, established painter inevitably made her artistically indebted to him. To those so blinkered, she had apparently joined that deadly artistic category: "Wife who also paints."

Fortunately for Helen there was enough support for her work from beyond that critical class to help her ignore their comments. "You know, it's

nicer to be liked than not to be liked, just as I'd rather have someone take a good picture of me than a bad picture," she said decades later, "but if you stop to worry too much about what people think, you can't do half the things you have to do in life."[7] And Helen's life was full. Frank and Porter McCray had added Joan and Helen to the lineup for a show even larger than *New American Painting*. Called *Documenta II*, it was scheduled to open in Kassel, Germany, in July.[8] She had also been chosen to be in the Fifth Bienal de São Paulo in Brazil.[9] As exciting as those invitations were, however, they paled in comparison to a surprise from France. Helen learned in October that she had won first prize for painting in the Première Biennale de Paris at the Musée d'Art Moderne de la Ville de Paris. The award was for her 1957 work *Jacob's Ladder*.[10] "My God! Me?!," she wrote Barbara Guest. "Did you read it in the *Times*?"[11] Helen's old Dalton School teacher Rufino Tamayo was one of the judges. He was pleased to see what had become of the little girl he had once mentored.[12] Helen, meanwhile, celebrated with Frank over a two-hour lunch from which he emerged with a massive hangover.[13] No, petty critics didn't depress her, she had too much to do.

As Elaine had opened her studio to all and sundry, Helen opened her home. Sculptor David Smith became a member of the family; she and Bob gave him a key to their house.[14] One day, he appeared in the doorway with a hunk of bear meat—his offering from Bolton Landing for the dinner party Helen was preparing that evening. Helen left the two men poring over recipes, trying to find the best way to cook it, and disappeared on what Motherwell called a "mysterious errand." Later, when their twelve guests were assembled at the table, "high on Scotch and wine and animated conversation," Helen brought in the cooked bear on a platter, sat down and, realizing she hadn't been noticed, said, "David, look at me!" She was wearing an apron over a bear costume she had rented that afternoon from a theatrical supply shop.[15] That dinner became legend, as did others because of the guests who assembled at Helen's table: Ralph Ellison, actress Hedy Lamarr (whom Helen tried to fix up with David), the *Partisan Review* crowd, Charles Mingus, Frank, Franz, Grace, and Barbara Guest, among many others.[16] In later years, in order to enjoy all her guests, Helen purchased chairs with wheels so she could zoom up and down the length of the table. Soon, all the chairs were moving like a "roller derby."[17]

In some quarters of the art world, Helen and Bob were mocked as "royalty" for flaunting their wealth.[18] The criticism was unfair. They were quite simply enjoying themselves with family and friends the way they could, the way they wanted, and as they had been raised.[19] During those first years together, Bob and Helen were very much in love.[20] In March, after Bob's second solo show at Sidney Janis, during which *his* paintings

displayed *Helen's* influence (a fact left unmentioned by critics), she taped a note to the refrigerator: "I'm proud to be Mrs. Motherwell."[21] She was strong enough in herself and secure enough in her work to say so. In answer to the nagging question, can an artist reconcile life and art, she had answered yes. Helen, for a time, was happy. Grace wanted to be, too.

"Everybody'd gotten either rich or famous or dead," Grace said. "And that doesn't make for a very nice community.... Artists were at each other's throats if someone was showing more than another or selling more than other people were."[22] "The innocent life was gone," she concluded. "Life had suddenly become unfair."[23] No one looking at Grace's career would have thought so. The previous New Year's Eve, Dorothy Miller and the newly elected New York governor, Nelson Rockefeller, worked until the last minute hanging paintings in the governor's mansion ahead of Rockefeller's inaugural dinner.[24] Grace's was one of the paintings in a place of privilege in his dining room, along with a Léger tapestry and a Miró.[25] Another important collector had also paid tribute to Grace that season. While in New York, Peggy bought Grace's painting *Ireland* and had it shipped back to Venice to hang among her Pollocks. "I have been meaning to write to you to tell you how much I love it," she wrote Grace from her palazzo, "and how grateful I am to you for having let me have it." Alfred Barr, Rothko, and the poet Gregory Corso were at Peggy's to celebrate its arrival.[26] At the other end of the celebrity spectrum, Grace was immortalized in the artists' favorite paint store, Leonard Bocour's shop on 15th Street, by having a color named in her honor—"Hartigan Violet." (Bocour called himself "President of the Grace Hartigan...Fan Club.")[27] And yet, none of that seemed to matter. Grace was deeply blue.

In letters, her friends often expressed their concern.[28] The woman who had been so voluble, so brash, so confident, had been replaced by someone if not timid, then at least worryingly reflective. Grace had been socializing too much and not painting enough. "You're running hard. You're out of your element," Rex Stevens said of Grace at that stage. "Fame had sort of gotten her. It was a fast crowd, fast and wild."[29] By contrast, Grace saw her artist friends doing the unthinkable—settling down. Joan, who had been on Long Island with Jean-Paul that summer, appeared headed in that direction (and Grace had done her best to persuade her to take that path).[30] Larry had fallen in love with a waitress.[31] Even Frank had found someone, the twenty-year-old dancer Vincent Warren.[32] They all seemed ready to embrace a stability in their lives that allowed them, in those changing times, to produce their art. It was exactly this foundation that Grace lacked. She was especially inspired by the changes in Helen's life.

Professionally, Grace had been jolted by her fellow painter's decision to leave Tibor de Nagy. She told Joan, "I saw Helen once for a drink and she said the difference between the de Nagy and Emmerich is like Woolworth's and Bonwit's—or was it Bergdorfs—anyhow."[33] Grace had sold more than twenty-six-thousand dollars' worth of work in 1959, which, though exceptional, was only a fraction of the amount Bill would earn that year.[34] While money may not have mattered to some artists, Grace's existence had been hardscrabble from the moment she left home. She *liked* earning money. In 1959, she thought she could do better.[35] Grace had name recognition aplenty but she was burdened by two handicaps: She was a woman in what had become a man's market and she believed, like Helen, that John and Tibor's operation had not kept up with the times—either in its approach to potential buyers or its support of its artists.[36] Just when Grace began considering the possibility of leaving Tibor de Nagy, she met a sculptor named Beatrice Perry who owned the Gres Gallery in Washington, DC.[37] Beati had big plans to expand into New York and to forge connections with dealers in Europe. She told Grace she wanted to represent her. She could offer a stipend and support for the costs of mounting her shows.[38] "*Stipend?* You might as well be hugging me all day," Rex Stevens said of Grace's reaction to the offer.[39] Unwilling to give up on Tibor de Nagy entirely, she negotiated a deal that would allow her to sell work through other galleries, Beati's among them.[40]

In that spirit of reassessing her position, Grace also looked at her personal situation. She wanted to try out the kind of comfort-filled bourgeois existence that had left Helen so wonderfully free to paint. Rex called that decision Grace's "safety reflex."...

> You've got to get your life together. So, what are your needs? What's your everyday looking like?...I need a place to paint, I'd like to go live out in East Hampton, because if you follow the scene, they're all moving out to East Hampton, already getting away from the city—the heat, the rats.... This seemed like a good thing. He would take care of her.[41]

"He" was Bob Keene. "Taking care of her" wasn't a matter of money. Grace earned her own. It wasn't even a matter of love. While Grace liked him, there was no consuming passion. Reading Virginia Woolf again, she was reminded that a woman needed peace and space.[42] Bob had purchased an early nineteenth-century house called Ludlow Grange in Bridgehampton near the Red House, complete with a turret, wraparound porch, and a barn beside vast potato fields. He offered to restore the barn as Grace's studio.[43] In her confused state, trying to rediscover herself—a person far different from the Grace Hartigan she read about in magazines—that house

and barn seemed the perfect refuge. And, during her first summer there, it appeared she had chosen wisely. Paintings poured out of her.[44] Between entertaining friends at what Al called her "estate" and Barbara called "the House of Hartigan," Grace produced seventeen works and believed she had made a breakthrough.[45] Until she discovered otherwise. The work was too easy, a bit like her new life. "I don't know if there has ever been an artist who has made as many embarrassing mistakes and false steps as I have," she wrote Barbara.

> So like a dull repetitive gong I say again that I was wrong in what I thought was a "break-through" this summer....
> Anyhow I guess what I'm saying is oh boy am I ever stuck with myself.... [I] triumph or exult for a moment and I mean a moment at the most five minutes of pure sublime exultation and then "oh that's not what I meant or hoped at all at all." Then drinking. Do I drink out of cowardice, that I can't bear the true and painful pressure of my sober self, but think or rationalize that I'll find greater truths and unknowns if I "dive under"?
> These are thoughts at three in the afternoon of the darkest rainiest New York lower east side day.... Mary [Abbott] hits town and its live live and drink late for tomorrow we die. Not that I don't do a bit of that all by myself.[46]

Grace felt she was falling apart and wondered whether she could survive with Bob at Ludlow Grange. "It was all so wonderful; the expanses of the potato fields, the skies, the sea," she recalled. "All so gorgeous, that I was worried. I was happy there but I don't mind being miserable as long as I'm painting well."[47] She was not. Nonetheless, Grace chose the comfort of Kansas over the thrill of Oz, though not without apprehension. Even as she moved to Bridgehampton and married Bob Keene, she kept her place on Essex Street.[48]

Three days before her wedding in December 1959, she and Frank had a night together of "drunken tears and kisses and reassurances of our love for each other" as well as what Grace called "an almost fatal fight."[49] Grace didn't think Vincent Warren "worthy" of Frank. He was too cold, too shallow. Frank saw in Keene a man devoid of magic.[50] That summer, Frank had sent Grace a poem, "L'Amour avait passé par là," in anticipation of the end of their long and wonderful love affair.

> ...to get to the Cedar to meet Grace
> I must tighten my moccasins
> and forget the minute bibliographies of disappointment
> anguish and power
> for unrelaxed honesty

> *this laissez-passer for chance and misery, but taut*
> *a candle held to the window has two flames*
> *and perhaps a horde of followers in the rain of youth*
> *as under the arch you find a heart of lipstick or a condom*
> *left by the parade*
> *of a generalized intuition*
> *it is the great period of Italian art when everyone imitates Picasso*
> *someone has just pushed me into the Po*
> *in Ann Arbor the grass has turned brown in the sun*
> *here there are repercussions and warnings in the wet night*
> *a catalog of idiocies and fears dictates a letter*
> *and it is signed Frank*
> *but I don't have to mail it*
> *yet*[51]

Fittingly, that decisive year would end with an exhibition, *Hartigan and Rivers with O'Hara,* at Tibor de Nagy. It was a show of the two visual artists' collaborations with Frank: Larry and Frank's series of lithographs called *Stones,* and Grace and Frank's 1952 series, *Oranges.*[52] Lawrence Campbell in *ArtNews* called the works an homage by Grace and Larry to Frank.[53] They were, in fact, an homage to their shared past and deep friendship. Through the show, Grace relived those happiest of times just before she left the scene—and the person she had been within it, a star—for good.

Joan would go even farther afield. In 1959, she gave the keys to her St. Mark's Place studio to Frank and Joe LeSueur, and left for Paris.[54] She had decided to make France her permanent home and do all her painting there. Friends were surprised that she took that step just as her career in New York seemed assured, just when the Modern had begun including her in major exhibitions. "She divorced America," Barney said decades later. "To this day it remains a mystery for me."[55] Joan may have chosen to leave precisely because the New York environment had become so frenetic. "My relationship with the art world is distant," she explained, "and occurs mainly through individuals. As I love painting, I go to galleries, museums, to artists' homes, but the art world has never really interested me."[56] Joan wanted very little in life. She wanted to paint ("I have an addiction to painting, it's like a malady").[57] She wanted love ("I want so much to love & not to hate, and I suppose I mostly want someone to love me").[58] And she wanted "one small child" and a man to share that responsibility.[59] It was a simple prescription for happiness and she had decided that she could do all of it best in France.

Joan had grown so comfortable in Paul Jenkins's Paris studio that she had it assessed in the hopes of buying it, which produced something of a standoff: She refused to leave and he refused to sell.[60] Finally, Paul took a boat from New York to France, let himself into his atelier, and climbed into bed. When Riopelle and Joan returned to discover him under the covers, he said, "It's over." Paul won.[61] Given little choice but to find her own studio, Joan discovered a gem in an ancient stable building at 10, rue Frémicourt, between L'École Militaire and the Eiffel Tower. Joan leased the attic loft for fifteen years and began renovations to turn it into an enormous studio and living area. A garage below could accommodate all Jean-Paul's cars, and there was enough space in the loft for Joan's three dogs.[62] "Just plunked down a cool million for a place this morning," Joan happily wrote Paul. "The major part of the skylight is in but there's so much snow it's hard to finish the roof. The back part, which will be billiard room & bedroom, should be done quickly.... Each room is roughly ten by ten metres—makes me pee in my pants when I look at it—it's <u>mine</u>."[63] Friends called Frémicourt "fantastic."[64]

Finding a home, however, would be the easy part of establishing a life in France. The questions of a man and a child remained unresolved. Jean-Paul's wife, who had finally learned about Joan and agreed to divorce him, had moved back to Canada, where marriage had to be dissolved by a private act of the Canadian government.[65] Though both parties agreed, and though Jean-Paul promised it would only take a few months, the divorce would not be finalized for four years.[66] This meant Joan couldn't settle that other outstanding issue: a baby. Her pregnancies through the years had always ended in abortion.[67] Unlike Elaine and Grace, Joan's problem hadn't been one of balancing art with motherhood. She had never felt her situation stable enough to make that choice, and she believed it would not be until she had resolved the marriage issue with Jean-Paul.[68] At thirty-four, she had time, though not an eternity, and it weighed on her like an unfinished painting. And then it weighed on her like a nightmare.

In March 1959, just when the work on her Frémicourt loft was nearly finished and she would be able to move in, she learned that Jean-Paul's young gallery assistant had become pregnant by him and planned to have the baby.[69] The horror of that discovery after having committed so completely to Paris, and after having waited for a resolution of Jean-Paul's marriage, was devastating. Joan returned to New York.[70] But that city, which she had fantasized about in moments of loneliness or confusion, provided no consolation. It only exacerbated her despair. In the brief time she had been away, so much had changed there that she no longer saw her place in it. Blond, lithe, talented Patsy Southgate had divorced her husband, Peter Matthiessen, and married Mike.[71] As had happened with Bunny Lang,

Frank formed a third party to that union. Who loved whom became difficult to decipher.[72]

History was repeating itself, and Joan knew how that story ended. The last time she had witnessed a similar drama was the summer she had tried to take her own life. Joan called her Mike Goldberg period "another bitter chapter" over which she claimed not to have shed any tears.[73] But it is hard to imagine in her already fragile state that she wasn't shaken and saddened. With Mike racing around town in a Bugatti he bought in Italy on his honeymoon, and living with Patsy and her two children (and, often, Frank) on Second Avenue near St. Mark's Place, Joan had no peace.[74] A contrite Jean-Paul, meanwhile, sent her letters begging her to return: "Joan, *Chérie*, . . . if you don't come, I'll smash everything."[75] Despite his infidelities, Jean-Paul was "very in love with Joan," according to a friend who saw them often.[76] Finally, Jean-Paul came to New York to plead his case in person, and after two months, he succeeded. She agreed to return to France.[77]

Oddly, Joan's period of deep indecision coincided with Grace's own as she pondered marriage to Bob. The two women saw each other frequently while Joan was in the States. They had never been close — their personalities were equally strong and diametrically opposed — but they became so briefly that summer of 1959.[78] Grace understood Joan's dilemma. She would have been able to offer survival tips and advice to that extremely vulnerable woman with the tough-as-nails exterior. Grace had met Riopelle when she was in Paris the previous fall, and she had come away believing that despite obvious difficulties, Joan's relationship with him was good.[79] During Jean-Paul's mission to retrieve Joan, they visited Grace and Bob at Ludlow Grange, and though that lifestyle was not what Joan desired, the atmosphere may have been therapeutic: two macho men talking about cars and boats (Jean-Paul's latest passion), while two women talked over their indecision about those men — and art. By August, Joan was ready to return to France.[80] As Frank would say in the poem "Adieu to Norman, Bon Jour to Joan and Jean-Paul," which he wrote commemorating her visit to New York,

> *the only thing to do is simply continue*
> *is that simple*
> *yes, it is simple because it is the only thing to do*
> *can you do it*
> *yes,*[81]

Joan began her life in Frémicourt, working in a studio she allowed no one to enter.[82] Though she continued to show in New York at the Stable

Gallery, in Paris, Joan had no gallery.[83] A woman painter in France garnered even less respect than in the States, and an American woman artist was both resented and ignored. An outspoken one like Joan occupied her own category. "They call me *sauvage* in Europe," she said many years later. "Lots of things women can't be, *sauvage* is one of them."[84] Joan became invisible as an artist in France, occupying the shadow Jean-Paul cast. His paintings hung on the walls in Frémicourt, and when other artists came to the loft for drinks or dinner, it was his work they discussed.[85] "She was viewed as the great man's wife," wrote art historian Cindy Nemser.[86] Somewhat surprisingly, Joan for a time seemed comfortable receding into the background. "It was as if they had a sort of tacit agreement between them: he is the star, a state difficult to contest because he was acclaimed throughout Europe," Riopelle's biographer explained.[87]

Joan's position was similar to the one Lee had accepted during Jackson's lifetime. Joan never tried to wrest the spotlight away from Jean-Paul, and she defended him so aggressively that she earned the title "American Ogress."[88] She also goaded him into painting, saying, "When you are tired, depressed or even sick...there is only one cure: get up and work."[89] Joan felt isolated, but that was a familiar, almost welcome condition because it allowed her to paint.[90] Under age-old beams and the slate-gray Paris sky, with her terriers at her feet and music filling her grand studio, Joan freed herself on canvas. New colors appeared, both hot—cadmium orange, red, and yellow—and cool—rose madder, phthalo blue, and white. Colors reminiscent of those she had used in her magnificent painting *City Landscape*. Her brushstrokes, too, were once again cracking, defying anyone to stop their motion. A visitor remembered seeing her at Frémicourt: "Her fingers were covered with paint, as if she had reinvented skin."[91] Joan believed she created some of her boldest work during this period.[92] Alone, in her studio, she was happy. The world beyond seemed to offer only regret.

Not long after Joan returned to Paris from New York, she, Jean-Paul, and his two young daughters Yseult and Sylvie joined French dealer Georges Duthuit, his wife, Marguerite Matisse Duthuit, and their son, Claude, on a sailing voyage from Athens to Istanbul across the glistening, blue-green Aegean Sea.[93] Jean-Paul had been planning this trip aboard the luxury yacht *Fantasia* for months.[94] The highlight of the journey was to be a visit to Mount Athos and an eleventh-century Orthodox monastery full of art treasures. It was very rare for outsiders to be given access to it, and women and children were never allowed in. However, Claude Duthuit said no one had had the courage to tell Joan of those restrictions. When the group prepared to ascend to the monastery, the guide charged with taking them there was given the unpleasant task. Predictably, Joan flew into a rage, throwing shoes and curses, as the men proceeded to the holy site

while she, Marguerite, and the children stayed behind.[95] She could accept a life in the shadows, but not that sort of humiliation, the implication that she was lesser, just a woman. *She was an artist.* To ensure that the return trip was horrendous for everyone aboard the *Fantasia,* Joan drank heavily, fought continually with Jean-Paul, and insulted the small group held captive on the yacht. Jean-Paul lost his protector, Duthuit. The two men parted ways after the debacle.[96] The fissures in Joan's relationship with Jean-Paul also widened.

Though she remained in France as Jean-Paul's mistress, she would not do so silently in the face of social and personal indignities. She baited Jean-Paul in public. "Are you going to fuck me tonight REM-BRANDT?" she once shouted at him for all at the Café de Flore to hear.[97] She began calling Riopelle "Jimmie," after her original male tormentor, Jimmie Mitchell. "So, Jimmie, are ya going to marry me tonight? Are ya going to fuck me?"[98] Said art critic Peter Schjeldahl, who witnessed one of Joan's later tirades against Riopelle, hers was a "craziness of a scary and rare order."[99] Jean-Paul, meanwhile, responded by having more flagrant affairs and exhibiting wild jealousy at the thought that Joan might be having them, too. He was especially frantic about her relationship with Beckett.[100] The verbal fights soon devolved into physical fights, as they had with Mike. One French painter called Joan "the Billie Holiday of Abstract Expressionist painters"—"I love my man though he treats me so bad. That was Joan: masochistic."[101] The sick pattern continued.

During those first years in France, truth and beauty existed for Joan but only on her canvas. "Painting is safety to me," she told Mike. "I understand that now—make me a house of many stretchers."[102] No man could do so. Joan built her own and she lived there.

Lee had understood the lesson that she could not find safety in anyone but herself and anyplace but her canvas much earlier. Having done so, however, had not made her life easier. Hers had been a battle with more losses than victories. At fifty, she was shaken, though she remained resolute. Lee's Martha Jackson show the year before boosted her confidence and brought her once again to the attention of the art world. Her mosaic project at the Uris Building, completed in 1959 with the help of her nephew Ron Stein, established her artistic vision on a massive scale for all of New York to see. The only comparable work being done with that material was by Gaudí in Spain.[103] At that moment of triumph, however, a malign umbra in the form of Clem Greenberg came back into Lee's professional life.

After his breakup with Helen in 1955, Clem had felt shunned not just by the art community but by the writing community around the *Partisan Review.* His old friends there had continued their association with Helen,

while turning coolly away from him.[104] "I felt isolated as hell," he said. "All those years. Yeah. Isolated as all get-out. Absolutely." Between 1955 and 1959 he wrote very little about art and, after 1957, when he lost his job at *Commentary* magazine, very little of anything at all.[105] It was during that dry spell that Clem was offered a chance to get back into the art business from which he had been exiled. In the fall of 1958, a group of men drove up to his Bank Street apartment in a limousine and asked him to help them expand French & Company antiques. The high-end antique business was dying, and they wanted to save it by getting in on the booming modern art craze. Clem agreed to advise them.[106]

By March 1959, French & Company's contemporary art gallery opened in a penthouse at East 76th Street and Madison Avenue. André Emmerich called it "the largest and most spectacular gallery in New York."[107] Clem launched the gallery with a show by Barney Newman and filled subsequent exhibition slots with Color Field School painters.[108] (Though the style arose from Helen's painting, her work did not appear in Clem's gallery.) Unfortunately for Clem, the work didn't sell as well as his increasingly desperate employers had hoped. They and Clem hit upon Pollock as the answer to their financial woes.[109] As he had twenty years earlier when he first arrived on the scene in need of help, Clem paid a visit to Lee.

Despite her anger over his refusal to eulogize Jackson, Lee had remained on friendly terms with Clem. They saw each other socially, listened to jazz together at the Five Spot, and found themselves seated around the same dinner tables. Knowing about his new job, she may not have been surprised by his request: He wanted to mount an exhibition of Jackson's work.[110] The suggestion did not displease her. After having pulled Jackson's paintings from Janis's gallery, Lee had not known what step to take next. "I went to museum directors and asked their advice of what to do and they couldn't care less," she said. "Finally I froze."[111] Lee had wanted Clem's help in molding Jackson's legacy. She had even asked him to write a book on Pollock, which he refused. (Frank did it instead.)[112] Clem knew Jackson's work nearly as well as she. He might be just the person to handle his estate. In response to Clem's request about a show, Lee said maybe.

She invited Clem and Jenny to her apartment to discuss it.[113] Over dinner, Lee proposed that Clem show Jackson's 1950–1951 black-and-white work and, after that exhibition, Lee's own paintings. Clem demurred. He didn't like the idea of exhibiting them both. In a surprising spirit of generosity, he offered to show Lee but not Jackson. Jenny vehemently objected, and so he agreed to two exhibitions, starting with Lee.[114] That settled, Clem and Jenny left for Europe on a three-and-a-half-month scouting tour for French & Company, and Lee returned to her studio.[115] As had happened with Betty Parsons, and regularly throughout Lee's long career, as

she prepared for her show, her work took a sharp detour in an entirely different direction.

Lee's mother had died earlier that year, and the grief that she had kept out of her paintings after Jackson's death finally surfaced.[116] She couldn't sleep. She tried walking her dogs in the middle of the night to no avail. Finally, she decided to use those hours before dawn to paint.[117] "And I realized that if I was going to work at night, I would have to knock color out altogether because I wouldn't deal with color except in daylight," she explained.[118] What color she did use was mournful, resembling dead earth, parched soil, charred ruins. She herself found the works so somber that they were painful to "enter."[119] The one aspect she retained of her "Earth Green" series was scale. She painted large because her emotions were so overwhelming she needed an arena to express them. Lee called the series "Night Journeys." In Hebrew mythology that meant a descent into darkness.[120]

In late July, Lee had a small retrospective at the Signa Gallery in East Hampton. Covering the walls were fifteen works, ranging from her Little Image paintings of the late 1940s to her collages of the mid-1950s and the more recent, large "Earth Green" series. The entire summer crowd turned out for the opening: artists, critics, architects, dealers, collectors.[121] French & Company director Spencer Samuel was there, too. Congratulating Lee on the show, he discussed giving her a "serious retrospective" at French.[122] The opening was a success and the party at Lee's afterward celebratory. It had taken a long time to receive the recognition she valued most, that of her peers, but that July she did. At one point a shaggy group sauntered up the driveway and toward the back where the party was under way. Lee stopped them. It was Jack Kerouac and an entourage of his friends. "I thought this was an open party," he said. "It's not *that* open," Lee replied.[123] How did she feel closing the door on the literary equivalent of her late husband? One suspects she did so with satisfaction. It was *her* day.

By late summer, Clem and Jenny had returned from Europe and came to Springs to discuss Lee's show.[124] The barn where Clem had expected to find Lee's "Earth Green" series was filled instead with her "Night Journeys." Along one wall was the seven-and-a-half-by-twelve-foot black-and-white painting *The Gate*.[125] Like a vortex, it drew the viewer in as it had the artist. Long, lashing strokes of white, like pelting rain or anguished tears, poured across the width of the grand canvas. Smaller flashes of black could be birds in frenzied flight against a storm. A hooded eye, that hideous image that had haunted Lee before Jackson's death and haunted her still, floated in the upper right corner. The impact of that painting in the stark studio would have been overwhelming. And around it were others, only slightly less large and only slightly less troubling. The fantastic energy, the unbridled expression, the courageous confrontation that must have

occurred between the artist and her pain were undeniable. As if that weren't enough to inspire awe, Lee's paintings were quite simply beautiful. Clem looked around and said he didn't like them.[126]

"Lee was not a good painter," he said matter-of-factly, recalling that day years later. "She was so accomplished but it was hollow. So then I had to tell her. And Lee wasn't large-souled, she wasn't magnanimous.... I didn't refuse her the show. I said, 'We're gonna show you anyhow.' "[127] Lee asked Clem on what basis he had offered her an exhibition in the first place. "On the basis of what I thought you would do," he replied.[128] Lee was livid. Clem had destroyed her confidence before with his merciless condescension. She held him responsible in part for having ruined Jackson by his abrupt withdrawal of support and by anointing another "the greatest" at a time of Jackson's extreme vulnerability. Lee had remained mute through those earlier episodes for Jackson's sake.[129] For her own sake, she no longer did so. Lee told Clem, the customs house clerk she had helped turn into a kingmaker, "As of this minute, my show is canceled."[130] To an interviewer later Lee explained, "I wouldn't work with him, and that's that.... I knew I'd have to pay for that and I did."[131]

Jenny wanted to leave immediately but Clem, either delusional or monstrously cruel, said they shouldn't part angry. "We'll sweat this out," he told her, "we're friends." He and Jenny had dinner at Lee's and stayed the night. "I got up the next morning and Lee's face was swollen," he said. "You know there are people, and I've noticed this before, who when they sleep on their rage, when they get up their faces are swollen." His concession to Lee's obvious distress was telling her after she drove them to the train station, "Don't wait for the train with us."[132] Lee did not. Instead, she set to work trying to destroy Clem, spreading the word all over town that she had canceled her show at the great man's gallery. Clem, meanwhile, had to break the news to French & Company that, because of her decision, the show they had literally banked on—Pollock—would not occur. Within a few months, French ceased its contemporary art adventure. Clem was out of work.[133] Lee had had her revenge, but it was not as sweet as the triumph of having stood by her principles. "I daresay if this show had come about, my 'career' would have moved in a different direction—but it went the way it went," she said.[134] As for whether her decision to confront Clem took courage, Lee said, "I know that's been said, but I can't imagine any other decision."[135] She explained,

> I lived so closely to Pollock, who had it like, big, I knew that [fame] was not a glorious gem that you try to get...like so many others do. They don't care what, they gotta get there.... I knew I could sustain it. I don't have a million options, but those are some of them. Some part of me must have had an

enormous confidence. No matter how hard the thing was, I sustained and kept going. I can't pretend that it was a yellow brick road that you stick on. Tough position, tough place, and a hell of a lot of resentment for the stuff that went.... So, that's that. You know, you stay with it. You keep going.[136]

Lee prepared to soldier on alone. The community of goodwill and creativity in which she had come of age as an artist thirty years before had disappeared under a tidal wave of money. The innovation and ideas that had thrilled her in others—Gorky, Bill, but most of all Pollock—had gone, too. What remained was fashion. As impossible as it might have been at that arid moment to imagine, however, Lee did not believe she had witnessed the death of true art. It was too strong. It arose like religion, no matter how secular the landscape. Lee stood vigil, waiting for the great pendulum that was the history of art to swing back, as it inevitably would, toward discovery. "I think a new bunch of people will come through that will do something," Lee said. "I'm not even sure I know where it will happen. I just feel that if I see it, I'd like to be able to say, 'Wow, there it is again!'"[137]

As the Ninth Street women and their fellow artists demonstrated, that sort of revolutionary advance took a combination of courage, commitment, and vision. They had made their marks and would continue to do so, and some of those marks would be magnificent. The next revolution, however, would be left to a new generation. All those who had contributed to the story of art could do in the meantime was inspire.

Epilogue

LEE'S BREAK WITH Clem and Janis only increased her alienation from the art world, where she had become recognized more as "art widow" than artist. She showed her work and received mixed to good reviews. She even fell in love for a time with a most un-Pollock-like character: a suave British art dealer, seventeen years her junior, whom her friends dismissed as an opportunist if not a gigolo.[1] But mostly, Lee was raging—against the art establishment and the direction the art world had taken. "All of this has happened, which is quite fantastic," she said of the environment out of which she had arisen. "Now, where is it?... The 50s were vitally alive and meaningful, and in the 60s, I don't know what takes place but brother, what a job they did." By 1965, however, after three years of medical problems that began with a brain aneurysm in 1962, Lee emerged calmer. The outpouring of concern for her during her convalescence revived her spirits.[2] An offer from London also helped. A critic and curator there contacted her saying he wanted to mount a traveling retrospective of her work.

Opening at the Whitechapel Gallery in 1965, the show was praised by critics who heralded Lee's talent and recognized her place in the pantheon of modern artists. Some also wondered why she hadn't had a similar show in the States.[3] The question nagged Lee as well, but she tried to ignore it through constant work (a priest who met her at that time said, "Lee was almost like a nun") and exchanges with young people at colleges where she served as artist-in-residence.[4] It was the late 1960s, and Lee fed on the political radicalism that gave rise to various movements, especially feminism, whose proponents embraced her as a "heroine."[5] When the Museum of Modern Art mounted an exhibition of First Generation Abstract Expressionists in 1969, Lee's status as a pioneer was evident: She was the sole woman in the show.[6]

In 1972, sixteen years after Jackson's death, Lee finally relinquished control of the Pollock estate. In turning it over to art dealer Eugene Thaw, Lee declared, "Now, I can once again concentrate on being Lee Krasner, the painter."[7] The art world seemed to respond in kind. The next year Lee had her first solo exhibition at a New York museum when the Whitney mounted *Lee Krasner: Large Paintings*.[8] But neither that nor the awards and recognition she received from groups throughout the United States, England, and France sufficed. "Do you realize that to date no god-damned

museum in New York City, where I have been born and bred and am part of the history—where I *fought the battle*—no museum has given me a retrospective?," Lee, who was seventy-three at the time, lamented.[9] "My claims are not that I'm the greatest painter in the world, but my God, I certainly know I can paint and can hold a place with a lot of people who have rocketed through."[10]

Two years later, the Museum of Modern Art finally gave her the recognition she sought. Featuring one hundred and fifty two paintings and drawings, and curated by art historian Barbara Rose, who had worked for nearly twenty years to draw attention to Lee's art, *Lee Krasner: A Retrospective* opened first in Houston in 1983.[11] Attending the gala in a wheelchair because she was crippled with arthritis, Lee returned home to await the triumph of her opening at the Modern. She would be the first woman to have a retrospective at that museum.[12] By the time crowds lined up in the fall of 1984 to see it, however, Lee wasn't among them. She had died in June and was buried near Jackson at Green River Cemetery in Springs.[13]

Lee's last contribution to the art world, beyond the inspiration of her life, work, and the Pollock legacy she had protected, was a foundation to help struggling artists. Using most of the improbably large nest egg she had accumulated since Jackson's death—twenty million dollars in cash and art—she established the Pollock-Krasner Foundation to provide grants and support to artists less well endowed. She further stipulated in her will that her home on Fireplace Road in Springs become a museum and study center. The rural farmhouse she and Jackson bought on a whim in 1945, which was the scene of so much anguish and ecstasy, became a National Historic Landmark in 1994.[14] Its rooms and studio have been preserved as Lee left them.

After 1959, Elaine split her time between New York and the dozens of universities and colleges—Yale, Pratt Institute, Carnegie Mellon, Penn State, the University of California Davis, Brandeis, Cooper Union, and the University of Georgia, among them—where she taught and collected honorary degrees and admirers.[15] Her studio on Broadway, one floor below Bill's, became a meeting place for young people interested in art and social justice.[16] During the 1960s, Elaine organized protests against the death penalty, led artists at a civil rights march in New York coinciding with Martin Luther King Jr.'s March on Washington, and joined demonstrations against the Vietnam War.[17] Unlike Lee, Elaine did not initially have time for feminism. "When feminism came up in the seventies, she got an invitation to march and speak," her nephew Clay recalled. "She answered, 'No, thank you. I never needed you guys.' They said, 'No, we need *you*.'"[18] Unable to refuse a plea for help, she took to the street carrying a banner demanding equal rights for women.[19]

Amid all that activity, Elaine had continued to write and paint, expanding her body of visual art to include cylindrical pieces, which she exhibited at the Robert Graham Gallery in New York in 1961. The review in the *New York Times* was scathing, but it included a large reproduction and caught the eye of a powerful patron. In the spring of 1962, Elaine was startled when a White House representative bearing a copy of the article appeared in her studio asking if she'd like to paint the president.[20]

Her dealer had initiated the process that led to the commission. He knew the Truman Library in Missouri wanted a portrait of President John F. Kennedy and was looking for an artist to paint it.[21] The choice of Elaine was as apt as it was ironic. Apt because Kennedy represented a new, vibrant culture in America; ironic because it had been Harry Truman who criticized modern art at the public dawn of the Abstract Expressionists as "the vaporings of half-baked, lazy people."[22] Elaine accepted. In December 1962, she traveled to Palm Beach, Florida, where Kennedy had a "winter White House" and set up her easel.[23] "The whole Florida episode was like a fairy tale—or rather," she wrote Edith Schloss, "I felt like twelve-year-old Elaine having a far-fetched day-dream."[24] The project consumed her during her two weeks in Florida with Kennedy, and back in New York where, gradually, hundreds of drawings, prints, and paintings of Kennedy—one nearly ten feet high—covered her studio and living area, including the bathroom and kitchen.[25] (Elaine even sculpted a sand likeness of Kennedy at the beach.)[26] In early November 1963, she felt she needed just two more hours with him in person to finish. It was while working in her studio, anticipating their meeting, that she heard the news that Kennedy had been shot. Writing "November 22, 1963," on the painting before her, she put down her brush and did not pick it up again for a year.[27] When she did, she returned to his portrait.[28]

Kennedy's assassination, coming as it did a year after the sudden death of Franz Kline (who Elaine said died of his ill-fitting celebrity), destabilized her.[29] She began to drink so much that even she knew she had a problem.[30] Elaine's sister, Marjorie, eventually intervened. She filmed Elaine while drunk and showed her the tape when she was sober.[31] Horrified at what she had become, Elaine gave up alcohol, replacing it with exercise, a healthy diet, vitamins, and a mission.[32] She set out to save Bill.

By 1977, he had built a fantastic studio in Springs and was worth millions of dollars, but he was drinking so much and taking so many pills that he couldn't paint and, gradually, the combination began affecting his mind.[33] Bill was surrounded by what Elaine's painter friend Connie Fox called "a bunch of bad buddies.... These guys were just using him."[34] Elaine staged her own intervention, getting Bill into a hospital to dry out and replacing his "friends" with her brother Conrad, her nephews, and

close associates who helped her wean him from alcohol and the Valium he'd been given by a "Dr. Feelgood."[35] "It was a big deal getting him off booze," Connie said. "Nobody else could have done it."[36] In 1979, Bill was finally sober.[37] Elaine had her own house and studio nearby but, after a twenty-year separation, she, at age sixty-one, and Bill, at seventy-five, were again husband and wife.

During the next few years, while she traveled the world painting and teaching, Bill remained happily and safely at work in his studio. The memory loss some had attributed to drinking continued. It was, in fact, a sign of dementia. Elaine tried to protect him by speaking for him, explaining away his absentmindedness as the eccentricity of a genius.[38] She knew Bill was no longer the person he had once been. None of them were. A poignant example of that occurred in 1979, when Elaine organized a visit to see her blustery old muse, Kaldis. He lived in one room in a residential hotel where he painted landscapes at a small easel. She, Bill, and Kaldis reminisced about old times and changed fortunes, memories that made them all young again for a moment. As they made to leave, the hotel was very quiet. "There wasn't anybody around," Connie, who was also there, recalled. "We went out in the corridor and as we left [Kaldis] started singing us a Greek song.... All you heard was his song."[39] It was Kaldis's farewell. He died soon afterward. Elaine, too, was ill but wasn't sure of the cause. In 1984 she discovered that, after a lifetime of smoking, she had lung cancer.[40]

Elaine agreed to surgery but refused chemotherapy, saying she'd take her chances, which doctors estimated at fifty-fifty.[41] She lost her wager with fate. The cancer recurred and spread to her bones.[42] Keeping her illness a secret from most friends (Joan was one of the few she confided in), she explained away her weakness as Lyme disease.[43] By 1988, however, Elaine was in excruciating pain and it was clear she suffered from something far worse. It had become difficult for her to speak. She was short of breath and coughed constantly.[44] By early 1989, she was hospitalized. On February 1, just before her seventy-first birthday, her sister Marjorie and her Village running mate Ernestine were in her room when a nurse told them to say their final farewells. "It was hard to believe that she was dying because she looked so amazingly good," Ernestine said. "Absolutely beautiful."[45] Elaine even attempted to buoy the spirits of those around her, nodding and smiling as they joked and told tales. But that day in February the woman who had believed she could defy gravity admitted being daunted by life's final mystery. Before she died, Elaine held Ernestine's hand and whispered, "I'm scared."[46]

Elaine's memorial service lasted for three hours as twenty-seven people delivered eulogies. But no one told Bill that Elaine was gone.[47] At eighty-

four, living in a world of his own, he believed she was beside him where she had always been, even during their long separation. As for Elaine's work, her painting career in those last years had flourished despite her condition. She had had her first and only sold-out show in 1986 and died with her studio full of recent canvases.[48] She also left unfinished her autobiography, which she had signed a contract to publish in 1988. The book was based on as many as one hundred palm-sized journals she had kept through the years, diaries recording her life from the time she met Bill. Marjorie took over the project, but she, too, soon died.[49] The book was, therefore, never written and the whereabouts of the journals, if they still exist, is unknown. Luckily, Elaine's legacy was not misplaced along with them. Frank O'Hara's "White Goddess," Edith Schloss's "queen of the lofts," Stephen Chinlund's "patron saint of the whole scene," the role model, "fairy godmother," and one of the most powerful figures in America's first great artistic revolution lived vividly in the minds of those who knew her.[50] For the rest of us, she lives on through her work, her writing, and the stories of her that continue to be told.

Grace's December 1959 marriage to Bob Keene lasted only a few months.[51] The life on Long Island that hadn't fully satisfied her before her wedding did not magically begin to do so afterward. The balance of her life shifted once again to Manhattan and her Essex Street studio. While she looked for an escape from another marital misadventure, she had learned that an epidemiologist at Johns Hopkins in Baltimore had purchased her painting *Autumn Harvest* from Beati Perry's gallery in Washington and that he would like to meet her. Months later while in New York, Dr. Winston Price finally contacted Grace, asking her to join him for lunch at his hotel.[52] "Well I didn't know any scientists," she explained. "I thought they were little men with big heads, and this tall, handsome, prematurely gray man answered the door. And I stayed three days."[53] By the end of their visit, each planned to divorce their respective spouses and begin a life together. "The first three marriages were like vaccines that didn't take. It was like marrying boyfriends. This was the marriage for the rest of my life."[54]

Consulting her analyst, Grace was advised to formally break off her relations with John Myers and Frank because, he said, she would not be able to freely and fully enter a relationship with Win Price if her loyalties were divided. Grace duly wrote farewell letters to each of them. Their response was venomous.[55] John vowed to ruin her marriage. He even spread a rumor that she'd gone insane. Frank was equally cruel, divulging intimate secrets, mocking the bombast he had previously enjoyed and encouraged.[56] Meanwhile, Grace also received ominous warnings from friends that leaving New York would mean the end of her painting

career.[57] Al Leslie and Joan's friend Sam Francis took her corner and threatened to leave Martha Jackson's gallery unless she gave Grace a contract. Martha did.[58] But amid the rise of Pop, the Color Field School, and the increasing exclusion of women artists, even Al's help wasn't enough to ensure Grace's position. Though she had become the most famous contemporary American woman artist because of the Modern's traveling shows, after marrying Win she planned to move to *Baltimore*. By New York art world standards that city didn't exist, nor did anyone in it.

Grace's powerful imagination helped her ignore that reality. At thirty-eight, she fantasized that she would be at the center of a salon of artists, scientists, and writers in the city where Edgar Allan Poe had written and the sister duo Etta and Claribel Cone had built their famous art collection.[59] Upon arriving there, however, Grace realized immediately how mistaken she had been. Baltimore in 1960 was a backwater of racial bigotry and social conservatism. "I thought I'd die, literally," Grace said. "It was the pits.... They didn't like me because I was Win's second wife and I wasn't a Vassar woman and I wasn't a club woman and I didn't play bridge." She loathed everything about the city, except her husband, which for a time was enough.[60] She forbore even when she learned that Beati planned to close her gallery and keep as compensation for her support of Grace all the Hartigan paintings that hadn't sold during their two-year association. Those important works "simply disappeared from the public eye," according to art historian Robert Saltonstall Mattison.[61] Undaunted still, Grace left the manicured lawns of her upper-middle-class neighborhood and found a studio in a deserted factory to paint more.[62]

She produced some of her most beautiful and revelatory work there. The lyricism of her paintings in the early years of her marriage gave way to dark violence as the 1960s devolved into social chaos.[63] In Baltimore, Grace saw on the troubled streets and even in her own protected life the injustice of racism. A black artist friend who visited her with a group from New York had to stay the night in her studio because he wasn't allowed to check into a hotel with his white traveling companions or eat with them in restaurants.[64] Grace escaped Baltimore during the sixties as frequently as she could, sometimes merely to meet Helen for lunch in Philadelphia (halfway between New York and Baltimore), sometimes heading up to New York for her own or a friend's opening.[65] Occasionally she bumped into Frank, but their relations were coldly cordial. Until, that is, the early summer of 1966 when she invited him and a group of friends to join her and Win for drinks on Long Island. Finally, they discussed their rupture: the necessity on her part to break away from him to start a new life, his hurt and disappointment that she had done so.[66] They left the evening as friends with a commitment to see each other again, soon.[67] But by the end

of July, Frank was dead. He had been struck and killed in the early morning by a beach buggy driving on the sand at Fire Island. Frank had just turned forty. Everyone who knew and loved him was shattered, especially as they pondered the bizarre circumstances of his death. Grace felt she had lost part of her own life.[68]

Perhaps it was being robbed of Frank just when their friendship had been rekindled that made Grace feel so lonely. She took the extraordinary step of calling the only art school in Baltimore, the Maryland Institute College of Art, to ask if there were any graduate students who needed a mentor.[69] The call was serendipitous. The school had just received funding to begin a graduate program. In 1967, Grace became its first director, a position she would hold for more than thirty years.[70] The job proved to be one of the few constants in her increasingly troubled existence. Grace's lifeline to New York, her dealer Martha Jackson, drowned in a swimming pool in Los Angeles in 1969.[71] And, around the same time, Win began to show signs of severe depression. Unbeknownst to Grace he had been experimenting on himself with a live vaccine he was developing to treat encephalitis. Feeling an inexplicable distance from him, Grace took a lover and began living her life, she said, in "fragments."[72]

Grace existed in that state, numbed by alcohol, until 1978, when she discovered that her now-deranged husband had lost his job, that his tales of imminent scientific breakthroughs and appointments were sheer fantasy, and that he had drained their bank accounts—on one occasion, driving to New York to buy a Cézanne—without bothering to mention their dwindling resources to Grace. She sold the art they had collected, moved into a small apartment, and painted what she thought would be her last work, *I Remember Lascaux*. Grace took fifty Valium tablets, drank a bottle of vodka, and waited for death. Win found her and she recovered—temporarily.[73] In 1981, after an illness that had left him comatose, Win succumbed to meningitis and died,[74] and Grace went on a bender that would have killed her if she hadn't landed at Johns Hopkins Hospital. It was a moment of decision: stop drinking or die. Grace chose life.[75]

As she had thirty years before, Grace returned to the old masters to help find herself again on canvas.[76] She had a flat and gallery in New York, and a loft in Baltimore, where she lived and painted in a port neighborhood filled with strip joints, sailor bars, and shops selling Elvis artifacts. "There's nothing that's going to stop me!" she declared in 1990 at the age of sixty-eight. "Everything's possible. I could go anywhere. I could paint masterpieces. I could get famous again. I could fall in love again. I could get thin!"[77] Painter Rex Stevens, who with his wife, Regina, and son Ryan lived with Grace, said that despite two hip replacements and numerous other ailments, Grace worked every day, disciplined, "taking the journey."[78]

Dore Ashton met Grace in Baltimore around that time and was shocked to see her Grand Girl using canes. As they talked, she was equally surprised by her attitude. "There should have been a big show of Grace Hartigan, she was an important figure," Dore said. But Grace evinced no bitterness over being displaced, if not forgotten. "She just didn't give a bloody damn.... She didn't care."[79] She had moved on, or back, to pure art.

Sixty years after she began painting, Grace's work was represented in more than three dozen public collections and formed part of shows at, among others, the Whitney and the Modern in New York; the Corcoran, the National Museum of American Art, and the Hirshhorn in Washington; and the Baltimore Museum of Art. Her adopted city had finally recognized the power of the woman who had chosen it as her home.[80] Indeed, Grace was a star in Baltimore. Students flocked to her and emissaries from another era came to visit: Helen, Lee, Elaine, Larry, Bill, Dorothy Miller, Mercedes, Philip Guston, all made the journey south to see her. When Grace died in 2008 at eighty-six, she was prepared for her ending. She had lived the life she had chosen. Her only regret, she joked, was a small one: She had never learned to tango.[81]

The summer after Joan's disastrous sailing trip with Jean-Paul through the Aegean, she persuaded him to join her for a taste of life on Long Island. Though she was showing in New York, Minneapolis, Paris, Milan, and Munich, and though her work sold well despite the rush to Pop, in France she was still regarded as the big man's "wife." The summer of 1960 on Long Island, however, their roles were reversed: Joan was the artist and Jean-Paul the partner who "also painted." As had she, he bridled at that position and Joan's evident delight in being back among her tribe. Jean-Paul tried to strike out on his own: He took over the studio at Bob Keene's that had been newly deserted by Grace, bought a gray Jaguar and a boat, and found himself a mistress. Still he felt lesser. And still Joan did not alter her behavior. Their disagreements turned physical. One day, Joan appeared with a black eye behind her large sunglasses.[82] The melodrama continued until Joan returned with Jean-Paul to Paris, and the sanctity of her studio.

Back on the rue Frémicourt, Joan's canvases grew to ten feet long and combined elements of her best work of the mid-1950s. She seemingly could not miss in the paintings she produced between 1960 and 1962, and yet she kept them turned to the wall of her studio.[83] She had been the subject of a cover story in *ArtNews* in 1961, but no one in Paris really knew what she was doing.[84] That is, until 1962, when Joan had an exhibition coordinated by two galleries on either side of the Seine. It was her biggest show so far in Europe. Jean-Paul was there, as were Barney, Beckett, Zuka—all the friends she had collected in Paris.[85]

The show was a tremendous success: The exhibition on the Right Bank, at Galerie Dubourg, sold out. At the second venue, Galerie Lawrence on the Left Bank, her triumph was also sweet but unfortunately brief. That gallery was run by American Lawrence Rubin, who had reached a deal with Joan to show her work, and to buy ten thousand dollars' worth of paintings from her studio each year. Not long after the exhibition, however, he abruptly announced an end to the agreement. Joan discovered that he did so at Clem's behest. Now fully backing hard-edged abstraction and the Color Field School, Greenberg told Rubin to "get rid of that gestural horror" Mitchell, and Rubin did.[86] Joan found herself without a gallery in Paris until 1967.

Though disappointed and angry, Joan remained resolute. She felt no inclination to make her creations palatable to the likes of Clem. "My paintings have nothing to do with what's in and what's not.... I'm not selling Palmolive soap," she told art critic Deborah Solomon.[87] Joan returned to paint in the shadows while appearing publicly at Jean-Paul's side as he collected prizes, sailed the Med, rented villas in tony Côte d'Azur enclaves, and made the social circuit among a swarm of celebrities.[88] And then in 1967, Joan's life became the one *she* wanted. She signed on with the Galerie Jean Fournier in Paris and found a refuge in which to live and work.

Following the death of her mother that year, Joan inherited a small fortune.[89] Though she thought of herself as a "Cedar bar or Montparnasse" person, she used her grandfather's "bridge money" to buy an estate an hour northwest of Paris at Vétheuil.[90] The large stone house, situated on a hill amid two acres of gardens and trees, overlooked the Seine. The grounds were dotted with smaller structures, one of which had been the home of Claude Monet.[91] Beginning in 1968, a much more turbulent artist took up residence on that hill and remained for more than twenty years. Having a ground-floor studio (the doors of which she could lock) separated from the main house changed Joan's work dramatically.[92] In an environment so rich in natural bounty, buffeted by wind and overlooking water as she had as a child, a part of Joan long buried awakened. The "violent" high notes of yellows and reds she first used as a girl returned.[93] Joan's canvases shone like light. "I become the sunflower, the lake, the tree. I no longer exist," she explained.[94]

Though Joan had removed herself from New York, even largely from Paris, and though she had not bowed to art-world fashions, her work garnered increasing attention. Tucked away in her studio in rural France as Jackson had been in his barn in Springs, Joan had stayed true to herself on canvas, and the art world came to appreciate the extraordinary beauty of what she had done. At forty-seven, Joan had her first solo museum exhibition at the Everson Museum of Art in Syracuse, New York. Two years

later, in 1974, she had a solo show at the Whitney.[95] And in 1976 she joined the Xavier Fourcade Gallery in New York, which also represented Bill and the Gorky estate.[96] Joan's painting life was healthy on all fronts. Her personal life, however, was in shambles. One young woman who met Joan described her as "the most distraught, lonely, agonized person in the world."[97]

Joan never married Jean-Paul and never had the "one small child" she had so wanted, but she accepted Jean-Paul's daughters, Yseult and Sylvie, as her own. She marked the birth of Yseult's first child with a painting, *Bonjour Julie,* and loved the infant as her granddaughter.[98] Her attachment to his family, however, did not save Joan's relationship with Jean-Paul. Their battles became epic. Their distance from one another grew. In 1979, Jean-Paul left Joan for a young woman she derisively called her "dog-sitter."[99]

The young woman in question was a twenty-four-year-old American named Hollis Jeffcoat whose arrival in the mid-seventies had revived Joan's personal life in the way the Vétheuil sunflowers had reawakened her paintings. Elaine had been teaching at an American art school in Paris where Hollis worked and suggested she accompany her to Vétheuil to see Joan. Elaine's trip was partly to proselytize the virtues of sobriety to her alcoholic friend. Joan, however, remained skeptical. She needed liquor to paint. She would not risk trying to work without it.[100] But she was thrilled by Elaine's companion and the talented young painter became part of Joan's household after Elaine left. Men existed in the two women's lives, but, Hollis said, "My real passion was with Joan. And hers was with me."[101] During the second half of the 1970s, however, the dynamics at Vétheuil shifted. Joan's paintings—especially a series she called *Tilleul*—reflected the change: The brushstrokes are strident, the space claustrophobic, the mood stormy. Jean-Paul had decided that he, too, was in love with Hollis.[102] And when it became necessary to choose between them, Hollis picked Riopelle. Devastated, Joan recorded her desolation with a nine-foot-by-twenty-two-foot painting, which she sarcastically called *La Vie en Rose*.[103]

Joan's life was saved by the appearance of a thirty-one-year-old French composer named Gisèle Barreau. For the rest of Joan's life, she brought music and support—personal and artistic—to the troubled painter. They supported each other.[104] Joan's work in the wake of her friendship with Gisèle was among her most radiant, especially the *Grande Vallée* series based on a story Gisèle told her.[105] Painted beginning in 1983, the series did not, however, form part of her most important show in France. In 1982, Joan became the first American woman to have an exhibition at the Musee d'Art Moderne de la Ville de Paris.[106]

The pattern of Joan's turbulent life was such that a professional victory

was nearly always followed by a personal defeat. And such was the case after her exhibition. The next year, Joan learned she had cancer.[107] At the age of fifty-nine, she began a slow and painful physical descent and wondered about her place as an artist so many lifetimes from where she had begun. "I'm not so sure the likes of us count very much in the world anymore," she wrote Barney in 1986. "I mean 'art' writing etc—those things one believed in."[108] But Joan *did* have a place in the world. Her contribution to Western art during those final years was recognized in awards: She was appointed Commandeur des Arts et Lettres by the French Ministry of Culture and given the Grand Prix National de Peinture in France, as well as the Grand Prix des Arts de la Ville de Paris.[109] Meanwhile, her work was celebrated in shows, including a retrospective that toured the United States, a solo exhibition of her drawings at the Whitney, and annual gallery shows in New York and Paris.[110]

Quite remarkably, despite advanced cancer and two hip surgeries, Joan continued to produce large-scale works at her Vétheuil studio and a series of large color lithographs at Tyler Graphics in 1992. The lithographs were made during Joan's last trip to New York.[111] Not long afterward, the U.S. State Department noted the death of an American in Paris with a certificate:

> Joan Mitchell age 67
> Died October 30, 1992, at 12:50 am, natural causes, cremated.
> Traveling/residency abroad with relatives or friends as follows:
> Name: Alone[112]

Joan had not been alone. She had Gisèle, the young people she collected, lifelong friends who loved her, her faithful dogs, and her work. And yet that one word "alone," typed by a bureaucrat who did not know her, was poetically astute. Throughout her life, Joan had done her best to drive people away by her cantankerous behavior, which worsened with age. Before her death, discussing funeral plans with a friend, Joan supposedly asked her to tell people at the service to consider for a moment the one terrible thing she had done to them and to forgive her. "Looking about, I saw people figuratively counting one, two, three," wrote Irving Sandler of the memorial.[113] And yet, as painful as it was for her *and* those she knew, Joan had alienated people for a reason. Her isolation had enabled her to survive and thrive. Without it she could not have left behind such riches.

As directed in her will, the artist-endowed nonprofit Joan Mitchell Foundation was established the year after her death to preserve her legacy and help support diverse artists and organizations with grants. Through the past decades, it has added programs to help older artists with their legacies.

* * *

At just thirty-one, after painting professionally for less than a decade, Helen was awarded a retrospective in January 1960. The Jewish Museum in New York displayed nineteen paintings by Helen from the 1950s and selected Frank O'Hara to write the catalog essay. The show marked in every way a turning point for Helen, displaying in the museum's three rooms how far the young woman who appeared on the scene fresh from Bennington had come and the revolution in painting she had created.[114] The mixed reviews of the show were also revelatory, providing a glimpse of the opposition she would face in the coming decades as her celebrity grew. The articles reflected less on Helen than on the changed atmosphere in the art world toward women, as well as a brewing resentment among some over the Motherwells' perceived exalted social position. *Art International* critic Barbara Butler reduced Frank's long and embracing catalog essay on Helen's work to just three words: Her review quoted him as saying Helen's paintings had a "Watteau-like sweetness."[115] *ArtNews* was similarly dismissive, prompting Helen's friend B. H. Friedman to fire off a letter over the "dishonest" review that compared Helen's paintings to Rorschach tests. "I'm willing to go out on a limb" and "bet" the critic didn't like Helen "for reasons completely outside the work," he wrote.[116]

In the early 1960s, women painters faced peculiar criticism. Reviewers no longer merely discredited their work, they also attacked their persons. "Nowadays there is a rather handsomely garbed *monde* of women artists in New York, but they have for the most part married and adopted lives of more or less stable rhythm," Eleanor Munro concluded in a 1961 article on Joan in *ArtNews*.[117] Jane Freilicher responded with a biting critique of "anthropological art criticism," but an angry letter could not turn the critical tide.[118] With each exhibition, an artist like Helen had to brace for reviews reacting as much to herself as to her art. "What a pity," Helen wrote her fellow artistic and social trailblazer Grace, "that we married, chic, square, bourgeois females cannot share the true American bohemia of other women!"[119] At the start, Helen was so busy she was able to joke about the subject. In the spring of 1960, she and Bob traveled to Paris to collect her first prize for painting from the Biennale de Paris.[120] And in the fall, Bob's ex-wife Betty sent their children, Jeannie, eight, and Lise, six, to live with Bob and Helen while Betty navigated her way through another divorce.

The girls thought they were visiting their father for Thanksgiving as they had done in the past, but they learned after the holiday that they wouldn't be returning to their mother in Virginia.[121] They were terrified, traumatized, and sad. "Helen got caught up in the emotional aftermath of my mother leaving us," Lise explained, "and I think she probably got a lot

of the hated stepmother because of that. It had nothing to do with her, really, but because it's easier to hate your stepmother, who has taken you in, than your mother who left you."[122] For Helen, the sudden transition from wife to mother was equally unnerving. "I have had so many things mirrored glaringly in my face this winter—health, age, being a woman, wife, artist; independent and free, attached (and often feeling) trapped," she wrote Grace after the girls moved in. "The truths and choices can get so blurred at times."[123] Tensions gradually eased, however, for the Motherwell women large and small, and soon the fun they had in each other's company featured largely in their lives as family. A young Irish nanny helped considerably in that regard.[124]

Helen entrusted her stepdaughters to the school that had rescued her as a teenager, Dalton. "At Dalton everybody's parents were divorced, and everybody's parents were famous," Jeannie said. "So that was kind of a comfort zone."[125] Recognizing that children needed order in their lives, Helen also established an uncharacteristically rigid routine.[126] Helen had moved her studio to East 83rd Street, about ten blocks south of their home, and kept a schedule as strictly as any working mother, albeit one whose life involved exhibitions in Paris, Milan, Los Angeles, and New York.[127] The perfectionist in her deftly juggled her work and her young charges, who visited her in her studio, painting and dancing (to Chubby Checker and the Beatles) along with her.[128] But the arrangement only lasted two years. Helen's and Bob's steps to gain permanent custody having failed, in 1962 they reached an agreement with Betty to share custody. The girls would live in Virginia during the winter and with Helen and Bob in the summer.[129]

Unlike Lee, Grace, Elaine, or Joan, Helen's paintings became "fashionable" during the early and mid-1960s. She became a favorite subject of mainstream magazines that appealed to high-end readers.[130] At a time when her old artist friends were engaged in leftist political struggles, Helen was increasingly associated—rightly or wrongly—with their opposite. It was during this period that Helen Frankenthaler's name began to be erased from the avant-garde honor roll, again based not on what she did in her studio but on how she lived her life. The sting of being so misunderstood was diminished somewhat by the presence of friends who truly knew her. Sculptor David Smith was an important one of them.

In 1964, Helen began to work in ceramics in Vermont with him.[131] Since her marriage to Bob, her relationship with David had become familial. He had daughters the ages of Jeannie and Lise, and the two families spent summers together at Provincetown, where Helen and Bob had a home and studios. He closed a circle in their lives. He was Bob's best friend and, aside from Grace, Frank, and poet Barbara Guest, the person from the

1950s downtown scene whom Helen loved best. That was why in May 1965 his death proved so devastating. In his truck, Smith had been chasing artist Kenneth Noland's Lotus sports car over a mountain road on the way to an opening at Bennington. Smith hit a guardrail and his truck overturned. After Noland called Bob in the city to say the injuries were grave, Helen "threw some things in a bag and I drove one hundred and ten miles per hour to Albany," where David had been taken, Bob recalled. "He died about fifteen minutes before we got there."[132]

During the next few years, Helen showed and taught at a manic pace: solo shows in New York, Toronto, Los Angeles, Detroit, and a retrospective at the Whitney that traveled to London and Berlin; group exhibitions throughout the United States and in 1966 at the Venice Biennale; teaching stints at Yale, Columbia, Hunter College, and Princeton.[133] And still she painted. In fact, in 1967 she created her largest work ever, the thirty-one-foot-high *Guiding Red* for a dome designed by Buckminster Fuller.[134] Throughout all that activity, Helen also maintained a full social life. "She liked to go to six parties in a night instead of just one," explained Lise. "She liked to be where the action was."[135] At first Helen's outrageously outgoing nature enlivened Bob. She drew him into a broader, more active society. But gradually Bob began drinking more.[136] So many of his friends had died. David. Frank on the beach in 1966. Barney Newman of a heart attack. Mark Rothko, a suicide in his studio.[137] Bob grew more introspective, and he and Helen drifted apart. In 1970, he purchased a house in Greenwich, Connecticut, thinking a move from the city might be good for them both. Their marriage, however, proved too fragile to make the change. In July 1971, Helen and Bob divorced.[138]

At forty-two, after thirteen years of marriage, Helen found herself alone on East 94th Street suffering the second major depression of her life, the first having been after the death of her father.[139] Art provided a refuge. She designed a set for the Erick Hawkins Dance Company, and traveled to London to work with Anthony Caro to produce ten welded-steel sculptures. She created painted book covers, which were shown at the Metropolitan Museum of Art, and returned to clay sculpture. But most importantly she revolutionized the art of woodcut printing. Said *New York Times* critic Grace Glueck, Helen's first woodcut, *East and Beyond*, "became to contemporary printmaking in the 1970s what Ms. Frankenthaler's paint staining in *Mountains and Sea* had been to the development of Color Field painting twenty years earlier."[140] The medium was changed forever after. Helen had moved deeply into art, all aspects of it. But by the mid-1970s, she declared that she was withdrawing from the society of artists. Renting a summer place in Connecticut to avoid Long Island or the Cape, she surrounded herself with intellectuals, most of whom, she said,

were "concerned with words."[141] Among them were loyal critics and historians she could count on to treat her work with respect. One of them, Gene Baro, curated a show of her paintings at the Corcoran Gallery in Washington in 1975.[142]

The press attention was extraordinary. Helen's shows always garnered coverage, but the Corcoran exhibition occurred amid a contentious and widespread debate, begun by feminist scholars, about a woman's place in the art world. Helen did not think of herself as a "woman artist" and did not subscribe to feminism, but because she was considered by some cultural arbiters to be the most important living woman artist, her show attracted an unusual amount of interest. Once again, some of it was negative and based not on Helen's art but on the times. In the *Washington Post*, her "regal" posture, "intentionally bland" responses, "gliding" gait, and status as the "queen of American abstract art" was mocked. Critic Paul Richard seemed to count against her that ambassadors, senators, and Supreme Court justices had accepted invitations to the museum's ball in her honor. "Women artists here and elsewhere regard her as a heroine," he wrote.[143] That, in fact, may have been the rub. He mistook Helen's guardedness in response to his questions as arrogance.[144] Unfortunately, by 1989, when Helen became only the second woman, after Lee, to have a retrospective at the Museum of Modern Art, this was the reputation that dogged her, and she responded accordingly.[145]

Helen became two women. "In private, she seemed in many ways to be the woman she was said to have been in the 1950s—adventurous, loving, spontaneous, funny," said her niece, Ellen M. Iseman.[146] Publicly, she had developed a shield of protection so thick that her other self was nearly invisible.[147] She was called "aloof" and "patrician."[148] "Her eyes are wide and brown, and this particular morning, faintly skeptical," a writer reported in the *Christian Science Monitor*. "She speaks in a low, controlled voice with a faint rasp.... Her words are carefully spaced."[149] Helen's face, previously so open, reflected the change in her attitude toward the outside world. Though still beautiful, as she aged her jaw became more prominent, more set. Helen complained that she was lonely and at times, succumbed to terrible depression and wondered about the life she had chosen.[150] When asked what stardom and money meant, Helen replied, "Beans."[151]

In 1994, at sixty-five, Helen settled as far outside the world of art as she could have. She married investment banker Stephen DuBrul Jr., a former head of the Export-Import Bank who had worked for the CIA during the Korean war, and moved into a house on the water in Darien, Connecticut.[152] Outwardly, she had become the person her detractors described: a woman of the haute bourgeoisie. But as her work circled the globe, Helen

the artist continued to create for more than a decade.[153] At eighty she produced one of her most beautiful prints, *Weeping Crabapple,* which looked in technique and sensibility as though it might have been done by that much younger Helen of 1952. When Helen died at home in 2011, after a long illness that affected her physically and mentally, she left behind nearly sixty years of paintings that told the story of who she really was.

Helen was buried on the Bennington campus.[154] Like Lee and Joan, she also bequeathed the bulk of her vast estate to fund a foundation: the Helen Frankenthaler Foundation. In addition to preserving her legacy, its goal is to promote greater public interest in and understanding of the visual arts.

Acknowledgments

There are so many individuals and organizations to thank in connection with this project that I feel inadequate in undertaking to do so. Biographers are pesky types. They introduce themselves to those they would like to interview with a simple phone call or e-mail, and then proceed to bother the person at the other end of the line for years to come. There is always one more question to ask, one more document to find, one more anecdote to corroborate. In the case of this book, I have pestered some friends and relatives of my characters for seven years! I often wonder if they regret having uttered their fateful first yes to my question "Can we meet to discuss..." But without those generous individuals, this book—any biography—could not be written. If we're no longer around to tell our own tales, most of us are a mere accumulation of statistics until those who knew us flesh out our lives with their memories. I was incredibly lucky in undertaking this project that so many people were willing to help, and that so many of them were superb storytellers. If, after reading this book, you feel you understand Lee, Elaine, Grace, Joan, or Helen a little better, it is because of them.

A project of this scope involves a good deal of planning, but it is often the serendipitous encounters that are the most rewarding. A series of those began for me after I contacted a woman named Doris Aach, whose name I had seen in the back of Mark Stevens and Annalyn Swan's biography of Bill. I wanted to speak with her about Elaine's death but, in the course of our first conversation, she happened to mention—almost as a verbal postscript—that she had transcribed, as a favor to Elaine, fourteen interviews or lectures Elaine had done or given over the years. She asked if I would like them. The transcriptions amounted to about two hundred pages of Elaine de Kooning at her most candid. I could only have been more thrilled had I had Elaine herself sitting in front of me. But that wasn't the end of the surprises Doris, with her boundless generosity and intelligence, held in store for me. It was through her that I met some of the people who would be critical in telling the *Ninth Street Women* story: painter Natalie Edgar, and Ernestine and Denise Lassaw among them.

Natalie had not only lived the scene, she wrote about it in a wonderful

and essential book called *Club Without Walls*. During a few meetings (some formal, others not so), several telephone calls, and many e-mails, she was a constant source of information about the characters and the times, as well as other people to contact, and places where I might find important documents. Natalie was also a sounding board I turned to frequently for advice. As to the Lassaws, it would have been impossible to tell Elaine's story, especially, without them. When I met them in 2013, Ernestine was one hundred years old and it is no exaggeration to say that her mind had not diminished one bit from the girl she was when she had arrived in New York at twenty. She spoke for several hours about Elaine, Bill, her late husband, Ibram, New York in the 1940s and 1950s, and the many characters she counted as friends and family. What Ernestine failed to tell me, her daughter, Denise, did. She was raised amid the characters of the New York School and knows their story intimately. She is also an expert archivist: Denise had seemingly any document related to her family and their closest friends within reach. After Ernestine died in 2014, Denise continued to speak for the family and about her godmother, Elaine, and she continued to help.

Some of the artists I've written about established foundations or study centers to protect their legacy and assist other artists. All such organizations I consulted were very helpful, but two went well beyond what might have been expected. Laura Morris, archivist at The Joan Mitchell Foundation, allowed me to sit beside her in an office the size of a large closet for many weeks while I pored through primary material related to Joan. Her patience was extraordinary, and her guidance invaluable through the years as I've consulted her on numerous issues related to Joan. She, too, undertook introductions on my behalf and helped me secure interviews with people who might have been reluctant to speak with one more probing writer. I would also like to thank the foundation's chief executive officer, Christa Blatchford, for allowing me to use archival material, and Courtney Lynch for ensuring that I did so correctly. The Helen Frankenthaler Foundation opened its doors to me and my project before it even had a proper office. Elizabeth Smith was named director at about the time I arrived in New York asking for help. Though she had a myriad of other concerns in transforming the foundation from a somewhat private organization to a more public one, she graciously extended a hand. Elizabeth not only advised me, she helped me connect with friends and family of the artist. Very soon, she was joined at the foundation by Maureen St. Onge, Sarah Haug, and Cecelia Barnett, who were indispensable to this project and to whom I turned countless times for help. Maureen even spent an afternoon with me in a Bronx warehouse, as we sifted through letters

found among Helen's papers that still had not been transferred to a permanent facility. I'd also like to thank Helen Harrison of the Pollock-Krasner House and Study Center, as well as artist Ruby Jackson, who no longer works there. Helen and Ruby allowed me to sit in Lee's kitchen while researching her portion of my book. It was thrilling to read Lee's words and hear her interviews where she lived, and it was equally exciting to wander around her house and out to Pollock's barn as I tried to understand the remarkable happenings at that humble home a half century earlier. Through the years, Helen continued to advise me as questions arose, not only about Lee, but about Elaine, whom she knew, and the art scene in East Hampton, on which she is an expert. Finally, I would like to thank Gertrude Stein and the Schaina and Josephina Lurje Memorial Foundation, Inc., for their generous grant, which helped me secure some of the many images required to tell this story. Gertrude also introduced me to Boris Lurie's work and his place in, not just Elaine's story, but the story of the movement.

I am grateful to the staff at the Archives of American Art in Washington and New York for its help both during the months I spent using the archive's facilities and at a distance in responding to my many requests. Marisa Bourgoin, Bettina Smith, Elizabeth Botten, Margaret Zoller, and Craig Schiffert in Washington, and Joy Goodwin in New York helped make this project possible by allowing me access to their unparalleled trove of primary material.

I would also like to thank Reva Shovers and her late husband, Philip, for giving me access to the marvelous audiotaped interviews between the late curator Jack Taylor and the many artists involved in the Ninth Street Show. Biographer Annalyn Swan is temporarily the keeper of these tapes, and she graciously allowed me to hear them.

I would be remiss if I failed to mention the contributions made, not just to this project but to history broadly, by several art historians and art writers without whose work we might know very little indeed about the women of the New York School. Beginning in the 1960s, while the official art world was preoccupied with the latest trends in art—and primarily the men behind them—a handful of writers courageously ignored their peers to write about women the art world might have otherwise forgotten. Writers like Barbara Rose, Cindy Nemser, Ellen Landau, Eleanor Munro, Joan Marter, Deborah Solomon, Phyllis Tuchman, Linda Nochlin, Amei Wallach, and Karen Wilkin have all made research like mine easier by having written about and published interviews by women who worked in painting and sculpture over the past sixty years. I would like to particularly thank Barbara Rose and Deborah Solomon for generously making available invaluable audiotapes they made with many of the characters in this

book, and for their advice and guidance. I want to thank and remember two art historians who were critical to this project. The late Irving Sandler for sharing his experiences with the people who populate my book, and his insights into the era. And the late Dore Ashton, who I had the great, great pleasure of interviewing for many hours one afternoon at her home. Though she was ill, it was one of the liveliest exchanges I had during the course of my research, and one of the most important.

I would also like to mention two men whose interviews and resulting books paint brilliant portraits of the times: John Gruen and Jeffrey Potter. Both conducted extensive interviews with dozens of characters from the Abstract Expressionist period. And both have left behind not only wonderful books—Gruen's *The Party's Over Now* and Potter's *To a Violent Grave*—but troves of remarkable interviews. My thanks to the Pollock-Krasner House and Study Center for giving me access to Potter's original interviews, as well as the rights to quote his book, and Julia Gruen for granting me the right to use her father's work, published and unpublished, in my own. I would also like to mention a book I read in manuscript form but is expected to be published soon, Edith Schloss's memoir, *The Loft Generation*. Her description of the scene in Chelsea in the 1940s is remarkable, and I thank Jacob Burckhardt for allowing me to quote from it. Finally, I would like to thank Maureen O'Hara for allowing me to quote from her brother Frank's important letters and poems.

And this brings me to family members of my five women. While some historians knew the characters personally, most were able to shed light primarily on the artists' professional lives. Without family members willing to share stories, many of the characters in my book might have seemed relatively one dimensional. I am immensely grateful to the nieces and nephews who entrusted me with information about their aunts and their extended families. I would like to thank Maud Fried-Goodnight, Luke Luyckx, Clay Fried, Charles Fried, and Dr. Guy Fried for helping me discover Elaine. Also, a special thanks to Paula Fried, Elaine's sister-in-law, for sharing her thoughts. I am very grateful to Clifford Ross, Fred Iseman, Ellen M. Iseman, and Jeannie and Lise Motherwell for their many recollections and insights into Helen, and in the case of Lise and Jeannie, acquainting me with their father. I thank Donna Sesee for her wonderful memories of her aunt, Grace, and Rex Stevens, who occupied a special place in Grace's life. Donna's and Rex's stories brought Grace roaring back to life. And finally, I thank Astrid Myers Rosset, for introducing me vicariously to her remarkable late husband, Barney. All of you were extremely generous with your time and your memories, and I hope you recognize your extraordinary family members in this work.

The following list is not comprehensive, but includes some individuals I

would like to thank and have not mentioned above: Mary Abbott, Francis Antonelli, Elizabeth Baker, Stefano Basilico, Mark Borghi, Eric Brown, E.A. Carmean Jr., Stephen Chinlund, Steve Clay, Tim Clifford, Tom Damrauer, Barbaralee Diamonstein-Spielvogel, Terence Diggory, Nicolette Dobrowolski, Geoff Dorfman, Sherman Drexler, John Elderfield, Andrea Felder, Jack Flam, Hermine Ford, Brandon Bram Fortune, Irene Foster, Connie Fox, David Frankfurter, Isaac Gewirtz, Brad Gooch, Joy Goodwin, Kimberly Goff, Timothy Greenfield-Sanders, John Gutman, Genie Henderson, Matthew Jackson, Shirley Jaffe, Suzanne D. Jenkins, David Joel, Dodie Kazanjian, Michael Klein, Karen Koch, Mikaela Sardo Lamarche, Jim Levis, Mark Lewis, Edvard Lieber, Monica Little, Nicholas Martin, Robert Saltonstall Mattison, Joshua McKeon, Sandy Gotham Meehan, Teresa Morales, Zuka Mitelberg, Steven Naifeh, Cynthia Navaretta, Hart Perry, Charmelle Pool, John Lee Post, Shawn Provencal, Margaret Randall, Katie Rogers, Alison Rowley, Amy Schichtel, Geoff Shandler, Anne Sisco, Jan Pierce-Stinchcomb, Mary Stubelek, Marvin Taylor, Elisabeth Thomas, Lynn Umlauf, Janice Van Horne, Joan Washburn, Jill Weinberg, Liz Woods, and Rufus Zogbaum.

I would also like to thank my agent, Brettne Bloom, for urging me to resurrect this project, which had been dormant for too long. Her instincts were, as always, impeccable. And I thank my editor, Asya Muchnick, for her patience, guidance, and diligence throughout this very long and complicated book. Asya's deep understanding of this story, the period, and seemingly everything else—cultural, historical, and social—helped me write the book I had hoped to write. Her attention to both the sweep of the narrative and the details that comprised it were invaluable. I also thank Genevieve Nierman, Sarah Haugen, and Cynthia Saad, who worked with Asya at Little, Brown to organize the many moving parts of this project, and Betsy Uhrig and David Coen, who steered the book through the all-important copyediting process.

And finally, I would like to thank the two most important people in my life. My husband John has lived all my books, but this one was perhaps the most difficult, if only because it was the most consuming. He made it possible for me to exist completely inside this story, and he made it more memorable—and fun—by joining me there. John was critical to every aspect of this project, from its conception to its realization, and I could not have written it without him. The other person is my mother. This project is very much indebted to her. She had a habit, when I was a child, of waking me up with dramatic announcements: about the Cuban missile crisis or the assassination of Bobby Kennedy, for example. But one message was far less historic—in fact, she probably doesn't even remember it. One morning she sat on my bed and said, apropos of nothing, that I could be

anything I wanted to be. *She* could have been anything she wanted to be but, like the Ninth Street Women, she was a product of mid-twentieth-century America, and because she was born a girl, no one had ever said that to her. Her great gift to me was giving me the freedom to see if she was right. It was a selfless act of love, which she has every right to regret but for which I will be forever grateful.

Copyright and Permissions Acknowledgments

Previously published material

ArtNews: Excerpts from reviews and articles published with permission of *ArtNews*, Copyright © Art Media Holdings, LlC.

City Lights: Frank O'Hara, excerpts from "A Step Away from Them" and "Adieu to Norman, Bonjour to Joan and Jean-Paul" from *LUNCH POEMS*. © 1954 by Frank O'Hara. Reprinted with the permission of The Permissions Company, Inc., on behalf of CityLights Books, citylights.com, and Maureen Granville-Smith, Administratrix of the Estate of Frank O'Hara.

Counterpoint: *A COMPLICATED MARRIAGE: MY LIFE WITH CLEMENT GREENBERG*, by Janice Van Horne, © 2012 Janice Van Horne. Reprinted by permission of Counterpoint.

Dr. Barbaralee Diamonstein-Spielvogel: *INSIDE THE NEW YORK ART WORLD*, by Barbaralee Diamonstein-Spielvogel. Rizzoli International Publications, Inc., 1979. Rights granted by copyright holder Dr. Barbaralee Diamonstein-Spielvogel.

Geoffrey Dorfman: *OUT OF THE PICTURE, MILTON RESNICK AND THE NEW YORK SCHOOL*, by Geoffrey Dorfman. Midmarch Arts Press, 2003. Permission granted by copyright holder Geoffrey Dorfman.

Natalie Edgar: *CLUB WITHOUT WALLS, SELECTIONS FROM THE JOURNALS OF PHILIP PAVIA*, Natalie Edgar, ed. Midmarch Arts Press, 2007. Permission granted by copyright holder Natalie Edgar.

Farrar, Straus and Giroux: Excerpts from "Joseph Cornell," "Edwin's Head," "In Memory of My Feelings," "Poem Read at Joan Mitchell's," "Poem," and "The Day the Lady Died" from *DIGRESSIONS ON SOME POEMS BY FRANK O'HARA: A MEMOIR* by Joe LeSueur. Copyright © 2003 by The Estate of Joe LeSueur. Reprinted by permission of Farrar, Straus and Giroux.

David Frankfurter: Quotations from *ORIGINALS: AMERICAN WOMEN ARTISTS*, by Eleanor Munro, A Touchstone Book, Simon & Schuster, Inc., 1982. Permission granted by copyright holder, David Frankfurter.

Grove: Excerpts from *MEDITATIONS IN AN EMERGENCY*, copyright © 1957 by Frank O'Hara. Used by permission of Grove/Atlantic, Inc., and Maureen Granville-Smith, Administratrix of the Estate of Frank O'Hara. Any third party use of this material, outside of this publication, is prohibited.

Julia Gruen: Quotations from *THE PARTY'S OVER NOW, REMINISCENCES OF THE FIFTIES—NEW YORK'S ARTISTS, WRITERS, MUSICIANS, AND THEIR FRIENDS*, by John Gruen. Copyright © John Gruen, 1972. The Viking Press, 1972. Permission granted by Julia Gruen.

HarperCollins: Twenty-four quotations [pp. 13–442, 811 words] from *CITY POET: THE LIFE AND TIMES OF FRANK O'HARA*, by Brad Gooch, © 1993, by Brad Gooch. Reprinted by permission of HarperCollins Publishers.

Excerpts from pp. 26–31, 38–9, 99, 117, 128, 169–71, 174, 178, 193–4, 266 from *ELAINE AND BILL: PORTRAIT OF A MARRIAGE*, by Lee Hall. © 1993 by Lee Hall. Reprinted by permission of HarperCollins Publishers.

Twenty brief quotes as submitted [pp. 55–366] from *LEE KRASNER: A BIOGRAPHY*, by Gail Levin. © 2011 by Gail Levin. Reprinted by permission of HarperCollins Publishers.

Penguin Random House: "Poem Read at Joan Mitchell's," "Olive Garden," and "L'amour avait passé par là" from *THE COLLECTED POEMS OF FRANK O'HARA*, edited by Donald Allen,

copyright © 1971 by Maureen Granville-Smith, Administratrix of the Estate of Frank O'Hara, copyright renewed 1999 by Maureen O'Hara Granville-Smith and Donald Allen. Used by permission of Alfred A. Knopf, an imprint of the Knopf Doubleday Publishing Group, a division of Penguin Random House LLC. All rights reserved.

Excerpt(s) from *DE KOONING: AN AMERICAN MASTER* by Mark Stevens and Annalyn Swan, copyright © 2004 by Mark Stevens and Annalyn Swan. Used by permission of Alfred A. Knopf, an imprint of the Knopf Doubleday Publishing Group, a division of Penguin Random House LLC. All rights reserved.

Excerpt(s) from *JOAN MITCHELL: LADY PAINTER* by Patricia Albers, copyright © 2011 by Patricia Albers. Used by permission of Alfred A. Knopf, an imprint of the Knopf Doubleday Publishing Group, a division of Penguin Random House LLC. All rights reserved.

Excerpt(s) from *TRACKING THE MARVELOUS* by John Bernard Myers, copyright © 1981, 1983 by John Bernard Myers. Used by permission of Random House, an imprint and division of Penguin Random House LLC. All rights reserved.

MB Art Publishing: *MERCEDES MATTER*, by Ellen G. Landau, Sandra Kraskin, Phyllis Braff, and Michael Zakian, MB Art Publishing, 2009, New York. Permission to quote from material in the book granted by Mark Borghi, Mark Borghi Fine Art.

Steven Naifeh: Quotations from *JACKSON POLLOCK, AN AMERICAN SAGA*, by Steven Naifeh and Gregory White Smith, Clarkson N. Potter, Inc. Publishers, 1989. © Steven Naifeh and Gregory White Smith, permission granted by Naifeh and Smith.

Cindy Nemser: Quotations from *ART TALK, CONVERSATIONS WITH 12 WOMEN ARTISTS*, by Cindy Nemser. Charles Scribner's Sons, 1975. Permission granted by copyright holder Cindy Nemser.

Oxford University Press: *RESTLESS AMBITION: GRACE HARTIGAN, PAINTER*, by Cathy Curtis (2015) 489w from pp. 14, 18, 40, 43, 48–49, 52, 56, 65, 67, 73–74, 134, 156, 160, 174–175, 338. By permission of Oxford University Press, USA.

Pollock-Krasner House and Study Center: *TO A VIOLENT GRAVE, AN ORAL BIOGRAPHY OF JACKSON POLLOCK*, by Jeffrey Potter. Pushcart Press, 1987. Permission to quote from material in the book granted by copyright holder, the Pollock-Krasner House and Study Center.

Simon & Schuster: *CLEMENT GREENBERG: A LIFE* by Florence Rubenfeld. Copyright © 1998 by Florence Rubenfeld. Reprinted with the permission of Scribner, a division of Simon & Schuster, Inc. All rights reserved.

Syracuse University Press: Syracuse University Press granted permission to reprint 1436 words from *THE JOURNALS OF GRACE HARTIGAN, 1951–1955*, edited by William T. La Moy and Joseph P. McCaffrey. © 2009 by Syracuse University Press.

VAGA: Text excerpts from *WHAT DID I DO? THE UNAUTHORIZED AUTOBIOGRAPHY* by Larry Rivers with Arnold Weinstein. (HarperCollins 1992). Approximately 1,045 words (spread throughout the publication). Text © Estate of Larry Rivers/Licensed by VAGA, New York, NY.

Estates

Estate of Janice Biala, for permission to quote from unpublished letters by Janice Biala. All quotes © Estate of Janice Biala.

Estate of Edith Schloss Burckhardt and Rudy Burckhardt, Jacob Burckhardt executor, for permission to quote from Edith Schloss's manuscript "The Loft Generation," and reproduce photographs by Rudy Burckhardt. All quotes and photographs © Estate of Edith Schloss Burckhardt and Rudy Burckhardt.

Estate of Michael Goldberg, Lynn Umlauf, director, for permission to quote from letters in the Michael Goldberg Papers at the Archives of American Art, and use of a photograph of Mike Goldberg. All quotes © Estate of Michael Goldberg.

Estate of John Gruen and Jane Wilson, Julia Gruen, executor, for permission to quote from the John Gruen and Jane Wilson Papers at the Archives of American Art, Smithsonian Institution, as well as to reproduce a John Gruen photograph. All quotes and photographs © Estate of John Gruen and Jane Wilson.

Estate of Grace Hartigan, Rex Stevens, executor, for use of spoken, written, and visual material by Grace Hartigan, including reproductions of the following paintings: *Grand Street Brides, Interior*

Copyright and Permissions Acknowledgments 725

'The Creeks,' Ireland, Six by Six, The Masker, The Persian Jacket, and Venus and Adonis after Peter Paul Rubens. All quotes and images © Estate of Grace Hartigan.

Harry A. Jackson Trust, Matthew Jackson director, for permission to quote from unpublished written material by Harry Jackson from the Trust's archives. All quotes © Harry A. Jackson Trust.

Estate of Paul Jenkins, Suzanne D. Jenkins executor, for permission to quote from letters and interviews by and to Paul Jenkins. All letters and interviews © Estate of Paul Jenkins.

Estate of Elaine de Kooning, Clay Fried executor, for use of spoken, written, and visual material by Elaine de Kooning, including reproductions of the following paintings: *Farol, Fairfield Porter, Joop Pink, Jaurez, Portrait of Leo Castelli, Self Portrait,* and *Untitled, Number 15*. All quotes and images © Elaine de Kooning Trust.

Estate of Lisa de Kooning for permission to use quotes by Willem de Kooning, courtesy of The Willem de Kooning Foundation. All quotes © Estate of Lisa de Kooning.

Estate of Ernestine and Ibram Lassaw, Denise Lassaw, executor, for permission to use spoken and written quotes by Ernestine and Ibram Lassaw, and photographs by Ibram Lassaw. All quotes and images © Estate of Ernestine and Ibram Lassaw.

Kenneth Koch Literary Estate and Karen Koch for permission to quote from the Kenneth Koch Papers at the New York Public Library, Henry W. and Albert A. Berg Collection of English and American Literature. All quotes © Kenneth Koch Literary Estate.

Estate of Frank O'Hara, Maureen O'Hara Granville-Smith executor, for permission to quote from written material, published and unpublished, by Frank O'Hara. All quotes © Estate of Frank O'Hara.

Estate of Larry Rivers and the Larry Rivers Foundation, for permission to quote unpublished papers in the Larry Rivers Papers at New York University. All quotes © Estate of Larry Rivers.

Estate of Barney Rosset, Astrid Myers Rosset executor, for permission to quote from published and unpublished material in the Barney Rosset Papers at Columbia University, and material in Ms. Myers Rosset's collection. All quotes © Estate of Barney Rosset.

Estate of Sonya Rudikoff, John Gutman and Elizabeth Gutman executors, for permission to quote from unpublished letters in the Sonya Rudikoff Papers at Princeton University. All quotes © Estate of Sonya Rudikoff.

Estate of Nina Sundell, for use of *Leo Castelli*, portrait by Elaine de Kooning.

Estate of Jack Taylor, Philip and Reva Shovers executors, for permission to quote from Taylor's audio-taped interviews with artists for a project on the Ninth Street Show.

Estate of Elisabeth and Wilfrid Zogbaum, Rufus Zogbaum executor, for permission to quote from the Elisabeth Zogbaum Papers at the Archives of American Art, and reproduce photographs by Wilfrid Zogbaum. All quotes © Estate of Elisabeth and Wilfrid Zogbaum; artwork © Estate of Elisabeth and Wilfrid Zogbaum/Artists Rights Society (ARS), New York.

Foundations

Josef and Anni Albers Foundation for use of unpublished printed material from its collection.

Helen Frankenthaler Foundation for the use of spoken, written, and visual material from the Foundation's archives and collection, including reproductions of the following paintings by Helen Frankenthaler: *Ed Winston's Tropical Gardens, Hôtel du Quai Voltaire, Mountains and Sea, Scene with Nude, Self Portrait,* and *Untitled* (1951). The Foundation also granted permission for the use of paintings outside its collection: *Jacob's Ladder* and *Trojan Gates*. Quotes and text by Helen Frankenthaler © Helen Frankenthaler Foundation, Inc. Artwork by Helen Frankenthaler © 2018 Helen Frankenthaler Foundation, Inc./Artists Rights Society (ARS), New York.

Joan Mitchell Foundation for use of spoken, written, and visual material from the Foundation's archives and collection, including reproductions of the following drawing and paintings by Joan Mitchell: *Untitled (Self Portrait), Untitled (1950), Cercando un Ago,* and *Untitled (1953)*. The Foundation also granted permission for the use of paintings outside its collection: *City Landscape, George Went Swimming at Barnes Hole, but It Got Too Cold,* and *Hemlock*. Quotes, text, and images by Joan Mitchell © the Estate of Joan Mitchell.

The Pollock-Krasner Foundation for use of spoken, written, and visual material by Lee Krasner, including the paintings and drawing: *Black and White, Milkweed, Seated Nude, Self-Portrait, Still Life, The Seasons, Untitled 1949,* and *White Squares*. Quotes, text, and artwork by Lee Krasner © the Pollock-Krasner Foundation/Artists Rights Society (ARS), New York.

Copyright and Permissions Acknowledgments

Larry Rivers Foundation, David Joel executive director, for use of quotations by Larry Rivers from the Larry Rivers Papers at New York University and the Grace Hartigan Papers at Syracuse University. All quotes © Estate of Larry Rivers.

Milton Resnick and Pat Passlof Foundation, Nathan Kernan president and Geoffrey Dorfman secretary, for use of a photograph of Elaine de Kooning, Bill de Kooning, and Pat Passlof. Image © the Milton Resnick and Pat Passlof Foundation.

Libraries and Study Centers

Museum of Modern Art Archives for use of quotations from the Thomas B. Hess/De Kooning Papers; James Thrall Soby Papers; Dorothy C. Miller Papers; Monroe Wheeler Papers; International Council Program Papers.

New York Public Library, Photography Collection, for use of photographs from The Walter Silver Collection.

New York Public Library, Astor, Lenox and Tilden Foundations, The Henry W. and Albert A. Berg Collection of English and American Literature, Isaac Gewirtz, curator, for use of quotations from the Kenneth Koch Papers.

New York University's Fales Library and Special Collections, Marvin Taylor, director, for use of quotations from written material, published and unpublished, in the Larry Rivers Papers.

Pollock-Krasner House and Study Center, Helen Harrison, director, for use of spoken, written, and visual material related to Lee Krasner, Jackson Pollock, and Elaine de Kooning, especially the audiotape collection of Jeffrey Potter interviews.

Princeton University Library, Manuscripts Division, Department of Rare Books and Special Collections, for use of quotations from unpublished letters in the Sonya Rudikoff Papers.

Syracuse University Libraries, Special Collections Research Center, for use of written and photographic material from the Grace Hartigan Papers.

University of Connecticut Libraries, Storrs, Archives & Special Collections at the Thomas J. Dodd Research Center, for use of quotations from the Allen Collection of Frank O'Hara Letters.

Media

Local Television for The Town of East Hampton, New York, Genie Henderson Archivist, for use of quotations from the programs *Summer of '57, Josephine Little: The Art Crowd, c. 1940s–50s, Art Barge—Artists Speak*, with Elaine de Kooning, *Elaine de Kooning Tribute, De Kooning at the Whitney*, and *A Sense of Place*. All quotes © LTV, Inc.

The author has made every attempt to contact copyright holders. If any have been inadvertently overlooked, the appropriate arrangements will be made at the first opportunity.

Notes

In citing works and interviews, short titles have been used, with full descriptions, titles, and publishing details given in the Bibliography. Institutions frequently cited have been abbreviated as follows:

AAA-SI—Archives of American Art, Smithsonian Institution, Washington, DC, and New York.
Columbia—Rare Book and Manuscript Library, Columbia University Library, New York.
GRI—Getty Research Institute, Los Angeles.
HFF—Helen Frankenthaler Foundation Archives, New York.
JMF—Joan Mitchell Foundation Archives, New York.
MOMA—The Museum of Modern Art Archives, New York.
NYPL—The Henry W. and Albert A. Berg Collection of English and American Literature, The New York Public Library, Astor, Lenox and Tilden Foundations.
NYU—Fales Library and Special Collections, New York University Libraries.
PKHSC—Pollock-Krasner House and Study Center, East Hampton, New York.
Princeton—Manuscripts Division, Department of Rare Books and Special Collections, Princeton University Library, Princeton, New Jersey.
Syracuse—Special Collections Research Center, Syracuse University Libraries, New York.
UConn—University of Connecticut Archives and Special Collections at the Thomas J. Dodd Research Center, Storrs, Connecticut.
Yale—Yale Collection of American Literature, Beinecke Rare Book and Manuscript Library, New Haven, Connecticut.

Introduction

1. Sara Ruddick and Pamela Daniels, eds., *Working It Out,* xv.
2. Erwin Panofsky, *Meaning in the Visual Arts,* 43–44; Meyer Schapiro, *Modern Art in the 19th and 20th Centuries,* 191, 220–21; John Dewey, *Art as Experience,* 13, 72–73; Cynthia Goodman, *Hans Hofmann,* 110. Artist and renowned teacher Hans Hofmann said, "Art is to me the glorification of the human spirit and as such it is the cultural documentation of the time in which it is produced."
3. Albert Camus, "The Artist as Witness of Freedom," commentarymagazine.com/articles/the-artist-as-witness-of-freedom.

Epigraph

1. Donald Allen, ed., *The Collected Poems of Frank O'Hara,* 92.

Prologue: The Ninth Street Show

1. Janice Biala to Jack and Wally [Tworkov], New Year's Eve, Naples, Italy, 1947, courtesy Tworkov Family Archives, New York.
2. Oral history interview with Milton Resnick, AAA-SI; oral history interview with Ludwig Sander, AAA-SI; Pat Passlof, "The Ninth Street Show," 61; Geoffrey Dorfman, ed., *Out of the Picture,* 284; Esteban Vicente, interview by Jack Taylor.
3. "9th Street, Nine Artists from the 9th Street Show," David Findlay Jr. Fine Art; Esteban Vicente, interview by Jack Taylor.

4. Oral history interview with Milton Resnick, AAA-SI; Pat Passlof, "The Ninth Street Show," 61; "9th Street, Nine Artists from the 9th Street Show," David Findlay Jr. Fine Art; Dorfman, *Out of the Picture,* 284; Bruce Altshuler, *The Avant-Garde in Exhibition,* 158. Some accounts say the artists rented the space at fifty dollars a month for two months. The show itself was up from May 21 to June 10, 1951.
5. Oral history interview with Esteban Vicente, April 6, 1982, AAI-SI; oral history interview with Esteban Vicente, November 27–December 4, 1982, AAA-SI; oral history interview with Ludwig Sander, AAA-SI; Esteban Vicente, interview by Jack Taylor.
6. Natalie Edgar, ed., *Club Without Walls,* 99.
7. Helen Frankenthaler, interview by Dodie Kazanjian, AAA-SI, 4; oral history interview with Ibram Lassaw and Ernestine Lassaw, AAA-SI; Milton Resnick, interview by Jack Taylor.
8. Edgar, *Club Without Walls,* 99; Dorfman, *Out of the Picture,* 284.
9. Leo Castelli, interview by Dodie Kazanjian, AAA-SI, 5–6; oral history interview with Leo Castelli, July 1969, AAA-SI; oral history interview with Leo Castelli, May 14, 1969, and June 8, 1973, AAA-SI; Laura de Coppet and Alan Jones, *The Art Dealers,* 82, 83.
10. *Summer of '57,* videotape courtesy of LTV, Inc.
11. Alice Goldfarb Marquis, *The Art Biz,* 240; Edith Schloss, "Edith Schloss Notes on Leo Castelli," from "The Castelli Saga," unpublished manuscript, Edith Schloss Burckhardt Papers (MS No. 1763), Subseries V.C., Box 16, Columbia.
12. Schloss, "Edith Schloss Notes on Leo Castelli," Columbia; Leo Castelli, interview by Dodie Kazanjian, AAA-SI, 5; Friedel Dzubas, interview by Charles Millard, AAA-SI.
13. Oral history interview with Milton Resnick, AAA-SI; Dorfman, *Out of the Picture,* 284.
14. Oral history interview with Leo Castelli, May 14, 1969–June 8, 1973, AAA-SI; Irving Sandler, *A Sweeper Up After Artists,* 38.
15. Altshuler, *The Avant-Garde in Exhibition,* 159; Mary Abbott, interview by author.
16. Eleanor Munro, *Originals,* 245; Thomas B. Hess, "There's an 'I' in 'Likeness,'" 85. In addition to Lee Krasner, Elaine de Kooning, Grace Hartigan, Joan Mitchell, and Helen Frankenthaler, the following women were also in the Ninth Street Show: Perle Fine, Anne Ryan, Day Schnabel, Sonia Sekula, Jean Steubing, and Yvonne Thomas.
17. "Lee Krasner Paintings from 1965–70," Robert Miller Gallery, January 4–26, 1991, n.p.
18. "After Mountains and Sea: Frankenthaler 1956–1959," 28.
19. Helen Frankenthaler, interview by John Gruen, AAA-SI, 8.
20. Pete Hamill, "Beyond the Vital Gesture," 110; Grace Hartigan journal excerpts, April 30, 1951, Box 31, Grace Hartigan Papers, Syracuse.
21. Marjorie Perloff, *Frank O'Hara: Poet among Painters,* 210n5.
22. "Joan Mitchell," transcript Barney/Sandy interview (Sandy Gotham Meehan), January 21, 2004, Barney Rosset Papers, Tape 5, Side 1, Series II, Box 3, Folder 5, Columbia; Albers, *Joan Mitchell,* 158.
23. Albers, *Joan Mitchell,* 164–65; oral history interview with Joan Mitchell, May 21, 1965, AAA-SI; Munro, *Originals,* 245.
24. Grace Hartigan, "Notes for Tribute to Elaine de Kooning" at Maria Rand College Gallery, Brooklyn, n.d., Box 9, Grace Hartigan Papers, Syracuse; Margaret Randall, telephone interview by author; Albers, *Joan Mitchell,* 189.
25. Elaine de Kooning and Rose Slivka, *Elaine de Kooning,* 28.
26. Oral history interview with Leo Castelli, July 1969, AAA-SI; "9th Street, Nine Artists from the 9th Street Show," David Findlay Jr. Fine Art; Altshuler, *The Avant-Garde in Exhibition,* 156; Edgar, *Club Without Walls,* 103. Philip Pavia said that the night before the show Franz Kline, Conrad Marca-Relli, and John Ferren made "mad adjustments" to Castelli's placement of the works.
27. Oral history interview with Leo Castelli, July 1969, AAA-SI; Altshuler, *The Avant-Garde in Exhibition,* 167.
28. Oral history interview with Leo Castelli, July 1969, AAA-SI.
29. Oral history interview with Ibram Lassaw and Ernestine Lassaw, AAA-SI; Sandler, *A Sweeper Up After Artists,* 39.
30. Herman Cherry, interview by Jack Taylor.
31. Oral history interview with Ludwig Sander, AAA-SI.
32. Russell Lynes, *Good Old Modern,* 299; oral history interview with Leo Castelli, May 14, 1969–June 8, 1973, AAA-SI.

33. Esteban Vicente, interview by Jack Taylor; Sandler, *A Sweeper Up After Artists,* 39; oral history interview with Ludwig Sander, AAA-SI; James Brooks, interview by Jack Taylor.
34. Edgar, *Club Without Walls,* 100.
35. Edith Schloss, "The Loft Generation," manuscript, Edith Schloss Burckhardt Papers (MS No. 1763), Subseries V.C., Box 15, Columbia, 172; Judith Malina, *The Diaries of Judith Malina,* 166; John Gruen, *The Party's Over Now,* 92; *Mercedes Matter,* interview by Sigmund Koch, Tape 1B, Aesthetics Research Archive; Edgar, *Club Without Walls,* 163. The list of events at The Club reproduced in *Club Without Walls* indicates the after-party for the Ninth Street Show occurred on June 8, but Malina's diary entry for May 21 has her attending the party on the night of the opening. It is possible there were two parties, which had been known to happen at the Club for a favorite artist's opening.
36. Philip Guston, interview by Jack Taylor; Steven Ezekiel Zucker, "Art in Dark Times," 58–59.
37. Lewin Alcopley, interview by Jack Taylor.
38. James Brooks, interview by Jack Taylor; Philip Guston, interview by Jack Taylor.
39. John O'Brian, ed., *Clement Greenberg: The Collected Essays and Criticism,* vol. 3, *Affirmations and Refusals, 1950–1956,* 120; Joellen Bard, "Tenth Street Days," 99. Charles Cajori said the Ninth Street Show inspired the cooperative art gallery movement because it proved artists could exhibit without the intervention of a dealer.

1. Lena, Lenore, Lee

1. Cindy Nemser, *Art Talk,* 58.
2. Lillian Kiesler, interview by Ellen G. Landau, AAA-SI, 2–3.
3. Ibid., 3–4.
4. Ibid., 4.
5. Ibid.; Larry Rivers with Arnold Weinstein, *What Did I Do?,* 79.
6. Goodman, *Hans Hofmann,* 52; Jeffrey Potter, *To a Violent Grave,* 64–65; Clement Greenberg, interview by Mitch Tuchman, AAA-SI, 2. Greenberg said, "Lee...was one of Hofmann's star students and Pollock got a lot from Hofmann through Lee. I think he got more than he realized from Hofmann's proximity."
7. Ellen G. Landau, *Lee Krasner: A Catalogue Raisonné,* 10, 300–301; Lee Krasner, interview by Barbara Novak, AAA-SI, 5; Gail Levin, *Lee Krasner,* 24, 40–41; Nemser, *Art Talk,* 83; Munro, *Originals,* 103.
8. Oral history interview with Lee Krasner, 1972, AAA-SI; Levin, *Lee Krasner,* 50, 55; Landau, *Lee Krasner: A Catalogue Raisonné,* 14, 301.
9. William H. Chafe, *Women and Equality,* 27; Marjorie Rosen, *Popcorn Venus,* 75–76.
10. Oliver W. Larkin, *Art and Life in America,* 10–11, 110–11; Richard D. McKinzie, *The New Deal for Artists,* 4; Celia S. Stahr, "The Social Relations of Abstract Expressionism, An Alternative History," 301; Rozsika Parker and Griselda Pollock, *Old Mistresses,* 38. Painter Mary Cassatt said she decided to live in France because in Europe a woman might be viewed as "someone, not something."
11. Steven Naifeh and Gregory White Smith, *Jackson Pollock,* 372.
12. *Lee Krasner, a Conversation with Hermine Freed,* videotape courtesy PKHSC; Lee Krasner, interview by Barbara Rose, AAA-SI, 9; Juanita H. Williams, "Woman: Myth and Stereotype," 238–39. Even the West's greatest thinkers have condemned women to physical and intellectual servitude. Hegel said, "Women can, of course, be educated, but their minds are not adapted to the higher sciences, philosophy, or certain of the arts." Said Nietzsche, "Man should be trained for war and women for the recreation of the warrior; all else is folly."
13. Lee Krasner, interview by Barbaralee Diamonstein, provided by Dr. Barbaralee Diamonstein-Spielvogel, interviewer and author, from *Inside New York's Art World* (© Dr. Barbaralee Diamonstein-Spielvogel), 204.
14. Nemser, *Art Talk,* 83; Lee Krasner, interview by Barbara Rose, 1975 GRI; B. H. Friedman, "Lee Krasner," draft manuscript 1965, Series 2.4, Box 10, Folder 7, Lee Krasner Papers, AAA-SI, 2; Levin, *Lee Krasner,* 30; Lee Krasner, interview by Barbara Novak, AAA-SI, 7.
15. Oral history interview with Lee Krasner, November 2, 1964–April 11, 1968, AAA-SI; Levin, *Lee Krasner,* 38–39; Landau, *Lee Krasner: A Catalogue Raisonné,* 301.

16. Levin, *Lee Krasner*, 49–50, 54–56; Ines Janet Engelmann, *Jackson Pollock and Lee Krasner*, 9; Naifeh and Smith, *Jackson Pollock*, 378.
17. Levin, *Lee Krasner*, 13, 59–61.
18. Oral history interview with Harold Rosenberg, AAA-SI; Naifeh and Smith, *Jackson Pollock*, 377.
19. Levin, *Lee Krasner*, 92, 95–96; Naifeh and Smith, *Jackson Pollock*, 378–81; Potter, *To a Violent Grave*, 64–65.
20. Lillian Kiesler, interview by Ellen G. Landau, AAA-SI, 5; Potter, *To a Violent Grave*, 65.
21. Levin, *Lee Krasner*, 62, 80–81; Lillian Kiesler, interview by Ellen G. Landau, AAA-SI, 3; Robert Hobbs, *Lee Krasner* (1993), 16; Naifeh and Smith, *Jackson Pollock*, 379.
22. Schapiro, *Modern Art*, 136; Larkin, *Art and Life in America*, 360–61; Sidney Janis, *Abstract and Surrealist Art in America*, 30; Herschel B. Chipp, *Theories of Modern Art*, 502; Jack A. Hobbs, *Art in Context*, 502. The first "modern" art movement in America was the Ash Can School, which existed from about 1907 to 1912. It was modern in part in that its subject was life on the street and those occupations that engaged the "little man" rather than the wealthy classes who bought art as decoration.
23. Willem and Elaine de Kooning, interview by Peter Busa and Sandra Kraskin, AAA-SI; Hobbs, *Art in Context*, 505–6; Dore Ashton, *The Life and Times of the New York School*, 30–31, 36; Chipp, *Theories of Modern Art*, 506.
24. Lynes, *Good Old Modern*, 4.
25. Ibid., 13–14, 20–21, 32–33.
26. John Bernard Myers, *Tracking the Marvelous*, 171; Lynes, *Good Old Modern*, 20, 249; Marquis, *Alfred H. Barr, Jr.*, 272–73.
27. Lynes, *Good Old Modern*, 43–44.
28. Ibid., 447; oral history interview with Lee Krasner, November 2, 1964–April 11, 1968, AAA-SI.
29. Landau, *Lee Krasner: A Catalogue Raisonné*, 302.
30. Lee Krasner, interview by Barbara Rose, 1972, AAA-SI, 1.
31. Lee Krasner, interview by Barbara Novak, AAA-SI, 11; Levin, *Lee Krasner*, 67; Lee Krasner, interview by Barbara Rose, 1972, AAA-SI, 1.
32. Terry Miller, *Greenwich Village and How It Got That Way*, 124.
33. Barbara Rose, *Lee Krasner: The Long View*, videotape courtesy PKHSC; Levin, *Lee Krasner*, 49; Deborah Solomon, *Jackson Pollock*, 112; John Lee Post, interview by author.
34. Naifeh and Smith, *Jackson Pollock*, 379; Lee Krasner, interview by Barbara Novak, videotape courtesy PKHSC; Lee Krasner, interview by Barbara Rose, 1972, AAA-SI, 1.
35. Lee Krasner, interview by Barbara Rose, 1972, AAA-SI, 1; Lee Krasner, interview by Barbara Novak, AAA-SI, 12; Levin, *Lee Krasner*, 75–76; Landau, *Lee Krasner: A Catalogue Raisonné*, 302; Robert Hobbs, *Lee Krasner* (1993), 17.
36. Levin, *Lee Krasner*, 75–76; oral history interview with Harold Rosenberg, AAA-SI; B. H. Friedman, *Jackson Pollock: Energy Made Visible*, 69.
37. Oral history interview with Ludwig Sander, AAA-SI; Lee Krasner, interview by Barbara Novak, AAA-SI, 11–12; Marquis, *Art Czar*, 134; "Abstract Expressionism: A Tribute to Harold Rosenberg," 9. Saul Bellow said of Harold, "I knew I had met a most significant person who did not, however, behave as significant persons generally do ... [he had a] workaday absurdist view of himself."
38. "Abstract Expressionism: A Tribute to Harold Rosenberg," 9; Sandler, *A Sweeper Up After Artists*, 182; Marquis, *The Art Biz*, 124.
39. Natalie Edgar, interview by author, January 20, 2014; Mark Stevens and Annalyn Swan, *De Kooning*, 222; Gruen, *The Party's Over Now*, 172.
40. Lee Krasner, interview by Barbara Novak, AAA-SI, 12.
41. Chandler Brossard, ed., *The Scene Before You*, 20; Lionel Abel, *The Intellectual Follies*, 34–35; Howard Zinn, *A People's History of the United States*, 386. According to Zinn, John Kenneth Galbraith blamed the crash on "unhealthy corporate and banking structures," "unsound foreign trade," "economic misinformation," and the "bad distribution of income." Said Zinn, "The highest five percent of the population received about a third of all personal income."
42. Peter Clements, *Prosperity, Depression and the New Deal*, 101–3, 132; Mauritz A. Hallgren, *Seeds of Revolt*, 271; Isabel Leighton, ed., *The Aspirin Age*, 286.
43. Hallgren, *Seeds of Revolt*, 48, 53–54, 64–65, 81, 118, 154, 165, 169, 191; Ashton, *The Life and Times of the New York School*, 18–19, 54; oral history interview with George Wittenborn, AAA-SI; Studs

Terkel, *Hard Times*, 381–82; Barbara Blumberg, *The New Deal and the Unemployed*, 17–18; Dorfman, *Out of the Picture*, 13; Ashton, *The Life and Times of the New York School*, 54.

44. Giorgio Cavallon, interview by Jack Taylor; Abel, *The Intellectual Follies*, 36–37; Terkel, *Hard Times*, 34, 381. The Empire State Building was at the time the world's tallest building, and the George Washington Bridge the world's longest suspension bridge.
45. Stevens and Swan, *De Kooning*, 111; Abel, *The Intellectual Follies*, 34–35; Brossard, *The Scene Before You*, 20.
46. Terkel, *Hard Times*, 380.
47. Gerald M. Monroe, "Artists as Militant Trade Union Workers during the Great Depression," 7.
48. Ross Wetzsteon, *Republic of Dreams*, 537; Elaine de Kooning and Slivka, *Elaine de Kooning*, 91.
49. Elaine de Kooning and Slivka, *Elaine de Kooning*, 92–93; Hayden Herrera, *Arshile Gorky*, 202–3; Giorgio Cavallon, interview by Jack Taylor.
50. Stevens and Swan, *De Kooning*, 96–97; Gruen, *The Party's Over Now*, 263–64; Nouritza Matossian, *Black Angel*, 151, 209; Edgar, *Club Without Walls*, 30.
51. Oral history interview with Harold Rosenberg, AAA-SI.
52. Oral history interview with Irving Block, AAA-SI.
53. Oral history interview with Harold Rosenberg, AAA-SI; Elaine Owens O'Brien, "The Art Criticism of Harold Rosenberg: Theaters of Love and Combat," 204–5.
54. Naifeh and Smith, *Jackson Pollock*, 379–80; Potter, *To a Violent Grave*, 64.
55. May Tabak Rosenberg, interview by Jeffrey Potter, audiotape courtesy PKHSC; Levin, *Lee Krasner*, 99; oral history interview with Harold Rosenberg, AAA-SI; O'Brien, "The Art Criticism of Harold Rosenberg," 204n83; Harold Rosenberg and May Tabak Rosenberg, interview by John Gruen, AAA-SI, 7.
56. Dore Ashton, *The New York School*, 53–54; Terkel, *Hard Times*, 298.
57. Richard Hofstadter, *The American Political Tradition and the Men Who Made It*, 414; Michael Parrish, *Anxious Decades*, 348. During its existence, the Works Progress Administration would employ eight million people, or about one-fifth of the nation's workforce.
58. Levin, *Lee Krasner*, 91; Ellen G. Landau, "Lee Krasner's Early Career, Part One," 112.
59. Barbara Rose, "Life on the Project," 76; Barbara Rose, *Lee Krasner: A Retrospective*, 34; Lee Krasner, interview by Betty Smith, November 3, 1973, courtesy PKHSC.
60. Oral history interview with Harold Rosenberg, AAA-SI; O'Brien, "The Art Criticism of Harold Rosenberg," 199–200; oral history interview with Irving Block, AAA-SI.
61. McKinzie, *The New Deal for Artists*, 77.
62. Ibid., 78–79; Ashton, *The Life and Times of the New York School*, 47.
63. McKinzie, *The New Deal for Artists*, 82; Gerald M. Monroe, "The Artists Union of New York," 19.
64. McKinzie, *The New Deal for Artists*, 99.
65. Ibid., 80; Alice Goldfarb Marquis, *Alfred H. Barr, Jr.*, 139.
66. Monroe, "The Artists Union of New York," 80, 149, 167.
67. Rose, "Life on the Project," 74–75; Levin, *Lee Krasner*, 87; Rose, *Lee Krasner*, 35; Monroe, "The Artists Union of New York," 73; Lee Krasner, interview by Barbara Novak, AAA-SI, 13; oral history interview with Max Spivak, AAA-SI; oral history interview with Harold Rosenberg, AAA-SI; Landau, *Lee Krasner: A Catalogue Raisonné*, 302–3.
68. Lee Krasner, interview by Barbara Novak, videotape courtesy PKHSC; O'Brien, "The Art Criticism of Harold Rosenberg," 203; oral history interview with Harold Rosenberg, AAA-SI; oral history interview with Max Spivak, AAA-SI; Ashton, *The New York School*, 53.
69. Robert Goldwater, "Reflections on the New York School," 20; oral history interview with Burgoyne Diller, AAA-SI; Lee Krasner, interview by Barbara Rose, 1972, AAA-SI, 2; Lee Krasner, interview by Betty Smith, courtesy PKHSC; Betty Smith, "Women on the Works Progress Administration/Federal Art Project," courtesy PKHSC; Stahr, "The Social Relations of Abstract Expressionism," 95; Clements, *Prosperity, Depression and the New Deal*, 209; Naifeh and Smith, *Jackson Pollock*, 269; David Sylvester, *Interviews with Artists*, 3; Giorgio Cavallon, interview by Jack Taylor. Cavallon said it was possible to live on three dollars a week, so the project salary was more than adequate. Philip Guston said some artists were uncomfortable "working for" the government.
70. Oral history interview with Harold Rosenberg, AAA-SI; Lee Krasner, interview by Barbara Rose, 1972, AAA-SI, 2; Whitney Chadwick, *Women, Art, and Society*, 297.

71. Lee Krasner, interview by Barbara Rose, 1972, AAA-SI, 2; Munro, *Originals*, 108; Chadwick, *Women, Art, and Society*, 297; Lee Krasner, interview by Betty Smith, courtesy PKHSC; Stahr, "The Social Relations of Abstract Expressionism," 95; Parrish, *Anxious Decades*, 348, 402, 405; William Henry Chafe, *The American Woman*, 39, 42; Clements, *Prosperity, Depression and the New Deal*, 209; Naifeh and Smith, *Jackson Pollock*, 269.
72. Jack Tworkov, interview by Anne Bowen Parsons, AAA-SI; Ann Eden Gibson, *Abstract Expressionism: Other Politics*, 10; Sylvester, *Interviews with American Artists*, 3; Lee Krasner, handwritten biographical notes, Series 2, Subseries 1, Box 7, Folder 14, Lee Krasner Papers, AAA-SI, 16; Harold Rosenberg, *Art on the Edge*, 196; Rose, *Lee Krasner*, 37–38.
73. *Lee Krasner*, interview by Barbara Novak, videotape courtesy PKHSC; Lee Krasner, interview by Barbara Rose, 1975, GRI; Lee Krasner, interview by Barbaralee Diamonstein, provided by Dr. Barbaralee Diamonstein-Spielvogel, interviewer and author, from *Inside New York's Art World*, 206; "Lee Krasner, Paintings, Drawings and Collages," 7; Landau, *Lee Krasner: A Catalogue Raisonné*, 304
74. Rose, *Lee Krasner*, 37–38; Monroe, "The Artists Union of New York," 54. The artists were so effective as protestors they were given the nickname "the fire brigade" and called in to help other unions or organizations man picket lines.
75. Oral history interview with Max Spivak, AAA-SI; oral history interview with Irving Block, AAA-SI; Monroe, "Artists as Militant Trade Union Workers," 8. Spivak said the women couldn't leave their children home alone, so they stayed throughout the noisy, emotional session.
76. Ellen G. Landau, Sandra Kraskin, Phyllis Braff, and Michael Zakian, *Mercedes Matter*, 26, 67n48; McKinzie, *The New Deal for Artists*, 96; Monroe, "Artists as Militant Trade Union Workers," 8.
77. Oral history interview with Eugenie Gershoy, AAA-SI.
78. Landau et al., *Mercedes Matter*, 26, 67n48; Levin, *Lee Krasner*, 118–19; McKinzie, *The New Deal for Artists*, 96; oral history interview with Irving Block, AAA-SI.
79. Schloss, "The Loft Generation," Edith Schloss Burckhardt Papers, Columbia, 174; *Mercedes Matter*, interview by Sigmund Koch, Tape 1A, Aesthetics Research Archive; Landau et al., *Mercedes Matter*, 13.
80. Landau et al., *Mercedes Matter*, 17–19, 62n16–17. The material on Mercedes's youth is from an undated "Autobiographical Sketch."
81. *Mercedes Matter*, interview by Sigmund Koch, Tape 1A, Aesthetics Research Archive; Landau et al., *Mercedes Matter*, 26; Matossian, *Black Angel*, 246.
82. *Mercedes Matter*, interview by Sigmund Koch, Tape 1A, Aesthetics Research Archive; Monroe, "Artists as Militant Trade Union Workers," 7; Landau et al., *Mercedes Matter*, 67n48–49. Quote on traveling up Fifth Avenue from "Mercedes Matter in Conversation," likely by Hayden Herrera.
83. Levin, *Lee Krasner*, 120; Landau et al., *Mercedes Matter*, 27; Lee Krasner, interview by Barbaralee Diamonstein, provided by Dr. Barbaralee Diamonstein-Spielvogel, interviewer and author, from *Inside New York's Art World*, 206; *Mercedes Matter*, interview by Sigmund Koch, Tape 1A, Aesthetics Research Archive.
84. Monroe, "Artists as Militant Trade Union Workers," 8; Monroe, "The Artists Union of New York," 71–72; *Mercedes Matter*, interview by Sigmund Koch, Tape 1A, Aesthetics Research Archive.
85. *Lee Krasner*, interview by Barbara Novak, videotape courtesy PKHSC.
86. Oral history interview with Max Spivak, AAA-SI; oral history interview with Irving Block, AAA-SI; *Mercedes Matter*, interview by Sigmund Koch, Tape 1A, Aesthetics Research Archive; Monroe, "Artists as Militant Trade Union Workers," 7–8; McKinzie, *The New Deal for Artists*, 96.
87. Oral history interview with Harold Rosenberg, AAA-SI; O'Brien, "The Art Criticism of Harold Rosenberg," 241, 254; Potter, *To a Violent Grave*, 64.
88. Levin, *Lee Krasner*, 95; Monroe, "Artists as Militant Trade Union Workers," 7; Landau, *Lee Krasner: A Catalogue Raisonné*, 303.
89. Oral history interview with Harold Rosenberg, AAA-SI.
90. Rose, *Lee Krasner*, 37–38; Landau, *Lee Krasner: A Catalogue Raisonné*, 304–5; Levin, *Lee Krasner*, 107–8, 112–13.
91. Levin, *Lee Krasner*, 95–96, 102; Naifeh and Smith, *Jackson Pollock*, 380–81.
92. Landau et al., *Mercedes Matter*, 22.

93. Cynthia Goodman, "Hans Hofmann as a Teacher," 122; Naifeh and Smith, *Jackson Pollock*, 382; Landau, *Lee Krasner: A Catalogue Raisonné*, 304. Hofmann's school was perennially short of cash because nearly half his students were on scholarships from the school's funds.
94. Lillian Kiesler, interview by Ellen G. Landau, AAA-SI, 5–6.

2. The Gathering Storm

1. Daniel Cotton Rich, "Freedom of the Brush," 48.
2. Ashton, *The New York School*, 87; William C. Seitz, *Abstract Expressionist Painting in America*, 158; Chipp, *Theories of Modern Art*, 157.
3. Levin, *Lee Krasner*, 115; Simone de Beauvoir, *America Day by Day*, 78–79; Abel, *The Intellectual Follies*, 34–35. The intellectuals around the artists spent their time at the Jumble Shop talking about "Charlie Marx."
4. Lynes, *Good Old Modern*, 133–35; oral history interview with Margaret Scolari Barr concerning Alfred H. Barr, AAA-SI.
5. Lynes, *Good Old Modern*, 134–35; oral history interview with Reuben Kadish, AAA-SI.
6. Lynes, *Good Old Modern*, 141.
7. Ashton, *The New York School*, 59; Jed Perl, *New Art City*, 18.
8. Lynes, *Good Old Modern*, 144–45; Ashton, *The New York School*, 85.
9. Lynes, *Good Old Modern*, 145, 150, 246, 248, 250, 299; oral history interview with Margaret Scolari Barr, AAA-SI; oral history interview with Dorothy C. Miller, AAA-SI; Dore Ashton, interview by author. In 1943 Barr went too far and was fired over a show he organized with Dorothy Miller called "American 1943: Realists and Magic Realists." Some of the pieces, including "puppet-like naked women," were seen as without aesthetic merit, especially at such a calamitous time in American history. Barr was given the opportunity to stay on at the museum writing—his office being the museum library—for half his salary. The museum, meanwhile, was run by a committee. In 1947, Barr was reinstated with the title Director of Museum Collections. Miller was named Curator of Museum Collections, and in 1950 René d'Harnoncourt, who had joined the Modern in 1944, was named museum director. Through all the turmoil, artists, critics, and collectors alike considered the Modern to be Barr's museum. Though stripped of his administrative power, he was viewed as its primary aesthetic and intellectual authority.
10. Lynes, *Good Old Modern*, 174; Stephen Polcari, *Abstract Expressionism and the Modern Experience*, 4–5. Even the word "culture" assumed new significance during this period because of the work of Margaret Mead and Ruth Benedict, who had determined that there was a distinctly "American culture" quite unlike the mostly European culture from which it was derived.
11. Terkel, *Hard Times*, 19.
12. Barbara Rose, *Art/Work/USA*, videotape courtesy Royal Academy of Art, London.
13. Parrish, *Anxious Decades*, 348, 405; Zinn, *A People's History*, 403.
14. Peter Conn, *The American 1930s*, 245; William Barrett, *Irrational Man*, 50; Stephen Polcari, *Lee Krasner and Abstract Expressionism*, 4.
15. George McNeil, interview by Jack Taylor; Abel, *The Intellectual Follies*, 30–31.
16. Lee Krasner, interview by Barbaralee Diamonstein, provided by Dr. Barbaralee Diamonstein-Spielvogel, interviewer and author, from *Inside New York's Art World*, 199; Levin, *Lee Krasner*, 123.
17. Rivers, *What Did I Do?*, 77–78.
18. Nemser, *Art Talk*, 72; Katharine Kuh, *The Artist's Voice*, 118.
19. Harold Rosenberg eulogy for Hans Hofmann, delivered at the artist's funeral on February 20, 1966, Box 15, Grace Hartigan Papers, Syracuse.
20. Harold Rosenberg, *The Anxious Object*, 132, 147.
21. Lillian Kiesler, interview by Ellen G. Landau, AAA-SI, 2; oral history interview with Lillian Orlowsky, AAA-SI; Rivers, *What Did I Do?*, 76.
22. Goodman, *Hans Hofmann*, 28; Hobbs, *Lee Krasner*, 23; Elaine de Kooning, "Hans Hofmann Paints a Picture," 38; Panofsky, *Meaning in the Visual Arts*, 381–82.
23. Rosenberg, *The Anxious Object*, 145; Ashton, *The New York School*, 79; Levin, *Lee Krasner*, 128; Lee Krasner, interview by Barbara Rose, June 27, 1978, GRI, 7; *Lee Krasner*, interview by Barbara Novak, videotape courtesy PKHSC; oral history interview with Harold Rosenberg, AAA-SI; Ashton, *The Life and Times of the New York School*, 79–80.

24. Hans Hoffman, Sara T. Weeks and Bartlett H. Hayes Jr., eds. *Search for the Real and Other Essays*, 40, 55; Goodman, *Hans Hofmann*, 40. "Creation is dominated by three absolutely different factors: first, nature, which works upon us by its laws; second, the artist who creates a spiritual contact with nature and his materials; third, the medium of expression through which the artist translates his inner world," Hofmann said. "The artist's technical problem is then to transform the materials with which he works back into the sphere of the spirit."
25. Kuh, *The Artist's Voice*, 119.
26. Virginia Admiral, interview by Tina Dickey, AAA-SI.
27. Barbara Rose, *Lee Krasner: The Long View*, videotape courtesy PKHSC; oral history interview with Lee Krasner, 1972, AAA-SI; Levin, *Lee Krasner*, 129; Donald Hall and Pat Corrington Wykes, eds., *Anecdotes of Modern Art*, 111; Germaine Greer, *The Obstacle Race*, 75. The compliment, while offered in praise of an individual is a condemnation of women generally. It implies that a woman who paints like a woman, according to Greer, is "second rank." Likewise, if an artist is praised as a "great woman painter" it again implies a secondary status.
28. Levin, *Lee Krasner*, 127.
29. Goodman, *Hans Hofmann*, 20, 25, 27, 28; Hobbs, *Art in Context*, 511; Jarrell C. Jackman and Carla M. Borden, eds., *The Muses Flee Hitler*, 30, 46; Deborah E. Lipstadt, *Beyond Belief*, 13–14; Rosenberg, *The Anxious Object*, 132–33.
30. Lipstadt, *Beyond Belief*, 13–15; Zucker, "Art in Dark Times," 14; Jackman and Borden, *The Muses Flee Hitler*, 30.
31. "Italy Invades Ethiopia," www.sahistory.org.za/dated-event/ww2-italy-invades-ethiopia; Terkel, *Hard Times*, 305.
32. Jackman and Borden, *The Muses Flee Hitler*, 37; oral history interview with Lillian Orlowsky, AAA-SI; Abel, *The Intellectual Follies*, 37; O'Brien, "The Art Criticism of Harold Rosenberg," 57. Dore Ashton said that between 1935 and 1939, the word "crisis" appeared in art magazines "incessantly."
33. Zucker, "Art in Dark Times," 151; Larkin, *Art and Life in America*, 430; Ashton, *The New York School*, 63–64.
34. Larkin, *Art and Life in America*, 430.
35. George McNeil, interview by Jack Taylor.
36. Rose, *Lee Krasner*, 37–38.
37. Ashton, *The Life and Times of the New York School*, 102.
38. Harry Holtzman, interview by Jack Taylor; James Brooks, interview by Jack Taylor; George McNeil, interview by Jack Taylor; Ashton; *The New York School*, 102–3.
39. Parrish, *Anxious Decades*, 453; James Brooks, interview by Jack Taylor; George McNeil, interview by Jack Taylor; Ashton, *The New York School*, 102–3; oral history interview with Lewis Iselin, AAA-SI.
40. "Bombing of Guernica," www.pbs.org/treasures of the world/guernica; Alfred H. Barr Jr., *What Is Modern Painting?*, 39.
41. Norman Davies, *Europe*, 985; Parrish, *Anxious Decades*, 452–53, 458.
42. George McNeil, interview by Jack Taylor; Parrish, *Anxious Decades*, 453.
43. George McNeil, interview by Jack Taylor.
44. Elaine de Kooning and Slivka, *Elaine de Kooning*, 226.
45. William Barrett, *The Truants*, 223.
46. Monroe, "Artists as Militant Trade Union Workers," 8–9; Parrish, *Anxious Decades*, 378.
47. Landau, *Lee Krasner: A Catalogue Raisonné*, 304; Levin, *Lee Krasner*, 120; Parrish, *Anxious Decades*, 378; Terkel, *Hard Times*, 303. After years of penurious stability, the economic situation in the United States had deteriorated markedly as a result of the WPA cuts. The country slid into a yearlong recession. It had been too soon to withdraw the money upon which millions depended to survive. Sidewalks around the Village were once again clogged with the sparse contents from the rooms and studios of evicted tenants
48. Levin, *Lee Krasner*, 99, 134; Solomon, *Jackson Pollock*, 113–14; Naifeh and Smith, *Jackson Pollock*, 381. Igor had also become something of a con man during those lean years. Playing the role of movie star, he perfected an act of sauntering into a restaurant, ordering whatever he pleased, and then offering to pay with a one-hundred-dollar bill, which the restaurant invariably did not have enough cash on hand to change. No doubt fearful of offending that rare breed—a well-heeled

customer—the restaurant routinely let him eat on the house. Lee's sister Ruth said Igor dined on that same hundred-dollar bill for years.
49. Rose, "Life on the Project," 80; Munro, *Originals*, 108; Willem de Kooning, interview by Anne Bowen Parsons, AAA-SI, 1; Stevens and Swan, *De Kooning*, 132; Levin, *Lee Krasner*, 130.
50. Levin, *Lee Krasner*, 130.
51. Munro, *Originals*, 108; Landau, *Lee Krasner: A Catalogue Raisonné*, 64; Bruce Glaser, "Interview with Lee Krasner," 26, 108; Hobbs, *Lee Krasner* (1993), 26–27.
52. Pepe Karmel, ed., *Jackson Pollock: Interviews, Articles, and Reviews*, 26.
53. Levin, *Lee Krasner*, 115.

3. The End of the Beginning

1. Wallace Stevens, "The Relations Between Poetry and Painting."
2. Levin, *Lee Krasner*, 133; Barbara Rose, "Life on the Project," 74, 79; Rose, *Art/Work/USA*, videotape courtesy Royal Academy of Art, London; Munro, *Originals*, 108.
3. Rose, *Art/Work/USA*, videotape courtesy Royal Academy of Art, London; Levin, *Lee Krasner*, 133; Landau, "Lee Krasner's Early Career, Part One," 16.
4. Goodman, *Hans Hofmann*, 28; Ashton, *The New York School*, 41.
5. Dore Ashton, ed., *Picasso on Art*, 145; Alfred H. Barr Jr., *Picasso*, 264.
6. Leon Trostky, "Art and Politics," 7–9.
7. Hobbs, *Art in Context*, 273; Dore Ashton, *The Life and Times of the New York School*, 106.
8. *Partisan Review* 5, no. 3 (August–September 1938), courtesy PKHSC.
9. Hellmut Lehmann-Haupt, *Art Under a Dictatorship*, 43, 243–44. Lehmann-Haupt writes that it is not the inherently political content of modern art that threatens a totalitarian regime but the power of its free expression.
10. Chipp, *Theories of Modern Art*, 459.
11. Ibid., 477–83.
12. Ibid., 474; Lehmann-Haupt, *Art Under a Dictatorship*, 78–82.
13. Lynes, *Good Old Modern*, 226–27; Lipstadt, *Beyond Belief*, 86, 88, 98, 108.
14. Lipstadt, *Beyond Belief*, 98–99; Paul Johnson, *A History of the Jews*, 485–86; "The Holocaust, Kristallnacht, Background and Overview, November 9–10, 1938," www.jewishvirtuallibrary.org/.
15. Parrish, *Anxious Decades*, 458; Lipstadt, *Beyond Belief*, 108, 314n106; Conn, *The American 1930s: A Literary History*, 10, 19; Hugh Brogan, *The Penguin History of the United States*, 487. Americans opposed to involvement in Europe believed the country had been duped into supporting European allies in the First World War and did not want to make that mistake again. Antiwar demonstrations were common throughout the country, and antiwar books were best sellers.
16. Lipstadt, *Beyond Belief*, 108; Lawrence S. Wittner, *Rebels Against War*, 35–36; Clements, *Prosperity, Depression and the New Deal*, 234; Brogan, *The Penguin History of the United States*, 595. The committee would continue its work, refocusing on communists, for twenty years.
17. Lipstadt, *Beyond Belief*, 124; Parrish, *Anxious Decades*, 409; Mordecai Richler, ed., *Writers on World War II*, 38–39.
18. Giorgio Cavallon, interview by Jack Taylor; Levin, *Lee Krasner*, 107–8; Abel, *The Intellectual Follies*, 49; "Death of Trotsky, Skull Fractured with Pickaxe," *The Guardian*, August 22, 1940, the guardian.com/century/1940-1949/Story/.
19. Glaser, "Interview with Lee Krasner," 27; Barbara Rose, "Krasner/Pollock: A Working Relationship," 8; Lee Krasner, interview by Ellen G. Landau, AAA-SI; Dore Ashton, *The New York School*, 75–76.
20. *Mercedes Matter*, interview by Sigmund Koch, Tape 1A, Aesthetics Research Archive; Harry Holtzman, interview by Jack Taylor; Thomas B. Hess and Elizabeth C. Baker, eds., *Art and Sexual Politics*, 62.
21. Lillian Kiesler, interview by Ellen G. Landau, AAA-SI, 5; Matossian, *Black Angel*, 278.
22. Willem and Elaine de Kooning, interview by Peter Busa and Sandra Kraskin, AAA-SI; Rosenberg, *The Anxious Object*, 147; Elaine de Kooning, interview by John Gruen, AAA-SI, 8; oral history interview with Vaclav Vytlacil, AAA-SI.
23. Oral history interview with Lillian Orlowsky, AAA-SI; Nemser, *Art Talk*, 72; anonymous, interview with author, December 2013, New York.

24. Oral history interview with Nathan Halper, AAA-SI; oral history interview with Lillian Orlowsky, AAA-SI; Dore Ashton with Joan Banach, eds., *The Writings of Robert Motherwell*, 309.
25. Naifeh and Smith, *Jackson Pollock*, 388; Lillian Kiesler, interview by Ellen G. Landau, AAA-SI, 6.
26. Matossian, *Black Angel*, 278–79.
27. Naifeh and Smith, *Jackson Pollock*, 388; Landau, *Lee Krasner: A Catalogue Raisonné*, 305.
28. May Tabak Rosenberg, interview by Jeffrey Potter, audiotape courtesy PKHSC; Solomon, *Jackson Pollock*, 114.
29. Levin, *Lee Krasner*, 136–38; *Lee Krasner*, interview by Robert Coe, videotape courtesy PKHSC; Ashton, *The New York School*, 65.
30. Arthur Rimbaud, *Poésies*, 173.
31. *Lee Krasner*, interview by Robert Coe, videotape courtesy PKHSC; Munro, *Originals*, 111; Levin, *Lee Krasner*, 138; Hobbs, *Lee Krasner* (1993), 21–22; "Lee Krasner, Paintings, Drawings and Collages," 8. Lee told Eleanor Munro the poem had been translated by Louise Varèse, who was living in New York with her composer husband, Edgard.
32. Robert de Niro Sr., interview by Tina Dickey, AAA-SI; Parrish, *Anxious Decades*, 453.
33. *Lee Krasner*, interview by Robert Coe, videotape courtesy the PKHSC; Hobbs, *Lee Krasner* (1993), 22; "Lee Krasner, Paintings, Drawings and Collages," 8; Christopher Bram, *Eminent Outlaws*, 15; Munro, *Originals*, 111.
34. Robert de Niro Sr., interview by Tina Dickey, AAA-SI; Levin, *Lee Krasner*, 174.
35. Lee Krasner, interview by Anne Bowen Parsons, AAA-SI, 1; Levin, *Lee Krasner*, 103, 167–68; Landau, *Lee Krasner: A Catalogue Raisonné*, 303.
36. Ashton, *The New York School*, 109.
37. Ashton, *The Life and Times of the New York School*, 31; Ashton, *The New York School*, 102, 109; Stevens and Swan, *De Kooning*, 137; Lynes, *Good Old Modern*, 214; Dorfman, *Out of the Picture*, 24. "Without doubt, *Guernica* drew, both from the press and the general public, the widest comment any modern art had ever had in America. More seriously, it stirred the artists profoundly," wrote Dore Ashton.
38. Levin, *Lee Krasner*, 135; "Guernica," www.pablopicasso.org/guernica.jsp.
39. Levin, *Lee Krasner*, 135.
40. Lee Krasner, interview by Emily Wasserman, AAA-SI, 6; Rose, *Lee Krasner*, 38; Philip Pavia, interview by John Gruen, AAA-SI.
41. Lee Krasner, interview by Emily Wasserman, AAA-SI, 6.
42. Lynes, *Good Old Modern*, 203–5; Russell Lynes, "The Eye of the Beholder," lecture notes for Smith College Museum of Art, May 5, 1985, Box 1, Russell Lynes Papers 1935–1986, AAA-SI, 18.
43. Lynes, *Good Old Modern*, 204–6; Lynes, "The Eye of the Beholder," lecture notes for Smith College Museum of Art, May 5, 1985, Box 1, Russell Lynes Papers 1935–1986, AAA-SI, 18.
44. Martin Gilbert, *The Second World War*, 2, 4.
45. Matossian, *Black Angel*, 288–89.

4. Marie Catherine Mary Ellen O'Brien Fried's Daughter

1. Françoise Sagan, *A Certain Smile*, 28.
2. Elaine de Kooning, interview by Minna Daniels, 17–18.
3. Maud Fried Goodnight, telephone interview by author.
4. Rose Slivka, "A Few Statements by Elaine's Friends," Elaine de Kooning Memorial Tribute, March 12, 1990, the Great Hall at Cooper Union, New York, courtesy Doris Aach; Elaine De Kooning and Slivka, *Elaine de Kooning*, 35; Lee Hall, *Elaine and Bill*, 38.
5. Elaine de Kooning, C. F. S. Hancock Lecture, 1–2; Hess and Baker, *Art and Sexual Politics*, 66.
6. Hess and Baker, *Art and Sexual Politics*, 66; Stevens and Swan, *De Kooning*, 158.
7. Munro, *Originals*, 251; Elaine de Kooning, interview by Antonina Zara, 4; Elaine de Kooning, interview by John Gruen, AAA-SI, 1.
8. Munro, *Originals*, 251–52; Elaine de Kooning, interview by Molly Barnes, 7; Dorothy Dehner, interview by Colette Roberts, AAA-SI. Dehner said that, outside New York, artist's models in classrooms wore "bloomers" and were not completely naked.
9. Elaine de Kooning, interview by John Gruen, AAA-SI, 1; Elaine de Kooning, interview by Antonina Zara, 4; oral history interview with Elaine de Kooning, AAA-SI; Conrad Marca-Relli,

interview by Anne Bowen Parsons, AAA-SI, 1; oral history interview with Conrad Marca-Relli, AAA-SI; Stevens and Swan, *De Kooning,* 160; Willem and Elaine de Kooning, interview by Peter Busa and Sandra Kraskin, AAA-SI.
10. Hall, *Elaine and Bill,* 27.
11. Stevens and Swan, *De Kooning,* 160.
12. Constance Lewallen, ed. "Interview with Elaine de Kooning," by Robin White, *View,* 12.
13. Stevens and Swan, *De Kooning,* 160.
14. Elaine de Kooning, interview by Molly Barnes, 7; Munro, *Originals,* 252.
15. Elaine de Kooning, interview by Antonina Zara, 4; Elaine de Kooning, interview by Molly Barnes, 7; Hess and Baker, *Art and Sexual Politics,* 68; Willem and Elaine de Kooning, interview by Peter Busa and Sandra Kraskin, AAA-SI.
16. Elaine de Kooning, discussion with Mildred and Michael Loew, 20; Stevens and Swan, *De Kooning,* 129.
17. *Summer of '57,* videotape courtesy LTV; Lawrence Campbell, "Elaine de Kooning Paints a Picture," 63; Munro, *Originals,* 252.
18. Elaine de Kooning, interview by Molly Barnes, 8; Elaine de Kooning, interview by Antonina Zara, 4; Hess and Baker, *Art and Sexual Politics,* 68; Elaine de Kooning, interview by John Gruen, AAA-SI, 1; Elaine de Kooning discussion with Michael Loew and Mildred Loew, 20–21.
19. Schloss, "The Loft Generation," Edith Schloss Burckhardt Papers, Columbia, 116, 118; Elaine de Kooning, interview by Antonina Zara, 5; "Conversations with Willem de Kooning," by Sally Yard, unpublished interview, October 14, 1976, Courtesy of The Willem de Kooning Foundation.
20. Dorfman, *Out of the Picture,* 309.
21. Nell Blaine, interview by Larry Rivers, unpublished notes, Larry Rivers Papers, MSS 293, Series II, Subseries C, Box 25, Folder 23, NYU; Schloss, "The Loft Generation," Edith Schloss Burckhardt Papers, Columbia, 116, 118–19.
22. Elaine de Kooning, interview by Arthur Tobier, 2–3; Schloss, "The Loft Generation," Edith Schloss Burckhardt Papers, Columbia, 119.
23. Edvard Lieber, *Willem de Kooning, Reflections in the Studio,* 16.
24. Ibid; Elaine de Kooning, interview by John Gruen, AAA-SI, 2; Gruen, *The Party's Over Now,* 208.
25. Elaine de Kooning, interview by Molly Barnes, 8; Elaine de Kooning, interview by Antonina Zara, 5.
26. Elaine de Kooning and Slivka, *Elaine de Kooning,* 16; Lieber, *Reflections in the Studio,* 17; Elaine de Kooning, interview by John Gruen, AAA-SI, 2.
27. Stevens and Swan, *De Kooning,* 73, 113, 117, 118, 152.
28. Elaine de Kooning, discussion with Mildred and Michael Loew, 1; Hall, *Elaine and Bill,* 29; Munro, *Originals,* 252; Stevens and Swan, *De Kooning,* 155; Lieber, *Reflections in the Studio,* 17.
29. Stevens and Swan, *De Kooning,* 155.
30. Sally Yard, "Conversations with Willem de Kooning," unpublished interview, October 14, 1976, Courtesy of The Willem de Kooning Foundation; Emile de Antonio, *Painters Painting,* film; Stevens and Swan, *De Kooning,* xxiii, 56, 57; Thomas B. Hess, *Willem de Kooning* (1968), 17; Thomas B. Hess, draft manuscript dated July 8, 1968, for Thomas B. Hess's 1968 de Kooning show at the Museum of Modern Art, Box1/1, Thomas B. Hess/De Kooning Papers, MOMA, 12.
31. Stevens and Swan, *De Kooning,* 17.
32. Ibid., 15, 25–26, 55, 71, 92–93, 101.
33. Oral history interview with Lee Krasner, November 2, 1964–April 11, 1968, AAA-SI.
34. Elaine de Kooning and Slivka, *Elaine de Kooning,* 131.
35. Dorfman, *Out of the Picture,* 15; Stevens and Swan, *De Kooning,* 161–62.
36. Munro, *Originals,* 252.
37. Ibid.; Stevens and Swan, *De Kooning,* 161–62; Ernestine Lassaw, interview by author.
38. Munro, *Originals,* 252.
39. Ernestine Lassaw, interview by author.
40. Ibid.; Ernestine Lassaw, "A Few Statements by Elaine's Friends," Elaine de Kooning Memorial Tribute, March 12, 1990, the Great Hall at Cooper Union, New York, transcript courtesy Doris Aach.
41. Ernestine Lassaw, interview by author; Denise Lassaw, e-mail to author, September 6, 2016.

42. Elaine de Kooning, interview by Antonina Zara, 5; Ernestine Lassaw, interview by author.
43. Ernestine Lassaw, interview by author.
44. Ibid.
45. Campbell, "Elaine de Kooning Paints a Picture," 41.
46. Elaine de Kooning, interview by Molly Barnes, 3; Elaine de Kooning, interview by Antonina Zara, 6; Munro, *Originals,* 252.
47. Munro, *Originals,* 252–53.
48. Elaine de Kooning, interview by Antonina Zara, 6; Elaine de Kooning, interview by Molly Barnes, 4.
49. Elaine de Kooning, interview by Minna Daniels, 16; Hess and Baker, *Art and Sexual Politics,* 62–63. Elaine said, "As far as I'm concerned, nobody had to grant me anything to become an artist, except for my mother."
50. Elaine de Kooning, interview by Antonina Zara, 3; Elaine de Kooning, interview by Minna Daniels, 14; Munro, *Originals,* 249; Jill Rachelle Chancey, "Elaine de Kooning: Negotiating the Masculinity of Abstract Expressionism," 18–19; Maud Fried Goodnight, telephone interview by author; Dr. Guy Fried, telephone interview by author.
51. Elaine de Kooning, interview by Minna Daniels, 14; Munro, *Originals,* 249.
52. Maud Fried Goodnight, telephone interview by author; Dr. Guy Fried, telephone interview by author; Stevens and Swan, *De Kooning,* 156; Munro, *Originals,* 249–50.
53. Elaine de Kooning, interview by Charles Hayes, 4; Elaine de Kooning, interview by Molly Barnes, 6; Munro, *Originals,* 250.
54. Munro, *Originals,* 251; Elaine de Kooning, interview by Charles Hayes, 5.
55. Hess and Baker, *Art and Sexual Politics,* 66; Elaine de Kooning, interview by Antonina Zara, 3–4.
56. Elaine de Kooning, interview by Charles Hayes, 4; Maud Fried Goodnight, telephone interview by author; Stevens and Swan, *De Kooning,* 156.
57. Charles Fried, telephone interview by author.
58. Elaine de Kooning, interview by Minna Daniels, 14; Stevens and Swan, *De Kooning,* 157; Dr. Guy Fried, telephone interview by author.
59. Dr. Guy Fried, telephone interview by author; Ernestine Lassaw, interview by author.
60. Stevens and Swan, *De Kooning,* 156; Elaine de Kooning, interview by Minna Daniels, 17; Clay Fried, interview by author; Ernestine Lassaw, interview by author.
61. Stevens and Swan, *De Kooning,* 157; Ernestine Lassaw, interview by author.
62. Stevens and Swan, *De Kooning,* 157; Dr. Guy Fried, telephone interview by author.
63. Stevens and Swan, *De Kooning,* 158.
64. Dr. Guy Fried, telephone interview by author.

5. The Master and Elaine

1. May Natalie Tabak, *But Not for Love,* 112.
2. Munro, *Originals,* 253; Lieber, *Reflections in the Studio,* 18; Elaine de Kooning, interview by John Gruen, AAA-SI, 2–3.
3. Munro, *Originals,* 253.
4. Elaine de Kooning, interview by Jeffrey Potter, audiotape courtesy PKHSC; Munro, *Originals,* 253.
5. Janis, *Abstract and Surrealist Art in America,* 16.
6. Lewallen, "Interview with Elaine de Kooning," 12; Jane K. Bledsoe, *E de K,* 25.
7. Elaine de Kooning, interview by Molly Barnes, 4.
8. Elaine de Kooning, C. F. S. Hancock Lecture, 3; Elaine de Kooning, interview by Jeffrey Potter, courtesy PKHSC.
9. Stevens and Swan, *De Kooning,* 153, 162.
10. Hall, *Elaine and Bill,* 28.
11. Elaine de Kooning, interview by John Gruen, AAA-SI, 3; Stevens and Swan, *De Kooning,* 163.
12. Elaine de Kooning, interview by Minna Daniels, 38; Elaine de Kooning, interview by Antonina Zara, 6; Willem and Elaine de Kooning, interview by Peter Busa and Sandra Kraskin, AAA-SI; Elaine de Kooning, interview by Ellen Auerbach, 7; Stevens and Swan, *De Kooning,* 164.
13. Matossian, *Black Angel,* 210; Herrera, *Arshile Gorky,* 209–10.
14. Matossian, *Black Angel,* 158.
15. Ibid., 252; Elaine de Kooning, interview by Minna Daniels, 35.

16. Herrera, *Arshile Gorky,* 202; oral history interview with Dorothy C. Miller, AAA-SI; Dorothy C. Miller, interview by Barbara Rose, February 15, 1980, Series V, Box 13, R.2, Barbara Rose Papers, GRI.
17. Matossian, *Black Angel,* 231, 234–35; Thomas B. Hess, *Willem de Kooning* (1959), 115.
18. Elaine de Kooning, interview by Antonina Zara, 7–8.
19. Elaine de Kooning and Slivka, *Elaine de Kooning,* 23–24.
20. Matossian, *Black Angel,* 300.
21. Marcia Epstein Allentuck, *John Graham's System and Dialectics of Art,* 93, 95; Herrera, "John Graham: Modernist Turns Magus," 100; Herrera, *Arshile Gorky,* 662n178; Ashton, *The New York School,* 68, 70. Ashton said Graham's pronouncements in his book were "literally articles of faith for the small band of painters."
22. Allentuck, *John Graham's System and Dialectics of Art,* xvi; Ashton, *The Life and Times of the New York School,* 24–25; Fairfield Porter, "John Graham: Painter as Aristocrat," 39; Herrera, "John Graham: Modernist Turns Magus," 100.
23. Ellen G. Landau, *Jackson Pollock,* 79–80.
24. Edgar, *Club Without Walls,* 30.
25. Allentuck, *John Graham's System and Dialectics of Art,* xxi; Herrera, "John Graham: Modernist Turns Magus," 100, 105; Matossian, *Black Angel,* 175; Barrett, *Irrational Man,* 133–34; William Barrett, "What Existentialism Offers Modern Man: A Philosophy of Fundamental Human Realities, 18.
26. Allentuck, *John Graham's System and Dialectics of Art,* 28–29; Herrera, "John Graham: Modernist Turns Magus," 100; Dorfman, *Out of the Picture,* 21. "When Graham laughed," Milton Resnick said, "all that French art and all the meanings given to us in *Cahiers d'art* were brought down.... He took Europe off its pedestal."
27. Allentuck, *John Graham's System and Dialectics of Art,* 93.
28. Ibid., 97–98.
29. Ibid., 120.
30. Ibid., 103, 106–7.
31. Joan M. Lukach, *Hilla Rebay: In Search of the Spirit in Art,* xiii, 1, 98, 141; Ashton, *The New York School,* 112.
32. Ashton, *The Life and Times of the New York School,* 112–13; Thomas B. Hess, *Abstract Painting: Background and American Phase,* 83; Schapiro, *Modern Art in the Nineteenth and Twentieth Centuries,* 204.
33. Lukach, *Hilla Rebay,* 100, 120–22, 151–53, 174.
34. Willem and Elaine de Kooning, interview by Peter Busa and Sandra Kraskin, AAA-SI.
35. Ashton, *The Life and Times of the New York School,* 112–13.
36. Schapiro, *Modern Art,* 204; Ashton, *The Life and Times of the New York School,* 112–13; Larkin, *Art and Life in America,* 353; Matossian, *Black Angel,* 192.
37. Ernestine Lassaw, interview with author.
38. Ibid.; Milton Resnick, interview by Deborah Solomon.
39. Milton Resnick, interview by Deborah Solomon
40. Ernestine Lassaw, interview with author.
41. Elaine de Kooning, interview by Minna Daniels, 38; Stevens and Swan, *De Kooning,* 182–83.
42. Stevens and Swan, *De Kooning,* 11, 194.
43. Ernestine Lassaw, interview with author.
44. Stevens and Swan, *De Kooning,* 8, 12, 194–95; Lieber, *Reflections in the Studio,* 18.
45. Elaine de Kooning and Slivka, *Elaine de Kooning,* 229; Elaine de Kooning, interview by John Gruen, AAA-SI, 11; Zinn, *A People's History,* 384.
46. Willem de Kooning, interview by Anne Bowen Parsons, AAA-SI.
47. Marshall Berman, *All That Is Solid Melts into Air,* 303.
48. "Fiorello LaGuardia, 1882–1947," jewishvirtuallibrary.org/fiorello-laguardia.
49. Leighton, *The Aspirin Age,* 438–43.
50. Clements, *Prosperity, Depression and the New Deal,* 194–96; John Patrick Diggins, *The Proud Decades,* 158. The Nazi menace was not just reported in the media, it appeared in the movies. World War II was the first war to be the subject of feature films while the war was being fought.
51. Munro, *Originals,* 253.

6. The Flight of the Artists

1. Albert Camus, *Exile and the Kingdom*, 103.
2. Edgar, *Club Without Walls*, 39–40; Virginia Pitts Rembert, "Mondrian, America, and American Painting," vi.
3. Parrish, *Anxious Decades*, 463; Gilbert, *The Second World War*, 60–61, 67–68, 77, 83, 85–86, 90–91.
4. Gilbert, *The Second World War*, 94, 97, 101–2, 105, 108.
5. Harold Rosenberg, "The Fall of Paris," 440–41.
6. Parrish, *Anxious Decades*, 465.
7. Gilbert, *The Second World War*, 94, 111, 116, 123, 134, 153.
8. Oral history interview with Margaret Scolari Barr, AAA-SI; Marquis, *Alfred H. Barr, Jr.*, 104, 106, 108, 153.
9. Marquis, *Alfred H. Barr, Jr.*, 177, 182, 185–87; Lynes, *Good Old Modern*, 226, 231.
10. Oral history interview with Margaret Scolari Barr, AAA-SI.
11. Lynes, *Good Old Modern*, 226, 231; oral history interview with Dorothy C. Miller, AAA-SI; oral history interview with Margaret Scolari Barr, AAA-SI; Jackman and Borden, *The Muses Flee Hitler*, 81.
12. Oral history interview with Rebecca Reis, AAA-SI; Anton Gill, *Art Lover*, 241–43; Jackman and Borden, *The Muses Flee Hitler*, 81, 83; Marquis, *Alfred H. Barr, Jr.*, 185–87; Lynes, *Good Old Modern*, 231; "The 1940 Census: Employment and Income," National Archives, www.archives.gov.
13. Jackman and Borden, *The Muses Flee Hitler*, 50, 54, 80; Lynes, *Good Old Modern*, 231–32. U.S. immigration figures show 702 painters and sculptors arrived among the total number of 132,000 immigrants allowed into the country from Europe between 1933 and 1941.
14. Frank O'Hara, *Robert Motherwell*, 9; Alfred Leslie, interview by Jack Taylor.
15. Harry Holtzman, interview by Jack Taylor; oral history interview with George L. K. Morris, AAA-SI.
16. Rembert, "Mondrian," 44; Harry Holtzman, interview by Jack Taylor.
17. May Tabak Rosenberg, interview by Jeffrey Potter, courtesy PKHSC; Levin, *Lee Krasner*, 138, 141–42; Rose, *Lee Krasner*, 45.
18. Levin, *Lee Krasner*, 127; Landau, *Lee Krasner: A Catalogue Raisonné*, 59.
19. Rembert, "Mondrian," 45; Landau et al., *Mercedes Matter*, 33, 68n63.
20. Sandler, *A Sweeper Up After Artists*, 51.
21. Landau et al., *Mercedes Matter*, 13, 34; Goodman, *Hans Hofmann*, 31.
22. John O'Brian, ed., *Clement Greenberg: The Collected Essays and Criticism*, vol. 1, *Perceptions and Judgments, 1939–1944*, 188.
23. *Mercedes Matter*, interview by Sigmund Koch, Tape 4A, Aesthetics Research Archive; oral history interview with Nell Blaine, AAA-SI.
24. Rembert, "Mondrian," 78; Gill, *Art Lover*, 282; O'Brian, *Clement Greenberg: The Collected Essays and Criticism*, 1:189.
25. Hall and Wykes, *Anecdotes of Modern Art*, 72; Rembert, "Mondrian," 78n75–76.
26. Ilya Bolotowsky and Henry Geldzahler, "Adventures with Bolotowsky," 25; Rembert, "Mondrian," 45–46; Levin, *Lee Krasner*, 151; oral history interview with George L. K. Morris, AAA-SI.
27. Lee Krasner, interview by Barbaralee Diamonstein, provided by Dr. Barbaralee Diamonstein-Spielvogel, interviewer and author, from *Inside New York's Art World*, 199–200.
28. David W. Stowe, "The Politics of Cafe Society," 1384, 1387.
29. Lee Krasner, interview by Barbaralee Diamonstein, provided by Dr. Barbaralee Diamonstein-Spielvogel, interviewer and author, from *Inside New York's Art World*, 200; Rose, *Lee Krasner*, 40; Rembert, "Mondrian," 78n75–76.
30. *Lee Krasner*, interview by Barbara Novak, videotape courtesy PKHSC.
31. Hobbs, *Lee Krasner* (1999), 29.
32. Rembert, "Mondrian," 46.
33. Oral history interview with Lee Krasner, November 2, 1964–April 11, 1968, AAA-SI.
34. Dewey, *Art as Experience*, 56–57; Martica Sawin, *Nell Blaine*, 20.
35. Oral history interview with Lee Krasner, November 2, 1964–April 11, 1968, AAA-SI.
36. Landau, *Lee Krasner: A Catalogue Raisonné*, 76; Landau, "Lee Krasner's Early Career, Part One," 16.

37. Rembert, "Mondrian," 78n75–76.
38. Landau, *Jackson Pollock*, 86; *It Is* 3 (Winter–Spring 1959): 10; Landau, "Krasner's Past Continuous," 71. Hofmann once said, "Seeing without awareness... is just short of blindness. 'Seeing' with awareness is a visual experience, it is an art. We must learn to see."
39. Landau, *Lee Krasner: A Catalogue Raisonné*, 306; Lee Krasner, interview by Ellen G. Landau, AAA-SI; Naifeh and Smith, *Jackson Pollock*, 391; Levin, *Lee Krasner*, 164; Rose, *Lee Krasner*, 45.
40. Lee Krasner, interview by Barbara Novak, videotape courtesy PKHSC; Lee Krasner, interview by Barbaralee Diamonstein, provided by Dr. Barbaralee Diamonstein-Spielvogel, interviewer and author, from *Inside New York's Art World*, 201.
41. John Graham to Lenore Krasner, note, November 12, 1941, Series 2.2, Box 8, Folder 3, Lee Krasner Papers, AAA-SI.
42. Lee Krasner, interview by Barbara Novak, videotape courtesy PKHSC.
43. Naifeh and Smith, *Jackson Pollock*, 391.
44. Lee Krasner, interview by Robert Coe, videotape courtesy PKHSC.
45. Oral history interview with Lee Krasner, November 2, 1964–April 11, 1968, AAA-SI.
46. Ibid.; Naifeh and Smith *Jackson Pollock*, 392; Levin, *Lee Krasner*, 166; Lee Krasner, interview by Barbaralee Diamonstein, provided by Dr. Barbaralee Diamonstein-Spielvogel, interviewer and author, from *Inside New York's Art World*, 201.
47. Lee Krasner, interview by Robert Coe, videotape courtesy PKHSC; *Lee Krasner*, interview by Barbara Novak, videotape courtesy PKHSC; Levin, *Lee Krasner*, 165; Landau, *Lee Krasner: A Catalogue Raisonné*, 75.
48. Lee Krasner, *Pollock*, unpublished, undated notes, Series 1.3, Box 2, Folder 41, Jackson Pollock and Lee Krasner Papers, AAA-SI, 2.
49. Cindy Nemser, "A Conversation with Lee Krasner," 43; Lee Krasner, interview by Barbara Rose, 1972, AAA-SI, 6.
50. Munro, *Originals*, 112.
51. "Lee Krasner, Paintings, Drawings and Collages," 8–9.
52. Gruen, *The Party's Over Now*, 230.
53. *Lee Krasner: An Interview with Kate Horsfield*, courtesy PKHSC.
54. Naifeh and Smith, *Jackson Pollock*, 43, 124, 129, 130, 136; Philip Guston, interview by Jack Taylor. A young Philip Guston was expelled along with Pollock.
55. Solomon, *Jackson Pollock*, 46–47; Arnold Hauser, *The Social History of Art*, vol. 2, *Renaissance, Mannerism, Baroque*, 48, 60; Naifeh and Smith, *Jackson Pollock*, 155.
56. Naifeh and Smith, *Jackson Pollock*, 167, 170, 227.
57. Ibid., 255; Edgar, *Club Without Walls*, 25.
58. Naifeh and Smith, *Jackson Pollock*, 124, 202, 248–49.
59. Ibid., 278–79, 310, 313, 318; Solomon, *Jackson Pollock*, 90.
60. Naifeh and Smith, *Jackson Pollock*, 325–26, 336; Solomon, *Jackson Pollock*, 90.
61. Naifeh and Smith, *Jackson Pollock*, 336, 343, 346; John D. Graham, "Primitive Art and Picasso," 236–37; Lee Krasner, interview by Barbara Novak, AAA-SI, 30.
62. Naifeh and Smith, *Jackson Pollock*, 347, 359, 361; Lee Krasner, interview by Barbara Novak, AAA-SI, 30; Solomon, *Jackson Pollock*, 101.
63. Levin, *Lee Krasner*, 172.
64. Zinn, *A People's History*, 425; Richard Polenberg, *War and Society*, 4–5; Wittner, *Rebels Against War*, 10–11. Between 1940 and 1944, the U.S. GDP went from $90 billion to $200 billion, with corporate profits reaching their highest level in history.
65. Parrish, *Anxious Decades*, 466–67, 470–71; Polenberg, *War and Society*, 4-5; Gilbert, *The Second World War*, 129, 187; Diggins, *The Proud Decades*, 10.
66. Zinn, *A People's History*, 425; James E. B. Breslin, *Mark Rothko*, 153.
67. Parrish, *Anxious Decades*, 447, 469; Gilbert, *The Second World War*, 132.
68. Oral history interview with Sylvan Cole, AAA-SI.
69. Robert Motherwell, interview by Barbaralee Diamonstein, provided by Dr. Barbaralee Diamonstein-Spielvogel, interviewer and author, from *Inside New York's Art World*, 243.
70. Richler, *Writers on World War II*, 263; Brogan, *The Penguin History of the United States*, 557.
71. Leighton, *The Aspirin Age*, 483; oral history interview with Elisabeth Ross Zogbaum, AAA-SI.

72. Leighton, *The Aspirin Age*, 483; Gilbert, *The Second World War*, 272.
73. Oral history interview with Elisabeth Ross Zogbaum, AAA-SI; Clements, *Prosperity, Depression and the New Deal*, 198; Gilbert, *The Second World War*, 216, 271, 275–76, 278, 280.
74. Oral history interview with Elisabeth Ross Zogbaum, AAA-SI.
75. Diggins, *The Proud Decades*, 4.
76. Julien Levy, *Memoir of an Art Gallery*, 258.
77. Leighton, *The Aspirin Age*, 488.
78. Ibid., 486; Clements, *Prosperity, Depression and the New Deal*, 199; Diggins, *The Proud Decades*, 5; Gilbert, *The Second World War*, 272, 275; oral history interview with Sylvan Cole, AAA-SI.
79. Breslin, *Mark Rothko*, 153.
80. Hans Hofmann to Lillian Kiesler, letter, July 12, 1941, Lillian and Friederick Kiesler Papers, AAA-SI.
81. Archibald MacLeish, "The Irresponsibles," 622–23.

7. It Is War, Everywhere, Always

1. Samuel Beckett, *Waiting for Godot*, 61.
2. Oral history interview with Ludwig Sander, AAA-SI; Diggins, *The Proud Decades*, 15. Those initial recruits swelled to 5 million volunteers. By 1944, 10 million more men would be drafted.
3. Naifeh and Smith, *Jackson Pollock*, 364.
4. These targets included French Indochina, British Burma, Malaya, and Hong Kong, for example. See Clements, *Prosperity, Depression and the New Deal*, 198; Gilbert, *The Second World War*, 216, 271, 275–76, 278, 280.
5. Gilbert, *The Second World War*, 170, 174.
6. Ibid., 187, 204, 237, 241, 247, 268, 275, 284–85.
7. Lipstadt, *Beyond Belief*, 151–53, 157.
8. Ibid., 150; Gilbert, *The Second World War*, 220, 250–51, 274, 292. Those "mobile" gas chambers would be used to kill 360,000 people.
9. Naifeh and Smith, *Jackson Pollock*, 363; Solomon, *Jackson Pollock*, 104–5; Gruen, *The Party's Over Now*, 213; Stevens and Swan, *De Kooning*, 176; "Edwin Denby Remembered, Part 1," 14. Rudy Burckhardt had been drafted. Edwin had tried to follow him by enlisting but was rejected.
10. Potter, *To a Violent Grave*, 32, 39; Landau, *Lee Krasner: A Catalogue Raisonné*, 307; Lillian Kiesler, interview by Ellen G. Landau, AAA-SI, 5.
11. Landau, *Lee Krasner: A Catalogue Raisonné*, 75; oral history interview with Lee Krasner, November 2, 1964–April 11, 1968, AAA-SI.
12. Lee Krasner, interview, by Robert Coe, videotape courtesy PKHSC; oral history interview with Lee Krasner, November 2, 1964–April 11, 1968, AAA-SI; Levin, *Lee Krasner*, 178.
13. Lee Krasner, interview by Barbara Rose, June 27, 1978, GRI, 7; Allentuck, *John Graham's System and Dialectics of Art*, 20–21; Herrera, "John Graham: Modernist Turns Magus," 101. Some historians have suggested that it was Graham who "discovered" Pollock, Gorky, David Smith, and Bill de Kooning. If so, his act of discovery amounted to encouraging those artists at the critical start of their artistic journey. Graham believed, "to exist, to create, genius needs understanding and appreciation.... Genius cannot function in a vacuum."
14. Peyton Boswell, "Comments: Congenial Company," 18; Solomon, *Jackson Pollock*, 115.
15. *Lee Krasner: An Interview with Kate Horsfield*, videotape courtesy PKHSC.
16. Gruen, *The Party's Over Now*, 230.
17. Lee Krasner, interview by Barbara Novak, videotape courtesy PKHSC; Naifeh and Smith, *Jackson Pollock*, 396; Dorfman, *Out of the Picture*, 32.
18. Hobbs, *Lee Krasner*, 32; Michael Brenson, "Lee Krasner Pollock Is Dead," www.nytimes.com/.../lee-krasner-pollock-is-dead-painter-of.
19. Landau, *Jackson Pollock*, 83, 85; Ellen G. Landau, "Lee Krasner's Early Career, Part Two," 80–81; Naifeh and Smith, *Jackson Pollock*, 395.
20. Willem and Elaine de Kooning, interview by Peter Busa and Sandra Kraskin, AAA-SI.
21. Munro, *Originals*, 112.
22. Elaine de Kooning, interview by Jeffrey Potter, courtesy PKHSC.
23. Grace Glueck, "Scenes from a Marriage, Krasner and Pollock," 58.
24. Gruen, *The Party's Over Now*, 230.

25. Levin, *Lee Krasner*, 189; Landau, *Lee Krasner: A Catalogue Raisonné*, 76, 93; Monroe, "The Artists Union of New York," 24–25; Dorothy Miller, interview by Anne Bowen Parsons, AAA-SI, 1; oral history interview with Peter Agostini, AAA-SI. The art created under the Project was allocated to whatever organization or entity would take it when the Project ended. But because much of the art was modern, it went unclaimed and was consigned to a warehouse. In 1946, a bureaucrat, according to Miller, ordered the contents of the warehouse dumped. A junk dealer on Canal Street took everything, including the art, and sold it by the pound to the highest bidder.
26. Lee Krasner, interview by Anne Bowen Parsons, AAA-SI, 1; Levin, *Lee Krasner*, 189–90, 194; Robert Hobbs, *Lee Krasner* (1999), 56; Landau, *Lee Krasner: A Catalogue Raisonné*, 93; McKinzie, *The New Deal for Artists*, 168; oral history interview with Peter Busa, AAA-SI.
27. Glueck, "Scenes from a Marriage," 58.
28. Naifeh and Smith, *Jackson Pollock*, 396.
29. Levin, *Lee Krasner*, 167, 190; Naifeh and Smith, *Jackson Pollock*, 395; Solomon, *Jackson Pollock*, 108.
30. Gibson, *Abstract Expressionism*, 3.
31. Landau, "Lee Krasner's Early Career, Part Two," 80.
32. Munro, *Originals*, 114.
33. Landau, *Jackson Pollock*, 84; Landau, "Lee Krasner's Early Career, Part Two," 80; Lee Krasner, interview by Barbara Rose, 1972, AAA-SI, 6.
34. Levin, *Lee Krasner*, 147, 188; Solomon, *Jackson Pollock*, 108; Levin, *Lee Krasner*, 147, 188; Landau, "Lee Krasner's Early Career, Part Two," 80.
35. Oral history interview with Lee Krasner, November 2, 1964–April 11, 1968, AAA-SI.
36. Landau, "Lee Krasner's Early Career, Part Two," 81.
37. Interview with Lee Krasner, by Emily Wasserman, AAA-SI, 1.
38. Solomon, *Jackson Pollock*, 106, 115.
39. Willem and Elaine de Kooning, interview by Peter Busa and Sandra Kraskin, AAA-SI.
40. Potter, *To a Violent Grave*, 64–65.
41. Lillian Kiesler, interview by Ellen G. Landau, AAA-SI, 6.
42. Naifeh and Smith, *Jackson Pollock*, 399; Potter, *To a Violent Grave*, 65.
43. Lee Krasner, interview by Barbaralee Diamonstein, provided by Dr. Barbaralee Diamonstein-Spielvogel, interviewer and author, from *Inside New York's Art World*, 202.
44. Oral history interview with Lee Krasner, November 2, 1964–April 11, 1968, AAA-SI.
45. Lee Krasner, interview by Barbaralee Diamonstein, provided by Dr. Barbaralee Diamonstein-Spielvogel, interviewer and author, from *Inside New York's Art World*, 202.
46. Ibid. Lee described this episode many times to many interviewers. Her description is consistent but in each case she adds details that help flesh out the encounter.
47. Landau, "Lee Krasner's Early Career, Part Two," 81; oral history interview with Lee Krasner, November 2, 1964–April 11, 1968, AAA-SI.
48. Potter, *To a Violent Grave*, 65–66.
49. Landau et al., *Mercedes Matter*, 264.
50. Eila Kokkinen, "John Graham During the 1940s," 99–100; Levin, *Lee Krasner*, 186; Herrera, "John Graham: Modernist Turns Magus," 100.
51. Willem and Elaine de Kooning, interview by Peter Busa and Sandra Kraskin, AAA-SI; Lee Krasner, interview by Ellen G. Landau, AAA-SI; Dorfman, *Out of the Picture*, 21. Resnick described Graham's attire as a dark skirt, "a kilt without designs."
52. Porter, "John Graham, Painter as Aristocrat," 39.
53. Landau, *Jackson Pollock*, 253n23.
54. Herrera, "John Graham: Modernist Turns Magus," 100; Herrera, "Le Feu Ardent," 8; Elaine de Kooning, interview by Jeffrey Potter, courtesy PKHSC.
55. Allentuck, *John Graham's System and Dialectics of Art*, 120, 145–46.
56. Graham, "Primitive Art and Picasso," 237.
57. Herrera, "John Graham: Modernist Turns Magus," 101.
58. Allentuck, *John Graham's System and Dialectics of Art*, 175–77.
59. Ibid., 96–97, 136–37; Herrera, "John Graham: Modernist Turns Magus," 101.
60. Lee Krasner, interview by Jack Taylor; Naifeh and Smith, *Jackson Pollock*, 396; Karmel, *Jackson Pollock: Interviews, Articles, and Reviews*, 35; Elaine de Kooning, "The Modern Museum's Fifteen:

Dickinson and Kiesler," 20. Kiesler was nicknamed "Doktor Raum" because of his possessive attitude toward "space," according to Elaine.
61. "The American Abstract Artist 6th Annual Exhibition catalog," Box 10, Folder 40, Jackson Pollock and Lee Krasner Papers, AAA-SI, 2; Levin, *Lee Krasner*, 184.
62. Levin, *Lee Krasner*, 179; Rembert, "Mondrian," 60. Perhaps not surprisingly, Mondrian himself did not appear. After painting for nearly 50 years without a show, his first commercial success might have seemed a little beside the point.
63. Lee Krasner, "Pollock," 3; Naifeh and Smith, *Jackson Pollock*, 400; Levin, *Lee Krasner*, 190–91.
64. Oral history interview with Elisabeth Ross Zogbaum, AAA-SI.
65. Naifeh and Smith, *Jackson Pollock*, 395, 400–1; Levin, *Lee Krasner*, 193.
66. Potter, *To a Violent Grave*, 75.
67. Landau, *Lee Krasner: A Catalogue Raisonné*, 307; Gruen, *The Party's Over Now*, 230.

8. Chelsea

1. Rainer Maria Rilke, *Letters to a Young Poet*, 7–8.
2. Gruen, *The Party's Over Now*, 213; Chancey, "Elaine de Kooning," 23; Lieber, *Reflections in the Studio*, 120n39; Elaine de Kooning, interview by Antonina Zara, 24; Stevens and Swan, *De Kooning*, 179–80.
3. Schloss, "The Loft Generation," Edith Schloss Burckhardt Papers, Columbia, 33.
4. Hermine Ford, interview by author; Schloss, "The Loft Generation," Edith Schloss Burckhardt Papers, Columbia, 33.
5. Clay Fried, interview by author.
6. Schloss, "The Loft Generation," Edith Schloss Burckhardt Papers, Columbia, 2.
7. Elaine de Kooning, interview by Minna Daniels, 5; "Virgil Thomson (1896–1989), About/Biography," virgilthomson.org; Willem and Elaine de Kooning, interview by Peter Busa and Sandra Kraskin, AAA-SI.
8. Elaine de Kooning, interview by John Gruen, AAA-SI, 5; John Rockwell, "Virgil Thomson, Composer, Critic," www.nytimes.com/books/97/07/06/reviews/thomson-obit.htm; virgil thomson.org.
9. Oral history interview with Fairfield Porter, AAA-SI.
10. "Edwin Denby Remembered, Part 1," 12; Schloss, "The Loft Generation," Edith Schloss Burckhardt Papers, Columbia, 66.
11. Patricia Passlof, Notes and interviews for "The 30s, Painting in New York" exhibition catalog, Reel 69–45, Pat Passlof Papers, 1957–1969, AAA-SI; oral history interview with Rudy Burckhardt, AAA-SI; "Ibram Lassaw on Bill de Kooning," November 3, 1997, notes compiled by Denise Lassaw, courtesy Denise Lassaw; Stevens and Swan, *De Kooning*, 144; Hess, *Willem de Kooning* (1968), 21.
12. "Edwin Denby Remembered, Part 1," 7, 12.
13. Schloss, "The Loft Generation," Edith Schloss Burckhardt Papers, Columbia, 53.
14. Ibid., 46. Edith's "letter" to Elaine published in "The Loft Generation" was written after she learned of Elaine's death.
15. "Edwin Denby Remembered, Part 1," 29.
16. Schloss, "The Loft Generation," Edith Schloss Burckhardt Papers, Columbia, 19; Andreas Feininger and Susan E. Lyman, *The Face of New York*, n.p.
17. Lieber, *Reflections in the Studio*, 28–29; Edgar, *Club Without Walls*, 37.
18. "Edwin Denby Remembered, Part 1," 30.
19. Schloss, "The Loft Generation," Edith Schloss Burckhardt Papers, Columbia, 57.
20. Campbell, "Elaine de Kooning Paints a Picture," 63.
21. "Edwin Denby Remembered, Part 1," 29; Schloss, "The Loft Generation," Edith Schloss Burckhardt Papers, Columbia, 67.
22. "Ellen Auerbach, 1906–2004," Jewish Women's Archive, http://jwa.org/encyclopedia/article/auerbach-ellen; Schloss, "The Loft Generation," Edith Schloss Burckhardt Papers, Columbia, 27.
23. "Ellen Auerbach, 1906–2004," Jewish Women's Archive, http://jwa.org/encyclopedia/article/auerbach-ellen; Schloss, "The Loft Generation," Edith Schloss Burckhardt Papers, Columbia, 15, 27–28.

24. Schloss, "The Loft Generation," Edith Schloss Burckhardt Papers, Columbia, 116.
25. Ibid., 44, 176.
26. Hermine Ford, interview by author.
27. Schloss, "The Loft Generation," Edith Schloss Burckhardt Papers, Columbia, 3.
28. Oral history interview with Nell Blaine, AAA-SI; Munro, *Originals*, 263, 265–66; Sawin, *Nell Blaine*, 17, 19; Helen A. Harrison, *Larry Rivers*, 11.
29. Munro, *Originals*, 263.
30. Sawin, *Nell Blaine*, 19.
31. Nell Blaine, interview by Larry Rivers, unpublished notes, Larry Rivers Papers, MSS 293, Series II, Subseries C, Box 25, Folder 23, NYU; Sawin, *Nell Blaine*, 19; oral history interview with Nell Blaine, AAA-SI; Munro, *Originals*, 266.
32. Oral history interview with Nell Blaine, AAA-SI; Munro, *Originals*, 266; Sawin, *Nell Blaine*, 24. Bob would play in the military band as well as keep his job in the orchestra at a Broadway theater.
33. Oral history interview with Nell Blaine, AAA-SI; Sawin, *Nell Blaine*, 25.
34. Sawin, *Nell Blaine*, 24; Myers, *Tracking the Marvelous*, 121.
35. Ibram and Ernestine Lassaw, interviews for article on Willem de Kooning, Charlotte Willard Papers, AAA-SI; Daniel Belgrad, *The Culture of Spontaneity*, 179–80; Sawin, *Nell Blaine*, 22, 24.
36. Sawin, *Nell Blaine*, 22, 24, 25.
37. Munro, *Originals*, 266–67.
38. David Lehman, *The Last Avant-Garde*, 62.
39. Auden, *The Age of Anxiety*, 17; Stephen Polcari, "From Omaha to Abstract Expressionism," 10n; John Costello, *Virtue Under Fire*, 177; Polenberg, *War and Society*, 11–12, 16. Car and light truck production was suspended, iron and steel were banned from consumer goods, home construction came to a halt.
40. D'Ann Campbell, *Women at War with America*, 177, 179; Polenberg, *War and Society*, 32.
41. Gruen, *The Party's Over Now*, 213.
42. Gilbert, *The Second World War*, 290, 318, 330; Diggins, *The Proud Decades*, 35.
43. Polenberg, *War and Society*, 51.
44. Gruen, *The Party's Over Now*, 213.
45. Ernestine Lassaw, interview by author.
46. Polenberg, *War and Society*, 60–61.
47. Campbell, *Women at War with America*, 71; Polenberg, *War and Society*, 43.
48. Polenberg, *War and Society*, 44–45; Zucker, "Art in Dark Times," 22; Helen A. Harrison and Constance Ayers Denne, *Hamptons Bohemia*, 71.
49. Polenberg, *War and Society*, 47–48, 138.
50. Ibid., 50; Elaine de Kooning, discussion with Michael and Mildred Loew, 6.
51. Polenberg, *War and Society*, 75.
52. Lipstadt, *Beyond Belief*, 187–88.
53. Hobbs, *Lee Krasner* (1999), 65.
54. Lipstadt, *Beyond Belief*, 171–72, 180–81, 183, 199.
55. Ibid., 200; Hobbs, *Lee Krasner* (1999), 66.
56. Polcari, *Abstract Expressionism*, 17; Irving Sandler, interview by author; Hannah Arendt, "The Concentration Camps," 744–45; Lipstadt, *Beyond Belief*, 210, 216. From rural towns to city apartment blocks, constant visual reminders appeared honoring the sacrifices individual families had made. Those with a father or son in the military displayed a blue star in the window of their homes. If that serviceman was killed in action, the blue star would be replaced by a gold one.
57. Brossard, *The Scene Before You*, 20–21; Lynes, "The Eye of the Beholder," lecture notes for Smith College Museum of Art, May 5, 1985, Box 1, Russell Lynes Papers 1935–1986, AAA-SI, 19; Lynes, *Good Old Modern*, 451–53; Ashton, *The Life and Times of the New York School*, 146; Ashton, *The New York School*, 117–18; Matossian, *Black Angel*, 320–21. Corporations—IBM, Dole Pineapple, Pepsi—had also begun to "support the arts" as an act of patriotism, as had the federal government with a "Buy American Art Week."
58. A. H. Mayor, "The Artists for Victory Exhibition," 141, www.metmuseum.org/pubs/bulletin/1/pdf.
59. Manny Farber, "What Artists and What Victory?"149; Arnold Hauser, *The Social History of Art*, vol. 1, *From Prehistoric Times to the Middle Ages*, 89, 92–93, 105. The linkage of art and conflict by rulers,

governments, or financial powers was at least as old as fourth-century Greece, where an upper class whose world had been wracked by war rushed to buy art that masked reality with their own glorious imaginings. But, historically, true artists rejected that soothing deception. Amid the wars, and religious and social changes of the sixteenth century, Michelangelo had not sought to produce a work of reassuring beauty that would please the most people. He painted *The Last Judgment*, "a picture of bewilderment and despair, a cry for redemption from the chaos which suddenly threatens to swallow up the world of the Renaissance," according to art historian Hauser, who called the work "the first important artistic creation of modern times which is *no longer* 'beautiful.'" Michelangelo's work dared to reflect his time.

60. Ashton, *The Life and Times of the New York School*, 148–49.
61. Edgar, *Club Without Walls*, 24–25, 39.
62. Elaine de Kooning, interview by Charles Hayes, 12.
63. Julien Levy, *Surrealism*, 3, 188; Ashton, *The Life and Times of the New York School*, 115–17; Arnold Hauser, *The Social History of Art*, vol. 4, *Naturalism, Impressionism: The Film Age*, 222; Robert Hughes, *The Shock of the New*, 212–13; Alex Danchev, ed., *One Hundred Artists' Manifestos*, 247–48, 273–74. The French poet Guillaume Apollinaire coined the phrase "sur-realisme" in 1917 to describe the ballet *Parade* on which Picasso, Jean Cocteau, Erik Satie, and Léonid Massine collaborated. Breton adopted it three years later to describe a new reality for art—a "sur-reality" or what he called "absolute reality"—found or experienced in dreams, the unconscious, and sensual desire, those arenas in which reason does not impinge. The result would be freedom from what most people accepted as inescapable reality.

9. Intellectual Occupation

1. Gertrude Stein, *Wars I Have Seen*, 44.
2. Levy, *Surrealism*, 12; Peggy Guggenheim, *Out of This Century*, 189; "Philip Pavia Talks on the War Years," 17; Hughes, *The Shock of the New*, 212.
3. Gill, *Art Lover*, 298; oral history interview with James Thrall Soby, AAA-SI; "Philip Pavia Talks on the War Years," 18; Ashton, *The New York School*, 118.
4. Passlof, notes and interviews for "The 30s: Painting in New York," Pat Passlof Papers, AAA-SI; John Bernard Myers, interview by Barbara Rose, March 12, 1968, Series V, Box 13, R3, GRI.
5. Janis, *Abstract and Surrealist Art*, 126.
6. Edgar, *Club Without Walls*, 22; "Philip Pavia Talks on the War Years," 18; oral history interview with Fritz Bultman, AAA-SI. The first wave of artistic immigrants to impact the New York group had included Hans Hofmann, Josef Albers and the Bauhaus group. The second wave included the Surrealists. Bultman said they "represented two separate and overlapping influences."
7. Gill, *Art Lover*, 278.
8. Zucker, "Art in Dark Times," 82; Diggins, *The Proud Decades*, 224, 229.
9. Diggins, *The Proud Decades*, 221–22; Jackman and Borden, *The Muses Flee Hitler*, 139–40.
10. Diggins, *The Proud Decades*, 223.
11. Ibid., 223–24.
12. Ashton, *The New York School*, 122; Donald Fleming and Bernard Bailyn, eds., *The Intellectual Migration*, 420–21, 444–45; Barrett, *The Truants*, 230; Juliet Mitchell, *Psychoanalysis and Feminism*, 298–99. Fleming and Bailyn write that Freud's theories dominated the field of psychology and psychoanalysis in the United States because fewer Jungians, who were largely based in Switzerland, were forced to flee Europe. Among the artists, Jung's ideas were important for their work, but those who underwent psychoanalysis were mostly in the hands of Freudians. Indeed, Barrett said in the 1940s, Freud replaced Marx for many intellectuals. "If you could dig up any money at all, you had a moral and an intellectual duty to face yourself in psychoanalysis." Mitchell writes that the acceptance of Freudian analysis, and its concepts of biological determinism, helped justify the unequal treatment of women at the very time debate raged over how to get women back into the home at the end of the war.
13. Zucker, "Art in Dark Times," 77, 83; Panofsky, *Meaning in the Visual Arts*, 370–72; Fleming and Bailyn, *The Intellectual Migration*, 568–69.
14. Zucker, "Art in Dark Times," 74; James Schuyler, "Is There an American Print Revival? New York," 36.

15. Oral history interview with George Wittenborn, AAA-SI; Gill, *Art Lover*, 269–70; Ashton with Banach, *The Writings of Robert Motherwell*, 6; Fleming and Bailyn, *The Intellectual Migration*, 601.
16. Hess, *Abstract Painting*, 97; Robert Motherwell, interview by John Jones, AAA-SI.
17. "Philip Pavia Talks on the War Years," 17–18; Matossian, *Black Angel*, 332; Robert Motherwell, interview by John Jones, AAA-SI; Edgar, *Club Without Walls*, 22.
18. Edgar, *Club Without Walls*, 23; Hess, *Willem de Kooning* (1959), 11; Goldwater, "Reflections on the New York School," 22–24.
19. Robert Motherwell, interview by John Jones, AAA-SI.
20. "Philip Pavia Talks on the War Years," 17; oral history interview with Adolph Gottlieb, October 25, 1967, AAA-SI; Hess, *Willem de Kooning* (1959), 10–11. Hess said from the Europeans the Americans learned two things: the fabled artists from Paris were human beings and "they acted as though art were a distinguished, honored profession...that took in the whole intellectual world."
21. Oral history interview with Ibram Lassaw, AAA-SI; "Philip Pavia Talks on the War Years," 17; Philip Pavia, interview by Jack Taylor; Edgar, *Club Without Walls*, 21.
22. Edgar, *Club Without Walls*, 10.
23. Ibid., 4, 12–13; Philip Pavia, interview by John Gruen, AAA-SI, 12.
24. Edgar, *Club Without Walls*, 24; Philip Pavia, interview by Jack Taylor.
25. De Antonio, *Painters Painting*, film; Rosamond Bernier, "The Decisive Decade," 430. "Here are these guys living through this terrible war in Europe, and they came over here and their painting doesn't change at all. They paint as if nothing had happened," said Annalee Newman, who with her painter husband, Barney, was part of the Waldorf crowd.
26. Edward Alden Jewell, "'The Problem of Seeing'," X7.
27. Philip Pavia, interview by John Gruen, AAA-SI, 13; Edgar, *Club Without Walls*, 30.
28. Edgar, *Club Without Walls*, 30; Philip Pavia, interview by John Gruen, AAA-SI, 13; Gruen, *The Party's Over Now*, 266–67.
29. Gruen, *The Party's Over Now*, 268.
30. Edgar, *Club Without Walls*, 11.
31. Ibid., 17.
32. Rose, "Krasner/Pollock: A Working Relationship," 8.
33. Solomon, *Jackson Pollock*, 124–25; Engelmann, *Jackson Pollock and Lee Krasner*, 25.
34. John Bernard Myers, interview by Barbara Rose, audiotape, March 12, 1968, Series V, Box 13, R3, GRI.
35. Lee Krasner, interview by Barbara Novak, videotape courtesy PKHSC.
36. Potter, *To a Violent Grave*, 68.
37. Lee Krasner, unpublished notes, December 1977, Series 2, Subseries 5, Box 10, Folder 11, Jackson Pollock and Lee Krasner Papers, AAA-SI, 1.
38. Rose, "Krasner/Pollock: A Working Relationship," 8.
39. Naifeh and Smith, *Jackson Pollock*, 433; Solomon, *Jackson Pollock*, 127.
40. Landau, *Lee Krasner: A Catalogue Raisonné*, 307.
41. Naifeh and Smith, *Jackson Pollock*, 434; Glueck, "Scenes from a Marriage," 60.
42. Potter, *To a Violent Grave*, 72; Naifeh and Smith, *Jackson Pollock*, 434; Ellen G. Landau, "Lee Krasner's Early Career, Part Two," 81; Solomon, *Jackson Pollock*, 127.
43. Marquis, *The Art Biz*, 242; Landau, *Lee Krasner: A Catalogue Raisonné*, 70; Levin, *Lee Krasner*, 209; Friedman, *Jackson Pollock: Energy Made Visible*, 66.
44. Landau, *Lee Krasner: A Catalogue Raisonné*, 70; Janis, *Abstract and Surrealist Art in America*.
45. Les Levine, "A Portrait of Sidney Janis," 52; Naifeh and Smith, *Jackson Pollock*, 474; Solomon, *Jackson Pollock*, 146.
46. Potter, *To a Violent Grave*, 68; Friedman, *Jackson Pollock: Energy Made Visible*, 65; Naifeh and Smith, *Jackson Pollock*, 442.
47. Gill, *Art Lover*, 316; Melvin P. Lader, "Howard Putzel," 87.
48. Oral history interview with Theodoros Stamos, AAA-SI.
49. Gill, *Art Lover*, 315.
50. Naifeh and Smith, *Jackson Pollock*, 443; Lader, "Howard Putzel," 91.
51. Lader, "Howard Putzel," 91; Naifeh and Smith, *Jackson Pollock*, 448, 458–59; Marquis, *Art Czar*, 94.
52. Letter from Lee Krasner to Mercedes Matter reprinted in Landau et al., *Mercedes Matter*, 72n86.

53. Amei Wallach, "Lee Krasner's Triumph," 501.
54. Ashton and Banach, *The Writings of Robert Motherwell*, 1, 2, 5; Jack Flam, Katy Rogers, and Tim Clifford, *Robert Motherwell*, viii, 184, 186; Abel, *The Intellectual Follies*, 88; Robert Motherwell, interview by Barbaralee Diamonstein, provided by Dr. Barbaralee Diamonstein-Spielvogel, interviewer and author, from *Inside New York's Art World*, 239; H. H. Arnason, *Robert Motherwell*.
55. Robert Motherwell, interview by Barbaralee Diamonstein, provided by Dr. Barbaralee Diamonstein-Spielvogel, interviewer and author, from *Inside New York's Art World*, 240–41; Flam et al., *Robert Motherwell*, 184, 186.
56. Abel, *The Intellectual Follies*, 90; Solomon, *Jackson Pollock*, 121; Naifeh and Smith, *Jackson Pollock*, 429; Abel, *The Intellectual Follies*, 90; Flam et al., *Robert Motherwell*, 7.
57. Naifeh and Smith, *Jackson Pollock*, 422, 424; Flam et al., *Robert Motherwell*, 184; Solomon, *Jackson Pollock*, 123–24; Landau, "Lee Krasner's Early Career, Part Two," 81–82.
58. Naifeh and Smith, *Jackson Pollock*, 424–26; Levy, *Memoir of an Art Gallery*, 247; Abel, *The Intellectual Follies*, 90–91.
59. Levy, *Surrealism*, 52; Abel, *The Intellectual Follies*, 107, 109; Parker and Pollock, *Old Mistresses*, 137–39; John Bernard Myers, ed., *The Poets of the New York School*, 12; Terrence Diggory and Stephen Paul Miller, eds., *The Scene of My Selves*, 192.
60. Parker and Pollock, *Old Mistresses*, 137–39; Levy, *Surrealism*, 52; Mary Ann Caws, Rudolf Kuenzli, and Gwen Raaberg, eds., *Surrealism and Women*, 1–2, 17–18, 19, 20.
61. Lee Krasner, interview by Barbara Cavaliere, AAA-SI, 10; *Lee Krasner*, interview by Barbara Novak, videotape courtesy PKHSC; Lee Krasner, interview by Barbaralee Diamonstein, provided by Dr. Barbaralee Diamonstein-Spielvogel, interviewer and author, from *Inside New York's Art World*, 202.
62. *Lee Krasner*, interview by Barbara Novak, videotape courtesy PKHSC; Lee Krasner, interview by Barbaralee Diamonstein, provided by Dr. Barbaralee Diamonstein-Spielvogel, interviewer and author, from *Inside New York's Art World*, 202.
63. Evelyn Bennett, "Lee Krasner, In Her Own Right," *The Bridgehampton Sun*, August 20, 1980, Series 2, Subseries 8, Box 11, Folder 16, Jackson Pollock and Lee Krasner Papers, AAA-SI, 2; Solomon, *Jackson Pollock*, 124.
64. Landau, "Lee Krasner's Early Career, Part Two," 82; Levin, *Lee Krasner*, 211.
65. *Lee Krasner*, interview by Barbara Novak, videotape courtesy PKHSC.
66. Bennett, "Lee Krasner: In Her Own Right," 2.
67. *Lee Krasner*, interview by Barbara Novak, videotape courtesy PKHSC.
68. Ibid.
69. Helen Harrison, telephone interview with author.
70. Lillian Kiesler, interview Ellen G. Landau, AAA-SI, 9.
71. Glueck, "Scenes from a Marriage," 60; *Lee Krasner: An Interview with Kate Horsfield*, videotape courtesy PKHSC.
72. Gibson, *Abstract Expressionism*, 135.
73. Nemser, "A Conversation with Lee Krasner," 43–44; oral history interview with Lee Krasner, November 2, 1964–April 11, 1968, AAA-SI; Landau, *Lee Krasner: A Catalogue Raisonné*, 97; Landau, "Lee Krasner's Early Career, Part Two," 82.
74. Philip Pavia, interview by John Gruen, AAA-SI, 14.
75. Myers, *Tracking the Marvelous*, 32; oral history interview with Enrico Donati, AAA-SI.
76. Gill, *Art Lover*, 335.
77. *Lee Krasner: An Interview with Kate Horsfield*, videotape courtesy PKHSC.
78. Gill, *Art Lover*, 335.
79. Guggenheim, *Out of This Century*, 12–13, 21, 24, 27, 161–62.
80. Ibid., 209, 215–16, 219.
81. Ibid., 216, 220, 230, 233, 245.
82. Ashton, *The Life and Times of the New York School*, 121; oral history interview with Rebecca Reis, AAA-SI; Gill, *Art Lover*, 290, 305.
83. Gill, *Art Lover*, 306, 315.
84. Ibid., 285, 304; Myers, *Tracking the Marvelous*, 24.
85. Guggenheim, *Out of This Century*, 280–84.

86. Ibid., 284–85; Potter, *To a Violent Grave*, 71–72; Landau, "Lee Krasner's Early Career, Part Two," 83; oral history interview with James Thrall Soby, AAA-SI. Soby would be particularly important because in 1943, he would become the assistant director of the Museum of Modern Art.
87. Rembert, *Mondrian*, 82, 85.
88. Potter, *To a Violent Grave*, 71–72.
89. Guggenheim, *Out of This Century*, 284–85; Theodoros Stamos, interview by Jack Taylor.

10. The High Beam

1. Sagan, *A Certain Smile*, 75.
2. Elaine de Kooning, interview by Antonina Zara, 24; Edwin Denby, "My Friend de Kooning," 84; Hess, *Willem de Kooning* (1968), 46.
3. Stevens and Swan, *De Kooning*, 193.
4. Ibid., 194.
5. Elaine de Kooning, interview by Ellen Auerbach, 1, 3; Stevens and Swan, *De Kooning*, 192, 194.
6. Hall, *Elaine and Bill*, 45–46.
7. Schloss, "The Loft Generation," Edith Schloss Burckhardt Papers, Columbia, 6; Elaine de Kooning, interview by Ellen Auerbach, 1–2.
8. Elaine de Kooning, interview by Ellen Auerbach, 1–2; Lieber, *Reflections in the Studio*, 25–26.
9. Elaine de Kooning, interview by Molly Barnes, 9; Elaine de Kooning, interview by Ellen Auerbach, 1–2; Lieber, *Reflections in the Studio*, 26; Stevens and Swan, *De Kooning*, 179, 209; John Elderfield, *De Kooning: A Retrospective*, 982. Elaine's job financed the construction, and Bill paid living expenses through the sale of his work.
10. Denby, *My Friend de Kooning*, 84; Schloss, "The Loft Generation," Edith Schloss Burckhardt Papers, Columbia, 9; Lieber, *Reflections in the Studio*, 26; Stevens and Swan, *De Kooning*, 195–96.
11. Lieber, *Reflections in the Studio*, 26; Stevens and Swan, *De Kooning*, 92, 196.
12. Schloss, "The Loft Generation," Edith Schloss Burckhardt Papers, Columbia, 10.
13. Elaine de Kooning, interview by Ellen Auerbach, 20.
14. Elaine de Kooning, interview by Arthur Tobier, 15.
15. Elaine de Kooning, interview by Antonina Zara, 14. Bill's advice to students was "look for the lowest possible standard of living and guard your time." To which, Elaine added, "If you want to be a painter…spend as little time as possible surviving."
16. Neil McWilliam, Catherine Méneux, and Julie Ramos, "Henri de Saint-Simon, L'Artiste, le Savant, et l'Industrial, 1824," *L'Art social de la Révolution à la Grande Guerre. Anthologie de textes sources*, Institute national d'histoire de l'art, June 10, 2014, http://inha.revues.org/5083. The military term "avant-garde" was used in relation to artists in the 1830s by the French socialist Henri de Saint-Simon, who saw the artist as a force of social change. Its current usage, meaning the most advanced art, was adopted decades later.
17. Gruen, *The Party's Over Now*, 209–10.
18. Schloss, "The Loft Generation," Edith Schloss Burckhardt Papers, Columbia, 37.
19. Clay Fried, interview by author.
20. Schloss, "The Loft Generation," Edith Schloss Burckhardt Papers, Columbia, 35, 37.
21. Elaine de Kooning, interview by John Gruen, AAA-SI, 10–11.
22. Hall, *Elaine and Bill*, 28.
23. Elaine de Kooning, interview by Ellen Auerbach, 2.
24. Elaine de Kooning, interview by Minna Daniels, 11; Elaine de Kooning, interview by Ellen Auerbach, 1.
25. Elaine de Kooning, interview by Minna Daniels, 12.
26. Gruen, *The Party's Over Now*, 216; Hall, *Elaine and Bill*, 26, 39.
27. Hall, *Elaine and Bill*, 43.
28. Elaine de Kooning, interview by Ellen Auerbach, 3; oral history interview with Elaine de Kooning, AAA-SI.
29. Stevens and Swan, *De Kooning*, 277; Passlof, "Willem de Kooning, on his Eighty-Fifth Birthday," 229.
30. Søren Kierkegaard, *Fear and Trembling*, 14–16, 75, 90–91.
31. Gaugh, *Willem de Kooning*, 15.

32. Gilbert, *The Second World War*, 391, 393–94, 398–400, 404, 410, 412, 421, 426, 437, 443.
33. Richler, ed., *Writers on World War II*, 435.
34. Elaine de Kooning and Koos Lassooy, discussion, 1988, 3–4; Stevens and Swan, *De Kooning*, 168.
35. Stevens and Swan, *De Kooning*, 17, 182–83, 194–95; Brandon Bram Fortune, Ann Eden Gibson, and Simona Cupic, *Elaine de Kooning: Portraits*, 22.
36. Elaine de Kooning, interview by Minna Daniels, 16; Stevens and Swan, *De Kooning*, 195.
37. Matossian, *Black Angel*, 344; oral history interview with Reuben Kadish, AAA-SI.
38. Lieber, *Reflections in the Studio*, 122n49; Herrera, *Arshile Gorky*, 321.
39. Elaine de Kooning, interview by Minna Daniels, 38.
40. Matossian, *Black Angel*, 300–2, 308.
41. Herrera, *Arshile Gorky*, 321.
42. Ibid., 322.
43. Ibid.
44. Ibid., 321–22; Matossian, *Black Angel*, 299, 343; Lieber, *Reflections in the Studio*, 122n49.
45. Matossian, *Black Angel*, 303, 307, 342, 344.
46. Schloss, "The Loft Generation," Edith Schloss Burckhardt Papers, Columbia, 41.
47. Naifeh and Smith, *Jackson Pollock*, 450–51.
48. Ibid., 448; Landau, *Jackson Pollock*, 103.
49. Naifeh and Smith, *Jackson Pollock*, 449; Nemser, *Art Talk*, 88; Levin, *Lee Krasner*, 201.
50. Nemser, *Art Talk*, 88.
51. Guggenheim, *Out of This Century*, 295, 314–15; Naifeh and Smith, *Jackson Pollock*, 450–51; Jackson Pollock to Lee Krasner, New York to Huntington Station, Long Island, July 1943, Pollock Krasner Papers, Box 1, Folder 46, AAA-SI. Lee was away visiting her parents when Jackson agreed to terms with Peggy. He wrote her, "Dear Lee, Have signed the contract and have seen the wall space for the mural—it's all very exciting. See you Saturday Love Jackson."
52. Francis V. O'Connor, *Jackson Pollock*, 28; Naifeh and Smith, *Jackson Pollock*, 459–60; Guggenheim, *Out of This Century*, 315.
53. Naifeh and Smith, *Jackson Pollock*, 454, 460; Stevens and Swan, *De Kooning*, 209.
54. Nemser, *Art Talk*, 88; Naifeh and Smith, *Jackson Pollock*, 460; Guggenheim, *Out of This Century*, 315.
55. Naifeh and Smith, *Jackson Pollock*, 464.
56. Guggenheim, *Out of This Century*, 303–4.
57. Naifeh and Smith, *Jackson Pollock*, 466.
58. Elaine de Kooning, interview by Jeffrey Potter, courtesy PKHSC.
59. Douglas T. Miller and Marion Nowak, *The Fifties: The Way We Really Were*, 131–32.
60. Schloss, "The Loft Generation," Edith Schloss Burckhardt Papers, Columbia, 46.
61. Gruen, *The Party's Over Now*, 161, 213; Denby was the *Herald Tribune*'s critic from 1942 to 1945.
62. Elaine de Kooning, interview by John Gruen, AAA-SI, 5.
63. Gruen, *The Party's Over Now*, 214.
64. "Edwin Denby Remembered, Part I," 8, 10; Larry Rivers with Carol Brightman, "The Cedar Bar," 42.
65. Stahr, *The Social Relations of Abstract Expressionism*, 219.
66. Joe LeSueur, *Digressions on Some Poems by Frank O'Hara*, 95.
67. Campbell, "Elaine de Kooning Paints a Picture," 63; "Edwin Denby Remembered, Part I," 29; oral history interview with Rudy Burckhardt, AAA-SI.
68. "Edwin Denby Remembered, Part I," 29.
69. Ibid., 7.
70. Ibid., 8; Ashton, *The New York School: A Cultural Reckoning*, 142–43, 145.
71. Campbell, "Elaine de Kooning Paints a Picture," 63.
72. Elaine de Kooning, interview by Minna Daniels, 7.
73. Elaine de Kooning, interview by Arthur Tobier, 9.
74. Campbell, "Elaine de Kooning Paints a Picture," 63.
75. Stevens and Swan, *De Kooning*, 197; Elaine de Kooning, interview by John Gruen, AAA-SI, 4.
76. Lieber, *Reflections in the Studio*, 27; Elaine de Kooning, interview by John Gruen, AAA-SI, 3–4.
77. Lieber, *Reflections in the Studio*, 27.

78. Gruen, *The Party's Over Now*, 209; Lieber, *Reflections in the Studio*, 27; Stevens and Swan, *De Kooning*, 196.
79. Lieber, *Reflections in the Studio*, 27, 120n42; Stevens and Swan, *De Kooning*, 145.
80. Lieber, *Reflections in the Studio*, 27, 120n42.
81. Elaine de Kooning, interview by John Gruen, AAA-SI, 2; Lieber, *Reflections in the Studio*, 27; Stevens and Swan, *De Kooning*, 197; Gruen, *The Party's Over Now*, 209; "Abstract Expressionism, Second to None," Thomas McCormick Gallery, Chicago, 2004, 7.
82. Elaine de Kooning, interview by John Gruen, AAA-SI, 4; Gruen, *The Party's Over Now*, 209.
83. Lieber, *Reflections in the Studio*, 28.
84. Ernestine Lassaw, interview by author.
85. Richler, ed., *Writers on World War II*, 435.
86. Flam et al., *Robert Motherwell*, 172n.
87. Richler, ed., *Writers on World War II*, 435; Gilbert, *The Second World War*, 476, 481; Flam et al., *Robert Motherwell*, 46, 172n77; "The Fight for Tarawa," *Life* 15, no. 24 (December 13, 1943): 27; George P. Horne, "Battle for Tarawa," 4.
88. Richler, ed., *Writers on World War II*, 311, 432–33, 435–36.

11. A Light That Blinds, I

1. Paul Goodman, *The Empire City*, 266.
2. Gilbert, *The Second World War*, 704.
3. Lipstadt, *Beyond Belief*, 233; Albert Camus, "Neither Victims nor Executioners," 141. The bomb, Camus said, had condemned humankind to "a dog's life" without imaginings, robbed of tomorrows.
4. Dwight Macdonald, *The Memoirs of a Revolutionist*, 169; Dwight M. Macdonald, "The Root Is Man, Part II," 194. Here Macdonald wrote, "The course which our society is taking is so catastrophic that one is forced to rethink for himself all sorts of basic theoretical questions which in a happier age could have been more or less taken for granted.... Determinism v. Free Will, Materialism v. Idealism, the concept of Progress, the basis for making value judgements, the precise usefulness of science to human ends, and the nature of man himself."
5. Stephen Polcari, "Martha Graham and Abstract Expressionism," 3.
6. Parker and Pollock, *Old Mistresses*, 93.
7. Hess, *Willem de Kooning* (1968), 46; Elaine de Kooning, interview by Antonina Zara, 24. Elaine said, "When I went back to painting, it was as though I had been painting the whole year, because I started again, in a totally different place."
8. Munro, *Originals*, 254.
9. Bledsoe, *E de K*, 34.
10. Ernestine Lassaw, e-mail to author via Denise Lassaw, January 20, 2014.
11. Campbell, "Elaine de Kooning Paints a Picture," 39; Aliza Rachel Edelman, "Modern Woman and Abstract Expressionism," 151n23.
12. Fortune et al., *Elaine de Kooning: Portraits*, 18, 92–93; Munro, *Originals*, 254; Elaine de Kooning, interview by Antonina Zara, 9.
13. Thomas B. Hess, "There's an 'I' in 'Likeness,'" 85.
14. Bledsoe, *E de K*, 37; Stevens and Swan, *De Kooning*, 226; Gruen, *The Party's Over Now*, 215.
15. Gruen, *The Party's Over Now*, 214.
16. Simon Pettet, *Conversations with Rudy Burckhardt*, n.p.
17. Schloss, "The Loft Generation," Edith Schloss Burckhardt Papers, Columbia, 47.
18. Elaine de Kooning, interview by John Gruen, AAA-SI, 7; Gruen, *The Party's Over Now*, 214; Campbell, "Elaine de Kooning Paints a Picture," 63.
19. Elaine de Kooning and Slivka, *Elaine de Kooning*, 9.
20. Elaine de Kooning, interview by John Gruen, AAA-SI, 7; Gruen, *The Party's Over Now*, 214.
21. Schloss, "The Loft Generation," Edith Schloss Burckhardt Papers, Columbia, 47; Stevens and Swan, *De Kooning*, 211; oral history interview with Rudy Burckhardt, AAA-SI.
22. Elaine de Kooning, interview by Minna Daniels, 30.
23. Schloss, "The Loft Generation," Edith Schloss Burckhardt Papers, Columbia, 139; Ernestine Lassaw, interview by author.
24. David Sylvester, Richard Shiff, and Marla Prather, *Willem de Kooning Paintings*, 82.

25. Denby, "My Friend de Kooning," 91.
26. Elaine de Kooning, interview by John Gruen, AAA-SI, 5.
27. Elaine de Kooning, interview by Antonina Zara, 10. Elaine said Bill "never did show with Peggy Guggenheim."
28. Oral history interview with Rudy Burckhardt, AAA-SI; Rudy Burckhardt, "Long Ago with Willem de Kooning," 224.
29. Stevens and Swan, *De Kooning*, 178.
30. Lieber, *Reflections in the Studio*, 20–21, 28.
31. Stevens and Swan, *De Kooning*, 211.
32. Elaine de Kooning, interview by Ellen Auerbach, 2, 18; Lieber, *Reflections in the Studio*, 25.
33. Schloss, "The Loft Generation," Edith Schloss Burckhardt Papers, Columbia, 38, 42.
34. Ernestine Lassaw, interview by author; "Ibram Lassaw," November 9, 1997, notes from audiotape compiled by Denise Lassaw, courtesy of Denise Lassaw; Denise Lassaw, e-mail to author, September 6, 2016.
35. Elaine de Kooning, interview by Ellen Auerbach, 6–7.
36. Oral history interview with Rudy Burckhardt, AAA-SI; Rudy Burckhardt, "Long Ago with Willem de Kooning," 224; Denise Lassaw, e-mail to author, January 20, 2014.
37. Ernestine Lassaw, interview by author; Denise Lassaw, e-mail to author April 26, 2014, April 27, 2014; oral history interview with Ibram Lassaw, AAA-SI.
38. Ernestine Lassaw, interview by author.
39. Ibid.
40. Lieber, *Reflections in the Studio*, 31; Ernestine Lassaw, e-mail to author via Denise Lassaw, April 26, 2014.
41. Chancey, "Elaine de Kooning," 55.
42. Elaine de Kooning, interview by Molly Barnes, 6.
43. Stevens and Swan, *De Kooning*, 198.
44. Schloss, "The Loft Generation," Edith Schloss Burckhardt Papers, Columbia, 48.
45. Elaine de Kooning, interview by Minna Daniels, 32–33.
46. Elaine de Kooning, interview by Antonina Zara, 29.
47. Ibid., 14.
48. Elaine de Kooning, interview by Minna Daniels, 13.
49. Elaine de Kooning, interview by Molly Barnes, 8.
50. Glenda Riley, *Inventing the American Woman*, 6, 186; Sidney Ditzion, *Marriage, Morals and Sex in America*, 16, 21, 29; Williams, "Woman: Myth and Stereotype," 221–22; Parker and Pollock, *Old Mistresses*, 99; Eric John Dingwall, *The American Woman*, 68–70; Chafe, *The American Woman*, 57. Of course, frontier women, poor women, and slaves continued their lives of *backbreaking* labor no matter the greater circumstances in society.
51. Riley, *Inventing the American Woman*, 196; Parrish, *Anxious Decades*, 139–41.
52. Rosen, *Popcorn Venus*, 76; Chafe, *The American Woman*, 49, 50, 51–52; Riley, *Inventing the American Woman*, 203; Maureen Honey, "Images of Women in 'The Saturday Evening Post,'" 352–53, 356. Throughout the 1930s, the *Saturday Evening Post*, which had in 1928 the largest magazine circulation in the world at three million, often depicted smart, successful, confident women engaged in careers. But when in its stories the choice came between a family and a profession, most of the women accepted the more traditional role.
53. Rosen, *Popcorn Venus*, 84; Rosalyn Baxandall and Linda Gordon, eds., *America's Working Woman*, 193.
54. Rosen, *Popcorn Venus*, 82, 143, 146, 149, 150; Betty Friedan, *The Feminine Mystique*, 32–33; Conn, *The American 1930s, A Literary History*, 127.
55. Elaine de Kooning, interview by Charles Hayes, 4–5; Munro, *Originals*, 39, 251. Munro wrote, "Women of the second wave, schooled in the 30s of progressive education, political activism and cultural optimism, were raised to be winners."
56. Dingwall, *The American Woman*, 134; Rosen, *Popcorn Venus*, 164, 174–75, 207, 209–10; Molly Haskell, *From Reverence to Rape*, 95, 172, 230; Kathryn Weibel, *Mirror, Mirror*, 104–5, 106–7, 114–17; Friedan, *The Feminine Mystique*, 33.
57. Baxandall and Gordon, *America's Working Woman*, 248; Riley, *Inventing the American Woman*, 229; Clements, *Prosperity, Depression and the New Deal*, 211; Chafe, *Women and Equality*, 92–93.

58. Campbell, *Women at War with America,* 66–68, 72–74 84; Chafe, *The American Woman,* 137–38, 140–42, 146, 149; Weibel, *Mirror, Mirror,* 209; Chafe, *Women and Equality,* 92–93; Costello, *Virtue Under Fire,* 179–80. As many as two million women were employed in heavy industry during the war, and two million more in offices.
59. Campbell, *Women at War with America,* 20; Riley, *Inventing the American Woman,* 229; Costello, *Virtue Under Fire,* 40, 41, 42, 47; Chafe, *The American Woman,* 121. The magnitude of the shift can be appreciated when one considers that in 1940, the year before the war, eleven states did not allow a woman to hold her earnings in her own name without her husband's permission; sixteen states denied women the right to make contracts; and a woman was not a "person in the eyes of the law" in some jurisdictions.
60. Rosen, *Popcorn Venus,* 217, 219, 239; Campbell, *Women at War with America,* 72–74, 86; Chafe, *Women and Equality,* 94; Riley, *Inventing the American Woman,* 232; Chafe, *The American Woman,* 176–77; Baxandall and Gordon, *America's Working Woman,* 262; Juliet Mitchell, *Psychoanalysis and Feminism,* 298; Weibel, *Mirror, Mirror,* 120–21; Simone de Beauvoir, *The Second Sex,* 83; Kate Millett, *Sexual Politics,* 203; Friedan, *The Feminine Mystique,* 11, 95–97, 178. Friedan said the concept "penis envy" was seized upon in the United States in the 1940s to explain "all that was wrong with American women." And yet, she said, "much of what Freud described as characteristic of universal human nature was merely characteristic of certain middle class European men and women at the end of the nineteenth century."
61. Gilbert, *The Second World War,* 532–34, 538, 544, 551.
62. Ibid., 571, 578, 580–81; Diggins, *The Proud Decades,* 44.
63. Gilbert, *The Second World War,* 624; MacDonald, *The Memoirs of a Revolutionist,* 161.
64. Gilbert, *The Second World War,* 640–41; Zinn, *A People's History of the United States,* 421; Diggins, *The Proud Decades,* 40.
65. Gilbert, *The Second World War,* 649.
66. Ibid., 634.
67. Ibid., 658, 661.
68. Zucker, "Art in Dark Times," 149.
69. "F.D.R. Dies!" *San Francisco Chronicle,* April 13, 1945, 1; "Death Shakes National Capital to Its Foundation," *The Staunton (Va.) News-Leader,* April 13, 1945; "President Roosevelt Is Dead: Truman to Continue Policies: 9th Crosses Elbe, Nears Berlin," *New York Times,* April 12, 1945, 1.
70. Frank Kluckhohn, "Crowds in Tears Watch Funeral Train Roll North," *New York Times,* April 14, 1945, 1.
71. Gilbert, *The Second World War,* 670, 674, 676, 678, 680, 683, 689, 690.

12. A Light That Blinds, II

1. Arendt, "The Concentration Camps," 747.
2. Letter from Janet Hauck to Mercedes Matter, reprinted in Landau et al., *Mercedes Matter,* 41, 72n84.
3. Gilbert, *The Second World War,* 697, 705; www.history.com/topics/world-war-ii/bombing-of-hiroshima.
4. Gilbert, *The Second World War,* 697, 704, 707; Abel, *The Intellectual Follies,* 146.
5. C. Wright Mills, "The Powerless People," 69.
6. Martin J. Sherwin, *A World Destroyed,* 232; Chipp, *Theories of Modern Art,* 560; Schloss, "The Loft Generation," Edith Schloss Burckhardt Papers, Columbia, 37.
7. Gilbert, *The Second World War,* 712–13; "Bombing of Hiroshima and Nagasaki," www.history.com/topics/world-war-ii/bombing-of-hiroshima-and-nagasaki; Sherwin, *A World Destroyed,* 232, 234.
8. Matossian, *Black Angel,* 392; "Abstract Expressionism, 1945," http://www.warholstars.org/abstract-expressionism/timeline/abstractexpressionism1945b.html.
9. Gilbert, *The Second World War,* 715.
10. Ibid., 715, 717; Chafe, *The American Woman,* 174; Diggins, *The Proud Decades,* 51; "Bombing of Hiroshima and Nagasaki," www.history.com/topics/world-war-ii/bombing-of-hiroshima-and-nagasaki.
11. Barrett, *The Truants,* 28.
12. Rivers, *What Did I Do?,* 24; Malina, *The Diaries of Judith Malina,* 33–34.
13. Gilbert, *The Second World War,* 1, 746, 747.

14. Zucker, "Art in Dark Times," 155.
15. Miller and Nowak, *The Fifties*, 379; Rollo May, *Man's Search for Himself*, 13–14.
16. Abel, *The Intellectual Follies*, 147, 150; Edgar, *Club Without Walls*, 39; "Boris Lurie: NO!," 12; Norman Jacobs, ed., *Culture for the Millions?*, 51.
17. *KZ-KAMPF-KUNST Boris Lurie: NO!ART*, 139–40; Miller and Nowak, *The Fifties*, 234–35.
18. Zinn, *A People's History of the United States*, 417; Myers, *Tracking the Marvelous*, 49–50; Clements, *Prosperity, Depression and the New Deal*, 225.
19. Richler, *Writers on World War II*, 435.
20. Ibid., 436.
21. Zinn, *A People's History of the United States*, 414.
22. Gino Severini, *The Artist and Society*, 74.
23. Levin, *Lee Krasner*, 226; Naifeh and Smith, *Jackson Pollock*, 499, 501; Potter, *To a Violent Grave*, 80–81; Harrison and Denne, *Hamptons Bohemia*, 75.
24. Steven Gaines, *Philistines at the Hedgerow*, 118, 122–23; Harrison and Denne, *Hamptons Bohemia*, 74.
25. Interview with May Tabak Rosenberg, by Jeffrey Potter, audiotape courtesy PKHSC; Potter, *To a Violent Grave*, 80–81; Landau, *Jackson Pollock*, 155; Naifeh and Smith, *Jackson Pollock*, 499; Solomon, *Jackson Pollock*, 155.
26. Letter from Lee Krasner to Mercedes Matter reprinted in Landau et al., *Mercedes Matter*, 43–44, 72n86.
27. Gaines, *Philistines at the Hedgerow*, 187.
28. Letter from Lee Krasner to Mercedes Matter reprinted in Landau et al., *Mercedes Matter*, 43–44, 72n86.
29. Rembert, "Mondrian," iii–iv, 90–91; Marquis, *Alfred H. Barr, Jr.*, 213; oral history interview with Nell Blaine, AAA-SI, 6.
30. Rembert, "Mondrian," 92; Schloss, "The Loft Generation," Edith Schloss Burckhardt Papers, Columbia, 46–47; Bernier, "The Decisive Decade," 426; Harry Holtzman, interview by Jack Taylor. Mondrian was buried in Brooklyn.
31. Levin, *Lee Krasner*, 19.
32. Letter from Lee Krasner to Mercedes Matter reprinted in Landau et al., *Mercedes Matter*, 43–44, 72n86.
33. Naifeh and Smith, *Jackson Pollock*, 486–87.
34. Letter from Hans Hofmann to Mercedes Matter reprinted in Landau et al., *Mercedes Matter*, 70n75.
35. Friedman, *Jackson Pollock: Energy Made Visible*, 78; Gill, *Art Lover*, 330.
36. Naifeh and Smith, *Jackson Pollock*, 482, 484; Levin, *Lee Krasner*, 221; Landau, *Lee Krasner: A Catalogue Raisonné*, 30; Potter, *To a Violent Grave*, 77.
37. *Lee Krasner, a Conversation with Hermine Freed*, videotape courtesy PKHSC; Letter from Lee Krasner to Mercedes Matter reprinted in Landau et al., *Mercedes Matter*, 43–44, 72n86; Solomon, *Jackson Pollock*, 137. Lee's move also followed Jackson's decision to tear out a wall in their apartment in order to work on his mural for Peggy.
38. Nemser, *Art Talk*, 87.
39. Lee Krasner, interview by Barbara Novak, AAA-SI, 49.
40. Wallach, "Lee Krasner's Triumph," 501.
41. Levin, *Lee Krasner*, 220; Friedman, *Jackson Pollock: Energy Made Visible*, 78; Gill, *Art Lover*, 330; Lader, "Howard Putzel," 92–94; Michael Auping and Lawrence Alloway, eds., *Abstract Expressionism: The Critical Developments*, 18.
42. Lader, "Howard Putzel," 95; Levin, *Lee Krasner*, 230.
43. Guggenheim, *Out of This Century*, 316; Gill, *Art Lover*, 331; Lader, "Howard Putzel," 95.
44. Lee Krasner, interview by Barbara Rose, 1972, AAA-SI, 8; Alan Gussow, *A Sense of Place*, videotape.
45. Lee Krasner, interview by Barbara Rose, 1972, AAA-SI, 8.
46. Krasner, "Pollock," unpublished, undated notes, Series 1.3, Box 2, Folder 41, Jackson Pollock and Lee Krasner Papers, AAA-SI, 5; Lee Krasner, interview by Barbara Rose, 1972, AAA-SI, 8; Lee Krasner, interview by Barbara Rose, 1975, GRI; Solomon, *Jackson Pollock*, 157.
47. Lee Krasner, interview by Barbara Rose, 1972, AAA-SI, 8.

48. Lee Krasner, interview by Barbara Novak, AAA-SI, 35; Krasner, "Pollock," unpublished, undated notes, Series 1.3, Box 2, Folder 41, Jackson Pollock and Lee Krasner Papers, AAA-SI, 5; Potter, *To a Violent Grave*, 85–86.
49. Barbara Rose, *Lee Krasner: The Long View*, videotape courtesy PKHSC; Munro, *Originals*, 113; Landau, *Lee Krasner: A Catalogue Raisonné*, 309; Solomon, *Jackson Pollock*, 157–58.
50. Nemser, *Art Talk*, 87.
51. Landau, *Lee Krasner: A Catalogue Raisonné*, 309.
52. Naifeh and Smith, *Jackson Pollock*, 503.
53. May Tabak Rosenberg, interview by Jeffrey Potter, courtesy PKHSC; Landau, *Lee Krasner: A Catalogue Raisonné*, 309.
54. Lee Krasner, interview by Barbara Novak, AAA-SI, 34; Nemser, *Art Talk*, 87; May Tabak Rosenberg, interview by Jeffrey Potter, audiotape courtesy PKHSC; Potter, *To a Violent Grave*, 86; Naifeh and Smith, *Jackson Pollock*, 503; Glueck, "Scenes from a Marriage," 60.
55. May Tabak Rosenberg, interview by Jeffrey Potter, audiotape courtesy PKHSC.
56. Lee Krasner, interview by Barbara Novak, AAA-SI, 34; Nemser, *Art Talk*, 88; Glueck, "Scenes from a Marriage," 60.
57. May Tabak Rosenberg, interview by Jeffrey Potter, audiotape courtesy PKHSC; Naifeh and Smith, *Jackson Pollock*, 503–4; Landau, *Jackson Pollock*, 156; Solomon, *Jackson Pollock*, 159.
58. Guggenheim, *Out of This Century*, 316; Krasner, "Pollock," unpublished, undated notes, Series 1.3, Box 2, Folder 41, Jackson Pollock and Lee Krasner Papers, AAA-SI, 5.
59. Krasner, "Pollock," unpublished, undated notes, Series 1.3, Box 2, Folder 41, Jackson Pollock and Lee Krasner Papers, AAA-SI, 5; Solomon, *Jackson Pollock*, 157.
60. Krasner, "Pollock," unpublished, undated notes, Series 1.3, Box 2, Folder 41, Jackson Pollock and Lee Krasner Papers, AAA-SI, 5; Solomon, *Jackson Pollock*, 157.
61. Rose, "Krasner/Pollock: A Working Relationship," 6; Friedman, *Jackson Pollock, Energy Made Visible*, 82.
62. Oral history interview with James Brooks, AAA-SI; James Brooks, interview by Jack Taylor.
63. Naifeh and Smith, *Jackson Pollock*, 504.
64. *Lee Krasner, a Conversation with Hermine Freed*, videotape courtesy PKHSC; Lee Krasner, interview by Barbara Rose, 1972, AAA-SI, 8.
65. Naifeh and Smith, *Jackson Pollock*, 508–9; Lee Krasner, interview by Barbara Rose, audiotape, 1975, GRI.
66. Lee Krasner, interview by Barbara Rose, 1972, AAA-SI, 8.
67. Lee Krasner, interview by Barbara Rose, 1975, GRI.
68. Lee Krasner, interview by Barbara Rose, 1972, AAA-SI, 8.
69. Letter from Lee Krasner to Mercedes Matter reprinted in Landau et al., *Mercedes Matter*, 72n89.
70. Stevens and Swan, *De Kooning*, 213–14.
71. Ernestine Lassaw, interview by author.
72. Ibid.
73. Elaine de Kooning, interview by Minna Daniels, 29.
74. Schloss, "The Loft Generation," Edith Schloss Burckhardt Papers, Columbia, 271.
75. Gruen, *The Party's Over Now*, 210; Elaine de Kooning, interview by Minna Daniels, 29.
76. Ernestine Lassaw, interview by author.
77. Schloss, "The Loft Generation," Edith Schloss Burckhardt Papers, Columbia, 139–40, 144.
78. Stevens and Swan, *De Kooning*, 214; Gruen, *The Party's Over Now*, 210; Lieber, *Reflections in the Studio*, 26.
79. Dorfman, *Out of the Picture*, 37–41; Milton Resnick and Pat Passlof, interview by Cynthia Nadelman, AAA-SI.
80. Dorfman, *Out of the Picture*, 38–41.
81. Stahr, "The Social Relations of Abstract Expressionism," 262.
82. Larry Rivers Journal, July 13, 1948, Larry Rivers Papers, MSS 293, Series II, Subseries A, Box 20, Folder 1, NYU.
83. Dorfman, *Out of the Picture*, 41; oral history interview with James Brooks, AAA-SI; Brossard, *The Scene Before You*, 22.
84. Oral history interview with Milton Resnick, AAA-SI; Stevens and Swan, *De Kooning*, 214.
85. Dorfman, *Out of the Picture*, 41, 81.
86. Ashton with Banach, *The Writings of Robert Motherwell*, 28.
87. Dwight Macdonald, "The Root Is Man, II," 194.

13. It's 1919 Over Again!

1. The phrase is from Barrett, *The Truants*, 31.
2. Phyllis Rose, ed., *The Norton Book of Women's Lives*, 59.
3. Barrett, *The Truants*, 31, 101; Anatole Broyard, *Kafka Was the Rage*, 8, 93.
4. Broyard, *Kafka Was the Rage*, vii.
5. Oral history interview with Reuben Kadish, AAA-SI.
6. Irving Sandler, *Abstract Expressionism and the American Experience*, 22; "Abstract Expressionism," July 7, 1947, Exposition Internationale du Surréalisme, warholstars.org.
7. Adrienne Cecile Rich, *A Change of World*, 8.
8. Jack Tworkov, interview with Dorothy Seckler, AAA-SI.
9. May, *Man's Search for Himself*, 14.
10. Philip Pavia, interview by Jack Taylor; Esteban Vicente, interview by Jack Taylor; Stevens and Swan, *De Kooning*, 218; "Philip Pavia Talks on the War Years," 18.
11. Philip Pavia, interview by Jack Taylor; Esteban Vicente, interview by Jack Taylor; Stevens and Swan, *De Kooning*, 218; "Philip Pavia Talks on the War Years," 18.
12. Oral history interview with Philip Pavia, January 19, 1965, AAA-SI, 4; Stahr, *The Social Relations of Abstract Expressionism*, 157–58.
13. Oral history interview with Will Barnet, AAA-SI; Philp Pavia, interview by John Gruen, AAA-SI, 25.
14. James Brooks, interview by Jack Taylor; Brossard, *The Scene Before You*, 21; Naifeh and Smith, *Jackson Pollock*, 479; Alfred Leslie, interview by Jack Taylor. That undercurrent of hostility would resurface for decades when some of those former fighters discussed the heights painters like de Kooning and Pollock had attained.
15. Elaine de Kooning, interview by Arthur Tobier, 26.
16. Herman Cherry, interview by Jack Taylor; Philip Pavia, interview by John Gruen, AAA-SI, 15.
17. Doris Aach, interview by author.
18. Oral history interview with Ludwig Sander, AAA-SI; George McNeil, interview by Jack Taylor.
19. Herbert Read, *The Politics of the Unpolitical*, 77–79, 158.
20. Mercedes Matter, interview by Jack Taylor; *Mercedes Matter*, interview by Sigmund Koch, Tape 1B, Aesthetics Research Archive.
21. Edgar, *Club Without Walls*, 47–49; Philip Pavia, interview by Jack Taylor; Pat Passlof, interview by Jack Taylor.
22. Philip Pavia, interview by Jack Taylor; Thomas B. Hess, interview by Mitch Tuchman, AAA-SI, 5. Pavia said the concept "somehow grabbed."
23. "Existentialist," *The New Yorker*, March 16, 1946; Barrett, *The Truants*, 101; Myers, *Tracking the Marvelous*, 61, 64; Valerie Hellstein, "Grounding the Social Aesthetics of Abstract Expressionism," 87; Walter Kaufmann, "The Reception of Existentialism in the United States," 71, 76, 79, 84; Abel, *The Intellectual Follies*, 116. Some writers, including Abel, put Sartre's first visit to New York in 1948, but his interview in a "Talk of the Town" article in *The New Yorker* of March 1946 makes clear it occurred two years earlier.
24. Abel, *The Intellectual Follies*, 118.
25. Myers, *Tracking the Marvelous*, 64; Abel, *The Intellectual Follies*, 146.
26. Myers, *Tracking the Marvelous*, 70. John Myers wrote in his journal of April 1946 that the language of Existentialism—alienation, dread, nothingness—began to overtake psychoanalytic lingo in conversation at this time.
27. Abel, *The Intellectual Follies*, 128–29; Seitz, *Abstract Expressionist Painting*, xviii.
28. Jean-Paul Sartre, *Existentialism and Humanism*, 29.
29. Ibid., 30.
30. Ibid., 47.
31. Ibid., 31.
32. Ibid., 43.
33. Ibid., 65.
34. Stahr, *The Social Relations of Abstract Expressionism*, 137; Seitz, *Abstract Expressionist Painting*, 101.
35. Barrett, *Irrational Man*, 20.
36. Ibid., 226; Barrett, "What Existentialism Offers Modern Man," 20.
37. Gaines, *Philistines at the Hedgerow*, 117–18; Naifeh and Smith, *Jackson Pollock*, 507–8.

38. Lee Krasner, interview by Barbara Rose, 1972, AAA-SI, 8.
39. Ibid.; *Lee Krasner*, interview by Barbara Novak, videotape courtesy PKHSC; Naifeh and Smith, *Jackson Pollock*, 516; Solomon, *Jackson Pollock*, 160; *Lee Krasner, a Conversation with Hermine Freed*, videotape PKHSC; Levin, *Lee Krasner*, 237.
40. Lee Krasner, interview by Barbara Rose, 1972, AAA-SI, 8; Lee Krasner, interview by Barbara Rose, 1975, GRI; *Lee Krasner, a Conversation with Hermine Freed*, videotape PKHSC.
41. Levin, *Lee Krasner*, 239.
42. Potter, *To a Violent Grave*, 93; Gaines, *Philistines at the Hedgerow*, 119.
43. Solomon, *Jackson Pollock*, 161; *Lee Krasner*, interview by Barbara Novak, videotape courtesy PKHSC.
44. John Szarkowski and John Elderfield, eds., *The Museum of Modern Art at Mid-Century*, 65.
45. Naifeh and Smith, *Jackson Pollock*, 531.
46. Ibid., 568–69.
47. Levin, *Lee Krasner*, 234–35; Naifeh and Smith, *Jackson Pollock*, 516; Solomon, *Jackson Pollock*, 164–65; Mercedes Matter interview with Jeffrey Potter reprinted excerpt in Landau et al., *Mercedes Matter*, 73–74n98.
48. Levin, *Lee Krasner*, 235, 237.
49. Glueck, "Scenes from a Marriage," 60.
50. Naifeh and Smith, *Jackson Pollock*, 408.
51. Gruen, *The Party's Over Now*, 230.
52. Munro, *Originals*, 114.
53. Levin, *Lee Krasner*, 237; O'Connor, *Jackson Pollock*, 38.
54. Oral history interview with Lee Krasner, 1972, AAA-SI. Good examples of this convergence of styles include Lee's *Untitled* (1946) and Pollock's *Croaking Movement* (c. 1946).
55. Nemser, "A Conversation with Lee Krasner," 44; Nemser, *Art Talk*, 88–89; Lee Krasner, interview by Barbara Rose, June 27, 1978, GRI; Landau, *Jackson Pollock*, 86.

14. Awakenings

1. Clement Greenberg, "The Situation at the Moment," 82.
2. Florence Rubenfeld, *Clement Greenberg: A Life*, 44, 50; *Lee Krasner*, interview by Barbara Novak, videotape courtesy PKHSC.
3. Rubenfeld, *Clement Greenberg*, 31, 33–34, 41, 43, 44, 97, 144; Caroline A. Jones, *Eyesight Alone*, 31; Deborah Solomon, notes on Clement Greenberg based on interview, December 19, 1983, Series 1, Box 1, Folder 2, the Clement Greenberg Papers, 1937–1983, AAA-SI, 1; oral history interview with Harold Rosenberg, AAA-SI.
4. Rubenfeld, *Clement Greenberg*, 32, 37, 41, 43, 50; Jones, *Eyesight Alone*, 5, 23, 31, 267, 277.
5. Rubenfeld, *Clement Greenberg*, 42–44, 50; Norman L. Kleeblatt, ed., *Action/Abstraction*, 143; Ashton, *The Life and Times of the New York School*, 79–80; Jones, *Eyesight Alone*, 267, 277.
6. Clement Greenberg, "Art," *The Nation*, April 21, 1945, 469; Kleeblatt, *Action/Abstraction*, 143. Clem further wrote that he "owes more to the initial illumination received from Hofmann's lectures than to any other source."
7. Clement Greenberg, "Avant-Garde and Kitsch," 37–41, 44; Rubenfeld, *Clement Greenberg*, 51–52, 78; Jones, *Eyesight Alone*, 22.
8. Greenberg, "Avant-Garde and Kitsch," 37–40.
9. Ibid., 46–48.
10. Rubenfeld, *Clement Greenberg*, 61, 68; Ashton, *The New York School*, 157.
11. Deborah Solomon, notes on Clement Greenberg, based on interview, December 19, 1983, Series 1, Box 1, Folder 2, the Clement Greenberg Papers, 1937–1983, AAA-SI, 1.
12. Jones, *Eyesight Alone*, 471; Marquis, *Art Czar*, 67.
13. Deborah Solomon, notes on Clement Greenberg, based on interview, December 19, 1983, Series 1, Box 1, Folder 2, the Clement Greenberg Papers, 1937–1983, AAA-SI, 2; Solomon, *Jackson Pollock*, 110; Rubenfeld, *Clement Greenberg*, 70–71; Potter, *To a Violent Grave*, 66.
14. Clement Greenberg, "Goose-Step in Tishomingo," 768–69.
15. Rubenfeld, *Clement Greenberg*, 63, 71–73; Jones, *Eyesight Alone*, 46, 48; Marquis, *Art Czar*, 76, 78. His diagnosis was "maladjusted, slightly neurotic."
16. Marquis, *Art Czar*, 78–79; Clement Greenberg, "Art," *The Nation*, November 27, 1943, 621.

17. Clement Greenberg, "Art," *The Nation*, April 7, 1945, 397–98; Kirk Varnadoe with Pepe Karmel, *Jackson Pollock*, 42; Elaine de Kooning, interview by Jeffrey Potter, courtesy PKHSC. Elaine said Clem acted as "an unpaid PR man. It came from his heart's blood. He meant every word of it, but he performed services for Jackson. Period."
18. Rubenfeld, *Clement Greenberg*, 78, 91.
19. Solomon, *Jackson Pollock*, 153; Jones, *Eyesight Alone*, 261.
20. Clement Greenberg, interview by James Valliere, AAA-SI.
21. Deborah Solomon, notes on Clement Greenberg, based on interview, December 19, 1983, Series 1, Box 1, Folder 2, the Clement Greenberg Papers, 1937–1983, AAA-SI, 3.
22. Varnadoe and Karmel, *Jackson Pollock*, 321–22; O'Connor, *Jackson Pollock*, 35–36.
23. *Lee Krasner: An Interview with Kate Horsfield*, videotape courtesy PKHSC; John Bernard Myers, interview by Barbara Rose, audiotape, March 12, 1968, Series V, Box 13, R3, GRI; Naifeh and Smith, *Jackson Pollock*, 608–9.
24. Naifeh and Smith, *Jackson Pollock*, 528; Edgar, *Club Without Walls*, 45
25. Dorfman, *Out of the Picture*, 58.
26. *Lee Krasner: An Interview with Kate Horsfield*, videotape courtesy PKHSC.
27. Lee Krasner, interview by Barbaralee Diamonstein, provided by Dr. Barbaralee Diamonstein-Spielvogel, interviewer and author, from *Inside New York's Art World*, 210; Barbara Rose, "Jackson Pollock at Work," 86.
28. Landau, "Lee Krasner's Early Career, Part Two," 82–83; Landau, *Lee Krasner: A Catalogue Raisonné*, 106; Hobbs, *Lee Krasner* (1993), 42.
29. *Lee Krasner*, interview by Barbara Novak, videotape courtesy PKHSC.
30. Nemser, "A Conversation with Lee Krasner," 44.
31. Landau, *Lee Krasner: A Catalogue Raisonné*, 115.
32. Nemser, "A Conversation with Lee Krasner," 44.
33. Levin, *Lee Krasner*, 20, 245–46; Landau, *Lee Krasner: A Catalogue Raisonné*, 230; Hobbs, *Lee Krasner* (1999), 72; Munro, *Originals*, 105.
34. Nemser, *A Conversation with Lee Krasner*, 44; *Lee Krasner: An Interview with Kate Horsfield*, videotape courtesy PKHSC.
35. Naifeh and Smith, *Jackson Pollock*, 544.
36. Hall and Wykes, *Anecdotes of Modern Art*, 329.
37. Aline B. Louchheim, "Betty Parsons: Her Gallery, Her Influence," 194; Lee Hall, *Betty Parsons*, 18, 20, 25, 77.
38. Oral history interview with Betty Parsons, June 11, 1981, AAA-SI; Hall, *Betty Parsons*, 29, 44–45; Louchheim, "Betty Parsons: Her Gallery, Her Influence," 194.
39. Oral history interview with Betty Parsons, June 4 and June 9, 1969, AAA-SI; Hall, *Betty Parsons*, 36, 171.
40. Potter, *To a Violent Grave*, 91.
41. Naifeh and Smith, *Jackson Pollock*, 545, 547; Solomon, *Jackson Pollock*, 173; oral history interview with Betty Parsons, June 4–June 9, 1969, AAA-SI; Hall, *Betty Parsons*, 171.
42. Russell Lynes, *The Tastemakers*, 256–57; Diggins, *The Proud Decades*, 98–99; Read, *The Politics of the Unpolitical*, 47–48.
43. Marquis, *Alfred H. Barr, Jr.*, 228.
44. *ArtNews*, 43, no. 9 (July 1944): 14, 23.
45. Oral history interview with Samuel M. Kootz, April 13, 1964, AAA-SI.
46. Marquis, *The Art Biz*, 235.
47. Parker and Pollock, *Old Mistresses*, 114; Hess and Baker, *Art and Sexual Politics*, 57; Gibson, *Abstract Expressionism*, 22.
48. Kleeblatt, *Action/Abstraction*, 17; Larkin, *Art and Life in America*, 465. A survey in 1944 found that the average male artist had an annual income of just over eleven hundred dollars and the average woman artist made about five hundred dollars per year.
49. Nemser, *Art Talk*, 91.
50. Gibson, *Abstract Expressionism*, 142.
51. Pearl S. Buck, *Of Men and Women*, 76–77.

15. Separate Together

1. Zinn, *A People's History of the United States,* 506.
2. Stevens and Swan, *De Kooning,* 215; Elaine de Kooning, interview by Arthur Tobier, 3. Bill's famous phonograph had been destroyed in a power surge earlier.
3. Schloss, "The Loft Generation," Edith Schloss Burckhardt Papers, Columbia, 24; Stevens and Swan, *De Kooning,* 215; Lieber, *Reflections in the Studio,* 27.
4. Maud Fried Goodnight, telephone interview by author; Elaine de Kooning, interview by Arthur Tobier, 3.
5. Charles Fried, e-mail to author, June 13, 2015.
6. Stevens and Swan, *De Kooning,* 238.
7. Michael Kimmel, *Manhood in America,* 224; Ferdinand Lundberg and Marynia F. Farnham, M.D., *Modern Woman: The Lost Sex,* 7–8.
8. Thomas B. Hess and Linda Nochlin, eds., "Woman as Sex Object," 232.
9. Lee Krasner, interview by Barbara Cavaliere, AAA-SI, 10; Dodie Kazanjian, "Keeper of the Flame," 160. Annalee Newman, the wife of Barnet Newman, was an extreme example of Lee's contention. Annalee said in a 1991 interview that she sat in her husband's studio while he worked "and taught myself not to open my mouth.... I sat there without saying a word. I didn't even read, because I wanted to be alert to him without having to ask questions."
10. Stahr, "The Social Relations of Abstract Expressionism," 117.
11. Stevens and Swan, *De Kooning,* 239.
12. Gruen, *The Party's Over Now,* 209; Lieber, *Reflections in the Studio,* 29, 121n460; Stevens and Swan, *De Kooning,* 215.
13. Elaine de Kooning, interview by John Gruen, AAA-SI, 4; Elaine de Kooning, interview by Jeffrey Potter, audiotape courtesy the PKHSC; Gruen, *The Party's Over Now,* 209.
14. Lieber, *Reflections in the Studio,* 30.
15. Stevens and Swan, *De Kooning,* 216.
16. Ibid., 227–28; Elaine de Kooning, interview by Arthur Tobier, 3–4.
17. Fortune et al., *Elaine de Kooning: Portraits,* 89; Lewallen, "Interview with Elaine de Kooning," 13.
18. Hall, *Elaine and Bill,* 62–63.
19. Elaine de Kooning, interview by Arthur Tobier, 23–24.
20. Greer, *The Obstacle Race,* 40; Nemser, *Art Talk,* 90. Nemser wrote, "It's possible for some man to be influenced or activated by another man without being called a follower, but if a woman is in contact with a man—well she is his disciple forever."
21. Stahr, *The Social Relations of Abstract Expressionism,* 215.
22. Munro, *Originals,* 254; Elaine de Kooning, interview Antonina Zara, 8.
23. Munro, *Originals,* 254; Elaine de Kooning, interview by Molly Barnes, 4–5; Lawrence Campbell, "Elaine de Kooning: Portraits in a New York Scene," 39.
24. Campbell, "Elaine de Kooning Paints a Picture," 63.
25. Elaine de Kooning, C. F. S. Hancock Lecture, 3–4.
26. "Elaine de Kooning, Portraits," The Art Gallery, Brooklyn College, February 28–April 19, 1991, 12.
27. Gibson, *Abstract Expressionism,* 135.
28. Celia S. Stahr, "Elaine de Kooning, Portraiture and the Politics of Sexuality."
29. Greer, *The Obstacle Race,* 77; Munro, *Originals,* 254; Gibson, *Abstract Expressionism,* 135; Some authors have suggested Elaine's "gyroscopes" were also a reference to the figure being still while the paint swirls around them.
30. David Riesman with Nathan Glazer and Reuel Denney, *The Lonely Crowd,* 6; Eric Fromm, *The Sane Society,* 107. Fromm wrote, the capitalist society of the mid-twentieth century "needs men who cooperate smoothly in large groups; who want to consume more and more, and whose tastes are standardized and can be easily influenced and anticipated. It needs men who feel free and independent... yet [are] willing to be commanded, to do what is expected, to fit into the social machine without friction."
31. Riesman, *The Lonely Crowd,* 25, 36; Miller and Nowak, *The Fifties,* 130, 278; May, *Man's Search for Himself,* 24–25, 169. Miller and Nowak said, "anything outside mainstream awareness" was

labelled "deviant," and the "happy man" in popular novels of the time was the fellow who was "just like everybody else." Rollo May explained that the dominant values of society at the time for most were "being liked, accepted and approved of."

32. Gruen, *The Party's Over Now,* 211.
33. Elaine de Kooning, interview by John Gruen, AAA-SI, 8–9; Hall, *Elaine and Bill,* 63–64; Stevens and Swan, *De Kooning,* 237–38.
34. Charles Fried, telephone interview by author.
35. Stevens and Swan, *De Kooning,* 233–34.
36. Ibid., 239; Gibson, *Abstract Expressionism,* 134; David Kennedy, *Birth Control in America,* 183, 208–9, 266–67; Fred M. Kaplan, *1959: The Year Everything Changed,* 227–29. The favored birth control methods for women at the time were spermicidal jelly and a diaphragm, as well as the unreliable rhythm method. Abortion often featured as an unspoken third option. The birth control pill was not introduced to the public until 1957, and then as a treatment for menstrual disorders. Within two years, half a million women were prescribed the drug. It was approved by the Food and Drug Administration to prevent pregnancy in 1960.
37. Luke Luyckx, telephone interview by author; Ernestine Lassaw, e-mail to author via Denise Lassaw, January 20, 2014; Denise Lassaw, e-mail to author, September 16, 2016. Bill repaid Ernestine with a small painting.
38. Stevens and Swan, *De Kooning,* 239; Hall, *Elaine and Bill,* 170–71; Elaine de Kooning, interview by Antonina Zara, 31.
39. Kazanjian, "Keeper of the Flame," 163; Hall, *Elaine and Bill,* 170–71.
40. May Tabak Rosenberg, interview by Jeffrey Potter, audiotape courtesy PKHSC; Landau, *Jackson Pollock,* 263n13.
41. Naifeh and Smith, *Jackson Pollock,* 531; Levin, *Lee Krasner,* 290; Potter, *To a Violent Grave,* 190.
42. May Tabak Rosenberg, interview by Jeffrey Potter, audiotape courtesy PKHSC; Naifeh and Smith, *Jackson Pollock,* 531.
43. Rose, *Lee Krasner: The Long View,* videotape courtesy PKHSC; Landau, *Jackson Pollock,* 263n13; Levin, *Lee Krasner,* 9.
44. Naifeh and Smith, *Jackson Pollock,* 531; oral history interview with David Hare, AAA-SI. Hare said Jackson told Lee he had had an affair with Maria Motherwell, but it wasn't true.
45. Levin, *Lee Krasner,* 252.
46. Elaine de Kooning, interview by Molly Barnes, 11; Beauvoir, *The Second Sex,* 122.
47. *Elaine de Kooning, Portraits,* The Art Gallery, Brooklyn College, 7–8.
48. Munro, *Originals,* 251; Elaine de Kooning, interview by Molly Barnes, 7.
49. David Christos Cateforis, "Willem de Kooning's Women of the 1950s," 92; Polcari, *Abstract Expressionism and the Modern Experience,* 287.
50. Kennedy, *World Birth Control in America,* 266–67; Polcari, *Abstract Expressionism and the Modern Experience,* 287; Hess and Nochlin, *Woman as Sex Object,* 32; Costello, *Virtue Under Fire,* 262; Polcari, *From Omaha to Abstract Expressionism,* 12.
51. Polenberg, *War and Society,* 151; Weibel, *Mirror, Mirror,* 211–12; Broyard, *Kafka Was the Rage,* 134, 140.
52. Dingwall, *The American Woman,* 133.
53. Esteban Vicente, interview by Jack Taylor; Lewin Alcopley, interview by Jack Taylor; Natalie Edgar, interview by author, December 8, 2013, East Hampton.
54. Edgar, *Club Without Walls,* 10; Natalie Edgar, interview by author, December 8, 2013.
55. Stevens and Swan, *De Kooning,* 224–25; Ashton, *The New York School,* 168; Dorfman, *Out of the Picture,* 61.
56. Oral history interview with Peter Agostini, AAA-SI; Edgar, *Club Without Walls,* 96.
57. Gruen, *The Party's Over Now,* 234; oral history interview with Herman Cherry, May 8, 1989–March 19, 1992, AAA-SI; Edgar, *Club Without Walls,* 96.
58. Schloss, "The Loft Generation," Edith Schloss Burckhardt Papers, Columbia, 271.
59. Ibid.; Stevens and Swan, *De Kooning,* 271.
60. Elaine de Kooning, "Franz Kline Memorial Exhibition," 11–12; Wetzsteon, *Republic of Dreams,* 544; Dore Ashton, interview by author; Philip Pavia, interview by John Gruen, AAA-SI, 38–39; Harry Gaugh, *Franz Kline,* 72.

61. Elaine de Kooning, "Franz Kline Memorial Exhibition," 9; Conrad Marca-Relli, interview by Elizabeth Zogbaum, 1975, Elisabeth Zogbaum Papers on Franz Kline, Box 1, AAA-SI; Gaugh, *Franz Kline,* 68. Kline told his wife, Elizabeth, "I have always felt that I'm like a clown and that my life might work out like a tragedy, a clown's tragedy."
62. B. H. Friedman, Dictionary of American Biography draft on Franz Kline, Elisabeth Zogbaum Papers on Franz Kline, Box 1, AAA-SI; Gaugh, *Franz Kline,* 13.
63. Elizabeth Zogbaum, notes on Franz Kline, n.d., Elisabeth Zogbaum Papers on Franz Kline, Box 1, AAA-SI.
64. Gruen, *The Party's Over Now,* 272.
65. Elizabeth Zogbaum, notes on Franz Kline, n.d., Elisabeth Zogbaum Papers on Franz Kline, Box 1, AAA-SI; Dorfman, *Out of the Picture,* 64.
66. Gaugh, *Franz Kline,* 42–43.
67. Elaine de Kooning, "Franz Kline Memorial Exhibition," 11–12, 14–15; Gaugh, *Franz Kline,* 43; Philip Pavia, interview by John Gruen, AAA-SI, 38–39.
68. Gaugh, *Franz Kline,* 164; Barrett, *The Truants,* 140–41.
69. Frank O'Hara, "Franz Kline Talking," 64.
70. Matossian, *Black Angel,* 373–74, 379–80; Peyton Boswell, "Revolt of the Critics," n.p.
71. Matossian, *Black Angel,* 399–401; oral history interview with Fritz Bultman, AAA-SI.
72. Matossian, *Black Angel,* 402–3, 407–9, 425, 429.
73. Ibid., 429, 451–52.
74. Ibid., 439.
75. Elaine de Kooning, interview by Arthur Tobier, 23–24.
76. Elaine de Kooning, interview by Antonina Zara, 9; *De Kooning at the Whitney,* videotape courtesy LTV, Inc.

16. Peintres Maudits

1. Ellen G. Landau, ed., *Reading Abstract Expressionism,* 156.
2. Perl, *New Art City,* 159; Seitz, *Abstract Expressionist Painting in America,* 109; Arnold Hauser, *The Social History of Art,* vol. 3, *Rococo, Classicism and Romanticism,* 156–66. Hauser describes the Romantic period at the time of the French Revolution as the "true beginning of modern art." It recognized the artist's work as self-expression, rather than a creation to please society, arising out of the artist's immediate history. In the case of the Romantics, Hauser said they believed "the more bewildering the chaos, the more radiant the star, it is hoped, that will emerge from it."
3. Beauvoir, *America Day by Day,* 36.
4. John Ferren, "Epitaph for an Avant-Garde," 25.
5. Ashton, *The Life and Times of the New York School,* 60.
6. Seitz, *Abstract Expressionist Painting in America,* xii–xiii, 115, 132.
7. Hess, *Abstract Painting,* 63.
8. Ferren, "Epitaph for an Avant-Garde," 25.
9. Seitz, *Abstract Expressionist Painting in America,* 166.
10. Ibid., 132.
11. David Anfam, *Abstract Expressionism,* 107.
12. Marquis, *Alfred H. Barr, Jr.,* 242.
13. Diggins, *The Proud Decades,* 61, 63, 73.
14. Barton J. Bernstein, ed., *Towards a New Past,* 356.
15. Daniel Catton Rich, "Freedom of the Brush," 50.
16. Marquis, *Art Czar,* 106; Catton Rich, "Freedom of the Brush," 5.
17. Catton Rich, "Freedom of the Brush," 50; Ashton, *The New York School,* 207.
18. Catton Rich, "Freedom of the Brush," 50.
19. David Caute, *The Great Fear,* 36–37; Miller and Nowak, *The Fifties,* 25.
20. Lehmann-Haupt, *Art Under a Dictatorship,* 239–40; Diggins, *The Proud Decades,* 236.
21. Catton Rich, *Freedom of the Brush,* 51.
22. Anfam, *Abstract Expressionism,* 106; Diggins, *The Proud Decades,* 141; Michael Davidson, *Guys Like Us,* 56. The CIA's first covert mission was an intervention in Iran to restore the shah to power after he had been overthrown in a nationalist coup.

23. Caute, *The Great Fear*, 26–27, 90, 488, 515. By the end of the investigation into communist sympathizers in Hollywood, about two hundred fifty people were blacklisted and one hundred "graylisted."
24. Diggins, *The Proud Decades*, 161; Miller and Nowak, *The Fifties*, 26; Zinn, *A People's History*, 429; Caute, *The Great Fear*, 28.
25. Miller and Nowak, *The Fifties*, 25–26; Nancy Jachec, *The Philosophy and Politics of Abstract Expressionism*, 39; Polcari, *Abstract Expressionism*, 325; Barrett, *The Truants*, 114; Timothy Snyder, "Hitler Versus Stalin: Who Killed More?" *New York Review of Books*, March 10, 2011, www.nybooks.com/articles/2011/03/10/hitler-vs-stalin-who-killed-more; Clements, *Prosperity, Depression and the New Deal*, 231; Diggins, *The Proud Decades*, 73, 76, 101; Caute, *The Great Fear*, 29–31; Zinn, *A People's History*, 417–18; Chafe, *The American Woman*, 190. The strikes had begun during the war (fourteen thousand industrial actions, more than any other comparable period in U.S. history) mostly over the enormous profits businesses were making and the fact that workers' wages did not reflect that bounty.
26. Beauvoir, *America Day by Day*, 51.
27. Gilbert, *The Second World War*, 733.
28. *KZ-KAMPF-KUNST Boris Lurie: NO!ART*, 103–4; Doris Aach, interview by author.
29. Larkin, *Art and Life in America*, 481; Ashton, *The Life and Times of the New York School*, 177.
30. Oral history interview with Peter Agostini, AAA-SI.
31. Stahr, *The Social Relations of Abstract Expressionism*, 103; Dorfman, *Out of the Picture*, 65; oral history interview with Milton Resnick, AAA-SI.
32. Oral history interview with Milton Resnick, AAA-SI. Elaine de Kooning, interview by Charles Hayes, 6–7. Resnick said the decision to use lesser materials was also a response to the war. "All that crap about permanence and all that was gone after the war," he said.
33. Stevens and Swan, *De Kooning*, 244–45; Elaine de Kooning, interview by Charles Hayes, 6.
34. Harold Rosenberg, "Introduction to Modern American Painters," 75.
35. John O'Brian, ed., *Clement Greenberg: The Collected Essays and Criticism*, vol. 2, *Arrogant Purpose, 1945–1949*, 166–67, 169–70.
36. Marquis, *Art Czar*, 107–8.
37. Naifeh and Smith, *Jackson Pollock*, 552.

17. Lyrical Desperation

1. The phrase is from Frank O'Hara, *Jackson Pollock*, 22.
2. Solomon, *Jackson Pollock*, 178.
3. Malina, *The Diaries of Judith Malina*, 15.
4. Naifeh and Smith, *Jackson Pollock*, 553.
5. Ibid., 556–57.
6. Solomon, *Jackson Pollock*, 178–79.
7. Kuh, *The Artist's Voice*, 81.
8. Maurice Merleau-Ponty, "Cezanne's Doubt," 464.
9. Krasner, *Pollock*, unpublished, undated notes, Series 1.3, Box 2, Folder 41, Jackson Pollock and Lee Krasner Papers, AAA-SI, 5; Naifeh and Smith, *Jackson Pollock*, 880n.
10. Krasner, *Pollock*, unpublished, undated notes, Series 1.3, Box 2, Folder 41, Jackson Pollock and Lee Krasner Papers, AAA-SI, 5; *Lee Krasner: An Interview with Kate Horsfield*, videotape courtesy PKHSC; Lee Krasner, interview by Barbara Rose, 1972, AAA-SI, 6.
11. Lee Krasner, interview by Emily Wasserman, AAA-SISI, 3.
12. Lee Krasner, interview by Barbara Rose, June 27, 1978, GRI, 5.
13. Krasner, *Pollock*, unpublished, undated notes, Series 1.3, Box 2, Folder 41, Jackson Pollock and Lee Krasner Papers, AAA-SI, 6.
14. Ibid.
15. Varnadoe and Karmel, *Jackson Pollock*, 48.
16. Oral history interview with Lee Krasner, 1972, AAA-SI; Karmel, *Jackson Pollock: Interviews, Articles, and Reviews*, 41; Glueck, "Scenes from a Marriage," 61.
17. Sandler, *A Sweeper Up After Artists*, 93–94.
18. George McNeil, interview by Jack Taylor.

19. Edgar, *Club Without Walls,* 67.
20. Gibson, *Abstract Expressionism,* 22.
21. Oral history interview with Betty Parsons, June 4–9, 1969, AAA-SI.
22. Hall, *Betty Parsons,* 90.
23. Karmel, *Jackson Pollock: Interviews, Articles, and Reviews,* 59–60.
24. Elaine de Kooning, "A Stroke of Genius," 38.
25. Alcopley, interview by Jack Taylor.
26. Karmel, *Jackson Pollock: Interviews, Articles, and Reviews,* 59.
27. Ibid., 60; Thomas B. Hess, interview by Barbaralee Diamonstein, provided by Dr. Barbaralee Diamonstein-Spielvogel, interviewer and author, from *Inside New York's Art World,* 140. Said Tom Hess years later, "Pollock was covered with invective by critics who were totally unprepared for his approach, who were still having a great deal of difficulty with the Matisse of the 1920s."
28. Karmel, *Jackson Pollock: Interviews, Articles, and Reviews,* 59; Hall, *Betty Parsons,* 92.
29. Naifeh and Smith, *Jackson Pollock,* 555.
30. Ibid., 558; *Lee Krasner: An Interview with Kate Horsfield,* videotape courtesy PKHSC.
31. Naifeh and Smith, *Jackson Pollock,* 557; Potter, *To a Violent Grave,* 93.
32. Potter, *To a Violent Grave,* 93–94; Naifeh and Smith, *Jackson Pollock,* 558.
33. Naifeh and Smith, *Jackson Pollock,* 557; Levin, *Lee Krasner,* 249.
34. Lee Krasner, interview by Barbara Rose, June 27, 1978, GRI, 6.
35. Krasner, *Pollock,* unpublished, undated notes, Series 1.3, Box 2, Folder 41, Jackson Pollock and Lee Krasner Papers, AAA-SI, 6.
36. Oral history interview with Esteban Vicente, AAA-SI.
37. Thomas B. Hess, interview by Barbaralee Diamonstein, provided by Dr. Barbaralee Diamonstein-Spielvogel, interviewer and author, from *Inside New York's Art World,* 142.
38. George McNeil, interview by Jack Taylor.
39. O'Hara, *Robert Motherwell,* 54.
40. Lieber, *Reflections in the Studio,* 30.
41. Luke Luyckx, telephone interview with author.
42. Elaine de Kooning, interview by Antonina Zara, 9.
43. Elaine de Kooning, interview by Amei Wallach, 5; Renée Arb, "They're Painting Their Way," 81. Artist Clifford Wright was also named in the *Harper's Jr. Bazaar* article.
44. Elaine de Kooning and Slivka, *Elaine de Kooning,* 10; Elaine de Kooning, interview by Amei Wallach, 13.
45. Elaine de Kooning and Slivka, *Elaine de Kooning,* 10; Ernestine Lassaw, e-mail to author via Denise Lassaw, January 20, 2014.
46. Natalie Edgar, interview by author, January 20, 2014.
47. Schloss, "The Loft Generation," Edith Schloss Burckhardt Papers, Columbia, 270; Cateforis, "Willem de Kooning's Women of the 1950s," 96; John Russell, "Thomas Hess, Art Expert, Dies," B2; Marquis, *Art Czar,* 134; Natalie Edgar, interview by author, January 20, 2014, and December 8, 2013.
48. Natalie Edgar, interview by author, January 20, 2014; Elizabeth Baker, interview by author; David Frankfurter, e-mail to author, May 18, 2017.
49. Elizabeth Baker, interview by author; John Bernard Myers, interview by Barbara Rose, audiotape, March 12, 1968, Series V, Box 13, R3, GRI; Schloss, "The Loft Generation," Edith Schloss Burckhardt Papers, Columbia, 270; Friedman, *Energy Made Visible,* 61; Marquis, *The Art Biz,* 114. Hess had, in 1944, bought a painting by Pollock from Peggy Guggenheim's gallery. Edith Schloss said Tom "had a killer instinct for the Real Thing."
50. Russell, "Thomas Hess, Art Expert, Dies," B2; Natalie Edgar, interview by author, January 20, 2014; Elizabeth Baker, interview by author; Elizabeth Baker, telephone interview by author; Schloss, "The Loft Generation," Edith Schloss Burckhardt Papers, Columbia, 270.
51. Elaine de Kooning and Slivka, *Elaine de Kooning,* 10.
52. Elaine de Kooning, interview by Amei Wallach, 4.
53. Ibid.
54. *Mercedes Matter,* interview by Sigmund Koch, Tape 4A, Aesthetics Research Archive; Elaine de Kooning and Slivka, *Elaine de Kooning,* 11; Philip Pavia, interview by Jack Taylor.

55. *Mercedes Matter*, interview by Sigmund Koch, Tape 4A, Aesthetics Research Archive, Boston University.
56. Ibid.; Kleeblatt, *Action/Abstraction*, 216; Sandler, *Abstract Expressionism*, 31; Carl Gustav Jung, *Modern Man in Search of a Soul*, 169. The Jungians among the artists would have seen in the similar imagery arising on both sides of the Atlantic Jung's collective unconscious at work. Jung said, "Whenever the collective unconscious becomes a living experience and is brought to bear upon the conscious outlook of an age, this event is a creative act which is of importance to everyone living in that age. A work of art is produced that contains what may truthfully be called a message to generations of men."
57. Elaine de Kooning, interview by Amei Wallach, 13; Elaine de Kooning and Slivka, *Elaine de Kooning*, 11; O'Brian, *Clement Greenberg: The Collected Essays and Criticism*, 2:207; Kleeblatt, *Action /Abstraction*, 216.
58. Elaine de Kooning, interview by Amei Wallach, 13.
59. Doris Aach, interview by author.
60. Elaine de Kooning, interview by John Gruen, AAA-SI, 7.
61. Elaine de Kooning, interview by Amei Wallach, 13.
62. Ibid., 5; Elaine de Kooning and Slivka, *Elaine de Kooning*, 12.
63. Elaine de Kooning, interview by John Gruen, AAA-SI, 7; Elaine de Kooning, interview by Antonina Zara, 11; Elaine de Kooning, interview by Amei Wallach, 3.
64. Elaine de Kooning, interview by Antonina Zara, 11.
65. Elaine de Kooning and Slivka, *Elaine de Kooning*, 9.
66. Gruen, *The Party's Over Now*, 217.
67. Schloss, "The Loft Generation," Edith Schloss Burckhardt Papers, Columbia, 290; Edgar, *Club Without Walls*, 107; Stahr, *The Social Relations of Abstract Expressionism*, 195.
68. Rubenfeld, *Clement Greenberg*, 174; Doris Aach, interview by author; Herman Cherry, interview by Jack Taylor.
69. Schloss, "The Loft Generation," Edith Schloss Burckhardt Papers, Columbia, 270.
70. Stevens and Swan, *De Kooning*, 251.
71. Hess, *Willem de Kooning* (1968), 72.
72. Stevens and Swan, *De Kooning*, 251–53; Anfam, *Abstract Expressionism*, 131.
73. Gruen, *The Party's Over Now*, 214–15; Schloss, "The Loft Generation," Edith Schloss Burckhardt Papers, Columbia, 44; Elaine de Kooning, interview by Antonina Zara, 10; Stevens and Swan, *De Kooning*, 252. Charlie was as broke as the artists he exhibited; he even slept in his gallery.
74. Edgar, *Club Without Walls*, 69.
75. William Corbett, "But Here's a Funny Story," 49; Stevens and Swan, *De Kooning*, 252; Clement Greenberg, "Art," *The Nation*, April 24, 1948, 448.
76. James Lord, *Giacometti*, 287.
77. Elaine de Kooning, "De Kooning Memories," 352; Stevens and Swan, *De Kooning*, 251.
78. Elaine de Kooning, interview by Amei Wallach, 5.
79. Elaine de Kooning and Slivka, *Elaine de Kooning*, 215; Elaine de Kooning, "A Stroke of Genius," 37; Coppet and Jones, *The Art Dealers*, 82–83.
80. Coppet and Jones, *The Art Dealers*, 84; Marquis, *The Art Biz*, 218.
81. Leo Castelli, interview by Dodie Kazanjian, AAA-SI 4, 6; oral history interview with Leo Castelli, July 1969, AAA-SI; Coppet and Jones, *The Art Dealers*, 83–84; Marquis, *The Art Biz*, 219.
82. Elaine de Kooning, interview by John Gruen, AAA-SI, 6; Harrison and Denne, *Hamptons Bohemia*, 79.
83. Solomon, *Jackson Pollock*, 184.
84. Naifeh and Smith, *Jackson Pollock*, 560.
85. Lieber, *Reflections in the Studio*, 30, 122n; Naifeh and Smith, *Jackson Pollock*, 558–59; Herrera, *Arshile Gorky*, 388–89; Matossian, *Black Angel*, 373.
86. Naifeh and Smith, *Jackson Pollock*, 558–59.
87. Herrera, *Arshile Gorky*, 388–89; Matossian, *Black Angel*, 373.
88. Naifeh and Smith, *Jackson Pollock*, 559.
89. Elaine de Kooning, interview by John Gruen, AAA-SI, 6.
90. Levin, *Lee Krasner*, 251; Hall and Corrington Wykes, *Anecdotes of Modern Art*, 205. An artist's decision to use her own name, rather than a more famous husband's, was a difficult one. Whether she

opted for a declaration of independence or accepted marital convention, the greater art world still regarded her as "Mrs." and therefore lesser. After her marriage to photographer Alfred Stieglitz, Georgia O'Keeffe told those who dared to call her Mrs. Stieglitz, "I am Georgia O'Keeffe.... I've had a hard time hanging on to my name, but I hang on to it with my teeth. I like getting what I've got on my own."

91. Ernestine Lassaw, interview by author.
92. Lionel Trilling, *The Liberal Imagination,* 224; Dingwall, *The American Woman,* 126.
93. Trilling, *The Liberal Imagination,* 229; *Partisan Review* 15, no. 4 (April 1948), courtesy Helen Harrison, Pollock-Krasner House and Study Center, East Hampton, New York.
94. Gavin Butts, *Between You and Me,* 33; Diggins, *The Proud Decades,* 205–6. The Kinsey report triggered a backlash against gays, which undercut the freedoms they experienced after the war. Some authors have suggested it contributed to the zeal with which gays were pursued by anti-communist investigators.
95. Lionel Trilling, "Sex and Science: The Kinsey Report," 478.
96. Levin, *Lee Krasner,* 253.
97. Stevens and Swan, *De Kooning,* 156.
98. Excerpt from "Remembering Jackson Pollock: A Dialogue of His Friends," at the Museum of Modern Art in November 1998, reprinted in Landau et al., *Mercedes Matter,* 73n94; Levin, *Lee Krasner,* 252.
99. Francine du Plessix and Cleve Gray, "Who Was Jackson Pollock?," 53; Friedman, *Jackson Pollock: Energy Made Visible,* 89; Naifeh and Smith, *Jackson Pollock,* 87–89. Tony Smith, an architect and sculptor Jackson had befriended at Betty's gallery, said Jackson was the most puritanical man he had ever met.

18. *Death Visits the Kingdom of the Saints*

1. Jung, *Modern Man in Search of a Soul,* 173.
2. Oral history interview with V. V. Rankine, AAA-SI; Lieber, *Reflections in the Studio,* 31.
3. Lieber, *Reflections in the Studio,* 31.
4. Elaine de Kooning, "De Kooning Memories," 352.
5. Stevens and Swan, *De Kooning,* 268.
6. Ibid., 269.
7. Ernestine Lassaw, interview by author.
8. Hall, *Elaine and Bill,* 38.
9. Mary Emma Harris, *The Arts at Black Mountain College,* 146; oral history interview with John Cage, AAA-SI; Barbara Rose, *American Painting: The 20th Century,* 60.
10. Elaine de Kooning, "De Kooning Memories," 352.
11. Ibid.
12. Oral history interview with Elaine de Kooning, AAA-SI.
13. Elaine de Kooning, "De Kooning Memories," 352; Stevens and Swan, *De Kooning,* 256; Harris, *The Arts at Black Mountain College,* 156.
14. Elaine de Kooning, "De Kooning Memories," 352.
15. Martin Duberman, *Black Mountain,* 42, 44.
16. Ibid., 275.
17. Ibid., 42.
18. Elaine de Kooning, "De Kooning Memories," 352; Duberman, *Black Mountain,* 45.
19. Duberman, *Black Mountain,* 47, 50.
20. Ibid., 53; Elaine de Kooning, "De Kooning Memories," 352.
21. Elaine de Kooning, "De Kooning Memories," 353.
22. Ibid.; Vincent Katz, ed., *Black Mountain College,* 110; Duberman, *Black Mountain,* 260–61, 282, 292, 295; Harris, *The Arts at Black Mountain College,* 146, 151; oral history interview with Richard Lippold, AAA-SI; Lieber, *Reflections in the Studio,* 32.
23. Oral history interview with Richard Lippold, AAA-SI.
24. Elaine de Kooning, "De Kooning Memories," 394; Elaine de Kooning, interview by Minna Daniels, 28.
25. Elaine de Kooning, "De Kooning Memories," 353, 394; Stevens and Swan, *De Kooning,* 145, 258.

26. Ashton, *The New York School*, 143, 145; Duberman, *Black Mountain*, 298.
27. Elaine de Kooning, "De Kooning Memories," 393.
28. Katz, *Black Mountain College*, 115; Elaine de Kooning, "De Kooning Memories," 393.
29. Elaine de Kooning, "De Kooning Memories," 353, 393; Harris, *The Arts at Black Mountain College*, 151.
30. Elaine de Kooning, "De Kooning Memories," 393; *Conversations with Artists, Elaine Benson Interviews Elaine de Kooning*, videotape courtesy LTV, Inc.
31. Elaine de Kooning, "De Kooning Memories," 393; Duberman, *Black Mountain*, 297; *Conversations with Artists, Elaine Benson Interviews Elaine de Kooning*, videotape courtesy LTV.
32. Schloss, "The Loft Generation," Edith Schloss Burckhardt Papers, Columbia, 195–96.
33. Steven Johnson, ed., *The New York Schools of Music and the Visual Arts*, 118.
34. Elaine de Kooning, "De Kooning Memories," 394; Katz, *Black Mountain College*, 136; Duberman, *Black Mountain*, 299, 301–3; Harris, *The Arts at Black Mountain College*, 154–56.
35. Elaine de Kooning, "De Kooning Memories," 353.
36. Bledsoe, *E de K*, 28–29; "Elaine de Kooning, Black Mountain Paintings from 1948," Washburn Gallery, October 1–November 2, 1991. Elaine would roll up her paintings and not look at them again until 1985—a "testimonial to the durability of paint, if nothing more," she explained.
37. Hall, *Elaine and Bill*, 85; Bledsoe, *E de K*, 28–30.
38. Elaine de Kooning, interview by Minna Daniels, 27.
39. Ibid., 28.
40. Lieber, *Reflections in the Studio*, 32. Some accounts said they learned the news in a letter from Charlie Egan, others from Gorky's sister-in-law V. V. Rankine, or from the newspaper.
41. Oral history interview with Irving Block, AAA-SI.
42. James Brooks, interview by Jack Taylor.
43. David Hare, interview by Jack Taylor.
44. Matossian, *Black Angel*, 425–29; John Bernard Myers, interview by Barbara Rose, audiotape, March 12, 1968, Series V, Box 13, R3, GRI; Herrera, *Arshile Gorky*, 600.
45. Levy, *Memoir of an Art Gallery*, 248, 252.
46. John Bernard Myers, interview by Barbara Rose, audiotape, March 12, 1968, Series V, Box 13, R3, GRI.
47. Matossian, *Black Angel*, 453; John Bernard Myers, interview by Barbara Rose, audiotape, March 12, 1968, Series V, Box 13, R3, GRI.
48. Matossian, *Black Angel*, 472.
49. Ibid., 455; Levy, *Memoir of an Art Gallery*, 287–88.
50. Matossian, *Black Angel*, 455–56; Levy, *Memoir of an Art Gallery*, 289–91.
51. Matossian, *Black Angel*, 456–57.
52. Ibid., 457–60; Levy, *Memoir of an Art Gallery*, 287–88.
53. Matossian, *Black Angel*, 458.
54. Levy, *Memoir of an Art Gallery*, 287.
55. Matossian, *Black Angel*, 459–60, 463; Herrera, *Arshile Gorky*, 601.
56. Matossian, *Black Angel*, 464, 467.
57. Ibid., 466–67; Herrera, *Arshile Gorky*, 605–6.
58. Matossian, *Black Angel*, 474; Herrera, *Arshile Gorky*, 611; Levy, *Memoir of an Art Gallery*, 293.
59. Levy, *Memoir of an Art Gallery*, 294–95; Herrera, *Arshile Gorky*, 611.
60. Matossian, *Black Angel*, 475, 488; Herrera, *Arshile Gorky*, 612. Levy mounted a show of Gorky's work and then, haunted by guilt, closed his gallery forever.
61. Passlof, "The 30s Painting in New York," Pat Passlof Papers, AAA-SI.
62. Pat Passlof, "Willem de Kooning on his Eighty-Fifth Birthday," 229; Stevens and Swan, *De Kooning*, 261–62; Lieber, *Reflections in the Studio*, 32.
63. Stevens and Swan, *De Kooning*, 261–62.

19. The New Arcadia

1. Elaine de Kooning, "Two Americans in Action," 174.
2. Passlof, "Willem de Kooning on his Eighty-Fifth Birthday," 229; Stevens and Swan, *De Kooning*, 263.

3. Elaine de Kooning, "De Kooning Memories," 394.
4. Stevens and Swan, *De Kooning*, 263; Passlof, "Willem de Kooning on his Eighty-Fifth Birthday," 229; Elaine de Kooning, "De Kooning Memories," 394.
5. Edvard Lieber, e-mail to author, August 20, 2015; unidentified magazine clipping, Box 1/1, Folder 2, Thomas B. Hess/Willem de Kooning Papers, MOMA, 71; Elaine de Kooning, "De Kooning Memories," 394; Stevens and Swan, *De Kooning*, 262; Duberman, *Black Mountain*, 304.
6. Elaine de Kooning, interview by John Gruen, AAA-SI, 6; Duberman, *Black Mountain*, 297, 298.
7. Elaine de Kooning, "De Kooning Memories," 394.
8. Stevens and Swan, *De Kooning*, 271–72.
9. Ibid., 272.
10. Ibid., 240.
11. Oral history interview with Milton Resnick, AAA-SI; Edgar, *Club Without Walls*, 69; Albert Parry, *Garrets and Pretenders*, 364; Dorfman, *Out of the Picture*, 29; Barrett, *The Truants*, 144.
12. Oral history interview with Milton Resnick, AAA-SI; Stahr, *The Social Relations of Abstract Expressionism*, 99.
13. Edgar, *Club Without Walls*, 69; Elaine de Kooning, interview by Arthur Tobier, 4; Passlof, "Willem de Kooning on his Eighty-Fifth Birthday," 229; "Pat Passlof, Biography," http://resnickpasslof.org/the-artists/pat-passlof.
14. Edgar, *Club Without Walls*, 69; oral history interview with Al Held, AAA-SI. Held said for young artists Tenth Street seemed like "wonderland.... Everybody was making art."
15. Stahr, *The Social Relations of Abstract Expressionism*, 100.
16. Rivers, *What Did I Do?*, 10–11, 75–76; Elaine de Kooning, interview by Amei Wallach, 13.
17. Rivers, *What Did I Do?*, 76; George Ortman, *New York Artists Equity Association 55th Anniversary Journal*, 52. Ortman said in 1954 he congratulated Bill de Kooning on his exhibition at Janis, saying he saw that Bill had sold several paintings. "Yes," Bill said, looking embarrassed. "I must be doing something wrong."
18. Mills, "The Powerless People," 68.
19. Ashton, *The New York School*, 160.
20. Clement Greenberg, "The Situation at the Moment," 82–83.
21. Rivers, *What Did I Do?*, 180
22. Ashton, *The New York School*, 161.
23. Mary Lee Corlett, "Jackson Pollock: American Culture, the Media and the Myth," 80–81, 83–84; Solomon, *Jackson Pollock*, 186–87.
24. Solomon, *Jackson Pollock*, 187; "Critics Denounced by Artists' Group," *New York Times*, May 6, 1948, 26.
25. "A Life Roundtable on Modern Art," 56, 62, 63; Rubenfeld, *Clement Greenberg*, 107. The discussion focused mostly on "modern art" of the pre–World War Two European variety.
26. *Life* 25, no. 15 (October 11, 1948): 52, 62–63, 72–73.
27. Flam et al., *Robert Motherwell*, 195; Robert Motherwell, interview by Jack Taylor; AnnaLee Newman, interview by Dodie Kazanjian, AAA-SI.
28. *Mercedes Matter*, interview by Sigmund Koch, Tape 1B, Aesthetics Research Archive; Robert Motherwell, interview by Jack Taylor.
29. Oral history interview with David Hare, AAA-SI; oral history interview with Philip Pavia, AAA-SI, 9.
30. Robert Coates, "The Art Galleries: Abroad and at Home," 83–84.
31. Naifeh and Smith, *Jackson Pollock*, 569–70.
32. Ibid., 569; John Bernard Myers, interview by Barbara Rose, audiotape, March 12, 1968, Series V, Box 13, R3, GRI. John Myers said Pollock was no "Don Juan" or "woman chaser." Some women flung themselves at Pollock, but he "told them to fly a kite."
33. May Tabak Rosenberg, interview by Jeffrey Potter, audiotape courtesy PKHSC.
34. Naifeh and Smith, *Jackson Pollock*, 569.
35. Gruen, *The Party's Over Now*, 231; Plessix and Gray, "Who Was Jackson Pollock?," 51.
36. Landau, *Lee Krasner: A Catalogue Raisonné*, 106; Levin, *Lee Krasner*, 253–54; Lee Krasner, "Little Image Paintings," iv.
37. Malina, *The Diaries of Judith Malina*, 54.

38. Landau, *Lee Krasner: A Catalogue Raisonné*, 106; Landau, "Lee Krasner's Early Career, Part Two," 83; Levin, *Lee Krasner*, 254–55.
39. Naifeh and Smith, *Jackson Pollock*, 571, 575.
40. Ibid., 576.
41. Ibid.
42. Ibid.
43. Lori Rotskoff, *Love on the Rocks*, 61–62, 64–65.
44. Potter, *To a Violent Grave*, 102; Naifeh and Smith, *Jackson Pollock*, 576–577; Solomon, *Jackson Pollock*, 189. Heller's widow denied her husband gave Pollock tranquilizers, saying he simply treated Jackson with "sympathy."
45. Solomon, *Jackson Pollock*, 189; Potter, *To a Violent Grave*, 102; Naifeh and Smith, *Jackson Pollock*, 577.
46. Potter, *To a Violent Grave*, 102.
47. Ibid.
48. Malina, *The Diaries of Judith Malina*, 32–33; Caute, *The Great Fear*, 31.
49. Malina, *The Diaries of Judith Malina*, 51.
50. David Halberstam, *The Fifties*, 15.
51. Ibid., 12, 15; Malina, *The Diaries of Judith Malina*, 49; Caute, *The Great Fear*, 163–64, 187.
52. Halberstam, *The Fifties*, 11; Caute, *The Great Fear*, 58–59; Diggins, *The Proud Decades*, 112.
53. Brogan, *The Penguin History of the United States*, 595–96; Halberstam, *The Fifties*, 180; Miller and Nowak, *The Fifties*, 344. In 1946, there were 7,000 television sets in the United States. Four years later, in 1950, there were 4.4 million, and by 1956, Americans purchased 20,000 televisions a day. The advent of the "tube" so homogenized society, Halberstam wrote, that "studies showed that when a popular program was on, toilets flushed all over certain cities, as if on cue, during commercials or the moment the program was over."
54. Malina, *The Diaries of Judith Malina*, 59–60.
55. Diggins, *The Proud Decades*, 108–9.
56. Ibid., 181–83; Miller and Nowak, *The Fifties*, 133–34, 136.
57. Robert Motherwell, "The Modern Painter's World," 10; Sandler, *Abstract Expressionism*, 26. Sandler believed artists allowed their canvases to look "unfinished" in part to counter, if not violate, the middle-class order then abroad in the land.
58. Corlett, "Jackson Pollock: American Culture, the Media and the Myth," 78.
59. Antonin Artaud, "The Duty," https://www.babelio.com/auteur/Antonin-Artaud/2204/citations.
60. Richard H. Parke, "New Snow in Sight as City Digs Out," *New York Times*, December 21, 1948, 1; Musa Mayer, *Night Studio*, 69.

20. *The Call of the Wild*

1. Beauvoir, *The Second Sex*, 641.
2. Grace Hartigan, interview by author.
3. Rex Stevens, interview by author.
4. Grace Hartigan, interview by author.
5. Grace Hartigan, "Factors & Persons Who Helped to Influence," notes, Box 31, Grace Hartigan Papers, Syracuse; Donna Sesee, interview by author; Robert Saltonstall Mattison, *Grace Hartigan*, 10; Cathy Curtis, *Restless Ambition*, 7–8.
6. Grace Hartigan to Gertrude Kasle, March 29, 1964, Series 1, Box 2, Folder 22, The Gertrude Kasle Gallery Records, 1949–1999 (bulk 1964–1983), AAA-SI.
7. Nemser, *Art Talk*, 151–52.
8. Curtis, *Restless Ambition*, 8, 16; Rex Stevens, interview by author; Murray Grigor, *Shattering Boundaries*, film.
9. Grace Hartigan statement notes for inclusion in World Artists: 1950–1975, Box 31, Grace Hartigan Papers, Syracuse; Grace Hartigan, Factors & Persons Who Helped to Influence, notes, Box 31, Grace Hartigan Papers, Syracuse; Donna Sesee, interview by author; Curtis, *Restless Ambition*, 10, 12–13.
10. Donna Sesee, interview by author.
11. Grace Hartigan to Gertrude Kasle, March 29, 1964, Series 1, Box 2, Folder 22, The Gertrude Kasle Gallery Records, 1949–1999 (Bulk 1964–1983), AAA-SI.

12. Oral history interview with Grace Hartigan, AAA-SI.
13. Oral history interview with Grace Hartigan, AAA-SI; Curtis, *Restless Ambition*, 10–11, 13; Grace Hartigan to Dorian and Jeffrey (In Julian and Karen Weissman File), July 1, 2001, Box 31, Grace Hartigan Papers, Syracuse.
14. Oral history interview with Grace Hartigan, AAA-SI; Curtis, *Restless Ambition*, 8, 17; Nemser, *Art Talk*, 152.
15. Donna Sesee, interview by author; Grigor, *Shattering Boundaries*, film.
16. Curtis, *Restless Ambition*, 18.
17. Oral history interview with Grace Hartigan, AAA-SI; Curtis, *Restless Ambition*, 18; Nemser, *Art Talk*, 153.
18. Oral history interview with Grace Hartigan, AAA-SI; Nemser, *Art Talk*, 153.
19. Grigor, *Shattering Boundaries*, film; oral history interview with Grace Hartigan, AAA-SI.
20. Oral history interview with Grace Hartigan, AAA-SI.
21. Mattison, *Grace Hartigan*, 11; Curtis, *Restless Ambition*, 22–23.
22. Rex Stevens, interview by author.
23. Curtis, *Restless Ambition*, 22; oral history interview with Grace Hartigan, AAA-SI.
24. Nemser, *Art Talk*, 153.
25. Ibid.
26. Grigor, *Shattering Boundaries*, film.
27. Mary Gabriel, "Amazing Grace," 64.
28. Nemser, *Art Talk*, 153.
29. Ibid., 154.
30. Oral history interview with Grace Hartigan, AAA-SI; Curtis, *Restless Ambition*, 24; Grace Hartigan, Factors & Persons Who Helped to Influence, notes, Grace Hartigan Papers, Syracuse.
31. Costello, *Virtue Under Fire*, 189.
32. Mattison, *Grace Hartigan*, 11; Curtis, *Restless Ambition*, 25.
33. Ashton, *The New York School*, 15. Fine arts courses outside of New York City were rare, and really only began to proliferate in the late 1950s as a result of the popularity of Abstract Expressionism.
34. Gabriel, "Amazing Grace," 64; Nemser, *Art Talk*, 153.
35. Gabriel, "Amazing Grace," 64–65.
36. Oral history interview with Grace Hartigan, AAA-SI; Rex Stevens, interview by author.
37. Grigor, *Shattering Boundaries*, film.
38. Nemser, *Art Talk*, 154.
39. Oral history interview with Grace Hartigan, AAA-SI; Curtis, *Restless Ambition*, 25, 28.
40. Betsy Prioleau, *Seductress*, 159.
41. Costello, *Virtue Under Fire*, 262; Barrett, *The Truants*, 20, 263; Brogan, *Penguin History of the United States*, 566; Clements, *Prosperity, Depression and the New Deal*, 212; Polenberg, *War and Society*, 244. During the four years of war, 20 million Americans moved to work in wartime industry and more than 12 million left home to join the service. The United States, said Brogan, "became a nation of transients," which changed the social, political and cultural patterns established before 1941. The population of California, the land of defense plants during the war, surged by 72 percent and many of those newcomers chose to remain.
42. Lundberg and Farnham, *Modern Woman: The Lost Sex*, 71, 120; Ditzion, *Marriage, Morals and Sex in America*, 405; Costello, *Virtue Under Fire*, 272; Margaret Mead, *Male and Female*, 274–76; Williams, "Woman: Myth and Stereotype," 241. One best-selling writer at the time labeled the housewife-mother "The Queen of Hell."
43. Lundberg and Farnham, *Modern Woman: The Lost Sex*, 201.
44. Friedan, *The Feminine Mystique*, 37; Mead, *Male and Female*, 274–76; Chafe, *The American Woman*, 200.
45. Beauvoir, *The Second Sex*, 159–60.
46. Oral history interview with Grace Hartigan, AAA-SI.
47. Rex Stevens, interview by author.
48. Curtis, *Restless Ambition*, 27; *Grace Hartigan*, 11.
49. Oral history interview with Grace Hartigan, AAA-SI; Curtis Mattison, *Grace Hartigan*, 11.
50. Oral history interview with Grace Hartigan, AAA-SI; Mattison, *Grace Hartigan*, 11.

51. Mattison, *Grace Hartigan*, 11.
52. Curtis, *Restless Ambition*, 38.
53. Mattison, *Grace Hartigan*, 11.
54. Nemser, *Art Talk*, 155.
55. Mattison, *Grace Hartigan*, 12.
56. Grace Hartigan notes for Elaine de Kooning Memorial, May 12, 1990, Box 9, Grace Hartigan Papers, Syracuse.
57. Oral history interview with Grace Hartigan, AAA-SI.
58. Ibid.
59. Rex Stevens, interview with author.
60. Mattison, *Grace Hartigan*, 12.
61. Curtis, *Restless Ambition*, 29.
62. Oral history interview with Grace Hartigan, AAA-SI; Grace Hartigan notes for inclusion in World Artists: 1950–1975, Box 31, Grace Hartigan Papers, Syracuse; Gabriel, "Amazing Grace," 65; Curtis, *Restless Ambition*, 40.
63. Nemser, *Art Talk*, 154.
64. Oral history interview with Grace Hartigan, AAA-SI.
65. Nemser, *Art Talk*, 154.
66. Friedan, *The Feminine Mystique*, 38; Lundberg and Farnham, *Modern Woman*, 202; Riley, *Inventing the American Woman*, 238–39; Miller and Nowak, *The Fifties*, 155.
67. Rex Stevens, interview by author.
68. Donna Sesee, interview by author.
69. Grigor, *Shattering Boundaries*, film.
70. Barrett, *The Truants*, 58.
71. Ibid.; E. B. White, *Here Is New York*, 46; "City of New York & Boroughs: Population & Population Density from 1790," demographia.com/dm-nyc.htm.
72. Feininger and Lyman, *The Face of New York*, n.p.; Perl, *New Art City*, 27; Beauvoir, *America Day by Day*, 264–65.
73. Beauvoir, *America Day by Day*, 28–29, 67–68; White, *Here Is New York*, 46.
74. Feininger and Lyman, *The Face of New York*, n.p.
75. Beauvoir, *America Day by Day*, 36.
76. Rivers, *What Did I Do?*, 161–62.
77. Brossard, *The Scene Before You*, 26; Ned Polsky, "The Village Beat Scene," 340. Polsky writes that the 1940s words "hip" and "hep" derived from the phrase "to be on the hip," a reference to the position assumed while smoking opium. Opium smoking died off, but the phrase remained and became associated with drug-taking in general. In the late 1950s, it assumed its current usage—someone "in the know."
78. Anatole Broyard, "Portrait of a Hipster," 722–23; Brossard, *The Scene Before You*, 26.
79. Broyard, "Portrait of a Hipster," 722; Paul Goodman, *Growing Up Absurd*, 181.
80. Broyard, "Portrait of a Hipster," 723.
81. Rex Stevens, interview by author; oral history interview with Grace Hartigan, AAA-SI.
82. William Grimes, "Harry Jackson, Artist Who Captured the West, Dies at 87," *New York Times*, April 28, 2011, www.nytimes.com/.../arts/.../harry-jackson-artist-who-captured-the; Naifeh and Smith, *Jackson Pollock*, 564.
83. Grimes, "Harry Jackson"; Naifeh and Smith, 562, 564.
84. Grimes, "Harry Jackson."
85. Oral history interview with Grace Hartigan, AAA-SI.
86. B. H. Friedman, ed., *Give My Regards to Eighth Street*, 5, 94; oral history interview with Grace Hartigan, AAA-SI; Schloss, "The Loft Generation," Edith Schloss Burckhardt Papers, Columbia, 198, 201.
87. Oral history interview with Grace Hartigan, AAA-SI.
88. Grimes, "Harry Jackson"; oral history interview with Grace Hartigan, AAA-SI.
89. Nemser, *Art Talk*, 155.
90. Harry Jackson Journal, October 2, 1948, courtesy Harry A. Jackson Trust, 10; Harry Jackson Journal, November 3, 1948, 11. Some writers have questioned whether the pair could have hitch-

hiked while carrying a sample of Harry's work, but his paintings at the time were small, and his drawings done in a small sketchbook.
91. Oral history interview with Grace Hartigan, AAA-SI.
92. Ibid.; Grigor, *Shattering Boundaries,* film.
93. Nemser, *Art Talk,* 151.
94. Curtis, *Restless Ambition,* 43.
95. Nemser, *Art Talk,* 151; *Shattering Boundaries,* film; oral history interview with Grace Hartigan, AAA-SI.
96. Oral history interview with Grace Hartigan, AAA-SI.
97. Mattison, *Grace Hartigan,* 12.
98. Grigor, *Shattering Boundaries,* film.
99. Ibid.; Mattison, *Grace Hartigan,* 12.
100. Mattison, *Grace Hartigan,* 13; Gabriel, "Amazing Grace," 65.
101. Mattison, *Grace Hartigan,* 13.
102. Grace Hartigan, unpublished notes on the New York Scene, Box 31, Grace Hartigan Papers, Syracuse.
103. Hall, *Elaine and Bill,* 128–29.
104. Grace Hartigan, "Notes for Tribute to Elaine de Kooning," Syracuse; Grace Hartigan, "Notes for Elaine de Kooning Memorial," May 12, 1990, Box 9, Grace Hartigan Papers, Syracuse; Gibson, *Abstract Expressionism,* 127.
105. Barrett, *Irrational Man,* 154–55.

21. The Acts of the Apostles, I

1. Lehman, *The Last Avant-Garde,* 11.
2. Harry A. Jackson and Grace Hartigan Jachens Marriage Certificate, Village of Springs, January 8th, 1949, courtesy of the Harry A. Jackson Trust; Harry Jackson Journals, January 14, 1949, courtesy of the Harry A. Jackson Trust, 14; Curtis, *Restless Ambition,* 50.
3. Harry Jackson Journals, January 14, 1949, courtesy of the Harry A. Jackson Trust, 14.
4. Interview with Rex Stevens, author.
5. Curtis, *Restless Ambition,* 50–51.
6. Oral history interview with Grace Hartigan, AAA-SI; Clements, *Prosperity, Depression and the New Deal,* 226.
7. Naifeh and Smith, *Jackson Pollock,* 566.
8. Solomon, *Jackson Pollock,* 189; Karmel, *Jackson Pollock: Interviews, Articles, Reviews,* 19. Lee said Jackson numbered his paintings to "make people look at a picture for what it is, pure painting."
9. Harry A. Jackson Journals, January 14, 1949, courtesy of the Harry A. Jackson Trust, 16.
10. Robert Saltonstall Mattison, telephone interview by author.
11. Harry A. Jackson Journals, January 14, 1949, courtesy of the Harry A. Jackson Trust, 16; Naifeh and Smith, *Jackson Pollock,* 578; Gail Levin, "The Extraordinary Intervention of Alfonso Ossorio," 9.
12. Naifeh and Smith, *Jackson Pollock,* 578.
13. Harry A. Jackson Journals, January 24, 1949, courtesy of the Harry A. Jackson Trust, 17. Harry described Elaine's three companions in his journal as "pimps" followed by the comments "she is a shit" and "Bill ought to kill her."
14. Harry A. Jackson Journals, January 24, 1949, courtesy of the Harry A. Jackson Trust, 17; Harry Jackson Journals, courtesy of the Harry A. Jackson Trust, January 18, 1949, 15.
15. Matthew Jackson, president of Harry Jackson Studios, e-mail to author, October 17, 2013; Curtis, *Restless Ambition,* 52. Harry also suffered from a "character disorder with obsessive-compulsive trends."
16. Curtis, *Restless Ambition,* 52.
17. "Reviews," *ArtNews* 48, no. 1 (March 1949): 44; *Conversations with Artists: Elaine Benson interviews Elaine de Kooning,* videotape courtesy LTV. In the fabled competition between Lee and Elaine it is often implied that she did not appreciate Pollock's work. Clem was partly to blame for that interpretation, because he once famously accused her of panning a Pollock show in a review. But in fact, Elaine said Jackson and his work were important to both her and Bill.
18. Karmel, *Jackson Pollock: Interviews, Articles, and Reviews,* 62.
19. O'Brian, *Clement Greenberg: The Collected Essays and Criticism,* 2:286.

20. Solomon, *Jackson Pollock*, 191; B.H. Friedman, *Alfonso Ossorio*, 13, 32; Varnadoe with Karmel, *Jackson Pollock*, 47; Levin, "Extraordinary Interventions of Alfonso Ossorio," 5, 8. The Modern had not purchased anything by Jackson since his first show in 1943 at Peggy's gallery.
21. Corlett, "Jackson Pollock: American Culture, the Media and the Myth," 84.
22. "Words," *Time*, February 7, 1949, 7.
23. Solomon, *Jackson Pollock*, 194–95; Marquis, *Art Czar*, 115; Naifeh and Smith, *Jackson Pollock*, 590.
24. Naifeh and Smith, *Jackson Pollock*, 590.
25. Solomon, *Jackson Pollock*, 192–93.
26. Ibid., 193.
27. Naifeh and Smith, *Jackson Pollock*, 591.
28. Elaine de Kooning and Slivka, *Elaine de Kooning*, 220; Elaine de Kooning, "A Stroke of Genius," 42.
29. Potter, *To a Violent Grave*, 95.
30. Ibid., 115.
31. Sandler, *A Sweeper Up After Artists*, 47.
32. Harry Jackson Journal, November 12, 1949, courtesy of the Harry A. Jackson Trust, 21: Robert Motherwell, interview by Jack Taylor; Robert Motherwell, interview by Dodie Kazanjian, AAA-SI, 2.
33. Robert Motherwell, interview by Jack Taylor.
34. Ibid. Larry Rivers, "Cedar," unpublished notes, Larry Rivers Papers, MSS 293, Series II A, Box 19, Folder 23, NYU, 2.
35. Annalee Newman, interview by Dodie Kazanjian, AAA-SI, 4.
36. Annalee Newman, interview by Dodie Kazanjian, AAA-SI, 2–3; Hess, *Willem de Kooning* (1968), 18; Hall, *Elaine and Bill*, 110; "Statement by Philip Pavia," New York Artists Equity Association, 20; oral history interview with Rudy Burckhardt, AAA-SI. Rudy said Denby taught Elaine to write "and then Elaine wrote down what Bill said." On this particular speech, Philip Pavia disputed Annalee Newman's account, saying it was written at The Club.
37. Thomas B. Hess, Draft Manuscript dated July 8, 1968, for Thomas B. Hess's 1968 de Kooning show at the Museum of Modern Art, Box 1/1, Thomas B. Hess/De Kooning Papers, MOMA, 8–9.
38. Hess, *Willem de Kooning* (1968), 15–16; Hall, *Elaine and Bill*, 110.
39. Annalee Newman, interview by Dodie Kazanjian, AAA-SI, 3; oral history interview with Fairfield Porter, AAA-SI; "Statement by Philip Pavia," New York Artists Equity Association, 20. Pavia said Bill only agreed to give the lecture if Motherwell read the speech, and that Motherwell's intervention in the evening was prearranged.
40. Elaine de Kooning and Slivka, *Elaine de Kooning*, 215.
41. Harry Jackson Journals, March 8, 1949, courtesy of the Harry A. Jackson Trust, 18; Harry Jackson Journals, February 4, 1949, 17; Mattison, *Grace Hartigan*, 13.
42. Curtis, *Restless Ambition*, 48; Hall, *Elaine and Bill*, 30–31.
43. Hall, *Elaine and Bill*, 30–31.
44. Curtis, *Restless Ambition*, 48.
45. Mattison, *Grace Hartigan*, 13; Harry A. Jackson Journals, May 21, 1949, courtesy of the Harry A. Jackson Trust, 19.

22. The Acts of the Apostles, II

1. Oral history interview with Jane Freilicher, AAA-SI.
2. Stevens and Swan, *De Kooning*, 273.
3. Elaine de Kooning, interview by Amei Wallach, 5–6.
4. Hall, *Elaine and Bill*, 99.
5. Mary Abbott, interview by author.
6. Ibid.
7. Ibid.
8. Ibid.
9. Stevens and Swan, *De Kooning*, 321.
10. Mary Abbott, interview by author.
11. Stevens and Swan, *De Kooning*, 275.
12. Mary Abbott, interview by author.
13. Elaine de Kooning, interview by Amei Wallach, 7.

14. Elaine de Kooning, interview by John Gruen, AAA-SI, 8.
15. Oral history interview with Nell Blaine, AAA-SI, 9; Sawin, *Nell Blaine,* 26, 32.
16. Rivers, *What Did I Do?,* 18–19, 43–44, 137. His sister Goldie called them all "raging communists."
17. Ibid., 18–19, 20, 22.
18. Ibid., 20.
19. Ibid., 33–34.
20. Oral history interview with Jane Freilicher, AAA-SI.
21. Rivers, *What Did I Do?,* 36.
22. Larry Rivers, interview by Barbaralee Diamonstein, provided by Dr. Barbaralee Diamonstein-Spielvogel, interviewer and author, from *Inside New York's Art World,* 317–18.
23. Sawin, *Nell Blaine,* 35; oral history interview with Jane Freilicher, AAA-SI.
24. Munro, *Originals,* 204–5.
25. Oral history interview with Larry Rivers, AAA-SI.
26. Harold Rosenberg eulogy for Hans Hofmann, Grace Hartigan Papers, Syracuse.
27. Rivers, *What Did I Do?,* 136–38.
28. Ibid., 193–94; Sam Hunter, "On Larry Rivers," unpublished notes, Roll 630, Sam Hunter Papers Concerning Larry Rivers, 1950–1969, AAA-SI.
29. Rivers, *What Did I Do?,* 195, 199.
30. Jane Freilicher, interview by Deborah Solomon.
31. Harrison, *Larry Rivers,* 17. Larry's left hand shook, but the cause of the tremors was never diagnosed.
32. Rivers, *What Did I Do?,* 176; Elaine de Kooning, interview by Amei Wallach, 2.
33. O'Brian, *Clement Greenberg: The Collected Essays and Criticism,* 2:301; Harrison, *Larry Rivers,* 16–17; Elaine de Kooning, interview by Amei Wallach, 2.
34. O'Brian, *Clement Greenberg: The Collected Essays and Criticism,* 2:301; Rivers, *What Did I Do?,* 176.
35. Hall, *Elaine and Bill,* 87; Elaine de Kooning, "De Kooning Memories," 394.
36. Rivers, *What Did I Do?,* 134.
37. Ibid., 132–33.
38. Elaine de Kooning, interview by John Gruen, AAA-SI, 8.
39. Goodman, *Hofmann,* 60–61.
40. Ibid., 61.
41. Elaine de Kooning, interview by John Gruen, AAA-SI, 8.
42. Nell Blaine, interview, Box 1, Folder 14, Irving Sandler Papers, ca. 1944–2007 (bulk 1944–1980), AAA-SI.
43. Harrison, *Larry Rivers,* 13; Harold Rosenberg, "The Teaching of Hans Hofmann," 18. Harold said of Hofmann's teaching method, "It was a question of making students realize that they were entering into this new order, living and not simply acquiring some new skills."
44. Elaine de Kooning, interview by Molly Barnes, 5.
45. Hess and Baker, *Art and Sexual Politics,* 58.
46. Ibid., 57–58; Peter Manso, *Provincetown: Art, Sex, and Money on the Outer Cape,* 33, 34.
47. Ashton with Banach, *The Writings of Robert Motherwell,* 309; Mary Abbott, interview by author.
48. Flam et al., *Robert Motherwell,* 64, 195.
49. Robert Motherwell, interview by Jack Taylor; Flam et al., *Robert Motherwell,* 197.
50. "1940–49 Chronology," dedalusfoundation.org/motherwell/chronology; Flam et al., *Robert Motherwell,* 197; Robert Motherwell, interview by Barbaralee Diamonstein, provided by Dr. Barbaralee Diamonstein-Spielvogel, interviewer and author, from *Inside New York's Art World,* 244. Motherwell said in an interview he first used the phrase in 1950 in a catalog essay he wrote for a gallery in Beverly Hills.
51. Stevens and Swan, *De Kooning,* 283–84.
52. Lieber, *Reflections in the Studio,* 33; Stevens and Swan, *De Kooning,* 285.
53. Manso, *Provincetown,* 33, 34.
54. Dorothy Seiberling, "Jackson Pollock," 42.
55. Oral history interview with Lillian Orlowsky, AAA-SI.
56. Elaine de Kooning, interview by Antonina Zara, 12; "Jackson Pollock: An Artists' Symposium"; Ashton, *The Life and Times of the New York School,* 154. Elaine said Jackson was the first "American painter to be devoured as a package by critics and collectors."

23. Fame

1. Nora Wydenbruck, *Rilke, Man and Poet*, 96.
2. James Brooks and Charlotte Park Brooks, interview by James T. Valliere, Jackson Pollock and Lee Krasner Papers, AAA-SI, 7; oral history interview with Elisabeth Ross Zogbaum, AAA-SI.
3. Seiberling, "Jackson Pollock," 42–45.
4. Ibid., 45.
5. Landau, *Jackson Pollock*, 181; "Letters to the Editor," *Life* 27, no. 9 (August 29, 1949): 9. The article prompted more letters to the editor than any other that year, and of those who responded to the question, 80 percent said no.
6. "Red Visitors Cause Rumpus," 42–43.
7. Chipp, *Theories of Modern Art*, 490.
8. Elaine de Kooning and Slivka, *Elaine de Kooning*, 16.
9. Oral history interview with Elisabeth Ross Zogbaum, AAA-SI.
10. Wetzsteon, *Republic of Dreams*, 558.
11. Potter, *To a Violent Grave*, 114.
12. Solomon, *Jackson Pollock*, 195–96; Naifeh and Smith, *Jackson Pollock*, 596; Ruby Jackson, interview by author.
13. Les Levin, "The Spring of '55, A Portrait of Sam Kootz," 34.
14. Landau, *Reading Abstract Expressionism*, 155–56.
15. Stuart Preston, "By Husband and Wife," X9.
16. Ibid.
17. "Review," *ArtNews* 48, no.6 (October 1949): 45.
18. Friedan, *The Feminine Mystique*, 95–97, 100; Mead, *Male and Female*, 275–76; Millett, *Sexual Politics*, 203.
19. Greer, *The Obstacle Race*, 42–43.
20. Mead, *Male and Female*, 289–90. Mead cited a *Fortune* magazine poll conducted immediately after the war that found more men wanted to marry a "girl" who was "moderately successful" at her job than one who was "extremely successful."
21. Marquis, *The Art Biz*, 242.
22. Oral history interview with Lee Krasner, November 2, 1964–April 11, 1968, AAA-SI.
23. Hall, *Elaine and Bill*, 86.
24. Oral history interview with Lee Krasner, November 2, 1964–April 11, 1968, AAA-SI.
25. "Lee Krasner, Little Image Paintings," iv; Naifeh and Smith, *Jackson Pollock*, 586.
26. Oral history interview with Lee Krasner, November 2, 1964–April 11, 1968, AAA-SI; Landau, *Lee Krasner: A Catalogue Raisonné*, 310.
27. Potter, *To a Violent Grave*, 120.
28. Curtis, *Restless Ambition*, 56.
29. Nemser, *Art Talk*, 156.
30. "Grace Hartigan, Painting from Popular Culture"; Harry A. Jackson Journals, November 12, 1949, courtesy Harry A. Jackson Trust, 19; Harry A. Jackson Journals, July 7, 1949, courtesy Harry A. Jackson Trust, 21.
31. Curtis, *Restless Ambition*, 54.
32. Oral history interview with Grace Hartigan, AAA-SI.
33. Rex Stevens, interview by author.
34. Ibid.; Harry A. Jackson Journals, November 12, 1949, courtesy Harry A. Jackson Trust, 21; Grace Hartigan, letter to Gertrude Kasle, December 9, 1989, Baltimore to Detroit, Series 1, Box 2, Folder 27, The Gertrude Kasle Gallery Records, AAA-SI.
35. Grace Hartigan to Gertrude Kasle, December 9, 1989, Folder 27, Box 2, The Gertrude Kasle Gallery Records, AAA-SI.
36. Polcari, *Abstract Expressionism and the Modern Experience*, 291.
37. Oral history interview with Grace Hartigan, AAA-SI; Robert Motherwell, interview by Jack Taylor; Altshuler, *The Avant-Garde in Exhibition*, 156.
38. Oral history interview with Grace Hartigan, AAA-SI; Alfred Leslie, interview by Jack Taylor; Mattison, *Grace Hartigan*, 16.

39. Alfred Leslie, interview by Jack Taylor.
40. Naifeh and Smith, *Jackson Pollock*, 597; Solomon, *Jackson Pollock*, 198–99; Gaines, *Philistines at the Hedgerow*, 113; Levin, "Extraordinary Interventions of Alfonso Ossorio," 9.
41. Naifeh and Smith, *Jackson Pollock*, 597, 600–601; Friedman, *Alfonso Ossorio*, 42; Gaines, *Philistines at the Hedgerow*, 113.
42. Solomon, *Jackson Pollock*, 199.
43. Ibid., 198–99; Naifeh and Smith, *Jackson Pollock*, 600–601.
44. Dorfman, *Out of the Picture*, 59; Solomon, *Jackson Pollock*, 198; Naifeh and Smith, *Jackson Pollock*, 598–99.
45. Sandler, *Abstract Expressionism and the American Experience*, 181.
46. Dorfman, *Out of the Picture*, 59.
47. Naifeh and Smith, *Jackson Pollock*, 598–600. Eighteen of the twenty-seven works in the exhibition would sell.
48. David Hare, interview by Jack Taylor.
49. Elaine de Kooning, interview by Charles Hayes, 27.
50. Dorfman, *Out of the Picture*, 60.
51. Deborah Solomon, notes on Clement Greenberg based on interview, December 19, 1983, Series 1, Box 1, Folder 2, the Clement Greenberg Papers, 1937–1983, AAA-SI, 5.
52. Solomon, *Jackson Pollock*, 198; Deborah Solomon, notes on Clement Greenberg based on interview, December 19, 1983, Series 1, Box 1, Folder 2, the Clement Greenberg Papers, 1937–1983, AAA-SI, 5.
53. Elizabeth Baker, telephone interview by author; Schloss, "The Loft Generation," Edith Schloss Burckhardt Papers, Columbia, 276. Tom Hess's first "Paints a Picture" article appeared in May 1949 and Elaine's in September of that year.
54. Hellstein, "Grounding the Social Aesthetics of Abstract Expressionism," 17–19; L. Alcopley, "The Club, Its First Three Years," 46; Gruen, *The Party's Over Now*, 267–68. Like the Cedar Bar, the Club is often referred to in histories of the period as "The Artists' Club" or "The Eighth Street Club." The artists who were members from the beginning referred to it simply as "The Club," because no one at the organizational meeting, according to Ernestine, could agree on anything else to call it.
55. Gruen, *The Party's Over Now*, 267–68.
56. Parry, *Garrets and Pretenders*, 267; oral history interview with Ibram and Ernestine Lassaw, November 1–2, 1964, AAA-SI.
57. George Scrivani, ed., *Collected Writings of Willem de Kooning*, 110.
58. Oral history interview with Ibram and Ernestine Lassaw, AAA-SI; Alcopley, "The Club, Its First Three Years," 46; Hellstein, "Grounding the Social Aesthetics of Abstract Expressionism," 17–18; oral history interview with Philip Pavia, AAA-SI, 13; Gruen, *The Party's Over Now*, 268–69. The year the Club began is one of those disputes. Some, including the definitive book on the subject, *Club Without Walls*, say unequivocally that the Club began in 1948. In that case, Pavia is said to have found a loft on Eighth Street during the summer of 1948. However, Pavia stated in three interviews—one with Jack Taylor, the other an Oral History interview with the Archives of American Art, and again with John Gruen that it began in 1949. Elaine de Kooning also put its beginning in late 1949.
59. Alcopley, "The Club, Its First Three Years," 46; Edgar, *Club Without Walls*, 53; Dorfman, *Out of the Picture*, 7.
60. Edgar, *Club Without Walls*, x; Gruen, *The Party's Over Now*, 272–73.
61. Philip Pavia, interview by Jack Taylor; Alcopley, "The Club, Its First Three Years," 46; oral history interview with Rudy Burckhardt, AAA-SI; Pat Passlof, "The Ninth Street Show," 61; Dorfman, *Out of the Picture*, 7; Schloss, "The Loft Generation," Edith Schloss Burckhardt Papers, Columbia, 182.
62. Hellstein, "Grounding the Social Aesthetics of Abstract Expressionism," 19–20, 23; Natalie Edgar, interview by author.
63. Alcopley, "The Club, Its First Three Years," 46; Hellstein, "Grounding the Social Aesthetics of Abstract Expressionism," 21–22; Natalie Edgar, interview by author.
64. Esteban Vicente, interview by Anne Bowen Parsons, AAA-SI; Elaine de Kooning, interview by Amei Wallach, 7; Hellstein, "Grounding the Social Aesthetics of Abstract Expressionism," 21.
65. *Summer of '57*, videotape courtesy LTV.; *Mercedes Matter*, interview by Sigmund Koch, Tape 1B, Aesthetics Research Archive; Landau et al., *Mercedes Matter*, 75n109.

66. Natalie Edgar, interview by author; Hellstein, "Grounding the Social Aesthetics of Abstract Expressionism," 21; Club Minutes of Meetings, Membership Lists, Box 1, Folder 1, Irving Sandler Papers, ca. 1944–2007, bulk 1944–1980, AAA-SI. All the "Ninth Street Women" except Lee, who rarely ventured into the Club, would become members. Helen was voted in as a member in November 1951, Grace in September 1952 (supported in her application by Leo Castelli), and Joan in January 1952. In November 1952, Elaine became one of only seventeen voting members.
67. Oral history interview with Ibram and Ernestine Lassaw, AAA-SI.
68. Oral history interview with Leo Castelli, May 14, 1969–June 8, 1973, AAA-SI; Hellstein, "Grounding the Social Aesthetics of Abstract Expressionism," 21–22; Alcopley, "The Club, Its First Three Years," 46.
69. Edgar, *Club Without Walls*, 58, 96.
70. Alcopley, "The Club, Its First Three Years," 46; Hellstein, "Grounding the Social Aesthetics of Abstract Expressionism," 22; Edgar, *Club Without Walls*, 59.
71. Natalie Edgar, e-mail to author, January 21, 2014.
72. Oral history interview with Ludwig Sander, AAA-SI.
73. Alcopley, "The Club, Its First Three Years," 47; oral history interview with Ludwig Sander, AAA-SI.
74. Landau et al., *Mercedes Matter*, 49.
75. Jack Tworkov, interview by Anne Bowen Parsons, AAA-SI.
76. Oral history interview with Leo Castelli, May 14, 1969–June 8, 1973, AAA-SI.
77. Alcopley, "The Club, Its First Three Years," 46; Edgar, *Club Without Walls*, 54.
78. Thomas B. Hess, "The Battle of Paris, Strip-tease and Trotsky," 30; oral history interview with Ludwig Sander, AAA-SI.
79. Oral history interview with Ludwig Sander, AAA-SI.
80. Oral history interview with Ibram and Ernestine Lassaw, AAA-SI; Denise Lassaw, interview by author.
81. Edgar, *Club Without Walls*, 54; Elaine de Kooning interview by Amei Wallach, 9; oral history interview with Ludwig Sander, AAA-SI.
82. Oral history interview with Ludwig Sander, AAA-SI; Edgar, *Club Without Walls*, 55; Gruen, *The Party's Over Now*, 176–77.
83. Edgar, *Club Without Walls*, 54; Schloss, "The Loft Generation," Edith Schloss Burckhardt Papers, Columbia, 174.
84. Oral history interview with Ibram Lassaw and Ernestine Lassaw, AAA-SI.
85. Alcopley, "The Club, Its First Three Years," 47; Gruen, *The Party's Over Now*, 178; oral history interview with Ibram Lassaw and Ernestine Lassaw, AAA-SI.
86. Oral history interview with Ludwig Sander, AAA-SI; Edgar, *Club Without Walls*, 54.
87. Oral history interview with Ludwig Sander, AAA-SI; Stevens and Swan, *De Kooning*, 292.
88. Oral history interview with Ludwig Sander, AAA-SI.

24. The Flowering

1. Statement by Grace Hartigan, Gertrude Kasle Gallery, Detroit, Gertrude Kasle Papers, Series 1, Box 2, Folder 25, The Gertrude Kasle Gallery Records, AAA-SI.
2. Nemser, *Art Talk*, 156.
3. Harry A. Jackson Journals, November 1950, courtesy of the Harry A. Jackson Trust, 22.
4. Grigor, *Shattering Boundaries*, film; rental agreement, 25 Essex Street, Box 17, Grace Hartigan Papers, Syracuse.
5. Curtis, *Restless Ambition*, 65.
6. Grigor, *Shattering Boundaries*, film.
7. Prioleau, *Seductress*, 159.
8. Ed Colker, "Present Concerns in Studio Teaching," 33.
9. Alfred Leslie, interview by Jack Taylor.
10. Ibid.
11. Myers, *Tracking the Marvelous*, 127.
12. Alfred Leslie, interview by Jack Taylor.
13. Ibid.
14. Ibid.

15. Ibid.
16. Ibid.
17. Ibid.
18. Oral history interview with Harold Rosenberg, AAA-SI; Dorfman, *Out of the Picture*, 283.
19. Rental agreement, 25 Essex Street, Grace Hartigan Papers, Syracuse.
20. Weather history for KGLA, New York, New York, https://www.wunderground.com/history/airport/KLGA/1950/2/14/DailyHistory.html; https://www.wunderground.com/history/airport/KLGA/1950/3/14/DailyHistory.html.
21. Curtis, *Restless Ambition*, 65.
22. Ibid.
23. Ibid., 66–67.
24. Rex Stevens, interview by author.
25. Brogan, *The Penguin History of the United States*, 401.
26. Beauvoir, *America Day by Day*, 315.
27. White, *Here Is New York*, 45.
28. Beauvoir, *America Day by Day*, 315.
29. Myers, *Tracking the Marvelous*, 125.
30. Malina, *The Diaries of Judith Malina*, 230; Beauvoir, *America Day by Day*, 316; Myers, *Tracking the Marvelous*, 125.
31. Louise Elliot Rago, "We Visit with Grace Hartigan," 35.
32. Oral history interview with David Hare, AAA-SI.
33. Mary Gabriel, *The Art of Acquiring*, 50.
34. Oral history interview with Grace Hartigan, AAA-SI; Myers, *Tracking the Marvelous*, 126.
35. Mattison, *Grace Hartigan*, 16.
36. Nemser, *Art Talk*, 168–69.
37. Ibid., 169.
38. Ibid.
39. Dorfman, *Out of the Picture*, 287; Brad Gooch, *City Poet*, 202; Irving Sandler, "The Cedar Bar," 1.
40. Irving Sandler, "The Cedar Bar," 1; Lieber, *Reflections in the Studio*, 127n65. The Cedar is often referred to by later chroniclers of the period as the "Cedar Tavern" or "Cedar Street Tavern." During the 1950s, however, its denizens referred to it almost exclusively as the Cedar Bar. It became known as the "Tavern" after the Cedar moved and reopened on University Place in 1964.
41. *Mercedes Matter*, interview by Sigmund Koch, Tape 1B, Aesthetics Research Archive.
42. Alfred Leslie, interview by Jack Taylor; Giorgio Cavallon, interview by Jack Taylor; oral history interview with Ludwig Sander, AAA-SI.
43. Irving Sandler, "The Cedar Bar," 5; Joe Stefanelli, "The Cedar Bar," 59.
44. George McNeil, interview by Jack Taylor.
45. Stahr, *The Social Relations of Abstract Expressionism*, 189.
46. Elaine de Kooning, "Hans Hofmann Paints a Picture," 38–41, 58–59.
47. Oral history interview with Rudy Burckhardt, AAA-SI; Corbett, "But Here's a Funny Story," 48.
48. Elaine de Kooning, interview by Amei Wallach, 3.
49. Marquis, *The Art Biz*, 113–14.
50. Rubenfeld, *Clement Greenberg*, 174.
51. Ernestine Lassaw, interview by author.
52. Gruen, *The Party's Over Now*, 207.
53. Elaine de Kooning and Slivka, *Elaine de Kooning*, 27.
54. Frank O'Hara, "Larry Rivers: A Memoir," offprint from an exhibition catalog, Brandeis University, 1965, Box 182, Folder 18, Kenneth Koch Papers, 1939–1995, NYPL.
55. April Kingsley, *The Turning Point*, 15–16.
56. "Pictorial Essay: 19 Young American Artists, Under 36," 82.
57. Nemser, *Art Talk*, 155; Mattison, *Grace Hartigan*, 16–18.
58. Nemser, *Art Talk*, 156.
59. Ibid., 155.
60. Cindy Nemser, "Grace Hartigan: Abstract Artist, Concrete Woman," 31; Nemser, *Art Talk*, 155; Rubenfeld, *Clement Greenberg*, 143.

61. Nemser, *Art Talk*, 155–56; Rubenfeld, *Clement Greenberg*, 143; Thomas B. Hess, "Seeing the Young New Yorkers," 23; "Talent 1950," Kootz Gallery, Box 37, Grace Hartigan Papers, Syracuse.
62. Nemser, *Art Talk*, 156; oral history interview with Grace Hartigan, AAA-SI.
63. "Talent 1950," Kootz Gallery.
64. Mattison, *Grace Hartigan*, 16–18; Hess, "Seeing the Young New Yorkers," 23; Gaugh, *Franz Kline*, 88. Hess said the show was "one of the most successful and provocative exhibitions of younger artists I have ever seen."
65. Rubenfeld, *Clement Greenberg*, 142–43; Grace Hartigan, Factors & Persons Who Helped to Influence, unpublished notes by Grace Hartigan, Box 31, Grace Hartigan Papers, Syracuse.
66. Nemser, "Grace Hartigan: Abstract Artist, Concrete Woman," 31; Nemser, *Art Talk*, 155.
67. "Talent 1950," Kootz Gallery; Nemser, *Art Talk*, 156.
68. Edgar, *Club Without Walls*, 159; Ashton, *The New York School*, 212–13.
69. Altshuler, *Avant-Garde In Exhibition*, 156; Ashton, *The New York School*, 199–200; Sandler, *A Sweeper Up After Artists*, 27; Landau, *Reading Abstract Expressionism*, 164.
70. Landau, *Reading Abstract Expressionism*, 164.
71. Ibid.
72. Artists Session at Studio 35, 1950, Series 4, Subseries 2, Box 5, Folder 37, William Chapin Seitz Papers, ca. 1930–1995, AAA-SI.
73. Sandler, *A Sweeper Up After Artists*, 28.
74. Ibid.
75. Open Letter to Roland L. Redmond, President of the Metropolitan Museum of Art, May 20, 1950, Hedda Sterne Papers, AAA-SI.
76. Oral history interview with Hedda Sterne, December 17, 1981, AAA-SI; Sandler, *A Sweeper Up After Artists*, 28; "18 Painters Boycott Metropolitan: Charge 'Hostility to Advanced Art,'" *New York Times*, May 22, 1950, 1, https://timesmachine.nytimes.com/timesmachine/1950/05/22/issue.html.
77. Sandler, *A Sweeper Up After Artists*, 29; Lawrence Alloway and Mary Davis McNaughton, *Adolph Gottlieb*, 48; Naifeh and Smith, *Jackson Pollock*, 602; Landau, *Reading Abstract Expressionism*, 97–98n126.
78. Naifeh and Smith, *Jackson Pollock*, 600–601; oral history interview with Elisabeth Ross Zogbaum, AAA-SI.
79. Naifeh and Smith, *Jackson Pollock*, 602.
80. Lee Krasner, interview by Barbara Rose, 1975, GRI.
81. *Lee Krasner*, interview by Robert Coe, videotape courtesy the PKHSC.
82. Naifeh and Smith, *Jackson Pollock*, 602.
83. *Lee Krasner*, interview by Robert Coe, videotape courtesy the PKHSC.
84. Oral history interview with Elisabeth Ross Zogbaum, AAA-SI; Naifeh and Smith, *Jackson Pollock*, 640–41.
85. Naifeh and Smith, *Jackson Pollock*, 604–5.
86. Ibid., 638.
87. John Little, handwritten biographical statement, No. 8, undated, Folder 3, John Little Papers, 1935–1978, AAA-SI; *Josephine Little: The Art Crowd*, videotape courtesy LTV, Inc.
88. Helen A. Harrison, "East Hampton Avant-Garde," 13.
89. *Josephine Little: The Art Crowd*, videotape courtesy LTV.

25. Riot and Risk

1. The phrase is from Dore Ashton, "Jackson Pollock's Arabesque," 142.
2. Karmel, *Jackson Pollock: Interviews, Articles, and Reviews*, 20.
3. Krasner, *Pollock*, unpublished, undated notes, Series 1.3, Box 2, Folder 41, Jackson Pollock and Lee Krasner Papers, AAA-SI, 1; Varnadoe with Karmel, *Jackson Pollock*, 61; Naifeh and Smith, *Jackson Pollock*, 601.
4. Varnadoe with Karmel, *Jackson Pollock*, 60; Solomon, *Jackson Pollock*, 208–9.
5. Landau, *Lee Krasner: A Catalogue Raisonné*, 116–17, 119, 310; Rose, *Lee Krasner*, 68.
6. Naifeh and Smith, *Jackson Pollock*, 608–9.
7. Solomon, *Jackson Pollock*, 203; Naifeh and Smith, *Jackson Pollock*, 641–45.

8. Varnadoe with Karmel, *Jackson Pollock*, 60; Naifeh and Smith, *Jackson Pollock*, 642–46.
9. Naifeh and Smith, *Jackson Pollock*, 642, 645.
10. Solomon, *Jackson Pollock*, 204; Naifeh and Smith, *Jackson Pollock*, 646–47.
11. Solomon, *Jackson Pollock*, 203–4.
12. Harrison, "East Hampton Avant-Garde," 13; John Little, handwritten biographical statement, No. 8, undated, Folder 3, John Little Papers, AAA-SI.
13. Gaines, *Philistines at the Hedgerow*, 122–23.
14. Oral history interview with Hans Namuth, AAA-SI; Varnadoe with Karmel, *Jackson Pollock*, 89; Michael Peppiatt, "Hans Namuth Artists' Portraits," 41.
15. Peppiatt, "Hans Namuth Artists' Portraits," 41.
16. Oral history interview with Hans Namuth, AAA-SI; Varnadoe with Karmel, *Jackson Pollock*, 89.
17. Oral history interview with Hans Namuth, AAA-SI; Peppiatt, "Hans Namuth Artists' Portraits," 40.
18. Varnadoe with Karmel, *Jackson Pollock*, 88–89; oral history interview with Hans Namuth, AAA-SI; Peppiatt, "Hans Namuth Artists' Portraits," 41.
19. Halberstam, *The Fifties*, 21; Bradford R. Collins, "Life Magazine and the Abstract Expressionists," 284, 289n24.
20. Karmel, *Jackson Pollock: Interviews, Articles, and Reviews*, 18–19.
21. Elaine de Kooning to Grace Hartigan, October 28, 1977, Athens, Georgia, to Baltimore, Box 9, Elaine de Kooning Letters, Grace Hartigan Papers, Syracuse.
22. Peppiatt, "Hans Namuth Artists' Portraits," 44.
23. Oral history interview with Hans Namuth, AAA-SI; Varnadoe with Karmel, *Jackson Pollock*, 89.
24. Varnadoe with Karmel, *Jackson Pollock*, 89.
25. Oral history interview with Hans Namuth, AAA-SI.
26. Malina, *The Diaries of Judith Malina*, 119.
27. Ibid., 114, 119.
28. Halberstam, *The Fifties*, 26, 29, 46; Wittner, *Rebels Against War*, 240–41; Miller and Nowak, *The Fifties*, 56, 58, 60. After hydrogen bomb tests in the Pacific in 1954, which scattered radioactive ash on Japanese fishermen, concerns arose about the effect of nuclear "fall out." Some scientists sought to reassure the public their concerns were largely baseless. Nobel Peace Prize winner Dr. H. J. Muller said even survivors of Hiroshima were able to bear children who "looked about normal." But other scientists would find that birth defects worldwide had increased significantly due to the fallout from the 122 nuclear bombs the United States had exploded as tests between 1951 and 1958. By 1957, 11,000 scientists signed a petition against nuclear testing. A test ban, however, was said to be impractical from a security viewpoint.
29. Halberstam, *The Fifties*, 45–47, 98–99; Caute, *The Great Fear*, 63; Diggins, *The Proud Decades*, 86; Malina, *The Diaries of Judith Malina*, 101. The hydrogen bomb would be a thousand times more powerful than the atomic bombs used in Japan. Many in Washington believed the United States had to retain its military superiority at any cost because the threat was no longer just from the Soviet Union. Mao Tse-tung's communists had taken China and sent the U.S.-backed nationalist government fleeing to what would become Taiwan.
30. Halberstam, *The Fifties*, 53–54; Diggins, *The Proud Decades*, 113, 116; Caute, *The Great Fear*, 60–61.
31. Halberstam, *The Fifties*, 49–50; Diggins, *The Proud Decades*, 114; Miller and Nowak, *The Fifties*, 29; Brogan, *The Penguin History of the United States*, 598.
32. Halberstam, *The Fifties*, 50; Miller and Nowak, *The Fifties*, 29.
33. Halberstam, *The Fifties*, 51–52; Diggins, *The Proud Decades*, 114–15.
34. Miller and Nowak, *The Fifties*, 29–30, 32.
35. Caute, *The Great Fear*, 36–37, 49.
36. Corlett, "Jackson Pollock: American Culture, the Media and the Myth," 88n47; Diggins, *The Proud Decades*, 236; Caute, *The Great Fear*, 36–37, 49; D'Emilio, *Sexual Politics*, 41–42; Diggory and Miller, *The Scenes of My Selves*, 146–147; Baxandall and Gordon, *America's Working Woman*, 247.
37. Malina, *The Diaries of Judith Malina*, 119, 134; Dorfman, *Out of the Picture*, 305.
38. Halberstam, *The Fifties*, 66–68, 70, 75; Diggins, *The Proud Decades*, 89–90; Brogan, *The Penguin History of the United States*, 604; Wittner, *Rebels Against War*, 201–2; Clements, *Prosperity, Depression*

and the New Deal, 233. The conflict lasted three years and ended where it began, at the 38th parallel. The cost in lives lost was 1 million Korean civilians and 27,000 U.S. troops.
39. Malina, *The Diaries of Judith Malina*, 117–18.
40. Halberstam, *The Fifties*, 56–57.
41. Caute, *The Great Fear*, 63; oral history interview with Al Held, AAA-SI.
42. Corlett, "Jackson Pollock: American Culture, the Media and the Myth," 89.
43. Oral history interview with Hans Namuth, AAA-SI.
44. Varnadoe with Karmel, *Jackson Pollock*, 91, 324.
45. Oral history interview with Hans Namuth, AAA-SI.
46. Varnadoe with Karmel, *Jackson Pollock*, 91; Solomon, *Jackson Pollock*, 211.
47. Hans Namuth, *Pollock Painting*, film.
48. Potter, *To a Violent Grave*, 129.
49. Varnadoe with Karmel, *Jackson Pollock*, 324; Karmel, *Jackson Pollock, Interviews, Articles, and Reviews*, 70; Corlett, "Jackson Pollock: American Culture, the Media and the Myth," 89–90; Guggenheim, *Out of This Century*, 336.
50. Karmel, *Jackson Pollock: Interviews, Articles, and Reviews*, 68; Corlett, "Jackson Pollock: American Culture, the Media and the Myth," 89–90; Guggenheim, *Out of This Century*, 328. Alfieri had written a preface for the first catalog to Pollock's show in Venice. A second catalog, organized by Peggy, omitted his preface.
51. Karmel, *Jackson Pollock: Interviews, Articles, and Reviews*, 68–69.
52. Ibid., 70; Corlett, "Jackson Pollock: American Culture, the Media and the Myth," 89–91.
53. Potter, *To a Violent Grave*, 129–30.
54. Karmel, *Jackson Pollock: Interviews, Articles, and Reviews*, 71.
55. Solomon, *Jackson Pollock*, 202.
56. Oral history interview with Hedda Sterne, AAA-SI; Hedda Sterne, interview by Colette Roberts, AAA-SI.
57. Naifeh and Smith, *Jackson Pollock*, 649.
58. Ibid., 650.
59. Varnadoe with Karmel, *Jackson Pollock*, 325; Potter, *To a Violent Grave*, 130.
60. Potter, *To a Violent Grave*, 129.
61. Gaines, *Philistines at the Hedgerow*, 119, 129.
62. Potter, *To a Violent Grave*, 130; Gaines, *Philistines at the Hedgerow*, 13.
63. Malina, *The Diaries of Judith Malina*, 13.
64. Potter, *To a Violent Grave*, 131.
65. Gaines, *Philistines at the Hedgerow*, 119, 130.
66. Ibid., 130; Potter, *To a Violent Grave*, 132.
67. Potter, *To a Violent Grave*, 132.
68. Ibid., 132–33.
69. Gaines, *Philistines at the Hedgerow*, 131.
70. Varnadoe with Karmel, *Jackson Pollock*, 61.

26. The Deep End of Wonder

1. Janice Biala to Jack Tworkov, May 1, 1951, Paris, courtesy Tworkov Family Archives, New York.
2. Oral history interview with Helen Frankenthaler, 1968, AAA-SI.
3. Helen Frankenthaler, interview by Dodie Kazanjian, AAA-SI, 4.
4. Solomon, *Jackson Pollock*, 214.
5. Oral history interview with Helen Frankenthaler, AAA-SI.
6. Helen Frankenthaler, interview by Dodie Kazanjian, AAA-SI, 3–4.
7. "After Mountains and Sea," 31.
8. Ibid.
9. Oral history interview with Helen Frankenthaler, AAA-SI.
10. Helen Frankenthaler, interview by Dodie Kazanjian, AAA-SI, 4.
11. Carl Belz, "Frankenthaler: The 1950s," 9; Jones, *Eyesight Alone*, 322; John Elderfield, "Morris Louis and Twentieth-Century Painting," 24.
12. Munro, *Originals*, 210–11.

13. Helen Frankenthaler, interview by Deborah Solomon; oral history interview with Helen Frankenthaler, AAA-SI.
14. "Daughter to Mrs. A. Frankenthaler," 40; Helen Frankenthaler, interview by Barbara Rose, GRI.
15. Fred Iseman, interview by author.
16. Ibid.
17. Oral history interview with Helen Frankenthaler, AAA-SI.
18. Fred Iseman, interview by author; Ellen M. Iseman, interview by author.
19. Helen Frankenthaler, interview by Barbara Rose, GRI.
20. Clifford Ross, interview by author, February 18, 2014.
21. Helen Frankenthaler, interview by Barbara Rose, GRI.
22. Fred Iseman, interview by author; Munro, *Originals,* 212; Helen Frankenthaler, interview by Barbara Rose, GRI.
23. Helen Frankenthaler, interview by Barbara Rose, GRI.
24. Clifford Ross, interview by author, January 15, 2014.
25. Ibid.
26. Oral history interview with Helen Frankenthaler, AAA-SI.
27. Helen Frankenthaler, interview by Deborah Solomon.
28. Helen Frankenthaler, interview by Barbara Rose, GRI.
29. Ibid.
30. Clifford Ross, interview by author, January 15, 2014.
31. Munro, *Originals,* 211.
32. Ibid., 213.
33. Barbara Rose, *Frankenthaler,* 259.
34. Fred Iseman, interview by author.
35. Ibid.; Clifford Ross, interview by author, January 15, 2014; Ellen M. Iseman, interview by author.
36. Helen Frankenthaler, interview by Deborah Solomon; oral history interview with Helen Frankenthaler, AAA-SI.
37. Oral history interview with Helen Frankenthaler, AAA-SI.
38. Helen Frankenthaler, interview by Barbara Rose, GRI; oral history interview with Helen Frankenthaler, AAA-SI.
39. Helen Frankenthaler, interview by Deborah Solomon.
40. Munro, *Originals,* 211–12.
41. Deborah Solomon, unpublished notes for article "The Lyrical Mastery of Helen Frankenthaler," courtesy Deborah Solomon, 7.
42. Oral history interview with Helen Frankenthaler, AAA-SI.
43. Ibid.; Munro, *Originals,* 213. Helen said she was eleven and her classmates thirteen, though she did not explain whether she had skipped grades at her previous school.
44. Helen Frankenthaler, interview by Deborah Solomon.
45. Helen Frankenthaler, interview by Barbara Rose, GRI.
46. Oral history interview with Helen Frankenthaler, AAA-SI; Helen Frankenthaler, interview by Barbara Rose, GRI.
47. Hofmann-Lowenstein Family Tree, e-mailed to author by Karen Franklin, January 27, 2017; "Giessen," https://www.jewishvirtuallibrary.org/giessen; "Deportation of German, Austrian, and Czech Jews," https://www.ushmm.org/learn/timeline-of-events/1939-1941/deportations-of-german-austrian-and-czech-jews.
48. Fred Iseman, interview by author.
49. Amei Wallach, "Retrospective of a Risk-Taker, Works on Paper," 2.
50. Oral history interview with Helen Frankenthaler, AAA-SI.
51. Rose, *Frankenthaler,* 15; Helen Frankenthaler, interview by Barbara Rose, GRI.
52. Oral history interview with Helen Frankenthaler, AAA-SI; Rose, *Frankenthaler,* 14–15, 16.
53. Helen Frankenthaler, interview by Barbara Rose, GRI.
54. Oral history interview with Helen Frankenthaler, AAA-SI.
55. Solomon, "The Lyrical Mastery of Helen Frankenthaler"; Munro, *Originals,* 214; oral history interview with Helen Frankenthaler, AAA-SI.
56. Perl, *New Art City,* 482; Janice Van Horne, *A Complicated Marriage,* 22.

57. Oral history interview with Helen Frankenthaler, AAA-SI.
58. Helen Frankenthaler, interview by Barbara Rose, GRI.
59. Helen Frankenthaler, interview by Deborah Solomon.
60. Clifford Ross, interview by author, January 15, 2014.
61. Oral history interview with Helen Frankenthaler, AAA-SI.
62. *Nancy Lewis Oral History Interview on Helen Frankenthaler,* videotape courtesy HFF.
63. Paul Feeley biographical material, Roll 442, Paul Feeley Papers, 1911–1972, AAA-SI.
64. Helen Frankenthaler, interview by Barbara Rose, GRI.
65. *Nancy Lewis Oral History Interview on Helen Frankenthaler,* videotape courtesy HFF.
66. Rose, *Frankenthaler,* 16–17.
67. *Nancy Lewis Oral History Interview on Helen Frankenthaler,* videotape courtesy HFF.
68. Helen Frankenthaler, interview by Deborah Solomon.
69. Oral history interview with Helen Frankenthaler, AAA-SI.
70. *Nancy Lewis Oral History Interview on Helen Frankenthaler,* videotape courtesy HFF.
71. "After Mountains and Sea," 27.
72. Fred Iseman, interview by author.
73. "'Beacon'" Now a Reality," *The Beacon* 1, no. 1 (April 10, 1947): 1; "U.S. vs. U.S.S.R?" by M.S.M, *The Beacon* 1, no. 1 (April 10, 1947): 2; "Why I Am For Wallace," *The Beacon* 2, no. 6 (June 24, 1948): 1.
74. Solomon, "The Lyrical Mastery of Helen Frankenthaler," 8.
75. *Nancy Lewis Oral History Interview on Helen Frankenthaler,* videotape courtesy HFF.
76. Rose, *Frankenthaler,* 21.
77. *Nancy Lewis Oral History Interview on Helen Frankenthaler,* videotape courtesy HFF.
78. Oral history interview with Helen Frankenthaler, AAA-SI; Solomon, "The Lyrical Mastery of Helen Frankenthaler," 8.
79. Oral history interview with Helen Frankenthaler, AAA-SI.
80. Helen Frankenthaler, "The Chrysler Assignment," 8.
81. Clifford Ross, interview by author, January 15, 2014.
82. Helen Frankenthaler and Cynthia Lee, "A Brando Named 'Desire,'" 4, 6.
83. "After Mountains and Sea," 27.
84. Clifford Ross, interview by author, February 18, 2014.
85. Oral history interview with Helen Frankenthaler, AAA-SI; Rose, *Frankenthaler,* 21. Among the few painters studying with Harrison and socializing with Helen were James Brooks and Charlotte Park.
86. Oral history interview with Helen Frankenthaler, AAA-SI.
87. Helen Frankenthaler, interview by Deborah Solomon.
88. *Nancy Lewis Oral History Interview on Helen Frankenthaler,* videotape courtesy HFF.
89. John Elderfield, "Painted on 21st Street," 9.
90. Helen Frankenthaler, interview by John Gruen, AAA-SI, 2.
91. Helen Frankenthaler, interview by Barbara Rose, GRI.
92. Helen Frankenthaler, interview by John Gruen, AAA-SI, 2.
93. Helen Frankenthaler, interview by Deborah Solomon; Helen Frankenthaler, interview by Barbara Rose, GRI; Helen Frankenthaler, interview by John Gruen, AAA-SI, 1; oral history interview with Helen Frankenthaler, AAA-SI.
94. Dore Ashton, interview by author.
95. Helen Frankenthaler, interview by John Gruen, AAA-SI, 1.
96. Ibid., 2.
97. Ibid., 1.
98. Oral history interview with Helen Frankenthaler, AAA-SI; Helen Frankenthaler, interview by Barbara Rose, GRI.
99. Oral history interview with Helen Frankenthaler, AAA-SI; Rose, *Frankenthaler,* 15.
100. Helen Frankenthaler, interview by John Gruen, AAA-SI, 4–5; oral history interview with Helen Frankenthaler, AAA-SI.
101. Oral history interview with Helen Frankenthaler, AAA-SI; Barrett, *The Truants,* 138.
102. Oral history interview with Helen Frankenthaler, AAA-SI.
103. Helen Frankenthaler, interview by Barbara Rose, GRI.

104. Friedman, *Jackson Pollock: Energy Made Visible,* 137; Edgar, *Club Without Walls,* 74; John Bernard Myers, interview by Barbara Rose, audiotape, March 12, 1968, Series V, Box 13, R3, GRI.
105. Rubenfeld, *Clement Greenberg,* 106–7; John Bernard Myers, interview by Barbara Rose, audiotape, March 12, 1968, Series V, Box 13, R3, GRI.
106. Elderfield, "Painted on 21st Street," 46.
107. Oral history interview with Helen Frankenthaler, AAA-SI.
108. Helen Frankenthaler, interview by Deborah Solomon.
109. Helen Frankenthaler, interview by Barbara Rose, GRI.
110. Oral history interview with Helen Frankenthaler, AAA-SI; Helen Frankenthaler, interview by Barbara Rose, GRI; Clement Greenberg Journals, July 6 [ca. 1955], Series II, Box 16, Folder 1, Clement Greenberg Papers, GRI (950085).
111. Oral history interview with Helen Frankenthaler, AAA-SI.
112. "Life Goes to an Artists' Masquerade," 144.
113. Rubenfeld, *Clement Greenberg,* 145.
114. Helen Frankenthaler to Clement Greenberg, June 3, 1950, Series 3, Box 3, Folders 38–39, the Clement Greenberg Papers, 1937–1983, AAA-SI.
115. Oral history interview with Helen Frankenthaler, AAA-SI.
116. Helen Frankenthaler to Sonya Gutman, October 6, 1950, Box 1, Folder 2, Sonya Rudikoff Papers, 1935–2000, Princeton, 1; oral history interview with Helen Frankenthaler, AAA-SI. After her marriage, Sonya Rudikoff became Sonya Gutman.
117. Marquis, *Art Czar,* 128.
118. Oral history interview with Helen Frankenthaler, AAA-SI; Helen Frankenthaler, interview by Barbara Rose, GRI.
119. Helen Frankenthaler, interview by Barbara Rose, GRI; Helen Frankenthaler, interview by John Gruen, AAA-SI, 13–14.
120. Clifford Ross, interview by author, February 18, 2014.
121. Rubenfeld, *Clement Greenberg,* 153.
122. Jones, *Eyesight Alone,* 29.
123. Clement Greenberg, "Self-Hatred and Jewish Chauvinism," 430, 432.

27. The Thrill of It

1. Rose, *The Norton Book of Women's Lives,* 58.
2. Rubenfeld, *Clement Greenberg,* 146; Duberman, *Black Mountain,* 347.
3. Helen Frankenthaler to Clement Greenberg, June 3, 1950, Series 3, Box 3, Folder 38, Clement Greenberg Papers, AAA-SI.
4. Helen Frankenthaler, interview by John Gruen, AAA-SI, 5; Rubenfeld, *Clement Greenberg,* 145.
5. Helen Frankenthaler, interview by Deborah Solomon.
6. Helen Frankenthaler, interview by John Gruen, AAA-SI, 5.
7. Helen Frankenthaler, interview by Barbara Rose, GRI.
8. Ibid.
9. Ibid.; Helen Frankenthaler, interview by John Gruen, AAA-SI, 5.
10. Oral history interview with Helen Frankenthaler, AAA-SI.
11. Helen Frankenthaler, interview by Deborah Solomon.
12. Helen Frankenthaler, interview by Barbara Rose, GRI.
13. Oral history interview with Helen Frankenthaler, AAA-SI.
14. Helen Frankenthaler, interview by Barbara Rose, GRI.
15. Rubenfeld, *Clement Greenberg,* 145.
16. Ibid., 152.
17. Helen Frankenthaler, interview by John Gruen, AAA-SI, 5.
18. Helen Frankenthaler to Clement Greenberg, postcard postmarked, August 25, 1950, Series 3, Box 3, Folder 38, the Clement Greenberg Papers, AAA-SI; with Helen Frankenthaler, interview by Deborah Solomon.
19. Rubenfeld, *Clement Greenberg,* 42–45, 152–53. Clem and Danny's mother, Edwina "Toady" Ewing, were married after a three-week romance in California. A combination of factors, including Clem's lack of a steady income, his return to the East Coast, Toady's mother's disapproval of Clem, and

Toady's interest in other men combined to end the marriage within three years. In 1949, Toady moved to Washington, DC, and Danny began spending weekends with his father in New York.
20. Helen Frankenthaler, interview by Deborah Solomon; Rubenfeld, *Clement Greenberg*, 145; Duberman, *Black Mountain*, 348.
21. Oral history interview with Helen Frankenthaler, AAA-SI.
22. Rubenfeld, *Clement Greenberg*, 145.
23. Oral history interview with Helen Frankenthaler, AAA-SI.
24. Helen Frankenthaler to Clement Greenberg, postcard postmarked August 25, 1950, Series 3, Box 3, Folder 38, the Clement Greenberg Papers, AAA-SI.
25. Helen Frankenthaler to Clement Greenberg, postcard postmarked August 28, 1950, Series 3, Box 3, Folder 38, the Clement Greenberg Papers, AAA-SI.
26. Ibid.
27. Helen Frankenthaler to Clement Greenberg, postcard postmarked August 25, 1950, Series 3, Box 3, Folder 38, the Clement Greenberg Papers, AAA-SI.
28. Helen Frankenthaler, interview by John Gruen, AAA-SI, 3.
29. Alfred Leslie, interview by Jack Taylor; Rubenfeld, *Clement Greenberg*, 151.
30. Alfred Leslie, interview by Jack Taylor.
31. Naifeh and Smith, *Jackson Pollock*, 633.
32. "After Mountains and Sea," 27.
33. Helen Frankenthaler, interview by John Gruen, AAA-SI, 6–8.
34. Helen Frankenthaler, interview by Barbara Rose, GRI.
35. Oral history interview with Helen Frankenthaler, AAA-SI.
36. Elaine de Kooning, C. F. S. Hancock Lecture, 9.
37. Stevens and Swan, *De Kooning*, 309.
38. Hess and Nochlin, "Woman as Sex Object," 230.
39. Thomas B. Hess, "De Kooning Paints a Picture," 30; Stevens and Swan, *De Kooning*, 311.
40. Landau, *Reading Abstract Expressionism*, 604, 612n73.
41. Stevens and Swan, *De Kooning*, 314.
42. Ibid.
43. Helen Frankenthaler, interview by Barbara Rose, GRI.
44. Ibid.; Helen Frankenthaler, interview by Deborah Solomon.
45. Elaine de Kooning and Slivka, *Elaine de Kooning*, 75.
46. Lewallen, "Interview with Elaine de Kooning," 18–19; Elaine de Kooning, interview by Antonina Zara, 11.
47. albersfoundation.org/artists/biographies; metmuseum.org/toah/works-of-art/59.160; Kuh, *The Artist's Voice*, 11–12. Albers said color "behaves like" man; the proximity of one color to another, like one person to another, leaves both changed.
48. "Biographies," The Josef and Anni Albers Foundation, albersfoundation.org/artists/biographies.
49. Lewallen, "Interview with Elaine de Kooning," 19.
50. Elaine de Kooning and Slivka, *Elaine de Kooning*, 15.
51. Schloss, "The Loft Generation," Edith Schloss Burckhardt Papers, Columbia, 39; Stevens and Swan, *De Kooning*, 307.
52. Stevens and Swan, *De Kooning*, 307–8.
53. Ibid., 308.
54. O'Brian, *Clement Greenberg: The Collected Essays and Criticism*, 3:44; Edgar, *Club Without Walls*, 179; Gaugh, *Franz Kline*, 95; O'Hara, "Franz Kline Talking," 59; Thomas B. Hess, "Editorial: Franz Kline," 23, 53.
55. Elaine de Kooning, "Franz Kline Memorial Exhibition," 14–15.
56. Gaugh, *Franz Kline*, 13.
57. Elaine de Kooning, "Franz Kline Memorial Exhibition," 14; Gaugh, *Franz Kline*, 45–46.
58. Elaine de Kooning, "Franz Kline: Painter of his own life," 67–68; Elaine de Kooning, "Franz Kline Memorial Exhibition," 14–15; Gaugh, *Franz Kline*, 84; oral history interview with Peter Agostini, AAA-SI. Elaine's description of a "friend" having suggested Franz blow up his drawings has been taken to mean Bill, but may have been a reference to herself, according to Agostini's quote. It makes sense, given Elaine's personality. If Bill had made the suggestion to Kline, Elaine would have likely said so.

But given Elaine's disinclination to claim credit, if she had been the one to suggest Franz put his sketches under the Bell-Opticon, she might have used the ambiguous "friend" to hide her role in the discovery.
59. Elaine de Kooning, "Franz Kline: Painter of His Own Life," 67–68.
60. Oral history interview with Peter Agostini, AAA-SI; Gaugh, *Franz Kline*, 84.
61. Doris Aach, interview by author; Gaugh, *Franz Kline*, 95.
62. Edgar, *Club Without Walls*, 91.
63. Lieber, *Reflections in the Studio*, 34.
64. Ibid.
65. Hamill, "Beyond the Vital Gesture," 110.
66. Oral history interview with Peter Agostini, AAA-SI; Beth Coffelt, "Strokes of Genius," 33; Conrad Marca-Relli, interview by Ann Parsons, AAA-SI, 1. Marca-Relli said "some of the boys" told Charlie about Franz, who then gave him a show. It's likely, in fact, that he heard about Kline's breakthrough from many people, but given his closeness to Elaine, her role in helping him select artists for his gallery, and her position as one of the two people to see Kline's new work first, she no doubt reached Charlie quickly.
67. Edgar, *Club Without Walls*, 179; Coffelt, "Strokes of Genius," 33.
68. Manny Farber, "Art," *The Nation*, November 11, 1950, 443.
69. Edgar, *Club Without Walls*, 179.
70. O'Hara, "Franz Kline Talking," 59.
71. Stevens and Swan, *De Kooning*, 301.
72. Landau, *Lee Krasner: A Catalogue Raisonné*, 310.
73. Rose, *Frankenthaler*, 28; Elderfield, "Painted on 21st Street," 48.
74. Helen Frankenthaler to Sonya Gutman, "Sat.," postmarked October 21, 1950, Box 1, Folder 2, Sonya Rudikoff Papers, 1935–2000, Princeton, 1, 3, 5.
75. Helen Frankenthaler to Sonya Gutman, postcard, "Mon.," postmarked November 20, 1950, Box 1, Folder 2, Sonya Rudikoff Papers, 1935–2000, Princeton; Helen Frankenthaler to Sonya Gutman, October 6, 1950, Box 1, Folder 2, Sonya Rudikoff Papers, 1935–2000, Princeton, 2; Helen Frankenthaler to Sonya Gutman, "Tues am.," postmarked October 11, 1950, Box 1, Folder 2, Sonya Rudikoff Papers, Princeton, 1935–2000, 2; Helen Frankenthaler to Sonya Gutman, "Monday," postmarked November 14, 1950, Box 1, Folder 2, Sonya Rudikoff Papers, Princeton, 1935–2000, 2.
76. Helen Frankenthaler to Sonya Gutman, "Monday," postmarked November 14, 1950, Box 1, Folder 2, Sonya Rudikoff Papers, 1935–2000, Princeton, 2.
77. Helen Frankenthaler, interview by Dodie Kazanjian, AAA-SI, 2.
78. Van Horne, *A Complicated Marriage*, 15, 119.
79. Helen Frankenthaler written answers to five questions in preparation for an interview with Dodie Kazanjian, August 1998, Projects, Artist Files, Helen Frankenthaler, Dodie Kazanjian Papers, AAA-SI, 1.
80. Oral history interview with Helen Frankenthaler, AAA-SI.
81. Helen Frankenthaler, interview by Dodie Kazanjian, AAA-SI, 1, 3. Helen mentioned the painting may have been Pollock's *The Blue Unconscious* or possibly *Easter and the Totem*, but she couldn't from the distance of many years be sure.
82. Helen Frankenthaler, interview by Barbara Rose, GRI.
83. Helen Frankenthaler to Sonya Gutman, "Sat," postmarked October 14, 1950, Box 1, Folder 2, Sonya Rudikoff Papers, 1935–2000, Princeton, 2–3.
84. Helen Frankenthaler to Sonya Gutman, "Tues a.m.," postmarked November 28, 1950, Box 1, Folder 2, Sonya Rudikoff Papers, 1935–2000, Princeton.
85. Naifeh and Smith, *Jackson Pollock*, 656.
86. Ibid., 655–56.
87. Naifeh and Smith, *Jackson Pollock*, 655.
88. Ibid.
89. Ashbery, *The Invisible Avant-Garde*, 128; John Ashbery, *Reported Sightings*, 390.
90. Potter, *To a Violent Grave*, 134.
91. Ibid., 135.
92. Naifeh and Smith, *Jackson Pollock*, 656.
93. Helen Frankenthaler, interview by Barbara Rose, GRI; Helen Frankenthaler, interview by Mitch Tuchman, AAA-SI, 5.

94. Lehman, *The Last Avant-Garde*, 68; LeSueur, *Digressions on Some Poems by Frank O'Hara*, 21; Malina, *The Diaries of Judith Malina*, 159, 233.
95. Helen Frankenthaler, "Memories of the San Remo," 412–13.
96. Frankenthaler, "Memories of the San Remo," 413.
97. Halberstam, *The Fifties*, 109; Helen Frankenthaler to Sonya Gutman, "Sat a.m." postmarked December 3, 1950, Box 1, Folder 2, Sonya Rudikoff Papers, 1935–2000, Princeton, 2; Malina, *The Diaries of Judith Malina*, 119.
98. Helen Frankenthaler to Sonya Gutman, "Sat a.m." postmarked December 3, 1950, Box 1, Folder 2, Sonya Rudikoff Papers, 1935–2000, Princeton, 2.
99. Myers, *Tracking the Marvelous*, 47; Rivers, *What Did I Do?*, 203; Frankenthaler, "Memories of the San Remo," 414.
100. Curtis, *Restless Ambition*, 73. "John was one of the most outrageous gay men that you can imagine at a time when most gay people were not out," Al Leslie said.
101. Helen Frankenthaler, interview by John Gruen, AAA-SI, 3; Frankenthaler, "Memories of the San Remo," 414.
102. Helen Frankenthaler, interview by Barbara Rose, GRI.
103. Oral history interview with Helen Frankenthaler, AAA-SI.
104. Helen Frankenthaler, interview by John Gruen, AAA-SI, 4.
105. John Bernard Myers, interview by Barbara Rose, audiotape, March 12, 1968, Series V, Box 13, R3, GRI; John Bernard Myers, interview by Barbara Rose, n.d., transcript, Series II, Box 1, Folder 26, Barbara Rose Papers, GRI (930100), 1, 17.
106. Myers, *Tracking the Marvelous*, 4.

28. The Puppet Master

1. John Bernard Myers, interview by Barbara Rose, audiotape, March 12, 1968, Series V, Box 13, R3, GRI.
2. *Art Barge—Artists Speak, with Elaine de Kooning*, videotape courtesy LTV, Inc.
3. Douglas Crase and Jenni Quilter, *Painters and Poets*, 25–26.
4. Myers, *Tracking the Marvelous*, 49.
5. Ibid., 8, 11–12, 16–18, 47.
6. Crase and Quilter, *Painters and Poets*, 25–26.
7. John Bernard Myers, interview by Barbara Rose, audiotape, March 12, 1968, Series V, Box 13, R3, GRI.
8. Myers, *Tracking the Marvelous*, 19–20, 23, 25, 28, 45.
9. Ibid., 28.
10. Ibid., 65; Rubenfeld, *Clement Greenberg*, 98.
11. Myers, *Tracking the Marvelous*, 65–66.
12. John Bernard Myers, interview by Barbara Rose, March 12, 1968, Series V, Box 13, R3, GRI.
13. Myers, *Tracking the Marvelous*, 74–75, 97.
14. Coppet and Jones, *The Art Dealers*, 43–44.
15. Oral history interview with Tibor de Nagy, March 29, 1976, AAA-SI; Coppet and Jones, *The Art Dealers*, 43–44.
16. Grace Hartigan notes for Tibor de Nagy Memorial, April 15, 1994, Box 28, Grace Hartigan Papers, Syracuse.
17. Coppet and Jones, *The Art Dealers*, 43.
18. Oral history interview with Tibor de Nagy, AAA-SI.
19. Grace Hartigan notes for Tibor de Nagy Memorial, April 15, 1994, Box 28, Grace Hartigan Papers, Syracuse.
20. "A Memorial Service for John Bernard Myers," transcript courtesy Donna Sesee; Myers, *Tracking the Marvelous*, 98–99.
21. Oral history interview with Tibor de Nagy, AAA-SI.
22. Henry Hewesernst Beadle, "Actors with Their Strings Attached," 2X, http://www.nytimes.com/1950/05/21/archives/actors-with-their-strings-attached-ideas-and-enthusiasts-a-writer.htm.
23. Oral history interview with Tibor de Nagy, AAA-SI.
24. Ibid.; Beadle, "Actors with Their Strings Attached," 2X.

25. Myers, *Tracking the Marvelous,* 100, 105.
26. Oral history interview with Tibor de Nagy, AAA-SI.
27. John Bernard Myers, interview by Barbara Rose, n.d., transcript, Series II, Box 1, Folder 26, Barbara Rose Papers, GRI (930100), 14–16.
28. Oral history interview with Tibor de Nagy, AAA-SI.
29. Ibid.; Sawin, *Nell Blaine,* 42.
30. Oral history interview with Tibor de Nagy, AAA-SI; Coppet and Jones, *The Art Dealers,* 43–44.
31. Coppet and Jones, *The Art Dealers,* 43–44.
32. Crase and Quilter, *Painters and Poets,* 19, 24, 29; Myers, *Tracking the Marvelous,* 113.
33. John Bernard Myers, interview by Barbara Rose, audiotape, March 12, 1968, Series V, Box 13, R3, GRI.
34. John Bernard Myers, interview by Barbara Rose, transcript, Series II, Box 1, Folder 26, Barbara Rose Papers, GRI, 18.
35. Ibid. John said, "I tried to show in my very first show a group of *objets trouvés* of [the well-known sculptor Isamu] Noguchi. And it was a disaster. I mean, it never even came off. I then got talked into showing a group of sand sculptures by Tino Nivola, which also turned out to be a disaster."
36. Natalie Edgar, interview by author. Painter Natalie Edgar said when she began seeing Philip Pavia she asked him why she had to meet all these people. "He said I had to because they were going to be my family now—the other artists—and they were."
37. Thomas B. Hess, "U.S. Painting, Some Recent Directions," 174.
38. Elaine de Kooning and Slivka, *Elaine de Kooning,* 15.
39. John Bernard Myers, interview by Barbara Rose, audiotape, March 12, 1968, Series V, Box 13, R3, GRI (930100).
40. Grace Hartigan notes for statement for the Tibor de Nagy fortieth-anniversary show, April 17, 1991, John Bernard Myers file, Box 21, Grace Hartigan Papers, Syracuse.
41. "A Memorial Service for John Bernard Myers," transcript courtesy Donna Sesee.
42. Hess, "U.S. Painting, Some Recent Directions," 174; Grace Hartigan notes for Tibor de Nagy Memorial, Grace Hartigan Papers, Syracuse.
43. Rex Stevens, interview by author.
44. Myers, *Tracking the Marvelous,* 127.
45. Varnadoe with Karmel, *Jackson Pollock,* 84n160.
46. Nemser, "Grace Hartigan: Abstract Artist, Concrete Woman," 33.
47. Mattison, *Grace Hartigan,* 16; Curtis, *Restless Ambition,* 70.
48. "A Memorial Service for John Bernard Myers," transcript courtesy Donna Sesee.
49. Myers, *Tracking the Marvelous,* 125.
50. "A Memorial Service for John Bernard Myers," transcript courtesy Donna Sesee.
51. John Bernard Myers to Grace Hartigan, June 26, 1952, Box 21, Grace Hartigan Papers, Syracuse; John Bernard Myers to Grace Hartigan, ca. 1954, Box 21, Grace Hartigan Papers, Syracuse.
52. Myers, *Tracking the Marvelous,* 125–26.
53. Mattison, *Grace Hartigan,* 18; Harrison, *Larry Rivers,* 17; Sawin, *Nell Blaine,* 38; John Bernard Myers, interview by Barbara Rose, transcript, Series II, Box 1, Folder 26, Barbara Rose Papers, GRI (930100), 19. Excited by his discoveries, John quickly found his way to the rest of his early stable. Larry had just returned from Paris, where he had fled after the *Talent, 1950* show because he had begun to doubt his ability as a painter. Under the guidance of his "teacher" Nell Blaine, who was also in France, he tried to imbibe centuries of painterly tradition that he had never formally learned. John also recruited Robert de Niro Sr., whom he called "the hottest thing in town" but completely "crazy"; Bob Goodnough, a painter who at NYU had done a thesis on Pollock and was writing a "Pollock Paints a Picture" article for *ArtNews;* and Grace's estranged husband, Harry Jackson, who was painting Matisse-like abstractions.
54. Terrence Diggory, notes from Diggory's *Art Journal* article on Grace Hartigan, Box 10, Grace Hartigan Papers, Syracuse; Grace Hartigan Writings for Publication/Note, "Mis-statements," Box 31, Grace Hartigan Papers, Syracuse; oral history interview with Grace Hartigan, AAA-SI; Curtis, *Restless Ambition,* 73; William T. La Moy and Joseph P. McCaffrey, eds., *The Journals of Grace Hartigan,* xx–xxi; Nemser, *Art Talk,* 151; Susan Sontag, "Notes on Camp," 522–23. Sontag said "camp" is characterized by extravagance, "the attempt to do something extraordinary."

55. Curtis, *Restless Ambition,* 74.
56. Ibid., 73.
57. Gibson, *Abstract Expressionism,* 11, 22. The discrimination was not restricted to women. Alfonso Ossorio said he had trouble getting shows in the late forties because he was gay.
58. John Bernard Myers, interview by Barbara Rose, audiotape, March 12, 1968, Series V, Box 13, R3, GRI.
59. Helen Frankenthaler, interview by John Gruen, AAA-SI, 4.
60. Ibid., 6; John Bernard Myers, interview by Barbara Rose, transcript, Series II, Box 1, Folder 26, Barbara Rose Papers, GRI (930100), 20.
61. "Irascible Group of Advanced Artists Led Fight Against Show," 34.
62. Elaine de Kooning and Slivka, *Elaine de Kooning,* 92.
63. Allentuck, *John Graham's System and Dialectics of Art,* 136–37.
64. Helen Frankenthaler to Sonya Gutman, postmarked November 23, 1951, Box 1, Folder 3, Sonya Rudikoff Papers, 1935–2000, Princeton, 3; oral history interview with Helen Frankenthaler, AAA-SI; "After Mountains and Sea," 27, 30.
65. Elaine de Kooning and Slivka, *Elaine de Kooning,* 96.
66. Oral history interview with Fairfield Porter, AAA-SI; Rackstraw Downes, ed., *Art in Its Own Terms,* 30.
67. Oral history interview with Fairfield Porter, AAA-SI; Elaine de Kooning, interview by Amei Wallach, 3.
68. Naifeh and Smith, *Jackson Pollock,* 655.
69. Herrera, *Arshile Gorky,* 628; Naifeh and Smith, *Jackson Pollock,* 655.
70. Rose, *Lee Krasner: The Long View,* videotape courtesy PKHSC; Levin, *Lee Krasner,* 280.
71. Oral history interview with Helen Frankenthaler, AAA-SI; Naifeh and Smith, *Jackson Pollock,* 656; Potter, *To a Violent Grave,* 135.
72. Varnadoe with Karmel, *Jackson Pollock,* 63.
73. Naifeh and Smith, *Jackson Pollock,* 658.
74. Garnett McCoy, Alfred H. Barr Jr., Baldwin Smith, and Allen Rosenbaum, "A Continued Story," 8–9.
75. Naifeh and Smith, *Jackson Pollock,* 658–59.
76. Engelmann, *Jackson Pollock and Lee Krasner,* 70.
77. Potter, *To a Violent Grave,* 174.
78. Naifeh and Smith, *Jackson Pollock,* 660–61.
79. Levin, *Lee Krasner,* 271–72; Naifeh and Smith, *Jackson Pollock,* 661.
80. George Hartigan, Tibor de Nagy, January 15 to February 2, 1951, Box 36, Grace Hartigan Papers, Syracuse.
81. James Fitzsimmons, "George Hartigan," 18–19.
82. Mattison, *Grace Hartigan,* 18.
83. Malina, *The Diaries of Judith Malina,* 144.
84. Rex Stevens, interview by author; Grace Hartigan Writings for Publication/Note, "Misstatements," Box 31, Grace Hartigan Papers, Syracuse; oral history interview with Grace Hartigan, AAA-SI; Nemser, *Art Talk,* 151; Gibson, *Abstract Expressionism,* 156–57; Munro, *Originals,* 65. Often, when women did not adopt a man's name outright, they used only a surname (as did Mary Cassatt at the start of her career), an initial—rather than their first names—to identify themselves, or a middle name that could belong to a person of either sex. Ambiguity, in other words, was preferable for an artist to being identified as a woman.
85. "A Memorial Service for John Bernard Myers," transcript courtesy Donna Sesee.
86. Munro, *Originals,* 65; oral history interview with Grace Hartigan, AAA-SI; Myers, *Tracking the Marvelous,* 127; Fitzsimmons, "George Hartigan," 18.
87. Nemser, *Art Talk,* 150.
88. Ibid., 170.
89. Oral history interview with Tibor de Nagy, AAA-SI.
90. "A Memorial Service for John Bernard Myers," transcript courtesy Donna Sesee.
91. Grace Hartigan notes for Tibor de Nagy Memorial, April 15, 1994, Box 28, Grace Hartigan Papers, Syracuse.

92. Stahr, *The Social Relations of Abstract Expressionism*, 91.
93. Helen Frankenthaler, interview by Barbara Rose, GRI.
94. Alfred Leslie, interview by Jack Taylor. Among the people at Helen's pool were Gaby, Grace, Al, Franz, Harry Jackson, Clem, Pollock, Lee, John Myers, Waldemar Hansen, Mark and Mel Rothko, and Barney and Annalee Newman.
95. Myers, *Tracking the Marvelous*, 12.

29. Painted Poems

1. Munro, *Originals*, 236.
2. Astrid Myers Rosset, interview by author.
3. "Joan Mitchell," transcript Barney/Sandy interview [Sandy Gotham Meehan], January 21, 2004, Barney Rosset Papers, Tape 5, Side 1, Series II, Box 3, Folder 5, Columbia; Patricia Albers, *Joan Mitchell*, 134; Barney Rosset, interview by Jay Gertzman.
4. "Joan Mitchell," transcript Barney/Sandy Interview, January 21, 2004, Barney Rosset Papers, Tape 5, Side 1, Series II, Box 3, Folder 5, Columbia.
5. Ibid.; Barney Rosset, interview by Jay Gertzman.
6. "Joan Mitchell," transcript Barney/Sandy interview, January 21, 2004, Barney Rosset Papers, Tape 5, Side 1, Series II, Box 3, Folder 5, Columbia.
7. Joan Mitchell to Barney Rosset, postmarked July 5, 1948, 19 rue Vavin, Paris to 1600 Broadway, New York, JMFA003, JMF; Joan Mitchell to Barney Rosset, postmarked July 9, 1948, Paris to New York, JMFA003, JMF; Joan Mitchell to Barney Rosset, postmarked July 16, 1948, Paris to New York, JMFA003, JMF.
8. Munro, *Originals*, 244.
9. Oral history interview with Joan Mitchell, April 16, 1986, AAA-SI; Albers, *Joan Mitchell*, 134.
10. "Joan Mitchell," transcript Barney/Sandy interview, January 21, 2004, Barney Rosset Papers, Tape 5, Side 1, Series II, Box 3, Folder 5, Columbia; Albers, *Joan Mitchell*, 134.
11. Munro, *Originals*, 244.
12. Zuka Mitelberg, telephone interview by author.
13. Oral history interview with Joan Mitchell, April 16, 1986, AAA-SI.
14. "Joan Mitchell," transcript Barney/Sandy interview, January 21, 2004, Barney Rosset Papers, Tape 5, Side 1, Series II, Box 3, Folder 5, Columbia.
15. Ibid.
16. Barney Rosset, interview by Jay Gertzman.
17. Oral history interview with Joan Mitchell, April 16, 1986, AAA-SI.
18. "1948 Joan Mitchell," Barney Rosset/GAP [George A. Plimpton] vol. 2—ca. 1998, Barney Rosset Papers, Series II, Box 3, Folder 5, Columbia; "Joan Mitchell," Transcript Barney/Sandy interview, January 21, 2004, Barney Rosset Papers, Tape 5, Side 1, Series II, Box 3, Folder 5, Columbia.
19. "1948 Joan Mitchell," Barney Rosset/GAP, vol. 2—ca. 1998, Barney Rosset Papers, Series II, Box 3, Folder 5, Columbia.
20. Joan Mitchell to Barney Rosset, dated February 3, 1947, postmarked February 4, 1947, Chicago to New York, JMFA003, JMF; Joan Mitchell to Barney Rosset, dated February 2, 1947, Chicago to New York, JMFA003, JMF; Joan Mitchell to Barney Rosset, postmarked March 21, 1947, Chicago to New York, JMFA003, JMF.
21. Albers, *Joan Mitchell*, 99; Anne-Elisabeth Moutet, "An American in Paris," 76.
22. Marion Strobel to Joan Mitchell, dated August 19, 1949, Chicago to Le Lavandou, France, JMFA001, JMF.
23. Ibid.
24. "Joan Mitchell," transcript Barney/Sandy interview, January 21, 2004, Barney Rosset Papers, Tape 5, Side 1, Series II, Box 3, Folder 5, Columbia.
25. Oral history interview with Joan Mitchell, April 16, 1986, AAA-SI.
26. Ibid.; "1948 Joan Mitchell," Barney Rosset/GAP, vol. 2—ca. 1998, Barney Rosset Papers, Series II, Box 3, Folder 5, Columbia; Barney Rosset to parents, September 11, 1949, Le Lavendou to Chicago, "Remembering Joan," *Evergreen Review* 104 (January 2001), courtesy Astrid Myers Rosset.

27. "Joan Mitchell," transcript Barney/Sandy interview, January 21, 2004, Barney Rosset Papers, Tape 5, Side 1, Series II, Box 3, Folder 5, Columbia.
28. "1948 Joan Mitchell," Barney Rosset/GAP, vol. 2—ca. 1998, Barney Rosset Papers, Series II, Box 3, Folder 5, Columbia.
29. Oral history interview with Joan Mitchell, April 16, 1986, AAA-SI.
30. "Riviera Romance for Joan!," *Chicago Sun Times,* September 19, 1949, JMFA001, JMF.
31. Cholly Dearborn, "Smart Set," *Chicago Herald American,* September 19, 1949, JMFA001, JMF.
32. Barney Rosset to Joan Mitchell, "Sunday night," n.d. [ca. 1946], JMFA001, JMF.
33. Lehman, *The Last Avant Garde,* 50.
34. Oral history interview with Joan Mitchell, April 16, 1986, AAA-SI; "1948 Joan Mitchell," Barney Rosset/GAP, vol. 2—ca. 1998, Barney Rosset Papers, Series II, Box 3, Folder 5, Columbia; "Joan Mitchell," Transcript Barney/Sandy Interview, January 21, 2004, Barney Rosset Papers, Tape 5, Side 1, Series II, Box 3, Folder 5, Columbia; Albers, *Joan Mitchell,* 14, 21, 25, 28; Jane Livingston, *The Paintings of Joan Mitchell,* 10–12. Joan's grandfather was an engineer on the Chicago Stadium project.
35. Albers, *Joan Mitchell,* 80–81; Beauvoir, *America Day by Day,* 348.
36. Munro, *Originals,* 242. The vacation spot, Joan said, was composed of "ninety-nine percent Social Register people."
37. Albers, *Joan Mitchell,* 36.
38. Ibid., 36–37.
39. Edrita Fried, *The Ego in Love and Sexuality,* 40–42; Albers, *Joan Mitchell,* 38, 81. Albers described Marion's illness as serious, and requiring a thyroid operation, and later a mastoidectomy, hysterectomy, and the removal of a cervical tumor.
40. Albers, *Joan Mitchell,* 37; Judith Bernstock, *Joan Mitchell,* 15; Fried, *The Ego in Love and Sexuality,* 40–42.
41. Bernstock, *Joan Mitchell,* 15.
42. Albers, *Joan Mitchell,* 118.
43. Bernstock, *Joan Mitchell,* 15.
44. Munro, *Originals,* 239; Livingston, *The Paintings of Joan Mitchell,* 11.
45. Munro, *Originals,* 239.
46. Albers, *Joan Mitchell,* 30; Livingston, *The Paintings of Joan Mitchell,* 11; Bernstock, *Joan Mitchell,* 22. Joan's regard for her grandfather was so great that until her own death she kept his student notebooks and technical drawings. Joan never knew her grandmother because she had killed herself.
47. Zuka Mitelberg, telephone interview by author.
48. Oral history interview with Joan Mitchell, April 16, 1986, AAA-SI; Albers, *Joan Mitchell,* 64; Livingston, *The Paintings of Joan Mitchell,* 11.
49. Joan Mitchell, "Autumn," *Poetry Magazine,* 1935, JMFA006, JMF; Marion Strobel Papers, JMF; Albers, *Joan Mitchell,* 63.
50. Munro, *Originals,* 233.
51. Oral history interview with Joan Mitchell, April 16, 1986, AAA-SI; Albers, *Joan Mitchell,* 47.
52. Albers, *Joan Mitchell,* 46–47, 71; Livingston, *The Paintings of Joan Mitchell,* 12.
53. Marion Cajori, *Joan Mitchell: Portrait of an Abstract Painter,* film; Munro, *Originals,* 241; Albers, *Joan Mitchell,* 47; Livingston, *The Paintings of Joan Mitchell,* 12.
54. Albers, *Joan Mitchell,* 70; Cindy Nemser, "An Afternoon with Joan Mitchell," 6.
55. Albers, *Joan Mitchell,* 70; Cajori, *Joan Mitchell: Portrait of an Abstract Painter,* film; Munro, *Originals,* 242.
56. Albers, *Joan Mitchell,* 70.
57. Nemser, "An Afternoon with Joan Mitchell," 6; Albers, *Joan Mitchell,* 15.
58. Unidentified Chicago newspaper clipping, February 1935, JMFA001, Joan Mitchell Papers, JMF.
59. Unidentified Chicago newspaper clipping, 1938, JMFA001, Joan Mitchell Papers, JMF.
60. Unidentified Chicago newspaper clipping, 1939, JMFA001, Joan Mitchell Papers, JMF; Livingston, *The Paintings of Joan Mitchell,* 12.
61. Nemser, "An Afternoon with Joan Mitchell," 6; Albers, *Joan Mitchell,* 72.
62. Zuka Mitelberg, telephone interview by author; Livingston, *The Paintings of Joan Mitchell,* 12; Munro, *Originals,* 241.

63. Albers, *Joan Mitchell,* 21, 31–33; Conn, *The American 1930s, a Literary History,* 137. Launched in 1912, *Poetry* remains one of the most influential literary publications in America.
64. Riley, *Inventing the American Woman,* 203; Honey, "Images of Women in the 'Saturday Evening Post,'" 352–53, 356.
65. Joan Mitchell to Sally Perry (unsent letter), May 13, 1979, Vétheiul to California, JMFA001, Joan Mitchell Papers, JMF.
66. Deborah Solomon, "In Monet's Light," www.nytimes.com/1991/11/24/magazine/in-monet-s-light.html; Cora Cohen and Betsy Sussler, "Mitchell," 22.
67. Nemser, "An Afternoon with Joan Mitchell," 6.
68. Albers, *Joan Mitchell,* 84–85.
69. "Joan Mitchell," Transcript Barney/Sandy Interview, January 21, 2004, Barney Rosset Papers, Tape 5, Side 1, Series II, Box 3, Folder 5, Columbia; Livingston, *The Paintings of Joan Mitchell,* 12.
70. Benstock, *Joan Mitchell,* 14.
71. Albers, *Joan Mitchell,* 84–85; "Joan Mitchell," Transcript Barney/Sandy Interview, January 21, 2004, Barney Rosset Papers, Tape 5, Side 1, Series II, Box 3, Folder 5, Columbia.
72. Albers, *Joan Mitchell,* 86–87.
73. Ibid., 87–89, 122.
74. Notes from interview with Barney Rosset by unidentified person, n.d., Barney Rosset Papers, Series II, Box 2, Folder 33, Columbia; Albers, *Joan Mitchell,* 122; Kaplan, *1959,* 46.
75. Barney Rosset, interview by Jay Gertzman; Albers, *Joan Mitchell,* 122, 152; "The Billboard," 62.
76. Albers, *Joan Mitchell,* 122; Rob Goodman, "What Happened to the Roosevelts?," www.politico.com/magazine.
77. "Joan Mitchell," transcript Barney/Sandy Interview, January 21, 2004, Barney Rosset Papers, Tape 5, Side 1, Series II, Box 3, Folder 5, Columbia; Zuka Mitelberg, telephone interview by author; Albers, *Joan Mitchell,* 85–86.
78. Barney Rosset Journal, 1949, Barney Rosset Papers, Series II, Disc 3, Box 3, Folder 19, Columbia.
79. "1948 Joan Mitchell," Barney Rosset/GAP, vol. 2—ca. 1998, Barney Rosset Papers, Series II, Box 3, Folder 5, Columbia.
80. Ibid.
81. Ibid.; "Joan Mitchell," Transcript Barney/Sandy Interview, January 21, 2004, Barney Rosset Papers, Tape 5, Side 1, Series II, Box 3, Folder 5, Columbia.
82. Biographical materials, JMFA001, Joan Mitchell Papers, JMF. At fifteen, Joan had a calling card that read "Miss Joan Mitchell."
83. Joan Mitchell to Barney Rosset, postmarked April 24, 1947, Chicago to Brooklyn, JMFA003, Joan Mitchell Papers, JMF.
84. Barney Rosset, interview by Jay Gertzman; "Joan Mitchell," transcript Barney/Sandy interview, January 21, 2004, Barney Rosset Papers, Tape 5, Side 1, Series II, Box 3, Folder 5, Columbia.
85. Barney Rosset, interview by Jay Gertzman; "Joan Mitchell," transcript Barney/Sandy interview, January 21, 2004, Barney Rosset Papers, Tape 5, Side 1, Series II, Box 3, Folder 5, Columbia.
86. Richard Milazzo, "Caravaggio on the Beach," 6.
87. Ibid., 7.
88. Albers, *Joan Mitchell,* 90–91.
89. Munro, *Originals,* 243.
90. Albers, *Joan Mitchell,* 86, 91–92.
91. Ibid., 92–93.
92. Ibid., 92–94.
93. Livingston, *The Paintings of Joan Mitchell,* 12; Albers, *Joan Mitchell,* 95.
94. Oral history interview with Joan Mitchell, April 16, 1986, AAA-SI; Albers, *Joan Mitchell,* 95.
95. Oral history interview with Joan Mitchell, April 16, 1986, AAA-SI; Albers, *Joan Mitchell,* 95; Livingston, *The Paintings of Joan Mitchell,* 12; Munro, *Originals,* 243.
96. "1948 Joan Mitchell," Barney Rosset/GAP, vol. 2—ca. 1998, Barney Rosset Papers, Series II, Box 3, Folder 5, Columbia; Albers, *Joan Mitchell,* 95–96; Milazzo, "Caravaggio on the Beach," 6.
97. Albers, *Joan Mitchell,* 66–67, 95–96; Joan Mitchell to Mike Goldberg, n.d. [1955], Paris to New York, Michael Goldberg Papers, AAA-SI.
98. Irving Sandler, interview by author; Hamill, "Beyond the Vital Gesture," 110.

99. Albers, *Joan Mitchell*, 96–98.
100. Ibid., 96.
101. Munro, *Originals*, 240; oral history interview with Joan Mitchell, AAA-SI. Joan called the experience very "Frenchy."
102. Sarah Brown Boyden, "Intent Artist Overlooks Own Debut," unidentified Chicago newspaper, n.d. [October 1943], JMFA001, Joan Mitchell Papers, JMF.
103. Livingston, *The Paintings of Joan Mitchell*, 16; Albers, *Joan Mitchell*, 106–7.
104. Munro, *Originals*, 240; Livingston, *The Paintings of Joan Mitchell*, 16.
105. Livingston, *The Paintings of Joan Mitchell*, 16–17.
106. Ibid., 17.
107. Cajori, *Joan Mitchell: Portrait of an Abstract Painter*, film.
108. Albers, *Joan Mitchell*, 110–11; Munro, *Originals*, 242.
109. Albers, *Joan Mitchell*, 113–14.
110. Barney Rosset, interview by Jay Gertzman; "Joan Mitchell," Transcript Barney/Sandy Interview, January 21, 2004, Barney Rosset Papers, Tape 5, Side 1, Series II, Box 3, Folder 5, Columbia.
111. Milazzo, "Photos of Joan Mitchell by Barney Rosset."

30. Mexico to Manhattan via Paris and Prague

1. Cajori, *Joan Mitchell: Portrait of an Abstract Painter*, film.
2. Zuka Mitelberg, telephone interview with author.
3. Albers, *Joan Mitchell*, 114.
4. Zuka Mitelberg, telephone interview with author.
5. Ibid.
6. Ibid.
7. Zuka Mitelberg, e-mail to author, October 14, 2015.
8. Zuka Mitelberg, telephone interview with author; Albers, *Joan Mitchell*, 105–6.
9. Zuka Mitelberg, telephone interview with author.
10. Ibid.; Livingston, *The Paintings of Joan Mitchell*, 17.
11. Oral history interview with Joan Mitchell, April 16, 1986, AAA-SI; Zuka Mitelberg, telephone interview with author. Zuka's romance became so serious that she moved to Paris to be nearer her Mexican boyfriend, who was studying law in Europe. That relationship ended when Zuka met someone else.
12. Zuka Mitelberg, telephone interview with author.
13. Albers, *Joan Mitchell*, 117.
14. Livingston, *The Paintings of Joan Mitchell*, 17.
15. Albers, *Joan Mitchell*, 119, 121–22.
16. Barney Rosset, interview by Jay Gertzman.
17. Joan Mitchell to Barney Rosset, January 29, 1947, Chicago to New York, JMFA003, JMF; Joan Mitchell to Barney Rosset, January 30, 1947, Chicago to New York, JMFA003, JMF; Albers, *Joan Mitchell*, 123.
18. Milazzo, "Caravaggio on the Beach," 7; Livingston, *The Paintings of Joan Mitchell*, 17.
19. Bob Bergin, "Publisher-Hero as Combat Photographer in China," Columbia, https://exhibitions.cul.columbia.edu/exhibits/show/rosset/introtobr.
20. Ibid.
21. Barney Rosset to parents, June 8, 1945, Barney Rosset and China Exhibition, Columbia, https://exhibitions.cul.columbia.edu/exhibits/show/rosset/introtobr.
22. Astrid Myers Rosset, interview by author.
23. "Joan Mitchell," transcript Barney/Sandy interview, January 21, 2004, Barney Rosset Papers, Tape 5, Side 1, Series II, Box 3, Folder 5, Columbia.
24. Notes from interview with Barney Rosset by unidentified person, n.d., Barney Rosset Papers, Series II, Box 2, Folder 33, Barney Rosset Papers, Columbia; Livingston, *The Paintings of Joan Mitchell*, 17.
25. "Joan Mitchell," transcript Barney/Sandy interview, January 21, 2004, Barney Rosset Papers, Tape 5, Side 1, Series II, Box 3, Folder 5, Series II, Box 3, Folder 33, Columbia.

26. Joan Mitchell to Barney Rosset, January 29, 1947, Chicago to Brooklyn, JMFA003, JMF; Albers, *Joan Mitchell*, 113. Joan's sister, Sally, had just married a Yale dropout and band leader.
27. "Joan Mitchell," transcript Barney/Sandy interview, January 21, 2004, Barney Rosset Papers, Tape 5, Side 1, Series II, Box 3, Folder 5, Columbia; Notes from interview with Barney Rosset by unidentified person, Barney Rosset Papers, Series II, Box 2, Folder 33, Columbia.
28. Albers, *Joan Mitchell*, 85–86. Jimmie had even hated the fact that the Parker School accepted Jewish students.
29. "Joan Mitchell," transcript Barney/Sandy interview, January 21, 2004, Barney Rosset Papers, Tape 5, Side 1, Series II, Box 3, Folder 5, Series II, Box 2, Folder 33, Columbia.
30. James Mitchell to Joan Mitchell, dated August 29, 1949, JMFA001, Joan Mitchell Papers, JMF.
31. "1948 Joan Mitchell," Barney Rosset/GAP, vol. 2—ca. 1998, Barney Rosset Papers, Series II, Box 3, Folder 5, Columbia.
32. Albers, *Joan Mitchell*, 125–26.
33. Oral history interview with Joan Mitchell, April 16, 1986, AAA-SI; Albers, *Joan Mitchell*, 125–26; Current Population Reports, Consumer Income, U.S. Department of Commerce, January 15, 1960, www.2census.gov/prod2/popscan/p60-33.pdf.
34. Joan Mitchell to Barney Rosset, April 29, 1947, Chicago to Brooklyn, JMFA003, JMF; Albers, *Joan Mitchell*, 126.
35. Oral history interview with Joan Mitchell, April 16, 1986, AAA-SI; "1948 Joan Mitchell," Barney Rosset/GAP, vol. 2—ca. 1998, Barney Rosset Papers, Series II, Box 3, Folder 5, Columbia.
36. Notes from interview with Barney Rosset by unidentified person, Barney Rosset Papers, Series II, Box 2, Folder 33, Columbia; Milazzo, "Caravaggio on the Beach," 8; Livingston, *The Paintings of Joan Mitchell*, 17.
37. Joan Mitchell to Barney Rosset, March 18, 1947, Chicago to Brooklyn, JMFA003, JMF.
38. Joan Mitchell to Barney Rosset, April 15, 1947, Chicago to Brooklyn, JMFA003, JMF.
39. Joan Mitchell to Barney Rosset, postmarked April 29, 1947, Chicago to Brooklyn, JMFA003, JMF.
40. Barney Rosset interview by Jay Gertzman; Albers, *Joan Mitchell*, 127.
41. Cajori, *Joan Mitchell: Portrait of an Abstract Painter*, film.
42. Joan Mitchell to Barney Rosset, dated "Saturday night" February 8, 1947, postmarked February 10, 1947, Chicago to New York, JMFA003, Joan Mitchell Papers, JMF.
43. Oral history interview with Joan Mitchell, April 16, 1986, AAA-SI.
44. Ibid.
45. Bernstock, *Joan Mitchell*, 17.
46. Oral history interview with Joan Mitchell, May 21, 1965, AAA-SI; Bernstock, *Joan Mitchell*, 17.
47. Joan Mitchell to Sally Perry (unsent), May 13, 1979, Vétheuil, France, to California, JMFA001, JMF.
48. Fried, *The Ego in Love and Sexuality*, 41.
49. Barney Rosset to Joan Mitchell, dated July 17, 1948, New York to Paris, JMFA001, JMF.
50. Barney Rosset to Joan Mitchell, "Sunday 7 p.m." n.d. [ca. 1948], New York to Paris, on Frances Osato's stationery, JMFA001, JMF.
51. Joan Mitchell to Barney Rosset, postmarked July 3, 1948, Le Havre, Seine, to New York, JMFA003, JMF.
52. Oral history interview with Joan Mitchell, April 16, 1986, AAA-SI.
53. Joan Mitchell to Barney Rosset, postmarked July 3, 1948, Le Havre, Seine, to New York, JMFA003, JMF.
54. Ibid.
55. Munro, *Originals*, 243–44; oral history interview with Joan Mitchell, April 16, 1986, AAA-SI.
56. Moutet, "An American in Paris," 74.
57. Zuka Mitelberg, telephone interview by author; Joan Mitchell to Barney Rosset, postmarked July 5, 1948, Paris to New York, JMFA003, JMF; Livingston, *The Paintings of Joan Mitchell*, 18.
58. Oral history interview with Joan Mitchell, May 21 1965, AAA-SI.
59. Frances Morris, ed., *Paris Post War*, 16.
60. Ibid., 15–16, 18, 26–27, 39, 46; Simone de Beauvoir, "Eye for Eye," 135.

61. Morris, *Paris Post War,* 15–16, 18, 26–27, 39, 46; Jachec, *The Philosophy and Politics of Abstract Expressionism,* 62–63; William Barrett, "New Innocents Abroad," 284. That year was the start of "the greatest tourist season Europe had yet known," wrote philosopher William Barrett.
62. Oral history interview with Joan Mitchell, April 16, 1986, AAA-SI.
63. Joan Mitchell to Barney Rosset, postmarked July 8, 1948, 73 rue Galande, Paris, to New York, JMFA003, JMF.
64. Joan Mitchell to Barney Rosset, postmarked July 16, 1948, Paris to New York, JMFA003, JMF.
65. Joan Mitchell to Barney Rosset, postmarked July 9, 1948, Paris to New York, JMFA003, JMF.
66. Joan Mitchell to Barney Rosset, postmarked July 19, 1948, Paris to New York, JMFA003, JMF.
67. Notes from interview with Barney Rosset by unidentified person, Barney Rosset Papers, Series II, Box 2, Folder 33, Columbia.
68. Joan Mitchell to Barney Rosset, postmarked July 9, 1948, Paris to New York, JMFA003, JMF.
69. Joan Mitchell to Barney Rosset, postmarked July 8, 1948, Paris to New York, JMFA003, JMF; Joan Mitchell to Barney Rosset, dated July 15, 1948, and postmarked July 17, 1948, Paris to New York, JMFA003, JMF.
70. Joan Mitchell to Barney Rosset, dated July 22, 1948, postmarked July 23, 1948, Paris to New York, JMFA003, JMF.
71. Munro, *Originals,* 244.
72. Barney Rosset to Joan Mitchell, dated July 21, 1948, New York to Paris, JMFA001, JMF; Barney Rosset to Joan Mitchell, dated August 11, 1948, New York to Paris, JMFA001, JMF.
73. Joan Mitchell to Barney Rosset, postmarked July 9, 1948, Paris to New York, JMFA003, JMF.
74. "1948 Joan Mitchell," Barney Rosset/GAP, vol. 2—ca. 1998, Barney Rosset Papers, Series II, Box 3, Folder 5, Columbia; Barney Rosset to Joan Mitchell, "Sunday 7 p.m." n.d. [ca. 1948], on Frances Osato's stationery, New York to Paris, JMFA001, JMF.
75. "1948 Joan Mitchell," Barney Rosset/GAP, vol. 2—ca. 1998, Barney Rosset Papers, Series II, Box 3, Folder 5, Columbia.
76. Ibid.
77. Joan Mitchell to Barney Rosset, dated September 17, 1948, postmarked September 19, 1948, Paris to New York, JMFA003, JMF.
78. Joan Mitchell to Barney Rosset, postmarked September 23, 1948, Paris to New York, JMFA003, JMF.
79. Moutet, "An American in Paris," 74.
80. Marion Strobel to Joan Mitchell, dated October 1, 1948, Chicago to Paris, JMFA001, JMF; Marion Strobel to Joan Mitchell, dated October 6, 1948, Chicago to Paris, JMFA001, JMF; Joan Mitchell to Barney Rosset, postmarked September 30, 1948, Paris to New York, JMFA003, JMF.
81. Oral history interview with Joan Mitchell, May 21, 1965, AAA-SI; Moutet, "An American in Paris," 74.
82. Joan Mitchell to Barney Rosset, dated and postmarked September 16, 1948, Paris to New York, JMFA003, JMF; Joan Mitchell to Barney Rosset, dated September 17, 1948, postmarked September 19, 1948, Paris to New York, JMFA003, JMF.
83. Joan Mitchell to Barney Rosset, n.d., postmarked October 1948, Paris to New York, JMFA003, JMF; Joan Mitchell to Barney Rosset, postmarked October 8, 1948, Paris to New York, JMFA003, JMF.
84. Joan Mitchell to Barney Rosset, postmarked October 8, 1948, Paris to New York, JMFA003, JMF.
85. Joan Mitchell to Barney Rosset, postmarked October 29, 1948, Paris to New York, JMFA003, JMF; Joan Mitchell to Barney Rosset, postmarked October 1[?], 1948, Paris to New York, JMFA003, JMF.
86. Joan Mitchell to Barney Rosset, postmarked October 29, 1948, Paris to New York, JMFA003, JMF.
87. Joan Mitchell to Barney Rosset, postmarked October [1?] 1948, Paris to New York, JMFA003, JMF.
88. Joan Mitchell to Barney Rosset, postmarked October 17, 1948, Paris to New York, JMFA003, JMF.

89. Joan Mitchell to Barney Rosset, postmarked October 14, 1948, Paris to New York, JMFA003, JMF.
90. "1948 Joan Mitchell," Barney Rosset/GAP, vol. 2—ca. 1998, Barney Rosset Papers, Series II, Box 3, Folder 5, Columbia; Joan Mitchell to Barney Rosset, postmarked September 27, 1948, Paris to New York, JMFA003, JMF.
91. Barney Rosset autobiographical manuscript excerpt, n.d., JMFA001, JMF, 11–13.
92. Ibid.
93. Ibid., 11–15, 17.
94. Ibid., 20, 33, 37.
95. "Joan Mitchell," transcript Barney/Sandy Interview, January 21, 2004, Barney Rosset Papers, Tape 5, Side 1, Series II, Box 3, Folder 5, Columbia.
96. Barney Rosset autobiographical manuscript excerpt, undated, JMFA001, JMF, 38.
97. Marion Strobel to Joan Mitchell, dated December 14, 1948, Chicago to Paris, JMFA001, JMF.
98. Joan Mitchell to Barney Rosset, dated July 15, 1948, postmarked July 17, 1948, Paris to New York, JMFA003, JMF; Joan Mitchell to Barney Rosset, postmarked October 29, 1948, Paris to New York, JMFA003, JMF; Joan Mitchell to Barney Rosset, postmarked November 1, 1948, Paris to New York, JMFA003, JMF.
99. Joan Mitchell to Barney Rosset, dated and postmarked September 16, 1948, Paris to New York, JMFA003, JMF.
100. Lorraine Kowals, "Social Chicago: Set Party Dates Just for Art's Sake," unidentified Chicago newspaper, 1949, JMFA001, JMF.
101. Barney Rosset, interview by Patricia Albers, n.d., audiotape courtesy Astrid Myers Rosset; Rosset, "The Subject Is Left Handed," manuscript, courtesy Astrid Myers Rosset, n.p.; oral history interview with Joan Mitchell, April 16, 1986, AAA-SI.
102. Adeline Fitzgerald, "At The Moment," *Chicago Sun-Times*, 1949, JMFA001, JMF.
103. Marion Strobel to Joan Mitchell, dated June 5, 1949, Chicago to Paris, JMFA001, JMF.
104. Ibid.
105. Rosset, "The Subject Is Left Handed," manuscript courtesy Astrid Myers-Rosset, n.p.

31. Waifs and Minstrels

1. Hedda Sterne, interview by Colette Roberts, AAA-SI.
2. "1948 Joan Mitchell," Barney Rosset/GAP, vol. 2—ca. 1998, Barney Rosset Papers, Series II, Box 3, Folder 5, Columbia; "Joan Mitchell," transcript Barney/Sandy interview, January 21, 2004, Barney Rosset Papers, Tape 5, Side 1, Series II, Box 3, Folder 5, Columbia; Rosset, "The Subject Is Left Handed," manuscript courtesy Astrid Myers Rosset, n.p.
3. "Joan Mitchell," Transcript Barney/Sandy Interview, January 21, 2004, Barney Rosset Papers, Tape 5, Side 1, Series II, Box 3, Folder 5, Columbia; Rosset, "The Subject Is Left Handed," manuscript courtesy Astrid Myers Rosset, n.p.
4. Cajori, *Joan Mitchell: Portrait of an Abstract Painter*, film; Albers, *Joan Mitchell*, 144; oral history interview with Joan Mitchell, May 21 1965, AAA-SI.
5. Marion Strobel to Joan Mitchell, dated October 28, 1949, Chicago to New York, JMFA001, JMF.
6. Munro, *Originals*, 244–45; oral history interview with Joan Mitchell, April 16, 1986, AAA-SI; Albers, *Joan Mitchell*, 145–46; Diggins, *The Proud Decades*, 237.
7. Munro, *Originals*, 244–45; oral history interview with Joan Mitchell, April 16, 1986, AAA-SI.
8. Moutet, "An American in Paris," 74.
9. Hess, "Franz Kline, 1910–1962," 53.
10. Munro, *Originals*, 244.
11. Moutet, "An American in Paris," 74.
12. Munro, *Originals*, 244–45; Albers, *Joan Mitchell*, 149–50.
13. Albers, *Joan Mitchell*, 150.
14. Ibid., 150–51.
15. Munro, *Originals*, 245.
16. "Joan Mitchell," Transcript Barney/Sandy Interview, January 21, 2004, Barney Rosset Papers, Tape 5, Side 1, Series II, Box 3, Folder 5, Columbia; Rosset, "The Subject Is Left Handed," manuscript courtesy Astrid Myers Rosset, n.p.

17. Charles Baudelaire, *The Painter of Life,* 17.
18. Irving Sandler, "Mitchell Paints a Picture"; Marion Cajori to collectors to raise funds for film, *Joan Mitchell: Portrait of an Abstract Painter,* dated May 4, 1990, JMFA001, Joan Mitchell Papers, JMF.
19. Sandler, "Mitchell Paints a Picture," 47, 69; oral history interview with Joan Mitchell, May 21, 1965, AAA-SI.
20. Cholly Dearborn, "Smart Set: Joan Mitchell Rosset's Paintings to be Exhibited at Lake Forest Show," *Chicago Herald American,* May 29, 1950, 6, JMFA001, Joan Mitchell Papers, JMF.
21. Ibid.
22. "Joan Mitchell," transcript Barney/Sandy Interview, January 21, 2004, Barney Rosset Papers, Tape 5, Side 1, Series II, Box 3, Folder 5, Columbia.
23. Oral history interview with Joan Mitchell, April 16, 1986, AAA-SI; Albers, *Joan Mitchell,* 152.
24. Joan Mitchell to Barney Rosset, December 12, 1979, Vétheiul to New York, JMFA003, JMF.
25. Oral history interview with Joan Mitchell, April 16, 1986, AAA-SI; Bernstock, *Joan Mitchell,* 21.
26. Albers, *Joan Mitchell,* 151–52.
27. Oral history interview with Joan Mitchell, April 16, 1986, AAA-SI.
28. "Joan Mitchell," transcript Barney/Sandy interview, January 21, 2004, Barney Rosset Papers, Tape 5, Side 1, Series II, Box 3, Folder 5, Columbia; Altshuler, *The Avant-Garde in Exhibition,* 167.
29. Grace Glueck, "Michael Goldberg, 83, Abstract Expressionist, Is Dead," B7.
30. Albers, *Joan Mitchell,* 154; "Joan Mitchell," transcript Barney/Sandy interview, January 21, 2004, Barney Rosset Papers, Tape 5, Side 1, Series II, Box 3, Folder 5, Columbia.
31. Dore Ashton, interview by author.
32. Gooch, *City Poet,* 429.
33. Natalie Edgar, interview by author, January 20, 2014.
34. Albers, *Joan Mitchell,* 153; Paul Schimmel, B. H. Friedman, John Bernard Myers, and Robert Rosenblum, *Action/Precision,* 30.
35. Michael Goldberg, interview by Jack Taylor; Schimmel et al., *Action/Precision,* 30.
36. Glueck, "Michael Goldberg, 83, Abstract Expressionist, Is Dead," B7.
37. LeSueur, *Digressions on Some Poems by Frank O'Hara,* 88.
38. Albers, *Joan Mitchell,* 151–52, 154.
39. Ibid., 155.
40. "Joan Mitchell," transcript Barney/Sandy interview, Barney Rosset Papers, Tape 5, Side 1, Series II, Box 3, Folder 5, Columbia.
41. Albers, *Joan Mitchell,* 152.
42. Oral history interview with Joan Mitchell, April 16, 1986, AAA-SI; Albers, *Joan Mitchell,* 153.
43. Albers, *Joan Mitchell,* 152.
44. Notes from interview with Barney Rosset by unidentified person, Barney Rosset Papers, Series II, Box 2, Folder 33, Columbia; "Joan Mitchell," transcript Barney/Sandy interview, January 21, 2004, Barney Rosset Papers, Tape 5, Side 1, Series II, Box 3, Folder 5, Columbia.
45. "Larry Rivers on The Club," *The New Criterion Special Issue* 49, 1986, Larry Rivers Papers, MSS 293, Series II, Subseries A, Box 19, Folder 27, NYU, 51.
46. Ibid., 50.
47. Barrett, *The Truants,* 132; oral history interview with Ludwig Sander, AAA-SI.
48. Oral history interview with Ludwig Sander, AAA-SI.
49. Ibid.; Barrett, *The Truants,* 132–33.
50. Barrett, "What Existentialism Offers Modern Man," 19.
51. Barrett, *The Truants,* 133.
52. Edgar, *Club Without Walls,* 159; oral history interview with Ludwig Sander, AAA-SI.
53. Edgar, *Club Without Walls,* 158–60. The 1950 lineup included, among many others, philosophy professor Heinrich Blücher (husband of Hannah Arendt) on "Modern Style," anthropologist William Lipkind on Thomas Dewey, future Dostoevsky biographer Joseph Frank on "spatial form in modern literature," and novelist and provocateur Paul Goodman on psychology and the artist.
54. Schloss, "The Loft Generation," Edith Schloss Burckhardt Papers, Columbia, 172; Edgar, *Club Without Walls,* 86.
55. Edgar, *Club Without Walls,* 161–62.

56. Ibid., 161; Hellstein, "Grounding the Social Aesthetics of Abstract Expressionism," 117, 123; Friedman, *Give My Regards to Eighth Street*, 103.
57. Edgar, *Club Without Walls*, 83.
58. Johnson, ed., *The New York School of Music and Visual Arts*, 3–4.
59. Ibid., 63.
60. John Cage, interview by Dodie Kazanjian, n.d., AAA-SI, 11; Gruen, *The Party's Over Now*, 158. Writers, as well as artists, were affected by the new music. John Ashbery told Gruen he was about to give up writing, but he heard Cage's *Music of Changes* on New Year's Day 1952 and found the courage to continue. "I really felt that it was a kind of renewal" (ibid.).
61. Schloss, "The Loft Generation," Edith Schloss Burckhardt Papers, Columbia, 191.
62. Johnson, *The New York School of Music and Visual Arts*, 2–3, 5, 63, 78.
63. Ibid., 76.
64. Ibid., 60–61, 64. When Varèse lectured there that year, Alcopley said, "the Club was so overcrowded that some people present . . . were scared stiff the entire building would collapse."
65. Ibid., 21; Friedman, *Give My Regards to Eighth Street*, 15.
66. Johnson, *The New York School of Music and Visual Arts*, 34.
67. Friedman, *Give My Regards to Eighth Street*, 5, 115–16.
68. Schloss, "The Loft Generation," Edith Schloss Burckhardt Papers, Columbia, 229; Johnson, *The New York School of Music and Visual Arts*, 10.
69. Johnson, *The New York School of Music and Visual Arts*, 5, 80–81, 159–60.
70. Friedman, *Give My Regards to Eighth Street*, 116.
71. Ibid., 47.
72. Ibid., 97; LeSueur, *Digressions on Some Poems by Frank O'Hara*, 142.
73. Potter, *To a Violent Grave*, 139; Naifeh and Smith, *Jackson Pollock*, 663; oral history interview with Hans Namuth, AAA-SI.
74. Friedman, *Give My Regards to Eighth Street*, 97.
75. Albers, *Joan Mitchell*, 181.
76. Gooch, *City Poet*, 272.
77. Livingston, *The Paintings of Joan Mitchell*, 20.
78. Albers, *Joan Mitchell*, 173; Munro, *Originals*, 243; Livingston, *The Paintings of Joan Mitchell*, 19.
79. Joan Mitchell to Mike Goldberg, n.d. [1955], Paris to New York, Michael Goldberg Papers, AAA-SI; Gooch, *City Poet*, 271–72; Gruen, *The Party's Over Now*, 41–42.
80. Riley, *Inventing the American Woman*, 239; Rosen, *Popcorn Venus*, 282–84.
81. Dorfman, *Out of the Picture*, 279; Albers, *Joan Mitchell*, 176.
82. Joan Mitchell to Mike Goldberg, Sat., n.d. [ca. 1951], Michael Goldberg Papers, 1942–1981, AAA-SI; Rosset, "The Subject Is Left Handed," courtesy Astrid Myers Rosset, n.p.; oral history interview with Joan Mitchell, April 16, 1986, AAA-SI; Livingston, *The Paintings of Joan Mitchell*, 20.
83. Rosset, "The Subject Is Left Handed," courtesy Astrid Myers Rosset, n.p.; "1948 Joan Mitchell," Barney Rosset/GAP, vol. 2—ca. 1998, Barney Rosset Papers, Series II, Box 3, Folder 5, Columbia.
84. "Joan Mitchell," transcript Barney/Sandy interview, January 21, 2004, Barney Rosset Papers, Tape 5, Side 1, Series II, Box 3, Folder 5, Columbia.
85. Joan Mitchell to Mike Goldberg, April 26, 1951, Michael Goldberg Papers, 1942–1981, AAA-SI; Albers, *Joan Mitchell*, 158.
86. Joan Mitchell to Mike Goldberg, April 26, 1951, Michael Goldberg Papers, 1942–1981, AAA-SI.
87. Joan Mitchell to Mike Goldberg, Sat., n.d. [c. 1951], Michael Goldberg Papers, 1942–1981, AAA-SI; Joan Mitchell to Mike Goldberg, April 26, 1951, Michael Goldberg Papers, 1942–1981, AAA-SI.
88. Joan Mitchell to Mike Goldberg, April 26, 1951, Michael Goldberg Papers, 1942–1981, AAA-SI; Joan Mitchell to Mike Goldberg, Tuesday evening, 1951, Michael Goldberg Papers, 1942–1981, AAA-SI.
89. Joan Mitchell to Mike Goldberg, Tuesday evening, 1951, Michael Goldberg Papers, 1942–1981, AAA-SI.
90. Joan Mitchell to Mike Goldberg, Sat., n.d. [c. 1951], Michael Goldberg Papers, 1942–1981, AAA-SI; Fried, *The Ego in Love and Sexuality*, 15.

91. Edrita Fried, *Active/Passive: The Crucial Psychological Dimension* (New York: Grune & Stratton, 1970), 4–5, Joan Mitchell Library, JMF.
92. Fried, *The Ego in Love and Sexuality*, 1, 15, 17.
93. "Joan Mitchell," transcript Barney/Sandy interview, January 21, 2004, Barney Rosset Papers, Tape 5, Side 1, Series II, Box 3, Folder 5, Columbia.
94. Ibid.
95. Albers, *Joan Mitchell*, 163.
96. "Joan Mitchell," transcript Barney/Sandy interview, January 21, 2004, Barney Rosset Papers, Tape 5, Side 1, Series II, Box 3, Folder 5, Columbia.
97. Gruen, *The Party's Over Now*, 41–42; Rosset, "The Subject Is Left Handed," manuscript courtesy Astrid Myers Rosset, n.p.
98. Joan Mitchell to Mike Goldberg, April 26, 1951, Michael Goldberg Papers, 1942–1981, AAA-SI.

32. Coming Out

1. Perloff, *Frank O'Hara*, 31. The phrase is from an entry in a journal by Frank O'Hara written during his junior year at Harvard, 1948–1949.
2. Joseph Campbell, *The Hero with a Thousand Faces*, 178.
3. Grigor, *Shattering Boundaries*, film.
4. Larry Campbell to Grace Hartigan, April 10, 1984, Box 6, Grace Hartigan Papers, Syracuse.
5. Grigor, *Shattering Boundaries*, film.
6. Bennett, "Lee Krasner, in Her Own Right," 2.
7. Helen Frankenthaler to Sonya Gutman, postcard postmarked March 15, 1951, Box 1, Folder 3, Sonya Rudikoff Papers, 1935–2000, Princeton.
8. Helen Frankenthaler to Sonya Gutman, January 30, 1951, Box 1, Folder 3, Sonya Rudikoff Papers, 1935–2000, Princeton, 2; Helen Frankenthaler to Sonya Gutman, Sunday, postmarked March 19, 1951, Box 1, Folder 3, Sonya Rudikoff Papers, 1935–2000, Princeton, 1.
9. Helen Frankenthaler to Sonya Gutman, postmarked January 17, 1951, Box 1, Folder 3, Sonya Rudikoff Papers, 1935–2000, Princeton, 1.
10. Potter, *To a Violent Grave*, 135.
11. Engelmann, *Jackson Pollock and Lee Krasner*, 74.
12. Helen Frankenthaler to Sonya Gutman, January 30, 1951, Box 1, Folder 3, Sonya Rudikoff Papers, 1935–2000, Princeton, 3.
13. Helen Frankenthaler to Sonya Gutman, postmarked January 17, 1951, Box 1, Folder 3, Sonya Rudikoff Papers, 1935–2000, Princeton, 1.
14. Helen Frankenthaler to Sonya Gutman, dated "Sunday," postmarked March 19, 1951, Box 1, Folder 3, Sonya Rudikoff Papers, 1935–2000, Princeton, 1.
15. Helen Frankenthaler, interview by John Gruen, AAA-SI, 1.
16. Helen Frankenthaler to Sonya Gutman, May 7, 1951, Box 1, Folder 3, Sonya Rudikoff Papers, 1935–2000, Princeton, 2.
17. Helen Frankenthaler to Sonya Gutman, Sunday, postmarked March 19, 1951, Box 1, Folder 3, Sonya Rudikoff Papers, 1935–2000, Princeton; Elderfield, "Painted on 21st Street," 49.
18. Helen Frankenthaler to Sonya Gutman, dated "Monday pm," postmarked May 29, 1951, Box 1, Folder 3, Sonya Rudikoff Papers, 1935–2000, Princeton, 1.
19. Helen Frankenthaler, interview by Deborah Solomon.
20. Helen Frankenthaler to Sonya Gutman, dated "Monday pm," postmarked May 29, 1951, Box 1 Folder 3, Sonya Rudikoff Papers, 1935–2000, Princeton, 1.
21. "After Mountains and Sea," 29.
22. Helen Frankenthaler, interview by Barbara Rose, GRI.
23. Helen Frankenthaler, interview by Deborah Solomon.
24. Ibid.
25. Helen Frankenthaler to Sonya Gutman, May 7, 1951, Box 1, Folder 3, Sonya Rudikoff Papers, 1935–2000, Princeton, 2.
26. Solomon, *Jackson Pollock*, 221.
27. Robert Goodnough, "Pollock Paints a Picture," 78; "Jackson Pollock: Black and White," 7–8.

28. *Lee Krasner,* interview by Robert Coe, videotape courtesy PKHSC; Naifeh and Smith, *Jackson Pollock,* 672; Solomon, *Jackson Pollock,* 222.
29. Friedman, *Jackson Pollock: Energy Made Visible,* 179–80; Naifeh and Smith, *Jackson Pollock,* 672.
30. *Lee Krasner,* interview by Robert Coe, videotape courtesy PKHSC.
31. Potter, *To a Violent Grave,* 139.
32. Naifeh and Smith, *Jackson Pollock,* 672.
33. Rose, *Frankenthaler,* 29; Munro, *Originals,* 216–17; Deborah Solomon, "Interview with Helen Frankenthaler," 793.
34. Solomon, "Interview with Helen Frankenthaler," 793.
35. Naifeh and Smith, *Jackson Pollock,* 641.
36. Potter, *To a Violent Grave,* 139.
37. Landau, *Lee Krasner: A Catalogue Raisonné,* 123.
38. Helen Frankenthaler, interview by Deborah Solomon.
39. Rose, *Frankenthaler,* 30–31; Solomon, "Interview with Helen Frankenthaler," 793.
40. Rose, *Frankenthaler,* 30–31.
41. "After Mountains and Sea," 31.
42. "Jackson Pollock: An Artists' Symposium, Part I"; Alison Rowley, *Helen Frankenthaler,* 8.
43. Potter, *To a Violent Grave,* 156–57.
44. "Jackson Pollock: An Artists' Symposium, Part I."
45. Potter, *To a Violent Grave,* 156–57.
46. "Jackson Pollock: An Artists' Symposium, Part I."
47. Alfred Leslie, interview conducted by Jack Taylor; Rose, *Frankenthaler,* 30; Helen Frankenthaler, interview by Dodie Kazanjian, AAA-SI, 4.
48. Hiram Carruthers Butler, "De Kooning and Friends," 25; Helen Frankenthaler, interview by Dodie Kazanjian, AAA-SI, 5.
49. Alcopley, interview by Jack Taylor.
50. Grace Hartigan journal excerpts, April 17, 1951, Box 31, Grace Hartigan Papers, Syracuse; Grace Hartigan journal excerpts, April 25, 1951, Box 31, Grace Hartigan Papers, Syracuse; Grace Hartigan Journal Excerpts, April 30, 1951, Box 31, Grace Hartigan Papers, Syracuse.
51. Grace Hartigan journal excerpts, April 30, 1951, Box 31, Grace Hartigan Papers, Syracuse.
52. Ibid.
53. Oral history interview with Grace Hartigan, AAA-SI.
54. Stevens and Swan, *De Kooning,* 315.
55. Ibid., 316.
56. Oral history interview with Leo Castelli, July 1969, AAA-SI.
57. Oral history interview with James Rosati, AAA-SI.
58. Mary Abbott, interview by author; Lieber, *Reflections in the Studio,* 38; oral history interview with Ludwig Sander, AAA-SI.
59. Lieber, *Reflections in the Studio,* 38.
60. Ibid.
61. Herman Cherry, interview by Jack Taylor; oral history interview with Ludwig Sander, AAA-SI; Edgar, *Club Without Walls,* 96; Giorgio Cavallon, interview by Jack Taylor.
62. Harold and May Rosenberg, interview by John Gruen, AAA-SI, 30.
63. Herman Cherry, interview by Jack Taylor; oral history interview with Ludwig Sander, AAA-SI; Edgar, *Club Without Walls,* 96; Giorgio Cavallon, interview by Jack Taylor; Harold and May Rosenberg, interview by John Gruen, AAA-SI, 30.

33. The Perils of Discovery

1. Lee Krasner, unpublished notes for a lecture at the New York Studio School, December 1977, Series 2, Subseries 5, Box 10, Folder 11, Jackson Pollock and Lee Krasner Papers, AAA-SI, 36.
2. Helen Frankenthaler to Grace Hartigan, August 3, 1951, Box 12, Grace Hartigan Papers, Syracuse.
3. Grace Hartigan journal excerpts, June 11, 1951, Box 31, Grace Hartigan Papers, Syracuse; Grace Hartigan journal excerpts, June 26, 1951, Box 31, Grace Hartigan Papers, Syracuse.

4. Grace Hartigan journal excerpts, June 26, 1951, Box 31, Grace Hartigan Papers, Syracuse; Grace Hartigan journal excerpts, July 5, 1951, Box 31, Grace Hartigan Papers, Syracuse.
5. Grace Hartigan journal excerpts, July 30, 1951, Box 31, Grace Hartigan Papers, Syracuse; oral history interview with Grace Hartigan, AAA-SI; Grace Hartigan journal excerpts, July 5, Box 31, Grace Hartigan Papers, Syracuse.
6. Helen Frankenthaler to Grace Hartigan, August 3, 1951, Box 12, Grace Hartigan Papers, Syracuse; Grace Hartigan journal excerpts, August 21, 1951, Box 31, Grace Hartigan Papers, Syracuse.
7. Oral history interview with Joan Mitchell, May 21, 1965, AAA-SI; Albers, *Joan Mitchell,* 172.
8. Albers, *Joan Mitchell,* 172.
9. Ibid., 171; Joan Mitchell to Michael Goldberg, "Wednesday," n.d., 1951, Michael Goldberg Papers, 1942–1981, AAA-SI; Joan Mitchell to Michael Goldberg, n.d., 1951, Michael Goldberg Papers, AAA-SI.
10. Joan Mitchell to Michael Goldberg, n.d., 1951, Michael Goldberg Papers, 1942–1981, AAA-SI.
11. Oral history interview with Joan Mitchell, April 16, 1986, AAA-SI; Albers, *Joan Mitchell,* 170; Bernstock, *Joan Mitchell,* 21.
12. Marion Stroebel to Joan Mitchell, n.d. [spring/summer 1951], JMFA001, JMF.
13. Albers, *Joan Mitchell,* 177–79.
14. Oral history interview with Eugene V. Thaw, AAA-SI; oral history interview with Joan Mitchell, May 21, 1965, AAA-SI; Stefanelli, "The Cedar Bar," 59; Albers, *Joan Mitchell,* 172–73.
15. Joan Mitchell to Michael Goldberg, n.d., 1951, Michael Goldberg Papers, 1942–1981, Archives of American Art.
16. Milazzo, "Caravaggio on the Beach," 12.
17. "Grove Genesis," interview with Barney Rosset, Barney Rosset Papers, Series II, Box 3, Folder 21, Disk 12, Columbia.
18. "Grove Genesis," interview with Barney Rosset, Series II, Box 3, Folder 21, Disk 12, Barney Rosset Papers, Columbia; "On Buying Grove," Barney Rosset interview, Barney Rosset Papers, Box 3, Folder 34, Series II, Disk 30, Columbia.
19. "Barney Rosset Reminiscences of Moving to New York in 1949," Barney Rosset Papers, Columbia University Library; "Grove Genesis," Barney Rosset interview, Barney Rosset Papers, Series II, Box 3, Folder 34, Disk 12, Columbia; "On Buying Grove," Barney Rosset interview, Barney Rosset Papers, Box 3, Folder 34, Series II, Disk 30, Columbia.
20. "Barney Rosset Reminiscences of Moving to New York in 1949," Barney Rosset Papers, Columbia University Library; "Grove Genesis," Barney Rosset interview, Barney Rosset Papers, Series II, Box 3, Folder 34, Disk 12, Columbia. Joan had read the book in French, but it was out of print in English.
21. Landau, *Lee Krasner: A Catalogue Raisonné,* 123.
22. Ibid.
23. Solomon, *Jackson Pollock,* 225.
24. Norma Broude and Mary D. Garrard, eds., *The Expanding Discourse,* 431.
25. Landau, *Lee Krasner: A Catalogue Raisonné,* 123.
26. Potter, *To a Violent Grave,* 146.
27. Oral history interview with Lee Krasner, November 2, 1964–April 11, 1968, AAA-SI; Solomon, *Jackson Pollock,* 222–23; Landau, *Lee Krasner: A Catalogue Raisonné,* 123.
28. *Paintings by Helen Frankenthaler,* Tibor de Nagy Gallery, November 12, 1951.
29. Nemser, *Art Talk,* 92.
30. Lee Krasner, interview by Barbara Cavaliere, AAA-SI, 24.
31. Livingston, *The Paintings of Joan Mitchell,* 22.
32. Grace Hartigan, journal excerpts, October 23, 1951, Box 31, Grace Hartigan Papers, Syracuse.
33. Helen Frankenthaler, interview by Deborah Solomon.
34. Ellen M. Iseman, "Helen Frankenthaler," 338; Helen Frankenthaler to Sonya Gutman, November 8, 1951, Box 1, Folder 3, Sonya Rudikoff Papers, 1935–2000, Princeton, 1.
35. Helen Frankenthaler to Sonya Gutman, postmarked November 23, 1951, Box 1, Folder 3, Sonya Rudikoff Papers, 1935–2000, Princeton, 1–2.
36. Myers, *Tracking the Marvelous,* 154.
37. Grace Hartigan journal excerpts, December 3, 1951, Box 31, Grace Hartigan Papers, Syracuse.

38. Greer, *The Obstacle Race*, 142; Charles Sterling, "A Fine 'David' Reattributed," 121–32; Parker and Pollock, *Old Mistresses*, 106; Marie Joséphine Charlotte du Val d'Ognes (d. 1868), http://www.metmuseum.org/art/collection/search/437903. The portrait of Marie Joséphine Charlotte du Val d'Ognes was later determined by the Met to be the work of another woman, French artist Marie Denise Villers.
39. Malina, *The Diaries of Judith Malina*, 248; Lynn White Jr., *Educating Our Daughters*, 46. White's book concluded, "In the face of the rapidly mounting evidence that cultural creativity is very nearly sex-linked, the orthodox feminist…finds herself forced to the tragic conclusion that women are an inferior variety of our species."
40. Philip Pavia, interview by Jack Taylor.
41. Grace Hartigan journal excerpts, December 3, 1951, Box 31, Grace Hartigan Papers, Syracuse.
42. Mattison, *Grace Hartigan*, 42; La Moy and McCaffrey, *The Journals of Grace Hartigan*, 19.
43. Helen Frankenthaler to Sonya Gutman, December 17, 1951, Box 1, Folder 3, Sonya Rudikoff Papers, 1935–2000, Princeton, 1.
44. Helen Frankenthaler, interview by Deborah Solomon.
45. Naifeh and Smith, *Jackson Pollock*, 678; Solomon, *Jackson Pollock*, 225–26.
46. O'Brian, *Clement Greenberg: The Collected Essays and Criticism*, 3:105; Rubenfeld, *Clement Greenberg*, 160.
47. O'Brian, *Clement Greenberg: The Collected Essays and Criticism*, 3:105.
48. Munro, *Originals*, 116.
49. "Jackson Pollock: Black and White," 7–8.
50. Solomon, *Jackson Pollock*, 227.
51. Ibid., 226–27.
52. Munro, *Originals*, 116.
53. "Jackson Pollock: Black and White," 8.

34. Said the Poet to the Painter

1. Perloff, *Frank O'Hara*, 31. The phrase is from an entry in a journal by Frank O'Hara written during his junior year at Harvard, 1948–1949.
2. Oral history interview with Joan Mitchell, April 16, 1986, AAA-SI; Joan Mitchell to Michael Goldberg, June 13, 1954, Springs, East Hampton, to New York, Michael Goldberg Papers, AAA-SI.
3. Oral history interview with Joan Mitchell, April 16, 1986, AAA-SI; oral history interview with Joan Mitchell, May 21, 1965, AAA-SI; Larry Rivers Journal, Monday, January 14, 1952, Larry Rivers Papers, MSS 293, Series II, Subseries A, Box 20, Folder 3, NYU.
4. Albers, *Joan Mitchell*, 182–83.
5. Milazzo, "Caravaggio on the Beach," 13; Albers, *Joan Mitchell*, 182–83; Rosset, "The Subject Is Left Handed," manuscript courtesy Astrid Myers Rosset, n.p.
6. Oral history interview with Eugene V. Thaw, AAA-SI.
7. Paul Brach, "Review: Joan Mitchell," n.p.; Livingston, *The Paintings of Joan Mitchell*, 21–22.
8. Oral history interview with Joan Mitchell, May 21, 1965, AAA-SI.
9. Elaine de Kooning, interview by Amei Wallach, 7, 12; Ernestine Lassaw, interview by author; Elaine de Kooning to Josef Albers, n.d., New York to New Haven, Connecticut, courtesy The Josef and Anni Albers Foundation.
10. La Moy and McCaffrey, *The Journals of Grace Hartigan*, 22; Albers, *Joan Mitchell*, 182–83.
11. La Moy and McCaffrey, *The Journals of Grace Hartigan*, 21–22.
12. Albers, *Joan Mitchell*, 183; Edgar, *Club Without Walls*, 168; Munro, *Originals*, 245.
13. Philip Pavia, "The Hess Problem," 9, 12.
14. Hess, *Abstract Painting*, 66–67, 69, 83.
15. Ibid., 28–92, 83; Pavia, "The Hess Problem," 9; Morris Wright, "The Violent Land," 99, 101. Curiously, Hess spends almost no time on Impressionism or Manet's influence on modern art.
16. Pavia, "The Hess Problem," 9; Hess, *Abstract Painting*, 83. Hess also mentioned Surrealism as an influence, not because of the way the paint was applied but because of the Surrealist notion of the unconscious as a source of inspiration. He described the abstractionists as having "authority," the expressionists "emotional intensity," and the Surrealists "personal liberty."

17. Sandler, *A Sweeper Up After Artists*, 36; Edgar, *Club Without Walls*, 109; Pavia, "The Hess Problem," 9.
18. Pavia, "The Hess Problem," 12.
19. Ibid., 9, 12; Edgar, *Club Without Walls*, 165.
20. Edgar, *Club Without Walls*, 168–69; Natalie Edgar, interview by author, December 8, 2013; Lehman, *The Last Avant-Garde*, 7.
21. LeSueur, *Digressions on Some Poems by Frank O'Hara*, 85; "Art with the Touch of a Poet: Frank O'Hara," n.p.
22. Frank O'Hara to Judith Schmidt, January 18, 1957, Donald Allen Collection of Frank O'Hara Letters, UConn.
23. Perloff, *Frank O'Hara*, 3.
24. Ashbery, *Reported Sightings*, 241; Lehman, *The Last Avant-Garde*, 56.
25. Gooch, *City Poet*, 14–16.
26. Ibid., 23, 31–32.
27. Ibid., 38–39.
28. Ibid., 47, 56; Perloff, *Frank O'Hara*, 34.
29. James Schuyler, "Frank O'Hara: Poet Among Painters," 44; Lehman, *The Last Avant-Garde*, 40; Gooch, *City Poet*, 47, 58–59, 77.
30. Perloff, *Frank O'Hara*, 32.
31. Ibid.; Lehman, *The Last Avant-Garde*, 40.
32. Rivers, *What Did I Do?*, 464.
33. Ibid.; Gooch, *City Poet*, 51; LeSueur, *Digressions on Some Poems by Frank O'Hara*, 62, 68–69; Terrell Scott Herring, "Frank O'Hara's Open Closet," 416, 425–26. Herring argues that Frank did not try to pass as a straight writer in his poems either. His were not confessional poems, but he took no pains to hide who he was.
34. John D'Emilio, *Sexual Politics, Sexual Communities*, 14.
35. Ibid., 24; Bram, *Eminent Outlaws*, 12.
36. Gooch, *City Poet*, 85.
37. Ibid., 90, 92, 95, 102, 106; Schuyler, "Frank O'Hara: Poet Among Painters," 44.
38. Perloff, *Frank O'Hara*, 31, 35.
39. Gooch, *City Poet*, 115; Perloff, *Frank O'Hara*, 35; Albers, *Joan Mitchell*, 89–90.
40. Gooch, *City Poet*, 136–37.
41. Ibid.
42. Lehman, *The Last Avant-Garde*, 9–11; John Ashbery, "The Invisible Avant-Garde," 125. Ashbery wrote: "There was in fact almost no experimental poetry being written in this country, unless you counted the rather pale attempts of a handful of poets who were trying to imitate some of the effects of the French Surrealists. The situation was a little different in the other arts."
43. Frank O'Hara to Jane Freilicher, June 6, 1951, Michigan to New York, Series I, F10, Jane Freilicher Papers, 1945–1995 (MS Am 2072), Houghton Library, Harvard University.
44. Lehman, *The Last Avant-Garde*, 256.
45. Ibid., 41.
46. Ibid., 257, 259; Bill Berkson and Joe LeSueur, eds., *Homage to Frank O'Hara*, 82; LeSueur, *Digressions*, xiv.
47. Rivers, *What Did I Do?*, 273.
48. Kenneth Koch notes for "On Frank O'Hara," July 7, 1988, Box 166, Folder 3, Kenneth Koch Papers, NYPL.
49. Lehman, *The Last Avant-Garde*, 213–16.
50. Ibid., 42–43, 217.
51. Rivers, *What Did I Do?*, 214.
52. Lehman, *The Last Avant-Garde*, 121–23.
53. Ibid., 126, 131.
54. Jane Freilicher, interview by author; Lehman, *The Last Avant-Garde*, 55.
55. Kenneth Koch, "A Physical World," lecture at Jane Freilicher exhibition, Manchester, New Hampshire, 1986, Box 165, Folder 10, Kenneth Koch Papers, 1939–1995, NYPL; Jane Freilicher, interview by author; Lehman, *The Last Avant-Garde*, 55.
56. Jane Freilicher, interview by author; Ashbery, *Reported Sightings*, 240.

57. Hauser, *The Social History of Art*, 2:57.
58. Gooch, *City Poet*, 174; Gruen, *The Party's Over Now*, 141; LeSueur, *Digressions*, xxiii.
59. *Jane Freilicher, Painter Among the Poets*, 50; Berkson and LeSueur, *Homage to Frank O'Hara*, 23.
60. Kenneth Koch notes for "On Frank O'Hara," July 7, 1988, Box 166, Folder 3, Kenneth Koch Papers, NYPL.
61. Schuyler, "Frank O'Hara: Poet Among Painters," 45.
62. Perloff, *Frank O'Hara*, 196; Lehman, *The Last Avant-Garde*, 166.
63. Howard Griffin Notes on Frank O'Hara, Holograph Draft, ca. 1966, Frank O'Hara Collection of Papers, NYPL; Kenneth Koch notes for "On Frank O'Hara," July 7, 1988, Box 166, Folder 3, Kenneth Koch Papers, NYPL.
64. Berkson and LeSueur, *Homage to Frank O'Hara*, 13; Friedman, *Give My Regards to Eighth Street*, 105.
65. Gooch, *City Poet*, 177–78.
66. Rivers, *What Did I Do?*, 228; Gruen, *The Party's Over Now*, 141.
67. Gooch, *City Poet*, 175–76.
68. Rivers, *What Did I Do?*, 228.
69. Barrett, *Irrational Man*, 130.
70. Baudelaire, *The Painter of Modern Life*, 9–10.
71. Schuyler, "Frank O'Hara: Poet Among Painters," 45; Gooch, *City Poet*, 207; Perloff, *Frank O'Hara*, 57–58.
72. Schuyler, "Frank O'Hara: Poet Among Painters," 45.
73. Allen, *The Collected Poems of Frank O'Hara*, viii.
74. Kenneth Koch, Frank O'Hara Random Remarks, or an Adventure in Conversation, Box 166, Folder 3, Kenneth Koch Papers, 1939–1995, NYPL; Robert Hampson and Will Montgomery, eds., *Frank O'Hara Now*, 196; Allen, *The Collected Poems of Frank O'Hara*, viii.
75. Frank O'Hara, "Larry Rivers: A Memoir," offprint from an exhibition catalog, Brandeis University, 1965, Box 182, Folder 18, Kenneth Koch Papers, 1939–1995, NYPL.
76. Frank O'Hara, "Larry Rivers: A Memoir," offprint from an exhibition catalog, Brandeis University, 1965, Box 182, Folder 18, Kenneth Koch Papers, 1939–1995, NYPL.
77. Natalie Edgar, interviews by author, October 20, 2014, New York, and December 8, 2013, East Hampton, New York; Edgar, *Club Without Walls*, 61; Lehman, *The Last Avant-Garde*, 7; Gooch, *City Poet*, 216.
78. Elaine de Kooning, interview by Arthur Tobier, 9.
79. Edgar, *Club Without Walls*, 168–69; Gooch, *City Poet*, 216.
80. "Larry Rivers on The Club," 50.
81. Larry Rivers Journals, March 11, 1952, Larry Rivers Papers, MSS 293, Series II, Subseries A, Box 20, Folder 3, NYU; Notes on Larry Rivers, Sam Hunter Papers, Roll 630, AAA-SI.
82. La Moy and McCaffrey, *The Journals of Grace Hartigan*, 25.
83. Larry Rivers Journals, March 11, 1952, Larry Rivers Papers, MSS 293, Series II, Subseries A, Box 20, Folder 3, NYU.
84. Alfred Leslie, interview by Jack Taylor; Larry Rivers Journals, March 11, 1952, Larry Rivers Papers, MSS 293, Series II, Subseries A, Box 20, Folder 3, NYU.
85. Larry Rivers Journals, March 11, 1952, Larry Rivers Papers, MSS 293, Series II, Subseries A, Box 20, Folder 3, NYU.
86. Alfred Leslie, interview by Jack Taylor; Larry Rivers Journals, March 11, 1952, Larry Rivers Papers, MSS 293, Series II, Subseries A, Box 20, Folder 3, NYU.
87. David Lund, "Scenes from the Cedar," 49; Alfred Leslie, interview by Jack Taylor.
88. Dorfman, *Out of the Picture*, 277; Lund, "Scenes from the Cedar," 49; Alfred Leslie, interview by Jack Taylor.
89. Alfred Leslie, interview by Jack Taylor
90. Ibid.; oral history interview with Elaine de Kooning, AAA-SI.
91. "Larry Rivers on The Club," 51; Rivers, *What Did I Do?*, 282; oral history interview with Harold Rosenberg, AAA-SI.
92. Edgar, *Club Without Walls*, 64; oral history interview with Harold Rosenberg, AAA-SI.
93. Edgar, *Club Without Walls*, 64.

94. Schloss, "The Loft Generation," Edith Schloss Burckhardt Papers, Columbia, 234.
95. Hartigan exhibition catalog, Gruenebaum Gallery, January 4–January 29, 1986, Box 36, Grace Hartigan Papers, Syracuse; Mattison, *Grace Hartigan*, 20.
96. Mattison, *Grace Hartigan*, 20; Hartigan exhibition catalog, Gruenebaum Gallery, January 4–January 29, 1986, Box 36, Grace Hartigan Papers, Syracuse; Polcari, *Abstract Expressionism and the Modern Experience*, 349; Allen, *The Collected Poems of Frank O'Hara*, 513.
97. Oral history interview with Grace Hartigan, AAA-SI; Nemser, *Art Talk*, 156.
98. Gibson, *Abstract Expressionism*, 22.
99. Polcari, *Abstract Expressionism and the Modern Experience*, 349; La Moy and McCaffrey, *The Journals of Grace Hartigan, 1951–1955*, 24.
100. Nemser, *Art Talk*, 156–57.
101. Ibid., 157.
102. Oral history interview with Grace Hartigan, AAA-SI.
103. Larry Rivers, "Cedar," unpublished notes, Larry Rivers Papers, MSS 293, Series II, Subseries A, Box 20, Folder 3, NYU, 12–13.
104. Mattison, *Grace Hartigan*, 21.
105. "Grace Hartigan, Painting from Popular Culture, Three Decades," Susquehanna Art Museum.
106. Ibid.
107. La Moy and McCaffrey, *The Journals of Grace Hartigan, 1951–1955*, 24.
108. Curtis, *Restless Ambition*, 81.
109. Rex Stevens, interview by author.
110. Rivers, *What Did I Do?*, 302.
111. Grace Hartigan journal excerpts, August 31, 1951, Box 31, Grace Hartigan Papers, Syracuse; Curtis, *Restless Ambition*, 81.
112. Rex Stevens, interview by author.
113. Ibid.
114. Oral history interview with Grace Hartigan, AAA-SI; Gooch, *City Poet*, 211.
115. Koch, "A Physical World," lecture at Jane Freilicher exhibition, Kenneth Koch Papers, Box 165, Folder 10, Kenneth Koch Papers, 1939–1995, NYPL; Lehman, *The Last Avant-Garde*, 59.
116. Jane Freilicher, interview by author.
117. Sawin, *Nell Blaine*, 45.
118. Lehman, *The Last Avant-Garde*, 64.
119. Gooch, *City Poet*, 13, 210–11.
120. Frank O'Hara to Philip O'Hara, January 11, 1963, Donald Allen Collection of Frank O'Hara Letters, UConn.
121. Gooch, *City Poet*, 211.
122. Grigor, *Shattering Boundaries*, film.
123. LeSueur, *Digressions*, 103.
124. Gooch, *City Poet*, 213.
125. Ibid., 212; Maggie Nelson, *Women, the New York School, and Other True Abstractions*, 53. Grace and Frank's relationship was not unusual for the period. Because of social censure, many homosexuals and lesbians married members of the opposite sex and formed loving relationships, while finding sexual satisfaction elsewhere.
126. Larry Rivers Journals, February 14, 1952, Larry Rivers Papers, MSS 293, Series II, Subseries A, Box 20, Folder 3, NYU; Larry Rivers Journals, February 17, 1952, Larry Rivers Papers, MSS 293, Series II, Subseries A, Box 20, Folder 3, NYU.
127. Rivers, *What Did I Do?*, 129.
128. Jane Freilicher, interview by author.
129. *Frank O'Hara Poems from the Tibor de Nagy Editions*, 7; Gooch, *City Poet*, 213.
130. Berksen and LeSueur, *Homage to Frank O'Hara*, 142.
131. La Moy and McCaffrey, *The Journals of Grace Hartigan*, 27; Grace Hartigan Journals, March 12, 1952, Box 31, Grace Hartigan Papers, Syracuse.
132. La Moy and McCaffrey, *The Journals of Grace Hartigan*, 26.
133. Ibid., 27.
134. Rubenfeld, *Clement Greenberg*, 156.

135. Mattison, *Grace Hartigan,* 20.
136. Rubenfeld, *Clement Greenberg,* 156–57.
137. Mary Abbott, interview by author.
138. Grace Hartigan Journals, March 29, 1952, Box 31, Grace Hartigan Papers, Syracuse.
139. La Moy and McCaffrey, *The Journals of Grace Hartigan, 1951–1955,* 30.
140. T. S. Eliot, *The Sacred Wood,* 45.
141. La Moy and McCaffrey, *The Journals of Grace Hartigan,* 29–30, 31–32.
142. Ibid., 28, 31.
143. Ibid., 40.

35. Neither by Design nor Definition

1. Elaine de Kooning, "Two Americans in Action," 89.
2. Marquis, *Alfred H. Barr, Jr.,* 139, 141; Szarkowski and Elderfield, *The Museum of Modern Art at Mid-Century,* 69; oral history interview with Dorothy C. Miller, AAA-SI.
3. Szarkowski and Elderfield, *The Museum of Modern Art at Mid-Century,* 69–70; Perl, *New Art City,* 417.
4. Oral history interview with Dorothy C. Miller, AAA-SI.
5. Ibid.; Marquis, *Alfred H. Barr, Jr.,* 140; Dorothy C. Miller, interview by Barbara Rose, GRI; Matossian, *Black Angel,* 309.
6. Oral history interview with Dorothy C. Miller, AAA-SI; John Gruen, typewritten draft article on Dorothy Miller, 1976, John Jonas Gruen and Jane Wilson Papers, 1952–2003, AAA-SI, 5; Potter, *To a Violent Grave,* 79–80, 157.
7. Paul Jenkins, interview by Deborah Solomon, January 12, 1984, New York, © 2017 Estate of Paul Jenkins, transcript courtesy of Suzanne D. Jenkins.
8. Irving Sandler, interview by author.
9. Lynes, "The Eye of the Beholder," lecture notes for Smith College Museum of Art, May 5, 1985, Box 1, Russell Lynes Papers 1935–1986, AAA-SI, 19.
10. Oral history interview with Dorothy C. Miller, AAA-SI; Szarkowski and Elderfield, *The Museum of Modern Art at Mid-Century,* 58; Gruen, typewritten draft article on Dorothy Miller, 1976, John Jonas Gruen and Jane Wilson Papers, 1952–2003, AAA-SI, 8
11. Oral history interview with Dorothy C. Miller, AAA-SI.
12. Ibid.; Dore Ashton, interview by author.
13. Szarkowski and Elderfield, *The Museum of Modern Art at Mid-Century,* 58, 68; Marquis, *Alfred H. Barr, Jr.,* 139.
14. Oral history interview with Dorothy C. Miller, AAA-SI; Szarkowski and Elderfield, *The Museum of Modern Art at Mid-Century,* 57–58.
15. Szarkowski and Elderfield, *The Museum of Modern Art at Mid-Century,* 58–59.
16. Myers, *Tracking the Marvelous,* 79.
17. Oral history interview with Dorothy C. Miller, AAA-SI; Szarkowski and Elderfield, *The Museum of Modern Art at Mid-Century,* 65.
18. Szarkowski and Elderfield, *The Museum of Modern Art at Mid-Century,* 70, 73.
19. Oral history interview with Dorothy C. Miller, AAA-SI; Szarkowski and Elderfield, *The Museum of Modern Art at Mid-Century,* 74–75.
20. Oral history interview with Dorothy C. Miller, AAA-SI.
21. Szarkowski and Elderfield, *The Museum of Modern Art at Mid-Century,* 75.
22. Ibid., 73, 88; Seitz, *Abstract Expressionist Painting in America,* 56. Seitz said an avant-garde artist realizes his or her work can appear "repugnant" on first viewing. "They are aware of the psychological and historical truth that the rapport of a painting with an audience is a developing transaction."
23. Szarkowski and Elderfield, *The Museum of Modern Art at Mid-Century,* 68; Lukach, *Hilla Rebay,* 48, 293; Daniel Belasco, "Between the Waves," 121; Kaplan, *1959,* 161. Hilla Rebay, who had built the Guggenheim collection over a period of twenty-five years, had been one of the few but she was fired in 1952 by the late Solomon Guggenheim's nephew. He had decided the Solomon R. Guggenheim Museum should be directed by a man.
24. Szarkowski and Elderfield, *The Museum of Modern Art at Mid-Century,* 67–68.
25. Ibid., 72; Marquis, *Alfred H. Barr, Jr.,* 255.
26. Oral history interview with Dorothy C. Miller, AAA-SI.

27. Szarkowski and Elderfield, *The Museum of Modern Art at Mid-Century,* 71; Marquis, *Alfred H. Barr, Jr.,* 255; Eric Hodgins and Parker Lesley, "The Great International Art Market," 156; Deirdre Robson, "The Avant-Garde and the On-Guard," 220.
28. Szarkowski and Elderfield, *The Museum of Modern Art at Mid-Century,* 70.
29. Stevens and Swan, *De Kooning,* 320; Willem de Kooning 1951 income tax return, Willem and Elaine de Kooning Papers, AAA-SI.
30. Stevens and Swan, *De Kooning,* 320.
31. Elaine de Kooning, interview by Arthur Tobier, 4–5; Stevens and Swan, *De Kooning,* 331.
32. "Philip Pavia Talks on the War Years," 19.
33. Elaine de Kooning to Josef Albers, n.d. [ca. spring 1952], courtesy The Josef and Anni Albers Foundation.
34. Elaine de Kooning, interview by Arthur Tobier, 4–5; Dawson, *An Emotional Memoir of Franz Kline,* 35–37.
35. Gruen, *The Party's Over Now,* 218; Stevens and Swan, *De Kooning,* 331.
36. Elaine de Kooning, interview by Jeffrey Potter, courtesy the PKHSC; oral history interview with Harold Rosenberg, AAA-SI.
37. Herrera, "Le Feu Ardent," 8–9.
38. Elaine de Kooning, interview by Jeffrey Potter, courtesy the PKHSC.
39. De Coppet and Jones, *The Art Dealers,* 85–86; Stevens and Swan, *De Kooning,* 316, 319. Castelli recommended to Bill that he join Janis in 1951.
40. Stevens and Swan, *De Kooning,* 316.
41. Oral history interview with Leo Castelli, July 1969, AAA-SI.
42. Gruen, *The Party's Over Now,* 218.
43. Elaine de Kooning to Aristodemis Kaldis, June 1952, Aristodemis Kaldis Papers, Roll D177, AAA-SI.
44. Elaine de Kooning, interview by Charles Hayes, 27.
45. Gruen, *The Party's Over Now,* 218; "Elaine de Kooning Portraits," The Art Gallery, Brooklyn College, 17; Hall, *Elaine and Bill,* 134.
46. Stahr, "Elaine de Kooning, Portraiture, and the Politics of Sexuality," 28.
47. Hess, *Willem de Kooning* (1968), 75; Gooch, *City Poet,* 235.
48. *Mercedes Matter,* interview by Sigmund Koch, Tape 4A, Aesthetics Research Archive.
49. Gruen, *The Party's Over Now,* 218; Stevens and Swan, *De Kooning,* 344–45; Gooch, *City Poet,* 235.
50. Mercedes Matter, interview by Jack Taylor; Lionel Abel, "Scenes from the Cedar Bar," 42.
51. Abel, *The Intellectual Follies,* 216.
52. Abel, "Scenes from the Cedar Bar," 42; Elaine de Kooning, interview by Ellen Auerbach, 25–26.
53. Abel, *The Intellectual Follies,* 215; Abel, "Scenes from the Cedar Bar," 42.
54. Elaine de Kooning, interview by Ellen Auerbach, 25–26; Lieber, *Reflections in the Studio,* 37.
55. Elaine de Kooning, interview by Minna Daniels, 40.
56. Gruen, *The Party's Over Now,* 218–19.
57. Harrison and Denne, *Hamptons Bohemia,* 75; Potter, *To a Violent Grave,* 122.
58. Oral history interview with Harold Rosenberg, AAA-SI; Stevens and Swan, *De Kooning,* 334; Kleeblatt, *Action/Abstraction,* 208, 212–13.
59. Waldemar Hanson to Grace Hartigan, Sept. 10, 1952, Easthampton to New York, Box 14, Grace Hartigan Papers, Syracuse.
60. Richard M. Cook, ed., *Alfred Kazin's Journals,* 134n59.
61. Harold Rosenberg, "The American Action Painters," 49.
62. Rosenberg, "The American Action Painters," 22; Dewey, *Art as Experience,* 26–27. In 1934 Dewey, who Rosenberg read and discussed with his colleagues, wrote that what characterized true art was "the act" of creation. He concluded that the distinction between fine art and commercial art was the viewer's ability to discern an artist's activity on canvas or stone, to experience the artist as alive in their work, no matter how long departed.
63. Rosenberg, "The American Action Painters," 23.
64. Ibid., 23, 48.
65. Ibid., 48.
66. Ibid., 23.
67. Rosenberg, *The Anxious Object,* 42, 44; Kleeblatt, *Action/Abstraction,* 126.

68. Oral history interview with Harold Rosenberg, AAA-SI.
69. Thomas B. Hess, interview by Barbaralee Diamonstein, provided by Dr. Barbaralee Diamonstein-Spielvogel, interviewer and author, from *Inside New York's Art World,* 140.
70. Sandler, *A Sweeper Up After Artists,* 182. Sandler adds to that "power base" the artist they all admired, Bill.
71. Rubenfeld, *Clement Greenberg,* 173.
72. Hall, *Elaine and Bill,* 117.
73. Gruen, *The Party's Over Now,* 183.
74. Oral history interview with Herman Cherry, AAA-SI.
75. George McNeil, interview by Jack Taylor.
76. Elizabeth Baker, interview by author; "Larry Rivers on The Club," 51; Myers, *Tracking the Marvelous,* 196; Schloss, "The Loft Generation," Edith Schloss Burckhardt Papers, Columbia, 280.
77. Elizabeth Baker, interview by author, January 20, 2014.
78. Oral history interview with Fairfield Porter, June 6, 1968, AAA-SI.
79. Rubenfeld, *Clement Greenberg,* 174; Hess, *Abstract Painting,* 110.
80. Natalie Edgar, interview by author.
81. Rubenfeld, *Clement Greenberg,* 173.
82. Gruen, *The Party's Over Now,* 208.
83. Hall, *Elaine and Bill,* 116–17.
84. Stevens and Swan, *De Kooning,* 346.
85. Stahr, "The Social Relations of Abstract Expressionism," 209.
86. Natalie Edgar, interview by author, January 20, 2014.
87. Stahr, "The Social Relations of Abstract Expressionism," 210.
88. Elaine de Kooning, interview by Molly Barnes, 10.
89. Stevens and Swan, *De Kooning,* 347; Natalie Edgar, interview by author, January 20, 2014.
90. Gruen, *The Party's Over Now,* 208; Stevens and Swan, *De Kooning,* 347–49.
91. Natalie Edgar, interview by author, January 20, 2014; Clay Fried, interview by author.
92. Schloss, "The Loft Generation," Edith Schloss Burckhardt Papers, Columbia, 279; Hellstein, "Grounding the Social Aesthetics of Abstract Expressionism," 51–52; oral history interview with Ibram Lassaw and Ernestine Lassaw, AAA-SI.
93. Diggins, *The Proud Decades,* 126–27; Halberstam, *The Fifties,* 234.
94. Halberstam, *The Fifties,* 232, 236.
95. Friedan, *The Feminine Mystique,* 53; Chafe, *Women and Equality,* 16.
96. Halberstam, *The Fifties,* 234.
97. Diggins, *The Proud Decades,* 125–26; Halberstam, *The Fifties,* 211–12, 239–40, 250–51.
98. Barbara Guest to Mr. And Mrs. John Pelzel, November 15, 1952, Uncat ZA MS 271, Box 24, Barbara Guest Papers, Yale; Diggory and Miller, *The Scene of My Selves,* 3, 232, 245–46. Diggory writes that Guest's reputation was "underground" until recently because when an anthology of the New York School poets was written in 1970, she was omitted. Neither was she embraced by feminists in the 1970s, who sought to restore some neglected art figures to their rightful places. But Guest was very much one of the New York School poets. In describing his poet friends who hung around the Cedar and the Club in the early days, Frank O'Hara had included John Ashbery, Kenneth Koch, and Barbara Guest.
99. La Moy and McCaffrey, *The Journals of Grace Hartigan,* 54.
100. Diggins, *The Proud Decades,* 128, 131; Brogan, *The Penguin History of the United States,* 609.
101. Miller and Nowak, *The Fifties: The Way We Really Were,* 383.

36. Swimming against a Riptide

1. Cindy Nemser, "Art Talk, Forum Women in Arts," 18.
2. Ibid.
3. Helen Frankenthaler, interview by John Jones, AAA-SI, 5.
4. Rubenfeld, *Clement Greenberg,* 284; de Antonio, *Painters Painting,* film; Marquis, *Art Czar,* 129; Helen Frankenthaler, interview by Mitch Tuchman, AAA-SI, 6.
5. Helen Frankenthaler, interview by Deborah Solomon.
6. Rose, *Frankenthaler,* 54.
7. Friedel Dzubas, interview by Charles Millard, Friedel Dzubas Interviews, AAA-SI; Charles W. Millard, *Friedel Dzubas,* 26.

8. Friedel Dzubas, interview by Charles Millard, AAA-SI; Millard, *Friedel Dzubas*, 22.
9. Friedel Dzubas, interview by Charles Millard, AAA-SI; Millard, *Friedel Dzubas*, 23.
10. Friedel Dzubas, interview by Charles Millard, AAA-SI; Millard, *Friedel Dzubas*, 23–24.
11. Millard, *Friedel Dzubas*, 25.
12. Sandler, *A Sweeper Up After Artists*, 190–91.
13. Millard, *Friedel Dzubas*, 27; Friedel Dzubas, interview, n.d., Box 1, Folder 14, Irving Sandler Papers, ca. 1944–2007 (bulk 1944–1980), AAA-SI.
14. Friedel Dzubas, interview by Charles Millard, AAA-SI; Millard, *Friedel Dzubas*, 11, 26.
15. Friedel Dzubas, interview by Charles Millard, AAA-SI.
16. Rubenfeld, Clement Greenberg, 157; La Moy and McCaffrey, *The Journals of Grace Hartigan*, 107; E.A. Carmean Jr., *Helen Frankenthaler*, 12.
17. Donna Poydinecz-Conley, unpublished interview with Helen Frankenthaler, June 14, 1978. Helen Frankenthaler Papers, HFF.
18. De Antonio, *Painters Painting*, film; Munro, *Originals*, 218; Helen Frankenthaler, interview by Mitch Tuchman, AAA-SI, 6–7.
19. Helen Frankenthaler, interview by Mitch Tuchman, AAA-SI, 7.
20. "After Mountains and Sea," 39.
21. Helen Frankenthaler, interview by Mitch Tuchman, AAA-SI, 8.
22. Friedel Dzubas, interview by Charles Millard, AAA-SI.
23. Rose, *Frankenthaler*, 34–35, 56–57; Gregory Battcock, "Helen Frankenthaler," 54.
24. John Elderfield, *Helen Frankenthaler*, 66.
25. Helen Frankenthaler, interview by Mitch Tuchman, AAA-SI, 9.
26. Elderfield, *Helen Frankenthaler*, 66.
27. Carmean Jr., *Helen Frankenthaler*, 12.
28. Helen Frankenthaler, interview by Mitch Tuchman, AAA-SI, 9; Friedel Dzubas, interview by Charles Millard, AAA-SI; Elderfield, *Helen Frankenthaler*, 66.
29. Carmean Jr., *Helen Frankenthaler*, 12; E.A. Carmean Jr., Oral History Interview on Helen Frankenthaler, videotape courtesy HFF.
30. James Brooks, interview by Jack Taylor; Polcari, *Abstract Expressionism and the Modern Experience*, 259.
31. Elderfield, *Helen Frankenthaler*, 66.
32. John Bernard Myers, interview by Barbara Rose, audiotape, March 12, 1968, Series V, Box 13, R3, GRI.
33. Naifeh and Smith, *Jackson Pollock*, 674.
34. Potter, *To a Violent Grave*, 165.
35. Solomon, *Jackson Pollock*, 233; Naifeh and Smith, *Jackson Pollock*, 698.
36. Potter, *To a Violent Grave*, 166–67.
37. Naifeh and Smith, *Jackson Pollock*, 674; Levin, *Lee Krasner*, 276–77.
38. Naifeh and Smith, *Jackson Pollock*, 674–75.
39. Solomon, *Jackson Pollock*, 226; Naifeh and Smith, *Jackson Pollock*, 674.
40. Solomon, *Jackson Pollock*, 227.
41. Levin, "The Extraordinary Interventions of Alfonso Ossorio,"14; Gaines, *Philistines at the Hedgerow*, 91, 102; B. H. Friedman, "Alfonso Ossorio," 30.
42. Naifeh and Smith, *Jackson Pollock*, 677–79.
43. Solomon, *Jackson Pollock*, 230; Naifeh and Smith, *Jackson Pollock*, 677–79, 684; Levine, "Portrait of Sidney Janis," 52; Potter, *To a Violent Grave*, 147; Hall, *Betty Parsons*, 94.
44. Levine, "Portrait of Sidney Janis," 52.
45. Potter, *To a Violent Grave*, 163.
46. Hall, *Betty Parsons*, 102–3; Naifeh and Smith, *Jackson Pollock*, 677–79; Betty Parsons, interview by John Gruen, AAA-SI, 9.
47. Solomon, *Jackson Pollock*, 231.
48. Levin, *Lee Krasner*, 279; Lee Krasner, interview by John Gruen, AAA-SI, 22.
49. Potter, *To a Violent Grave*, 159, 162–63; oral history interview with Conrad Marca-Relli, AAA-SI; Levin, *Lee Krasner*, 282; Stevens and Swan, *De Kooning*, 335.
50. Potter, *To a Violent Grave*, 161.
51. Ibid., 185.

52. Solomon, *Jackson Pollock*, 234; Naifeh and Smith, *Jackson Pollock*, 696.
53. Naifeh and Smith, *Jackson Pollock*, 696.
54. Solomon, *Jackson Pollock*, 235–36. Twenty-one years later, the painting Pollock called *Number 11, 1952*, which came to be known as *Blue Poles*, sold for $2 million, then the highest price ever paid for a work by an American artist.
55. Solomon, *Jackson Pollock*, 235; Potter, *To a Violent Grave*, 165.
56. Levine, "Portrait of Sidney Janis," 52; Solomon, *Jackson Pollock*, 235. Janis's secretary bought one small piece for one thousand dollars.
57. Solomon, *Jackson Pollock*, 235.
58. Ibid., 236.
59. Ibid.; Levin, *Lee Krasner*, 284.
60. Solomon, *Jackson Pollock*, 236; Naifeh and Smith, *Jackson Pollock*, 697; Rubenfeld, *Clement Greenberg*, 163; Deborah Solomon, notes on Clement Greenberg based on interview, December 19, 1983, Series 1, Box 1, Folder 2, the Clement Greenberg Papers, 1937–1983, AAA-SI, 5. Clem would later say Lee and Jackson had chosen the work.
61. Potter, *To a Violent Grave*, 169.
62. Levin, "The Extraordinary Interventions of Alfonso Ossorio," 14.
63. Rubenfeld, *Clement Greenberg*, 164; Karen Wilkin, *David Smith*, 11; Landau, *Reading Abstract Expressionism*, 636–37.
64. Wilkin, *David Smith*, 42, 45; Landau, *Reading Abstract Expressionism*, 634–35, 636, 644n. Smith was declared unfit for military service because of his "violent tendencies."
65. Landau, *Reading Abstract Expressionism*, 636–37.
66. Rubenfeld, *Clement Greenberg*, 164.
67. Ashton with Banach, *The Writings of Robert Motherwell*, 282. Helen's gesture of artistic and financial support earned a place for her in his heart that did not die until he did in 1965.
68. Rubenfeld, *Clement Greenberg*, 164.
69. Ibid.
70. Levin, *Lee Krasner*, 285.
71. Solomon, *Jackson Pollock*, 236.
72. Ibid.; Rubenfeld, *Clement Greenberg*, 164; Levin, *Lee Krasner*, 286.
73. Naifeh and Smith, *Jackson Pollock*, 693; Levin, *Lee Krasner*, 286.
74. Deborah Solomon, notes on Clement Greenberg based on interview, December 19, 1983, Series 1, Box 1, Folder 2, the Clement Greenberg Papers, 1937–1983, AAA-SI, 5; Solomon, *Jackson Pollock*, 236; Rubenfeld, *Clement Greenberg*, 164.
75. Solomon, *Jackson Pollock*, 237; Rubenfeld, *Clement Greenberg*, 164.
76. Clement Greenberg, interview by James T. Valliere, AAA-SI; Rubenfeld, *Clement Greenberg*, 164.
77. Rubenfeld, *Clement Greenberg*, 164–65; Solomon, *Jackson Pollock*, 237; Naifeh and Smith, *Jackson Pollock*, 698.
78. Lee Krasner, interview by John Gruen, AAA-SI, 2; Solomon, *Jackson Pollock*, 237.
79. Copy of *ArtNews* issue with "American Action Painters," by Harold Rosenberg, with Lee Krasner's notations, Series 2, Subseries 8, Box 13, Folder 7, Jackson Pollock and Lee Krasner Papers, ca. 1914–1984, AAA-SI, 19, 21.
80. Lee Krasner, interview by John Gruen, AAA-SI, 2–3.
81. Potter, *To a Violent Grave*, 169.

37. At the Threshold

1. Virginia Woolf, *To the Lighthouse*, 118–19.
2. Virginia Woolf, *A Room of One's Own*, 54.
3. Oral history interview with Joan Mitchell, April 16, 1986, AAA-SI.
4. Greer, *The Obstacle Race*, 105; Woolf, *A Room of One's Own*, 44–45. Woolf described women's role in artistic creation through history as paradoxical in the extreme. On the one hand she was the inspiration for the greatest literature and art, and yet a "chattel" of her family and husband, and utterly lacking in social significance. "A very queer composite thus emerges.... She pervades poetry from cover to cover; she is all but absent from history. She dominates the lives of kings and conquerors in fiction; in fact, she was the slave of any boy whose parents forced a ring upon her finger."

5. Woolf, *A Room of One's Own*, 6.
6. "Joan Mitchell," transcript Barney/Sandy interview, January 21, 2004, Barney Rosset Papers, Tape 5, Side 1, Series II, Box 3, Folder 5, Columbia.
7. Decree of Divorce, JMFA001, Joan Mitchell Papers, JMF; Cholly Dearborn, "Barney Rosset Jr. Sues his Socialite Artist Wife," *Smart Set, Chicago Herald American*, May 8, 1952, JMFA001, Joan Mitchell Papers, JMF, 14.
8. Oral history interview with Joan Mitchell, April 16, 1986, AAA-SI; Albers, *Joan Mitchell*, 189.
9. "1948 Joan Mitchell," Barney Rosset/GAP, vol. 2—ca. 1998, Barney Rosset Papers, Series II, Box 3, Folder 5, Columbia.
10. Ibid.
11. Joan Mitchell," transcript Barney/Sandy interview, January 21, 2004, Barney Rosset Papers, Tape 5, Side 1, Series II, Box 3, Folder 5, Columbia.
12. "Grove Genesis," interview with Barney Rosset, Barney Rosset Papers, Series II, Box 3, Folder 34, Disk 12, Columbia.
13. Albers, *Joan Mitchell*, 190–91.
14. Edgar, *Club Without Walls*, 168–69.
15. Benstock, *Joan Mitchell*, 46; Cajori, *Joan Mitchell: Portrait of an Abstract Painter*, film.
16. Milazzo, "Caravaggio on the Beach," 14; Albers, *Joan Mitchell*, 190–91.
17. Rosset, "The Subject Is Left Handed," manuscript courtesy Astrid Myers Rosset, n.p.; oral history interview with Joan Mitchell, April 16, 1986, AAA-SI.
18. Marcia Tucker, *Joan Mitchell*, 7.
19. Albers, *Joan Mitchell*, 190–91.
20. Ibid.; Bernstock, *Joan Mitchell*, 21.
21. Joan Mitchell to Barney Rosset, October 8, 1948, Paris to New York, JMFA003, JMF.
22. Albers, *Joan Mitchell*, 193; Bernstock, *Joan Mitchell*, 33.
23. Bernstock, *Joan Mitchell*, 21; Albers, *Joan Mitchell*, 191.
24. Bard, *Tenth Street Days*, vi, 1. Two artist-run co-operative galleries had also opened in 1952 showing Second Generation and younger, non–Abstract Expressionist artists.
25. Oral history interview with Joan Mitchell, April 16, 1986, AAA-SI.
26. Buck, *Of Men and Women*, 67
27. Eleanor Heartney, "How Wide Is the Gender Gap?," 141.
28. Oral history interview with Joan Mitchell, April 16, 1986, AAA-SI.
29. *Summer of '57*, videotape courtesy LTV.
30. Nemser, *Art Talk*, 60.
31. Chadwick, *Women, Art, and Society*, 266.
32. Doris Aach, interview by author.
33. Stahr, "The Social Relations of Abstract Expressionism," 224–25; Heartney, "How Wide Is the Gender Gap?," 141.
34. Les Levin, "The Golden Years, A Portrait of Eleanor Ward," 42; oral history interview with Eleanor Ward, February 8, 1972, AAA-SI; oral history interview with Esteban Vicente, AAA-SI; Myers, *Tracking the Marvelous*, 194; Stahr, "The Social Relations of Abstract Expressionism," 224.
35. Levine, "The Golden Years: A Portrait of Eleanor Ward," 42; oral history interview with Eleanor Ward, AAA-SI.
36. John Bernard Myers to Larry Rivers, February 11, 1954, Larry Rivers Papers, Series 1, Subseries A, Box 10, Folder 11, NYU.
37. Oral history interview with Joan Mitchell, April 16, 1986, AAA-SI.
38. Levine, "The Golden Years, A Portrait of Eleanor Ward," 42; oral history interview with Eleanor Ward, AAA-SI.
39. Letter to artists from committee organizing third Stable Annual, dated December 9, 1953, Stable Gallery business records, JMFA001, Joan Mitchell Papers, JMF; Stahr, "The Social Relations of Abstract Expressionism," 143.
40. O'Brian, *Clement Greenberg: The Collected Essays and Criticism*, 3:120.
41. Myers, *Tracking the Marvelous*, 194; oral history interview with Grace Hartigan, AAA-SI; Mary Lynn Kotz, *Rauschenberg*, 83. Rauschenberg's work, which at that period included live plants that required watering, was appreciated by his fellow artists as an aesthetic prankster. Grace called him a "court jester."

42. Oral history interview with Eleanor Ward, AAA-SI; "Abstract Expressionism," January 1953, warholstars.org; Stahr, "The Social Relations of Abstract Expressionism," 224; Myers, *Tracking the Marvelous*, 194.
43. Levine, "The Golden Years, A Portrait of Eleanor Ward," 42; oral history interview with Eleanor Ward, AAA-SI.
44. La Moy and McCaffrey, *The Journals of Grace Hartigan*, 66–67.
45. Elaine de Kooning, interview by Arthur Tobier, 18; Les Levine, "The Golden Years, A Portrait of Eleanor Ward," 43; Myers, *Tracking the Marvelous*, 185. Myers said by 1956 his best customers were people in the "middle-income bracket" who could afford to spend up to nine hundred dollars and often purchased art on an installment plan.
46. Letter to artists from committee organizing third Stable Annual, dated December 9, 1953, Stable Gallery Business records, IMFA001, JMF; The Second Stable Annual, Charles Cajori Papers, 1940–2015, Series 4, Box 3, Folder 11, AAA-SI; Stahr, "The Social Relations of Abstract Expressionism," 143; Herman Cherry, interview by Jack Taylor. The Stable Annual rules stipulated that artists who had appeared in one annual could invite the artists for the next; the invited artist chose their own work for the show; and a committee of artists hung the show.
47. Albers, *Joan Mitchell*, 196–97.
48. Dore Ashton, interview by author; Albers, *Joan Mitchell*, 197. "Franz and Bill, they liked floozies," said Dore Ashton. "I suppose it was to stay free."
49. Albers, *Joan Mitchell*, 197.
50. Margaret Randall, telephone interview by author.
51. Oral history interview with Joan Mitchell, April 16, 1986, AAA-SI; Stahr, "The Social Relations of Abstract Expressionism," 170; Chafe, *Women and Equality*, 3; Ruddick and Daniels, *Working It Out*, 287. Painter Mimi Schapiro said, "I don't think that another woman, at that time, really cared about my opinion of her work. She wanted a man's opinion." This phenomenon is not particular to the art world, or Western culture. As William Chafe wrote, "Women clearly comprise the largest group in the world...[they also] constitute the only group which is treated unequally as a whole, but whose members live in greater intimacy with their 'oppressors' than with each other."
52. Nemser, "Art Talk, Forum Women in Arts," 18.
53. Levine, "The Golden Years, A Portrait of Eleanor Ward," 42.
54. Stahr, "The Social Relations of Abstract Expressionism," 190.
55. "Joan Mitchell Paintings, 1950–55," Robert Miller Gallery, May 5 to June 5, 1998, New York; Gooch, *City Poet*, 145; Benstock, *Joan Mitchell*, 46.
56. Elderfield, *Helen Frankenthaler*, 88.
57. "After Mountains and Sea," 37.
58. Ibid.
59. Ibid., 36.
60. Ibid., 38.
61. Halberstam, *The Fifties*, 273, 277–78, 570–71; Kimmel, *Manhood in America*, 255; Nowak and Miller, *The Fifties*, 152.
62. Weibel, *Mirror, Mirror*, 124; Haskell, *From Reverence to Rape*, 230.
63. Helen Frankenthaler, interview by Deborah Solomon.
64. Elderfield, "Painted on 21st Street," 53.
65. Ibid.
66. Stuart Preston, "Diverse Showings, Realism and Surrealism," X9; "Reviews and Previews," *ArtNews* 31, no. 10 (February 1953): 55.
67. Deborah Solomon, "An Interview with Helen Frankenthaler," 244.
68. Ibid.
69. John Bernard Myers, interview by Barbara Rose, transcript, Series II, Box 1 Folder 26, Barbara Rose Papers, GRI (930100), 20.
70. Rubenfeld, *Clement Greenberg*, 157.
71. La Moy and McCaffrey, *The Journals of Grace Hartigan*, 68.
72. Larry Rivers to Helen Frankenthaler, Tuesday, February 17, 1953. Helen Frankenthaler Papers, HFF.
73. Helen Frankenthaler scribbled notes on envelope, n.d. [ca. February 1951]. Helen Frankenthaler Papers, HFF.

74. Helen Frankenthaler to Larry Rivers, February 1953, unknown if sent. Helen Frankenthaler Papers, HFF.
75. Larry Rivers to Helen Frankenthaler, March 11, 1953. Helen Frankenthaler Papers, HFF.
76. John Bernard Myers to Helen Frankenthaler, June 14, 1957. Helen Frankenthaler Papers, HFF; Myers, *Tracking the Marvelous*, 155; Gruen, *The Party's Over Now*, 188; Rivers, *What Did I Do?*, 206–7.
77. La Moy and McCaffrey, *The Journals of Grace Hartigan*, 107; Gruen, *The Party's Over Now*, 188.
78. Rubenfeld, *Clement Greenberg*, 181.
79. Ibid.; Clement Greenberg and Janice Van Horne, interview by Dodie Kazanjian, n.d., AAA-SI; Deborah Solomon, "Artful Survivor," 66; Katz, *Black Mountain College*, 66. While Helen's own recollection to friends was that she was not at her studio when Clem brought the group to see her painting, and though Clem's biographer Florence Rubenfeld said, after interviewing Clem, that Helen was not there, his diary indicates that he was with Helen on the day of the event, visiting 57th Street together, and then following the studio visit, having dinner at Helen's apartment.
80. Carmean Jr., *Helen Frankenthaler*, 12; Helen Frankenthaler, interview by Deborah Solomon.
81. Carmean Jr., *Helen Frankenthaler*, 12; Rubenfeld, *Clement Greenberg*, 181.
82. Carmean Jr., *Helen Frankenthaler*, 12.
83. Rubenfeld, *Clement Greenberg*, 181.
84. Elderfield, "Morris Louis and Twentieth-Century Painting," 24.
85. Jones, *Eyesight Alone*, 332; E.A. Carmean Jr., *Oral History Interview on Helen Frankenthaler*, videotape courtesy HFF; Elderfield, "Morris Louis and Twentieth-Century Painting," 24.
86. E.A. Carmean Jr., *Oral History Interview on Helen Frankenthaler*, videotape courtesy HFF.
87. Rubenfeld, *Clement Greenberg*, 182.
88. Clement Greenberg, "Louis and Noland," 27; Jones, *Eyesight Alone*, 332.
89. Oral history interview with Helen Frankenthaler, AAA-SI; Clifford Ross, interview by author, February 18, 2014.
90. Irving Sandler, interview by author.
91. Marquis, *Art Czar*, 139.
92. Helen Frankenthaler to Sonya Gutman, "Tues a.m.," postmarked October 11, 1950, Box 1, Folder 2, Sonya Rudikoff Papers, 1935–2000, Princeton, 2.
93. Elderfield, "Painted on 21st Street," 53.

38. Figures and Speech

1. Scrivani, *Collected Writings of Willem de Kooning*, 88–89.
2. James Fitzsimmons, "Art," 4; Ashton, *The New York School*, 213; Cateforis, "Willem de Kooning's Women of the 1950s," 24.
3. Oral history interview with Grace Hartigan, AAA-SI; Nemser, *Art Talk*, 158.
4. La Moy and McCaffrey, *The Journals of Grace Hartigan*, 74.
5. Sylvester et al., *Willem de Kooning*, 130; oral history interview with Grace Hartigan, AAA-SI; Nemser, *Art Talk*, 158.
6. Fitzsimmons, "Art," 4, 6, 8.
7. La Moy and McCaffrey, *The Journals of Grace Hartigan*, 75.
8. Cateforis, "Willem de Kooning's Women of the 1950s," 24, 41.
9. Ibid., 132–33.
10. Miller and Nowak, *The Fifties*, 86.
11. Millet, *Sexual Politics*, 38, 46; Friedan, *The Feminine Mystique*, 11–12, 29–32, 37–38, 41, 48, 124, 152, 161, 170; Clements, *Prosperity, Depression and the New Deal*, 228. Friedan wrote, "The new mystique makes the housewife-mothers, who never had a chance to do anything else, the model for all women; it presupposes that history has reached a final and glorious end in the here and now, as far as women are concerned." Many of these women, she wrote, didn't leave their homes "except to shop, chauffeur their children, or attend social engagements with their husbands."
12. Lawrence K. Frank and Mary Frank, *How to Be a Woman*, 83; Hess and Nochlin, "Woman as Sex Object," 230.
13. Gaugh, *Willem de Kooning*, 48–49. By 1954, Monroe's personal and professional life regularly featured in newspaper headlines. She had married and divorced Joe DiMaggio, entertained the troops

in South Korea, and was featured in *Life* magazine. Bill de Kooning had a copy of her famous calendar hanging in his studio. He would do a painting he called *Marilyn* in 1954. Grace also painted her own *Marilyn* later in 1962.
14. Frank and Frank, *How to Be a Woman*, 83.
15. Hess and Nochlin, "Woman as Sex Object," 230.
16. Ibid.
17. Sylvester et al., *Willem de Kooning*, 34.
18. Rosenberg, *The Anxious Object*, 119.
19. Cateforis, "Willem de Kooning's Women of the 1950s," 51; Elaine de Kooning to William Theophilus Brown, ca. 1953, Reel 1095, Frames 39–40, William Theo Brown Papers, 1845–1971, AAA-SI.
20. Cateforis, "Willem de Kooning's Women of the 1950s," 164; Elaine de Kooning to William Theophilus Brown, ca.1953, Reel 1095, Frames 39–40, William Theo Brown Papers, 1845–1971, AAA-SI.
21. O'Brian, *Clement Greenberg: The Collected Essays and Criticism*, 3:122; Hess, *Willem de Kooning* (1968), 74.
22. Stevens and Swan, *De Kooning*, 358–59.
23. Ibid., 358.
24. Ibid.
25. Schloss, "The Loft Generation," Edith Schloss Burckhardt Papers, Columbia, 156.
26. Ibid., 157, 159, 165.
27. Tim Clifford, e-mail to author, December 18, 2015. Motherwell purchased his home in early March 1953, possibly March 9. Though Edith remembers the post-exhibition party occurring at that 94th Street residence, it may have occurred at Motherwell's nearby apartment on 82nd Street.
28. Schloss, "The Loft Generation," Edith Schloss Burckhardt Papers, Columbia, 165–66, 171.
29. Joint federal tax return, Willem and Elaine de Kooning, 1953, Elaine and Willem de Kooning financial records, 1951–1969, AAA-SI.
30. Hess, *Willem de Kooning*, 74; joint federal tax return, Willem and Elaine de Kooning, 1953, Elaine and Willem de Kooning financial records, 1951–1969, AAA-SI.
31. Friedman, *Give My Regards to Eighth Street*, 116.
32. Edgar, *Club Without Walls*, 73–74.
33. Schloss, "The Loft Generation," Edith Schloss Burckhardt Papers, Columbia, 41.
34. Oral history interview with Jane Freilicher, AA-SI; Tabak, *But Not for Love*, 79–80. Tabak wrote that the artist "housewife" felt similarly about her work. "A woman who has washed two tubs of laundry, cooked three meals and nursed an ailing child, complains to a friend that she hasn't had a chance to 'work' all day. It is by this particularized 'work' that our friends distinguish themselves from the rest of mankind."
35. La Moy and McCaffrey, *The Journals of Grace Hartigan*, 72; Rex Stevens, interview by author.
36. Oral history interview with Grace Hartigan, AAA-SI.
37. William Lach, ed., *New York, New York*, 41.
38. White, *Here Is New York*, 25–26.
39. La Moy and McCaffrey, *The Journals of Grace Hartigan*, 72.
40. "Grace Hartigan, Painting from Popular Culture, Three Decades," Susquehanna Art Museum.
41. Berksen and LeSueur, *Homage to Frank O'Hara*, 24.
42. Sandler, *A Sweeper Up After Artists*, 22.
43. Gooch, *City Poet*, 231.
44. Wydenbruck, *Rilke, Man and Poet*, 246.
45. La Moy and McCaffrey, *The Journals of Grace Hartigan*, 67, 79, 152.
46. Larry Rivers, interview by Barbaralee Diamonstein, provided by Dr. Barbaralee Diamonstein-Spielvogel, interviewer and author, from *Inside New York's Art World*, 324–25.
47. Rodger Kamenetz, "Frank's Grace,"13.
48. Ibid.
49. Gooch, *City Poet*, 141; *Frank O'Hara: Poems from the Tibor de Nagy Editions*, 9; Perloff, *Frank O'Hara*, 49.
50. Gooch, *City Poet*, 236; *Frank O'Hara: Poems from the Tibor de Nagy Editions*, 9.
51. Kamenetz, "Frank's Grace," 13.

52. Mattison, *Grace Hartigan*, 30.
53. Ibid., 30–31.
54. Gooch, *City Poet*, 236.
55. *Grace Hartigan, Paintings from Popular Culture, Three Decades*, Susquehanna Art Museum.
56. La Moy and McCaffrey, *The Journals of Grace Hartigan*, 67.
57. Ibid., 62.
58. Ibid., 70, 75.
59. Ibid., 75.
60. Kamenetz, "Frank's Grace," 13; "A Memorial Service for John Bernard Myers," Thursday, October 15, 1988, The Grey Art Gallery; La Moy and McCaffrey, *The Journals of Grace Hartigan*, 75; Crase and Quilter, *Painters and Poets*, 40; *Frank O'Hara: Poems from the Tibor de Nagy Editions*, 9. John produced an additional mimeographed run of about fifty.
61. La Moy and McCaffrey, *The Journals of Grace Hartigan*, 75.
62. Crase and Quilter, *Painters and Poets*, 8, 32–33, 34.
63. Ibid., 8, 34.
64. James Fitzsimmons, "Art," *Arts & Architecture* 70, no. 5 (May 1953): 9.
65. La Moy and McCaffrey, *The Journals of Grace Hartigan*, 75, 77.
66. Crase and Quilter, *Painters and Poets*, 7; Grace Hartigan, notes for Tibor de Nagy memorial, April 15, 1994, Box 28, Grace Hartigan Papers, Syracuse; La Moy and McCaffrey, *The Journals of Grace Hartigan*, 77–78.
67. Grace Hartigan, notes for Tibor de Nagy memorial, April 15, 1994, Box 28, Grace Hartigan Papers, Syracuse; Crase and Quilter, *Painters and Poets*, 7.
68. Crase and Quilter, *Painters and Poets*, 8.
69. Ibid.; Al Leslie to Grace Hartigan, July 11, 1953, Box 17, Grace Hartigan Papers, Syracuse.
70. Grace Hartigan Journals, May 9, 1953, Box 31, Grace Hartigan Papers, Syracuse.
71. Grace Hartigan Journals, May 12, 1953, Box 31, Grace Hartigan Papers, Syracuse.
72. Ibid.; Perloff, *Frank O'Hara*, 70; Grace Hartigan Journals, May 13, 1953, Box 31, Grace Hartigan Papers, Syracuse. The painting was sold for four hundred dollars.
73. Oral history interview with Tibor de Nagy, AAA-SI.
74. Ibid.
75. Rivers, *What Did I Do?*, 209; Myers, *Tracking the Marvelous*, 169; Kamenetz, "Frank's Grace," 13.
76. John Bernard Myers to Larry Rivers, n.d., ca. 1952, Series I, Subseries A, Box 10, Folder 14, NYU.
77. Malina, *The Diaries of Judith Malina*, 209.
78. "A Memorial Service for John Bernard Myers," Thursday, October 15, 1988, The Grey Art Gallery.
79. The Artists' Theatre, subscription statement, 1953; Myers, *Tracking the Marvelous*, 164; Rivers, *What Did I Do?*, 207.
80. Abel, *The Intellectual Follies*, 217–18; Myers, *Tracking the Marvelous*, 166.
81. *Artists' Theatre New York, Four Plays*, 7; Gruen, *The Party's Over Now*, 92; Perl, *New Art City*, 197. Perl writes that the "golden age of theater" in New York and the "golden age of painting" in New York occurred "practically simultaneously."
82. Caute, *The Great Fear*, 535; Sandler, *Abstract Expressionism and the American Experience*, 204.
83. *Artists' Theatre New York, Four Plays*, 8–9.
84. Diggins, *The Proud Decades*, 238.
85. The Artists' Theatre, subscription statement, 1953.
86. *Artists' Theatre New York, Four Plays*, 8–9.
87. The Artists' Theatre, subscription statement, 1953; Malina, *The Diaries of Judith Malina*, 270; Lehman, *The Last Avant-Garde*, 22; Myers, *Tracking the Marvelous*, 166; *Art Barge—Artists Speak, with Elaine de Kooning*, videotape courtesy LTV.
88. Oral history interview with Grace Hartigan, AAA-SI; Gooch, *City Poet*, 232; "A Memorial Service for John Bernard Myers," Thursday, October 15, 1987, The Grey Art Gallery.
89. "A Memorial Service for John Bernard Myers," Thursday, October 15, 1987, The Grey Art Gallery.
90. *Mercedes Matter*, interview by Sigmund Koch, Tape 1B, Aesthetics Research Archive.
91. Gruen, *The Party's Over Now*, 214–15.

92. *Artists' Theatre New York, Four Plays,* 7; Abel, *The Intellectual Follies,* 218. Barney's Grove Press would eventually publish the plays in *Artists' Theatre New York.*
93. *Art Barge—Artists Speak,* with Elaine de Kooning, videotape courtesy LTV.

39. Refuge

1. William Faulkner, banquet speech, 1949, "Nobel Prizes and Laureates," nobelprize.org.
2. Caute, *The Great Fear,* 106.
3. Ibid., 85, 88–89, 164–65, 166, 187, 284; Davidson, *Guys Like Us,* 56, 66; Halberstam, *The Fifties,* 360, 371. Indeed, across the government a surveillance culture had been born, with five new federal agencies created to oversee it.
4. I. F. Stone, *The Haunted Fifties,* 35.
5. William H. Whyte, *The Organization Man,* 162–63.
6. Caute, *The Great Fear,* 349–50; Miller and Nowak, *The Fifties,* 111; Clements, *Prosperity: Depression and the New Deal,* 234.
7. Malina, *The Diaries of Judith Malina,* 284; Caute, *The Great Fear,* 62, 66; Davidson, *Guys Like Us,* 54.
8. Lieber, *Reflections in the Studio,* 39; Barney Rosset, "Real Estate," notes, Series II, Box 3, Folder 32, Barney Rosset Papers, Columbia.
9. Stahr, "The Social Relations of Abstract Expressionism," 191–92.
10. Ibid., 131.
11. Oral history interview with Jane Freilicher, AAA-SI; Barbara Guest, Notebook 8, Box 5, Uncat ZA MS 271, Barbara Guest Papers, Yale; Harrison and Denne, *Hamptons Bohemia,* 95.
12. Stahr, "The Social Relations of Abstract Expressionism," 191–92; Gruen, *The Party's Over Now,* 218.
13. Stahr, "The Social Relations of Abstract Expressionism," 192; Elaine de Kooning Lecture, C. F. S. Hancock Lecture, 4.
14. Frank O'Hara to Larry Rivers, May 6, 1953, Larry Rivers Papers, MSS 293, Series I, Subseries A, Box 11, Folder 7, NYU.
15. Frank O'Hara to Larry Rivers, June 27, 1953, Larry Rivers Papers, MSS 293, Series I, Subseries A, Box 11, Folder 7, NYU; La Moy and McCaffrey, *The Journals of Grace Hartigan,* 85.
16. Gooch, *City Poet,* 237.
17. Larry Rivers to Frank O'Hara, n.d., Larry Rivers Papers, MSS 293, Series I, Subseries A, Box 11, Folder 7, NYU; Larry Rivers to Frank O'Hara, September 18, 1953, Larry Rivers Papers, MSS 293, Series I, Subseries A, Box 11, Folder 8, NYU.
18. Gooch, *City Poet,* 239.
19. La Moy and McCaffrey, *The Journals of Grace Hartigan,* 86; oral history interview with Jane Freilicher, AAA-SI.
20. La Moy and McCaffrey, *The Journals of Grace Hartigan,* 86.
21. Frank O'Hara to Larry Rivers, June 27, 1953, Larry Rivers Papers, MSS 293, Series I, Subseries A, Box 11, Folder 7, NYU.
22. La Moy and McCaffrey, *The Journals of Grace Hartigan,* 86.
23. Fried, *The Ego in Love and Sexuality,* 41, 195; Livingston, *The Paintings of Joan Mitchell,* 21.
24. Livingston, *The Paintings of Joan Mitchell,* 21.
25. Albers, *Joan Mitchell,* 202.
26. Nelson, "Women: The New York School," 22.
27. James Fitzsimmons, "Art," *Arts & Architecture* 70, no. 5 (May 1953): 8.
28. Albers, *Joan Mitchell,* 196.
29. Oral history interview with Patricia Faure, November 17–24, 2004, AAA-SI.
30. Gruen, *The Party's Over Now,* 43.
31. Ibid., 60.
32. Ibid., 42–43.
33. Albers, *Joan Mitchell,* 67–68.
34. Abel, *The Intellectual Follies,* 227; Bradford Morrow, "Not Even Past: Hybrid Histories," 9.
35. Nelson, *Women: The New York School,* 18.
36. Grace Hartigan Journal Entry, July 31, 1953, Box 32, Grace Hartigan Papers, Syracuse.
37. Ibid.

38. Albers, *Joan Mitchell,* 199.
39. La Moy and McCaffrey, *The Journals of Grace Hartigan,* 94–95.
40. Grace Hartigan journal entry, August 11, 1953, Box 32, Grace Hartigan Papers, Syracuse.
41. Nemser, *Art Talk,* 235.
42. Albers, *Joan Mitchell,* 198; Malina, *The Diaries of Judith Malina,* 30, 235–37; Gruen, *The Party's Over Now,* 111.
43. Belgrad, *The Culture of Spontaneity,* 181, 193–94; Kaplan, *1959,* 84, 88–89; Michael Magee, "Tribes of New York," 708–9.
44. Lawrence Rivers, "The Heroin Addicts," *Neurotica Quarterly* 7 (Autumn 1950): 41, Larry Rivers Papers, MSS 293, Series II, Subseries A, Box 19, Folder 44, NYU.
45. Frank O'Hara to Larry Rivers, August 4, 1953, Larry Rivers Papers, MSS 293, Series I, Subseries A, Box 11, Folder, 7, NYU.
46. La Moy and McCaffrey, *The Journals of Grace Hartigan,* 96.
47. Ibid.
48. Ibid.
49. Gooch, *City Poet,* 228.
50. Jane Freilicher, interview, Larry Rivers Papers, MSS 293, Series II, Subseries C, Box 25, Folder 28, NYU.
51. Elaine de Kooning, interview by Amei Wallach, 2.
52. Ibid., 3–4.
53. *Jane Freilicher, Painter Among the Poets,* 16.
54. Grace Hartigan to Larry Rivers, n.d. [ca. 1953], Larry Rivers Papers, MSS 293, Series I Subseries A, Box 6, Folder 17, NYU.
55. Larry Rivers to Frank O'Hara, September 18, 1953, Larry Rivers Papers, MSS 293, Series I, Subseries A, Box 11, Folder 8, NYU.
56. Gooch, *City Poet,* 243.
57. Potter, *To a Violent Grave,* 122.
58. Ellen G. Landau, "Channeling Desire," 28.
59. Lee Krasner, unpublished notes, Series 2, Subseries 5, Box 10, Folder 11, Jackson Pollock and Lee Krasner Papers, ca. 1914–1984, AAA-SI, 16; Landau, "Channeling Desire," 28.
60. Lee Krasner, interview by Barbaralee Diamonstein, provided by Dr. Barbaralee Diamonstein-Spielvogel, interviewer and author, from *Inside New York's Art World,* 204–5; Nemser, "A Conversation with Lee Krasner," 45; Hobbs, *Lee Krasner* (1993), 51.
61. *Lee Krasner,* interview by Barbara Novak, videotape courtesy PKHSC; Nemser, "A Conversation with Lee Krasner," 49.
62. Oral history interview with Lee Krasner, November 2, 1964–April 11, 1968, AAA-SI.
63. Landau, *Lee Krasner: A Catalogue Raisonné,* 131, 134; Landau, "Channeling Desire," 27; Levin, *Lee Krasner,* 290; Lee Krasner, interview by Barbara Rose, 1975, GRI; Ellen G. Landau, "Lee Krasner, Collages, 1953–1955," 3–4; oral history interview with Lee Krasner, November 2, 1964–April 11, 1968, AAA-SI.
64. Fairfield Porter, *ArtNews Annual* (1957): 174; Landau, *Lee Krasner: A Catalogue Raisonné,* 131; Rose, *Lee Krasner,* 79.
65. Friedman, *Jackson Pollock: Energy Made Visible,* 220.
66. *Lee Krasner, a Conversation with Hermine Freed,* videotape courtesy PKHSC; Rose, *Lee Krasner: A Retrospective,* 89. Instead of signing her work with her initials "LK" as she had done previously, Lee signed her full name, "Lee Krasner," on two of the large collages from this period.
67. *Lee Krasner,* interview by Barbara Novak, videotape courtesy PKHSC.
68. Naifeh and Smith, *Jackson Pollock,* 699–700, 753.
69. Levin, *Lee Krasner,* 290.
70. Exhibition notices, Series 2, Subseries 8, Box 10, Folder 40, Jackson Pollock and Lee Krasner Papers, ca. 1914–1984, AAA-SI, 4, 7, 9.
71. Lee Krasner, unpublished notes, Series 2, Subseries 5, Box 10, Folder 11, Jackson Pollock and Lee Krasner Papers, ca. 1914–1984, AAA-SI, 9–10; Landau, "Channeling Desire," 28.
72. Potter, *To a Violent Grave,* 157.
73. Naifeh and Smith, *Jackson Pollock,* 695, 723–25.

74. Friedman, *Jackson Pollock: Energy Made Visible*, 205; Naifeh and Smith, *Jackson Pollock*, 727.
75. Wetzsteon, *Republic of Dreams*, 472, 481; Dan Wakefield, *New York in the Fifties*, 130.
76. Oral history interview with Ibram Lassaw and Ernestine Lassaw, AAA-SI.
77. Wetzsteon, *Republic of Dreams*, 482–83.
78. Ibid., 483–84.
79. Ibid., 484–85.
80. Ibid., 486.
81. Sara W. Tracy, *Alcoholism in America*, 1, 3.
82. Ibid., 276, 279; Rotskoff, *Love on the Rocks*, 61–62, 198–99. In the late 1940s, 75 percent of American men and 65 percent of American women drank.
83. Rotskoff, *Love on the Rocks*, 86, 92.
84. Malina, *The Diaries of Judith Malina*, 301–2.
85. Ibid., 302.
86. Ibid.
87. "Abstract Expressionism," December 23, 1953, warholstars.org.

40. A Change of Art

1. "NO! Boris Lurie," David David Gallery, 6.
2. Gooch, *City Poet*, 252–53; Grace Hartigan to Larry Rivers, November 14, 1953, Sunday, Larry Rivers Papers, MSS 293, Series I, Subseries A, Box 6, Folder 17, NYU.
3. Rivers, *What Did I Do?*, 314.
4. Larry Rivers, interview by Nell Blaine, unpublished notes, Larry Rivers Papers, MSS 293, Series II, Subseries C, Box 25, Folder 23, NYU; Larry Rivers, interview by Barbaralee Diamonstein, provided by Dr. Barbaralee Diamonstein-Spielvogel, interviewer and author, from *Inside New York's Art World*, 321–22.
5. Larry Rivers to Grace Hartigan, September 10, 1953, Box 24, Grace Hartigan Papers, Syracuse.
6. Larry Rivers to Elaine de Kooning, n.d. [ca. fall 1953], Larry Rivers Papers, MSS 293, Series I, Subseries A, Box 3, Folder 31, NYU.
7. Gooch, *City Poet*, 253. He said later, in any case, she was "too big, too wordy." He preferred "babysitters."
8. Grace Hartigan to Larry Rivers, November 14, 1953, Sunday, Larry Rivers Papers, MSS 293, Series I, Subseries A, Box 3, Folder 17, NYU.
9. John Bernard Myers to Grace Hartigan, August 1954, New York to Southampton, Box 21, Grace Hartigan Papers, Syracuse; La Moy and McCaffrey, *The Journals of Grace Hartigan*, 107 8.
10. La Moy and McCaffrey, *The Journals of Grace Hartigan*, 107–9.
11. Ibid., 108–9.
12. Nemser, *Art Talk*, 157; Nemser, "Grace Hartigan: Abstract Artist," 33; La Moy and McCaffrey, *The Journals of Grace Hartigan*, 117.
13. Mattison, *Grace Hartigan*, 34; Nemser, *Art Talk*, 157.
14. Schimmel et al., *Action/Precision*, 36.
15. Sandler, *Sweeper Up After Artists*, 33; Les Levine, "Suffer, Suffer, Suffer," 38; Ashton, *The New York School*, 209; Clement Greenberg, "Abstract and Representational," 7. Declared Clem in a lecture at Yale at the time, "The best art of our day tends, increasingly, to be abstract. And most attempts to reverse this tendency seem to result in second-hand, second-rate painting....In fact, it seems as though, today, the image and object can be put back into art only by *pastiche* or parody."
16. Elaine de Kooning, "Subject: What, How or Who?," 62.
17. Faulkner, "Banquet Speech," nobelprize.org; Miller and Nowak, *The Fifties*, 22–23, 89; Halberstam, *The Fifties*, 345, 347, 406, 410; Zinn, *A People's History*, 341; Diggins, *The Proud Decades*, 279, 283; Stone, *The Haunted Fifties*, 61; Belgrad, "The Culture of Spontaneity," 144. A national survey found that three-quarters of Americans were prepared to report their neighbors to authorities if they suspected them of communism.
18. Caute, *The Great Fear*, 106.
19. Zinn, *A People's History of the United States*, 430, 436; Miller and Nowak, *The Fifties*, 32, 36; Caute, *The Great Fear*, 107.

20. Miller and Nowak, *The Fifties*, 36; Clements, *Prosperity, Depression and the New Deal*, 236; Caute, *The Great Fear*, 108; Malina, *The Diaries of Judith Malina*, 323. Malina said the hearings absorbed everyone's attention.
21. "McCarthy Army Hearings Begin," April 22, 1954, www.history.com.
22. Morton Borden, *Voices of the American Past*, 341; Stone, *The Haunted Fifties*, 61, 72; Miller and Nowak, *The Fifties*, 37; Caute, *The Great Fear*, 107–8; Diggins, *The Proud Decades*, 152.
23. Miller and Nowak, *The Fifties*, 234–35; Diggins, *The Proud Decades*, 199, 201.
24. Kaplan, *1959*, 77.
25. Miller and Nowak, *The Fifties*, 292, 295–96; Zinn, *A People's History of the United States*, 442.
26. Oral history interview with Elaine de Kooning, AAA-SI.
27. Gruen, *The Party's Over Now*, 175.
28. Schloss, "The Loft Generation," Edith Schloss Burckhardt Papers, Columbia, 32; Sherman Drexler, telephone interview by author. Elaine later dismissed any suggestion of unseemly promiscuity, saying that of course there had been coupling within that circle—they didn't know anyone else!
29. Schloss, "The Loft Generation," Edith Schloss Burckhardt Papers, Columbia, 32.
30. Gruen, *The Party's Over Now*, 197.
31. Sandler, *A Sweeper Up After Artists*, 41–42.
32. Pacini, *Marisol*, 159.
33. Ibid., 12; Marisol, interview by Colette Roberts, AAA-SI.
34. Marina Pacini, *Marisol*, 12.
35. Ibid.; Marisol, interview by John Gruen, AAA-SI, 5.
36. Marisol, interview by John Gruen, AAA-SI, 35; Gruen, *The Party's Over Now*, 205.
37. Pacini, *Marisol*, 14.
38. Berman, *All That Is Solid Melts into Air*, 14.
39. Allen, *The Collected Poems of Frank O'Hara*, 513.
40. Elaine de Kooning, "Two Americans in Action," 90.
41. Pacini, *Marisol*, 117.
42. Marisol, interview by John Gruen, AAA-SI, 33; Gruen, *The Party's Over Now*, 204.
43. Gruen, *The Party's Over Now*, 204.
44. Elaine de Kooning, interview by Antonina Zara, 27.
45. Elaine de Kooning, interview by Amei Wallach, 5.
46. Dorfman, *Out of the Picture*, 299.
47. Clay Fried, interview by author.
48. Elaine de Kooning to Larry Rivers, n.d., Larry Rivers Papers, MSS 293, Series I, Subseries A, Box 3, Folder 31, NYU.
49. Elaine de Kooning, interview by Antonina Zara, 27.
50. Elaine de Kooning, interview by Molly Barnes, 5; Chancey, "Elaine de Kooning," 114, 117; Lewallen, "Interview with Elaine de Kooning," 14.
51. Helen Harrison, telephone interview by author.
52. "Elaine de Kooning Statement," *It Is* 5 (Spring 1960): 29; "Elaine de Kooning, Portraits," The Art Gallery, Brooklyn College, 9.
53. Rose Slivka, "Elaine de Kooning: The Bacchus Paintings," 68.
54. Clay Fried, interview by author.
55. Elaine de Kooning to Aristodemos Kaldis, June 1952, Aristodemos Kaldis Papers, Roll D177, AAA-SI.
56. Elaine de Kooning, interview by Antonina Zara, 34.
57. Elaine de Kooning to Larry Rivers, February 26–March 4, 1954, Larry Rivers Papers, MSS 293, Series I, Subseries A, Box 3, Folder 31, NYU.
58. James Thrall Soby, Lloyd Goodrich, John I. H. Baur, and Dorothy C. Miller, "The Eastern Seaboard," 10–11, 18; Tibor de Nagy pamphlet for 1954 Grace Hartigan exhibition, Box 36, Grace Hartigan Papers, Syracuse.
59. La Moy and McCaffrey, *The Journals of Grace Hartigan*, 126.
60. Ibid.
61. Ibid.
62. Frank O'Hara, "Reviews and Previews, George Hartigan," 45.

63. Larry Rivers to Grace Hartigan, February 9, 1954, Long Island to New York City, Box 24, Grace Hartigan Papers, Syracuse.
64. Tibor de Nagy to Sandra L. Langar, July 17, 1980, New York to Columbia, South Carolina, Tibor de Nagy Gallery Records, 1941–1993, Series 1, Subseries 5, Box 7, Folder 12, AAA-SI.
65. La Moy and McCaffrey, *The Journals of Grace Hartigan*, 119, 123–26.
66. Ibid.
67. Frank O'Hara to Grace Hartigan, February 20 [1954], Frank O'Hara folder, Box 22, Grace Hartigan Papers, Syracuse.
68. La Moy and McCaffrey, *The Journals of Grace Hartigan*, 127–28, 138; Curtis, *Restless Ambition*, 124.
69. Hermine Ford, interview by author; Levy, *Memoir of an Art Gallery*, 19; Grace Hartigan to Larry Rivers, postmarked April 16, 1954, Larry Rivers Papers, MSS 293, Series I, Subseries A, Box 6, Folder 17, NYU.
70. La Moy and McCaffrey, *The Journals of Grace Hartigan*, 104, 117 126; Grace Hartigan to Larry Rivers, postmarked April 16, 1954, Larry Rivers Papers, MSS 293, Series I, Subseries A, Box 6, Folder 17, NYU.
71. John Bernard Myers, transcript of interview by Barbara Rose, n.d., Series II, Box 1, Folder 26, Barbara Rose Papers, GRI (930100), 29–30.
72. Ibid.; Gruen, *The Party's Over Now*, 216; De Coppet and Jones, *The Art Dealers*, 46.
73. Hermine Ford, interview by author.
74. Elaine de Kooning, interview by John Gruen, AAA-SI, 9.
75. Hermine Ford, interview by author; oral history interview with Tibor de Nagy, AAA-SI; Josephine Novak, "Tracking the Marvelous Grace Hartigan," *Baltimore Evening Sun*, n.d. [ca. 1983], C5.
76. La Moy and McCaffrey, *The Journals of Grace Hartigan*, 104.
77. Alexander Bing to Grace Hartigan, April 20, 1954, Athens, Greece, to New York, Box 4, Grace Hartigan Papers, Syracuse; Grace Hartigan to Larry Rivers, postmarked April 16, 1954, Larry Rivers Papers, MSS 293, Series I, Subseries A, Box 6, Folder 17, NYU.
78. Alexander Bing to Grace Hartigan, May 15, 1954, Madrid to New York, Box 4, Grace Hartigan Papers, Syracuse.
79. Alexander Bing to Grace Hartigan, April 22, 1954, Athens, Greece, to New York, Box 4, Grace Hartigan Papers, Syracuse; La Moy and McCaffrey, *The Journals of Grace Hartigan*, 126.
80. Dorothy Miller to Grace Hartigan, June 8, 1954, Museum of Modern Art File, Box 21, Grace Hartigan Papers, Syracuse.
81. Dorothy Miller to Grace Hartigan, July 2, 1954, Museum of Modern Art File, Box 21, Grace Hartigan Papers, Syracuse.
82. Fairfield Porter, "Reviews and Previews, Elaine de Kooning," 45.
83. Ibid.
84. Elaine de Kooning, "Renoir: As If by Magic," 43.
85. Elaine de Kooning, "My First Exhibition...To Now," 1; Grace Hartigan to Larry Rivers, Tuesday March 2 [n.d.], Larry Rivers Papers, MSS 293, Series I, Subseries A, Box 6, Folder 17, NYU.
86. Campbell, "Elaine de Kooning Paints a Picture," 63; "Elaine de Kooning Portraits," The Art Gallery, Brooklyn College, 15; Sandler, *A Sweeper Up After Artists*, 184; Irving Sandler, interview by author.
87. Stahr, "The Social Relations of Abstract Expressionism," 217.
88. Elaine de Kooning to Larry Rivers, February 26–March 4, 1954, Larry Rivers Papers, MSS 293, Series I, Subseries A, Box 3, Folder 31, NYU.
89. Stevens and Swan, *De Kooning*, 87–88, 282, 382; Elaine de Kooning to Larry Rivers, February 26–March 4, 1954, Larry Rivers Papers, MSS 293, Series I, Subseries A, Box 3, Folder 31, NYU.
90. Stevens and Swan, *De Kooning*, 382; Wakefield, *New York in the Fifties*, 233–36. Wakefield writes abortions were legal in a hospital if the woman had "psychiatric reasons" for obtaining one or if her life was threatened. But many women resorted to illegal abortions. In 1956, *Reader's Digest* estimated conservatively that well over three hundred thousand such abortions were performed annually in the United States.
91. Lieber, *Reflections in the Studio*, 40.
92. Ibid.

41. Life or Art

1. "Helen Frankenthaler: A Retrospective," Modern Art Museum of Fort Worth, September–October 1989 Calendar, Office of the Director, 1.
2. Helen Frankenthaler to Grace Hartigan, February 23, 1961, Box 12, Grace Hartigan Papers, Syracuse.
3. Poydinecz-Conley, unpublished interview with Helen Frankenthaler, HFF.
4. Ibid.
5. Ibid.
6. Helen Frankenthaler to Clement Greenberg, postcard, August 15, 1953, Spain to New York, Series 3, Box 3, Folder 38, the Clement Greenberg Papers, 1937–1983, AAA-SI.
7. Poydinecz-Conley, unpublished interview with Helen Frankenthaler, HFF.
8. Ibid.
9. Helen Frankenthaler to Clement Greenberg, postcard, August 9, 1953, Spain to New York, Series 3, Box 3, Folder 38, the Clement Greenberg Papers, 1937–1983, AAA-SI; Helen Frankenthaler to Clement Greenberg, postcard, July 26, 1953, Spain to New York, Series 3, Box 3, Folder 38, the Clement Greenberg Papers, AAA-SI; Helen Frankenthaler to Clement Greenberg, postcard, July 23, 1953, Madrid to New York, Series 3, Box 3, Folder 38, the Clement Greenberg Papers, AAA-SI.
10. Helen Frankenthaler to Clement Greenberg, postcard, August 24, 1953, France to New York, Series 3, Box 3, Folder 38, the Clement Greenberg Papers, 1937–1983, AAA-SI.
11. Helen Frankenthaler to Clement Greenberg, postcard, August 25, 1953, Cannes, France, to New York, Series 3, Box 3, Folder 38, the Clement Greenberg Papers, 1937–1983, AAA-SI.
12. Helen Frankenthaler to Clement Greenberg, postcard, August 27, 1953, Clement Greenberg Papers, 1937–1983, AAA-SI; Helen Frankenthaler, interview by John Gruen, AAA-SI, 6–8.
13. Helen Frankenthaler to Sonya Gutman, February 12, 1954, Box 1, Folder 6, Sonya Rudikoff Papers, 1935–2000, Princeton, 1.
14. Friedel Dzubas, interview by Charles Millard, AAA-SI; Millard, *Friedel Dzubas*, 26.
15. Helen Frankenthaler to Sonya Gutman, February 12, 1954, Box 1, Folder 6, Sonya Rudikoff Papers, 1935–2000, Princeton, 1.
16. La Moy and McCaffrey, *The Journals of Grace Hartigan*, 107; John Bernard Myers to Helen Frankenthaler, postcard, January 30, 1954, Helen Frankenthaler Papers, HFF.
17. La Moy and McCaffrey, *The Journals of Grace Hartigan*, 107. It was an almost refreshing twist on that old theme because instead of being accused of using her feminine wiles on behalf of a husband painter, Grace was accused of using them to promote herself.
18. Helen Frankenthaler to Sonya Gutman, February 12, 1954, Box 1, Folder 6, Sonya Rudikoff Papers, 1935–2000, Princeton, 2.
19. La Moy and McCaffrey, *The Journals of Grace Hartigan*, 119.
20. Helen Frankenthaler to Sonya Rudikoff, February 12, 1954, Box 1, Folder 6, Sonya Rudikoff Papers, 1935–2000, Princeton, 1–2. Among the paintings worth mentioning, Helen felt, was one by Bob Motherwell.
21. Seitz, *Abstract Expressionist Painting in America*, 165.
22. Helen Frankenthaler to Sonya Gutman, February 12, 1954, Box 1, Folder 6, Sonya Rudikoff Papers, 1935–2000, Princeton, 1.
23. Uniform Crime Reports for the United States, issued by the Federal Bureau of Investigation, U.S. Department of Justice, Washington, DC, *Annual Bulletin* 25, no. 2 (1954), National Archive of Criminal Justice Data, icpsr.umich.edu, 69–70.
24. LeSueur, *Digressions on Some Poems by Frank O'Hara*, 42; Gooch, *City Poet*, 194.
25. Malina, *The Diaries of Judith Malina*, 312; Alan M. Wald, *American Night*, 250; Edward Field and Dylan Foley, "The Last Bohemians," April 1, 2013, lastbohemians.blogspot.com/.
26. Helen Frankenthaler to Sonya Gutman, February 12, 1954, Box 1, Folder 6, Sonya Rudikoff Papers, 1935–2000, Princeton, 3.
27. Malina, *The Diaries of Judith Malina*, 312.
28. Gooch, *City Poet*, 250–51.
29. Kenneth Koch notes for "On Frank O'Hara," July 7, 1988, Box 166, Folder 3, Kenneth Koch Papers, NYPL; Gooch, *City Poet*, 250.

30. Gooch, *City Poet*, 251; Berkson and LeSueur, *Homage to Frank O'Hara*, 82.
31. Gooch, *City Poet*, 250–51; Kenneth Koch notes for "On Frank O'Hara," July 7, 1988, Box 166, Folder 3, Kenneth Koch Papers, NYPL.
32. Gooch, *City Poet*, 250–51.
33. Lehman, *The Last Avant-Garde*, 72.
34. Kenneth Koch notes for "On Frank O'Hara," July 7, 1988, Box 166, Folder 3, Kenneth Koch Papers, NYPL.
35. LeSueur, *Digressions on Some Poems by Frank O'Hara*, 40–41.
36. Kenneth Koch notes for "On Frank O'Hara," July 7, 1988, Box 166, Folder 3, Kenneth Koch Papers, NYPL.
37. Gooch, *City Poet*, 251; Kenneth Koch notes for "On Frank O'Hara," July 7, 1988, Box 166, Folder 3, Kenneth Koch Papers, NYPL.
38. Frank O'Hara to Ben Weber, March 20, 1954, Southampton, Donald Allen Collection of Frank O'Hara Letters, UConn.
39. Frank O'Hara to Grace Hartigan, March 17, 1954, Southampton to New York, Box 22, Grace Hartigan Papers, Syracuse.
40. Helen Frankenthaler to Sonya Gutman, March 15, 1954, Box 1, Folder 6, Sonya Rudikoff Papers, 1935–2000, Princeton, 1.
41. Fred Iseman, interview by author. Helen's nephew Fred Iseman heard the story of just how much so from his mother, Helen's eldest sister, Marjorie, who had been asked to lunch by a Vassar friend not long after Helen's move. Meeting at Longchamps on 78th and Madison, a restaurant Fred called "very much a 'ladies who lunch place,'" Marjorie wasn't sure why her friend had wanted to see her so particularly. Finally, she came around to it and said, "Marjorie is it true what I hear?"
"About what?" my mother said.
"About your younger sister, Helen."
"What did you hear about Helen?"
"Well, that she's living with a man on the *West Side*."
"My mother could never get over the fact that, living with a man, fine, but on the *West Side!*" Fred said.
42. Clement Greenberg Diary, 1954, Series II, Box 19, Clement Greenberg Papers, GRI (950085); Rubenfeld, *Clement Greenberg*, 186; Helen Frankenthaler, interview by John Gruen, AAA-SI; Clement Greenberg Journal, June 3, 1956, Box 16, Folder 3, Journal 18, Series II, Clement Greenberg Papers, GRI (950085).
43. Helen Frankenthaler to Clement Greenberg, postcard, August 15, 1953, Spain to New York, Series 3, Box 3, Folder 38, the Clement Greenberg Papers, 1937–1983, AAA-SI; Belasco, "Between the Waves," 62.
44. Rubenfeld, *Clement Greenberg*, 186.
45. Helen Frankenthaler to Sonya Gutman, March 15, 1954, Box 1, Folder 6, Sonya Rudikoff Papers, 1935–2000, Princeton, 1.
46. Don Cyr, "A Conversation with Helen Frankenthaler," 31–32.
47. Grace Hartigan to Clement Greenberg, April 1, 1954, Box 13, Grace Hartigan Papers, Syracuse.
48. Larry Rivers to Helen Frankenthaler, "Thursday" April [16], 1954, Helen Frankenthaler Papers, HFF.
49. Grace Hartigan to Clement Greenberg, April 1, 1954, Box 13, Grace Hartigan Papers, Syracuse.
50. Nicolas Calas, *Art in the Age of Risk*, xii.
51. Varnadoe with Karmel, *Jackson Pollock*, 46.
52. Mary Abbott, interview by author.
53. Clifford Ross, interview by author, January 15, 2014.
54. Nemser, "Art Talk, Forum Women in Art," 18.
55. Clement Greenberg Appointment Book, April 22, 1954, Series II, Box 19, Clement Greenberg Papers, GRI (950085); Fred Iseman, interview by author; Elderfield, "Painted on 21st Street," 54.
56. Fred Iseman, interview by author.
57. Ellen M. Iseman, interview by author.

58. Fred Iseman, interview by author; Clifford Ross, interview by author, January 15, 2014; Helen Frankenthaler to Sonya Gutman, February 12, 1954, Box 1, Folder 6, Sonya Rudikoff Papers, 1935–2000, Princeton, 3.
59. Helen Frankenthaler to Sonya Gutman, March 15, 1954, Box 1, Folder 6, Sonya Rudikoff Papers, 1935–2000, Princeton.
60. Helen Frankenthaler to Sonya Gutman, postmarked March 30, 1954, Box 1, Folder 6, Sonya Rudikoff Papers, 1935–2000, Princeton, 1.
61. Clement Greenberg Appointment Book, February 7, 1954–April 20, 1954, Series II, Box 19, Clement Greenberg Papers, GRI (950085).
62. Clement Greenberg Appointment Book, April 22, 1954, Series II, Box 19, Clement Greenberg Papers, GRI (950085).
63. Fred Iseman, interview by author; Clifford Ross, interview by author, January 15, 2014.
64. Poydinecz-Conley, unpublished interview with Helen Frankenthaler, HFF.
65. Ibid.
66. Ibid.
67. Clement Greenberg Appointment Book, April 25, 1954, Series II, Box 19, Clement Greenberg Papers, GRI (950085).
68. Helen Frankenthaler, interview by Deborah Solomon.
69. Ibid.
70. Rubenfeld, *Clement Greenberg,* 186.
71. Helen Frankenthaler to Barbara Guest, July 3, 1954, New York to Reno, Nevada, Box 16, Uncat ZA MS 271, Barbara Guest Papers, Yale.
72. Ibid.
73. Helen Frankenthaler to Sonya Gutman, July 2, 1954, Box 1, Folder 6, Sonya Rudikoff Papers, 1935–2000, Princeton, 1.
74. Helen Frankenthaler to Barbara Guest, July 16, 1954, New York to Reno, Nevada, Box 16, Uncat ZA MS 271, Barbara Guest Papers, Yale.
75. Rubenfeld, *Clement Greenberg,* 186; Helen Frankenthaler to Sonya Gutman, July 2, 1954, Box 1, Folder 6, Sonya Rudikoff Papers, 1935–2000, Princeton, 1.
76. Clement Greenberg Journal, June 3, 1956, Box 16, Folder 3, Journal 18, Series II, Clement Greenberg Papers, GRI (950085).
77. Fred Iseman, interview by author; Rubenfeld, *Clement Greenberg,* 186. Clem made about seven thousand dollars a year, more than the average household earnings of five thousand dollars but not even close to Helen's wealth.
78. Clement Greenberg Journal, June 3, 1956, Box 16, Folder 3, Journal 18, Series II, Clement Greenberg Papers, GRI (950085); Clement Greenberg Journal, June 7, 1955, Box 16, Folder 2, Journal 17, Clement Greenberg Papers, GRI (950085).
79. Rubenfeld, *Clement Greenberg,* 186.
80. Clement Greenberg Journal, January 10, 1957, Box 16, Folder 3, Journal 18, Clement Greenberg Papers, GRI (950085).
81. Marquis, *Art Czar,* 139–40.
82. Ibid.
83. Helen Frankenthaler to Sonya Gutman, postcard, September 6, 1954, Padua, Italy, to Hanover, New Hampshire, Box 1, Folder 6, Sonya Rudikoff Papers, 1935–2000, Princeton.
84. Helen Frankenthaler to Sonya Gutman, postmarked November 8, Box 1, Folder 6, Sonya Rudikoff Papers, 1935–2000, Princeton, 6.
85. Helen Frankenthaler to Sonya Gutman, October 15, 1954, Box 1, Folder 6, Sonya Rudikoff Papers, 1935–2000, Princeton, 1.
86. Helen Frankenthaler to Sonya Gutman, postmarked November 8, Box 1, Folder 6, Sonya Rudikoff Papers, 1935–2000, Princeton, 3, 4.
87. Peggy Guggenheim guestbook page, November 9, 1954, Helen Frankenthaler Papers, HFF.
88. Helen Frankenthaler to Sonya Gutman, October 15, 1954, Box 1, Folder 6, Sonya Rudikoff Papers, 1935–2000, Princeton, 1.
89. Myers, *Tracking the Marvelous,* 155.
90. Rubenfeld, *Clement Greenberg,* 186; Marquis, *Art Czar,* 141.

91. Elderfield, "Painted on 21st Street," 54; Helen Frankenthaler to Sonya Gutman, postmarked November 8, 1954, Box 1, Folder 6, Sonya Rudikoff Papers, 1935–2000, Princeton, 1, 2.

42. The Red House

1. Joan Mitchell to Barney Rosset, August 26, 1979, Paris to New York, JMFA003, JMF.
2. Elaine de Kooning, interview by Jeffrey Potter, courtesy PKHSC.
3. Ibid.
4. Ibid.
5. Lieber, *Reflections in the Studio*, 40; Harrison and Denne, *Hamptons Bohemia*, 79.
6. Lieber, *Reflections in the Studio*, 40.
7. Oral history interview with Ludwig Sander, AAA-SI.
8. Lieber, *Reflections in the Studio*, 40.
9. Ibid.
10. Larry Rivers to Grace Hartigan, June 16, 1954, Southampton to New York, Box 24, Grace Hartigan Papers, Syracuse.
11. Frank O'Hara to Larry Rivers, June 4, 1954, Larry Rivers Papers, MSS 293, Series I, Subseries A, Box 11, Folder 8, NYU.
12. Oral history interview with Ludwig Sander, AAA.
13. Stevens and Swan, *De Kooning*, 370.
14. Lieber, *Reflections in the Studio*, 41.
15. Stevens and Swan, *De Kooning*, 375.
16. Lieber, *Reflections in the Studio*, 40; Stevens and Swan, *De Kooning*, 375.
17. Lieber, *Reflections in the Studio*, 40; Stevens and Swan, *De Kooning*, 377.
18. Lieber, *Reflections in the Studio*, 40; Dorfman, *Out of the Picture*, 294.
19. Stevens and Swan, *De Kooning*, 376.
20. Dorfman, *Out of the Picture*, 294–95.
21. Stevens and Swan, *De Kooning*, 376–77.
22. Ibid.
23. Ibid., 373.
24. Oral history interview with Ludwig Sander, AAA-SI.
25. Elaine de Kooning and Slivka, *Elaine de Kooning*, 27; Stevens and Swan, *De Kooning*, 163.
26. Stahr, "The Social Relations of Abstract Expressionism," 166. There are many variations on this story, with other characters playing catcher, pitcher, and basemen. The common thread is that Elaine was behind the prank and painted the grapefruit and that Philip Pavia was at bat.
27. Solomon, *Jackson Pollock*, 239.
28. Naifeh and Smith, *Jackson Pollock*, 731–32.
29. Friedman, *Jackson Pollock: Energy Made Visible*, 214; Solomon, *Jackson Pollock*, 242.
30. Potter, *To a Violent Grave*, 189, 197; Levin, *Lee Krasner*, 292.
31. Potter, *To a Violent Grave*, 189; Naifeh and Smith, *Jackson Pollock*, 735.
32. Potter, *To a Violent Grave*, 198.
33. Ibid., 198–99.
34. Ibid., 199.
35. Robert McG. Thomas Jr., "Patsy Southgate, Who Inspired 50's Literary Paris, Dies at 70," July 26, 1998, www.nytimes.com/1998/.../26/.../patsy-southgate-who-inspired-50-s; Gooch, *City Poet*, 307.
36. Gooch, *City Poet*, 30; "Joan Mitchell," transcript Barney/Sandy interview, January 21, 2004, Barney Rosset Papers, Tape 5, Side 1, Series II, Box 3, Folder 5, Columbia. At Smith, where Patsy went to college, one professor admitted going to the pool just to watch her swim. "It was the highlight of his day," said Barney, who knew the smitten fellow.
37. Naifeh and Smith, *Jackson Pollock*, 734–35; Potter, *To a Violent Grave*, 189.
38. Naifeh and Smith, *Jackson Pollock*, 736.
39. Harrison, "East Hampton Avant-Garde," 13; Lieber, *Reflections in the Studio*, 128n74.
40. Potter, *To a Violent Grave*, 208; Harrison, "East Hampton Avant-Garde," 13; Harrison and Denne, *Hamptons Bohemia*, 100.
41. Potter, *To a Violent Grave*, 208; Naifeh and Smith, *Jackson Pollock*, 736.
42. Potter, *To a Violent Grave*, 202.

43. Lieber, *Reflections in the Studio*, 41.
44. Mary Abbott, interview by author.
45. Lieber, *Reflections in the Studio*, 39.
46. Elaine de Kooning, interview by Jeffrey Potter, courtesy PKHSC.
47. Ibid.
48. Potter, *To a Violent Grave*, 201.
49. Naifeh and Smith, *Jackson Pollock*, 736.
50. Potter, *To a Violent Grave*, 205; Naifeh and Smith, *Jackson Pollock*, 736.
51. Potter, *To a Violent Grave*, 201–2.
52. Ibid., 202.
53. Ibid.
54. Ibid., 202–3.
55. Miriam Schapiro to Grace Hartigan, June 19, 1954, Box 25, Grace Hartigan Papers, Syracuse.
56. Joan Mitchell to Mike Goldberg, dated "Friday afternoon" [June 18, 1954], postmarked June 19, 1954, Michael Goldberg Papers, 1942–1981, AAA-SI.
57. Ibid.
58. Ibid.
59. Alison Lurie, *V. R. Lang*, 46.
60. Marion Strobel to Joan Mitchell, June 9, 1954, Chicago to New York, JMFA001, JMF.
61. "Grove Genesis," interview with Barney Rosset, Barney Rosset Papers, Series II, Box 3, Folder 34, Disk 12, Columbia.
62. Kaplan, *1959*, 46.
63. Gooch, *City Poet*, 148.
64. Joan Mitchell to Mike Goldberg, dated "Friday afternoon" [June 18, 1954], postmarked June 19, 1954, Michael Goldberg Papers, 1942–1981, AAA-SI.
65. Lurie, *V. R. Lang*, 5, 9, 11.
66. Ibid., 3; Gooch, *City Poet*, 75.
67. Lurie, *V. R. Lang*, 3.
68. Ibid., 27.
69. Ibid., 13, 36.
70. Ibid., 13.
71. Ibid., 37–38.
72. Gooch, *City Poet*, 270.
73. Ibid.; Albers, *Joan Mitchell*, 202.
74. Lurie, *V. R. Lang*, 46.
75. Bunny Lang to Mike Goldberg, undated, Michael Goldberg Papers, 1942–1981, AAA-SI.
76. Lurie, *V. R. Lang*, 46–47, 49–50.
77. Ibid.; Gooch, *City Poet*, 271.
78. Lurie, *V. R. Lang*, 50.
79. Ibid., 52–53.
80. Bunny Lang to Mike Goldberg, July 13, 1954, Michael Goldberg Papers, 1942–1981, AAA-SI.
81. Lurie, *V. R. Lang*, 53, 62–63; Gooch, *City Poet*, 272; Albers, *Joan Mitchell*, 215. Bunny's play would be awarded a prize in *Poetry* magazine the next year.
82. Albers, *Joan Mitchell*, 204–5.
83. Ibid., 205.
84. Hermine Ford, interview by author.
85. Albers, *Joan Mitchell*, 206.
86. Ibid., 207.
87. Natalie Edgar, interview by author, October 20, 2014.
88. Joan Mitchell to Mike Goldberg, August 13, 1954, Michael Goldberg Papers, 1942–1981, AAA-SI.
89. Albers, *Joan Mitchell*, 207.
90. Ibid.
91. Cajori, *Joan Mitchell: Portrait of an Abstract Painter*, film.
92. Joan Mitchell to Mike Goldberg, dated "Friday afternoon" [June 18, 1954], postmarked June 19, 1954, Michael Goldberg Papers, 1942–1981, AAA-SI.

93. Joan Mitchell to Mike Goldberg, August 28, 1954, Chicago to New York, Michael Goldberg Papers, 1942–1981, AAA-SI; Albers, *Joan Mitchell*, 207.
94. Cajori, *Joan Mitchell: Portrait of an Abstract Painter*, film.
95. Joan Mitchell to Mike Goldberg, August 19, 1954, Michael Goldberg Papers, 1942–1981, AAA-SI.
96. Joan Mitchell to Mike Goldberg, July 31, 1954, Michael Goldberg Papers, 1942–1981, AAA-SI.
97. Ibid.
98. Ibid.
99. Joan Mitchell to Mike Goldberg, August 13, 1954, Michael Goldberg Papers, 1942–1981, AAA-SI.
100. Joan Mitchell to Mike Goldberg, August 28, 1954, Chicago to New York, Michael Goldberg Papers, 1942–1981, AAA-SI.
101. Albers, *Joan Mitchell*, 211; Joan Mitchell to Mike Goldberg, August 28, 1954, Michael Goldberg Papers, 1942–1981, AAA-SI; Joan Mitchell to Mike Goldberg, n.d., Michael Goldberg Papers, 1942–1981, AAA-SI; Joan Mitchell to Mike Goldberg, n.d., Grand Hotel du Mont Blanc, Paris, to New York, Michael Goldberg Papers, 1942–1981, AAA-SI.
102. Joan Mitchell to Mike Goldberg, August 20, 1954, Michael Goldberg Papers, 1942–1981, AAA-SI.
103. Lieber, *Reflections in the Studio*, 43; Harrison and Denne, *Hamptons Bohemia*, 80.
104. Lieber, *Reflections in the Studio*, 44; Hall, *Elaine and Bill*, 168.
105. Lieber, *Reflections in the Studio*, 44; Harrison and Denne, *Hamptons Bohemia*, 80; Lindsey Gruson, "Is It Art or Just a Toilet Seat? Bidders to Decide on a de Kooning," *New York Times*, January 15, 1992; "Bidders Close Wallets, Lid on Toilet Seat Painting," articles.orlandosentinel.com/1992-03-01/news/9203010383. Elaine called the notion that the toilet counted as a painting "ridiculous."
106. Lieber, *Reflections in the Studio*, 44; Hall, *Elaine and Bill*, 168; Stevens and Swan, *De Kooning*, 373–74.
107. Lieber, *Reflections in the Studio*, 44; Stevens and Swan, *De Kooning*, 373.
108. Lieber, *Reflections in the Studio*, 44; Stevens and Swan, *De Kooning*, 374.
109. La Moy and McCaffrey, *The Journals of Grace Hartigan*, 147; Frank O'Hara to Kenneth Koch, August 14, 1954, Series XI, Kenneth Koch Papers, NYPL.
110. Joan Mitchell to Mike Goldberg, August 10, 1954, Michael Goldberg Papers, 1942–1981, AAA-SI.
111. Frank O'Hara to Grace Hartigan, May 21, 1954, 1:98, Allen Collection of Frank O'Hara Letters, UConn.
112. La Moy and McCaffrey, *The Journals of Grace Hartigan*, 144; Berkson and LeSueur, *Homage to Frank O'Hara*, 29. The *Folder* crew included Daisy Aldan, Olga Petroff, Richard Miller, and print impresario Floriano Vecchi.
113. La Moy and McCaffrey, *The Journals of Grace Hartigan*, 142.
114. Grace Hartigan to Larry Rivers, postmarked April 16, 1954, Larry Rivers Papers, MSS 293, Series I, Subseries A, Box Folder 17, NYU.
115. John Bernard Myers to Grace Hartigan, August 1954, New York to Southampton, Box 21, Grace Hartigan Papers, Syracuse.
116. Myers, *Tracking the Marvelous*, 197; Albers, *Joan Mitchell*, 206.
117. Potter, *To a Violent Grave*, 208.
118. Myers, *Tracking the Marvelous*, 197.
119. Potter, *To a Violent Grave*, 198; Naifeh and Smith, *Jackson Pollock*, 739.
120. Stevens and Swan, *De Kooning*, 373.
121. Elaine de Kooning, interview by John Gruen, AAA-SI, 12.
122. Hall, *Elaine and Bill*, 169.
123. Lieber, *Reflections in the Studio*, 44; Malina, *The Diaries of Judith Malina*, 340.
124. Albers, *Joan Mitchell*, 212; Stevens and Swan, *De Kooning*, 374.
125. Lieber, *Reflections in the Studio*, 44–45.
126. Ibid., 45.
127. Ibid.; Naifeh and Smith, *Jackson Pollock*, 739.
128. Albers, *Joan Mitchell*, 213.
129. Lieber, *Reflections in the Studio*, 45.
130. Potter, *To a Violent Grave*, 206.
131. Ibid.
132. Ibid.; Naifeh and Smith, *Jackson Pollock*, 739–40.

133. Potter, *To a Violent Grave*, 206–7; Naifeh and Smith, *Jackson Pollock*, 740.
134. Naifeh and Smith, *Jackson Pollock*, 740.

43. The Grand Girls, I

1. Hess and Baker, *Art and Sexual Politics*, 84–85.
2. La Moy and McCaffrey, *The Journals of Grace Hartigan*, 151; René d'Harnoncourt, "The Museum of Modern Art Twenty-Fifth Anniversary Year," 9.
3. D'Harnoncourt, "The Museum of Modern Art Twenty-Fifth Anniversary Year," 9; Lynes, *Good Old Modern*, 349, 354.
4. La Moy and McCaffrey, *The Journals of Grace Hartigan*, 151–52.
5. Ibid., 152.
6. Ibid.
7. Ibid.
8. Ibid., 154.
9. Ibid.
10. Ibid.
11. Ibid., 149.
12. Ibid., 157.
13. Ibid., 152.
14. Ibid., 163; joint federal tax return Willem and Elaine de Kooning, 1954, Elaine and Willem de Kooning financial records, 1951–1969, AAA-SI.
15. La Moy and McCaffrey, *The Journals of Grace Hartigan*, 157.
16. Ibid.
17. Ibid., 153, 154, 160; Exhibitions, Box 37, Grace Hartigan Papers, Syracuse; John Bernard Myers to Larry Rivers, Larry Rivers Papers, MSS 293, Series 1, Subseries A, Box 10, Folder 12, NYU.
18. Curtis, *Restless Ambition*, 134–35.
19. "A transcript of a recorded conversation between Linda Nochlin and Molly Nesbit in New York City," January 28, 2011, vassar.edu/histories/art/nochlin.html.
20. LeSueur, *Digressions on Some Poems by Frank O'Hara*, 103.
21. Ibid., 104.
22. Ibid.
23. Ibid., 105.
24. La Moy and McCaffrey, *The Journals of Grace Hartigan*, 163; LeSueur, *Digressions on Some Poems by Frank O'Hara*, n.p.
25. La Moy and McCaffrey, *The Journals of Grace Hartigan*, 163; LeSueur, *Digressions on Some Poems by Frank O'Hara*, n.p.
26. Diggins, *The Proud Decades*, 181, 187; Miller and Nowak, *The Fifties*, 277; Deirdre Robson, "The Market for Abstract Expressionism," 20.
27. Robson, "The Avant-Garde and the On-Guard," 221; Hodgins and Lesley, "The Great International Art Market," 157.
28. Lynes, *The Tastemakers*, 259; Robson, "The Avant-Garde and the On-Guard," 220.
29. Oral history interview with Nathan Halper, AAA-SI.
30. Hodgins and Lesley, "The Great International Art Market," 118; Robson, "The Market for Abstract Expressionism," 20.
31. Hodgins and Lesley, "The Great International Art Market," 118–19.
32. Ibid., 120–21, 152.
33. Ibid., 121, 152.
34. Ibid.
35. Lynes, *The Tastemakers*, 262; Arthur A. Houghton Jr. "The Artist in an Industrial Society," lecture delivered at the Museum of Fine Arts, Boston, March 22, 1955, Russell Lynes Papers, Box 1, Folder 3, AAA-SI, 12; Robson, "The Avant-Garde and the On-Guard," 215.
36. Houghton, "The Artist in an Industrial Society," Russell Lynes Papers, Box 1, Folder 3, AAA-SI, 12; Lynes, *The Tastemakers*, 262.
37. D'Harnoncourt, "The Museum of Modern Art Twenty-Fifth Anniversary Year," 5; Lynes, *The Tastemakers*, 262.

38. Lynes, *The Tastemakers*, 263; Rosenberg, *The Anxious Object*, 264–65.
39. Oral history interview with Samuel M. Kootz, April 13, 1964, AAA-SI.
40. Malina, *The Diaries of Judith Malina*, 353.
41. Interview with May Tabak Rosenberg, AAA-SI.
42. La Moy and McCaffrey, *The Journals of Grace Hartigan*, 167, 170, 171.
43. Exhibitions, Box 30, Grace Hartigan Archives, Syracuse.
44. Thomas B. Hess, "Trying Abstraction on Pittsburgh," 42, 56. Hess singled out Helen, Joan, and Elaine for mention in his article, calling Helen's painting "a successful attempt at concretizing experience directly into swirled paint," Joan's as a "bravura equivalent of a grand landscape," and Elaine as among the "outstanding younger complicators" for introducing figures into a "furnace of color."
45. Hess, "Trying Abstraction on Pittsburgh," 40; Tibor de Nagy Gallery Files, Box 28, Folder 1, AAA-SI. *ArtNews* featured a picture of Helen's work in its story about the exhibition. Helen's painting was purchased by Bernard Reis for three hundred dollars.
46. Helen Frankenthaler to Sonya Gutman, Tuesday, December 14, 1954, Box 1, Folder 6, Sonya Rudikoff Papers, 1935–2000, Princeton, 1; "Frankenthaler: The 1950s," 30; Elderfield, "Painted on 21st Street," 55.
47. Dore Ashton, interview by author.
48. Nemser, *Art Talk*, 181.
49. Irving Sandler, interview by author.
50. Munro, *Originals*, 52; oral history interview with Yvonne Jacquette, AAA-SI. Painter and printmaker Yvonne Jacquette, who was in her early twenties in the mid-1950s, said after the established women had climbed out on a limb to make art, a younger artist in their wake no longer had to make the "extreme choices" and sacrifices their elders did to be taken seriously. "You didn't have to be incredible," she said.
51. Friedan, *The Feminine Mystique*, 41, 122, 124, 152, 158, 161, 165, 170; Mead, *Male and Female*, 290. In 1954, the term "togetherness" was coined by *McCall's* magazine to describe a bond in which the woman did not agree to share as much as to submit. From the moment she said "I do," a wife's very person became subsumed by her husband. She might have gone into the ceremony as a woman named Jane Smith but she emerged from it a socially veiled being named Mrs. Tom Jones. Jane, herself, would essentially disappear.
52. Chafe, *Women and Equality*, 106; William H. Whyte Jr, "The Wife Problem," 34.
53. Alfred C. Kinsey, Clyde Martin, and Wardell Pomeroy, *Sexual Behavior in the Human Female*, 339, 442.
54. Miller and Nowak, *The Fifties*, 157–58; Friedan, *The Feminine Mystique*, 184.
55. Miller and Nowak, *The Fifties*, 157–58.
56. Friedan, *The Feminine Mystique*, 249–50, 255, 315; Riesman, *The Lonely Crowd*, 148. Riesman's best-selling book also noted this trend. "Today millions of women, freed by technology from any household task, given by technology many 'aids to romance,' have become pioneers, with men, on the frontier of sex." He described such sex as humorless, anxiety producing, and though readily available, "too sacred an illusion."
57. Friedan, *The Feminine Mystique*, 250.
58. Ibid., 161; Miller and Nowak, *The Fifties*, 256.
59. Mead, *Male and Female*, 28–29; Friedan, *The Feminine Mystique*, 128–30.
60. Beauvoir, *The Second Sex*, 69.
61. Ibid., 711.
62. Ibid., 713–17, 723.
63. Rose, *The Norton Book of Women's Lives*, 433–34.
64. Pacini, *Marisol*, 118.
65. La Moy and McCaffrey, *The Journals of Grace Hartigan*, 171.
66. Ibid., 176.
67. Mary Clyde (Abbott) to Grace Hartigan, n.d., 1955, Box 8, Grace Hartigan Papers, Syracuse.
68. Larry Rivers to Grace Hartigan, May 16, 1955, Box 24, Grace Hartigan Papers, Syracuse.
69. La Moy and McCaffrey, *The Journals of Grace Hartigan*, 175.
70. Jane Freilicher, interview by author.
71. John Ashbery to Larry Rivers, May 18 [ca. 1955], Larry Rivers Papers, MSS 293, Series I, Subseries A, Box 1, Folder 19, NYU; Jane Freilicher, interview by author.

72. Grace Hartigan Journals, May 31, 1955, Box 32, Grace Hartigan Papers, Syracuse.
73. Grace Hartigan Journals, May 30, 1955, Box 31, Grace Hartigan Papers, Syracuse; Frank O'Hara to Anne and Fairfield Porter, June 9, 1955, 1:134, Allen Collection of Frank O'Hara Letters, UConn.
74. Curtis, *Restless Ambition,* 338n111.
75. Jane Freilicher, interview by author; Grace Hartigan Journals, June 6, 1955, Box 32, Grace Hartigan Papers, Syracuse.
76. Grace Hartigan Journals, June 6, 1955, Box 32, Grace Hartigan Papers, Syracuse.
77. Ibid.
78. La Moy and McCaffrey, *The Journals of Grace Hartigan,* 179, 183.
79. Grace Hartigan Journals, June 10, 1955, Box 32, Grace Hartigan Papers, Syracuse; Grace Hartigan Journals, June 15, 1955, Box 32, Grace Hartigan Papers, Syracuse; La Moy and McCaffrey, *The Journals of Grace Hartigan,* 183.
80. La Moy and McCaffrey, *The Journals of Grace Hartigan,* 183–84.
81. Ibid., 184.
82. Larry Rivers with Carol Brightman, "The Cedar Bar," 41–42.
83. Rex Stevens, interview by author.
84. La Moy and McCaffrey, *The Journals of Grace Hartigan,* 184.
85. Ibid., 185; Nemser, *Art Talk,* 168–69.
86. La Moy and McCaffrey, *The Journals of Grace Hartigan,* 187.
87. Ibid., 188.
88. Ibid.
89. Ibid.

44. The Grand Girls, II

1. Rose, *The Norton Book of Women's Lives,* 666–67.
2. Chancey, "Elaine de Kooning," 106; Elaine de Kooning, interview by Arthur Tobier, 5.
3. Elaine de Kooning, interview by Arthur Tobier, 5–6.
4. Elaine de Kooning, interview by John Gruen, AAA-SI, 12.
5. Stevens and Swan, *De Kooning,* 377.
6. Elaine de Kooning, interview by Antonina Zara, 27.
7. Ibid., 29.
8. Interview with Natalie Edgar, author, December 8, 2013, East Hampton, New York.
9. Sales in '55 worksheet, Elaine and Willem de Kooning financial records, 1951–1969. AAA-SI; Hess, *Willem de Kooning* (1968), 100. Bill would sell thirteen thousand dollars' worth of work that year.
10. Elaine de Kooning, interview by Arthur Tobier, 6.
11. Lytle Shaw, *Frank O'Hara: The Poetics of Coterie,* 89; La Moy and McCaffrey, *The Journals of Grace Hartigan,* 174; Mattison, *Grace Hartigan,* 35; Crase and Quilter, *Painters and Poets,* 8.
12. John Ashbery, "Frank O'Hara's Question."
13. Edgar, *Club Without Walls,* 176–77.
14. Franco Zeffirelli, "Turned-On Architecture," 20; Elaine de Kooning and Slivka, *Elaine de Kooning,* 143–49.
15. Elaine de Kooning, "Subject: What, How or Who?," 29.
16. Ibid., 29, 62.
17. Edgar, *Club Without Walls,* 177.
18. Albers, *Joan Mitchell,* 213.
19. Joan Mitchell to Mike Goldberg, n.d., Paris to New York, Michael Goldberg Papers, 1942–1981, AAA-SI; Joan Mitchell to Mike Goldberg, postmarked August 28, 1954, Chicago to New York, Michael Goldberg Papers, 1942–1981, AAA-SI.
20. Joan Mitchell to Mike Goldberg, December 27, 1954, Michael Goldberg Papers, 1942–1981, AAA-SI.
21. Ibid.
22. Ibid.; Joan Mitchell to Mike Goldberg, December 28, 1954, Michael Goldberg Papers, 1942–1981, AAA-SI.
23. Joan Mitchell to Mike Goldberg, December 28, 1954, Michael Goldberg Papers, 1942–1981, AAA-SI.
24. Joan Mitchell to Mike Goldberg, December 29, 1954, Michael Goldberg Papers, 1942–1981, AAA-SI.

25. Ibid.
26. Ibid.
27. Ibid.
28. Albers, *Joan Mitchell*, 216. For his part, Jimmie Mitchell lived and, unlike his daughter, returned home almost refreshingly unchanged.
29. Joan Mitchell to Mike Goldberg, December 27, 1954, Michael Goldberg Papers, 1942–1981, AAA-SI, 3.
30. Rilke, *Letters to a Young Poet*, 42, 86, 54.
31. Photograph by Rudy Burckhardt for "Mitchell Paints a Picture," by Irving Sandler, *ArtNews* 56, no. 6 (October 1957): 44.
32. Bernstock, *Joan Mitchell*, 31.
33. Ibid., 34.
34. Nemser, "An Afternoon with Joan Mitchell," 6.
35. Albers, *Joan Mitchell*, 218; Marion Strobel to Joan Mitchell, n.d. [ca. early 1955], JMFA001, JMF.
36. Joan Mitchell to Mike Goldberg, December 27, 1954, Chicago to New York, Michael Goldberg Papers, 1942–1981, AAA-SI; Barbara Guest, Diary 1955, February 22, Uncat MSS 947, Box 26, Barbara Guest Papers, Yale.
37. "Reviews and Previews," *ArtNews* 54, no. 1 (March 1955): 50.
38. Albers, *Joan Mitchell*, 233.
39. Oral history interview with Joan Mitchell, April 16, 1986, AAA-SI; Belasco, "Between the Waves," 218; Joan Mitchell to Mike Goldberg, postmarked September 15, 1965, Paris to New York, Michael Goldberg Papers, 1942–1981, AAA-SI.
40. Joan Mitchell to Mike Goldberg, n.d., Paris to New York, Michael Goldberg Papers, 1942–1981, AAA-SI; LeSueur, *Digressions on Some Poems by Frank O'Hara*, 163.
41. Lurie, *V. R. Lang*, 62–65.
42. LeSueur, *Digressions on Some Poems by Frank O'Hara*, 163.
43. Elaine de Kooning, interview by Amei Wallach, 3.
44. LeSueur, *Digressions on Some Poems by Frank O'Hara*, 162.
45. Joan Mitchell to Mike Goldberg, n.d., Paris to New York, Michael Goldberg Papers, 1942–1981, AAA-SI; Joan Mitchell to Mike Goldberg, n.d., Paris to New York, Michael Goldberg Papers, 1942–1981, AAA-SI.
46. Oral history interview with Joan Mitchell, April 16, 1986, AAA-SI; Albers, *Joan Mitchell*, 218; Joan Mitchell to Mike Goldberg, postmarked September 15, 1965, Paris to New York, Michael Goldberg Papers, 1942–1981, AAA-SI; Joan Mitchell to Mike Goldberg, December 27, 1954, Chicago to New York, Michael Goldberg Papers, 1942–1981, AAA-SI; Belasco, "Between the Waves," 218.
47. Albers, *Joan Mitchell*, 218.
48. Elizabeth Baker, telephone interview by author.
49. Thomas B. Hess to Elaine de Kooning, October 10, 1955, Series 1, Box 1, Reel 5821, Stable Gallery Records, 1916–1999, bulk 1953–1970, AAA-SI; Albers, *Joan Mitchell*, 233.
50. Jane Freilicher, interview by author.
51. Oral history interview with Joan Mitchell, May 21, 1965, AAA-SI.
52. Frank O'Hara to Kenneth Koch, May 9, 1955, Series XI, Kenneth Koch Papers, NYPL; "April–July 3, 1955, Fifty Years of American Art in Paris," Abstract Expressionism, 1955, warholstars.org.
53. "April–July 3, 1955, Fifty Years of American Art in Paris," Abstract Expressionism, 1955, warhol stars.org.
54. Frank O'Hara to Kenneth Koch, May 9, 1955, Series XI, Kenneth Koch Papers, NYPL; La Moy and McCaffrey, *The Journals of Grace Hartigan*, 166.
55. Joan Mitchell to Mike Goldberg, n.d., Paris to New York, Michael Goldberg Papers, 1942–1981, AAA-SI; Albers, *Joan Mitchell*, 230; La Moy and McCaffrey, *The Journals of Grace Hartigan*, 185–86.
56. "April–July 3, 1955, Fifty Years of American Art in Paris," Abstract Expressionism, 1955, warholstars.org; Gooch, *City Poet*, 258; Jachec, *The Philosophy and Politics of Abstract Expressionism*, 190, 211; Kleeblatt, *Action/Abstraction*, 27.
57. Paul Jenkins, interview by Deborah Solomon, transcript courtesy of Suzanne D. Jenkins, © Estate of Paul Jenkins.

58. Shirley Jaffe, telephone interview by author.
59. Ibid.
60. Ibid.
61. Joan Mitchell to Barney Rosset, postmarked May 23, 1955, Paris to New York, JMFA003, JMF; oral history interview with Joan Mitchell, April 16, 1986, AAA-SI.
62. Albers, *Joan Mitchell*, 219; LeSueur, *Digressions on Some Poems by Frank O'Hara*, 162; Joan Mitchell to Mike Goldberg, n.d., Paris to New York, Michael Goldberg Papers, 1942–1981, AAA-SI; Shirley Jaffe, telephone interview by author.
63. Joan Mitchell to Mike Goldberg, n.d., Paris to New York, Michael Goldberg Papers, 1942–1981, AAA-SI.
64. Joan Mitchell to Barney and Loly Rosset, postmarked June 17, 1955, Paris to New York, JMFA003, JMF.
65. Joan Mitchell to Barney and Loly Rosset, postmarked May 23, 1955, Paris to New York, JMFA003, JMF.
66. Bernstock, *Joan Mitchell*, 106.
67. "Joan Mitchell," Transcript Barney/Sandy Interview, January 21, 2004, Barney Rosset Papers, Tape 5, Side 1, Series II, Box 3, Folder 5, Columbia.
68. Deirdre Bair, *Samuel Beckett*, 488.
69. Cora Cohen and Betsy Sussler, "Joan Mitchell," 20.
70. Bair, *Samuel Beckett*, 488.
71. Joan Mitchell to Barney and Loly Rosset, postmarked June 17, 1955, Paris to New York, JMFA003, JMF.
72. Albers, *Joan Mitchell*, 281.
73. Joan Mitchell to Barney and Loly Rosset, postmarked June 17, 1955, Paris to New York, JMFA003, JMF; Joan Mitchell to Mike Goldberg, n.d., Paris to New York, Michael Goldberg Papers, 1942–1981, AAA-SI.
74. Joan Mitchell to Mike Goldberg, n.d., Paris to New York, Michael Goldberg Papers, 1942–1981, AAA-SI, 4.
75. Joan Mitchell to Barney and Loly Rosset, postmarked June 17, 1955, Paris to New York, JMFA003, JMF.
76. Ibid.; Frank O'Hara to Kenneth Koch, May 9, 1955, Series XI, Kenneth Koch Papers, NYPL; Frank O'Hara to Kenneth Koch, May 23, 1955, Series XI, Kenneth Koch Papers, NYPL.
77. Joan Mitchell to Barney and Loly Rosset, postmarked June 17, 1955, Paris to New York, JMF.
78. Joan Mitchell to Mike Goldberg, n.d., Paris to New York, Michael Goldberg Papers, 1942–1981, AAA-SI.
79. Joan Mitchell to Mike Goldberg, n.d., Paris to New York, Michael Goldberg Papers, 1942–1981, AAA-SI.
80. Joan Mitchell to Mike Goldberg, n.d., Paris to New York, Michael Goldberg Papers, 1942–1981, AAA-SI.
81. Albers, *Joan Mitchell*, 232; Joan Mitchell to Mike Goldberg, n.d., Paris to New York, Michael Goldberg Papers, 1942–1981, AAA-SI.
82. Joan Mitchell to Mike Goldberg, n.d., Paris to New York, Michael Goldberg Papers, 1942–1981, AAA-SI.
83. Joan Mitchell to Mike Goldberg, n.d., Paris to New York, Michael Goldberg Papers, 1942-1981, Archives of American Art, Smithsonian Institution.
84. Joan Mitchell to Mike Goldberg, n.d., Michael Goldberg Papers, 1942-1981, Archives of American Art, Smithsonian Institution.
85. Gilbert Érouart, *Riopelle in Conversation*, 5.
86. Hélène de Billy, *Riopelle*, 109–10; Albers, *Joan Mitchell*, 226.
87. De Billy, *Riopelle*, 87.
88. Ibid., 17, 48, 125; Frank O'Hara, "Riopelle: International Speedscapes," 33.
89. De Billy, *Riopelle*, 56, 67, 71, 80, 88, 102, 106, 107.
90. Ibid., 13, 99, 120.
91. Ibid., 117, 119.
92. Ibid., 84, 112, 119.

93. Joan Mitchell to Mike Goldberg, n.d., Paris to New York, Michael Goldberg Papers, 1942–1981, AAA-SI; de Billy, *Riopelle,* 61. Ironically the same building Riopelle had earlier occupied with his wife.
94. Joan Mitchell to Barney Rosset, postmarked July [?] 9, 1955, Paris to New York, JMFA003, JMF; Joan Mitchell to Mike Goldberg, n.d., Paris to New York, Michael Goldberg Papers, 1942–1981, AAA-SI, 3.
95. Joan Mitchell to Barney Rosset, postmarked July [?] 9, 1955, Paris to New York, JMFA003, JMF; Letter from Joan Mitchell to Mike Goldberg, n.d., Paris to New York, Michael Goldberg Papers, 1942–1981, AAA-SI, 3.
96. Joan Mitchell to Mike Goldberg, n.d., Paris to New York, Michael Goldberg Papers, 1942–1981, AAA-SI, 1.
97. De Billy, *Riopelle,* 120.
98. Joan Mitchell to Barney Rosset, postmarked May 23, 1955, Paris to New York, JMFA003, JMF; Joan Mitchell to Barney and Loly Rosset, n.d. [ca. 1955], Paris to New York, JMFA003, JMF.
99. Joan Mitchell to Barney Rosset, postmarked October 17, 1955[?], Paris to New York, JMFA003, JMF.
100. De Billy, *Riopelle,* 80.
101. Jill Weinberg Adams, interview by author. This anecdote was told to Jill by Joan.
102. Ibid.
103. De Billy, *Riopelle,* 117, 120.
104. Ibid., 108, 120.
105. Shirley Jaffe, telephone interview by author.
106. De Billy, *Riopelle,* 116.
107. Joan Mitchell to Barney and Loly Rosset, postmarked September 19, 1955, Paris to New York, JMFA003, JMF.
108. Joan Mitchell to Mike Goldberg, n.d., Paris to New York, Michael Goldberg Papers, 1942–1981, AAA-SI.
109. Joan Mitchell to Barney and Loly Rosset, postmarked September 19, 1955, Paris to New York, JMFA003, Joan Mitchell Papers, JMF.
110. Joan Mitchell to Barney and Loly Rosset, postmarked October 17, 1955[?], Paris to New York, JMFA003, JMF; Albers, *Joan Mitchell,* 232.
111. Joan Mitchell to Barney and Loly Rosset, postmarked September 5, 1955, Paris to New York, JMFA003, JMF.
112. Ernestine and Denise Lassaw, e-mail to author, January 20, 2014.
113. Dr. Guy Fried, telephone interview by author.
114. Hall, *Elaine and Bill,* 174.
115. Ibid., 172; Elaine de Kooning, interview by John Gruen, AAA-SI, 12.
116. Clay Fried, interview by author.
117. Grace Hartigan notes for Elaine de Kooning memorial, May 12, 1990, Box 9, Grace Hartigan Papers, Syracuse.
118. Hall, *Elaine and Bill,* 172, 174.
119. Margaret Randall, telephone interview by author.
120. Stevens and Swan, *De Kooning,* 385; Hall, *Elaine and Bill,* 172, 174.
121. Draft manuscript for Thomas B. Hess's De Kooning Show at the Museum of Modern Art, draft dated July 8, 1968, Thomas B. Hess/De Kooning Papers, Box 1/1, MOMA, 52; Hess, *Willem de Kooning* (1968), 100.
122. Thomas B. Hess to Elaine de Kooning, October 10, 1955, Series 1, Box 1, Reel 5821, Stable Gallery Records, 1916–1999, bulk 1953–1970, AAA-SI; Albers, *Joan Mitchell,* 233.
123. Elaine de Kooning, interview by Charles Hayes, 5.
124. Elaine de Kooning, interview by Antonina Zarà, 28.

45. *The Grand Girls, III*

1. Tennessee Williams, *The Theatre of Tennessee Williams,* 39.
2. Helen Frankenthaler to Barbara Guest, July 23, 1955, Uncat ZA MS 271, Box 16, Barbara Guest Papers, Yale; Elderfield, "Painted on 21st Street," 55.
3. Van Horne, *A Complicated Marriage,* 70.

4. Helen Frankenthaler to Barbara Guest, July 13, 1955, New York to Southampton, Box 16, Uncat ZA MS 271, Barbara Guest Papers, Yale.
5. Helen Frankenthaler to Sonya Gutman, Tuesday, postmarked December 14, 1954, Box 1, Folder 6, Rudikoff Papers, 1935–2000, Princeton, 1.
6. Rubenfeld, *Clement Greenberg*, 186.
7. Ibid.
8. Ibid., 187, 189; John Bernard Myers to Larry Rivers, postmarked April 18, 1955, Larry Rivers Papers, MSS 293, Series I, Subseries A, Box 10, Folder 11, NYU.
9. Rubenfeld, *Clement Greenberg*, 189; Clement Greenberg Journal, October 12, 1955, Box 16, Folder 3, Journal 18, Clement Greenberg Papers, GRI (950085).
10. Marquis, *Art Czar*, 144.
11. O'Brian, *Clement Greenberg: The Collected Essays and Criticism*, 3: 217.
12. Ibid., 228.
13. Ibid., 226.
14. Ibid., 236.
15. Naifeh and Smith, *Jackson Pollock*, 746.
16. Rubenfeld, *Clement Greenberg*, 187–88.
17. Jones, *Eyesight Alone*, 426; Phoebe Hoban, "Psycho Drama," 45–46.
18. Rubenfeld, *Clement Greenberg*, 188; Jones, *Eyesight Alone*, 428; Hoban, "Psycho Drama," 46.
19. Rubenfeld, *Clement Greenberg*, 188–89; Naifeh and Smith, *Jackson Pollock*, 768; Marquis, *Art Czar*, 142–43, 146; David Black, "Totalitarian Therapy on the Upper West Side," 54, 56, 57, 58, 60, 62; Hoban, "Psycho Drama," 46.
20. Rubenfeld, *Clement Greenberg*, 249.
21. Ibid., 189.
22. Janice Van Horne, interview by author.
23. Rubenfeld, *Clement Greenberg*, 189; Marquis, *Art Czar*, 144.
24. Naifeh and Smith, *Jackson Pollock*, 744, 753.
25. Ibid., 742.
26. Potter, *To a Violent Grave*, 221.
27. O'Connor, *Jackson Pollock*, 71; Levin, *Lee Krasner*, 303.
28. Potter, *To a Violent Grave*, 193.
29. Levine, "A Portrait of Sidney Janis," 52.
30. Hilton Kramer, "Interview with Helen Frankenthaler," 240.
31. Paul Jenkins, interview by Deborah Solomon, transcript courtesy of Suzanne D. Jenkins, © Estate of Paul Jenkins, 1.
32. Naifeh and Smith, *Jackson Pollock*, 744–45.
33. Levin, *Lee Krasner*, 303–4.
34. Potter, *To a Violent Grave*, 192–93.
35. Ibid., 202.
36. Naifeh and Smith, *Jackson Pollock*, 747.
37. Rubenfeld, *Clement Greenberg*, 194.
38. Ibid.; Marquis, *Art Czar*, 145.
39. Naifeh and Smith, *Jackson Pollock*, 746–47.
40. Rubenfeld, *Clement Greenberg*, 194–95.
41. Naifeh and Smith, *Jackson Pollock*, 746–47.
42. Rubenfeld, *Clement Greenberg*, 195.
43. Naifeh and Smith, *Jackson Pollock*, 742–43.
44. Rubenfeld, *Clement Greenberg*, 195.
45. Ibid., 188, 195; Marquis, *Art Czar*, 145; Levin, *Lee Krasner*, 295.
46. Potter, *To a Violent Grave*, 223.
47. Levin, *Lee Krasner*, 296; Black, "Totalitarian Therapy on the Upper West Side," 57; Pat Lipsky, "What Tony and Lee and Clem Told Me, a Reminiscence," transcript of a lecture delivered at the Pollock-Krasner House and Study Center on July 1995, Pat Lipsky Papers, AAA-SI. Clem said after Lee stopped seeing Siegel he had grown so dependent upon her that he called her every day.
48. Levin, *Lee Krasner*, 299; Landau, *Lee Krasner: A Catalogue Raisonné*, 311.

49. Lee Krasner, unpublished notes, Series 2, Subseries 5, Box 10, Folder 11, Jackson Pollock and Lee Krasner Papers, ca. 1914–1984, AAA-SI, 6–9, 11, 13.
50. Ibid, 9–10, 14.
51. Ibid., 30.
52. Ibid., 33.
53. Friedman, *Energy Made Visible*, 224.
54. Letter Jackson Pollock to Helen Frankenthaler, ca. 1954–1955, Springs to New York, Box 085, Helen Frankenthaler Archives, HFF.
55. Friedman, *Energy Made Visible*, 224–25; Paul Jenkins, interview by Deborah Solomon, transcript courtesy Suzanne D. Jenkins, © Estate of Paul Jenkins. Paul said Jackson was "seriously planning to have an exhibition of drawings with the Gimpel Fils Gallery in London."
56. Potter, *To a Violent Grave*, 223.
57. Barbara Guest, Diary 1955, July 30 entry, Uncat ZA MS 271, Box 26, Barbara Guest Papers, Yale.
58. Barbara Guest, Diary 1955, August 5 entry, Uncat ZA MS 271, Box 26, Barbara Guest Papers, Yale; Barbara Guest, Diary 1955, August 7 entry, Uncat ZA MS 271, Box 26, Barbara Guest Papers, Yale.
59. Barbara Guest, Diary 1955, August 6 entry, Uncat ZA MS 271, Box 26, Barbara Guest Papers, Yale.
60. Jeannie Motherwell, telephone interview by author, August 12, 2014; Lise Motherwell, telephone interview by author.
61. Barbara Guest, Diary 1955, August 6 entry, Uncat ZA MS 271, Box 26, Barbara Guest Papers, Yale.
62. "Hurricanes: Science and Society, 1955–Hurricane Diane," www.hurricanescience.org.
63. Rubenfeld, *Clement Greenberg*, 197.
64. Barbara Guest, Diary 1955, August 25 entry, Uncat ZA MS 271, Box 26, Barbara Guest Papers, Yale.
65. Ernestine Lassaw, interview by author.
66. Potter, *To a Violent Grave*, 202.
67. Hobbs, *Lee Krasner* (1993), 57; *Lee Krasner: An Interview with Kate Horsfield*, video courtesy PKHSC.
68. Rose, *Lee Krasner*, 89.
69. Rubenfeld, *Clement Greenberg*, 197.
70. Potter, *To a Violent Grave*, 208–29.
71. Ibid., 209.
72. Rose, *Lee Krasner: The Long View*, videotape courtesy PKHSC; Landau, *Lee Krasner: A Catalogue Raisonné*, 311.
73. Friedman, *Energy Made Visible*, 220.
74. Oral history interview with Lee Krasner, November 2, 1964–April 11, 1968, AAA-SI; Potter, *To a Violent Grave*, 208.
75. "Month in Review," *Arts* 30, no. 1 (October 1955): 52.
76. Landau, *Lee Krasner: A Catalogue Raisonné*, 312.
77. "Lee Krasner Painting, Drawings and Collages," Whitechapel Gallery, 4; Levin, *Lee Krasner*, 371; "Lee Krasner: Paintings from the Late Fifties," Robert Miller Gallery, October 25–November 20, 1982, 7; Helen Harrison, telephone interview by author.
78. Rubenfeld, *Clement Greenberg*, 197.
79. Ibid., 196–97; oral history interview with B. H. Friedman, 1972, AAA-SI.
80. Rubenfeld, *Clement Greenberg*, 196.
81. Ibid., 197.
82. Rivers, *What Did I Do?*, 183; Barbara Guest, Diary 1955, October 4 entry, Uncat ZA MS 271, Box 26, Barbara Guest Papers, Yale.
83. Rubenfeld, *Clement Greenberg*, 197; Clement Greenberg and Janice Van Horne, interview by Dodie Kazanjian, AAA-SI, 10–11.
84. Janice Van Horne, interview by author; Van Horne, *A Complicated Marriage*, 3, 5–6; Rivers, *What Did I Do?*, 183–84.
85. Rivers, *What Did I Do?*, 183–84.

86. Van Horne, *A Complicated Marriage*, 23.
87. Janice Van Horne, interview by author; Rivers, *What Did I Do?*, 183.
88. Janice Van Horne, interview by author.
89. Van Horne, *A Complicated Marriage*, 23.
90. Rubenfeld, *Clement Greenberg*, 198.
91. Rivers, *What Did I Do?*, 183–84.
92. Rubenfeld, *Clement Greenberg*, 198; Rivers, *What Did I Do?*, 184.
93. Van Horne, *A Complicated Marriage*, 6–7.
94. Janice Van Horne, interview by author.
95. Halberstam, *The Fifties*, 59–60.
96. Rubenfeld, *Clement Greenberg*, 198.
97. Van Horne, *A Complicated Marriage*, 7.
98. Janice Van Horne, interview by author.
99. Van Horne, *A Complicated Marriage*, 7.
100. Rubenfeld, *Clement Greenberg*, 198.
101. Van Horne, *A Complicated Marriage*, 16; Rubenfeld, *Clement Greenberg*, 199; Clement Greenberg Journal, October 12, 1955, Box 16, Folder 3, Journal 18, Clement Greenberg Papers, GRI (950085); Clement Greenberg Journal, October 13, 1955, Box 16, Folder 3, Journal 18, Clement Greenberg Papers, GRI (950085); Clement Greenberg Journal, October 17, 1955, Box 16, Folder 3, Journal 18, Clement Greenberg Papers, GRI (950085); Clement Greenberg Journal, October 18, 1955, Box 16, Folder 3, Journal 18, Clement Greenberg Papers, GRI (950085); Clement Greenberg Journal, November 7, 1955, Box 16, Folder 3, Journal 18, Clement Greenberg Papers, GRI (950085).
102. Helen Frankenthaler to Sonya Gutman, January 9, 1956, Box 1, Folder 8, Sonya Rudikoff Papers, 1935–2000, Princeton, 2; Barbara Guest, Diary 1955, October 7 entry, Uncat ZA MS 271, Box 26, Barbara Guest Papers, Yale; Barbara Guest, Diary 1955, October 20 entry, Uncat ZA MS 271, Box 26, Barbara Guest Papers, Yale.
103. Clement Greenberg Journal, March 11, 1956, Box 16, Folder 3, Journal 18, Clement Greenberg Papers, GRI (950085).
104. Clement Greenberg Journal, November 28, 1955, Box 16, Folder 3, Journal 18, Clement Greenberg Papers, GRI (950085).
105. Rubenfeld, *Clement Greenberg*, 199.
106. Solomon, *Jackson Pollock*, 239.
107. Corlett, "Jackson Pollock: American Culture, the Media and the Myth," 95; Varnadoe with Karmel, *Jackson Pollock*, 17; Solomon, *Jackson Pollock*, 244.
108. Rubenfeld, *Clement Greenberg*, 199.
109. Hall, *Elaine and Bill*, 174.
110. Clement Greenberg Journal, June 3, 1956, Box 16, Folder 3, Journal 18, Series II, Clement Greenberg Papers, GRI (950085).
111. Van Horne, *A Complicated Marriage*, 18.
112. Clement Greenberg Journal, December 29, 1955, Box 16, Folder 3, Journal 18, Clement Greenberg Papers, GRI (950085).
113. Van Horne, *A Complicated Marriage*, 18.
114. Clement Greenberg Journal, December 29, 1955, Box 16, Folder 3, Journal 18, Clement Greenberg Papers, GRI (950085).
115. Clement Greenberg Journal, loose pages, n.d. [fall 1955], Box 16, Folder 1, Journal 16, Clement Greenberg Papers, GRI (950085); Van Horne, *A Complicated Marriage*, 24.
116. Mercedes Matter, interview by Jack Taylor; Miller, *Greenwich Village and How It Got That Way*, 258; Philip Guston, interview by Jack Taylor. Guston said, "Everybody knew that it wasn't going to last. Historically it's true, any group being together, whether the Cubists or Impressionists, they never lasted more than five years." As for the neighborhood, in 1961 real estate agents began marketing it as the "East Village."
117. Alfred Leslie, interview by Jack Taylor; Gruen, *The Party's Over Now*, 217.
118. Club-related material, Box 1, Folder 4, Irving Sandler Papers, ca. 1944–2007 (bulk 1944–1980), AAA-SI.

119. Edgar, *Club Without Walls,* 131. He would no longer stir debate through panels but through a magazine he founded called *It Is.*
120. Diggins, *The Proud Decades,* 196–98; Halberstam, *The Fifties,* 480.
121. Davidson, *Guys Like Us,* 12; Kimmel, *Manhood in America,* 242; Malina, *The Diaries of Judith Malina,* 377; Miller and Nowak, *The Fifties,* 66.
122. Halberstam, *The Fifties,* 465–66, 472, 478; Kaplan, *1959,* 84; Miller and Nowak, *The Fifties,* 301, 309.
123. Halberstam, *The Fifties,* 436–37, 626; Diggins, *The Proud Decades,* 279, 283, 290, 293; Zinn, *A People's History of the United States,* 450; Borden, *Voices of the American Past,* 341; Stone, *The Haunted Fifties,* 61. Halberstam said the ruling on desegregation sparked a white reaction unlike any in a century, but significantly it also triggered a black response.
124. "Allen Ginsberg Reads 'Howl' For the First Time—October 7, 1955," http://www.history.com/this-day-in-history/ginsberg-reads-howl-for-the-first-time.
125. Allen Ginsberg, *Howl,* https://www.poetryfoundation.org/poems-and-poets/poems/detail/49303; Ashton, *The New York School,* 227. Dore Ashton said that after *Howl* was finally published in 1956 the Beats returned east and began socializing with the painters.

46. Embarkation Point

1. Hadley Haden Guest, ed., *The Collected Poems of Barbara Guest,* 9.
2. Stevens and Swan, *De Kooning,* 382–83.
3. Grace Hartigan, Notes for Elaine de Kooning memorial, May 12, 1990, Box 9, Grace Hartigan Papers, Syracuse.
4. Dr. Guy Fried, telephone interview by author.
5. Grace Hartigan, Notes for Elaine de Kooning memorial, May 12, 1990, Box 9, Grace Hartigan Papers, Syracuse; Stevens and Swan, *De Kooning,* 384–85.
6. Grace Hartigan, Notes for Elaine de Kooning memorial, May 12, 1990, Box 9, Grace Hartigan Papers, Syracuse; Stevens and Swan, *De Kooning,* 385.
7. Clay Fried, interview by author.
8. Ernestine Lassaw, interview by author.
9. Stevens and Swan, *De Kooning,* 385; Hall, *Elaine and Bill,* 243.
10. Clay Fried, interview by author.
11. Stevens and Swan, *De Kooning,* 383.
12. Ibid., 383–84.
13. Maud Fried Goodnight, telephone interview by author; Hess, *Willem de Kooning* (1968), 101.
14. Hall, *Elaine and Bill,* 100; Ernestine Lassaw, interview by author.
15. Chancey, "Elaine de Kooning," 106; Elaine de Kooning, C. F. S. Hancock Lecture, 3.
16. *Art Barge—Artists Speak, with Elaine de Kooning,* videotape courtesy LTV, Inc.
17. Elaine de Kooning, C. F. S. Hancock Lecture, 3.
18. Ibid., 2.
19. Elaine de Kooning, interview by Molly Barnes, 3.
20. Elaine de Kooning, C. F. S. Hancock Lecture, 2.
21. Oral history interview with Helen Frankenthaler, AAA-SI.
22. Clement Greenberg Diary Entry February 3, 1956, Friday, Greenberg Journal, Black Journal 18, 1.1.14, Clement Greenberg Papers, GRI (950085).
23. Oral history interview with Elaine de Kooning, AAA-SI; James E. B. Breslin, *Mark Rothko,* 386–87.
24. Wetzsteon, *Republic of Dreams,* 538–39; oral history interview with Elaine de Kooning, AAA-SI.
25. Ashton, *The New York School,* 199; oral history interview with Sally Avery, AAA-SI; Stahr, "The Social Relations of Abstract Expressionism," 120.
26. Oral history interview with Elaine de Kooning, AAA-SI.
27. Ibid.; Breslin, *Mark Rothko,* 387.
28. Elaine de Kooning, "Two Americans in Action," 176.
29. Ibid., 177.
30. Ibid.
31. Stevens and Swan, *De Kooning,* 386.

32. Hess, *Willem de Kooning* (1968), 100.
33. Stevens and Swan, *De Kooning*, 387; Hess, *Willem de Kooning* (1968), 100.
34. Hess, *Willem de Kooning* (1968), 100; Thomas B. Hess, interview by Mitch Tuchman, AAA-SI, 19.
35. Thomas B. Hess, interview by Mitch Tuchman, AAA-SI, 20.
36. Abstract Expressionists, 1956, warholartstars.org; Naifeh and Smith, *Jackson Pollock*, 765, 777; Robson, "The Market for Abstract Expressionism," 20; Marquis, *The Art Biz*, 244.
37. Deborah Daw, "Lee Krasner, On Climbing a Mountain of Porcelain," Series 2, Subseries 4, Box 10, Folder 9, Lee Krasner Papers, AAA-SI, 23.
38. Van Horne, *A Complicated Marriage*, 133.
39. Ibid.
40. Ibid., 134.
41. Ibid.
42. Ibid., 135.
43. Ibid., 134.
44. Solomon, *Jackson Pollock*, 245; Hobbs, *Lee Krasner* (1999), 14.
45. Van Horne, *A Complicated Marriage*, 134.
46. Solomon, *Jackson Pollock*, 245.
47. Landau, *Lee Krasner: A Catalogue Raisonné*, 311; Naifeh and Smith, *Jackson Pollock*, 768–69.
48. Naifeh and Smith, *Jackson Pollock*, 767.
49. Ibid.
50. Ibid., 769.
51. Potter, *To a Violent Grave*, 210.
52. Ibid., 228.
53. Ibid.
54. Ruth Kligman, *Love Affair*, 15. She considered a limo a fundamental accoutrement.
55. Potter, *To a Violent Grave*, 228.
56. Oral history interview with Audrey Flack, AAA-SI; Potter, *To a Violent Grave*, 228; Kligman, *Love Affair*, 26.
57. Kligman, *Love Affair*, 25; Van Horne, *A Complicated Marriage*, 77.
58. Van Horne, *A Complicated Marriage*, 77; Kligman, *Love Affair*, 29.
59. Kligman, *Love Affair*, 26–28.
60. Ibid., 29.
61. Dawson, *An Emotional Memoir of Franz Kline*, 81.
62. Kligman, *Love Affair*, 29.
63. Ibid., 29–30.
64. Ibid., 30–31.
65. Naifeh and Smith, *Jackson Pollock*, 777–78.
66. Corlett, "Jackson Pollock: American Culture, the Media and the Myth," 95, 97.
67. Potter, *To a Violent Grave*, 228.
68. Levin, *Lee Krasner*, 307.
69. Paul Jenkins, interview by Deborah Solomon, transcript courtesy of Suzanne D. Jenkins, © Estate of Paul Jenkins, 3.
70. Ibid., 2, 3, 6.
71. Ibid., 2, 5.
72. Ibid., 3–4.
73. Albert E. Elsen, *Paul Jenkins*, 37, courtesy Suzanne D. Jenkins.
74. Paul Jenkins, interview by Deborah Solomon, transcript courtesy of Suzanne D. Jenkins, © Estate of Paul Jenkins, 3; Paul Jenkins to Jackson Pollock and Lee Krasner, April 17, 1956, © 2017 Estate of Paul Jenkins, courtesy Suzanne D. Jenkins.
75. Solomon, *Jackson Pollock*, 244.
76. Szarkowski and Elderfield, *The Museum of Modern Art at Mid-Century*, 75.
77. Ibid., 76–78.
78. Ibid., 76–77.

79. Ibid., 75, 77; Tibor de Nagy Gallery Files, Box 28, Folder 1, AAA-SI. Grace sold *City Life* to Nelson Rockefeller for two thousand dollars. The Metropolitan Museum purchased *Show Case* the next month, July 1956, for fifteen hundred dollars.
80. "Grace Hartigan, Painting from Popular Culture, Three Decades," Susquehanna Art Museum; Michael Kimmelman, "Review/Art; Explosive Painting: The Path to Pop," *New York Times,* July 9, 1993, http://www.nytimes.com/1993/07/09/arts/review-art-explosive-painting-the-path-to-pop.html?pagewanted=all. In the exhibition and catalog *Hand-Painted Pop: American Art in Transition, 1955–1962* (Los Angeles Museum of Contemporary Art), curator Paul Schimmel wrote that Grace and Larry were the bridge between the Abstract Expressionists and Pop Art.
81. Letter from prison inmate to Grace Hartigan, c/o Dorothy Miller, Twelve Americans Show, Dorothy C. Miller Papers, I.9.b, MOMA.
82. Szarkowski and Elderfield, *The Museum of Modern Art at Mid-Century,* 77.
83. "Month in Review, In the Galleries," *Arts* 30, no. 9 (June 1956): 49; Ashton, *The Life and Times of the New York School,* 212; "Young Americans, 1956," Dorothy C. Miller Papers, I.12, MOMA.
84. "Month in Review, In the Galleries," *Arts* 30, no. 9 (June 1956): 49.
85. Albers, *Joan Mitchell,* 237.
86. De Coppet and Jones, *The Art Dealers,* 85–86; Philip Guston, interview by Jack Taylor.
87. Albers, *Joan Mitchell,* 237.
88. "Month in Review, In the Galleries," *Arts* 30, no. 9 (June 1956): 50.
89. Oral history interview with Joan Mitchell, April 16, 1986, AAA-SI; oral history interview with Joan Mitchell, May 21, 1965, AAA-SI; Joan Mitchell to Barney and Loly Rosset, May 18, 1955, 150 Avenue Emile Zola, JMFA003, JMF; Joan Mitchell to Barney and Loly Rosset, September 17, 1955, Paris to New York, JMFA003, JMF; Joan Mitchell to Barney Rosset, October 1948, November 3, 1948, July 22, 1948, July 16, 1948, Paris to New York, JMFA003, JMF.
90. Moutet, "An American in Paris," 74.
91. Bair, *Samuel Beckett,* 488.
92. Ibid.
93. Albers, *Joan Mitchell,* 239.
94. Helen Frankenthaler to Sonya Gutman, February 25, 1956, Box 1, Folder 8, Sonya Rudikoff Papers, 1935–2000, Princeton, 1.
95. Helen Frankenthaler to Sonya Gutman, Tuesday evening April 17, 1956, Box 1, Folder 8, Sonya Rudikoff Papers, 1935–2000, Princeton, 2; Helen Frankenthaler to Sonya Gutman, February 2, 1956, Box 1, Folder 8, Sonya Rudikoff Papers, 1935–2000, Princeton, 1; Helen Frankenthaler to Sonya Gutman, January 23, 1956, Box 1, Folder 8, Sonya Rudikoff Papers, 1935–2000, Princeton, 1.
96. Helen Frankenthaler to Sonya Gutman, Tuesday evening April 17, 1956, Sonya Rudikoff Papers, 1935–2000, Princeton, 2; Helen Frankenthaler to Sonya Gutman, February 2, 1956, Sonya Rudikoff Papers, 1935–2000, Princeton, 1.
97. Helen Frankenthaler to Sonya Gutman, October 30, 1956, Box 1, Folder 8, Sonya Rudikoff Papers, 1935–2000, Princeton, 3.
98. Barbara Guest, Diary 1956, March 14 entry, Uncat Za MS 271, Box 26, Barbara Guest Papers, Yale.
99. Helen Frankenthaler to Sonya Gutman, Tuesday evening April 17, 1956, Box 1, Folder 8, Sonya Rudikoff Papers, 1935–2000, Princeton, 1.
100. Van Horne, *A Complicated Marriage,* 70; Rubenfeld, *Clement Greenberg,* 200; Helen Frankenthaler to Barbara Guest, June 7, 1956, Southampton to New York, Uncat ZA MS 271, Box 16, Barbara Guest Papers, Yale.
101. Helen Frankenthaler to Barbara Guest, July 23, 1956, Uncat ZA MS 271, Box 16, Barbara Guest Papers, Yale; Helen Frankenthaler to Sonya Gutman, April 17, 1956, Box 1, Folder 8, Sonya Rudikoff Papers, 1935–2000, Princeton, 1.
102. Naifeh and Smith, *Jackson Pollock,* 779.
103. Dorfman, *Out of the Picture,* 61; oral history interview with Dorothy C. Miller, AAA-SI.
104. Potter, *To a Violent Grave,* 230–31.
105. Friedman, *Energy Made Visible,* 232–33.
106. Hobbs, *Lee Krasner* (1999), 14; Rubenfeld, *Clement Greenberg,* 200.

107. Potter, *To a Violent Grave,* 232.
108. Ernestine Lassaw, interview by author.
109. Kligman, *Love Affair,* 72, 79.
110. Naifeh and Smith, *Jackson Pollock,* 778–79.
111. Dorfman, *Out of the Picture,* 61.
112. Potter, *To a Violent Grave,* 223.
113. Kligman, *Love Affair,* 83; Potter, *To a Violent Grave,* 230–32; Naifeh and Smith, *Jackson Pollock,* 780.
114. Kligman, *Love Affair,* 90; Naifeh and Smith, *Jackson Pollock,* 780.
115. Oral history interview with Lee Krasner, November 2, 1964–April 11, 1968, AAA-SI; Levin, *Lee Krasner,* 305.
116. Oral history interview with Lee Krasner, November 2, 1964–April 11, 1968, AAA-SI; Levin, *Lee Krasner,* 305; *Lee Krasner,* interview by Robert Coe, videotape courtesy PKHSC.
117. Kligman, *Love Affair,* 89–90, 92.
118. Ibid., 95–96.
119. Ibid., 96.
120. Van Horne, *A Complicated Marriage,* 76; Rubenfeld, *Clement Greenberg,* 200.
121. Solomon, *Jackson Pollock,* 247; Naifeh and Smith, *Jackson Pollock,* 782.
122. Potter, *To a Violent Grave,* 233; Naifeh and Smith, *Jackson Pollock,* 782.
123. Potter, *To a Violent Grave,* 250; Kligman, *Love Affair,* 98.

47. Without Him

1. Friedman, *Give My Regards to Eighth Street,* 103.
2. Lee Krasner to Jackson Pollock, Saturday July 21, 1956, Paris to Springs, Jackson Pollock and Lee Krasner Papers, AAA-SI. In this letter Lee acknowledges the roses and gives Jackson the Quai du Voltaire address, which means he did not, as is often described, send the flowers to her hotel room but likely sent them to the Jenkinses', where she stayed when she arrived.
3. Wallach, "Lee Krasner's Triumph," 501; Rose, *Lee Krasner: The Long View,* videotape courtesy PKHSC.
4. Lee Krasner to Jackson Pollock, 1956, from Paris to East Hampton, Jackson Pollock Papers, Box 1, Folder 46, AAA-SI; Hôtel du Quai Voltaire, en.parisinfo.com/paris-hotel-accommodation/69360/hôtel-du-quai-voltaire.
5. Lee Krasner to Jackson Pollock, Saturday July 21, 1956, from Paris to East Hampton, Jackson Pollock Papers, Box 1, Folder 46, AAA-SI.
6. Ibid.
7. Helen Frankenthaler to Barbara Guest, n.d. 1956, Venice, Italy, to New York, Uncat ZA MS 271, Box 16, Barbara Guest Papers, Yale..
8. Larry Rivers to Frank O'Hara, June 25, 1956, Larry Rivers Papers, MSS 293, Series I, Subseries A, Box 11, Folder 9, NYU.
9. Helen Frankenthaler to Barbara Guest, n.d. 1956, Venice, Italy, to New York, Uncat ZA MS 271, Box 16, Barbara Guest Papers, Yale.
10. Helen Frankenthaler to Barbara Guest, July 23, 1956, Paris to Long Island, Uncat ZA MS 271, Box 16, Barbara Guest Papers, Yale.
11. Lee Krasner to Jackson Pollock, 1956, postcard from Paris to East Hampton, Jackson Pollock Papers, Series 1, Box 1, Folder 46, AAA-SI.
12. Lee Krasner to Mr & Mrs Jenkins, July 30, 1956, Menerbes to Paris, Paul Jenkins Papers, 1932–2009, AAA-SI; Lee Krasner to Jackson Pollock, n.d. [1956], postcard from Menerbes to East Hampton, Jackson Pollock Papers, Series 1, Box 1, Folder 46, AAA-SI; Postcard from Lee Pollock to Mr. and Mrs. Clement Greenberg, n.d. [1956], Menerbes to East Hampton, Clement Greenberg Papers, 1937–1983, AAA-SI.
13. Lee Krasner to Jackson Pollock, n.d. [1956], postcard Menerbes to East Hampton, Jackson Pollock Papers, Series 1, Box 1, Folder 46, AAA-SI.
14. Lee Pollock to Mr. and Mrs. Clement Greenberg, n.d. [1956], postcard Menerbes to East Hampton, Clement Greenberg Papers, 1937–1983, AAA-SI.
15. Guggenheim, *Out of This Century,* 336, 346–47.

16. Diamonstein-Spielvogel, *Inside New York's Art World*, 208; Lee Krasner to Jackson Pollock, 1956, from Menerbes to East Hampton, Jackson Pollock Papers, Box 1, Folder 46, AAA-SI.
17. Rose, *Lee Krasner*, 98.
18. Levin, *Lee Krasner*, 315.
19. Helen Frankenthaler to Clem and Jenny Greenberg, August 3, 1956, postcard Amsterdam to New York, Series 3, Box 3, Folder 38, Clement Greenberg Papers, 1937–1983, AAA-SI; Elderfield, "Painted on 21st Street," 91.
20. Paul Jenkins, interview by Deborah Solomon, transcript courtesy of Suzanne D. Jenkins, © Estate of Paul Jenkins, 11; Solomon, *Jackson Pollock*, 248.
21. Paul Jenkins, interview by Deborah Solomon, transcript courtesy of Suzanne D. Jenkins, © Estate of Paul Jenkins, 12.
22. Ibid., 13.
23. Naifeh and Smith, *Jackson Pollock*, 783–84.
24. Paul Jenkins, interview by Deborah Solomon, transcript courtesy of Suzanne D. Jenkins, © Estate of Paul Jenkins, 13–14.
25. Hobbs, *Lee Krasner* (1999), 15; Rose, *Lee Krasner*, 95; Potter, *To a Violent Grave*, 262; Paul Jenkins, interview by Deborah Solomon, transcript courtesy of Suzanne D. Jenkins, © Estate of Paul Jenkins, 13.
26. Suzanne D. Jenkins, interview by author; Paul Jenkins, interview by Deborah Solomon, transcript courtesy of Suzanne D. Jenkins, © Estate of Paul Jenkins, 13.
27. Helen Frankenthaler to Barbara Guest, July 23, 1956, Uncat ZA MS 271, Box 16, Barbara Guest Papers, Yale.
28. Paul Jenkins, interview by Deborah Solomon, transcript courtesy of Suzanne D. Jenkins, © Estate of Paul Jenkins, 13.
29. Ibid.
30. Maurice Poirier, "Helen Frankenthaler: Working Papers," n.p.; Alison Rowley, *Helen Frankenthaler*, 110–12. Interviews with several of Frankenthaler's closest associates, and art historians who worked with her on several major projects, failed to produce a clear link between Helen's *Hotel du Quai Voltaire* and Pollock's death. But Alison Rowley, in her book *Helen Frankenthaler: Painting History, Writing Painting*, does make the connection. She showed Helen her manuscript for prepublication approval and Helen did not object to Rowley's description of the painting as being created in response to Pollock's death. Nor did Helen object to the inclusion of critic Maurice Poirier's statement, made after interviewing Helen, that it was painted while the artist was in a "high state of agitation" and that she felt "compelled to express her feelings in visual form." I believe it is reasonable to assume that news of the violent death of the artist whose work was critical in helping Helen find her own direction and develop her own style, as she herself stated frequently, would have inspired her to respond with a painting. Other artists less artistically connected to Pollock, among them Joan Mitchell, did as well. Additionally, Helen was known to paint biographical details and events into her work, and to memorialize the passing of fellow artists who were significant to her. Other than the date of the painting, August 1956, it is not clear when Helen produced *Hôtel du Quai Voltaire*. I have placed it in this narrative on the day she learned of Jackson's death because I believe that shocking news precipitated its creation.
31. Paul Jenkins to Clement Greenberg, August 15, 1956, Series 3, Box 3, Folder 15, Clement Greenberg Papers, 1937–1983, AAA-SI.
32. Dodie Kazanjian, Notes from interview with Helen Frankenthaler, Project Artist Files, Dodie Kazanjian Papers, ca. 1980–2010, AAA-SI; Paul Jenkins, interview by Deborah Solomon, transcript courtesy of Suzanne D. Jenkins, © Estate of Paul Jenkins, 13.
33. Paul Jenkins, interview by Deborah Solomon, transcript courtesy of Suzanne D. Jenkins, © Estate of Paul Jenkins, 13.
34. Friedman, *Energy Made Visible*, 247; Potter, *To a Violent Grave*, 247; Paul Jenkins to Clement Greenberg, August 15, 1956, Series 3, Box 3, Folder 15, Clement Greenberg Papers, 1937–1983, AAA-SI.
35. Paul Jenkins, interview by Deborah Solomon, transcript courtesy of Suzanne D. Jenkins, © Estate of Paul Jenkins, 13.
36. Dawson, *An Emotional Memoir of Franz Kline*, 88.

37. Paul Jenkins to Clement Greenberg, August 15, 1956, Series 3, Box 3, Folder 15, Clement Greenberg Papers, 1937–1983, AAA-SI; Friedman, *Energy Made Visible*, 248.
38. Friedman, *Energy Made Visible*, 248–49; Potter, *To a Violent Grave*, 252–53.
39. Friedman, *Energy Made Visible*, 248; Potter, *To a Violent Grave*, 252–53.
40. Potter, *To a Violent Grave*, 228.
41. Van Horne, *A Complicated Marriage*, 78; Potter, *To a Violent Grave*, 228.
42. Potter, *To a Violent Grave*, 232–39.
43. Naifeh and Smith, *Jackson Pollock*, 783, 785.
44. Kligman, *Love Affair*, 127.
45. Friedman, *Energy Made Visible*, 235; Kligman, *Love Affair*, 166.
46. Naifeh and Smith, *Jackson Pollock*, 784.
47. Van Horne, *A Complicated Marriage*, 79.
48. Potter, *To a Violent Grave*, 235–36.
49. Naifeh and Smith, *Jackson Pollock*, 786; Kligman, *Love Affair*, 171.
50. Kligman, *Love Affair*, 171, 174, 179–80, 188.
51. Ibid., 180.
52. Ibid., 187.
53. Ibid., 188–89.
54. Ibid., 191.
55. Deborah Solomon, notes on Clement Greenberg based on interview, December 19, 1983, Series 1, Box 1, Folder 2, Clement Greenberg Papers, 1937–1983, AAA-SI, 6; Potter, *To a Violent Grave*, 239; Kligman, *Love Affair*, 192.
56. Kligman, *Love Affair*, 197, 199.
57. Ibid., 200; Deborah Solomon, notes on Clement Greenberg based on interview, December 19, 1983, Series 1, Box 1, Folder 2, Clement Greenberg Papers, 1937–1983, AAA-SI, 6.
58. Potter, *To a Violent Grave*, 240.
59. Kligman, *Love Affair*, 200; Fielding Dawson, *An Emotional Memoir of Franz Kline*, 81.
60. Kligman, *Love Affair*, 193–94.
61. Ibid., 200.
62. Ibid., 201.
63. Ibid.; Potter, *To a Violent Grave*, 240; Deborah Solomon, notes on Clement Greenberg based on interview, December 19, 1983, Series 1, Box 1, Folder 2, Clement Greenberg Papers, 1937–1983, AAA-SI, 6.
64. Potter, *To a Violent Grave*, 16, 240–41.
65. Ibid., 241–42.
66. Ibid., 242–43.
67. Ibid., 244.
68. Ibid., 244, 246.
69. Van Horne, *A Complicated Marriage*, 82–83; Friedman, *Energy Made Visible*, 237; Deborah Solomon, notes on Clement Greenberg based on interview, December 19, 1983, Series 1, Box 1, Folder 2, Clement Greenberg Papers, 1937–1983, AAA-SI, 6; Potter, *To a Violent Grave*, 245; Francine du Plessis and Cleve Gray, "Who was Jackson Pollock?," 57.
70. Deborah Solomon, notes on Clement Greenberg based on interview, December 19, 1983, Series 1, Box 1, Folder 2, Clement Greenberg Papers, 1937–1983, AAA-SI, 6.
71. Van Horne, *A Complicated Marriage*, 83.
72. Deborah Solomon, notes on Clement Greenberg based on interview, December 19, 1983, Series 1, Box 1, Folder 2, Clement Greenberg Papers, 1937–1983, AAA-SI, 6.
73. Clement Greenberg to B. H. Friedman, August 10, 1972, Clement Greenberg Papers, Box 3, Folder 15, Clement Greenberg Papers, 1937–1983, AAA-SI; Potter, *To a Violent Grave*, 245.
74. Van Horne, *A Complicated Marriage*, 83; Rubenfeld, *Clement Greenberg*, 202–3; Potter, *To a Violent Grave*, 246.
75. Van Horne, *A Complicated Marriage*, 84.
76. Ibid., 84–85; Potter, *To a Violent Grave*, 252.
77. Deborah Solomon, notes on Clement Greenberg based on interview, December 19, 1983, Series 1, Box 1, Folder 2, Clement Greenberg Papers, 1937–1983, AAA-SI, 6.
78. Potter, *To a Violent Grave*, 250.

79. Ibid., 253.
80. Deborah Solomon, notes on Clement Greenberg based on interview, December 19, 1983, Series 1, Box 1, Folder 2, Clement Greenberg Papers, 1937–1983, AAA-SI, 6; Van Horne, *A Complicated Marriage,* 87; Rubenfeld, *Clement Greenberg,* 202–3.
81. Potter, *To a Violent Grave,* 253.
82. Deborah Solomon, notes on Clement Greenberg based on interview, December 19, 1983, Series 1, Box 1, Folder 2, Clement Greenberg Papers, 1937–1983, AAA-SI, 6.
83. Potter, *To a Violent Grave,* 253; Deborah Solomon, notes on Clement Greenberg based on interview, December 19, 1983, Series 1, Box 1, Folder 2, Clement Greenberg Papers, 1937–1983, AAA-SI, 6.
84. Thomas B. Hess, "The Battle of Paris, Strip-Tease and Trotsky," 30.
85. Myers, *Tracking the Marvelous,* 192; Albers, *Joan Mitchell,* 241.
86. Elaine de Kooning, interview by Jeffrey Potter, audiotape courtesy the PKHSC.
87. Potter, *To a Violent Grave,* 246.
88. Karmel, *Jackson Pollock: Interviews, Articles,* 84.
89. Frank O'Hara, *Jackson Pollock,* 32.
90. Friedman, *Energy Made Visible,* 250–51; Van Horne, *A Complicated Marriage,* 87–88; Potter, *To a Violent Grave,* 250, 256.
91. Oral history interview with Dorothy C. Miller, AAA-SI.
92. Nemser, *Art Talk,* 154.
93. Oral history interview with Dorothy C. Miller, AAA-SI.
94. Potter, *To a Violent Grave,* 251; *Summer of '57,* videotape courtesy LTV, Inc.
95. Rose Slivka, "Willem de Kooning, on His Eighty-Fifth Birthday," 220.
96. Friedman, *Energy Made Visible,* 251.
97. Van Horne, *A Complicated Marriage,* 88; Potter, *To a Violent Grave,* 259.
98. Theodoros Stamos to Paul Jenkins, n.d., Paul Jenkins Papers, 1932–2009, AAA-SI.
99. Friedman, *Energy Made Visible,* 253; Potter, *To a Violent Grave,* 258.
100. Naifeh and Smith, *Jackson Pollock,* 794.
101. *Summer of '57,* videotape courtesy LTV, Inc.; Friedman, *Energy Made Visible,* 255.
102. Van Horne, *A Complicated Marriage,* 88.
103. *Summer of '57,* videotape courtesy LTV, Inc.
104. Potter, *To a Violent Grave,* 260.
105. Van Horne, *A Complicated Marriage,* 88.
106. Potter, *To a Violent Grave,* 261.
107. Ibid., 260; Van Horne, *A Complicated Marriage,* 89.
108. Hobbs, *Lee Krasner* (1999), 15; Rose, *Lee Krasner,* 95; Potter, *To a Violent Grave,* 262.
109. Alfred Leslie, interview by Jack Taylor; oral history interview with Harold Rosenberg, AAA-SI.
110. Alfred Leslie, interview by Jack Taylor; Herman Cherry, interview by Jack Taylor; oral history interview with Jack Tworkov, AAA-SI; Mary Abbott, interview by author; Rivers, *What Did I Do?,* 342; LeSueur, *Digressions on Some Poems by Frank O'Hara,* 194; Jane Kramer, *Off Washington Square,* 111; Kaplan, *1959,* 207–8.
111. Alfred Leslie, interview by Jack Taylor.
112. Ibid.; Herman Cherry, interview by Jack Taylor.
113. Michael Magee, "Tribes of New York," 696–97.
114. Grace Hartigan to Tom Hess, September 4, 1959, Roll 5690, Thomas B. Hess Papers, AAA-SI. In a letter to Hess criticizing his statement that Pollock was of little help to other painters, Grace wrote, "Of the younger artists in the years 1947 to about 1952...there was not one of us who didn't learn from and lean on and be inspired by the work and presence of Pollock."

48. The Gold Rush

1. Frank O'Hara to Lawrence Osgood, October 19, 1950, Donald Allen Collection of Frank O'Hara Letters, UConn.
2. O'Hara, *Jackson Pollock,* 117.
3. Friedman, "Lee Krasner," draft manuscript, 1965, Series 2.4, Box 10, Folder 7, Lee Krasner Papers, AAA-SI, 12, 14.
4. *Lee Krasner: An Interview with Kate Horsfield,* videotape courtesy PKHSC.

5. Hobbs, *Lee Krasner* (1999), 15.
6. Ibid.
7. Van Horne, *A Complicated Marriage*, 139.
8. Hubert Crehnan, "Recent Attacks on Abstract Art," 62; Van Horne, *A Complicated Marriage*, 139; Robson, "The Market for Abstract Expressionism," 22–23; Potter, *To a Violent Grave*, 272.
9. Levine, "A Portrait of Sidney Janis," 53; Gruen, *The Party's Over Now*, 251–52; Robson, "The Market for Abstract Expressionism," 20–22; Halberstam, *The Fifties*, 587. To put the price in perspective, a middle-class family in 1956 had an income of about five thousand dollars a year.
10. Gruen, *The Party's Over Now*, 251–52; Gill, *Art Lover*, 328.
11. Gruen, *The Party's Over Now*, 251–52; John Lee Post, interview by author.
12. Levine, "A Portrait of Sidney Janis," 53.
13. Gruen, *The Party's Over Now*, 251–53.
14. Robson, "The Market for Abstract Expressionism," 22; Irving Sandler, interview by author; Sandler, *A Sweeper Up After Artists*, 228.
15. Levine, "A Portrait of Sidney Janis," 53; Solomon, *Jackson Pollock*, 253; Robson, "The Market for Abstract Expressionism," 22.
16. Potter, *To a Violent Grave*, 272; Harold Rosenberg, "The Art Establishment," 114. Harold credited her with "almost singlehandedly" forcing up the prices for American abstract art.
17. Crehnan, "Recent Attacks on Abstract Art," 62; Marquis, *The Art Biz*, 184; Marquis, *Art Czar*, 152; Robson, "The Market for Abstract Expressionism," 19–23; Leo Castelli, interview with Mitch Tuchman, AAA-SI, 1.
18. Thomas B. Hess, "A Tale of Two Cities," 38; Marquis, *The Art Biz*, 206–7; Crehnan, "Recent Attacks on Abstract Art," 62–63; oral history interview with André Emmerich, AAA-SI. Hess said the Vanguard audience "goes to the art world for amusement, relaxation, diversion, most of all for a comfortable, colorful social milieu."
19. Gruen, *The Party's Over Now*, 219.
20. Michael Goldberg, interview by Jack Taylor.
21. George Ortman, *New York Artists Equity Association 55th Anniversary Journal*, December 18, 2002, 52.
22. Marquis, *The Art Biz*, 13; Saul Ostrow, "Michael Goldberg," bombmagazine.org/article/2382/michael-goldberg.
23. Ostrow, "Michael Goldberg."
24. Albers, *Joan Mitchell*, 246.
25. "Je ne puis penser qu'à toi." Jean-Paul Riopelle to Joan Mitchell, February 6, 1957, Paris to New York, JMFA001, JMF; "Je n'ai jamais vu Paris aussi triste, je suis un véritable Robot...que tu le sais une fois pour toute que je n'ai envie de rien d'autre que toi." Jean-Paul Riopelle to Joan Mitchell, dated Saturday, September [?] 21, 1957, Paris to New York, JMFA001, JMF. Translations by author.
26. Albers, *Joan Mitchell*, 264.
27. "Abstract Expressionism, 1957," warholartstars.org.
28. Philip Guston, interview by Jack Taylor.
29. Levine, "The Golden Years," 43.
30. Hess, *Willem de Kooning* (1968), 101.
31. Oral history interview with Harold Rosenberg, AAA-SI.
32. William Rubin, "The New York School, Part II," 22. Rubin said the strongest action painters of the Second Generation were women. "I think of Elaine de Kooning and Joan Mitchell, particularly." He noted Helen as well.
33. Curtis, *Restless Ambition*, 147; Myers, *Tracking the Marvelous*, 44. John Bernard Myers said Grace and Joan were among the first women artists "to be accepted as artists without question as to their femaleness.... Both Joan Mitchell and Grace Hartigan, along with at least a dozen other women of talent, found it possible to gain serious attention at this time. And I think their work contributed to the feisty exuberance of the art world."
34. James Thrall Soby, "Interview with Grace Hartigan," 26.
35. Grace Hartigan to James Thrall Soby, September 26, 1957, The Creeks to New Canaan, Connecticut, James Thrall Soby Papers, I.121, MOMA.
36. Bert Glinn, "New York's Spreading Upper Bohemia," 49.

37. Albers, *Joan Mitchell*, 244; Grace Hartigan to Helen Frankenthaler, June 10, 1957, Creeks to West End Avenue, Helen Frankenthaler Papers, HFF.
38. Sandler, "Mitchell Paints a Picture," 44.
39. Ibid., 45.
40. Albers, *Joan Mitchell*, 250.
41. Kleeblatt, *Action/Abstraction*, 30. In 1958, a chimpanzee would be immortalized on *Mad Magazine*'s cover doing an abstract painting.
42. Sandler, "Mitchell Paints a Picture," 46–47, 69.
43. Cajori, *Joan Mitchell: Portrait of an Abstract Painter*, film; oral history interview with Joan Mitchell, May 21, 1965, AAA-SI.
44. Cajori, *Joan Mitchell: Portrait of an Abstract Painter*, film; oral history interview with Joan Mitchell, May 21, 1965, AAA-SI.
45. Corbett, "But Here's a Funny Story," 48.
46. Dorothy Seiberling, "Women Artists in Ascendance," 74–78.
47. Barbara Rose, "First-Rate Art by the Second Sex," 80.
48. Albers, *Joan Mitchell*, 245.
49. Ibid., 245, 260.
50. Elderfield, "Painted on 21st Street," 95.
51. Seiberling, "Women Artists in Ascendance," 75.
52. Melody Davis, "The Subject of/is the Artist: The Many Cultures of Grace Hartigan," Box 7A, Grace Hartigan Papers, Syracuse; oral history interview with Grace Hartigan, AAA-SI.
53. Myers, *Tracking the Marvelous*, 177–79.
54. Exhibition material, Box 36, Grace Hartigan Papers, Syracuse.
55. Oral history interview with Larry Aldrich, April 25–June 10, 1972, AAA-SI.
56. Myers, *Tracking the Marvelous*, 155.
57. Oral history interview with Larry Aldrich, AAA-SI.
58. LeSueur, *Digressions on Some Poems by Frank O'Hara*, 150–51.
59. Ibid., 151.
60. Ibid., 150.
61. Ibid.
62. Ibid.; Dore Ashton, interview by author.
63. Davis, "The Subject of/is the Artist," Box 7A, Grace Hartigan Papers, Syracuse.
64. Schuyler, "Frank O'Hara: Poet Among Painters," 45; Szarkowski and Elderfield, *The Museum of Modern Art at Mid-Century*, 133; Gooch, *City Poet*, 257–58.
65. Gooch, *City Poet*, 273; Schuyler, "Frank O'Hara: Poet Among Painters," 45.
66. Szarkowski and Elderfield, *The Museum of Modern Art at Mid-Century*, 45–46, 88; Jachec, *The Philosophy and Politics of Abstract Expressionism*, 190, 211; Lynes, *Good Old Modern*, 384. In 1953 Nelson Rockefeller helped move money from a family fund to create a five-year grant to establish an International Circulating Exhibitions program at the Museum of Modern Art. Some writers have cited his involvement in the creation of the program, among other factors, as evidence of government collusion in the museum's programming. Rockefeller had been head of the Office of Inter-American Affairs, fighting fascism in Latin America, and had been a special assistant to President Dwight Eisenhower on Cold War strategy.
67. Schuyler, "Frank O'Hara: Poet Among Painters," 45.
68. Ibid.
69. Gooch, *City Poet*, 294.
70. Ibid.; Szarkowski and Elderfield, *The Museum of Modern Art at Mid-Century*, 88, 133; Charlotte Dyer to Porter McCray, memo, July 8, 1957, International Council and International Program Records, I.A.3024, MOMA.
71. Mattison, *Grace Hartigan*, 42.
72. Ibid.; Gaines, *Philistines at the Hedgerow*, 135.
73. Harrison, "East Hampton Avant-Garde," 14; Harrison and Denne, *Hamptons Bohemia*, 100; Gaines, *Philistines at the Hedgerow*, 138.
74. Harrison, "East Hampton Avant-Garde," 14. After three years, the Braiders had closed their bookstore and carport gallery to return to the city. That had left a large hole in the summer exhibition

calendar when at least two-thirds of the New York School artists were gathered on the island, as were a growing number of collectors.
75. Oral history interview with Harold Rosenberg, AAA-SI; Harrison, "East Hampton Avant-Garde," 14, 15, 17, 20–22. Grace showed at the Signa in 1957, 1958, and 1959; Lee in 1957, 1958, 1959, and 1960; Elaine and Joan both had shows there in 1958.
76. Rivers, *What Did I Do?*, 302.
77. Natalie Edgar, interview by author, October 20, 2014.
78. Ibid.
79. Ibid.; Rivers, *What Did I Do?*, 302.
80. Curtis, *Restless Ambition*, 156.
81. Rivers, *What Did I Do?*, 302.
82. Gaines, *Philistines at the Hedgerow*, 135.
83. Gooch, *City Poet*, 283–84; Lurie, *V. R. Lang*, 69.
84. Gooch, *City Poet*, 288; Allen, *The Collected Poems of Frank O'Hara*, 258.
85. Gooch, *City Poet*, 288, 290.
86. Ibid., 296.
87. Allen, The Collected Poems of Frank O'Hara, 214.
88. Gooch, *City Poet*, 297.
89. LeSueur, *Digressions on Some Poems by Frank O'Hara*, 105.
90. Gooch, *City Poet*, 297.
91. Ibid.
92. Ibid.
93. Ibid.
94. *Summer of '57,* videotape courtesy LTV, Inc.
95. Potter, *To a Violent Grave,* 264; Richard Howard, *Paper Trail,* 226; Dore Ashton, interview by author; John Lee Post, interview by author.
96. Levin, *Lee Krasner,* 339; Levin, "Extraordinary Interventions of Alfonso Ossorio," 15; Ruby Jackson, interview by author.
97. Levin, *Lee Krasner,* 339; Levin, "Extraordinary Interventions of Alfonso Ossorio," 9.
98. Daw, "Lee Krasner, on Climbing a Mountain of Porcelain," Series 2.4, Box 10, Folder 9, Lee Krasner Papers, AAA-SI, 27.
99. Wallach, "Lee Krasner's Triumph," 501.
100. Oral history interview with Lee Krasner, November 2, 1964–April 11, 1968, AAA-SI.
101. Ibid.
102. Lee Krasner, interview by Barbara Cavaliere, AAA-SI, 25; oral history interview with Lee Krasner, November 2, 1964–April 11, 1968, AAA-SI.
103. Hobbs, *Lee Krasner* (1999), 15; *Lee Krasner, a Conversation with Hermine Freed,* videotape courtesy PKHSC; *Summer of '57,* videotape courtesy LTV, Inc.
104. *Lee Krasner,* interview by Barbara Novak, videotape courtesy PKHSC.
105. Hobbs, *Lee Krasner* (1993), 66.
106. Landau, *Lee Krasner: A Catalogue Raisonné,* 165; Rose, *Lee Krasner,* 114, 157; Hobbs, *Lee Krasner* (1993), 67.
107. *Lee Krasner,* interview by Barbara Novak, videotape courtesy PKHSC; Lee Krasner, interview by Emily Wasserman, AAA-SI, 10.
108. *Lee Krasner,* interview by Barbara Novak, videotape courtesy PKHSC.
109. "Conversation between Lee Krasner and Richard Howard, Lee Krasner Paintings, 1959–1962," The Pace Gallery, February 3–March 10, 1979.
110. Landau, *Lee Krasner: A Catalogue Raisonné,* 163.
111. *Lee Krasner,* interview by Barbara Novak, videotape courtesy PKHSC.
112. Harrison, "East Hampton Avant-Garde," 10.
113. *Summer of '57,* videotape courtesy LTV, Inc.
114. Harrison, "East Hampton Avant-Garde," 9; Ernestine Lassaw, interview by author.
115. Harrison, "East Hampton Avant-Garde," 9.
116. *Summer of '57,* videotape courtesy LTV, Inc.; Harrison, "East Hampton Avant-Garde," 10.

117. Rivers, *What Did I Do?*, 323.
118. Halberstam, *The Fifties*, 645.
119. Helen Harrison, telephone interview by author; Gruen, *The Party's Over Now*, 40. Painter Jane Wilson was also a contestant on the show. During her appearance, she won one thousand dollars and a lifetime supply of Kent cigarettes.
120. Rivers, *What Did I Do?*, 323–24; Helen Frankenthaler to Sonya Gutman, n.d. [ca. June 1957], Box 1, Folder 9, Sonya Rudikoff Papers, 1935–2000, Princeton, 4; Helen Frankenthaler to Sonya Gutman, May 18, 1957, Box 1, Folder 9, Sonya Rudikoff Papers, 1935–2000, Princeton; Frank O'Hara to Barbara Guest, May 27, 1957, New York to Yaddo Artists Colony, Uncat ZA MS 271, Box 16, Barbara Guest Papers, Yale; Helen Frankenthaler to Barbara Guest, June 10, 1957, West End Avenue to Yaddo Artists Colony, Uncat ZA MS 271, Box 16, Barbara Guest Papers, Yale.
121. Rivers, *What Did I Do?*, 323; Frank O'Hara to Barbara Guest, May 27, 1957, New York to Yaddo Artists Colony, Uncat ZA MS 271, Box 16, Barbara Guest Papers, Yale; "The $64,000 Challenge," warholstars.org/abstractexpressionists/larryrivers.html.
122. Larry Rivers, interview by John Gruen, AAA-SI, 20.
123. Rivers, *What Did I Do?*, 325.
124. Gooch, *City Poet*, 298–99; Rivers, *What Did I Do?*, 325; Larry Rivers with Carol Brightman, "The Cedar Bar," 40.
125. *Summer of '57*, videotape courtesy LTV, Inc.
126. Harrison, *Larry Rivers*, 73; oral history interview with Larry Rivers, AAA-SI.
127. *Summer of '57*, videotape courtesy LTV, Inc.; Harrison and Denne, *Hamptons Bohemia*, 100.
128. Natalie Edgar, e-mail to author, April 26, 2016; *Summer of '57*, videotape courtesy LTV, Inc.; Harrison and Denne, *Hamptons Bohemia*, 100.
129. Natalie Edgar, e-mail to author; *Summer of '57*, videotape courtesy LTV, Inc.
130. Ibid.
131. *Summer of '57*, videotape courtesy LTV, Inc.
132. Ibid.
133. Landau et al., *Mercedes Matter*, 76n116; Miller and Nowak, *The Fifties*, 89; *Summer of '57*, videotape courtesy LTV, Inc.
134. Rivers, *What Did I Do?*, 466.

49. A Woman's Decision

1. Rose, *The Norton Book of Women's Lives*, 69.
2. Elaine de Kooning, interview by Arthur Tobier, 21.
3. Myers, *The Poets of the New York School*, 14; Kaplan, *1959*, 208; Rivers, *What Did I Do?*, 342–43; LeSueur, *Digressions*, 194.
4. Wakefield, *New York in the Fifties*, 310; Kaplan, *1959*, 208; Magee, "Tribes of New York," 704, 713; Wakefield, *New York in the Fifties*, 307–8.
5. Kaplan, *1959*, 207–8; Rivers, *What Did I Do?*, 342; Magee, "Tribes of New York," 713.
6. Rivers, *What Did I Do?*, 342; Kaplan, *1959*, 208.
7. Magee, "Tribes of New York," 704n11, 713–14; Wakefield, *New York in the Fifties*, 310.
8. Magee, "Tribes of New York," 704.
9. Wakefield, *New York in the Fifties*, 310.
10. Kaplan, *1959*, 207–8; Wakefield, *New York in the Fifties*, 307; Rivers, *What Did I Do?*, 342; Magee, "Tribes of New York," 713.
11. Halberstam, *The Fifties*, 678–87; Stone, *The Haunted Fifties*, 111; Brogan, *The Penguin History of the United States*, 626.
12. LeSueur, *Digressions on Some Poems by Frank O'Hara*, 194; Donald Clarke, *Wishing on the Moon*, 403–4.
13. LeSueur, *Digressions on Some Poems by Frank O'Hara*, 194.
14. Ibid., 193; Wakefield, *New York in the Fifties*, 314–15; Gooch, *City Poet*, 327.
15. Magee, "Tribes of New York," 710; LeSueur, *Digressions on Some Poems by Frank O'Hara*, 195.
16. Elaine de Kooning, interview by Arthur Tobier, 21.
17. Clarke, *Wishing on the Moon*, 411.
18. Wakefield, *New York in the Fifties*, 311.

19. Hall, *Elaine and Bill,* 178.
20. Gruen, *The Party's Over Now,* 219; oral history interview with John Chamberlain, AAA-SI.
21. Hall, *Elaine and Bill,* 178.
22. Ibid., 193–94; Doris Aach, interview by author; "Elaine de Kooning Portraits," The Art Gallery, Brooklyn College, 13.
23. Doris Aach, interview by author.
24. Ibid.; Maud Fried Goodnight, telephone interview by author; Stephen Chinlund, interview by author.
25. Hall, *Elaine and Bill,* 194.
26. Clay Fried, interview by author.
27. Sandler, *A Sweeper Up After Artists,* 190.
28. Stevens and Swan, *De Kooning,* 398–400.
29. Ibram and Ernestine Lassaw, interviews for article on Willem de Kooning, Charlotte Willard Papers, 1939–1970, AAA-SI.
30. Elaine and Willem de Kooning records, 1957, Elaine and Willem de Kooning financial records, 1951–1969, AAA-SI. Bill's checks to Elaine each month of 1957 averaged $250. Bill gave Joan Ward a total of $4,510 from January 1957 to January 1958.
31. Liquor store receipts, 1957, Elaine and Willem de Kooning financial records, 1951–1969, AAA-SI. In 1957, Bill collected nearly fifty receipts for charges to a liquor store on Tenth Street for Gordon's gin, and Lord Calvert, Cutty Sark, and Jack Daniel's whiskey—even though he spent nearly every night in the bar.
32. Ibram and Ernestine Lassaw, interviews for article on Willem de Kooning, Charlotte Willard Papers, 1939–1970, AAA-SI; Lily Loew to Michael Loew, Spring 1957, Folder 3, Michael Loew Papers, 1930–1997, AAA-SI; Neil Weiss to Michael Loew, May 21, 1957, Folder 3, Michael Loew Papers, 1930–1997, AAA-SI; Dore Ashton, interview by author; Stevens and Swan, *De Kooning,* 505.
33. Dore Ashton, interview by author.
34. Ibid.
35. Stevens and Swan, *De Kooning,* 400–2, 405.
36. Elaine de Kooning, interview by Molly Barnes, 18.
37. Ad Reinhardt, "Twelve Rules for a New Academy," 37–38, 56.
38. "Ad Reinhardt, Abstract Painting," www.guggenheim.org/artwork/3698; Phyllis D. Rosenzweig, *The Fifties, Aspects of Painting in New York,* 24.
39. Reinhardt, "Twelve Rules for a New Academy," 37–38, 56.
40. Campbell, "Elaine de Kooning Paints a Picture," 45.
41. "Month in Review," *Arts* 30, no. 9 (June 1956): 51; "Reviews and Previews," *ArtNews* 55, no. 3 (May 1956): 51.
42. Elaine de Kooning to Eleanor Ward, n.d. [ca. 1957], Series 1, Box 1, Reel 5821, Stable Gallery Records, 1916–1999, bulk 1953–1970, AAA-SI.
43. Ibid.
44. Irving Sandler, interview by author; Sandler, *A Sweeper Up After Artists,* 226–27.
45. Stahr, "The Social Relations of Abstract Expressionism," 220; Ashton, *The Life and Times of the New York School,* 212.
46. Elaine de Kooning, C. F. S. Hancock Lecture, 4.
47. Helen Harrison, telephone interview by author; Natalie Edgar, interview by author, October 20, 2014.
48. Hall, *Elaine and Bill,* 224; Elaine de Kooning Lecture, C. F. S. Hancock Lecture, 4.
49. Bledsoe, *E de K,* 113.
50. "Reviews and Previews," *ArtNews* 56, no. 7 (November 1957): 12.
51. Helen Frankenthaler to Sonya Gutman, February 15, 1957, Box 1, Folder 9, Sonya Rudikoff Papers, 1935–2000, Princeton, 1.
52. LeSueur, *Digressions on Some Poems by Frank O'Hara,* 123.
53. Helen Frankenthaler to Sonya Gutman, February 15, 1957, Box 1, Folder 9, Sonya Rudikoff Papers, 1935–2000, Princeton, 1–2.
54. LeSueur, *Digressions on Some Poems by Frank O'Hara,* 123.
55. Allen, The Collected Poems of Frank *O'Hara,* 265, 267.

56. Helen Frankenthaler to Sonya Gutman, February 15, 1957, Box 1, Folder 9, Sonya Rudikoff Papers, 1935–2000, Princeton, 1.
57. Helen Frankenthaler to Sonya Gutman, October 9, 1956, Sonya Rudikoff Papers, 1935–2000, Princeton, 2; Helen Frankenthaler to Sonya Gutman, n.d. [ca. June, 1957], Box 1, Folder 9, Sonya Rudikoff Papers, 1935–2000, Princeton, 3; Helen Frankenthaler to Sonya Gutman, May 18, 1957, Box 1, Folder 9, Sonya Rudikoff Papers, 1935–2000, Princeton, 1; Helen Frankenthaler to Sonya Gutman, February 1957, Box 1, Folder 9, Sonya Rudikoff Papers, 1935–2000, Princeton, 2.
58. Helen Frankenthaler to Sonya Gutman, October 30, 1956, Box 1, Folder 8, Sonya Rudikoff Papers, 1935–2000, Princeton, 1–2; Helen Frankenthaler to Sonya Gutman, November 24, 1956, Box 1, Folder 8, Sonya Rudikoff Papers, 1935–2000, Princeton; Helen Frankenthaler to Sonya Gutman, October 9, 1957, Box 1, Folder 9, Sonya Rudikoff Papers, 1935–2000, Princeton, 2; Helen Frankenthaler to Sonya Gutman, May 18, 1957, Box 1, Folder 9, Sonya Rudikoff Papers, 1935–2000, Princeton, 1.
59. Oral history interview with Helen Frankenthaler, AAA-SI.
60. John Bernard Myers to Helen Frankenthaler, June 14, 1957, Southampton to West End Avenue, Helen Frankenthaler Papers, HFF.
61. Elderfield, "Painted on 21st Street," 92–96.
62. Frank O'Hara to Barbara Guest, May 27, 1957, New York to Yaddo Artists Colony, Uncat ZA MS 271, Box 16, Barbara Guest Papers, Yale.
63. Barbara Guest, Diaries, 1953, 1955, 1956, Box 26, Uncat ZA MS 271, Barbara Guest Papers, Yale; Frank O'Hara to Barbara Guest, July 20, 1956, Uncat ZA MS 271, Box 16, Barbara Guest Papers, Yale.
64. Helen Frankenthaler to Sonya Gutman, n.d. [ca. June 1957], Box 1, Folder 9, Sonya Rudikoff Papers, 1935–2000, Princeton, 4; Frank O'Hara to Helen Frankenthaler, April 8, 1957, Donald Allen Collection of Frank O'Hara Letters, UConn; LeSueur, *Digressions on Some Poems by Frank O'Hara,* 128.
65. Helen Frankenthaler to Barbara Guest, June 3, 1957, East Hampton to Yaddo Artists Colony, Uncat ZA MS 271, Box 16, Barbara Guest Papers, Yale; Gooch, *City Poet,* 299.
66. Helen Frankenthaler to Barbara Guest, June 3, 1957, East Hampton to Yaddo Artists Colony, Uncat ZA MS 271, Box 16, Barbara Guest Papers, Yale.
67. Prioleau, *Seductress,* 161.
68. Helen Frankenthaler to Barbara Guest, June 3, 1957, East Hampton to Yaddo Artists Colony, Uncat ZA MS 271, Box 16, Barbara Guest Papers, Yale.
69. Helen Frankenthaler to Grace Hartigan, June 4, 1957, Box 12, Grace Hartigan Papers, Syracuse.
70. Grace Hartigan to Helen Frankenthaler, Monday, June 10, 1957, Helen Frankenthaler Papers, HFF.
71. Helen Frankenthaler to Barbara Guest, June 3, 1957, East Hampton to Yaddo Artists Colony, Uncat ZA MS 271, Box 16, Barbara Guest Papers, Yale.
72. Miz Hofmann to Helen Frankenthaler, May 23, 1957, Helen Frankenthaler Papers, HFF; oral history interview with Helen Frankenthaler, AAA-SI.
73. Oral history interview with Helen Frankenthaler, AAA-SI; E.A. Carmean Jr., *Oral History Interview on Helen Frankenthaler,* videotape courtesy HFF.
74. Hobbs, *Lee Krasner* (1999), 15.
75. Ibid.
76. Oral history interview with Helen Frankenthaler, AAA-SI.
77. Helen Frankenthaler, interview by Barbara Rose, GRI; Myers, *Tracking the Marvelous,* 199; Rivers, *What Did I Do?,* 376.
78. "Reginald Pollack Painting," reginaldpollackpainting.com.
79. Myers, *Tracking the Marvelous,* 199; Helen Frankenthaler, interview by Barbara Rose, GRI. It is possible Helen was introduced to him through Hans, who was friendly with Reggie's brother, Lou, who owned the Peridot Gallery.
80. Helen Frankenthaler to Grace Hartigan, October 12, 1957, Box 12, Grace Hartigan Papers, Syracuse.
81. Mattison, *Grace Hartigan,* 42; Grace Hartigan to James Thrall Soby, September 26, 1957, The Creeks to New Canaan, Connecticut, JTS, I.121, MOMA.

82. Mattison, *Grace Hartigan*, 43.
83. Soby, "Interview with Grace Hartigan," 26.
84. Ibid.
85. Curtis, *Restless Ambition*, 158–60; Rivers, *What Did I Do?*, 302; Mattison, *Grace Hartigan*, 42–43.
86. Curtis, *Restless Ambition*, 158–60.
87. Rivers, *What Did I Do?*, 300; Curtis, *Restless Ambition*, 159; *Summer of '57*, videotape courtesy LTV, Inc.; Harrison and Denne, *Hamptons Bohemia*, 99–100.
88. Curtis, *Restless Ambition*, 160.
89. Natalie Edgar, interview by author, January 20, 2014, New York; Grace Hartigan to Helen Frankenthaler, postcard, November 1, 1957, Helen Frankenthaler Papers, HFF; Rivers, *What Did I Do?*, 300–302.
90. Rivers, *What Did I Do?*, 302.
91. Ibid.
92. Belasco, "Between the Waves," 181n65.
93. Helen Frankenthaler to Grace Hartigan, October 12, 1957, Box 12, Grace Hartigan Papers, Syracuse.
94. Oral history interview with Helen Frankenthaler, AAA; Helen Frankenthaler, interview by Barbara Rose, GRI.
95. Flam et al., *Robert Motherwell*, 205–6, 209.
96. Oral history interview with Helen Frankenthaler, AAA-SI; Helen Frankenthaler, interview by Barbara Rose, GRI.
97. Flam et al., *Robert Motherwell*, 201, 204, 206.
98. Jeannie Motherwell, telephone interview by author, August 12, 2014.
99. Lise Motherwell, telephone interview by author.
100. Helen Frankenthaler to Sonya Gutman, November 20, 1950, Box 1, Folder 2, Sonya Rudikoff Papers, 1935–2000, Princeton, 1; oral history interview with Helen Frankenthaler, AAA-SI.
101. Helen Frankenthaler to Sonya Gutman, February 12, 1954, Box 1, Folder 6, Sonya Rudikoff Papers, 1935–2000, Princeton, 1–2.
102. Van Horne, *A Complicated Marriage*, 18.
103. Leo Castelli, interview by Dodie Kazanjian, AAA-SI, 1; Leo Castelli, interview by Mitch Tuchman, AAA-SI, 1.
104. "Exhibition History, 1957," www.castelligallery.com/history/4e77.html.
105. Helen Frankenthaler, interview by Barbara Rose, GRI.
106. Myers, *Tracking the Marvelous*, 199.
107. Helen Frankenthaler, interview by Barbara Rose, GRI.
108. Oral history interview with Helen Frankenthaler, AAA-SI.
109. Lise Motherwell, telephone interview by author.
110. Jeannie Motherwell, telephone interview by author, August 12, 2014.

50. Sputnik, Beatnik, and Pop

1. "Twelve Americans Show," Dorothy C. Miller, II.A.3, MOMA.
2. "The Year's Best 1955," *ArtNews* 54, no. 9 (January 1956): 40; Albers, *Joan Mitchell*, 260.
3. Albers, *Joan Mitchell*, 253–54; Joan Mitchell to Mike Goldberg, n.d. [ca. 1957], Paris to New York, Michael Goldberg Papers, 1942–1981, AAA-SI.
4. Albers, *Joan Mitchell*, 253.
5. Ibid., 253–54.
6. Joan Mitchell to Mike Goldberg, n.d. [ca. 1957], Paris to New York, Michael Goldberg Papers, 1942–1981, AAA-SI.
7. De Billy, *Riopelle*, 125; Albers, *Joan Mitchell*, 258.
8. De Billy, *Riopelle*, 125.
9. Kaplan, *1959*, 196.
10. De Billy, *Riopelle*, 125.
11. Albers, *Joan Mitchell*, 258.
12. Ibid., 254.

13. De Billy, *Riopelle*, 133.
14. Ibid.; Albers, *Joan Mitchell*, 255, 258; Frank O'Hara to Mike Goldberg, August 26, 1957; 1:103, Allen Collection of Frank O'Hara Letters, UConn.
15. Joan Mitchell to Mike Goldberg, n.d., Grand Hotel du Mont Blanc, Paris, to New York, Michael Goldberg Papers, 1942–1981, AAA-SI; Albers, *Joan Mitchell*, 257; Paul Jenkins to Esther Jenkins, December 13, 1957, Paul Jenkins Papers, 1932–2009, AAA-SI.
16. Joan Mitchell to Paul Jenkins, n.d. [ca. 1958], Paul Jenkins Papers, 1932–2009, AAA-SI.
17. De Billy, *Riopelle*, 134.
18. Ibid.
19. Joan Mitchell to Paul Jenkins, n.d. [ca. 1959], Paul Jenkins Papers, 1932–2009, AAA-SI.
20. Ken Jordan, "Interview with Barney Rosset"; Miller and Nowak, *The Fifties*, 383. The authors called *Evergreen Review* "the most enduring of the avant-garde periodicals."
21. John Clellon Holmes, "'This Is the Beat Generation,'" http://www.nytimes.com/1952/11/16/archives/this-is-the-beat-generation-despite-its-excesses-a-contemporary.html; Kaplan, *1959*, 27–28. Beats became "Beatniks" when a San Francisco columnist said they were as far out as Sputnik.
22. Jordan, "Interview with Barney Rosset."
23. Ibid.
24. Bram, *Eminent Outlaws*, 34; Jordan, "Interview with Barney Rosset."
25. Albers, *Joan Mitchell*, 259–60; Joan Mitchell to Mike Goldberg, n.d., Michael Goldberg Papers, 1942–1981, AAA-SI.
26. Frank O'Hara to Gregory Corso, March 20, 1958, Allen Collection of Frank O'Hara Letters. UConn; Bram, *Eminent Outlaws*, 36.
27. Oral history interview with Joan Mitchell, April 16, 1986, AAA-SI; Matthew Nilsson, "The Beat Hotel: American Writers in Paris, 1957–1963," *Literary Traveler*, www.literarytraveler.com/.../the-beat-hotel-american-writers-in-paris-1957.
28. Jordan, "Interview with Barney Rosset."
29. Gooch, *City Poet*, 318–19; Joan Mitchell to Mike Goldberg, n.d., Michael Goldberg Papers, 1942–1981, AAA-SI.
30. Gooch, *City Poet*, 203.
31. Albers, *Joan Mitchell*, 259–60.
32. David Savram, *Taking It Like a Man*, 44.
33. Joan Mitchell to Barney Rosset, dated February 13, 1967, postmarked February 14, 1967, Paris to New York, JMFA003, JMF; Joan Mitchell to Barney Rosset, postmarked October 2, 1969, Paris to New York, JMFA003, JMF; Richard Milazzo, "Barney and Joan," *Evergreen Review* 104 (January 2001): n.p.
34. Marion Stroebel to Joan Mitchell, dated September 25, 1955, Chicago to Paris, JMFA001, JMF; Marion Stroebel to Joan Mitchell, dated October 26, 1957, Chicago to Paris, JMFA001, JMF; Albers, *Joan Mitchell*, 255. Joan also received four hundred dollars a month from her mother and earnings from the sale of her work.
35. "Joan Mitchell," transcript Barney/Sandy Interview, January 21, 2004, Barney Rosset Papers, Tape 5, Side 1, Series II, Box 3, Folder 5, Columbia.
36. Albers, *Joan Mitchell*, 261.
37. Ibid., 244, 260–61.
38. Ashton, *The Life and Times of the New York School*, 212; Perl, *New Art City*, 355.
39. Kaplan, *1959*, 174.
40. Leo Castelli, interview by Mitch Tuchman, AAA-SI, 3–4.
41. Leo Castelli, interview by Dodie Kazanjian, AAA-SI, 5; Leo Castelli, interview by Mitch Tuchman, AAA-SI, 4–5.
42. Oral history interview with Leo Castelli, AAA-SI.
43. Perl, *New Art City*, 355; Marquis, *The Art Biz*, 220, 273. The Modern had its first Johns show in 1958. "Everything but one item was sold to museum benefactors," Marquis wrote.
44. Rubenfeld, *Clement Greenberg*, 211.
45. Grigor, *Shattering Boundaries*, film; Milton Resnick, interview by Jack Taylor.
46. Diggins, *The Proud Decades*, 312; Halberstam, *The Fifties*, 624, 627.

47. Brogan, *The Penguin History of the United States,* 612; Friedan, *The Feminine Mystique,* 26; Riley, *Inventing the American Woman,* 241; Diggins, *The Proud Decades,* 136, 312; Miller and Nowak, *The Fifties,* 65, 138. Miller and Nowak write that the sale of tranquilizers went from almost none in 1954 to 1.2 million pounds of pills, worth $4.75 million, in 1959. Friedan said suburban housewives were popping tranquilizers "like cough drops."
48. Halberstam, *The Fifties,* 625.
49. Diggins, *The Proud Decades,* 135, 314; Arendt, *The Human Condition,* 1, 3.
50. Sandler, *A Sweeper Up After Artists,* 231–32.
51. John Bernard Myers to Helen Frankenthaler, August 27, 1957, Helen Frankenthaler Papers, HFF.
52. Ashton, *The Life and Times of the New York School,* 212–13; Thomas B. Hess, "Younger Artists and the Unforgivable Crime," 46.
53. Perl, *New Art City,* 355.
54. Barrett, *Irrational Man,* 11, 269–70; George McNeil, interview by Jack Taylor. McNeil said, "It was popular art because it was easily understood."
55. Miller and Nowak, *The Fifties,* 128, 257, 347–49.
56. Ibid.
57. Kleeblatt, *Action/Abstraction,* 30; Ibram Lassaw, interview by Jack Taylor. Ibram said the Pop "jolt" came fast and hard. "There was something very calculated.... Many of those artists seemed to be very much involved with the market, with sales, with promotion.... They hired publicity people." As for Pop being an all-boys club, a notable exception in New York in the 1960s was Rosalyn Drexler.
58. Elizabeth C. Baker, "Hans Hofmann, Abstract-Expressionism and Color in New York, 110; Goodman, *Hans Hofmann,* 73.
59. Baker, "Hans Hofmann, Abstract-Expressionism and Color in New York," 108–9, 110.
60. Rosenberg, *The Anxious Object,* 147; Tom Wolfe, *The Painted Word,* 74.
61. Miller and Nowak, *The Fifties,* 393.
62. Szarkowski and Elderfield, *The Museum of Modern Art at Mid-Century,* 45, 86.
63. Rich, "Freedom of the Brush," 50; Ashton, *The New York School: A Cultural Reckoning,* 207; Szarkowski and Elderfield, *The Museum of Modern Art at Mid-Century,* 93.
64. "A New York Museum is Stealing the Honors from the United States Government in selling America's Boldest Abstract Art Abroad," February 25, 1959, United Press International, I.4.g.; New American Painting, International Council Program, MOMA; Bernstein, *Towards a New Past,* 344, 356; Jachec, *The Philosophy and Politics of Abstract Expressionism,* 190, 211; Szarkowski and Elderfield, *The Museum of Modern Art at Mid-Century,* 46. "The British Government sends its most advanced art overseas under government sponsorship, so does the French," Dorothy Miller explained to a journalist at the time. "Our government is one of the few in the world that is too timid to.... We think that it should. So we do the job instead."
65. *The New American Painting,* 52; Lynes, *Good Old Modern,* 387; Szarkowski and Elderfield, *The Museum of Modern Art at Mid-Century,* 87.
66. Szarkowski and Elderfield, *The Museum of Modern Art at Mid-Century,* 86.
67. *The New American Painting,* 52.
68. "New American Painting," I.A.727, IC/IP, I.A.3024, MOMA.
69. Memo Porter McCray to lenders, April 4, 1958, IC/IP, I.A.3024, MOMA.
70. *Die Weltwoche,* "May 9, 1958, New American Painting," IC/IP I.A.3024, MOMA; Memo Porter McCray to lenders, April 4, 1958, IC/IP, I.A.3024, MOMA.
71. Letter from Monroe Wheeler on fire at the Modern, June 4, 1958, Monroe Wheeler Papers, I.18, MOMA.
72. Ibid.; Lynes, *Good Old Modern,* 359–60, 363, 365.
73. Lynes, *Good Old Modern,* 365, 367, 368; oral history interview with Margaret Scolari Barr, AAA-SI.
74. Letter from Monroe Wheeler on fire at the Modern, June 4, 1958, Monroe Wheeler Papers, I.18, MOMA; Lynes, *Good Old Modern,* 367–68.
75. Lynes, *Good Old Modern,* 368, 374.
76. *Die Weltwoche,* May 9, 1958, "1958 New American Painting," IC/IP I.A.3024, MOMA.
77. Mademoiselle Magazine Merit Award, Box 18, Grace Hartigan Papers, Syracuse.

78. "The 'Rawness,' the Vast," *Newsweek,* May 11, 1959, 113–14; "Human Image in Abstraction," *Time* 72 (August 11, 1958): 48.
79. Allen Barber, "Making Some Marks," 51.
80. Grace Hartigan to Helen Frankenthaler, postcard, November 6, 1957, East Hampton, Long Island, to West End Avenue, New York, Helen Frankenthaler Papers, HFF.
81. Rex Stevens, interview by author.
82. Oral history interview with Audrey Flack, AAA-SI; Jane Freilicher, interview by author; LeSueur, *Digressions on Some Poems by Frank O'Hara,* 151.
83. Jane Freilicher, interview by author.
84. Rex Stevens, interview by author.
85. Dore Ashton, interview by author; Jane Freilicher, interview by author; Rex Stevens, interview by author; LeSueur, *Digressions on Some Poems by Frank O'Hara,* 151.
86. Mary Abbott to Grace Hartigan, 1956, Grenoble to New York, Box 8, Grace Hartigan Papers, Syracuse.
87. "Grace Hartigan, Painting from Popular Culture, Three Decades," Susquehanna Art Museum.
88. Mary Abbott to Grace Hartigan, February 4, 1958, Box 8, Grace Hartigan Papers, Syracuse.
89. Prioleau, *Seductress,* 169.
90. Mary Abbott to Grace Hartigan, February 4, 1958, Box 8, Grace Hartigan Papers, Syracuse.
91. Grace Hartigan to Helen Frankenthaler, July 14, 1958, Helen Frankenthaler Papers, HFF.
92. Rosen, *Popcorn Venus,* 270–71; Haskell, *From Reverence to Rape,* 4–5; Ruddick and Daniels, *Working It Out,* 288, 305; Halberstam, *The Fifties,* 162–63, 579–80; Rose, *The Norton Book of Women's Lives,* 433; Friedan, *The Feminine Mystique,* 38. Friedan said in 1959 not a single heroine in stories in the three major women's magazines had a commitment to any occupation other than housewife. A career woman was considered "frustrated," masculine, and no longer sexually attractive to her husband. Most women heard the message. During that period, there were fewer women in college than there had been in the 1920s. More than two million women had joined the workforce, but a third of them were secretaries. Author Joyce Johnson said that in Manhattan, that acquiescent army, egg-salad sandwiches and the steamy bestseller *Peyton Place* in hand, could be seen marching each day toward Madison Avenue, where they worked before settling into their real career, marriage. And in films the "great" women were most often depicted as remote, flawed, overly driven, even cruel, while their female friend, sister, or helpmate appeared as the more appealing character.
93. Rose, *The Norton Book of Women's Lives,* 570; Chafe, *The American Woman,* 100. Margaret Mead said, "A woman has two choices: be a woman and therefore less an achieving individual, or an achieving individual and therefore less a woman."
94. Rose, *The Norton Book of Women's Lives,* 570.

51. *Bridal Lace and Widow's Weeds*

1. "Interview with Lee Krasner," *Evening Standard* [London], Wednesday, September 22, 1965, Series 2, Subseries 7, Box 10, Folder 38, Jackson Pollock and Lee Krasner Papers, ca. 1914–1984, AAA-SI, 4.
2. E.A. Carmean Jr., *Oral History Interview on Helen Frankenthaler,* videotape courtesy HFF.
3. Ibid.
4. Lise Motherwell, telephone interview by author; Jeannie Motherwell, telephone interview by author, July 8, 2014, and August 12, 2014.
5. Dore Ashton, interview by author; Jeannie Motherwell, telephone interview by author, August 12, 2014; Lise Motherwell, telephone interview by author.
6. Helen Frankenthaler, interview by John Gruen, AAA-SI, 21.
7. Flam et al., *Robert Motherwell,* 80, 82, 93.
8. Ibid., 93.
9. Ibid.
10. Helen Frankenthaler to Grace Hartigan, October 12, 1957, Box 12, Grace Hartigan Papers, Syracuse.
11. Elderfield, "Painted on 21st Street," 96, 98.
12. Flam et al., *Robert Motherwell,* 93.
13. Norman Bluhm to Paul Jenkins, n.d., Paul Jenkins Papers, 1932–2009, AAA-SI.

14. Elderfield, "Painted on 21st Street," 98.
15. Guest list for Helen Frankenthaler's Wedding Shower, Box 12, Grace Hartigan Papers, Syracuse; Barbara Guest, Diary 1958, April 4 entry, Uncat ZA MS 271, Box 26, Barbara Guest Papers, Yale.
16. Barbara Guest wrote a poem for Helen as her shower gift, "A Wedding Cake for Helen."
17. Elderfield, "Painted on 21st Street," 98.
18. Oral history interview with Rebecca Reis, AAA-SI.
19. Ibid.
20. Eugene Goossen to Helen Frankenthaler, March 12, 1958, Helen Frankenthaler Papers, HFF.
21. Robert Motherwell, interview by John Gruen, AAA-SI, 5.
22. Lise Motherwell, telephone interview by author; Flam et al., *Robert Motherwell*, 209; Barbara Guest, Diary 1958, May 15 entry, Uncat ZA MS 271, Box 26, Barbara Guest Papers, Yale; Robert Motherwell, interview by John Gruen, AAA-SI, 6.
23. Lise Motherwell, telephone interview by author.
24. Ibid. Bob had a fear from childhood of dying in his sleep due to life-threatening asthma, which was worst at night.
25. Flam et al., *Robert Motherwell*, 93.
26. Ibid., 209.
27. Ibid., 182, 209.
28. Ibid., 93, 209.
29. Ibid.
30. Ibid., 94, 210.
31. *The New American Painting*, 8–9; Milan's *Corriere della Sera* dismissed the work, writing, "It is not new. It is not painting.... There is no spiritual flight." But a critic at *Il Giorno* in that same city declared it "astonishing."
32. *The New American Painting*, 9; Curtis, *Restless Ambition*, 166.
33. Flam et al., *Robert Motherwell*, 94, 210; Carmean Jr., *Oral History Interview on Helen Frankenthaler*, videotape courtesy HFF.
34. Flam et al., *Robert Motherwell*, 210.
35. Ibid.; E.A. Carmean Jr., *Oral History Interview on Helen Frankenthaler*, videotape courtesy HFF.
36. Flam et al., *Robert Motherwell*, 210; E.A. Carmean Jr., *Oral History Interview on Helen Frankenthaler*, videotape courtesy HFF.
37. Flam et al., *Robert Motherwell*, 210.
38. Helen Frankenthaler to Barbara Guest, St. Jean de Luz, France, to Paris, June 25, 1958, Uncat ZA MS 271, Box 16, Barbara Guest Papers, Yale.
39. Helen Frankenthaler to Becky and Bernard Reis, June 23, "Mon Eve," Series I, Folder 11, Bernard and Rebecca Reis Papers, GRI.
40. Flam et al., *Robert Motherwell*, 210.
41. Robert Motherwell to Eugene Goossen, July 30, 1958, E. C. Goossen Archives, Ars Libri Ltd, www.arslibri.com/collections/GoossenArchive.pdf, 7.
42. Helen Frankenthaler to Grace Hartigan, July 8, 1958, St. Jean de Luz, France, to New York, Box 12, Grace Hartigan Papers, Syracuse.
43. Ibid.
44. Grace Hartigan to Helen Frankenthaler, July 14, 1958, Essex Street to St. Jean de Luz, France, Helen Frankenthaler Papers, HFF.
45. Helen Frankenthaler to Barbara Guest, St. Jean de Luz, France, to Paris, July 3, 1958, Uncat ZA MS 271, Box 16, Barbara Guest Papers, Yale.
46. Flam et al., *Robert Motherwell*, 210.
47. *The New American Painting*, 9.
48. Helen Frankenthaler to Becky and Bernard Reis, July 16, 1958, Series I, Folder 11, Bernard and Rebecca Reis Papers, GRI.
49. Flam et al., *Robert Motherwell*, 210.
50. Ibid.; Helen Frankenthaler to Barbara Guest, December 10, 1958, Uncat ZA MS 271, Box 16, Barbara Guest Papers, Yale.
51. Jeannie Motherwell, telephone interviews by author, July 8, 2014, and August 12, 2014; Lise Motherwell, telephone interview by author.

52. Jeannie Motherwell, telephone interview by author, July 8, 2014.
53. Jeannie Motherwell, telephone interviews by author, July 8, 2014, and August 12, 2014.
54. Jeannie Motherwell, telephone interview by author, July 8, 2014.
55. Lise Motherwell, telephone interview by author; Jeannie Motherwell, telephone interview by author, July 8, 2014.
56. Jeannie Motherwell, telephone interview by author, August 12, 2014.
57. Lise Motherwell, telephone interview by author.
58. Ibid.; Jeannie Motherwell, telephone interviews by author, July 8, 2014, and August 12, 2014.
59. Helen Frankenthaler to Grace Hartigan, November 30, 1961, Box 12, Grace Hartigan Papers, Syracuse.
60. Elderfield, "Painted on 21st Street," 99.
61. Helen Frankenthaler to Barbara Guest, December 10, 1958, Uncat ZA MS 271, Box 16, Barbara Guest Papers, Yale.
62. Myers, *Tracking the Marvelous*, 198; Helen Frankenthaler, interview by John Gruen, AAA-SI, 14.
63. Myers, *Tracking the Marvelous*, 199; John Bernard Myers to Helen Frankenthaler, June 27, 1958, Helen Frankenthaler Papers, HFF.
64. John Bernard Myers to Larry Rivers, n.d., Larry Rivers Papers, MSS 293, Series I, Subseries A, Box 10, Folder 13, NYU.
65. Myers, *Tracking the Marvelous*, 198; Helen Frankenthaler, interview by John Gruen, AAA-SI, 14.
66. John Bernard Myers to Helen Frankenthaler, June 14, 1957, Helen Frankenthaler Papers, HFF.
67. Helen Frankenthaler to Sonya Gutman, Friday evening, November 24, 1956, Box 1, Folder 8, Sonya Rudikoff Papers, 1935–2000, Princeton, 1.
68. John Bernard Myers to Helen Frankenthaler, June 14, 1957, Helen Frankenthaler Papers, HFF; Myers, *Tracking the Marvelous*, 155; Gruen, *The Party's Over Now*, 188; Rivers, *What Did I Do?*, 206–7.
69. Helen Frankenthaler, interview by John Gruen, AAA-SI, 13.
70. Elderfield, "Painted on 21st Street," 99.
71. Myers, *Tracking the Marvelous*, 199.
72. Gooch, *City Poet*, 441–42.
73. Frank O'Hara to John Ashbery, October 10, 1958, 1:136, Allen Collection of Frank O'Hara Letters, UConn.
74. John Bernard Myers to Mrs. Robert Motherwell, October 4, 1958, Helen Frankenthaler Papers, HFF.
75. Myers, *Tracking the Marvelous*, 199.
76. Oral history interview with André Emmerich, January 18, 1993, AAA-SI.
77. Ibid.
78. De Coppet and Jones, *The Art Dealers*, 62–63.
79. Myers, *Tracking the Marvelous*, 199.
80. Helen Frankenthaler to Barbara Guest, December 10, 1958, Uncat ZA MS 271, Box 16, Barbara Guest Papers, Yale.
81. Ibid.
82. Landau, *Lee Krasner: A Catalogue Raisonné*, 312.
83. Levin, *Lee Krasner*, 328–29.
84. Memo Charlotte Dyer to Porter McCray, July 18, 1957, IC/IP, I.A.3024, MOMA; Frank O'Hara to Lee Krasner, May 27, 1958, and October 31, 1958, IC/IP, I.A.3024, MOMA; Hobbs, *Lee Krasner* (1993), 71.
85. Gruen, *The Party's Over Now*, 252; James T. Valliere, *Lee Krasner and Jackson Pollock's Legacy*, 1. Valliere wrote Lee had decided to withdraw Jackson's work from Janis's gallery because Sidney would not represent her as well, but in an interview with John Gruen (John Jonas Gruen and Jane Wilson Papers, 1952–2003, May 8, 1969, AAA-SI, 23) Lee argued that after her terrible experience with Betty Parsons she did not want to form part of a Pollock "package."
86. Hobbs, *Lee Krasner* (1999), 15.
87. Ibid.
88. Valliere, *Lee Krasner and Jackson Pollock's Legacy*, 35.
89. Lee Krasner, interview by John Gruen, AAA-SI, 26–27.
90. Ibid.

91. Ibid.
92. Landau, *Lee Krasner: A Catalogue Raisonné,* 314.
93. Lee Krasner, interview by Barbara Cavaliere, AAA-SI, 23.
94. "Lee Krasner, at Martha Jackson Gallery," 1958, Series 2, Subseries 8, Box 12, Folder 19, Jackson Pollock and Lee Krasner Papers, ca. 1914–1984, AAA-SI, 7.
95. Ibid., 9.
96. Landau, *Lee Krasner: A Catalogue Raisonné,* 314.
97. Ibid.
98. Hobbs, *Lee Krasner* (1999), 16.
99. Levin, *Lee Krasner,* 328.
100. "Krasner, Painting, Drawing and Collage," Whitechapel Gallery, 1965, 12; Nemser, "A Conversation with Lee Krasner," 46; Levin, *Lee Krasner,* 329.
101. Levin, *Lee Krasner,* 326; Landau, *Lee Krasner: A Catalogue Raisonné,* 312.
102. Friedman, *Jackson Pollock: Energy Made Visible,* 252, 254.
103. Levin, *Lee Krasner,* 327–28.
104. Frank O'Hara to Hal Fondren, July 19, 1958, 1:127, Allen Collection of Frank O'Hara Letters, UConn.
105. Ernestine Lassaw to Alice Baber, n.d. [summer 1958], Alice Baber Papers, 1934-1983, AAA-SI; Franz Schulze, "Abstract Expressionism: An Obituary," *New York Daily News,* n.d., Box 1, Folder 1, Thomas B. Hess/Willem de Kooning Papers, MOMA. Barney's party anticipated the end of Abstract Expressionism as described by Schulze several years later. "To the international art world, the early 1960s are the Morning After that wild bash which just ended over at the Abstract Expressionists' place. We Americans threw it partly to celebrate our victory over European art in the last great war, and partly perhaps, to escape the awfulness of 20th century existence, which that war so gruesomely symbolized."
106. Barney Rosset Papers, MS 1543, Box 3, Folder 32, Series II, Columbia; Denise Lassaw, e-mail to author, September 6, 2016.
107. Ernestine Lassaw to Alice Baber, n.d. [summer 1958], Alice Baber Papers, 1934-1983, AAA-SI; Denise Lassaw, e-mail to author, September 6, 2016.
108. Ibid.
109. Ibid.
110. Ernestine Lassaw to Alice Baber, n.d. [summer 1958], AAA-SI; Stevens and Swan, *De Kooning,* 409–10.
111. Ernestine Lassaw to Alice Baber, n.d. [summer 1958], Alice Baber Papers, 1934–1983, AAA-SI; Denise Lassaw, e-mail to author, September 6, 2016.
112. *Josephine Little: The Art Crowd,* videotape courtesy LTV, Inc.; Denise Lassaw, e-mail to author, September 6, 2016.
113. *Josephine Little: The Art Crowd,* videotape courtesy LTV, Inc.
114. Denise Lassaw, e-mail to author, September 6, 2016.

52. Five Paths...

1. Samuel Beckett, *The Complete Dramatic Works,* 262.
2. Guggenheim, *Out of This Century,* 358, 362.
3. Lukach, *Hilla Rebay,* 293; Kaplan, *1959,* 157–58, 161.
4. Guggenheim, *Out of This Century,* 362–63.
5. Thomas B. Hess, "A Tale of Two Cities," 39; Berman, *All That Is Solid,* 288, 313, 314. Berman wrote, "Because the modern economy has infinite capacity for redevelopment and self-transformation, the modernist imagination, too, must reorient and renew itself again and again." Berman called the United States in the late 1950s an "expressway world."
6. Hess, "A Tale of Two Cities," 39; Miller and Nowak, *The Fifties,* 277; Wolfe, *The Painted Word,* 18–19. Wolfe wrote the art collector in America had attained a "semi-sacred status" as benefactor of the arts. "The arts have always been a doorway into Society" while at the same time illustrating that one stood apart from and above the bourgeoisie.
7. Crehnan, "Recent Attacks on Abstract Art," 63; Ashton, *The Life and Times of the New York School,* 229. By then about three hundred "respectable" galleries of all types existed in New York alone. In 1951, there were just thirty galleries.

8. Marquis, *The Art Biz,* 224, 238.
9. Ibid.
10. Ibid., 14, 250, 255.
11. Marquis, *The Art Biz,* 14; *Art Barge—Artists Speak, with Elaine de Kooning,* videotape courtesy LTV, Inc.
12. Sandler, *A Sweeper Up After Artists,* 43–44; oral history interview with Richard Bellamy, 1963, AAA-SI; Harold Rosenberg, "Tenth Street: A Geography of Modern Art," 120–137, 184.
13. Hess and Baker, *Art and Sexual Politics,* 116.
14. Natalie Edgar, interview by author, January 20, 2014.
15. Oral History interview with Chuck Close, AAA-SI.
16. *The New American Painting,* 13.
17. Ibid.
18. Porter McCray memo, n.d., New American Painting, IC/IP, I.A.3024, MOMA.
19. *Manchester Guardian,* February 27, 1959, New American Painting, IC/IP, I.A.3024, MOMA; *Le Figaro,* January 18, 1959, Paris, New American Painting, IC/IP, I.A.3024, MOMA; Thomas B. Hess, "Great Expectations, Part 1," 60.
20. Curtis, *Restless Ambition,* 168–70.
21. Grace Hartigan to Barbara Guest, October 21, 1958, Uncat ZA MS 271, Box 14, Barbara Guest Papers, Yale.
22. "New Work by Grace Hartigan, April 28–May 30, 1959," Tibor de Nagy, Box 37, Grace Hartigan Papers, Syracuse.
23. Joan Mitchell to Grace Hartigan, n.d. [1958], Paris to New York, Box 20, Grace Hartigan Papers, Syracuse; Gooch, *City Poet,* 314.
24. Gooch, *City Poet,* 314.
25. Ibid.
26. Ibid., 360.
27. Curtis, *Restless Ambition,* 175.
28. Grace Hartigan to Dorothy Miller, September 21, 1962, Series 2, Box 3, Folders 34–35, Dorothy C. Miller Papers, ca. 1912–1992, bulk 1959–1984, AAA-SI.
29. Berkson and LeSueur, *Homage to Frank O'Hara,* 77; Gooch, *City Poet,* 314.
30. Frank O'Hara to Barbara Guest, September 14, 1958, Paris to London, Uncat ZA MS 271, Box 16, Barbara Guest Papers, Yale.
31. *The New American Painting,* 14; Minutes of Museum of Modern Art Board of Trustees meeting, April 9, 1959, New American Painting, IC/IP, I.A.3024, MOMA; Sandler, *Abstract Expressionism and the Modern Experience,* 189.
32. Minutes of Museum of Modern Art Board of Trustees Meeting, April 9, 1959, New American Painting, IC/IP, I.A.3024, MOMA.
33. *The New American Painting,* 13.
34. Minutes of Museum of Modern Art Board of Trustees Meeting, April 9, 1959, New American Painting, IC/IP, I.A.3024, MOMA.
35. "New American Painting," 1.14.f, IC/IP, I.A. 3024, MOMA.
36. Kaplan, *1959,* 196.
37. David Hare, interview by Jack Taylor.
38. Szarkowski and Elderfield, *The Museum of Modern Art at Mid-Century,* 78–79; Kaplan, *1959,* 175; Rose, *American Painting,* 87; Perl, *New Art City,* 419.
39. Sandler, *A Sweeper Up After Artists,* 241; Sandler, *Abstract Expressionism and the American Experience,* 199; Marquis, *The Art Biz,* 115.
40. Giorgio Cavallon, interview by Jack Taylor.
41. Elaine de Kooning 1958 financial records, Elaine and Willem de Kooning financial records, 1951–1969, AAA-SI; Deborah Boll, Peter Walch, and Malin Wilson, "Albuquerque '50s," 9–10.
42. Elaine de Kooning, interview by Molly Barnes, 14.
43. Munro, *Originals,* 255.
44. "Elaine de Kooning Statement," 29.
45. Gruen, *The Party's Over Now,* 220.
46. Boll et al., "Albuquerque '50s," 44–45.

47. Elaine de Kooning and Slivka, *Elaine de Kooning,* 185–86; Boll et al., "Albuquerque '50s," 16.
48. Lewallen, "Interview with Elaine de Kooning," 7; Boll et al., "Albuquerque '50s," 16.
49. Doris Aach, interview by author, November 16, 2013; Hall, *Elaine and Bill,* 266.
50. Margaret Randall, telephone interview by author.
51. Ibid.
52. Margaret Randall, *My Town,* 87–88.
53. Margaret Randall, telephone interview by author.
54. Ibid.; Gruen, *The Party's Over Now,* 220; Randall, *My Town,* 92; Elaine de Kooning record of cash outlay not covered by receipts or checks, 1958, Elaine and Willem de Kooning financial records, 1951–1969, AAA-SI; Boll et al., "Albuquerque '50s," 16.
55. Elaine de Kooning's 1958 record of cash outlay not covered by receipts or checks, Elaine and Willem de Kooning financial records, 1951–1969, AAA-SI; Elaine de Kooning, interview by Molly Barnes, 2–3.
56. Campbell, "Elaine de Kooning Paints a Picture," 43; Elaine de Kooning, interview by Antonina Zara, 20; Lewallen, "Interview with Elaine de Kooning," 7; Campbell, "Elaine de Kooning Paints a Picture," 45.
57. Lewallen, "Interview with Elaine de Kooning," 8; Elaine de Kooning Lecture, C. F. S. Hancock Lecture, 4–5; Munro, *Originals,* 255; Campbell, "Elaine de Kooning Paints a Picture," 44.
58. Campbell, "Elaine de Kooning Paints a Picture," 45; Connie Fox, interview by author.
59. Margaret Randall, telephone interview by author.
60. Connie Fox, interview by author.
61. Margaret Randall, telephone interview by author.
62. Connie Fox, interview by author.
63. "Elaine de Kooning Portraits," The Art Gallery, Brooklyn College, 15, 19, 22.
64. Gruen, *The Party's Over Now,* 220.
65. Stephen Chinlund, interview by author.
66. Maud Fried Goodnight, e-mail to author, February 17, 2014; Charles Fried, telephone interview by author.
67. Johnson, *The New York Schools of Music and Visual Arts,* 46; Lieber, *Reflections in the Studio,* 121n47.
68. Elaine de Kooning, interview by Molly Barnes, 14; Maud Fried Goodnight, e-mail to author, February 17, 2014; Margaret Randall, telephone interview by author; Doris Aach, interview by author; "Elaine de Kooning Portraits," The Art Gallery, Brooklyn College, 19; Luke Luyckx, telephone interview by author; Elaine de Kooning and Slivka, *Elaine de Kooning,* 29. Elaine's collection had grown to one thousand pieces by the time she died.
69. Elaine de Kooning, interview by Molly Barnes, 16.
70. Elaine de Kooning financial statement, 1959, Elaine and Willem de Kooning financial records, 1951–1969, AAA-SI. Elaine indicates her studio address and preferred mailing address to be 791 Broadway. She also indicated she had lived there for twelve months.
71. Campbell, "Elaine de Kooning Paints a Picture," 61–62; Charles Fried, telephone interview by author; Luke Luyckx, telephone interview by author.
72. Maud Fried Goodnight, e-mail to author, February 17, 2014.
73. Campbell, "Elaine de Kooning Paints a Picture," 62; Maud Fried Goodnight, e-mail to author, February 17, 2014.
74. Charles Fried, telephone interview by author.
75. Maud Fried Goodnight, telephone interview by author; Luke Luyckx, telephone interview by author.
76. Maud Fried Goodnight, e-mail to author.
77. "Elaine de Kooning Portraits," The Art Gallery, Brooklyn College, 13.
78. Charles Fried, telephone interview by author.
79. Maud Fried Goodnight, telephone interview by author; Dorfman, *Out of the Picture,* 278.
80. Doris Aach to "Jean," August 20, 1989, East Hampton, New York, courtesy Doris Aach. The letter recounts various speakers at Elaine's memorial. This anecdote is attributed to Herman Cherry.
81. Doris Aach, interview by author, November 16, 2013.
82. Dorfman, *Out of the Picture,* 278.
83. Maud Fried Goodnight, telephone interview by author.

84. Clay Fried, interview by author.
85. Luke Luyckx, telephone interview by author; "Elaine de Kooning Portraits," The Art Gallery, Brooklyn College, 13.
86. Randall, *My Town,* 91; Margaret Randall, telephone interview by author.
87. Clay Fried, interview by author.
88. Sherman Drexler, telephone interview by author.
89. Luke Luyckx, telephone interview by author; Stevens and Swan, *De Kooning,* 412.
90. Stevens and Swan, *De Kooning,* 412–13; oral history interview with Harold Rosenberg, AAA-SI; Ashton, *The New York School,* 229. Two years later, when Bill, Philip Guston, and David Smith threw a party (complete with invitations), Pinkerton guards were hired to keep the eight hundred guests in line.
91. Stevens and Swan, *De Kooning,* 413.
92. Downes, *Art in Its Own Terms,* 36.
93. Edith Schloss, "The Loft Generation," Edith Schloss Burckhardt Papers, Columbia, 154; Tom Hess to Paul Jenkins, June 6, 1961, Paul Jenkins Papers, AAA-SI.
94. Stevens and Swan, *De Kooning,* 411.
95. Elaine de Kooning, interview by Arthur Tobier, 7.
96. Ibid., 7–8.
97. Stephen Chinlund, interview by author.
98. Margaret Randall, telephone interview by author; Waldorf Panel on Sculpture, II, March 17, 1965, moderated by Philip Pavia, Tape 1, Waldorf Panel on Sculpture, February 17 and March 17, 1965, AAA-SI; Connie Fox, interview by author.
99. Elaine de Kooning, interview by Arthur Tobier, 8; Maud Fried Goodnight, e-mail to author.
100. Stephen Chinlund, interview by author.
101. Oral history interview with Alice Baber, 1973, AAA-SI; *NO! Boris Lurie,* David David Gallery, 12–13; *KZ-KAMPF-KUNST Boris Lurie: NO!ART,* 146.
102. *KZ-KAMPF-KUNST Boris Lurie: NO!ART,* 8.
103. Ibid., 11.
104. Ibid., 156–57.
105. Marquis, *The Art Biz,* 328.

53. ...Forward

1. Barbara Rose, "First-Rate Art by the Second Sex," 80.
2. Elderfield, "Painted on 21st Street," 101.
3. Nadine Brozan, "The Evening Hours," *New York Times,* February 22, 1985, http://www.nytimes.com/1985/02/22/style/the-evening-hours.html.
4. "In the Galleries," *Arts Magazine* 33, no. 8 (May 1959): 56; *New York Herald Tribune,* Sunday April 5, 1959, n.p.
5. Ibid.
6. "Reviews and Previews," *ArtNews,* May 1959, n.p.
7. Charlotte Willard, "Women of American Art,", 75; "The Vocal Girls," 74; "Editor's Letters," *ArtNews* 52, no. 4 (June–July–August 1953): 6; Deborah Solomon, typed notes for article "The Lyrical Mystery of Helen Frankenthaler," courtesy Deborah Solomon, 6. Though Willard's article was meant to be a celebration of women artists, her description of Helen betrayed her prejudice against them. Beginning in the fifth sentence, she wrote that Frankenthaler "is married to painter Robert Motherwell. In debt to the late Jackson Pollock and Hans Hoffman [*sic*] for her technique..." In other words, the men around her were responsible for her vision. The *Time* article mentions in its first sentence on Helen that the thirty-one-year-old artist is the daughter of a judge and wife of Bob Motherwell. In a hilarious letter to the editor of *ArtNews* in 1953, painter Janice Biala drew attention to this phenomenon by saying in the case of "lady painters; they seldom appear in your pages detached from the conjugal yoke. In my own case I have never been given a review in your journal unaccompanied by one dear husband or another, and now the secret is out. I have a brother too!"
8. Frank O'Hara Papers for Documenta II Exhibition, IC/IP, I.A.3024, MOMA; Gooch, *City Poet,* 325.
9. Elderfield, "Painted on 21st Street," 102.

10. "28 Art Awards Listed in Paris; Five Frenchmen, Three from U.S. Among Winners at First Biennial Show," *New York Times,* Wednesday, October 7, 1959, 85; "After Mountains and Sea," 93.
11. Helen Frankenthaler to Barbara Guest, October 9, 1959, New York to Washington, DC, Uncat ZA MS 271, Box 16, Barbara Guest Papers, Yale.
12. Oral history interview with Helen Frankenthaler, AAA-SI.
13. Frank O'Hara to John Ashbery, October 13, 1959, 1:192, Allen Collection of Frank O'Hara Letters, UConn.
14. Gruen, *The Party's Over Now,* 191; Ashton with Banach, *The Writings of Robert Motherwell,* 284.
15. Gruen, *The Party's Over Now,* 193.
16. Helen Frankenthaler to Barbara Guest, November 6, 1959, New York to Washington, DC, Uncat ZA MS 271, Box 16, Barbara Guest Papers, Yale; Gruen, *The Party's Over Now,* 195; Grace Glueck, "Helen Frankenthaler, Abstract Painter Who Shaped a Movement," http://www.nytimes.com/2011/12/28/arts/helen-frankenthaler-abstract-painter-dies-at-83.html.
17. E.A. Carmean Jr., *Oral History Interview on Helen Frankenthaler,* videotape courtesy HFF.
18. Glueck, "Helen Frankenthaler, Abstract Painter Who Shaped a Movement."
19. Jeannie Motherwell, telephone interviews by author, July 8, 2014, and August 12, 2014; Clifford Ross, interview by author, January 15, 2014.
20. Helen Frankenthaler to Barbara Guest, December 10, 1958, Uncat ZA MS 271, Box 16, Barbara Guest Papers, Yale; Robert Motherwell to Eugene Goossen, July 30, 1958, The E. C. Goossen Archives, Ars Libri Ltd, www.arslibri.com/collections/GoossenArchive.pdf, 7; *E.A. Carmean Jr., Oral History Interview on Helen Frankenthaler,* videotape courtesy HFF.
21. Flam et al., *Robert Motherwell,* 101; Helen Frankenthaler, interview by John Gruen, AAA-SI, 21.
22. Oral history interview with Grace Hartigan, AAA-SI.
23. "Grace Hartigan, Palette Fresh and Brilliant," *Truro (Mass.) Post,* n.d. [1982], n.p.
24. Jean Lipman, ed., *The Collector in America,* 23.
25. Note, Series 2, Box 3, Folders 34–35, Dorothy C. Miller Papers, ca. 1912–1992, bulk 1959–1984, AAA-SI; Marquis, *The Art Biz,* 170. Rockefeller said his "taste in art endangered his political career."
26. Peggy Guggenheim to Grace Hartigan, September 15, 1955, Box 13, Grace Hartigan Papers, Syracuse; John Bernard Myers to Grace Hartigan, July 10, 1959, Box 21, Grace Hartigan Papers, Syracuse; Tibor de Nagy Gallery Files, Box 28, Folder 1, AAA-SI. Peggy purchased *Ireland* in April 1959 for two thousand dollars.
27. Curtis, *Restless Ambition,* 174; Leonard Bocour to Grace Hartigan, October 30, 1962, Box 5, Grace Hartigan Papers, Syracuse.
28. Frank O'Hara to Barbara Guest, August 17, 1959, 1:181; Allen Collection of Frank O'Hara Letters, UConn; Mary Abbott to Grace Hartigan, January 15, 1959, Box 8, Grace Hartigan Papers, Syracuse.
29. Rex Stevens, interview by author; Donna Sesee, interview by author.
30. Grace Hartigan to Joan Mitchell, dated November 13 [ca. 1958], JMFA001, JMF.
31. Rivers, *What Did I Do?,* 319–20.
32. Gooch, *City Poet,* 329; Frank O'Hara to Barbara Guest, October 19, 1959, New York to Washington, Box 16, UnCat ZA MS 271, Barbara Guest Papers, Yale.
33. Grace Hartigan to Joan Mitchell, dated November 13 [ca. 1958], JMFA001, JMF.
34. Curtis, *Restless Ambition,* 175–76; Tibor de Nagy Gallery Files, Box 28, Folder 3, AAA-SI. Gallery records indicate Grace sold $14,427 through Tibor de Nagy. The remainder of her sales likely came through the Gres Gallery.
35. John Bernard Myers to Grace Hartigan, August 26, 1959, Box 21, Grace Hartigan Papers, Syracuse.
36. Curtis, *Restless Ambition,* 176, 180.
37. Ibid., 181; Hart Perry, interview by author.
38. Notes on discussions between Grace Hartigan and Beatrice Perry, August 1959, Box 23, Grace Hartigan Papers, Syracuse.
39. Rex Stevens, interview by author.
40. Tibor de Nagy to Grace Hartigan, February 24, 1960, Tibor de Nagy Gallery Records, 1941–1993, Series 1, Subseries 5, Box 7, Folder 12, AAA-SI; Grace Hartigan to Tibor de Nagy, August 1 [ca. 1959], Tibor de Nagy Gallery Records, 1941–1993, Series 1, Subseries 5, Box 7, Folder 12, AAA-SI.

41. Rex Stevens, interview by author.
42. Mary Abbott to Grace Hartigan, April 26, 1958, Box 8, Grace Hartigan Papers, Syracuse.
43. Grace Hartigan to Joan Mitchell, November 13 [ca. 1958], JMFA001, JMF; Curtis, *Restless Ambition*, 173; Grace Hartigan to Helen Frankenthaler Motherwell, July 24, 1959, Helen Frankenthaler Papers, HFF.
44. Grace Hartigan to Barbara Guest, November 17, 1959, Essex Street to Washington, DC, Uncat ZA MS 271, Box 14, Barbara Guest Papers, Yale.
45. Barbara Guest to Helen Frankenthaler, July 10, 1959, Helen Frankenthaler Papers, HFF; Al Leslie to Bob Motherwell and Helen Frankenthaler, July 13, 1959, Helen Frankenthaler Papers, HFF; Grace Hartigan to Barbara Guest, November 17, 1959, Essex Street to Washington, DC, Uncat ZA MS 271, Box 14, Barbara Guest Papers, Yale; Mattison, *Grace Hartigan*, 50.
46. Grace Hartigan to Barbara Guest, November 17, 1959, Essex Street to Washington, DC, Uncat ZA MS 271, Box 14, Barbara Guest Papers, Yale.
47. Oral history interview with Grace Hartigan, AAA-SI; Nemser, *Art Talk*, 162.
48. Grace Hartigan to Barbara Guest, December 11, 1959, Essex Street to Washington, DC, Uncat ZA MS 271, Box 14, Barbara Guest Papers, Yale; oral history interview with Grace Hartigan, AAA-SI. Grace and Mary Abbott both wore what Grace called "DIVINE mink hats for the nuptials."
49. Grace Hartigan to Barbara Guest, December 11, 1959, Essex Street to Washington, DC, Uncat ZA MS 271, Box 14, Barbara Guest Papers, Yale.
50. Gooch, *City Poet*, 359–60.
51. Frank O'Hara to Grace Hartigan, August 20, 1959, containing typed poem "L'Amour avait passé par là," dated August 19, 1959; *Locus Solus: The New York School of Poets*, April 14, 2016, https://newyorkschoolpoets.wordpress.com; Perloff, *Frank O'Hara*, 79–80.
52. "Reviews and Previews," *ArtNews* 58, no. 8 (December 1959): 18; O'Hara, fliers for readings and exhibitions, "Hartigan and Rivers with O'Hara," Series VIII, Kenneth Koch Papers, NYPL.
53. Lawrence Campbell, "Grace Hartigan, Larry Rivers, Frank O'Hara," 18.
54. LeSueur, *Digressions on Some Poems by Frank O'Hara*, 208.
55. De Billy, *Riopelle*, 141.
56. Livingston, *The Paintings of Joan Mitchell*, 40; John Ashbery, "An Expressionist in Paris," 44.
57. Bernstock, *Joan Mitchell*, 181.
58. Joan Mitchell to Mike Goldberg, n.d., Michael Goldberg Papers, 1942–1981, AAA-SI.
59. Marion Strobel to Joan Mitchell, June 9, 1954, Chicago to New York, JMFA001, JMF; Albers, *Joan Mitchell*, 264.
60. Joan Mitchell to Paul Jenkins, n.d., Paul Jenkins Papers, 1932–2009, AAA-SI.
61. Suzanne D. Jenkins, interview by author.
62. Joan Mitchell paid 45,000 francs from January 15, 1959, until April 1, 1959, and then 180,000 francs a year after; 10 rue Frémicourt rent documents, JMFA001, Joan Mitchell Papers, JMF; de Billy, *Riopelle*, 140; Albers, *Joan Mitchell*, 273–74, 277.
63. Joan Mitchell to Paul Jenkins, n.d., Paul Jenkins Papers, 1932–2009, AAA-SI.
64. De Billy, *Riopelle*, 140; Albers, *Joan Mitchell*, 273–74. Joan's father and Jean-Paul helped her buy it.
65. Albers, *Joan Mitchell*, 264–65, 271.
66. Jean-Paul Riopelle to Joan Mitchell, dated June 8, 1958, Paris to New York, JMFA001, Joan Mitchell Papers, JMF; Albers, *Joan Mitchell*, 271.
67. Albers, *Joan Mitchell*, 190, 240.
68. Ibid., 240, 264, 272.
69. Ibid., 274–75.
70. Ibid., 275.
71. Joan Mitchell to Paul Jenkins, n.d., Paul Jenkins Papers, 1932–2009, AAA-SI.
72. Gooch, *City Poet*, 307–9.
73. Joan Mitchell to Paul Jenkins, n.d., Paul Jenkins Papers, 1932–2009, AAA-SI.
74. Barbara Guest to Helen Frankenthaler, July 8, 1959, Helen Frankenthaler Papers, HFF; Albers, *Joan Mitchell*, 283; Gooch, *City Poet*, 307–8.
75. Albers, *Joan Mitchell*, 275.
76. De Billy, *Riopelle*, 144.
77. Albers, *Joan Mitchell*, 275.

78. Joan Mitchell to Grace Hartigan, Greece to Bridgehampton, n.d., ca.1959, Box 20, Grace Hartigan Papers, Syracuse; Joan Mitchell to Grace Hartigan, postcard, Greece to Bridgehampton, n.d., ca. 1959, Box 20, Grace Hartigan Papers, Syracuse.
79. Grace Hartigan to Joan Mitchell, dated November 13 [ca. 1958], JMFA001, Joan Mitchell Papers, JMF.
80. De Billy, *Riopelle,* 153.
81. Allen, *The Collected Poems of Frank O'Hara,* 328–29.
82. De Billy, *Riopelle,* 140.
83. Stable Gallery business records, JMFA001, Joan Mitchell Papers, JMF; oral history interview with Joan Mitchell, April 16, 1986, AAA-SI.
84. Cajori, *Joan Mitchell: Portrait of an Abstract Painter,* film.
85. De Billy, *Riopelle,* 140, 142.
86. Nemser, "An Afternoon with Joan Mitchell," 6.
87. De Billy, *Riopelle,* 143; Deborah Solomon, "In Monet's Light,"www.nytimes.com/1991/11/24/magazine/in-monet-s-light.html.
88. De Billy, *Riopelle,* 142.
89. Ibid., 143.
90. Bernstock, *Joan Mitchell,* 114–15.
91. Marion Cajori, letter to collectors to raise funds for film *Joan Mitchell: Portrait of an Abstract Painter,* dated May 4, 1990, JMFA001, Joan Mitchell Papers, JMF; Sandler, "Mitchell Paints a Picture," 45.
92. Oral history interview with Joan Mitchell, May 21, 1965, AAA-SI.
93. De Billy, *Riopelle,* 145–46.
94. Albers, *Joan Mitchell,* 275.
95. De Billy, *Riopelle,* 145–46; Albers, *Joan Mitchell,* 276.
96. Albers, *Joan Mitchell,* 276; de Billy, *Riopelle,* 147.
97. Albers, *Joan Mitchell,* 279.
98. Ibid., 273.
99. Peter Schjeldahl, "Tough Love," www.newyorker.com/magazine/2002/07/15/tough-love-3.
100. Albers, *Joan Mitchell,* 279–80.
101. Ibid., 280, 283; de Billy, *Riopelle,* 153.
102. Joan Mitchell to Mike Goldberg, n.d., Michael Goldberg Papers, 1942–1981, AAA-SI.
103. B. H. Friedman, "Manhattan Mosaic," 26–29; Nemser, "A Conversation with Lee Krasner," 46; Friedman, "Lee Krasner," draft manuscript, 1965, Series 2.4, Box 10, Folder 7, Lee Krasner Papers, AAA-SI, 18.
104. Clement Greenberg Journal, March 11, 1956, Box 16, Folder 3, Journal 18, Series II, Clement Greenberg Papers, GRI (950085).
105. Clement Greenberg, interview by John Gruen, n.d., AAA-SI, 10; Jachec, *The Philosophy and Politics of Abstract Expressionism,* 19; Marquis, *Art Czar,* 164.
106. Marquis, *Art Czar,* 166–68; Greenberg and Van Horne, interview by Dodie Kazanjian, AAA-SI, 1.
107. Marquis, *Art Czar,* 166–67, 169.
108. Ibid., 169–71; Greenberg and Van Horne, interview by Dodie Kazanjian, AAA-SI, 1.
109. Rubenfeld, *Clement Greenberg,* 222; Marquis, *Art Czar,* 172.
110. Rubenfeld, *Clement Greenberg,* 218.
111. Lee Krasner, interview by John Gruen, AAA-SI, 27.
112. Ibid. 14; Gooch, *City Poet,* 341.
113. Rubenfeld, *Clement Greenberg,* 218. Porter McCray, the head of the Modern's International Program, joined them.
114. Ibid.
115. Ibid., 218–19; Greenberg and Van Horne, interview by Dodie Kazanjian, AAA-SI, 1; Nemser, "A Conversation with Lee Krasner," 49.
116. Lee Krasner, interview by Richard Howard, Box 10, Folder 1, Lee Krasner Papers, AAA-SI; "Lee Krasner Paintings, 1959–1962," The Pace Gallery, February 3–March 10, 1979.
117. Lee Krasner, interview by Richard Howard, Box 10, Folder 1, Lee Krasner Papers, AAA-SI; *Lee Krasner,* interview by Robert Coe, videotape courtesy PKHSC; "Lee Krasner Paintings, 1959–1962," The Pace Gallery.

118. Lee Krasner, interview by Richard Howard, Box 10, Folder 1, Lee Krasner Papers, AAA-SI.
119. "Lee Krasner Paintings, 1959–1962," The Pace Gallery.
120. Lee Krasner, interview by Richard Howard, Box 10, Folder 1, Lee Krasner Papers, AAA-SI; "Lee Krasner Paintings, 1959–1962," The Pace Gallery; Hobbs, *Lee Krasner* (1999), 154.
121. Harrison, "East Hampton Avant-Garde," 18; Friedman, "Lee Krasner," draft manuscript, 1965, Series 2.4, Box 10, Folder 7, Lee Krasner Papers, AAA-SI, 18–19.
122. Lee Krasner notes, August 1, 1959, Box 8, Folder 21, Lee Krasner Papers, AAA-SI.
123. Hobbs, *Lee Krasner* (1999), 18.
124. Rubenfeld, *Clement Greenberg*, 220; Nemser, *Art Talk*, 99.
125. Landau, *Lee Krasner: A Catalogue Raisonné*, 314.
126. Rubenfeld, *Clement Greenberg*, 220; Janice Van Horne, interview by author; Van Horne, *A Complicated Marriage*, 140–42; Nemser, "A Conversation with Lee Krasner," 47.
127. Rubenfeld, *Clement Greenberg*, 220.
128. Nemser, "A Conversation with Lee Krasner," 47; Nemser, *Art Talk*, 99; Rubenfeld, *Clement Greenberg*, 221.
129. Rubenfeld, *Clement Greenberg*, 158–59, 217.
130. Nemser, *Art Talk*, 99; Nemser, "A Conversation with Lee Krasner," 47; Rubenfeld, *Clement Greenberg*, 217.
131. *Lee Krasner*, interview by Robert Coe, videotape courtesy PKHSC.
132. Rubenfeld, *Clement Greenberg*, 220–21.
133. Ibid., 221–22; Marquis, *Art Czar*, 173.
134. Nemser, *Art Talk*, 99; Nemser, "A Conversation with Lee Krasner," 47.
135. Nemser, "A Conversation with Lee Krasner," 47.
136. Lee Krasner, interview by Barbara Cavaliere, AAA-SI, 24–25.
137. Ibid., 26.

Epilogue

1. Levin, *Lee Krasner*, 340–44, 359, 382; Landau, *Lee Krasner: A Catalogue Raisonné*, 315, 318.
2. Lee Krasner, interview by Barbara Rose, 1975, GRI; Levin, *Lee Krasner*, 360–61; Landau, *Lee Krasner: A Catalogue Raisonné*, 315.
3. Landau, *Lee Krasner: A Catalogue Raisonné*, 316.
4. Levin, *Lee Krasner*, 366, 381; Landau, *Lee Krasner: A Catalogue Raisonné*, 317.
5. Landau, *Lee Krasner: A Catalogue Raisonné*, 12, 317–18; Bennett, "Lee Krasner, In Her Own Right," 2. Lee would say "the belated recognition I have received is largely due to consciousness raising by the feminist movement, which I consider the major revolution of our time." Lee joined a picket line outside the Museum of Modern Art in 1972 to protest the lack of women artists in its exhibitions.
6. Landau, *Lee Krasner: A Catalogue Raisonné*, 317.
7. Ibid., 318.
8. Ibid.
9. Ibid., 318–19.
10. Wallach, "Lee Krasner's Triumph," 444; *Lee Krasner*, interview by Robert Coe, videotape courtesy PKHSC.
11. Levin, *Lee Krasner*, 365, 442; Landau, *Lee Krasner: A Catalogue Raisonné*, 319.
12. Georgia O'Keeffe, in 1946, and Loren MacIver, in 1948, had shows at the Modern but they were not retrospectives. Lynes, *Good Old Modern*, 455–456; Levin, *Lee Krasner*, 442.
13. Levin, *Lee Krasner*, 448–50; Landau, *Lee Krasner: A Catalogue Raisonné*, 319.
14. Grace Glueck, "New Foundation to Aid Visual Artists," www.nytimes.com/1985/04/11/arts/new-foundation-to-aid-visual-artists.html; Deborah Solomon, "Open House at the Pollocks," 81; Landau, *Lee Krasner: A Catalogue Raisonné*, 319.
15. Elaine de Kooning, interview by Molly Barnes, 9; Bledsoe, *E de K*, 107–9; Rose Slivka, "Elaine de Kooning: The Bacchus Paintings," 69. Elaine would eventually teach, lecture, and hold workshops and artist-in-residences at some sixty colleges and universities in the United States and Europe.
16. "Elaine de Kooning Portraits," The Art Gallery, Brooklyn College, 4.

17. Bledsoe, *E de K,* 19, 108.
18. Clay Fried, interview by author.
19. "Elaine de Kooning Portraits," The Art Gallery, Brooklyn College, 4.
20. Elaine de Kooning, interview by Antonina Zara, 21; Lewallen, "Interview with Elaine de Kooning," 8; Elaine de Kooning Lecture, C. F. S. Hancock Lecture, 6; Ernestine Lassaw, interview by author. Ernestine Lassaw recalled a different scenario. She said a mutual friend of Elaine's and the Kennedys, an artist named Bill Walton, suggested she do the portrait of JFK.
21. Fortune et al., *Elaine de Kooning, Portraits,* 113.
22. Rich, "Freedom of the Brush," 50; Ashton, *The New York School,* 207; Fortune et al., *Elaine de Kooning, Portraits,* 113–14.
23. Elaine de Kooning, interview by Antonina Zara, 21; Elaine de Kooning, C. F. S. Hancock Lecture, 6.
24. Elaine de Kooning to Edith Schloss Burckhardt, February 4, 1963, New York to Rome, Edith Schloss Burckhardt Papers, MS No. 1763, Subseries I.A., Box 2, Columbia.
25. Elaine de Kooning, interview by Antonina Zara, 22; Elaine de Kooning to Ernestine Lassaw, n.d. [1963], Box 1, Folder 3, Elaine de Kooning Papers, ca. 1959–1989, AAA-SI; Elaine de Kooning, C. F. S. Hancock Lecture, 7; Lewallen, "Interview with Elaine de Kooning," 10.
26. Fortune et al., *Elaine de Kooning, Portraits,* 50.
27. Elaine de Kooning, interview by Antonina Zara, 22; Ben Wolf, "Portrait of a President," n.p., article courtesy Doris Aach; Lewallen, "Interview with Elaine de Kooning," 12. During this period Elaine worked on sculptures.
28. Elaine de Kooning, interview by Antonina Zara, 23.
29. Gruen, *The Party's Over Now,* 212.
30. Hall, *Elaine and Bill,* 176; Connie Fox, interview by author.
31. Stevens and Swan, *De Kooning,* 577; Connie Fox, interview by author; Luke Luyckx, telephone interview by author.
32. Dr. Guy Fried, telephone interview by author.
33. Elaine de Kooning, interview by Jeffrey Potter, audiotape courtesy PKHSC; Stevens and Swan, *De Kooning,* 569–70.
34. Connie Fox, interview by author.
35. Elaine de Kooning, interview by Antonina Zara, 24; Clay Fried, interview by author; Stevens and Swan, *De Kooning,* 583–85.
36. Connie Fox, interview by author.
37. Stevens and Swan, *De Kooning,* 585.
38. Ibid., 587–88; Clay Fried, interview by author.
39. Connie Fox, interview by author; Stevens and Swan, *De Kooning,* 597.
40. Dr. Guy Fried, telephone interview by author.
41. Ernestine Lassaw, interview by author.
42. Dr. Guy Fried, telephone interview by author.
43. Doris Aach to Mark Stevens and Annalyn Swan, January 23, 2005, letter courtesy Doris Aach; Dr. Guy Fried, telephone interview by author; Schloss, "The Loft Generation," Edith Schloss Burckhardt Papers, Columbia, 2; Marjorie Luyckx to Joan Mitchell, dated November 30, 1989, Box 2, JMFA001, Joan Mitchell Papers, JMF.
44. Dr. Guy Fried, telephone interview by author; Doris Aach to Mark Stevens and Annalyn Swan, January 23, 2005, letter courtesy Doris Aach.
45. Ernestine Lassaw, interview by author.
46. Ibid.
47. LeSueur, *Digressions on Some Poems by Frank O'Hara,* 102; Stevens and Swan, *De Kooning,* 624.
48. Elaine de Kooning to James Mitchell, August 7, 1986, James Mitchell Papers, 1981–1988, AAA-SI.
49. Doris Aach, interview by author, November 16, 2013; Luke Luyckx, telephone interview by author; Charles Fried, telephone interview by author; Helen Harrison, telephone interview by author.
50. Schloss, "The Loft Generation," Edith Schloss Burckhardt Papers, Columbia, 2; Gooch, *City Poet,* 216; Stephen Chinlund, interview by author; Hall, *Elaine and Bill,* 266; Denise Lassaw, "Talk for Elaine's Memorial," 1990, Cooper Union, typed notes courtesy Denise Lassaw.

51. Curtis, *Restless Ambition*, 185.
52. Ibid., 182, 185; Phyllis Foster to Grace Hartigan, postmarked April 21, 1960, Box 1, Grace Hartigan Papers, Syracuse; Mattison, *Grace Hartigan*, 53.
53. Grigor, *Shattering Boundaries*, film.
54. Gabriel, "Amazing Grace," 66.
55. Gooch, *City Poet*, 359–60; Curtis, *Restless Ambition*, 187–88; Grigor, *Shattering Boundaries*, film.
56. Grigor, *Shattering Boundaries*, film; Gooch, *City Poet*, 359–60; Curtis, *Restless Ambition*, 187–88; May Natalie Tabak to Larry Rivers, postmarked March 9, 1964, Larry Rivers Papers, MSS 293, Series I, Subseries A, Box 14, Folder 24, NYU; Gruen, *The Party's Over Now*, 136.
57. Dore Ashton, interview by author; Curtis, *Restless Ambition*, 193, 198.
58. Norman Bluhm to Paul Jenkins, n.d., Paul Jenkins Papers, 1932–2009, AAA-SI.
59. Dore Ashton, interview by author; Nemser, *Art Talk*, 166.
60. Gabriel, "Amazing Grace," 66–67.
61. Mattison, *Grace Hartigan*, 54; Rex Stevens, interview by author. Beati's son, Hart Perry, and art dealer Michael Klein now frequently show the works from that period of Grace's life.
62. Gabriel, "Amazing Grace," 67.
63. Mattison, *Grace Hartigan*, 61, 66.
64. Grace Hartigan to Paul Anbinder, n.d., Box 31, Grace Hartigan Papers, Syracuse.
65. Helen Frankenthaler to Grace Hartigan, February 23, 1961, Box 12, Grace Hartigan Papers, Syracuse; Gabriel, "Amazing Grace," 67.
66. Grigor, *Shattering Boundaries*, film; Gabriel, "Amazing Grace," 67; Gooch, *City Poet*, 454.
67. Grigor, *Shattering Boundaries*, film; Rex Stevens, interview by author; Mattison, *Grace Hartigan*, 70.
68. Gooch, *City Poet*, 459–66; Mattison, *Grace Hartigan*, 70.
69. Gabriel, "Amazing Grace," 67.
70. Ibid.
71. Mattison, *Grace Hartigan*, 79; "Martha Jackson Dies on Coast," 19. It was speculated she may have had a heart attack while swimming.
72. Curtis, *Restless Ambition*, 243; Mattison, *Grace Hartigan*, 84.
73. Gabriel, "Amazing Grace," 102; Grigor, *Shattering Boundaries*, film; Mattison, *Grace Hartigan*, 102.
74. Curtis, *Restless Ambition*, 264.
75. Gabriel, "Amazing Grace," 102; Mattison, *Grace Hartigan*, 108.
76. Mattison, *Grace Hartigan*, 112.
77. Gabriel, "Amazing Grace," 64.
78. Grigor, *Shattering Boundaries*, film.
79. Dore Ashton, interview by author.
80. Mattison, *Grace Hartigan*, 110, 150–52.
81. Curtis, *Restless Ambition*, 301.
82. De Billy, *Riopelle*, 153–54; oral history interview with Joan Mitchell, April 16, 1986, AAA-SI.
83. Thomas B. Hess, "Inside Nature," 41, 65; John Ashbery to Tom Hess, June 12 (n.d.), Paris to New York, Thomas B. Hess Papers, 1937–1978, AAA-SI. Joan had become what Tom Hess described in an article on nature in art that had featured her 1956 painting *Hemlock*. Hess said Joan and her fellow post-movement artists followed his or her own vision. "Painting and sculpture continue as they always have in the past, in confusing waves of motion, in moments of pause, bewilderment, invention, triumph. Cannot bewilderment be triumph? Pause, the greatest speed? . . . The change is from moment to moment, in each individual. This continuing difference precisely is the sign of vitality."
84. *ArtNews* 60, no.7 (November 1961).
85. Albers, *Joan Mitchell*, 288.
86. Ibid., 289.
87. Solomon, "In Monet's Light," n.p.
88. Albers, *Joan Mitchell*, 288, 295–97, 303.
89. Ibid., 308, 312.
90. Munro, *Originals*, 237; Bernstock, *Joan Mitchell*, 73.
91. Bernstock, *Joan Mitchell*, 73; Solomon, "In Monet's Light," n.p.; Albers, *Joan Mitchell*, 312.
92. Solomon, "In Monet's Light," n.p.

93. Munro, *Originals,* 233.
94. Bernstock, *Joan Mitchell,* 69.
95. Ibid., 213.
96. Nemser, "An Afternoon with Joan Mitchell," 24; Albers, *Joan Mitchell,* 320.
97. Albers, *Joan Mitchell,* 332.
98. Ibid., 321.
99. Oral history interview with Joan Mitchell, April 16, 1986, AAA-SI.
100. Albers, *Joan Mitchell,* 320, 344, 346.
101. Ibid., 347.
102. Ibid., 349.
103. Ibid., 353; "Bio, Joan Mitchell, 1979," JMF, http://joanmitchellfoundation.org.
104. Albers, *Joan Mitchell,* 355–56, 364.
105. Ibid., 372.
106. Ibid., 369; Bernstock, *Joan Mitchell,* 164; "Bio, Joan Mitchell, 1981, 1982," JMF, http://joanmitchellfoundation.org. It was a triumph amid a season of loss. Joan's analyst, Edrita Fried, to whom Joan had turned once again to help her through the Riopelle-Jeffcoat debacle, had died in New York in 1981. And around the time of her museum show in Paris, Joan's elder sister, Sally, died.
107. "Bio, Joan Mitchell, 1984," JMF, http://joanmitchellfoundation.org.
108. Joan Mitchell to Barney Rosset, June 7, 1986, Vétheuil, France, to New York, JMFA003, JMF.
109. "Bio, Joan Mitchell, 1989, 1991," JMF, http://joanmitchellfoundation.org.
110. "Solo Exhibitions, Joan Mitchell, Timeline," JMF, http://joanmitchellfoundation.org/work/artist/timeline/1990; "Bio, Joan Mitchell, 1988–1989," JMF, http://joanmitchellfoundation.org.
111. "Bio, Joan Mitchell, 1992," JMF, http://joanmitchellfoundation.org; "Joan Mitchell, Timeline," JMF, http://joanmitchellfoundation.org/work/artist/timeline/1990; Albers, *Joan Mitchell,* 424–26.
112. "Report of the Death of an American Citizen Abroad," Department of State, Joan Mitchell Papers, JMF.
113. Sandler, *A Sweeper Up After Artists,* 219; Deborah Solomon, "The Gallery," April 28, 1993, *Wall Street Journal;* Albers, *Joan Mitchell,* 386.
114. Barbara Butler, "New York Letter," 55; Douglas Dreishpoon, "Giving Up One's Mark," 83.
115. Butler, "New York Letter," 55.
116. B. H. Friedman to *ArtNews* editor, March 14, 1960, HFF.
117. Eleanor Munro, "The Found Generation," 39.
118. "Editor's Letters," *ArtNews* 60, no. 8 (December 1961): 6.
119. Helen Frankenthaler to Grace Hartigan, November 30, 1961, Box 12, Grace Hartigan Papers, Syracuse.
120. Flam et al., *Robert Motherwell,* 212.
121. Ibid., 213; Jeannie Motherwell, telephone interview by author, July 8, 2014.
122. Lise Motherwell, telephone interview by author.
123. Helen Frankenthaler to Grace Hartigan, February 23, 1961, New York to Baltimore, Box 12, Grace Hartigan Papers, Syracuse.
124. Jeannie Motherwell, telephone interview by author, July 8, 2014.
125. Ibid.
126. Jeannie Motherwell, telephone interview by author, August 12, 2014.
127. Dreishpoon, "Giving Up One's Mark," 83; Carmean Jr., *Helen Frankenthaler,* 96.
128. Jeannie Motherwell, telephone interview by author, July 8, 2014; Lise Motherwell, telephone interview by author.
129. Flam et al., *Robert Motherwell,* 213.
130. Robert Motherwell, "Two Famous Painters' Collection," 88–91.
131. Dreishpoon, "Giving Up One's Mark," 83.
132. Robert Motherwell, interview by Dennis Young, Ontario College of Art Talk, audiotape, 1970, Art Gallery of Ontario; Charles A. Riley II, *The Saints of Modern Art,* n.p.; Gruen, *The Party's Over Now,* 194; Grace Hartigan to Gertrude Kasle, June 3, 1965, Series 1, Box 2, Folder 22, The Gertrude Kasle Gallery Records, 1949–1999 (bulk 1964–1983), AAA-SI; Munro, *Originals,* 221.
133. Dreishpoon, "Giving Up One's Mark," 84–85; Carmean Jr., *Helen Frankenthaler,* 97.
134. "People," *Time* 109, no. 17 (April 25, 1977): n.p.; Munro, *Originals,* 219.

135. Lise Motherwell, telephone interview by author.
136. Jeannie Motherwell, telephone interview by author, August 12, 2014; Lise Motherwell, telephone interview by author.
137. Gruen, *The Party's Over Now,* 274; Gooch, *City Poet,* 466.
138. Gruen, *The Party's Over Now,* 194; Flam et al., *Robert Motherwell,* 141.
139. Amei Wallach, "Living Color," 11.
140. Ibid.; Glueck, "Helen Frankenthaler, Abstract Painter Who Shaped a Movement"; Dreishpoon, "Giving Up One's Mark," 85; Carmean Jr., *Helen Frankenthaler,* 98.
141. Deborah Solomon, "Artful Survivor," 68; Michael Demarest, "The Arts: Helen Frankenthaler," 43; Clifford Ross, interview by author, February 18, 2014; Dreishpoon, "Giving Up One's Mark," 86.
142. Dreishpoon, "Giving Up One's Mark," 86.
143. Paul Richard, "Much Ado about Frankenthaler," D1, D3.
144. Ibid. He declared her "almost impossible to interview," offering as an example of Helen's reticence her lack of comment when told her clothes matched the color of her paintings.
145. Karen Wilkin, "Frankenthaler and Her Critics," 20–21; Helen Frankenthaler, interview by Barbara Rose, GRI; Gregory Galligan, "An Interview with Helen Frankenthaler," n.p.
146. Ellen M. Iseman, interview by author.
147. Wallach, "Living Color," 11; Clifford Ross, interview by author, February 18, 2014.
148. "Helen Frankenthaler," *The Telegraph,* December 28, 2011.
149. Louise Sweeney, "Helen Frankenthaler, Painter of the Light Within," B2.
150. Sophy Burnham, "Portrait of the Artist as a Woman," 96, 99; "Lunch," *Lear's* (November–December 1988): 31; Clifford Ross, interview by author, January 14, 2014.
151. "Lunch," *Lear's,* 34.
152. "Stephen M. DuBrul Jr., 82, Darien: $20 million," *Hartford Courant,* http://www.courant.com/news/connecticut/hc-who-they-were-top-10; Glueck, "Helen Frankenthaler, Abstract Painter Who Shaped a Movement."
153. "Helen Frankenthaler Artworks, Prints, 2000s," HFF, www.frankenthalerfoundation.org/.
154. Jeannie Motherwell, telephone interview by author, July 8, 2014.

Bibliography

Libraries, Archives, and Collections

Aesthetics Research Archive, Boston University: Mercedes Matter interviews with Sigmund Koch.
Archives of American Art, Smithsonian Institution, Washington, DC, and New York: Leon Berkowitz and Ida Fox Berkowitz Collection; Nell Blaine Papers; Brooklyn Museum of Art Interviews with Artists; William Theo Brown Papers; Charles Cajori Papers; Elaine de Kooning Papers; Willem and Elaine de Kooning Records; Paul Feeley Papers; Jane Freilicher Papers; Michael Goldberg Papers; Clement Greenberg Papers; John Jonas Gruen and Jane Wilson Papers; Thomas B. Hess Papers; Sam Hunter Papers; Paul Jenkins Papers; Aristodemos Kaldis Papers; Gertrude Kasle Gallery Records; Dodie Kazanjian Papers; Lillian and Friederick Kiesler Papers; Pat Lipsky Papers; John Little Papers; Michael Loew Papers; Russell Lynes Papers; Dorothy C. Miller Papers; James Mitchell Papers; Anne Bowen Parsons Papers; Patricia Passlof Papers; Jackson Pollock and Lee Krasner Papers; Colette Roberts Papers; Harold and May Tabak Rosenberg Papers; Irving Sandler Papers; Dorothy Seckler Papers; William Seitz Papers; Stable Gallery Records; Hedda Sterne Papers; Tibor de Nagy Gallery Files; Mitch Tuchman Papers; Charlotte Willard Papers; Elisabeth Zogbaum Papers.
Archives & Special Collections at the Thomas J. Dodd Research Center, University of Connecticut Libraries, Storrs, Connecticut: Allen Collection of Frank O'Hara Letters.
Crossett Library Digital Archive, Bennington College, Bennington, Vermont.
E. C. Goossen Archive, www.arslibri.com/collections/GoossenArchive.pdf.
Fales Library and Special Collections, New York University Libraries: Larry Rivers Papers.
Getty Research Institute, Los Angeles: Barbara Rose Papers; Clement Greenberg Papers; Bernard and Rebecca Reis Papers; Harold Rosenberg Papers.
The Henry W. and Albert A. Berg Collection of English and American Literature, The New York Public Library: Kenneth Koch Papers; Frank O'Hara Collection of Papers.
Houghton Library, Harvard University, Cambridge, Massachusetts: Jane Freilicher Papers; John Ashbery Papers; Nell Blaine Papers.
Library of Congress, Washington, DC.
Manuscripts Division, Department of Rare Books and Special Collections, Princeton University Library, Princeton, New Jersey: Sonya Rudikoff Papers.
Museum of Modern Art Archives, New York: Thomas B. Hess/De Kooning Papers; James Thrall Soby Papers; Dorothy C. Miller Papers; Monroe Wheeler Papers; International Council Program Papers.
Museum of Modern Art Library, New York.
Rare Book and Manuscript Library, Columbia University Library, New York: Edith Schloss Burckhardt Papers; Barney Rosset Papers.
Special Collections Research Center, Syracuse University Libraries, Syracuse, New York: Grace Hartigan Papers.
Stuart A. Rose Manuscript, Archives, and Rare Book Library, Emory University, Atlanta, Georgia: Philip Pavia and Natalie Edgar Archive of Abstract Expressionist Art.
Thomas J. Watson Library, The Metropolitan Museum of Art, New York.
Walker Art Center Archives and Library, Minneapolis.
Yale Collection of American Literature, Beinecke Rare Book and Manuscript Library, New Haven, Connecticut: Barbara Guest Papers.

Foundations and Study Centers
Boris Lurie Art Foundation, New York.
Dedalus Foundation, New York.
Helen Frankenthaler Foundation, New York.
Joan Mitchell Foundation, New York.
The Josef and Anni Albers Foundation, Bethany, Connecticut.
Larry Rivers Foundation, New York.
The Milton Resnick and Pat Passlof Foundation, New York.
Pollock-Krasner House and Study Center, Springs, East Hampton, New York.
The Pollock-Krasner Foundation, New York.
The Willem de Kooning Foundation, New York.

Museum and Art Collections
Albright-Knox Art Gallery, Buffalo, New York.
Art Institute of Chicago.
Baltimore Museum of Art.
Frances Lehman Loeb Art Center, Vassar College, Poughkeepsie, New York.
The Jewish Museum, New York.
Kemper Museum of Contemporary Art, Kansas City, Missouri.
The Metropolitan Museum of Art, New York,
The Museum of Modern Art, New York.
National Gallery of Art, Washington, DC.
National Portrait Gallery, Washington, DC.
Rose Art Museum, Brandeis University, Waltham, Massachusetts.
Solomon R. Guggenheim Museum, New York.
Whitney Museum of American Art, New York.

Archives of American Art Oral History Interviews
Agostini, Peter, 1968.
Aldrich, Larry, April 25–June 10, 1972.
Avery, Sally, February 19, 1982.
Baber, Alice, May 24, 1973.
Barnet, Will, January 15, 1968.
Barr, Margaret Scolari, February 22–May 13, 1974.
Bellamy, Richard, 1963.
Blaine, Nell, June 16, 1967.
Block, Irving, April 16, 1965.
Brach, Paul, 1971.
Brooks, James, June 10 and June 12, 1965.
Burckhardt, Rudy, January 14, 1993.
Busa, Peter, September 5, 1965.
Cage, John, May 2, 1974.
Castelli, Leo, July 1969, and May 14, 1969–June 8, 1973.
Catlin, Stanton L., July 1 and September 14, 1989.
Chamberlain, John, January 29–30, 1991.
Cherry, Herman, 1965, and May 8, 1989–March 19, 1992.
Cole, Sylvan, June–October 2000.
Dehner, Dorothy, October 1965, December 1966.
De Kooning, Elaine, August 27, 1981.
De Kooning, Willem and Elaine, ca. 1978.
De Nagy, Tibor, March 29, 1976.
Diller, Burgoyne, October 2, 1964.
Donati, Enrico, January 7, 1997.
Emmerich, André, January 18, 1993.
Evergood, Philip, December 3, 1968.
Faure, Patricia, November 17–24, 2004.

Flack, Audrey, February 16, 2009.
Ford, Hermine, February 18–19, 2010.
Frankenthaler, Helen, 1968.
Freilicher, Jane, August 4–5, 1987.
Friedman, B. H., 1972.
Gershoy, Eugenie, October 15, 1964.
Gorelick, Boris, May 20, 1964.
Gottlieb, Adolph, October 25, 1967, and September 29, 1969.
Halper, Nathan, July 8–August 14, 1980.
Hare, David, January 17, 1968.
Hartigan, Grace, May 10, 1979.
Held, Al, November 19, 1975–January 8, 1976.
Hurtado, Luchita, May 1 1994, and April 13, 1994.
Iselin, Lewis, April 10, 1969.
Jacquette, Yvonne, June 6–December 13, 1989.
Kadish, Reuben, April 15, 1992.
Kantor, Morris, January 22, 1963.
Kienbusch, William, November 1–7, 1968.
Kootz, Sam, March 2, 1960, and April 13, 1964.
Krasner, Lee, November 2, 1964–April 11, 1968, and 1972.
Lassaw, Ibram, November 1–2, 1964.
Lassaw, Ibram and Ernestine, August 26, 1968.
Levy, Julien, May 30, 1975.
Lippold, Richard, December 1, 1971.
Marca-Relli, Conrad, June 10, 1965.
Marisol, February 8, 1968.
Miller, Dorothy C., May 26, 1970–September 28, 1971.
Mitchell, Joan, May 21, 1965, and April 16, 1986.
Morris, George L. K., December 11, 1968.
Motherwell, Robert, and Helen Frankenthaler, April 29 [no year].
Namuth, Hans, August 12–September 8, 1971.
Noland, Kenneth, October 9 and December 12, 1971.
Orlowsky, Lillian, August 5–26, 1996.
Parsons, Betty, June 4 and 9, 1969, and June 11, 1981.
Pavia, Philip, January 19, 1965.
Poindexter, Elinor, September 9, 1970.
Porter, Fairfield, June 6, 1968.
Rankine, V. V., March 2–22, 1990.
Rebay, Hilla, 1966.
Reis, Rebecca, 1980.
Resnick, Milton, July 13–October 11, 1988.
Rivers, Larry, November 2, 1968.
Rockefeller, Nelson, July 24, 1972.
Rosati, James, April–May 1968.
Rosenberg, Harold, December 17, 1970–January 28, 1973.
Rosenberg, May Tabak, n.d.
Sander, Ludwig, February 4–12, 1969.
Soby, James Thrall, July 7, 1970.
Spivak, Max, circa 1963.
Stamos, Theodoros, April 23, 1968.
Stankiewicz, Richard, February 1963.
Sterne, Hedda, December 17, 1981.
Thaw, Eugene V., October 1–2, 2007.
Tworkov, Jack, August 17, 1962, and May 22, 1981.
Vicente, Esteban, August 27, 1968, April 6, 1982, and November 27–December 4, 1982.
Vytlacil, Vaclav, March 2, 1966.

Ward, Eleanor, February 8, 1972.
Wittenborn, George, April 12, 1973.
Yunkers, Adja, May 1968.
Zogbaum, Elisabeth Ross, December 3, 1981.
Zogbaum, Wilfrid and Elisabeth, November 2, 1964.

Unpublished Interviews Conducted by Author

Aach, Doris, November 16, 2013, New York.
Abbott, Mary, March 10, 2012, Southampton, Long Island, New York.
Adams, Jill Weinberg, Friday, November 15, 2013, New York.
Ashton, Dore, September 26, 2014, New York.
Baker, Elizabeth, February 21, 2014, New York, and telephone interview September 7, 2016, Ireland to New York City.
Chinlund, Stephen, November 25, 2013, New York.
Drexler, Sherman, February 2, 2014, New York to New Jersey.
Edgar, Natalie, December 8, 2013, East Hampton, Long Island, New York; January 20, 2014 and October 20, 2014, New York.
Ford, Hermine, January 7, 2014, New York.
Fox, Connie, December 7, 2013, Amagansett, Long Island, New York.
Freilicher, Jane, March 16, 2012, New York.
Fried, Charles, January 8, 2014, New York to Texas.
Fried, Clay, February 6, 2014, New York.
Fried, Dr. Guy, February 9, 2014, New York to Philadelphia.
Fried-Goodnight, Maud, February 16, 2014, New York to New Jersey.
Goff, Kimberly, May 27, 2014, Montegiorgio, Italy, to Long Island.
Gutman, John, September 24, 2014, New York to Princeton, New Jersey.
Harrison, Helen, December 2, 2014, Montegiorgio, Italy, to Springs, East Hampton, Long Island, New York.
Hartigan, Grace, September 1990, Baltimore.
Iseman, Ellen M., October 7, 2014, New York.
Iseman, Fred, October 7, 2014, New York.
Jackson, Ruby, December 11, 2013, Springs, East Hampton, Long Island.
Jaffe, Shirley, February 23, 2015, Montegorgio, Italy, to Paris.
Jenkins, Suzanne, February 22, 2014, New York.
Lassaw, Denise, December 8, 2013, Springs, East Hampton, Long Island, New York.
Lassaw, Ernestine, December 8, 2013, Springs, East Hampton, Long Island, New York.
Luyckx, Luke, February 19, 2014, New York.
Mattison, Robert Saltonstall, February 13, 2014, New York to Pennsylvania.
Mittelberg, Zuka, October 12, 2015, Montegiorgio, Italy, to Paris.
Motherwell, Jeannie, July 8, 2014 and August 12, 2014, Montegiorgio, Italy, to Boston.
Motherwell, Lise, June 17, 2014, Montegiorgio, Italy, to Provincetown, Massachusetts.
Myers Rosset, Astrid, December 3, 2013, New York.
Perry, Hart, January 7, 2014, New York.
Post, John Lee, January 6, 2014, New York.
Randall, Margaret, December 19, 2013, New York to New Mexico.
Rose, Barbara, May 23, 2017, Cashel, Ireland.
Ross, Clifford, January 15, 2014 and February 18, 2014, New York.
Sandler, Irving, February 3, 2014, New York.
Sesee, Donna, February 15, 2014, New York.
St. Onge, Maureen, February 8, 2016, Montegiorgio, Italy, to New York.
Stevens, Rex, January 27, 2014, Baltimore.
Van Horne, Janice, December 11, 2013, New York.
Washburn, Joan, January 17, 2014, New York.

I cite the following unpublished interviews conducted by the late curator Jack Taylor in preparation for an exhibition on the Ninth Street Show, courtesy Reva and Philip Shover, executors of Taylor's estate, and author Annalyn Swan, who is temporarily safeguarding the important recordings.

Alcopley, Lewin, n.d., 1972.
Brooks, James, August 1, 1973, Springs, East Hampton, Long Island, New York.
Cavallon, Giorgio, August 8, 1972, New York.
Cherry, Herman, January 4, 1973, New York.
Goldberg, Mike, August 16, 1972, New York.
Guston, Philip, July 22, 1972, Woodstock, New York.
Hare, David, December 4, 1972, New York.
Hartigan, Grace, August 2, 1972, Baltimore.
Holtzman, Harry, July 25, 1973, New York.
Krasner, Lee, August 1, 1973, Springs, East Hampton, Long Island, New York.
Lassaw, Ibram, August 21, 1972, Springs, East Hampton, Long Island, New York.
Leslie, Alfred, August 14, 1972, Massachusetts.
Leslie, Alfred, February 23, 1973, at the Figurative Artists Club, New York.
Marca-Relli, Conrad, February 6, 1975, New York.
Matter, Mercedes, August 24, 1972, Bethlehem, Connecticut.
McNeil, George, August 15, 1972, Brooklyn, New York.
Motherwell, Robert, August 19, 1974, Provincetown, Massachusetts.
Passlof, Pat, August 18, 1972, New York.
Pavia, Philip, August 18, 1972, New York.
Pavia, Philip, Steve Wheeler, Robert Motherwell, January 26, 1973, College Art Association, New York.
Resnick, Milton, July and August 1972, New York.
Sander, Ludwig, August 23, 1972, Bridgehampton, Long Island, New York.
Sanders, Joop, July 21, 1973, Stone Ridge, New York.
Stamos, Theodoros, May 12, 1972, New York.
Vicente, Esteban, August 22, 1972, Bridgehampton, Long Island, New York.

Unpublished Interviews and Lectures

Admiral, Virginia. Interview by Tina Dickey, April 14, 1991, research material compiled by Tina Dickey concerning Hans Hofmann, 1991–2000. Archives of American Art, Smithsonian Institution.
Brooks, James, and Charlotte Park Brooks. Interview by James T. Valliere, 1965, Series 1.4, Box 2, Folder 60–62, Jackson Pollock and Lee Krasner Papers, ca. 1905–1984. Archives of American Art, Smithsonian Institution.
Cage, John. Interview by Dodie Kazanjian, n.d., Dodie Kazanjian Papers [ca. 1980–2017]. Archives of American Art, Smithsonian Institution.
Castelli, Leo. Interview by Dodie Kazanjian, n.d., Dodie Kazanjian Papers [ca. 1980–2017]. Archives of American Art, Smithsonian Institution.
———. Interview by Mitch Tuchman, n.d., Box 1, Folder 17, Mitch Tuchman Papers related to the book *Painters Painting*, 1980–1989. Archives of American Art, Smithsonian Institution.
Dehner, Dorothy. Interview by Colette Roberts, 1971, Series 8.3, Box 7, Item 4, Colette Roberts papers and interviews with artists, 1918–1971. Archives of American Art, Smithsonian Institution.
de Kooning, Elaine. Interview by Ellen Auerbach, February 24, 1988, courtesy Doris Aach.
———. Interview by Molly Barnes, April 17, 1988, courtesy Doris Aach.
———. C. F. S. Hancock Lecture, May 1985, courtesy Doris Aach.
———. Interview by Minna Daniels, June 28, 1988, courtesy Doris Aach.
———. Interview by John Gruen, November 21, 1969, John Jonas Gruen and Jane Wilson Papers, 1936-2009. Archives of American Art, Smithsonian Institution.
———. Interview by Charles Hayes, July 15, 1988, courtesy Doris Aach.
———. de Kooning and Koos Lassooy, discussion, 1988, courtesy Doris Aach.
———. de Kooning, discussion with Mildred and Michael Loew, courtesy Doris Aach.
———. Interview by Jeffrey Potter, July 22, 1980, courtesy the Pollock-Krasner House and Study Center, East Hampton, New York.
———. Interview by Arthur Tobier, St. Mark's Church-In-The-Bowery, 1985 courtesy Doris Aach.
———. Interview by Amei Wallach, March 17, 1988, courtesy Doris Aach.

———. Interview by Antonina Zara, May 6, 1988, courtesy of Doris Aach.
de Kooning, Willem. Interview by Anne Bowen Parsons, October 11, 1967, Anne Bowen Parsons Collection of Interviews on Art, 1967-1968. Archives of American Art, Smithsonian Institution.
de Kooning, Willem, and Elaine de Kooning. Interview by Peter Busa and Sandra Kraskin, ca. 1978, for Susan Larsen, Oral History Interviews Relating to the American Abstract Artists Group. Archives of American Art, Smithsonian Institution.
De Niro, Robert, Sr. Interview by Tina Dickey, October 18, 1992, research material compiled by Tina Dickey concerning Hans Hofmann, 1991–2000. Archives of American Art, Smithsonian Institution.
Dzubas, Friedel Interview by Charles Millard, August 5 and 17, 1982, Friedel Dzubas Interviews. Archives of American Art, Smithsonian Institution.
Frankenthaler, Helen. Interview by John Gruen, June 12, 1969, John Jonas Gruen and Jane Wilson Papers, 1936–2009. Archives of American Art, Smithsonian Institution.
———. Interview by John Jones, October 24, 1965, John Jones Interviews with Artists, October 5, 1965–November 12, 1965, AAA-SI.
———. Interview by Dodie Kazanjian, August 1998, Projects, Artist Files, Dodie Kazanjian Papers [ca. 1980–2017]. Archives of American Art, Smithsonian Institution.
———. Interview by Barbara Rose, July 8, 1968, Series V, Box 10, C.49, C.50, C.51, C.52, July 8, 1968, Barbara Rose Papers. Getty Research Institute, Los Angeles (930100).
———. Interview by Barbara Rose, n.d., Series II, Box 1, Folder 20, Barbara Rose Papers. Getty Research Institute, Los Angeles (930100).
———. Interview by Deborah Solomon, January 16, 1989, audiotape courtesy Deborah Solomon.
———. Interview by Mitch Tuchman, n.d., Box 1, Folder 26, Mitch Tuchman Papers related to the book *Painters Painting,* 1980–1989. Archives of American Art, Smithsonian Institution.
Freilicher, Jane. Interview by Deborah Solomon, n.d., audiotape courtesy of Deborah Solomon.
Goldberg, Michael. Interview by Lynne Miller, n.d., Irving Harry Sandler Papers, ca. 1944–2007, bulk 1944–1980. Archives of American Art, Smithsonian Institution.
Greenberg, Clement. Interview by John Gruen, n.d., John Jonas Gruen and Jane Wilson Papers, 1936-2009. Archives of American Art, Smithsonian Institution.
———. Interview by Deborah Solomon, December 19, 1983, Series 1, Box 1, Folder 2, Clement Greenberg Papers, 1937–1983. Archives of American Art, Smithsonian Institution.
———. Interview by Mitch Tuchman, n.d, Box 1, Folder 12, Mitch Tuchman Papers related to the book *Painters Painting,* 1980–1989. Archives of American Art, Smithsonian Institution.
———. Interview by James T. Valliere, March 20, 1968, Series 1.4, Box 2, Folder 63; Box 3, Folders 1–2, Jackson Pollock and Lee Krasner Papers, ca. 1905–1984. Archives of American Art, Smithsonian Institution.
Greenberg, Clement, and Janice Van Horne. Interview by Dodie Kazanjian, n.d., Project Files, Curators Critics, Dodie Kazanjian Papers [ca. 1980]–2017. Archives of American Art, Smithsonian Institution.
Hess, Thomas B. Interview by Mitch Tuchman, n.d., Box 1, Folder 8, Mitch Tuchman Papers related to the book *Painters Painting,* 1980–1989. Archives of American Art, Smithsonian Institution.
Jenkins, Paul. Interview by Deborah Solomon, January 12, 1984, New York, transcript courtesy of Suzanne D. Jenkins.
Kiesler, Lillian. Interview by Ellen G. Landau, 1989, Series 1.11.4, Box 29, Folder 5, Lillian and Frederick Kiesler Papers, ca. 1910s–2003, bulk 1958–2000, Archives of American Art, Smithsonian Institution.
Krasner, Lee. Interview by Barbara Cavaliere, Series 2.3, Box 9, Folder 43, Lee Krasner Papers, 1927–1984. Archives of American Art, Smithsonian Institution.
———. Interview by John Gruen, May 8, 1969. John Jonas Gruen and Jane Wilson Papers. 1936–2009. Archives of American Art, Smithsonian Institution.
———. Interview by Ellen G. Landau, February 28, 1979, Series 2.3, Box 10, Folder 4, Lee Krasner Papers, 1927–1984. Archives of American Art, Smithsonian Institution.
———. Interview by Anne Bowen Parsons, Anne Bowen Parsons collection of interviews on art, 1967–1968. Archives of American Art, Smithsonian Institution.

———. Interview by Barbara Novak for WBGH-TV, 1979, Series 2.3, Box 10, Folder 5, Lee Krasner Papers, 1927–1984. Archives of American Art, Smithsonian Institution.
———. Interview by Barbara Rose, 1972, Series 2.3, Box 10, Folder 1, Lee Krasner Papers, 1927–1984. Archives of American Art, Smithsonian Institution.
———. Interview by Barbara Rose, 1975 (audiotape indicates 1972), Series V, Box 10, C. 76, C. 77, 1975, Barbara Rose Papers. Getty Research Institute, Los Angeles (930100).
———. Interview by Barbara Rose, June 27, 1978, transcript, Series III, Box 3, Folder 17, Barbara Rose Papers. Getty Research Institute, Los Angeles (930100).
———. Interview by Emily Wasserman, 1968, Series 2.3, Box 9, Folder 46, Lee Krasner Papers, ca. 1927–1984. Archives of American Art, Smithsonian Institution.
Lassaw, Ibram, and Ernestine. Interviews for article on Willem de Kooning, Charlotte Willard Papers, 1939–1970. Archives of American Art, Smithsonian Institution.
Marca-Relli, Conrad. Interview by Anne Bowen Parsons, October 14, 1967, Anne Bowen Parsons collection of interviews on art, 1967–1968. Archives of American Art, Smithsonian Institution.
Marisol. Interview by Colette Roberts, 1968, Series 8.3, Box 9, Item 14, Colette Roberts papers and interviews with artists, ca. 1918–1971. Archives of American Art, Smithsonian Institution.
———. Interview by John Gruen, June 3, 1969, John Jonas Gruen and Jane Wilson Papers, 1936–2009. Archives of American Art, Smithsonian Institution.
Miller, Dorothy C. Interview by Barbara Rose, February 15, 1980, Series V, Box 13, R2, Barbara Rose Papers. Getty Research Institute, Los Angeles (930100).
Motherwell, Robert. Interview by John Gruen, June 1, 1969, John Jonas Gruen and Jane Wilson Papers, 1936–2009. Archives of American Art, Smithsonian Institution.
———. Interview by John Jones, October 26, 1965, John Jones Interviews with Artists, October 5, 1965–November 12, 1965. Archives of American Art, Smithsonian Institution.
———. Interview by Dodie Kazanjian, n.d., Dodie Kazanjian Papers. Archives of American Art [ca. 1980]–2017, Smithsonian Institution.
Myers, John Bernard. Interview by Barbara Rose, March 12, 1968. Series V.B, Box 13, R3, Barbara Rose Papers. Getty Research Institute, Los Angeles (930100).
———. Interview by Barbara Rose, n.d., Series II, Box 1, Folder 26, Barbara Rose Papers. Getty Research Institute, Los Angeles (930100).
Newman, Annalee. Interview by Dodie Kazanjian, January 9, 1991, Dodie Kazanjian Papers [ca. 1980]–2017. Archives of American Art, Smithsonian Institution.
Parsons, Betty. Interview by John Gruen, May 20, 1969, John Jonas Gruen and Jane Wilson Papers, 1936–2009. Archives of American Art, Smithsonian Institution.
Pavia, Philip. Interview by John Gruen, May 23, 1969, John Jonas Gruen and Jane Wilson Papers, 1936–2009. Archives of American Art, Smithsonian Institution.
Resnick, Milton. Interview by Deborah Solomon, April 10, 1984, audiotape courtesy of Deborah Solomon.
Rivers, Larry. Interview by John Gruen, June 25, 1969, John Jonas Gruen and Jane Wilson Papers, 1936–2009. Archives of American Art, Smithsonian Institution.
Rosenberg, Harold, and May Tabak Rosenberg. Interview by John Gruen, John Jonas Gruen and Jane Wilson papers, 1936–2009. Archives of American Art, Smithsonian Institution.
Rosenberg, May Tabak. Interview by Jeffrey Potter, July 27, 1982, audiotape courtesy Pollock-Krasner House and Study Center, East Hampton, New York.
Rosset, Barney. Interview by Patricia Albers, n.d., audiotape courtesy Astrid Myers Rosset.
———. Interview by Jay Gertzman, January 23, 2001, audiotape courtesy Astrid Myers Rosset.
———. Interview by Sandy Gotham Meehan, January 21, 2004, Tape 5, Side 1, Series II, Box 3, Folder 5, Barney Rosset Papers. Rare Book and Manuscript Library, Columbia University Library, New York.
———. Interview by George A. Plimpton, vol. 2—ca. 1998, Series II, Box 3, Folder 5, Barney Rosset Papers. Rare Book and Manuscript Library, Columbia University Library.
Sterne, Hedda. Interview by Colette Roberts, 1967, Series 8.3, Box 10, Item 10, Colette Roberts papers and interviews with artists, 1918–1971. Archives of American Art, Smithsonian Institution.
Thaw, Eugene V. Interview by Anne Bowen Parsons, n.d., Anne Bowen Parsons collection of interviews on art, 1967–1968. Archives of American Art, Smithsonian Institution.

Tworkov, Jack. Interview by Anne Bowen Parsons, November 27, 1967, Anne Bowen Parsons collection of interviews on art, 1967–1968. Archives of American Art, Smithsonian Institution.
———. Interview by Dorothy Seckler, August 17, 1962, Dorothy Gees Seckler collection of sound recordings relating to art and artists, 1962–1976. Archives of American Art, Smithsonian Institution.
Vicente, Esteban. Interview by Anne Bowen Parsons, March 11, 1968, Anne Bowen Parsons collection of interviews on art, 1967–1968. Archives of American Art, Smithsonian Institution.

Videotapes and Films

Art and Its Ties to the Hamptons, Life in 1950's Art Community, host Steve Scheuer, 1992. LTV, Inc. (Local Television for the Town of East Hampton, New York).
Art Barge—Artists Speak, with Elaine de Kooning, July 16, 1983. LTV, Inc. (Local Television for the Town of East Hampton, New York).
Art/Work/USA, American Art in the Thirties, directed by Barbara Rose, 1978, distributed by Barbara Rose.
Conversations with Artists, Elaine Benson interviews Elaine de Kooning, 1987. LTV, Inc. (Local Television for the Town of East Hampton, New York).
De Kooning at the Whitney, 1983. LTV, Inc. (Local Television for the Town of East Hampton, New York).
E.A. Carmean Jr., Oral History Interview on Helen Frankenthaler. Interviewed by Mary Marshall Clark, June 28, 2011, Oral History Project, Helen Frankenthaler Foundation Archives, New York.
Ernestine Lassaw on Elaine de Kooning, uncut interview taped for memorial service, 1989. LTV, Inc. (Local Television for the Town of East Hampton, New York).
Joan Mitchell: Portrait of an Abstract Painter, directed by Marion Cajori, 1993.
Josephine Little: The Art Crowd, ca. 1940–1950s. Introduction by Inez Whipple at the East Hampton Historical Society, 1985. LTV, Inc. (Local Television for the Town of East Hampton, New York).
Lee Krasner, interview by Robert Coe, January 25, 1979, videotape courtesy the Pollock-Krasner House and Study Center.
Lee Krasner, a Conversation with Hermine Freed, 1973, videotape courtesy the Pollock-Krasner House and Study Center.
Lee Krasner, interview by Barbara Novak, WGBH-TV, 1979, for series *Prospective Archives of Twentieth Century American Artists,* videotape courtesy the Pollock-Krasner House and Study Center.
Lee Krasner: The Long View, by Barbara Rose, 1978. Distributed by American Federation of Arts.
Lee Krasner: An Interview with Kate Horsfield, 1981. Video Data Bank Preservation Project.
Mercedes Matter, interview by Sigmund Koch, 1997, videotapes 1A, 1B, 4A. Aesthetics Research Archive, Boston University Productions.
Nancy Lewis Oral History Interview on Helen Frankenthaler. Interviewed by Mary Marshall Clark, May 26, 2011, Oral History Project, Helen Frankenthaler Foundation Archives, New York.
New York Review of Art, Elaine de Kooning Interview, September 2, 1982. LTV, Inc. (Local Television for the Town of East Hampton, New York).
New York Review of Art, Elaine de Kooning Show @ Gruenebaum Gallery, produced by Bill King and Connie Fox, October 29, 1982. LTV, Inc. (Local Television for the Town of East Hampton, NewYork).
Obscene, A Portrait of Barney Rosset and Grove Press, directed by Neil Ortenberg and Daniel O'Connor, 2007. ArtHouse Film.
Painters Painting: A Candid History of the New York Art Scene, 1940–1970, directed by Emile de Antonio, 1973.
Pollock Painting, by Hans Namuth, 1951, New York.
Rose Slivka on Elaine de Kooning, taped for Memorial Service 1989. LTV, Inc. (Local Television for the Town of East Hampton, New York).
A Sense of Place: The Artist and the American Landscape, by Alan Gussow, videotape, 1980. LTV, Inc. (Local Television for the Town of East Hampton, New York).
Shattering Boundaries: Grace Hartigan, director Murray Grigor, 2008.
Summer of '57, an Artists Alliance panel discussion moderated by Rose Slivka, August 6, 1990. LTV, Inc. (Local Television for the Town of East Hampton, New York).
Tribute to Elaine de Kooning, presented at the memorial service, host Elaine Benson, 1989. LTV, Inc. (Local Television for the Town of East Hampton, New York).

Books, Articles, Catalogs, Dissertations, and Manuscripts

Abel, Lionel. "Harold Rosenberg, 1906–1978." *ArtNews* 77, no. 8 (September 1978).

———. *The Intellectual Follies: A Memoir of the Literary Venture in New York and Paris.* New York: W. W. Norton and Co., 1984.
———. "Scenes from the Cedar Bar." *Commentary,* December 1, 1982.
Abstract Expressionism, Second to None. Chicago: Thomas McCormick Gallery, 2004.
Abstract Expressionism: A Tribute to Harold Rosenberg, Paintings and Drawings from Chicago Collections. Chicago: The David and Alfred Smart Gallery, The University of Chicago, October 11–November 25, 1979.
Action/Precision: The New Direction In New York, 1955–60. Newport Beach, CA: Newport Harbor Art Museum, 1984.
After Mountains and Sea: Frankenthaler 1956–1959. New York: Solomon R. Guggenheim Museum, January 15–May 3, 1998, Solomon R. Guggenheim Foundation, 1998.
Albers, Patricia. *Joan Mitchell: Lady Painter, a Life.* New York: Alfred A. Knopf, 2011.
Alberti, Leon Battista. *On Painting.* New Haven, CT: Yale University Press, 1966.
Alcopley, L. "The Club, Its First Three Years." *Issue: A Journal for Artists* 4 (1985).
Allen, Donald, ed. *The Collected Poems of Frank O'Hara.* Berkeley: University of California Press, 1995.
Allentuck, Marcia Epstein. *John Graham's System and Dialectics of Art, Annotated From Unpublished Writings with a Critical Introduction by Marcia Epstein Allentuck.* Baltimore, MD: Johns Hopkins University Press, 1971.
Alloway, Lawrence. "Sign and Surface (Notes on Black and White Painting in New York)." *Quadrum* 9, 1960.
Alloway, Lawrence, and Mary Davis McNaughton. *Adolph Gottlieb: A Retrospective.* New York: Hudson Hills, 1995.
Altshuler, Bruce. *The Avant-Garde in Exhibition, New Art in the 20th Century.* New York: Harry N. Abrams, Inc., 1994.
Anfam, David. *Abstract Expressionism.* London: Thames & Hudson World of Art, 2012.
Arb, Renée. "They're Painting Their Way." *Harper's Jr. Bazaar* (1947).
Arendt, Hannah. "The Concentration Camps." *Partisan Review* 15, no. 7 (July 1948).
———. *The Human Condition.* Chicago: University of Chicago Press, 1958.
Arnason, H. H. *Robert Motherwell.* New York: Harry N. Abrams, Inc., 1977.
Art with the Touch of a Poet: Frank O'Hara. Storrs, CT: The William Benton Museum of Art, the University of Connecticut, January 24–March 13, 1983.
Artists of the New York School Second Generation, Paintings by Twenty-Three Artists. New York: The Jewish Museum, March 10 to April 28, 1957.
Artists' Theatre New York, Four Plays. New York: Grove Press, 1960.
Ashbery, John. "An Expressionist in Paris." *ArtNews* 64, no. 2 (April 1965).
———. "Frank O'Hara's Question." *Book Week,* September 25, 1966.
———. "In Memory of My Feelings." *ArtNews* 66, no. 9 (January 1968).
———. Interview. "The Invisible Avant-Garde." *ArtNews Annual* 34 (1968).
Ashbery, John, edited by David Bergman. *Reported Sightings: Art Chronicles, 1957–1987.* New York: Alfred A. Knopf, 1989.
Ashton, Dore. *A Joseph Cornell Album.* New York: The Viking Press, 1974.
———. "Jackson Pollock's Arabesque." *Arts Magazine* 53, no. 7 (March 1979).
———. *The Life and Times of the New York School.* Bath, Somerset, UK: Adams & Dart, 1972.
———. *The New York School: A Cultural Reckoning.* Berkeley: University of California Press, 1973.
Ashton, Dore, ed. *Picasso on Art: A Selection of Views.* New York: Da Capo Press, 1972.
Ashton, Dore, with Joan Banach, eds. *The Writings of Robert Motherwell.* Berkeley: University of California Press, 2007.
Auden, W. H. *The Age of Anxiety: A Baroque Eclogue.* New York: Random House, 1947.
Auping, Michael, and Lawrence Alloway, eds. *Abstract Expressionism: The Critical Developments.* New York: Harry N. Abrams, 1987.
Bair, Deirdre. *Samuel Beckett: A Biography.* New York: Harcourt Brace Jovanovich, 1978.
Baker, Elizabeth C. "Hans Hofmann, Abstract-Expressionism and Color in New York, 1945–65." *ArtNews Annual* 37. New York: Macmillan Company, 1971.
Barber, Allen. "Making Some Marks." *Arts Magazine* 48 (June 1974).

Bard, Joellen. "Tenth Street Days: An Interview with Charles Cajori and Lois Dodd." *Arts Magazine* 52, no. 4 (December 1977).

———. *Tenth Street Days: The Co-Ops of the 50s: The Galleries, Tanager, Hansa, James, Camino, March, Brata, Phoenix, Area.* New York: Education, Art and Service, Inc., 1977.

Baro, Gene. "Artistic Revolution by Being Wholly Herself, Helen Frankenthaler." *Vogue,* June 1975.

Barr, Alfred H., Jr. *Picasso: Fifty Years of His Art.* New York: The Museum of Modern Art, by the Arno Press, 1980.

———. *What Is Modern Painting?* New York: The Museum of Modern Art, 1943.

Barrett, William. *Irrational Man: A Study in Existential Philosophy.* New York: Doubleday Anchor Book, 1962.

———. "New Innocents Abroad." *Partisan Review* 17, no. 3 (1950).

———. *The Truants: Adventures Among the Intellectuals.* New York: Anchor Press/Doubleday, 1982.

———. "What Existentialism Offers Modern Man." *Commentary,* July 1951.

Barzun, Jacques. "Romanticism: Definition of a Period." *Magazine of Art* 42, no. 7 (November 1949).

Baskin, Wade, ed. *Jean-Paul Sartre: Essays in Existentialism.* New York: The Citadel Press, 1970.

Baudelaire, Charles. *The Painter of Modern Life and Other Essays.* New York: Phaidon Press, Inc., 1964.

Baxandall, Rosalyn, and Linda Gordon, eds. *America's Working Woman: A Documentary History 1600 to the Present.* New York: W. W. Norton & Company, 1995.

Beadle, Henry Hewesernst. "Actors with Their Strings Attached: Ideas and Enthusiasts, a Writer Learns." *New York Times,* May 21, 1950.

Beauvoir, Simone de. *America Day by Day.* London: Victor Gollancz, 1998.

———. "Eye for Eye." *Politics* 4 (July–August 1947).

———. *The Second Sex.* London: Picador Classics, 1988.

Beckett, Samuel. *Samuel Beckett: The Complete Dramatic Works.* London: Faber and Faber Ltd., 2006.

———. *Waiting for Godot.* New York: Grove Press, 1954.

Belasco, Daniel. "Between the Waves: Feminist Positions in American Art, 1949–1962." PhD dissertation, New York University, 2008.

Belgrad, Daniel. *The Culture of Spontaneity: Improvisation and the Arts in Postwar America.* Chicago: The University of Chicago Press, 1998.

Belton, Robert J. "Edgar Allan Poe and the Surrealists' Image of Women." *Woman's Art Journal* 8, no. 1 (Spring–Summer 1987).

Belz, Carl. *Frankenthaler: The 1950s.* Waltham, MA: Rose Art Museum, Brandeis University, May 10–June 28, 1981.

Bergin, Bob. *Publisher-hero as Combat Photographer in China, Barney Rosset and China* exhibition at Kunming Municipal Museum, Kunming City, Yunan, China, February 20, 2014. Rare Book & Manuscript Library, Butler Library, Columbia University, New York.

Berkson, Bill. "In Living Chaos: Joan Mitchell." *ArtForum* 27, no. 1 (September 1988).

Berkson, Bill, and Joe LeSueur, eds. *Homage to Frank O'Hara.* Bolinas, CA: Big Sky, 1978.

Berman, Marshall. *All That Is Solid Melts into Air: The Experience of Modernity.* London: Verso, 1993.

Bernier, Rosamond. "The Decisive Decade." *Vogue* 181 (March 1991).

Bernstein, Barton J., ed. *Towards a New Past: Dissenting Essays in American History.* New York: Pantheon Books, 1968.

Bernstock, Judith. *Joan Mitchell.* New York: Hudson Hills Press, 1988.

Bettelheim, Bruno. "The Study of Man: The Victim's Image of the Anti-Semite." *Commentary,* February 1948.

The Billboard: The World's Foremost Amusement Weekly, December 12, 1942.

Black, David. "Totalitarian Therapy on the Upper West Side." *New York,* December 15, 1975.

Blanc, Peter. "The Artist and the Atom." *Magazine of Art* 44, no. 4 (April 1951).

Bledsoe, Jane K. *E de K, Elaine de Kooning.* Athens: Georgia Museum of Art, University of Georgia, 1992.

Blumberg, Barbara. *The New Deal and the Unemployed: The View from New York City.* Lewisburg, PA: Bucknell University Press, 1979.

Boll, Deborah, Peter Walch, and Malin Wilson. *Albuquerque '50s.* Albuquerque: University of New Mexico Art Museum, September 24, 1989–January 21, 1990.

Bolotowsky, Ilya, and Henry Geldzahler. "Adventures with Bolotowsky." *Archives of American Art Journal* 22, no. 1 (1982).

Borden, Morton, ed. *Voices of the American Past: Readings in American History.* Lexington, MA: D. C. Heath, 1972.
Boris Lurie: NO! New York: Boris Lurie Art Foundation at The Chelsea Art Museum, 2011.
Boswell, Peyton. "Comments: Congenial Company." *Art Digest* 16, no. 8 (January 15, 1942).
———. "Revolt of the Critics." *Art Digest,* February 1, 1948.
Bowles, Jane. *My Sister's Hand in Mine: The Collected Work of Jane Bowles.* New York: Farrar, Straus and Giroux, 1976.
Brach, Paul. "Review: Joan Mitchell." *Art Digest* 26 (January 15, 1952).
Bram, Christopher. *Eminent Outlaws: The Gay Writers Who Changed America.* New York: Twelve, Hachette Book Group, 2012.
Braudy, Leo. *The Frenzy of Renown: Fame and Its History.* New York: Oxford University Press, 1986.
Brenson, Michael. "Lee Krasner Pollock Is Dead: Painter of New York School." *New York Times,* June 21, 1984.
Breslin, James E. B. *Mark Rothko: A Biography.* Chicago: The University of Chicago Press, 1993.
Bretall, Robert, ed. *A Kierkegaard Anthology.* Princeton, NJ: Princeton University Press, 1946.
Brogan, D. W. "The Problem of High Culture and Mass Culture." *Diogenes* 5 (Winter 1954).
Brogan, Hugh. *The Penguin History of the United States,* 2nd ed. London: Penguin Books, 2001.
Brossard, Chandler, ed. *The Scene Before You: A New Approach to American Culture.* New York: Rinehart and Co., Inc., 1955.
Broude, Norma, and Mary D. Garrard, eds. *The Expanding Discourse: Feminism and Art History.* New York: Icon Editions, 1992.
Broyard, Anatole. *Kafka Was the Rage: A Greenwich Village Memoir.* New York: Vintage Books, Random House, 1997.
———. "Portrait of a Hipster." *Partisan Review* 15, no. 6 (June 1948).
Brozan, Nadine. "The Evening Hours." *New York Times,* February 22, 1985.
Buck, Pearl S. *Of Men and Women.* New York: The John Day Company, 1941.
Burckhardt, Rudy. "Long Ago with Willem de Kooning." *Art Journal* 48, no. 3 (Autumn 1989).
Burke, Edmund. *A Philosophical Enquiry into the Origin of Our Ideas of the Sublime and Beautiful.* Oxford: Oxford World's Classics, 2008.
Burnham, Sophy. "Portrait of the Artist as a Woman." *New Woman,* June 1990.
Butler, Barbara. "New York Letter." *Art International* 4, no. 23 (1960).
Butler, Hiram Carruthers. "De Kooning and Friends: Downtown in the Fifties." *Horizon* 24, no. 6 (June 1981).
Butts, Gavin. *Between You and Me: Queer Disclosures in the New York Art World, 1948–63.* Durham, NC: Duke University Press, 2005.
Calas, Nicolas. *Art in the Age of Risk, and Other Essays.* New York: Dutton, 1968.
Campbell, D'Ann. *Women at War with America: Private Lives in a Patriotic Era.* Cambridge, MA: Harvard University Press, 1984.
Campbell, Joseph. *The Hero with a Thousand Faces.* Novato, CA: New World Library, 2008.
Campbell, Lawrence. "Elaine de Kooning Paints a Picture." *ArtNews* 59, no. 8 (December 1960).
———. "Elaine de Kooning: Portraits in a New York Scene." *ArtNews* 62, no. 2 (April 1963).
———. "Grace Hartigan, Larry Rivers, Frank O'Hara." *ArtNews* 58, no. 8 (December 1959).
Camus, Albert. *Exile and the Kingdom.* Middlesex, UK: Penguin Modern Classics, 1986.
———. "Neither Victims nor Executioners." *Politics* 4 (July–August 1947).
———. "Interview: The Artist as Witness of Freedom." *Commentary,* December 1949.
Carmean, E. A., Jr. *Helen Frankenthaler: A Paintings Retrospective.* New York: Abrams in Association with the Modern Art Museum of Fort Worth, 1989.
Carr, Carolyn Kinder, and Steven Watson. *Rebels: Painters and Poets of the 1950s.* Washington, DC: National Portrait Gallery, February 24, 1996–June 2, 1996.
Carr, E. H. *What Is History?* London: Penguin, 1991.
Cateforis, David Christos. "Willem de Kooning's Women of the 1950s: A Critical Study of Their Reception and Interpretations." PhD dissertation, Stanford University, 1992.
Caute, David. *The Great Fear: The Anti-Communist Purge under Truman and Eisenhower.* New York: A Touchstone Book, Simon and Schuster, 1979.

Caws, Mary Ann, Rudolf E. Kuenzli, and Gloria Gwen Raaberg. *Surrealism and Women*. Cambridge, MA: The MIT Press, 1990.
Chadwick, Whitney. *Women, Art, and Society*. London: Thames and Hudson, 1990.
Chafee, William H. *The American Woman: Her Changing Social, Economic, and Political Roles, 1920–1970*. New York: Oxford University Press, 1972.
———. *Women and Equality: Changing Patterns in American Culture*. New York: Oxford University Press, 1978.
Chancy, Jill Rachelle. "Elaine de Kooning: Negotiating the Masculinity of Abstract Expressionism." PhD dissertation, University of Kansas, 2006.
Chipp, Herschel B. *Theories of Modern Art, A Source Book by Artists and Critics*. Berkeley: University of California Press, 1968.
Clarke, Donald. *Wishing on the Moon: The Life and Times of Billie Holiday*. New York: Viking, 1994.
Clements, Peter. *Prosperity, Depression and the New Deal: The USA 1890–1954*. London: Hodder Education, 2005.
Coates, Robert. "The Art Galleries: Abroad and at Home." *The New Yorker*, March 30, 1946.
Coffelt, Beth. "Strokes of Genius." *WNET/Thirteen*, May 1984.
Cohen, Barbara, Seymour Chwast, and Steven Heller, eds. *New York Observed: Artists and Writers Look at the City, 1650 to the Present*. New York: Harry N. Abrams, 1987.
Cohen, Cora, and Betsy Sussler. "Joan Mitchell." *Bomb* 17, Fall 1986.
Colker, Ed. "Present Concerns in Studio Teaching." *Archives of American Art Journal* 42, no. 1 (Spring 1982).
Collins, Bradford R. "Life Magazine and the Abstract Expressionists, 1948–1951: A Historiographic Study of a Late Bohemian Enterprise." *The Art Bulletin* 73, no. 2 (June 1991).
Conn, Peter. *The American 1930s: A Literary History*. Cambridge: Cambridge University Press, 2009.
"Conversation between Lee Krasner and Richard Howard." *Lee Krasner Paintings, 1959–1962*, New York: The Pace Gallery, February 3–March 10, 1979.
Corbett, William. "But Here's a Funny Story." *Modern Painters*, Winter 1999.
Corlett, Mary Lee. "Jackson Pollock: American Culture, the Media and the Myth." *The Rutgers Art Review* 8 (1987).
Costello, John. *Virtue Under Fire: How World War II Changed Our Social and Sexual Attitudes*. Boston: Little, Brown and Company, 1985.
Crase, Douglas, and Jenni Quilter. *Painters and Poets: Tibor de Nagy Gallery*. New York: Tibor de Nagy Gallery, 2012.
Crehnan, Herb. "Recent Attacks on Abstract Art." *It is* 1 (Spring 1958).
Curtis, Cathy. *A Generous Vision: The Creative Life of Elaine de Kooning*. New York: Oxford University Press, 2017.
———. *Restless Ambition: Grace Hartigan, Painter*. New York: Oxford University Press, 2015.
Cyr, Don. "A Conversation with Helen Frankenthaler." *School Arts* 67, no. 8 (April 1968).
Danchev, Alex, ed. *100 Artists' Manifestos, From the Futurists to the Stuckists*. London: Penguin Modern Classics, 2011.
"Daughter to Mrs. A. Frankenthaler." *New York Times*, December 14, 1928.
Davidson, Michael. *Guys Like Us: Citing Masculinity in Cold War Poetics*. Chicago: The University of Chicago Press, 2004.
Davies, Norman. *Europe, A History*. London: Pimlico, 1997.
Davis, Melody. "The Subject of/is the Artist: The Many Cultures of Grace Hartigan."
Daw, Deborah. "Lee Krasner, on Climbing a Mountain of Porcelain." School paper, Cambridge, Massachusetts, 1979.
Dawson, Fielding. *An Emotional Memoir of Franz Kline*. New York: Pantheon Books, 1967.
de Billy, Hélène. *Riopelle*. Montreal: Éditions Art Global, 1996.
de Coppet, Laura, and Alan Jones. *The Art Dealers: The Powers Behind the Scene Tell How the Art World Works*. New York: Clarkson N. Potter, Inc., 1984.
d'Emilio, John. *Sexual Politics, Sexual Communities: The Making of a Homosexual Minority in the U.S., 1940–1970*. Chicago: University of Chicago Press, 1983.
d'Harnoncourt, René. "Challenge and Promise: Modern Art and Modern Society." *Magazine of Art* 41, no. 7 (November 1948).

———. *The Museum of Modern Art Twenty-Fifth Anniversary Year, Final Report.* New York: The Museum of Modern Art, 1954.
de Kooning, Elaine. "De Kooning Memories, Starting Out in the 1940s, A Personal Account." *Vogue,* December 1983.
———. "Dickinson and Kiesler." *ArtNews* 51, no. 2 (April 1952).
———. "Dymaxion Artist." *ArtNews* 51, no. 5 (September 1952).
———. "Edwin Denby Remembered, Part I." *Ballet Review* 12, no. 1 (Spring 1984).
———. *Franz Kline Memorial Exhibition.* Washington, DC: Washington Gallery of Modern Art, 1962.
———. "Franz Kline: Painter of His Own Life." *ArtNews* 61, no. 7 (November 1962).
———. "Hans Hofmann Paints a Picture." *ArtNews* 48, no. 10 (February 1950).
———. "Modern Museum's Fifteen: Dickinson and Kiesler." *ArtNews* 51, no. 2 (April 1952).
———. "Pure Paints a Picture." *ArtNews* 56, no. 4 (Summer, 1956).
———. "Renoir: As If by Magic." *ArtNews* 55, no. 6 (October 1956).
———. "A Stroke of Genius." *Horizon* 27, no. 4 (May 1984).
———. "Stuart Davis: True to Life." *ArtNews* 56, no. 2 (April 1957).
———. "Subject: What, How or Who?" *ArtNews* 54, no. 2 (April 1955).
———. "Two Americans in Action: Franz Kline, Mark Rothko." *ArtNews Annual* 27 (1958).
de Kooning, Elaine, and Rose Slivka. *Elaine de Kooning: The Spirit of Abstract Expressionism, Selected Writings.* New York: George Braziller, Inc., 1994.
Demarest, Michael. "The Arts, Helen Frankenthaler." *Avenue,* June 1977.
Denby, Edwin. "My Friend de Kooning." *ArtNews Annual* 29 (1964).
Dewey, John. *Art as Experience.* New York: Capricorn Books, G. P. Putnam's Sons, 1958.
Diamonstein-Spielvogel, Dr. Barbaralee, interviewer and author. *Inside New York's Art World.* New York: Rizzoli International Publications, Inc., 1979.
Diggons, John Patrick. *The Proud Decades: America in War and Peace, 1941–1960.* New York: W. W. Norton & Company, 1988.
Diggory, Terence. "Questions of Identity in Oranges by Frank O'Hara and Grace Hartigan." *Art Journal* 52, no. 4 (Winter 1993).
Diggory, Terence, and Stephen Paul Miller, eds. *The Scene of My Selves: New Work on New York School Poets.* Chicago: National Poetry Foundation, 2001.
Dingwall, Eric John. *The American Woman: A Historical Study.* London: Gerald Duckworth & Co., Ltd., 1956.
Ditzion, Sidney. *Marriage, Morals and Sex in America: A History of Ideas.* New York: Bookman Associates, 1953.
Dorfman, Geoffrey, ed. *Out of the Picture: Milton Resnick and the New York School.* New York: Midmarch Arts Press, 2003.
Downes, Rackstraw, ed. *Art in Its Own Terms: Selected Criticism, 1935–1975 by Fairfield Porter.* Cambridge, MA: Zoland Books, 1979.
Dreishpoon, Douglas. *Giving Up One's Mark: Helen Frankenthaler in the 1960s and 1970s.* Buffalo, NY: Albright Knox Art Gallery, 2014.
Dubermann, Martin. *Black Mountain: An Exploration in Community.* Garden City, NY: Anchor Press, Doubleday, 1973.
Dunas, William. "Edwin Denby Remembered, Part 1." *Ballet Review* 12, no. 1 (Spring 1984).
Duncan, Robert. "The Homosexual in Society." *Politics,* August 1944.
du Plessix, Francine, and Cleve Gray. "Who was Jackson Pollock? Interviews by Francine du Plessix and Cleve Gray." *Art in America* 55 (May–June 1967).
Edelman, Aliza Rachel. "Modern Woman and Abstract Expressionism: Ethel Schwabacher, Elaine de Kooning, and Grace Hartigan in the 1950s." PhD dissertation, Rutgers University, 2006.
Edgar, Natalie, ed. *Club Without Walls: Selections from the Journals of Philip Pavia.* New York: Midmarch Arts Press, 2007.
"Editor's Letters." *ArtNews* 52, no. 4 (June–August 1953).
"18 Painters Boycott Metropolitan: Charge 'Hostility to Advanced Art.'" *New York Times,* May 22, 1950.
Elaine de Kooning: Portraits. Brooklyn, NY: The Art Gallery, Brooklyn College, February 28–April 19, 1991.
"Elaine de Kooning Statement." *It Is,* 5 (Spring 1960).

Elderfield, John. *Helen Frankenthaler.* New York: Abrams, 1989.
———. "Morris Louis and Twentieth-Century Painting." *Art International* 21, no. 3 (May–June 1977).
———. *Painted on 21st Street: Helen Frankenthaler from 1950 to 1959.* New York: Gagosian Gallery, March 8–April 13, 2013.
Eliot, T. S. *The Sacred Wood: Essays on Poetry and Criticism.* London: Faber & Faber, 1997.
Elkoff, Marvin. "The American Painter as a Blue Chip." *Esquire,* January 1965.
Elsen, Albert E. *Paul Jenkins.* New York: Harry N. Abrams, Inc., 1973.
Engelmann, Ines Janet. *Jackson Pollock and Lee Krasner.* Munich: Pegasus Library, Prestel Verlag, 2007.
Epstein, Helen. "Meyer Schapiro: 'A Passion to Know and Make Known.'" *ArtNews* 82, no. 5 (May 1983).
Érouart, Gilbert. *Riopelle in Conversation.* Toronto: House of Anansi Press, Ltd., 1995.
"Existentialist." *The New Yorker,* March 16, 1946.
Farber, Manny. "What Artists and What Victory?" *The New Republic* 108 (February 1, 1943).
Feininger, Andreas. *The Face of New York: The City as It Was and as It Is.* New York: Crown Publishers, Inc., 1955.
Ferren, John. "Epitaph for an Avant-Garde." *Arts* 33, no. 2 (November 1958).
———. "Stable State of Mind." *ArtNews* 54, no. 3 (May 1955).
Firestone, Evan R. "James Joyce and the First Generation New York School." *Arts* 56 (June 1982).
Fitzsimmons, James. "Art." *Arts & Architecture* 70, no. 5 (May 1953).
———. "George Hartigan." *Art Digest* 25, no. 9 (February 1, 1951).
Flam, Jack, Katy Rogers, and Tim Clifford. *Robert Motherwell Paintings and Collages: A Catalogue Raisonné, 1941–1991. Volume 1, Essays and References.* New Haven, CT: Yale University Press, 2012.
Fleming, Donald, and Bernard Bailyn, eds. *The Intellectual Migration: Europe and America, 1930–1960.* Cambridge, MA: The Belknap Press of Harvard University Press, 1969.
Fortune, Brandon Bram, Anne Eden Gibson, and Simona Cupic. *Elaine de Kooning: Portraits.* Washington, DC, and Munich: National Portrait Gallery, Smithsonian Institution, and DelMonico Books, Prestel Verlag, 2015.
Fox, Richard Wightman, and T. J. Jackson Lears, eds. *The Culture of Consumption: Critical Essays in American History, 1880–1980.* New York: Pantheon Books, 1983.
Franc, Helen M. *The Early Years of the International Program and Council: The Museum of Modern Art at Mid-Century at Home and Abroad.* New York: The Museum of Modern Art, 1994.
Frank, Lawrence, and Mary Frank. *How to Be a Woman.* New York: Maco Magazine Book, 1954.
Frank O'Hara Poems from the Tibor de Nagy Editions, 1952–1966. New York: Tibor de Nagy, 2006.
Frankenthaler, Helen. "The Chrysler Assignment." *MKR's Art Outlook* 1, no. 32 (February 17, 1947).
———. "Memories of the San Remo." *Partisan Review* 49, no. 3 (Summer 1982).
Frankenthaler, Helen, and Cynthia Lee. "A Brando Named 'Desire.'" *The Beacon* 2, no. 6 (June 24, 1948).
Fried, Edrita. *Active/Passive: The Crucial Psychological Dimension.* New York: Grune & Stratton, 1970.
———. *The Ego in Love and Sexuality.* New York: Grune & Stratton, 1960.
Friedan, Betty. *The Feminine Mystique.* New York: Dell Publishing, Inc., 1964.
Friedman, B. H. *Alfonso Ossorio.* New York: Harry N. Abrams, Inc., 1973.
———. "Alfonso Ossorio, a Biography, Mostly of His Work." *Art International* 3 (April 1962).
———. *Jackson Pollock: Energy Made Visible.* New York: Da Capo Press, 1995.
———. "Manhattan Mosaic." *Craft Horizons* 19 (January–February 1959).
Friedman, B. H., ed. *Give My Regards to Eighth Street, The Collected Writings of Morton Feldman.* Cambridge, MA: Exact Change, 2000.
Fromm, Eric. *The Sane Society.* London: Routledge Classics, 2002.
Gabriel, Mary. "Amazing Grace: Painter Grace Hartigan Re-Emerges with Four Exhibitions and a Monograph." *Museum & Arts, Washington* (November–December 1990).
———. *The Art of Acquiring: A Portrait of Etta and Claribel Cone.* Baltimore, MD: Bancroft Press, 2002.
Gaines, Steven. *Philistines at the Hedgerow: Passion and Property in the Hamptons.* Boston: Back Bay Books, Little, Brown and Company, 1988.
Galligan, Gregory. "An Interview with Helen Frankenthaler." *Art International* 7 (Summer 1989).
Gaugh, Harry. *Franz Kline.* New York: Abbeville Press, 1985.
———. *Willem de Kooning.* New York: Abbeville Press, 1983.
Geldzahler, Henry. "An Interview with Helen Frankenthaler." *ArtForum* 4, no. 2 (October 1965).
Gibson, Ann Eden. *Abstract Expressionism: Other Politics.* New Haven, CT: Yale University Press, 1997.

Gilbert, Martin. *The Second World War: A Complete History*. New York: Henry Holt and Company, 1991.
Gill, Anton. *Art Lover: A Biography of Peggy Guggenheim*. New York: HarperCollins Publishers, 2002.
Glaser, Bruce. "Interview with Lee Krasner." *Arts Magazine* 41, no. 6 (April 1964).
Glinn, Bert. "New York's Spreading Upper Bohemia." *Esquire* 48, no. 1 (July 1957).
Glueck, Grace. "Helen Frankenthaler, Abstract Painter Who Shaped a Movement, Dies at 83." *New York Times*, December 27, 2011.
———. "Michael Goldberg, 83, Abstract Expressionist, Is Dead." *New York Times*, January 4, 2008.
———. "New Foundation to Aid Visual Artists." *New York Times*, April 11, 1985.
———. "Scenes from a Marriage, Krasner and Pollock." *Art News* 80, no. 19 (December 1981).
Goldwater, Robert. "Reflections on the New York School." *Quadrum* 8 (1960).
Gooch, Brad. *City Poet: The Life and Times of Frank O'Hara*. New York: Alfred A. Knopf, 1993.
Goodman, Cynthia. *Hans Hofmann*. New York: Abbeville Press, 1986.
———. "Hans Hofmann as a Teacher." *Arts Magazine* 53 (April 1979).
Goodman, Paul. *The Empire City: A Novel of New York*. Santa Rosa, CA: Black Sparrow Press, 2001.
———. *Growing Up Absurd*. New York: Vintage Books, 1960.
Goodman, Rob. "What Happened to the Roosevelts?" *Politico Magazine*, October 7, 2014.
Goodnough, Robert. "Pollock Paints a Picture." *ArtNews* 50, no. 3 (May 1951).
Grace Hartigan: Painting from Popular Culture, Three Decades. Harrisburg, PA: Susquehanna Art Museum, April 12, 2000.
"Grace Hartigan, Palette Fresh and Brilliant." *Truro (Mass.) Post*, n.d. (1982).
Graham, John D. "Primitive Art and Picasso." *Magazine of Art* 30, no. 4 (April 1937).
Greenberg, Clement. "Abstract and Representational." *Arts Digest* 29, no. 3 (November 1, 1954).
———. "Art." *The Nation*, November 27, 1943.
———. "Art." *The Nation*, April 7, 1945.
———. "Avant-Garde and Kitsch." *Partisan Review* 6, no. 5 (Fall 1939).
———. "The Crisis of the Easel Picture." *Partisan Review* 15, no. 4 (April 1948).
———. "Goose-Step in Tishomingo." *The Nation* (May 29, 1943).
———. "Louis and Noland." *Art International* 4, no. 5 (May 25, 1960).
———. "Self-Hatred and Jewish Chauvinism, Some Reflections on 'Positive Jewishness.'" *Commentary* (November 1950).
———. "The Situation at the Moment." *Partisan Review* 15, no. 1 (January 1948).
Greenfield-Sanders, Timothy, and Robert Pincus-Witten. *The Ninth Street Show*. Toronto: Lumiere Press, 1987.
Greer, Germaine. *The Female Eunuch*. London: Fourth Estate, 2012.
———. *The Obstacle Race: The Fortunes of Women Painters and Their Work*. New York: Farrar, Straus and Giroux, 1979.
Grimes, William. "Harry Jackson, Artist Who Captured the West, Dies at 87." *New York Times*, April 28, 2011.
Gruen, John. *The Party's Over Now: Reminiscences of the Fifties—New York's Artists, Writers, Musicians, and their Friends*. New York: Viking Press, 1972.
Gruson, Lindsey. "Is it Art or Just a Toilet Seat? Bidders to Decide on a de Kooning." *New York Times*, January 15, 1992.
Guggenheim, Peggy. *Out of this Century: Confessions of an Art Addict*. London: André Deutsch Limited, 1980.
Haden Guest, Hadley, ed. *The Collected Poems of Barbara Guest*. Middletown, CT: Wesleyan University Press, 2008.
Halberstam, David. *The Fifties*. New York: A Fawcett Columbine Book, 1993.
Hall, Donald, and Pat Corrington Wykes, eds. *Anecdotes of Modern Art: From Rousseau to Warhol*. New York: Oxford University Press, 1990.
Hall, Lee. *Betty Parsons: Artist, Dealer, Collector*. New York: Harry N. Abrams, Inc., 1991.
———. *Elaine and Bill: Portrait of a Marriage*. New York: Cooper Square Press, 2000.
Hallgren, Mauritz A. *Seeds of Revolt: A Study of American Life and the Temper of the American People During the Depression*. New York: Alfred A. Knopf, 1933.
Hamill, Pete. "Beyond the Vital Gesture." *Art & Antiques* 7, no. 5 (May 1990).

Hampson, Robert, and Will Montgomery, eds. *Frank O'Hara Now: New Essays on the New York Poet*. Liverpool: Liverpool University Press, 2010.
Harap, Louis. *Social Roots of the Arts*. New York: International Publishers, 1949.
Harris, Mary Emma. *The Arts at Black Mountain College*. Cambridge, MA: The MIT Press, 1987.
Harrison, Helen A. *Larry Rivers*. New York: An ArtNews Book, Icon Editions, Harper & Row, Publishers, 1984.
———. *East Hampton Avant-Garde: A Salute to the Signa Gallery, 1957–1960*. East Hampton, NY: Guild Hall Museum, August 12–September 23, 1990.
Harrison, Helen A., and Constance Ayers Denne. *Hamptons Bohemia: Two Centuries of Artists and Writers on the Beach*. San Francisco: Chronicle Books, 2002.
Haskell, Molly. *From Reverence to Rape: The Treatment of Women in the Movies*. New York: Penguin, 1974.
Hauptman, William. "The Suppression of Art in the McCarthy Decade." *ArtForum* 12, no. 2 (October 1973).
Hauser, Arnold. *From Prehistoric Times to the Middle Ages*. Vol. 1 of *The Social History of Art*. London: Routledge, 1999.
———. *Naturalism, Impressionism: The Film Age*. Vol. 4 of *The Social History of Art*. New York: Routledge, 1999.
———. *Renaissance, Mannerism, Baroque*. Vol. 2 of *The Social History of Art*. London: Routledge, 1999.
———. *Rococo, Classicism and Romanticism*. Vol. 3 of *The Social History of Art*. London: Routledge, 1999.
Heartney, Eleanor. "How Wide Is the Gender Gap?" *ArtNews* 86, no. 6 (Summer 1987).
Heilbut, Anthony. *Exiled in Paradise: German Refugee Artists and Intellectuals in America, from the 1930s to the Present*. New York: Viking Press, 1983.
"Helen Frankenthaler: A Retrospective." Modern Art Museum of Fort Worth, September–October 1989 Calendar, Office of the Director.
Hellstein, Valerie. "Grounding the Social Aesthetics of Abstract Expressionism: A New Intellectual History of the Club." PhD dissertation, Stony Brook University, 2010.
Henry, Gerrit. "Jane Freilicher and the Real Thing." *ArtNews* 84, no. 1 (January 1985).
Herrera, Hayden. *Arshile Gorky: His Life and Work*. London: Bloomsbury, 2003.
———. "John Graham: Modernist Turns Magus." *Arts Magazine* 51, no. 2 (October 1976).
———. "Le Feu Ardent: John Graham's Journal." *Archives of American Art Journal* 14, no. 2 (1974).
Herring, Terrell Scott. "Frank O'Hara's Open Closet." *PMLA* 117, no. 3 (May 2002).
Hess, Thomas B. *Abstract Painting: Background and American Phase*. New York: The Viking Press, 1951.
———. "The Battle of Paris, Strip-tease and Trotsky." *It Is* 5 (Spring 1960).
———. "De Kooning Paints a Picture." *ArtNews* 52, no. 1 (March 1953).
———. "Franz Kline, 1910–1962." *ArtNews* 61, no. 4 (Summer 1962).
———. "Great Expectations, Part 1," *ArtNews* 55, no. 4 (June–August 1956).
———. "Inside Nature," *ArtNews* 56, no. 10 (February 1958).
———. "Introduction to Abstract." *ArtNews Annual* 20 (1951).
———. "Mixed Pickings from Ten Fat Years." *ArtNews* 54, no. 4 (Summer 1955).
———. "Mutt Furioso." *ArtNews* 55, no. 8 (December 1956).
———. "Seeing the Young New Yorkers." *ArtNews* 49, no. 3 (May 1950).
———. "A Tale of Two Cities." *Location* 1, no. 2 (Summer 1964).
———. "There's an 'I' in 'Likeness.'" *New York* (November 24, 1975).
———. "Trying Abstraction on Pittsburgh: The 1955 Carnegie." *ArtNews* 54, no. 7 (November 1955).
———. "U.S. Painting, Some Recent Directions." *ArtNews* 25th Annual Christmas Edition (1956).
———. "Where U.S. Extremes Meet." *ArtNews* 51, no. 2 (April 1952).
———. *Willem de Kooning*. New York: George Braziller, Inc., 1959.
———. *Willem de Kooning*. New York: The Museum of Modern Art, 1968.
———. "Younger Artists and the Unforgivable Crime." *ArtNews* 56, no. 2 (April 1957).
Hess, Thomas B., and Elizabeth C. Baker, eds. *Art and Sexual Politics: Why Have There Been No Great Women Artists?* New York: ArtNews Series, Collier Books, 1973.
Hess, Thomas B., and Linda Nochlin, eds. *Woman as Sex Object: Studies in Erotic Art, 1730–1970*. *ArtNews Annual* 38 (1972).
Hirschman, Jack, ed. *Artaud Anthology*. San Francisco: City Lights Books, 1965.

Hoban, Phoebe. "Psycho Drama: The Chilling Story of How the Sullivanian Cult Turned a Utopian Dream into a Nightmare." *New York* (June 19, 1989).
Hobbs, Jack A. *Art in Context*. 3rd ed. New York: Harcourt Brace Jovanovich, 1985.
Hobbs, Robert. *Lee Krasner*. New York: Abbeville Press Publishers, 1993.
———. *Lee Krasner*. New York: Independent Curators International, with Harry N. Abrams, Inc., 1999.
Hodgins, Eric, and Parker Lesley. "The Great International Art Market." *Fortune* (December 1955).
Hofmann, Hans, Sara T. Weeks, and Bartlett H. Hayes Jr., eds. *Search for the Real*. Cambridge, MA: The MIT Press, 1967.
Hofstadter, Richard. *The American Political Tradition and the Men Who Made It*. New York: Vintage Books, 1989.
Holmes, John Clellon. "'This Is the Beat Generation.'" *New York Times*, November 16, 1952.
Honey, Maureen. "The Images of Women in the 'Saturday Evening Post,' 1931–1936," *Journal of Popular Culture* 10, no. 2 (Fall 1976).
Horne, George P. "Battle for Tarawa the Hardest in Marine History says Carlson." *New York Times*, November 27, 1943.
Howard, Richard. *Paper Trail: Selected Prose, 1963–2003*. New York: Farrar, Straus and Giroux, 2004.
Hughes, Robert. *The Shock of the New: Art and the Century of Change*. London: Thames and Hudson, 1993.
"Human Image in Abstraction." *Time* 72 (August 11, 1958).
Hunter, Sam. "Jackson Pollock." *Museum of Modern Art Bulletin* 24, no. 2 (1956–57).
"Interview with Lee Krasner." *Evening Standard*, September 22, 1965.
"Irascible Group of Advanced Artists Led Fight against Show." *Life* 30, no. 3 (January 15, 1951).
Iseman, Ellen M. "Helen Frankenthaler." *The Century Yearbook 2012*. New York: The Century Association.
———. "Travels with my Aunt, Helen Frankenthaler, 1928–2011." *Connections* (Spring 2012).
"Is There a New Academy?" *ArtNews* 58, no. 4 (June–August 1959).
Jachec, Nancy. *The Philosophy and Politics of Abstract Expressionism, 1940–1960*. Cambridge: Cambridge University Press, 2000.
Jackman, Jarrell C., and Carla M. Borden, eds. *The Muses Flee Hitler: Cultural Transfer and Adaptation, 1930–1945*. Washington, DC: Smithsonian Institution Press, 1983.
"Jackson Pollock: An Artists' Symposium, Part I." *ArtNews* 66, no. 2 (April 1967).
Jackson Pollock: Black and White. New York: Marlborough-Gerson Gallery Inc., March 1969.
Jacobs, Norman, ed. *Culture for the Millions? Mass Media in Modern Society*. Princeton, NJ: D. Van Nostrand Company, Inc., 1961.
Jane Freilicher: Painter Among the Poets. New York: Tibor de Nagy Gallery, 2013.
Janis, Sidney. *Abstract and Surrealist Art in America*. New York: Reynal & Hitchcock, 1944.
Jewell, Edward Alden. "'The Problem of Seeing'; Vitally Important Matter of Approach—American Artist and His Public." *New York Times*, August 10, 1941.
Joan Mitchell Paintings, 1950–55. New York: Robert Miller Gallery, May 5 to June 5, 1998.
Johnson, Ellen H. *American Artists on Art, from 1940 to 1980*. New York: Icon Editions, Harper & Row, Publishers, 1982.
Johnson, Paul. *A History of the Jews*. New York: Harper & Row, Publishers, 1987.
Johnson, Steven, ed. *The New York Schools of Music and the Visual Arts*. New York: Routledge, 2002.
Jones, Caroline A. *Eyesight Alone: Clement Greenberg's Modernism and the Bureaucratization of the Senses*. Chicago: The University of Chicago Press, 2005.
Jordan, Ken. "Interview with Barney Rosset: The Art of Publishing No. 2." *The Paris Review* 145 (Winter 1997).
Jung, Carl Gustav. *Modern Man in Search of a Soul*. London: Routledge Classics, 2008.
———. *The Undiscovered Self: The Dilemma of the Individual in Modern Society*. New York: Signet Book, 2006.
Kaplan, Fred M. *1959: The Year Everything Changed*. Hoboken, NJ: John Wiley & Sons, 2009.
Karmel, Pepe, ed. *Jackson Pollock, Interviews, Articles, and Reviews*. New York: The Museum of Modern Art, 1998.
Katz, Vincent, ed. *Black Mountain College: Experiment in Art*. Cambridge, MA: The MIT Press, 2013.

Kaufmann, Walter. "The Reception of Existentialism in the United States." *Salmagundi* 10–11 (Fall 1969–Winter 1970).
Kazanjian, Dodie. "Keeper of the Flame." *Vogue* (July 1991).
Kennedy, David. *Birth Control in America: The Career of Margaret Sanger*. New Haven, CT: Yale University Press, 1970.
Kierkegaard, Søren. *Fear and Trembling*. London: Penguin Books, 2005.
Kimmel, Michael. *Manhood in America: A Cultural History*. New York: The Free Press, 1997.
Kimmelman, Michael. "Review/Art; Explosive Painting: The Path to Pop." *New York Times*, July 9, 1993.
Kingsley, April. *The Turning Point: The Abstract Expressionists and the Transformation of American Art*. New York: Simon & Schuster, 1992.
Kinsey, Alfred C., Clyde E. Martin, Wardell B. Pomeroy, and Paul H. Gebhard. *Sexual Behavior in the Human Female*. New York: Pocketbooks, 1970.
Kinsey, Alfred C., Wardell B. Pomeroy, and Clyde E. Martin. *Sexual Behavior in the Human Male*, Vol. 2. New York: Ishi Press, 2010.
Kleeblatt, Norman L., ed. *Action/Abstraction: Pollock, De Kooning, and American Art, 1940–1976*. The Jewish Museum, New York, May 4–September 21, 2008. New Haven, CT: Yale University Press, 2008.
Kligman, Ruth. *Love Affair: A Memoir of Jackson Pollock*. New York: William Morrow & Company, Inc., 1974.
Kokkinen, Eila. "John Graham During the 1940s." *Arts Magazine* 51, no. 3 (Summer 1976).
Kotz, Mary Lynn. *Rauschenberg: Art and Life*. New York: Harry N. Abrams, Inc., 1990.
Kramer, Hilton. "Clement Greenberg in the Forties." *The New Criterion* (January 1987).
———. "Interview with Helen Frankenthaler." *Partisan Review* 61, no. 2 (Spring 1994).
Kramer, Jane. *Off Washington Square: A Reporter Looks at Greenwich Village, N.Y.* New York: Duell, Sloan and Pearce, 1963.
Kuh, Katharine. *The Artist's Voice: Talks with Seventeen Modern Artists*. New York: Da Capo Press, 2000.
KZ-KAMPF-KUNST Boris Lurie: NO!ART. Cologne: NS-Dokumentationszentrum der Stadt Köln, Germany, August 27, 2014–November 2, 2014.
Lach, William, ed. *New York, New York: The City in Art and Literature*. New York: The Metropolitan Museum of Art, Universe, 2006.
Lader, Melvin. "Howard Putzel: Proponent of Surrealism and Early Abstract Expressionism in America." *Arts Magazine* 56 (March 1982).
La Moy, William T., and Joseph P. McCaffrey, eds. *The Journals of Grace Hartigan, 1951–1955*. Syracuse, NY: Syracuse University Press, 2009.
Landau, Ellen G. "Channeling Desire: Lee Krasner's Collages of the Early 1950s." *Woman's Art Journal* 18, no. 2 (Autumn 1997–Winter 1998).
———. *Jackson Pollock*. New York: Abradale Press, Harry N. Abrams, Inc., 1989.
———. "Krasner's Past Continuous." *ArtNews* 83, no. 2 (February 1984).
———. *Lee Krasner: A Catalogue Raisonné*. New York: Harry N. Abrams, Inc., 1995.
———. *Lee Krasner, Collages, 1953–1955*. New York: Jason McCoy Inc., 1995.
———. "Lee Krasner's Early Career, Part One: Pushing in Different Directions," *Arts Magazine* 56, no. 2 (October 1981).
———. "Lee Krasner's Early Career, Part Two: The 1940s." *Arts Magazine* 56, no. 3 (November 1981).
Landau, Ellen G., ed. *Reading Abstract Expressionism: Context and Critique*. New Haven, CT: Yale University Press, 2005.
Landau, Ellen G., Sandra Kraskin, Phyllis Braff, and Michael Zakian. *Mercedes Matter*. New York: MB Art Publishing, 2009.
"The Language of Art." *Bulletin of the Cleveland Museum of Art* 1, no. 1 (November 9, 1964).
Larkin, Oliver W. *Art and Life in America*. New York: Holt, Rinehart and Winston, 1949.
Larsen, Susan C. "The American Abstract Artists: A Documentary History, 1936–1941." *Archives of American Art Journal* 14, no. 1 (1974).
Lassaw, Denise. "Talk for Elaine's Memorial," lecture notes, 1990.
Lee Krasner: Little Image Paintings, 1946–1950. East Hampton, NY: Pollock Krasner House and Study Center, 2008.

Lee Krasner: Paintings, Drawings and Collages. London: Whitechapel Gallery, September–October, 1965.
Lee Krasner: Paintings from 1965 to 1970. New York: Robert Miller Gallery, January 4–26, 1991.
Lehman, David. *The Last Avant-Garde: The Making of the New York School of Poets*. New York: Anchor Books, 1999.
Lehmann-Haupt, Hellmut. *Art Under a Dictatorship*. New York: Oxford University Press, 1954.
Leighton, Isabel, ed. *The Aspirin Age, 1919–41*. Middlesex, UK: Penguin Books, 1964.
Lerner, Max. *America as a Civilization*. Volume 2, *Culture and Personality*. New York: Simon and Schuster, 1957.
———. "The Flowering of the Latter-Day Man." *The American Scholar* 25, no. 1 (Winter, 1955–1956).
LeSueur, Joe. *Digressions on Some Poems by Frank O'Hara: A Memoir*. New York: Farrar, Straus and Giroux, 2003.
Levin, Gail. "The Extraordinary Interventions of Alfonso Ossorio, Patron and Collector of Jackson Pollock and Lee Krasner." *Archives of American Art Journal* 50, nos. 1–2 (Spring 2011).
———. *Lee Krasner: A Biography*. New York: William Morrow, 2012.
Levine, Les. "The Golden Years: A Portrait of Eleanor Ward." *Arts Magazine* 48, no. 7 (April 1974).
———. "A Portrait of Sidney Janis on the Occasion of his 25th Anniversary as an Art Dealer." *Arts Magazine* 48, no. 2 (November 1973).
———. "The Spring of '55: A Portrait of Sam Kootz." *Arts Magazine* 48, no. 7 (April 1974).
———. "Suffer, Suffer, Suffer: A Portrait of John Bernard Myers." *Arts Magazine* 48, no. 7 (April 1974).
Levy, Julian. *Memoir of an Art Gallery*. Boston: ArtWorks, MFA Publications, 2003.
———. *Surrealism*. New York: Da Capo Press, 1995.
Lewallen, Constance, ed. "Elaine de Kooning, Interview by Robin White." *View*. San Francisco: Crown Point Press, 1985.
Lieber, Edvard. *Willem de Kooning: Reflections in the Studio*. New York: Harry N. Abrams, Inc., 2000.
"Life Goes to an Artists' Masquerade: New Yorkers Dress Up for a Bohemian Ball." *Life* 28, no. 24 (June 12, 1950).
"A 'Life' Roundtable on Modern Art." *Life* 25, no. 15 (October 11, 1948).
Lipman, Jean, ed. *The Collector in America*. London: Weidenfeld and Nicolson, 1971.
Lipstadt, Deborah E. *Beyond Belief: The American Press and the Coming of the Holocaust, 1933–1945*. New York: The Free Press, 1986.
Livingston, Jane. *The Paintings of Joan Mitchell*. New York: Whitney Museum, 2002.
Lord, James. *Giacometti: A Biography*. New York: Farrar, Straus, Giroux, 1985.
Louchheim, Aline B. "Betty Parsons: Her Gallery, Her Influence." *Vogue* (October 1, 1951).
Lowenthal, Leo. "The Crisis of the Individual: II. Terror's Atomization of Man." *Commentary* (January 1946).
Lukach, Joan M. *Hilla Rebay: In Search of the Spirit in Art*. New York: George Braziller, Inc., 1983.
"Lunch." *Lear's* (November–December 1988).
Lund, David. "Scenes from the Cedar." *New York Artists Equity Association 55th Anniversary Journal*, December 1, 2002.
Lundberg, Ferdinand, and Marynia F. Farnham, M.D. *Modern Woman: The Lost Sex*. New York: The Universal Library, Grosset & Dunlap, 1947.
Lurie, Alison. *V. R. Lang: Poems and Plays with a Memoir by Alison Lurie*. New York: Random House, 1975.
Lynes, Russell. *Good Old Modern: An Intimate Portrait of the Museum of Modern Art*. New York: Atheneum, 1973.
———. *The Tastemakers: The Shaping of American Popular Taste*. New York: Dover Publications, 1980.
Macdonald, Dwight. *The Memoirs of a Revolutionist: Essays in Political Criticism*. New York: Farrar, Straus and Cudahy, 1957.
———. "The Root Is Man, Part II." *Politics* (July 1946).
MacLeish, Archibald. "The Irresponsibles." *The Nation* (May 18, 1940).
Magee, Michael. "Tribes of New York: Frank O'Hara, Amiri Baraka, and the Poetics of the Five Spot." *Contemporary Literature* 42, no. 4 (Winter 2001).
Malina, Judith. *The Diaries of Judith Malina: 1947–1957*. New York: Grove Press, Inc., 1984.
Manso, Peter. *Provincetown: Art, Sex, and Money on the Outer Cape*. New York: Simon and Schuster, 2003.
Marquis, Alice Goldfarb. *Alfred H. Barr, Jr., Missionary for the Modern*. Chicago: Contemporary Books, 1989.

Bibliography

———. *The Art Biz: The Covert World of Collectors, Dealers, Auction Houses, Museums, and Critics.* Chicago: Contemporary Books, 1991.
———. *Art Czar: The Rise and Fall of Clement Greenberg.* Boston: MFA Publications, 2006.
Marter, Joan. *Women and Abstract Expressionism: Painting and Sculpture, 1945–1959.* New York: Baruch College, City University of New York, 1997.
Marter, Joan, ed. *Women of Abstract Expressionism.* New Haven, CT: Yale University Press, 2016.
"Martha Jackson Dies on Coast; Gallery Aided Abstract Artists." *New York Times,* July 5, 1969.
Matossian, Nouritza. *Black Angel: A Life of Arshile Gorky.* London: Pimlico, 2001.
Mattison, Robert Saltonstall. *Grace Hartigan: A Painter's World.* New York: Hudson Hills Press, 1990.
May, Rollo. *Man's Search for Himself.* New York: W. W. Norton and Co., 2009.
Mayer, Musa. *Night Studio: A Memoir of Philip Guston, by his daughter Musa Mayer.* New York: Alfred A. Knopf, 1988,
Mayor, A. H. "The Artists for Victory Exhibition." *Metropolitan Museum of Art Bulletin,* December 1942.
McCarthy, Mary. *The Company She Keeps.* London: Virago Press, 2011.
McCoy, Garnett, Alfred H. Barr Jr., Baldwin Smith, and Allen Rosenbaum. "A Continued Story: Alfred H. Barr, Jr., Princeton University, and William C. Seitz." *Archives of American Art Journal* 21, no. 3 (1981).
McKinzie, Richard D. *The New Deal for Artists.* Princeton, NJ: Princeton University Press, 1973.
McG. Thomas Jr., Robert. "Patsy Southgate, Who Inspired 50's Literary Paris, Dies at 70." *New York Times,* July 26, 1998.
Mead, Margaret. *Male and Female: A Study of the Sexes in a Changing World.* New York: Penguin Books, 1981.
———. "Night After Night." *trans/formation* 1, no. 2 (1951).
"A Memorial Service for John Bernard Myers." The Grey Art Gallery, New York, Thursday, October 15, 1987.
Merleau-Ponty, Maurice. "Cezanne's Doubt." *Partisan Review* 13, no. 4 (September–October 1946).
Milazzo, Richard. "Caravaggio on the Beach." *Evergreen Review* 101 (Winter 1998).
———. *Photos of Joan Mitchell by Barney Rosset.* New York: Danziger Gallery, October 23–November 28, 1998.
Michaud, Yves. *Joan Mitchell: La Grande Vallée.* Paris: Galerie Jean Fournier, 1984.
Millard, Charles W. *Friedel Dzubas.* Washington, DC: Smithsonian Institution and Hirshhorn Museum, 1983.
Miller, Dorothy C., ed. *Fourteen Americans.* New York: Museum of Modern Art, 1946.
———. *Sixteen Americans.* New York: Museum of Modern Art, 1959.
———. *Twelve Americans.* New York: Museum of Modern Art, 1956.
Miller, Lynn F., and Sally S. Swenson. *Lives and Works: Talks with Women Artists.* Metuchen, NJ: The Scarecrow Press, Inc., 1981.
Miller, Douglas T., and Marion Nowak. *The Fifties: The Way We Really Were.* Garden City, NY: Doubleday & Company, Inc., 1977.
Miller, Terry. *Greenwich Village and How It Got That Way.* New York: Crown Publishers, 1990.
Millet, Kate. *Sexual Politics.* London: Virago Press Ltd, 1983.
Mills, C. Wright. "The Powerless People: The Role of the Intellectual in Society." *Politics* 1, no. 3 (April 1944).
Mitchell, Joan. "Autumn." *Poetry Magazine,* 1935.
Mitchell, Juliet. *Psychoanalysis and Feminism.* New York: Pantheon Books, 1974.
Monroe, Gerald M. "Artists as Militant Trade Union Workers during the Great Depression." *Archives of American Art Journal* 14, no. 1 (1974).
———. "The Artists Union of New York." PhD dissertation, New York University, 1971.
Morris, Frances, ed. *Paris Post War: Art and Existentialism, 1945–1955.* London: Tate Gallery, 1993.
Morrow, Bradford. "Not Even Past: Hybrid Histories." *Conjunctions* 53 (2009).
Motherwell, Robert. "Beyond the Aesthetic." *Design* 47, no. 8 (April 1, 1946).
———. "The Modern Painter's World." *DYN* 1 (November 1944).
———. "Two Famous Painters' Collection." *Vogue* (January 15, 1964).
Moutet, Anne-Elisabeth. "An American in Paris." *Elle* 11, no. 6 (February 1988).
Munro, Eleanor. "The Found Generation." *ArtNews* 60, no. 7 (November 1961).

———. *Originals: American Women Artists*. New York: A Touchstone Book, Simon & Schuster, Inc., 1982.

"My First Exhibition...to Now, Elaine de Kooning." *Art/World Museums International News Gallery Guide* 7, no. 1.

Myers, John Bernard. *Tracking the Marvelous: A Life in the New York Art World*. New York: Random House, 1983.

Myers, John Bernard, ed. *The Poets of the New York School*. Philadelphia: University of Pennsylvania Graduate School of Fine Arts, 1969.

Naifeh, Steven, and Gregory White Smith. *Jackson Pollock: An American Saga*. New York: Clarkson N. Potter, Inc., 1989.

Nelson, Maggie. *Women, The New York School, and Other True Abstractions*. Iowa City: University of Iowa Press, 2007.

Nemser, Cindy. "An Afternoon with Joan Mitchell." *The Feminist Art Journal* 3, no. 1 (1974).

———. *Art Talk: Conversations with 12 Women Artists*. New York: Charles Scribner's Sons, 1975.

———. "Art Talk Forum: Women in Art." *Arts Magazine* 45, no. 33 (February 1971).

———. "A Conversation with Lee Krasner." *Arts Magazine* 47, no. 6 (April 1973).

———. "A Conversation with Marisol." *The Feminist Art Journal* 2, no. 3 (Fall 1973).

———. "Grace Hartigan: Abstract Artist, Concrete Woman." *Ms.*, March 1975.

Netter, D. Terence. *Homage to Lee Krasner*. New York: The Metropolitan Museum of Art, September 17, 1984.

The New American Painting, A Show in Eight European Countries, 1958–1959. New York: The Museum of Modern Art, distributed by Doubleday & Co., Inc., 1959.

Ninth Street: Nine Artists from the Ninth Street Show. New York: David Findlay Jr. Fine Art, June 9–20, 2006.

NO! Boris Lurie, David David Gallery, Philadelphia, November 14–December 12, 2012.

Novak, Josephine. "Tracking the Marvelous Grace Hartigan." *Baltimore Evening Sun*, n.d. [ca. 1983].

O'Brian, John, ed. *Affirmations and Refusals, 1950–1956*. Vol. 3 of *Clement Greenberg: The Collected Essays and Criticism*. Chicago: University of Chicago Press, 1995.

———. *Arrogant Purpose, 1945–1949*. Vol. 2 of *Clement Greenerg: The Collected Essays and Criticism*. Chicago: University of Chicago Press, 1986.

———. *Perceptions and Judgments, 1939–1944*. Vol. 1 of *Clement Greenberg: The Collected Essays and Criticism*. Chicago: The University of Chicago Press, 1988.

O'Brien, Elaine Owens. "The Art Criticism of Harold Rosenberg: Theaters of Love and Combat." PhD dissertation, City University of New York, 1997.

O'Connor, Francis V. *Jackson Pollock*. New York: The Museum of Modern Art, 1967.

O'Hara, Frank. *Art Chronicles, 1954–1966*. New York: George Braziller, 1975.

———. "Franz Kline Talking." *Evergreen Review* 2, no. 6 (Autumn 1958).

———. *Jackson Pollock*. New York: George Braziller, Inc., 1959.

———. "Porter Paints a Picture." *ArtNews* 53, no. 9 (January 1955).

———. "Reviews and Previews, George Hartigan." *ArtNews* 52, no. 10 (February 1954).

———. "Riopelle: International Speedscapes." *ArtNews* 62, no. 2 (April 1963).

———. *Robert Motherwell, with Selections from the Artist's Writings*. New York: The Museum of Modern Art, 1965.

Ortman, George. *New York Artists Equity Association 55th Anniversary Journal*. New York: December 18, 2002.

Ostrow, Saul. "Michael Goldberg." *Bomb* 75 (Spring 2001).

Pacini, Marina. *Marisol Sculptures and Works on Paper*. New Haven, CT: Yale University Press, 2014.

Padgett, Ron. "Poets and Painters in Paris, 1919–1939." *ArtNews Annual XXXVIII*.

Panofsky, Erwin. *Meaning in the Visual Arts*. London: Penguin Books, 1993.

Parker, Rozsika, and Griselda Pollock. *Old Mistresses: Women, Art and Ideology*. London: Pandora, an imprint of HarperCollins Publishers, 1981.

Parrish, Michael E. *Anxious Decades: America In Prosperity and Depression, 1920–1941*. New York: W. W. Norton & Company, 1994.

Parry, Albert. *Garrets and Pretenders: A History of Bohemianism in America*. New York: Dover Publications, 1960.

Passlof, Pat. "The Ninth Street Show." *New York Artists Equity Association 55th Annual Journal,* December 18, 2002.

———. "Willem de Kooning on his Eighty-Fifth Birthday, '1948.'" *Art Journal* 48, no. 3 (Autumn 1989).

Pavia, Philip. "The Hess Problem and Its Seven Panels at The Club." *It Is,* 5 (Spring 1960).

Peppiatt, Michael. "Hans Namuth; Artists Portraits." *Art International,* Spring 1989.

Perl, Jed. *New Art City: Manhattan at Mid-Century.* New York: Vintage Books, 2007.

Perloff, Marjorie. *Frank O'Hara: Poet among Painters.* Austin: University of Texas Press, 1979.

Pettet, Simon. *Conversations with Rudy Burckhardt about Everything.* New York: Vehicle Editions, 1987.

"Philip Pavia Talks on the War Years and the Start of The Club, Wartime 1940–1945." *New York Artists Equity Association 5th Anniversary Journal,* December 18, 2002.

"Pictorial Essay: 19 Young American Artists, Under 36." *Life* 28, no. 12 (March 20, 1950).

Poirier, Maurice. "Helen Frankenthaler: Working Papers." *ArtNews* 84, no. 6 (Summer 1985).

Polcari, Stephen. *Abstract Expressionism and the Modern Experience.* Cambridge: Cambridge University Press, 1994.

———. *From Omaha to Abstract Expressionism: Americans Respond to World War II,* curated by Stephen Polcari. New York: Sidney Mishkin Gallery, Baruch College, November 10 to December 14, 1995.

———. *Lee Krasner and Abstract Expressionism.* Stony Brook: State University of New York at Stony Brook, Fine Arts Gallery, 1988.

———. "Martha Graham and Abstract Expressionism." *Smithsonian Studies in American Art* 4, no. 1 (Winter 1990).

Polenberg, Richard. *War and Society: The United States, 1941–1945.* Philadelphia: J. B. Lippincott Company, 1972.

Polsky, Ned. "The Village Beat Scene: Summer 1960." *Dissent* 8, no 3 (Summer 1961).

Porter, Fairfield. "John Graham: Painter as Aristocrat." *ArtNews* 59, no. 6 (October 1960).

———. "Reviews and Previews, Elaine de Kooning." *ArtNews* 53, no. 2 (April 1954).

Potter, Jeffrey. *To a Violent Grave: An Oral Biography of Jackson Pollock.* Wainscott, NY: Pushcart Press, 1987.

Poydinecz-Conley, Donna. Unpublished interview with Helen Frankenthaler, June 14, 1978.

Preston, Stuart. "By Husband and Wife; A Group Show by Teams—Three Modernists." *New York Times,* September 25, 1949.

———. "Diverse Showings, Realism and Surrealism—'Collectors' Finds'." *New York Times,* February 8, 1953.

Prioleau, Betsy. *Seductress: Women Who Ravished the World and Their Lost Art of Love.* New York: Viking, 2003.

Rago, Louise Elliott. "We Visit with Grace Hartigan." *School Arts: The Art Education Magazine* 59, no. 9 (May 1960).

Randall, Margaret. *Ecstasy Is a Number: Poems.* Phoenix, AZ: Orion Press, 1961.

———. *My Town: A Memoir of Albuquerque, New Mexico in Poems, Prose, and Photographs.* San Antonio, TX: Wings Press, 2010.

"The 'Rawness,' the Vast." *Newsweek,* May 11, 1959.

Read, Herbert. *The Politics of the Unpolitical.* London: Routledge, 1945.

"Red Visitors Cause Rumpus: Dupes and Fellow Travelers Dress Up Communist Fronts." *Life* 26, no. 14 (April 4, 1949).

Reinhardt, Ad. "Twelve Rules for a New Academy." *ArtNews* 56, no. 3 (May 1957).

Rembert, Virginia Pitts. "Mondrian, America, and American Painting." PhD dissertation, Columbia University, 1970.

"Remembering Joan." *Evergreen Review* 104 (January 2001).

Rich, Adrienne Cecile. *A Change of World.* New Haven, CT: Yale University Press, 1951.

Rich, Daniel Cotton. "Freedom of the Brush." *Atlantic Monthly* 181 (February 1948).

Richard, Paul. "Much Ado about Frankenthaler." *Washington Post,* April 19, 1975.

Richler, Mordecai, ed. *Writers on World War II: An Anthology.* New York: Alfred A. Knopf, 1991.

Riesman, David, with Nathan Glazer and Reuel Denney. *The Lonely Crowd: A Study of the Changing American Character.* New Haven, CT: Yale University Press, 1978.

Riley, Charles H. *The Saints of Modern Art: The Ascetic Ideal in Contemporary Painting, Sculpture, Architecture, Music, Dance, Literature, and Philosophy*. Hanover, NH: University Press of New England, 1998.
Riley, Glenda. *Inventing the American Woman: A Perspective on Women's History*. Arlington Heights, IL: Harlan Davidson, Inc., 1986.
Rilke, Rainer Maria. *Letters to a Young Poet*. New York: Random House, 1984.
Rimbaud, Arthur. *Poésies: Derniers vers, Une saison en enfer, Illuminations*. Paris: Le Livre de Poche, 1972.
Rivers, Larry. "Larry Rivers on The Club." *The New Criterion Special Issue*, no. 49 (1986).
Rivers, Larry, and Arnold Weinstein. *What Did I Do? The Unauthorized Autobiography*. New York: Aaron Asher Books, HarperCollins Publishers, 1992.
Rivers, Larry, with Carol Brightman. "The Cedar Bar," *New York* 12, no. 43 (November 5, 1979).
Robertson, Brian. *Lee Krasner, Paintings, Drawings and Collages*. London: Whitechapel Gallery, September–October 1965.
Robson, Deirdre. "The Avant-Garde and the On-Guard: Some Influences on the Potential Market for the First Generation Abstract Expressionists in the 1940s and Early 1950s." *Art Journal* 47, no. 3 (Autumn 1988).
———. "The Market for Abstract Expressionism: The Time Lag between Critical and Commercial Acceptance." *Archives of American Art Journal* 25, no. 3 (1985).
Rockwell, John. "Virgil Thomson, Composer, Critic and Collaborator with Stein, Dies at 92." *New York Times*, October 1, 1989.
Rose, Barbara. "American Great: Lee Krasner." *Vogue* (June 1972).
———. "First-Rate Art by the Second Sex." *New York* 7, no. 14 (April 8, 1974).
———. *Frankenthaler*. New York: Harry N. Abrams, Inc., 1972.
———. "Jackson Pollock at Work." *Partisan Review* 47, no. 1 (Winter 1980).
———. *Krasner/Pollock: A Working Relationship*. East Hampton, NY: Guild Hall Museum, August 8–October 4, 1981.
———. "The Landscape of Light, Joan Mitchell." *Vogue* (June 1974).
———. *Lee Krasner: A Retrospective*. New York: The Museum of Modern Art, 1983.
———. "Life on the Project." *Partisan Review* 52, no. 2 (Spring 1985).
Rose, Barbara, edited by Alexis Gregory. *American Painting: The Twentieth Century*. Lausanne: SKIRA, 1969.
Rose, Phyllis, ed. *The Norton Book of Women's Lives*. New York: W. W. Norton and Company, 1993.
Rosen, Marjorie. *Popcorn Venus: Women, Movies and the American Dream*. New York: Avon Books, 1974.
Rosenberg, Eric M., Lisa Saltzman, and Timothy McElreavy. *Friedel Dzubas: Critical Painting*. Medford, MA: Tufts University Gallery, 1998.
Rosenberg, Harold. "Action Painting: A Decade of Distortion." *ArtNews* 61, no. 8 (December 1962).
———. "After Next, What?" *Art In America* 2 (1964).
———. "The American Action Painters." *ArtNews* 51, no. 8 (December 1952).
———. *The Anxious Object*. Chicago: The University of Chicago Press, 1966.
———. "The Art Establishment." *Esquire* (January 1965).
———. *Art on the Edge: Creators and Situations*. New York: Macmillan Publishing Co., Inc.,1971.
———. "The Fall of Paris." *Partisan Review* 6, no. 7 (November–December 1940).
———. "Introduction to Modern American Painters." *Possibilities* 1 (Winter 1947–48).
———. "Parable for American Painters." *ArtNews* 52, no. 9 (January 1954).
———. "The Teaching of Hans Hofmann." *Arts Magazine* 45, no. 3 (December 1970–January 1971).
———. "Tenth Street: A Geography of Modern Art." *ArtNews Annual* 28 (1959).
———. *The Tradition of the New*. New York: Da Capo Press, 1994.
Rosenzweig, Phyllis D. *The Fifties, Aspects of Painting in New York: Hirshhorn Museum and Sculpture Garden*. Washington, DC: Smithsonian Institution Press, 1980.
Ross, Clifford. *Abstract Expressionism: Creators and Critics, an Anthology*. New York: Harry N. Abrams, Inc., 1990.
Rosset, Barney. "The Subject Is Left Handed," manuscript, courtesy Astrid Myers Rosset.
Rotskoff, Lori. *Love on the Rocks: Men, Women, and Alcohol in Post–World War II America*. Chapel Hill: University of North Carolina, 2002.
Rowley, Alison. *Helen Frankenthaler: Painting History, Writing Painting*. London: I. B. Tauris, 2007.

Rubenfeld, Florence. *Clement Greenberg: A Life.* Minneapolis: University of Minnesota Press, 2004.
Rubin, William. "The New York School, Part II." *Art International* 2, nos. 2–3 (Summer 1958).
Ruddick, Sara, and Pamela Daniels, eds. *Working It Out: 23 Women Writers, Artists, Scientists, and Scholars Talk about Their Lives and Work.* London: Pantheon Books, 1997.
Russell, John. "Thomas Hess, Art Expert, Dies: Writer and Met Official Was 57." *New York Times,* July 14, 1978.
Sadoff, Ira. "Frank O'Hara's Intimate Fictions." *American Poetry Review* 35, no. 6 (November–December 2006).
Sagan, Françoise. *Bonjour Tristesse.* New York: Penguin Books Ltd, 2011.
———. *A Certain Smile.* Chicago: University of Chicago Press, 1956.
Sandler, Irving. *Abstract Expressionism and the American Experience: A Re-evaluation.* New York: Hudson Hills, 2009.
———. *The Cedar Bar.* New York: Washburn Gallery, January 2009.
———. "The Club, How the Artists of the New York School Found Their First Audience—Themselves." *ArtForum* 4, no. 1 (September 1965).
———. "Mitchell Paints a Picture." *ArtNews* 56, no. 6 (October 1957).
———. *A Sweeper Up After Artists: A Memoir.* London: Thames and Hudson, 2003.
Sartre, Jean-Paul. *Existentialism and Humanism.* London: Methuen, 2007.
Savram, David. *Taking It Like a Man: White Masculinity, Masochism and Contemporary American Culture.* Princeton, NJ: Princeton University Press, 1998.
Sawin, Martica. *Nell Blaine: Her Life and Art.* New York: Hudson Hills Press, 1998.
Sawyer, Kenneth B. "The Artist as Collector: Alfonso Ossorio." *Studio International* 169, no. 863 (March 1965).
———. "The Importance of a Wall: Galleries." *Evergreen Review* 2, no. 8 (Spring 1959).
Schapiro, Meyer. "The Liberating Quality of Avant-Garde Art." *ArtNews* 56, no. 4 (Summer 1956).
———. *Modern Art in the 19th and 20th Centuries: Selected Papers.* 1958. Reprint. New York: George Braziller, 1979.
Scharf, Lois. *To Work and to Wed: Female Employment, Feminism, and the Great Depression.* Westport, CT: Greenwood Press, 1980.
Schiller, Friedrich. *On the Aesthetic Education of Man.* Mineola, NY: Dover Publications, Inc., 2004.
Schjeldahl, Peter. "Tough Love." *The New Yorker* (July 15, 2002).
Schloss, Edith, "The Castelli Saga." Unpublished manuscript, MS no. 1763, Subseries VC, Box 16, Edith Schloss Burckhardt Papers, Columbia University Library.
———. "The Loft Generation: Intimate Memories of Vanished Art Worlds in New York and Rome." Manuscript, MS no. 1763, Subseries VC, Box 15, Edith Schloss Burckhardt Papers, Columbia University Library.
Schulze, Franz. "Thomas Hess, 1920–1978." *ArtNews* 77, no. 6 (September 1978).
Schuyler, James. "Frank O'Hara: Poet Among Painters." *ArtNews* 73, no. 5 (May 1974).
———. "Is There an American Print Revival?" *ArtNews* 60, no. 9 (January 1962).
Scrivani, George, ed. *Collected Writings of Willem de Kooning.* New York: Hanuman Books, 1988.
Seiberling, Dorothy. "Jackson Pollock: Is He the Greatest Living Painter in the United States?" *Life* 27, no. 6 (August 8, 1949).
———. "Women Artists in Ascendance: Young Group Reflects Lively Virtues of U.S. Painting." *Life* 42, no. 19 (May 13, 1957).
Seitz, William. *Abstract Expressionist Painting in America.* Cambridge, MA: Harvard University Press, 1983.
———. "The Rise and Dissolution of the Avant-Garde." *Vogue* (September 1, 1963).
Severini, Gino. *The Artist and Society.* London: The Harvill Press, 1946.
Shaw, Lytle. *Frank O'Hara: The Poetics of Coterie.* Iowa City: University of Iowa Press, 2006.
Sherwin, Martin J. *A World Destroyed: Hiroshima and Its Legacies.* Stanford, CA: Stanford University Press, 2003.
Simon, Sidney. "Concerning the Beginnings of the New York School: 1939–1943 (Interviews with Busa, Matta, and Motherwell)." *Art International* 11, no. 6 (Summer 1967).
Slivka, Rose. "Elaine de Kooning: The Bacchus Paintings." *Arts Magazine* 57 (October 1982).
———. "Willem de Kooning, on His Eighty-Fifth Birthday." *Art Journal* 48, no. 3 (Autumn 1989).

Smith, Betty. "Women on the Works Progress Administration/Federal Art Project. New York." Unpublished graduate school paper, 1973.
Soby, James Thrall. "Interview with Grace Hartigan." *The Saturday Review* 9, no. 40 (October 5, 1957).
Soby, James Thrall, Lloyd Goodrich, John I. H. Baur, and Dorothy C. Miller. "The Eastern Seaboard, New York City—Art Capital." *Art in America* 42, no. 1 (Winter 1954).
Solomon, Deborah. "Artful Survivor: Helen Frankenthaler Stays Loyal to Abstract Expressionism." *New York Times Magazine,* May 14, 1989.
———. "In Monet's Light." *New York Times Magazine,* November 24, 1991.
———. "Interview with Grace Hartigan." *The Saturday Review* 11, no. 40 (October 5, 1957).
———. "Interview with Helen Frankenthaler." *Partisan Review* 51, no. 4, no. 1 (1984–1985).
———. *Jackson Pollock: A Biography.* New York: Cooper Square Press, 2001.
——— "The Lyrical Mastery of Helen Frankenthaler." Unpublished notes for article, 1989.
———. "Open House at the Pollocks." *The New Criterion* 6, no. 9 (May 1988).
Sontag, Susan. "Notes on Camp." *Partisan Review* 31, no. 4 (Fall 1964).
Stahr, Celia S. "Elaine de Kooning, Portraiture and the Politics of Sexuality." *Genders Online Journal* 38 (2003).
———. "The Social Relations of Abstract Expressionism: An Alternative History." PhD dissertation, University of Iowa, 1997.
"Statement by Philip Pavia." *New York Artists Equity Association 55th Anniversary Journal,* December 18, 2002.
Stefanelli, Joe. "The Cedar Bar." *New York Artists Equity Association 55th Anniversary Journal,* December 18, 2002.
Stein, Gertrude. *Wars I Have Seen.* New York: Brilliance Books, 1984.
Sterling, Charles. "A Fine 'David' Reattributed." *The Metropolitan Museum of Art Bulletin* 9, no. 5 (January 1951).
Stevens, Mark, and Annalyn Swan. *De Kooning: An American Master.* New York: Alfred A. Knopf, 2011.
Stevens, Wallace. *Collected Poetry and Prose.* New York: The Library of America, 1997.
———. *The Relations between Poetry and Painting.* New York: The Museum of Modern Art, 1951.
Stewart, Regina, ed. *New York Artists Equity Association 55th Annual Journal,* December 18, 2002.
Stone, I. F. *The Haunted Fifties.* London: The Merlin Press Ltd., 1964.
Stowe, David W. "The Politics of Cafe Society." *The Journal of American History* 84, no. 4 (March 1998).
Sweeney, James Johnson. "Five American Painters." *Harper's Bazaar,* no. 2788 (April 1944).
Sweeney, Louise. "Helen Frankenthaler: Painter of the Light Within." *Christian Science Monitor,* September 16, 1980.
Sylvester, David. *Interviews with American Artists.* London: Pimlico, 2002.
Sylvester, David, Richard Schiff, and Marla Prather. *Willem de Kooning Paintings.* New Haven, CT: Yale University Press, 1996.
"A Symposium: The State of American Art." *Magazine of Art* 42, no. 3 (March 1949).
Szarkowski, John, and John Elderfield, eds. "Revisiting the Revisionists: The Modern, Its Critics, and the Cold War." *The Museum of Modern Art at Mid-Century at Home and Abroad.* New York: The Museum of Modern Art, 1994.
Tabak, May Natalie. *But Not for Love.* New York: Horizon Press, 1960.
Taylor, John. "An Interview with Elaine de Kooning in Athens." *Contemporary Art/Southeast* 1, no. 1 (April–May 1977).
Terkel, Studs. *Hard Times: An Oral History of the Great Depression.* New York: The New Press, 1986.
Tracy, Sara W. *Alcoholism in America: From Reconstruction to Prohibition.* Baltimore, MD: Johns Hopkins University Press, 2005.
Trilling, Lionel. *The Liberal Imagination: Essays on Literature and Society.* New York: New York Review of Books, 2008.
———. "Sex and Science: The Kinsey Report." *Partisan Review* 15, no. 4 (April 1948).
Trotsky, Leon. "Art and Politics: A Letter to the Editors of the Partisan Review." *Partisan Review* 5, no. 3 (August–September 1938).
Tuchman, Phyllis. "Landscape of Color." *Vogue* (February 1985).
Tucker, Marcia. *Joan Mitchell.* New York: The Whitney Museum of American Art, 1974.

"28 Art Awards Listed in Paris; Five Frenchmen, Three from U.S. Among Winners at First Biennial Show." *New York Times,* Wednesday, October 7, 1959.
Valliere, James T. *Lee Krasner and Jackson Pollock's Legacy.* New York: Stony Brook Foundation, 2009.
Van Horne, Janice. *A Complicated Marriage: My Life with Clement Greenberg.* Berkeley, CA: Counterpoint, 2012.
Varnadoe, Kirk, with Pepe Karmel. *Jackson Pollock.* New York: Museum of Modern Art, 1998.
"The Vocal Girls." *Time* 75, no. 18 (May 2, 1960).
Wagner, Anne Middleton. *Three Artists (Three Women): Modernism and the Art of Hesse, Krasner, and O'Keeffe.* Berkeley: University of California Press, 1996.
Wakefield, Dan. *New York in the Fifties.* New York: Houghton Mifflin, 1992.
Wald, Allen M. *American Night: The Literary Left in the Era of the Cold War.* Chapel Hill: University of North Carolina Press, 2014.
Wallach, Amei. "Lee Krasner's Triumph." *Vogue* (November 1983).
———. "Living Color." *New York Newsday,* June 5, 1989.
———. "Retrospective of a Risk-Taker, Works on Paper." *Newsday,* February 24, 1985.
Ward, John L. *American Realist Painting 1945–1980.* Ann Arbor, MI: UMI Research Press, 1990.
Weibel, Kathryn. *Mirror, Mirror: Images of Women Reflected in Popular Culture.* New York: Anchor Books, 1977.
Wetzsteon, Ross. *Republic of Dreams, Greenwich Village: The American Bohemia, 1910–1960.* New York: Simon & Schuster, 2002.
White, E. B. *Here Is New York.* New York: The Little Bookroom, 1999.
Whyte, Lynn, Jr. *Educating Our Daughters: A Challenge to the Colleges.* New York: Harper and Bros., 1950.
Whyte, William, Jr. "The Wife Problem." *Life* 32, no. 1 (January 2, 1952).
Whyte, William H. *The Organization Man.* New York: Penguin Books, 1961.
Wilkin, Karen. *David Smith.* New York: Abbeville Press, 1984.
———. "Frankenthaler and Her Critics." *The New Criterion* 8, no. 2 (October 1989).
———. "Frankenthaler at the Guggenheim." *The New Criterion* 16, no. 7 (March 1998).
———. *Frankenthaler Works on Paper 1949–1984.* New York: George Braziller in association with the International Exhibitions Foundation, 1984.
Willard, Charlotte. "Women of American Art." *Look,* September 27, 1960.
Williams, Juanita H. "Woman: Myth and Stereotype." *International Journal of Women's Studies* 1, no. 3 (May–June 1978).
Williams, Tennessee. *In the Bar of a Tokyo Hotel and Other Plays.* Vol. 7 of *The Theatre of Tennessee Williams.* New York: New Directions, 1950.
Wittner, Lawrence S. *Rebels Against War: The American Peace Movement, 1941–1960.* New York: Columbia University Press, 1969.
Wolf, Ben. "Portrait of a President: President John F. Kennedy, an Exhibition of Portraits and Sketches by Elaine de Kooning." Kansas City Art Institute and School of Design, 1965.
Wolfe, Tom. *The Painted Word.* New York: Picador, 1975.
Woolf, Virginia. *A Room of One's Own.* London: Penguin, 1928.
———. *To the Lighthouse.* Ware, Hertfordshire, UK: Wordsworth Classics, 1994.
Wright, Morris. "The Violent Land—Some Observations on the Faulkner Country." *Magazine of Art* 45, no. 3 (March 1952).
Wydenbruck, Nora. *Rilke, Man and Poet: A Biographical Study.* London: John Lehmann, 1949.
Yard, Sally. "The Angel and the Demoiselle: Willem de Kooning's 'Black Friday.'" *Record of the Art Museum, Princeton University* 50, no. 1 (1991).
"The Year's Best 1955." *ArtNews* 54, no. 9 (January 1956).
Young, Edward. *Edward Young's Conjectures on Original Composition.* London: Forgotten Books, 2012.
Zeffirelli, Franco. "Turned-On Architecture: De Kooning and Friends." *Horizon,* June 1981.
Zinn, Howard. *A People's History of the United States.* New York: Harper Perennial Modern Classics, 2005.
Zucker, Steven Ezekiel. "Art in Dark Times: Abstract Expressionism, Hannah Arendt and the 'Natality' of Freedom." PhD dissertation, City University of New York, 1997.

Index

Aach, Doris, 167, 472, 638, 684
Abbott, Mary, 8, 263–64, 413, 438, 452, 556, 570, 632, 646, 659, 691, 859n48; attacked by Pollock, 534; Bill de Kooning's relationship with, 263–64, 452
Abel, Lionel, 116, 446, 491–92
Abstract Expressionism: *ArtNews* as house organ for, 290; end of era, 653–55, 679–80, 854n105; first doctoral thesis on, 196; Graham's *System and Dialectics of Art* as aesthetic theory forming basis of, 68–70, 83, 85, 169; naming of movement, 230, 293; pervasive in student work from colleges and universities around the country, 520; Sartre's *Existentialism and Humanism* as philosophical footing for, 169–70; women artists sidelined in official history of, xii–xiii, 677. *See also specific artists*
abstraction, abstractionists: advertising art and, 198; as affront to fascism, 98; American Abstract Artists and, 48, 57; avant-garde, inclusion of figurative elements and, 433–34, 481, 487–88, 506–7, 512, 513–14, 541, 561–63, 817n15; deemed subversive, 337, 359; Federal Art Project and, 44; Graham's *Systems and Dialectics of Art* and, 68–70; Hess's *Abstract Painting* and, 419, 423–25, 431–32, 438, 447, 449, 467, 801nn15–16; Johns's directness as challenge to, 655; postwar consumer society rejected by, 272
Abstract Painting and Sculpture in America (New York, 1951), 350–51
ACA Gallery, New York, 42

Action Painting, Rosenberg's theory of, 447–50
Addams, Jane, 143
Adler, Stella, 320, 321, 633
Admiral, Virginia, 50, 121
Advancing American Art (traveling exhibition, 1946), 197–98, 202, 656
Agee, James, 504
Agostini, Peter, 191, 200, 333
Albee, Edward, 9; *Who's Afraid of Virginia Woolf*, 511
Albers, Anni, 219
Albers, Josef, 98, 219–20, 443, 746n9; *Homage to the Square*, 332
Albers, Patricia, 398
Albright Art Gallery (now Albright-Knox Art Gallery), Buffalo, 669
Alcopley, Lewin, 13–15, 206, 218, 264, 280, 282, 331, 411, 519, 797n64
Aldrich, Larry, 626
Alfieri, Bruno, 304–5, 780n51
Allen, Don, 651–52
Alloway, Lawrence, 655
Altamira, Spain, cave at, 519, 664, 667
American Abstract Artists, 48, 57, 81–82, 98, 121
American Artists' Congress, 40, 45, 51
American Artists School, New York, 60, 61, 67
American Museum of Natural History, New York, 190
American Painting Today (New York, 1950), 291, 294–96, 305, 351
Americans 1942: 18 Artists from 9 States (New York, 1942), 441
Anfam, David, 196
Annie Get Your Gun, 183

INDEX

anti-communism: *Advancing American Art* exhibition (1946) and, 197–98; allegations against military and, 507–8; allegations against State Department and, 301–2; backlash against gays and, 765n94; Bodenheim murder and, 521; disdain for avant-garde art and, 197–98, 272, 442; in early 1950s, 300–303, 452, 453, 491, 493–94, 817n17; film industry and, 198–99, 762n23; gays as target of, 765n94; House Un-American Activities Committee and, 47–48, 198–99, 233–34, 391, 735n16; in immediate years after Second World War, 196–99; labor unions and, 493–94; *Life*'s photographs of so-called communist sympathizers and, 272; McCarthy and, 198, 301–2, 389, 442, 453, 493, 507–8

Apollinaire, Guillaume, 425, 746n63

Arb, Renée, 213; "They're Painting Their Way," 209

Architectural Forum, 231

Arendt, Hannah, 111, 148, 150, 395

Armory Show (New York, 1913), 14, 36

Armstrong, Louis, 333, 654–55

Artaud, Antonin, 234–35, 380; "The Duty," 235

Art Digest, 93, 257, 323, 417, 418, 422, 480, 494, 496

L'Arte Moderna, 297, 304–5

Art Institute of Chicago, 363, 380, 443, 553; Bill de Kooning's *Excavation* bought by, 443; Mitchell as student in School of, 369, 376–77; Mitchell at Oxbow outpost of, 368–69, 371–72, 378

Art International, 712

Artists: Man and Wife (New York, 1949), 273–74, 275, 279

Artists Equity Association, 323

Artists for Victory (New York, 1942), 108

Artists' Theatre, 490–92, 537, 815n92

Artists Union, 28–29, 34, 45, 50, 60, 61, 215, 229–30, 294, 732n74–75; Communist Party and, 45, 48; Krasner's departure from, 48, 80; reductions in Federal Art Project funding protested by, 31–32, 33, 42; rise of fascism and, 40–41

art market: art-as-investment mindset and, 551, 595, 596; auctions and, 677; change in U.S. tax code (1955) and, 550–51; "cult of personality" around dealers and, 676–77; death of artist and, 620–21; for female vs. male artists, xiii, 552–54, 677; in late 1950s, 676–77, 854nn5–7; novelty value and, 676, 865n5; raised prices for American artists (1957), 621–23

ArtNews, 111, 137, 209–12, 213, 229, 267, 273, 303, 377, 417, 418, 422, 437, 451, 464, 476, 496, 516, 527, 538, 541, 566, 567, 625, 639, 673, 692, 708, 712, 775n53, 827n45; "Abstract Expressionism has died!" declared in, 655; Elaine de Kooning's articles and reviews for, 210–12, 213, 257, 268, 279, 290, 303, 349–50, 412, 562–63, 595–96, 640, 775n53; Goodnough's "Pollock Paints a Picture," 408–9; Hartford's wife reviewed by, 596; Hess's editorship of, 449; as house organ for Abstract Expressionists, 290; Johns's *Target with Four Faces* on cover of, 653, 654; O'Hara writing for, 513, 514, 627; Porter hired by, 350; Rosenberg's "The American Action Painters," 448–49, 466–68; Sandler's "Mitchell Paints a Picture," 623–25, 650

Art of This Century, New York, 118–19, 120–21, 153, 763n49; juried Spring Salon exhibition (1943), 118, 120–21; Pollock's shows at, 129–30, 171, 175, 176, 178, 214

Arts, 584, 639, 687

Arts & Architecture, 488, 496

Art Students League, New York, 85, 86, 166, 288, 392, 405, 452

Ashbery, John, 337, 428–29, 429, 541, 557, 561, 570, 670, 797n60, 802n42; on O'Hara, 425, 427, 430, 431

Ash Can School, 730n22

Asher, Elise, 11

Ashton, Dore, 36, 41, 46, 195, 229, 392, 602, 632, 638–39, 686, 708; "Grand Girls" of, 553, 659, 660

Atlantic Monthly, 198, 234

atom bomb, 150, 197, 200, 301; dropped on Hiroshima and Nagasaki (1945), 135–37, 149, 150, 154, 193, 301, 373
Auden, W. H., 319, 428, 486
Auerbach, Ellen "Pit," 103–4
Auerbach, Walter, 103–4
"avant-garde," usage of term in relation to artists, 749n16
Avery, Milton, 247

Bacon, Francis, 210–11
Bair, Deirdre, 569, 603
Baker, Elizabeth, 677
Baker, Russell, 88
Balanchine, George, 102, 103, 111, 277
Barneby, Rupert, 344
Barnet, Will, 166, 405
Baro, Gene, 715
Barr, Alfred, Jr., 30, 120–21, 196, 209, 259, 278, 295, 436–37, 550, 561, 655, 657, 658, 689; Abstract Expressionists endorsed by, 351; acquisitions and, 483, 489, 513, 515, 547, 621; exhibitions mounted by, 35–36, 440–41, 601, 733n9; Hartigan accused of wooing, 519–20; Hitler's rise to power and, 79–80; Miller's contributions compared to those of, 439, 440, 442–43; naming of Abstract Expressionism and, 230, 293; Ninth Street Show and, 12–13, 413; opening of Museum of Modern Art and, 25–26, 547; physical appearance and demeanor of, 26
Barreau, Gisèle, 710
Barrett, William, 42, 165, 193, 254, 335, 394–95, 655
Bashkirtsev, Marie, 241
Bass, Bob, 105, 745n32
Batista, Fulgencia, 391
Baudelaire, Charles, 98, 282, 334, 390, 430, 524, 608
Bauhaus, 79, 219, 746n9
Baziotes, Bill, 121, 214, 335, 473
Baziotes, Ethel, 93, 94
Beach, Sylvia, 383
Beacon, The, 318–19
Beaton, Cecil, 343, 658
Beats, 655; Mitchell's friendships with, 652–53; origin of phrase "Beat Generation" and, 652; published by Rosset, 651–52
Beauvoir, Simone de, 165, 199, 326, 381, 383, 447; *The Second Sex*, 246, 555, 560
Beckett, Samuel, 90, 210, 416, 536, 652, 676, 708; Mitchell's relationship with, 569–70, 603, 651, 696; *Waiting for Godot*, 497–98
Bell, Leland, 105
Bell-Opticon, Kline's use of, 333–34, 784n58
Bellow, Saul, 604, 730n37
Benedict, Ruth, 733n10
Bennington College: Frankenthaler as student at, 316–21; Pollock retrospective at (1952), 464–66; show of works by alumnae of, 321–22, 407
Benton, Thomas Hart, 85, 86, 87, 95, 153–54
Berberova, Nina, 635
Berenson, Bernard, 527
Berkowitz, Ida, 478
Berkowitz, Leon, 478
Berkson, Bill, 132, 185
Berlin, Irving, 183
Bernstein, Leonard, 570
Biala (Janice Tworkov Brustlein), 5, 104, 134, 311, 857n7
Billy, Hélène de, 571–72, 573
Bing, Alexander, 514–15
Black Mountain College, Ashville, N.C., 264, 332; de Koonings' summer at, 217–22, 225, 226–27, 228, 253, 268, 682; Greenberg and Frankenthaler at, 323, 326, 327–29, 478
Blaine, Nell, 104–6, 209, 264, 265, 266, 284, 345, 429, 435–36, 499, 509, 625, 647, 787n53
Blake, Peter, 306
Bliss, Lizzie P., 25
Block, Irving, 28–29
Bluhm, Norman, 569, 622, 649, 663
Blumberg, Ernestine. *See* Lassaw, Ernestine Blumberg
Bocour, Leonard, 77, 92, 689
Bodenheim, Max, 521
Bonheur, Rosa, 64, 186
Bonnard, Pierre, 92, 267, 633
Bonwit Teller, New York, 110, 141

Borregaard, Nancy, 380
Bourgeois, Louise, 525
Bowles, Jane, 104, 509; *In the Summer House*, 520; *Two Serious Ladies*, 104
Bowles, Paul, 104
Bowman, Dick, 368–70, 373, 391
Brach, Paul, 212, 391–92, 393, 422, 495, 536, 539, 602, 634, 649
Braider, Carol and Don, 534, 535, 539, 540, 541–42, 543, 646, 843n74
Brainard, Joe, 522
Brancusi, Constantin, 25, 645
Brando, Marlon, 272; Frankenthaler's date with, 319–20; Pollock compared to, 271, 276, 600
Braque, Georges, 46, 84, 92, 114, 119, 206, 214, 267
Breton, André, 109, 110, 116, 120, 193, 341, 431, 746n63
Brodovitch, Alexey, 298, 299
Brodsky, Joseph, 526
Brooks, James, 156–57, 166, 178, 271, 272, 298, 305, 461, 474, 543, 600, 782n85
Brossard, Chandler, 584
Brown, Earl, 396
Brown, Margaret, 478
Browne, Byron, 48, 50
Browne, Rosalind, 48
Browner, Juliet (later Mrs. Man Ray), 59, 67
Broyard, Anatole, 165, 190, 337–38
Brustlein, Biala. *See* Biala
Brustlein, Daniel (Alain), 104, 134
Buck, Pearl S., 143, 181; *Of Men and Women*, 471
Bultman, Fritz, 34, 50, 96, 97, 183, 207, 258–59
Bultman, Jeanne, 183
Bunce, Lou, 84
Burckhardt, Edith Schloss. *See* Schloss, Edith
Burckhardt, Rudy, 15, 66, 67, 102–3, 104, 132, 140, 220, 267, 282, 290, 332, 409, 483–84, 509, 593, 742n9; Mitchell photographed for *ArtNews* by, 624–25
Burke, Edmund, 388
Burke, Kenneth, 319
Burliuk, David, 84
Burroughs, William, 416, 652

Busa, Peter, 68, 71, 86, 93, 94, 96, 121
Busbey, Fred E., 198
Butler, Barbara, 712

Café Society Downtown, New York, 61, 82, 105
Cage, John, 13, 111, 201, 251, 252, 397, 604, 683, 797n60; Artists' Theatre and, 491, 492; at Black Mountain College, 218, 220, 221, 222, 226, 328; the Club and, 280, 281, 395–96; *Concerto for Piano and Orchestra*, 683; visual artists' responses to work of, 395, 396
Cage, Xenia, 221
Cahill, Holger "Eddie," 30, 68, 439, 440, 618
Cajori, Charles, 205, 729n35
Calas, Nico, 422
Calder, Alexander, 120
Campbell, Joseph, 395, 405
Campbell, Lawrence, 62, 405, 692
Camus, Albert, xvi, 77, 331
Canaday, John, 680
Carles, Mercedes. *See* Matter, Mercedes
Carmean, E.A., Jr., 479, 661, 665
Carnegie Institute, Pittsburgh, 553, 582, 669
Carnegie International (Pittsburgh, 1955), 553, 566, 574, 827nn44–45
Caro, Anthony, 714
Carone, Nick, 37, 351, 543, 579–80, 613, 633; Stable Gallery and, 472–73, 474
Cassatt, Mary, 39, 729n10
Castelli, Ileana, 444, 648
Castelli, Leo, 422, 452, 463–64, 657, 662, 776n66; on the Club, 281; *Collector's Annual* (1957), 649; "cult of personality" and, 677; de Koonings' summer with (1952), 444–46; East Hampton home of, 444–46, 463, 494, 495, 536, 645; Elaine de Kooning's portrait of, 445; gallery opened by, 621, 648–49, 654, 662, 677; introduced to New York art scene, 213–14; Johns's emergence and, 653–54; Ninth Street Show and, 7, 8, 11–12, 13, 400, 411, 413, 602, 728n26; as scout for Janis, 444–45, 602, 648, 806n39
Cavallon, Giorgio, 282, 514, 680, 731n69

896 INDEX

Cedar Bar, New York, 5, 11, 13, 288–90, 291, 322, 324, 330, 350, 353, 390, 393, 394, 396, 397, 398, 413, 425, 429, 440, 452, 463, 476, 491–92, 634, 652, 673, 777n40; abandoned by regulars, 587–88, 619; Kligman's first encounter with Pollock at, 598–99; Pollock's death and, 617, 619
censorship, 475, 664–65
Central Art Supply, New York, 200
Cézanne, Paul, 25, 26, 46, 66, 98, 174, 204, 206, 282, 330, 359, 373, 434, 609, 656, 677, 707
Chagall, Marc, 519
Chamber of Commerce, 494
Charpentier, Constance Marie, 418
Cherry, Herman, 12, 385, 449, 618, 619, 683
Chicago and Vicinity Annual (1947), 377
Chicago Herald-American, 361, 390–91
Chicago Sun-Times, 361
Chinlund, Stephen, 685, 705
Christian Science Monitor, 715
Chrysler, Walter, 622
Chrysler Corporation, 319
Churchill, Winston, 197
CIA, 197
civil rights movement, 588, 702
Claudel, Camille, 483–84
the Club, New York, 6, 11, 13, 289, 291, 301, 324, 328, 330, 334, 340, 353, 390, 393, 413, 422, 437, 438, 440, 452, 476, 491, 509, 541, 566, 654, 673, 739n35; achievements of, 281; anti-communist witch hunts and, 280–81; avant-garde composers at, 395–97; change in location and leadership of, 588; drinking and dancing at, 432–33; figuration in abstract painting debated at, 561, 563; founding of, 279–83, 775n58; Friday night lectures at, 394–95, 413, 648, 796n53; Hess's *Abstract Painting* discussed at, 423–25, 431–32; name of, 279, 775n54; parties at, 282–83; poets invited to, 425, 431; presidential election of 1952 and, 452–53, 493; Thomas's visits to, 503; women made members of, 776n66
Coates, Robert, 230

Cocteau, Jean, 101, 102, 357, 746n63
Cold War, 196–200, 233–35, 357, 507, 656, 779n29; artists' estrangement from larger world during, 199–200, 234–35; Korean war and, 302–3, 329, 338, 715, 780n38; Sputnik II and, 654. *See also* anti-communism
Coleman, Ornette, 636
College Art Association (CAA), 30
Collins, Pat, 84
Color Field School, 460, 697, 706, 709, 714; Frankenthaler's *Mountains and Sea* and, 459–60, 478–79
Coltrane, John, 635–36
Commentary, 250–51, 458, 697
communism: the Club's political views and, 280–81; Mitchell's conversion to, 359, 375; New York artists' disillusionment with, 169. *See also* anti-communism
Communist Party, 28, 34, 41, 45, 60, 63, 198, 345, 375, 447; Rosset's Prague trip and, 384–85
Congress, U.S., 301, 493, 654; disdain for modern art among members of, 197–98, 272; Federal Art Project and, 30, 31–32, 42; House Un-American Activities Committee, 47–48, 198–99, 233–34, 391, 735n16
Connolly, Jean, 175, 328
Contemporary Jewish Record, 176
Contemporary Music School, New York, 396
Cooper, Douglas, 609
Cooper Union, New York, 22, 23
Copland, Aaron, 103
Corcoran Gallery, Washington, D.C., 708, 715
Cornell, Joseph, 12, 473, 474
Corso, Gregory, 652, 689
Cubism, 25, 35, 36, 39, 70, 81, 85, 165, 196, 247, 291, 320, 321, 379, 424, 460, 496; Krasner's collages and, 583–84; Mitchell's experimentation with, 359
Cubism and Abstract Art (New York, 1936), 36
"culture," significance of word, 733n10
Cunningham, Merce, 13, 220, 222, 395–96, 492, 494

INDEX

Daily Worker, 375
Dalí, Salvador, 110, 119
Daniels, Minna, 133, 139
David, Jacques-Louis, 418, 801n38
Davis, Miles, 387, 499, 585, 636
Davis, Stuart, 40, 59, 83, 84, 230; Elaine de Kooning's article on, 138–39
Dean, James, 588, 600
Dearborn, Cholly, 361, 390–91
Degas, Edgar, 39, 551, 570
"degenerate" art, Nazi campaign against, 46–47, 71, 78, 79, 119
Dehner, Dorothy, 465
de Kooning, Cornelia (Willem's mother), 331, 517, 530, 531–32, 560
de Kooning, Elaine (née Fried), xiv, 11, 42, 49, 55–68, 69, 71–74, 97, 100–104, 113, 118, 129, 137–43, 149, 157–61, 167, 168, 182–88, 208–16, 235, 257, 260, 277, 278–79, 285, 286, 292, 299–300, 302, 324, 330, 332–33, 335, 336, 343, 351, 397, 398, 413, 414, 424, 429, 437, 439, 443–52, 467, 473, 481, 488, 491, 499, 507, 511–13, 534, 543, 553, 560–63, 574–75, 587, 593–96, 621–22, 628, 632, 633, 639–41, 657, 659, 663, 674, 675, 677, 680–84, 702–5, 708, 738n49, 749n15, 771n13, 827n44, 842n32; abstract paintings first seen by, 57; Albers visited at Yale by, 332; on alcohol's impact on art scene, 262; *Artists: Man and Wife* (1949) and, 273, 274; on artists' ambivalence toward fame, 278; art training of, 55, 56–57, 60, 61, 63, 66–68, 220–22, 260, 267, 681; Bill's artistic influence on, 63, 66–67, 68, 184–85, 260; Bill's first encounter with, 58–59, 60; Bill's liaisons with other women and, 227, 263–64, 473–74, 516–17, 542, 574, 605, 639, 680; Bill's monthly checks to, 638, 683, 846n30; as Bill's promoter, 130–31, 194, 209, 212, 215, 451; Bill's relationship with, 71–73, 74, 122–26, 133–35, 137, 139, 141–43, 145, 157–59, 160–61, 183–85, 186–88, 189, 227, 259, 262–64, 450–52, 511, 516–17, 542, 560–61, 574, 593–94, 685, 703–4; Bill's *Women* paintings and, 331, 446, 482–83; on Bing, 514–15; birth of Bill's daughter and, 593–94, 595; at Black Mountain College, 217–22, 225, 226–27, 253, 268; Bullfight Series, 681–82; at Castelli's summer home in East Hampton, 444–46, 463, 494–95; Chelsea bohemian scene and, 100–104; the Club and, 280, 281, 394, 431, 776n66; "cocktail portraits," 594; in college, 55, 56; commitment question and, 660; death of, 704–5; defense plant job of, 100, 140; Denby's mentorship of, 131–33, 138, 139, 681, 683, 772n36; on development of younger artists, 510; drinking of, 637, 682, 703; financial support from family, 60–61; financial worries of, 140, 158, 187, 208–9, 213, 217–18, 412, 484, 530, 680; First and Second Generation designations and, 344–46; at Five Spot, 635–37; Frankenthaler's possible influence on, 595; on GI Bill's impact on arts, 228; Gorky found American girlfriend by, 127–28; Gorky's influence on, 67–68, 101; Gorky's suicide and, 222, 225; Gorky tribute written by, 349–50; Gyroscope Men series, 186, 512, 516, 759n29; "Hans Hofmann Paints a Picture," 290; *Harold Rosenberg*, 594–96; Hartigan's first meeting with, 254; at Henzler's New Jersey farm, 446; Hess's sexual relationship with, 209–10, 450; homes and domestic life of, 122–23, 127, 134–35, 140, 141–42, 159, 160, 182–84, 186–87, 560, 594, 683–84, 702; independence of, 112, 133, 137, 181, 184–85, 681; intellectual kinship of Rosenberg, Hess and, 447–51; jealousy within art scene toward, 451; *Juarez*, 682; Kennedy portrait by, 330, 703; Kline's black-and-whites and, 333, 334, 784n58, 785n66; Krasner's relationship with, 213–14, 215–16, 771n17; Lassaws' wedding and, 140–41; liaisons of, with men other than Bill, 158–59, 182, 191, 227, 262–63, 412, 450–52; life apart from Bill built by, 561; Mallary's affair with, 682; Mitchell's first solo show attended by, 422–23; Mitchell's relationship with, 473–74, 563, 704;

money given away by, 680, 683; motherhood decision and, 187–88, 189, 288, 516–17, 574; mother-in-law's visit and, 517, 530, 531–32, 560; mother's influence on, 63–65; mugging incident and, 637–38; never satisfied with her paintings, 194; in New Mexico (1958–59), 640–41, 674, 680–82; new role for women struck by, 189–91, 681; Ninth Street Show and, 6, 9, 11, 12; nontraditional materials used by, 200; other people's work bought by ("inadvertent collection"), 683, 856n68; painting process of, 183, 184; physical appearance and demeanor of, 56–57, 61, 62, 100, 122, 131, 215, 259, 561; Pollock's death and, 617, 618; Pollocks first visited in Springs by (1948), 214, 215; portrait painting and artistic breakthroughs of, 137–38, 184–86, 330, 594–96; as principal player in New York art scene, 289–91; Provincetown sojourn (1949), 264, 267–70; Provincetown trip with Hardy (1945), 158–59, 182, 262; Red House summer (1954), 530–32, 534–35, 540–41, 542; Resnick's romantic relationship with, 61–62, 71, 72, 159, 160; returned to New York (1959), 680, 682–84, 685–86; Rivers and, 266, 437; Rothko's possible influence on, 595–96; self-portraiture of, 184, 200; social dissidence and, 685–86, 702; on social life in mid-1950s, 509; social realism and, 63, 67; solo shows at Stable, 512–13, 515–16, 594, 639–40; sports figure iconography and, 268, 511–12, 516; Stable Annual and, 472; "Subject: What, How, or Who?", 562–63; as teacher, 681, 702, 710, 861n15; Tibor de Nagy show (1957), 641, 643; Wall Street buildings sketched by, 103; war's impact on, 106, 109; wedding of, 122, 133–35; window displays for Bonwit Teller made by, 141; "Women Fill the Art Schools, Men Do the Painting," 269, 270; women in action as interest of, 144; women's role in art and society researched by, 268–69, 270; working habits of, 445; writing career of, 138–39, 209–12, 213, 217, 257, 266, 268, 279, 290, 303, 332, 349–50, 409, 412, 443, 484, 516, 561–63, 567, 595–96, 640, 775n53

de Kooning, Johanna Lisbeth "Lisa" (Willem's daughter), 618, 639, 674, 685; birth of, 593–94, 595, 596

de Kooning, Leendert (Willem's father), 187

de Kooning, Willem "Bill," xiv, 28, 42, 51, 57, 63, 66–68, 69, 92, 97, 101, 107, 110, 113, 114, 118, 128, 129, 138, 157–61, 168, 191, 200, 203, 230, 255, 257, 259, 265, 273, 277, 278, 293, 326, 330, 334, 336, 343, 349, 351, 393, 397, 409, 423, 424, 431, 438, 443–47, 458, 463, 467, 473, 475, 480–84, 488, 495, 509, 514, 534, 543, 548, 551, 587, 598, 621, 632, 649, 657, 673–74, 690, 708, 742n13, 749n15, 857n90; Abbott's affair with, 263–64; arrival in America, 59; Art Institute of Chicago's purchase of work by, 443; *Asheville*, 222, 253; *Attic*, 388; black-and-white abstractions (1948), 212–13, 253, 331–32; at Black Mountain College, 217–22, 225, 226, 228, 253, 682; Castelli's introduction to, 213–14; at Castelli's summer home in East Hampton, 444–46, 463, 494; Chelsea bohemian scene and, 100, 102–4; the Club and, 279, 281, 282; competitive with artist friends, 208; drinking of, 269–70, 331, 511, 596, 638–39, 685, 703–4, 846n31; East Tenth Street studio of, 443–44, 594; education and intellectual experience of, 124; Egan shows, 194, 208, 209, 212–13, 217, 226, 253, 412, 444–45; Elaine's artistic development and, 63, 66–67, 68, 184–85; Elaine's death and, 704–5; Elaine's family first met by, 72–73; Elaine's first encounter with, 58–59, 60; Elaine's intervention and, 703–4; Elaine's promotion of, 130–31, 194, 215, 451; Elaine's relationship with, 71–73, 74, 122–26, 133–35, 137, 139, 141–43, 145, 157–59, 160–61, 183–84, 186–88, 189, 227, 259, 262–64, 450–52, 511,

516–17, 542, 560–61, 574, 593–94, 685, 703–4; Elaine's romantic liaisons and, 158, 159, 182, 191, 262–63, 450–52; *Excavation*, 331–32, 351, 389, 443; as father, 516–17, 573–74, 593–94, 596, 639, 685; financial worries of, 140, 158, 187, 208–9, 213, 217–18, 412, 443, 484, 530; First Generation designation and, 344–45; Fourth Avenue studio of, 184, 227–28, 443; frustrated with his painting in 1940s, 139–40; gallery representation changed by, 444–45; Giacometti's 1948 show and, 210, 211; Gorky's suicide and, 222, 225, 226; Graham's *French and American Painting* show and, 84, 92–93; Hartigan's admiration for, 405; Hartigan's relationship with, 241, 253–54; as Hartigan's teacher, 241, 260–61; on Hiroshima bombing, 149; homes and domestic life of, 122–23, 127, 134–35, 140, 141–42, 159, 160, 182–84, 186–87, 831; Janis shows, 444–45, 480–84, 563, 596, 684–85, 767n17; Joan Ward's relationship with, 452, 511, 516–17, 573–74, 593–94, 605, 639, 846n30; Kligman's affair with, 639, 674, 680; Kline's friendship with, 192–93; Krasner's completion of mural started by, 43; Krasner's supposed cessation of painting and, 176, 177; Lassaws' wedding and, 140–41; lecture at Subjects of the Artist given by, 259–60, 772nn36 and 39; Léger and, 81; liaisons with women other than Elaine, 227, 263–64, 451–52, 473–74, 516–17, 542, 573–74, 594, 639; *Marilyn*, 813n13; Marisol's relationship with, 510–11; Mitchell influenced by, 388, 389; mother's visit and, 517, 530, 531–32, 560; mural-sized format adopted by, 332; never satisfied with his paintings, 194; Ninth Street Show and, 7, 8, 11, 12, 411; nontraditional materials used by, 200; Pollock's death and, 617, 618, 638; Pollocks visited in Springs, 176, 177, 214, 215; *Portrait of a Man*, 93; prices for works by, 551; Provincetown sojourn of (1949), 269–70; Red House summer (1954), 530–32, 534, 535, 540, 542, 543; speculation about subjects of his *Women* paintings, 331, 445–46, 483; teaching at Yale, 332–33; titles given works by, 212; Venice Biennale and, 441–42, 528; violence in character of, 139, 639; wedding of, 122, 133–35; *Woman I*, 330–31, 389, 482, 483, 596; *Woman II*, 483; *Woman on a Bicycle*, 445–46; *Women* paintings, 331, 416, 445–46, 480–84, 483, 563, 574, 596; in year after Pollock's death, 638–39

Delacroix, Eugène, 142, 405, 434
de Laszlo, Violet, 99
Denby, Edwin, 57, 102–3, 104, 110, 111, 123, 125, 131–33, 139, 140, 158, 159, 225, 265, 483, 509, 749n9; as ballet critic, 131, 132–33, 139; as Elaine de Kooning's mentor, 131–33, 138, 139, 681, 683, 772n36
De Niro, Robert, Sr., 50, 787n53
Depression, Great, 6, 8, 26–29, 40, 42, 57, 73, 101, 107, 146, 228, 242, 313, 345, 507, 730n41; cultural flowering during, 36–37; end of, in America, 87, 88; Federal Art Project and, 29–32, 439, 440; Krasner's financial worries during, 26–27; political radicalism and, 27–29
Derain, André, 84, 92, 570
Dewey, John, xv, 331, 796n53, 806n62
Dewey, Thomas, 233
Diaz, Nini, 59, 84
Dickinson, Edwin, 279
Didion, Joan, 485
Dietrich, Marlene, 135
Diliberto, Sam, 619
Dior, Christian, 190, 472
Dix, Dorothy, 144
Documenta II (Kassel, Germany, 1959), 688
Dogwood Maiden, The (movie), 267
Dondero, George A., 272
Downs, Cile, 535, 581, 616
Downtown Gallery, New York, 84
Dragon, Ted, 277, 295, 306, 307, 308, 615, 630
Dreier, Katherine, 25
Drexler, Rosalyn, 850n57
Drexler, Sherman, 684

Galerie Dubourg, Paris, 709
DuBrul, Stephen, Jr., 715
Duchamp, Marcel, 25, 110, 119, 120–21, 129, 130, 204, 341
Valentine Dudensing Gallery, New York, 51, 70, 98
Duhrssen, Betsy (Egan), 227, 262
Duthuit, Georges and Marguerite Matisse, 695–96
Dyn, 176
Dzubas, Friedel, 7, 418, 457–59, 519, 582, 595, 649; Frankenthaler's *Mountains and Sea* and, 459, 460, 461; Nazi Germany fled by, 457–58

Earhart, Amelia, 143, 144, 145
Eben Demarest Trust, 214
Eccatani, Larry, 55, 56
Eckert, Loly. *See* Rosset, Loly Eckert
Ederle, Gertrude, 143
Edgar, Natalie, 191, 280, 281, 392, 431, 450, 451, 629, 787n36
Egan, Charles, 191, 215, 280, 324, 330, 334, 340, 346, 432, 474, 478, 514; background and early career of, 191; Bill de Kooning's change in representation and, 444–45; Bill de Kooning's 1948 show at, 194, 208, 209, 212–13, 217, 226, 253; Bill de Kooning's 1951 show at, 412; Elaine de Kooning's affair with, 191, 227, 262–63, 412, 451; Kline's shows at, 333, 334, 515, 785n66; marriage of, 227, 262
Einstein, Albert, 40, 111, 272
Eisenhower, Dwight D., 135, 453, 493, 654
Eliot, T. S., 438; "Four Quartets," 581–82
Ellison, Ralph, 319, 604, 619, 688
Emmerich, André, 670, 687, 690, 697
Ernst, Max, 46, 119, 120, 273
Esquire, 623, 677
Evergreen Review, 651–52
Everson Museum of Art, Syracuse, N.Y., 709
Existentialism, 69, 126, 168–70, 210, 394, 395, 756n26
Existentialism and Humanism (Sartre), 169–70
Expressionism, 35, 36, 85

Fagan, Ruth, 521
Fantastic Art: Dada and Surrealism (New York, 1936), 36
Farber, Manny, 108, 334
fascism: abstract art as affront to, 98; rise of, in 1930s, 39–42, 165; in U.S. during Second World War, 107
Faulkner, William, 126, 212, 493
Faure, Patricia, 496–97
Fauvism, 36, 70
FBI, 198, 302
Federal Art Project, 6, 29–34, 49, 50, 52, 56, 58, 73, 84, 180, 230, 281, 345, 439, 440, 447, 465, 731n69, 743n25; creation of, 29; Krasner's assignments for, 29–31, 33–34, 43, 44, 81, 94, 673; protests against reduction in funding for, 31–32, 33, 42; regionalism promoted by, 62–63; supplanted by new War Services Department, 94
Federal Writers' Project, 33
Feeley, Paul, 317–18, 322, 466, 584–85
Feldman, Morty, 13, 251, 281, 395, 396–97, 485, 491, 604–5, 608
Felsenthal, Francine, 378, 415, 416
feminist movement, 701, 702, 715, 861n5
Ferber, Herbert, 483
Fermi, Enrico, 111
Ferren, John, 6, 166, 195, 196, 333, 728n26
15 Americans (New York, 1952), 441–43, 483
Fifteen Unknowns (New York, 1950), 335, 348
Fifty Years of American Art (Paris, 1955), 568
Figaro, Le, 677–78
"Final Solution," 91–92
Finch, Earl, 615
Fine, Perle, 280, 473, 728n16
First Generation, 6, 191, 194, 277, 283, 284, 285–86, 292, 334–35; differences between Second Generation and, 344–46; Second Generation disparaged by, 417–18. *See also specific artists*
Fitzgerald, Adele, 385
Fitzgerald, F. Scott, 406, 407
Fitzsimmons, James, 480, 488, 495, 496
Five Spot, New York, 588, 619, 629, 635–37, 652, 659, 673, 697

Fizdale, Bobby, 495, 500
Flack, Audrey, 598
Flam, Jack, 662
Folder, 541, 561
Fondren, Hal, 474
Ford, Ford Madox, 104
Ford, Hermine, 538
Fortune, 110, 551, 552, 596, 774n20
Forum '49 (Provincetown, Mass., 1949), 269, 270, 271–72
Four Americans (New York, 1956), 602–3
Xavier Fourcade Gallery, New York, 710
Galerie Jean Fournier, Paris, 709
Fourteen Under Thirty-Six (New York, 1950), 292
Fourth International Art Exhibition (Japan, 1957), 628
Fox, Connie, 681, 703–4
Fox, Ruth, 351–52
Francis, Sam, 569, 706
Franco, Francisco, 41, 42, 52, 664–65
Frankenthaler, Alfred (father), 312, 313–14, 317, 319, 322–23, 362; death of, 314, 315, 317
Frankenthaler, Gloria (later Gloria Ross, sister), 314–15, 418, 525, 526, 663
Frankenthaler, Helen, xiv, xvi, 9–10, 13, 311–30, 334–38, 406–8, 414, 423, 433, 457–61, 473, 474–79, 518–20, 521, 522–29, 543, 553, 582, 628, 641–45, 654, 661–70, 680, 687–89, 708, 712–16, 776n66, 809n67, 827n44; art training of, 316, 317–18, 326–27; assortment of techniques employed by, 662; *Beach*, 335, 348; at Bennington, 316–21; Bennington alumnae show organized by, 321–22, 407; Bill de Kooning's impact on, 331, 332; Black Mountain College visited by, 327–29; *Blue Territory*, 643; car trip to Pollock retrospective at Bennington (1952), 464–66; in Castelli's 1957 *Collector's Annual*, 649; childhood of, 312–16, 362; commitment question and, 660; in community of artists, 407–8; Corcoran Gallery show (1975), 715; dating after breakup with Greenberg, 584, 585, 587; death of, 716; dinner parties of, 688; on distance between artist and society, 518–19; *East and Beyond*, 714; eccentric behavior of, 313; *Eden*, 642; Emmerich's representation of, 670, 687, 690; European sojourn of (1954), 526, 527–28; European sojourn of (1956), 604, 609, 610, 611–12; *The Facade*, 553, 582, 827n45; family background of, 312–13; first solo show (1951), 348, 416, 417–18; forced to depart Spain (1958), 664–65, 666–67; Friedel's friendship with, 457–59; *Giralda*, 642; at girls' weekend in East Hampton (1957), 643–44; Gorky's influence on, 349; Greenberg's relationship with, 9–10, 311, 322–25, 327–29, 353, 479, 522–29, 576–78, 584–87, 641, 642, 648, 696–97; Greenberg's tirade about women artists and, 418, 419; *Guiding Red*, 714; Hartigan's relationship with, 437, 519–20, 524, 643–44; as Hofmann's student, 326–27, 644; Hofmanns visited by (1957), 644–45; *Hôtel Quai du Voltaire* (1956), 611–12, 839n30; *Jacob's Ladder*, 642, 688; Jewish Museum retrospective (1960), 712; in Kootz's *Fifteen Unknowns* (1950), 335, 348; Krasner's s relationship with, 406, 609; mass media interest in, 623, 625, 713; master's degree in art history considered by, 321; mother's suicide and, 525–26, 528, 576; Motherwell's influence ascribed to work of, 687, 857n7; Motherwell's relationship with, 645, 647–48, 649, 661–62, 663–64, 665, 667–68, 688–89, 712, 714; *Mountains and Sea*, 459–60, 474–75, 476, 478–79, 714; move to West End Avenue, 522–23, 821n41; museum collection first entered by work of, 553; New York art world entered by, 329–30, 334, 335–36; *New York Bamboo*, 642; New York homes and studios of, 320–21, 330, 353, 406–7, 408, 419–20, 457, 519, 522–23, 663, 668, 713; 1920s-themed party of, 406, 407; Ninth Street Show and, 9–10, 12, 411; Nova Scotia holiday of Greenberg and (1952), 457; O'Hara's relationship with, 643; personality of, 317, 319–20, 662, 714; physical appearance and demeanor of, 322, 715; Pollack's relationship with,

645, 649, 847n79; Pollock's death and, 611–12, 839n30; Pollock's influence on, 311–12, 337, 349, 409–10, 411, 458, 459; Pollock's visited by (1951), 409–11; as printmaker, 714, 716; *Provincetown Bay*, 327, 332; rebelliousness of, 318; Rivers's relationship with, 476–78, 519, 523; *Scene with Nude*, 475–76; Second Generation designation and, 344–45; *Seven Types of Ambiguity*, 642; Spanish sojourn of (1953), 479, 519; Springs rental of (1955), 576, 578, 582–83; staining technique of, 459–61, 474–76, 595, 697; stepdaughters' relationship with, 667–68, 712–13; tapestry commission, 604; as teacher, 647, 714; Tibor de Nagy Gallery left by, 668–70; Tibor de Nagy shows, 348, 416, 417–18, 475–78, 523, 525, 529, 553, 593, 643, 663, 669, 687; *Trojan Gates*, 604; troubled schoolgirl years of, 315–16; *Vanguard 1955* and, 587; wedding and honeymoon of, 661, 663, 664–67, 687; *Weeping Crabapple*, 716; *Woman on a Horse*, 323; in year after Pollock's death, 641–45

Frankenthaler, Marjorie (later Marjorie Iseman, sister), 314, 418, 525, 526, 663, 821n41

Frankenthaler, Martha Lowenstein (mother), 312–16, 317, 321, 322, 323, 418, 523; Holocaust and, 315–16; suicide of, 525–26, 528, 576

Helen Frankenthaler Foundation, 716

Frankfurter, Alfred, 209, 449

Freas, Jean, 465, 466

Freilicher, Jane, 56, 213, 262, 264, 265–66, 267, 345, 427, 429, 430, 431, 435–36, 473, 483, 484, 488, 491, 522, 541, 561, 712; Hazan's marriage to, 556–57, 641, 642, 644, 660

Frelinghuysen, Suzy, 81

French and American Painting (New York, 1942), 84, 92–94, 98

French & Company, 697, 698–99

Freud, Sigmund, 40, 97, 102, 555, 746n12, 753n60

Fried, Charles (Elaine's father), 63–64, 65, 72–73, 127, 134

Fried, Charles (Elaine's nephew), 64, 187, 683

Fried, Clay (Elaine's nephew), 101, 124, 512, 574, 594, 684, 702

Fried, Conrad (Elaine's brother), 63, 64, 65, 72, 122, 127, 182–83, 184, 443, 532, 703; Elaine and Bill's domestic life and, 182–83, 184; Elaine's portraits of, 184

Fried, Edrita, 399, 566–67, 650, 864n106

Fried, Elaine. *See* de Kooning, Elaine

Fried, Guy (Elaine's nephew), 65, 593

Fried, Marie Catherine (Elaine's mother), 63–65, 72, 73, 101; culture imparted to her children by, 64–65; Elaine's wedding boycotted by, 133; grotesque in Bill's painting modeled on, 127; institutionalized for failing to conform to societal norms, 65, 101, 450; mutual dislike of Bill de Kooning and, 73

Fried, Marjorie (sister). *See* Luyckx, Marjorie Fried

Fried, Paula (Elaine's sister-in-law), 683

Fried, Peter (Elaine's brother), 63, 72, 125, 127, 134, 594

Friedan, Betty, 182; *The Feminine Mystique*, 554–55, 753n60, 812n11, 850n47, 851n92

Friedman, B. H. "Bob," 420, 584, 619, 620, 644–45, 647, 671, 672–73, 712

Fromm, Erich, 111, 319, 335, 759n30

Fry, Varian, 79–80, 120, 299

Fuchs, Klaus, 301

Fuller, Buckminster, 220–21, 226, 714

Futurism, 35, 36, 165, 424

Gallatin, A. E., Collection, 25

Gallery 67, New York, 154

García Lorca, Federico, 42, 269

Gasparo, Oronzo Vito, 113

Gauguin, Paul, 26, 46, 80, 98, 424, 551

Geist, Sidney, 609

Geller, Rubin, 658

Genauer, Emily, 257, 602

Gentileschi, Artemisia, 186

German Expressionism, 25, 70

Germany, Nazi, 46–48, 71, 73, 219, 299, 399, 457, 458; American supporters of, 48; artists and intellectuals driven from their countries by, 110–13; defeat of,

INDEX

126, 145; European countries invaded and occupied by, 52, 77–78, 87–88, 89, 91, 119–20; immigration to U.S. from, 47–48; modern art targeted for destruction in, 46–47, 71, 78, 79, 119; violence against Jews perpetrated by, 47, 79, 91–92, 107–8, 136, 146, 315–16

Gershoy, Eugenie, 32

Giacometti, Alberto, 179, 210–11, 213, 565, 603, 649, 651

GI Bill, 166, 227, 228, 255, 275, 285, 345, 393, 426, 452

Gide, André, 357, 558

Gilot, Françoise, 273

Gimpel, Charles, 582, 604, 609

Gimpel, Kay, 582, 604, 609, 610

Gimpel, Peter, 582

Gimpel Fils Gallery, London, 582, 833n55

Ginsberg, Allen, 416; *Howl*, 588, 652, 835n125

Glueck, Grace, 714

Godard, Jean-Luc, 679

Goebbels, Joseph, 46, 47

Gold, Arthur, 500

Goldberg, Mike (Michael Stuart), 10–11, 392–93, 411, 484, 539, 540, 569, 602, 628, 653, 674, 693–94, 696; Beats and, 652; change in financial fortunes of, 622; at Five Spot, 635–37; Hartigan's affair with, 568; Lang's relationship with, 536, 537–38, 567; marriage proposal of, 622; Mitchell's letters to, 536, 537, 563, 564–65, 568, 570, 573; Mitchell's relationship with, 393, 397, 398–400, 415, 495–96, 536, 538, 566–67, 568, 602–3, 622, 651, 693–94; O'Hara's relationship with, 536, 538, 567, 694; Rosset's check forged by, 398–400; Southgate's marriage to, 693–94

Gooch, Brad, 630

Goodman, Paul, 136, 328, 340, 418, 796n53

Goodman, Sam, 686

Goodnough, Bob, 329, 345, 407, 411, 419, 422, 437, 473, 602, 787n53; "Pollock Paints a Picture," 408–9

Goossen, Eugene, 665

Gorey, Edward St. John "Ted," 427, 564

Gorky, Agnes Magruder "Mougouch" (wife), 128, 129, 149, 194, 214, 223, 224

Gorky, Arshile, 28, 32–33, 57, 63, 69, 73, 83, 92, 112, 113, 114, 127–29, 154, 183, 208, 229, 303, 351, 439, 463, 547, 657, 742n13; Armenian genocide survived by, 28, 52; cancer diagnosis and, 194, 214, 222; in car accident with Levy, 223–24; critical praise achieved by, 193, 194; as de Koonings' close companion, 28, 59, 67–68, 101, 127–28, 129, 193, 194, 225, 349–50; *Diary of a Seducer*, 193, 349; difficult life of, 68, 193–94, 222–24; Hirshhorn's purchase of works by, 128–29; *How My Mother's Embroidered Apron Unfolds in My Life*, 349; Levy's gallery and, 180, 193, 377, 766n60; marriage and children of, 127–28, 149, 194, 214, 223, 224; Mitchell influenced by, 377, 390; Picasso's *Guernica* and, 51, 193; Pollock's fight with, 214–15; in Provincetown, 49; Second World War and, 52, 225; studio fire and, 194, 214, 222; suicide of, 222–25, 226, 654; Surrealists and, 180, 193, 222, 223, 225; talking about art, 35, 67–68, 222; Venice Biennale and, 303, 441–42; Whitney retrospective (1951), 349–50, 352

Gottlieb, Adolph, 247, 293, 335, 515, 663

Goya, Francisco de, 51, 89, 433, 506

Graham, John, 28, 59, 68–70, 72, 87, 101, 109, 113, 114, 331, 444, 611, 739n26, 742n13; *French and American Painting* show organized by (1942), 84, 92–94, 98; influence on Pollock and Krasner, 87, 97–98; Krasner's chance meeting with, 83–84; Saturday teas at Greenwich Avenue studio of, 97; *System and Dialectics of Art*, 68–70, 83, 85, 169, 739n21

Graham, Martha, 137

Robert Graham Gallery, New York, 702

Great Neck Adult Education, 647

Greenberg, Clement, 81, 83, 139, 172, 173–76, 193, 201, 211, 213, 215, 230, 232, 258, 264, 277, 278, 285, 292, 305, 334, 335, 337, 350, 378–79, 397, 411,

414, 449, 458, 561, 582, 595, 598, 604, 606, 610, 643, 654, 657, 669, 670, 673, 696–700, 729n6, 730n37, 771n17; "American-Type Painting," 577, 580; artists grown tired of pronouncements of, 524, 577, 586; "Avant-Garde and Kitsch," 174–75; background and early career of, 173–76; at Black Mountain College, 326, 327–29, 478; car trip to Pollock retrospective at Bennington (1952), 464–66; Castelli introduced to artists by, 213–14; "Clem's stable" and, 329, 411, 438; competitive with other art critics, 419; Elaine de Kooning's rebuttal of, 562; first marriage of, 783n19; Frankenthaler accompanied on European trip by (1954), 527, 528; Frankenthaler introduced to artists and art ideas by, 311, 326, 329, 407; Frankenthaler's mother's suicide and, 525, 526, 576; Frankenthaler's *Mountains and Sea* and, 460, 478–79; Frankenthaler's new paramours attacked by, 584, 585, 587; Frankenthaler's 1953 trip to Europe without, 479, 519; Frankenthaler's relationship with, 9–10, 311, 322–25, 327–29, 353, 479, 522–29, 576–78, 584–87, 641, 642, 648, 696–97; gatherings in Bank Street apartment of, 336; Hartigan's work disparaged by, 437–38, 519–20, 523–24; Hofmann's influence on, 38, 174, 757n6; incorporation of figurative imagery decried by, 562, 817n15; Krasner's collages and, 583, 584; Krasner's confidence undermined by mean-spirited comments from, 410, 417, 580–81, 699; Krasner's Little Images and, 178; Krasner's post-Pollock dealings with, 697–700, 701; Krasner's relationship with, 172, 173, 174, 175, 176, 178, 580–81, 696–700, 701; military service of, 175; Mitchell dropped by gallery at behest of, 709; Myers's gallery and, 338, 344, 346, 348; Myers's relationship with, 338, 341, 344; New York artists described and promoted by, 201–2, 228–29; Ninth Street Show and, 13, 15; Nova Scotia holiday of Frankenthaler and (1952), 457; Pollock reviewed by, 175–76, 206, 420, 758n17; Pollock's death and, 611, 615–17, 618, 697; Pollock's drinking and, 461, 533; Pollocks' estrangement from, 466, 467, 577, 580–81, 586, 699; Pollocks' marital issues and, 580–81, 606; Pollock's relationship with, 172, 173, 175–76, 336; postwar Jewish-American society and, 324–25; Rivers's work admired by, 266–67; San Remo frequented by, 324, 337–38; Springs visits of (1955), 580–81, 582–83, 597; Van Horne's relationship with, 587, 585–86; women artists disparaged by, 418–19, 471, 524–25

Greenberg, Danny (son), 328, 414, 577, 783n19

Greenberg, Edwina "Toady" (first wife), 783n19

Greenberg, Jenny Van Horne (second wife). *See* Van Horne, Jenny

Greenberg, Martin (brother), 578

Greer, Germaine, 184–85, 274, 734n27

Gres Gallery, Washington, D.C., 690, 858n34

Grillo, John, 267

Grippe, Florence, 220

Grippe, Peter, 220

Grosman, Tatyana, 111

Grosser, Maurice, 101, 104

Grove Press, 416, 572, 674, 815n92; Beat writers published by, 652

Gruen, John, 290, 450, 452, 497

Guernica, Spain, bombing of (1937), 41, 45; Picasso's painting of, 51, 70, 79, 85, 98, 193, 208, 736n37

Guest, Barbara, 453, 526, 527, 576, 582, 593, 604, 609, 643, 663, 665, 666, 667, 678, 679, 688, 691, 807n98

Guggenheim, Peggy, 118–21, 139, 153, 154, 170, 171, 179, 295, 340, 341, 609; flight from Europe to New York, 119–20; Frankenthaler's impressions of, 528; Krasner's attempt to visit (1956), 610; physical appearance of, 120, 179; Pollock show in Venice organized by

(1950), 295, 297, 300, 304; Pollock's monthly stipend and contractual arrangement with, 129–30, 153, 156, 179, 203, 207, 214, 610; Pollocks' mural commission and, 129–30, 750n51, 754n37; Pollocks' wedding and, 156; returned to Europe after war, 176, 178, 342, 344; returned to New York (1959), 676, 689; Spring Salon of 1943 and, 118, 120–21, 129. *See also* Art of This Century, New York
Guggenheim, Solomon, 70, 71, 676
Solomon R. Guggenheim Museum, New York, 70, 676, 805n23
Guild Hall, East Hampton, N.Y., 502; *Ten East Hampton Abstractionists*, 295, 298–99
Guston, Musa, 483–84, 626–27, 644, 663
Guston, Philip, 86, 166, 200, 281, 446, 473, 483–84, 623, 626–27, 644, 657, 708, 731n69, 857n90

Hackett, Malcolm, 365, 389
Hague, Raoul, 67
Halberstam, David, 234, 768n53
Hale, Robert Beverly, 291
Halper, Nathan, 551
Hamill, Pete, 10
Hammerstein, Oscar: "The Last Time I Saw Paris," 78
Hansen, Waldemar, 341
Harburg, E. Y. "Yip," 37
Hardy, Bill, 158, 159
Hare, David, 130, 222, 227, 230, 263, 278, 287, 335, 441, 570, 680; Tenth Street studio of, rented by Frankenthaler, 407, 457
Harper's Jr. Bazaar, 209
Harrison, Helen, 512, 640
Harrison, Wallace, 320, 461, 782n85
Hartford, Huntington, 596
Hartigan, Grace, xiv, 10, 125, 241–54, 259, 284, 286–88, 299, 319, 338, 346–48, 397, 398, 407, 408, 414, 418, 431, 432, 473, 476, 491, 496, 505–7, 513–15, 542, 544, 547–50, 556–59, 574, 585, 586, 618, 663, 688, 689–91, 705–8, 776n6, 810n41, 842n33; as artist's model, 276, 288, 405–6; art training of, 241, 243–45, 247, 252–54, 260–61, 275–76, 288; author's 1990 conversation with, xi–xiv; *Autumn Harvest*, 705; in Baltimore, 705, 706, 707–8, 863n61; Bill de Kooning's relationship with, 241, 253–54; Bill de Kooning's women paintings and, 480, 483; Bing as benefactor of, 514–15; childhood of, 241–42; *City Life*, 601, 623, 657, 837n79; commitment question and, 660; death of, 708; Elaine de Kooning's first meeting with, 254; *Essex Market*, 657; Essex Street loft of, 284, 286–88, 347, 434, 435, 484, 601, 659, 691, 705, 707; European travels of (1958), 678, 679; fashion transformation of, 626–27; figurative elements in abstractions by, 433–34, 437–38, 481, 487–88, 506–7, 512, 513–14, 541, 561, 655; financial worries of, 412, 414, 434, 484, 485, 690, 707; first marriage of (Jachens), 242–43, 246, 248; first solo show of (1951), 347–48, 352–53, 405, 416; Fitzsimmons's affair with, 480, 495; at Five Spot, 635–37; Frankenthaler's relationship with, 437, 519–20, 524, 643–44; Frankenthaler's wedding shower hosted by, 663; gender discrimination and, 245, 457; "George Hartigan" as *nom de brosse* of, 347–48, 352–53, 487, 515, 549; Goldberg's affair with, 568; *Grand Street Brides*, 506–7, 510, 552; *Greek Girl*, 513, 548; Greenberg's disparagement of, 437–38, 519–20, 523–24; Greenberg's tirade about women artists and, 418, 419, 524; *Hartigan and Rivers with O'Hara* (New York, 1959), 692; *Interior, 'The Creeks,'* 630, 657; intimidated by Greenwich Village scene, 250–51; *Ireland*, 689; *I Remember Lascaux*, 707; Keene's relationship with, 646–47, 659, 666, 678, 690–92, 694, 705; *Kindergarten Chats*, 347; *The King Is Dead*, 346–47; landscape painting attempted by, 495; literary influences on, 486–87; Long Island life and, 645–46, 659, 690–91, 705, 708; *Masquerade*, 553; *The Massacre*, 423, 434, 437; mass media interest in, 623, 625, 626, 627, 658–59; Mexican sojourn of (1949), 255, 260, 261, 275–76, 557;

Mexico trip of (1955), 557; Mitchell's uneasy relationship with, 423, 498, 570–71, 694; *Montauk Highway*, 645; *Months and Moons*, 346; Muse's relationship with, 245, 246–48; Museum of Modern Art's first purchase of work by, 489, 498; Myers's recruitment of, 346–48; Myers's relationship with, 669, 705; *New American Painting* (1958) and, 657, 658, 664, 666, 678; new breed of American woman embodied by, 549; New Year's Eve party thrown by (1954), 550; New York homes and studios of, 284, 286–87, 414, 419, 434 (*see also* Hartigan, Grace—Essex Street loft of); New York scene left by, 690–92; Ninth Street Show and, 9, 10, 12, 411, 412; O'Hara shooting incident and, 521, 522; O'Hara's relationship with, 10, 433, 435–36, 437, 438, 485–87, 495, 549–50, 557, 626–27, 628, 629–30, 678–79, 691–92, 705, 706–7, 804n125; old master studies of, 433, 434; *On Orchard Street*, 657; *Oranges* series, 486–87, 514, 692; *Peonies and Hydrangeas*, 552–53; *The Persian Jacket*, 489, 498; physical appearance and demeanor of, 250–51, 256, 284, 347; "Place Paintings," 645–46; plagued by doubt and confusion, 498; Pollock's influence on, 247, 252–53; on Pollock's influence on younger artists, 841n115; Pop and, 601, 837n80; *Portrait of W*, 434, 437; pregnancy and childbearing of, 243, 244; presidential election of 1952 and, 453; Price's marriage to, 705, 706, 707; at Red House party (1954), 541; relationships and commitments untenable for, 557–59; *River Bathers*, 489, 513, 515, 547–48, 568, 657; Rivers's overdose and, 499–500; Rivers's relationship with, 495, 505–6, 513, 556, 557, 692; Second Generation designation and, 344–45; second marriage of (Jackson), 255, 261, 276, 284; *Secuda Esa Bruja*, 275, 292; *Show Case*, 837n80; Silver's relationship with, 434–35, 495, 548, 557–59; *Six Square*, 412; son of, given to his paternal grandparents to raise, 10, 241, 248–49, 288, 412, 549; Spaventa's affair with, 629, 646–47; Studio 35 and, 276–77; success and celebrity as experienced by, 547–49, 556, 634, 658–60, 678–79, 689; suicide attempt of, 707; summering in Springs (1957), 628–29, 630, 632, 643–44, 645–47; *Talent 1950* and, 292, 335; as teacher at Maryland Institute College of Art, xi, 707; Tibor de Nagy shows, 347–48, 352–53, 405, 416, 434, 437–38, 487–89, 513–14, 552–53, 690, 858n34; *12 Americans* (1956) and, 601–2; *Venus and Adonis*, 475; vibrant New York life encountered by, 249–51; Virgin Islands trip of (1958), 659; wartime employment at aeronautics plant, 244, 245; *The Widow*, 437; *Woman*, 419

Hartigan and Rivers with O'Hara (New York, 1959), 692

Hartley, Marsden, 197

Erick Hawkins Dance Company, 714

Hayter, Stanley William, 111, 259, 392

Hazan, Joe, 499, 556–57; Freilicher's marriage to, 641, 642, 644, 660

Hearst Press, 197

Hefner, Hugh, 475

Heidegger, Martin, 14, 170, 446

Heijenoort, Jean Louis van, 395

Heisenberg, Werner, 38

Heller, Ben, 612

Heller, Edwin, 232–33, 257, 296, 300, 351, 768n44

Henzler, Fritz, 446

Herman, Evans, 415

Hess, Audrey, 452

Hess, Tom, 9, 111, 137, 138, 209–10, 229, 259, 279, 280, 286, 290, 409, 412, 421, 438, 484, 516, 566, 567, 596, 617, 621, 650, 655, 657, 676, 747n20, 763nn27 and 49, 775n53, 827n44; *Abstract Painting*, 419, 423–25, 431–32, 438, 447, 449, 467, 801nn15–16; on Bill de Kooning's paintings, 213, 480, 482; as both "writers' editor" and "artists' editor," 449; Elaine de Kooning hired to write art reviews by, 210, 211, 212, 213; Elaine de Kooning's sexual relationship with, 209–10, 450;

exhibition of younger artists curated by (1955), 567, 574; intellectual kinship of Elaine de Kooning, Rosenberg and, 448–51; on Mitchell, 863n83; Porter hired by, 350; Rosenberg's "The American Action Painters" and, 448–49
"hip" and "hep," origin and usages of words, 770n77
Hirohito, Emperor, 149
Hiroshima bombing (1945), 135–37, 149, 150, 154, 193, 301, 373
Hirshhorn, Joseph, 128–29
Hiss, Alger, 234
Hitler, Adolf, 39–40, 41, 42, 48, 71, 73, 90, 147, 168, 299, 457, 458; culture of kitsch and, 174; defeat of, 126, 145; European countries invaded and occupied by, 52, 77–78, 87–88, 89, 91, 119–20; Nazi prisoners of war and, 175; persecution of intellectuals and artists throughout Europe and, 39, 40, 46–47, 110–13, 119; violence against Jews perpetrated, 47, 79, 91–92, 107–8, 136, 146, 315–16
Hofmann, Hans, 12, 48, 69, 70, 82, 105, 153, 154, 166, 174, 196, 202, 219, 251, 258, 259, 270, 273, 279, 330, 331, 335, 388, 393, 443, 473, 474, 509, 561, 655–56, 727n2, 733n93, 734n24, 741n38, 746n9, 757n6; closing of his school and return to painting, 656; Elaine de Kooning as student of, 267–68, 681; Elaine de Kooning's article on, 290; Frankenthaler as student of, 326–27, 644; Frankenthaler's 1957 visit to, 644–45; Freilicher and Rivers as students of, 265–66, 267; Friday evening lectures of, 39–40, 174, 394; Hartigan as model for, 276, 288; idiosyncratic "English" spoken by, 21–22, 37, 268; Krasner as student of, 21–22, 34, 37–39, 44, 80–81, 113–14, 729n6; Mitchell as student of, 378; Mondrian's influence and, 81; Paris trip of (1949), 267; Pollock's first meeting with, 96; Provincetown summer school of, 48–49, 264, 267–68, 326–27; stranded in America during 1930s, 39; teaching methods of, 37–38, 267–68, 773n43

Hofmann, Miz, 39, 81, 153, 644
Holiday, Billie, 105, 636–37
Holmes, John Clellon, 652
Holocaust, 40, 47, 91–92, 107–8, 136, 146, 150, 165, 315–16, 614, 742n8; camp survivors living in New York and, 199–200; Jewish-American society's responses to, 324–25
Holty, Carl, 80
Holtzman, Harry, 41
Hook, Sidney, 335
Hoover, J. Edgar, 198, 494
Hopper, Edward, 197
Horizon, 176, 201–2, 654
House Beautiful, 183
House Un-American Activities Committee, 47–48, 198–99, 233–34, 391, 735n16
How to Be a Woman (L. K. Frank and M. Frank), 481–82
Hubble Space Telescope, 206
Hunter, Edys, 579
Hunter, Sam, 579
Hurricane Carol (1954), 542–43
Hurricane Diane (1955), 582
hydrogen bomb, 301, 680, 779nn28–29
Hyman, Stanley Edgar, 319

immigration, U.S. policy on, 47–48
Impressionism, 35, 36, 70, 801n15
Institute of Contemporary Art, Boston, 229
Intersubjectives, The (New York, 1949), 273, 279
Introduction to Modern American Painting (Paris, 1947), 201
"Irascibles," *Life* article on, 348–49
Iseman, Ellen M. (Frankenthaler's niece), 715
Iseman, Fred (Frankenthaler's nephew), 312, 313, 314, 316, 318, 525, 821n41
Iseman, Marjorie (Frankenthaler's sister), 314, 418, 525, 526, 663, 821n41

Jachens, Bob (Hartigan's first husband), 242–44, 246, 248, 514, 618
Jachens, Jeffrey (Hartigan's son), 244, 245, 247, 248, 347, 414, 514, 618; given to his

paternal grandparents to raise, 10, 241, 248–49, 288, 412, 549; moved to California with his father, 618

Jackson, Harry (Hartigan's second husband), 251–52, 253, 255, 256, 284, 338, 345, 407, 408, 437, 519, 770n77, 771nn13 and 15, 787n53; Mexican sojourn of (1949), 255, 260, 261, 275–76, 557; neurological condition of, 257, 275

Jackson, Martha, and Martha Jackson Gallery, New York, 538, 602, 622, 706, 707; Braiders' gallery pillaged by, 541–42; Krasner's 1958 show at, 672–73, 696; Oldsmobile swapped for Pollock painting by, 542

Jackson, Shirley, 319

Jacquette, Yvonne, 827n50

Jaffe, Shirley, 358, 568–69, 573

Jane Street Gallery, New York, 266

Janis, Sidney, and Sidney Janis Gallery, New York, 13, 541, 616, 623; *Abstract and Surrealist Art in America*, 114–15; *Artists: Man and Wife*, 273–74, 275, 279; Bill de Kooning represented by, 444–45, 480–84, 563, 596, 684–85, 806n39; Castelli as scout for, 444–45, 602, 648, 806n39; *Four Americans* (1956), 602–3; Krasner and Pollock's first dealings with, 114–15; Krasner's withdrawal of Pollock's work from, 671–72, 697, 701, 853n85; Pollock represented by, 462–63, 464, 503, 533, 586, 620–21; women artists not usually shown by, 471, 602

Jeffcoat, Hollis, 710

Jenkins, Esther, 608–9, 611

Jenkins, Paul, 439, 568, 578–79, 600–601, 608–9, 610, 663, 693; Mitchell's apartment swap with, 651, 693; Pollock's death and, 611, 612, 616, 618

Jewish Museum, New York, 643, 653, 712

Jews: blamed by Americans for conflict, 107; Nazis' violence against, 47, 79, 91–92, 107–8, 136, 146, 315–16. *See also* Holocaust

Johns, Jasper, 653–55, 656, 680; American flag series, 655; *Target with Four Faces*, 653–55

Johnson, Joyce, 556, 851n92

Johnson, Ray, 220, 225

Johnson, Samuel, 194

Jonas, Robert, 56–57

Jones, James, 135, 151

Josephson, Barney, 82

Joyce, James, 101, 165, 383, 426, 486

Jumble Shop, New York, 35, 40, 59, 104, 113, 349

Jung, Carl, 95, 97, 217, 764n56

Kadish, Barbara, 152, 154, 155

Kadish, Reuben, 86, 95, 152, 153, 154, 155, 166, 618

Kaldis, Aristodimos, 83, 166, 217, 280, 432, 445, 683–84, 704; Elaine de Kooning's portraits of, 330, 594

Kandinsky, Vassily, 21, 35, 70–71, 114, 119, 196, 230, 332, 373, 424

Kaprow, Alan, 617

Katzen, Lila, 498

Kazin, Alfred, 146

Keene, Bob, 646–47, 659, 678, 690–92, 694, 705, 708

Keller, George, 139–40

Kelly, Ellsworth, 680

Kennedy, John F., 330, 703

Kerouac, Jack, 387, 416, 652, 698

Kierkegaard, Søren, 126, 168, 331, 451, 510

Kiesler, Frederick, 98, 120, 519

Kiesler, Lillian (née Olinsey), 21, 22, 24, 49, 89, 117–18

King, Rev. Martin Luther, Jr., 588, 702

Kinsey, Alfred: *Sexual Behavior in the Human Female*, 475, 554; *Sexual Behavior in the Human Male*, 215–16, 765n94

Kirkland, Jack, 28

"kitsch," Greenberg's aesthetic theory and, 174

Klee, Paul, 119

Klein, Ralph, 577, 581, 598

Kligman, Ruth, 598–600, 604, 605, 606, 607, 612–15, 616; Bill de Kooning's affair with, 639, 674, 680; in car accident with Pollock, 613–15, 674; Krasner sued by, 674; Pollock's first encounter with, 599–600

Kline, Elizabeth Vincent Parsons (Franz's wife), 192, 333, 534, 688

Kline, Franz, 191–93, 281, 292, 335, 345, 393, 432, 446, 473, 478, 483–84, 514, 515, 543, 551, 593, 596, 598, 633, 637, 657, 659, 703; Bill de Kooning's friendship with, 192–93; black-and-white abstractions, 192, 333–34, 388, 784n58; early years of, 192; financial worries of, 484; first solo show of, 333, 334, 785n66; Mitchell's first meeting with, 388–89; Monroe's visit and, 633, 634; Ninth Street Show and, 6, 8, 11, 12, 411, 728n26; nontraditional materials used by, 200; personality of, 389; physical appearance of, 192–93; Pollock's death and, 611–12, 617, 638; Red House summer (1954) and, 530, 531, 532, 534, 535, 540

Klonsky, Milton, 250–51, 337–38

Koch, Kenneth, 427, 428, 429, 436, 491, 522, 550, 557, 570, 674

Koestler, Arthur, 335

Kootz, Jane, 483

Kootz, Samuel M. "Sam," and Samuel Kootz Gallery, New York, 112–13, 156, 171, 273, 296, 346, 541, 552, 604, 648; *Fifteen Unknowns* (1950), 335, 348; *The Intersubjectives* (1949), 273, 279; *Talent, 1950*, 292, 329, 335, 778n64; women deemed "too much trouble" to show by, 180

Korean war, 302–3, 329, 338, 715, 780n38

Kramer, Hilton, 460, 654

Krasner, Joseph (Lee's father), 23, 153, 155

Krasner, Lee, xiv, 9, 11, 21–52, 59, 60, 61, 63, 69, 80–85, 92–99, 101, 113–18, 137, 139, 143–44, 152–57, 161, 166, 170–72, 176–79, 203, 230–33, 255, 294–300, 303–8, 336, 338, 341, 343, 406, 408, 409, 414, 418, 461–67, 473, 500–503, 543, 553, 578–82, 604–21, 628, 657, 661, 708, 776n66; *Abstraction* (1942), 92, 93, 94; *Artists: Man and Wife* (1949) and, 273–74, 275; art training of, 21–22, 23, 26, 34, 37–39, 44, 80–81, 86, 113–14; Bennington trip of (1952), 464–66; Betty Parsons's dismissal of, 463, 464, 473, 501, 502, 853n85; Betty Parsons show (1951), 409, 410, 414, 416–17, 420, 463; *Birth*, 631; breakthroughs in paintings of, 80–81, 82–83, 118, 172, 177–78, 274–75, 296, 409, 410; *Burning Candles*, 597; calligraphy as interest of, 178; collages, 501–2, 583–84, 597, 598, 631, 698, 816n66; commitment question and, 660; *Composition*, 114; death of, 702; debut as professional artist, 42; dream analysis and, 581–82, 598; driving license of, 533; "Earth Green" series, 631, 673, 698; Elaine de Kooning's relationship with, 213–14, 215–16, 771n17; *Embrace*, 631; European sojourn of (1956), 604, 605–12; as executor of Jackson's estate, 619, 620–21, 671–72, 697, 699, 701, 853n85; family and childhood of, 22; father's death and, 153, 155; Federal Art Project and, 29–32, 33–34, 42, 43, 44, 49, 50, 83, 94, 673; financial worries of, 26–27, 42, 49, 207–8, 214, 462, 620; First Generation designation and, 344–45; first woman to have retrospective at Museum of Modern Art, 702; Frankenthaler's relationship with, 406, 609; *The Gate*, 698–99; on gender discrimination, 457; Graham's first meeting with, 83; Graham's *French and American Painting* show and, 84, 92–94; Graham's relationship with, 97–98; Greenberg's estrangement from, over his denigrations of Jackson, 466, 467, 577, 580–81, 586; Greenberg's mean-spirited remarks to, 410, 417, 580–81, 699; Greenberg's 1955 visit to, 580–81; Greenberg's relationship with, 172, 173, 174, 175, 176, 178, 580–81, 696–700, 701; Guggenheim's relationship with, 118–19, 129–30; Hartigan's first encounter with, 252; as Hofmann's student, 21–22, 34, 37–39, 44, 80–81, 113–14, 729n6; Hurricane Carol (1954) and, 543; ill health of, 534, 535, 543, 579, 580, 609; Jackson's broken ankle and, 535; Jackson's celebrity and, 270, 271–73, 277, 278, 294–95, 299–300; Jackson's death and, 611, 612–13, 616–19, 620–21, 638, 698; Jackson's first drip paintings and, 204–5; Jackson's first

encounters with, 50, 84–85, 87; Jackson's flirtations with other women and, 216, 231, 600, 605, 606, 760n44; as Jackson's promoter and secondary dealer, 117–18, 121, 129–30, 156, 157, 171, 172, 173, 181, 207, 214, 215, 232, 252, 256–57, 258–59, 272, 295, 604, 610; Jackson's promotion of, 409; Jackson's relationship with, 9, 24, 92, 93–99, 113–14, 115, 117–18, 153–54, 155–56, 171–72, 176–77, 188–89, 230–31, 232, 274–75, 295, 351, 416–17, 543, 579–82, 583, 597–98, 605–11, 612, 613; Jackson's resumption of drinking and, 306–8, 350, 351–52, 406, 420, 461–62, 466, 500, 502–3, 579–80, 597; Janis's dealings with, 114–15; Janis's sales after Jackson's death and, 620–21, 671, 853n85; jazz and dancing enjoyed by, 82; Jenkins's 1956 visit to, 600–601; *Junk Dump Fair*, 274; letter protesting Metropolitan Museum's *American Painting Today* show and, 294–95, 305; *Life* article (1949) and, 258–59, 271, 272; *Listen*, 632; Little Image paintings, 178, 200, 231, 274, 296, 334–35, 698; Martha Jackson show (1958), 672–73, 696; Mondrian's relationship with, 81, 82–83, 121, 152–53; mosaic murals, 673, 696; mosaic tables, 177–78, 207, 231–32, 673; motherhood decision and, 188–89, 288; mother's death and, 698; Motherwell's friendship with, 170–71; move to Springs, 152, 154–55, 156–57, 170–72, 176, 500 (*see also* Springs, N.Y., Pollocks' home in); Myers's gallery and, 338, 344, 346; Namuth's photos and movie of Jackson painting and, 300, 304, 305–6, 397; nascent modern art scene in New York and, 24–26; New York apartment rented by (1957), 670; next generation of women artists different from, 181, 344–45, 417–18; "Night Journeys," 698–99; Ninth Street Show and, 9, 12; *Noon*, 178; *Ochre Rhythm*, 409; one-day solo show in East Hampton (1954), 534; Pantuhoff's relationship with, 23–24, 29, 34, 42–43, 48, 49, 50, 80, 92, 231; personality and demeanor of, 24, 216; physical appearance of, 24, 82, 216; political radicalism and, 27–29, 31–32, 33, 34, 48; "Pollock motifs" ascribed to, 673; post-Pollock life of, 630–32, 644–45, 670–74, 696–702; *Prophecy*, 605–6, 613, 631, 673; rise in prices for American artists and, 621; rise of fascism and, 40, 41; Rosenberg's "Action Painters" and, 466–68; rumored to have stopped painting, 117–18, 176–77; Schaefer's show (1948), 231–32; *The Seasons*, 631–32; sexism of postwar years and, 180–81; signing of canvases by, 95, 583, 816n66; Southgate's friendship with, 533–34; Stable show (1955), 583–84, 597; stature of, in New York art scene, 93, 673; subconscious explored by, 598, 605–6; Surrealists' sexism disdained by, 116–17; therapist seen by, 581, 597–98, 832n47; *Three in Two*, 631; *Time*'s disparaging articles and, 299, 303, 304–5; *Untitled* (1951), 409; as War Services Department supervisor, 94, 114; wedding of, 155–56. *See also* Springs, N.Y., Pollocks' home in

Kristallnacht, 47, 108
Kuh, Katharine, 415
Kuhn, Walt, 84
Kunitz, Stanley, 319, 604

labor unions, anti-communist crusaders and, 493–94
Ladies' Home Journal, 143
La Guardia, Fiorello, 73
Lamarr, Hedy, 688
Lang, V. R. "Bunny," 536–38, 567, 629, 693–94; *I, Too, Have Lived in Arcadia*, 538
large paintings: availability of inexpensive Belgian customs house canvas and, 200, 208; Bill de Kooning's move to, 332; dearth of buyers with eighteen-foot walls and, 337, 462; historic responses to, 208; Pollock's first drip paintings and, 203–6, 208
Lassaw, Denise, 141, 267, 674–75
Lassaw, Ernestine Blumberg, 65, 71, 72, 73, 104, 137, 187, 218, 267, 290, 492, 503, 583, 674, 675, 704; arrival and early

years in New York, 61–62, 63; the Club founding and, 279, 280; on Elaine and Bill de Kooning's relationship, 67, 73, 134, 139, 158, 159, 227, 593; wedding of, 140–41

Lassaw, Ibram, 12, 31, 62, 92, 130, 166, 267, 269, 280, 282, 492, 503, 605, 674; wedding of, 140–41

Galerie Lawrence, Paris, 709

Lee, Cynthia, 320

Lee Krasner: Large Paintings (1973), 701

Léger, Fernand, 81–82, 119, 441, 649, 689

Lenya, Lotte, 103

Leonardo da Vinci Art School, New York, 55, 56–57, 60

Leslie, Al, 80, 277, 284–86, 288, 292, 329, 330, 338, 346, 347, 353, 407, 408, 411, 414, 418, 419, 431, 473, 489, 541, 619, 628, 633, 663, 680, 691, 706; art training of, 285; childhood and education of, 284–85; in Club panel on Hess's book, 431, 432; Essex Street loft shared by Hartigan and, 284, 286–87, 347, 412, 434; recruited by Myers for his gallery, 347; Second Generation designation and, 344–45

LeSueur, Joe, 132, 393, 436, 549–50, 567, 626–27, 630, 692; at Five Spot, 635–37

Lever Brothers, 141

Levi-Straus, Levi, 111

Levy, Julien, 180, 193, 223, 224, 377, 766n60

Levy, Muriel, 223

Lewis, Nancy, 317, 318

Lewitin, Landes, 166, 680398

Lieber, Edvard, 183

Life, 230, 244, 305, 319, 323, 413, 596, 627, 687; "Irascibles" photo in (1951), 348–49; nineteen best modern painters in nation named by, 291–92; photographs of so-called communist sympathizers published in, 272; Pollock article in (1949), 258–59, 270, 271–73, 276, 277, 294, 298, 336, 348, 625, 774n5; "The Wife Problem," 554; "Women Artists in Ascendance," 625, 626, 687

Lippold, Richard, 220, 251, 293

Little, John, 34, 130, 166, 258, 306, 628

Little, Josephine, 295, 616

Living Theatre, 13, 491

Look, 197

Lord, James, 213

Louis, Morris, 478–79

Löwenstein, Prince Hubertus zu, 456

Luce, Henry, 303

Lurie, Alison, 537–38

Lurie, Boris, 505, 686

Luyckx, Luke (Elaine de Kooning's nephew), 684

Luyckx, Marjorie Fried (Elaine de Kooning's sister), 63, 72, 97, 122, 127, 134, 187, 212, 332, 443, 531, 703, 704, 705

Lynes, Russell, 440

Macdonald, Dwight, 136–37, 160–61, 751n4

Machiz, Herbert, 490–91

macho artist, image of, xiii, 305; culture at large and, 585; Federal Art Project and, 31; Pollock and, 86, 117; women artists and, 398, 472

MacLeish, Archibald, 89, 151

Mademoiselle, 209, 268, 623, 627, 658

Galerie Maeght, Paris: *Introduction to Modern American Painting* (1947), 201

Magazine of Art, 87, 89

Magritte, René, 119

Malevich, Kazimir, 114

Malina, Judith, 13, 150, 301, 491, 504, 521, 552

Mallary, Robert, 640, 641, 682

Manet, Édouard, 21, 26, 124, 482, 551, 656, 677, 801n15

Mango, Roberto, 346

Mann, Thomas, 499

Mao Tse-tung, 128

Marca-Relli, Anita, 446, 582

Marca-Relli, Conrad, 6, 92, 166, 192, 331, 415, 446, 582, 583, 728n26; as Elaine de Kooning's first teacher, 56; Pollock's death and, 615, 617; Springs artist community and, 463, 534, 535, 543, 576, 578, 674; Stable Gallery and, 472–73, 474, 512

March Gallery, New York, 685–86

Marcuse, Herbert, 111

Margolies, David, 49

Margulis, Max "the Owl," 134
Marin, John, 206
Marisol (Maria Sol Escobar), 509–11, 512, 553, 556, 570, 615, 649; Bill de Kooning's relationship with, 510–11
Mark, Grant, 461–62
Marsh, Reginald, 197
Marshall, George C., 197
Marx, Karl, 33, 40, 97, 746n12
Masson, André, 110, 341
Matisse, Henri, 21, 22, 25, 26, 46, 83, 84, 92, 114, 174, 244–45, 247, 268, 274, 287, 430–31, 441, 498, 551
Pierre Matisse Gallery, New York, 210, 603
Matta Echaurren, Roberto, 116, 213, 223, 224, 341, 570
Matter, Alexander Pundit Nehru, 97
Matter, Herbert, 81, 96–97, 115, 117
Matter, Mercedes (née Carles), 81, 114, 115, 117, 152, 153, 154, 157, 210, 473, 491–92, 587, 627, 708; Bill de Kooning's *Women* paintings and, 445–46, 483; on Cedar Bar, 289; the Club and, 280, 281; family background of, 32; Federal Art Project and, 31, 32, 33; Gorky and, 32–33; Hofmann and, 34, 48; Krasner's break with, 216; Pollock and, 96–97, 189; on Waldorf Cafeteria, 167–68
Matthiessen, Peter, 533, 693
Mattison, Robert Saltonstall, 256, 706
May, Rollo, 150, 166, 760n31
McBride, Henry, 441, 443
McCall's, 827n51
McCarthy, Joe, 198, 301–2, 389, 442, 453, 493, 507–8
McCray, Porter, 657, 665, 678, 688
McMahon, Audrey, 30, 32
McNeil, George, 37, 41, 42, 43, 90, 92, 130, 166, 167, 205, 208, 289, 449, 478
Mead, Margaret, 497, 555, 733n10, 851n93; *Male and Female*, 274, 555, 774n20
Merleau-Ponty, Maurice, 446
Merrill, James, 340, 490, 552
Metropolitan Museum of Art, New York, 26, 64, 67–68, 243, 312, 349, 394, 418, 434, 478, 552, 601, 621, 714, 801n38, 837n79; *American Painting Today* (1950), 291, 294–96, 305, 348, 351; *Artists for Victory* (1942), 108

Metzger, Edith, 613–15, 616
Mexico: Hartigan's sojourn in (1949), 255, 260, 261, 275–76; Mitchell's sojourns in (1945, 1946, and 1950), 371–74, 376, 378, 391
Michaud, Yves, 539
Michelangelo, 64, 86, 268, 746n59
Miller, Arthur, 272, 491, 633, 634
Miller, Dorothy, 12–13, 30, 68, 209, 415, 436–37, 439–43, 489, 515, 618, 628, 648, 678, 689, 708, 733n9, 850n64; *Americans* shows curated by, 441–43, 601–2, 648, 680; *New American Painting* (1958) organized by, 656–57, 658, 664–65, 666–67, 677–78, 679–80; as prime mover on avant-garde American art at Museum of Modern Art, 439–40, 442–43
Millett, Kate, 145, 660
Mills, C. Wright, 149
Mingus, Charles, 636, 688
Miró, Joan, 21, 66, 83, 95, 114, 119, 154, 194, 267, 464, 689
Mitchell, James "Jimmie" (father), 361, 362, 363–64, 367, 368, 369–70, 371, 372, 373, 379, 496, 534, 696, 863n83; health problems of, 563, 564–65, 566, 829n28; Joan's 1954–55 visit with, 563–65, 829n28; Rosset disdained by, 375–76
Mitchell, Joan, xiv, 10–11, 357–94, 397–400, 413, 417, 427, 431, 433, 468–71, 473, 527, 530, 534, 535, 536, 538–40, 542, 553, 561, 563–73, 581, 623–25, 628, 637, 638, 659, 662, 680, 692–96, 708–11, 712, 827n44, 842nn32–33; art training of, 368–69, 376–77, 378, 415; Beats and, 652–53; Beckett's relationship with, 569–70, 603, 651, 696; Bill de Kooning's influence on, 388, 389, 390; *Bonjour Julie*, 710; at Bossy Farm cottage, Springs (1954), 535, 536, 538–40, 542–43; *City Landscape*, 565–66, 602, 695; the Club and, 423, 425, 432, 776n66; commitment question and, 660; Cuba trip of (1950), 391; death of, 711; drinking of, 567, 651, 710; East Hampton first visited by (1951), 414,

415–16; Elaine de Kooning's relationship with, 473–74, 563, 704; excluded from Tibor de Nagy show, 414–15; family visited in Chicago (1954–55), 563–65; figurative influences on, 373; as figure skater, 364, 365, 367, 388; financial resources of, 387; first New York School painters met by, 388–89; first New York solo show of (New Gallery, 1952), 415, 422–23, 496; *Four Americans* (1956) and, 602–3; France made permanent home by, 692; Fried's therapy and, 399, 566–67, 650, 651, 864n106; gallery representation sought by, 387, 414–15; *George Went Swimming at Barnes Hole, but It Got Too Cold*, 624; Goldberg's check forgery and, 398–400; Goldberg's relationship with, 393, 397, 398–400, 415, 495–96, 536, 538, 566–67, 568, 602–3, 622, 651, 693–94; Gorky's influence on, 377, 390; *Grande Vallée* series, 710; growing up in wealthy Chicago family, 361–67, 369; Hartigan's uneasy relationship with, 423, 498, 570–71, 694; *Hemlock*, 602, 863n83; Herman's relationship with, 415; in high school with Rosset, 365–66; Hurricane Carol (1954) and, 542–43; living in France (1948–49), 357–61, 379–84, 385; mass media interest in, 623, 625; Mexican sojourns of (1945, 1946, 1950), 371–74, 376, 378, 391; move to New York (1947), 377–79; New Gallery show (1952), 415, 422–23, 496; New York homes and studios of, 387, 393, 398, 408, 470–71, 560, 602, 650, 692; New York visit of (1959), 693–94; Ninth Street Show and, 9, 10–11, 12, 400, 411, 414, 569; nonobjective abstraction adopted by, 358–60, 378, 390; O'Hara's friendship with, 470, 536, 624; at Oxbow, 368–69, 371–72, 378; Paris homes and studios of, 572, 573, 651; Paris's allure for, 603–4; Paris sojourns of (1955–68), 567–73, 602, 622, 650–53, 692–96, 708–9; party for Freilicher and Hazan thrown by, 641; physical appearance and demeanor of, 368, 397–98, 497, 569, 573; poetry written by, 363; Prague visited by (1948), 384–85; pregnancies and abortions of, 470, 693; as printmaker, 392, 711; radical politics and, 357, 359, 373, 375, 376; remembered landscapes as inspiration for, 565–66; return to New York (1949), 360–61, 385–87; return to New York (1956), 602; Riopelle's daughters and, 710; Riopelle's relationship with, 571–72, 573, 602, 603, 622, 650–51, 653, 689, 693, 694, 695–96, 708, 709, 710; Rose Cottage summer (Three Mile Harbor, 1953), 495–96, 498, 499, 536, 538; Rosset's divorce from, 469–70, 495; Rosset's marriage to, 360–61, 385–86; Rosset's relationship with, 357, 358, 359, 360–61, 370, 373–74, 375–76, 377–78, 379, 384, 391, 393, 397, 398, 399–400, 415–16, 469–70, 495–97, 536, 653; Sandler's article for *ArtNews* on, 623–25, 650; show of early work in Lake Forest, Ill., 390–91; at Smith College, 367–68, 369; solo museum exhibitions of, 709–10; Stable shows, 473–74, 496, 566, 623, 624, 653, 694–95; suicide attempt of, 540; *Sunday, August 12th*, 617; temper and violent outbursts of, 496, 538–39, 696; *Tilleul* series, 710; *Untitled* (1950), 390; *Vanguard 1955* and, 566, 587; Vétheuil home and studio of, 709, 710, 711; *La Vie en Rose*, 710

Mitchell, Marion Strobel (mother), 360, 361, 362–63, 364–65, 371, 375, 376, 379, 383, 386, 391, 398, 429, 536, 537, 566, 567, 790n39, 849n34; Joan's 1954–55 visit with, 563–65

Mitchell, Sally (sister), 360, 361, 362, 363, 364, 365, 372, 864n106

Mitchell, Sue, 264

Joan Mitchell Foundation, 711

Mitelberg, Louis, 380, 381

Mitelberg, Zuka, 358, 363, 371–73, 379, 380, 381, 383, 557, 708, 792n11

MKR's art outlook, 319

modern dance, birth of, 132–33

modernism: in first three decades in twentieth-century America, 24–25, 730n22; postwar, 447

Modern Woman: The Lost Sex (Lundberg and Farnham), 246
Modigliani, Amedeo, 92, 98
Momentum, 382
Mona Lisa's Mustache, 196
Mondrian, Piet, 77, 80, 81–83, 85, 120–21, 130, 206, 424, 649, 744n62; death of, 152–53; jazz and dancing enjoyed by, 81, 82
Monet, Claude, 551, 656, 658, 709
Monk, Thelonious, 635–36
Monroe, Marilyn, 481–82, 633–34, 812–13n13
Morley, Grace McCann, 442
Morris, George L. K., 81, 82
Motherwell, Betty (second wife), 463, 483, 644, 645, 647, 662, 663, 712, 713
Motherwell, Jeannie (daughter), 483, 648, 667–68, 712–13
Motherwell, Lise (daughter), 648, 664, 667–68, 712–13, 714
Motherwell, Maria (first wife), 155, 170, 171, 189, 269, 760n44
Motherwell, Robert, 12, 114, 121, 139, 160, 213, 234, 273, 298, 334, 335, 349, 587, 644–45, 661–68, 670, 687, 688–89, 712–14, 813n27; on artists' mental state after Second World War, 195–96; art school founded by (Subjects of the Artist), 230, 251, 259–60, 263, 269, 276, 292–93, 394, 648, 772n39; Bill de Kooning's women paintings and, 483, 484; drinking of, 662, 664, 714; *Elegies to the Spanish Republic* series, 269, 664–65, 666; first Stable Annual and, 473; forced to depart Spain (1958), 664–65, 666–67; at Forum '49 gathering in Provincetown, 269; Frankenthaler's relationship with, 645, 647–48, 649, 661–62, 663–64, 665, 667–68, 688–89, 712, 714; influence of, ascribed to Frankenthaler's work, 687, 857n7; on large format, 208; left by second wife, 647, 662, 663; *Madrid*, 665; marital problems with first wife, 189, 269; Mexican art and, 116; Museum of Modern Art's exhibition and acquisition of works by, 441, 648, 657; *New American Painting* traveling exhibition and (1958), 657, 658, 664–65, 666–67; personality of, 648, 649, 662, 714; phrase "The New York School" coined by, 269, 773n50; Pollocks' relationship with, 115–16, 170–71, 189, 463; prices for works by, 551; "Reflections on Painting Now," 269; on Rodin's assistant Camille Claudel, 483–84; shows at Kootz Gallery, 180, 292, 648; summer seasons in the Hamptons and, 155, 170–71, 444, 463, 494, 536, 644; Surrealists and, 116, 230, 648; on wartime flight of European artists and intellectuals to New York, 80, 111, 112; wedding and honeymoon of, 661, 663, 664–67; writing about art, 111, 201, 648, 649

Mumford, Lewis, 40
Munch, Edvard, 25
Munro, Eleanor, 554, 712
Murray, Elizabeth, 371
Murrow, Edward R., 107, 108
Muse, Isaac Lane "Ike," 245, 246–48, 251, 253
Musée d'Art Moderne de la Ville de Paris, 568, 688, 710
museum attendance figures, 551–52
Museum of Modern Art, New York, 10, 12–13, 21, 30, 35–36, 47, 79, 95, 119, 128, 171, 179, 209, 210, 247, 249, 345, 397, 424, 541, 552, 654, 692, 701, 708, 715, 733n9, 861n5; *Abstract Painting and Sculpture in America* (1951), 350–51; *Americans 1942: 18 Artists from 9 States* (1942), 441; Bill de Kooning paintings acquired by, 483; *Cubism and Abstract Art* (1936), 36; Davis show (1945), 138–39; European art works stored by, during Second World War, 79; *Fantastic Art: Dada and Surrealism* (1936), 36; *15 Americans* (1952), 441–43, 483; *Fifty Years of American Art* (1955), 568; fire on second floor of (1958), 657–58; *Fourteen Americans* show (1946), 171; Frankenthaler's *Trojan Gates* acquired by, 604; Hartigan paintings acquired by, 489, 498, 513, 515, 547–48, 552–53; inaugural exhibition at West 53rd Street

building (*Art in Our Time*, 1939), 51–52; International Program of, 627, 628, 657, 843n66; Krasner as first woman to have retrospective at, 702; Miller as prime mover on avant-garde American art at, 439–40; Motherwell paintings acquired by, 441, 648; *New American Painting* (1958), 656–57, 658, 664–65, 666–67, 677–78, 679–80; *Nineteen Living Americans* (1929), 440–41; O'Hara's job at, 430–31, 489, 514, 627–28, 657; opening of, 25–26; *Paintings from the Museum Collection* (1954), 547–48; Picasso retrospective (1939), 50; Pollock legacy and, 671; Pollock paintings acquired by, 115, 176, 257, 579, 621, 772n20; Pollock retrospective (1956), 601, 620; Rivers's *Washington Crossing the Delaware* acquired by, 507; Rockefeller's grant to, 843n66; "The Modern Artist Speaks" symposium at (1948), 230; *12 Americans* (1956), 601–2; Van Gogh show (1936), 35–36, 363; Venice Biennale and, 295, 303, 441–42, 528; war-themed exhibitions at, 108; "What Abstract Art Means to Me" symposium (1951), 351; *Young Americans* (1956), 602

Museum of Non-Objective Painting, New York, 70–71, 95, 114, 125

Mussolini, Benito, 40, 126–27

Myers, John Bernard, 13, 113, 223, 322, 338–44, 352, 353, 418, 423, 431, 433, 435–37, 471, 472, 476, 484, 488, 489–92, 514, 515, 519, 523, 528, 549, 553, 557, 561, 576, 585, 617, 639–40, 649, 654–55, 705, 842n33; artists' grumblings about, 668–69, 690; artists recruited by, 346–48, 787n53; Artists' Theatre and, 490–92, 537; at Feeley's Stable opening (1955), 585; Frankenthaler's departure from gallery and, 668–70; gallery founded by, 338, 340, 343–44, 787n35 (*see also* Tibor de Nagy Gallery, New York, *under* Nagy); Miller's bellwether *Americans* shows and, 601; Mitchell's work not liked by, 414–15; physical appearance and demeanor of, 338; as puppeteer, 338–39; 342–43; Surrealist circle and, 341, 342, 343; at Venice Biennale, 668, 669

Nabokov, Vladimir, 335

Nagasaki bombing (1945), 136, 149, 150, 193

Nagy, Tibor de, 342–43, 344, 353, 489–90, 514

Tibor de Nagy Editions, 437

Tibor de Nagy Gallery, New York, 13, 339, 343–44, 411, 471, 499, 549, 787n35; artists recruited for, 346–48; Elaine de Kooning's 1957 show at, 641, 643; Feeley's 1955 show at, 584–85; financial difficulties of, 489–90; founding of, 339, 343–44; Frankenthaler's departure from, 668–70, 690; Frankenthaler's shows at, 348, 416, 417–18, 475–78, 523, 525, 529, 553, 593, 643, 663, 669, 687; *Hartigan and Rivers with O'Hara* (1959), 692; Hartigan's shows at, 347–48, 352–53, 405, 416, 434, 437–38, 487–89, 513–14, 552–53, 690, 858n34; Mitchell excluded from, 414–15; *New Generation* (1951), 407; poetry and theater presented by, 340, 437; Rivers's 1953 show at, 505–6; "Tibor Five" and, 407–8, 416, 476, 519

Tibor Nagy Marionettes, 342–43

Naifeh, Steven, 599–600

Namuth, Carmen, 306

Namuth, Hans, 298–99, 847n79; Bill de Kooning's women paintings and, 446; Pollock filmed at work by, 298–99, 300, 303–4, 305–6, 397; Pollock's fight with, 307–8; wartime experiences of, 299

Nation, 89, 174, 175, 176, 206, 213, 229, 334, 418

National Academy of Design, 23–24, 26, 35, 39, 86

Nature in Abstraction (traveling exhibition, 1958), 662

Nemser, Cindy, 248, 695

Neuberger, Roy, 278, 597

Neumann, Robert von, 369

J. B. Neumann Gallery, New York, 25, 191

Nevelson, Louise, 21, 49, 180, 472, 547, 647

New American Painting (traveling exhibition, 1958), 656–57, 658, 664–65, 666–67, 677–78, 679–80
New Gallery, New York, Mitchell's first New York solo show at (1952), 415, 422–23, 496
New Generation (New York, 1951), 407
Newman, Annalee, 259, 260, 606, 747n25, 759n9
Newman, Arnold, 258
Newman, Barnett (Barney), 97, 179, 259, 260, 281, 293–94, 418, 464, 606, 657, 663, 697, 714, 759n9
New Republic, 108, 176
New School for Social Research, 111, 299, 302, 317
New Talent in the U.S.A. (New York, 1956), 602
New Yorker, 104, 207, 230, 299, 418
New York Herald Tribune, 91, 101, 131, 132, 231–32, 294, 348, 418, 496, 601, 602, 687
New York Post, 57
"New York School," coining of phrase, 269, 773n50
New York Times, 40, 88, 91, 107, 112–13, 196, 229, 231, 257, 273, 291, 303, 312, 323, 343, 417, 476, 601, 631, 638, 652, 663, 673, 680, 688, 714
New York University (NYU), 25, 111, 227, 285
New York World-Telegram, 231, 257
Nineteen Living Americans (New York, 1929), 440–41
Ninth Street Show (New York, 1951), 5–15, 400, 411–13, 421, 441, 471, 569, 602; announcements designed by Kline for, 12, 411; cooperative art gallery movement and, 729n39; as first "Stable Annual," 472; hanging of, 7, 11–12, 728n26; inclusiveness issue and, 6, 411; opening of, 12–13, 729n35; paintings transported to, 7–8; planning committee for, 6; preparation of exhibition space for, 6–7; storefront rented for, 5–6, 728n4; submission and acceptance of works for, 8–9, 411; success of, 13, 412–13; unity of work in, 12; women exhibited at, 9–11, 728n16

Nixon, Richard M., 453, 493
"NO! Art" movement, 686
Nochlin, Linda, 549
Noguchi, Isamu, 52, 191, 224, 441, 474, 787n35
Noland, Cornelia, 321
Noland, Kenneth, 220, 664, 714; Frankenthaler's *Mountains and Sea* and, 478–79
nontraditional materials, 200
nuclear weapons, 301, 303, 338, 588; hydrogen bomb, 301, 680, 779nn28–29. *See also* atom bomb

Obolensky, Serge, 343
O'Hara, Frank, 3, 193, 291, 416, 422, 425–31, 428, 500, 520, 531, 533, 541, 556, 617, 620, 637, 642, 664, 669–70, 674, 688, 689, 697, 705; "Adieu to Norman, Bon Jour to Joan and Jean-Paul," 694; "L'Amour avait passé par là," 691–92; artists' spirits buoyed by, 485–87; Artists' Theatre and, 491; Beats and, 652; circle of New York School artists and poets entered by, 429–31; *A City Winter and Other Poems*, 437; dancing at the Club, 432–33; death of, 706, 714; on development of younger artists, 510; family background of, 425, 436; at Five Spot, 635–37; "For Grace, After a Party," 630; Frankenthaler retrospective (1960) and, 712; Frankenthaler's relationship with, 643; Goldberg's relationship with, 536, 538, 567, 694; *Hartigan and Rivers with O'Hara* (New York, 1959), 692; Hartigan's relationship with, 10, 433, 435–36, 437, 438, 485–87, 495, 549–50, 557, 626–27, 628, 629–30, 678–79, 691–92, 705, 706–7, 804n125; homosexuality of, 426, 436, 630, 802n33, 804n125; invited to the Club, 425, 431, 432–33; on Kline's paintings, 334; *Meditations in an Emergency*, 643; military service of, 425–26; Mitchell's friendship with, 470, 536, 624; "Nature and New Painting," 561; *New American Painting* (1958) and, 657, 678, 679; *Oranges*, 486–87, 488, 514, 692; physical

appearance and demeanor of, 425, 429–30; "Poem Read at Joan Mitchell's," 641; "Portrait of Grace," 438; Rivers's relationship with, 430, 495, 692; "Second Avenue," 489; shot by street thugs, 521–22; Stable Gallery and, 474; "A Step Away from Them," 629; *Stones*, 692; working at Museum of Modern Art, 430–31, 489, 514, 627–28, 657; writing for *ArtNews*, 513, 514, 627
O'Keeffe, Georgia, 35, 197, 552, 765n90
Oppenheim, Méret: *Object*, 116
Orlovsky, Peter, 652
Orozco, José Clemente, 372
Osaka International Festival (1958), 662
Osato, Timothy, 367
Osgood, Lawrence, 485
Ossorio, Alfonso, 306, 350, 409, 461–62, 464, 473, 534, 614, 788n57; East Hampton estate of (the Creeks), 462, 628–29, 645; Krasner's post-Pollock life and, 630, 673; Pollock paintings sold to, 257, 337, 462; Pollock's death and, 612, 615, 616; Pollocks' stays at MacDougal Alley carriage house of, 277, 294, 406; Signa Gallery and, 628
Oxbow, Saugatuck, Mich., 368–69, 371–72, 378

Panofsky, Erwin, xv
Pantuhoff, Igor, 23–24, 26, 27, 29, 34, 42–43, 48, 57, 92, 231, 734–35n48; Krasner's breakup with, 49, 50, 80
Park, Charlotte, 543, 616, 673, 782n85
Parker, Charlie, 105, 588
Parker, Elizabeth, 628
Francis W. Parker School, Chicago, Mitchell and Rosset at, 365–67, 375
Parsons, Betty, and Betty Parsons Gallery, New York, 232, 340, 346, 377, 415, 471, 472, 512, 553, 584, 608; as artist in her own right, 179; decision to represent Pollock, 178–79; exodus of Pollock and other artists from (1952), 462–63; Krasner dismissed by, 463, 464, 473, 501, 502, 853n85; Krasner's 1951 show at, 409, 410, 414, 416–17, 420, 463; on Pollock's paintings, 206; Pollock's 1948 show at, 203, 205, 206–7, 212–13, 247, 252, 378, 763n27; Pollock's 1949 show at, 255–57, 277–78; Pollock's 1950 show at, 300, 303, 308, 311, 336–37, 350; Pollock's 1951 show at, 420, 461
Partisan Review, 45, 46, 150, 174, 176, 216, 229, 322, 324, 335, 378–79, 420, 453, 458, 577, 580, 688, 696–97
Passlof, Pat, 220, 226, 227–28, 280, 302, 345, 511, 532, 684
Patton, George S., 159
Pavia, Philip, 77, 109, 118, 191, 192, 210, 213, 227, 322, 419, 467, 484, 531, 532, 535, 618, 787n36; the Club and, 279, 280, 281, 282–83, 395, 432, 493, 588, 775n58; Hess's *Abstract Painting* and, 423–25; Monroe's visit to, 633–34; Ninth Street Show and, 6, 12, 13, 728n28; on Pollock's first drip paintings, 205; on refugee artists in New York, 110, 111–12; on Waldorf Cafeteria, 112, 113, 168, 279
Pease, Roland, 488
Penn, Arthur, 220, 221
Perry, Beatrice "Beati," 690, 705, 706
Phillips, Edna, 335, 336
Phillips, William, 335, 336
Picasso, Pablo, 21, 22, 25, 26, 35, 41, 46, 50–51, 68, 83, 84, 92, 97, 113, 114, 154, 174, 180, 206, 214, 247, 267, 273, 304, 321, 346, 373, 385, 392, 441, 498, 551, 570, 679, 746n63; *Demoiselles d'Avignon*, 460; faulted for lack of strong response to Second World War, 193; *Guernica*, 51, 70, 79, 85, 98, 193, 208, 736n37; New York artists acknowledged by, 45, 46
Pink Slips over Culture (New York, 1937), 42
Plath, Sylvia, 494, 560
Playboy, 475
Poetry, 361, 363, 364, 429, 537
Politics, 176
Pollack, Reggie, 645, 649, 847n79
Pollock, Alma (sister-in-law), 157, 207, 297
Pollock, Arloie (sister-in-law), 84, 87
Pollock, Charles (brother), 85, 86, 87, 297

Pollock, Jackson, xiv, 12, 22, 69, 84–87, 92–99, 113–18, 152–57, 161, 166, 170–72, 201, 202, 203–8, 229, 230–33, 241, 251, 255, 285, 294–300, 303–8, 330, 331, 334, 343, 349, 350–52, 365, 396, 408–11, 418, 423, 431, 439, 461–67, 482, 496, 500–503, 551, 578–83, 584, 593, 596–601, 604–21, 628, 642, 649, 653, 654, 679, 729n6, 742n13, 763n49; ankle broken by, 527, 535, 543, 578; art investors and, 551, 578; Art of This Century shows, 129–30, 171, 175, 176, 178, 214; art training of, 85, 86; *Autumn Rhythm*, 621; Betty Parsons shows, 178–79, 203, 205, 206–7, 212–13, 247, 252, 255–57, 277–78, 300, 303, 308, 311, 336–37, 350, 378, 420, 461, 763n27; *Birth*, 93, 94; black-and-white series (1950–51), 420, 461, 481, 497, 697; *Blue Poles* (also known as *Number 11*), 464, 473, 501, 578, 809n54; car accidents of, 420, 613–15; celebrity of, 270, 271–73, 277–78, 294–95, 299–300, 678, 773n56; childhood of, 85–86; coexistance of visionary and real for, 420–21; death of, 611–21, 629, 697, 698; disdainful remarks about paintings of, 271–72; drinking of, 86–87, 93, 99, 153, 172, 176, 178, 188, 189, 214, 216, 231, 232–33, 252, 256–57, 274–75, 277, 296, 306–8, 336–37, 350, 351–52, 406, 420, 461–62, 463, 466, 500, 502–3, 504, 533, 579–80, 597, 599, 613, 614; Dzubas influenced by, 458; *Easter and the Totem*, 606; Elaine de Kooning challenged to wrestling match by, 534–35; financial worries of, 207–8, 214, 462; first drip paintings, 203–6, 208, 460, 461, 481; First Generation designation and, 344–45; flirtations with other women, 216, 231, 600, 605, 606, 760n44, 767n32; Frankenthaler influenced by, 311–12, 337, 349, 409–10, 411, 458, 459; Frankenthaler's first social encounter with, 336; funeral for, 616–18; Gorky retrospective and, 350, 352; Gorky's fight with, 214–15; Goodnough's *ArtNews* article on, 408–9; Graham's *French and American Painting* show and, 84, 92–94; Graham's relationship with, 97–98; Greenberg's denigrations and estrangement from, 466, 467, 577, 580, 586, 699; Greenberg's 1955 visit to, 580–81; Greenberg's relationship with, 172, 173, 175–76; Greenberg's reviews of, 175–76, 206, 420, 758n17; Guggenheim's monthly stipend and contractual arrangements with, 129–30, 153, 156, 179, 203, 207, 214, 609; Guggenheim's mural commission and, 129–30, 750n51, 754n37; Guggenheim's 1943 juried Spring Salon and, 121, 129; Guggenheim's show in Venice (1950), 295, 297, 300, 304; Hartigan influenced by, 247, 252–53; Hartigan's *The King Is Dead* and, 346–47; Heller's treatment of, 232–33, 257, 296, 300, 351, 768n44; Hess's *Abstract Painting* and, 424; Hofmann's first meeting with, 96; influence on younger artists, 841n115; Janis's business dealings with, 114–15, 462–63, 464, 503, 533, 671–72, 697, 853n85; Janis shows, 464, 586, 620–21, 671; Jenkins's 1956 visit to, 600–601; Kligman's affair with, 598–600, 604, 605, 606, 607, 612–13, 616; large format and, 203–6, 208, 332, 337, 441, 462; *Lavender Mist*, 305; Lee as executor of estate of, 619, 620–21, 671–72, 697, 699, 701, 853n85; Lee as promoter and secondary dealer for, 117–18, 121, 129–30, 156, 157, 171, 172, 173, 181, 207, 214, 215, 232, 252, 256–57, 258–59, 272, 295, 604, 609; Lee eclipsed by notoriety of, 294–95; Lee's collages and, 501; Lee's European sojourn (1956) and, 604, 605, 606–7; Lee's first encounters with, 50, 84–85, 87; Lee's first year without, 630–32, 644–45; Lee's relationship with, 9, 24, 92, 93–99, 113–14, 115, 117–18, 153–54, 155–56, 171–72, 176–77, 188–89, 230–31, 232, 274–75, 295, 351, 416–17, 543, 579–82, 583, 597–98, 605–11, 612, 613; letter protesting Metropolitan Museum's *American Painting Today* show and, 294–95, 305; *Life* article on (1949), 258–59, 270, 271–73, 276, 277, 294,

298, 336, 348, 625, 774n5; living on sale of his art as goal of, 114, 115, 118, 129, 203, 214; London dealer sought for, 582, 833n55; *Magic Mirror*, 85; *Male and Female*, 113; Mitchell compared to, 539; *The Moon Woman*, 113; mother's relationship with, 99, 116; Motherwell's friendship with, 116, 170–71; move to Springs, 152, 154–55, 156–57, 170–72, 176, 500 (*see also* Springs, N.Y., Pollocks' home in); Museum of Modern Art retrospective (1956), 601, 620; Museum of Modern Art's acquisitions, 115, 176, 257, 579, 621, 772n20; Namuth's photos and movie of, 298–99, 300, 303–4, 305–6, 397; *New American Painting* (1958) and, 657, 658, 664; *Number 1*, 658; *Number 14*, 642; *Number 17*, 270; Oldsmobile swapped for paintings by, 542; physical appearance and demeanor of, 92, 276, 341; *Portrait and a Dream*, 503; prices for works by, 551, 620–21, 671; Red House incident (1954), 533, 534–36; retrospective exhibition at Bennington College (1952), 464–66; Rosenberg's "Action Painters" and, 466–68; sanitized-for-public-consumption version of, 549; *The She-Wolf*, 115, 130; Southgate's interventions and, 533–34; *Stenographic Figure*, 113, 121; *Summertime*, 258, 348; Surrealists' sexism disdained by, 116–17; therapist seen by, 581, 597–98; *Time*'s disparaging articles on, 299, 303, 304–5; titles given works by, 175, 256, 771n8; Venice Biennale and, 303, 441–42; violent outbursts of, 214–15, 231, 232, 579–80; wedding of, 155–56; welding considered by, 605. *See also* Springs, N.Y., Pollocks' home in
Pollock, Jay (brother), 157, 297
Pollock, Sande McCoy (brother), 84, 87, 99, 297
Pollock, Stella (mother), 99, 116, 171, 297, 503, 618
Pollock-Krasner Foundation, 702
Pop, 601, 655, 680, 706, 708, 837n80, 850n57
Porter, Anne, 101–2, 104, 137, 494
Porter, Fairfield, 101–2, 137, 265, 473, 499, 509, 584, 685; Elaine de Kooning's focus on portraiture inspired by, 102, 104, 494–95; Gorky as viewed by, 350; Greenberg's "American-Type Painting" rebutted by, 577; on Krasner's collages, 502, 584; Rivers's suicide attempt and, 499; visitors to Southampton home of, 494–95, 541, 576; writing for *ArtNews*, 350, 449, 476, 516
Possibilities, 201, 271, 378
Post, John Lee, 621
Potter, Jeffrey, 272, 274, 304–5, 306, 307–8, 535, 605, 618
Potter, Penny, 306, 618
Powell, Diana, 633–34
Prado Museum, Madrid, 45
Pratt Institute, Brooklyn, 285, 702
presidential elections: of 1948, 233, 234; of 1952, 452–53, 493
Presley, Elvis, 588
Price, Vincent, 278
Price, Winston, 705, 706, 707
primitive art and imagery, 35, 85, 97
Princeton University, 351
Problem for Critics, A (New York, 1945), 154
Progressive Party, 233
Prohibition, 27, 504
Proust, Marcel: *Remembrance of Things Past*, 100
Provincetown, Mass.: de Koonings' 1949 sojourn in, 264, 267–70; Elaine de Kooning's 1945 trip with Hardy to, 158–59, 182, 262; Forum '49 in, 269, 270, 271–72; Hofmann's school in, 48–49, 264, 267–68, 326–27
psychoanalysis, 111, 746n12
Purdy, H. Levill, 84
Putzel, Howard, 115, 119, 120–21, 129, 130, 153, 154, 231, 264

race relations, 199, 588
Randall, Margaret, 574, 681, 682
Rankine, V. V., 217, 218
Raphael, 56, 64
Rauschenberg, Robert, 220, 328, 473, 474, 653, 680, 810n41; Ninth Street Show and, 12, 411, 569

Read, Herbert, 167
Reader's Digest, 554
Rebay, Hilla, 70–71, 95, 114, 119, 125, 676, 805n23
Red Cross, 120
Red House, Bridgehampton, N.Y. (1954), 530–32, 540–44; Bill de Kooning's mother's visit to, 530, 531–32; furniture donated for, 531, 534; legendary blowout at, 540–42; Pollock incident at, 533, 534–36; slammed by Hurricane Carol, 542–43
John Reed Club, New York, 28, 60
regionalism, 62–63
Reich, Wilhelm, 111
Reinhardt, Ad, 12, 166, 293, 639, 655
Reis, Bernard, 582, 827n45
Reis, Rebecca, 582, 663
Rembrandt, 64, 68, 98
Renoir, Auguste, 472, 516, 677
Resnick, Milton, 60, 63, 69, 93, 176, 191, 200, 257, 277–78, 282, 292, 433, 446, 473, 509, 604, 605, 739n26; Elaine de Kooning's romance with, 61–62, 71, 72, 159, 160; military service of, in Second World War, 92, 159–60, 166, 345, 629; Ninth Street Show and, 5–6, 7, 12
Revista (Barcelona), 666–67
Reynal, Jeanne, 128
Rich, Adrienne, xiii–xiv, 165
Rich, Daniel Catton, 198
Richard, Helen, 365
Richard, Paul, 715
Rieger, Charles, 97
Riesman, David: *The Lonely Crowd*, 186, 827n56
Rilke, Rainer Maria, 100, 271, 486, 565, 608
Rimbaud, Arthur, 98, 425, 555, 556; *A Season in Hell*, 50
Riopelle, Jean-Paul, 650–51; marriage of, 573, 651, 693; Mitchell's relationship with, 571–72, 573, 602, 603, 650–51, 653, 689, 693, 694, 695–96, 708, 709, 710; Mitchell's relationship with daughters of, 710; physical appearance and demeanor of, 571, 650–51; Rosset's opinion of, 653
Ripley, Dwight, 344, 489

Rivers, Larry, 37, 105, 149–50, 160, 229, 250, 251, 264–67, 286, 292, 335, 338, 393, 394, 407, 419, 428, 429, 431, 432, 433, 435–36, 449, 472, 473, 481, 488, 490, 491, 498, 509, 516, 520, 522, 531, 534, 536, 541, 551, 552, 585, 596, 601, 628, 629, 634, 643, 645, 647, 669, 689, 708; art history studied by, 433–34; art training of, 265–66, 267–68; drug use of, 264, 265, 266, 422, 499–500; family background of, 264, 266; on fight of Hartigan's paramours, 646–47; figurative elements in abstractions by, 505–6, 512, 561; financial worries of, 437; at Five Spot, 635–37; Frankenthaler's relationship with, 423, 476–78, 519; full-length nude portrait of his teenage son, 646; on GI Bill's impact on arts, 228; *Hartigan and Rivers with O'Hara* (New York, 1959), 692; on Hartigan's interest in career vs. men, 558; Hartigan's relationship with, 495, 505–6, 513, 556, 557, 692; as jazz musician, 264–65, 266, 499, 635; Keene's bookstore and gallery and, 646; literary influences on, 486; Marisol compared to, 509–10; O'Hara's relationship with, 430, 495, 692; Pollocks visited by (1951), 410–11; Pop art and, 837n80; prices for works by, 551; recruited for Tibor de Nagy Gallery, 787n53; Second Generation designation and, 344–45; on *The $64,000 Challenge*, 632–33, 845n119; in Southampton (1953), 495, 499, 505–6; *Stones*, 692; suicide attempt of, 499; unconventional domestic arrangements of, 264, 266, 267; *Washington Crossing the Delaware*, 505–6, 507, 510, 658
Rockefeller, Mrs. John D., III (Blanchette), 278, 483
Rockefeller, Mrs. John D., Jr., 25
Rockefeller, Nelson, 552–53, 601, 657, 689, 837n79, 843n66
Rodgers, Gaby, 321, 323, 328, 337, 353, 418, 588, 643, 670
Rodin, Auguste, 25, 271, 330, 483–84, 556
Rodman, Selden, 596

Romantic ideals, 195–96, 286, 761n2
Roosevelt, Eleanor, 44, 108
Roosevelt, Franklin D., 29, 30, 31, 42, 44, 52, 74, 88, 89, 107, 127, 135, 301; death of, 146–47
Rosati, James, 413
Rose, Barbara, 113, 114, 625, 687, 702
Rosenberg, Ethel and Julius, 303, 494, 568
Rosenberg, Harold, 29, 78, 156, 173, 193, 195, 196, 302, 446–50, 482, 492, 552, 619, 623, 632, 677, 730n37; "The American Action Painters," 447–50, 466–67; artists' culture elucidated by, 201, 273, 421; Artists Union and, 28; the Club and, 280, 281, 413; Elaine de Kooning's portrait of, 594–96; Elaine de Kooning's sexual affair with, 450; Federal Art Project and, 30–31, 33–34; on Hofmann and his school, 38, 39, 656, 773n43; intellectual kinship of Elaine de Kooning, Hess and, 447–51; Krasner's first encounters with, 27; physical appearance and demeanor of, 27; on social life in mid-1950s, 509
Rosenberg, May Tabak. *See* Tabak, May Natalie
Rosenberg, Patia, 188
Ross, Clifford (Frankenthaler's nephew), 313–14, 317, 320, 324
Ross, Gloria (Frankenthaler's sister), 314–15, 418, 525, 526, 663
Rosset, Astrid Myers, 374–75
Rosset, Barnet Lee, Sr. (Barney's father), 366, 376, 385–86, 391, 469, 470
Rosset, Barney, 10, 357–61, 374–76, 393–94, 422, 425, 495–98, 536, 564, 618, 624, 643, 651, 692, 708, 711, 815n92; Beat writers published by, 651–52; Beckett published by, 497–98, 536; Brooklyn apartment of, 377, 378; Cuba trip of (1950), 391; drinking and drug use of, 374–75; East Hampton first visited by (1951), 415–16; end-of-season party thrown by (1958), 674–75, 854n105; as filmmaker, 374, 375, 378, 382, 384, 385, 391, 416; financial resources of, 387; girlfriends of, after divorcing Mitchell, 496–97, 498, 536; Goldberg's check forgery and, 398–400;

Grove Press bought by, 416; growing up in wealthy Chicago family, 366; Hamptons real estate bought by, 536, 674; in high school with Mitchell, 365–66; living in France (1948–49), 357–61, 385; military service of, 374–75; Mitchell's divorce from, 469–70, 495–96; Mitchell's first complete abstractions and, 359; Mitchell's gallery representation and, 414–15; Mitchell's marriage to, 360–61, 385–86; Mitchell's Paris sojourns (1955–57) and, 569, 570, 572, 573, 653; as Mitchell's protector, 359; Mitchell's relationship with, 357, 358, 359, 360–61, 370, 373–74, 375–76, 377–78, 379, 384, 391, 393, 397, 398, 399–400, 415–16, 470–71, 495–97, 536, 653; Mitchell visited in France by (1948), 381, 382–83; New York homes of, 387, 393; Prague visited by (1948), 384–85; radical politics and, 357, 359, 375, 390; return to New York (1949), 357, 360–61, 385–87, 389–90; working for U.N., 389, 391
Rosset, Loly Eckert (Barney's second wife), 497, 498, 536, 564
Rosset, Mrs. Barnet Lee, Sr. (Barney's mother), 376, 385, 564
Rothko, Mark, 97, 114, 154, 247, 251, 273, 334, 349, 377, 439, 551, 644, 657, 663, 689, 714; change in financial fortunes of, 622–23; Elaine de Kooning's visits to studio of, 595–96
Rubenfeld, Florence, 450
Rubin, William, 258, 290, 442, 709, 842n32
Rudikoff, Sonya, 320–21, 330, 335, 336, 338, 349, 406, 407, 418, 419, 520, 523, 525, 527, 528, 529, 576, 583, 648, 663
Russell, John, 631
Russian Revolution, 41, 196
Ryan, Anne, 416, 728n16

Sackler, Howard, 585, 587, 609
Sagan, Françoise, 55, 122; *Bonjour Tristesse*, 555–56
Sam Johnson's nightclub, New York, 27, 521

Samuel, Spencer, 698
Sander, Lutz, 12, 90, 92, 166, 167, 281, 282, 283; Red House summer (1954), 530, 531, 532, 540, 542
Sanders, Joop, 73, 138, 184, 267, 269, 531, 532
Sandler, Irving, 368, 390, 440, 449, 479, 509, 543, 553, 621, 640, 654, 711, 768n57; "Mitchell Paints a Picture," 623–25, 650
San Francisco Museum, 442
San Remo, New York, 324, 337–38, 397, 435, 521
Sartre, Jean-Paul, 168–70, 210, 331, 383, 447, 491, 756n23; *Existentialism and Humanism*, 169–70
Satie, Erik, 101, 221, 226, 746n63
Saturday Evening Post, 752n52
Saturday Review, 623
Schaefer, Bertha, 231–32
Schapiro, Meyer, xv, 292, 321, 329, 331
Schapiro, Miriam "Mimi," 391–92, 393, 495, 535–36, 539, 634, 663, 811n51
Schimmel, Paul, 837n80
Schjeldahl, Peter, 696
Schloss, Edith (Burkhardt), 100, 101, 102, 103, 104, 106, 123, 124, 131, 158–59, 191, 212, 267, 396, 432, 483–84, 509, 685, 703, 705
Schnabel, Day, 606, 728n16
Schoenberg, Arnold, 111
School of Paris, 35, 87, 92, 93, 112, 165
Schuyler, James, 427–28, 429–30, 431, 491, 550, 557, 627–28, 641
Schwartz, Delmore, 149, 335
Scolari-Barr, Marga, 79, 80
Seckler, Dorothy, 566
Second Generation, 6, 10, 13, 331, 335, 431–32; "Clem's stable" and, 329, 411, 438; differences between First Generation and, 344–46; First Generation's disparagement of, 417–18; Kootz's *Talent, 1950* show and, 292, 329; Leslie's response to, 285–86; Myers's focus on, 338–39, 341, 344, 347; shift of attention to, 601–2; thespian acts of, 499. *See also specific artists*
Seiberling, Dorothy, 258, 271, 625
Seitz, William, 196, 805n22

Sekula, Sonia, 251–52, 728n16
Jacques Seligmann Gallery, New York, 321–22
Sesee, Donna (Hartigan's niece), 249
Seventeen, 209
Severini, Gino, 119; *The Artist and Society*, 151, 152
Shahn, Ben, 197, 528
Shrauger, William, 221
Siegel, Eli "Deutsch," 27
Siegel, Leonard, 581, 832n47
Signa Gallery, East Hampton, N.Y., 628–29, 632, 633, 646, 698
Silver, Walt, 434–35, 486, 495, 541, 548; Hartigan left by, 557–59
Siqueros, David, 85
$64,000 Challenge, The, 632–33, 845n119
Slivka, Rose, 55, 290–91, 618, 632
Smith, David, 12, 87, 141, 201, 202, 465–66, 619, 649, 664, 688, 713–14, 742n13, 765n99, 809n67, 857n90; death of, 714; Pollocks' overnight stop at Vermont home of, 465–66
Smith, Gregory White, 599–600
Smith, Herbert, 375
Smith, Tony, 276, 285, 464
Soby, James Thrall, 120–21, 623, 628
social realism, 34, 45, 63, 67, 528
Société Anonyme, 25
Solomon, Deborah, 709
Sotheby's, London, 677
Southgate, Patsy, 171, 533–34, 581, 598, 612, 616, 674, 693–94, 823n36
Soutine, Chaim, 211, 424
Soviet Union, 45, 48, 381, 384, 627; Cold War and, 196–200, 494, 654, 656; mass murder under Stalin in, 199; nuclear weapons developed by, 301, 303; Second World War and, 88, 91
Spain, Motherwell and Frankenthaler's forced departure from, 664–65, 666–67
Spanish Civil War, 41–42, 49, 52, 63, 193, 299, 300, 345, 391, 664. *See also* Guernica, Spain, bombing of
Spaventa, Giorgio, 166, 629, 646–47
Speyer, Darthea, 611
Spillenger, Ray, 228
Spivak, Max, 30–31, 62

Spock, Benjamin, 248
Springs, N.Y., Pollocks' home in, 702; artistic breakthroughs at, 172, 177–78, 203–6, 409; daily routine at, 204, 207–8, 230–31; de Koonings' visits to, 176, 177, 214, 215; dire financial situation and, 207–8; disastrous dinner party at (1950), 305–8, 336; Frankenthaler's 1951 visit to, 409–11; Greenberg's 1955 visit to, 580–81; Hartigan's 1948 visit to, 252–53; heat and hot water at, 170, 257; Hurricane Carol (1954) and, 543; Jenkins's 1956 visit to, 600–601; Lee as gatekeeper at, 189; Lee's activism and, 295, 297–98; Lee's decision to only spend summers at, 670–71; move to, 152, 154–55, 156–57, 170–72, 176, 500; Myers's 1949 visit to, 343; Namuth's film of Jackson painting at, 298–99, 300, 303–4, 305–6, 397; Pollock family gathering at (1950), 297; studios at, 170, 172, 177, 204, 207, 502, 605, 631; summer of 1950 at, 296–300, 303–8; summer of 1951 at, 408–11; summer of 1952 at, 461–64; summer of 1953 at, 500–503; summer of 1954 at, 533–35, 543; summer of 1955 at, 578–83, 597; summer of 1956 at, 605–7, 613–19; summer of 1957 at, 630–32; summer of 1958 at, 674; uninvited visitors to, 296–97
Sputnik II (1957), 654
Stable Gallery, New York, 472–74; Elaine de Kooning's shows at, 512–13, 515–16, 594, 639–40; Krasner's 1955 show at, 583–84, 597; Mitchell's shows at, 473–74, 496, 566, 623, 624, 653, 694–95; Stable Annual exhibitions, 472–73, 520, 556, 811n46; *U.S. Painting: Some Recent Directions* (1955), 567, 574; *Vanguard 1955*, 566, 587
Stalin, Joseph, 31, 48, 88, 169, 199
Stamos, Theodoros, 115, 121, 291, 323, 328, 618
Stankiewicz, Richard, 474
State Department, U.S., 80, 107–8, 234; *Advancing American Art* exhibition (1946) and, 197–98, 202, 656; McCarthy's allegations against, 301–2

Stefanelli, Joe, 289
Stein, Gertrude, 101, 110, 255, 608
Stein, Ron (Krasner's nephew), 583, 612, 616, 696
Stein, Ruth (Krasner's sister), 22, 203, 207, 231
Steinberg, Saul, 569, 572
Stella, Frank, 680
Stephan, Ruth, 201
Sterne, Hedda, 97, 121, 291, 305, 349, 387, 451, 474
Steubing, Jean, 5–6, 728n16
Stevens, Rex, 246, 248–49, 251, 276, 286–87, 435, 558, 689, 690, 707
Stevens, Wallace, 44, 486
Stevenson, Adlai, 452–53, 493
Stewart's Cafeteria, New York, 58, 102, 103, 104, 131
Stieglitz, Alfred, 24–25
Still, Clyfford, 439, 577
Strange Victory, 375, 378, 382, 384, 385
Stravinsky, Igor, 101, 178
Strobel, Charles (Mitchell's grandfather), 361, 362, 364, 709, 790n46
Studio 35, New York, 276–77, 279, 292–93, 294, 394
Subjects of the Artist, New York, 230, 251, 263, 269, 276, 292–93, 394, 648; Bill de Kooning's lecture at, 259–60, 772nn36 and 39; three-day symposium at, on issues confronting New York artists, 293
Sullivan, Harry Stack, 577
Sullivan, Mrs. Cornelius J., 25
Surrealism, Surrealists, 7, 29, 35, 57, 70, 85, 97, 118, 152, 168, 198, 291, 746n9; advertising art and, 198; aesthetic response to postwar world and, 165; coining of term, 746n63; European, in wartime New York, 110, 114, 116–17, 120, 130, 180, 193, 230; Gorky and, 180, 193, 222, 223, 225; Guggenheim and, 120, 130; as influence on abstractionism, 801n16; Motherwell and, 116, 230, 648; Museum of Modern Art's 1936 show on, 36; Myers's involvement with, 341, 342, 343; returned to postwar Europe, 342; sexism and sex games of, 116–17, 180, 223

Sweeney, James Johnson, 115, 120–21, 214, 252
System and Dialectics of Art (Graham), 68–70, 83, 85, 169

Tabachnick, Anne, 267
Tabak, May Natalie (Mrs. Harold Rosenberg), 29, 33, 49, 66, 157, 173, 446, 663; on artist "housewife," 813n34; on Krasner's decision not to have children, 188; Pollock first encountered by, 96; Pollock's wedding and, 155–56; on sexual prejudices in abstract movement, 552
Talent, 1950 (New York), 292, 329, 335, 778n64
Tamayo, Rufino, 255, 316, 317, 688
Tanager Gallery, New York, 640, 662
Tanguy, Yves, 119, 120
Tanning, Dorothea, 120, 273
Tate Gallery, London, 679
Taylor, Cecil, 636
Taylor, Frances H., 234, 293
television age, dawn of, 234, 768n53
Teller, Edward, 111, 654
Temps Modernes, Les, 447
Ten East Hampton Abstractionists (East Hampton, N.Y., 1950), 295, 298–99
Termini, Iggy, 635
Termini, Joe, 635, 659
Thaw, Eugene, 415, 423, 701
theosophy, 86
"They're Painting Their Way" (Arb), 209
Thomas, Caitlin, 503
Thomas, Dylan, 281, 503–4, 521
Thomas, Yvonne, 728n16
Thomson, Virgil, 101, 104, 138, 139, 395
Tibor de Nagy Gallery. *See under* Nagy
Tiger's Eye, 201, 230, 378
Time, 202, 257, 299, 303, 304–5, 378, 480, 538, 586, 596, 600, 658, 666
Toklas, Alice, 383
Tomlin, Bradley Walker, 271, 281, 467, 473; death of, 500–501
Toscanini, Arturo, 111
Trilling, Diana, 335
Trilling, Lionel, 216, 335
Trotsky, Leon, 22, 31, 33, 48, 331, 395; "Art and Politics," 45, 46

Truman, Harry S., 146, 148, 149, 197–98, 199, 233, 234, 301, 302, 318, 338, 703
12 Americans (New York, 1956), 601–2
291 Gallery, 25
Tworkov, Jack, 12, 31, 104, 165–66, 281, 474, 515, 516, 538, 657
Tworkov, Rachel "Wally," 104
Tyler Graphics, 711

Uris Building, New York, 696
U.S. Painting: Some Recent Directions (New York, 1955), 567, 574

Vail, Laurence, 119, 120
Valliere, James, 671, 853n85
Vanderbilt, Gloria, 507
van der Schelling, Bart, 134
van Gogh, Vincent, 25, 26, 35–36, 38, 46, 98, 363, 373, 424, 551, 570, 572, 609, 656, 677
Vanguard 1955 (traveling exhibition), 566, 587
Van Horne, Janice "Jenny" (Mrs. Clement Greenberg), 577, 578, 585–86, 587, 597, 599, 604, 613, 615, 618, 620, 648, 673, 697, 698, 699
Varèse, Edgard, 97, 103, 142, 281, 396, 797n64
Varnadoe, Kirk, 308
Vassar College, 549
Velde, Bram van, 603
Venice Biennale, 295, 303, 441–42, 529, 604, 664, 668, 669, 714
Vermeer, Johannes, 551
Vicente, Esteban, 6, 55, 280, 532, 639
View, 168, 341, 342, 343
Villers, Marie Denise, 801n38
Vonnegut, Kurt, 687

Waldorf Cafeteria, New York, 112–13, 130, 140, 213, 349, 521; founding of the Club and, 279, 281; postwar scene at, 166, 167–68, 189–90, 191, 192
Waldron, Mal, 636–37
Wallace, Henry, 233, 319
Ward, Eleanor, 472, 473, 474, 512–13, 553, 566, 583, 621, 623, 640, 653, 657. *See also* Stable Gallery, New York

Ward, Joan, 446, 452, 511, 605, 618, 638, 639, 846n30; daughter's birth and, 593–94; pregnancies of, 516–17, 542, 573–74, 593
Ward, Nancy, 446, 452, 483–84; Red House summer (1954), 530, 540, 542
War Manpower Commission, 144
Warren, Vincent, 689, 691
War Services Department, 94, 114
Washington Post, 715
Weill, Kurt, 103
Weinberg, Harold, 521
Welles, Orson, 74
Weltwoche, Die (Zurich), 658
"We Will Never Die" (New York, 1943), 108
White, E. B., 287, 485
Whitechapel Gallery, London, 701
Whitney, Gertrude Vanderbilt, 26
Whitney Museum of American Art, New York, 26, 119, 193, 194, 247, 345, 513, 549, 623, 643, 669, 708, 710, 711, 714; Gorky retrospective (1951), 349–50; Hartigan paintings acquired by, 513, 548, 552; *Lee Krasner: Large Paintings* (1973), 701; *Nature in Abstraction* (traveling exhibition, 1958), 662; 1955 Annual, 553, 566
Who's Afraid of Virginia Woolf (Albee), 511
Wilcox, Lucia, 616
Wilcox, Roger, 232, 614
Wild One, The, 508
Williams, Tennessee, 50, 103, 491, 576
Williams, William Carlos, 364, 486
Wilson, Jane, 290, 625, 845n119
Wittenborn, George, 111
WNYC radio, mural project for, 83, 94
Wolff, Christian, 396
Wolpe, Stefan, 396
Woman of the Year, 142
Woman Problem, 246
woman suffrage, 143
women artists, xiv, 468–69, 471–72, 758n48, 801n39; *Artists: Man and Wife* (1949) and, 273–74; Ashton's "Grand Girls," 553, 659; choices faced by First Generation vs. Second Generation, 553, 827n50; Club members' resentment of, 6; commitment question and, 660; "compliments" grudgingly given to, 39, 734n27; criticisms of, in early 1960s, 712; discrimination subject as viewed by, 457; disparaged by Greenberg and other critics, 418–19, 471, 524–25; Elaine de Kooning's research and lecture on, 268–69, 270; Federal Art Project and, 31, 44; first to gain serious attention, 842n33; gallery quota systems and, 471; institutional bias against, in postwar years, 180–81; lacking support from other women artists, 474, 659, 811n51; market for works by, xiii, 552–54, 677; married to an artist, assumed to be artistically indebted to husband, 184–85, 687, 857n7; mass media interest in, 623–27, 687; men deemed inappropriate subject matter for, 186; motherhood decision and, 187–88, 288, 760n36; signing with own name rather than husband's, 764–65n90, 788n84; story of Rodin's assistant and lover Camille Claudel and, 483–84; Surrealists' arrival in New York and, 116–17, 180; survival of obstacles faced by, 468–69, 472; "trying to be like the boys," 398; young vs. old, social and artistic landscape and, 660
women's status in society, 142–45, 729nn10 and 12; Beauvoir's *The Second Sex* and, 246, 555, 560; Bill de Kooning's *Woman I* and, 330–31; birth control and abortion availability, 760n36, 819n90; cycles of radical change in, 143–44, 752nn50 and 52; in early 1950s, 481–82, 506; Frankenthaler's rebelliousness and, 318; Friedan's *The Feminine Mystique* and, 554–55, 753n60, 812n11, 850n47, 851n92; Mead's *Male and Female* and, 274, 555; in mid-1950s, 554–56, 753n60, 827nn51 and 56; in postwar years, 144–45, 182–83, 189–91, 245–46; during Second World War, 144–45, 753nn58 and 59; sexuality and, 554–55, 827n56; Stevenson's 1952 candidacy and, 452–53; traditional role of "artist's wife" and, 182–83, 247, 299, 759n9

Woolf, Virginia, 468, 486, 548, 690, 809n4
Works Progress Administration (WPA), 29, 34, 37, 42, 177, 228, 731n57, 734n47. *See also* Federal Art Project
World Jewish Congress, 107
World's Fair (New York, 1939), 51, 73
World War I, 39, 41, 73, 78, 143, 145, 165, 197, 267, 652, 735n15
World War II, 14, 73–74, 87–99, 126–27, 135, 145–52, 154, 158, 187, 192, 225, 233, 281, 314, 321, 342, 345, 399, 427–28, 453, 507, 652, 739n50, 745n56, 769n41; anti-Semitism and violence against Jews in era of, 47, 79, 91–92, 107–8, 136, 146, 315–16 (*see also* Holocaust); art exhibitions related to, 108; artists' responses to, 8, 109, 112–13, 165–66, 195–96; artists serving in military during, 90, 92, 130, 159–60, 166–67, 168, 175, 374–75, 425–26, 742n9, 747n25; celebrating end of, 147, 148, 149–50, 158; community of damaged souls after, 159–61, 652; culture of kitsch and, 174; D-Day invasion in, 145, 159, 299; debate over artist's role in, 89; Dresden firebombing in, 136, 145; economic recovery in U.S. and, 87, 88; European artists and intellectuals seeking refuge in New York during, 7, 39, 77, 79–80, 110–13, 116–17, 119–20, 166, 174, 299, 740n13, 746n63, 747n20; experience of fighting in, 90–91; Frankenthaler family's experiences during, 314, 315–16; gay servicemen in, 426; German, Italian, and Japanese defeats in, 126–27, 145–46, 147; guilt on part of men who had not fought in, 166–67; Hartigan's employment at aeronautics plant during, 244, 245; Hiroshima and Nagasaki bombings in, 135–37, 149, 150, 154, 193, 301, 373; impact in New York of, 106–9; internment of Japanese Americans during, 106, 367; invasion and occupation of Paris in, 77–78, 119–20; Jewish-American society's responses to atrocities of, 324–25; liberation of Paris in, 145; life in France after, 380–81; mythologized by mass-culture machine, 150–51; Nazi campaigns against artists and intellectuals in lead up to, 39–40, 46–47; Nazi prisoners of war and, 175; onset of Cold War after, 196–200; Pearl Harbor attack and, 88–89, 90, 92, 244, 366–67; Picasso's lack of strong response to, 193; plots by foreigners within U.S. and, 106–7; rationing and other privations during, 106; rise of fascism in 1930s and, 39–42, 46–48, 90; "Romantic revolution" in arts after, 195–96, 761n2; Roosevelt's death and, 146–47; social norms regarding women and sexuality impacted by, 189–91, 245–46; soldiers' return home from, 151; soul-searching at end of, 150, 151–52; start of, 52, 77–79; Tokyo carpet bombing in, 136, 146; Vichy government in, 78, 80; "war psychosis" in U.S. after, 199; Warsaw Ghetto uprising in, 126; women's status in society and, 144–45
Wyeth, Andrew, 332

Yale University, Bill de Kooning's teaching job at, 332–33
Young Americans (New York, 1956), 602

Zelevansky, Lynn, 442
Zen, 395
Ziegler, Adolf, 46
Zobgaum, Wilfrid, 306, 483–84, 538, 633, 645
Zogbaum, Betsy, 99, 192, 272, 295, 306, 483–84

About the Author

MARY GABRIEL is the author of *Love and Capital: Karl and Jenny Marx and the Birth of a Revolution,* which was a finalist for the Pulitzer Prize, the National Book Award, and the National Book Critics Circle Award, as well as of *Notorious Victoria: The Life of Victoria Woodhull, Uncensored* and *The Art of Acquiring: A Portrait of Etta and Claribel Cone.* She worked in Washington and London as a Reuters editor for nearly two decades and lives in Ireland.

Also by Mary Gabriel

Love and Capital: Karl and Jenny Marx and the Birth of a Revolution

Finalist for the Pulitzer Prize
Finalist for the National Book Award
Finalist for the National Book Critics Circle Award

"A thrilling story, heroically researched, with passages on every page so startling, exact, moving, or perceptive that I wanted to quote them all. Hard to imagine that a weighty book on Karl Marx could be a page-turner, but this one is." —Elaine Showalter, *Washington Post*

"*Love and Capital* is an erudite, sensitive look at the world-changing man and, most of all, the overlooked women in his life, who sacrificed much happiness to help him evangelize his vision of class equality."
—Torie Bosch, *Slate*

"Beautifully written... The particular attraction of *Love and Capital* resides in the book's unsparing portrait of a brilliant man who would never claim responsibility for his own failures when he could easily fob them off on financial, familial, or political obstacles."
—Michael Washburn, *Boston Globe*

"*Love and Capital* is a huge, often gripping book. It gives an entertaining and balanced portrait of Marx, Engels, their colorful milieu of exiles, freaks, and revolutionaries, and the little-known Marx family, dominated by Karl's political obsession. It also details illicit love affairs, the deaths of children, and financial struggles, all based on vast research and narrated with empathetic passion." —Simon Sebag Montefiore, *New York Times*

"Mary Gabriel provides a fresh approach to this oft-examined topic...a gripping tale of intellectual abundance coupled with physical poverty."
—Jennifer Siegel, *Wall Street Journal*

Back Bay Books
Available wherever books are sold

About the Author

MARY GABRIEL is the author of *Love and Capital: Karl and Jenny Marx and the Birth of a Revolution,* which was a finalist for the Pulitzer Prize, the National Book Award, and the National Book Critics Circle Award, as well as of *Notorious Victoria: The Life of Victoria Woodhull, Uncensored* and *The Art of Acquiring: A Portrait of Etta and Claribel Cone.* She worked in Washington and London as a Reuters editor for nearly two decades and lives in Ireland.

Also by Mary Gabriel

Love and Capital: Karl and Jenny Marx and the Birth of a Revolution

Finalist for the Pulitzer Prize
Finalist for the National Book Award
Finalist for the National Book Critics Circle Award

"A thrilling story, heroically researched, with passages on every page so startling, exact, moving, or perceptive that I wanted to quote them all. Hard to imagine that a weighty book on Karl Marx could be a page-turner, but this one is." —Elaine Showalter, *Washington Post*

"*Love and Capital* is an erudite, sensitive look at the world-changing man and, most of all, the overlooked women in his life, who sacrificed much happiness to help him evangelize his vision of class equality."
—Torie Bosch, *Slate*

"Beautifully written... The particular attraction of *Love and Capital* resides in the book's unsparing portrait of a brilliant man who would never claim responsibility for his own failures when he could easily fob them off on financial, familial, or political obstacles."
—Michael Washburn, *Boston Globe*

"*Love and Capital* is a huge, often gripping book. It gives an entertaining and balanced portrait of Marx, Engels, their colorful milieu of exiles, freaks, and revolutionaries, and the little-known Marx family, dominated by Karl's political obsession. It also details illicit love affairs, the deaths of children, and financial struggles, all based on vast research and narrated with empathetic passion." —Simon Sebag Montefiore, *New York Times*

"Mary Gabriel provides a fresh approach to this oft-examined topic... a gripping tale of intellectual abundance coupled with physical poverty."
—Jennifer Siegel, *Wall Street Journal*

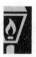

Back Bay Books
Available wherever books are sold